D0146391

Duchamp

in Context

Duchamp in Context

Science and Technology in the *Large Glass* and Related Works

Linda Dalrymple Henderson

Princeton University Press
Princeton, New Jersey

*Publication of this book has been aided by a grant from the
Graham Foundation. Additional support has been provided by the
University Cooperative Society of the University of Texas at Austin
and by the McDermott Foundation.*

Designed by Bessas & Ackerman
This book has been composed in Times and Trade Gothic

Library of Congress Cataloging-in-Publication Data
Henderson, Linda Dalrymple, 1948–
 Duchamp in context : science and technology in the Large
Glass and related works / Linda Dalrymple Henderson.
 p. cm.
 Includes bibliographical references and index.
 ISBN 0-691-05551-3 (cl : alk. paper)
 1. Duchamp, Marcel, 1887–1968. Bride stripped bare by her
bachelors, even. 2. Duchamp, Marcel, 1887–1968.—Criticism and
interpretation. 3. Art and science. I. Title.
N6853.D8A64 1998
709'.2—dc21 97-41792
 CIP

Princeton University Press books are printed on acid-free paper
and meet the guidelines for permanence and durability of the
Committee on Production Guidelines for Book Longevity of the
Council on Library Resources

Printed in the United States of America

10 9 8 7 6 5 4 3 2 1

for
George, Andrew, and Elizabeth
and my father, the late Donald Dalrymple,
electrical engineer and inventor extraordinaire

Contents

List of Illustrations

Acknowledgments

Two individuals who were very important to this project did not live to see its final form: Alexina Duchamp, the widow of Marcel Duchamp, and my father, Donald Dalrymple. Mme Duchamp offered gracious support and encouragement throughout my endeavor, and her expression of pleasure at the final manuscript of the text was a source of great satisfaction for me. Her children, Jacqueline Matisse Monnier and Paul Matisse, have likewise been very helpful. It was my father's collection of physics textbooks from his days as an electrical engineering student in the 1920s that first opened the door for me to turn-of-the-century science. Growing up with an inventor's laboratory in the basement perhaps conditioned me to undertake a study of Duchamp and science and technology. Whatever the case, my father's advice was crucial to this venture at a number of junctures.

The research and writing of this book was an eight-year odyssey, and I have been fortunate to have a number of traveling companions on my adventure. I could not have accomplished this task without the generous assistance of two scholars, Bruce Hunt and Francis Naumann. A specialist in Victorian physics at the University of Texas, Bruce Hunt was an ever-ready consultant as Duchamp successively led me from one field of science to another; he also read each chapter as it was written, providing much-appreciated advice. Francis Naumann's knowlege of the details of Duchamp's life and career and his unfailing generosity in sharing resources is legendary among Duchamp scholars. I was the beneficiary of that expertise and goodwill, along with his careful reading of the manuscript. The artist and author Tony Robbin also read chapters as they were written and offered vital encouragement as the book developed.

I owe a special debt to Robert Herbert, who first brought together the realms of art and science for me when I was a graduate student at Yale and whose scholarship continues to be a touchstone for my own. A number of other scholars have also contributed to this book in one way or another. I am grateful for the assistance of Craig Adcock, Mark Antliff, Willard Bohn, Ecke Bonk, William Camfield, Jacques Caumont, Jean Clair, Anne d'Harnoncourt, Charlotte Douglas, Gladys Fabre, Jennifer Gough-Cooper, George Heard Hamilton, Richard Hamilton, Archie Henderson, David Hopkins, Charles

Hunt, Douglas Kahn, Barbara Larson, Pat Leighten, Rose-Carol Washton Long, Herbert Molderings, Molly Nesbit, Hector Obalk, Robert Palter, Krisztina Passuth, the late Daniel Robbins, Margit Rowell, Naomi Sawelson-Gorse, Arturo Schwarz, Hélène Seckel, Jean Suquet, Athena Tacha, Calvin Tomkins, and M. E. Warlick. In addition, my work has benefited greatly from interchanges with my colleagues in the Society for Literature and Science, Donald Benson, John Greenway, Sidney Perkowitz, Martin Rosenberg, Stephen Weininger, and especially Bruce Clarke.

My colleagues and friends at the University of Texas at Austin also helped me in a variety of ways. They include John Clarke, the late Charles Edwards, Peter Jelavich, Brenda Preyer, Ann Reynolds, and Jeffrey Chipps Smith, as well as Gwen Barton, Susan Bill, Foster Foreman, Sigrid Knudsen, Michael Larvey, Emma-Stina Prescott, Nancy Schuller, Christopher Schiff, and Paul Willard. In particular, I wish to thank Richard Shiff, whose imprint on my own thinking is visible in a number of places in this book. Most numerous among my fellow travelers on this project were my graduate students at the University of Texas, many of whom participated in the Duchamp seminars I have taught in recent years. Together we came to see Duchamp in new ways, and I am most appreciative of their stimulation and companionship. Those students or former students who made specific contributions to the project, working as research assistants or helping in other ways, include John Cantú, Janis Bergman-Carton, David Cole, Anne Collins, Charles Cramer, Maria Di Pasquale, James Housefield, Sherry Jacks, Nancy Keeler, Jill Morena, Andrew Otwell, Stephen Petersen, Stephen Pinson, Wendy Salmond, Debra Schafter, Jan Schall, and David Schele, whose computer expertise was essential. Graphic design student Jana C. Wilson produced the line drawing in figure 82.

I began research for this book in 1988–89, during which time I held a John Simon Guggenheim Fellowship and a Faculty Research Assignment at the University of Texas. Several Special Research Grants from the university subsequently supported the acquisition of photographs for the book, and funding from the Jacks Travel Fund in the Department of Art and Art History assisted with travel near the end of the project. Additional support for publication came in the form of grants from the Graham Foundation and from the Eugene McDermott Foundation as well as a University Cooperative Society Subvention Grant awarded by the University of Texas. The libraries at the University of Texas facilitated my work at every stage; I am indebted to staff members at the Inter-Library Service of the Perry-Castañeda Library, the Harry Ransom Humanities Research Center, the Collections Deposit Library, and the Fine Arts

Acknowledgments

Library, whose librarians, Janine Henri and Laura Schwartz, were particularly helpful.

Many museums and collections supplied photographs for this volume, the majority coming from the Philadelphia Museum of Art. At Philadelphia, members of the curatorial staff, particularly Michael Taylor, Ann Temkin, and Marge Kline, provided crucial assistance, and the Rights and Reproductions staff over several years, Beth Rhoads, Conna Clark, Caroline Armacost, and Kathleen Ryan, always stood ready to help me. The staff of the Conservatoire des Arts et Métiers in Paris and the Deutsches Museum in Munich also offered valuable aid. Among collectors and dealers, Robert Shapazian and Guy Ladrière were especially generous in sharing information and photographs. At Princeton University Press, Elizabeth Powers served as Fine Arts Editor during the years the manuscript was in preparation; Elizabeth Johnson shepherded the book through the initial stages of production under the new editorship of Patricia Fidler. In addition to Ms. Johnson and Ms. Fidler, I owe debts to former Fine Arts Editor Eric Van Tassel, who initiated the idea, to Ms. Powers, who waited patiently as the book developed, to my excellent copy editor, Karen Gangel, and to the press's current production editor, Curtis Scott. Kathleen Friello worked with me to design the index, which she then skillfully created.

Most of all, my gratitude goes to my family for their incredible forbearance during this long endeavor. From a distance, my sisters, Ann Baird, Mary Putnam, and Nancy Sutton, each contributed special gifts to this work. It was primarily my husband and children, however, who felt the impact of this eight-year project and provided the support that enabled me to complete it. The dedication of this text to George, Andrew, and Elizabeth is but a small sign of my appreciation.

Introduction

Between 1915 and 1923 the young Frenchman Marcel Duchamp created the major work of his career, *La Mariée mise à nu par ses célibataires, même,* or *The Bride Stripped Bare by Her Bachelors, Even*, also known as the *Large Glass* (pl. 1, figs. 76, 165). Housed today in the Philadelphia Museum of Art, Duchamp's masterpiece completely transcended contemporary approaches to both technique and subject matter in painting. Composed of two panes of glass that stand over nine feet tall, the *Large Glass* incorporates such unorthodox materials as lead wire, lead foil, mirror silver, and dust, in addition to more conventional oil paint and varnish. Although his subject was ostensibly the relationship of the sexes, Duchamp presented his protagonists as biomechanical or purely mechanical creatures: a "Bride," in the upper panel, hovers over the "Bachelors" or "Bachelor Apparatus," below, among whose chief organs is a large "Chocolate Grinder."

The complex iconography of the *Large Glass,* which bears idiosyncratic names and functions for each of its elements, can be fathomed only with reference to the multitude of notes Duchamp began to make in 1912, in preparation for the work. Duchamp published these notes in facsimile in three sets during his lifetime: the *Box of 1914* (16 notes), the 1934 *Green Box* (94 documents, including 11 reproductions of works and 83 notes and drawings), and the 1966 *A l'infinitif* (79 notes). Over a decade after his death in 1968, a final group of 289 previously unknown notes was published in 1980 by the Centre Georges Pompidou under the title *Marcel Duchamp: Notes*.[1] Duchamp considered his notes an essential complement to the *Large Glass*, a logical stance for a painter who was determined, as he said, "to put painting once again at the service of the mind."[2] As he explained later, the notes, "somewhat like a Sears Roebuck catalogue," were "to accompany the glass and to be quite as important as the visual material."[3]

As André Breton wrote in his 1935 essay on the *Large Glass,* "In this work it is impossible not to see at least the trophy of a fabulous hunt through virgin territory, at the frontiers of eroticism, of philosophical speculation, of the spirit of sporting competition, *of the most recent data of science,* of lyricism and of humor."[4] Indeed, Duchamp's notes reveal a witty, iconoclastic, and probing intellect at work in pursuit of what he termed "a *reality which would be possible by slightly distending* the laws of physics and chem-

istry."[5] Yet, before the 1966 publication of *A l'infinitif,* which included a large number of notes devoted to the subject of four-dimensional geometry, scholars had not attempted to deal in any depth with the nature of Duchamp's "Playful Physics," as he described it.[6]

Since that time both my book, *The Fourth Dimension and Non-Euclidean Geometry in Modern Art* (1983), based on a 1975 dissertation, and Craig Adcock's *Marcel Duchamp's Notes from the "Large Glass": An N-Dimensional Analysis* (1983) have analyzed Duchamp's exploration of four-dimensional and non-Euclidean geometries as revealed in his notes.[7] The possible existence of a higher, unseen fourth dimension of space and the curved spaces of geometries defying Euclid's long-reigning system were widely discussed in the late nineteenth and early twentieth centuries and stimulated a number of artists. Duchamp, however, studied these geometries far more extensively than any other artist; here, perhaps, was the core of his Playful Physics, embodied primarily in his attempt to make the Bride's realm four-dimensional as well as in his demonstration of non-Euclidean curvature in the *3 Standard Stoppages* of 1913–14 (fig. 68). Like Adcock and myself, Herbert Molderings, in a 1983 study, also noted the influence of Henri Poincaré's conventionalist philosophy, based on debates about the nature of geometrical axioms, in Duchamp's rejection of absolutes in geometry, science, or art.[8]

In the meantime, the publication of *Marcel Duchamp: Notes* had made accessible a large quantity of new notes with a more overtly scientific orientation. These also shed light on scientific themes in the *Green Box* that were not fully developed in the notes published there. Nevertheless, it was only in the context of another research project, examining the possible relevance of the discovery of X-rays for Duchamp, Kupka, and the Cubists, that I began to encounter the issues in contemporary physics and chemistry to which Duchamp seemed to be responding. Indeed, for an artist interested in introducing ideas into the realm of painting, science in the late nineteenth and early twentieth centuries offered a succession of revolutionary new discoveries that challenged accepted notions of the nature of reality. Technological developments, too, produced major changes that are somewhat better known but have not been studied fully in their contemporary context.

If Duchamp the observer of science has a counterpart among writers, it is Alfred Jarry, one of his favorite authors, particularly since Jarry made a similar creative and often iconoclastic use of the scientific ideas he gathered, as will be seen below.[9] Yet in terms of the range of specific subjects that interested Duchamp, a closer parallel exists in a book Duchamp did not know, *The Education of*

Henry Adams, in the chapters entitled "The Dynamo and the Virgin" and "The Grammar of Science."[10] Adams, an American historian and Harvard professor, was in his sixties when he visited the 1900 Exposition Universelle in Paris. His troubled response to the powerful dynamos on view as new symbols of force equal to the Virgin has been widely discussed; it has even been compared to Duchamp's identification of the Bride of the *Large Glass* with a machine.[11] Equally interesting but less well known is the chronicle of contemporary scientific discoveries and theories that Adams provides in these two chapters. The aging Adams, writing in the first years of the new century, felt threatened by these recent developments in science, whereas the young Duchamp would welcome their challenge to the status quo; nonetheless, both focused on many of the same topics.

Adams recited his litany of the new science as evidence of a "supersensual world" that for him represented "Multiplicity, Diversity, Complexity, Anarchy, [and] Chaos" as opposed to the order and unity that he, as a historian, sought.[12] Within these two chapters he referred at least once to each of the following subjects: radium, "vibrations and rays," X-rays, the Branly coherer (used to detect electromagnetic radio waves), frozen air (an aspect of the process of liquefying gases), the atom, "chance collisions of movements imperceptible to the senses," Brownian movement, energy, force, radiant matter, the kinetic theory of gases, the radiometer (as well as the barometer), non-Euclidean geometry, magnetism and gravitation, elasticity, capillary attraction, and "chemical attractions, repulsions or indifferences."[13] Adams also listed a number of scientists who were to interest Duchamp: Lord Kelvin, Sir William Crookes, Röntgen, Mme Curie (who "threw on [man's] desk the metaphysical bomb she called radium"),[14] James Clerk Maxwell, and Henri Poincaré. And in the realm of technology, in addition to the dynamo, several other of Duchamp's concerns figured in Adams's discussion, including the airship, the automobile, and, by means of his talk of Marconi and Branly, wireless telegraphy.[15]

In contrast to Adams, Duchamp believed this "recent data of science" (to use Breton's phrase) represented an opening up of creative possibilities, first in the context of oil painting (1911–12) and, subsequently, in the new mediums and style of the *Large Glass* and its preparatory works. Instead of fearing "supersensual chaos," Duchamp and many of his fellow avant-garde artists actively pursued both the previously invisible reality revealed by X-rays and a suprasensible fourth dimension of space.[16] Gabrielle Buffet-Picabia, in her essay "Some Memories of Pre-Dada: Picabia and Duchamp," recalled that this period was characterized by "an ebullience of invention,

of exploration beyond the realm of the visible and the rational in every domain of the mind—science, psychology, imagination." She concluded: "It would seem, moreover, that in every field, a principal direction of the 20th century was the attempt to capture the 'nonperceptible.'"[17]

Indeed, during the early twentieth century modern movements in a variety of fields would celebrate the very complexity and multiplicity that so distressed Adams, a voice of the nineteenth century. The optimistic quest by Duchamp and others for new models of reality is therefore much more characteristic of the mood of the new century than is Adams's plaintive text. Support for such pursuits came also from the domain of occultism, which was not so clearly demarcated from pure science as it is today. Many scientists, such as Crookes, pursued psychical research or even spiritualism, and occultists regularly drew upon recent scientific developments to argue their case for the reality of invisible worlds. In 1908 Pierre Piobb proclaimed in *L'Année occultiste et psychique*: "After the discovery of cathode rays, the realization of wireless telegraphy, the verification of radioactivity, [and] the conquest of the air by aviation, can we doubt that this century will realize progress even more fundamental?"[18]

Although it has become a commonplace to associate modernism with the revolutions in science brought about by Einstein's special and general theories of relativity and the quantum physics issuing from the work of Max Planck, the science that dominated the popular imagination in the pre–World War I period had not yet been transformed by these discoveries.[19] Instead, the prewar years witnessed the last flowering of classical ether physics, centered on the "luminiferous ether" as the hypothetical medium that made possible the transmission of electromagnetic waves, such as light or the Hertzian waves of wireless telegraphy. First embraced by physicists in the 1830s, the mysterious ether was believed to fill all space without impeding the free movement of bodies, such as planets, through it. Conceptions of the invisible ether ranged from a thin elastic jelly to a swirling fluid whose stresses and strains might account for electric and magnetic forces and even the structure of matter. Ultimately displaced by Einstein's relativity theory in the second decade of the century, the ether was nonetheless central to physics as praticed from the second half of the nineteenth century through the early twentieth century. In this period, then, the latest scientific news pertained not to the yet-unknown relativity theory or quantum physics but to phenomena like the X-ray, the electron, and radioactivity.[20]

In contrast to the highly mathematical and abstract nature of the relativity theory and quantum physics to come, science in the years before World War I was still

within reach of the layperson. The general public could keep abreast of the latest developments in physics and chemistry in a wide range of popular periodicals—from *Harper's Monthly* to *La Nature*. In addition, in America, highly accessible articles by prominent scientists were published each year by Adams's friend, Samuel Langley, in the *Annual Report* of the Smithsonian Institution. Most important, even when dealing with invisible phenomena, ether physics could still be visualized: scientists talked in terms of models, and interested artists, like Duchamp, could attempt to give form to the new discoveries that were redefining reality and transforming contemporary life. Thus, rather than Einstein and Planck, the international scientist-heroes of the early twentieth century were individuals such as Crookes, J. J. Thomson, Ernest Rutherford, and Oliver Lodge, representing British science; Poincaré, the Curies, Jean Perrin, and Gustave Le Bon, a popularizer of science, in France; and, for a time at least, the engineer Nikola Tesla in America.

The present volume commences with Duchamp's first major scientific interest, X-rays, which he explored in paintings of 1911 and 1912, including the *Bride,* where he initially developed the basic forms of the Bride of the *Large Glass.* My consideration of Duchamp and science concludes with his interest in optics during the later phases of work on the *Glass;* the coda offers a brief consideration of Duchamp's optical experiments of the 1920s and 1930s. In the context of the science of electromagnetic waves (e.g., X-rays, visible light, and radio waves), Duchamp's work in optics can now be recognized as a part of a larger whole; in fact, the physics of electromagnetism forms a major thread in this reexamination of Duchamp's oeuvre in the context of science. "Make a painting *of frequency,*" he wrote in a note published in the *Box of 1914,* a notion that was to be central to his thinking about the *Large Glass.*[21] Yet there is no single scientific theme that dominates the *Glass:* it is a complex and witty overlay of visual and verbal ideas, often based on analogies of appearance or function as well as wordplays. Thus, in addition to electromagnetism and chemistry, it addresses such scientific issues as atomic theory, radioactivity, electrical discharges in gas-filled tubes, changing states of matter, the liquefaction of gases, the kinetic-molecular theory of gases, Brownian movement, thermodynamics, classical mechanics, systems of measurement, meteorology, and biology, as well as the technology of the automobile, wireless telegraphy, incandescent and neon lightbulbs, power generation (old and new), and contemporary agriculture.

In their scientific breadth, Duchamp's notes suggest that one model for the *Large Glass* might have been the table of contents of a science textbook or the displays in a museum of science and technology. Yet this was not science for its own sake but rather a Playful Physics by which to redefine the nature of artistic practice and to create a humorous commentary on a range of issues—from traditional, positivist French science to sexuality and other themes in Western culture. Even though the science of the *Large Glass* went far beyond the kind of parlor tricks demonstrated in the popular "Tom Tit" series of *La Science amusante* books or with equipment sold under the rubric "physique amusante," humor remained a central issue in the project Duchamp referred to as his "hilarious picture."[22] That hilarity would often derive from Duchamp's remarkable ability to discern counterparts and counterpoints to a given phenomenon, a talent epitomized in an anecdote related by George Heard Hamilton in 1973: "When our new Dalmatian puppy tumbled into the living room one evening he said, 'So you have the positive! What do you suppose the negative looks like?'"[23] This was the spirit in which Duchamp approached science and technology in the early years of the century, discovering there a rich store of analogues for human experience. Indeed, by the time he encountered the Hamiltons' Dalmatian, he had explored similar positive/negative dichotomies in the *Large Glass* in a variety of contexts, some with definite sexual overtones: magetism, electricity, numbers, molds and casts, and photography.[24]

Just as the positive/negative theme could glide from one subject to another, the *Large Glass* and its notes present a similarly fluid field of interpenetrating signifiers, which are never limited to one meaning. Commentators on Duchamp's art and life have repeatedly noted his rejection of single readings and his delight in multiplicity.[25] As Robert Lebel, Duchamp's friend and first biographer, has commented, "Nothing characterizes him better . . . than his repugnance toward solidifying in a single tendency, a single conviction, a single technique, in a single country, a single milieu or even in a single identity and a single sex, as his feminine pseudonym Rrose Sélavy testifies."[26] Although, as we shall see, at the beginning of his career Duchamp was determined to define a specific position against the reigning Cubist avant-garde in Paris and tended generally to voice stronger commitments to certain issues than in his later years, his celebration of multivalence was clear in the *Large Glass* from the start. In it no image has a simple, single identity; rather, the visual evidence, together with Duchamp's written notes, presents an inventive fusion of multiple forms and ideas, amplified by metaphor and metonymy.

Yet the literature on the *Large Glass* to date has generally missed many of these layers of humor and complexity—in large part because we have lost the context of

the early twentieth-century science and technology to which Duchamp was responding so creatively. Recent hermeneutical and poststructuralist studies have provided a healthy reminder to historians that context is a complex and elusive notion and that, of course, one can never see phenomena from a given period as did the artists or writers of that time.[27] With this caution in mind, however, and with a renewed commitment to a self-conscious practice of historical investigation, we can proceed. In the field of art and science, in particular, such contextual investigation is essential, because we operate on the other side of a major paradigm shift (the coming of relativity theory and quantum physics) that swept away the late classical ether physics dominating scientific practice in the early years of the century. Although we can never know Duchamp's intentions exactly, we can establish a range of possible meanings that are historically grounded, that is, the parameters in which he was operating. In his notes for the *Large Glass,* Duchamp himself talked of what he termed the "Possible," a concept that is highly appropriate to the historical consideration of his project in its context. In other words, just as Duchamp explored the "choice of the Possibilities authorized" by the conditions he established for the *Large Glass,* the present study sets the *Glass* against a context of historical possibilities and proposes what, in my view, may be likely choices of meaning on Duchamp's part.[28]

Obviously, Duchamp's multilayered scientific or technological identities in the *Large Glass* are not the only levels of meaning in this work, and the present book does not claim to tell the whole story of the *Glass.* Indeed, in the course of my work several other issues—for example, Duchamp's anti-Bergsonism, his deep engagement with language, and the allegorical dimensions of the project—unexpectedly asserted themselves. Further, Duchamp's interest in the fourth dimension is given a decidedly lower profile here than it deserves, simply because Craig Adcock and I have dealt with the subject elsewhere. For me, a focus on science and technology provided a path by which to navigate the intricate realms of Duchamp's notes, particularly the highly complex and difficult posthumously published notes. My goal here is to open up discussion of the *Large Glass* and to move it beyond the narrative that has indeed solidified, based on a few early scholars' readings of the notes published during Duchamp's lifetime. As the comments above on the multivalence of the *Glass* should make clear, if my study functions on one level as a kind of iconographic recovery of scientific or technological imagery, I do not mean to propose only one-to-one correspondences. Toward this end, the illustrations are purposely reproduced together to

serve as a visual catalogue of the general look of science and technology in this period, and comparisons regularly extend beyond simple pairings of images.

The book is divided into four large sections. Parts 1 and 2 consider Duchamp's early paintings of 1911–12 and his works of late 1912 through 1914, in which he redefined himself as artist-engineer rather than painter as he commenced the *Large Glass* project.[29] In addition to chapter 4, which examines the science popularized by William Crookes and Nikola Tesla (and the use of such science by Jarry and Raymond Roussel), most chapters include mini-histories of particular aspects of science or technology as popularly known in that period, thereby providing one of the first overviews of the popular scientific backdrop against which modernism developed. Part 3 (chaps. 6–11) centers on the *Large Glass* and Duchamp's preparatory notes for it, a written record of the evolution of a single project that is unparalleled among modern artists. Integrating the notes Duchamp published during his lifetime with the 289 posthumously published notes, these chapters make the first systematic study of this body of writings in relation to the imagery of the *Large Glass* and to turn-of-the-century science and technology.[30] Among the new discoveries set forth here are the recovery of "lost" elements of the *Glass,* such as the "Desire Dynamo" and the "Precision Friction Plates," as well as what appears to be Duchamp's selection in the late 1950s of a group of early, unpublished notes that could have formed a "box" augmenting some of the *Glass*'s earlier scientific themes (see app. A). For the reader who wishes an overview of the book, the two-part conclusion in part 4 offers, in chapter 12, a consideration of style and content in the *Glass* based upon the findings of the previous chapters and, in chapter 13, a review of the book's contents cast in terms of Duchamp's progressive self-fashioning during the course of his project. In addition to the discussion of the collection of notes gathered in appendix A, the coda addresses the manifestations of Duchamp's interest in electricity and electromagnetism in his later optical works and in his last major project, *Etant donnés* (1946–66; fig. 183).

A vast amount of literature has been written on the subject of *The Bride Stripped Bare by Her Bachelors, Even* (*The Large Glass*), and a variety of interpretations of the work have been put forward, some of which are more solidly grounded in Duchamp's notes than others.[31] Although Duchamp in later life rarely bothered to contradict readings of the *Large Glass* with which he disagreed, he stated his basic position succinctly in a 1959 radio interview: "In the *Large Glass* there is nothing to converse about, unless you make an effort to read the notes in

the *Green Box*."[32] That directive can be extended to the whole body of Duchamp's notes as they are now available. Reading Duchamp's notes against the possibilities suggested by the scientific and technological milieu of the early years of the century, we can begin to converse in new ways about the *Large Glass* and the works that led to it. Illuminated in this manner, the *Glass* can be recognized, as it should be, as a remarkable synthesis of contemporary ideas that stands as one of the great monuments of early twentieth-century art and culture.[33]

Part I

Duchamp and Invisible Reality, 1911–1912

Chapter 1

Duchamp's First Quest for the Invisible
X-Rays, Transparency, and Internal Views of the Figure, 1911–1912

Marcel Duchamp was eight years old when Wilhelm Conrad Röntgen detected the mysterious new rays he termed X-rays in November 1895. A young boy coming to terms with the world around him could hardly have chosen a more exciting period in the history of science in which to mature. New discoveries concerning the nature of matter and energy rapidly succeeded one another and were widely publicized in the popular press. After X-rays came radioactivity and, subsequently, the development of practicable wireless telegraphy, allowing undreamed-of communication over great distances. The field of science must have seemed as fantastic as the imaginings of any science fiction writer.

In 1904 the seventeen-year-old Duchamp moved from his native Blainville, near Rouen, to Paris, where his two older brothers, Jacques Villon and Raymond Duchamp-Villon, were working as artists following periods of study in law and medicine, respectively (fig. 1). Eleven years younger than Raymond, the younger of the two, Duchamp was closer in age and spirit to his sister Suzanne, born two years after him.[1] Nonetheless, his older brothers initially served as important role models for him, and although he had excelled in mathematics as a student, he, too, decided to pursue a career in art, a path Suzanne would follow as well.[2] Their maternal grandfather had been an engraver of some note, and in 1905–6 a brief stint in the printing trade provided the young artist a means to shorten his compulsory military service. After an apprenticeship in a Rouen printing establishment and the successful completion of an examination, Duchamp was certified as an "art worker," one of the trades for which active military service was reduced from two years to one.

During his initial stay in Paris, Duchamp had studied painting briefly at the Académie Julian, but when he returned in late 1906, he began to produce cartoons, fol-lowing his brothers, who were also publishing cartoons and commercial illustrations. Here Duchamp's wry humor first appears, along with a flair for the observation of costume and, in earlier drawings, uniforms, themes that would resurface in the *Large Glass* project.[3] Soon, however, Duchamp again turned his attention to painting and gradually began to absorb the radical new developments in French art, beginning with Fauvism and, by 1910 and after, the art of Paul Cézanne and Cubism. In 1908 the jury of the Salon d'Automne accepted three of his paintings, and between 1909 and 1912 he would exhibit at both the spring Salon des Indépendants and the Salon d'Automne.

Duchamp's *Portrait of Dr. Dumouchel* (fig. 2) is characteristic of his painting style by 1910. Here, the heightened color and simplified forms of Henri Matisse's Fauvism are tempered by Duchamp's interest in Cézanne as well as the Symbolist Odilon Redon. Even in this early painting Duchamp incorporated an element that could not have been derived from his observations of contemporary art alone: the curious reddish-pink halo surrounding the hands and, to a lesser degree, the torso of Dr. Dumouchel. As will be seen, such bodily projections were a standard element of the practice of Magnetism (i.e., hypnotism by the supposed manipulation of magnetic fluids), which gained new currency in the 1890s in the wake of developments in the physics of electromagnetism and the discovery of radioactivity. Two of Duchamp's closest friends, Raymond Dumouchel and Ferdinand Tribout, had finished their medical studies in 1909, and the interests of either or both of the young doctors may well have been a stimulus for this first attempt by Duchamp to paint the invisible.[4]

By this time Duchamp had also found an unconventional artistic mentor: the Czech painter František Kupka, a practicing spiritualist medium and Theosophist, who was deeply interested in science. Kupka, who was sixteen years older than Duchamp, had been a fellow cartoonist and close friend of Duchamp's two brothers since the turn of the century, and around 1905–6 all three moved to neighboring studios in Puteaux, a suburb of Paris. Duchamp, who moved to nearby Neuilly, became part of the regular gatherings at the Puteaux compound; the three brothers were photographed there in the garden in 1913 (fig. 1). Thus, even before Duchamp encountered Cubist paintings in the spring 1911 Salon des Indépendants, Kupka offered him the example of an artist with concerns beyond the purely "retinal aspect in painting," which Duchamp would subsequently seek to transcend.[5] Kupka

was one of the first artists in Paris to explore specific aspects of X-ray imagery (before 1910), and he and Duchamp seem to have pursued the subject in tandem during late 1911 and early 1912. Indeed, Kupka's scientific (and, to a certain extent, occult) interests undoubtedly served as a major encouragement for Duchamp's growing interest in science during 1912 and 1913.

Another important source for Duchamp's artistic development was the visual example of Cubism and the theory associated with it. By fall 1911 the gatherings at Puteaux had grown to include the circle of Cubists whom the three Duchamp brothers came to know after the first public manifestation of Cubism in rooms 41 and 43 of the 1911 Salon des Indépendants. This group, including Albert Gleizes, Jean Metzinger, Fernand Léger, Robert Delaunay, Henri Le Fauconnier, and Roger de La Fresnaye, operated largely independently of the originators of the Cubist style, Pablo Picasso and Georges Braque.[6] Yet, on the model of Picasso and Braque in paintings such as Picasso's *Nude* of 1910 (fig. 3), the Salon Cubists placed a premium on conception over vision. Rejecting traditional techniques for rendering figures and spaces (e.g., classical modeling and perspective), they sought to create fluid realms that could evoke a higher reality beyond immediate sense perception.

Unlike Picasso and Braque, however, the circle of painters around Gleizes and Metzinger was far more theoretically oriented, and Puteaux became the site of regular Sunday afternoon discussions on all facets of contemporary culture as they might apply to art. The group was augmented by writers such as Alexandre Mercereau and Guillaume Apollinaire; the painter Juan Gris (who, with Apollinaire and the "mathematician"–insurance actuary Maurice Princet, was one of the few links to the Picasso-Braque circle); and associates of the Duchamp family from the Société Normande de Peinture Moderne, including Duchamp's new friend Francis Picabia. Topics of discussion ranged from literature and philosophy (particularly the writings of Henri Bergson) to science, technology, and mathematics, including non-Euclidean geometry and the highly popular idea of a fourth dimension. An outgrowth of the *n*-dimensional geometries developed in the nineteenth century, the fourth dimension signified a higher spatial dimension beyond visual perception and became a prominent element in Cubist theory.[7]

As part of his pursuit of science, Duchamp was to make a far more detailed study of the four-dimensional and non-Euclidean geometries than had any Cubist painter. Nonetheless, although he would leave Cubism behind by the summer of 1912, it was in the context of Cubism that he painted his first mature canvases and

against its backdrop that he (and Kupka) explored the artistic possibilities of X-rays most fully. As will be seen, X-rays would certainly have played a role in the discussions at Puteaux, as a major facet of the "exploration beyond the realm of the visible" that Gabrielle Buffet-Picabia later remembered as so characteristic of the period.[8]

Until recently, the possible contribution of X-rays to the evolution of the art of Duchamp and Kupka as well as to the Cubist movement had not been examined—undoubtedly, in part, because the major published theoretical texts of Cubism do not refer to X-rays by name.[9] This reticence on the part of the Puteaux Cubists to discuss X-rays publicly may well have resulted from the bold claim of the rival Italian Futurists, who, in their "Technical Manifesto of Futurist Painting" of April 1910, cited X-rays as a justification for their painting. In that text, which was subsequently reprinted in the catalogue for the Futurists' Paris exhibition of February 1912, Umberto Boccioni and his fellow painters assert: "Who can still believe in the opacity of bodies, since our sharpened and multiplied sensitiveness has already penetrated the obscure manifestations of the medium? Why should we forget in our creations the doubled power of our sight, capable of giving results analogous to those of the X-rays?"[10]

In the face of the Futurists' contention, Cubist authors like Gleizes and Metzinger expressed their debt to X-rays in far more subtle terms in their published writings. Yet, once the variety of images, concepts, and individuals associated with X-rays is rediscovered, it is clear that X-rays made a vital contribution to the art and theory of Duchamp (as well as Kupka and the Cubists). As Léon Rosenthal observed in his review of the 1912 Salon des Indépendants for the *Gazette des Beaux-Arts*: "Everything renews itself around us: wireless telegraphy, aviation, X-rays overturn all established notions. Scientific fervor consumes us; photography [and] artificial light have modified the very conditions of our vision."[11]

X-Rays: History and Popularization

Röntgen's discovery of X-rays in 1895 occurred in the course of his research on cathode rays, which were the subject of much scientific study in this period.[12] Working with the type of vacuum tubes perfected by the English chemist William Crookes in the 1870s, Röntgen and other researchers studied the activity of the cathode rays generated between the cathode (negative terminal) and anode (positive terminal) of the tube when an electrical current was applied. Cathode rays produced fluorescent effects where they struck the glass wall of the tube or other objects within the tube yet seemed unable to penetrate the

glass itself. In 1895 there was still considerable debate about the nature of cathode rays, although it was strongly suspected (and subsequently confirmed) that they were streams of negatively charged particles (i.e., the electrons or "corpuscles" J. J. Thomson would identify in 1897).

In his effort to investigate the strength of the rays, Röntgen encased his Crookes tube in a cardboard shield, so that any fluorescent effects outside the tube would not be obscured by the light of the tube itself. To his great surprise, when he applied current to the tube, a barium platinocyanide "lightscreen" that was lying on his work table began to fluoresce. Because the new rays passed through glass and could not be deflected by a magnet, Röntgen was convinced these were not cathode rays but some new kind of radiation generated at the point where the cathode ray struck the glass wall. When Röntgen tested the rays' ability to expose a photographic plate with an object placed in front of it, he documented the characteristic of the rays that would capture the world's imagination. With varying degrees of ease the rays passed through a variety of organic and inorganic materials of different depths and densities leaving a "shadow," as Röntgen termed it, on the plate.

In their fluorescence and their chemical photographic action, the new rays were like light, yet Röntgen's further experiments with the rays did not produce the refraction, reflection, or polarization characteristic of light waves. Only in 1912 would the nature of the rays finally be determined experimentally, when researchers working under Max von Laue in Munich succeeded in producing X-ray refraction by means of crystalline plates and established definitively their similarity to light waves.[13] Von Laue's findings confirmed what many scientists had theorized before 1912: that X-rays are a part of the spectrum of electromagnetic radiation, with a wavelength shorter than visible light or ultraviolet radiation. Following James Clerk Maxwell's theoretical identification of light and electromagnetism in the 1860s, Heinrich Hertz had confirmed the existence of such electromagnetic waves in 1888 (the "Hertzian" or radio waves that led to the rise of wireless telegraphy in the 1890s). Now X-rays (with a wavelength in the range of one billionth of a meter) officially joined the much longer Hertzian waves (with wavelengths of about one meter to one kilometer) at the opposite end of the electromagnetic spectrum.[14]

Röntgen's publication of his findings at the end of December 1895 triggered the most immediate and widespread reaction to any scientific event before the explosion of the first atomic bomb in 1945.[15] During 1896 more than fifty books and pamphlets and well over a thousand papers were published on the subject of X-rays, or Rönt-gen rays, as they were often called.[16] On January 1, 1896, Röntgen mailed copies of his report to many prominent physicists, and the first newspaper article on his discovery appeared in the *Wiener Presse* on January 5. The story was quickly picked up by newspapers around the world, by journals covering science, electricity, medicine, and photography and, eventually, by general-interest magazines. In Paris, for example, on January 25, 1896, *L'Illustration* published an article entitled "La Découverte d'une lumière nouvelle" showing an X-ray view of a hand; on February 1 a photograph of Röntgen and two X-ray images by Jean Perrin were featured on the cover. By March 1896, three months after Röntgen's announcement, twenty lectures on X-rays had been delivered before the French Académie des Sciences and were published in their *Comptes Rendus*.[17]

What can explain the remarkable public response to X-rays? Obviously, the ability to see through clothing and flesh to the skeleton offered a startling new view of living beings, a reorientation not lost on contemporary cartoonists for whom the humorous consequences of X-ray vision became a regular theme (fig. 4). The medical profession immediately seized upon the diagnostic possibilities of X-rays, and in the spirit of what has been termed "medical futurism," many individuals believed that all diseases and even death itself might be overcome by the miraculous new rays. Popular coverage of X-rays often sounded little less fantastic than the stories of H. G. Wells and other science fiction writers such as Gaston de Pawlowski, who drew inspiration from this latest scientific wonder.[18]

After the development of the fluoroscope by Thomas Edison and others in 1896, penetrating X-ray vision was also available without the intervention of photography: the shadow image could now be seen by looking into a cameralike bellows fitted with a fluorescent screen. Public demonstrations were staged in locations ranging from Bloomingdale's in New York to the Cinématographe Lumière in Paris, which advertised "Rayons X—Expériences scientifiques et publiques" on its mezzanine in conjunction with the featured film attraction.[19] Georges Méliès produced a film entitled *Les Rayons X* in 1898, and "special effects" were likewise used in the popular Montmartre "Cabaret du Néant," where reflective illusions mimicked the transformation of an individual into a skeleton by X-rays.[20]

Because only a cathode-ray tube and a power source were needed to generate X-rays, Röntgen's experiments could be repeated immediately in Europe, England, and America. Photographers considered the X-ray process a natural extension of their medium, and how-to manuals and photography journal articles proliferated during 1896

and after, as did suppliers specializing in X-ray equipment (fig. 5).[21] X-rays were also a prominent feature of the 1900 Exposition Universelle in Paris, where X-ray photographs or equipment was exhibited in both the photography and medicine sections of the Palais de l'Enseignement, as well as in the Palais de l'Electricité and the Palais de l'Optique.[22]

The extrasensory reality revealed by X-rays pointed to the most important lesson to be drawn from Röntgen's experiments: the inadequacy of human sense perception. The popular articles announcing the discovery bore titles such as "The World beyond Our Senses" and often included diagrams illustrating the fraction of the spectrum represented by visible light versus the much greater range of radiations on either side (i.e., ultraviolet radiation with shorter wavelengths and infrared and "electrical" radiations [Hertzian waves] with wavelengths longer than visible light).[23] In a May 1896 article in *The Arena*, "Professor Roentgen's Discovery and the Invisible World around Us," James Bixby sounded what would become a recurrent theme in the literature on X-rays: "The more carefully science examines the senses, the more surely it demonstrates their limitations and of how small a part of the universe these fleshly organs can catch a glimpse."[24]

It is not surprising that X-rays interested artists of the early twentieth century, who considered their Impressionist precursors too preoccupied with visual sensation alone. Many commentators on Röntgen's discovery saw X-rays as a powerful blow against scientific positivism's exclusive reliance on sense data. In *L'Inconnu et les problèmes psychiques* of 1900, the astronomer Camille Flammarion used the discovery of X-rays in his argument for the scientific legitimacy of researches into the unknown. For Flammarion, X-rays were one more proof that "sensation and reality are two different things":

The late discovery of the Röntgen rays, so inconceivable and so strange in its origins, ought to convince us how very small is the field of our usual observations. To see through opaque substances! to look inside a closed box! to see the bones of an arm, a leg, a body, through flesh and clothing! Such a discovery is, to say the least, quite contrary to everything we have been used to consider certainty. This is indeed a most eloquent example in favor of the axiom: it is unscientific to assert that realities are stopped by the limit of our knowledge and observation.[25]

The mathematician and scientist Henri Poincaré, an important source for Duchamp (and, initially at least, for Gleizes and Metzinger), wrote in his *La Science et l'hypothèse* (1902) of cathode rays, X-rays, and radioactivity:

"Herein lies a whole world that no one suspected. How many unexpected inhabitants must be stowed away!"[26] From his earlier work on non-Euclidean geometry, Poincaré was already convinced of the relativity of human knowledge, and his resultant openness to the possible existence of higher dimensional spaces was to be an important support for Cubist interest in the fourth dimension. Yet, unlike the gradual emergence of philosophical and popular concern with four-dimensional and non-Euclidean geometries, X-rays provided an immediate, experimental demonstration of the relativity of perception. Thus, even though their discovery occurred more than fifty years after the formulation of *n*-dimensional geometry, X-rays paved the way for the artistic investigation of higher spatial realms in the years before World War I.

William Crookes cited X-rays in his text "De la relativité des connaissances humaines," a section of his presidential address before the Society for Psychical Research, which was published in the *Revue Scientifique* in May 1897. After demonstrating how the size of an observer (e.g., a homunculus on a cabbage leaf) will alter his or her perception of events, Crookes provided a table of vibrations, ranging from sound waves through the very rapidly vibrating X-rays, with various steps of unknown vibrations in between and at each end.[27] For Crookes, varying degrees of vibration offered the clue to the workings of telepathy, and his table of vibrations was widely reproduced in this period (Flammarion included it in *L'Inconnu*, for example). Like many other contemporary figures in the world of science, both Crookes and Flammarion were interested in spiritualism and psychical research.[28]

Like the other suprasensible vibrations of the electromagnetic spectrum, X-rays offered contemporary occultists a scientific rationale for such phenomena as clairvoyance and telepathy. Annie Besant and C. W. Leadbeater cited X-rays in the introduction to their 1901 book *Thought-Forms* (translated into French in 1905), in which they focused on vibrations as the means for transferring thought patterns from one individual to another.[29] Leadbeater had dealt more extensively with X-rays in his 1899 *Clairvoyance*, which was translated and published in Paris in 1910. In that text he explained clairvoyant vision as the result of expanding one's receptivity to new ranges of vibrations:

The experiments with the Röntgen rays give us an example of the startling results which are produced when even a very few of these additional vibrations are brought within human ken, and the transparency to these rays of many substances hitherto considered opaque at once shows us

6

one way at least in which we may explain such elementary clairvoyance as is involved in reading a letter inside a closed box, or describing those present in an adjoining apartment. To learn to see by means of the Röntgen rays in addition to those ordinarily employed would be quite sufficient to perform a feat of magic of this order.[30]

X-rays were an area where science and occultism readily met. Given the penchant of French occultists in the early twentieth century to try to prove their claims scientifically, X-rays were a frequent element in occult literature in this period.[31] In particular, spiritualists such as those associated with the periodical *La Vie Mystérieuse*, including the Cubists' friend Mercereau and their publisher, Eugene Figuière, pointed to X-ray photographs as revelations of an invisible reality akin to spirit photographs.[32] The eye was now considered less sensitive than the photographic plate, a tool that could register not only invisible light rays (X-rays) but also spirit manifestations and other kinds of emanations from the body. These psychic projections included the "vital force" of the human soul Hippolyte Baraduc sought to capture on photographic plates (fig. 85), which were discussed by Besant and Leadbeater in *Thought-Forms*; the "exteriorization of sensibility" studied by Albert de Rochas; and various other types of human emanations.[33]

In the context of medicine, a connection between psychic and X-ray photography also existed in the person of Albert Londe, the chief photographer at the Salpêtrière Hospital from 1882 through 1900, including the period when Duchamp's brother Raymond was a medical intern there in the late 1890s.[34] In addition to producing documentary photographs for Dr. Charcot (such as those of hysteria patients under hypnosis), Londe was also a major pioneer of X-ray photography in France; his X-ray images were widely reproduced in books and periodicals (fig. 6). Chronophotography was another of Londe's pursuits, and his chronophotographic studies of movement were also to contribute to Duchamp's analysis of motion in certain X-ray-related paintings (figs. 12, 14).[35] Like X-rays and spirit photographs, the chronophotographs that interested Duchamp (and Kupka), including the single-plate images of Etienne-Jules Marey (fig. 7), also revealed a type of invisible reality, though in this case, a reality in flux.[36]

Such a dynamic conception of reality was encouraged in this era not only by Henri Bergson's antimaterialist philosophy of "becoming" but also by developments in physics following Henri Becquerel's discovery of the radioactivity of certain substances in 1896.[37] Initially, Becquerel's research attracted little attention, and "Becquerel rays" were subsumed within the general category of mysterious

rays that could expose photographic plates. But, after Pierre and Marie Curie's isolation in 1898 of two new radioactive elements, polonium and radium, and Ernest Rutherford's formulation of the theory of radioactive decay in 1902–3, radioactivity caught the attention of the general public.[38] Suddenly, in addition to X-rays and cathode rays, there were new, invisible alpha, beta, and gamma rays produced by radioactive materials. Despite the similar ability of radium and X-rays to expose a photographic plate (radium was dubbed the "pocket edition of the Roentgen tube"),[39] there was a startling difference. In the process of emitting the new rays, radioactive substances were actually changing their chemical composition.

Although, as chapter 2 establishes, the science of radioactivity would contribute to the determination of the substructure of the atom (and thereby verify the discontinuous nature of matter), initially the discovery of radioactivity augmented the view of the physical world as a fluid and continuous interaction between matter and ether, form and space. One of the major French proponents of this view (along with the idea of universal radioactivity and the related dematerialization of all matter) was the pseudoscientist Gustave Le Bon.[40] Le Bon's propagandizing from 1896 through the first decade of the century contributed substantially to the continued interest of the French in X-rays and radioactivity. Trained in medicine, Le Bon published his famous study of crowd psychology, *Psychologie des foules*, in 1896, the same year in which he turned his attention to the problem of radiation raised by Röntgen's discovery of X-rays. An amateur in physics, Le Bon was nevertheless a friend of Poincaré and several other members of the Académie des Sciences, where he presented his own discovery of what he believed to be a new kind of radiation, "la lumière noire."[41] In May 1896 *L'Illustration* published Le Bon's X-ray-like photographs of objects emitting the so-called black light he believed could be stimulated to flow from any material struck by rays of visible light.[42]

If Le Bon's claims for black light and invisible phosphorescence were rather quickly rejected by the scientific establishment, his general conclusion that the production of all kinds of radiation was the result of the disassociation of the atom made him an important popularizer of contemporary physics. In articles such as "La Dematérialisation de la matière" and his best-selling books *L'Evolution de la matière* (1905) and *L'Evolution des forces* (1907), Le Bon expressed his view that matter is simply "a stable form of intra-atomic energy" in the gradual process of disappearing into the ether.[43] Le Bon was also a friend of Bergson, and contemporaries cited Le Bon's ideas as scientific support for Bergson's philosophy of continuity.[44]

X-rays and radioactivity had made it impossible for the layperson to think of matter as solid and impenetrable or of space as a void. Instead, space must be filled with invisible electromagnetic rays and particulate radioactive emissions like those whose presence was registered in the spinthariscope, a popular toy invented by Crookes in 1903 (fig. 30).[45] With reality so radically redefined by X-rays and radioactivity, avant-garde artists like Duchamp faced a serious challenge to the romantic notion that artists possessed more highly developed sensibilities than the average individual. Could the modern artist, like the photosensitive plate struck by X-rays, reveal an invisible reality?

Duchamp's Painting and X-Rays, 1911–1912

Duchamp most likely learned of the possible relevance of X-rays for modern painting from Kupka. Kupka's notebook of 1910–11(?) and his treatise *Tvoření v umění výtvarném* (Creation in the Plastic Arts), written in 1912–13, demonstrate his remarkable scientific erudition, his interest in higher dimensions, and his belief in a complex, vital reality beneath the surface of nature.[46] Electromagnetic waves are a recurrent theme in Kupka's treatise, and, although by late 1912 he had become more interested in the Hertzian waves of wireless telegraphy, X-rays were his first pursuit in the domain of electromagnetism. Beyond the wealth of popular scientific literature on the subject, Kupka would have gained information on X-rays in the lectures on physics, physiology, and biology he attended at the Sorbonne during 1905.[47] He was also a student of optics and perception, issues that were often treated together with X-rays in books on sources of light both visible and invisible.[48]

Just as Kupka's scientific concerns led him to X-rays, references to X-rays abounded in the occult literature in which he was equally interested. As a Theosophist, Kupka would have known Besant's and Leadbeater's publications with their references to X-rays, as well as such specifically spiritualist sources as Léon Denis's *Dans l'invisible* of 1904. In comparing spirit photographs to X-rays, Denis referred to the photographic plate as a "glimpse into the invisible";[49] and in his notebook of 1910–11 Kupka likewise used the analogy of a photographic plate or film, describing the mind of the artist as "an ultrasensitive film, capable of sensing (seeing) even the unknown worlds of which the rhythms would seem incomprehensible to us."[50] Nor would Kupka have been the sole source of such spiritualist and occult views at Puteaux. Duchamp-Villon's brother-in-law, Jacques Bon, who had moved to Puteaux at the same time as the others, has been described as a "fervent spiritualist."[51] And once

the Gleizes-Metzinger circle of Cubists began to frequent Puteaux on Sunday afternoons, the spiritualist orientation of the poet Mercereau and the publisher Figuière would have increased interest in the occult interpretation of X-rays. Mercereau's and Figuière's active involvement with the spiritualist periodical *La Vie Mystérieuse*, which regularly cited X-rays in contexts ranging from clairvoyance and spirit photography to Magnetism, makes that magazine another relevant source of ideas and images related to X-rays.[52]

Beyond Kupka's contribution of scientific and occult ideas on X-rays and the general openness toward occultism at Puteaux, Duchamp had personal connections to X-ray practice in the field of medicine. Not only had his brother Duchamp-Villon interned at the Salpêtrière, where Albert Londe was based, but his friend Ferdinand Tribout, a medical student, was studying radiology and went on to become a major figure in the field.[53]

Beyond these personal connections, the artistic and literary interests of the Duchamp brothers' new Cubist circle testify further to an awareness of X-rays and their implications in this period. In his *Paris-Journal* column of May 19, 1914, Apollinaire wrote of Marcel Duchamp's having given up painting for a time to work as a librarian at the Bibliothèque Sainte-Geneviève, noting that "he catalogues books not far from the same Charles Henry whose scientific investigations concerning painting exerted a great influence on Seurat and ultimately led to the birth of divisionism."[54] In fact, Henry, the director of the Laboratory of the Physiology of Sensations at the Sorbonne, was associated not only with psychophysics but with X-rays; in 1897 he had published a book entitled *Les Rayons Röntgen* and was recognized as a French pioneer in the field.[55] Seurat's art continued to interest artists of the Cubists' generation (including Duchamp, who in 1915 named Seurat as his favorite painter),[56] and they would certainly have been alert to Henry's activities.

In the context of literature, Mercereau and Gleizes were among the founders of the review *Les Bandeaux d'Or*, which featured several articles by their colleague Théo Varlet touching on such subjects as electricity, electromagnetic waves, and X-rays.[57] The members of the Mercereau circle were also admirers of the writer Remy de Gourmont, whose *La Revue des Idées* actively monitored contemporary French science. Published between 1904 and 1913, the *Revue* provided generous coverage of the new developments in physics in these years, ranging from the ideas of Poincaré and the work of the Curies in radioactivity to the "N-rays" of Réné Blondlot and the theories of Le Bon.[58] Like Le Bon's black light, N-rays, "discovered" in 1903 by Blondlot, a physicist in Nancy,

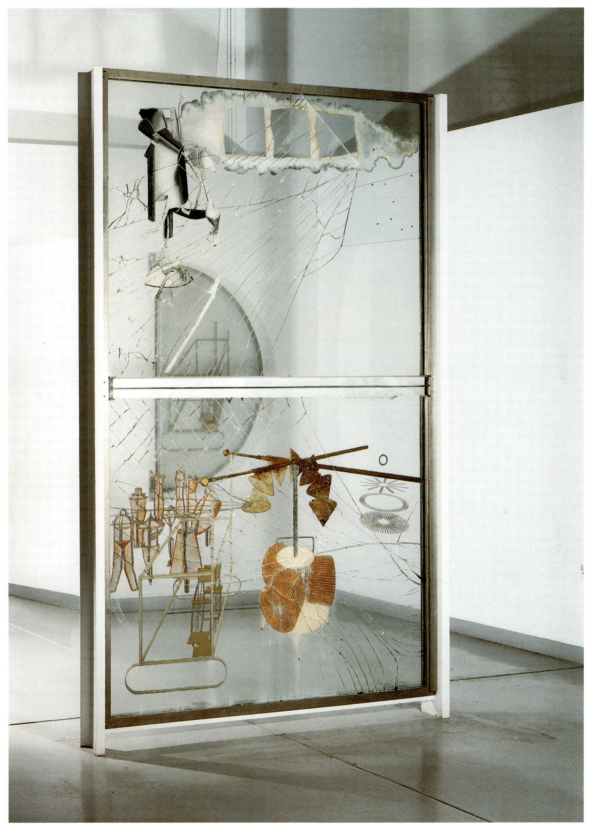

1 Marcel Duchamp, *The Bride Stripped Bare by Her Bachelors, Even (The Large Glass),* 1915–23, oil, varnish, lead wire, lead foil, mirror silvering, and dust on two glass panels (cracked), each mounted between two glass panels, with five glass strips, aluminum foil, and a wood and steel frame, 109¼ × 69¼ in. (277.5 × 175.8 cm) overall, Philadelphia Museum of Art, Bequest of Katherine S. Dreier, as installed by the artist at the Philadelphia Museum of Art. *Glider Containing a Water Mill (in Neighboring Metals)* (fig. 151) is visible in the background.

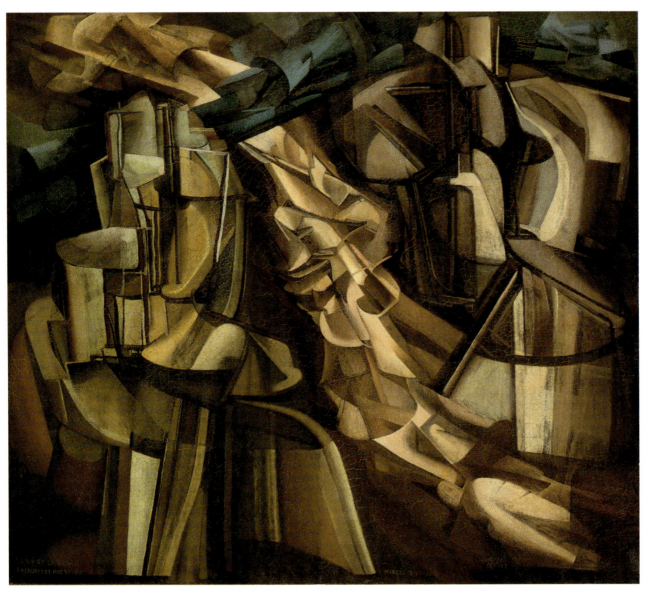

2 Duchamp, *The King and Queen Surrounded by Swift Nudes,* 1912, oil on canvas, Philadelphia Museum of Art, The Louise and Walter Arensberg Collection.

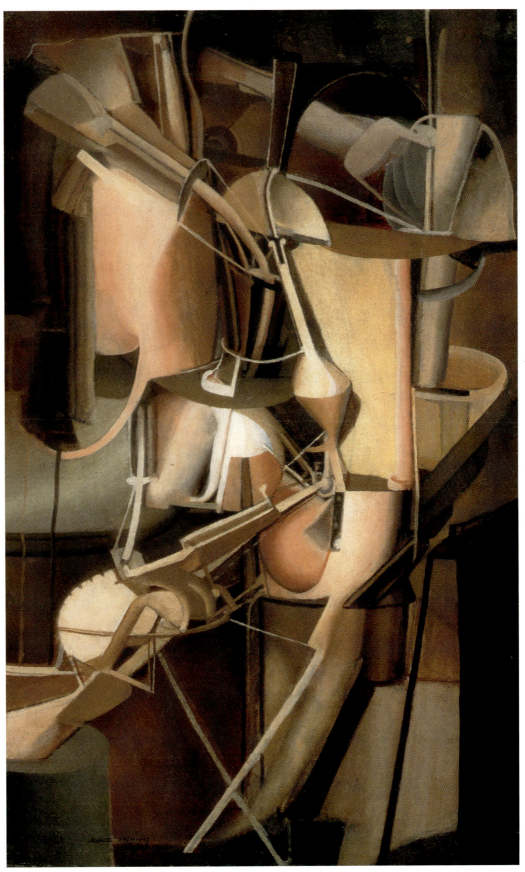

3 Duchamp, *Bride,* 1912, oil on canvas, Philadelphia Museum of Art, The Louise and Walter Arensberg Collection.

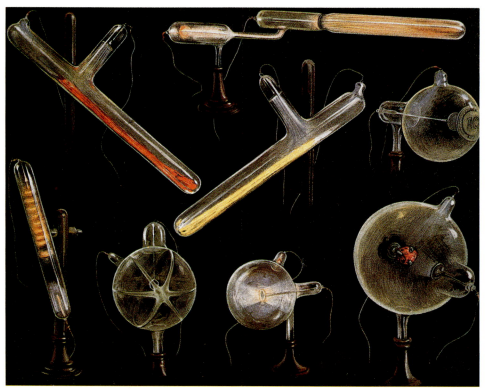

4 Geissler tubes and other electrical discharge tubes, from Wilhelm M. Meyer, *Die Naturkräfte,* Leipzig, 1903, following p. 388.

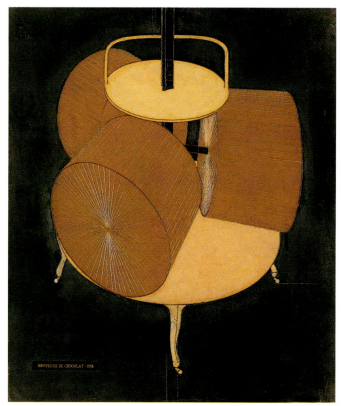

5 Duchamp, *Chocolate Grinder (No. 2),* 1914, oil and thread on canvas, Philadelphia Museum of Art, The Louise and Walter Arensberg Collection.

were a product of the "ray fever" that led to numerous claims (ultimately unjustifiable) for a variety of new kinds of rays.[59] Championing French science, *La Revue des Idées* reported extensively on Blondlot's N-rays in 1904, as it did subsequently on the publications of Le Bon, although, of necessity, the coverage of radioactivity and atom theory became increasingly international over the next decade.

Le Bon's role as a sage for the Cubist avant-garde, as well as for Gourmont, is confirmed indirectly by an article in the July–September issue of the review *Pan,* with which the Mercereau circle was also associated. There, in the wake of the publication of his *Les Opinions et les croyances* (1911), Le Bon was denounced as "l'ex-savant de l'avant-garde" for his rejection of the possibility of a scientific occultism.[60] Apparently, before 1911 many of the occultists and others (e.g., avant-garde writers and painters) who drew support from Le Bon's antimaterialist philosophy had not been aware of his personal antipathy toward spiritualism and occultism, and they now felt betrayed by his denial of one of their basic goals.

Yet another literary link to X-rays and electromagnetism was the work of the writer Alfred Jarry, which was to prove particularly important for Duchamp. Jarry had drawn much inspiration for his fantastic tales from the writings of British scientists such as Crookes, who, unlike Le Bon, were equally interested in science and psychical research. Associated both with the X-ray tube and with telepathy by means of vibrations, Crookes would have loomed large at Puteaux in 1911 owing to the posthumous publication of Jarry's *Gestes et opinions du docteur Faustroll, pataphysicien.* In a chapter dedicated to the British chemist, Jarry had used Crookes's 1897 *Revue Scientifique* article on the relativity of knowledge, noted above, as the basis for Faustroll's adventure on a cabbage leaf. In a subsequent chapter Jarry indirectly evoked Crookes's interest in telepathy when, after his death, Faustroll writes two "telepathic letters" to Lord Kelvin (William Thomson), another of Jarry's favorite British scientists.[61]

Given the awareness of X-rays at Puteaux, their initial appeal to visual artists like Duchamp and Kupka (as well as to the Cubists) is graphically demonstrated in Londe's widely reproduced images that pair the "shadow" photograph made with X-rays with a standard photograph made with visible light (fig. 6). Here was a new kind of light that allowed a painter to go beyond the preoccupation of earlier artists with surface appearances (such as the tactile fur of the rat) to concentrate on the essence of form. In his notebook of 1910–11 Kupka had referred to the "relativity of sensation" and distinguished between the "perception of matter under its exterior form" and the "perception of the form in itself."[62] Duchamp recalled later, "I was so conscious of the retinal aspect in painting that I personally wanted to find another vein of exploration."[63] Although this comment is usually associated with his cessation of painting during 1913, X-rays had established the limitations of the retina considerably earlier for Duchamp as well as for Kupka.

The contrast between external appearance and internal form, like that demonstrated by Londe, is the theme of Duchamp's first overt response to X-ray imagery: the painting he made in late summer 1911 of his younger sisters, *Yvonne and Magdeleine Torn in Tatters* (Yvonne et Magdeleine déchiquetées) (fig. 9). Although the profiled heads evoke the works of Redon, whom Duchamp admired, the dark nose of Magdeleine (second from left) links Duchamp's image specifically to X-rays. Because the nose consists primarily of cartilage instead of bone, an X-ray of a head will produce a triangular gap where the X-rays pass readily through the nose but are resisted by the denser bones of the skull (fig. 8). Duchamp also used a darkened nose in *Sonata* (Philadephia Museum of Art, The Louise and Walter Arensberg Collection), another of his stylistic experiments painted after seeing Cubist paintings for the first time at the spring 1911 Salon des Indépendants.[64]

Both *Yvonne and Magdeleine* and *Sonata* employ transparent, partly dematerialized forms overlapping one another, and the "déchiquetées" of the title of the former carries the connotation of "cutting" in the way that an X-ray cuts or sections a figure. In his two recorded references to X-rays in notes made in the 1920s or later, Duchamp connected them to the ideas of transparency and cutting. The two notes read: "X Rays ?/infra thin/Transparency or cuttingness" and "the cutting edge of a blade and transparency/and X-Rays and the 4th Dim."[65]

Yvonne and Magdeleine Torn in Tatters is a study of modes of representation with the nose as the focus. The two profiles to the left provide a contrast like that of Londe: the nose of Yvonne, at the very left (with its flesh modeled by the shadows of visible light), is opposed to the dark, "X-ray nose" of Magdeleine, an X-ray shadow that, ironically, is attached to the most highly modeled face of the four heads. The next profile, again Yvonne's, conflates the two kinds of shadows: a modeled nose floats in front of the profile, overlapping a black X-ray nose underneath. Finally, the profile at the right presents a silhouette (i.e., a shadow cast by visible light) that reverses light and dark. This silhouette may also be thought of as a geometric section or "cut," one of the ideas Duchamp would increasingly explore in connection with the fourth dimension.[66]

Kupka had made a similar comparison of internal and external form in his *Planes by Colors, Large Nude* of 1909–10 (Solomon R. Guggenheim Museum, New York), in which the right leg of the figure is painted as if it were X-rayed in contrast to the "sensual" pink flesh modeled by visible light on the nude's left side.[67] After these "juxtaposition paintings," Duchamp and Kupka rejected the retinal completely and began to explore the characteristics of X-ray plates and photographs as a means to evoke invisible reality in painting. In a series of works dating from 1910 through 1912, Kupka painted translucent, dematerialized figures such as the woman in his *Planes by Colors* (fig. 10), exhibited in the spring 1912 Salon des Indépendants. Significantly, the model in *Planes by Colors* (as well as its preparatory studies) has a contrasting, X-ray nose. With its back lighting, Kupka's image is like an X-ray plate held up to the light, the "psychic film" on which the artist has captured the immaterial, invisible reality of his model. Kupka had actually mused on the possibility of painting on a transparent material, and here the painted canvas stands as the equivalent of the psychic film of the clairvoyant artist.[68]

The surface of *Planes by Colors* is emphasized by the presence of planes and lines, divisions of the canvas that also suggest the rotational motion of the figure. Interested in chronophotography from the turn of the century, Kupka had experimented with depicting cinematic motion in several earlier works.[69] By later 1911, Duchamp, too, was exploring motion, and his works from fall 1911 and early 1912, such as *Portrait (Dulcinea)* (fig. 11) and *Nude Descending a Staircase (No. 1)* (Philadelphia Museum of Art, The Louise and Walter Arensberg Collection) and *Nude Descending a Staircase (No. 2)* (fig. 12), demonstrate the concern for chronophotography he shared with Kupka.[70] These paintings also add a new X-ray-related element to Duchamp's continued exploration of transparency and cutting: stripping and nudity.

The ability of X-rays to penetrate clothing and flesh made the danger of being denuded a humorous and slightly salacious theme in cartoons, poems, and songs. Some manufacturers actually advertised lead underwear to protect women from peering X-ray eyes, and cartoonists suggested other kinds of precautionary fashions (fig. 4, no. 11). An early poem published in *Photography Magazine* emphasized the naughtiness of X-rays:

The Roentgen Rays, the Roentgen Rays
What is this craze?
The town's ablaze
With the new phase
Of X-rays' ways.

I'm full of daze
Shock and amaze;
For now-a-days
I hear they'll gaze
Thro' cloak and gown—and even stays,
These naughty, naughty Roentgen Rays.[71]

Or, as *L'Illustration* suggested in its March 1896 article entitled "La Radiographie," which was illustrated with Londe's pairs of photographs: "The best dressed and most warmly wrapped woman, seen by 'cathodic light,' will appear on the photographic plate as *déshabillé* as the rabbit of M. Albert Londe."[72]

Duchamp claimed that the model for *Portrait (Dulcinea)* (fig. 11) was simply a woman he had seen walking her dog in Neuilly, rendering the "sweetheart" (*dulcinée*) of the title ironic.[73] Like the women who feared the effects of X-ray vision, Dulcinea is progressively denuded as she moves through the painting, exiting to the left wearing only her hat. Depicted in successive stages of movement, Dulcinea's body is partially transparent and dematerialized, in the manner of the X-ray (and Cubist painting), which opened up the closed boundaries of forms. Here, too, Duchamp has adopted the muted, almost monochromatic palette of much early Cubist painting, using the warm tones of yellow and brown (and, at times, green) that would characterize his painting through summer 1911.

In *Nude Descending a Staircase (No. 2)* (fig. 12), both clothing and flesh disappear. As Duchamp told Pierre Cabanne, "There is no flesh, only a simplified anatomy, the up and down, the arms and legs."[74] In his 1946 interview with James Johnson Sweeney, Duchamp confirmed that the idea of a skeleton had occurred to him, even though he ultimately chose a more linear, geometric form for expressing movement: "A form passing through space would traverse a line. . . . Therefore I felt justified in reducing a figure in movement to a line rather than to a skeleton. Reduce, reduce, reduce was my thought;—but at the time my aim was turning inward, rather than toward externals."[75] In its final form, Duchamp's nude does bear a certain resemblance to the skeleton revealed in a full-body X-ray (fig. 13), particularly in the prominent pelvic cavity of the most complete view of the nude at the right side of the canvas.[76] Picasso's nudes of 1909–10 exhibit similiarly prominent hip bones (fig. 3).

Because Duchamp mentioned the name of Marey, the pioneer of chronophotography, in his conversations with Cabanne, scholars have most often compared the sequential motion of the *Nude Descending a Staircase (No. 2)* to Marey's works and, particularly, to his method of

"chronophotographie géometrique."[77] In these images the contrasting set of lines and dots Marey placed on the costume of the moving figure produced a clear record of linear translation (fig. 7), just as the dotted circles in Duchamp's painting suggest the circular motion of the nude's elbow. Duchamp's *Nude*, however, likely owes a debt to Albert Londe's chronophotography as well, even though Londe photographed separate images rather than superimposing them on a single plate, as Marey did.

Paul Richer, a professor of anatomy at the Ecole des Beaux-Arts, used Londe's chronophotographs as the basis for the "squelettes schématiques" he published in such books as *Physiologie artistique de l'homme en mouvement* of 1895 (fig. 14).[78] With the knowledge that Richer's image derives from a chronophotograph by Londe, who was already of interest to Duchamp, the case for a connection to this source is much stronger. Indeed, Richer actually transformed the model from Londe's chronophotograph into a skeletal head and linear spine, the two forms Duchamp considered for the *Nude*. Because the four steps of Richer's figure match so closely the configuration of Duchamp's painting, Richer's diagram is almost certainly the prototype for Duchamp's composition.

To Richer's image Duchamp added the tracings recorded in Marey's superimposed chronophotographs and in Kupka's paintings of motion in order to suggest the invisible "virtual volumes" created by the repetition of a geometric form in motion. Terming this repetition "elementary parallelism" or "demultiplication," Duchamp considered this technique a means of generating higher dimensional forms. He had been exploring such ideas since October 1911, when he began the studies for his *Portrait of Chess Players* (fig. 15), completed in December 1911. As the artist later stated, "Using again the technique of demultiplication in my interpretation of the Cubist theory, I painted the heads of my two brothers playing chess, not in a garden this time, but in indefinite space."[79] I have argued elsewhere that Duchamp's attempt to evoke the indefinite space of the fourth dimension by painting the mental states of his brothers during a chess game was in part a response to the geometer E. Jouffret's assertion that conceptualizing the fourth dimension is analogous to, but more difficult than, playing blindfold chess.[80] Yet, the invisible reality of *Portrait of Chess Players* suggests a connection to X-rays as well, in that seeing into the brain was a major theme of X-ray literature from the beginning.

McClure's Magazine for April 1896 reported the work of Professor Czermark of Graz in X-raying the skull as well as Edison's assertion that he hoped to be able to photograph the human brain through the skull.[81] The March

1896 article "La Radiographie," mentioned above, devoted considerable attention to possible means by which X-rays might "penetrate all the mysteries of the human body" and even "'open' the brain."[82] As noted earlier, occultists were also discussing the notion of capturing thoughts or dreams by means of an X-ray or other type of photographic plate. Thus, whether related to the scientific pursuit of seeing through the skull to the brain or to the occultists' goal of recording thoughts as psychic emanations, brain or thought photography was a prominent motif in this period.

Although in the final version of *Portrait of Chess Players* the chess pieces are localized between the heads of the two brothers, in the preparatory drawings and the oil study Duchamp distributed the pieces more widely, including some within the heads of the two figures. These drawings strongly suggest that Duchamp's stimulus for the work may have been the numerous contemporary cartoons in which X-rays of the heads of well-known individuals reveal objects symbolizing their character or interests (fig. 16).[83] Because Duchamp entitled the work *Portrait of Chess Players* and not simply *The Chess Game*—as in his 1910 version of the theme, also in the Philadelphia Museum of Art—the painting is indeed a mental portrait of these devotees of the game, who, like Duchamp himself, have chess "on the brain."

By spring 1912 Duchamp had begun to explore other scientific issues, such as the electrons that are at the root of his "Swift Nudes" series of that spring, the subject of chapter 2. The stripping of matter to its ultimate "corpuscles" represented a natural extension of Duchamp's earlier interest in stripping successive layers from the human figure, though X-rays would continue to prove relevant, at least through the summer of 1912. As a result, many of the works of spring and summer 1912 are an overlay of several scientific or technological sources, a technique Duchamp would cultivate deliberately in the complex visual punning of the *Large Glass*. The analysis of certain works discussed here in the context of X-rays is supplemented in the next two chapters, as Duchamp's new concerns in science, technology, and even occultism are brought to bear on some of these same works.

Duchamp's final phase of X-ray investigation concluded with his *Bride* (pl. 3, fig. 17), painted in August 1912 in Munich, where he had traveled in late June and remained into September. In 1968 Duchamp told John Russell that his trip to Munich was simply a manifestation of his "intense pleasure in being *away*": "If I went to Munich it was because I met a...German who painted cows...and when this cow-painter said 'Go to Munich' I got up and went there and lived for months in a little furnished

room."[84] Recently, this cow painter was discovered to be Max Bergmann, a German artist who had met Duchamp while visiting Paris in the spring of 1910 and who had become his near-constant companion. Just as Duchamp had shown Bergmann Paris and its nightlife, Bergmann introduced Duchamp to Munich and surrounding areas.[85]

Yet, other attractions drew Duchamp to Munich as well. Germany was a great center of advanced science and technology, which was showcased in the recently established Deutsches Museum. Röntgen himself, director of the Physical Institute at the University of Munich, was closely connected to the museum, which included exhibits of X-ray equipment and images.[86] In July 1912 X-rays were once again in the news when their identity as electromagnetic waves akin to light was finally proven by scientists at the Munich Physical Institute who had succeeded in refracting the rays through crystalline plates.[87] Beyond X-rays, the Deutsches Museum contained a striking survey of other aspects of science and technology that were beginning to interest Duchamp (e.g., figs. 37, 38), as discussed in subsequent chapters. It is a testament to the significance of the Deutsches Museum for Duchamp that in the 1960s he took his wife, Alexina, there so that she might see it.[88]

With Munich offering a fresh array of X-ray images, Duchamp's July 1912 drawings, *Virgin (No. 1)* (fig. 35) and *Virgin (No. 2)* (fig. 36), may be in part a response to the bodily abstractions produced by the standard method of X-raying only part of a figure at a time. With their striking dark-light contrasts and free arrangements of form, the *Virgin* drawings are like conflations of partial X-ray images of assorted body parts, akin to Willem de Kooning's later use of "intimate proportions" as a way to free up his drawing style.[89] In addition, as we shall see, *Virgin (No. 1)* has a substructure based on a technological source freely reinterpreted. In his notes for the *Large Glass*, Duchamp talks of a similar approach that would use "photographic records which no longer look like photographs of something," an idea that could apply both to X-rayed bodies and to close-up views of machines.[90]

In contrast to the drawings, Duchamp's approach in the oil paintings produced in Munich, *The Passage from Virgin to Bride* (fig. 33) and *Bride* (pl. 3, fig. 17), is more overtly organic in appearance and may draw on ideas and images that Duchamp had encountered earlier in Paris. Although in his notes for the *Large Glass* Duchamp refers to the Bride as "a kind of spinal column," she is actually more organic and fleshy than skeletal.[91] As he later explained, "This is not the realistic interpretation of a bride but my concept of a bride expressed by the juxtaposition of mechanical elements and visceral forms."[92]

This new preoccupation with the internal organs of the body may relate to advances in X-ray technology, which could now readily examine internal organs and even chronicle bodily processes, such as digestion, by means of X-ray cinematography. In addition, the notion that the interior essence of a person could be expressed by one's internal organs is close to the theories set forth by the occultist known as Papus in a fall 1911 series of articles in *La Vie Mystérieuse*, entitled "Comment est constitué l'Etre Humain."[93]

In 1896 scientists had discovered that injecting organs with fluorescent substances would produce an image of the otherwise transparent organ on an X-ray plate.[94] In the early years of the technology, however, X-ray exposure involved a relatively lengthy procedure. It was not until the end of the first decade of this century that an efficient method for direct X-ray cinematography was developed. The Marey Institute in Paris was an active center of research in this area; some of the first successful films made there recorded animal digestion (fig. 18).[95] The structure of the Bride at the center of Duchamp's painting suggests a debt to images of tubular organs like the digestive tube of a frog at the right of figure 18. Just as the cinematographic frames isolate each stage of the process, Duchamp's *Bride* is painted in clearly defined, static forms that differ sharply from the fluid, transparent, and often dynamic forms of his X-ray-related works of fall 1911 and spring 1912.

The new scientific focus on internal processes was paralleled by the concern of occultists like Papus with the physiology of the human body, the subject of his fall 1911 series for *La Vie Mystérieuse*. Papus's interest in physiology had preceded the discovery of X-rays, however, for he had studied the subject at the Faculty of Medicine in Paris in the 1880s. Under his given name, Gérard Encausse, Papus had published in 1891 an *Essai de physiologie synthétique*, which was intended to provide a larger, more synthetic consideration of questions in physiology than did medical texts.[96] The book contained the essence of the ideas expressed in the *La Vie Mystérieuse* series, which was reprinted from Papus's 1900 pamphlet of the same name. Given both Kupka's study of physiology and the medical studies of Duchamp-Villon and Duchamp's friends, Dumouchel and Tribout, Duchamp may well have encountered Papus's imagery even before it appeared in *La Vie Mystérieuse*. Although he is little known today, Papus, the editor of *L'Initiation* and author of numerous books on a variety of occult subjects, was a prominent figure in Paris at this time. Apollinaire, for example, owned five of his books, including the second edition of the *Essai de physiologie synthétique* (1909).[97]

In his synthetic physiology, Papus concentrated on "astral man" as the mediator between a human's spirit and animal nature and posited the astral body's three centers of action as the "cervical plexus" (controlling the brain), the "cardiac plexus" (controlling the chest), and the "solar plexus" (governing the stomach and digestive system). Papus's illustration (fig. 19) shows the three centers (labeled G), the organs to which they relate (to the right), and a schematic, tubular spinal column (to the left). In the central image of the *Bride* (pl. 3, fig. 17) Duchamp uses a similar schema: the fan-shaped form in the middle of the upper half of the painting suggests the head or brain, which is joined to a vertical tube that swells below to become the symbol for the chest cavity and is connected further down to the baglike stomach and "solar plexus" to the left of the curved central tube. Because Papus's image was a unisex human, he suggested the female sex only by means of the sign for female at the base of his drawing. By contrast, sexuality was Duchamp's central theme, and he ultimately identified the Bride's conical midsection as her "Sex Cylinder," adding further reproductive organs at the lower left, such as her "Desire-gear" (see fig. 82, nos. 5, 11; fig. 105).[98]

Duchamp said later that he "first glimpsed the fourth dimension in his work" in his *Bride* of 1912.[99] In the context of contemporary literature on the fourth dimension, the most feasible connection of the *Bride* to the fourth dimension would have been through the notion of clairvoyance: a four-dimensional being could easily observe the interior of solid, three-dimensional forms, just as X-rays had enabled modern man to do. Because four-dimensional vision was also frequently linked to "astral vision," Duchamp's *Bride*, drawing upon X-rays of internal organs as well as Papus's image of astral man, united science and occultism in the quest for invisible reality.

During this period Duchamp would also have been aware of the anatomical drawings of Leonardo da Vinci, a number of whose manuscripts had recently been published (see chap. 6). Convincing visual comparisons have been suggested between the *Bride* and Leonardo's drawings of female anatomy.[100] Indeed, X-ray photography and occult physiology would have allowed Duchamp to update Leonardo's studies of interior body structures. Yet the *Bride* marked the end of Duchamp's period of active exploration of organic forms and his use of X-ray imagery as a means to reveal an invisible, perhaps four-dimensional reality. Nonetheless, he was pleased enough with this image to reuse the central form of the *Bride* in the upper half of the new work he first sketched out in 1913: *The Bride Stripped Bare by Her Bachelors, Even* (pl. 1, figs. 76, 165). As a result of Duchamp's growing scientific and

technological interests, the Bride in that work would take on multiple connotations beyond her anatomical sources.

Just as certain forms in Duchamp's *Bride* and the *Large Glass* seem to derive from images related to human anatomy, Duchamp's preoccupation with themes such as "The Passage from Virgin to Bride" and "Bride" may reflect to some degree his personal experience. At the same time he was entertaining Max Bergmann in Paris, he established a liaison with a married woman, Jeanne Serre, who served as his model in paintings such as *The Bush* of 1910–11 (Philadelphia Museum of Art, The Louise and Walter Arensberg Collection). During April 1910 Duchamp and Bergmann were two "bachelors" accompanying a "bride"; in February 1911 this bride of another man bore Duchamp a daughter.[101] This previously unknown fact unquestionably adds another dimension of meaning to Duchamp's works of this era. The *Large Glass*, however, would move far beyond the level of individual experience to function as a universal allegory of sexual or religious-philosophical striving, recast humorously in the language of science and technology.

Picabia, Cubism, and X-Rays

Duchamp gave his canvas of the *Bride* to his friend Picabia who, along with his wife, Gabrielle Buffet, had participated actively in the gatherings at Puteaux during later 1911 and 1912. During the course of 1912, Duchamp, Picabia, and Apollinaire were to become increasingly close and share a number of activities, including at least two events that would bear directly on the evolution of the *Large Glass*: a performance of Raymond Roussel's *Impressions d'Afrique*, probably in May or June 1912, and an October 1912 automobile trip to Buffet's family home in the Jura Mountains.[102] In February 1913 Picabia and Buffet traveled to New York for the International Exhibition of Modern Art (better known as the Armory Show), America's first large-scale introduction to modern European art, including Cubist paintings and Duchamp's *Nude Descending a Staircase (No. 2)*. While in New York, Picabia and Buffet were closely associated with the circle around Alfred Stieglitz's "291" gallery, and Picabia produced a series of watercolors on the theme of New York City.[103] The title of one of these works specifically documents Picabia's interest in X-rays: *La Ville de New York aperçue à travers le corps* (fig. 20) alludes to one of the standard designations for X-ray photography in this period, "photographie à travers les corps" (fig. 5). Before their return to Paris in April 1913, Picabia, who was undoubtedly stimulated by Duchamp's interests, also created the "object portrait" *Mechanical Expression*

Seen through Our Own Mechanical Expression (fig. 57), which is based in part on the Crookes tubes used to produce X-rays.[104]

Although in numerous interviews in New York Picabia announced that his art was "post-Cubist," the theoretical ideas he and Buffet expressed were clearly rooted in the Cubist theory that had developed during 1911 and 1912 at Puteaux. For example, Buffet's article for *Camera Work*, "Modern Art and the Public," a text demonstrating the enthusiasm for recent science she and Picabia shared with Duchamp, asserts that the modern artist "plumb[s] to the depths" and "pierce[s] below the surface of objects."[105] Such revelatory vision, with its evocation of X-rays, had been a prominent theme of Gleizes and Metzinger's *Du Cubisme*, published in December 1912. In that essay, the first major enunciation of Cubist theory, Gleizes and Metzinger presented Cubism as a new mode of vision based on a new kind of revelatory light that penetrates instead of being reflected from forms, as the light of Realism and Impressionism had been. Like Buffet in her article, the Cubist authors had revealed their post-Röntgen way of thinking about light and vision by claiming, for example, that Cubism "plunges with Cézanne into profound reality, growing luminous as it forces the unknowable to retreat."[106]

Another echo of Puteaux Cubist theory as transmitted to New York by Picabia and Buffet is the article by the American critic Christian Brinton, "Evolution Not Revolution in Art," which testifies specifically to the importance of X-rays for the modern artists. In his attempt to explain European modern art to an American audience encountering it for the first time, Brinton drew in part upon the ideas of Picabia and Buffet and gave considerable attention to the art of Picasso and Picabia. Using the term "Expressionistic" to signify art since Impressionism, Brinton concludes his text with the following argument:

There is no phase of activity or facet of nature which should be forbidden the creative artist. The X-ray may quite as legitimately claim his attention as the rainbow, and if he so desire he is equally entitled to renounce the static and devote his energies to the kinetoscopic. If the discoveries of Chevruel [*sic*] and Rood in the realm of optics proved of substantial assistance to the Impressionists, there is scant reason why those of von [*sic*] Röntgen or Edison along other lines should be ignored by Expressionist and Futurist. . . . The point is that they will add nothing [to "the accumulated treasury of the ages"] unless they keep alive that primal wonder and curiosity concerning the universe, both visible and invisible, which was characteristic of the caveman, and which has proved the mainstay of art throughout successive centuries.[107]

Brinton's text thus seconds the view expressed in Léon Rosenthal's review of the 1912 Indépendants salon, noted earlier. Appropriately, Duchamp's *Nude Descending a Staircase (No. 2)* (fig. 12), which was originally to have been exhibited in the spring 1912 Indépendants exhibition, was among the paintings to which Brinton's counsel would apply.[108]

Unlike Rosenthal and Brinton, French artists and critics were never as direct in citing the importance of the redefinition of reality produced by X-rays. As noted earlier, it is likely that the Italian Futurists' prior claim to X-ray vision (as early as 1910) contributed significantly to this relative silence on the subject in avant-garde writings. Thus, the Cubist painter Le Fauconnier, for example, expressed himself with characteristic subtlety in October 1912: "Scientific accomplishments offer to our eye forms until now unknown."[109] Gleizes and Metzinger, in *Du Cubisme*, mention "Fraunhofer lines," which are the dark bands within a spectrum that reveal the presence of a particular chemical element absorbing light at a certain wavelength, such as the helium gas that was discovered in the solar spectrum before it was isolated on earth.[110] Widely discussed in this period in the context of spectroscopy, Fraunhofer lines, like X-rays, were a sign of previously undetected aspects of physical reality.[111]

On the subject of Picasso's Cubism the critic Apollinaire had likewise used language that implies the penetration of X-ray vision, describing the artist as one who "sharply questioned the universe" and "accustomed himself to the immense light of depths."[112] In discussing works of 1909–10 such as the *Nude* (fig. 3), Picasso's dealer, Daniel-Henry Kahnweiler, wrote that the artist had "pierced the closed form" or the "skin" of objects, metaphorically evoking the literal penetration of X-rays.[113] By summer 1910 Picasso's figures had become a type of skeleton, consisting of a linear grid, with object and space completely interpenetrating—as suggested by Bergson's philosophy of continuity, radioactivity, Le Bon's popular theories of the dematerialization of all matter, and the transparent, fluid forms of X-ray photographs. Such discoveries had fundamentally changed conceptions of not only matter and space but visible light, the primary form-creating element in painting since the Renaissance.

As an artist, Picasso cannot have been unaware of these changes, particularly in view of the X-ray fad in Parisian popular culture. Moreover, Picasso was an amateur photographer (a field in which X-ray photography was actively discussed) and an admirer of Jarry. Picasso's curiosity about X-rays is documented in a sketchbook of 1917, in which he queried, "Has anyone put a prism in front of X-ray light?"[114] Indeed, the presence of distin-

guishable shafts of light in many of Picasso's and Braque's Cubist paintings (e.g., the Danae-like shower of light over the right shoulder of the model in *Nude*) strongly suggests that the contrast of visible light and X-ray vision was a concern of both artists.

Duchamp had adopted Cubism's palette and the generalized fluidity and transparency for his first X-ray-related works in late summer 1911. He and Kupka went much further, however, in exploring specific aspects of X-ray imagery (e.g., noses) and, in Duchamp's case, other concepts associated with X-rays (humorous stripping, the photography of thought, and the X-ray cinematography of digestion). By later 1912 Kupka had abandoned X-rays in favor of other ranges of the electromagnetic spectrum (primarily Hertzian or radio waves) as a model for artistic communication. As will be seen, his pure color abstractions, such as *Vertical Planes I* (fig. 86), were meant to be generators of specific ranges of vibrations of visible light. As Kupka and Duchamp ventured further into the realm of science, Kupka wrote critically in October 1913 of the rest of the avant-garde (perhaps not without a gentle indictment of his own and Duchamp's earlier paintings):

They will think of every imaginable endeavor to express nature by four dimensions, to express movement by immobile means, etc.; they will philosophize, become excited in the domain of ideas and even, perhaps, science. They will paint X-rays, electric waves; they will paint the interior of the earth, the bottom of the sea, and thus going on to infinity, they paint madly. And is this the purpose of art? . . . Certainly not.[115]

By 1913 the goal of painting for Duchamp and Kupka would no longer be the creation on canvas of a suprasensual "window" through which a viewer could glimpse higher reality as revealed by the artist. Instead, scientific processes and, particularly for Duchamp (and Picabia), the equipment of science and technology would offer a fertile new area of exploration. Duchamp may well have discovered the equipment of physics and chemistry in books on X-rays, which, because of the uncertainty about their nature, regularly included chapters surveying relevant issues in physics and physical chemistry. Here, too, he would have encountered the latest developments in the growing area of atom theory, which drew on research involving the streams of electrons known as cathode rays and the latest discoveries in radioactivity. As a result, before he abandoned his creation of models of an invisible world for his role as Playful Physic[ist] and chemist in the *Large Glass*, Duchamp produced a number of works in which he sought to penetrate the essence of matter even more deeply than X-rays had done.

Chapter 2

The Invisible Reality of Matter Itself

Electrons, Radioactivity, and Even Alchemy, Spring and Summer 1912

After his completion of the *Nude Descending a Staircase (No. 2)* in January 1912, Duchamp's exploration of motion entered a new phase. In March he began a series of works on paper on the theme of "Swift Nudes," which culminated in his May 1912 painting *The King and Queen Surrounded by Swift Nudes* (pl. 2, fig. 21). These preparatory works include two pencil drawings, *2 Nudes: One Strong and One Swift* of March 1912 (fig. 22) and *The King and Queen Traversed by Swift Nudes* of April 1912 (fig. 23), and a watercolor and gouache study, *The King and Queen Traversed by Nudes at High Speed* of April 1912 (fig. 24).[1] Having long eluded any interpretation beyond the themes of speed, nudity, and chess suggested by their titles, this series becomes far more meaningful when considered in the light of contemporary science, in particular, research related to electrons and electricity.[2]

In contrast to what Duchamp termed the "static representation of movement" in the *Nude Descending a Staircase*, these new works emphasized speed and fluid motion.[3] Duchamp's new interest was undoubtedly stimulated by the most dramatic artistic event of early 1912 in Paris, the Italian Futurists' February exhibition at the Galerie Bernheim-Jeune. Whether in F. T. Marinetti's "Founding and Manifesto of Futurism" of 1909, which dramatically extolled the "beauty of speed," as exemplified by "a racing car whose hood is adorned with great pipes, like serpents of explosive breath," or in the numerous paintings in the exhibition that treated themes of modern transportation, Futurism glorified the intensity and speed of modern experience.[4] Indeed, Duchamp's small drawing, *2 Personages and a Car (Study)* (fig. 25), may well be a response to Futurist ideas as well as to popular images of "automobilisme," such as a 1906 Michelin advertisement in which a racing automobile speeds diagonally past a stationary viewer (fig. 26).

With its two flanking figures, *2 Personages* exhibits a basic structural resemblance to *The King and Queen Surrounded by Swift Nudes* and is likely the precursor of the "Swift Nudes" series. As an overt depiction of popular technology, however, the drawing is unusual among Duchamp's works.[5] Although the theme of the automobile would be central to his initial conception of the Bride of the *Large Glass*, Duchamp would never again treat the automobile in such a specifically Futurist manner.[6] Instead, he left behind Futurist notions of speed to explore a velocity far surpassing that of a mere machine: that of the electron.

As noted earlier, in 1897 J. J. Thomson had established the existence of "corpuscles" of electricity, or electrons, in the course of his cathode-ray research. Electrons, which represented a further stage in the "denuding" of matter, were the subject of much scientific study and the topic of a surprising amount of popular literature. Before examining what scientific literature may have offered Duchamp on the subject of electrons as well as means to give visual form to electricity, it is useful to review the artist's own later statements on the significance of the "Swift Nudes" series. Apollinaire's discussion of Duchamp's works of this period in his *Les Peintres Cubistes* of 1913 is also revealing and supports the thesis that science had come to play an increasingly central role in Duchamp's thinking.

In a 1964 lecture on his work, Duchamp described the painting *The King and Queen Surrounded by Swift Nudes* as follows:

The title *King and Queen* was once again taken from chess but the players of 1911 (my two brothers) have been eliminated and replaced by the chess figures of the king and queen. The swift nudes are a flight of imagination introduced to satisfy my preoccupation of movement still present in this painting. . . . It's a theme of motion in a frame of static entities.[7]

Two years earlier, in an interview with Katherine Kuh, Duchamp had been more specific about the nature of the motion of the nudes around the king and queen, who are described in the drawings as "traversés" (traversed) and in the painting's title as "entourés" (surrounded). Contrasting the *King and Queen* to the *Nude Descending a Staircase*, he explained: "Here 'the swift nudes,' instead of descending, were included to suggest a different kind of speed, of movement—a kind of flowing around and between the central figures. The use of nudes completely

removed any chance of suggesting an actual scene or an actual king and queen."[8]

Later in the 1960s, in discussing the *King and Queen* painting with Pierre Cabanne, Duchamp further distinguished this work from the *Nude Descending a Staircase*: "Obviously the difference was the introduction of the strong nude and the swift nude. . . . There was the strong nude who was the king; as for the swift nudes, they were the trails which crisscross the painting, which have no anatomical detail, no more than before."[9] And, as he told Arturo Schwarz in the same period: "I expected to render the idea of a strong king, or a male king and a feminine queen, a female queen. And the nudes were not anatomical nudes, rather things floating around the King and Queen without being hampered by their materiality."[10]

Apollinaire's text on Duchamp was included in the second half of *Les Peintres Cubistes*, among similar essays on Picasso, Braque, and the Puteaux Cubists. Because Duchamp had become increasingly close to Apollinaire during late 1912, the critic's remarks provide important clues to Duchamp's thinking in this period.[11] Like the other Cubist painters, Apollinaire notes, Duchamp "has abandoned the cult of appearances"; "he uses forms and colors, not to render appearances, but to penetrate the essential nature of forms and formal colors."[12] In contrast to his discussions of the other painters, however, Apollinaire emphasizes Duchamp's intellect, noting that he writes "an extremely intellectual title" directly on the canvas and "is not afraid of being criticized as esoteric or unintelligible." Moreover, the "traces of beings" present in Duchamp's paintings "take on a character whose plastic traits can be indicated by a purely intellectual operation."

Apollinaire's curious discussion of traces of beings in Duchamp's paintings precedes his comment that "Duchamp is the only painter of the modern school who today (autumn, 1912) concerns himself with the nude: *King and Queen Surrounded by Swift Nudes*, *King and Queen Traversed by Swift Nudes*, *Nude Descending a Staircase*." Apollinaire had introduced the idea of traces by stating that "all men, all the beings that have passed near us, have left some imprints on our memory, and these imprints of lives have a reality, the details of which can be studied and copied." Although this sentence has a strongly Bergsonian ring to it,[13] Apollinaire's subsequent paragraphs also suggest that such traces might be physical manifestations of some type of "dematerialization of matter," to use Gustave Le Bon's phrase.

In these final paragraphs, Apollinaire writes:

An art directed to wresting from nature, not intellectual generalizations, but collective forms and colors, the perception of which has not yet become knowledge, is certainly conceivable, and a painter like Marcel Duchamp is very likely to realize such an art.

It is possible that these unknown, profound, and abruptly grandiose aspects of nature do not have to be aestheticized in order to move us; this would explain the flame-shaped colors [l'aspect flammiforme des couleurs], the compositions in the form of an N, the rumbling tones, now tender, now firmly accented. These conceptions are not determined by an aesthetic, but by the energy of a few lines (forms or colors).

This technique can produce works of a strength so far undreamed of. It may even play a social role.

Just as Cimabue's pictures were paraded through the streets, our century has seen the airplane of Blériot, laden with the efforts humanity made for the past thousand years, escorted in glory to the Arts-et-Métiers. Perhaps it will be the task of an artist as detached from aesthetic preoccupations, and as preoccupied with energy as Marcel Duchamp, to reconcile art and the people.

Apollinaire included *The King and Queen Surrounded by Swift Nudes* among the illustrations of Duchamp's works in *Les Peintres Cubistes*, and his reference to "compositions in the form of an N," the basic structure of the *King and Queen* drawings and painting (figs. 21, 23, 24), further links these final paragraphs to the "Swift Nudes" series. As with Apollinaire's earlier reference to Duchamp's desire "to penetrate the essential nature of forms," here the talk of "unknown, profound, and abruptly grandiose aspects of nature" ("the perception of which has not yet become knowledge"), of Duchamp's "preoccupation with energy," and even the "flame-shaped colors" points to electrons and the science of electromagnetism, as will be seen. Further, Apollinaire provides a direct clue to one of Duchamp's important sources of information: the "Arts-et-Métiers," the Conservatoire National des Arts et Métiers and its museum (mistranslated in the standard English version of Apollinaire's text as the "Academy of Arts and Sciences").[14]

As subsequent chapters reveal, the Musée Industriel (or Musée National des Techniques, as it is called today) of the Conservatoire National des Arts et Métiers seems to have been a direct stimulus for many of Duchamp's works from 1913 through the *Large Glass*. Filled with the equipment of physics and chemistry as well as examples of recent technology (wireless telegraphy apparatuses, automobiles, and airplanes such as that of Louis Blériot, who had crossed the English Channel in 1909), the Arts et Métiers (fig. 164) would have provided a wealth of images and ideas for Duchamp. Kupka, Duchamp's infor-

mal mentor, has been described as an "assiduous visitor" to the Musée des Arts et Métiers; and, according to Mme Duchamp, her husband, in addition to showing her the Deutsches Museum in the 1960s, took her both to the Arts et Métiers and to the Palais de la Découverte, a science museum that opened in 1937.[15] Fall 1912, the period when Apollinaire was completing his text, was also the moment that Duchamp made his famous comment to Léger and Constantin Brancusi upon visiting the Salon de la Locomotion Aérienne (fig. 40): "Painting's washed up. Who'll do any better than that propeller? Tell me, can you do that?"[16] This was not a sudden revelation for Duchamp, however, because given his visits to the Arts et Métiers and the Deutsches Museum (fig. 38), he would have been well acquainted with airplane technology, as his Munich wash drawing *Airplane* (fig. 37) documents.

Apollinaire was undoubtedly referring to Duchamp's growing interest in science and technology (encoded in the phrase "preoccupation with energy") when he suggested that Duchamp might be the one artist who could "reconcile art and the people." In contrast to the "aesthetic preoccupations" of artists and the art world, here was an artist who, like the average Frenchman, was more excited by Blériot's airplane than by the masterpieces in the Louvre. After 1912 Duchamp executed only a few works in the traditional medium of oil on canvas, and the equipment of science and technology came to function as a key source for his art. In the end, however, reconciling art and people was not Duchamp's goal in these works, which more often than not have mystified their audience and concealed their specific scientific or technological roots.

If Apollinaire's prediction was incorrect, his text nevertheless provides a near-contemporary reflection of Duchamp's interests at the time of the "Swift Nudes" series and the drawings and paintings made in Munich. Aesthetic sources have already been replaced by scientific ones in these works, but it is the processes uncovered by science, and not yet the equipment of science or technology, on which Duchamp concentrates. Bracketed by two works overtly indebted to transportation technology, *2 Personages and a Car* (fig. 25) and the August–September drawing *Airplane* (fig. 37), the drawings and paintings of spring–summer 1912 are unified by their debt to the scientific phenomena Duchamp first encountered in the literature on X-rays: electrons as studied in research on cathode rays and radioactivity, as well as electric sparks. Given the prevalence of references to alchemy in the popular literature on radioactivity, Duchamp's elusive Munich drawing *First Study for: The Bride Stripped Bare by the Bachelors* (fig. 31), with its slight variation on the title he would use for the *Large Glass*, can likewise be recognized as a part of this group of works rooted in contemporary science.

Giving Form to Electrons

Unlike X-rays, the cathode rays that generated them had never drawn widespread public attention. "Cathode rays have no practical application," declared A. Dastre in the *Revue des Deux Mondes* in 1901, never suspecting the key role cathode ray tubes would play in the future field of electronics—from television tubes to computer screens.[17] During the first decade of the century, however, the electrons Thomson had demonstrated to be the components of the ray flowing from the cathode to the anode of a Crookes tube began to attract notice. The existence of such infinitesimal particles, "less than one-thousandth part of the mass of an atom of hydrogen," stimulated much new theorizing about the nature of matter and electricity.[18] Most important, as Thomson concluded in 1897, atoms were not indivisible, as had been thought, but contained "negatively electrified particles [that] can be torn from them by the action of electrical forces."[19]

Beyond the insights Thomson and others continued to draw from cathode-ray research, the discovery of radioactivity and, particularly, the contributions of Ernest Rutherford added important new information to the enigma of the atom during the early years of the century.[20] The beta "rays" Rutherford had identified as one of the radioactive emissions were discovered to be streams of electrons, like cathode rays, and the alpha "rays" were found to be positively charged particles.[21] The popular literature on radioactivity and, in France especially, the related writings of Le Bon further stimulated interest in atom theory and electrons. It was suggested that the electron might be the fundamental unit of all matter, or as Sir Oliver Lodge, the widely published British physicist, declared in 1904, "Matter . . . appears to be composed of positive and negative electricity and nothing else."[22]

Physics now offered a new challenge to the imagination of the artist, the invisible reality of the electron within the atom. Despite the "hopeless invisibility of an atom," certain themes emerged from scientific and popular discussions of the electrons composing cathode rays and radioactive beta emissions.[23] Indeed, their image as projectiles whizzing at enormous velocities dominated popular discussions from 1896 onward. Once Thomson's experiments determined that electrons traveled over 10,000 kilometers per second and radioactive beta emissions were subsequently found to travel even faster, electron velocities of 160,000 kilometers per second and higher were regularly cited.[24]

A number of hypothetical models of atomic structure were also put forward, including Thomson's conception of electrons embedded throughout the atom like pieces of plum in a plum pudding. Others proposed structures of the planetary type, a hypothesis Rutherford would establish experimentally and announce in March 1911, clarifying at the same time the small size of the central area of positive charge (i.e., the nucleus) in relation to the atom as a whole.[25] Thus, in the decade before Rutherford's announcement, the general analogy of the atom to the solar system was already being discussed in the publications of Lodge, Joseph Larmor, Jean Perrin, Le Bon, and others.[26] For example, Lucien Poincaré wrote in his survey of contemporary physics, *La Physique moderne, son evolution*, of 1907:

The atom may be regarded as a sort of solar system in which electrons in considerable numbers gravitate around the sun formed by the positive ion. . . . The phenomena of the emission of light compels us to think that the corpuscles revolve round the nucleus with extreme velocities, or at the rate of thousands of billions of evolutions per second. It is easy to conceive from this that, notwithstanding its lightness, an atom thus constituted may possess an enormous energy.[27]

That such a realm could offer stimulation to a writer or artist is confirmed in an October 1908 article in *Mercure de France* entitled "Histoire extraordinaire des Electrons." The author, Georges Matisse, begins his text by recalling Henri Poincaré's remark on assuming the presidency of the Société Française de Physique several years before: it was, he said, "a great source of joy, of pure intellectual satisfaction to be able to follow the fantastic progress of physical science at the beginning of the twentieth century."[28] Matisse continues, arguing that physics is indeed "full of marvelous tales":

One of these especially seems made to bring to the soul of the artist the "pure intellectual satisfaction" of which Poincaré speaks: it is called, I believe, Extraordinary adventures or Theory of electrons. Electrons are charming, petite beings who recall the elves and trolls of Scandinavia. They are extremely tenuous: 1,000 times smaller than the hydrogen atom, say some; 2,000 times, claim others. . . . Large numbers of these electrons, dressed in negative electricity, are the subjects of a king for whom they form the court. This monarch is a large atom wearing a cloak of positive electricity, not a common atom, but the quintessence which remains after a certain number of light and "short-skirted" particles have detached themselves from him. Around the

royal highness hover and whirl his courtiers, negative electrons, who waltz rapidly in his presence.

Matisse then adds the ideas of a queen and the dematerialization of matter posited by Le Bon:

Observing them [the electrons], it is impossible not to think of the charming fairy scene of Giselle, conceived by Théophile Gautier. . . . All night [the spirits] dance furiously, flying and whirling around their queen. Untiringly, they continue to dance until dawn, when they disappear into the plants from which they had emerged. Our electrons are like them: after having agilely turned about for a certain time, they disappear, recombine themselves and return into the atom from which they had left. J. J. Thomson has calculated "the mean duration of freedom"—one might say the life—of a corpuscle. This life is very short, shorter than that of the ephemerids; however, many are reborn after their death. . . . M. Gustave Le Bon has wondered if some family relationship does not exist among ordinary atoms, ions, electrons, X-rays, and energy. Well, if so, there is an intimate one: matter dematerializes little by little; it disincarnates itself, as a spiritist would say. An atom becomes an ion, an ion becomes an electron, then an X-ray, and, finally, energy and ether.[29]

After further discussion of the wonders of electrons, Matisse concludes with an affirmation: "Rejoice with Poincaré that we live in the twentieth century: this will be the century of electrons."[30] Such imaginative, anthropomorphic discussions of electrons surely lie behind Duchamp's conception of the series culminating in *The King and Queen Surrounded by Swift Nudes* (pl. 2, figs. 21–24).[31] Matisse's inclusion of Poincaré's statement regarding the "pure intellectual satisfaction" of physics was tailor-made for Duchamp at this moment. Already an admirer of Poincaré, he was now determined to incorporate "mental ideas" in his art.[32]

There is a striking conjunction between electron theory as presented by sources such as Matisse, and Duchamp's own statements on the "Swift Nudes." According to Matisse, not only are electrons swift, they are nude—"dressed in negative electricity." Duchamp, in 1915, spoke of "a procession of rapidly moving nudes" that flow around and between the central figures, including "the strong nude who was the king."[33] In the context of electrons and atom theory, the "strong nude" in Duchamp's first drawing of the series, *2 Nudes: One Strong and One Swift* (fig. 22), suggests not only a king but also the strong positive charge at the center of the atom that binds the swift negative electrons in their whirling orbits.[34]

In subsequent drawings the "Swift Nudes" become accessories to a royal pair, a king and queen (associated also with chess), "surrounding" or "traversing" them, "without being hampered by their materiality," as Duchamp later explained.[35] Rutherford, Perrin, and others regularly used the term *traverse* in their discussions of activity within an atom.[36] Duchamp's words also bring to mind Matisse's talk of electrons detaching themselves from and reentering the sphere of the atom's charge and his subsequent discussion of the dematerialization of matter. Duchamp's claim that the "Swift Nudes" are "unhampered" by their materiality echoes Le Bon's view, based on Lodge, Larmor, Hendrik Lorentz, and others, that the electron "has no property in common with matter, except a certain inertia varying with the velocity, [and] is more like ether than matter and forms a transition between them."[37] In this view, the electron was indeed a "bare" charge.

As noted in chapter 1, Le Bon saw the material atom as an "enormous condensation" of "intra-atomic energy" in the gradual process of dematerializing back into the ether, as electrons and other radioactive emissions escaped from the atom.[38] Matisse's text noted the formation of ions (an atom or molecule that has lost or gained electrons and is therefore positively or negatively charged) as a stage in this process. Duchamp's later reference to "trails which crisscross the painting" further strengthens the interpretation of the "Swift Nudes" as charged particles or electrons. Although in spring 1912 Duchamp was probably unaware of the British scientist C. T. R. Wilson's "cloud chamber," Wilson's work in tracing the paths of ionizing particles offers an interesting parallel to Duchamp's concerns in the "Swift Nudes" series.

In the 1890s Wilson had collaborated with J. J. Thomson in his research on the ionization of gases by X-rays, and in 1911 it was Wilson's cloud chamber that enabled Rutherford to determine the characteristic paths of the various radioactive emissions.[39] In this chamber Wilson was able to produce water condensation around the ions generated by the passage of charged particles or X-rays, resulting in vapor trails that could be recorded photographically (figs. 145, 146). In his first publication of two such photographs in November 1911, "On a Method of Making Visible the Paths of Ionising Particles through a Gas," Wilson referred to his images as the "tracks" of individual particles and the "traces of ions" left by them.[40] Yet it is hard to imagine how Duchamp in spring 1912 would have known of this first article, published in the *Proceedings of the Royal Society of London* and apparently not noted in popular literature. The same language, nonetheless, occurs in a far more elaborate Wilson article of December 1912, complete with nineteen examples of

"instantaneous photography," which Duchamp in his work on the *Large Glass* does seem likely to have encountered, directly or indirectly.[41] Duchamp's reference to "trails" may stand as a later confirmation of the intention he shared with Wilson to manifest the invisible realm of the electron and other subatomic particles. If in 1912 Duchamp was still attempting to embody such traces in drawings and paintings, Wilson's cloud-chamber photographs pointed the way toward the registering apparatus and techniques he would explore in the *Large Glass*.

When Apollinaire wrote in *Les Peintres Cubistes* of the presence of "traces of beings" ("all men, all the beings that have passed near us, have left some imprints on our memory"), he, like Matisse, linked the world of the dematerializing atom to the world of human interactions—in this case, the Bergsonian philosophy familiar to his readers. More directly, Apollinaire identified Duchamp's preoccupation as energy, a term that in this period would have brought to mind the internal energy of the atom touted by Le Bon and widely discussed in the literature on radioactivity.[42] According to Apollinaire, Duchamp explores "unknown, profound, and abruptly grandiose aspects of nature" and directs his art "to wresting from nature...collective forms and colors, the perception of which has not yet become knowledge." The imperceptible, internal world of the atom and electron had not yet become common knowledge and would require a "purely intellectual operation" to reveals its "plastic traits," as Apollinaire wrote, speaking of Duchamp's revelation of "traces of beings."[43]

In discussing the *Nude Descending a Staircase* with James Johnson Sweeney in 1946, Duchamp had emphasized the notion of decomposing forms "along the lines the cubists had done" but noted that he "wanted to go further—much further—in fact in quite another direction altogether."[44] Beyond the previously invisible realm for which X-rays had provided new visual clues, Duchamp in the "Swift Nudes" series undertook the ultimate decomposition of form—that of matter itself. As he stated later, "Before the *Nude* my paintings were visual. After that they were ideatic...."[45] Like the fourth dimension, the world of electrons was beyond visual perception and required that Duchamp "recreat[e] ideas in painting," as he said.[46]

That Duchamp tried several different means to evoke the invisible, speeding electrons is apparent from the differing manifestations of the nudes in the successive drawings and the final painting of the "Swift Nudes" series. The amorphous form of the Swift Nude at the right of the *2 Nudes* drawing (fig. 22) becomes, in the next drawing (fig. 23) and in the watercolor and gouache study (fig. 24),

a more tubular structure, projecting a fluid or flamelike "substance." Commentators have noted the strongly phallic quality of the forms, especially in figure 24, and their similarity to the menacing projectiles in the Munich drawing *First Study for: The Bride Stripped Bare by the Bachelors* (fig. 31). Here the sexual encounter that was to be the theme of the *Large Glass* is given its most literal treatment, with the almost robotic Bachelors at left and right aggressively brandishing phallic weapons that suggest lances or guns.[47]

Surprisingly, both the growing sexual overtones of the series and the ballistic aspect of the "Swift Nudes" and Bachelors can be linked to electrons and electricity. As discussed in subsequent chapters, the sexually suggestive language of electrical theory and practice was to be at the core of Duchamp's *Large Glass* project. X-rays already had produced a kind of electrical stripping of female figures; now, in certain works of the "Swift Nudes" series, Duchamp associated the rapidly flowing, newly denuded electrons with phallic emissions, emphasizing their aggressive, projectile character (figs. 23, 24). Indeed, the literature on electrons emphasized exactly this ballistic, bulletlike nature.

Before Thomson's identification of the electron, the nature of cathode rays had been uncertain. One view, strong among German scientists, was that they were indeed "rays" or ether waves akin to light; William Crookes and other British scientists, on the other hand, believed that the stream flowing from the cathode to the anode of a Crookes tube was a kind of high-velocity "molecular bombardment."[48] Crookes conducted a number of experiments to prove his theory of bombardment, which were regularly illustrated and discussed in sources on X-rays and cathode rays.[49] One of the most famous was Crookes's "mill wheel" or "paddle wheel," which was supported on two glass rods within a Crookes tube (fig. 152) and set into motion by the stream of particles of the cathode ray. Moving back and forth according to the direction of current flow into the tube, Crookes's mill wheel may have also been an antecedent, on a laboratory scale, of Duchamp's "Water Mill Wheel" in the *Large Glass* (figs. 151, 76, 77). In 1912, however, it was most important as part of the standard interpretation of cathode rays, that of bombarding electrons "projected like bullets"[50] and producing "blows of an appreciable proportion."[51]

By 1913, in his preparatory works for the *Large Glass* and in the *Glass* itself, Duchamp would turn increasingly to the actual equipment of science, such as Crookes tubes, assuming the role of amateur scientist as he speculated on the laws of his Playful Physics and chemistry. In 1912, however, he still sought to make visible the stream of electrons whose presence was confirmed by the turning

mill wheel or the glow of the gas in a Crookes tube. How to depict electricity was the challenge. As Georges Bohn declared in his review of Lucien Poincaré's *L'Electricité* in *Mercure de France* in 1907, "Our senses, so poorly adapted to the exterior world, remain mute with regard to electricity."[52] Yet there was one visual manifestations of electricity upon which Duchamp could draw—the electric spark or discharge, the laboratory version of the electrical effects embodied in lightning.

Electric sparks and discharges were not simply the subject of physics books in this period. The engineer Nikola Tesla, a native of Croatia who worked in the United States from 1884 onward, had, in the 1890s, produced spectacular flamelike electrical discharges in widely publicized demonstrations in America and Europe. Tesla was not only a brilliant inventor but also a visionary and a showman who made science intriguing to the public. He had lectured before the Société Française de Physique in Paris in 1892 (fig. 59), and his stature as a prominent international figure assured his presence in French publications ranging in topic from the scientific to the occult.[53]

Tesla was well known to the public for his work with high-frequency alternating currents and for the dramatic sparking discharges he was able to generate (figs. 27, 61), which were described as "flames." Figure 27 is drawn from the article, "Les Merveilles électriques de M. Tesla," published in *La Revue des Revues* in May 1895. Electric sparks (and lightning) are produced by the ionization of gases in the air as electron distributions alter with the buildup of electrical charge. Tesla created these conditions by means of a Tesla coil, an oscillation transformer that could step up the current to 100,000 volts, with frequencies as high as a million cycles a second. As illustrated in figure 27, Tesla's high-frequency perturbation of the earth's magnetic field drew forth the "superb sparks" for which he was famous.[54]

These flaming sparks, best known to the public by means of Tesla's showmanship but also available to Duchamp in any standard discussion of the physics of electricity (including Le Bon's *L'Evolution de la matière*), would have represented a physical manifestation of the invisible electrons.[55] Apollinaire, in *Les Peintre Cubistes*, had referred to the "flamelike quality" of Duchamp's colors, and the projection from the phallic opening left of center in figure 24 is particularly flamelike. In the final painting, or *The King and Queen Surrounded by Swift Nudes* (pl. 2, fig. 21), the flickering flow of nudes from lower right to upper left is composed of segmented forms akin to those of the bodies of the king and queen. Yet the second stream of nudes (across the top of the painting) is far more evanescent and sparklike and is painted blue, a

color that had come to be associated with electricity because of the recently coined term "electric blue."[56]

Beyond Tesla, Duchamp was aware of another, earlier association between flames and electricity that dovetailed into his new scientific concerns. This was the practice of Magnetism, noted briefly above in relation to the emanations surrounding the body of Dr. Dumouchel in Duchamp's portrait of his friend (fig. 2). In particular, the writings of Colonel Albert de Rochas, such as his *L'Extériorisation de la sensibilité* of 1895, illustrated flamelike magnetic emanations issuing both from the human body (fig. 28A) and from electrified electromagnets and natural magnets (fig. 28B). Moreover, the work of Rochas is treated in a book Duchamp is documented as having read: P. Camille Revel's *Le Hasard, sa loi et ses conséquences dans les sciences et en philosophie; suivi d'un essai sur La Métempsychose, basée sur les principes de la biologie et du magnétisme physiologique*, of 1909.[57]

A former administrator of the Ecole Polytechnique and a friend of Charles Henry, Rochas was an adherent of Animal Magnetism as modified by the German chemist Baron Karl von Reichenbach, who had set forth his idea of "Od" or "Odic force" in the 1840s and 1850s. Reichenbach had given this name to the force he believed he had observed emanating from magnets, crystals, and various body parts. In the context of the physics of electromagnetism in the 1890s (particularly X-rays and the discovery of radioactivity), Reichenbach's magnetic "vital force" experienced a revival. Rochas, who had translated Reichenbach's works into French, included discussions of Odic force in his own writings on the states of hypnosis (a process he and other Magnetizers still linked to the action of magnetic fluid) and on the exteriorization of sensibility (*sensibilité*) and motor activity (*motricité*) by mediums or other sensitive subjects.[58]

In *L'Extériorisation de la sensibilité*, which was in its sixth edition in 1909, Rochas introduced the issue of exteriorization with a discussion of the emanations observed by the hypnotized (and thus highly sensitized) patients of Dr. Luys. In general, Luys's subjects had witnessed blue or violet emanations coming from the right side of the body and the north pole of a magnet and red emanations from the left side and the south pole (figs. 28A, 28B). When an electric current was employed to produce an electromagnet, whose poles could be reversed with the direction of the current, the subjects observed blue coloration at the entrance of the current (north pole) and red at its exit (south pole) (fig. 28B [figs. 1, 3]). Rochas specifically described these projections as flames and cited the work of Tesla (and Crookes) in his discussion of scientific parallels to such effects.[59]

In his *Portrait of Dr. Dumouchel* Duchamp had explored the projections of generalized magnetic emanations from the hands (and body) of his newly trained physician friend. Now, however, he was more interested in effects associated with electromagnetism and electricity itself. Thus, in the drawing *The King and Queen Traversed by Swift Nudes* (fig. 23), the flamelike stream of electrons is surrounded by a succession of circles suggesting the magnetic field generated around a wire carrying a current. Images such as figure 29, which illustrate the "Corkscrew Rule" or "Right-Hand Rule," were (and are) a standard element in any discussion of the reciprocal relation between electric current and magnetism. Whether the straight arrow represents current flow and the circle, the direction of magnetic force around it (as, perhaps, in fig. 23), or the arrow represents a metal rod with a wire spiraling around it in the direction indicated by the circle (as in fig. 28B [fig. 3]), "the direction of the current and that of the resulting magnetic force are related to one another, as are the rotation and the forward travel of an ordinary (right-handed) corkscrew."[60] As will be seen, Duchamp employed similar circular or spiraling imagery in several subsequent works as an indicator of the presence of electricity or electromagnetism (see figs. 91, 92, 101, 112, 173).

Although Duchamp did not use such specific circular electromagnetic imagery for the final painting of *The King and Queen Surrounded by Swift Nudes*, Rochas, along with Tesla, was to contribute further to the central electromagnetic themes of the *Large Glass*. Like the work of Crookes, which blended science with the occult, Rochas's writings on Magnetism drew heavily on contemporary ether physics, particularly the research of British scientists such as Lodge.[61] Thus, although Duchamp may have first encountered Rochas in an occult context—mainly through friends like Dumouchel and Kupka—Rochas's publications provided access to other scientific ideas and even translations of British and American texts.[62]

Although electricity and electromagnetism were to become increasingly important for Duchamp as he conceived the *Large Glass* in late 1912 and 1913, during his summer trip to Munich, the atom apparently remained a central concern. Instead of electrons alone, however, the larger issue of radioactivity was capturing his interest. In Munich Duchamp also made his first inventive use of forms abstracted from contemporary technology.

Munich Works, Summer 1912: Radioactivity, Alchemy, and Chemistry

In contrast to the more specialized realm of cathode rays and electrons, radioactivity generated widespread public interest, just as X-rays had done. Even more than X-rays,

the discovery of radioactivity produced a fundamental reorientation of accepted thinking about the natural world.[63] As a result of atomic disintegration, radioactive substances were spontaneously and continuously emitting energy and, in the process, being transformed into other elements. Indeed, the themes of energy and alchemy were prominent elements of the popular literature on radioactivity.

During the first decade of the century, scores of articles marveled at the potential energy stored within the radioactive elements, declaring, for example, that there was "enough radiant energy in one ounce of radium to lift 10,000 tons one mile high."[64] Yet, until science could unlock the atom to release this energy, enthusiasts of radioactivity had to content themselves with futuristic dreams and modest demonstrations of its energy.[65] One of the most successful was provided by Crookes's spinthariscope (fig. 30). Within this tiny cylindrical instrument fitted with a magnifying lens, a viewer could observe the flashes of light produced when alpha particles from a speck of radium struck the zinc-sulphide screen within.[66]

Like X-rays, radium also entered the sphere of popular entertainment: the self-luminescence produced by alpha particles in radioactive ore could also induce a glow in other phosphorescent or fluorescent materials. The result was a rage for everything from radium cocktails to Loie Fuller's "radium dances." And, just as the dangers of X-rays had become apparent only gradually, the hazards of radium exposure were not yet known. The public view of radium as a magical, perpetual source of heat and light—and perhaps even the elixir of life—far outweighed concern about its potential perils, such as serious tissue burns.[67]

Crookes's spinthariscope provided a graphic illustration for Le Bon's theories of the dematerialization of matter and intra-atomic energy, which were themselves supported by discoveries about radioactivity. Indeed, with Becquerel and the Curies at the forefront of early radioactivity research and Le Bon as its popularizer, radioactivity became an object of French national pride. French scientific periodicals, including *Le Radium*, founded in 1904, as well as journals such as Gourmont's *La Revue des Idées*, were filled with discussions of radioactivity, a French cause far less problematic than that of N-rays.[68]

Occultists also responded quickly to the discovery of radioactivity, which offered support for various aspects of a "scientific" occultism, just as X-rays had done. An important example of the occultists' response is an article by the Rosicrucian Sâr Péladan, "Le Radium et l'hyperphysique," published in *Mercure de France* in June 1904. Defining "hyperphysics" as "the study of supernatural phenomena," Péladan believed radioactivity embodied a definitive break with the positivist science of the past.[69]

Although, in the end, science itself was not his primary focus, he established his knowledge of the subject by citing the work of the Curies, Rutherford, and Sir William Ramsay, as well as Crookes, Herz [*sic*], and Tesla (including his remarkable sparks) in the related area of electromagnetism. Having adopted the popular hypothesis of the radioactivity of all matter, Péladan applied the notion to the human body and theorized that human interactions could be explained in terms of permanent *rayons humains* (akin to those of the Magnetizers). On both metaphysical and sociological levels, Péladan believed that human radioactivity offered a rationale for the "relations between spirit and body, ourselves and others, and the individual and the group."[70]

Péladan's article also raises briefly the issue of alchemy, the aspect of occultism most closely tied to radioactivity. In 1899 Rutherford had discovered that decaying radioactive elements produced an "emanation," as he termed it, which was capable of inducing radioactivity in any substances with which it came in contact.[71] This property, which Rutherford referred to as "excited activity," explains the pervasive traces of radioactivity in air and water, for example, which at the time lent support to the theory of universal radioactivity propounded by Le Bon and others. Working with the chemist Frederick Soddy, Rutherford subsequently identified the mysterious "emanation" as an inert gas of the argon family—to which Soddy is said to have exclaimed, "Rutherford, this is transmutation: the thorium is disintegrating and transmuting itself into an argon gas." To which Rutherford replied, "For Mike's sake, Soddy, don't call it transmutation. They'll have our heads off as alchemists."[72]

Although Rutherford cautiously used the terms "transformation" and "sub-atomic chemical changes" in his publications, he would later title his 1934 book on radioactivity *The Newer Alchemy*.[73] By contrast, Soddy, a chemist with a prior interest in alchemy, immediately cultivated the association of radioactivity with alchemy in his lectures, his articles and, ultimately, his 1909 book, *The Interpretation of Radium*. Soddy even suggested in print that radium might be the alchemist's long-sought "Philosopher's Stone," capable of transmuting metals and serving as well as the "elixir of life."[74]

The conclusive evidence for the transmutation of elements had been provided in 1903 when Soddy's new collaborator, Sir William Ramsay, the discoverer of the inert gases, detected the spectral lines of helium in radium's emanation.[75] That radium produced another element, helium, confirmed Rutherford's theory of subatomic transformation and gave new support to advocates of alchemy and an evolutionary view of the elements. Rutherford

would subsequently establish that the alpha particle was, in fact, a helium atom minus its electrons.[76]

Soddy's advocacy of alchemy was hardly the sole cause for the linking of radioactivity and alchemy in this period. Alchemy was not just an ancient occult science; it was alive and well in France in the hands of the Société Alchimique de France. Members of this group, led by François Jollivet Castelot, espoused an evolutionary view of the chemical elements based on the work of such figures as the French chemist and historian of alchemy Marcellin Berthelot, as well as Crookes and the British astronomer Sir Norman Lockyer, author of *Inorganic Evolution* (1900). Significantly, Le Bon also cited these three sources to support his theory of the evolution of matter, so that Le Bon, though not himself an advocate of alchemy, served as another source for alchemists like Jollivet Castelot.[77]

The prominence of Jollivet Castelot and his colleagues in the Société Alchimique (including Papus and the Swedish playwright August Strindberg) is documented by the article "The Revival of Alchemy," published in the Smithsonian Institution's *Annual Report* for 1897, even before the radioactivity craze.[78] Jollivet Castelot was well known in Paris: he edited *L'Hyperchimie—Rosa Alchemica* from 1896 to 1901 and went on to found the remarkable periodical *Les Nouveaux Horizons de la Science et de la Pensée*, which he published from 1904 to 1914. The author of numerous books on alchemy and also an advocate of Fourierist socialism, he was the subject of a 1914 biography, *Fr. Jollivet Castelot: L'Ecrivain—le poète—le philosophe*, issued by the Cubists' publisher, Eugène Figuière.[79]

Aside from this laudatory biography, there is further evidence that Jollivet Castelot's activities and writings were known to the Puteaux circle, and certainly to Duchamp. Apollinaire owned at least two issues of *Les Nouveaux Horizons*, which are preserved in his library.[80] Moreover, in the same 1912 article in the avant-garde review *Pan* in which Marc Stéphane had attacked Le Bon for his rejection of a scientific spiritualism, he had extolled the "liberty and luminosity" of Jollivet Castelot as the model of a contemporary thinker.[81]

Jollivet Castelot was an extremely effective spokesman for alchemy in its old and new forms. The ancient alchemists had believed that all matter was made up of a single *materia prima* and had sought to transform various metals into gold (or silver) by means of a complex series of secret operations. The steps included the "chemical marriage" of sulphur (the warm, dry, male principle symbolized by the sun or king) and mercury (the cold, wet, feminine principle symbolized by the moon or queen) and, as set forth by Jollivet Castellot, the subsequent stages of

putrefaction (black), ablution (white), rubification (red), fermentation and, finally, "projection," a process that ultimately transformed the metal into gold.[82] On a symbolic level, alchemy also functioned as a model for the perfection of the soul of the practitioner and of the world.

Although the distillation processes of medieval alchemy subsequently gave rise to chemistry, alchemy's basis in the four Aristotelian elements of earth, water, air, and fire had made it a fossil science by the eighteenth century. Scientific developments in the late nineteenth century, however, suggested to Jollivet Castelot and others that the quest of the early alchemists might be realizable in light of the newest theories of physics and chemistry. In November 1905, Jollivet Castelot therefore declared in *Mercure de France* that "the certainty of the Unity of Matter forms the basis, properly so called, of Alchemy because for bodies to be able to change themselves one into another, the constituting substances must be not simply analogous, but identical; thus it is impossible today for any man of good faith who devotes himself to scientific study not to recognize the truth of the unitary system."[83]

Jollivet Castelot could support this view by citing the experiments of the well-known chemists Marcellin and Daniel Berthelot, among others, who had succeeded in deriving one metal from another by modifying its molecular structure. "There are no simple bodies," no unchangeable elements, Jollivet Castelot and others argued. The recent theories of Crookes and Lodge reinforced this view.[84] In Crookes's idea of a fourth state of matter, which he called "radiant matter," Jollivet Castelot found the modern equivalent of fire, the fourth Aristotelian element, completing the parallel between solid (earth), liquid (water), gas (air), and radiant (fire).[85] More important, the ether, as discussed by Lodge, provided an identification for the long-sought unitary substance out of which all material atoms were formed.[86] The transmutation of elements composed of differing proportions of these ether atoms was easily imaginable. With Thomson's identification of the "corpuscle," or electron, and subsequent developments in atom theory leading to the "electric theory of matter" proposed by Lodge and others, the electron joined the ether as another possible candidate for the *materia prima*.[87]

The alchemical revival was further encouraged by the popular idea that the chemical elements were part of an evolutionary chain akin to that of organic beings. In 1886 Crookes had given a lecture entitled "The Genesis of the Elements," in which he proposed that the elements had evolved in successive stages from a finer, universal matter he termed "protyle."[88] In 1900 the astronomer Lockyer, who had discovered helium gas on the sun before it was identified on earth, published his *Inorganic Evolution as*

Studied by Spectrum Analysis, which argued that the chemical elements in the stars had evolved progressively as the stars cooled.[89] As noted above, Le Bon drew on Lockyer's ideas (as well as those of Berthelot) to support his views on the genesis and evolution of atoms. Thus, both in Lockyer's text and in Le Bon's best-selling books, Jollivet Castelot found contemporary validation for the alchemical theory of hylozoism, which held that matter "is alive, evolves, and transforms itself."[90]

The discovery of radioactivity seemed to be an answer to the prayers of alchemists, who now possessed cogent new evidence for their views: radium decayed through a series of stages and actually produced another element, helium. Jollivet Castelot's journal *Les Nouveaux Horizons de la Science et de la Pensée* became a prime source for information on radioactivity, publishing, for example, what must be the first French translations of sections of Rutherford's 1904 book, *Radio-activity*, between December 1906 and January 1908. In a typical issue of the journal, readers could find ancient alchemical texts, such as the Arab alchemist Geber's *La Somme de la perfection*, accompanied by recent scientific writings by such figures as Crookes, Lodge, Ramsay, and Le Bon.[91]

According to Jollivet Castelot, the goal of the ancient alchemists would be achieved through modern chemistry, which he pursued actively at the headquarters of the Société Alchimique de France, in Douai. His *La Synthèse d'or* of 1909, in fact, gives far less space to ancient alchemy than to his homage to chemistry, "La Chimie et son avenir," and to a lengthy positive review of Le Bon's *L'Evolution de la matière* and *L'Evolution des forces*.[92] In the end, it was Le Bon's theory of matter as a stable form of "intra-atomic energy" ready to dissociate back into the universal ether that provided the clearest scientific basis for modern alchemy in Jollivet Castelot's view. Thus he concluded in *La Synthèse d'or*: "These atomic edifices, dissociated by us in laboratories, will be able to recombine in the form we desire. That will be the synthesis of the bodies called simply, the Transmutation of Elements: ALCHEMY."[93]

Several writers on Duchamp have suggested that alchemy played a role in the genesis of *The Bride Stripped Bare by Her Bachelors, Even*—both in his first drawing of this theme in 1912 (fig. 31) and in the *Large Glass*. None of these interpretations has considered alchemy in Duchamp's contemporary cultural context, however, and the suggested ties to imagery from earlier alchemical texts have thus remained speculative.[94] Now, from an overview of radioactivity as a popular phenomenon, it is clear that Duchamp could hardly have avoided an acquaintance with alchemy, which was associated with the latest scientific developments that so interested him. As a 1912 article published in the Puteaux-related *La Vie Mystérieuse* asserted:

The modern scientist has taken up again the ideas of his medieval brothers; our epoch has become again that of the Alchemists and does nothing but apply the principles enunciated earlier.

Did not Moissan transform carbon into diamond? Berthelot, by the process of synthesis, created carbides of hydrogen, alcohols, and their derivatives; Curie and Le Bon overthrow the best-established axioms. What is radium? a stone that burns without wasting away, which produces mutations and transmutations, which heals. Chemists and Alchemists you can join hands, because you are nothing but the devotees of a religion called science.[95]

Or, as Robert Kennedy Duncan wrote, discussing the same theme in his chapter on radioactivity ("Modern Alchemy") in his 1905 book *The New Knowledge*: "The alchemist became the chemist, and the chemist has become the alchemist."[96]

Although the content of Duchamp's notes for the *Large Glass* does not support the argument that alchemy played a central role in the evolution of its imagery or ideas, his first exploration of the theme of "The Bride Stripped Bare by the Bachelors" in the July–August 1912 drawing may well be rooted in an alchemical theme.[97] Moreover, Duchamp seems possibly to have used alchemical imagery as early as his pre-Cubist painting of spring 1911, *Young Man and Girl in Spring* (Vera and Arturo Schwarz Collection, Milan), at a time when he was interested in the types of esoteric themes discussed in chapter 1. Here the images of a male and a female flank a transparent glass sphere containing what appears to be a winged figure, analogous to the numerous alchemical illustrations of winged Mercury in a globe, often supported by a pair of figures.[98]

As in the case of the link between Magnetism and electromagnetism, alchemy was already associated with radioactivity by the time Duchamp first encountered it. On the model of Jollivet Castelot, whose works he would have known through the Puteaux circle, Duchamp's alchemical interests were to gravitate increasingly toward chemistry. Thus, a second work of July–August 1912, *The Passage from Virgin to Bride* (fig. 33), may well be a counterpart to the alchemical theme of the *Bride Stripped Bare* drawing, now couched more overtly in the imagery of chemistry and radioactivity.

The notion of stripping, which had been of interest to Duchamp in his work with X-ray imagery and "nude"

electrons, was also associated with alchemy. Since the so-called marriage of male/sulphur/king and female/mercury/queen was one of the primary stages of the chemical process, the language and imagery of alchemy has a strong sexual component: Jollivet Castelot, for example, referred to the process as "chemical copulation."[99] There is an interesting parallel between Duchamp's *Bride Stripped Bare* drawing (fig. 31) and an alchemical engraving from Basile Valentin's "Twelve Keys of Philosophy" (fig. 32), first published in the Duchamp literature by John Moffitt. Moffitt notes the publication of Valentin's engraving in three volumes: *Die zwölf Schlüssel* of 1599, the 1627 *Chymisches Lustgärtlein*, and the 1677 anthology *Museum hermeticum*.[100] It is possible, however, to connect the image more directly to Duchamp's Parisian milieu through Jollivet Castelot, who included Valentin's *Les Douze Clefs* in the "Bibliographie alchimique" of his 1909 *La Synthèse d'or* and advertised it on the back cover.[101]

Figure 32 represents the second key of Basilius, the "purification of mercury," here identified with the central figure. The allegorical text accompanying the illustration is strikingly similar to Duchamp's emphasis on the stripping of a Virgin/Bride, as Moffitt has noted:

Before being given in marriage a virgin is gloriously adorned in a variety of the most splendid garments in order to please her fiancé, and by her presence she kindles intensely the amorous fires in him. When she is to be united with him according to the custom of carnal union, she is stripped of all her various garments and is left with nothing except that which she was given by the Creator at birth. . . .

But, my friend, note principally here that the fiancé and his fiancée must both be nude when they are conjoined; toward this end, all the things prepared for the embellishment of the garments and concerning the beauty of the countenance must again be removed so that they enter the sepulchre [i.e., the alchemical vessel] naked as they were born in order that their seed is not corrupted by a foreign mixture.[102]

The full caption for the image illustrating the second key (fig. 32) is the "Purification of Mercury by the 'Laveures ignées' (Fiery Laundries)," or, as it was identified in the *Chymisches Lustgärtlein*, "Two Swordsmen Stripping Precipitated Mercury."[103] Fire, symbolized by the lances of the figures, is the agent of change, because, as Albert Poisson told the readers of his 1891 *Théories et symboles des alchimistes*, "the symbols of fire are: the chisel, the sword, the lance, the scythe, the hammer, in a word, all the instruments capable of wounding."[104] And it was Poisson's colleague, Jollivet Castelot, who in 1895

had already linked the alchemist's fire to Crookes's fourth state of matter, the radiant matter Crookes associated with the stream of particles (i.e., electrons) in a Crookes tube.

Given the prominence of kings and queens in alchemy, the painting *The King and Queen Surrounded by Swift Nudes* and its preparatory works might also have possessed an alchemical association for Duchamp, in addition to their professed link to chess.[105] In the end, however, the activity depicted and the formal language of the "Swift Nudes" series seem to have derived largely from the science of electrons and electricity. The *Bride Stripped Bare* drawing, on the other hand, may indeed be a recasting of an alchemical emblem, such as figure 32, in the robotlike forms that evolved in the "Swift Nudes" series.

In the *Bride Stripped Bare* drawing, the ballistic character of electrons (and radioactive emissions) is depicted literally in the form of weapons, which themselves become the agents of the stripping. In contrast to the mysterious processes of the ancient alchemists, the new alchemy involved the manipulation of atomic structure, as Jollivet Castelot explained:

In short, it is necessary to strip each metal of its particular individual properties, restoring it to the state of prime matter. . . . Since matter, a condensed form of energy, is one, innumerable molecular and atomic chemical compounds can be restored to this unity and then such and such a condensation corresponding to such and such a body can be reconstituted.[106]

During this period, radium was being used by Jollivet Castelot and others, including Ramsay, in attempts to produce transmutation in particular metals.[107] At the same time, Rutherford was investigating the alpha particle by "shooting" radioactive particles at various materials, which led to his proof of the concentrated nuclear structure of the atom in 1911. Both electrons and radioactive particles had been likened to "the projectile from a gun," and now alpha particles were actually being projected through Rutherford's tubes and functioning like bullets as they "attacked" atoms.[108] Instead of "Two Swordsmen Stripping Precipitated Mercury," in the drawing *The Bride Stripped Bare by the Bachelors* the traditional alchemical image is translated into the language of modern chemistry and physics.

When Robert Lebel asked Duchamp about alchemy in 1957, he responded, "If I have ever practiced alchemy, it was the only way it can be done now, that is to say without knowing it."[109] This statement has often been interpreted as a denial of any interest in alchemy on his part.

His answer, however, is couched in terms of the *practice* of alchemy (as understood in the milieu of late Surrealism), not in terms of its possible contribution to the imagery of earlier works of art, such as *Young Man and Girl in Spring* or the *Bride Stripped Bare* drawing. Alchemy, particularly in the context of radioactivity, was undoubtedly one of the many sources on which Duchamp drew in the years 1911 through 1913. In addition to Kupka and the *La Vie Mystérieuse* associates at Puteaux, Apollinaire's link to that circle provided another source of information on the hermetic tradition—both "ancient" alchemy and the newer interpretations offered by Jollivet Castelot.[110] Yet, in the *Large Glass*, Duchamp was to be more interested in the *practice* of a playful chemistry (and physics), and any traditional alchemical associations that remained were the result of parallelisms between the old chemistry and the new—as well as his desire to multiply the referents for each component of the *Glass*.

Radioactivity took on certain sexual overtones, just as alchemy had, making it equally appropriate to Duchamp's "Mécanisme de la pudeur/Pudeur mécanique," or "Mechanism of chastity/Mechanical chastity," as he subtitled the *Bride Stripped Bare* drawing. In "Le Radium et l'hyperphysique," Péladan's explanation of human interactions in terms of universal radioactivity had included not only instinctual attractions and repulsions but also love and passion.[111] That such associations for radioactivity were widely accepted is confirmed by the decorative panel *Radioactivité, magnétisme* (fig. 34), painted by Clémentine Hélène Dufau for the Sorbonne and exhibited with its companion panel, *Astronomie, Mathématiques*, at the 1908 Salon des Artistes Français. The imagery of the painting is clarified by the reviewer for the *Gazette des Beaux-Arts*:

From the side of a blue mountain . . . rises the immense body of a half-swooning woman, on whose lips falls the kiss of a virile sky. A rainbow, partly blocked by the large nudes, signals the marriage of these elements. And then, on the ground . . . an idyll of grace and love: mounted on two horses, a nude man and woman, surrendering to the attraction of the first pleasure, embrace each other, amorous imitators of the earth and sky. Thus, the radiant forces of nature multiply their varied and impetuous effects.[112]

Duchamp would surely have found the Dufau image comical: it is a pointed demonstration of how inadequate traditional allegories had become in the face of a radically altered conception of reality. Although in his painting *The Passage from Virgin to Bride* (fig. 33) Duchamp would seem to have maintained a similar equation of radioactivity and sexuality, his forms are drawn from science itself, as

they had been in the "Swift Nudes" series. Specifically, the anthropomorphic language used in describing the equipment and procedures for research on radioactivity offered a striking parallel to human sexual relationships and points to a possible reading for *The Passage from Virgin to Bride*.

It was the induced or "excited activity" produced by radioactive emanation that had led Rutherford and Soddy to their discovery of atomic transmutation. Georges Bohn's January 1904 article in *La Revue des Idées*, "Le Radium et la radio-activité de la matière," provides a contemporary French perspective on this issue as it was being explored by Pierre and Marie Curie. Placing an ampoule containing radium salts in a closed *enceinte* (container), Curie had found that the radioactivity of the radium was gradually transferred to a succession of metal plates within the space and finally to the *paroi de l'enceinte* (lining of the container).[113] Given Duchamp's sensitivity to language, he would surely have recognized the sexual possibilities of such a laboratory event: *enceinte* is the French adjective for "pregnant," and the anatomical definition for *paroi* is "lining" (e.g., of an organ); together the two suggest a womb and the process of impregnation. Adding to the sexual nuance of the process is the discussion of the transmission of radioactive emanation through "capillary tubes," which would figure importantly in the *Large Glass*. *Aimants* (magnets), with their suggestion of the root *aimer* (to love), also appear in the this text, as they do in the literature on Magnetism and electromagnetism.[114]

The "passage" in figure 33 is not the physical motion of the *Nude Descending a Staircase* or *The King and Queen Surrounded by Swift Nudes*, or even the action of the *Bride Stripped Bare* drawing, from which it seems to have grown. Instead, *The Passage from Virgin to Bride*, painted in tones evoking flesh and membrane, renders a change of state—from virginity to sexual activity and marriage.[115] This work marks the first appearance in painting of Duchamp's central figure of the Bride (pl. 3, fig. 17), with its roots in the visceral imagery of X-ray cinematography and, perhaps, in Papus's schema of the astral body (figs. 18, 19), as well as its formal links to the central figure of the *Bride Stripped Bare* drawing. A number of commentators have noted the suggestion of chemical (or alchemical apparatus) in both the *Bride* and *Passage*, and through radioactivity the Bride's association with chemistry gains more credibility.[116] *Enceintes* and *tubes capillaires* suggest the laboratory in which sexual "excited activity" occurs, producing a biological transmutation from Virgin to Bride. In contrast to the clarity of the *Bride*, however, the indeterminate forms of *Passage* emphasize the fluctuant state of change within such vessels rather than the vessels themselves. Nonetheless, the

Bride of the *Large Glass* herself would come once again to be associated with a glass vessel in Duchamp's subsequent development of her attributes.

Munich Works, Summer 1912: First Borrowings from the Language of Technology

Duchamp's two July 1912 drawings, *Virgin (No. 1)* (fig. 35) and *Virgin (No. 2)* (fig. 36), preceded the creation of *The Passage from Virgin to Bride* and, most likely, the *Bride Stripped Bare* drawing, which bears the inscription "July 1912." Like these works, the *Virgin* drawings exhibit a greater sense of formal exploration and a less clear structure than the final *Bride* (pl. 3, fig. 17). In his subsequent notes Duchamp described the Bride of the *Large Glass* as an *arbre type* (tree or arbor type) and stated that he had made two relevant studies in Munich (i.e., the *Virgin* drawings).[117] This term has led to considerable speculation on the subject of Duchamp and trees, but contemporary literature on the automobile reveals that the transmission shaft was standardly termed an *arbre de transmission*.[118] Thus, although Duchamp would play on the double meaning of the term (referring, for example, to the Bride's "boughs" and her "blossoming"), his *arbre type* was closely tied to the automobile persona he initially established in his first extensive notes on the Bride.[119] And his linking of the *arbre type* to his Munich drawings confirms his interest in the technology he would have observed that summer at the Deutsches Museum in Munich (fig. 38) and at the Musée des Arts et Métiers in Paris.

Duchamp's drawing *Airplane* (fig. 37), dated August–September 1912, documents his most direct response to new technological forms during that summer, while also providing a clue to his working method in this and the preceding *Virgin* drawings. In *Airplane* Duchamp creates a free-form variation on the theme of the skeletal frames and fabric coverings of early airplane construction (fig. 38).[120] Its arrows and dotted lines also evoke diagrams of the aerodynamics of flight, such as figure 39, which illustrates the direction of forces on a plane, G indicating its center of gravity.[121] Duchamp also uses the circular symbol for grommets or rivets present in his brother Jacques Villon's subsequent recording of the 1912 aviation exhibition (fig. 40). In his notes Duchamp would write of his desire to make a kind of pictorial "dictionary": "With films, taken close up of parts of large objects, obtain photographic records which no longer look like photographs of something."[122] The large objects that inspired this idea would seem to have been the airplanes and automobiles that, like the great paintings of the past, had become museum pieces.

As noted in chapter 1, the tonal variations of Duchamp's *Virgin* drawings also suggest such a working method, as if portions of X-ray images of various body parts had been combined. Yet, like *Airplane*, these studies for the *arbre type* are also linked to contemporary technology and, in the case of *Virgin (No. 1)*, to the automobile. As will be seen, the juxtaposition of Duchamp's *Virgin (No. 1)* drawing with a contemporary didactic diagram of an automobile strongly suggests that the structure beneath her diaphanous, organic forms is derived from such vehicles (figs. 50, 51).

If the *Virgin (No. 1)* drawing was connected to technology primarily through its underlying structure, Duchamp's *Bride Stripped Bare* drawing (fig. 31) exhibited the type of shaded cylindrical forms that in his *Airplane* drawing allude to the fabric coverings of airplane frames. In the *Bride Stripped Bare* drawing, however, these elements had a more overtly metallic look, and certain forms in *Virgin (No. 1)* can also be read in these terms. Duchamp connected certain "mossy metal" forms in the Bride of the *Large Glass* to that drawing, explaining a sketch in one of the notes published in 1980 (fig. 128; app. A, no. 14/15) as follow: "The Hatching indicates the way of ending the upper part of the bride in mossy metal (like in the 1st study of Munich)."[123] Indeed, a kind of mossy metal does seem to be suggested in certain of the modeled areas of Duchamp's *Bride* (and the Bride of the *Glass*) and even in certain of the gray areas of *The Passage from Virgin to Bride*.[124]

Duchamp's adoption for the Bride of the hint of metallic surfaces found in his Munich drawings, and particularly the structural association of the *Virgin (No. 1)* drawing with an automobile, demonstrates the layering of associations that would characterize his approach to the components of the *Large Glass*. Thus, to the Bride's roots in organic X-ray imagery and synthetic physiology and her possible links to the chemical apparatus associated with radioactivity, can be added a third layer of analogy, via the automobile, the first of a number of new technological identities the Bride was to assume. Such overlays of visual form and functional punning were to be standard in the *Large Glass*, where the equipment of science and technology would reign supreme.

After the summer of 1912 Duchamp would no longer attempt to embody in painted representations the invisible world revealed by recent scientific discoveries ranging from X-rays to atom theory and radioactivity. Instead, objects drawn from science and technology (as well as other sources) would become the persona in the *Large Glass*, his realm created "*by slightly distending* the laws of physics and chemistry," both old and new.[125]

Part II

The Transition from Painter to
Artist as Engineer-Scientist,
Fall 1912–1914

Chapter 3

From Painter to Engineer, I
Depersonalization of Drawing Style and Adoption of Human-Machine Analogies, Fall 1912–1913

Duchamp returned to Paris in early October 1912, after an absence of nearly four months, during which time his ideas about making art had evolved substantially. "My stay in Munich was the scene of my complete liberation, when I established the general plan of a large size work which would occupy me for a long time on account of all sorts of new technical problems to be worked out," Duchamp asserted in his 1964 lecture, "Apropos of Myself."[1] Although the general plan of the *Large Glass* (fig. 75) was not drawn up until sometime in 1913, Duchamp returned from Munich as an artist firmly committed to finding alternatives to traditional painting techniques and subject matter.

In a 1963 interview Duchamp stated pointedly his attitude toward the craft of painting by fall 1912: "My hand became my enemy in 1912. I wanted to get away from the palette. This chapter of my life was over and immediately I thought of inventing a new way to go about painting. That came with the *Large Glass*."[2] Duchamp was to find a model for a depersonalized expression, free of "taste," in the techniques of mechanical drawing or scientific illustration that he would adopt in 1913.[3]

As to the subject matter of his art, Duchamp declared his allegiance to the realm of ideas and intellect by taking a job as a librarian-in-training at the Bibliothèque Sainte-Geneviève in November 1912, a position he held through at least early 1915.[4] In October 1913 he moved from the suburb of Neuilly to the rue Saint-Hippolyte, physically distancing himself from the painting culture of neighboring Puteaux in favor of proximity to his job and, presumably, the university environment surrounding the Sorbonne. Duchamp later described his new situation to Cabanne in response to a question about his interaction with such avant-garde painters as Picasso and Braque:

Obviously I stayed very much apart, being a librarian at the Sainte-Geneviève Library; and then I had my studio in the rue Saint-Hippolyte, which wasn't really a studio, but a seventh floor apartment with lots of light. I was already working on my "Glass," which I knew was going to be a long-term project. I had no intention of having shows, or creating an *oeuvre*, or living a painter's life.[5]

Duchamp began making notes in earnest for the *Large Glass* project in fall 1912, and he would write the largest number of these during 1913, as he conceptualized the program for this work. The notes, as subsequently published in the *Box of 1914*, the *Green Box*, *A l'infinitif*, and the posthumous 1980 *Notes*, provide a chronicle of Duchamp's pursuit of ideas in this period—including the reexamination of the question of perspective, the investigation of four-dimensional and non-Euclidean geometries, and the exploration of issues in contemporary science, that is, the physics and chemistry whose laws he would "slightly distend" in the *Large Glass*.[6] On such subjects as geometry or science, Duchamp by late 1912 and 1913 would go beyond the popular sources his fellow painters would have known in order to investigate those fields more deeply. Duchamp's only peer in this regard was Kupka, whose scholarly scientific concerns probably continued to serve as a model for him, just as they had in the context of X-rays.

During late 1912 through 1914 Duchamp sought to transform himself from a practitioner of painting to an inventor, a word he used in later interviews to describe his approach to art making.[7] "I wanted to be intelligent," he told Francis Roberts in 1968, following his assertion that "the painter was considered stupid, but the poet and writer very intelligent."[8] Along with Jarry, Roussel, and, to some degree, his friend Apollinaire, scientists and engineers were to serve as stimuli for Duchamp. Such widely known scientific figures as Crookes and Tesla, whose ideas had also nourished the imaginations of Jarry and Roussel, offered an inviting, accessible introduction to contemporary science. As the art dealer Julien Levy later recalled of his friend Duchamp, "He thought that, with its sensitivity to images and sensations, the artist's mind could do as well as the scientific mind with its mathematical memory."[9]

The literature on Duchamp has dealt with his change of style in 1913 almost solely in terms of the machine and mechanical drawing.[10] Yet the laboratory equipment and

the scientific-illustration style that the artist would have encountered in the literature on X-rays and radioactivity should also be considered. Moreover, like the Deutsches Museum, the Musée des Arts et Métiers brought together the histories of science and technology. Given his interest in science, the analogies often drawn between humans and machines in this period would have encouraged Duchamp to base his dehumanized stand-ins in the *Large Glass* not only on machine forms and but also on scientific equipment. Thus, the *Glass* was not to be simply a futuristic vision of machine sexuality. Instead, Duchamp would ultimately establish complex interrelationships among the mechanical or biomechanical creatures who enact the drama of *The Bride Stripped Bare by Her Bachelors, Even*—relationships based on his creative response to physics, chemistry, and other aspects of contemporary science and technology.

New Approaches to the Drawn Line

Duchamp painted his first mechanical object at the end of 1911: *Coffee Mill* (fig. 41), a small canvas he executed at the request of his brother Duchamp-Villon as a decoration for his kitchen. In spring 1913 he would paint another such domestic object, *Chocolate Grinder (No. 1)* (fig. 66), followed in early 1914 by *Chocolate Grinder (No. 2)* (pl. 5, fig. 91). All three works represent a distinct departure from Duchamp's major paintings of fall 1911 or 1912, from the *Chess Players* through the *Bride*, and demonstrate the evolution of a mechanical, quasi-scientific mode of representation. An even greater distinction exists, however, among the works themselves: unlike the *Coffee Mill*, the images in the two *Chocolate Grinder* paintings were conceived as part of the Bachelor Apparatus of the *Large Glass*, that is, as substitutes for human subjects. Further, as will be seen in chapter 8, the *Chocolate Grinder (No. 2)* is no longer simply a domestic tool; it possesses an identity in the context of the physics of electromagnetic waves and wireless telegraphy.

Duchamp later remarked that the *Coffee Mill* "opened a window onto something else."[11] A comparison of the *Coffee Mill* with an illustration of various "mills" from the *Petit Larousse illustré* (fig. 42) emphasizes the degree to which Duchamp has rearranged the coffee mill's component parts, bringing together several views of the object and indicating the circular motion of the handle by means of dotted lines and an arrow. On one hand, Duchamp's technique was rooted in the geometrically oriented drawing methods he learned in the French public schools, as Molly Nesbit has established.[12] Those methods, a response to a perceived crisis in French industrial design, drew

heavily upon the descriptive geometry of mechanical drawing. In the end, however, the model of mechanical drawing itself was even more important for Duchamp, who would refer directly and repeatedly to it in later statements on his escape from "traditional pictorial painting."[13]

With its loose, somewhat painterly execution, however, the *Coffee Mill* did not yet exemplify the precision Duchamp was to achieve in his drawings of 1913 and in the final version of the *Chocolate Grinder*. Discussing these later works, he noted: "I wanted to go back to a completely *dry* drawing, a *dry* conception of art. I was beginning to appreciate the value of exactness, of precision, and the importance of chance. . . . And the mechanical drawing was for me the best form of that dry conception of art." He summed up his rationale by observing that "a mechanical drawing has no taste in it."[14]

Yet, the *Coffee Mill* already shares the schematic orientation of certain types of mechanical drawings, such as those by Charles Dupin, a pioneer in this field (fig. 43), and scientific illustrations (fig. 44). In such images, views from the front, top, or side (fig. 43, Dupin's figs. 14, 15) or horizontal and vertical cuts (fig. 44) provide optimum information; an alternative kind of "line" (composed of a pattern of dots or dashes) may connect the views (fig. 43, Dupin's fig. 1) or provide some other indication of the relationship of one to the other (fig. 44). In the *Coffee Mill*, Duchamp, too, juxtaposes horizontal and vertical views of the object, as if overlaying the two types of cuts or sections in an image such as figure 44, a "Foucault Interrupter" for generating high-frequency alternating currents, discussed by Charles Henry in his 1897 *Les Rayons Röntgen*.[15]

With the addition of an arrow, the dotted line in the *Coffee Mill* functions diagrammatically, although Duchamp originally derived it as a sign of motion from the chronophotographs of Marey (fig. 7). Duchamp likewise used the dotted line to suggest motion in the paintings *Sad Young Man on a Train* (Peggy Guggenheim Collection, Venice), *Nude Descending a Staircase (No. 2)* (fig. 12), and *The King and Queen Surrounded by Swift Nudes* (pl. 2, fig. 21). By summer 1912, however, he had replaced the dots with dashes, which are more directly indicative of mechanical drawing or scientific illustration. Such dashed lines appear in the paintings *The Passage from Virgin to Bride* (fig. 33) and *Bride* (pl. 3, fig. 17), as well as in the drawings *Virgin (No. 2)* (fig. 36), *The Bride Stripped Bare by the Bachelors* (fig. 31), and *Airplane* (fig. 37), whose similarity to aeronautical diagrams has been noted.

In the painting *The King and Queen Surrounded by Swift Nudes* Duchamp had begun to eliminate traces of

brushwork by smoothing the paint onto the canvas with his fingers, a technique he continued in his Munich paintings. The addition of lines of dashes to the works of summer 1912 suggests that, for a time at least, he hoped that this borrowed symbol joined to a depersonalized application of paint would free free him from the realm of "arty handiwork."[16] The contrast he sought is apparent in the change from *Virgin (No. 1)* to *Virgin (No. 2)*, where the lines of dashes (and dots) give Duchamp's watercolor image the look of a diagram. The patterned lines variously suggest connections between component parts, the existence of obscured or invisible elements, and perhaps even the functional dashed lines of dressmakers' patterns.[17] In his notes for the *Large Glass* Duchamp would describe the Bride's freedom from mensurability in terms of a sphere of "*any* radius," with "the radius given to represent it . . . 'fictitious and dotted.'"[18]

In discussing his replacement of human forms with skeletal lines and dots in the *Nude Descending a Staircase (No. 2)*, Duchamp told James Johnson Sweeney, "And later, following this view, I came to feel an artist might use anything—a dot, a line, the most conventional or unconventional symbol—to say what he wanted to say."[19] The exploration of alternatives to the drawn line—traditionally viewed as the most direct and personal means of expression for an artist—was a major theme in Duchamp's reevaluation of the art-making process during 1913 and 1914. Apart from the two versions of the *Chocolate Grinder* and the 1914 *Network of Stoppages* (fig. 73), as well as the later *Tu m'* (fig. 173), Duchamp abandoned painting on canvas, first, for the creation of working drawings for the *Large Glass*—drawings modeled upon mechanical drawings, geometrical diagrams, or scientific illustrations (figs. 45, 97, 153)—and, second, for technical experiments on glass (fig. 151).

Duchamp assumed the persona of a mechanical draftsman in his 1913 drawing for the *Boxing Match* (fig. 45), a never-executed component of the *Large Glass*, employing a technique similar to that of Dupin in his illustrations of the mechanics of pulleys (fig. 43, Dupin's figs. 2–7). Yet Duchamp also treats the image as if it were a geometrical proof, labeling elements of the diagram and indicating the relationship of parts with "fictitious and dotted" lines. Indeed, as described in the labels at the right, the image is the plan for a "stripping" mechanism resembling a pinball machine in which a "Combat Marble" is propelled toward three successive summits, producing the fall of the Bride's "Clothing," which is supported on the "Rams" at the top of the image. Other drawings from the first half of 1913 include measured drawings Duchamp designated as at the scale of 1/10

both for the Bachelor Apparatus in plan and elevation (Marcel Duchamp Archive, Villiers-sous-Grez) and for the general layout of the entire *Large Glass* (fig. 75). In the latter study the lower half of the *Glass* is depicted in a strict perspective scheme, as are the related drawings for the *Cemetery of Uniforms and Liveries (No. 1)* (fig. 96) and the *Water Mill Wheel* (fig. 153).

By mid-1913 Duchamp had evolved a suitably precise drawing style, and during late 1913 and 1914 he would continue to expand the concept of the drawn line. His notion of line would come to include thread shaped by chance while falling (*3 Standard Stoppages* [fig. 68]) or sewn through canvas (*Chocolate Grinder [No. 2]* [pl. 5, fig. 91]) and, ultimately, lead wire applied to a glass surface, as in the *Large Glass* itself and preparatory works such as the *Glider Containing a Water Mill (in Neighboring Metals)* (fig. 151) and the *9 Malic Molds*, 1914–15 (Marcel Duchamp Archive, Villiers-sous-Grez). The cast of characters for *The Bride Stripped Bare by Her Bachelors, Even* was being assembled. It is necessary now to return to events of 1912 and Duchamp's cultural context to explore how his subjects became as mechanical and scientific as his style had.

Duchamp, the Machine, and Human-Machine Analogies

On June 6, 1912, in an article in *L'Intransigeant*, Apollinaire wrote: "It has been said that there is no such thing as a modern style. I personally believe that those who say so are mistaken and that a modern style does exist; but I believe that the characteristics of this style are to be found not so much in the facades of houses or in furnishings as in iron constructions—machines, automobiles, bicycles and airplanes."[20] In late October or early November 1912 Duchamp made his declaration to Léger and Brancusi, quoted earlier, that painting was "washed up" and challenged them to "do better than that propeller."[21] Two other events of that year encouraged Duchamp to consider the applicability of machines and scientific equipment to his art. In May or June he attended with Picabia and Apollinaire a performance of Raymond Roussel's *Impressions d'Afrique*, which he later credited as giving him the "general approach" for the *Large Glass*.[22] And in late October Duchamp, Apollinaire, and Picabia traveled by automobile to the Jura Mountains to visit Gabrielle Buffet. This trip would result in Duchamp's notes for a work devoted to the "Jura-Paris Road," which would center around a "machine-mother" and a "headlight child."[23]

Humans and machines are prominently linked in both *Impressions d'Afrique* and the Jura-Paris Road project,

works that also owe specific debts to contemporary science and technology, as we shall see. Initially, however, an overview of the human-machine analogies current in French culture helps clarify Duchamp's basic decision to adopt mechanical or biomechanical substitutes for human beings. During 1911 and 1912 he had ample exposure to machine forms and scientific equipment—from his reading of popular scientific literature to his visits to the Musée des Arts et Métiers and, undoubtedly, the Deutsches Museum.[24] The Futurists, as noted, had celebrated technology as central to modern experience. Duchamp, however, did not embrace the Futurists' romantic notion of technology as a cultural panacea; rather, he coolly appraised the usefulness of mechanical techniques as a new, precise stylistic mode and of machines as metaphorical analogues to, or replacements for, human organisms.[25]

Raymond Duchamp-Villon, in a January 1913 letter to Walter Pach, the brothers' American friend, wrote: "The power of the machine imposes itself and we scarcely conceive living beings any more without it."[26] In 1914 Duchamp-Villon would give form to this belief in a series of studies culminating in his sculpture *The Horse* (Museum of Modern Art, New York). Here an initial image of a horse and rider is gradually transformed into a powerful evocation of "horsepower": legs and joints become piston rods and flywheels and musculature becomes hard-edged and geometric.[27] A similar mechanical quality had already begun to appear in Duchamp's *Nude Descending a Staircase (No. 2)* (fig. 12) and, in particular, the "Swift Nudes" series (figs. 21–24), where, Duchamp asserted, "There are no human forms."[28] By summer 1912, in the "Virgin" and "Bride" works of his Munich stay, Duchamp was consciously cultivating a blend of organic and technological forms.

The concept of human functions being akin to those of a machine was deeply rooted in French culture, going back to Descartes's mechanistic philosophy in the seventeenth century and subsequent sources, such as Julien La Mettrie's *L'Homme machine* of 1747.[29] Even before Descartes and La Mettrie, however, the tradition of automata controlled by clockwork mechanisms had drawn attention to the human-machine analogy. Duchamp's interest in automatons (perhaps sparked by the important collection at the Musée des Arts et Métiers) is reflected in his references to clocks and clockwork mechanisms in his notes (see chap. 7). In addition, his early cartoon of a disrobing "Bébé marcheur" resembles the numerous "Bébé" automatons offered by the firm of L. Lambert in the early years of the century.[30]

The reverse notion, that of machines themselves as living beings with intelligence, was voiced menacingly in Samuel Butler's *Erewhon* of 1872, although anthropo-morphic readings of machines had begun to occur earlier in the century in relation to steam engines and locomotives.[31] Thus, neither the human as machine nor the machine as human was necessarily new or modern. What had changed by the early twentieth century, however, was the technology and science to which living beings were compared.

The automobile, as a symbol of speed and power, offered early twentieth-century artists and writers a completely new counterpart for human mental and physical processes. In his 1904 "En automobile" the Symbolist Maurice Maeterlinck described the functioning of the "marvelous beast" in terms of physiology, equating its "soul" with the electric spark that enflamed its "breath" and its "heart" with the carburetor.[32] Octave Mirbeau, in his *La 628-E8* of 1907, celebrated the "admirable organism that is the motor of my automobile, with its steel lungs and heart, its rubber and copper vascular system, [and] its electrical nervous system."[33] In his 1905 poem "To the Automobile" or "To My Pegasus," the Futurist Marinetti had implied the sexual union of car and driver;[34] in his 1909 "The Founding and Manifesto of Futurism," he went further, describing automobiles as female objects of desire. "We went up to the three snorting beasts, to lay amorous hands on their torrid breasts," begins Marinetti in his account of a wild night ride in his automobile.[35]

For Marinetti, automobiles were anthropomorphic machines. Conversely, he believed that humans themselves were evolving toward a machinelike state: "It is certain that if we grant the truth of Lamarck's transformational hypothesis we must admit that we look for the creation of a nonhuman type in whom moral suffering, goodness of heart, affection, and love, those sole corrosive poisons of inexhaustible vital energy, sole interrupters of our powerful bodily electricity, will be abolished."[36] Similar evolutionary ideas had stimulated late nineteenth- and early twentieth-century writers of science fiction, including Jarry, whose *Surmâle* of 1902 demonstrates superhuman, machinelike sexual prowess and is "conquered" only by the electricity from a high-voltage, alternating current dynamo, as recounted in chapter 4.[37] And, in an update of the automaton theme, the "future Eve" of the 1886 novel *L'Eve future*, by the Symbolist Villiers de l'Isle-Adam, is an android built by a fictional Thomas Edison, who utilizes the latest electrical innovations to create an ideal woman. Certain aspects of Villiers's book, like Jarry's, closely parallel elements in the *Large Glass*.[38]

Other science fiction writers or illustrators had also been concerned with electricity and other aspects of technology that suggested new human-machine analogies.

Albert Robida, the well-known cartoonist (fig. 4), also wrote and illustrated volumes devoted to future visions, including *Le Vingtième Siècle* of 1883 and *La Vie électrique* of 1890.[39] Figure 46, from *La Vie électrique*, updates an allegorical image of electricity (derived from Electra, nymph and goddess) by transforming the goddess's hair into the very wires that carry her power. Along these wires speed fairylike embodiments of electrons, similar to the dancing courtiers Georges Matisse had envisioned in his 1908 *Mercure de France* article on the structure of the atom. This human-machine hybrid, resembling an electrified Medusa, is the source of power and new modes of communication for the twentieth-century world as Robida conceived it.[40] Although in 1890 Robida could not yet imagine the coming revolution in wireless communication, which would be so important for Duchamp, his image offers interesting points of comparison to the *Large Glass*, as will be seen.

Closer in time to Duchamp, Gaston de Pawlowski's science-fiction tale *Voyage au pays de la quatrième dimension* of 1912 has been discussed in the Duchamp literature as a possible source of ideas—from the popular conception of the fourth dimension Pawlowski presents to his notion of the evolution of the automobile into an organic "new animal."[41] Pawlowski's exploration of human-machine interactions occurs in the middle phase of his tale, the scientific period, before the final revelation of the fourth dimension. In one chapter, Pawlowski describes the "the beating heart of [the automobile's] valves," "the spinal column of its transmission," and its "distinct networks" for "the circulation of water, the circulation of oil, [and] electrical 'innervation.'"[42] Distinguished from "natural beings" only by "the idea of the wheel and the gears," these automobile-animals suggest to scientists the possibility of building a race of homunculi who are ultimately destroyed when they become a threat to the scientists who built them.[43] Pawlowski also explored the reverse notion—that of human beings becoming machinelike. In the chapter entitled "Les Surhommes," he discusses the grafting onto humans of mechanical (and organic) appendages in order to create a race of supermen. The results, however, are so monstrous (e.g., "deformed beings carrying instruments for telepathic telegraphy, calculating machines, or encyclopedic collections uniting . . . all of human knowledge on a central switchboard") that they have to be hidden away.[44]

If such human-machine hybrids were hideous and slightly comical for Pawlowski, mechanical elements in the human realm were a source of comedy for Henri Bergson, who in 1900 set forth his theories on this subject in his essay on laughter, *Le Rire*. According to Bergson,

"The attitudes, gestures, and movements of the human body are laughable in exact proportion as that body reminds us of a simple machine." Discussing the drawings of "comic artists," in particular, he continues: "The more exactly these two images, that of a person and that of a machine, fit into each other, the more striking is the comic effect, and the more consummate the art of the draughtsman."[45] Bergson also devotes a lengthy discussion to the humorous elements of the theme he terms "something mechanical encrusted on the living," a phrase that describes well the hybrid nature of Duchamp's "Virgin" and "Bride" imagery of summer 1912 and, at first glance, the multiple associations that the Bride of the *Large Glass* would gradually accumulate.[46] Indeed, Bergson's theory of humor was undoubtedly one of the roots of Duchamp's description of the *Large Glass* as a "hilarious picture" on a page of notes headed "General notes. for a hilarious picture."[47]

Bergson concludes the section he titles "The Comic Element in Words" by contrasting once again the mechanical and the organic (as language): "The rigid, the ready-made, the mechanical, in contrast with the supple, the ever-changing and the living, absentmindedness in contrast with attention, in a word, automatism in contrast with free activity, such are the defects that laughter singles out and would fain correct."[48] In *Le Rire* Duchamp would have found a number of appealing ideas, including Bergson's notion of the ready-made. Given the Puteaux Cubists' interest in serious Bergsonian philosophy, as expressed in his *L'Evolution créatice* (1907), Duchamp's preference for *Le Rire* and the mechanization Bergson was rejecting was to be another means of subverting Cubist doctrine.[49]

Bergson, a major advocate of vitalism in the contemporary scientific debate over mechanism versus vitalism in biology, believed that any combination of the mechanical and organic was unnatural and therefore humorous.[50] Yet, such human-machine analogies were, in fact, widespread at the turn of the century—not only in science fiction but in science and technology as well.

By the late nineteenth and early twentieth centuries, mechanist interpretations of the human body were prevalent, particularly in the fields of physiology and biology. Given his interest in chronophotography, Duchamp was already well acquainted with studies of the human body as a moving machine. Trained as a physiologist, E.-J. Marey had developed his system of chronophotography in order to produce a graphic record of the motions of "la machine animale," also the title of his first book of 1873.[51] Nineteenth-century physiological studies viewed the body as a mechanism whose processes could be explained by phenomena of physics or chemistry.[52]

35

Moreover, the new emphasis on energy in the physics of thermodynamics provided yet another level of comparison between mechanical and human "motors." As Marey argued, "Modern engineers have created machines which are much more legitimately to be compared to animate motors."[53] The field of psychology was also affected by this mechanist view: Ernest Solvay could assert in 1909, in the *Revue Générale des Sciences Pures et Appliquées,* that psychology "has become frankly physico-chemical." Duchamp recorded his interest in psychology in one of his notes for the *Large Glass*, where he reminds himself to "see psychology manuals."[54]

One of the most prominent spokespersons for the view that "the sum of all life phenomena can be unequivocally explained in physico-chemical terms" was the biologist Jacques Loeb, who addressed this question in his 1912 book *The Mechanistic Conception of Life*.[55] Although he worked in the United States from 1891 on, the research and theories of the German-born Loeb were well known in France. He had first gained international attention with his successful experiments in artificial parthenogenesis, in which he induced the development of unfertilized sea urchin eggs into larvae by varying the levels of salt in the surrounding solution. Loeb's works were regularly translated into French and reviewed in sources such as *Mercure de France* and *La Revue des Idées*. In a 1908 review of Loeb's recently translated *La Dynamique des phénomènes de la vie*, Georges Bohn cited Loeb's work in artificial parthenogenesis and the Curies' discovery of radioactivity as the two recent scientific discoveries that stirred the imagination as marvels. Yet, as Bohn explains, "For Loeb, living beings are [simply] chemical machines," and, according to Loeb himself, nothing prevents our "supposing that experimental science will succeed one day in producing living machines artificially."[56] Loeb's description of living beings as chemical machines brings to mind Duchamp's *Bride* and her chemical associations, noted in chapter 2. Similarly, his prophecy of "producing living machines artificially" metaphorically suggests the mechanical transformation of sexuality that would occur in the subsequent works of Duchamp and Picabia. Picabia, in particular, seems to evoke the artificial creation of life in his mechanomorphic images entitled *Girl Born without a Mother* of 1915 and 1916–18.[57]

The biologist Loeb, like many nineteenth-century physiologists, was also interested in internal and external electricity, another context for human-machine analogies. Ever since the late eighteenth century, with Luigi Galvani's electrophysiological experiments with frog legs and Franz Mesmer's inauguration of Animal Magnetism, electricity

had offered an important bridge between the animate and inanimate worlds.[58] Throughout the nineteenth century scientific and popular literature regularly compared bodily functions and electrical effects (e.g., nerves as electrical circuits), the integration of which served as the basis for the growing field of "electric medicine." The metaphor of the battery frequently appeared in discussions of nervous conditions: Strindberg, for example, described himself as "an overcharged Leyden jar."[59] Closer to the Puteaux circle, Jules Romains, paralleling themes in Walt Whitman, employed similar electrical metaphors for physiological processes. In *La Vie unanime* of 1908 he wrote:

I will imitate you, neurons, I will be
. .
A joyous crossroads of unanime rhythms.
A condenser of universal energy;
At my approach, sparks will fly forth.[60]

The language of electricity was also used to describe romantic or sexual interaction; authors spoke of magnetic attraction or the spark of love, a usage that appears, for example, in Camille Flammarion's *Stella* of 1897.[61] As early as the seventeenth century, the Jesuit Athanasius Kircher had associated love with magnetism in his 1654 *L'Aimant, ou de l'art magnétique*, which dealt with magnetic effects of electricity and included a chapter entitled "Erotomagnetism or Magnetism of Love."[62] Nearer to Duchamp in time, the fictional Edison in Villiers's *L'Eve future* declares that "modern love . . . from the standpoint of physical science is a question of equilibrium between a magnet and an electricity."[63] At the same time, nineteenth-century electrical practice applied organic terminology to equipment (e.g., male or female plugs) and to processes (e.g., "excitation" produced by an electrical current).

Finally, the French language encouraged linguistic exchange between the human and the machine realm. In the *Petit Larousse illustré* of 1919, which reflects usage in the pre–World War I period, the word *organe* is defined not only in relation to living organisms, as expected, but also in terms of machines: "in machines, elementary instrument [*appareil*] serving to transmit movement or to guide it." Similarly, *appareil* is defined first as a "machine, assemblage of instruments suited to execute a task" but is also given the anatomical definition of an: "ensemble of organs that contribute to a function: *l'appareil respiratoire.*" In the literature on automobiles, for example, the term *organe* appears repeatedly in discussions of a car's component parts. Thus, Captain D. Renaud begins his *Cours complet d'automobilisme* of 1909 by explaining that "all vehicles of this family [gas-

combustion engine and mechanical transmission] include similar organs and differ among themselves only by often insignificant details and by the placement of these same organs." Such "elemental organs" include "organes de distribution," "organes de direction," and "organes de commande." And, like living beings, the engines of these vehicles require "alimentation," or feeding.[64] We have come full circle to the automobile, which Mirbeau, Marinetti, and Pawlowski all treated in anthropomorphic terms. It should now be clear that although literary sources such as these would have encouraged Duchamp's interest in the subject, the human-machine analogy was basic to the language of science and technology in this period and that writers like Marinetti and Pawlowski were themselves responding to their larger cultural context.

The "Jura-Paris Road" Project

Duchamp had begun to explore the integration of human and machine forms in his Munich works of summer 1912. About October 20, less than two weeks after returning from Munich, Duchamp accompanied Apollinaire and Picabia on an automobile trip to Gabrielle Buffet's family home in Etival, in the Jura Mountains.[65] According to her later memoir, the travelers arrived at night in a deluge of rain after what must have been a wild ride in one of Picabia's legendary automobiles.[66] Given the delight the three shared in humor, puns, and wordplay, one can imagine the witty repartee that took place during the trip to Jura. Its traces, complete with sexual allusions, are undoubtedly present in Duchamp's Jura-Paris Road notes, written during winter 1912.[67]

Until the publication of the final group of Duchamp's notes in 1980, the Jura-Paris Road was known only through a single note in the *Green Box*. The main portion of that note read:

The machine with 5 hearts, the pure child, of nickel and platinum, must dominate the Jura-Paris road.

On the one hand, the chief of the 5 nudes will be ahead of the 4 other nudes towards this Jura-Paris road. On the other hand, the headlight child will be the instrument conquering this Jura-Paris road.

This headlight child could, graphically, be a comet, which would have its tail in front, this tail being an appendage of the headlight child appendage which absorbs by crushing (gold dust, graphically) this Jura-Paris road.

The Jura-Paris road, having to be infinite only humanly, will lose none of its character of infinity in finding a termination at one end in the chief of the 5 nudes, at the other in the headlight-child.

The term "indefinite" seems to me more accurate than infinite. The road will begin in the chief of the 5 nudes. and will not end in the headlight child.

Graphically, this road will tend towards the pure geometrical line without thickness (the meeting of two planes seems to me the only pictorial means to achieve purity)[68]

Duchamp's note concludes by discussing the transformation of the finite "line" of the Jura-Paris road into an "ideal straight line which finds its opening toward the infinite in the headlight child" and, finally, the material to be used in the composition. Although he mentions "size of canvas" in the last line of the note, he also states his interest in new materials: "The pictorial matter of this Jura-Paris road will be *wood* which seems to me like the affective translation of powdered silex."[69]

If the physical form the project was to have taken remains something of a mystery, we learn much more about the iconographical scheme of the work—as well as its title—in the notes Duchamp chose not to publish during his lifetime. In one of these three posthumously published notes, Duchamp begins, "Title. The chief of the 5 nudes extends little by little his power over the Jura-Paris road," and then presents the theme in terms of a military conquest. Of the chief, he writes, "He and the 5 nudes form a tribe for the conquest by speed of this Jura-Paris road."[70] Another note (fig. 47) provides even more information: here Duchamp discusses the "pictorial translation" of the work and reveals new associations for the "machine-mother" (Virgin Mary) and for the "headlight child" (Jesus, child God).

Out of these rather cryptic notes, it is possible to identify certain of Duchamp's characters as they reflect technology or the human-machine analogies of this period, particularly the female as automobile. The "machine with 5 hearts" is very likely an automobile, the vehicle with the "steel lungs and heart" of Mirbeau and the "beating heart" of Pawlowski.[71] Such comparisons were commonplace in popular literature, as in the "Heart of the Automobile," from *The Book of Wonders* of 1916 (fig. 48).[72] The number five makes the analogy somewhat more complicated: Is this a five-cylinder engine (rare but extant in this period), or do the "5 hearts" perhaps signify either the engine of the automobile plus the four hearts of the humans driving from Paris (Duchamp, Apollinaire, Picabia, and Victor, Picabia's chauffeur) or the five human hearts on the return trip to Paris, Gabrielle Buffet having joined the travelers?[73]

The "headlight child," the "pure child, of nickel and platinum," is undoubtedly a modern headlight, capable of projecting a beam into the dark, in contrast to the oil

lamps that had first been used. Duchamp's reference most likely evokes the nickel-plated reflectors and platinum electrodes associated with the new electric headlamps.[74] "The Lights in Full Blast" (fig. 49), from a 1910 article, is a reminder of the novelty of headlights and night driving—an experience intensified for the Paris-Jura sojourners by a heavy rainstorm.[75] As a 1911 article in *Outing Magazine* declared, "If you own a car in a small city or in the country, you have doubtless tested the joys of night driving, and already realize how the pleasure of motoring is doubled when even familiar scenes are traversed after sundown."[76]

Duchamp's comparison of the light projected by the headlight child to a "comet, which would have its tail in front," recalls descriptions of searchlights, such as those at the 1881 Exposition Internationale d'Electricité in Paris, whose "beams were thrown like comets' tails in all directions."[77] Duchamp's version, however, implies a phallic association of this projection from the male headlight child. More original is Duchamp's thinking of the projected headlights as a new kind of line, drawn in space and continually moving through space toward infinity. He identifies the Jura-Paris Road itself with this line, which "in the beginning (in the chief of the 5 nudes) . . . will be very finite in width, thickness, etc., in order, little by little, to become without topological form in coming close to this ideal straight line which finds its opening towards the infinite in the headlight child."[78]

The "chief of the 5 nudes" is the most mysterious of the proposed characters and may well derive from the punning that occurred on the trip. Ulf Linde has suggested that the term "cinq nus" might be a pun on "seins nus," or bare breasts;[79] because Marinetti had referred to his automobile's "torrid breasts," Duchamp and his fellow travelers might well have played with this Futurist metaphor, augmenting the sexuality of the "machine-mother." This interpretation would also allow the merging of the 5 nudes with the automobile itself, an idea Duchamp describes in one of his posthumously published notes (fig. 47): "The 5 nudes, one the chief, will have to lose, in the picture, the character of multiplicity. They must be a machine of 5 hearts, an immobile machine of 5 hearts." Here, the Futurist theme of sexual union of driver and car is also evoked, for the machine-mother is to "give birth to the headlight," conferring on the chief nude (Duchamp?) the role of Bachelor/husband to the Virgin/Bride or machine-mother. Duchamp's identification of the 5 nudes with 5 hearts also suggests that the nudes might be the four passengers in the car, plus some aspect of the car itself as an extension of the "swift nudes" he had explored earlier.[80]

The headlight child is the "instrument conquering this Jura-Paris road," and conquest is the central theme of "The chief of the 5 nudes extends little by little his power over the Jura-Paris Road," as Duchamp tentatively entitled the composition.[81] Duchamp continues in this note: "This collision [between the 5 nudes and the Jura-Paris road] is the raison d'être of the picture." The chief "annexes to his estates, a battle (idea of a colony),"[82] and "he and the 5 nudes form a tribe for the conquest by speed of this Jura-Paris road."[83] The headlight child "absorbs by crushing (gold dust, graphically) this Jura-Paris road," whose "pictorial matter . . . will be *wood*."[84] As this last statement reminds us, this work would have nothing to do with landscape painting; it was to be raised to a "state entirely devoid of impressionism," just as the *Large Glass* would be.[85]

Given his description of the headlight child as "the pure child," "the child-God, rather like the primitives' Jesus," a child "radiant with glory" (fig. 47), his identity as a Christ figure, son of the Virgin Mary/automobile, is unmistakable.[86] As a headlamp, he is the new Light of the World, conquering it with the aide of a "tribe" (the tribes of Israel?). Even Duchamp's references to wood and gold dust suggest that the Jura-Paris Road would function simultaneously as the most modern of images (wood being a "translation of powdered silex" and gold dust relating to scientific theories about the makeup of comet's tails)[87] and the most traditional (wood and gold leaf being the materials for altarpieces). Such overlays of traditional religious imagery and modern technology were undoubtedly a part of the experience of the trip to Jura, because they were favorite themes of Apollinaire.

It was on this visit to Buffet's family home that Apollinaire first recited his poem "Zone," which he named in honor of this region of France.[88] In it Apollinaire writes with the same iconoclastic humor of "Christ who climbs the sky better than any aviator / He holds the world record for altitude."[89] Apollinaire, who identified himself with Christ in a draft version of "Zone" and in other poems, had also regularly associated his loves with the Virgin Mary.[90] He addressed his mistress, Marie Laurencin, in this manner in his poetry, and in "Les Fiançelles" of 1908, he updated the symbolism of Marie and the rose by referring to the "roses of electricity."[91] Modeling his approach in part on Apollinaire's erudition and his fusion of old and new, Duchamp, in the *Large Glass*, would go even further in recasting the icons of Western culture in terms of modern science and technology.

The theme of the automobile serves as a link between Duchamp's notes for the Jura-Paris Road (his first extensive exploration of human-machine analogies) and his ini-

tial juxtaposition of organic and mechanical forms in his Munich *Virgin* drawings. As noted in chapter 2, in subsequent notes on the Bride Duchamp would describe the Virgin/Bride as an *arbre type*, evoking the "arbre de transmission" (fig. 50) and various other *arbres*, or shafts, in an automobile.[92] Indeed, when *Virgin (No. 1)*, one of the "two studies of this arbor type" Duchamp made in Munich,[93] is turned ninety degrees to the right (fig. 51) and compared to a didactic illustration of an automobile, such as figure 50, the similarities are striking. In Duchamp's drawing a horizontal shaft anchors the composition, and the upper-right corner (in this orientation) calls to mind the brake lever tilted forward at a forty-five-degree angle in figure 50. There is even the suggestion of part of a tire or wheel at the right edge of the drawing, below the midpoint on that side.

In light of Duchamp's subsequent linking of automobile imagery to religious iconography in the Jura-Paris notes, abetted perhaps by the model of Apollinaire, Duchamp's use of the title "Virgin" for these drawings would seem to have been, on one level, a conscious reference to Mary, the Bride of Christ, whom he presents in twentieth-century language. It may well have been the term *arbre* that suggested this irreverent identification. In the prominent motif of the Tree of Jesse in Christian iconography, Mary is symbolized by the "rod" of the Tree and Christ by its "flower": he is literally the "divine blossoming" to which Duchamp refers in the Jura-Paris notes.[94] The notion of the Virgin as a modern *arbre*, or rod (i.e., a transmission shaft), would certainly have amused Duchamp and his colleagues; it also set the tone for the larger scheme of analogies and punning in the *Large Glass*.

Transferred to the Bride of the *Large Glass*, such iconoclastic religious overtones would continue as an underlying motif and would even be augmented with mythical associations (see chaps. 11 and 12). Yet, it was the Bride's scientific and technological identity that was Duchamp's primary concern in the notes he was making for the *Large Glass*. Thus, she acquired many other associations beyond the automobile (and her links to X-rays and chemistry equipment) and was not to be a direct translation of a single technological or scientific source.[95] The same cannot be said of Picabia, who shared certain of Duchamp's interests, but usually quoted his sources much more overtly.

Thus, Picabia's *De Zayas! De Zayas!* (fig. 52) is modeled on a diagram of a Delco starting and lighting system, as William Camfield has established.[96] Although in the *Large Glass* Duchamp would work out multiple analogies between anatomical functions and scientific and technical processes, Picabia simply grafted a female symbol, the corset, onto this electrical system. Picabia approached the lightbulb in a similar manner, using it directly in 1917 as a portrait of an American girl (fig. 131). Glass tubes and filaments were also to play an important role in one aspect of Duchamp's thinking about the Bride of the *Glass*, but she would never be identified solely with a lightbulb.

Duchamp had come closest to identifying a human as a light or lamp in the Jura-Paris headlight child. In addition to his association with a contemporary headlamp by means of his nickel and platinum materials, Duchamp describes the headlight child as being connected to his machine-mother by a construction "based . . . on the concept of the endless screw" (fig. 47), as if he were an electric lamp with a screw-base socket. As such, he is the "divine blossoming" of the electrical system of his automobile mother, who, we are reminded, is "more human" than he, the "pure machine." As imagined by Duchamp, his "radiant glory" updates Baroque nativity scenes in which light radiates from the manger of the Christ child.

Yet the Jura-Paris Road project was never executed, and Duchamp would not paint his first machine with human associations, *Chocolate Grinder (No. 1)* (fig. 66), until spring 1913. At the same time, while visiting New York, Picabia produced his first "object portrait" (fig. 57), the genre he would develop fully in works of 1915, such as *De Zayas! De Zayas!*[97] Like Duchamp in the headlight child, Picabia based his *Mechanical Expression Seen through Our Own Mechanical Expression* (fig. 56) on a light source—in this case, the glass Crookes tube used to produce X-rays. This choice was emblematic of the interest in scientific equipment that now joined Picabia's and Duchamp's shared concern with the machine, as each artist moved definitively beyond Cubism and its quest for the invisible. Unlike Picabia, however, for whom science seems to have served primarily as a new visual resource, Duchamp would devote himself to the ideas as well as the images of science in his search for subject matter that suitably reflected his "gray matter" and his "urge for understanding."[98]

39

Chapter 4

The Lure of Science

Imaginative Scientists (Crookes, Tesla) and Scientific Imaginations (Jarry, Roussel)

For Duchamp, science was never simply an ascetic intellectual pursuit. The rapid-fire discoveries of the late nineteenth century—X-rays, electrons, radioactivity, and wireless telegraphy, for example—could hardly be ignored, as commonly held notions about the nature of reality were challenged and new possibilities for creative expression emerged. The appeal of science in the early twentieth century was undoubtedly augmented by such charismatic figures as William Crookes (fig. 53) and Nikola Tesla (fig. 59), who, as spokespersons for contemporary science and engineering, enjoyed the status of cultural heroes. Not only had both men made major contributions to science and technology, but their lectures and writings often bore cosmological overtones or suggested utopian visions of future technologies. As Roger Shattuck has written of the attraction of Crookes and other British scientists for Alfred Jarry, "These investigators . . . all displayed a high degree of eccentric brilliance and freedom to roam among the physical sciences. For them . . . science was adventure, domestic and transcendent."[1]

In advance of Duchamp, Jarry and Raymond Roussel recognized in contemporary science a rich source for the fantasy and the humor they cultivated in their writing. Unlike Jarry, who obligingly revealed his sources, Roussel's use of science was more oblique. Yet when one reads *Impressions d'Afrique* with an eye to contemporary scientific developments, particularly those in electromagnetism (as Duchamp would have done), Roussel's interest in science is clear. Electromagnetism was an even more important theme for Jarry, and certain of his publications demonstrate his awareness of the work of both Crookes and Tesla. Duchamp's notes for the *Large Glass* suggest that he, too, responded to the work of Crookes and Tesla—as well as to the model of Jarry's and Roussel's scientific imaginings.

Crookes and Tesla, whose names were often linked in scientific and popular literature in the late nineteenth and early twentieth century, were acquainted by the time of the spectacular lectures Tesla staged in London and Paris in 1892. An article in *Scientific American* that year reported on the lectures, which featured displays of gas-filled tubes illuminated by high-frequency currents: "Mr. Tesla has taken us into some of the dark—metaphorically dark—places in nature. These fields have been but little trodden. Mr. Crookes and Mr. Tesla alone have had the *entree*."[2] Both men were thought of as discoverers of the mysteries of nature—an association that grew stronger when apparatus bearing their names (Crookes tubes, Tesla coils) came to be standard elements of X-ray work. The two men figure prominently in the X-ray literature, and, as in the case of X-rays themselves, their ideas were enthusiastically adopted by occultists and scientists alike. Both men were also associated with the other major late nineteenth-century invention based on electromagnetic waves: wireless telegraphy. Crookes, in 1892, and Tesla, in 1893, had predicted the possibility of "telegraphy without wires," and Tesla became one of the important developers of this technology. Given their involvement with these and other scientific developments, their fame at the turn of the century is not surprising. Moreover, in their hands, science could be a fantastic glimpse into the unknown or an entertaining spectacle.[3]

Sir William Crookes (1832–1919): Science and the Unknown

William Crookes established his reputation in British chemistry in 1861, with his discovery of the element thallium by means of spectrum analysis.[4] During the 1850s he had become interested in the possible scientific applications of the new medium of photography, which he would use in his subsequent work in spectroscopy. After serving briefly as editor of the *Photographic Journal*, Crookes in 1859 founded his own journal, *The Chemical News*, which he edited until 1906. During the 1860s and 1870s, he also served as editor of *The Quarterly Journal of Science*. Among his many prizes and awards, Crookes received a gold medal from the French Académie des Sciences in 1880 and was elected a corresponding member in 1906. Knighted in 1897, Sir William became the president of a number of British professional societies, including, in 1913, the Royal Society. Like so many of his contempo-

raries, Crookes combined highly respected experimental work in the laboratory with a deep fascination for the unseen world. He had a lifelong interest in psychic phenomena and, for a period in the early 1870s, was actively involved in spiritualism.[5] From 1896 to 1899, he served as president of the British Society for Psychical Research.

It was this unorthodox side of Crookes that made him so appealing to those who found the strict positivist orientation of early nineteenth-century science too confining. In his 1897 presidential address to the Society for Psychical Research, Crookes had emphasized the relativity of human knowledge. As noted earlier, the section of the address published in the *Revue Scientifique* included a table of vibrations structured around the recently discovered X-rays. Beyond the *Revue Scientifique*, Crookes's name appears frequently in a wide range of French publications of the period—for example, the major scientific journals, such as the *Revue Général des Sciences Pures et Appliquées* and the *Revue Scientifique*; virtually any book on X-rays or contemporary physics or chemistry; and such occult periodicals as *La Vie Mystérieuse*, Jollivet Castelot's *Les Nouveaux Horizons de la Science et de la Pensée*, and the *Journal du Magnétisme*.[6] A 1909 article in the avant-garde periodical *La Phalange* linked Crookes to Henri Poincaré, who was likewise admired by the Cubist avant-garde for his advocacy of the relativity of perception: "Without denying the material world, with which their occupations give them too much daily familiarity, some scientists, such as M. Poincaré or Dr. Crookes, point out the little faith that our observations merit. They do not tell us, 'All is illusion in the material world,' but, 'All that we perceive is only false appearance.'"[7]

In his effort to determine the atomic weight of thallium by using a balance within a vacuum, Crookes had begun experiments on the behavior of objects in a vacuum, which resulted in his development of the radiometer (fig. 54). This instrument demonstrates the effect of radiation falling on the blackened sides of its vanes, thereby causing the warmed gas molecules to bounce off with greater energy and turn the vanes.[8] Crookes's interest in the residual gases in vacuum tubes led to his work with electrical discharges in these tubes (figs. 55, 98). These were the tubes in which Crookes did his "beautiful experiments on cathode rays," to use J. J. Thomson's phrase, establishing, for example, their ability to turn a mill wheel (fig. 152)[9] and paving the way for Thomson's work with the electron as well as Röntgen's discovery of X-rays.

Yet the pioneering Crookes did not discover X-rays or identify the electron, in part, it would seem, because he was so preoccupied with the state of the residual gases in the radiometer and the cathode-ray tube.[10] To explain the motion of the radiometer's blades and the stream of cathode rays within a tube, Crookes believed it necessary to posit a new state of matter, "radiant matter," which he described as "a condition as far removed from the state of gas as a gas is from a liquid."[11] In his famous lecture on the subject, Crookes concluded that

in studying this Fourth state of Matter we seem at length to have within our grasp and obedient to our control the little indivisible particles which with good warrant are supposed to constitute the physical basis of the universe. We have seen that in some of its properties Radiant Matter is as material as this table, whilst in other properties it almost assumes the character of Radiant Energy. We have actually touched the border land where Matter and Force seem to merge into one another, the shadowy realm between Known and Unknown, which for me has always had peculiar temptations. I venture to think that the greatest scientific problems of the future will find their solution in this Border Land, and even beyond; here, it seems to me, lie Ultimate Realities, subtle, far-reaching, wonderful.[12]

Crookes's language suggests that the space of the radiometer or Crookes tube is a very special realm and makes clear why his ideas would have interested anyone concerned with higher realities, such as a fourth dimension. It is little wonder, for example, that the Theosophist Mme Blavatsky admired Crookes's work and cited it repeatedly in *Isis Unveiled* of 1877 and *The Secret Doctrine* of 1888.[13]

Soon after the identification of the electron in 1897, Crookes began to associate radiant matter with electrons and elaborated this connection in a number of lectures and articles.[14] In this context he also reinterpreted his notion of protyle, the primitive matter from which he believed all chemical elements had evolved.[15] Indeed, Crookes's concepts of protyle and radiant matter had encouraged scientific interest in the existence of bodies or substances more basic than atoms and had attracted turn-of-the-century alchemists such as Jollivet Castelot.[16]

Much of Crookes's scientific work was devoted to revealing previously invisible effects. Prominent examples are his cathode-ray experiments involving the mill wheel (fig. 152) and his inventions, the radiometer and the spinthariscope (fig. 30), the latter making radioactive emissions detectable by the human eye.[17] With a similar revelatory purpose, Crookes developed expertise in the relatively new technique of spectroscopy; in particular, he studied the spectra of elements that would phosphoresce when bombarded in a cathode-ray tube, terming this practice "radiant matter spectroscopy."[18] Finally, Crookes was

keenly interested in electromagnetic waves and in the work of his colleague Oliver Lodge and Tesla on these "electrical vibrations." Crookes's 1892 article "Some Possibilities of Electricity" offered the first public prediction of "the bewildering possibility of telegraphy without wires, posts, cables, or any of our present costly appliances." Crookes, who believed that such a development would depend on the creation of suitable instruments, posited a need for "more certain means of generating electrical rays of any desired wavelength" and "more delicate receivers," as well as a means of directing the signal, a feat Marconi would achieve in 1896 and the years following, building on the work of pioneers like Lodge and Tesla.[19]

Crookes was one of the first individuals to develop the analogy between wireless telegraphy and telepathy, "the transmission of thought and images directly from one mind to another without the agency of the recognized organs of sense," a favorite concern of the British Society for Psychical Research and of Crookes himself.[20] He set forth these ideas in two widely publicized presidential addresses: the first, his 1897 speech before the society, already noted; and the second, his 1898 lecture before the British Association for the Advancement of Science (BAAS). Like his address of 1897, Crookes's British Association speech was translated and published in the *Revue Scientifique*. Both texts subsequently appeared in 1903 as a single volume, *Discours récents sur les recherches psychiques*, which in May of that year was enthusiastically reviewed in the "Esotérisme et spiritisme" section of *Mercure de France*.[21]

As mentioned in chapter 1, Crookes saw X-rays as a possible key to the way "brain waves" might function in the process of telepathy. Crookes also suggested a connection to wireless telegraphy, although he believed that Hertzian or radio waves, whose wavelengths were much longer than those of X-rays, were far too low in frequency to serve as the model for penetrating brain waves. Nevertheless, Crookes proposed an analogy between the structure of the human brain (i.e., the narrow gap between nerve cells) and the Branly or Lodge coherer, the device used to detect Hertzian waves in wireless telegraphy.[22] Thus, Crookes added the newest technology in the field of communication to the lexicon of possible human-machine analogies. Duchamp and Kupka would respond in particular to that analogy, as well as to other aspects of Crookes's work.

Picabia's *Mechanical Expression* and the Crookes Tube

Like Duchamp and Kupka, Picabia also appears to have drawn upon Crookes—as in his first foray into the realm of scientific equipment, *Mechanical Expression Seen through Our Own Mechanical Expression* (fig. 57) of late March–early April 1913. This small watercolor-and-pencil "portrait" followed his series of watercolor landscapes on the theme of the city of New York, such as *La Ville de New York aperçue à travers le corps* (fig. 20), completed during his 1913 visit to New York. *Mechanical Expression* substitutes a scientific object for the exotic dancer Stacia Napierkowksa, whose name, minus a letter, appears below the object.[23] Willard Bohn has linked Picabia's image to a Crookes radiometer (fig. 54), but given Picabia's and Duchamp's interest in X-rays, a Crookes tube used to produce X-rays (figs. 55, 98) is an equally likely scientific source and serves to elucidate the background forms of *Mechanical Expression* as well.[24]

In Picabia's image the radiometer has been electrified and transformed into an X-ray "focus tube," so that what Bohn has identified as a single radiometer vane may also be read as the target or anticathode within the Crookes tube, against which the cathode-ray stream is directed.[25] In operation, a cathode-ray tube would be wired with a power source at the top and bottom of the bulb. Picabia suggests those electrical connections by the lightning-like sign for energy at the top, which may also signal the emission of X-rays, and by the rod extending from the target within the tube down through its supporting base. The thin tube curving down to the right may also be read as some kind of wiring or, possibly, the exhaust tube by which a vacuum was created and regulated in early cathode-ray tubes. In the same way that the bulb seems to float above its base, supported by a delicate arm (fig. 54), Picabia suspends his tube above its supporting base.

In the context of X-rays, it is also possible to suggest the genesis of the unusual object resembling a chest of drawers to the left of the tube. Besides a Crookes tube, the other essential piece of equipment for the production of X-rays was an induction coil, which was used to step up the voltage to the requisite level. In 1896 the Parisian firm Gaiffe advertised X-ray equipment fitted with a Tesla coil for producing high-frequency discharges (fig. 56). This configuration of a standard induction coil mounted on a wooden, stair-step base containing the coils of the oscillation transformer insulated in oil appears repeatedly in X-ray literature.

Perhaps in response to discussions of machine sexuality during the Jura-Paris trip, and in avant-garde culture in general, Picabia seems to have created a secular, female counterpart to Duchamp's male headlight child. As an X-ray tube, Mlle Napierkowska is made to function by the application of electrical current, which was to become for Picabia an embodiment of male force, as in his 1917 *Uni-*

versal Prostitution.[26] Moreover, the association with X-rays must have seemed particularly appropriate for the exotic dancer, whose New York performances in March 1913 had been halted by the police on the grounds of indecency. As early as his 1911 *Dulcinea* (fig. 11), Duchamp had responded to the ability of the naughty X-ray to strip women of clothing and flesh. Instead of revealing a stripped figure, however, Picabia substituted the object (i.e., the X-ray tube), whose stripping function paralleled that of the scantily clad Napierkowska.[27]

Beginning in 1915, Picabia would develop the idea of such substitutions fully in his mature object portraits.[28] Unlike these later object portraits, *Mechanical Expression Seen through Our Own Mechanical Expression* has suggestions of a landscape akin to that of *La Ville de New York aperçue à travers le corps*, with its unusual planar, geometric shapes. Although the small, dark vertical rectangles in the upper half of *Mechanical Expression* might be read simply as skyscraper windows, the larger, skewed, irregular shapes clinging to the surface militate against such an interpretation, as does Picabia's vocal rejection of painting in a "purely visual or optical manner" in his preface to his March–April exhibition at Stieglitz's "291" gallery.[29] Indeed, similar geometric forms, detached from any naturalistic context, appear in all the works of the New York series, including *La Ville de New York*. As noted in chapter 1, Picabia's use of the phrase "*à travers le corps*" for one of the images exhibiting the floating rectangular shapes strongly suggests that he associated all these sparse landscapes with some kind of X-ray vision of the city.

These planar, geometric shapes also resemble the geometric projections used by the American architect and fourth-dimension theorist Claude Bragdon to illustrate the trace or imprint left by higher-dimensional solids passing through a space of one less dimension (fig. 58). Bragdon's image, first published in his 1912 *Man the Square: A Higher Space Parable*, was reprinted in his 1913 *A Primer of Higher Space (The Fourth Dimension)*, a text in which Bragdon also connected X-rays to clairvoyant, four-dimensional vision.[30] Perhaps the placement of New York at the center of the Crookes tube in Picabia's *Mechanical Expression* is a clue that this is New York in a "fourth state of matter," a term with strong four-dimensional overtones in this period.

According to Gabrielle Buffet's June 1913 article in *Camera Work*, "Modern Art and the Public," the modern artist is interested in "an infinite world of new forms [that] is opened up to us—thanks to the continual analyses of chemistry and physics."[31] In *Mechanical Expression Seen through Our Own Mechanical Expression*, Picabia com-

bines visible signs of chemistry and physics and an evocation of an X-rayed New York landscape with its previously invisible forms revealed. Even his treatment of the scientific apparatus reduces and simplifies these objects into ideograms in a style that may well have drawn upon Duchamp's interest in mechanical drawing techniques and diagrammatic presentation. In his treatment of the base of the Crookes tube, in particular, Picabia goes beyond the standard line-drawing illustrations in scientific textbooks, which would normally suggest shading by grouping the vertical hatchings at one side or the other of the base.[32] By equalizing the spaces between the vertical lines, Picabia creates a conceptual abstraction that denies sense perception and negates the special place granted to light and its form-creating shadows in the Western artistic tradition.

At this same moment Duchamp himself was conducting an intensive study of modes of representation, as evidenced in the juxtaposition of his *Chocolate Grinder (No. 1)* (fig. 66) and *Chocolate Grinder (No. 2)* (pl. 4, fig. 91). Duchamp may have been the one who introduced Picabia to illustrations of scientific equipment and to the developments in chemistry and physics that Buffet mentions in "Modern Art and the Public." The tubes associated with Crookes were also to be important for Duchamp, as was Crookes's linking of wireless telegraphy wave detectors and the human brain. Just as the growing interest in wireless telegraphy kept Crookes's name in the forefront, Crookes tubes would remain important beyond the context of cathode rays, X-rays, and research on electrons. In addition, Tesla's widely publicized experiments in creating wireless lighting employed a variety of sealed glass tubes, including those of the Crookes type. Crookes spoke enthusiastically of Tesla's work in print and lent him tubes filled with various phosphorescent substances for his February 1892 lectures in London and Paris, the appearances that first brought Tesla international acclaim.[33]

Nikola Tesla (1856–1943): Science as Spectacle

Given his international renown at the turn of the century and the impact of his inventions on twentieth-century technology, it is remarkable that Nikola Tesla is so little known today.[34] Although he was best known to the public for his dramatic demonstrations in the 1890s of high-frequency electrical effects—including flaming sparks, new forms of lighting, and wireless control of his "telautomatons"—his invention of an alternating current motor in 1887–88 had already influenced the course of American electrification. Born in Croatia to a Serbian family, Tesla immigrated to the United States in 1884 and worked briefly for Thomas Edison; Tesla's commitment

to alternating current, however, soon led to conflict between the two men. Tesla and George Westinghouse would subsequently oppose Edison in the so-called battle of the currents of the early 1890s, supporting alternating current, which could be stepped up and transmitted over long distances. By contrast, the direct current that Edison favored required a power source for each square mile to which current was delivered.[35] Until Tesla's creation of an induction motor that could run on alternating current, however, the dominance of direct current seemed assured.

Through Westinghouse, who bought the patent rights for Tesla's motor and hired him as a consultant, Tesla's motor and his related development of an entire "polyphase" system for the generation and transmission of electricity were soon to achieve public success. Westinghouse won the contract to light the World's Columbian Exposition in Chicago in 1893, where Tesla's machines were prominently displayed; Tesla also lectured at the International Electrical Congress, staged in conjunction with the exposition.[36] That same year, Westinghouse won the contract to supply the equipment to harness the energy of Niagara Falls, using Tesla's polyphase alternating current generators and transmission system, a project covered in the international press. Alternating current would command the future, despite Edison's publicity campaign to discredit it as life-threatening, a campaign reinforced by the first electrocution of a criminal (by alternating current) in 1890.[37]

By 1890 Tesla was back in his own laboratory in New York, generating high-voltage alternating currents that oscillated at much higher frequencies. Tesla's goal was the creation of new systems of illumination that would be more efficient than the incandescent bulb. To produce the high frequencies and voltages necessary, Tesla created the oscillation transformer that came to be known as the Tesla coil, which enabled him to put a second circuit (with many more coil turns) into resonant oscillation with the first. When a condenser storing a great amount of electricity was discharged through his primary circuit, Tesla produced frequencies of between 100,000 and 1 million cycles a second and voltages of over 100,000 volts in the secondary circuit by means of electromagnetic induction.[38] These were far higher than the 2,000 volts used in executions and made all the more striking the demonstrations he carried out in his public lectures of 1891–93. The first of these, "Experiments on Alternate Currents of Very High Frequency and Their Application to Methods of Artificial Illumination," was presented in May 1891 before the American Institute of Electrical Engineers, at Columbia University, where in 1888 Tesla had first demonstrated his new alternating current motor. In February 1892 Tesla gave a similar lecture and demonstration in London before the Institution of Electrical Engineers; the response was so enthusiastic that Tesla was invited to repeat his presentation at the Royal Institution. From London he traveled to Paris, where he lectured before the Société de Physique and the Société Internationale des Electriciens (fig. 59).[39]

Tesla's lectures of 1891 and 1892 included demonstrations of flaming sparks that were relatively modest compared to the sparking discharges he would create in 1893 and later. The focus of the first lectures was the illumination of a variety of glass vacuum tubes using high-frequency alternating currents. These vessels ranged from highly decorative gas-filled Geissler tubes (fig. 99, right) to simpler Geissler tubes and Crookes tubes filled with gases or phosphorescent materials (pl. 4; figs. 97, 99), as well as tubes of his own design, some of which contained filaments or "buttons" of substances such as carbon. Tesla would dramatically hold a bulb in one hand and touch one terminal of his Tesla coil with the other, allowing the high-voltage alternating current to flow through his body and illuminate the bulb. In another demonstration, Tesla would thrust bulbs into the field of electrical oscillations created by his high-frequency alternating current (fig. 59), and without wires or bodily contact with a power source the tubes would be magically illuminated "like a flaming sword."[40] One of Tesla's later techniques involved holding a loop of wire over a coil, thereby inducing a current in the wire loop and the body of the demonstrator that lighted a bulb placed between the demonstrator's hands (fig. 60). The demonstrator illustrated is Tesla's friend Mark Twain, photographed in Tesla's New York laboratory, where Tesla delighted in after-dinner entertainments featuring his high-frequency apparatus.

Tesla's lectures of 1891–93 were covered extensively in American, British, and French periodicals. "The French papers this week are full of Mr. Tesla and his brilliant experiments," declared the *Electrical Engineer* in London on March 11, 1892.[41] E. Hospitalier, who was to report periodically on Tesla's work in *La Nature*, concluded enthusiastically:

For him, the light of the future is in the incandescence of solids, gases and phosphorescent bodies, *excited*, if you will pardon this somewhat vague expression, by high-voltage currents varying at very high frequencies.

The copious praise that welcomed [Tesla's] lectures in England and France, proves to him that he has succeeded in imparting his enthusiasm, if not his conviction, to the men most capable of appreciating the grandeur and importance of his work. We wish all success to this expert experi-

menter in his new line of research; we hope that on his next journey to Europe the light of the future will have become, for him at least, the light of the present.[42]

Although Tesla himself would never develop the practical applications of his lighting discoveries, his ideas retained currency through the continued interest in electrical discharges in gas-filled vacuum tubes.[43] Indeed, the centenary of the Conservatoire des Arts et Métiers in 1898 was celebrated with a display using equipment similar to that utilized by Tesla to produce his dramatic lighting effects (fig. 99), an image reproduced in Georges Claude's discussion of high-frequency currents in his popular *L'Electricité à la portée de tout le monde*, first published in 1901 and in its seventh edition by 1911. In that text Claude, who was himself to pioneer the use of the inert gas neon as a lighting source in late 1910, noted that Tesla's lectures had given a "remarkable renown" to luminescent gas tubes.[44] Tesla's bulbs, which were an important precursor to neon and fluorescent lighting, were included in the display of new light sources in the Palais de l'Optique at the Paris Exposition Universelle in 1900.[45]

The names of Tesla and Crookes were frequently associated in the 1890s; at this time Tesla was as close as he would ever be to a mainstream scientific discovery, as opposed to the technological innovations he would continue to make. Tesla's demonstrations of high-frequency currents gave further support to Crookes's theory of radiant matter, and he, like Crookes, espoused the interpretation of cathode rays as bombarding projectiles. Crookes, in his *Fortnightly Review* article on electricity, published in part in the *Revue Scientifique* of January 1892 as "L'Atome électrique," spoke enthusiastically of Tesla's experiments with lighting techniques.[46] Further, he extolled the sparks that offered the possibility of "a flame which yields light and heat without the consumption of material and without any chemical process" as well as communication via the ether vibrations to which they gave rise.[47]

Tesla was to focus increasingly on the application of high-frequency alternating currents to the area of wireless communication. He had presented his initial views on the subject in 1893 in a speech entitled "On Light and Other High Frequency Phenomena," presented at the Franklin Institute in Philadelphia and excerpted in the *Revue Scientifique* as "Les Vibrations électriques fréquentes."[48] This lecture included new demonstrations of lighting effects and spark discharges, using new types of lamps and narrow, cylindrical glass tubes bent into unique shapes and even words.[49] It was also marked by a new degree of boldness, as Tesla, in response to the rumors about the dangers of alternating current being circulated by Edison

and his colleagues, sought to show the safety of alternating current at high voltages and frequencies. As proof, Tesla produced a "stream of light" from his fingertips by allowing an alternating current of 200,000 volts (at one million cycles per second) to flow through his body as he approached a brass sphere on the other terminal of his coil.[50] Such daring presentations were eagerly covered by the popular press, in language as dramatic as the demonstrations themselves: "Showing the Inventor in the Effulgent Glory of Myriad Tongues of Electric Flame after He Has Saturated Himself with Electricity."[51]

According to Tesla, however, "the subject that constantly fill[ed] [his] thoughts" was "the transmission of intelligible signals or perhaps even power to any distance without the use of wires."[52] He envisioned using the earth itself as a condenser and now devoted himself to developing the equipment needed to produce ever higher voltages and frequencies. Tesla continued to enlarge the scale of his coils, eventually making them as large as a room: in his New York laboratory the primary circuit circled the room and could set the coil in the center of the room into resonant, higher-frequency oscillations.[53] This was the arrangement documented in the 1895 *Revue des Revues* article on Tesla (fig. 27), in which the earth served as a large-scale condenser to produce great sparking discharges from the metal sphere at the top of the coil. With the goal of establishing a system of worldwide wireless communication and transmission of power, Tesla in 1899 built a laboratory outside Colorado Springs, Colorado, that incorporated the largest coil arrangement ever made. Using a coil fifty-two feet in diameter and a tower and mast over 200 feet high, topped by a three-foot copper ball, Tesla rivaled natural lightning by generating spark discharges of over 200 feet (fig. 61).[54]

Tesla's large-scale electrical oscillator operated on the principle of resonant tuning, which was to be crucial to the development of wireless telegraphy and radio. Likewise, the Tesla coil was itself to become standard equipment for the production of the high-frequency discharges that generated Hertzian waves. Thus, once the field began to develop, Tesla's name would figure in most sources on wireless telegraphy, particularly after Marconi's first successful transatlantic transmission in 1901.[55] Yet, rather than participate in the race for the first practicable wireless telegraphy system, as did Marconi, Tesla pursued his dream of global, wireless transmission of communications and even energy itself (utilizing a more powerful vibration than the Hertzian waves he considered too weak), which led to grand schemes that ultimately failed.[56]

In a major article in *Century Magazine* in 1900, Tesla set forth his inventions to date in the context of new pos-

sibilities for present-day life on earth and for the society of the future.[57] He included a discussion of his pioneering work in what he termed "telautomatics," or "the art of controlling the movements and operations of distant automatons" by means of electrical vibrations.[58] In 1898 Tesla had maneuvered a telautomaton in the form of a boat (fig. 62) for an audience in Madison Square Garden. In his *Century* article he presented such machines as the way to eliminate future warfare. Tesla's automaton was the precursor of all subsequent radio-controlled mechanisms; he anticipated by several years, for example, the Frenchman Edouard Branly's experiments with wireless activation of various mechanical events (figs. 107, 108). Tesla's activities in this area were covered in French publications,[59] and his discussion of himself as an automaton in the *Century* article both testifies to the prevalence of human-machine analogies in this period and anticipates Duchamp's creation of a mechanical Bachelor Apparatus in the *Large Glass*:

I have, by every thought and every act of mine, demonstrated, and do so daily, to my absolute satisfaction, that I am an automaton endowed with power of movement, which merely responds to external stimuli beating upon my sense organs, and thinks and acts and moves accordingly. . . .

With these experiences it was only natural that long ago, I conceived the idea of constructing an automaton which would mechanically represent me. . . . Such an automaton evidently had to have motive power, organs for locomotion, directive organs, and one or more sensitive organs so adapted as to be excited by external stimuli. This machine would, I reasoned, perform its movements in the manner of a living being, for it would have all the chief mechanical characteristics or elements of the same. . . . As to the capacity for propagation, it could likewise be left out of consideration, for in the mechanical model it merely signified a process of manufacture.[60]

In 1900 Tesla, a confirmed bachelor, was still an international celebrity, with equally famous friends, such as Mark Twain, and financial backers, such as J. P. Morgan. A brilliant inventor and visionary dreamer, he had adopted early on the persona of a dandy in his daily routines, dressing elegantly for work in his laboratory and entertaining regally at the Waldorf-Astoria. This was the Tesla captured in a 1908 caricature by Marius de Zayas (fig. 63), a member of the Stieglitz circle and one of Picabia's close associates during his sojourns in New York.[61] Yet, during the course of the next decade, Tesla suffered his first major professional failures—most notably the forced abandonment of his Wardenclyffe transmission tower on Long Island—and increasing financial problems. His *Century* article, with its utopian prophecies, including the certainty of communication with distant planets, elicited the first public criticism of him, the charge being that he had indulged in sensationalism and exceeded the bounds of practical science and invention.[62] Although the *Literary Digest* announced on December 18, 1915 (several weeks after its article on Duchamp and the "European art invasion" [fig. 74]), that Tesla was to receive a Nobel Prize for his inventions, the story was in error. By 1915, Tesla's period of prominence and international acclaim, particularly in the United States, had ended, and he became an increasingly marginalized and, ultimately, tragic figure.[63] Nonetheless, because of the great impact of his activities and inventions during the 1890s, Tesla remained something of a legend.

In both scientific and occult contexts in Paris, however, Tesla's name and inventions retained currency in the pre–World War I period. A Tesla coil was acquired for the collection of the Musée des Arts et Métiers in 1896, as was one of his more powerful oscillation transformers in 1902.[64] Indeed, by the early years of the twentieth century, Tesla coils (along with Geissler and Crookes tubes) had become standard equipment in demonstrating the effects of high-frequency currents.[65] His name continued to appear in the scholarly and popular literature on X-rays and wireless telegraphy, as well as in more general scientific sources such as Claude's *L'Electricité à la portée de tout le monde*.[66] High-frequency Tesla currents had also been adopted for medical "electrotherapy," providing another context for continued interest in Tesla.[67]

Because of the appeal of Tesla's ideas to occultists, their publications likewise kept his name before a French audience. His demonstrations of electrical discharges projecting from his body offered Albert de Rochas further evidence of the existence of magnetic emanations; in *L'Exteriorisation de la sensibilité* of 1895, Rochas cites "the experiences of Crookes and Tesla" with "radiant matter."[68] Papus, in his pamphlet *L'Occulte à l'Exposition*, an occult guide to the 1900 Exposition Universelle, discussed the new "cold light" exhibited in the Palais de l'Optique, linking it to Tesla's work in induced phosphorescence and to radioactivity: "In all the rooms of the palace we see the most recent discoveries made with radioactive substances—Crookes, Röntgen, Gessler [*sic*], d'Arsonval, Tresla [*sic*] have contributed, and *cold* light is shown here as the light of the future."[69] Péladan, in "Le Radium et l'hyperphysique" of 1904, discussed Tesla in the context of electromagnetic Hertzian waves, noting Tesla's creation of meter-long sparks and his telautomaton, "a truly fabulous boat without a pilot or any human

presence and which, tuned to the vibrations of an oscillator, receives orders from a great distance and executes them."[70] Finally, in *La Synthèse d'or* of 1909 Jollivet Castelot mentioned Tesla's "Light of the Future" and, pointed to Tesla's and Branly's work in wireless control as support for the reality of telepathy.[71]

From cathode rays and radiant matter to telegraphy and telepathy, Crookes and Tesla had made major contributions to science and technology, but they also made science accessible and entertaining. Each also dreamed of future developments—of telepathy, in the case of Crookes, or of worldwide communication and power transmission, in the case of Tesla. Human-machine analogies also played a role in each man's thinking. Most appealing to avant-garde writers or artists, undoubtedly, were their speculations on the unknown, such as Crookes's fourth state of matter or Tesla's belief in the possibility of communication with Mars. Such ideas were the stuff of science fiction, and, in the tradition of Jules Verne, both Jarry and Roussel would mine contemporary science, at times as presented by Crookes or Tesla, as a rich source for literary themes.

Alfred Jarry (1873–1907): Themes of Electromagnetism and Electricity in *Docteur Faustroll* and *Le Surmâle*

Apollinaire hailed Jarry's *Gestes et opinions du docteur Faustroll, pataphysicien* (fig. 64), completed in 1898 but not published until 1911, as "the most important publication of 1911."[72] Thus, even before Duchamp accompanied Picabia and Apollinaire to Roussel's *Impressions d'Afrique* in 1912, it is likely that he would have been aware of Jarry's work.[73] Jarry had made his reputation in the 1890s as the iconoclastic creator of the satirical farce *Ubu Roi*, which had caused a scandal in 1896. A member of the Symbolist circle around the periodical *Mercure de France*, Jarry had collaborated with Remy de Gourmont on the short-lived periodical *L'Imagier* in the early 1890s. He subsequently adopted an eccentric persona rivaling Ubu's, as evidenced by his idiosyncratic lodgings and attire, not to mention his legendary devotion to the new sport of cycling and, less sanguinely, firearms and alcohol. In the early years of the new century, Jarry was admired by a group of younger poets, including his friend Apollinaire, as well as by Picasso.[74]

Behind his public persona, Jarry was deeply interested in contemporary developments in science and geometry, which offered a means to challenge traditional positivism. Jarry first introduced the term "Pataphysics" in 1893, in a short section of what would become his play *Ubu Cocu*;

the following year he announced in *Les Minutes de sable mémorial* that he would publish *Eléments de pataphysique*.[75] That plan came to fruition in *Gestes et opinions du docteur Faustroll, pataphysicien*, in which Jarry defined Pataphysics as "the science of imaginary solutions," which "will examine the laws governing exceptions, and will explain the universe supplementary to this one."[76] Building upon his basic scientific education at the Lycée de Rennes and, for a time, at the Lycée Henri IV, Jarry also read independently at the Bibliothèque Sainte-Geneviève, as Duchamp would do later.[77] He responded particularly to the possibilities for fantasy and humor in the work of late Victorian British scientists such as Crookes and Lord Kelvin, who regularly employed imaginary creatures or mechanical models to explain physical principles. In a 1903 article, "De quelques romans scientifiques," Jarry praised Kelvin's imaginative approach to science as "more fantastic" than anything in contemporary science fiction.[78] Further, because of his own interest in the occult, Jarry would have appreciated the openness of figures such as Crookes and Lodge to psychical research and even spiritualism.[79]

Since only the least scientific chapters of *Gestes et opinions du docteur Faustroll* had been published before 1911, the first of Jarry's truly Pataphysical texts to appear in print was an essay published in *Mercure de France* in February 1899, "Commentaire pour servir à la construction pratique de la machine à explorer le temps," which was signed "Dr. Faustroll."[80] Jarry's article was a response to H. G. Wells's *The Time Machine*, which had been serialized in *Mercure de France* during the winter of 1898–99. Wells's story deals with the notion of time as a fourth dimension, in contrast to the standard interpretation of a spatial fourth dimension, which he had used in other stories.[81] Jarry's text began with a Bergsonian discussion of time as succession and space as simultaneity, which included references to both four-dimensional spaces, derived from *n*-dimensional geometry, and the curved spaces of the non-Euclidean geometries of G. F. B. Riemann and N. I. Lobachevsky. For Jarry and, subsequently, for Duchamp and other members of the avant-garde, these new geometries—particularly, non-Euclidean geometry, with its overt challenge to the sovereignty of Euclid's geometry as absolute truth—could function as a subversive symbol for the rejection of tradition and established laws.[82]

Jarry found in contemporary hypothesizing about the luminiferous ether the qualities he believed necessary to isolate travelers from the flow of duration, allowing them to emerge in the past or future. In addition to meeting his requirements that the machine be nonmagnetic and free of

the effects of the earth's turning, the ether offered the strangely contradictory characteristics of the rigidity of an elastic solid (necessary for the transmission of wave vibrations) and the rarification that allowed the free motion of bodies through it. To demonstrate these latter properties, Lord Kelvin had created a model of the ether as a network of spring-balance structures containing gyrostatic flywheels. Jarry borrowed lengthy sections from one of Kelvin's lectures on the subject, even providing a scholarly citation, and then adopted the gyrostat as a central element for his machine.[83] In a typical Pataphysical twist, however, Jarry, the passionate cyclist, proposed attaching the gyrostats to an ebony bicycle frame. Jarry's talk of the nickel *fourches* (forks) of the gyrostats links them to actual bicycle wheels and suggests that, on one level, Duchamp's *Bicycle Wheel* of 1913 (see fig. 70), the first of the chosen objects he would later term "Readymades," may have been associated with Jarry and ether physics. Indeed, Oliver Lodge, in his lectures of the period, actually used a bicycle wheel to demonstrate the ether's similarity to a fluid in motion: both were transparent to light when stationary and were opaque and impervious when in motion.[84]

Victorian physics also served Jarry as a fertile source in *Gestes et opinions du docteur Faustroll, pataphysicien.* The book draws upon numerous scientists, most notably, Crookes and C. V. Boys, whose work on soap bubbles and film phenomena fascinated him. Many of Faustroll's adventures occur during his travels "from Paris to Paris" in a "sieve-boat," which floats because of the effects studied by Faustroll's "learned friend C. V. Boys." Even in his description of Faustroll, Jarry employs the language of science to humorous effect: the doctor's height is given in "atomic diameters," and he is beardless owing to "the judicious use of baldness microbes."[85]

Jarry begins his account of Faustroll's adventures in "Faustroll Smaller than Faustroll," a chapter based on a section of Crookes's 1897 address to the Society for Psychical Research, published in the *Revue Scientifique* as "De la relativité des connaissances humaines." To make his point that "we are demonstrably standing on the brink . . . of one unseen world," that being of "the world of the infinitely little," Crookes introduced a microscopic homunculus on a cabbage leaf, who would experience at close range the "molecular forces which in common life we hardly notice—such as surface tension, capillarity, the Brownian movements."[86] Jarry followed Crookes closely, with Doctor Faustroll deciding one day "to be smaller than himself" and explore one of the elements, water, "in order to examine any disturbance which this change in size might involve in this mutual relationship." On a cabbage leaf Faustroll encounters dewdrops which for him,

as for Crookes's homunculus, are huge, transparent globes revealing molecular effects on a larger-than-life scale.[87]

Crookes had used the altered perceptions of the homunculus to preface his discussion of telepathy and wave vibrations, arguing that "our boasted knowledge [may] be simply conditioned by accidental environments, and thus be liable to a large element of subjectivity hitherto unsuspected and scarcely possible to eliminate."[88] Such a view was at the very core of Jarry's Pataphysics as well: "Pataphysics . . . will describe a universe which can be—and perhaps should be—envisaged in place of the traditional one, since the laws that are supposed to have been discovered in the traditional universe are also correlations of exceptions, albeit more frequent ones, but in any case accidental data."[89] As discussed in chapter 1, the discovery of X-rays had been an important support for the belief in the relativity of perception that Crookes expounded in his Society for Psychical Research address and that Jarry adopted. The existence of known and unknown ranges of vibrations ("not only in solid bodies, but in the air, and in a still more remarkable manner in the ether")[90] was a central theme of Crookes's argument for the possibility of thought transmission. Jarry not only used the theme of vibration throughout *Gestes et opinions* but wrote two chapters in the form of "Telepathic Letter[s] from Doctor Faustroll to Lord Kelvin," a decidedly ironic gesture in that Kelvin's lectures had made clear his rejection of occult phenomena.[91]

Duchamp, with his interest in creating a "painting *of frequency*," would have been especially alert to the various types of vibrations Jarry mentions.[92] Certain of these have to do with sound, for example, the "microphone" Jarry attributes to "Mr. Chichester Bell, cousin of Mr. Alexander Graham Bell," consisting of a rubber sheet stretched over the end of a cylinder, which amplifies the vibrations produced by a stream of water being poured on the cylinder.[93] More often, however, the vibrations are electromagnetic waves of invisible or visible light. Thus, when the bailiff Panmuphle reads Faustroll's manuscript, he must "substantiate the invisible ink of sulphate of quinine by means of the invisible infra-red rays of a spectrum whose other colors were locked in an opaque box."[94] And, Faustroll's monkey, Bosse-de-Nage, is described as wearing a black costume and "a Belgian hat capable of storing up luminous vibrations in wave lengths equal to those of his costume."[95]

Vibrations also play a role in "Concerning the Measuring Rod, the Watch and the Tuning Fork," the chapter containing Faustroll's first telepathic letter to Lord Kelvin, from whom Jarry borrowed extensively. In this segment of the final section of *Gestes et opinions*, subtitled "Ether-

nity," Faustroll's "astral body" writes to Kelvin following Faustroll's earthly death (another response to Kelvin's overt rejection of spiritualism).[96] Jarry's concern here with systems of measurement is especially relevant for Duchamp, who would combine his interest in measuring systems and in non-Euclidean geometry in the *3 Standard Stoppages* of 1913–14 (fig. 68). Jarry's narrative is based closely on a lecture by Kelvin entitled "Electrical Units of Measurements," in which he had discussed how a traveler in the universe "who had lost his watch and his tuning fork and his measuring-rod" could "recover his centimetre, and his mean solar second."[97]

Faustroll, after death, becomes that traveler, in an eternity he identifies with the ether, or "ethernity." In spite of having "left in one of my pockets by mistake my centimeter, an authentic copy in brass of the traditional standard," Faustroll saves himself by employing the equivalent standard measure of the centimeter in terms of the wavelength of yellow light. Consequently, the spectrum of yellow light, determined by means of two candles and a grating, "returned my centimeter to me by virtue of the figure 5.892×10^{-5}."[98] Likewise bereft of his watch and his vibrating tuning fork, Faustroll, in the next chapter ("Concerning the Sun as a Cool Solid," a second letter to Kelvin), recovers his solar second by means of "the absolute measure of 9,413 kilometers per mean solar second of the Siemens unit," a measure of electrical resistance.[99]

Just as Lord Kelvin and Crookes were crucial figures for Jarry, his *Gestes et opinions du docteur Faustroll, pataphysicien* would have been a rich source and effective model for Duchamp. Beyond its wide-ranging physics, Jarry's text also incorporates references to the four-dimensional geometry that interested Duchamp; novel applications of more basic geometrical principles ("God is the tangential point between zero and infinity");[100] elements of occultism; and even a painting machine, which contains paint in the "tubes of its stomach" and "ejaculate[s] onto the walls of its universe."[101] Jarry's Pataphysics, as presented in his *roman néo-scientifique*, or neo-scientific novel, as he subtitled the work, offered an alternative to traditional French science or what he would refer to in *Le Surmâle* as "SCIENCE with a grand SCIE [scythe]."[102] Demonstrating the artistic and iconoclastic potential of recent developments in British science, Jarry's imaginative Pataphysics pointed the way to Duchamp's own practice of "*slightly distending* the laws of physics and chemistry."[103]

When *Gestes et opinions* was finally published in 1911, the publisher appended a collection of Jarry's witty and satirical essays, entitled "Spéculations," which had originally appeared in the *Revue Blanche* between

December 1901 and December 1902. Although they are not devoted to scientific subjects as such (apart from medicine or psychology), they nonetheless include several texts relevant for Duchamp's subsequent work. One of these is Jarry's "The Passion Considered as an Uphill Bicycle Race," which scholars have cited as a possible source for Duchamp's drawing included in the *Box of 1914*, "To Have the Apprentice in the Sun" (fig. 79).[104] Equally important for Duchamp may have been Jarry's commentary on the theme of repopulation, "Copulatively Speaking," in which a number of the sexual elements of the *Large Glass* appear: the Virgin, a bride, *célibataires*, and *célibataires militaires*, complete with *uniformes*.[105] The nonscientific orientation of Jarry's "Spéculations" mirrors his separation of Faustroll's sexual exploits and Pataphysical musings in *Gestes et opinions*. In *Le Surmâle* of 1902, however, Jarry combined sex, the physics of electricity, human-machine analogies, and humor in a story that presages the *Large Glass* and even suggests a specific debt to Tesla.

In a 1903 article, "De quelques romans scientifiques," Jarry spoke not only of the scientist Kelvin but also of writers such as Wells ("the master of today") and of Villiers de l'Isle-Adam, "whose extraordinary Hadaly is revived in our music halls, under the name of the 'auto-virgin.'"[106] A number of authors have noted the importance of Villiers's "future Eve" (the android Hadaly is an automaton in deceptively human form) for Jarry's Adam-like "Supermale" (the human André Marcueil emulates the strength and endurance of a machine.)[107] Considered from the point of view of science and occultism, however, there are a number of previously unnoticed parallels between Jarry's thought and Villiers's views as expressed in his 1886 *L'Eve future*. The first of these is the admiration that both Villiers and Jarry shared for Crookes. According to Villiers, Hadaly is made so lifelike by being "projected through her RADIANT MATTER." "With electromagnetic power and Radiant Matter, I will deceive the heart of a mother and much more easily the passion of a lover," declares the fictional Thomas Edison, Hadaly's creator.[108] In this light, Picabia's use of a Crookes tube containing radiant matter to embody Stacia Napierkowska in *Mechanical Expression Seen through Our Own Mechanical Expression* (fig. 57) also suggests the possible relation of Villiers's future Eve to this work. Hadaly was to be an important prototype for Duchamp's own "auto-virgin," the Bride, as well.

Two other science-related themes are shared by *L'Eve future* and *Le Surmâle*. These are, first, the issues of thought transmission and hypnotism, or Magnetism, both of which could be linked to the science of electromagne-

tism, and, second, the major role played by electricity itself (albeit in different forms of current). In *L'Eve future* a good deal of telepathic thought transmission occurs "without conductors or wires," as does the projecting of one will upon another by means of Magnetism.[109] In *Le Surmâle* André Marcueil's many powers include hypnotism, a force he exercises over his partner, Ellen, during one stage of the sexual orgy that proves him to be a Supermale; Ellen's father and his colleagues also consider hypnotism as a way to make Marcueil fall in love with the young woman.[110] In the end, however, the three men settle on electricity—high-voltage, high-frequency alternating current—as the means to induce love in the irrepressible Marcueil. Their electromagnetic "machine-to-inspire-love" is the element that makes *Le Surmâle* particularly relevant for Duchamp's *Large Glass* and that clearly goes beyond the use of electricity by Villiers's Edison in *L'Eve future*.[111]

Jarry establishes the plot for his tale in the first chapter, when Marcueil boasts to guests that "the act of love is of no importance, since one can perform it indefinitely."[112] On this evening the guests at his estate, Lurance, include the American chemist and the inventor of "Perpetual-Motion-Food," William Elsen, the American engineer Arthur Gough, Dr. Bathybius, and Elsen's daughter, Ellen. Although he hardly resembles a man of boundless energy and strength ("Human strength and endurance know no limits," he asserts), Marcueil has secretly developed the machinelike potential of his body in response to an inherited deformity of some kind.[113] When the evening concludes, Marcueil demonstrates his strength to his friend Bathybius by demolishing a machine, a "dynamometer" he interprets as female.[114] His first public proof of his powers is known only to one other, Ellen. During a five-day, round-trip race between Paris and Siberia arranged by Elsen and Gough, Marcueil appears as a mysterious, phantom cyclist able to defeat both a locomotive designed by Gough (on which Ellen, her father, and Gough are traveling) and a five-man tandem bicycle team nourished by Elsen's "Perpetual-Motion-Food."[115]

Human-machine analogies pervade *Le Surmâle*. When Ellen drives to Lurance to see Marcueil the morning after his soirée, her car is described in organic terms: "The metallic beast, like a huge beetle, fluttered its wing-sheaths, scratched the ground, trembled, agitated its feelers, and departed."[116] To support his point about boundless sexual performance, Marcueil had cited the "Indian so celebrated by Theophrastus, Pliny and Athenaeus" who "with the aid of a certain herb did it seventy times and more in one day."[117] When Marcueil arranges a demonstration of sexual endurance lasting twenty-four hours (to be observed and chronicled by Dr.

Bathybius), he disguises himself as an American Indian, thereby juxtaposing primitive, sensual appetites (including ravenous banqueting) with a basically mechanical, machinelike approach to lovemaking. Although Marcueil has engaged seven courtesans to serve as partners, the virgin Ellen, also in disguise, locks up the women and takes their place. Accompanied toward the end by a mesmerizing song playing on a phonograph, the couple manages to achieve the record-breaking number of eighty-two, at which point Ellen seems to die, fulfilling the song's theme of love and death. For a moment, Marcueil feels love for Ellen, but when he discovers that she has only fainted, his tenderness vanishes.

The final chapter of *Le Surmâle* is devoted to the "machine-to-inspire-love," designed by Arthur Gough to help Ellen and her enraged father, who concludes of Marcueil, "He's not a man, he's a machine."[118] "Since this man had become a machine," Jarry adds, "the equilibrium of the world required that another mechanism should manufacture—a soul."[119] In two hours Gough constructs just such a machine: a "magneto-electric apparatus" that is "based on an experiment of Faraday's." Jarry continues his explanation:

Another known fact on which the device was based is that in America criminals are generally electrocuted by a current of twenty-two hundred volts. Death is instantaneous, the body fries, and the convulsive paroxysms are frightful to the point of making it seem as though the device that has killed it is setting upon the corpse in an effort to revive it. Now if a person be subjected to a current more than four times as strong—let's say ten thousand volts—*nothing happens*.

To elucidate what follows, let us note that the water running through the Lurance moat provided power for an eleven-thousand-volt dynamo.[120]

Although the presence of a phonograph, along with dynamos and other electrical equipment, has led some scholars to compare the events at Lurance to Edison's laboratory in Villiers's *L'Eve future*,[121] it is Edison's adversary, Tesla, who lies behind Jarry's argument for the safety of (high-frequency) high-voltage alternating current. Indeed, Jarry began studying at the Lycée Henri IV in Paris in 1891 and would have experienced firsthand the interest and enthusiasm that Tesla's 1892 lecture generated there. Even though the machine-to-inspire-love ultimately malfunctions in a deadly fashion because of Marcueil's incredible powers, the arrangement Jarry describes, that of connecting man and machine at high frequencies and voltages, evokes Tesla's widely publicized performances of human electrification.[122] Thus,

Jarry's *roman moderne*, or modern novel, as he subtitled *Le Surmâle*, not only responds to Villiers's *L'Eve future* but also updates electrical technology according to developments of the 1890s.

To connect Marcueil to the machine, Gough and his colleagues strap the nude, sleeping man spread-eagle in an armchair and place a "crenellated platinum crown with its teeth pointing downward" on his head, like a crucified Christ.[123] Wearing this crown of two "metal semicircles . . . insulated from each other by a thick sheet of glass," Marcueil becomes a kind of human condenser storing electricity (fig. 89): he is an analogue to "the overcharged Leyden jar" to which Strindberg had compared himself.[124] As Jarry explains, "Everyone knows that when two electrodynamic machines are coupled together, the one with the higher output *charges* the other." Yet, "within this antiphysical circuit connecting the nervous system of the Supermale to the eleven thousand volts, transformed perhaps into something that was no longer electricity," an unanticipated event occurs: the direction of charge reverses, and the dynamo begins to spin backwards. "It was THE MACHINE THAT FELL IN LOVE WITH THE MAN."

At this, the ever-practical Gough quickly links the dynamo to a group of *accumulateurs* (storage batteries) in order to store this unexpected flow of energy from the Supermale. The results are disastrous, however, for Marcueil's "nervous tension" has either reached "too fabulous a potential," immediately overcharging the accumulators, or weakened so much as he begins to awake that the direction of flow is again reversed, turning his "platinum crown first red and then white-hot." Marcueil breaks free of his chair but dies an anguished death, "drops of molten glass" flowing down his cheeks "like tears" and exploding on the floor. Although prior to this event an astonished Dr. Bathybius had declared Marcueil to be "stronger than a machine" and "the first of a new race," the Supermale is ultimately conquered by electrical machines, whose levels of energy and power are beyond even his capacities.[125]

Beyond the widespread human-machine analogies in *Le Surmâle*, Jarry's use of high-voltage electricity, glass insulators, and electrical condensers in a sexual context makes his text an important forerunner of Duchamp's *Large Glass*, as we shall see. Jarry's writings offered examples of the way science and technology could be manipulated to create a modern expression, a technique that depended not only on his knowledge of these fields but also on his inventive use of language. Jarry was particularly interested in ambiguity and the possibility of multiple, contradictory meanings for a word, just as

Duchamp would explore visual and verbal punning in the *Large Glass*, delighting in its multiple layers of meaning.[126] Raymond Roussel, another of Duchamp's favorite authors, was even more deeply involved in linguistic manipulation, and scholars of Roussel have focused almost solely on this aspect of his work. Yet, in the following statement by the Jarry scholar Linda Klieger Stillman, one could just as well substitute Duchamp's or Roussel's name: "Any analysis of *Faustroll* [read also the *Large Glass* or *Impressions d'Afrique*] that avoids consideration of Jarry's [Duchamp's, Roussel's] art as a product of social reality and scientific research of the era is necessarily reductive. It is impossible to bracket the extra-textual systems in which his world evolved."[127]

Raymond Roussel (1877–1933): Scientific Machines in *Impressions d'Afrique*

After Duchamp's mention of Roussel in his 1946 interview with James Johnson Sweeney, Roussel's name came up frequently in published conversations.[128] There are, in fact, many more statements by Duchamp about Roussel's importance for the *Large Glass* than about Jarry's, his comments to Sweeney and Cabanne being the most complete. In the context of his advocacy of art as an "intellectual expression," Duchamp called Jean-Pierre Brisset (known for his "philological analysis of language" and his puns) and Roussel "the two men in those years whom I admired for their delirium of imagination."[129] Of Roussel, Duchamp explained:

The reason I admired him was because he produced something that I had never seen. That is the only thing that brings admiration from my innermost being—something completely independent—nothing to do with the great names or influences. Apollinaire first showed Roussel's work to me. It was poetry. Roussel thought he was a philologist, a philosopher and a metaphysician. But he remains a great poet.

It was fundamentally Roussel who was responsible for my glass, *La Mariée mise à nu par ses célibataires, même*. From his *Impressions d'Afrique* I got the general approach. This play of his which I saw with Apollinaire helped me greatly on one side of my expression. I saw at once I could use Roussel as an influence. I felt that as a painter it was much better to be influenced by a writer than by another painter. And Roussel showed me the way.[130]

Because of Duchamp's emphasis on Roussel as a great poet in prose, most scholars have treated Duchamp's debt to Roussel solely in terms of the writer's remarkable lan-

guage play.[131] Yet, it was the events in the performance of *Impressions d'Afrique*, not its language, that initially impressed Duchamp. His interchange with Cabanne on the subject makes this clear:

Duchamp: It was tremendous. On the stage there was a model and a snake that moved slightly—it was absolutely the madness of the unexpected. I don't remember much of the text. One didn't really listen. It was striking. . . .

Cabanne: Was it the spectacle more than the language that struck you?

Duchamp: In effect, yes. Afterward, I read the text and could associate the two.[132]

The "madness of the unexpected" on the stage at the Théâtre Antoine was created by the succession of strange events and fantastic constructions or "machines" that follow one another in *Impressions d'Afrique* (fig. 65). Along with Jarry's *Le Surmâle*, Michel Carrouges has treated Roussel's inventions in *Impressions d'Afrique* and his 1914 *Locus Solus* as examples of "machines célibataires" or "fantastic images which transform love into a mechanics of death," an interpretation that may apply to certain of Roussel's constructions that possess sexual overtones.[133] Many of Roussel's most imaginative machines, however, are independent of any sexual associations and would have appealed to Duchamp as products of his brilliant inventiveness and the ironic commentary on technology that Duchamp noted in another statement on Roussel.[134] Far more impossible and humorous than the machines of Jarry, Roussel's creations must have been a delightful surprise at a time when Duchamp's interests were turning increasingly away from painting toward mechanical techniques and subjects. Moreover, Roussel's inventions, like those of Duchamp and Jarry, often responded to specific issues in contemporary science. Presented in a completely madcap context, Roussel's "scientific" machines would indeed have provided Duchamp with "something that [he] had never seen."

In contrast to Jarry, who was often penniless, Roussel lived much of his life in wealth and ease, dressed elegantly, and traveled throughout the world.[135] Trained in music, he grew up in a Paris household visited by opera singers and musicians, a background reflected in certain of the musical preoccupations of *Impressions d'Afrique*. Yet as a writer Roussel never achieved the recognition or acclaim he believed he deserved, and he felt this rejection deeply.[136] Unlike Jarry, Roussel was never involved with the contemporary literary or artistic avant-gardes, although he later developed a following among the Surrealists in the 1920s, an admiration he did not reciprocate.[137] Had Jarry

lived to see Roussel's *Impressions d'Afrique*, however, he would surely have identified with Roussel's philosophy of artistic creation, as described by Pierre Janet, who later treated Roussel: "[Roussel] has an interesting concept of literary beauty. The work must contain nothing real, no observations on the world or the mind, nothing but completely imaginary combinations: these are already the ideas of an extra-human world."[138]

Before his suicide in 1933, Roussel wrote a book for posthumous publication, *Comment j'ai écrit certains de mes livres*, which appeared in 1935. According to Roussel, writing his books, such as *Impressions d'Afrique*, *Locus Solus*, and others, "involved a very special method," which "it seems to me . . . is my duty to reveal . . . since I have the feeling that future writers may be able to exploit it fruitfully."[139] As Roussel explains in this text, most frequently he chose "two almost identical words" to which he "added similar words capable of two different meanings, thus obtaining two almost identical [sounding] phrases" with quite different meanings; he would then try to write a story beginning with one phrase and ending with the other. The theme for *Impressions d'Afrique*, he asserts, derived from the following two phrases: "1. Les lettres du blanc sur les bandes du vieux billard . . . [The white letters on the cushions of the old billiard table . . .] and 2. Les lettres du blanc sur les bandes du vieux pillard . . . [The white man's letters on the hordes of the old plunderer . . .]."[140]

Roussel provides several pages of examples of other pairings of such homophones or near homophones, whose evolution from a familiar phrase to an alternative, fantastic equivalent generated a number of the individual elements in *Impressions d'Afrique*. For example, "*fraise* [strawberry] *à nature* [raw]" becomes "*fraise* [ruff] *à nature* [the journal *La Nature*]," which gave Roussel the idea for the character Seil Kor's clownlike neck ruff made from the blue pages of the science journal *La Nature*. Similarly, "*aiguillettes* [slices] *à canard* [duck]" becomes "*aiguillettes* [shoulder braid of a uniform] *à canards* [false notes in music]," whence Louise Montalescot's musical shoulder braid.[141] Duchamp clearly detected Roussel's punning when he read *Impressions d'Afrique*, although he would have had no idea of the extent of Roussel's linguistic games until after the publication of *Comment j'ai écrit certains de mes livres*.[142] Nonetheless, as we shall see, Duchamp was to engage in a similar kind of wordplay in parts of the *Large Glass*, generating, like Roussel, "imaginary combinations" of machines and scientific events suggested, in part, by linguistic invention.[143] At the heart of the Bachelor Apparatus, for example, is the homophonic pair *buttoir* [plow] and *butoir* [buffer], which Duchamp interchanges verbally and visually.[144]

Like Duchamp, and Picabia after him, Roussel loved to explore dictionaries;[145] in fact, many writers have treated him as if he invented the worlds of *Impressions d'Afrique* and *Locus Solus* while hermetically sealed away from contemporary life, armed only with his dictionaries and the novels of his great hero, Jules Verne, whom he termed "that man of incommensurable genius."[146] Yet Michel Leiris, who knew the mysterious Roussel personally, noted as early as 1935 his enthusiasm for the books of Camille Flammarion.[147] Recently, scholars have begun to examine Roussel's works in the context of Flammarion's scientific philosophy and to argue that Roussel was not as naive as he has often been portrayed.[148] Roussel was certainly not as deeply involved in contemporary science as Jarry, who read Lord Kelvin's lectures and created alternative systems of physics. Nevertheless, Roussel's interest in Flammarion indicates that he would have known such books as the 1900 *L'Inconnu et les problèmes psychiques*, which contained Crookes's table of vibrations and discussions of X-rays and telepathy.[149] Moreover, Roussel's constructions in *Impressions d'Afrique* and *Locus Solus* demonstrate his awareness of current scientific issues such as radioactivity and electromagnetism, as well as the occult phenomena to which such scientists such as Flammarion and Crookes linked these developments. If not the *Revue Scientifique*, one can easily imagine Roussel poring over *La Nature*, the source of Seil-Kor's ruffled collar, in the same way he studied his beloved dictionaries.[150] For Roussel, as for Duchamp, the realms of science and technology vastly increased the verbal and visual vocabulary with which each could create.

Impressions d'Afrique was published in book form in 1910 and was performed as a play, with a script by Roussel, in 1911 and, in revised form, in 1912, the year Duchamp, Apollinaire, and Picabia attended.[151] The poster (fig. 65) gives a sense of the strange, collagelike nature of Roussel's novel and play: *Impressions d'Afrique* is a collection of seemingly unrelated events and performances in the central plaza of the capital of the African kingdom ruled by the emperor Talou VII. The reader learns only in the second half of the narrative that the non-African characters are a group of shipwrecked Europeans who are performing at their "Theater of the Incomparables" in order to gain their freedom, as are two additional characters, the chemist Louise Montalescot and her brother. This background and histories of the individual characters and their specific interactions with Talou and company were presented earlier in the play than in the book, giving the seemingly totally random events some relationship to one another.[152]

Recently discovered archival material now makes it possible to reconstruct which episodes were actually included in the play.[153] Some of the most fantastic ones, such as Fuxier's magic pastilles creating scenes in the river's water or Luxo's fireworks exploding in the form of various images of an Argentinian Baron, were virtually impossible to stage.[154] Because Duchamp subsequently read Roussel's book, however, he would have been familiar with all the inventions, whether in the play or not.

Impressions d'Afrique should be read by anyone interested in Duchamp, because it is so rich in material relevant to his ideas and works from late 1912 on. Carrouges cited three examples of "bachelor machines" in *Impressions d'Afrique*: Louise Montalescot (the metallic breathing tubes in her shoulder making her a human-machine) and her mechanical creations such as the whalebone statue of the Helot rolling on a carriage on gelatinous rails (fig. 65); the lightning-rod bed on which Djizmé is executed (fig. 65); and Fogar's "photographic plant."[155] More specific comparisons between Roussel's tale and Duchamp's works have focused most often on Louise as a Bride-like figure, her creation of a painting machine, and the back-and-forth motion of the Helot's carriage on its rails as a prototype of Duchamp's Chariot or Glider in the lower section of the *Large Glass*.[156] Noting Roussel's machines that paint, weave, or make music, Rosalind Krauss has remarked briefly on the general theme of the mechanization of artistic creation in Roussel's tale.[157] And John Golding has noted the prevalence of cross-dressing in *Impressions* as a foreshadowing of Duchamp's later female persona, Rrose Sélavy: clouding gender definitions, Talou VII insists on being coronated in the gown of one of the shipwrecked performers.[158]

Yet there is much more about Louise Montalescot, an avid chemist with wide scientific interests, that would have interested Duchamp. Likewise, there are other examples of human-machine hybrids in *Impressions d'Afrique* and, in addition to Louise's painting machine, a number of other commentaries on artistic virtuosity, including the role of chance in artistic creation. Beyond chemistry, additional scientific themes include electricity, electromagnetism, and vibrations—both electromagnetic waves, such as visible light, and other types of vibrations, particularly musical sounds. "Molecular alterations," "atomic transformations," and newly discovered elements with miraculous properties (all suggesting contemporary developments in atom theory and radioactivity) also figure in Roussel's tale.[159] Finally, hypnosis and Magnetism are present, as they are in Jarry's works and Villiers's *L'Eve future*.

Not only would the science-related activities of many of the characters have interested Duchamp, but their per-

formances take place in the context of a competition for best performance, which is accompanied by the selling of stock shares based on each individual's likelihood of winning the supreme prize. Duchamp later engaged in a similar activity when in 1924 he issued thirty shares of his *Monte Carlo Bond* (Museum of Modern Art, New York), based on the projected performance of a system he had devised for "break[ing] the bank in Monte Carlo."[160] Thus, the shipwrecked passengers build a miniature Bourse, or stock exchange, where shares of stock are traded daily, the orders placed in alexandrines and the prices fluctuating according to the health of a singer's throat or rumored problems with a performer's equipment.[161]

One of the machines most clearly derived from contemporary science is the chemist Bex's "thermo-mechanical orchestra," which functions by means of the thermal sensitivity of *bexium*, a new metal discovered by Bex (fig. 65).[162] Using a rolling platform that resembles the baggage *chariots* of a railway station and has newly nickel-plated wheel spokes, Bex wheels out a large glass cage enclosing his complex musical construction, including horns, strings, keyboards, and percussion, as well as two cylinders. Out of the top of the cage rises "the fragile tube of an excessively tall thermometer," suggesting Duchamp's 1921 "Assisted Readymade" *Why Not Sneeze Rose Sélavy?* (Philadelphia Museum of Art), which features a thermometer extending out of a bird cage (see fig. 72, to the right of the *Bottle Rack*).[163] The machine is powered by a concealed electric motor, and electricity also controls the two cylinders that produce the temperature changes to which the bexium responds: "The cylinders . . . served two opposite purposes—the red one containing a generator which produced constant heat, while the white one incessantly manufactured an intense cold, capable of liquifying any kind of gas" (a process that would be central to the lower half of Duchamp's *Glass*).[164] The miraculous qualities of bexium, as well as the special balm Bex develops using his "learned triturations," in order to handle the metal, strongly suggests that Roussel's bexium was a takeoff on radium.[165]

As the bexium reacts to temperature changes, various instruments are brought into play, resulting in vibrations in the transparent walls of the cage that produce the sounds of the "orchestra." Roussel's musical training is apparent as he describes in detail the performances of each instrument, which, significantly, are of virtuoso quality, even though no human hands touch these instruments (e.g., the keyboard's keys "moved of their own accord").[166] Virtuosity without the hand of a musician is a recurring theme in *Impressions d'Afrique*, as a variety of musical "machines" replace human performers—just as Louise's

painting machine subsequently replaces the hand of the artist. Beyond Bex's "thermomechanical orchestra" Roussel's other important musical construction is the Hungarian Skariofsky's zither, which is played by a large worm trained to allow drops of a special heavy water to fall on the strings from its mica trough above (fig. 65).[167] Because of the worm's "mysterious passion for the vibration of sound-waves in the air," Skariofsky is able to teach it a variety of tunes—waltzes, czardas, operetta selections, rhapsodies—until, finally, "a frenzied *presto* crowned the reptile's enthusiastic delirium and for several minutes it abandoned itself unreservedly to wild gymnastics."[168]

Roussel provides an even more direct commentary on traditional notions of artistic creation in the episode purportedly from the life of Handel, which was one of the *tableaux vivants* to be staged on Emperor Talou's coronation day.[169] Here Duchamp would have found an example of the use of chance in musical composition, an exercise he would carry out in one of the two versions of his *Musical Erratum* of 1913 (see chap. 5). As an old man, already blind for four years, Handel had responded to the assertion by one of his guests that "an ordinary theme treated by the most inspired mind must inevitably remain heavy and clumsy" by claiming that he could write "a whole oratorio worthy to be included in the list of his works, on a theme that had been mechanically constructed by accidental procedure."[170] Handel then proceeded to establish the theme of the oratorio by choosing among seven holly sprigs, each of which had been assigned a note, as he descended a staircase. At each step, the blind man chose a sprig from the bunch, thereby determining the sequence of notes in the theme, the length of which was determined by the twenty-three steps of the balustrade; as Roussel says, the phrase "had been worked out with no direction but that of chance."[171]

Chance was a theme that would increasingly interest Duchamp, and it appears as well in another of Roussel's comments on the notion of skill and expertise. This is the fencing machine of La Billaudière-Maisonnial, a machine resembling a knife grinder, which has an "articulated arm" attached to it.[172] During a fencing match with a human, the Frenchman is able to adjust a rod in his machine, making it possible to "produc[e] an infinite number of accidental results." La Billaudière-Maisonnial's fencing machine represents one of Roussel's human-machine hybrids; another is Louise Montalescot, whose surgically implanted metal lung tubes are aptly described by Bergson's phrase "something mechanical encrusted on the living."[173] Nearly everything about Louise would have intrigued Duchamp. As the scientist sister of an artist, Louise is the intellectual who conceives the plans for the

moving sculptures that must be created to satisfy Emperor Talou and gain their freedom.[174] Her artist brother, who possesses a "very real talent" but "lack[s] intelligence," simply carries out her plans for the figures, such as the whalebone Helot (fig. 65), whose back-and-forth motion is controlled by the actions of a magpie.[175] As the scientific intellect behind an artist as well as the engineer of a painting machine, Louise's character represents a challenge to the primacy of the artist's touch. As such, she extends Roussel's discussions of musical virtuosity and chance to the realm of art, highlighting issues that were central to Duchamp's thinking in this period and would ultimately lead to the creation of his first Readymades in 1913–14 (figs. 68, 69).

In addition to being an advocate of free love, Louise is trained in "all branches of science and letters," though she has a "fanatical devotion to chemistry."[176] Like Roussel's characters Bex and Fuxier, Louise also performs the "triturations" Duchamp would mention in his notes for the *Large Glass*.[177] Her chemical experiments in the past had led to a lung tumor and require the implantation of an "artificial escape" for her air in the form of "sounding tubes," which she disguises in the shoulder braid of the military uniform she adopts as her attire.[178] Louise is a kind of human harmonica, whose emotional state is registered as her "musical respiration quicken[s], increasing the frequency and power of the monotonous chords continually emitted by the tags of her shoulder-knot."[179] Determined to create a painting machine, in which "by photographic means, a motor force sufficiently precise to guide a pencil or brush with certainty" would be generated, Louise travels to Africa in search of an obscure plant whose oil is needed for the machine.[180] After Talou's capture of Louise and her brother, the successful creation of the painting machine becomes imperative as another means of gaining their freedom. Roussel's description of Louise's painting machine provides further evidence of his awareness of electromagnetism and contemporary interest in the transmission of visual images.

Louise's machine stands on a three-legged support (as Duchamp's "Juggler/Handler of Gravity" would do [fig. 112]), and consists of a photosensitive brown plate "endowed by Louise with strange, photo-mechanical properties":[181]

The brown plate alone set the whole process in motion, by means of a system based on the principle of electro-magnetisation. In spite of the absence of any lens, the polished surface, owing to its extreme sensitivity, received enormously powerful light-impressions, which it transmitted by means of the countless wires inserted in the back to activate the whole mechanism contained within the sphere, whose circumference must have measured more than a yard.[182]

From the sphere projected a hinged arm holding ten brushes radiating in a circle; when the sensitive plate was exposed to a landscape view, these brushes produced an "automatic reproduction."[183] Roussel's use of a photosensitive plate at the heart of the painting machine surely derives from contemporary concern with the recording of electromagnetic waves—whether visible or invisible light—on sensitive plates. Moreover, as an extension of telegraphy and telephony (with wires), a number of inventors were exploring the possibility of transmitting images—whether photographs, drawings, or handwriting—to be reproduced by a receiving "crayon" or registered "telephotographically." Of particular interest for Roussel's system are articles such as that on "La Vision à distance," published in *L'Illustration* in December 1909, which illustrates a transmitting plate whose back is covered by wires, in the manner of Louise's construction.[184]

Beyond Louise's painting machine, the theme of recording images on light-sensitive surfaces and projecting them is a recurring one in *Impressions d'Afrique*, and Roussel was clearly interested in early filmmaking.[185] However, in the case of the "photographic plants" of Fogar, the emperor's son, Roussel invents an organic, light-sensitive plant that records images by means of "molecular actions" and on which those images can then be "replayed" without film or projectors.[186] Roussel describes the process of changing from one scene to another: "The atoms [of the plant] all vibrated at once, as if endeavoring to rearrange themselves according to some other inevitable grouping."[187] Having found the mysterious plants at the bottom of a river, Fogar performs along with the shipwrecked travelers; he even demonstrates the self-induced "artificial catalepsy" he has learned from the witch doctor, which allowed him to do his underwater exploring.[188] Fogar lies on a bed, a photographic plant suspended above like a canopy, and projects images he has "filmed" from an illustrated volume of oriental tales and an album of animal prints. To this organic arrangement are added various electric lights by which "the changing views could be made alternately dazzling or obscure at the obedient caprice of a current turned on or off."[189]

Electricity, which appears throughout Roussel's novel, as it does in the works of Verne, plays its most dramatic role in the execution of Djizmé.[190] On the gala day of his coronation, Talou has also arranged to have one of his subjects, the African woman Djizmé, killed on the central plaza, in the sight of her lover, Naïr.[191] Talou has asked

the Europeans to suggest some penalty "in use in [their] own land"; the architect Chènevillot offers "a lightning conductor of the latest model" that he has with him, hoping that the rarity of stormy weather in the region will delay the young woman's being "electrocuted by the clouds."[192] Unfortunately, a storm does occur the day of the coronation, and Djizmé is electrocuted on the "lightning-rod bed" (fig. 65), a high-voltage machine to punish illicit love that recalls the fate of Jarry's *Surmâle* in the "machine-to-inspire-love."

Both electrocution by high voltages (and its association with alternating current and Tesla) and lightning conductors had been widely discussed in science periodicals in the 1890s and into the early years of the new century, again suggesting that Roussel was responding to contemporary issues.[193] Djizmé's association with high-voltage electricity by means of lightning suggests a subsequent link to Duchamp's Bride as well. Indeed, the ill-fated Djizmé and Naïr may well be one set of prototypes for the Bride and Bachelor(s) of the *Large Glass*: Naïr, who is "anchored" on a platform in the plaza, is condemned to spend his days weaving fabric for mosquito traps, and his back-and-forth motions are accompanied by "phrases he recited to himself . . . to regulate his precise delicate movements," which call to mind Duchamp's "litanies of the chariot."[194]

Electricity, electromagnetism, and Magnetism all figure in *Impressions d'Afrique*. Bex's second performance had been a remarkable demonstration of the magnetic attraction of various metals (including Duchamp favorites, platinum and nickel) for giant pencil-like projectiles. The leads of these pencils were made from another of Bex's creations, *magnetine*, whose force could be counteracted only by the intervention of his other discovery, *impervium*.[195] Breton later referred to Roussel as "the greatest magnetiser of modern times," a statement that overestimates Roussel's involvement with the practice of Magnetism and hypnotism, much like the Surrealists' attempt to transform Duchamp into a practicing alchemist in the 1950s.[196] Nonetheless, Roussel was certainly acquainted with the practice of Magnetism, which had attracted new interest in this period at the hands of Albert de Rochas and others, who emphasized its links to electromagnetism. Thus, beyond Fogar's self-induced "artificial catalepsy," the hypnotist Darriand heals his patient Seil Kor through hypnosis induced by "rare and valuable plants" that possess "magnetic qualities of extraordinary power." According to Roussel, "A subject placed beneath the scented roof would feel disturbing emanations penetrate his being, immediately plunging him into a true hypnotic trance."[197] Combining the organic and the mechanical, as he so often does, Roussel then has Dar-

riand heal Seil Kor using "a system of electric projections" that show Seil Kor a series of events from his life, which Darriand has arranged to have painted on transparent strips of film.[198]

Roussel's interest in occult themes and their electrical associations continued in his 1914 book *Locus Solus*, the name of an estate belonging to Martial Canterel, a bachelor who has been able to "devote his entire life to science."[199] Canterel's fantastic inventions are displayed on the grounds of his estate and include a large, diamond-like aquarium containing a special oxygenated liquid he terms *aqua-micans*. Here the fleshless head of the historic figure Danton, which Canterel had acquired, is made to orate by means of electrical charges administered by a swimming, hairless cat.[200] The aquarium is also the setting for the aquatic performance of the dancer Faustine, whose hair is electrified by the water and rendered musical by vibrations in its special individual sheaths.[201] The dominant feature of Canterel's estate is a 150-foot-long glass cage that is divided into eight stage sets. On these stages deceased individuals, resurrected by Canterel's discovery of *resurrectine* and *vitalium*, reenact crucial events of their lives. As recent scholarship has noted, in his theme of reanimating the dead, Roussel seems to have drawn upon Flammarion's idea that "the body is only a current—incessantly renewed, directed, governed, and organized by the immaterial force that animates it."[202]

Electricity, electromagnetism, and Magnetism pervade *Locus Solus* as they do *Impressions d'Afrique*, also playing a role in Canterel's remarkable *demoiselle*, or "paving beetle," which Carrouges has cited as another example of a *machine célibataire*.[203] This contraption, suspended in the air and controlled by wind currents, constructs a complex, figurative mosaic from piles of old teeth that Canterel had extracted from his patients, using his specially developed magnetic metals. Magnets are also central to the operation of the machine, whose performance can be predetermined by Canterel's highly developed weather forecasting capabilities: "A mass of fantastically sensitive and accurate instruments enabled him to determine the direction and force of every breath of wind at a given spot ten days in advance."[204] Similar weather instruments and wind currents would play a role in Duchamp's own *demoiselle*, the Bride. More important, Canterel's demonstration that his mechanical paving beetle could create "a work of aesthetic merit solely due to the combined efforts of the sun and wind" reinforced Roussel's challenge to virtuoso artistic creation set forth in *Impressions d'Afrique*.[205]

Roussel was obviously well aware of trends in contemporary science, technology, and occultism, which served as sources for his fantastic imagination.[206] Yet, as

Duchamp noted later, Roussel's attitude toward machines was "not at all admiring, but ironic," and that same irony is present in his approach to much of science as well.[207] Although previous scholarship has often treated Roussel as a naive believer in science and technology in contrast to Jarry, Duchamp correctly perceived the irony present in Roussel's works.[208] As Anne-Marie Amiot has argued, Roussel's machines are so humorous because of the disparity between "the amount of ingenuity expended [and] and the meagreness of the results obtained" as well as the fact that "the machines reveal nothing" and are "useful" only in a very unusual way.[209] Rather than create an alternative to bourgeois science in a complex Pataphysics based on recent British physics, as Jarry had done, Roussel parodied the scientific language known to the average Frenchman and used scientific methods for absurd, comical ends. In his pursuit of "completely imaginary combinations," however, Roussel did profit from aspects of recent science, which seemed tailor-made for science fiction writers: for example, radioactivity, new notions of the atom, electromagnetic waves, and even the possibility of transmitting visual images, as exemplified by Louise Montalescot's painting machine.[210]

Roussel, like Jarry, demonstrated for Duchamp the humorous possibilities of science and technology, as well as the fertile realm of human-machine hybrids and analogies. Far more than Jarry, Roussel functioned as an inventor of fantastic machines of the kind Duchamp was subsequently to design in the *Large Glass*. Also critical for Duchamp at this moment was Roussel's interest in mechanical replacements for the hand of the virtuoso musician or artist as well as the role of chance in the creative process. Carrouges has compared *Impressions d'Afrique* to the amusements of Luna Park, and *Locus Solus* to an "Exposition des Arts et Métiers."[211] The Arts et Métiers association is appropriate, for the Musée des Arts et Métiers, mentioned by Apollinaire in his *Peintres Cubistes* essay on Duchamp, written in fall 1912, was to be an important resource for the artist as he developed the *Large Glass* project and produced his first Readymades.[212] Inspired by Jarry's and Roussel's use of a science made more accessible by figures like Crookes and Tesla, Duchamp, now a librarian at the Bibliothèque Sainte-Geneviève, began to read extensively. The Musée des Arts et Métiers would have provided tangible illustrations to accompany his study.

Chapter 5

From Painter to Engineer, II

A Rousselian Dialogue with the Equipment of Science and Technology Begins, 1913–1914

Duchamp, Apollinaire, and Picabia left Paris for Jura about October 20, ten days after the opening of the Salon de "La Section d'Or," the major independent exhibition of the Puteaux Cubists and a culmination of the group's activities. On September 2, 1912, *Gil Blas* had announced that Marcel Duchamp would submit a painting entitled *Section d'Or*. The works shown, however, were *Portrait of Chess Players* (fig. 15), *Nude Descending a Staircase (No. 2)* (fig. 12), *The King and Queen Surrounded by Swift Nudes* (pl. 2, fig. 21), Duchamp's watercolor and gouache study for the *Swift Nudes* painting (fig. 24), as well as two works listed simply as *Peinture* and *Aquarelle*.[1] This was the first public showing of the *Nude Descending a Staircase (No. 2)*, which Duchamp had withdrawn from the spring 1912 Salon des Indépendants at the request of Gleizes and other senior Cubists seemingly troubled by its inclusion of motion in the wake of the February 1912 Futurist exhibition in Paris. Later Duchamp told several interviewers that this event convinced him he "would not be very interested in groups after that."[2] Yet, perhaps to assuage the insult of the spring, Duchamp's name was included on the invitation to the opening, along with those of Gleizes, Picabia, Pierre Dumont, and Henri Valensi.[3]

At the fall 1912 Salon d'Automne, held in the Grand Palais from October 1 to November 8, Duchamp exhibited only the drawing *Virgin (No. 1)* (fig. 35). This work was his sole contribution to the collaborative Puteaux Cubist project for the salon, the Maison Cubiste, a decorative arts ensemble organized by André Mare, a friend of the Duchamp family. Duchamp's brothers, along with others of the Puteaux group, were actively involved in this endeavor, which consisted of a mock-up of two rooms behind a facade designed by Duchamp-Villon and was intended as a demonstration of how the French decorative arts tradition might be revived and modernized.[4]

After his liberation in Munich, however, Duchamp was to pursue a very different course from that of his brothers and their fellow Cubists, a contrast pointed up in a 1915 photograph of Duchamp with his 1914 *Chocolate Grinder (No. 2)* seated in front of a Cubist painting by Villon (fig. 74). Indeed, the October trip to the Jura Mountains had functioned as a kind of counterdemonstration, a departure from the Puteaux Cubist realm at its moment of prominence. Upon returning from Jura, Duchamp visited the other major exhibition in the Grand Palais, the Salon de la Locomotion Aerienne (fig. 40), where he declared painting to be "washed up."[5] In early November he also began his library job, which gave him the opportunity to read widely on science in general, as well as on four-dimensional and non-Euclidean geometries in particular. In his consideration of dimensionality, Duchamp was also reexamining the issue of perspective, a central concern of artists for centuries and a technique the Cubists had soundly rejected. Thus, his reading also included numerous treatises on perspective, as he reminded himself in one note: "See Catalogue of Bibliothèque St. Geneviève/ the whole section on Perspective: *Niceron*, (Father Fr., S.J.)/*Thaumaturgis opticus.*"[6]

During 1913 Duchamp made a number of preliminary drawings for the *Large Glass* in the drawing style he modeled upon mechanical drawings and other types of scientific or geometric illustrations (figs. 45, 96, 153). *Impressions d'Afrique*, particularly once Duchamp had read Roussel's text, now emerges as another impetus for the freedom from the artist's touch Duchamp was seeking. Like Roussel's characters, whose musical or painting machines denied the possibility of virtuosity, Duchamp during 1913 and 1914 actively investigated alternatives to traditional modes of painting and of drawing lines. In addition, Duchamp, following Roussel's Handel, explored the role of chance in artistic creation and even experimented with chance-generated musical compositions. Gabrielle Buffet-Picabia's later description of Duchamp's working method in this period suggests his new image as an "inventor" or engineer denigrating the hand of the artist:[7] "Duchamp . . . by a discipline that was almost Jansenist and mystical, suppressed every impulse, every desire to create, suppressed all joy in creating, and to avert the danger of routine reminiscence or reflex, forced himself to a rule of conduct directly counter to the natural."[8]

"Painting of Precision": *Chocolate Grinder (No. 1)* and *Chocolate Grinder (No. 2)*

In several of his notes for the *Large Glass* Duchamp used the phrase "painting of precision and beauty of indifference," which encapsulates the two interrelated directions of his artistic production during 1913–14.[9] The painting of precision represented an extension of Duchamp's development of a "dry" drawing style, which he now applied to painting as he continued to create the characters for the *Large Glass*. As will be seen, Duchamp's concept of the beauty of indifference is embodied in his investigations of chance and indifferent alternatives to beauty and taste—from his *Musical Erratum* experiments through the *3 Standard Stoppages* to the chosen objects he termed Readymades. In both cases, Duchamp was pursuing the goal he expressed to Walter Pach in 1914: "I want something where the eye and the hand count for nothing."[10]

Chocolate Grinder (No. 1) (fig. 66) of February–March 1913,[11] Duchamp's only painting on canvas during 1913, and *Chocolate Grinder (No. 2)* (pl. 5, fig. 91) of early 1914 were his initial attempts to achieve precision in his painting style. Having evolved the basic form of the Bride for the upper half of the *Large Glass* in his 1912 *Bride* (pl. 3, fig. 17), Duchamp focused his exploration of style during 1913 and early 1914 on the Bachelor Apparatus, a central component of which was to be the Chocolate Grinder. Indeed, *Chocolate Grinder (No. 1)* forms a striking contrast to his previous paintings and emphasizes how completely he was reconsidering the métier of painting. In accordance with his readings on perspective at the Bibliothèque Sainte-Geneviève, Duchamp depicted his subject from a bird's-eye perspective and lit it dramatically, so that it casts the shadows whose depiction was also taught in treatises on perspective. Beyond his adoption of a mechanical draftsmanlike technique in his drawings of 1913–14, Duchamp here was seeking a dry form of painting to contrast with French modernist facture and Cubism itself. As voiced by Apollinaire, Cubism had rejected "that miserable tricky perspective...that fourth dimension in reverse...that infallible means for making things shrink," just as it had rejected visible light in favor of invisible X-rays.[12] In *Chocolate Grinder (No. 1)*, Duchamp purposefully subjected himself to the constraints of perspective and a precise application of paint in order to avoid the virtuosity encouraged by Cubism's freedom from visual models. Purified of any irregularities, even the ridges of its grinding wheels, the *Chocolate Grinder (No. 1)* exists in an airless, ideal realm.

A lost drawing of the Bachelor Apparatus from early 1913 (see upper left corner of fig. 140) documents

Duchamp's decision to set the lower half of the *Large Glass* in a one-point perspective construction, well before his initial layout of the full composition sometime later in 1913 (fig. 75).[13] Thus, when he created his second version of the grinder, *Chocolate Grinder (No. 2)* in February 1914, Duchamp used the same bird's-eye-perspective scheme for the grinder. However, seeking a painting mode closer to the style of mechanical drawing, he eliminated the dramatic light and shade of his first version and removed the decorative edge from the plate on which the rollers rest. Isolated and simplified, the *Chocolate Grinder (No. 2)* resembles an isometric perspective drawing of an object in a book on mechanical drawing. In executing the work, Duchamp also introduced two alternatives to standard painting practice, both designed to deny the artist's hand. He applied the paint to the canvas through stencils he had cut and wound thread through the canvas to produce the ridges of the grinding wheels, which he also outlined with thread.[14] As Duchamp observed later, "The general effect is like an architectural, dry rendering of the chocolate grinding machine purified of all past influences."[15]

In terms of subject matter, *Chocolate Grinder (No. 1)* and *Chocolate Grinder (No. 2)* stand as extensions of Duchamp's first exploration of human-machine hybrids in the *Virgin* drawings and the *Bride* painting and, subsequently, in the "machine-mother" of the Jura-Paris Road project. If the automobile and scientific laboratory equipment were the Bride's first inanimate counterparts, what objects lie behind Duchamp's rendering of the Chocolate Grinder in its first and second versions? Duchamp later pinpointed his first stimulus in developing the *Chocolate Grinder* paintings: "It was actually suggested by a chocolate grinding machine I saw in the window of a confectionary shop in Rouen" (fig. 94).[16] The association of mills and grinding with the erotic activities of the Bachelor, who "grinds his chocolate himself," was certainly appropriate.[17] Yet this is a very curious chocolate grinder, because although the large grinder to the right of the Gamelin shop door does appear to have three rollers, grinding mills standardly have only two (figs. 67, 42 [no. 3]). Similarly, Duchamp's *Chocolate Grinder* images include no container to keep the chocolate from spilling off the platform as it is ground.[18] Thus, in contrast to the 1911 *Coffee Mill* (fig. 41), with its emphasis on process and its inclusion of ground coffee, this machine is less a rendering of an actual chocolate grinder than a Rousselian invention based upon that chocolate grinder and other sources. One of those sources would seem to have been scientific apparatus arranged on flat circular plates, such as the wireless telegraphy wave detector discussed in

chapter 8 (fig. 93). In addition, Duchamp's notes document his association of the Chocolate Grinder with scientific or domestic objects in the style of Louis XV.

In his notes, Duchamp described the grinder as "mounted on a Louis XV nickled chassis," a specification for the Chocolate Grinder that, in part at least, may have been a playful response to the involvement of the Puteaux Cubists in the French decorative arts.[19] This element of humor is particularly apparent in Duchamp's note concerning the Milky Way of the upper half of the *Large Glass*: *"Milky way* or Louis XV clouds like the legs of the Grinder."[20] Duchamp's choice of Louis XV might have represented his alternative to André Mare's advocacy of Louis-Philippe as the appropriate model for a revival of French style or, even more pointedly, a mocking response to Gleizes and Metzinger's derogatory remarks on the Louis XV style in *Du Cubisme*.[21] In addition, Pawlowski in his *Voyage au pays de la quatrième dimension* had actually compared the style of early automobiles to Louis XV furniture (and Greek temples) in the passages preceding his discussion of the evolution of automobile-animals, noted in chapter 3.[22]

Equally important, Duchamp would have encountered utilitarian objects with such "Louis XV legs" at the Musée des Arts et Métiers, whose collection included many eighteenth-century tools and instruments with ornate legs and frames.[23] None of these, however, would have been nickel-plated, pointing up Duchamp's witty juxtaposition of a historical style and a contemporary technique used for purposes such as the reflectors in automobile headlamps. On both his canvases, Duchamp applied a leather label with the phrase "Broyeuse de chocolate" printed in gold, as if these images were objects of French culture destined for display in a museum of technology, to be exhibited along with other *moulins* and *broyeurs*.[24] As chapter 8 demonstrates, the Chocolate Grinder's three-grinder configuration and, particularly, its wound-thread construction link it to electromagnets and other scientific apparatus displayed at the Arts et Métiers, while its label associates it with displays of domestic culture on view there.

Duchamp's quest for a painting of precision would continue during 1914, as he began to experiment with glass as a support medium as well as new ways of marking on it. One of the alternatives he considered was the use of a grinding wheel or a "hydrofluoric pencil" to incise lines into the glass, although in the end he settled on lead wire to "draw" the forms of the *Large Glass*.[25] Lead wire thus replaced the thread of the *Chocolate Grinder (No. 2)*, that work having served, as he stated later, as the "first step toward depersonalizing straight lines by tension of lead wire."[26]

Before his summer 1915 departure for New York, where he would actually execute the *Large Glass*, Duchamp produced two studies on glass: the hinged panel *Glider Containing a Water Mill (in Neighboring Metals)* (fig. 151) and the *9 Malic Molds* (Marcel Duchamp Archive, Villiers-sous-Grez), dated 1914–15. In both of these works he applied lead wire and paint to the back of the sheet of glass, covering the painted areas with lead foil in the *9 Malic Molds*, as he would do in the *Large Glass*. These two panels, which demonstrated a new degree of precision, served as the technical trial runs for Duchamp's ultimate precision painting, the *Large Glass*.

"Beauty of Indifference": *Musical Erratum*, the *3 Standard Stoppages*, and the Early Readymades

Duchamp first saw the chocolate grinder in a confectioner's window in January 1913, while in Rouen on holiday.[27] During that stay he also created the first of his two musical compositions, *Erratum Musical* (Musical Erratum) (Marcel Duchamp Archive, Villiers-sous-Grez), a vocal trio to be performed by Marcel and his two youngest sisters, Yvonne and Magdeleine. A second musical experiment followed, titled *The Bride Stripped Bare by Her Bachelors, Even: Musical Erratum* (Foundation for Contemporary Performance Arts, New York).[28] Both of these works stand as direct responses to Roussel's interest in mechanical alternatives to virtuosity and the role of chance in composition. As such, they mark the beginning of Duchamp's exploration of the beauty of indifference as the counterpart to a painting of precision.

In the manner of Roussel's Handel, with his sprigs of holly, Duchamp determined the succession of notes for his first *Musical Erratum* by drawing notes from a hat.[29] For the vocal text Duchamp simply used the dictionary definition of the verb *imprimer* (to print): "To make an imprint mark with lines a figure on a surface impress a seal on wax."[30] Given the title, which means "musical printed error," Duchamp's choice of the definition of *imprimer* was an extension of this joke and a reminder, perhaps, of his own involvement in the printing trade in Rouen in 1905. This work and his second *Musical Erratum* were both written on music composition paper, paper that subsequently reappears in the drawing *To Have the Apprentice in the Sun*, included in the *Box of 1914* (fig. 79).[31] That Duchamp gave the second of his musical experiments the title he had chosen for the *Glass* itself suggests that sound frequencies or vibrations were indeed an extension of the interest in electromagnetic waves he expressed in his reference to making a "painting *of frequency*."[32]

The operation of chance was also central to Duchamp's *Bride Stripped Bare . . . Musical Erratum*, but the process for note selection was considerably more complex in this case. Rather than a vocal performance, this work was intended for a Rousselian mechanical instrument: "for precise musical instrument (mechanical piano, mechanical organs, or other new instruments for which the virtuoso intermediary is suppressed)."[33] The sequence of notes was to be determined by a "machine" equally worthy of Roussel, an "apparatus automatically recording fragmented musical periods." According to Duchamp's description and the drawing at the bottom of the sheet, from a "vase" containing eighty-nine balls one or more balls would drop into a succession of wagons passing beneath the opening at variable speeds. The emptying of the vase would determine the end of a "musical period," and the procedure could be repeated to generate other "equivalen[t] . . . periods," whose comparison to one another would allow the creation of a "new musical alphabet."

Duchamp's *Bride Stripped Bare. . . Musical Erratum* was the first of a number of experiments he outlined and performed during 1913 and after, as described in the notes for the *Large Glass*. The most prominent of these, his *3 Standard Stoppages* of 1913–14 (fig. 68), was later identified by Duchamp as his "first use of chance as a medium," although he had obviously explored the idea initially in his musical projects.[34] In the *Box of 1914* Duchamp included three notes relating to the "standard stoppages":

The Idea of the Fabrication
—If a straight horizontal thread one meter long falls from a height of one meter onto a horizontal plane distorting itself *as it pleases* and creates a new shape of the measure of length.—

—3 patterns obtained in more or less similar conditions; *considered in their relation to one another* they are an *approximate reconstitution* of the measure of length.

The *3 standard stoppages* are the meter diminished.[35]

The note headed "*The Idea of the Fabrication*," in a similar form, was later repeated in the *Green Box*, along with a note linking the project specifically to chance: "*3 Standard Stops* = canned chance—1914."[36]

To create his "meter diminished" Duchamp repeated the thread-dropping experiment three times, affixing the curved threads to three strips of canvas painted blue-black. In 1918, while at work on his final painting on canvas, *Tu m'* (fig. 173), Duchamp had wooden templates made to serve as "meter sticks" of the new measure; in 1936, at the time he was repairing the *Large Glass*, Duchamp reduced the width of the original canvases, mounted them on glass plates, and housed them in a wooden croquet box.[37] He explained that the source of the term *stoppages*, of the *3 Stoppages étalon*, was an advertisement he had seen, presumably for the invisible mending of garments signified by the term. In French this term also means a "stoppage" (as in the flow of a current); in his work the fall of the thread produced by gravity was actually stopped by the surface onto which it fell. Here Duchamp had indeed developed another way of "drawing" that removed the hand of the artist, leaving the results to chance. As Duchamp later told Cabanne, "The idea of 'chance,' which many people were thinking about at the time, struck me too. The intention consisted above all in forgetting the hand, since, fundamentally even your hand is chance. . . . Pure chance interested me as a way of going against logical reality. . . ."[38]

On an artist's questionnaire from the Museum of Modern Art, Duchamp answered the question about the "significance" of the *3 Standard Stoppages* as follows:

Part of reaction against "retinal" painting (peinture retinienne)
Broyeuse de chocolat—first step toward depersonalizing straight lines by tension of lead wire
A joke about the meter—a humorous application of Riemann's post-Euclidean geometry which was devoid of straight lines. Not first-hand but part! Cf. Max Stirner—*Le Moi et sa propriété*[39]

When this questionnaire came to light, Duchamp's remark about Riemann's post-Euclidean geometry confirmed the case I had first made in 1975 for the *3 Standard Stoppages* being Duchamp's response to the widespread interest in non-Euclidean geometry in the early twentieth century.[40] From his reading of Poincaré and others, Duchamp knew that the studies of congruence by mathematicians like Riemann had challenged Euclid's assumption that geometric figures would remain the same when moved about. As a result, a consistent geometry could be created in which figures would change shape when translated from one place to another; such a geometry is most easily visualized on surfaces of irregular curvature.[41] Like Jarry, Duchamp was well aware of the revolutionary philosophical import of non-Euclidean geometry, which overturned the belief, held for over two thousand years, that the axioms of Euclid's geometry were absolute truths. Instead, according to the widely respected view of Poincaré, geometrical axioms should be recognized as conventions, that

is, the most useful means at a given moment to describe particular circumstances.[42]

In his 1964 lecture "Apropos of Myself," Duchamp described the *3 Standard Stoppages* as "casting a pataphysical doubt on the concept of the straight line as being the shortest route from one point to another."[43] Jarry's Pataphysics had dealt humorously with systems of measurement and the problem for a traveler in "ethernity," who had left behind his "authentic copy in brass" of the standard centimeter. Given the status of the metric system as an object of French national pride and identity, Jarry's narrative, based on the Englishman Kelvin's writings, demonstrates an irreverence that may have reflected his own anarchist sympathies.[44] Likewise, Duchamp's reference to the anarchist Max Stirner's book of 1845, *Der Einzige und sein Eigentum* (The Ego and His Own), suggests that the *3 Standard Stoppages* were a commentary not only on geometry, but also on individualism versus nationalism. Stirner, a forerunner of Nietzsche, had touted the primacy of the individual ego and rejected any social institutions that limited the individual's development.[45] As Francis Naumann has noted, Duchamp's *3 Standard Stoppages*, "determined by the chance of a given individual" for his own use, stand as a challenge to the French standard meter, which is carefully maintained in the Pavillon de Breteuil in Sèvres (fig. 69).[46]

Beyond the Sèvres installation, Duchamp would have been exposed to French metrology in Paris at the Musée des Arts et Métiers and in numerous articles on the subject in scientific literature and even *La Revue des Idées*. The Conservatoire National des Arts et Métiers was charged with the construction of standard meter bars and the maintenance of the highest degree of accuracy; an entire room at the Musée des Arts et Métiers was devoted to systems of measurement and measuring devices.[47] Since its legal establishment in 1795, the metric system had continued to evolve, as meter standards progressed from the original definition of the meter as one ten-millionth of the meridian arc from the North Pole to the equator to a new, far more accurate measurement in terms of the wavelength of light.[48] Since 1875 an International Conference of Weights and Measures had convened at Sèvres regularly to deal with variations in standards in all fields of measurement; the conference met again in 1913, the year in which Duchamp conceived his own counter-demonstration in the *Stoppages*.[49]

Charles-Edouard Guillaume, who had written the text on X-rays illustrated with Albert Londe's comparative photographs (fig. 6), was assistant director of the International Bureau of Weights and Measures in 1912. His October 1912 article entitled "Métrologie et législation" reveals the nationalistic tenor of discussions of the meter and standards of measurement in this period: "The metric system, the most perfect of all the measuring codes established to the present, is not unalterably fixed in the admirable statute its creators devised; it has followed the evolution of the science of measures, gaining constantly in precision and scope." Guillaume's article concludes with a section on "The Fight for the Metric System," which celebrates the legal adoption of the metric system in many countries and seeks to counteract the continued partisanship of the yard and pound by the British. He reacts particularly strongly to David Lloyd George's recent claim that "the metric System has broken down hopelessly in France," a development that has, he says, "provoked on the Continent a veritable *stupeur*."[50] Supported by vast amounts of regulations and legislation, the metric system was clearly a matter of national pride and even an instrument of symbolic national conquest.

Duchamp would have been particularly sensitive to the contrast between British and French measuring systems, because he had just spent the month of August at Herne Bay, England, with his sister Yvonne.[51] For Duchamp, tradition-bound, nationalistic French metrology was exactly the type of science to which he reacted negatively. In order to "discredit science, mildly, lightly," as he said later, he challenged standards of measurement in the *3 Standard Stoppages*, none of which matches the other, and explored the "phenomenon of stretching in the unit of length," as he said in his notes for the *Large Glass*.[52] In his notion of diminishing the meter or stretching a unit of length, Duchamp was jokingly exaggerating the very problem that had haunted metrologists over the years—the tendency of metallic meter bars to contract or expand, thus undermining the claims to accuracy made for a succession of standard meters.[53] Duchamp's iconoclasm extended beyond measures of length to measurements of weight, the other primary domain of the International Bureau of Weights and Measures. Gravity was to be a major theme in the *Large Glass*, where the Juggler of the Center of Gravity or Handler of Gravity (fig. 112) would play an important role in Duchamp's plan for the Bride's realm. Duchamp's notes also propose the creation of an alternative to a Bureau of Standards: "Ministry of Coincidences. Department (or better): Regime of Coincidence/Ministry of Gravity."[54] Duchamp thus confronts the French bureaucracy's preoccupation with predictable, absolute standards by enshrining chance in a "Regime of Coincidence."

Duchamp subsequently used the *3 Standard Stoppages* to create the *Network of Stoppages* (fig. 73), which he used for the pattern of the Capillary Tubes connecting the

Nine Malic Molds or the Cemetery of Uniforms and Liveries in the lower half of the *Large Glass* (figs. 76, 77). In 1918 the *Stoppages* reappeared in *Tu m'* (fig. 173) in the form of the wooden templates he had recently had made. When Duchamp in 1936 mounted the thread-bearing canvas strips on glass plates, he confirmed the close relationship of the *Stoppages* to another element of the *Large Glass*: the three glass strips at its mid-section (fig. 88). The *Stoppages'* arrangement of one clear and two greenish glass plates parallels exactly that of the glass strips mounted on the *Large Glass*: the top strip is clear and the two below are greenish in hue. Because Duchamp located the Bride's "Clothing" at the midsection of the *Glass* (fig. 77 [no. 5]), the gravity-drawn thread lines of the *Stoppages* may have become for him a metonymical sign for the fallen garment of the Bride.[55]

Beyond their origins as a commentary on Euclidean geometry and the nationalistic, regulation-bound science of the metric system, the *3 Standard Stoppages* also embodied Duchamp's rejection of classical aesthetic systems. He later described the *Large Glass* as a "renunciation of all aesthetics," a renunciation that had begun overtly in 1913 with the *3 Standard Stoppages*.[56] Measure and proportion had been central to classical aesthetics. Plato, for example, had written in the *Statesman*, "Thus, if measure exists, so do the arts; and conversely, if there are arts, then there is . . . measurement. To deny either is to deny both."[57] In subverting the standard meter by generating three new inconsistent standards of measure, Duchamp had moved beyond traditional definitions of art itself. Indeed, during 1913–14 he was giving serious consideration to the question he recorded in a note dated 1913: "Can one make works that are not works of 'art'?"[58]

In rejecting measure, Duchamp was also undermining classical notions of beauty and taste, which were inextricably linked to measure. In contrast to Kant, who in the eighteenth century had raised taste to the level of a universal constant, Duchamp described taste simply as a "habit" to be avoided.[59] He had initially turned to the technique of mechanical drawing, because, as he said, it "upholds no taste."[60] Duchamp's goal, by contrast, was the beauty of indifference, the counterpart to his painting of precision.[61] He also spoke of the "liberty of indifference" and the "irony of indifference," and all of these phrases, like Roussel's procedure for Handel's chance-generated musical composition, place the emphasis on indifferent choice and chance events rather than on adherence to any standard of taste or beauty.[62]

Following upon the *3 Standard Stoppages*, Duchamp explored the idea of the beauty of indifference in the context of the objects he christened Readymades in 1915. As

chosen or found objects, the Readymades were meant to signal a complete "forgetting [of] the hand" and rejection of taste.[63] In addition to challenging classical aesthetics, Duchamp's attack on beauty and taste via the Readymades seems also to have been directed at a more immediate target: the Bergsonian Cubist theory set forth in Gleizes and Metzinger's *Du Cubisme*. Published in December 1912, *Du Cubisme* enshrined the creative intuition of the sensitive artist, echoing Bergson's belief that the artistic act was an expression of the "fundamental self."[64] The final chapter of *Du Cubisme* celebrates the sensitivity of the artist who embodies the operation of taste in his pursuit of beauty: "The painter will know no other laws than those of Taste," the authors assert, and "it is the faith in Beauty which provides the necessary strength."[65] Moreover, Bergson had characterized intellectual and scientific modes of thinking (those preferred by Duchamp) as external to the innate psychic processes of the organic, profound self.[66] According to Bergson, such intellectual ideas, "which we receive 'ready-made' [*tout fait*]," must remain external to the inner self of artistic creation.[67]

Bergson's use of the term *tout fait* in this context and in *Le Rire*[68] to signify the very state of being external or mechanical that Duchamp was seeking suggests that the philosopher's terminology lies behind Duchamp's adoption of its English translation, "ready-made," once he was in New York. As he wrote to his sister Suzanne in January 1916, "You know English well enough to understand the sense of '*ready made*' that I give these objects. I sign them and give them an English inscription. . . . Don't try too hard to understand it in the Romantic or Impressionist or Cubist sense—that does not have any connection with it."[69] Indeed, Duchamp's detached, mechanical practice and his name for it, Readymade, place these works directly in opposition to Bergsonian Cubist theory and painting. As Pontus Hulten has observed, Duchamp's first "pure" Readymade, the *Bottle Rack*, or *égouttoir* (fig. 71), of 1914, plays on the word *goût*, or taste, and, I would add, on the Puteaux Cubists' preoccupation with it (the word recurs almost like a mantra in sections of *Du Cubisme*).[70] Rather than a generalized challenge to all of art making, Duchamp's initial Readymades, including the *égouttoir* (able to drain drops [*gouttes*] and to avoid taste [*goût*]), seem to have been a response to local conditions—specifically, Puteaux Cubist theory and the painted celebration of Cubism's superior sensibilities in a work such as Metzinger's *Le Goûter* (fig. 169).

In addition to the *Bottle Rack*, Duchamp's Readymades ranged from the *Bicycle Wheel* of 1913 (fig. 70), a "Readymade Aided" in his subsequent terminology,[71]

through other purer examples of the genre, such as *Trap* (Trébuchet) of 1917 (the coat rack nailed to the floor of Duchamp's New York studio; fig. 70) and *Air of Paris (50 cc. of Paris Air)* (a miniature version of this glass vial hangs next to the *Large Glass* reproduction in fig. 166). Three other Readymades can be seen in another photograph of Duchamp's New York studio in 1917 or 1918 (fig. 118): *In Advance of the Broken Arm*, of 1915 (a snow shovel inscribed with this phrase); *Fountain*, of 1917 (a urinal hung at a ninety-degree angle); and *Hat Rack*, also of 1917. Few of Duchamp's earliest Readymades survive, with the notable exception of his "Assisted Readymade" *Pharmacy* (fig. 167) of January 1914, a cheap reproduction of a winter landscape Duchamp purchased in an art-supply store. To this landscape model Duchamp added two dots of red and green paint, evoking the bottles of colored liquid on view in pharmacists' windows.[72] Given his rejection of the artist's hand, the replicas of each Readymade (including *Pharmacy*) selected or produced later were equally valid in Duchamp's view: "Another aspect of the 'Readymade' is its lack of uniqueness... the replica of the 'Readymade' delivering the same message."[73] Or, as he said, he was seeking "to wipe out the idea of the original, which exists neither in music nor poetry."[74]

Toward the end of his life Duchamp explained that "a Readymade is a work of art without an artist to make it."[75] The Readymades stand as one of Duchamp's most iconoclastic discoveries and most important contributions to the subsequent development of twentieth-century art. The first Readymades, however, were not public statements but private experiments, and originally he did not consider them to be "works of art." Duchamp's conversation with Pierre Cabanne clarifies this point:

Cabanne: How did you come to choose a mass-produced object, a "readymade," to make a work of art?

Duchamp: Please note that I did not want to make a work of art out of it. The word "readymade" did not appear until 1915, when I went to the United States. It was an interesting word, but when I put a bicycle wheel on a stool, the fork down, there was no idea of a "readymade," or anything else. It was just a distraction. I didn't have any special reason to do it, or any intention of showing it, or describing anything. . . . The word "readymade" thrust itself on me then [in 1915]. It seemed perfect for these things that weren't works of art, that weren't sketches, and to which no art terms applied. That's why I was tempted to make them.

Cabanne: What determined your choice of readymades?

Duchamp: That depended on the object. In general I had to

be aware of its "look." It's very difficult to choose an object, because at the end of fifteen days, you begin to like it or hate it. You have to approach something with an indifference, as if you had no aesthetic emotion. The choice of readymades is always based on visual indifference and, at the same time, on the total absence of good and bad taste.[76]

Duchamp's effort to achieve a beauty of indifference and an escape from taste was therefore central to his conception of the Readymades. Thomas McEvilley has convincingly argued the relevance for Duchamp of the Greek philosopher Pyrrho, whose philosophy was closely tied to the notion of indifference. In conversation with Arturo Schwarz, Duchamp mentioned that while at the Bibliothèque Sainte-Geneviève he "had had the chance . . . of going through the works of the Greek philosophers once more, and the one which he appreciated most and found closest to his own interests was Pyrrho."[77] Although Pyrrho left no treatises, his teachings came down through his sayings and the writings of his students, such as Timon of Phlius. One of Pyrrho's sayings, "Nothing is in itself more this than that," was subsequently expanded by Timon, who argued that "things are indistinct from one another, and thus are not to be preferred over one another, but should be regarded with indifference."[78] Reading the ideas of Pyrrho, who was also cited by Max Stirner, would certainly have encouraged Duchamp in his exploration of the theoretical possibility of indifferent choice or decision making.[79]

Duchamp's *Notes*, published posthumously in 1980, also provide a new clue to his interest in the concept of indifference in this period. Two of these notes include the phrase "Free will = Ass of Buridan," a reference to the famous philosophical problem of "Buridan's Ass," named for the fourteenth-century French philosopher and scientist Jean Buridan.[80] The problem is summed up in the phrase "choice without preference" and is illustrated by the case of a donkey, equidistant from two equal bales of hay, who starves to death because he cannot make a choice between them.[81] In the works of Buridan and other philosophers, this question had been tied closely to that of free will, and from the time of John Duns Scotus in the thirteenth century, certain writers had insisted that free action would require indifference of will or the "liberty of indifference."[82] Indeed, the entry for "Buridan" in the *Larousse* dictionary concludes that Buridan's Ass "is the problem of *liberty of indifference*," the very phrase Duchamp used in one of his notes for the *Large Glass*.[83]

Duchamp's references to Buridan's Ass and to the liberty of indifference occur in notes relating to the

"Mobile," a mechanism (never executed) for determining the "3 crashes" that were to be produced in the Bachelor Apparatus of the *Large Glass*. In notes 101 and 153 of the notes published in 1980 (see fig. 148; app. A, no. 11), Duchamp set forth an experiment to be performed with a *mobile*, or "mover" (suspended from the Scissors of the Chocolate Grinder), whose chance falls offered three possibilities for the "crashes."[84] Better known are Duchamp's *Green Box* notes setting forth a related system of falling Weights (in the form of "Bottles of Benedictine" or a Hook), which were to be made of a substance of "oscillating density" that would produce irregular rates of descent. In fact, the two systems were closely interrelated through the action of the Scissors, as will be seen in chapter 11. According to Duchamp, "It is by this oscillating density that the choice is made between the three crashes," and "it is truly this oscillating density that expresses the liberty of indiff."[85]

Duchamp's interest in choice without preference, or the liberty of indifference, led him to a number of experiments with chance outcomes, from his *Musical Erratum* compositions, the *3 Standard Stoppages*, and the simple reference to the "Barrel Game" in a note in the *Box of 1914* to experiments involving complex procedures and diagrams set forth in the 1980 *Notes*.[86] This experimental activity would seem to have been a route by which Duchamp explored the cultivation of indifference and chance occurrences that he later spoke of as central to the visually indifferent choice of the Readymades. Thus, in his notes referring to "painting of precision and beauty of indifference," he continued, "Always or nearly always give the reasons for the choice between 2 or more solutions (by ironical causality)."[87]

In discussing the *3 Standard Stoppages*, which he equated with "canned chance" in one of the *Green Box* notes quoted above, Duchamp had stated to Cabanne that the idea of chance was something "which many people were thinking about at the time."[88] As noted earlier, Duchamp is known to have read P. Camille Revel's 1909 *Le Hasard, sa loi et ses conséquences dans les sciences et en philosophie*, an idiosyncratic blend of ideas on chance and scientific occultism.[89] In addition to discussions of random choice in the literature on Buridan's Ass, which Duchamp may also have consulted, he would have encountered chance in the writings of Poincaré—both in *Calcul des probabilités*, newly reprinted in 1912, and in a chapter devoted to chance in his 1908 *Science et méthode*. Indeed, the various experimental phenomena Poincaré cites in this chapter, from molecular collisions to the falling of an object in unstable equilibrium, may well have encouraged Duchamp to explore chance outcomes in

the experiments he designed for himself. In addition, Poincaré's chapter also dealt with the issue of causality, suggesting that seemingly chance occurrences are the "aggregate of complex causes" of which we have only limited understanding.[90] In a declaration of free will and individualism versus determinism, Duchamp created his own principle of "ironic causality," by which he would choose among the possible solutions produced by his experiments with chance.[91] In the end, as will be seen in chapter 10, Duchamp found the issue of chance (and the related ideas of free will and determinism) to have been a major theme in recent scientific thought, particularly in relation to the molecular behavior posited by the kinetic-molecular theory of gases.[92]

When Cabanne asked Duchamp if, like the *3 Standard Stoppages*, the Readymade *Pharmacy* (fig. 167) was "canned chance," he responded, "Certainly."[93] The attitude of indifference Duchamp later ascribed to the choice of his Readymades unquestionably represented a new degree of aesthetic distancing on the part of the artist, a freedom from "esthetic delectation."[94] Having rejected standards of taste, Duchamp now removed completely the touch of the artist's hand by choosing rather than making an object. Yet, as certain scholars have suggested in the past and as the present work establishes in a different way, Duchamp's choice of objects as Readymades was rarely, if ever, totally indifferent.[95] Although the philosophy of Pyrrho and the problem of Buridan's Ass provided models for a stance of indifference toward objects of the everyday world, neither *Pharmacy* nor any other of the Readymades demonstrated the degree of chance or completely indifferent choice manifested in his *Musical Erratum* projects, the *3 Standard Stoppages*, or the experiments associated with the Playful Physics of the *Large Glass*. Duchamp himself described the Readymades as having "no intention other than unloading ideas," indirectly confirming their thematic content or idea.[96] As discussed in subsequent chapters, many of the Readymades do seem to relate to the *Large Glass*, including the *Bottle Rack* (*égouttoir*), whose association with drops (*gouttes*) parallels a central theme and wordplay in the Bachelor Apparatus. Given Duchamp's sensitivity to words and the mass of ideas he was accumulating between 1912 and 1915, as registered in his notes, it would seem he was seeking visual indifference to various types of a desired object and not a completely random encounter with any object.

Duchamp's interested versus disinterested choice is most clear in the case of the *Bicycle Wheel* (fig. 70), which, as Duchamp explained to Cabanne, preceded the genesis of his actual notion of a Readymade object. The *Bicycle Wheel* unquestionably appealed to Duchamp visu-

ally, a response he tried to suppress in his subsequent Readymades. It was "a gadget," he told one interviewer, something he enjoyed watching in motion, "like a fire in the fireplace."[97] In addition, a spinning bicycle wheel would have had numerous associations for Duchamp—from Jarry's "time machine," with its gyroscopic bicycle wheels, and, possibly, Oliver Lodge's use of bicycle wheels to model the ether, to the silent, spinning dynamos of the 1900 Exposition Universelle (fig. 154) and the multivalent "Water Mill" for the *Large Glass*, which was central to the *Glider* studies he was then making (figs. 151, 153).[98] By mounting the wheel so that it could turn freely, Duchamp created an effect akin to the wheels on suspended airplanes exhibited at the Paris aviation salon he had attended with Léger and Brancusi (fig. 40) as well as at the Deutsches Museum (fig. 38) and the Musée des Arts et Métiers. Francis Naumann has also noted that the absence of the tire on the rim encourages a viewer to focus on the turning mechanism of the wheel—very likely a new type of largely frictionless ball bearing that had been introduced only in 1907—displayed as if in an exhibition of the latest bicycle technology.[99]

Both an airplane and a bicycle wheel on view in an exhibition or museum share the basic characteristic of the Readymades, a displacement from their normal context and functional usage.[100] As Thierry de Duve has noted in the context of his discussion of Duchamp's Munich trip, a Readymade loses its "utilitarian dimension" and gains a "function of pure symbol," becoming a "recording sign of industrial culture."[101] It seems possible, too, that the cases at the Musée des Arts et Métiers, filled with objects displaced from their original functions (fig. 164), may have served as a stimulus to Duchamp in asking the question, "Can one make works that are not works of 'art'?" The objects at the Musée des Arts et Métiers were museum pieces that would never be shown in an art museum like the Louvre. To modify André Breton's later definition of the Readymades as "manufactured objects promoted to the dignity of objects of art through the choice of the artist," the objects at the Arts et Métiers could be thought of as manufactured objects promoted to the dignity of objects of culture through the choice of a museum curator.[102] The majority of Duchamp's Readymades, in fact, could be described as cultural artifacts, the theme of racks, for example, unifying the *Bottle Rack* (fig. 71), *Trap* (fig. 70), and *Hat Rack* (fig. 118).[103]

As such, the inclusion of the *Bottle Rack* in a display case at the 1936 Exposition Surréaliste d'Objets (fig. 72) experienced a kind of Duchampian "mirrorical return."[104] Like the mathematical models from the Institut Poincaré on the top shelf of the case, the *Bottle Rack* was now dis-

played in much the way similar domestic objects of French manufacture, such as grinders, were exhibited at the Musée des Arts et Métiers. Although in his notes for the *Large Glass* and in his later execution of the work, Duchamp would be actively interested in the effects produced by glass cases, his Readymades themselves were never encased. Rather, he most often assured their displacement from a functional context by hanging them in his studio in arrangements that transformed it into a kind of display space (fig. 118).[105]

Duchamp also created a linguistic displacement for the Readymades by inscribing phrases on certain of them, such as the familiar "In Advance of the Broken Arm," which has become the functional title for the snow shovel (fig. 118). As Duchamp later explained, the "sentence" he inscribed "instead of describing the object like a title was meant to carry the mind of the spectator toward other regions more verbal."[106] Like his method of display, Duchamp's inscriptions also operated quite differently from museum labels and the labels he had placed on the two *Chocolate Grinder* paintings. Despite the altered contexts of the latter objects (in a museum display or in a painting), their descriptive labels reaffirm their original functions rather than "carry[ing] the mind of the spectator" elsewhere.

Although Duchamp had originally conceived of the Readymades as alternatives to "works of 'art,'" as he said, he later came to refer to them as works of art. In his 1964 "Apropos of Myself" lecture, for example, Duchamp explained the term *readymade* as follows: "I coined that word for ready made objects which I designated as works of art by simply signing them."[107] The view of Readymades as art works was first expressed in 1917 in *The Blind Man*, in an editorial defending *Fountain* (fig. 118), which Duchamp had submitted to the Society of Independent Artists exhibition in New York under the name R. Mutt. In response to the accusation that *Fountain* was merely plumbing and not "art," the editorial asserted that, "whether Mr. Mutt with his own hands made the fountain or not has no importance. He CHOSE it. He took an ordinary article of life, placed it so that its useful significance disappeared under the new title and point of view—created a new thought for that object."[108] Although the editorial was unsigned, it certainly expressed Duchamp's attitude, since *The Blind Man* was a collaborative project of Duchamp, Beatrice Wood, and H.-P. Roché.[109] By this time, thought and idea had become paramount in his conception of the nature of art, now put fully "at the service of the mind" in the *Large Glass*.[110]

Beyond Roussel's antivirtuoso stance and Duchamp's desire to achieve the beauty of indifference in the face of

Puteaux Cubist emphasis on taste and intuitive creation, Duchamp may have had yet another encouragement to challenge the traditional role of artistic craftsmanship by means of the Readymades, his vehicles for "unloading ideas."[111] By 1913, Kupka, Duchamp's fellow student of science and critic of Puteaux Cubism, was theorizing on the future possibility of the direct transfer of thought from the artist to his audience, "without being obliged, as today, to work laboriously when he creates a painting or sculpture."[112] For Kupka, as for Duchamp, the ideas in the mind of the artist had become the essence of a work of art. And, as will be seen, Kupka's interest in the means of conveying such ideas by means of electromagnetic waves would find a counterpart in Duchamp's use of the theme of wireless telegraphy in the *Large Glass.*

In his treatise written in 1912–13, Kupka frequently used the language of electromagnetism and electricity, including the term *réseau,* to refer to the network or system of conduits carrying electrical circuits in the "cerebral mechanism" of the brain.[113] Kupka's usage is a reminder of the technological orientation of Duchamp's title for his 1914 painting *Réseaux des stoppages* or *Network of Stoppages* (fig. 73). On this large canvas (nearly six feet tall) Duchamp in 1911 had painted an unfinished version of the *Young Man and Girl in Spring* theme in the golden and green tonalities of his Cubist palette. Over this image, now inverted, Duchamp added a pencil drawing of the layout of the *Large Glass,* painting over the excess canvas at each side of the drawing. Finally, as the top layer, Duchamp painted the plan of the nine Capillary Tubes connecting the Malic Molds, using the configuration of each of the *3 Standard Stoppages* three times. Drawn like a network of railway lines or electrical conduits, Duchamp's image stands as a particularly diagrammatic example of the painting of precision. In fact, the *Network of Stoppages* was to have served a technical function. Although in the end Duchamp had to make a perspective drawing, he had hoped to generate automatically the perspective projection of the Capillary Tubes for the *Large Glass* by photographing the *Network* painting at an oblique angle.[114]

Like his earlier painting *Yvonne and Magdeleine Torn in Tatters* (fig. 9), which juxtaposed X-ray imagery with that of visible light, Duchamp's *Network of Stoppages* contrasts two modes of representation: a kind of engineering diagram and his own earlier Cubist style. Duchamp established a similar contrast after the fact in a photograph taken for a November 1915 *Literary Digest* article, in which he posed with the *Chocolate Grinder (No. 2)* in front of Jacques Villon's *Portrait of Mr. J.B., Painter* (fig. 74). Duchamp seems to have staged this photograph

specifically to emphasize his new identity as an engineer-scientist, a painter of precision, and a cultivator of indifference, who, unlike his brother Villon, had left behind his role as a practitioner of Cubist painting. Instead of holding the customary artist's paintbrush, he holds his pipe in his left hand and nothing in his right hand, creating the distinct air of a thinker, not a painter.[115]

In October 1913 Duchamp moved to his studio in the rue Saint-Hippolyte, removing himself from the immediate surroundings of Puteaux Cubism. In early June 1915 he was to sail for New York, where he would carry out the production of the *Large Glass,* far removed from the atmosphere of wartime Paris. An April 1915 letter to Walter Pach, the American painter close to the three Duchamp brothers, reveals his state of mind:

For a long time and even before the war, I have disliked this "artistic life" in which I was involved. It is the exact opposite of what I want. So I had tried to somewhat escape from the artists through the library. Then during the war, I felt increasingly more incompatible with this milieu. I absolutely wanted to leave. Where to? New York was my only choice, because I knew you there. I hope to be able to avoid an artistic life there, possibly with a job which would keep me very busy. I have asked you to keep the secret from my brothers because I know this departure will be very hard on them.— The same for my father and sisters.[116]

By the time he sailed for New York, Duchamp had written the majority of his notes and had worked out most of the details of the *Large Glass,* although a few additional elements would be established in New York. As he recounted later, "It all came to me idea after idea between 1913 and 1915, and all of the visual ideas were in that drawing on the wall of my studio, so that from 1915 on I was just copying."[117] Like an engineer with a blueprint, Duchamp would carry forward the execution of the *Large Glass* as an intellectual, "scientific" endeavor.

Before he left Paris, Duchamp decided to "publish" a small group of the notes he had been recording "idea after idea" since late 1912. As will be seen in the next chapter, the *Box of 1914* stands as yet another exemplar of the anti-aesthetic, anti-Bergsonian stance embodied in Duchamp's Readymades and his general pursuit of painting of precision and the beauty of indifference. Just as Roussel, with his denial of virtuoso human performance in favor of fantastic machines and chance creation, has been the dominant nonartistic figure for the works discussed in this chapter, similar Rousselian notions are apparent in the *Box of 1914* notes. Yet during 1913 and 1914 Duchamp had also been making more specifically scientific notes

for the *Large Glass*, as he established the "laws" of Playful Physics by which the activities of the Bride and the Bachelors might be defined. At least one of those scientific themes (i.e., electromagnetic waves) is also suggested in the *Box of 1914*, pointing toward the larger consideration of the science of Crookes and Tesla, among others, in chapter 8. Finally, if Jarry (who is directly evoked in another note in the *Box of 1914*) served as a contemporary model for artistic invention based on science, an examination of the *Box of 1914* also suggests a historical model for Duchamp's interest in science and his note-making activity: Leonardo da Vinci.

Part III

"Playful" Science and Technology in *The Bride Stripped Bare by Her Bachelors, Even (The Large Glass)*, 1915–1923

Chapter 6

Toward the *Large Glass*
The *Box of 1914* and General Introduction to the *Glass*

In the interviews Duchamp gave when he arrived in New York, he emphasized his interest in science and his admiration for the painter Seurat, whom he described as "the greatest scientific spirit of the nineteenth century."[1] Verbalizing the nonpainterly approach to art making embodied in his 1915 photograph published in *Literary Digest* (fig. 74), Duchamp concluded his remarks on Seurat by asserting that "the twentieth century is to be still more abstract, more cold, more scientific."[2] And, according to the caption under a portrait photograph of Duchamp in a *Current Opinion* article, "We must, the brilliant young Frenchman declares, create new values in art—values scientific and not sentimental."[3]

Duchamp's pronounced declarations of his interest in science in the early years of the century contrast to his later, more circumspect statements on subjects such as science and mathematics. In 1967, in his most extensive interview, Cabanne's *Dialogues with Marcel Duchamp*, Duchamp downplayed almost completely the presence of any serious scientific or mathematical interests in the *Large Glass*. Robert Lebel, Duchamp's friend and commentator, was troubled by the tone of the Cabanne interviews and suggested that Duchamp had adopted the persona of a jokester for whom nothing mattered.[4] Indeed, certain of Duchamp's statements to Cabanne overtly contradict attitudes expressed quite consistently in earlier interviews. The most striking of these reversals concern the *Large Glass*: such statements as "I made it without an idea" and "Fundamentally, there are very few ideas"[5] are in stark contrast to his long-professed commitment to "mental ideas."[6] "I was interested in ideas—not merely in visual products," he had explained to Sweeney in 1946, as he recalled his goal of placing painting "at the service of the mind."[7] Or, as he explained to Calvin Tomkins in the early 1960s, "When an idea came to me I would immediately see if I could apply it to the rest of the conception. It all came to me idea after idea between 1913 and 1915. . . ."[8]

That such anomalous statements exist in the Cabanne interview must be kept in mind in considering this oft-quoted exchange:

Duchamp: All painting, beginning with Impressionism is antiscientific, even Seurat. I was interested in introducing the precise and exact aspect of science, which hadn't often been done, or at least hadn't been talked about very much. It wasn't for love of science that I did this; on the contrary, it was rather in order to discredit it, mildly, lightly, unimportantly. But irony was present.

Cabanne: On this scientific side, you have considerable knowledge. . . .

Duchamp: Very little. I never was the scientific type.

Cabanne: So little? Your mathematical abilities are astonishing, especially since you didn't have a scientific upbringing.

Duchamp: No, not at all. What we were interested in at the time was the fourth dimension.[9]

Duchamp's subsequent comments to Cabanne on the fourth dimension portray himself and his colleagues, such as the actuary Maurice Princet, as mere amateurs who simply found amusement in the subject but never had any serious understanding of four-dimensional geometry.

Although this attitude might well describe most of the Puteaux Cubist painters, Duchamp's engagement with both non-Euclidean and four-dimensional geometries (as chronicled in his notes and analyzed by Craig Adcock and myself) was certainly deeper than his later statements would suggest. Beyond the humorous, disinterested stance he cultivated in these years, an important clue to Duchamp's denigration of his mathematical and scientific knowledge is found in an exchange recorded by Cleve Gray, who translated the 1966 collection of notes, *A l'infinitif*. According to Gray,

One day when I was working, with his help, on some particularly personalized mathematics in a part of "A l'Infinitif," . . . he asked me: "Do you think this is all right, all of this? I mean does it make sense? You know I don't want to appear foolish. . . . Well, what I mean is that this was written long ago, and mathematics today has become such a special and complicated field, perhaps I ought not to get involved in it now." Another time he remarked in an interview filmed by French Television Producers, "You know, I always want-

ed to be a mathematician, but I never really had enough stuff in me."[10]

Although he had explored mathematically related ideas more seriously than any other early twentieth-century artist, Duchamp by mid-century was aware that his personal and creative use of geometry was far removed from contemporary mathematics, and he hardly wished to claim prowess in the area. The contrast between science past and present was even more apparent. Although Duchamp had also been actively involved with contemporary science and technology, albeit transformed into a humorous Playful Physics, the issues of that early period—considered so "modern" at the time—had been almost completely displaced. Relativity theory and quantum physics had replaced classical ether physics and Rutherford's atom; television and radio had supplanted the wireless telegraphy that had served as a central theme of the *Large Glass.* It is little wonder, then, that in the 1960s Duchamp had "changed his tune."

If Duchamp cited Seurat as an exemplar of a recent painter-scientist, Leonardo da Vinci, whom Duchamp did not name publicly at the time, served as a closer prototype for him in the prewar and wartime years. The figure of Leonardo loomed large in the early twentieth century, following publication of the first collected volumes of his manuscripts, which revealed an intellect equally at home in the realms of science and art.[11] Between 1881 and 1891, Charles Ravaisson-Mollien had published a six-volume edition of Leonardo's manuscripts in facsimile, with translations; that collection was followed by translations by Sâr Péladan, the *Textes choisis: Pensées, théories, préceptes, fables et facéties* (1908) and the *Traité de la peinture* (1910).[12] It was against this backdrop that Duchamp began to produce his own manuscript notes in 1912 and that he published his *Box of 1914,* a group of sixteen notes and one drawing reproduced in a photographic edition of about five examples (figs. 78, 79).[13] Significantly, whenever Duchamp published collections of his notes during his life, they, like the great Ravaisson-Mollien edition of Leonardo's manuscripts, were reproduced in facsimile.

The *Box of 1914* and the Model of Leonardo's Science

Several authors have discussed the striking parallels between Duchamp and Leonardo, who was actually the subject of an oral examination Duchamp took as part of his certification as an art worker in 1905.[14] Among the most prominent is each man's commitment to painting as a "mental thing," as Leonardo termed it, and to the process

of intellectual exploration in extensive notes for works of art and scientific machines that might never be realized.[15] Beyond their interest in science and technology, they also shared a number of other traits that have been noted by scholars: a precise, engineerlike drawing style and an interest in designing machines, a concern with optics and perspective, a desire to experiment with new materials and techniques (including dust), a belief in the validity of chance and accident in the creative process, a view of the human body in terms of its mechanical functioning, and personality traits such as secretiveness and a fascination with androgynous sexuality.[16] The latter was manifested in Duchamp's irreverent Dadaist comment on Leonardo's *Mona Lisa* in his 1919 *L.H.O.O.Q.* (Private Collection, Paris), a "rectified" Readymade created by the addition of a mustache and goatee to a reproduction of Leonardo's painting, and in the vulgar pun produced when the letters of the title are pronounced in French.[17]

The iconoclastic attitude manifested in *L.H.O.O.Q.*, however, was not typical of Duchamp's thinking in the prewar years. In the face of the Puteaux Cubists' Bergsonian focus on intuitive, emotive artistic creation, Leonardo as artist-scientist would have offered Duchamp crucial validation for his belief in art as an intellectual activity. Indeed, in the context of the *Large Glass* project, Duchamp was to carry out a number of activities suggested by Leonardo. These ranged from his playful exploration of the laws of mechanics to his gathering of dust on the *Glass* itself (*Raising of Dust*, fig. 123), an idea likely rooted in Leonardo's comments on dust as a measure of the passage of time and on collections of dust as miniature landscapes. "My landscapes begin where da Vinci's end," Duchamp told an interviewer in the 1960s.[18]

Duchamp was not alone among artists in prewar Paris in his admiration for Leonardo. His close colleague Kupka shared his respect for the mind and works of the artist-scientist.[19] Among the Cubists, Villon, Duchamp's brother, later recalled his own reading of Leonardo's *Treatise on Painting* and asserted that the name "Section d'Or," adopted by the Puteaux circle for their fall 1912 exhibition, was an homage to Leonardo's concern with the Golden Section.[20] In contrast to the Cubist painters, however, Duchamp's interest in Leonardo was not a retrospective one: he was not simply concerned with earlier ideas that bore Leonardo's imprimatur. Instead, he sought to act as the *new* Leonardo, responding actively to contemporary science and technology as Leonardo had done in the Renaissance.

Given Duchamp's far greater involvement in early twentieth-century science than has previously been thought, the case for Leonardo as a seminal precursor can

be made even more convincingly than in the past. For a young artist interested in science, Leonardo's written record of his scientific pursuits, as presented and analyzed in a variety of early twentieth-century sources, offered a compelling example of a great mind at work. For example, Péladan's introduction to *Textes choisis* argued that the manuscripts revealed a new Leonardo, different from the "sphinx-like painter of the *Joconde*," a Leonardo who possessed "the highest consciousness and the most lucid mind of any artist."[21] Reviewing Péladan's collection of texts, Remy de Gourmont, in the February 1908 issue of *La Revue des Idées*, concluded of Leonardo: "What is impossible to ignore is the force of his intellect. Whether he invents or he chooses [from past science], it is the same critical sense carried to the highest point. . . . He was a fanatic of experimentation and he is, before Bacon and since Aristotle, the best theorist."[22]

In his *Introduction à la méthode de Léonard de Vinci*, published initially in 1895, Paul Valéry had also focused on Leonardo's thought processes, celebrating a mind able to grasp "relations . . . *between things whose principles of continuity escape the rest of us*," an approach Duchamp would cultivate in his work on the *Large Glass*.[23] Although Valéry's text has been noted previously in the Duchamp scholarship, no consideration has been given to the three-volume *Etudes sur Léonard de Vinci* (1906, 1909, and 1913), written by Pierre Duhem, a prominent French scientist and chronicler of the history of science. Duhem's study informally added the sanction of the French scientific establishment to Leonardo's growing reputation. In his effort to clarify Leonardo's relationship to medieval scientists and philosophers, Duhem devoted considerable attention to the work of Jean Buridan, whose name appears in Duchamp's notes in the context of "Buridan's Ass." In addition, Duhem's treatment of Leonardo's interest in the problems of mechanics, such as equilibrium and the center of gravity, touched on issues central to the operation of parts of the *Large Glass*.[24]

In his preface, Duhem marveled at Leonardo's writings as rare revelations of the workings of a scientific mind:

Among those who have initiated the human intellect to the comprehension of new truths, he is the one who has left a meticulous description of the progress of his thoughts, who has written up, so to speak, the log-book of the voyage of discoveries that was his life. . . . These precious rough copies permit us to follow, from the first sketch to the completed, detailed design, the diverse forms that an invention has taken in the inspired judgment of Leonardo da Vinci.

The manuscripts of Leonardo are documents of inestimable value, because they are unique in their genre; none

other of those whose meditations have enriched science has given us such numerous, detailed, and immediate records of the development of their thoughts.[25]

According to Leonardo's example, to be an intelligent artist required intellectual invention on scientific themes, which would be documented in individual notes on various subjects. The powerful example of Leonardo's note making cannot be overlooked in considering Duchamp's inauguration of his own career as a prolific recorder of ideas and his preference for randomness in ordering the notes. Writers on Leonardo, from Jean Paul Richter, who compiled the first English edition of the notebooks in 1883, to Duhem himself, emphasized the lack of sequence from one manuscript page to another, even when the sheets were from notebooks whose pages were only subsequently dispersed. Duhem referred to the "chaos" of the pages, while Richter suggested that "even in the volumes, the pages of which were numbered by Leonardo himself, their order, so far as the connection of the texts was concerned, was obviously a matter of indifference to him."[26]

Duchamp ensured the absence of any clear sequence among his notes by recording them on separate pieces of paper, many of which were irregularly sized scraps (sometimes torn from larger sheets) or the backs of such things as gas bills.[27] Unlike Leonardo, however, who never carried out the final arrangement of his writings he had planned, Duchamp was determined to control the disposition of his notes by publishing them himself.[28] "I wanted to make a book, or rather a catalogue, like the *Armes et cycles de Saint-Etienne* in which every detail would have been explained—catalogued," he told Alain Jouffroy in the 1960s.[29] Or, as he wrote to Jean Suquet in 1949, "The glass in the end was not made to be looked at (with 'aesthetic' eyes); it must be accompanied by a text of 'literature' as amorphous as possible, which never takes form."[30]

Although we have come to think of Duchamp's published boxes as the catalogue to which he often referred, he actually qualified that notion for Katherine Kuh: "Originally I had planned to finish the glass with a catalogue like the Green Box, except, of course, the Green Box is a very incomplete realization of what I intended. It only presents preliminary notes for the Large Glass and not the final form which I had conceived as somewhat like a Sears, Roebuck catalogue to accompany the glass and be quite as important as the visual material."[31] Duchamp's posthumously published notes reveal extensive speculation on his part about a definitive "text" that was to be produced from the random notes he was making. "Text—typed, on good paper leaving the backs of

the pages for demonstration figures (which will be diagrams of the finished state) or photos retouched with red, blue ink for the explanation," he recorded in his long note on language headed "Text (general notes for the)" (app. A, no. 2).[32] Yet, he also clearly sought to avoid a rigid order for the notes and considered the possibility of "mak[ing] a *round* book i.e. without beginning or end (either with the pages unbound and ordered by having the last word of the page repeated on the following page (no numbered pages)—or with the back made of rings around which the pages turn."[33]

When Duchamp returned to the documentation of his project in 1934, however, he once again adopted the format he had used in the *Box of 1914*: reproductions of individual notes housed in a box. Thus, for both the *Green Box* (1934) and *A l'infinitif* (1966) Duchamp carefully selected individual sheets from his corpus of notes and had them printed commercially in facsimile, using a variety of types of paper and replicating the irregular shapes of the original notes. The result was a randomly ordered record of the genesis and evolution of the *Large Glass*, a fluid "text" of another type, which was also far more immediate than a carefully typed and distilled compendium would have been.[34]

Only the notes published posthumously in 1980 were, like Leonardo's, subjected to another individual's organization. Paul Matisse's discussion of the monumental task of preparing the notes for that publication, as well as Arturo Schwarz's earlier recounting of his attempt to establish an order for the *Green Box* and *A l'infinitif* notes in his *Notes and Projects for the Large Glass*, recall Richter's commentary on his struggle with Leonardo's massive body of notes.[35] In a sense, Duchamp's idea of a definitive text for the *Large Glass* did gain a conceptual existence, at least, through the 1980 publication of his notes on that particular subject. And the legal-tablet lists of unpublished notes he made in the 1950s (figs. 187–89 and app. A) confirm his continued desire to augment in some way the "incomplete realization" represented by the *Green Box*.

Whatever their form, in the end Duchamp succeeded in producing a body of notes that scholars now study as assiduously as they do Leonardo's. Like Duhem's work on Leonardo, one of the goals of the present book is to recover to some degree the scientific sources that nourished Duchamp's thinking. Yet, a crucial difference in tone exists between Duchamp's notes and those of his predecessor. When Leonardo wrote humorous notes, they were segregated from his scientific musings; by contrast, Duchamp, like Jarry before him, viewed recent science as a possible source for witty artistic creation. Duchamp

could use contemporary developments in electricity and electromagnetism, for example, to comment playfully on sexual relations, without any pretense of discovering new principles of physics.

It was one thing for Duchamp to make private notes intended as a future guidebook to the *Large Glass*. It was another, however, to publish the first collection of notes before he had even begun to execute the work itself. Although previous scholars have never treated the *Box of 1914* notes as a coherent group, Duchamp would certainly have selected those notes carefully: they were to function as an announcement of what was to come in the *Large Glass* at the same time they declared his commitment to random ordering and chance. In its small edition of about five, Duchamp's *Box* was intended only for his closest friends, including Raymond Dumouchel (see fig. 78), Walter Pach and, ultimately, Walter Arensberg; he retained at least one copy of the *Box of 1914* for himself (fig. 79).[36] Dumouchel, the subject of Duchamp's earlier *Portrait of Dr. Dumouchel* (fig. 2), with its electromagnetic overtones, would have been a particularly sympathetic reader for the new scientific interests Duchamp was to declare in the *Box of 1914*.

Before reading a single note in the 1914 *Box*, Dumouchel and other observers would have been alerted to the technological orientation of the project by the photographic technique Duchamp used to reproduce the notes and even more so by the boxes chosen to house the photographs of the notes. These boxes had originally contained glass photographic negatives, described on their labels as *plaques ultra-sensibles* (fig. 78) or *plaques extra rapides* (fig. 79). For Dumouchel's *Box* Duchamp altered the original carton by pasting a label for Kodak photography papers over the original one for negative plates. He then changed the label at the top from "Union Photographique Industrielle" to "15/16 Photographies Industriels," describing the new contents of the box. Like the Musée Industriel of the Conservatoire des Arts et Métiers, which collected photographs along with other artifacts of science and technology, Duchamp's *Box of 1914* was a miniature library or museum of the ideas of a modern artist-engineer.[37]

The theme of photographic "registering" of light on *plaques sensibles* presented on the containers for the *Box of 1914* announces a general theme of *appareils enregistreurs* (registering instruments) that will be seen to pervade the *Large Glass*.[38] Among the *Box of 1914* notes, however, only the note on the "barrel game," discussed below, specifically raises the issue of photographic registering. By contrast, the greatest number of notes on a single topic (three) are devoted to the "fabrication" of the

3 Standard Stoppages and thus establish Duchamp's interest in geometry and systems of measurement. These notes represented not only a subversion of the French metric system and Euclidean geometry but also Duchamp's creation of an alternative kind of indifferent line, drawn by chance (see chap. 5). Duchamp introduced the issue of chance directly in a subsequent note, "Make a painting: of *happy or unhappy chance* (luck or unluck)."[39]

Duchamp underscored his geometric orientation by adopting the language of geometry for the first of the notes on the *3 Standard Stoppages*. Thus, the note "If a straight horizontal thread one meter long falls from a height of one meter onto a horizontal plane distorting itself *as it pleases* and creates a new shape of the measure of length.—" is written in the form of a geometrical theorem, albeit with an element of humor added. Similarly, Duchamp's note "Given that....; if I suppose I'm suffering a lot...." translates a personal, emotional situation into the cool, precise language of a geometrical proof. Indeed, in 1913, when Duchamp wrote of his quest for the "painting of precision and beauty of indifference," he also discussed the possibility of language as an "instrument (of precision)" or of "transparent language," an impersonal mode for which geometry offered a possible model.[40] And it would be one of the *Green Box* notes in the "Given" form of a geometry proof that Duchamp would later adopt for the title of his final recasting of the *Large Glass* theme, *Etant donnés* of 1946–66 (fig. 183): *Given: 1. The Waterfall, 2. The Illuminating Gas.*[41]

In addition to his geometrically oriented notes, one other note in the *Box of 1914* points up Duchamp's concern with language, though in a more overtly humorous vein:

arrhe is to art as
shitte [*merdre*] is to shit [*merde*].
 arrhe shitte
 art shit
grammatically:
the arrhe of painting is feminine in gender

Duchamp's note contains an homage to Jarry in the word *merdre*, the famous transformed expletive uttered by Ubu at the beginning of *Ubu Roi*, which assured the play's scandalous reception.[42] As such, it served notice to the reader of the *Box of 1914* that wordplays in the tradition of Jarry (and Roussel) were also a part of Duchamp's project. Implicitly, too, Duchamp's allusion to Jarry, along with the humorous elements in several of the notes, set the tone for a Playful Physics, in the tradition of Jarry's Pataphysics, rather than the serious science of Duchamp's note-making model, Leonardo.

If the new system of measurement embodied in the *3 Standard Stoppages* represents an aspect of Playful Physics already established by 1914, two other notes in the *Box of 1914* provided clues to a scientific theme he would develop in the *Large Glass*: electromagnetism. "Make a painting *of frequency*," declared Duchamp in one note; "*Electricity at large*/The only possible utilisation of electricity 'in the arts,'" he asserted in the other. In the past, neither of these notes has been associated with the issue of electromagnetism. The term "frequency" has been assumed to be the opposite of "infrequency," and the phrase "électricité en large" has standardly been translated as "electricity breadthwise."[43] When read in conjunction with Duchamp's other notes and with the imagery of the *Large Glass*, however, the notion of electromagnetic waves, capable of transmitting power "at large" and characterized by the frequencies differentiating X-rays, visible light, and Hertzian waves, emerges as central to the operation of the *Large Glass*, Duchamp's ultimate "painting *of frequency*."

In addition, several other notes in the *Box of 1914* relate to this theme. The optics of visible light underlie the note discussing linear perspective, which begins "*Linear perspective* is a good means of *representing* equalities *in diverse ways*," and the note "Make a mirrored wardrobe/Make this mirrored wardrobe for the silvering." (Both perspective, with its geometric overtones, and the notion of mirrors were also to be central to Duchamp's speculation on ways of depicting a fourth dimension.) Another of the most elusive notes in the *Box of 1914*, which begins "Against compulsory military service," also relates to communication and control at a distance, like that accomplished via Hertzian waves (see chap. 8). The note reads:

Against compulsory military service: a "distancing" [*éloignement*] of each limb, of the heart and other anatomical parts: each soldier being already unable to put his uniform on again, his heart feeding *telephonically*, a remote arm, etc. *Then*, no more feeding: each "remote element" [*éloigné*] isolating himself. Finally, a Regulation of regrets from *one "remote element" to another.*[44]

Full of irony on a subject of immediate concern in 1914, the military, Duchamp's note also echoes his friend Apollinaire, who was likewise an enthusiast of communication at a distance. In his poem "Les Fenêtres," of 1912, Apollinaire had proposed a poem on the subject of a bird with one wing, which was to be communicated by a "message téléphonique." Earlier, Apollinaire's 1910 collection *L'Hérésiarque et Cie* had included a chapter entitled "Le Toucher à distance."[45]

Another note and the drawing *To Have the Apprentice in the Sun* (see fig. 79) also reflect the current interest in frequency and vibration as the link between sight and sound, an issue pointed up by Crookes's table of vibrations as well as by Jarry's wide-ranging interest in vibrations in *Gestes et opinions du Docteur Faustroll, Pataphysicien*.[46] The note in question is one of Duchamp's insightful musings: "One can look at [see] seeing; one can't hear hearing." The only drawing included in the *Box of 1914*, the enigmatic *To Have the Apprentice in the Sun* is drawn on music composition paper, implicitly linking sound to sight, which is represented by the drawing itself and by the sun, the source of a variety of visible and invisible electromagnetic radiations. Like Duchamp's Jura-Paris Road, the line on which the cyclist rides is reduced to an "ideal straight line," a line that might also symbolize one of the rays of the sun.[47]

As an impersonal, geometric line, the "ideal straight line" in Duchamp's drawing stands as another manifestation of his pursuit of a depersonalized expression free of "taste"—either in a mechanical-drawing style or in other alternatives to the drawn line, such as the threads in the *3 Standard Stoppages*. Their final configurations having been determined by gravity and chance, the lines of the *Stoppages* relate to a form of impersonal sculpture suggested in another of the *Box of 1914* notes as well (see fig. 79):

The barrel game is a very beautiful *"sculpture" of skill*: a photographic record should be made of [*il faut enregistrer (photographiquement)*] 3 successive performances; and "all the pieces in the frog's mouth" *should not be preferred* to "all the pieces outside" or (nor) above all to a good score.[48]

The note suggests another experimental procedure with a chance outcome, like that of his Rousselian *Musical Erratum* compositions, the *3 Standard Stoppages*, and the other experiments he defined for himself in various notes. Derived from the realm of the carnival (itself to be a subtheme of the *Large Glass*), the barrel game will produce a "beauty of indifference," the end result to be recorded or registered photographically. Here the cool precision of photography as a scientific recording tool is evoked—just as it had been in Duchamp's reference to "industrial photographs" on the cover of Dumouchel's *Box of 1914*. As a kind of *appareil enregistreur*, the photographic plates associated with the *Box of 1914* were to be joined in the *Large Glass* by a variety of other kinds of registering instruments as well.

Duchamp produced the *Box of 1914* the same year he chose his first pure Readymade, the *Bottle Rack* (fig. 71).

Although he did not include references to any of his actual Readymades in the *Box of 1914*, two of the remaining notes are evocative musings that celebrate objects from everyday life: "Long live! Clothes and the racquet press"; and "—one only has: for *female* the public urinal [*pissotière*] and one *lives* by it.—" By this time Duchamp had developed his identification of the "Clothing" of the Bride of the *Large Glass* with the three strips of glass that were to be mounted at its mid-section (fig. 88), an arrangement that does suggest the layers of a traditional wooden tennis-racquet press, as well as other, similarly layered objects (figs. 89, 170).[49] In the second note Duchamp's use of the word *pissotière* for urinal provides a previously unnoticed clue to his subsequent adoption of the title *Fountain* for his 1917 Readymade urinal (see fig. 118). *Pissotière* is defined in the *Petit Larousse illustré* of the period both as a "urinal" and as a "little stream of water" or "fountain that emits little water."[50] Duchamp's note links the *pissotière*'s form and function to a female, suggesting, in a melancholy tone, the theme of sexuality and substitution that would be central to *The Bride Stripped Bare by Her Bachelors, Even*.[51]

The one remaining note is perhaps the most enigmatic of all the notes in the *Box of 1914*: "*A World in Yellow*/The bridge of volumes/above or beneath the volumes/in order to watch the bateau-mouche go by." Yet, when considered in the contemporary context of Duchamp's rejection of Bergsonist Cubist painting, the note may be a playful linguistic turn at the expense of his Puteaux Cubist colleagues. If Gleizes and Metzinger's *Du Cubisme* stood as a notable expression of Cubism's debt to Bergson, an October 1912 essay by Henri Le Fauconnier, "La Sensibilité moderne et le tableau," published in the catalogue of the Moderne Kunstkring exhibition in Amsterdam, was equally Bergsonian. Although Le Fauconnier cited "scientific accomplishments [that] offer to our eye forms until now unknown," he, like Gleizes and Metzinger, tempered any appreciation of science with a decided preference for intuition versus intellect.[52] Thus, his essay extols the intuitive faculties of the Cubist painter, as opposed to the intellectually oriented "theoreticians" who miss qualitative values because of their preoccupation with logic and quantification. Le Fauconnier describes such theoreticians as having a "maniacal preoccupation" with creating a "coefficient of emotivity." In contrast, the Cubist painter, by means of "a relation of volumes, forms, and colored strokes," creates a "new inscription" embodying the response of his or her intuitive sensibility to the modern world.[53]

Duchamp's reference to a "bridge of volumes" might therefore be a humorous play on the Puteaux Cubist pre-

occupation with pictorial construction and the "relation of volumes" discussed by Le Fauconnier: he now connects such a pictorial bridge to a literal bridge over the Seine River, with its passenger boats (*bateaux-mouches*). Duchamp would use the phrase "a world in yellow" in several other *Large Glass* notes, perhaps because of the prevalence of ochre pigment in his paint formulas, for example, in his list of colors for various parts of the Munich *Bride* and his lists of the mixtures to be used for the metallic colors of the *Large Glass*.[54] As published in *A l'infinitif*, the listing for the *Bride* also includes a curious reference to "Bridge: Cypress burnt umber," raising the possibility that Duchamp's automobile-oriented Virgin/Bride (figs. 17, 50, 51) is associated in some way with his play on the bridge theme.[55]

Yet, just as Duchamp secularized the bridge of volumes by linking it to everyday life, he would add to the Bride's realm elements with precisely the mathematical or scientific associations Le Fauconnier had decried. For example, a "coefficient of displacement" figures importantly in Duchamp's schema for the Bride's role in the balancing act of the Juggler of Gravity or Handler of Gravity in the *Large Glass* (figs. 111, 112). Here the private world of sexual relations is given a mathematical coefficient, akin to Le Fauconnier's despised "coefficient of emotivity."[56] And in stark contrast to Le Fauconnier's description of the Cubist painter's "new inscription of forms and volumes," Duchamp would create a Top Inscription for the *Large Glass* associated with the cloud-like "cinematic blossoming" of the Bride (fig. 77).[57] Instead of the emotive manifestation of a Cubist painter's sensibility, this inscription functions as an image of the Bride's imagined orgasm as well as one of the practical vehicles for her communications to the Bachelors below. To produce the Top Inscription, Duchamp had originally hoped to imprint the form onto the glass photographically—replacing the self-expressive Bergsonian artistic act with a scientific, mechanical technique.[58]

Through his deep interest in science Duchamp had declared his allegiance to quantity versus quality, to intellect over intuition, to the world of Descartes versus that of Bergson and the Puteaux Cubists. Indeed, Duchamp described himself as a Cartesian in later interviews, associating the term with "an acceptance of all doubts . . . an opposition to unclear thinking." As he explained in a 1959 interview, in which he referred to himself as an "unfrocked Cartesian": "I was very pleased by the so-called pleasure of using Cartesianism as a form of thinking—logic and very close mathematical thinking. Yet I was also pleased with the idea of getting away from it."[59] The *Box of 1914* stands as another demonstration of Duchamp's rejection of

the painterly milieu of Puteaux Cubism in favor of the anti-Bergsonian realm of the intellect, the mechanical, and the ready-made. It is a veritable manifesto, paralleling the "painting of precision" and the "beauty of indifference" cultivated in his works of 1913–14.

New York, 1915: Execution of the *Large Glass* Begins

Upon arriving in New York in June 1915, Duchamp was met by Walter Pach and taken to the apartment of Walter and Louise Arensberg, where he lived for the first three months. The Arensbergs became his loyal patrons, and in exchange for the rent-free studio above their West 67th Street apartment, where Duchamp settled in 1916 (figs. 70, 118, 140), they ultimately acquired the *Large Glass*.[60] The Arensbergs' apartment would become a gathering point for members of the American avant-garde as well as a number of other wartime emigrés from France. These included Edgar Varèse, Jean and Yvonne Crotti, Albert and Juliette Gleizes, Henri-Pierre Roché, and Gabrielle Buffet and Picabia, who abandoned a military mission to Panama and Cuba when his ship docked in New York in June 1915.[61] In contrast to his position as a younger brother on the edge of the Puteaux circle in Paris, in New York Duchamp was a celebrity. As the painter whose *Nude Descending a Staircase (No. 2)* had scandalized conservative viewers of the 1913 Armory Show, Duchamp was good copy for American newspaper writers. More important, he now found himself at the center of the Arensberg salon and a group of "ready-made" American admirers.

In addition to Pach, the Americans who frequented the Arensberg apartment included Man Ray, John Covert, Morton Schamberg, Charles Sheeler, Charles Demuth, Joseph Stella, Marius de Zayas, Beatrice Wood, Katherine Dreier, Isadora Duncan, Alfred Kreymborg, Louise and Allen Norton, Carl Van Vechten, William Carlos Williams, and Wallace Stevens. With the exception of Picabia and, to some degree, Crotti, none of the Americans or Europeans shared Duchamp's creative involvement in science and technology, although they would certainly have been aware of popular science and of the technology changing their world. The one American artist who would subsequently respond to certain of Duchamp's interests, including the electromagnetic waves basic to optics and photography, was Man Ray.[62] On the whole, however, the intellectual focus of the Arensberg salon seems to have been linguistic games and punning—as well as chess—activities that, along with the optics of visible light, would assume increasing importance for Duchamp in years to come.[63] Nonetheless, the Arensberg circle was an eager

audience for Duchamp's pursuit of "scientific not sentimental" values in art—whether in the Readymades he now produced as public rather than private objects or in his painstaking, precise execution of the *Large Glass*.[64]

In the 1960s Duchamp recounted for Calvin Tomkins the beginning of his execution of the *Glass* in fall 1915, emphasizing his slow pace:

I bought two big plate-glass panes and started at the top, with the Bride. I worked at least a year on that. Then in 1916 or 1917 I worked on the bottom part, the Bachelors. It took so long because I could never work more than two hours a day. You see, it interested me but not enough to be *eager* to finish it. I'm lazy, don't forget that. Besides, I didn't have any intention to show or sell it at that time. I was just doing it, that was my life. And when I wanted to work on it I did, and other times I would go out and enjoy America. It was my first visit, remember, and I had to see America as much as I had to work on my *Glass*.[65]

Duchamp's comments tend to downplay the seriousness of the project, as he was wont to do in later interviews. Nonetheless, the great burst of intellectual excitement recorded in his notes was largely over by later 1915. Nearly all the major *ideas* for the *Large Glass*—Duchamp's professed primary concern in the project—had been worked out before his coming to New York, and, as he had told Tomkins earlier in the same interview, "From 1915 on I was just copying."[66] He echoed the same sentiment to Cabanne, explaining that he abandoned work on the *Large Glass* in 1923 because "it became so monotonous, it was just a transcription, and toward the end there was no invention."[67] Indeed, most of the invention that was to occur in New York involved technical questions of execution and not the conceptual program of the *Glass*.

Basic Iconography and Materials

Duchamp's 1913 measured drawing of the layout for the *Large Glass* (fig. 75) records both the key elements of the composition as conceived by that date and their carefully determined placement. With the exception of the Toboggan, the corkscrew form in the lower right corner, all these components appear in the *Large Glass* in its final form (pl. 1, figs. 76, 77). The Toboggan (no. 19), however, was not the only feature never translated from the original notes and drawings to the *Glass*. The placement of a number of other elements, including the important figure of the Juggler or Handler of Gravity (no. 10), was clarified by Duchamp only in a 1965 etching, *The Large Glass Completed*.[68] By that time the *Glass* had experienced a

final permutation: the two panels were broken during shipment by truck to Katherine Dreier's Connecticut home, following its inclusion in the Société Anonyme's "Brooklyn Exhibition." Duchamp reassembled the glass fragments during the summer of 1936, and the reconstituted panels were sandwiched between heavier panes of glass and mounted in the frame we see today.[69]

If the *Box of 1914* announced Duchamp's position as an artist concerned with ideas, the two subsequent boxes he published during his lifetime introduced, successively, the iconography and the formal, spatial aspects of the *Large Glass*. As a result, the notes in the *Green Box* have served as the primary source for discussions of the characters and basic operations of the *Large Glass*, while those in *A l'infinitif* have provided the clearest indication of Duchamp's concern with three- and four-dimensional spaces in the piece. An overview of present knowledge of these two aspects of the *Large Glass* provides a useful base from which to consider the *Glass* in relation to contemporary science and technology in the following chapters.

Duchamp made the selection of the notes for the *Green Box* of 1934 in the Surrealist milieu of Paris, with which he had become loosely associated after meeting André Breton in 1919 in the context of the Paris Dada activities that preceded the official emergence of Surrealism in 1924.[70] Breton, in his 1935 article "Phare de *La Mariée*," was the first major commentator on the iconography of the *Large Glass* set forth in the *Green Box*. With the exception of Tomkins, the authors of the other standard overviews of the operations of the *Large Glass* were either a part of the Surrealist milieu themselves (Marcel Jean, Robert Lebel) or shared its strong psychological orientation (Arturo Schwarz).[71] Their readings have focused on the basic psychosexual narrative that can be construed from the notes Duchamp chose to include in the *Green Box*.

Duchamp's dominant metaphor for the Bride (fig. 77, no. 1) in the *Green Box* notes is the automobile engine: she "basically is a motor."[72] Reduced to a "skeletal" state, the Bride hangs at the top of the *Glass* along with the Top Inscription/Milky Way (no. 2), the image of her "cinematic blossoming." Commands from the Bride, also referred to as *le Pendu femelle* (the female hanging person), the Sex Cylinder and, subsequently, the Wasp (figs. 105, 127), are transmitted to the Bachelors' realm below. Sent through the Air Current Pistons or Nets (no. 3) of the Top Inscription, these commands initiate a series of operations in the collection of objects known as the Bachelor Apparatus. The activity begins in the Nine Malic Molds (no. 11), which form the Cemetery of Uniforms and Liv-

eries, each Mold identified with a then-strictly masculine profession, such as Priest, Policeman, Undertaker, and Stationmaster (fig. 96). The "male-ish" (*malique*) Molds are further anthropomorphized by Duchamp's description of the "common horizontal plane" they share as the "plane of sex cutting them at the pnt. of sex."[73]

The Illuminating Gas collects in the Molds and these "gas castings" travel through the Capillary Tubes (no. 12) to the point where the tubes meet at the left side of the Sieves or Parasols (no. 13). There the Gas, having solidified during its journey through the tubes, is extruded in the form of "elemental rods," which break into "Spangles." Lighter than air, these Spangles rise and move through the semicircular structure of the Sieves (drawn by the never-executed Butterfly Pump [no. 18]), emerging as a "liquid elemental scattering." The Bachelors' liquid subsequently was to flow down the corkscrew-shaped Slopes of Flow (no. 19, the unexecuted Toboggan), where it would fall in a "Splash" that "ends the series of bachelor operations."[74]

According to the *Green Box* notes, however, from the base of the Toboggan the liquid was to have been projected upward through the Weight with Holes (not executed, no. 21), the Oculist Witnesses (no. 17), and a magnifying lens (no. 22), which is indicated in the *Large Glass* only by a circle.[75] Some portion of the Splash was to have activated the Boxing Match (not executed, no. 24), thereby "manoeuvering the handler of gravity" (no. 10; figs. 111, 112, respectively), who was to have "danced" on the Bride's Clothing at the horizon line (no. 5).[76] (That clothing is identified specifically with the three glass strips [fig. 88] or "isolating plates" of the Ribbed or Gilled Cooler [no. 6].) The primary destination of the Splashes is the area of the Nine Shots (no. 4) in the upper half of the *Glass*, which they reach by being "dazzled" though the silvery Oculist Witnesses and converted into a "Sculpture of Drops" (no. 9), which is "sent back mirrorically to the high part of the glass to meet the 9 shots" in the region of the Picture of Cast Shadows (no. 8).[77] This "mirrorical return" was to be accomplished with the aid of the "Wilson-Lincoln system" (no. 26), an optical effect that could transform one figure into another ("i.e. like the portraits which seen from the left show Wilson seen from the right show Lincoln—").[78] Duchamp referred to the degree to which each Splash or Shot was removed from its destination in a single point of the target as its "cote de distance," which has traditionally (and inaccurately) been translated as "coefficient of displacement."[79]

Accompanying (and seemingly stimulating) the production of the orgasmic liquid splash of the Malic Molds are the activities of the Chocolate Grinder (no. 14) and the

Chariot or Glider (no. 16) with its Water Mill Wheel (no. 16a). Sliding on rods free of friction because they are made of "emancipated metal," the Chariot/Glider moves back and forth, reciting its "litanies": "Slow life/Vicious Circle/Onanism/..." (fig. 156A).[80] It is the "litanies sung by the chariot" that are heard by the "gas castings" in the Malic Molds as they begin their journey through the Capillary Tubes and Sieves to the Slopes of Flow.[81] Atop the Chocolate Grinder's Bayonet perch the Scissors (nos. 14d, 14e), which open and close with the motion of the Chariot/Glider. That to-and-fro movement is actuated by the fall between the Chariot/Glider and the Chocolate Grinder of a Hook bearing a Weight (not executed; see figs. 111, 156C): "*It goes: a weight* falls and makes it go/*It comes:*...the glider resumes a little more slowly its first position, as it sends back in the air the *weight*."[82] Both the Hook and the Bottle(s) of Benedictine it carries as a Weight have the property of "oscillating density."[83]

Illustrating the Onanism referred to in the litanies, the Chocolate Grinder/Bachelor "grinds his chocolate himself—."[84] The destination of the chocolate product is never indicated by Duchamp, who says simply, "The chocolate of the rollers, *coming* from who knows where,/ Would deposit itself after grinding, as milk chocolate."[85] Apart from the Sculpture of Drops and the Nine Shots, no element from the Bachelor's domain ever enters the upper half of the *Large Glass*. Like the solitary Bachelors, the Bride remains isolated in the upper reaches of the *Glass*, in communication with the Bachelors, but untouched by them. Her "cinematic blossoming" is the result of imagination. As Duchamp told Schwarz, "The Bride's orgasm is purely intellectual, there is no physical contact, the physical relationship remains at the stage of intentions."[86]

Just as Duchamp recast his theme of sexual interaction in terms of biomechanical and mechanical players, the *Large Glass* became a kind of laboratory for experimentation with new kinds of non-art materials. Working on the back of large panes of glass, Duchamp used lead wire to "draw" the forms. Where paint was used within the wire outline, lead foil was applied to seal the paint in place.[87] Yet Duchamp was seeking alternatives to paint itself, or at least equivalents in paint for the appearance of various metals. In addition to lists of paint formulas for such metals as nickel, platinum, aluminum, and steel, *A l'infinitif* contains a number of notes speculating on the use of unorthodox materials, including toothpaste, cold cream, "soapy water + strong tea," and rust.[88] The best known of his experiments with new substances was the "raising of dust" for the Sieves, which involved allowing dust to gather on the glass for six months and then varnishing it in place (fig. 123).[89] The Oculist Witnesses are equally

free of paint: after that section of the glass had been commercially silvered, like a mirror, Duchamp painstakingly scraped away the unwanted areas of the design.[90]

In later interviews Duchamp celebrated the chance-generated, symmetrical cracking of the glass panels in 1927 as a "ready-made intention"—not his—that made the *Large Glass* "a hundred times better."[91] From the start, however, he had employed chance procedures and the "beauty of indifference" in this "painting of precision." A note in the *Green Box* lists certain of the impersonal, generative forces at work in the *Large Glass*:

Wind—for the air current pistons
Skill—for the holes
Weight—for the standard stops
 to be developed.[92]

Thus, the shapes of the Capillary Tubes are based on the chance falls of the threads of the *3 Standard Stoppages*, a motion produced by the pull of gravity. Similarly, the positions of the Nine Shots were determined by the nonartistic "skill" involved in shooting matchsticks dipped in paint from a toy cannon. In his quest for precision execution Duchamp then hired a glazier to drill a hole in the glass for each Shot, physically registering the pattern that had been determined by skill as well as chance.[93]

To determine the shapes of the three Air Current Pistons of the Top Inscription, Duchamp photographed small squares of *tulle* or net fluttering in the wind (fig. 120). At one stage he had speculated on the possibility of transferring the image of the Top Inscription to the glass surface by photographic means. Specifically, he considered having the upper region of the *Glass* coated with silver bromide (as if it were a photographic plate) and printing the image of the Top Inscription photographically.[94] Such a technique was typical of Duchamp's interest in "imprinting" and recording in the *Large Glass* (see chap. 8). In the end, however, he found it necessary to resort to paint for the images of the Top Inscription as well as the Bride. The photographic associations of the Bride were maintained, nonetheless, by using a scale of gray tonalities to replicate the look of a photograph: "The imitation of photography/make it noticeable in the Pendu femelle," he reminded himself in one of his notes.[95]

It is appropriate that the Bride stands as the element of the *Large Glass* most closely related to Duchamp's painting of 1912 and his Cubist origins, for his comments on space in the *A l'infinitif* notes reveal the radically different ways he thought of the upper and lower ranges of the *Large Glass*. If three-dimensional perspective reigns in

the Bachelor's realm, the Bride and her domain are meant to be four-dimensional. And although the Bride's organic origins were almost immediately supplemented with mechanical characteristics, her four-dimensional world embodies many of the qualities propounded in contemporary Cubist theory, including specifically Bergsonian elements, setting up a further unbridgeable distinction between upper and lower realms.

Space in the *Large Glass*: Perspective versus the Fourth Dimension

With one exception, Duchamp carefully excluded from the 1934 *Green Box* any notes referring to the fourth dimension.[96] Although one other note, entitled "Cast Shadows," which begins "*probably to relate to the notes on 4-dim'l perspective*," was published by Duchamp's friend Roberto Matta Echaurren in *Instead* in February 1948, the remainder of his notes addressing spatial concerns in the *Large Glass* were not made public until the appearance of *A l'infinitif* in 1966.[97] Before that date, in talking with interviewers and scholars about the role of perspective and the fourth dimension in the *Large Glass*, he had used only the most general terms. In the 1960s, however, a period of reaction against Abstract Expressionism that paralleled his anti-painterly mood of the pre–World War I years, Duchamp revealed the extent of his earlier involvement with geometry and perspective, though not without some hesitation about the quality of his mathematical knowledge, as noted earlier.[98]

Duchamp emphasized the importance of perspective in the *Large Glass* in his conversations with Cabanne:

Duchamp: The "Large Glass" constitutes a rehabilitation of perspective, which had then been completely ignored and disparaged. For me, perspective became absolutely scientific.
Cabanne: It was no longer realistic perspective.
Duchamp: No. It's a mathematical, scientific perspective.
Cabanne: Was it based on calculations?
Duchamp: Yes, and on dimensions. These were the important elements.[99]

He also summarized for Cabanne his final solution for evoking the fourth dimension in the upper half of the *Glass*:

Since I found that one could make a cast shadow from a three-dimensional thing, any object whatsoever—just as the projecting of the sun on the earth makes two dimensions—I thought that, by simple intellectual analogy, the fourth dimension could project an object of three dimensions, or,

to put it another way, any three-dimensional object, which we see dispassionately, is a projection of something four-dimensional, something we're not familiar with.

It was a bit of a sophism, but still it was possible. "The Bride" of the "Large Glass" was based on this, as if it were the projection of a four-dimensional object.[100]

Yet the idea of shadows or projections from higher dimensions was not the only approach Duchamp had considered. Before he returned to this theme—one of the most widely used in popular literature on the fourth dimension—he also investigated four-dimensional geometry and a number of more complex means to embody higher dimensions.[101] In addition, Duchamp was to use several other more philosophical associations of the fourth dimension, which allowed him to contrast the spaces of the upper and lower halves of the *Glass*.

The spatial distinction Duchamp wished to create between the Bride's and the Bachelors' realms is already apparent in the 1913 layout for the *Large Glass* (fig. 75). Duchamp's measured drawing of the lower section, set in a one-point-perspective scheme, creates a rational and ordered space, from which a three-dimensional model could be built.[102] By contrast, the skeletal indication of the Bride and the suggestion of the Milky Way (with its few numerical designations) exist in an unmeasured and, ultimately, immeasurable space. That distinction is further emphasized by Duchamp's inclusion in both the *Green Box* and *A l'infinitif* of a version of a note discussing the "principal forms, imperfect and freed" of the Bachelor Apparatus ("imperfect") and the Bride ("freed"):[103]

The *principal forms* of the bachelor machine are imperfect: rectangle, circle, parallelepiped, symmetrical handle, demi-sphere = i.e. they are mensurable (relation of their dimensions among themselves. and relation of these principal forms to their destination in the bachelor mach.)
In the bride, the *principal forms are more or less large or small*, have no longer in relation to their destination a mensurability: a sphere, in the bride will be of some radius or other (the radius given in the representation is fictitious and dotted.)[104]

Immeasurability was one of the ways Duchamp could suggest by association the four-dimensional nature of the Bride's realm. By the early twentieth century, the fourth dimension was often linked to infinity, functioning as the modern counterpart to the Romantic sublime.[105] It is this immeasurable fourth dimension that Apollinaire evokes in his 1913 *Les Peintres Cubistes* when he identifies the term with "space itself, the dimension of the infinite."[106] That

same year Boccioni, in his *Pittura scultura futuriste*, laid claim to the immeasurable for Futurism's expression of the fourth dimension as "a continuous projection of forces and forms intuited in their infinite unfolding," accusing the Cubists, by contrast, of having achieved only as "measured and finite" fourth dimension."[107]

Although Duchamp had originally considered "a long canvas, upright. Bride above—bachelors below" (fig. 81), he soon determined to use glass as the support medium for his composition of *The Bride Stripped Bare by Her Bachelors, Even*.[108] Interestingly, glass served Duchamp well for each of the contrasting spatial structures he wished to create. "Make a painting on glass so that it has neither front, nor back; neither top, nor bottom. (to serve probably as a *three-dimensional physical medium* in a 4-dimensional perspective)," he wrote in one of the notes published in 1980.[109] This freedom from orientation, particularly the sense of gravity, was another of the ideas associated with the fourth dimension in popular literature.[110] Glass allowed Duchamp to suspend the Bride and her Top Inscription in an indefinite space without clear orientation and without the earthbound quality of the Bachelors below. Yet at the same time, through its connections to Renaissance one-point perspective, glass had a long association with the very creation of such mensurated and gravity-filled worlds as that of the Bachelors.

Leonardo had declared in his notebooks, "Perspective is nothing else than seeing a place [or objects] behind a plane of glass, quite transparent, on the surface of which the objects behind that glass are to be drawn."[111] Indeed, given Duchamp's reference in a note to "the whole section on Perspective" of the catalogue of the Bibliothèque Sainte-Geneviève, he would have been aware of the use of such glass panels in the literature on perspective.[112] As Richard Hamilton has suggested, the lower half of the *Large Glass* "is an ideal demonstration of classical perspective, that is to say, the elements of the bachelor apparatus were first imagined as distributed on the floor behind the glass rather than as a composition on a two-dimensional surface."[113]

In addition to the ability of transparent glass "to give its maximum effectiveness to the rigidity of perspective" and to create an orientation-free space for the Bride, the medium was to serve several other important functions for Duchamp.[114] When Cabanne questioned Duchamp about his decision to use glass, his first response was that the idea came "through color," that is, the appeal of color seen from the other side of glass (as in his own glass palette) and the possibility of "sealing" color between glass and lead foil to retain its purity. He also noted that working on glass represented another means to escape

focus on the hand of the artist: oil paint seen behind glass offered a counterpart to his dry drawing style.[115] Walter Pach later asserted that Duchamp had adopted glass "in order to orient his work in the direction of pure idea."[116] And Duchamp was not alone in his interest in glass: Kupka had also speculated on the possibility of painting on transparent material in his notebook of 1910–11.[117]

In response to Cabanne's query "The glass has no other significance?" Duchamp responded, "No, no, none at all."[118] His notes—in the *Green Box* and *A l'infinitif*—belie this denial, however. Glass cases or containers are a recurrent element in the notes and were to be significant in his thinking about the *Large Glass*. If the *Green Box* note speculating on a project he described as "*Painting or Sculpture*. "Flat container. in glass—[holding] all sorts of liquids. Colored pieces of wood, of iron, chemical reactions. Shake the container and look through it" reflects in part his new conception of color as a depersonalized chemical formula to be seen through glass, other glass-related notes are more specifically related to the spatial concerns of the *Large Glass* and even to the genesis of its basic structure, as will be seen.[119] Those notes first appeared in *A l'infinitif*, but already in the *Green Box* Duchamp had declared, "Put the whole bride under a glass cover, or in a transparent cage."[120]

Returning again to Duchamp's spatial concerns in the *Large Glass*, it is clear from his notes that the possible four-dimensional associations of glass extended beyond the creation of a work with "neither front, nor back; neither top, nor bottom."[121] When used in conjunction with mirrors, glass might also produce a visual illusion of four-dimensional space. "Use transparent glass and mirror for perspective⁴ [i.e., four-dimensional perspective]," begins one of the notes included in *A l'infinitif*, extending perspective beyond the limits of three dimensions.[122] Before developing the visual possibilities of glass and mirrors fully, however, he explored the idea of four-dimensional perspective primarily in terms of perception through touch. These speculations, included in the sections of *A l'infinitif* entitled "Perspective" and "The Continuum," seem to be an outgrowth of Cubist concern with Poincaré's ideas on the role of tactile and motor spaces in the perception of higher dimensions.[123] They are generally characterized by a physical orientation toward tactility and involve a mobile, "'*tactile exploration*,' *3-dim'l wandering* by an ordinary eye" as a means toward "an imaginative reconstruction of the numerous 4-dim'l bodies."[124]

From his Cubist-oriented theorizing, Duchamp moved on to more complex ruminations on the laws of four-dimensional geometry and analogical suppositions about

such operations as rotation in four dimensions. In the Puteaux circle, Metzinger and Gris were originally the primary students of geometry (having studied for a time with the actuary Princet), but Duchamp soon outdistanced them, becoming the only modern artist of that period to study the propositions of four-dimensional geometry.[125] His enthusiasm for the subject is graphically documented by the number and variety of notes on the fourth dimension in *A l'infinitif* and by Gertrude Stein's 1913 description of Duchamp, whom she had just met, as a young man who talks "very urgently about the fourth dimension."[126] Yet rarely do Duchamp's notes on the principles of four-dimensional geometry simply reiterate the geometrical principles he had read.[127] Instead, they are often personal variations on such axioms, embellished by his simultaneous speculation on the nature of four-dimensional vision.[128]

As he sought to come to terms with four-dimensional geometry, Duchamp, like others before him, considered the generation of four-dimensional objects both by the motion of a three-dimensional object off into a perpendicular fourth direction (an extension of his "elemental parallelism") and by rotation; he also explored standard approaches to the study of higher dimensional objects— using cuts or sections as well as projections or shadows. Duchamp seems to have been particularly interested in the notion of a geometric hinge (such as a line around which a plane might rotate) and the way its four-dimensional counterpart (rotation around a plane) might work.[129] Indeed, the one note relating to to the fourth dimension that Duchamp included in the *Green Box* explored the issue of generational rotation in the fourth dimension and the way the resultant figure would escape the traditional left/right relationship with the axis.[130]

Duchamp had also speculated in another note in the *Green Box*:

Perhaps make a *hinge picture*. (folding yardstick, book....) develop the *principle of the hinge* in the displacements 1st in the plane and 2nd in space.
Find an *automatic description* of the hinge.
Perhaps introduce it in the Pendu femelle.[131]

That idea would find its most direct fulfillment in his semicircular glass panel of 1913–15, *Glider Containing a Water Mill (in Neighboring Metals)* (fig. 151), which rotates through space on a vertical hinge at its edge. However, Duchamp also incorporated the "folding yardstick" in his fanlike drawing illustrating the "Wilson-Lincoln system," the optical "hinge" through which the Sculpture of Drops was to be projected upward, into the fourth dimension.[132]

Before focusing on hinges and the related notion of mirror reversals as signs of four-dimensionality, he had explored other aspects of four-dimensional geometry. One of his sources was E. Jouffret's 1903 *Traité élémentaire de géométrie à quatre dimensions*, which he cites in a note on the subject of projected shadows, the idea to which he would ultimately return in the *Large Glass*. Duchamp also explored the topological notion of "cuts" as a means of determining dimensionality, following Poincaré's definitions of an *n*-dimensional continuum as that which can be cut completely by a continuum of $n - 1$ dimensions (that is, a three-dimensional space is cut completely by a two-dimensional plane). Blending his own interest in "elemental parallelism" and Poincaré's analysis of Dedekind cuts, he considered the possibility of generating a four-dimensional continuum by repeating the virtual images of an object off into a new, fourth direction. In a typical note, he explains,

Also, the 4-dim'l continuum: Poincaré's explanation about n-dim'l continuums by means of the [Dedekind] cut of the n-1 continuum is not in error. It is on the contrary confirmed and it is by even basing oneself on this explanation that one can justify the name of 4th dimension given to this continuum of virtual images in which the [Dedekind] cut could only be obtained by means of the 3-dim'l prototype object considered in its *geometric infinity*.[133]

Four-dimensional geometry had led Duchamp to virtual images, which in turn led him to explore the idea of virtuality and its connections with a concrete object, the mirror: "Virtuality as 4th dimension. Not the Reality in its sensorial appearance, but the virtual representation of a volume (analogous to the reflection in a mirror)."[134] Although Duchamp had noted the possibility of using "transparent glass and mirror for perspective⁴," it was only in the context of virtual images that he developed the possibilities of mirror space. In his view the space of a mirror offered a way to approximate the four-dimensional continuum's seeming reduction of a line, for example, to the status of a point.[135]

Mirrors had a long association with the fourth dimension in popular literature, especially with regard to the problem of three-dimensional symmetry. Immanuel Kant had noted that only a mirror can transform a right hand into a left hand; later writers interested in a fourth dimension of space, such as Lewis Carroll and H. G. Wells, believed that such a transformation necessarily implied the passage of the three-dimensional object through four-dimensional space.[136] Duchamp's transparent, hinged panel, *Glider Containing a Water Mill*, offered a three-dimensional analogue to this process of rotation, present-

ing mirror-reversed images of its front and back, albeit with some difference in appearance owing to Duchamp's materials. Similarly, his 1918 study for the *Large Glass*, *To Be Looked At (from the Other Side of the Glass) with One Eye, Close to, for Almost an Hour* (fig. 171), instructs the viewer to observe the mirror-reversed image on the back of the work.

Duchamp planned to include such a mirror reversal in the *Large Glass*: the Splash was to be projected upward becoming the Sculpture of Drops, its mirror image. Yet, while Duchamp's notes could posit the "mirrorical return" of the Splash through the fourth dimension, when it came to the actual execution of the Bride and her realm on the *Glass*, his ideas about virtuality and mirrors were too complex to be executed successfully.[137] Instead, he chose a simpler interpretation of the mirror as a two-dimensional "mold" of an object, a mold with three virtual dimensions.[138] In order to add a fourth dimension to his two-dimensional "mirror" with three virtual dimensions, Duchamp returned to the idea of shadows, discussed by Jouffret and others: "*The shadow* cast by a 4-dim'l figure on our space is a *3-dim'l* shadow (see Jouffret 'Géom. à 4 dim.' page 186, last 3 lines.)"[139] Thus, the Bride is like the image in a mirror or photograph of a three-dimensional Bride, understood to be the shadow or projection of a four-dimensional Bride.

What did it mean for Duchamp to undertake a serious study of four-dimensional (and non-Euclidean) geometries and perspective in late 1912?[140] When he first encountered members of the Gleizes-Metzinger circle in fall 1911, there was still a good deal of interest in the geometrical and mathematical associations of the fourth dimension. Metzinger's fall 1910 "Note sur la peinture," for example, had asserted that Picasso had created "a free, mobile perspective from which the ingenious Maurice Princet has deduced an entire geometry."[141] Princet was seen as a figure who could contribute to Cubist theory, and Duchamp later remembered that Metzinger, who was "studying" with Princet, "bamboozled us with all his quotations."[142] Similarly, Le Fauconnier's September 1910 essay, "Das Kunstwerk," had described Cubist painting in terms of "quadratic and cubic equations" and "numerical quantities."[143]

Yet, by fall 1912 Cubist theory had taken a distinctly Bergsonian turn, as demonstrated by Gleizes and Metzinger's *Du Cubisme* and by Le Fauconnier's "La Sensibilité moderne et le tableau." Although in *Du Cubisme* the authors do mention non-Euclidean geometry to support their belief in the legitimacy of deforming figures, they are, on the whole, antigeometrical and antimathematical in their stance.[144] The Cubist painter "changes quantity

into quality," they assert. "Geometry is a science, painting is an art. The geometer measures, the painter savors."[145] Similarly, Le Fauconnier's fall 1912 discussion of the "modern sensibility," noted in the discussion of Duchamp's *Box of 1914* above, had decried mathematical "coefficients" as well as perspective, a spatial technique definitively rejected by the Cubists as well.[146] Indeed, as Mark Antliff has observed, the Cubist theory set forth in *Du Cubisme* established a Bergsonian dichotomy setting "scientific, quantitative space—identified with traditional perspective—against an artistic, qualitative treatment of space, which the Cubists associate[d] with the ordering of space in a nonquantifiable manner."[147]

For Duchamp to take up a serious study of four-dimensional geometry and perspective was therefore to go directly against Puteaux Cubist ideas about the proper approach to the fourth dimension and to pictorial space, just as he would subsequently challenge Cubist ideas about taste with the anti-Bergsonian Readymades. According to Gleizes and Metzinger, "The diversity of the relations of line to line must be indefinite; on this condition it incorporates quality, the unmeasurable sum of the affinities perceived between that which we discern and that which already existed within us; on this condition a work of art moves us."[148] Such Bergsonian talk of immeasurability was undoubtedly one of the sources for the language Duchamp adopted in certain discussions of the Bride's realm, as we have seen. And, in fact, on one level, one can read the upper and lower halves of the *Large Glass* as representing an ironic commentary on the archetypal Bergsonian distinction between quality and quantity, the immeasurable and the measurable.[149]

In the end, however, neither realm was to be absolutely pure or free of elements characterizing the other. In the Bride's domain, for example, Duchamp's exploration of four-dimensional geometry distanced his conception of four-dimensional space from the Cubists' increasingly nongeometric, almost mystical approach to higher dimensionality. Even more overtly subversive was his inclusion of mechanical aspects in the character of the Bride, from the automobile to a "clockwork box" and a variety of other connections to scientific equipment (see chaps. 7–9).[150] Although by contaminating her pure, organic internality with external, mechanical elements Duchamp might have created the conditions for humor as defined by Bergson, he does not seem to have seen the Bride herself as a laughable figure.[151] He instead appears to have sought a subtle blending of organic and mechanical characteristics in this figure as he developed her many personae.

The Bachelors, by contrast, are the tragicomic figures, the ones who dream of transcending their measured, finite, earthbound realm. And, indeed, they do experience momentary glimpses of infinity and four-dimensionality. The journey of the "gas castings" and the attempt of the Splash to escape the gravity of the lower realm may well be Duchamp's wry commentary on contemporary discussions of the process for acquiring higher dimensional consciousness, that is, the mystical route to the fourth dimension.[152] As they exit from the Capillary Tubes, the gas castings, after the "phenomenon of stretching," have become "unequal *spangles. lighter than air.*"[153] Duchamp then anthropomorphizes the Spangles further:

As in a Derby, the spangles pass through the parasols A [first],C D.E F . . . B [last]. and as they gradually arrive at D,E,F, . . . etc. they are *straightened out* i.e. they lose their sense of up and down ([more precise term]).—The group of these parasols form a sort of *labyrinth of the 3 directions.*— The spangles dazed by this progressive turning. imperceptibly lose [*provisionally* they will find it again later] their *designation* of left, right, up, down, etc, lose their awareness of position.
The parasols. thus *straighten out* the spangles which, on leaving the tubes were free and wished to rise. . . .
to the point that: necessarily there is a change of condition in the spangles. They can no longer *retain their individuality* and they all *join* together after B [last Parasol].[154]

Duchamp's talk of the Spangles' loss of orientation derives from the language of mystically oriented discussions of the fourth dimension common by the end of the nineteenth century. One of the first proponents of what I have elsewhere termed "hyperspace philosophy," the Englishman Charles Howard Hinton, made this very argument: an individual must first "cast out the self," leaving behind the perceptual sense of left and right, particularly that of gravity (up and down), in order to "educate the 'space sense'" to new dimensions.[155] Hinton's ideas were themselves rooted in accounts of mystical experience, and Duchamp's final comment about the Spangles losing their individuality and joining into a unity suggests the mystically oriented philosophy of "Unanisme," propounded by Jules Romains, a friend of the Puteaux Cubists.[156] Subsequently, like star-struck mystics, the Spangles in the form of the Splash are "dazzl[ed]" upward by the Oculist Witnesses.[157]

Given his perceptually oriented approach to four-dimensional geometry, Duchamp was genuinely interested in the way traditional notions of left and right would be lost in the four-dimensional continuum. As he explained in the one note on the fourth dimension he chose to include in the *Green Box*, "The right and the left are

obtained by letting trail behind you a tinge of *persistence in the situation*. This symmetrical fashioning of the *situation distributed* on each side of the vertical axis is of practical value (as right different from left) only as a residue of experiences on fixed exterior points."[158] Nonetheless, Duchamp saw this as a geometric, perceptual problem, not as a step toward higher consciousness. Mystical transcendence was not to be realized in the *Large Glass*: when the Splash finally ascends in the form of the Nine Shots, the Shots fail to collapse into a single point on the target in the fourth dimension. Their "demultiplication" is one more sign of the insuperable dimensional gap between the Bride and Bachelors.[159]

Duchamp considered "Wind," "Skill," and "Weight" to be three key generational principles for the *Large Glass*; the gravity embodied in weight is the overriding issue, the element that can never be overcome by the Bachelors.[160] Since the fourth dimension was associated with freedom from gravity, the relationship of the Bride and the Bachelors to gravity defines in part their situation in the *Glass*. The earthbound, three-dimensional Bachelor Apparatus operates according to its principles. Even though the

"emancipated metal" of the Chariot/Glider's runners frees it from "all gravity in the horizontal plane," its action is controlled by gravity: "*a weight* falls and makes it go."[161] The Bride, by contrast, "does not need to satisfy the laws of weighted balance."[162] Indeed, in one of the notes first published in 1980 Duchamp wrote, "The picture in general is only a series of variations on 'the law of gravity.'"[163] And it is a Juggler/Handler of Gravity who serves as the intermediary between the three- and the four-dimensional realms.

Beyond its symbolic role as the opposite of four-dimensional freedom, gravity for Duchamp became a central theme in his Playful Physics. To a "principle of gravity," for example, he opposed a "principle of *anti*? gravity," complete with a "center of distraction" instead of attraction.[164] Duchamp's humorous play on the laws of gravity responded both to traditional mechanics and to developments in contemporary science and technology (e.g., fig. 160). Turning to an examination of the scientific and technological content of the body of *Large Glass* notes as a whole, it is clear that Duchamp more than fulfilled the prophecy of his intellectual intent set forth in the *Box of 1914*.

Chapter 7

First Conceptions of the Bride and Her Interaction with the Bachelors

As background, perhaps: An electric fete recalling the decorative lighting of Magic City or Luna Park, or the Pier Pavilion at Herne Bay.—garlands of lights against a black background (or background of the sea. Prussian blue and sepia)/Arc lamps.—Figuratively a fireworks—In short, a magical (distant) back drop in front of which is presented.... *the agricultural instrument*—[7]

Late in his life, when Duchamp discussed the origins of the Bride of the *Large Glass*, he sometimes mentioned the booths at country fairs "where you have the wedding scene and you have big balls that you throw at the heads of the bride, the bridegroom, and the guests...."[1] Indeed, popular entertainment was one of Duchamp's sources for the *Large Glass*—from his discussion in the *Box of 1914* of a carnival barrel game as a "'sculpture' of skill"[2] to the Toboggan component of the Bachelor Apparatus, based on the Grand Toboggan slide that accompanied the Grand Roue, or ferris wheel, at the 1900 Exposition Universelle in Paris.[3] Two of the notes published in 1980 refer specifically to the Neuilly Fair, then "the most popular Parisian fair of the year."[4] A note headed "Weights," which discusses the Bottles of Benedictine, begins with a drawing labeled "Neuilly Fair—test your strength." A second note (fig. 110) includes a drawing of the Bride and the Juggler/Handler of Gravity showing "transparent paper filaments alternately blossoming out from the 'Hanged' to the juggler's ball and coming back again like certain party whistles from the fair in Neuilly."[5] Although the Juggler/Handler of Gravity functions on a number of levels in the *Large Glass*, Duchamp's use of the term *jongleur* reveals his association with popular entertainers;[6] as such the Juggler of Gravity joins, but considerably alters, the long line of circus performers who provided imagery for painters from Seurat to Picasso.

Among the 1980 notes are also two notes that connect the setting of the events in the *Large Glass* to amusement parks far more spectacular than the Neuilly Fair. The more complete of the two includes an illustrated clipping of the Grand Pier Pavilion (fig. 80), which Duchamp had visited during his stay at Herne Bay, England, with his sister Yvonne during August and early September 1913. Devoted largely to technical issues of execution and documenting Duchamp's decision that "the picture will be executed on two large sheets of glass about 1,30 m × 1,40/one above the other (demountable)," the note begins:

The Theme of Collision: From Popular Culture to Science and Beyond

Typically for Duchamp, a number of other issues are raised in the notes cited here in relation to popular culture. For example, virtually all Duchamp's thoughts on the Juggler/Handler of Gravity are connected to principles of physics, such as center of gravity and equilibrium; in the case of the Herne Bay–Luna Park notes, his concern with lighting links these notes to the phenomenon of illuminated gas tubes (see chap. 8). In fact, Duchamp seems to have appreciated these entertainment themes, including the ballistic notion of throwing balls at a bride figure in a fair booth, as analogues to events in science and technology.

Duchamp's first conception of *The Bride Stripped Bare by Her Bachelors* in his 1912 Munich drawing (fig. 31) had presented a similarly aggressive situation, very likely rooted in the alchemical imagery of stripping and purifying metals before they are symbolically united as bride and groom. Yet, as has been suggested, the imagery is recast in a mechanomorphic form language related not only to new technological forms but generally to chemistry and physics and, perhaps specifically, to the high-speed electrons and radioactive particles so often described in terms of speeding projectiles and bombardment. Also, as noted earlier, in 1911 the ballistic theme had been given new currency in science in the context of Ernest Rutherford's experiments with alpha particles, as he attempted to determine the inner structure of the atom, experiments that ultimately led to his confirmation of the existence of a nucleus within the atom.[8] Finally, collisions were also a central aspect of the behavior of molecules as described by the kinetic-molecular theory of gases, and molecules would likewise come into play in the Bachelor Apparatus (see chap. 10).

The theme of collision between the Bride and the Bachelors and their respective worlds recurs in Duchamp's notes and finds further expression in the "blows" of the Combat Marble of the Boxing Match as

well as in the impact of the Nine Shots in the upper half of the *Glass*.[9] Moreover, Duchamp's various uses of the term *collision* demonstrate how his penchant for analogies constantly produced overlays from one discipline to another in the notes and imagery of the *Large Glass*. The most prominent reference to collision occurs in one of two versions of the *Green Box* note headed "Preface" or "Notice," from which he would derive the title of his 1946–66 assemblage, *Etant donnés: 1. la chute d'eau, 2. le gaz d'éclairage* (fig. 183). Functioning as a preface or foreword to Duchamp's notes for the *Glass*, the text establishes the centrality of the collision theme:

Notice
Given: [*in the dark*] I. the waterfall
If, given 2. the illuminating gas, *in the dark,*

 consider considerations
we shall determine (the conditions for) the extra-rapid

organization allegorical Reproduction
exposition (= allegorical appearance) of several
[assaults]
collisions seeming strictly to succeed

 unnecessary
each other *according to certain laws, in order to*
isolate the *Sign of the accordance* between this
extra-rapid exposition (capable of all the
eccentricities) *on the one hand* and the choice of the possibilities authorized by these laws *on the other.*

Algebraic comparison
a a being the exception
b̄ b " the possibilities
 the ratio $\frac{a}{b}$ is in no way given by a

number c $\frac{a}{b}$ = c but by the sign (–) which separates

a and b; as soon as a and b are being "*known*" they become
new units and lose their relative
numerical value (or in duration);
the sign of ratio—which separated them remains (*sign of the accordance* or rather *of......look for it*)[10]

Most commentators discussing this note have focused simply on its allusion to photography through use of the terms "extra-rapid" and "in the dark." Yet, it was no ordinary photography to which Duchamp referred. Instead, his use of "extra-rapid" and his choice of the phrase "instantaneous state of Rest" in the version of the note headed "Preface" point to an interest in the newest high-speed "instantaneous electric-

spark photography."[11] As Jean Clair has suggested, A. M. Worthington's "instantaneous photographs," especially his 1908 collection of such images, *A Study of Splashes* (fig. 147), are relevant to the content of Duchamp's notes and to the theme of splashes in the *Large Glass*.[12] A precursor of Harold Edgerton's stroboscopic images, Worthington's photographs registered previously invisible phenomena, just as certain of Duchamp's paintings and drawings of late 1911 and 1912 had attempted to do.

Worthington's method had been adopted by C. T. R. Wilson to produce his cloud-chamber photographs (figs. 145, 146; see chaps. 2, 10). Unlike Worthington's photographs, however, Wilson's extra-rapid photographs related directly to the theme of collision: they served as documentation for Rutherford's investigations of the behavior of subatomic particles.[13] And, indeed, if Duchamp's Preface and Notice notes begin like geometrical proofs (i.e., "Given..."), the main portions of the notes seem modeled after contemporary scientific writing on atom theory by figures like Rutherford and Jean Perrin.

Rutherford's presentation of his work on the collision of alpha particles with foils of various metals would have offered a prototype for Duchamp's role playing as a laboratory scientist setting up the conditions for an experimental procedure. In a May 1911 article entitled "The Scattering of α and ß Particles by Matter and the Structure of the Atom," for example, Rutherford proposed: "We shall first examine theoretically the single encounters with an atom of single structure...and then compare the deductions from the theory with the experimental data available." On the basis of numerous algebraic formulas and data introduced into those equations, he is then able to posit "laws of scattering" and a "law of distribution."[14] Not yet relying on Wilson's photographs at this date, Rutherford was nevertheless working "in the dark" (to use Duchamp's phrase), employing the scintillation method of counting alpha particles to monitor their behavior.[15] Like Rutherford, Duchamp speaks of "certain laws" and, further replicating the look of a scientific paper in the Notice note, recasts his thesis in algebraic language. The notion of scattering, which appears in Rutherford's title and repeatedly in his text (in references to "single scattering" and "compound scattering"), also attracted Duchamp, who introduced the idea of a "liquid elemental scattering" to describe the state of the Spangles upon exiting the Sieves.[16] Perrin, too, was concerned with the issue of scattering, and his work offers additional striking parallels to the language of Duchamp's Preface and Notice notes, among others.[17]

Beyond the subatomic world of scattering particles and the mundane world of fairground mannequins, the theme of collision in the *Large Glass* also points to broader philosophical, and even pseudoreligious, levels of meaning. The first hints of this content, discussed more fully in chapter 12, arise from a reconsideration of Duchamp's Jura-Paris Road project of winter 1912 in relation to the *Large Glass*. In one of the notes for that never-executed project, Duchamp asserts: "The Jura-Paris road, on one side, the 5 nudes one the chief, on another side, are the two terms of the collision. The collision is the raison d'être of the picture."[18] In light of the discussion of the contrast between the finite realm of the Bachelors and the association of the Bride's immeasurable, four-dimensional domain with infinity, it is now possible to detect a closer relationship between the Jura-Paris project and the *Large Glass*. For Duchamp, the Jura-Paris Road sets up a contrast (i.e., collision) between the road itself, which he associates at its extension with "infinity" or the "pure geometrical line without thickness," and the 5 nudes (probably based on the travelers in the car), who foreshadow the finite, three-dimensional realm of the Bachelors.[19] As in the *Large Glass* there is an inevitable clash or collision between the three-dimensional world of the Bachelors and the four-dimensional realm of the Bride.

The relation of finite and infinite in the Jura-Paris Road, however, is less clear-cut than in the *Large Glass*. The Jura-Paris road is not purely infinite: at its beginning "in the chief of the 5 nudes" (i.e., the *physical* space occupied by the car and its inhabitants) "it will be finite in width, thickness, etc., in order little by little, to become without topological form in coming close to this ideal straight line."[20] If in its extension toward infinity, the Jura-Paris road becomes the counterpart to the four-dimensional space of the upper half of the *Large Glass*, an "opening toward the infinite" is provided by the "headlight child," whom Duchamp identifies as the "instrument conquering this Jura-Paris road."[21] As a mediator between finite and infinite, the headlight child is also described by Duchamp as "the divine blossoming of this machine-mother" and "the child-God, rather like the primitives' Jesus."[22] That role of mediator/intercessor between three and four dimensions, between finite and infinite, was to be filled in the *Large Glass* by the Juggler/Handler of Gravity.

The greatest change between the Jura-Paris Road project and the *Large Glass* occurred in the role of the Virgin/Bride, who in the earlier project is identified solely with the automobile in which the nudes travel (including all the sexual implications suggested by their presence

within the machine). This is the entirely human Mary as Virgin and Bride, unlike the "divinité-mariée" (married divinity) of the *Large Glass*, who—despite her mechanical elements—partakes of the qualities of her spatial realm and is characterized by immeasurability and freedom from gravity.[23] In the *Large Glass* the Virgin/Bride is beyond the reach of the "humain célibataire" (celibate human): "Always to contrast the married divinity to the celibate human," Duchamp reminded himself in one of his posthumously published notes.[24] In the Jura-Paris Road project, by contrast, the collision leads to a "victory obtained little by little by the 5 nudes over the Jura-Paris road."[25] The "bachelors"/5 nudes are actually ensconced in the Virgin/"machine-mother" and, with the aid of the headlight child, succeed in the "conquest by speed of this Jura-Paris road," leading to infinity.

When Duchamp writes that the 5 nudes "will have to lose, in the picture, the character of multiplicity" (suggesting their link to the Spangles of Illuminating Gas who lose their individuality), the tone is one of assured success for these night travelers between Paris and the Jura Mountains.[26] Unlike the 5 nudes, however, even when the Spangles of the *Large Glass* experience a prelude to four-dimensional consciousness as they lose their sense of direction and their individuality in traversing the Sieves, they are not assured transit to infinity. Instead of successful conquest, the theme of the *Large Glass* is the frustrated collision between two realms: the "gas castings," according to Duchamp, "will never be able to *pass beyond the Mask*."[27] In this light, it is clearer why Duchamp associated the drawing *To Have the Apprentice in the Sun* (see the drawing in fig. 79) with the "Improvement of the [illuminating] gas to the slopes" and considered using it "as a '*Commentary*' on the section Slopes [Slopes of Flow]."[28] Here was a mechanical analogue to the Jura-Paris passenger-filled automobile, that is, a bicycle and rider, traversing a geometric "ideal straight line"—an image that could stand as the victorious counterpart to the frustrated quest for improvement to infinity and four-dimensionality by the Illuminating Gas of the Bachelor Apparatus.

The juxtaposition of Duchamp's Jura-Paris Road project and his subsequent notes for the *Large Glass* documents the increasing complexity of his ideas as he conceptualized the operations of the *Glass*. The metaphor of the Bride's desire for orgasm as "a motor car, climbing a slope in low gear" and other of her automobile-like characteristics remain, but she (and the Bachelors) acquire many other identities drawn from science and technology.[29] For example, the premises for the *Large Glass* given in Duchamp's Preface or Notice, quoted

above, are a waterfall and illuminating gas, elements closely tied to the fields of electricity and electromagnetism (figs. 99, 100). And, just as the idea of collision expressed in that note could be given religious overtones in the Jura-Paris Road project, the language of science and technology would lend itself to the description of a specific encounter between Bride and Bachelors and to a recasting of certain religious and mythological themes in Western thought.

The fields of science and technology offered Duchamp a new vocabulary of words, images, and operations with which to comment on bodily processes (especially sex) and spiritual experience (religion and myth). As in the case of Roussel, in particular, Duchamp's awareness of science and technology multiplied, almost exponentially, the possibilities for inventive wordplay and visual punning both in the notes and the *Glass*. In this fluid realm of Playful Physics, chemistry, and technology, Duchamp freely layered meaning over meaning, moving readily from fairground to science laboratory to mythic realms. To rediscover even a portion of the scientific and technological content of the *Large Glass* brings us closer to the rich complexity of Duchamp's thinking as he prepared the major work of his career.

The Bride as Automobile

Duchamp's longest continuous note (comprising ten pages) sets forth his first ideas about the functioning of the Bride in the context of the *Large Glass*, based on the mechanics of the automobile.[30] Derived from the machine-mother of the Jura-Paris Road notes, Duchamp's initial conception of the Bride also carried over her associations with the Virgin Mary, as the sketch included in this long note (fig. 81) suggests. Duchamp describes the composition as follows:

Graphic arrangement
 a long canvas, upright.
 Bride above—
 bachelors below.

 The bach. serving as an
architectonic base for the bride
The latter becomes a sort of
apotheosis of virginity.
 —steam engine
 on a masonry substructure
 on this brick base. a solid foundation,
the bachelor-machine fat
lubricious—(to develop.)

Duchamp's drawing presents in initial terms the collision that was to be basic to the *Large Glass*: that of the etherial realm of the Virgin/Bride, evoked by her costume and by the play on the tradition of airborne holy figures in the phrase "apotheosis of virginity," and the solid masonry structure initially anchoring the Bachelor Apparatus in the three-dimensional realm of gravity.

Yet the language of the note accompanying this sketch makes clear that the suggestion of a traditionally robed Virgin Mary was only shorthand for the Bride-as-automobile, whose persona Duchamp was in the process of developing. Although a denizen of a four-dimensional realm, the Bride as set forth in these notes has a strongly physical, mechanical presence based on Duchamp's response to technological forms during his Munich stay of summer 1912 and his Jura-Paris Road project. As Duchamp later told an interviewer, "The Bride is a sort of invention of a bride of my own, a new human being half robot and half four-dimensional."[31] His reference here to a robot points up another initial source for the Bride: the automatons that had so fascinated French thinkers from Descartes to Villiers de l'Isle-Adam, in *L'Eve future* of 1886. Indeed, the transformation of the tradition of the clockwork automaton at the hands of Villiers was to provide Duchamp yet another theme of contrast between the upper and lower realms of the *Large Glass*.

The publication of Duchamp's remaining notes in 1980 makes it possible to identify certain components of the Bride whose placement could not be determined on the basis of known drawings (e.g., those chosen for the *Green Box*; figs. 105, 127). A conflation of Duchamp's published drawings and the sketches in *Marcel Duchamp: Notes* proposes the location of various elements of the Bride (fig. 82), indicating sources for each term. In this scheme, most of the specifically mechanical, automobile-oriented elements of the Bride as she appears in the *Glass* inhabit the left half of the image, which contains the "Desire-gear," the "Reservoir of love gasoline" and, seemingly, the "Motor with quite feeble cylinders."[32] Indeed, if figure 82 is turned ninety degrees to the right, like the *Virgin (No. 1)* drawing (fig. 51), the Bride's "Motor" and "Reservoir of love gasoline" approximate the location of these elements in the Renault diagram (fig. 50). Further, this identification may clarify the nature of the narrow, vertically striped form to the left of the superimposed "12" (fig. 82), an element that had first appeared in the *Bride* painting and recurs in the *Large Glass*. Given the practice of applying several stripes to the sides of Renault hoods in this period, the form in question may signify the hood over the motor—executed in the "mossy metal" Duchamp had noted as an aspect of his summer 1912 drawings.[33]

In contrast to these primarily automobile-oriented elements, the *arbre type*, or tree type, at the right, which had been pictured as the rod of a transmission shaft in the *Virgin (No. 1)* drawing, had already returned to a more organic, visceral image for Duchamp's *Bride* painting of summer 1912 and would evolve further, acquiring new, nonautomotive associations in Duchamp's subsequent notes. Nonetheless, in the *Large Glass* the *arbre type* as "spinal column" or a collection of tubular internal organs continued to serve its mechanical function as a transmission shaft, described by Duchamp as having "its roots in the desire-gears," as does an *arbre de transmission* (figs. 50, 51).[34] A further technological-organic overlay occurs with Duchamp's identification of the inverted, conically shaped "swelling" of the shaft of the *arbre* as a mechanical-looking "Sex Cylinder" (fig. 105).[35] The other major automobile component located on the *arbre type* (below the Sex Cylinder) is the Bride's "Desire-magneto," an element Duchamp added to his automobile model in its second phase and that would be central to the Bride's functioning in both her automobile and wireless telegraphy modes.[36]

From the first several pages of Duchamp's ten-page *Green Box* note, it appears that initially he conceived both the upper and lower halves of the *Large Glass* in terms of the automobile, at the beginning of the note attributing to the Bachelor Machine "tormented gearing" and a "desire-part [which] then alters its mechanical state—which from steam then passes to the state of the internal combustion engine." He continues (fig. 81):

This desire motor is the last part of the bachelor machine. Far from being in direct contact with the Bride. the desire motor is separated by an air cooler. (or water).

This cooler. (graphically) to express the fact that the bride, instead of being merely an asensual icicle, warmly rejects. (not chastely) the bachelors' brusque offer. This cooler will be in transparent glass. Several plates of glass one above the other.

In spite of this cooler. there is no discontinuity between the bach. machine and the Bride. But the connections. will be. *electrical*. and will thus express the stripping: an alternating process. Short circuit if necessary—

Take care of the fastening: it is necessary *to stress* the introduction of the new motor: the bride.[37]

If Duchamp was thinking of the mid-section of the *Large Glass* as a kind of "cooler"[38] or radiator, its function changed as his goal became that of making "a painting *of frequency*"—no longer a painting on canvas with collage "plaques de verre," or glass plates, as set out in this original note and drawing, but rather a composition on glass. The mid-section (fig. 88), subsequently labeled an "insulator" by Duchamp, would come to resemble an electrical condenser; indeed, the theme of electricity becomes increasingly important within this note.[39] No longer simply the tandem functioning of two internal combustion motors (the Bride-as-motor and the Bachelors' "desire motor"), the process came to center on the theme of "electrical stripping" and the Bride's resultant "cinematic blossoming." Here the theme of stripping, first expressed in his Munich drawing *The Bride Stripped Bare by the Bachelors* (fig. 31), with its suggestion of bombarding electrons or radioactive particles, is recast in terms of actions accomplished by electricity and electromagnetism. Duchamp's conception of the two different processes by which the Bride's electrical stripping/blossoming occurs (the first "vertical" and the second "horizontal," as he subsequently defined them) introduces the theme of collision yet again: "On the coupling of these 2 appearances of pure virginity—On their collision, depends the whole blossoming, the upper part and crown of the picture."[40]

A sampling of passages from subsequent pages of Duchamp's long automobile note demonstrates the applicability of the automobile metaphor for his treatment of sexual processes as well as the continual development of his thinking as he recorded the notes:

The Bride basically is a motor. But before being a motor which transmits her timid power.—she is this very power—This timid-power is a sort of automobiline, love gasoline, that, distributed to the quite feeble cylinders, within reach of the *sparks of her constant life,* is used for the blossoming of this virgin who has reached the goal of her desire—. . .

This cinematic blossoming is controlled by the electrical stripping (see the passage of the bach. machine to the bride). . .

This electrical stripping sets in motion the motor with quite feeble cylinders which reveals the blossoming through stripping [*épanouissement en mise à nu*] by the bach. in its action on the clockwork gears.

Grafting itself on the arbor type—the cinematic blossoming. . .is the most important part of the painting. (graphically as a surface)

It is, in general, the halo of the bride, the sum total of her splendid vibrations; graphically, there is no question of symbolizing by a grandiose painting this happy goal—the bride's desire; only more clearly, in all this blossoming, the painting will be an inventory of the elements of this blossoming, elements of the sexual life imagined by this bride desiring. In this blossoming, The bride reveals herself nude

in 2 appearances: the first, that of the stripping by the bachelors. the second appearance that voluntary-imaginative one of the bride.[41]

Duchamp then suggests that the blossoming depends on the "collision" or "coupling" of these two appearances. In the "cinematic blossoming" these two blossomings are to fuse, as if in a chemist's "mixture, physical compound of the 2 causes (bach. and imaginative desire) unanalyzable by logic."[42]

Subsequent notes clarify Duchamp's idea of these two different phases of the stripping/blossoming as the "voluntary horizontal blossoming of the bride going to meet the vertical blossoming of the stripping-bare," a process that would come to focus on the Juggler/Handler of Gravity.[43] In his "First breakdown" of the components of the *Large Glass*, quoted below, Duchamp had also listed "9. Blossomings./(vertical of the Clockwork box [*Boîte d'horlogerie*]/horizontal of the branches of the *arbre type*—." Such terms as "clockwork box," "clockwork apparatus," or "clockwork system" in Duchamp's notes generally refer to the Boxing Match, the clockwork mechanism by which the Bride's garment was to have been manipulated, and are therefore associated with the "vertical blossoming of the stripping-bare."[44] (As discussed in the context of automatons below, however, Duchamp also posited a "Boîte d'horlogerie" as an element of the Bride, translating one kind of gearing [automobile] into another.)[45] The horizontal blossoming, by contrast, is associated with the branching of the *arbre type* and the Bride's voluntary, imagined orgasm.

This clarification is useful as a prelude to the final pages of Duchamp's original ten-page note and the three-page note on the subject added to it in the *Green Box*:

1. *Blossoming through stripping by bach.*
 Electrical control
 This blossoming-effect of the electrical stripping should, graphically, end in the clockwork movement (electrical clocks in railway stations)/Gearwheels, cogs, etc. (develop expressing the throbbing jerk of the minute hand.
 The whole in mat metal—(fine copper, steel silver,
2. Blossoming through stripping voluntarily imagined by the bride-desiring.
 This blossoming should be the refined development of the arbor type.
 It is born, as boughs on this arbor type.
 Boughs frosted in nickel. and platinum. As it gradually leaves the arbor, this blossoming is the image of of a motorcar climbing a slope in low gear. (The car wants more and more to reach the top, and while slowly accel-

erating, as if exhausted by hope, the motor of the car turns over faster and faster, until it roars triumphantly.
3. Blossoming-crown (Composed of the 2 preceding).
 The 1st blossoming. is attached to the motor with quite feeble cylinders.
 The 2nd to the arbor-type, of which it is the cinematic development. . . .
 The motor with quite feeble cylinders is a superficial organ of the bride; it is activated by the love gasoline, a secretion of the bride's sexual glands and by the electrical sparks of the stripping. (to show that the bride does not refuse this stripping by the bachelors, even accepts it since she furnishes the love gasoline and goes so far as to help towards complete nudity by developing in a sparkling fashion her intense desire for the orgasm.[46]

This section of the note supports further the location of the "Motor with quite feeble cylinders" in the upper left corner of the image of the Bride. Here Duchamp describes the motor as a "superficial organ of the bride, suggesting its removal from the shaft of the *arbre type* and the central organs of the Bride. Moreover, as Duchamp asserts, the "1st blossoming is attached to the motor with quite feeble cylinders," and he paints the "cinematic blossoming" issuing forth from the upper left quadrant of the Bride. Simultaneously, as suggested in Duchamp's drawings and Jean Suquet's projection of such images onto the *Large Glass* (figs. 110, 111), a second blossoming—blended with the first in the final image—does extend out from the *arbre type* itself.

In the second *Green Box* note on the Bride as automobile, headed "The Bride. Skeleton," Duchamp restates the automobile theme, adding a new element, the "Desire-magneto," which ultimately displaced the "Desire-gear" as the Bride's major organ of desire:[47]

The Bride. Skeleton.
The bride, at her base, is a reservoir of love gasoline. (or timid power). This timid-power, distributed to the motor with quite feeble cylinders, in contact with the sparks of her constant life (desire-magneto) explodes and makes this virgin blossom who has attained her desire.

Besides the sparks of the desire-magneto, the artificial sparks which are produced by the electrical stripping should supply explosions in the motor with quite feeble cylinders.

Hence, this motor with quite feeble cylinders has 2 strokes. The 1st stroke (sparks of the desire-magneto) controls the immobile arbor type. This arbor-type is a kind of spinal column and should be the support for the blossom-

ing through the bride's voluntary stripping. The 2nd stroke (artificial sparks of the electrical stripping) controls the clockwork apparatus. . . .

The bride accepts this stripping by the bachelors, since she supplies the love gasoline to the sparks of this electrical stripping; moreover, she furthers her complete nudity by adding to the 1st focus of sparks (electrical stripping) the 2nd focus of sparks of the desire-magneto.
Blossoming [48]

In these notes Duchamp developed fully the potential of the "organs" and functions of an automobile as a metaphor for the Bride and her sexual experience. Of the numerous authors who employed human-machine analogies in this period, Maeterlinck, Mirbeau, Marinetti, and Pawlowski had all described automobiles in anatomical terms. Pawlowski, prefiguring Duchamp, had identified the transmission shaft as a "spinal column"; Marinetti had treated the automobile as a sexual object, the fenders becoming "torrid breasts." [49] Moreover, given the long-standing metaphor of a sexually aroused body as "a great boiler heating up to blow off steam," the automobile's combustion engine now offered a more up-to-date model for sexual excitement. [50] In terms of the internal mechanics of motors as analogues for sexual activity, Joris-Karl Huysmans, in *La-bas* (1891), graphically described the pistons inside the cylinders of a steam locomotive as "steel Romeos inside cast-iron Juliets." [51]

This mechanistic view of sexual interaction received its most direct expression in a book that was much admired by Apollinaire and to which Duchamp would respond on several levels: Remy de Gourmont's 1903 *Physique de l'amour: Essai sur l'instinct sexuel*, which was in its tenth edition in 1912. In this highly popular work Gourmont asserts, "They [the sexual organs] are rigorously made the one for the other, and the accord in this case must be not only harmonic, but mechanical and mathematical. They are gears [*engrenages*] that must fit one in the other with exactitude." [52] Picabia would give form to Gourmont's metaphor directly in paintings such as *Machine Turn Quickly* of ca. 1916–18 (National Gallery of Art, Washington, D.C.), in which the female is embodied as a small gear turning rapidly to actuate the large, male gear that dominates the image. [53] On this subject, however, Duchamp would not follow Gourmont so closely: the contact between female and male was not to be direct. Although the Bride's components include both a potentially vaginal Sex Cylinder and a "Desire-gear," the firing of her internal combustion engine and her general functioning involves neither "male" pistons nor the meshing of gears.

Instead, the Bride possesses a largely self-sufficient Desire-magneto, which would have produced the alternating electrical current and the sparks necessary for the ignition of her "Motor with quite feeble cylinders." [54] As Duchamp's notes suggest, automobile technology associated with electricity offered a particularly rich supply of sexual human-machine analogies. For example, the December 1913 article "L'Electricité à bord des automobiles" declared the electromagnet the *organe-roi* (ruling organ) of electrical science and personified the "electromagnetic machines" of a car as "sisters." Referring to a permanent magnet as nude (*aimant nu*) and illustrated with graphic images of hollow electromagnets (*electro-aimants*) bearing wires labeled "excitation" and a human hand inserting a loop of wire into the hollow, the text explains the automobile's ability to manufacture its own electricity "by means of an '*electro-magnetic* machine.'" According to the author, "The *dynamo*, which henceforth will provide lighting for our cars, and the *magneto*, which for ten years has furnished the ignition for our motors, are the two sisters of this illustrious family." [55] Here, as elsewhere, the possible reading of *aimant* as "loving" would have augmented the human and sexual associations of such technological discussions for someone as sensitive to language as Duchamp.

Duchamp's addition of a Desire-magneto to the Bride's anatomy and his use of such phrases as "sparks of her constant life" introduced the theme of sparking to her functioning. Such terminology was common in automobile literature: an article on high-tension (i.e., high-voltage) magnetos in *Outing Magazine* for April 1911, for instance, was entitled "The Motor Car's Spark of Life." [56] As noted in chapter 3, sparks and magnetism had long-term associations with romantic attraction and lent themselves readily to sexual applications. Bergson, employing an unusually mechanistic analogy, related sparks and passion in *Le Rire*: "As contrary electricities attract each other and accumulate between two plates of the condenser from which the spark will presently flash, so, by simply bringing people together, strong attraction and repulsions take place followed by an utter loss of balance, in a word, by that electrification of the soul known as passion." [57] Typically, Picabia, whose object portrait *De Zayas! De Zayas!* (fig. 52) utilized a diagram of a Delco starting and lighting system, responded directly to the sexual associations of sparks in his 1915 *Portrait of a Young American Girl in the State of Nudity*, in which a nude young woman is transformed into a spark plug. In 1921–22 Picabia would use the magneto theme directly in two of his more abstracted machine-style works, entitled *Magnéto* and *Magnéto anglaise*. [58]

Magnetos can generate high-voltage alternating current and can short-circuit, two themes suggested near the beginning of Duchamp's long *Green Box* note: "But the connections will be. *electrical*. and will thus express the stripping: an alternating process. Short circuit if necessary."[59] Even more important, high-tension magnetos are capable of generating Hertzian waves, an idea that was to prove crucial for Duchamp as he sought to create the electrical connections posited in this note. He had now posited two systems of stripping/blossoming, stimulated not just by the sparks of the Desire-magneto associated with the *arbre type* but also by some sort of "artificial sparks" that are "produced by the electrical stripping" and "[control] the clockwork apparatus"[60] Duchamp now needed to develop the scenario that would allow this interaction between the Bride and her Bachelors—something that could not be accomplished simply by means of the automobile analogy, as effective as it had been initially to describe the Bride.

After abandoning the possibility of parallel automobile motors or engines, suggested at the beginning of the long *Green Box* note, the theme of clockwork mechanisms emerged as the primary characteristic to be shared by the upper and lower sections of the composition. The clockwork action of the Boxing Match, already present in Duchamp's drawing *Boxing Match* (fig. 45), was closely identified with the Bachelors' "stripping-bare" of the Bride, as Duchamp's long *Green Box* note quoted above confirms. A posthumously published note listing the "First breakdown" of the Bride and the Bachelors provides an overview of the components of the *Large Glass* in its early stages, including a "Boîte d'horlogerie" for the Bride, and documents the growing complexity of the Bachelor Apparatus, compared to his extended *Green Box* note:

First breakdown/ Bride.
1. *Stripping-bare.* (crossed out)
2. *Breast cylinders.*
3. *Clockwork box* [Boîte d'horlogerie]
4. *Sex cylinders*
5. *Point of timid-power*
6. *Arbor type or shaft/ stem model* [hampe-modèle]
7. *Reservoir.* for love gasoline
8. *Desire-magneto*
9. *Blossomings./* (vertical of the Clockwork box/horizontal of the branches of the standard arbor—

Intermediary
1. *Stripping-bare*
2. *Insulator* in transparent glass
[on verso of above]:

Breakdown:/ Bachelor machine—
1 *Chariot.* (supporting the/columns./ *Bumper.*
1a *motive force of the chariot./*(in the background)
2 *Chocolate grinder*
3 *Tubes of erotic concentration/*(intake of the illuminating gas:/ principle of the erotic liquid./ *Whistle*
4 *Desire dynamo—/ combustion chamber/ Desire* centers/ *Sources* of the stripping
5—Horizontal column[61]

Duchamp's listing, with "stripping-bare" deleted from the first position under the Bride's components, also records his distancing of the actual stripping bare from the "body" of the Bride to its location in the "intermediary" position at the horizon line. Indeed, the association of the "vertical blossoming" with the "Clockwork box" suggests the reciprocal functioning of two clockwork mechanisms now substituting for the original notion of Bride and Bachelor motors in tandem.

Characteristically for Duchamp, his automobile and clockwork themes had been conflated through the concept of gearwheels. In the same note in which he replaced "Rouage désir" with "Magneto désir," he had crossed out "Rouage désir" at another point and substituted "Appareil d'horlogerie" (clockwork apparatus).[62] In the "breakdown" note, that term became "Boîte d'horlogerie."[63] Given the central role of clockwork systems in the early notes for the *Large Glass*, the tradition of automata and other such mechanical toys, which were built around a "mouvement d'horlogerie," must also be considered as a source for Duchamp.[64] In particular, Villiers de l'Isle-Adam's Hadaly, the android "future Eve" of his 1886 science fiction tale, emerges as a probable model for certain aspects of the Bride.

The Bride as a Modern Automaton Descended from Villiers's *L'Eve future*

Artificial figures capable of independent movement were originally developed as parts of clocks: one of the first such automated figures was the wrought-iron, crowing cock on the Strasbourg Cathedral clock of 1354.[65] The seventeenth and eighteenth centuries witnessed the creation of increasingly complex human and animal figures animated by clockwork mechanisms, even though they were no longer used solely on timepieces. Automatons fascinated such seventeenth-century figures as the Jesuit Athanasius Kircher, whose interests in perspective and magnetism foreshadowed Duchamp's.[66] In Paris, the circle of French perspectivists, including Jean-François

Nicéron, whom Duchamp cited in his notes on perspective, responded to Descartes's discussion of automatons in his *Discours de la méthode* (1637).[67] Descartes had compared the functioning of the human body to that of a clockwork automaton, citing then-current technology as analogous to various body parts: "The nerves of the machine I am describing to you can be compared very well with the pipes of the machines of these fountains; his muscles and his tendons with the various devices and springs designed to work them. . . . What is more, respiration and other such acts . . . are like the movements of a clock or a mill which the ordinary course of the water can render continuous."[68]

The nineteenth century has been described as the golden age of automatons: by 1880 six firms were manufacturing automatons in the Marais district of Paris.[69] As noted earlier, the Musée des Arts et Métiers contained a collection of automatons (displayed in rooms devoted to clocks and similar instruments), and Duchamp's 1910 cartoon of a "Bébé marcheur," noted earlier, parallels not only department store dolls but also the many doll-like automatons offered by Parisian manufacturers.[70] The large number of automatons made in the form of clowns, acrobats, and jugglers also suggests another source in popular entertainment for Duchamp's Juggler/Handler of Gravity (fig. 112).[71] That figure is described by Duchamp as carrying out a "dance led by the clockwork box [*boîte d'horlogerie*] to the sounds of the stripping-bare."[72] Poised above the Boxing Match, the Juggler functions as a dancing automaton (fig. 111), although since he also communicates with the Bride in the upper realm, he transcends the stance of a mere clockwork mechanism.

The same cannot be said of Duchamp's Boxing Match, however. In contrast to the Juggler/Handler of Gravity, the Boxing Match (fig. 45) is nothing other than a clockwork system, which seems to have been modeled directly upon the traditional technology of automaton makers. Builders of automatons normally included the following components: "1) Motor. Generally, with a spring [*à ressort*] (also called clockwork movement [*mouvement d'horlogerie*]); . . . 2) Controls, drives [*commandes*]; 3) Transmissions; 4) Music. Music box or other instrument."[73] The Boxing Match's manipulation of the Bride's garment is accomplished by means of the "blows" of the Combat Marble and release of the Rams—actions controlled by what Duchamp labels and draws as a "système d'horlogerie," or system of clockwork wheels. The actions of the Boxing Match also resemble the workings of an automaton's mechanisms. Duchamp's labels at the bottom right explain: "A spring in red steel actuating the whole clockwork system—The

cogwheels, by means of a rack, push the fallen rams up again. . . . *R and R'*—R engaged [*engrenée*] position of the red transmission with the rack System—. . . DG moves to D'G' and like a door gently returns to DG (Automatic closure F) leaving time for the marble to produce the 2 following releases."[74] Here are the spring motor, the controls or drives, and the means to transmit the requisite actions. And suggested by Duchamp's talk of the Juggler's dancing to the "sound of the stripping-bare" is the presence of a musical mechanism.[75] That theoretical component of the *Large Glass* is also evoked in his reference to the stripping-bare as "'en forme' de piano," or in piano form, which evokes the mechanical analogy between the Boxing Match and a piano's hammers striking the strings.[76]

As noted above, Duchamp's Bride also included a "Boîte d'horlogerie," but she was to be a far more sophisticated creature than the Bachelors' Boxing Match—with many systems overlaid in her composition.[77] Most important, the Bride, like Villiers's Hadaly, was to represent a new breed of automaton, one that takes advantage of new technology instead of the clockwork mechanics of a much earlier era. Villiers's fictional Thomas Edison specifically derides that tradition as he seeks to convince the melancholy Lord Ewald that he can indeed create an ideal woman to replace the shallow Alicia Clary who preoccupies him:

Albertus Magnus, Vaucanson, Maelzel, Horner, and all that crowd were barely competent makers of scarecrows. Their automata deserve to be exhibited in the most hideous of wax museums; they are disgusting objects from which proceeds a rank smell of wood, rancid oil, and gutta-percha. . . . Just call to mind that succession of jerky, extravagant movements, reminiscent of Nuremberg dolls! The absurdity of their shapes and colors! Their animation, as of wigmakers' dummies! That noise of the key in the mechanism![78]

Duchamp had created just such an old-fashioned entity in the Boxing Match, whose clockwork apparatus he compared to the "throbbing jerk of the minute hand on electric clocks" in "railway stations."[79] (Duchamp also noted that the Chariot/Glider of the Bachelor Apparatus moves "at a *jerky* pace.")[80] For the fictional Edison, the latest developments in science—especially electricity—had made possible new heights in the replication of human appearance and action. Rather than a clockwork mechanism, electricity controls the android, who is also covered with a remarkable "pseudo-flesh" containing magnetized iron dust that is sensitive to electric current. Of her electrical

system Edison explains, "The steady continuity of the electric current eliminates any possibility of jerkiness, and thanks to it, one can achieve smiles of infinite subtlety, the expression of the Giaconda, tenderness, intimacy, and absolute identities which are really terrifying."[81] In the *arbre type* of the Bride, too, Duchamp seems to have sought a similarly smooth blending of the organic and inorganic.

If, philosophically, Villiers and Duchamp appear to have been pursuing the same ends, a comparison of the Bride with Villiers-Edison's description of Hadaly's interior system suggests that Duchamp was well aware of *L'Eve future*. In the chapter entitled "First Appearance of the Machine in Humanity," Villiers lists Hadaly's "four major parts," in a style paralleled in Duchamp's list of the Bride's components. Edison enunciates these parts "in the monotonous tone of one setting forth a geometrical theorem": "1. The living system of the interior . . . and the inward regulator of movements. . . . /2. The plastic mediator [containing the interior system]. /3. The flesh . . . placed over the plastic mediator. . . ./4. The epidermis or human skin." For the latter, for example, Edison includes in its characteristics "the coloring, the porosity, the features, the special glitter of the smile . . . the eye assembly, with the associated individuality of the glance.[82]

When Edison discusses the inner workings of his android, the parallels with Duchamp's Bride become most apparent. After noting the analogy between Hadaly's "central apparatus" and "the place in the spinal column from which springs the marvelous tree of the nervous system," Edison provides an overview of her functions:

This is the basic electro-magnetic motor, which I have miniaturized while at the same time multiplying its power. . . . This particular electric spark (it's on loan from Prometheus) has been trained to circle this magic ring, and thereby to produce respiration, by acting on this magnet, placed vertically between the two lungs where it can influence this nickel strip leading to a steel sponge, which moves and then returns to its original position under the regular influence of the isolator here.

Below Hadaly's "lungs," composed of two golden phonographs meant to record conversations by means of "needles of pure steel" on metallic strips, is "the Cylinder on which will be coded the gestures, the bearing, the facial expressions, and the attitudes of the adored being."[83] Duchamp's drawing *Sex Cylinder/Wasp* (fig. 105), with its initial automobile associations, also includes a notation of the Bride's "pulse needle," which was to play an important role in his wireless telegraphy paradigm for the Bride.[84]

In a subsequent chapter, "Equilibrium," Edison provides an elaborate discussion of the system by which the android's equilibrium is to be maintained. Two platinum cells, half full of quicksilver and connected by tubes, have been planted within her thighs; the flow of quicksilver within the cells controls an electrical current and system of magnets that can restore her balance. As if foretelling the balancing act of the Juggler of the Center of Gravity, as Duchamp originally termed his Juggler/Handler, Edison explains, "This oscillation, involving counterflow of the metal and displacement of the center of gravity, continues as the current which controls it is flowing."[85] Equilibrium and center of gravity were to be major aspects of the mechanics of the Bachelor Apparatus and Juggler/Handler of Gravity (see chap. 11).

Another of Duchamp's interests, photography, plays a prominent role in Edison's creation of Hadaly. Her "plastic mediator" having been modeled on Lord Ewald's Alicia Clary by means of "photosculpture," Hadaly is then covered with an epidermis, which has received an "imprint" of the "exact tints of the nudity being reproduced"—a process made possible by the "extraordinary recent advances in color photography."[86] "The result," according to Edison, "is to confuse completely the senses of human beings, to render the copy and the original indistinguishable," an idea that certainly would have appealed to Duchamp as he challenged notions of artistic virtuosity and self-expression in his works of 1913. Villiers also introduces the terms *appearance* and *apparition*, themes that Duchamp would develop in his own discussions of molds and imprinting.[87] Early in the book Edison had asserted to Lord Ewald that he could "steal her [Alicia's] own existence away from her": "I will reincarnate her entire external appearance, which to you is so deliciously mortal, in an Apparition whose HUMAN likeness and charm alone will surpass your wildest hopes and your most intimate dreams!"[88] Edison's comments are part of a continuing commentary that challenges distinctions between reality and illusion, the real and the artificial, the animate and the inanimate.[89]

Beyond specific terminology and processes, Duchamp's project for the *Large Glass* shares with Villiers's *L'Eve future* the same preoccupation with electricity and thought transmission found in Jarry's *Le Surmâle*. Villiers, Jarry, and Duchamp all drew from late nineteenth-century physics, particularly the work of William Crookes, whose concept of radiant matter is repeatedly cited by Villiers as an explanation for Hadaly's remarkably lifelike qualities.[90] There is, however, an important difference between Villiers's book, published in 1886, and the work of Jarry and Duchamp: both Jarry and Duchamp,

working after the discovery of X-rays in 1895, were deeply interested in electromagnetic waves, whose existence had first been confirmed by Hertz the year after Villiers's book was published. In addition, by the time Jarry and Duchamp were exploring the artistic applications of contemporary science, Tesla, Edison's rival, had popularized the high-frequency alternating currents that came to be associated with spectacular sparking effects and wireless telegraphy. Whereas in *L'Eve future* the term *vibration* refers simply to sound relating to Edison's phonograph, for Jarry and Duchamp the term would have been associated with electromagnetic waves.

Lacking the supporting evidence provided by electromagnetic waves, Villiers's treatment of telepathy, clairvoyance, and Magnetism is more overtly occult in orientation than Jarry's or Duchamp's. Unable yet to cite Crookes's hypothesizing on X-rays as a clue to telepathy, Villiers can only refer to Crookes's earlier accounts of spiritualist experiences and to new experiments in the "science of Human Magnetism," establishing that "the various currents of nervous fluid are no less a fact than are currents of electricity."[91] In fact, Hadaly, in the end was endowed with the "soul" of the mysterious "Sowana," with whom Edison had established a telepathic relationship.[92] All of Edison's electrical wizardry had not been enough; Villiers was forced to resort to spiritualism to account for Hadaly's magical communicative powers.

In Duchamp's "painting *of frequency*," Hertzian or wireless telegraphy waves would provide a model for the Bride's transmission of messages to the Bachelors, creating a means of communication between the upper and lower halves of the *Large Glass* that his earlier schemes of parallel automobile motors or clockwork mechanisms could not effect. In addition, in contrast to Villiers's tale, it is the Bride as modern automaton who is in control, not a male engineer-creator like Edison. In this role the Bride is also a descendant of Roussel's Louise Montalescot, the scientist heroine of *Impressions d'Afrique*, whose metallic lung implant gives her the hybrid character of a woman-machine. Yet unlike Louise—or Pawlowski's creatures fitted with awkward mechanical appendages and Robida's personification of electricity (fig. 46), whose hair suddenly turns into electrical wires—Duchamp's Bride paralleled the melding of animate and inanimate represented by Hadaly.[93]

What the fictional Edison achieved physically in his laboratory, Duchamp accomplished verbally in his notes by means of layering inorganic and organic metaphors. Duchamp's depiction of the Bride in the *Large Glass* remained close to the form in which he had painted her in

1912 and thus never became the comical conglomeration of things "mechanical encrusted on the living," as Bergson termed it, that her increasingly complex functions would have dictated.[94] Instead, like the motors and other technological elements composing Hadaly's "living system of the interior," the Bride's mechanical elements are largely hidden beneath the visceral forms of the *arbre type* or the "mossy metal" covering the "Motor with quite feeble cylinders."[95] Apart from her Desire-gear at the left, the Bride reveals no purely mechanical forms. As Duchamp explained in a later interview, in the *Large Glass* the motor "is invisible," as are so many other of the Bride's technological accoutrements. The *Glass*, according to Duchamp, "is like the 'hood' of the automobile. That which covers the motor"—literally, in the striped, mossy "hood" of the Bride and, figuratively, in the *Glass* as a whole, powered by its invisible text-motor, the notes.[96]

The language of Duchamp's notes encourages the conflation of inorganic and organic, just as contemporary usage of terms such as *organs* in the automobile literature would have done. Thus, the *arbre type*, with its automobile association, also becomes a "hampe-modèle," a stem or shaft, which develops boughs "frosted in nickel and platinum" and blossoms.[97] Similarly, Duchamp's Sex Cylinder becomes a Wasp that "secret[es] . . . love gasoline by osmosis" and "nourish[es] the filament substance."[98] As chapter 9 establishes, Duchamp's introduction of biological elements such as the Wasp was part of a larger decision to "introduce *organic materials* in the wasp and elsewhere."[99]

Near the beginning of his ten-page note on the Bride as automobile Duchamp wrote: "In general, if this bride motor must appear as the apotheosis of virginity. i.e. ignorant desire. blank desire (with a touch of malice) and if it (graphically) does not need to satisfy the laws of weighted balance. nonetheless. a shiny metal gallows could simulate the maiden's attachment to her girl friends and relatives."[100] Yet, he was to reject such an obvious metallic gallows, as he had overt automobile imagery; instead, Duchamp symbolized the hanging of the *Pendu femelle* only by the hooks at the top of the upper panel. Free of the "laws of weighted balance" (i.e., gravity in three dimensions) and associated with the Virgin as well as the "apotheosis of virginity," Duchamp's Bride is indeed a figure "half robot and half four-dimensional."[101]

The subtlety of the Bride's oppositional characteristics points up a further contrast between her and the Bachelors, with their "jerky" motions. Bergson had identified this distinction as a source of laughter in *Le Rire*: "the rigid, the ready-made, the mechanical, in contrast with the

supple, the ever-changing, and the living . . . in a word, automatism in contrast with free activity."[102] Much more so than the Bride, it is the mechanical Bachelors, as they attempt to function organically and strive fruitlessly to "pass beyond the Mask," who are the source of the Bergsonian humor in the *Large Glass*. In the end, the continuities of Duchamp's four-dimensional Bride transcend the purely mechanical state of the three-dimensional Bachelors, just as Villiers's Hadaly had surpassed all the automatons that had preceded her.

Chapter 8

The *Large Glass* as a Painting of Electromagnetic Frequency

Hertz's experimental confirmation in 1888 of the existence of the electromagnetic waves posited by Maxwell had established the essential unity of light and the new "electrical vibrations," or "electrical radiations," as they were often called.[1] Although many scientists theorized that X-rays, too, were part of this range of vibratory motions in the ether, and they were often treated in these terms in popular literature, the true nature of X-rays was not confirmed experimentally until 1912.[2] Thus, the theme of a unifying spectrum of varying frequencies of wave vibrations in the ether was introduced to the public primarily in the literature on wireless telegraphy. Just as cathode rays (and, later, radioactivity) had standardly figured in X-ray books and articles, discussions of the solar spectrum and optics were often included as an introduction to treatments of Hertzian waves and wireless telegraphy.[3]

By 1913 Duchamp's and Kupka's interest had shifted from X-rays to Hertzian waves, while Kupka had taken up optics as well. Frequency, addressed by Duchamp in his *Box of 1914* note declaring his intention to "make a painting *of frequency*," can now be recognized as the factor linking all these concerns.[4] The literature on X-rays had introduced Duchamp to the transparent, fluid forms of X-ray photographs and the imagery of scientific equipment; sources on wireless telegraphy now offered the new vocabulary of mechanical devices and the physics of electromagnetism with which to augment the themes of the *Large Glass* and to create a vehicle for communication at a distance between the Bride and the Bachelors.

Hertzian Waves and Wireless Telegraphy in French Culture and Avant-Garde Literature

Although wireless telegraphy, which evolved gradually during the late 1890s and early twentieth century, was not the overnight sensation that X-rays had been, it had a far greater impact on culture and daily life in general. By

making possible instantaneous communication over vast distances, wireless telegraphy transformed commonly held conceptions of time and space.[5] And for the French, the prominent role played by the wireless station on the top of the Eiffel Tower made *télégraphie sans fil* an object of national pride.[6]

Given its relevance for contemporary culture, it is not surprising that wireless telegraphy was a favorite topic of technical and popular literature during the first two decades of the twentieth century. For example, the subject catalogue of the Bibliothèque Nationale for the period 1898–1915 includes over one hundred books on the topic. Featured in the Palais de l'Electricité at the 1900 Exposition Universelle, the magical new process of wave-borne communication at a distance generated continued coverage in popular magazines.[7] In addition to the *Revue Scientifique* and the *Revue Générale des Sciences Pures et Appliquées,* such periodicals as the *La Revue des Idées, La Revue des Deux Mondes, La Nature, L'Illustration,* and *Je Sais Tout* also covered the latest developments. As early as summer 1912 *La Nature* published a two-part article, "La Télégraphie sans fil à la portée de tout le monde," which instructed readers how to set up an at-home wireless installation, using a metal balcony as the antenna for picking up signals from the Eiffel Tower; similar instructions appeared during 1913 in the new popular journal *La Science et la Vie.*[8]

Initially, the language of wireless telegraphy was the international Morse code (fig. 104); radio as we know it came about later, during World War I and after, with the development of equipment able to produce continuous waves that could be modulated for the transmission of voice.[9] Until the transition to radio, the physics of wireless telegraphy did not change radically from its early days. Although new mechanisms were developed, longer distances of transmission were achieved, and more successful means of tuning were established, the basic procedure remained similar to that of Hertz's first experiments. Hertz had generated electrical waves by means of a spark discharge that set up oscillations in a primary circuit; a spark in a secondary circuit across the room from the original emitter confirmed that the waves had produced a resonant oscillating current in the secondary circuit. The analogy used frequently in popular explanations was the tuning fork, which can set another fork into sympathetic vibration. Similarly, Henri Poincaré and others explained the rapidly oscillating circuit using the analogy of a

swinging pendulum (he termed the circuit an "electric pendulum") or the hydraulic model of two connected vessels with differing water levels seeking to reestablish a state of equilibrium—providing a model for the kind of interrelated energy systems Duchamp would create in the *Large Glass* and its notes.[10]

Although Hertz was not interested in the possible applications of his discoveries in the field of communication, others such as Crookes already mused in 1892 on "the bewildering possibility of telegraphy without wires, posts, cables."[11] As noted earlier, Crookes's interest in electrical vibrations had been stimulated by his awareness of the work of Lodge and Tesla in this area. Lodge (along with the Frenchman Edouard Branly) was the developer of the first successful "coherers," or wave detectors; Tesla, as mentioned, invented the oscillation transformer, or Tesla coil, which was widely used as a source for the high-frequency, high-voltage alternating currents required for large-scale wireless transmission.[12]

A number of components were basic to the practice of wireless "spark telegraphy," as it was commonly called.[13] The basis of the emitting apparatus was a source of alternating current, the voltage of which could be stepped up by a transformer (a Tesla coil or another type); a condenser to be charged by the high-voltage current; and a spark gap through which the current would be discharged when the circuit was completed by the closure of a telegraph key. The sparking between the balls of the spark gap and the resulting oscillations in the condenser–spark gap circuit would induce oscillations in a radiating antenna—oscillations at an even higher frequency if a Tesla coil were interposed in the circuit at this point. A simplified version of such an arrangement (fig. 102), appearing in *La Revue des Idées* in 1907, stands as an example of the multitude of such circuit diagrams published in sources on wireless telegraphy. (Here AB represents the spark gap; C, the condenser; and D, the coil coupling the condenser circuit with the open circuit of the radiating antenna.) The receiving apparatus generally consisted of another antenna coupled to a circuit in which "similar but feeble electrical oscillations"[14] would be set up; a wave detector for discerning the presence of the oscillations; and a receiving instrument to record the Morse code signal in visible or audible form.

During the later 1890s, the Italian Guglielmo Marconi, building upon the groundwork of various other figures, had aggressively developed the possibilities for long-range communication by means of Hertzian waves.[15] From 1896 on, Marconi conducted demonstrations in England under the sponsorship of the British Postal Telegraph Department, experimenting with tall antennae as a means to increase the distance the waves traveled. In March 1899 the first signals were transmitted across the English Channel, and in 1901 transatlantic communication was achieved. Yet Marconi was hardly the only name associated with wireless telegraphy. Tesla's basic contributions to the field received considerable attention, and a number of other engineers and scientists in Europe and America were also at work developing more effective apparatus for various stages of the process.[16]

Branly, who invented the Branly tripod coherer in 1902 (fig. 113), after pioneering a metallic-filings tube detector in 1890, was the most renowned French figure in the field. Like Tesla, he was also a pioneer in the area of radio control using Herzian waves.[17] No individual scientist, however, could rival the Eiffel Tower. Following Eugène Ducretet's first attempts at transmitting from the tower in 1898, successive experiments performed there and the establishment before World War I of an official French army wireless station at its top assured its status as the primary French icon of wireless telegraphy.[18] After the International Conference on Time held in Paris in 1912, the Eiffel Tower began to transmit Greenwich time, and in July 1913 the first time signal was transmitted around the world through a network of wireless telegraphy stations.[19] But the tower had become more than just "the watch of the universe"; functioning in conjunction with Gustave Eiffel's battery of meteorological instruments atop the tower (fig. 129), the wireless station also transmitted Morse code reports of weather conditions in Paris and other European cities.[20]

Poets were the first members of the artistic avant-garde to celebrate this new model of communication and the sense of a cohesive, simultaneous world it produced. In his 1912 "Technical Manifesto of Futurist Literature," Marinetti proclaimed the Futurists' invention of "wireless imagination" or the use of words without the connecting wires of syntax.[21] The French poet Blaise Cendrars wrote his 1913 poem "Tour" as an homage to his friend Robert Delaunay, who had been painting images of the Eiffel Tower since 1909. Cendrars, demonstrating his awareness of the unity of the electromagnetic spectrum, includes references to both X-rays and the solar spectrum in his celebration of the Eiffel Tower as a beacon shining "with all the splendor of the aurora borealis of your wireless telegraph."[22]

Like Cendrars, Delaunay was aware of the appropriateness of the Eiffel Tower, a source of Hertzian wave transmissions, as the subject for his explorations of the comparable wave phenomena of light and color. Paintings in his *Windows* series of 1912, such as *Simultaneous Window* (fig. 83), standardly combine a field of prismatic

color with a central silhouette of the tower itself. In an October 1913 text, "Simultaneity in Contemporary Modern Art, Painting, Poetry," Delaunay wrote of the tower that "communicates with the whole world" and of "rays of light, symphonic auditory waves."[23] His allusion to music may reflect the addition to the Eiffel Tower by 1911 of the new "musical spark" or "singing arc" technology, which permitted more accurate tuning through the use of tones.[24]

Apollinaire, Duchamp's cohort in 1912 who by 1913 had become an advocate of Delaunay's coloristic "Orphic Cubism," had already documented his interest in wireless telegraphy in 1910, in a chapter on the adventures of his Jarryesque Baron d'Ormesan, entitled "Le Toucher à distance."[25] Having discovered a means to appear simultaneously in multiple locations around the world (in the guise of the messiah), the baron explains the roots of "this new science." He is able to project his presence or "touch at a distance" because of his extensive experiments in "wireless telegraphy and telephony, the transmission of photographic images, color and relief photography, cinematography and photography."[26] Apollinaire would use the theme of wireless communication again in his story "Le Roi-lune" (see chap. 13), another fantastic tale that, like "Le Toucher à distance," seems to relate both to Jarry and to Roussel's *Impressions d'Afrique*.

Responding to the Futurists' typographical innovations, Apollinaire in June 1914 published his first visual poem, "Lettre-Océan," a celebration of the simultaneity of modern experience centered on the Eiffel Tower (fig. 84).[27] The letters "TSF" are the abbreviation for *télégraphie sans fil*, and at the center of each page the Eiffel Tower is evoked by the phrases "Haute de 300 mètres" (its height and common designation in its early years) and "Sur la rive gauche, devant le pont d'Iéna" (its location). Written as a long-distance conversation with his brother Albert in Mexico (amid ancient cultures), Apollinaire's poem visually embodies the Hertzian waves of modern wireless telegraphy: words radiate from the center of the right-hand page, like signals from the Eiffel Tower. Even the undulating lines at the top of each page, suggestive of a postal cancellation, support the theme of waves—both ocean waves and Hertzian waves. When Apollinaire reprinted the poem in his collection of visual poems entitled *Calligrammes*, he gave the subtitle "Ondes" (Waves) to the section that included "Lettre-Océan" and other works associated with wave vibrations, such as "Les Fenêtres," which deals with the spectrum of visible light.[28]

In England the poet Ezra Pound, who during his visits to Paris in 1911, 1912, and 1913 met various French poets, including Remy de Gourmont, Apollinaire, and the circle around the review *Les Bandeaux d'Or*, was equally alert to the issue of wave vibration and wireless telegraphy.[29] In April 1912 Pound defined the poet as "on the watch for new emotions, new vibrations sensible to faculties as yet ill understood." Equating the poet with a wave detector, Pound continued to find in wireless telegraphy (and, subsequently, radio) a valid metaphor for poetic creation and communication; he would later describe poets and artists as the "antennae of the race."[30] Pound's interest in the detection of previously undetectable vibrations probably also reflects the widely popularized discussions by Crookes and others of the ramifications of X-rays and wireless telegraphy for the phenomena of clairvoyance and telepathy.

Developments in wireless telegraphy during the early years of the century assured continued fascination with the world of electromagnetic waves. Anyone attuned to contemporary culture in the early twentieth century realized that a fundamental aspect of reality had been redefined as a realm of vibrating waves of varying frequencies. Pound's focus on vibrations finds a parallel in Kupka's treatise of 1912–13, which chronicles his move beyond X-ray imagery to telepathy and telegraphy as a model for artistic creation. Given Kupka's role as mentor and friend to Duchamp, his ideas on electromagnetic waves provide a final element in the backdrop for Duchamp's "painting *of frequency*."

Communication via Electromagnetic Waves in the Art and Theory of Kupka

"Emission et réalisation," the final chapter of Kupka's treatise "Creation in the Plastic Arts," begins with a remarkable projection for a future art form:

Observing the progress accomplished in diverse domains we may suppose and foresee the possibility of other means—new—of transmission: transmission more direct by magnetic waves like those of the hypnotizer. On this point the future holds surprises; we must wait to see appear *X...graphes* or *X...graphies,* of which the arrangement will expose events that are invisible, subtle, still poorly elucidated, as much of the exterior world as of the psyche of the artist. By these means, increasingly perfected, the artist will perhaps be able to make the viewer see the "film" of his rich subjective domain, without being obliged, as today, to work laboriously when he realizes a painting or sculpture.[31]

Kupka's use of emission, transmission, waves, X...graphes, and a film whose image is to be projected to a spectator is

characteristic of the language of his treatise as whole. By 1913, Kupka's emphasis had shifted from his earlier idea of the artist as possessed of an X-ray-like "film psychique" and therefore able to reveal a higher reality to a conception of the artist as an emitter of telepathic waves, which would be transmitted via the work of art to the mind of the viewer (or, in an ideal situation, transmitted directly without the intervention of a "laboriously" created object).[32]

In his notebook of 1910–11, Kupka wrote, "A painting is nothing other than a field of exteriorization."[33] In his treatise, however, the process of exteriorization is linked specifically to "emission" and the receiving or sending of waves in the ether on the model of wireless telegraphy. Such a change in theory also helps explain the emergence of Kupka's pure color abstractions during 1912—works that he considered to be self-sufficient generators of electromagnetic waves of color. The emphasis in Kupka's mature works, such as the *Vertical Planes* series of 1912 (fig. 86), is now on visible rather than invisible light (X-rays). In Kupka's view, these opaque color abstractions were also direct expressions of the psyche of the artist, making it possible "to transmit our thoughts and our sentiments."[34] As in the case of his interest in X-rays, both scientific and occult sources would have supported his theories on the possibility of communication by means of vibrations in the ether.

The process of exteriorization had been central to the writings of two well-known French occultists noted earlier, Albert de Rochas and Dr. Hippolyte Baraduc, both of whom advocated a version of Magnetism deriving from Baron Karl von Reichenbach's notion of "Od" or "Odic force," which had been reinforced in the late nineteenth century by developments in the science of electromagnetism.[35] In *L'Extériorisation de la sensibilité* (1895), Rochas had introduced the issue of exteriorization by discussing the *effluves,* or flamelike emanations, observed by hypnotized (and therefore highly sensitized) individuals (see chap. 2). In the statement quoted above, Kupka's reference to "magnetic waves like those of the hypnotizer" is most likely a response to a source like Rochas. Indeed, the writings of both Rochas and Baraduc are filled with references not only to exteriorization but also to emission, vibration, and electricity in general.[36]

Baraduc drew on Rochas's and Reichenbach's theories to support his notion of an all-pervasive "vital Odic force."[37] He examined the interaction of the human soul with the surrounding Od in his 1896 text *L'Ame humaine, ses mouvements, ses lumières; et L'Iconographie de l'invisible fluidique*, which was published in a new edition in 1911. By means of a photographic *plaque sensible,* or

photosensitive plate, at times aided by an electric current, Baraduc produced a series of photographs that he believed documented seven stages of that interaction. The most interesting of these "luminous vibrations of the soul" were the "psychicones," which he interpreted as photographs of the thought or state of mind of the subject.[38] As noted in chapter 1, Baraduc's images were subsequently cited by Besant and Leadbeater in *Thought-Forms* as the "scientific" counterpart to their own work.[39] In creating a typical *psychicone* (fig. 85), Baraduc, his hand extended toward a photographic plate, concentrated on a certain idea as an electrical current flowed through his body. According to Baraduc, "The mind exteriorizes itself in this form, which draws its image [*se graphe*] on the plate. . . . The *psychicone* is thus emitted directly."[40]

Although telepathy was not the primary concern of either Rochas or Baraduc, the latter's *L'Ame humaine* had raised the possibility of "psychicones télépathiques" and had drawn on developments in electromagnetism, including the work of Crookes and Lodge.[41] Rochas likewise found support for his theories in contemporary science (e.g., in the works of Crookes, Tesla, and Lodge)[42] and even provided fifteen relevant "notes" at the end of *L'Extériorisation de la sensibilité,* including an excerpt from Lodge's writings and a remarkable text by the American engineer Edwin Houston, "La Radiation cérébrale," reprinted from the *Journal of the Franklin Institute* of 1892.[43] Even before Crookes's discussions of telepathy in his addresses of 1897 and 1898, Houston's text speculated on the relevance for telepathy of Hertz's experiments.

Houston's article drew upon Hertz's proof of the ability of electrical oscillations in one circuit to create a synchronic "electrical resonance" in a distant circuit.[44] Based on the wave vibrations in the ether documented by Hertz, Houston posited a theory of "thought waves" that could travel through the ether and evoke "sympathetic vibrations" in the molecules of a "receiving brain."[45] Foretelling Baraduc, Houston suggested that these thought waves could perhaps be registered on a "suitably sensitized plate."[46] Like Kupka later, he hypothesized that in some future epoch such graphic records of thought waves might be able to stimulate the appropriate molecular vibrations in the brain of a viewer and give rise in his or her mind to the thought originally projected. As Besant and Leadbeater would do in *Thought-Forms,* Houston emphasized that what was transmitted was not a recognizable form but rather "the undulatory movements of the ether created by cerebral operations."[47]

Telepathy and the theory of wireless telegraphy (before it had come into use) therefore provided a rationale for a direct, abstract mode of communication, free of the identi-

fiable images that remained in Kupka's X-ray-related paintings. Although Houston's ideas were available in the numerous editions of Rochas's book, Crookes's far more widely known lectures of 1897 and 1898 could make an even stronger case for telepathy following the discovery of X-rays and the emergence of early wireless telegraphy practice. Thus, as noted earlier, Crookes adopted the rapidly vibrating, penetrating X-rays as a model for brain waves and compared the functioning of the brain itself to the technology of wireless telegraphy.[48]

Basic to Crookes's technological model of the human brain was his comparison of the narrow gap between nerve cells to the Branly or Lodge coherer or wave detector. Carrying his physics of the brain further, Crookes also posited the possible existence of "masses of nerve coherers in the brain," which could receive ether vibrations and produce "molecular movements in the brain."[49] Like Crookes, and Houston before him, Kupka often spoke of the "molecular state" of the brain. On the page of his notebook headed "Télépathie," Kupka seems to be responding directly to Crookes: "Undoubtedly, there is a correspondence between the general activity of the universe as a whole and the psychic and cerebral activity of an individual.—Is it always necessary that it happens consciously for him? Since the brain is susceptible to intercept the waves that another active individual sent forth in space."[50]

Kupka's treatise, in both its early and final forms, is filled with the language of telepathy and telegraphy, of the artist who both receives and emits signals. Of the sensitive artist as receiver, he writes, for "Imagine one of these states of the central nervous system, provoking or establishing telepathic contact, having become conductible, and opening itself to the wave of a thought—of an idea which is, as they say, in the air."[51] The process of emission, which Kupka discusses extensively in "Emission et réalisation," takes on definite telegraphic overtones through his frequent use of electrical terminology. Kupka describes an atmosphere conducive to creativity as "heavy with exciting energy, condensing of electricities, full of sparks ready to flash [*jaillir*]," and associates the artist's creativity with "étincelles," or sparks.[52] But he could equally be describing a wireless telegraphy installation. A contemporary discussion of the huge condensers atop the Eiffel Tower sounds much the same: after being charged by high-voltage current, "the oscillating discharge of this battery [of condensers] is produced by means of the spark-gap, where enormous sparks flash [*jaillissent*]."[53]

With regard to the viewer as receiver, Kupka's idea of direct, telepathic art relied upon the emergence of a sensi-

tive audience with proper receptors.[54] In the continuation of the initial passage quoted above, Kupka explains: "On his part the viewer will no longer need to use his eyes, since one imagines then immediate communication. . . . This progress assumes an intelligence—future—in viewers, capable of better seizing the 'vision of art.'"[55] Discussions of telepathy, which was defined as operating beyond the recognized organs of sense, often included allusions to the evolution of human consciousness, a theme touched upon by Crookes in his two addresses and an issue that certainly interested Kupka. Just as Crookes had speculated in 1897 that "a sensitive may be one who possesses the telepathic transmitting or receiving ganglion in an advanced state of development," Kupka wrote of the possibility of developing one's "receiving organs."[56]

Kupka believed that the future would bring dematerialized, wave-borne artistic communication, the "psychographes futurs" and "X...graphes" to which he refers in his treatise.[57] Recognizing the limitations of his audience at that time, however, he concluded, "For now, the work of art [must be] conceived and traditionally executed."[58] That the visible spectrum also consisted of electromagnetic waves allowed Kupka to incorporate the optics of visible light and color into his electromagnetic theory of art. Although the telepathic element of that theory implied transcending the organs of sense, his artistic theory and practice as set forth in 1912–13 relied squarely upon the generation of waves of colored light by the canvas and their perception by the sensitive eye. Kupka even referred to the eye as a "registering apparatus" (*appareil enregistreur*), a term used by scientists as well as spiritualists.[59]

In his 1898 speech before the British Association, Crookes had also provided a model for the appreciation of the eye as a receiver. He asserted that the feasibility of wireless telegraphy depended upon "the discovery of a singularly sensitive detector for Hertz waves—a detector whose sensitiveness in some cases seems almost to compare with that of the eye itself."[60] Crookes's discussion of X-rays and Hertzian waves and his mention of the eye (implying visible light) brought together the three types of electromagnetic waves that interested Kupka and would concern Duchamp as well, once he turned his attention to visible light in his optically oriented works of the late 1910s and early 1920s. This renewed interest in the optics of visible light and color, however, did not represent a return to the art of the past for either of them. Instead, this was new electromagnetic color, perceived by the "service d'électricité retinienne," as Kupka put it.[61]

For Kupka, works such as *Vertical Planes I* (fig. 86) were exteriorizations or emissions of the "vision of the

artist," self-sufficient objects that would in turn "emit" electromagnetic waves.[62] These waves of visible light are the counterpart to Edwin Houston's thought waves, the abstract patterns captured on a sensitive plate that might then generate molecular vibrations of thought in the mind of a viewer. Although the message could not be as specific as in telepathy, colors, and the shapes Kupka felt were appropriate to those colors, were to be the "vehicle of the impression," akin to a box of pastels, each color generating a "specific vibration."[63] Free of shadows and any sense of gravity, Kupka's mature color abstractions are no longer reproductions of nature but, rather, creations that parallel nature and likewise obey the laws of the physics of electromagnetism.

Kupka's theories were not the only place Duchamp would have encountered the idea of molecular vibrations as a means of transmitting visual images. Works by Crookes and Houston (via Rochas), as well as popular articles based on such texts, undoubtedly also lay behind the similar notions expressed by Roussel in *Impressions d'Afrique*.[64] Fogar's light-sensitive "photographic plant," for example, had recorded images using "molecular actions" and had changed one projected image into another by means of vibrating atoms. Louise Montalescot's painting machine had likewise drawn on photosensitivity and contemporary interest in recording electromagnetic waves, although without the overtones of occultism and Magnetism in Fogar's self-induced "artificial catalepsy."[65] A range of approaches to communication over distance existed in this period—from occult theories of telepathic projection, which drew on Hertzian waves, to scientific sources on wireless telegraphy and the technologically oriented articles on "vision at a distance" that stood behind Louise's machine.[66] Lacking Kupka's personal belief in the evolution of consciousness and his philosophical commitment to telepathy, Duchamp—on the model of Roussel or Jarry—was to sample freely from this body of material without declaring allegiance to any specific aspect of it.

If Kupka, the mystic, and Duchamp, the pragmatic, self-made engineer-scientist, were radically different in temperament, they nonetheless shared many interests. Kupka's notebook and treatise serve as a valuable record of certain of those ideas. Duchamp found in Kupka, a student of physics, biology, and physiology, the one artistic colleague who was also deeply concerned with science.[67] A fellow admirer of Leonardo, Kupka was also an eager visitor to the Musée des Arts et Métiers.[68] Not only had the two artists conducted parallel explorations of the relevance of X-rays for painting during 1911–12, but Kupka was also placing increasing importance on the conceptual

aspect of art making. His suggestion of the possibility of dispensing with the laborious crafting of a work of art in favor of mental transference offers a timely parallel to Duchamp's development of his first Readymades in 1913–14. Like Duchamp, Kupka, in his notebook of 1910–11, had also mentioned the possibility of painting on a transparent material like glass.[69] Finally, Kupka, an early advocate of the fourth dimension, continued to explore questions of dimensionality in his treatise, where he talked of creating the effect of infinity using a chamber of mirrors. Duchamp similarly mused on mirrors as a way to suggest the fourth dimension and mentioned them specifically in one of his notes: "Have a room entirely made of mirrors which one can move—and photograph mirror effects...."[70]

The theme of electromagnetic waves was to be the common interest that most influenced each artist's oeuvre. Unlike the shared transparency and fluidity of their X-ray-related paintings, however, the works they produced in response to Hertzian waves would have no visual similarities. Their awareness of the physics of Hertzian waves and wireless telegraphy was what united Kupka and Duchamp and what separated them from the other painters and poets, such as Delaunay and Apollinaire, who responded to wireless telegraphy in simpler terms. Nevertheless, the two men made different applications of their knowledge. Drawing on Crookes's analogy of the brain and a wave detector, Kupka, with his grounding in physiology, adopted the new technology as a model for the organic processes of the brain; artistic creation could now be described in terms of the emission and reception of waves. Duchamp, by contrast, replaced the human participants in the drama of the *Large Glass* with scientific equipment, a significant portion of which could be associated with the emission and reception of waves in wireless telegraphy.

Wireless Telegraphy, Telepathy, and Radio Control in the *Large Glass*

Because even Duchamp's *Green Box* notes had made it clear that the Bride was issuing commands to the Bachelors below, there have been passing references in the Duchamp literature to some kind of telegraphic communication between the upper and lower parts of the *Large Glass*. Marcel Jean, for example, wrote in 1959 of the Bride's Top Inscription, "Just as telegraph wires transmit messages, so the rose-colored cloud in which the wind's mouldings are cut should serve as a conductor for an *Inscription*."[71] Lebel, in his 1959 monograph, referred more generally to the Bride's "system of telecommunications," and Tomkins in 1966 described the Draft or Air

Current Pistons as "a kind of telegraph system."[72] The predominance of the Bride's automobile associations in the *Green Box,* however, seems to have discouraged any exploration of the nature of that telegraphy or its possible relation to Duchamp's *Box of 1914* reference to "électricité en large." Similarly, for observers in the later twentieth century, Duchamp's phrase "painting *of frequency*" was more likely to evoke temporal notions than the electromagnetic associations that would have been obvious in the first decades of the century.

The telegraphy theme received new emphasis in the Duchamp literature with the appearance of his 1959 drawing *Cols alités* (a pun on "causality," usually translated "Bedridden Mountains"; fig. 87), in which a telegraph/electrical pole is superimposed onto an image of the *Large Glass.*[73] Interpreted by Octavio Paz and others as a "hinge" between the *Large Glass* and Duchamp's then-secret assemblage *Etant donnés* (fig. 183), the drawing pointed up, by contrast, the absence of telegraph wires in the *Large Glass.* As Paz suggests in response to the *Green Box*'s indication that the communication between the Bride and Bachelors is electric, the 1959 drawing presents as "physical energy" what in the *Large Glass* had been "psychic energy."[74] Or, according to Hellmut Wohl, the inclusion of the telegraph pole "explicitly shows the transmission of the electricity" necessary for the events of *Etant donnés*: "The drawing announces that the theme of the *Glass* cannot any longer be embodied in the terms in which it was there formulated, and will henceforth unfold in the visible, tangible real world of sense experience."[75] Wohl's 1977 article introduced a previously unknown landscape drawing of 1959, *Du Tignet* (Collection Robert Shapazian, Los Angeles), which served Duchamp as a model for the landscape elements of *Cols alités,* including a specific telegraph pole.[76] Duchamp's image also finds an interesting precursor in the work of another enthusiast of wireless telegraphy, Apollinaire. "Voyage," another poem in the "Ondes" section of *Calligrammes,* included a drawing of the top of a similar telegraph pole, though in Apollinaire's image four single insulators are arrayed up each side and eight wires extend from the pole.[77]

Of the authors noting the contrast between *Cols alités* and the *Large Glass,* only Lebel specifically mentioned wireless telegraphy and its possible connection to "electricity at large." In one of his last essays, "Marcel Duchamp et l'électricité en large," written for the 1983 *Electra* exhibition in Paris, Lebel interpreted the phrase to mean "a freer and more viable reserve of energy." He continued: "[Duchamp] imagined a form of wire-less electricity (the term used to describe telegraphy around 1914) to which he allotted a quasi-mystical role in the communication—

difficult over a long distance—between the separate parts of the *Large Glass.*"[78] Having raised the issue of wireless telegraphy, Lebel discussed it no further.

The other Duchamp scholar who has suggested the relevance of electricity and electromagnetism to the *Large Glass*—without discussing wireless telegraphy as such—is Jean Suquet. Suquet's focus on the Juggler/Handler of Gravity, in particular, alerted him to the importance of wave-borne communication in the *Large Glass* (e.g., fig. 111). His awareness of science and technology is apparent in his writings, in which components of the *Large Glass* are compared to a variety of scientific or technological phenomena. Evoking giant sparks of lightning, he describes the Milky Way as "flashed through by the breath-writing which the Bride telegraphs to the Handler of Gravity."[79] Other references—for example, to the flow of female and male electricity and to the mid-section as a "high-voltage condenser"—poetically capture the spirit of the *Large Glass* without tying it specifically to contemporary science.[80]

Now, however, against the backdrop of popular interest in wireless telegraphy and the related issue of electromagnetic waves, the language of Duchamp's notes and the imagery of the *Large Glass* regain certain of their former associations. As noted earlier, the sexual overtones of much electrical terminology made it suitable to Duchamp's project, and wireless telegraphy was no exception. Sparks, vibrations, and oscillations were central to its practice, and other electrical elements, such as interrupters and *électro-aimants* (electromagnets), also appear in sources on the subject. Thus, in Duchamp's long, automobile-oriented *Green Box* note on the Bride, his frequent mention of sparks, joined to his description of the Bride's "cinematic blossoming" as "the sum total of her splendid vibrations," seems to point directly to spark telegraphy.[81] Further, Duchamp's reference to "electrical control" of the stripping and his explanation that "the connections. will be. *electrical.* and will thus express the stripping: an alternating process. Short circuit if necessary—," evoke "electrical radiations" (i.e., Hertzian waves) as well as the high-voltage, high-frequency alternating current necessary to generate those waves and the short circuits that could occur around a spark gap.[82]

Duchamp must have delighted in the overlays of function and in the double entendres he could achieve in borrowing from the technology of the automobile and wireless telegraphy. As noted, the sparking of the Bride's Desire-magneto could also give rise to Hertzian waves. Similarly, Duchamp's *arbre type,* rooted in the "desire-gears," was to carry out the "transmission of the desire"—a clever play on transmission shaft (*arbre de transmission*)

and the transmittal of messages of desire via wireless telegraphy. The Bride's "feeble cylinders" incorporate the term *faible,* which appears repeatedly in sources on electricity and wireless telegraphy (e.g., "feeble excitations," "feeble oscillations" or "feeble source of electricity") but not in literature on automobiles.[83]

When Duchamp introduced terminology from wireless telegraphy, he carried his game of metamorphosis further by using the terms primarily in nonelectrical contexts. Thus, transformers and receivers appear in his discussions of mechanical energy and chemistry in the lower part of the *Glass*; a Large Receiver also figures in the trituration and liquefaction of the Illuminating Gas passing through the Sieves.[84] (The Sieves, by contrast, would seem to have a second, wireless-telegraphy identity, as discussed below.) Finally, the oscillations of wireless telegraphy are echoed in the rather mysterious "oscillating bathtub" of the Bride as well as in the "oscillating density" of the molecular composition of the Hook and the Bottle of Benedictine as they rise and fall between the Chocolate Grinder and the Chariot/Glider.[85]

The most prominent conflation of automobile and electricity is located in the three strips of glass at its mid-section, where, as Suquet has intuited, Duchamp seems to have incorporated the form of an electrical condenser (figs. 88, 89). (That area consists of a central strip of glass mounted horizontally, which physically divides the upper and lower panels of the *Glass*; above and below the center strip, bands of glass are mounted on the front surface of the encasing glass structure.) In the *Green Box,* Duchamp described the "several plates of glass one above the other" that were originally to have been affixed to canvas (fig. 81) as a "refroidisseur à ailettes (ou à eau)," that is, an air cooler with ribs or gills or a water cooler. These were the two common cooling systems in contemporary automobiles, although the ribs of air-cooling radiators were metal, not glass.[86]

In terming this structure a "refroidisseur," Duchamp evoked the "cooling of the passions" associated with the term *refroidir*: "The Bride instead of being merely an asensual icicle, warmly rejects. (not chastely) the bachelors' brusque offer."[87] He augmented the distancing effect by labeling the mid-section an "Isolateur" (Insulator), a function associated with glass as a dielectric or a material that does not conduct electricity. Thus, by the time of the "First breakdown" of the components of the *Glass,* Duchamp described the mid-section not as a Cooler but as an "Insulator in transparent glass" and, subsequently, a "Large Insulator."[88]

Yet, the form of the mid-section also belies that simple identification: an "Insulator in glass" would have resem-

bled the molded electrical insulators used for high-voltage transmission lines (such as those advertised in fig. 90) or their latter-day counterparts in *Cols alités.* Such flat planes of glass, however, were actually used as insulators in an electrical condenser (the apparatus central to much electrical technology and required for the production of sparks in the high-frequency experiments of Tesla), in wireless telegraphy, and even for the ignition of an automobile. So well known were condensers in this period that, as noted earlier, Bergson, in *Le Rire,* had made a condenser central to his metaphor for passion, describing "contrary electricities" that accumulate "between the plates of the condenser from which the spark will presently flash."[89] An illustration from Georges Claude's *L'Electricité à la portée de tout le monde* (fig. 89), presents a typical condenser composed of alternating sheets of a conductor such as tinfoil and an insulator such as glass or mica, one of the materials Duchamp mentions in his notes.[90] Indeed, although the interstices between the glass strips seem to have been left transparent when he abandoned work on the *Large Glass* in 1923, during his repair work in 1936, he applied foil to these areas, completing his "condenser."[91]

The function of a condenser, today known as a capacitor, is to store electrical charge or energy, the potential Duchamp evokes in his reference to "storage of potential" in his notes on transformers and receivers.[92] When voltage is applied, the proximity of the alternating sheets of conducting and nonconducting material causes the segregation of positive and negative charges within the metallic conductor. As a result, additional charge may be added to the conducting plates far more easily than to a similar conductor in isolation. Early condensers took the form of glass jars coated with tinfoil inside and out—the Leyden jar to which Strindberg compared his overcharged nervous state.[93] Whatever the structure of the condenser, it could be discharged by connecting the isolated metal sheets, resulting in a powerful spark discharge and, in an associated circuit, an oscillating current.[94]

A condenser of some sort would have been essential to the Bride's production of sparks and her "splendid vibrations." That the mid-section strips are a sign for such a condenser is supported by the additional link Duchamp created between the Bride's Clothing (as associated with those strips) and the *3 Standard Stoppages* (fig. 68), which he mounted on glass plates in 1936, specifically repeating the pattern of one clear and two greenish glass strips.[95] As Ulf Linde has suggested, "This part, as it is executed on the Glass, looks exactly like the glass plates as they appear set in the croquet case—as if the Clothes simply repeated the three glass plates in profile."[96] Just as he added the

missing foil to the mid-section in 1936, in mounting and housing the *Stoppages* the way he did, Duchamp made manifest the implicit association of the mid-section and turn-of-the-century condenser technology. A 1905 description of the boxlike variable condenser used in the wireless telegraphy installation at the top of the Eiffel Tower offers a striking parallel to the mounted *Stoppages* in their box: "[The condenser] consists of a grooved box analogous to that employed for the drying of photographic negatives. In the grooves there slide a certain number of thick plates of glass to the center of which are glued sheets of tinfoil. The capacity of the condenser can thus be easily varied at the receiving station."[97]

Given Duchamp's familiarity with photography plates and their boxes (i.e., *Box of 1914*), as well as his refitting of the wooden croquet box for the *3 Standard Stoppages* as if it were a box for drying negatives, the model of such condensers seems to have been important both in the early stages of the *Large Glass* project and in his later work on it in 1936. Moreover, the technique of making a condenser, which involves gluing or varnishing foil to glass sheets, presages Duchamp's working method in the *Large Glass* much more closely than any previous artistic practice.[98] The do-it-yourself approach of electrical and wireless telegraphy literature, which offered ample instructions on how to affix foils to glass surfaces, offered ready lessons for the young Duchamp, eager to function as an engineer, not as a painter. Whereas Jules Romains had subsumed science within art, describing himself as "a condenser of universal energy" from whom "sparks will fly forth," Duchamp preferred to transform his art into a laboratory science and to build an approximation of a condenser.[99]

"In spite of this cooler. there is no discontinuity between the bach. machine and the Bride," Duchamp had written in his *Green Box* note, and wireless spark telegraphy offered a means for the continuity within the *Glass*.[100] Yet, if the *Large Glass* was to be a "painting *of frequency*," he was faced with the challenge of signifying the action of invisible electromagnetic waves in the work itself. In his earlier paintings, such as *Nude Descending a Staircase (No. 2)* (fig. 12) or *The King and Queen Surrounded by Swift Nudes* (pl. 2, fig. 21), Duchamp had attempted to give visual form to the invisible—to create images of the internal realities revealed by X-rays or of the intra-atomic realm of the speeding electron that could be evoked by flamelike emanations and sparks. Yet as he moved beyond Cubist painting, he seems to have shared Kupka's rejection of the Cubists' attempts to "paint X-rays."[101] Thus, like a contemporary scientist, Duchamp would focus on the process of *enregistrement,* the scientific registering or

recording of electromagnetic waves, rather than on a painterly approximation of their effects.

Between the literature on X-rays or spirit photography and his personal experience in conventional photography, Duchamp was well aware of the phenomenon of capturing invisible or visible light on *plaques ultra-sensibles*, such as those originally contained in his *Box of 1914* cartons (figs. 78, 79). As noted earlier, the *Box of 1914* had used the phrase "enregistrer (photographiquement)" in discussing the recording of the chance outcomes of a barrel game.[102] Photography thus offered not only a model for the "scientific" language of precision Duchamp sought, but also the possibility of registering invisible effects. Given his interest in contemporary science, however, Duchamp was also familiar with scientific registering instruments (e.g., figs. 116, 117) and had referred directly to an "appareil enregistrant" in his *Musical Erratum* project entitled *The Bride Stripped Bare by Her Bachelors, Even* of 1913.[103] Although Kupka had applied the same term to the human eye, such registering instruments were generally used in scientific and occult contexts to document physical events imperceptible to the human eye.[104]

Wireless telegraphy wave detectors, which took a variety of forms, were one of the most widely discussed registering apparatuses in the early years of the century.[105] Lucien Poincaré described the wave detector as "the most delicate organ in wireless telegraphy," and, as Crookes's comparison of the brain to a wave detector suggests, it served turn-of-the-century culture much as the computer does today—as the newest technological analogue for cerebral functioning.[106] Such human-machine analogies were made literal by certain wireless telegraphy experimenters. *La Nature* of September 1912 reported the registering of electromagnetic waves using frog legs, long known for their usefulness in studying the "electrical excitation of nerves."[107] In an earlier article, "Les Ondes électriques et le cerveau human," *La Nature* science writer Emile Guarini had discussed experiments using the human body as an antenna as well as actual brain matter as a wave detector, the latter encouraging Guarini to speculate on the feasibility of telepathy.[108] D. Berthelot dealt with similar issues in his 1913 presidential address before the Société Internationale des Electriciens, "Les Mécanismes biologiques et les phénomènes électriques," subsequently published in the *Revue Scientifique*.[109] Given the prevalence of such discussions, Duchamp, who was already steeped in the human-machine analogies of the period, would have found wave detectors and other wireless telegraphy apparatus especially relevant.

An examination of the *Large Glass* and its notes with

regard to registering instruments or detectors—particularly those associated with wireless telegraphy—reveals another layer of meaning for certain components of the *Glass*. The first of these is the primary Bachelor organ, the Chocolate Grinder, which Duchamp had initially depicted in his newly precise painting style in 1913 (fig. 66). In the *Chocolate Grinder (No. 2)* (pl. 5, fig. 91), Duchamp's quest for alternative, "non-arty" ways of making lines resulted in his looping thread through the canvas to create the ridges on the grindstones (see chap. 5). Yet in winding thread in this manner, Duchamp was replicating a basic procedure in physics—the winding of an electromagnet (fig. 92). Although actual winding was not possible on the *Large Glass*, Duchamp, like an electrician, replaced the thread with lead wire, which was standardly used in French households for making electrical fuses.[110] In fact, as with the outlining thread in the *Chocolate Grinder (No. 2)*, all the forms of the *Large Glass* are "drawn" with lead wire, as if Duchamp were consciously wiring his invention.

Electromagnets were used in certain types of Hertzian wave detectors, which operated on the principle of changes in magnetic states produced by the passage of electrical oscillations (fig. 93).[111] The juxtaposition of such a detector, composed of three electromagnets mounted on two flat circular plates, with Duchamp's Chocolate Grinder suggests that the Bachelor's function in the *Large Glass* is not only the sexually suggestive grinding of chocolate, a task that could not have been effectively accomplished in this configuration.[112] As discussed earlier, despite the unusual chocolate grinder with three rollers he had seen in Gamelin's window (fig. 94), most grinders or mills had only two rollers (figs. 42 [no. 3], 67). Although on two occasions Duchamp drew the Chocolate Grinder with two rollers, it is never depicted with the requisite rim to contain the ground chocolate.[113] Instead, Duchamp seems to have had a second, competing model in mind as he created his image. Very likely, it was a scientific implement modeled on a type of wave detector—constructed with electromagnets in the bi-level arrangement of circular plates used to insulate one part of an apparatus from another.

That Duchamp wished his Chocolate Grinder to have this second, scientific identity is further supported by his description of the "neck band" (upper plate) of the Grinder as being made of "a kind of aluminum paper."[114] Because aluminum foil as we know it was not commercially available for household use until the 1940s, the aluminum paper he specifies would have been used primarily for scientific purposes in this period.[115] For example, in the early 1890s Philipp Lenard's addition of an aluminum "window" to a cathode-ray tube, thereby allowing the "rays" (i.e., electrons) to travel a centimeter into the air, had marked an important step in the research that ultimately led to Röntgen's discovery of X-rays.[116] Duchamp's addition of *papier d'aluminium* to his Chocolate Grinder/wave detector assured its scientific pedigree.

Its electromagnets poised and ready, Duchamp's Chocolate Grinder was not alone in its responsibilities for detecting and receiving the Bride's commands. Both the phallic Bayonet and the Scissors atop the Chocolate Grinder suggest antennae, as do the Sieves or Umbrellas/Parasols through which the Illuminating Gas was to pass, changing from gas to solid in the process. In the early days of wireless communication, the notion of an antenna to pick up wave vibrations (as well as to emit them) was new, and a great deal of experimentation occurred with regard to sizes and shapes (figs. 95). The term is biological in origin (referring to the sensory organs of insects), but the use of conical shapes in addition to single aerials suggests the paradigm of catching or gathering in waves as well. (In fact, the term *umbrella* was used to designate this type of antenna in the literature on wireless telegraphy.)[117] Although the Sieves or Parasols perform other actions, such as liquefying gas, they also seem related to electromagnetic waves.

Perhaps the most significant reorientation of function in terms of wireless telegraphy and registering instruments in the *Large Glass* has to do with the Nine Malic Molds forming the Cemetery of Uniforms and Liveries (fig. 96), the "red fellows," as Duchamp referred to them, in which the Illuminating Gas is collected and begins its process of liquefaction.[118] Scholars have always interpreted Duchamp's references in his notes to *gaz d'éclairage* as signifying the kind of gas that is burned as a source of light and heat (e.g., coal gas or natural gas).[119] Although as a schoolboy Duchamp had made a drawing of a gas-burning lamp at the Ecole Bossuet and although much later, the "Bride" of *Etant donnés* (fig. 183) would hold up an imitation gas lamp (actually illuminated by an electric bulb), the *Large Glass* notes refer specifically to "inert illuminating gas."[120] Thus, the Illuminating Gas is not a gas to be burned but rather one of the inert rare or "noble" gases (helium, argon, neon, krypton, xenon, and radon) that had been discovered in the period 1895–1900, primarily by Sir William Ramsay.[121] These gases, which could be made to fluoresce by electrification, were also associated with liquefaction: Ramsay had made his discoveries by means of the fractional distillation of liquid air, and these gases were themselves the subject of successive attempts at liquefying and solidifying in this period (see chap. 10).[122]

The variously shaped glass tubes in which electrical discharges produced such fluorescence (pl. 4, fig. 97) were the subject of much scientific and popular interest from the late nineteenth century through World War I. Numerous scientific discoveries had been made in such tubes in a vacuum state, as noted earlier. Crookes had studied cathode rays in the tubes that came to bear his name, and Röntgen had discovered X-rays using a Crookes tube, leading to a proliferation of new types of tubes. The potentially anthropomorphic forms of these tubes (fig. 98) made them suggestive analogues for Duchamp's Malic Molds/Bachelors, just as a Crookes tube seems to have served Picabia at nearly the same time in his *Mechanical Expression Seen through Our Own Mechanical Expression* (figs. 55, 57).[123] Such tubes were also used in Crookes's "radiant matter spectroscopy," and it had been Ramsay's detection of the spectrum of helium in such a tube filled with radium "emanation" that had confirmed Rutherford's theory of radioactive transformation or transmutation.[124]

Crookes tubes, in fact, were descended from the first vacuum tubes made with platinum electrodes fused into them—the Geissler tubes produced in the 1850s by the German glassblower and scientific investigator Heinrich Geissler. Geissler's remarkable skill enabled him to create tubes ranging from simple cylinders (fig. 97, nos. 1–3; pl. 4) to complex decorative arrangements with capillary tubes connecting two or more segments (fig. 99). Filled with various gases, Geissler tubes were used not only in scientific experiments but also for public display and domestic entertainment.[125] A. Dastre described these well-known objects in an article for the *Revue des Deux Mondes* in 1902: "As these experiments are among the most brilliant and most attractive that can be performed with electricity, they are shown on every occasion, as much for the beauty of the spectacle as for the instruction of the spectator."[126] Used as decorations for Queen Victoria's Diamond Jubilee in 1897, Geissler tubes created remarkable coloristic effects that left indelible impressions on their viewers.[127] Kupka, for example, cites them in his discussion of color in his treatise.[128] And Duchamp, in his notes, speaks of "childhood memories of the illuminating gas," doubly evoking his own youth and the "childhood" of the anthropomorphized Gas. He also refers to the "sparkling brutality" of the Malic Molds, which he associates with "the decorated, the 'made in Germany.'"[129]

In a scientific context, Geissler tubes, which had become standard equipment for electrical experiments in laboratories and classrooms, regularly appeared in the literature on cathode rays and X-rays and were featured in displays at the Musée des Arts et Métiers.[130] The single

most important scientific popularizer of Geissler tubes, however, was probably Tesla, who used Geissler tubes and Crookes tubes in his dramatic lectures in the 1890s to demonstrate the effects of high-frequency alternating currents (see chap. 4). Not only had Tesla "excited" gas-filled tubes by allowing currents of high frequency and high voltage to flow through his body; he had also introduced a new kind of "wireless" illumination when he thrust his tubes into the field of electrical oscillations or electromagnetic waves produced by his Tesla coil and its sparks (fig. 59).[131] A plate from Claude's *L'Electricité à la portée de tout le monde* (fig. 99) re-creates one of Tesla's spectacular performances. Here the silhouette of Tesla, "flames" emanating from his fingertips, is surrounded by Geissler tubes and Crookes or other electrical discharge tubes containing decorative phosphorescent materials. Tesla's initial quest for new forms of illumination had made him a pioneer in the use of luminescent gas tubes as indicators of the presence of Hertzian waves.[132]

The connection of Geissler tubes to wireless telegraphy became official when Geissler tubes were adopted as wave detectors, particularly as a means to tune an antenna, an application that continued well into this century. Fleming's *Principles of Electric Wave Telegraphy*, for example, illustrates a "Neon Vacuum Tube" (identical to fig. 97, no. 5) and describes its red-orange glow in the presence of high-frequency electrical oscillations.[133] In this context, Duchamp's reddish Malic Molds, which are joined by the capillary tubes characteristic of Geissler tubes and filled with an "inert illuminating gas" like neon, seem to function as vacuum-tube wave detectors. Like the Chocolate Grinder, they stand ready to be "excited" by the Bride's "splendid vibrations."

Typically, Duchamp blends several functions in his conception of the Malic Molds. On one level the hollow uniforms signify various professions for the Bachelors (fig. 77, no. 11), but most of the characteristics he developed for the Molds relate to the theme of luminescent gases in tubes. In seeking to avoid conventional painting, Duchamp described the Malic Molds as "lead-oxided" (or undercoated)—"provisionally painted with red lead *while waiting* for each one to receive its color, like croquet mallets."[134] Yet, rather than mallets, the "red fellows" were molds, "envelopes" associated with the molding of chocolate as well as the "casting" of gas.[135] The issue of molding and casting is discussed further below, but it is instructive to consider Duchamp's comments on the nature of the substance within the Malic Molds. If the Malic Molds are "*waiting . . .* to receive [their] color," that color will not come as paint nor as the product of "extra solar lighting"; instead, it will be the result of "interior

lighting" and "luminous effects" dependent upon "molecular construction."[136] Further, "each substance in its chemical composition is endowed with a '*phosphorescence*' (?) and lights up like luminous advertisements not quite."[137] Thus, both the gas in the Malic Molds and the molded "object in chocolate," which Duchamp likewise describes as "illuminant" and capable of "emanating," suggest analogies to Crookes's radiant matter or even to radium emanation.[138] The latter, in fact, could be associated with neon, since Ramsay and Soddy had reported (erroneously) that neon, rather than helium, was produced by the disintegration of radium emanation if water was present in the tube.[139]

Duchamp's reference to "light[ing] up like luminous advertisements" provides one further association for the Illuminating Gas and the Malic Molds, a connection likewise involving neon. In the very years that Duchamp was at work on the *Large Glass,* Georges Claude, scientific popularizer and a pioneer in the liquefaction of air and the commercial production of neon, developed the first practical neon-tube lighting. Claude exhibited his first experimental neon tubes on the facade of the Grand Palais at the December 1910 Salon de l'Automobile; he also demonstrated the properties of liquid air and his new neon tubes at a stand titled "Scientia" at the Luna Park amusement park. In 1912 the first neon advertising sign was installed at the Palais Coiffeur barbershop on the boulevard Montmartre, and in 1913 the Church of Saint-Ouen, in Duchamp's native Rouen, was illuminated with fifty vertical neon tubes to celebrate Normandy's Millennium.[140] Popular interest in the new form of lighting is reflected in the immediate coverage given it in periodicals such as *La Nature* and *La Revue des Idées,* which featured a note on "Le Néon, gaz d'éclairage," in January 1911.[141] Geissler tubes may have evoked "childhood memories of the illuminating gas" for Duchamp, but neon, newly popularized in the context of wireless telegraphy, radioactivity, and Claude's new lighting system, represented the most up-to-date illuminating gas. Yet Claude, in his writings explaining his new discoveries during this period, referred to his tubes as "immense Geissler tubes," placing himself in the tradition of Tesla, whom he had praised in his book on electricity for his pioneering work with luminescent gas-tube lighting.[142]

"As background, perhaps: an electric fete recalling the decorative lighting of Magic City or Luna Park, or the Pier Pavilion at Herne Bay," wrote Duchamp in one of his notes. Although the note subsequently mentions "arc lamps," an earlier form of electrical lighting, the term "illuminating gas" in this period offered rich possibilities for an "electric fete"—from the model of Tesla's displays to Claude's latest experimental neon lighting and "luminous advertisements."[143] And once the electrical connections of the Illuminating Gas are reestablished, new insights into Duchamp's emblematic note "Given: 1. the waterfall / 2. the illuminating gas" are possible as well.[144] Two illustrations from Claude's *L'Electricité à la portée de tout le monde* (figs. 99, 100) make a convincing case for the unifying theme of electricity in the *Large Glass.*

Although certain Duchamp scholars, such as Arturo Schwarz, have interpreted the elements of water and gas as archetypally female and male, Duchamp's note seems instead to establish the initial conditions for the events of the *Large Glass*—both of which are tied to electricity.[145] From the 1890s on, waterfalls were increasingly being used for the generation of hydroelectric power, the most famous being Niagara Falls, where Tesla and Westinghouse had succeeded in establishing the use of alternating current on a large scale.[146] Although Duchamp never executed a waterfall in the *Large Glass,* such a cascade would have served as a source of *puissance,* or power, for the numerous mechanical operations of the Bachelor Apparatus, including the Water Mill Wheel as waterwheel and dynamo/alternator (figs. 151, 153, 154). Supplemented by a transformer and condenser, it could also have produced high-frequency alternating current and sparks for the Bride's generation of the wave-borne "electricity at large" to activate the Illuminating Gas in this "painting *of frequency.*"

Turning from the three-dimensional world of the Bachelors to the ostensibly four-dimensional realm of the Bride, we encounter the most complex of the characters in the *Large Glass* tableau, an organic, new automaton with sources in X-ray imagery, chemistry equipment, and the automobile. Although Duchamp would subsequently add characteristics linked to meteorology, incandescent lightbulbs, and biology, the Bride's ability to communicate via electromagnetic waves was central to her role. Thus, her anatomy and functions, like those of the Bachelors, parallel aspects of wireless telegraphy equipment. According to Duchamp, at the "life-center" of the Bride is a "spherical, *empty* emanating ball," or the kind of ball associated with a spark gap in wireless telegraphy.[147] As noted earlier, the Bride already had one source of sparks, the Desire-magneto, and the addition of a wireless telegraphy "emanating ball" represented another overlay between the two technologies.

Referred to as both the *Pendu femelle* (female hanging person) and an "isolated cage" (fig. 126), the Bride literally hangs at the top of the *Large Glass* (fig. 101), resembling the cage- or cone-type antennae used for emitting and receiving wireless transmissions at the Eiffel Tower

(fig. 103).[148] Because insulation from the tower itself was essential to the functioning of such antennae, the theme of the insulated or isolated cage is also a recurring one in the wireless telegraphy literature. A 1903 article in the *Revue Générale des Sciences Pures et Appliquées,* for example, includes a drawing similar to figure 103, labeled "Isolement de l'antenne d'émission."[149]

Duchamp gave the most direct visual form to the waves generated by the Bride in drawings depicting her interchange with the Juggler/Handler of Gravity (e.g., fig. 110). Apart from a related drawing in the *Green Box,* these images were first revealed only in the notes published in 1980.[150] The rarely noticed drawing in the *Green Box* occurs at the head of a note entitled "[Blossoming] ABC...," in which Duchamp states his intention to "make an Inscription of it," inaugurating the idea of the Top Inscription.[151] The Top Inscription assumed an even more important role as an analogue for the wireless projection of messages with Duchamp's introduction of the three Air Current Pistons or Nets, by which the Top Inscription is "obtained" and "through which pass the commands of the pendu femelle" (figs. 101, 120).[152] It was this Net-bearing Top Inscription, described by Duchamp as "concerned with the cannon shots," that suggested the telegraphy theme to scholars such as Jean, Lebel, and Tomkins.[153]

Duchamp's discussion of both systems—using waves alone or with Air Current Pistons/Nets—strongly suggests the presence of some kind of code: the Bride's interchange with the Juggler occurs by moving "alphabetic units"; the Nets through which her commands are transmitted are described as "a sort of triple 'cipher.'"[154] Rooted in his explorations of the nature of language, including the possibility of "prime words," Duchamp's treatment of the Bride's means of communication also seems to reflect the importance of Morse code as an international language (fig. 104).[155] The dots and dashes broadcast from the Eiffel Tower provided one model for the kind of "schematic sign designating . . . words" he considered in certain of his notes on language.[156]

If such allusions to code transmissions represent one aspect of the Bride's emission of electromagnetic waves, Duchamp's drawing of the Milky Way/Top Inscription (fig. 101) includes what may be another, less obvious sign of electrical activity: the spiraling form traversing the three mesh squares of the Air Current Pistons and extending downward to meet the Nine Shots. Duchamp's probable use of circular forms to suggest the flow of electricity or speeding electrons was noted earlier, in the discussion of the drawing *The King and Queen Traversed by Swift Nudes* (fig. 23; see chap. 2). In that context, Duchamp seemed to be drawing upon standard

technical illustrations of the relation between the flow of an electrical current and the resultant magnetic field (the Corkscrew Rule; fig. 29) or the creation of an electromagnet by wrapping an iron core with a current-carrying wire (fig. 28B). He had physically reproduced such a spiral in making the *Chocolate Grinder (No. 2).* In electrical literature, the spiral also indicated the presence of an induction coil in an electrical circuit (fig. 102). Such imagery was ubiquitous in books and articles on wireless telegraphy, even in a source such as *La Revue des Idées,* from which the illustration is taken.[157]

For Duchamp, circuit diagrams, whose objects were conceptualized into signs, would have represented a step beyond mechanical drawing and diagrammatic images such as the *Coffee Mill* (figs. 41, 43, 44), which already seemed dry in comparison with contemporary painting. A Tesla-type oscillation transformer, indicated by the spirals D and D' (fig. 102), creates resonant, higher-frequency oscillations in an emitting antenna. Similarly, in Duchamp's drawing (fig. 101), the spiraling form suggests an emitting antenna in which electrical oscillations have been created by the sparks of the Bride. Surrounding and traversing the Nets, this spiraling form also seems to stand for the "sort of Milky Way" he discusses in the text of the note. Like a field of electrical oscillations, the Milky Way, according to Duchamp, "supports and guides the said commands [of the Bride]."[158] Moreover, the Juggler/ Handler of Gravity himself also exhibits the spiral form (fig. 112), as if he were the resonant coil set in motion by the Bride's vibrations.[159]

Beyond the spiral as a sign of inductance in a circuit, Duchamp may also have responded to another ideogram in circuit diagrams (fig. 102)—that of the parallel lines at C representing a condenser. Thus, in addition to the form and materials of the mid-section of the *Glass* (fig. 88), Duchamp's use of parallel lines in his drawing (fig. 101) also mimics a condenser. Clearly, one of his basic goals in the *Large Glass* was the invention of a more conceptual pictorial language that would transcend traditional ideas of landscape and figure (see chap. 12). As in the circuit-like *Network of Stoppages* (fig. 73) as well, such electrical diagrams would have provided a highly useful model for this artist dedicated to "explor[ing] the mind more than the hand."[160]

The theme of air currents or drafts offered a further possibility for overlaying an electrical function in the Bride's domain. Duchamp's basic notion of pistons powered by air currents or drafts already conflated two energy systems and may well reflect contemporary studies of air currents and ventilation, such as William Napier Shaw's 1907 *Air Currents and the Laws of Ventilation.* In that text

Shaw compared the movement or circuit of air to electrical circuits.[161] Theorists on electricity, on the other hand, had earlier adopted the term "electric wind" for an electrical phenomenon discovered in the eighteenth century. –Silvanus Thompson, in *Elementary Lessons on Electricity and Magnetism* (French translation, 1898), for example, discusses electrical discharge from a point and describes the "air-currents [that] can be felt with the hand...due to the mutual repulsion between the electrified air particles near the point and the electricity collected on the point itself."[162]

The presence of electric wind was commonly documented by certain types of "dust figures," which are discussed below in relation to Duchamp's *Raising of Dust* (fig. 123). Occultists also drew on the idea of electric wind. Baraduc, for example, states that "electric wind" helps in the process of exteriorization.[163] Such associations of wind and electricity suggest that Duchamp's discussions of air currents in the Bride might be read on both meteorological and electrical levels. Thus, his notation "Ventilation: Partir d'un *courant d'air* intérieur" (fig. 105) may augment the theme of electrical oscillations suggested in the *Milky Way* drawing (fig. 101): from this point emanate the "splendid vibrations" of the Bride.

Given the close association of wireless telegraphy and telepathy in this period (particularly Kupka's active interest in the subject), the Bride's communications seem, on another level, to operate like a telepathic transfer of thought.[164] In this view, the cloudlike Milky Way and Top Inscription, which Duchamp hoped to imprint mechanically onto the glass, could be interpreted as a kind of "thought photograph," akin to Baraduc's *psychicones* (fig. 85). Baraduc had described these images as records of the soul's "luminous vibrations," offering a parallel to Duchamp's talk of the Bride's "cinematic blossoming" as the "sum total of her splendid vibrations" and of the need "to express [this blossoming] in a completely different way from the rest of the painting."[165]

In the context of electromagnetism and wireless telegraphy, telepathic communication would have been a logical extension of Duchamp's scientific concerns, particularly given the frequent analogies drawn between the *appareils enregistreurs* of wireless telegraphy and the human brain. Beyond Kupka, his most immediate connection to telepathy, Duchamp could draw on the works of scientists like Crookes, Lodge, and Flammarion, whose *L'Inconnu* included lengthy sections on telepathy, and authors like Villiers, for whom thought transference had been a central theme in *L'Eve future*. The Puteaux-related *La Vie Mystérieuse* and *Les Bandeaux d'Or* both carried articles on telepathy and electromagnetic waves, as did a

variety of occult, general-interest, and scientific magazines such as *La Nature* and *Le Radium*.[166] And because the ether itself was often associated with the fourth dimension in this period, the notion of the Bride's communication from the *au-delà*, or beyond, via ether waves suited well Duchamp's general scheme for the *Large Glass*.[167]

In his *Portrait of Dr. Dumouchel* (fig. 2) Duchamp had responded to Rochas's discussions of bodily emanations; later, in the *Portrait of Chess Players* series (fig. 15), he had attempted to give physical form to thought itself, using as a model X-rays of the brain. Once Duchamp's planning for the *Large Glass* had begun, however, his growing interest in photographic processes and the use of sensitive plates as registering instruments, in conjunction with Kupka's developing theories, dictated a new approach. The problem he faced in the *Glass* was to indicate physically the controlling thoughts, desires, and commands of the Bride. Certain drawings chronicle Duchamp's more overtly scientific ideas for manifesting these invisible vibrations or waves (figs. 101, 110). In the end, however, occultists such as Baraduc offered a more visually successful model for embodying thought projections. Nonetheless, as in the case of Houston, Crookes, and other scientists, such telepathic projections remained tied to the science of electromagnetism. Thus, although elements of occult practice may be reflected in the *Large Glass,* one need not posit a séance as its primary theme.[168] Instead, as was his practice, Duchamp, like Jarry and Roussel before him, simply borrowed useful models from the closely related realms of occultism and science.

In the *Large Glass* the relevance of telepathy and communication at a distance via Hertzian waves is further supported by the discovery of a little-known collage-painting by Duchamp's younger sister Suzanne: *Radiations de deux seuls éloignés* (Radiations of Two Lone Ones at a Distance), dated 1916–1918–1920 (fig. 106). Using lead wire, like her brother, along with glass beads, pearls, string, straws, and crumpled tinfoil, Suzanne suggests the communication of two lovers at a distance— probably in response to her own periods of geographical separation from the painter Jean Crotti, whom she met in Paris in 1916 and would marry in 1919.[169] Because of her residence in Paris during World War I, Suzanne would most likely have been aware of her brother's preparatory work on the *Large Glass* before his departure for New York in June 1915. Her use of the term *éloignés*, for example, echoes Duchamp's usage in one of the notes in the *Box of 1914*.[170]

Crotti, a painter loosely associated with the Puteaux milieu, had also spent time in New York, where he

111

became a good friend of Duchamp, working closely with him during the fall and winter of 1915 and even sharing his studio for a time. Crotti's encounter with the mechanomorphic style of Duchamp and Picabia had been so climactic for his artistic development that he described it as his second birth "by auto-procreation and self-delivery without umbilical cord."[171] Returning to Paris in 1916, he would have brought with him the latest news of Duchamp's developing project; in fact, during that year Crotti himself produced several works using glass and other materials that seem to be direct responses to the *Large Glass*. These include *The Mechanical Forces of Love in Movement* (Private Collection), *The Clown* (Musée d'Art Moderne de la Ville de Paris), whose spiral body Suquet had linked to the Juggler of Gravity, and *Solution de continuité* (Private Collection), the latter presumably deriving from Duchamp's note on the Bride stating that "in spite of this cooler, there is no disconti nuity [*pas de solution de continuité*] between the bach. machine and the Bride. But the connections will be. *electrical*. . . ."[172]

In Suzanne's *Radiations de deux seuls éloignés,* two central, outlined forms (established in her preparatory drawings) are surrounded by a field of brightly colored shapes, several of which suggest rays of light, augmenting the painting's electromagnetic theme. The upper form resembles a cage-type emitting antenna (fig. 103) and the lower gridded one implies a surface on which the "radiations" are to be recorded. In her drawings, codelike dots or solid squares appear in the lower grid, replicating the dot-filled squares at the center of the upper form, but in the final painting the registering process has just commenced, with a single dot indicated below.[173] Whether this is Morse code or a telepathic transfer of signs, the theme seems to echo that of the *Large Glass*: here an antennalike "Bride" (Suzanne herself?) projects her message. The use of the term *radiation*, in particular, links Suzanne's painting to the tradition of "cerebral radiations" propounded by Houston and Flammarion, who described telepathy as the "radiation of the human consciousness. . .by means of specially subtle waves."[174] The works of both Suzanne and Crotti would therefore seem to offer an informative parallel to Duchamp's *Large Glass* enterprise, functioning as Kupka's paintings had done earlier in Duchamp's X-ray phase and as Picabia's art had begun to do in 1913.[175]

Besides the communication of messages by wireless telegraphy (or telepathy), Hertzian waves were also the subject of experiments in this period in the operation of mechanical devices from a distance—what we now term radio control. Tesla, extrapolating from his conception of himself as an automaton responsive to external stimuli, had built the first radio-controlled "telautomaton"—his boat demonstrated in New York in 1898.[176] According to Tesla, "By means of an electric circuit placed within the boat, and adjusted, or 'tuned' exactly to electrical vibrations of the kind transmitted to it from a distant 'electrical oscillator,'" these vibrations (i.e., Hertzian waves) had "absolutely controll[ed], in every respect, all the innumerable translatory movements, as well as the operations of all the internal organs, no matter how many, of an individualized automaton."[177] Given Tesla's international reputation and popularity, his experiments in "telautomatics" and the remarkable language in which he discussed them could well have been known to Duchamp through an account more detailed than Péladan's brief mention in his "Le Radium et l'hyperphysique" of Tesla's boat controlled by the "vibrations of an oscillator."[178]

Beginning in 1905, the wireless telegraphy pioneer Edouard Branly carried out experiments similar to Tesla's in what he termed "telemechanics."[179] Branly's system was more complex than that of Tesla and involved the triggering of an entire sequence of mechanical processes by the transmission of a wave signal across Paris (figs. 107, 108). By means of an arrangement at the receiving station involving the detection of waves by a tripod coherer (figs. 107 [upper left], 113) and the control of individual events using a "distributing shaft driven by clockwork" (fig. 107), a wave signal could, for example, illuminate Geissler tubes (text, fig. 107) and activate a pistol, a ball to be lifted by electromagnets, a fan, and a bank of lamps (fig. 108).[180]

As in the case of Tesla's telautomaton, Branly's experiments present striking analogies to Duchamp's Bride and Bachelors of the *Large Glass*. As discussed below in relation to the Bride's communication with the Juggler/ Handler of Gravity, there are both visual and functional parallels between Duchamp's Juggler/Handler of Gravity and Branly's tripod coherer (figs. 112, 113). More specifically, however, in the context of radio control, the ability of the Bride to "displace a [stabilizer] (a ball or anything)" on the "plate" of the Juggler/Handler replicates Branly's electromagnetic lifting of a metal ball.[181] Further, the presence of a clockwork mechanism at the heart of Branly's receiving apparatus evokes the Bachelors' automatonlike Boxing Match, with its clockwork apparatus.[182] Indeed, Duchamp seems not to have been the only artist to respond to such imagery and ideas. Branly's mounted pistol, ready to be fired mechanically (fig. 108), strongly suggests Picabia's personification of a male-female relationship (albeit wired rather than wireless) in his drawing *Voilà elle* (fig. 109). Here a phallic pistol would seem to

be repeatedly recocked and fired by the "female" target at which it shoots.[183]

Radio control provided a concrete model for the kind of interaction Duchamp was seeking to convey among his mechanical counterparts to humans. Moreover, Tesla's experiments in telautomatics and Branly's in telemechanics were closely associated with wireless telegraphy as a whole and could even be tied to telepathy and the theme of exteriorization. For example, the alchemist Jollivet Castelot, editor of *Les Nouveaux Horizons de la Science et de la Pensée*, proclaimed in 1909, "The action at a distance of electricity according to the astonishing methods of Tesla and Branly proves the possibility of telepathy and the facts of exteriorization of sensibility and *motricité* in the psychic order."[184] In the end, the notion of the Bride not only as a transmitter of telegraphic/telepathic messages to the Bachelors but also as an active controller of their activities—from a distance—would seem basic to the operation of the *Large Glass*. As Duchamp emphasized to Arturo Schwarz, "There is no physical contact, the physical relationship remains at the stage of intentions."[185]

The Bride, however, is not only an emitter of signals; she is also a receiver of communications from the Juggler/Handler of Gravity (figs. 110, 111). In a *Green Box* note postdating his automobile-oriented treatment of the Bride, Duchamp lists four "properties" of the Bride as Wasp, demonstrating the continued importance of vibrations and waves as well as the growing role of meteorological and biological themes. In addition to "1. *Secretion* of love gasoline by osmosis" and "4. Ventilation . . .," Duchamp lists "2. *Flair* or sense receiving *the waves* of *disequilibrium from the black ball* . . ." and "3. Vibratory property determining the pulsations of the needle."[186] Balancing his "black ball," seemingly also capable of emissions like the Bride's "spherical *empty* emanating ball," the Juggler/Handler, whose spiral form also suggests an emitting coil (fig. 112), carries on a wave-borne dialogue with the Bride.[187] Duchamp gave physical form to that exchange in certain drawings based on the notion of the Bride unrolling her "filaments" in the manner of the *soufflets* found at the Neuilly Fair, akin to children's party blowers that roll out and curl up again (fig. 110).[188] In typical fashion Duchamp conflates here a mechanical process, the Juggler's balancing act as he juggles his "center of gravity," with the transmission and reception of electromagnetic waves, which are themselves the product of the electromagnetic disequilibrium created by an oscillatory spark discharge.[189]

Duchamp had indicated the Bride's "pulse needle" in his drawing of the Sex Cylinder/Wasp (figs. 105, 82). Its

pulsations determined by her "vibratory property," this needle—along with several other of the Bride's characteristics—may associate her with the detection of Hertzian waves, among her other functions. Magnetized needles had long been central to experiments with electricity and were used in a number of wave detectors, where they would have pulsed in response to wave vibrations. In addition, in the context of the meteorological functions presented in the note listing the Wasp's properties, Duchamp also introduces a "tympanum" and the Bride's "filament paste" or "filament material."[190] Like Geissler tubes, bulbs with filaments could be used in wave detectors. Similarly, the tympanum or diaphragm in a telephone apparatus was central to any sound-oriented detection of wireless-telegraphy waves and to the developing practice of wireless telephony.[191]

In addition to their use in registering apparatuses (figs. 116, 117), needles may also have had two other complementary associations. In *L'Eve future,* Villiers-as-Edison had equipped Hadaly with a needle and "Cylinders" on the model of the phonograph. Such cylinders functioned literally as a "recording instrument," which could in turn produce the voice and control the actions of Hadaly.[192] More important, the theme of a needle also evoked the larger association of magnetism and sexual attraction, an analogy long in use but given new currency in Duchamp's milieu in Remy de Gourmont's *Physique de l'amour.* Frankly equating biological and mechanical functions, Gourmont wrote: "In short, two forces are present, the magnet and the needle. Usually the female is the magnet, sometimes she is the needle. These are details of mechanism which do not modify the general march of the machine to its goal."[193]

This latter theme was undoubtedly one impetus for Duchamp to incorporate a needle into the Bride's constitution. In this instance, the female is the needle, responding to the Juggler's "ball in *black* metal," which has "the property of attracting the filaments or branches" of the Bride.[194] (Conversely, elements of the Bachelors' Boxing Match experience "ascensional magnetization" toward a "center of distraction" above, suggesting that the controlling Bride also functions as a magnet [see chap. 11].)[195] Yet, given the centrality of electricity and electromagnetism in the *Large Glass,* the Bride's "pulse needle" is necessarily much more than simply a compass needle. In particular, the Bride's "Flair," equated by Duchamp with her "sense receiving *the waves* of *disequilibrium*," evokes a dog's superhuman sense of smell and therefore implies a perceptual capability beyond normal human powers.

Pawlowski had also used this meaning of the word *flair* in his *Voyage au pays de la quatrième dimension,* in a

chapter devoted to the perception of suprasensible wave vibrations, "La Vision de l'invisible." Introducing the episode with a Crookes-like discussion of the range of invisible vibrations "perceived...by the thermometer, photographic plates, or registered by electrical apparatus," Pawlowski cites a dog's flair as inspiration for the founding of a special institute he called "Photophonium."[196] The goal of the institute is to develop sense perceptions to new levels, including educating the eye to perceive invisible electromagnetic waves. A "catastrophe" results when, during a session in the institute's amphitheatre, "all past sensations, all the vibrations accumulated in the air over the centuries" suddenly surge forth, producing a "horrifying tumult."[197] Once again, as in the case of his treatment of automobile and human-machine analogies, Pawlowski's mirroring of contemporary interest in electromagnetic waves may well have contributed to Duchamp's treatment of that theme in the *Large Glass.*

The Juggler/Handler of Gravity not only transmits the "waves of disequilibrium" to the Bride but, like the Bachelors below, also receives her commands. In certain of Duchamp's drawings (fig. 112), the Juggler, functioning as a wave detector, resembles the well-known Branly tripod coherer (figs. 113, 107). (Although Duchamp at times drew the Juggler with four legs, he specified in his notes: "Only give the juggler 3 feet because 3 pts of support are necessary for stable equilibrium. . . .")[198] At the same time, however, the Juggler, "dancing" on the Bride's Clothing at the mid-section, also serves as another kind of registering instrument, manifesting the effects of the Bachelors' Boxing Match as it manipulates the garment. Indeed, the operation of a tripod coherer might be thought of as a kind of subtle "dance," since in response to an electromagnetic wave the "feet" of the coherer would be drawn into contact with its metal platform, completing a circuit, and would subsequently be released.[199] As a mediator between the three- and four-dimensional realms of the *Large Glass,* the Juggler/Handler-as-detector responds both to the mechanical effects of the Boxing Match and to the etherial wave-borne activities of the Bride above.

In the Juggler/Handler of Gravity, the two blossomings of the Bride come together. Duchamp's text (fig. 110) identifies this image, showing the "movement of these filaments...due to the desire magneto" as the "stripped-bare self blossoming of the Bride" or the "horizontal blossoming of the bride" (also associated with the "sparks of her constant life").[200] This "voluntary horizontal blossoming go[es] to meet the vertical blossoming of the stripping-bare" in what Duchamp terms the "blossoming through reconciliation." The Bride's vertical blossoming,

"end[ing] in the clockwork movement" (i.e., the Boxing Match), is registered by the Juggler in his "dance led by the clockwork box to the sounds of the stripping-bare."[201] In the context of electromagnetic frequency, then, the vertical blossoming would seem to result from the Bride's wireless "broadcast" of her commands to the Bachelors through the Air Current Pistons of the Top Inscription and her "radio control" of their activities. Her voluntary horizontal blossoming and communication with the Juggler, on the other hand, may parallel more closely the processes of thought projection and telepathy as modeled on wireless telegraphy. A different kind of spark is linked to each type of blossoming. The "artificial sparks of the electrical stripping" that control the "clockwork machinery" are associated with the vertical blossoming and the wireless telegraphy commands issued from the Bride's "emanating ball."[202] By contrast, the "sparks of [the Bride's] constant life" issue from her Desire-magneto and embody her telegraphic/telepathic horizontal self-blossoming.

Of all the inhabitants of the *Large Glass,* only one registers physical effects primarily by means of vision—the Oculist Witnesses (fig. 114). The *Témoins oculistes,* as Duchamp termed them, evoking the idea of eyewitnesses (*témoins oculaires*), were a later addition to his scheme for the *Large Glass.* Based on the eye chart opticians use to test for astigmatism, the first of the Witnesses appeared in Duchamp's work of 1918, *To Be Looked At (from the Other Side of the Glass) with One Eye, Close to, for Almost an Hour* (figs. 115, 171).[203] That twenty-inch glass panel, which includes the lowest of the three witnesses and the righthand tips of the Scissors, was created in Buenos Aires during a sojourn of nearly ten months, from late August 1918 through June 1919. As Duchamp wrote to Crotti in October 1918, "I started a small glass to experiment with an effect that I will carry over to the large glass—when I return to N.Y."[204] The effect Duchamp was exploring was the use of the optics of visible light as the vehicle for "dazzling the splash" into the upper half of the *Glass.*[205] By means of a lens glued to the glass and the mirror-reflective surfaces of the Oculist Witnesses, the Witnesses would now accomplish the task originally planned for the Mobile and the Desire Dynamo (see chap. 11). (In the end, however, the actual lens incorporated on the surface of *To Be Looked At* is suggested only by a circle on the *Large Glass.*)

To Be Looked At announces not only Duchamp's renewed concern with issues of perspective but also his growing interest in optical effects (see chap. 14). Nonetheless, because visible light is simply another range of the electromagnetic spectrum, the Oculist Witnesses also represent a natural extension of his concerns in the *Large*

Glass. Indeed, the "Zone-plate of Tinfoil on Glass" (fig. 172), which offers a strong visual parallel to the rings around the lens in *To Be Looked At,* is drawn from Oliver Lodge's 1900 book *Signalling across Space without Wires: The Work of Hertz and His Successors,* in its fourth edition by 1913. The "Zone-plate" image appears in Lodge's discussion of the "ordinary optical experiments with Hertz waves," which had established that electrical oscillations, like light, were subject to reflection, refraction, absorption, polarization, diffraction, and interference.[206] Lodge also sets forth an "electrical theory of vision," in which he, like Crookes, compares the eye to a Hertzian wave detector, suggesting that "quite possibly the sensitiveness of the eye is of the coherer kind."[207] Given such analogies and the essential unity between light and Hertzian waves, Duchamp's Oculist Witnesses can be seen as counterparts to the numerous other electromagnetic wave detectors in the *Large Glass.*

Despite their overtly visual orientation, the Oculist Witnesses may also exhibit more direct connections to wireless telegraphy and telepathy. In general, as several authors have noted, the inclusion of eyewitnesses in the *Large Glass* might imply some kind of occult activity, such as the telepathy discussed earlier, for which the "scientific" testimony of an eyewitness is required.[208] More specifically, in terms of wireless telegraphy, Duchamp's creation of the images of the Witnesses by scraping away the mirror silver applied to that area of the lower panel parallels the method for creating a wave detector developed by the Italian Augusto Righi, who had been Marconi's mentor. According to Hugh Aitken, a historian of wireless telegraphy,

Rather than adopt some kind of coherer, Righi deposited on a sheet of glass, by electrolysis, a thin film of silver in the form of a long narrow rectangle. Across the middle of this rectangle he scribed a thin line with a diamond, cutting through the silver and leaving a gap only a few thousandths of a millimeter wide. The silver film served as a miniature dipole, the scribed line as a detecting spark gap.[209]

Once again, the field of science or technology offered the model for Duchamp's techniques of execution in the *Large Glass,* whether or not he actually thought of the Oculist Witnesses as a kind of spark gap capable of responding to the Bride's sparks and emanating vibrations.

Finally, the photograph of *To Be Looked At,* hanging by wires on a balcony in Buenos Aires (fig. 115), suggests that he may have thought of the work playfully, as a kind of receiving apparatus for electromagnetic waves. (Recall that articles in prewar Paris instructed Parisians on how to use a balcony as an antenna for receiving signals from the Eiffel Tower.)[210] Like the *Large Glass* itself, this panel was far removed from the tradition of oil paintings on canvas that were framed and isolated from the real world; rather, it exists as an object interactive with its environment. From Buenos Aires in spring 1919 Duchamp sent a letter to the newly married Suzanne and Jean Crotti in Paris, instructing them to hang a geometry book on their balcony and let the wind "go through the book, choose its own problems, turn and tear out the pages."[211] Beyond its implicit commentary on geometry, the *Unhappy Readymade,* as Duchamp titled it, was also a kind of registering apparatus—this time, meteorological—which produced a physical record of its interaction with the weather. Indeed, although the present section has focused on the *appareils enregistreurs* associated with wireless telegraphy, registering instruments, which might be thought of as mechanical eyewitnesses, existed in many fields. We now turn to a consideration of the more general question of the registering function of a number of elements of the *Large Glass,* including Duchamp's use of photography in its various guises.

Appareils Enregistreurs and Other Indexical Signs in the *Large Glass*

At the turn of the century, when scientists were investigating numerous phenomena largely invisible to the naked eye—X-rays, electrons, radioactive particles, and Hertzian waves—highly sensitive registering apparatuses played a crucial role in experimentation.[212] *Appareils enregistreurs* were also known to the general public through the popular literature on wireless telegraphy and X-rays, which directed attention to Hertzian wave detectors and to the photographic *plaques sensibles* used to register visible and invisible light. Yet another range of more traditional *appareils enregistreurs* existed in the realms of electrical technology and meteorology. Early twentieth-century advertisements for the firm of Richard Frères (figs. 116, 117) introduce a variety of instruments capable of "constant surveillance," ranging from ammeters and voltmeters to barometers, hygrometers, thermometers, anemometers, and manometers, all available with dials or with the ability to record by means of a needle and rotating cylinder. Similarly equipped instruments were also used in physiology, the chronophotographer Marey having designed a number of such apparatuses.[213] Occultists, too, embraced "accurate scientific instruments" in hopes of documenting the existence of various spirit phenomena.[214]

Technically, a true *appareil enregistreur* will produce a permanent record of an event, such as the lines traced

on a rotating cylinder or the image fixed on a photographic plate. Yet the term *appareil enregistreur* was also used more generally in this period to describe any instrument that detects or indicates the presence of a phenomenon—from human sense organs to the most delicate instruments capable of detecting effects invisible to the human eye. Discussions of electromagnetic waves standardly referred to the inability of the human eye to register Hertzian waves, while, as noted earlier, Kupka considered the eye a registering apparatus for visible light.[215] It was this interpretation, focusing on detection or observation, that encouraged human-machine analogies such as Kupka's, Crookes's comparison of the brain to a Hertzian wave detector, and Duchamp's substitution of registering instruments for human characters in the *Large Glass*.

The key issue, then, was not necessarily the production of a permanent record but rather the ability of an *appareil enregistreur* to *indicate* the presence of a phenomenon. In the semiological theory of the American philosopher Charles Sanders Peirce (1839–1914), such registering instruments are examples of "indexical signs," which Peirce defined as having a physical or causal connection to another object or event. Peirce's indexical sign is distinct from what he termed an "icon" in his "trichotomy" of Icon, Index, Symbol, for the icon simply resembles another object but bears no necessary physical relation to it.[216] An index, like a footprint or a weather vane, functions as evidence of another phenomenon, such as the presence of a person or a gust of wind. Duchamp's wave detectors in the *Large Glass* can now be seen as indexes of electromagnetic waves, paralleling the better-known indexical signs in the *Large Glass* that Rosalind Krauss has discussed. These noninstrument indexes include Duchamp's *Raising of Dust* (fig. 123) in the area of the Sieves as well as his use of photography and of cast shadows in this and other works. Indexicality is particularly apparent in *Tu m'* (fig. 173), a parade of shadows, complete with a pointing index finger, as Krauss has noted.[217]

Duchamp's additional identities for the Bride as a barometer (fig. 126) and weathercock or weather vane (fig. 128) parallel Peirce's use of meteorological instruments, including, specifically, barometers and weathercocks, to illustrate his distinction between index and icon.[218] Duchamp could not possibly have known the theories Peirce was developing in the early years of the century, for they were published only posthumously, beginning in the 1930s.[219] Nonetheless, the remarkable parallels between the two men mark them as products of a particular cultural moment. Just as Peirce's background in chemistry and his work for the U.S. Geodetic Survey had

exposed him to measuring and recording instruments, Duchamp's fascination with science, in an era aimed at chronicling the imperceptible, alerted him to the vital role of registering apparatuses.

With his lively interest in language, Duchamp would certainly have delighted in reading Peirce's discussions of indexical signs, further examples of which include yardsticks and bullet holes. Just as Peirce had interpreted the yardstick as an indexical response to the yard standard, the Capillary Tubes of the *Large Glass* and the *Network of Stoppages* (fig. 73) become indexes of the new meter "standards" Duchamp created in the *3 Standard Stoppages* (fig. 68). Similarly, Duchamp's Nine Shots find a counterpart in Peirce's example of an index as "a piece of mould with a bullet-hole in it as a sign of a shot; for without the shot there would have been no hole."[220]

Photographs, which look like an object at the same time they register its physical presence, are both iconic and indexical.[221] Yet, as Duchamp's use of boxes for glass negatives to house the *Box of 1914* suggests, it was the indexical nature of sensitive photographic plates (with "tous les révélateurs") that most interested him (fig. 78). Unlike photographs, X-ray images are more clearly indexical in nature, presenting a new, previously invisible image of the body whose physical presence is recorded on the plate. Similarly, spirit photographs and Baraduc's *psychicones* were considered by their proponents to stand as physical evidence of the existence of spirits or thought projections—as indexical footprints of invisible phenomena. In this same vein, Duchamp and Henri-Pierre Roché seem to have created a humorous takeoff on spirit photography in Duchamp's New York studio in 1917 or 1918, the sitter (probably Roché) having moved out of the frame before the exposure was complete, leaving a ghostlike, indexical imprint of his image (fig. 118).[222]

As noted earlier, Duchamp had speculated on the possibility of a similar photographic imprinting of the Top Inscription onto the *Large Glass*—as if it were the Bride's *psychicone*. He had used conventional photographs to determine the shapes of the three Air Current Pistons ("i.e. cloth [net] accepted and rejected by the air current"; fig. 120) and considered two other methods of transferring their forms to the area of the Milky Way.[223] Duchamp's first idea involved laying the net fabric on the glass surface in its three configurations as a means of imprinting the images of the Pistons. In his *Green Box* note on the Air Current Pistons, he had written, "Then 'place' them for a certain time. (2 to 3 months) and let them leave their imprint as 3 *nets*. . . ."[224] Although Duchamp never carried out the process he described, a contemporary scientific model did exist for the procedure: the well-known

property of radioactive substances of imprinting their images on adjacent photosensitive material over time. It was, in fact, this phenomenon that led to Becquerel's discovery of radioactivity.[225] An illustration from a 1904 *Century Magazine* article (fig. 119) shows the photographic image produced by the radioactive thorium present in common household gas mantles (the mesh material that produced a steady flame in a gas lamp).[226] With their similar mesh texture and irregular shapes, the Air Current Pistons, like the gas mantle, would have "drawn their own picture," as William Henry Fox Talbot noted in his first description of the photographic process, pointing up its indexical quality.[227]

Arturo Schwarz describes a related, second system, asserting that Duchamp "had planned to glue three squares of gauze, frozen into the shape which the photographs had revealed directly onto the glass."[228] Although he ultimately rejected this approach, Juliette Gleizes's unpublished memoirs confirm that Duchamp did experiment with it in New York. Of the *Large Glass* in its early stages, Mme Gleizes recalled, "On an empty space about ten centimeters square, glued by one of its edges, a tiny bit of *tulle* fluttered."[229] An advertisement from *Vanity Fair* of April 1915 (fig. 121) is a reminder of the specifically feminine associations such fabric would have had, since it was traditionally used for veils on fashionable hats. As glued to the glass, the netting would have functioned as a collage element, metonymically evoking a female presence by its texture. In the end, however, Duchamp removed the pieces of net, distancing his composition from an overt parallel to the collage technique of Picasso and Braque in the prewar years. At the same time his temporary application of the netting suggests a symbolic carrying out of his earlier indexical, radioactivity-oriented scheme.

The 1904 *Century* article entitled "The New Element Radium," noted above, also includes a number of illustrations labeled "Shadow Photographs Taken with the Becquerel Rays," which show images of such common objects as keys and paper clips. These and early X-ray photographs of the contents of wooden boxes or drawers support Francis Naumann's observation that Man Ray's "Rayographs" may be rooted in this tradition of scientific cameraless photography.[230] Like Crotti, Man Ray was significantly influenced by Duchamp's art and theory and subsequently shared his interests in the indexical characteristics of photography and shadows.[231] It was Man Ray who suggested to Duchamp, as the Frenchman laboriously scraped silver from the area of the Oculist Witnesses, that "there might be a photographic process that would expedite matters," to which Duchamp replied, "Yes, perhaps in the future photography would replace all art."[232] In addi-

tion, Man Ray responded to Duchamp's concern with mechanical *appareils enregistreurs* in such works as his 1920 *Catherine Barometer* (Private Collection, Paris), an object portrait of Katherine Dreier, and his 1916 *Self-Portrait* (original destroyed). The latter is in the form of an indexical print of Man Ray's hand on a female "torso," defined at its base by a doorbell placed between the hip-like curves of two violin sound holes and at its top by concave breasts created by two sounder bells.[233]

Before considering Duchamp's highly indexical *Raising of Dust* (fig. 123), which was photographed by Man Ray, an extension of the theme of imprinting by photographic means in the *Glass* should be mentioned. Duchamp's notes collected in the section of *A l'infinitif* entitled "Appearance and Apparition" distinguish between the "appearance" of an object and its "apparition." According to Duchamp, the apparition is the $n-1$ dimensional "mold" of the appearance of the object, "a kind of mirror image *looking* as if it were used for the making of this object."[234] Molding is necessarily an indexical process, and Duchamp connected it as well to photography: "By mold is meant: from the point of view of form and color, the *negative* (photographic)."[235] Here Duchamp almost echoes Villiers in *L'Eve future*, where Edison had created on Hadaly's surface the "apparition" of the "external appearance" of Alicia Clary, even utilizing the technique of "photosculpture."[236]

Although in the notes quoted here Duchamp was discussing the molding "of a chocolate object for ex.," the approach extended to the Bride, whose photographic or mirrorlike image functions as the three-dimensional apparition of her four-dimensional appearance. As mentioned earlier, Duchamp's notes on the molding of chocolate also bring in the issue of emanation, with its associations to radioactivity. "The emanating object is an *apparition,*" he writes of the chocolate object.[237] Yet here, too, the Bride's activity may have similar overtones: as an apparition of her four-dimensional self, she is also an "emanating object" by virtue of her "*empty* emanating ball."[238]

In the early twentieth century, terms such as *apparition* and *emanation* used in conjunction with the process of molding would also have had unmistakable occult associations. Spirit photography had been augmented by the technique of "transcendental plastiques" (fig. 122), casts or imprints allegedly produced by mediums such as Eusapia Palladino as evidence of an apparition or her own out-of-body activity.[239] The imprint was said to appear on clay that had been wrapped in linen and placed within a box; the images in figure 122, however, are actually positive casts made from the original negative imprints.[240] Widely publicized in the writings of Cesare

Lombroso and other spiritualist sources, these indexical imprints, which function as the three-dimensional analogues to the spectral forms in spirit photographs, are the apparition (mold) of the appearance of a phantom. Lombroso includes "Imprints on plastic material" as one phenomenon within the various classes of Eusapia's activity.[241]

Other mediumistic activities in Lombroso's list—for example, "Functional movements of mechanical instruments at a distance"; "Radio-active action on photographic plates"; "Independent levitations of the table" ("dances of the table *a solo*"); and the general activation of a variety of *appareils enregistreurs*, all in the presence of eyewitnesses—parallel so closely Duchamp's interests in the *Large Glass* that his discussions of apparitions and the manifestations of an invisible fourth dimension would seem certainly to have been enriched in some way by such occult sources. That such manifestations were a part of both his New York and Parisian milieus is documented in a December 1922 letter to his brother Jacques Villon: "I know a photographer here who does photos of ectoplasm on a male medium—I had promised to attend his performances and I got lazy but that would amuse me very much," Duchamp writes.[242] As this statement and the "ghost" figures in his various studio photographs (figs. 118, 174) suggest, Duchamp could draw upon occultism to add another witty layer to his creations yet remain detached from his sources.

Mediumistic "sculpture," another kind of impersonal art making without the intervention of the hand, would also have attracted Duchamp. Even though he did no actual molding or casting in the production of the *Large Glass,* impersonal casting had been the central activity he theorized for the Malic Molds, particularly in their guise as the "Matrice d'éros" (Die of Eros).[243] Here Duchamp conflates the organic definition of *matrice* as "womb" and its technological meaning as "die," the stamps or forms used in industrial presses.[244] Indeed, industrial dies were another demonstration of the theme of imprinting that so fascinated Duchamp, and he would have seen the die pressman as the ideal, detached "sculptor." Like the stamper of coins, the pressman was free of aesthetic appraisals of his product and subject only to the accept-or-reject decisions Duchamp alluded to in the phrase "*striking of bad coins* point of view."[245]

Later in his career Duchamp became increasingly interested in the indexical casting of body parts in the context of his work on *Etant donnés* (fig. 183), begun in 1946. Indeed, his 1959 self-portrait, *With My Tongue in My Cheek* (Musée National d'Art Moderne, Paris), with its molded tonguelike cheek set in relief against a drawn

profile, strangely evokes Eusapia's mediumistic profile images.[246] A literal representation of the title on one level, it might have functioned on another level as a tongue-in-cheek commentary on such earlier transcendental plastiques. In relation to *Etant donnés* Duchamp had also produced casts or suggestions of casts of sexual organs, such as the 1950 *Female Fig Leaf* and the 1951 *Objet Dard* (both in the Marcel Duchamp Archive, Villiers-sous-Grez, France).[247] Although these images go far beyond spiritualist tracings, they do find a turn-of-the-century precursor in Gourmont's description in *Physique de l'amour* of male and female sexual organs as "gears" that fit together like the "mold to the cast [*statue*]."[248]

Turning from imprinting and casting to Duchamp's *Raising of Dust,* we encounter perhaps the most direct indexical interaction of the *Large Glass* with its environment: the physical gathering of dust on its panes. Duchamp noted that the glass "had been lying flat on sawhorses for months," during which time he "watched the Broadway dust accumulate on it"; after six months he secured the dust in the area of the Sieves by applying varnish. He and Man Ray referred to this as "'Raising Dust' (in the same sense as 'raising pigs')."[249] Nonetheless, there were historical precedents for this procedure in art and literature. Leonardo in his notebooks had speculated on letting dust collect on soaped glass as a measure of time. And Jarry's Dr. Faustroll wore "tiny little gray boots with even layers of dust carefully preserved on them, at great expense, for many months past, broken only by the dry-geysers of ant-lions."[250]

As mentioned earlier, in the context of electric wind, there were also scientific prototypes for the action of dust on glass, particularly in relation to electricity. These included the "electric dust-figures" or "Lichtenberg figures" produced by touching a charged conductor, such as a Leyden jar, to a glass surface and then sprinkling it with a powder of red lead, the material Duchamp used to coat the Malic Molds.[251] In addition, another type of "photoelectric dust-figure" was being investigated following the discovery of X-rays and the resultant interest in "electric images" (fig. 124).[252] Just as X-rays beamed through a drawer could produce an image on a photosensitive plate, it was hypothesized that dust-figures were produced on the glass case illustrated "with [only] the sun and lamps as agents in their formation": "As a matter of course the surfaces of the lamps would reflect the light in such as way as to make bright spots . . . upon the glass of the containing case, and if the latter were in any sense charged with negative atmospheric electricity, this light would cause a variable amount of dust to be attracted according to the intensity of the rays striking the glass."[253] In the glass

case, as well as in the glass plates used in experiments with Lichtenberg figures, the parallels to Duchamp's raising of dust on the *Large Glass* are apparent: in each instance electrostatic effects would have affected the formation of dust patterns.

This instance of the contents of a glass case seemingly imprinting itself on the glass surface points up what may be the ultimate indexical relationship of the *Large Glass*—that of Duchamp's two-dimensional panes to the three-dimensional objects of science and technology displayed in the cases at the Musée des Arts et Métiers (figs. 164, 165). As shown in this early twentieth-century photograph of the Arts et Métiers, the size and bi-level structure of the cases is strikingly similar to the format of the *Large Glass*.[254] In the context of his notes on geometry, Duchamp wrote of experimenting with a "show case with sliding glass panes—place some *fragile* objects inside." He also talked of assembling on a table "the largest number of *fragile* objects and of different shapes." He then noted: "*. . . Squeeze them together as much as possible . . .* ," and "Perhaps: make a good photo of a table thus prepared, make *one* good print and then break the plate.—"[255]

The *Large Glass* might therefore be thought of as a two-dimensional compression of the interior space of cases filled with fragile glass objects, such as cathode-ray tubes, X-ray tubes, and Geissler tubes, as well as a variety of other scientific instruments and examples of new technological apparatus. Even the distinction between the Bride's four-dimensional realm and the perspectival, three-dimensional domain of the Bachelors is paralleled in the contrast between the frontal view of objects close to eye level in the upper case and the suggestion of perspective created as one looks down into the lower case. One of Duchamp's most familiar statements about the *Large Glass*, read in its entirety, seems to confirm this theme of compressing and molding: "The whole picture seems to be in papier mâché because the whole of this representation is the sketch (like a mold) for a *reality which would be possible by slightly distending* the laws of physics and chemistry."[256] "In general, the picture is the apparition of an appearance . . . ," Duchamp had declared in his "General notes. for a hilarious picture."[257]

One paradigm for the *Large Glass*, then, is the physical impressing of an image of *visible,* three-dimensional objects onto the two-dimensional glass panes. "Make an imprint," Duchamp had declared in the text for his first 1913 *Musical Erratum*, a procedure that also figuratively describes the operation of photography in visible light.[258] Yet, in the early twentieth century the photographic plate also offered the promise of revealing the *invisible,* as in

X-ray and spirit photographs. It was this new, revelatory power of *plaques ultra-sensibles* that particularly intrigued Duchamp and that embodies the second paradigm for the *Glass*: that of an ultrasensitive registering apparatus capable of making visible the invisible.

As noted, in his two versions of the Preface or Notice for the *Large Glass,* "Given: 1. the waterfall / 2. the illuminating gas," Duchamp specifies that these events occur "in the dark"; he also notes, "For the instantaneous state of Rest = bring in the term extra rapid" and refers to "extra rapid exposure" and "extra rapid exposition." Similarly, the label on one of the versions of the *Box of 1914* had declared that the new "plaque l'intensive" contained within could "record the most rapid *instantanés* [snapshots] as in current practice" (fig. 78A). Wishing to create more than simply a snapshot, however, Duchamp seems to have been interested in the revelatory power exemplified by the new instantaneous photographs being made by A. M. Worthington and C. T. R. Wilson (figs. 145–47).[259] In particular, Wilson's cloud-chamber photographs, which he described as "tracks," are the indexical footprints registering the passage of invisible electrons, radioactive particles, or X-rays. Like X-ray photographs, Wilson's images reveal an invisible reality, and his cloud chamber may have been among the indexical registering instruments that interested Duchamp.

In view of Duchamp's association of the Bride's realm with the fourth dimension, Jean Clair has proposed that the lower part of the *Large Glass* is like a "photographic apparatus directed at the invisible, the extra-retinal, the non-perceptible to the three-dimensional senses" embodied in the "higher reality" of the Bride.[260] Clair has also referred to the *Glass* as a "giant photographic plate"; with the proviso that it is a plate extremely sensitive to invisible effects, this analogy, in the tradition of Kiesler's designation of the *Large Glass* as "the first X-ray painting of space," is a more useful one.[261] Indeed, the work as a whole can be compared to any indexical *appareil enregistreur* sensitive to invisible effects—whether projections from the fourth dimension or, more generally, electromagnetic waves in a variety of frequencies.[262] Although Duchamp's most elaborate use of the model of wireless telegraphy wave detectors occurs in the interaction of the Bride, Bachelors, and Juggler/Handler of Gravity, the *Large Glass* as a physical object represents a new genre of artwork which, like *To Be Looked At,* suspended on a Buenos Aires balcony (fig. 115), interacts with its environment. Indeed, the cracks that occurred when the *Glass* was being trucked to Connecticut registered vibratory effects, if not specifically electromagnetic frequency.

The uniqueness of Duchamp's approach is emphasized by the juxtaposition of the *Large Glass* with a pencil drawing (probably related to a lost 1915 painting) by the Russian Suprematist painter Kazimir Malevich, *Suprematist Composition Expressing the Sensation of Wireless Telegraphy* (fig. 125).[263] Like Duchamp, Malevich was deeply concerned with the idea of four-dimensional space and is best known for his intensely colored geometric shapes floating in an infinite white space, free of gravity and specific orientation. Yet Malevich's approach to the fourth dimension was not that of a geometer but rather that of a seeker of transformed consciousness, as preached by the Russian mystic philosopher P. D. Ouspensky. Malevich's painted forms may parallel imagery suggested in one of Ouspensky's sources, the Englishman Charles Howard Hinton's model of a film or fluid plane that would register the shapes of higher-dimensional objects passing through it.[264] (The American fourth-dimension theorist Claude Bragdon had given visual form to such "tracings" of three-dimensional elements passing through a plane in his *Primer of Higher Space (The Fourth Dimension)* of 1913 [fig. 58].) And just as Malevich shared Duchamp's interest in manifesting invisible four-dimensional forms, his remarkably literal representation of Morse code (fig. 125) confirms his equal concern with invisible Hertzian waves.[265]

Although the intent of both artists was the registering of traces, Malevich's evocation of wireless telegraphy by means of drawn or painted dots and dashes is a completely different technique from that of the anti-painter Duchamp. Unlike Malevich, Duchamp-as-engineer virtually built the *Large Glass* as if it were some kind of indexical registering instrument, at the same time incorporating a drama carried out by wave-borne communication. The works of Kupka (fig. 86) stand somewhere between these two methods. Painterly inventions similar to Malevich's abstract canvases, Kupka's images are, nonetheless, not imaginary

imprints or tracings; based on his theories involving electromagnetic wave emission and detection, they are meant to be wave-emitting, telepathic exteriorizations of the artist's mind.

The theme of the interaction of electromagnetic waves with a registering apparatus also offers another level of meaning for Duchamp's speculation in a *Green Box* note on the phrase "Delay in Glass" (*Rétard en verre*) as a "Kind of Subtitle" for the *Large Glass*: "Use 'delay' instead of picture or painting; picture on glass becomes delay in glass—but delay in glass does not mean picture on glass—," he writes.[266] Such a delay is precisely what occurs when a wave of visible light (or any other electromagnetic wave) intersects a pane of glass; it is refracted, or slowed, and thus bent by the encounter. Such effects of refraction, featured in sources on the optics of visible light, had been central to the early investigations of X-rays and to Hertz's experiments with electrical radiations.[267] Distancing himself from the tradition of painting pictures on canvas, Duchamp would create a glass "delay" in an impersonal, mechanically exact style free of touch, which, like his Readymades, also challenged his fellow artists' Bergsonian emphasis on profound self-expression. Duchamp must also have delighted in the humorous plays on notions of time created as he contrasted delays and instantaneities and subtitled his "painting *of frequency*" a "Delay in Glass."

If electromagnetic waves—Duchamp's "electricity at large"—were central to the *Large Glass*, his Playful Physics and chemistry would ultimately provide additional themes for the work. Yet throughout his odyssey, the notion of the *Glass* as an indexical *appareil enregistreur* able to register both visible and invisible effects remained one of its defining features. In a 1959 interview Duchamp chose a telling analogy to illustrate his belief in the impossibility of defining art: "You don't define electricity," he said; "you just see the results."[268]

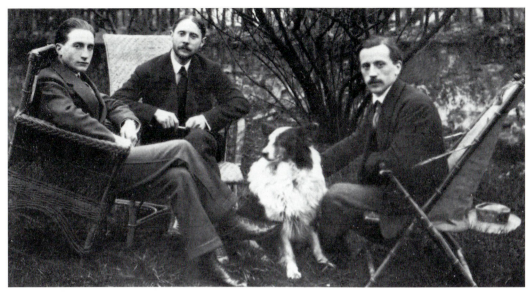

1 The Duchamp brothers (*left to right,* Marcel Duchamp, Jacques Villon, and Raymond Duchamp-Villon) in the garden at Puteaux, *New York Times,* April 13, 1913.

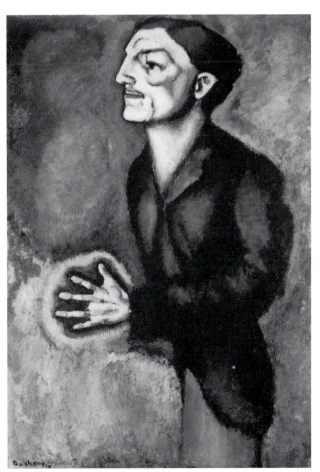

2 Duchamp, *Portrait of Dr. Dumouchel,* 1910, oil on canvas, Philadelphia Museum of Art, The Louise and Walter Arensberg Collection.

3 Pablo Picasso, *Nude,* 1910, oil on canvas, Albright-Knox Art Gallery, Buffalo, N.Y.

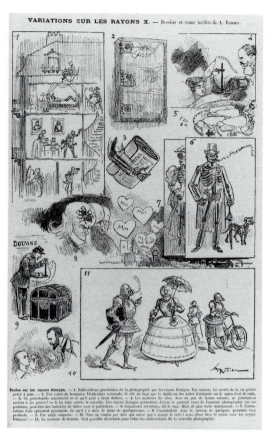

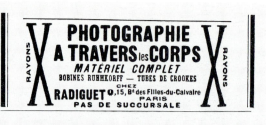

5 Early French advertisements for X-ray equipment, from Otto Glasser, *Wilhelm Conrad Röntgen und die Geschichte der Röntgenstrahlen,* Berlin, 1931, p. 281.

4 Albert Robida, "Variations sur les rayons X," *La Nature,* May 9, 1896, p. 91.

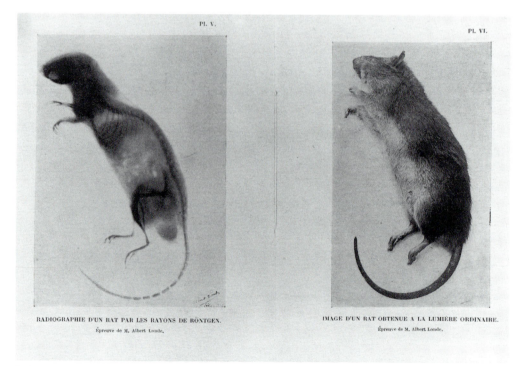

6 Albert Londe, photographs taken with X-rays and with ordinary light, from Charles-Edouard Guillaume, *Les Rayons X et la photographie à travers le corps,* Paris, 1896, plates 5, 6.

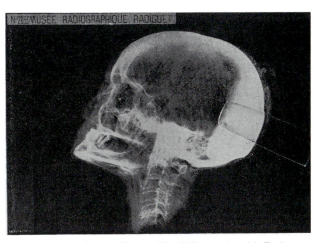

8 X-ray of a skull, from Gaston Henri Niewenglowski, *Technique et applications des rayons X,* Paris, 1898, plate 3.

7 Etienne-Jules Marey, "Geometric chronophotograph" of a walking figure, 1883, Archives du Collège de France, Paris.

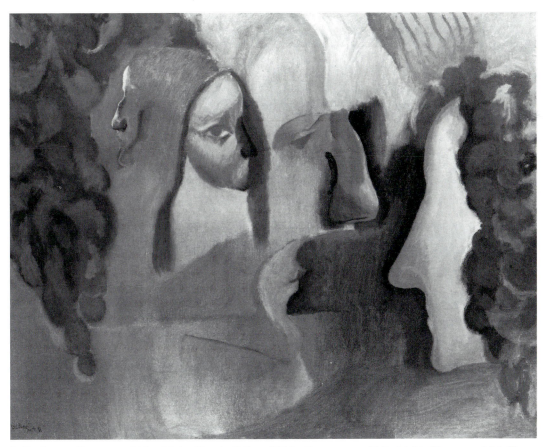

9 Duchamp, *Yvonne and Magdeleine Torn in Tatters,* 1911, oil on canvas, Philadelphia Museum of Art, The Louise and Walter Arensberg Collection.

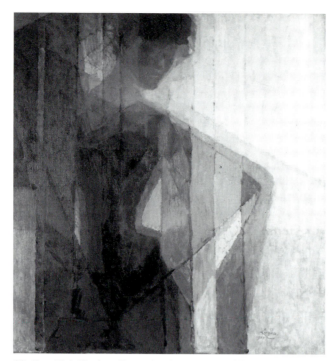

10 František Kupka, *Planes by Colors,* 1911–12, oil on canvas, Musée National d'Art Moderne, Centre Georges Pompidou, Paris.

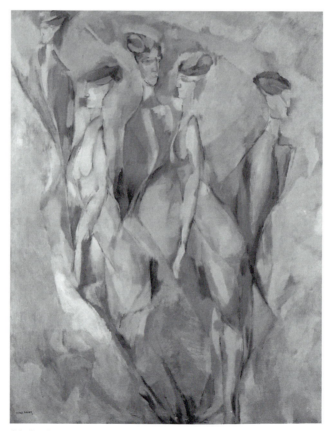

11 Duchamp, *Portrait (Dulcinea),* 1911, oil on canvas, Philadelphia Museum of Art, The Louise and Walter Arensberg Collection.

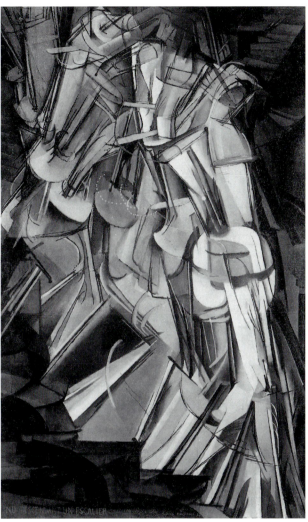

12 Duchamp, *Nude Descending a Staircase (No. 2),* 1912, oil on canvas, Philadelphia Museum of Art, The Louise and Walter Arensberg Collection.

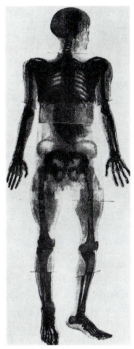

13 Zehnder and Kempke, X-ray skeleton of a man, 1896, from Otto Glasser, *Wilhelm Conrad Röntgen und die Geschichte der Röntgenstrahlen,* Berlin, 1931, figure 77.

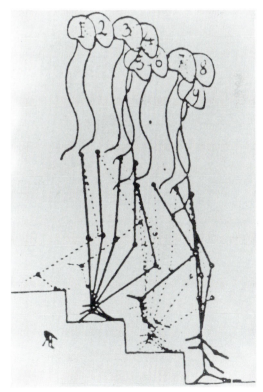

14 Paul Richer, "Two Successive Double Steps in the Descent of a Staircase," from *Physiologie artistique de l'homme en mouvement,* Paris, 1895, figure 115.

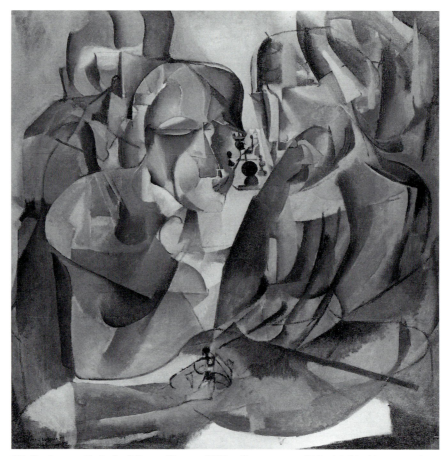

15 Duchamp, *Portrait of Chess Players,* 1911, oil on canvas, Philadelphia Museum of Art, The Louise and Walter Arensberg Collection.

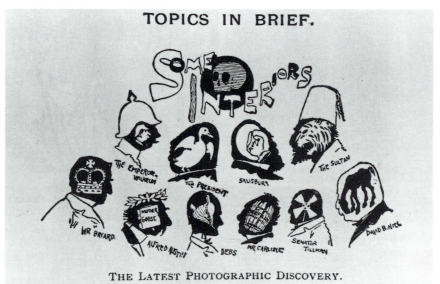

16 "The Latest Photographic Discovery," *Literary Digest,* February 15, 1896, p. 459.

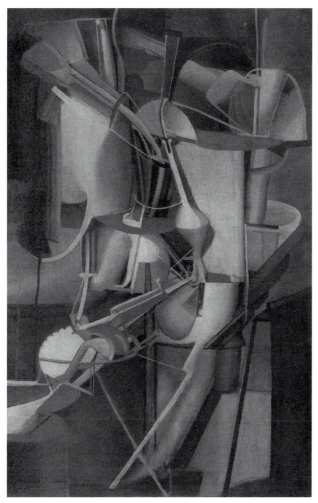

17 Duchamp, *Bride,* 1912, oil on canvas, Philadelphia Museum of Art, The Louise and Walter Arensberg Collection.

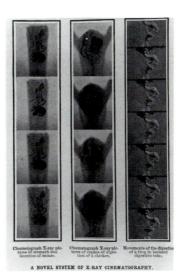

18 J. Carvallo, Cinematic X-ray images of digestion, from Alfred Gradenwitz, "A Novel System of X-Ray Cinematography," *Scientific American,* September 24, 1910, p. 232.

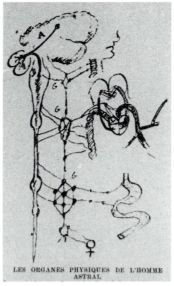

19 Papus, "The Physical Organs of Astral Man," from "Comment est constitué l'Etre Humain," *La Vie Mystérieuse,* September 25, 1911, p. 276.

20 Francis Picabia, *La Ville de New York aperçue à travers le corps,* 1913, watercolor on paper, Galerie Ronny Van de Velde, Antwerp.

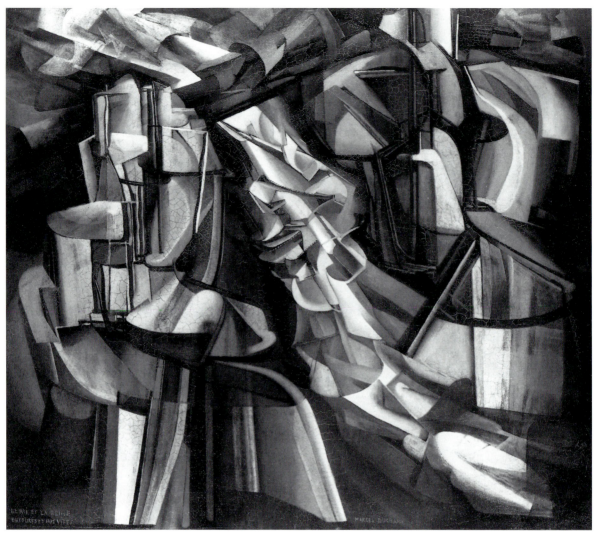

21 Duchamp, *The King and Queen Surrounded by Swift Nudes,* 1912, oil on canvas, Philadelphia Museum of Art, The Louise and Walter Arensberg Collection.

22 Duchamp, *2 Nudes: One Strong and One Swift,* 1912, pencil on paper, Private Collection, Paris.

23 Duchamp, *The King and Queen Traversed by Swift Nudes,* 1912, pencil on paper, Philadelphia Museum of Art, The Louise and Walter Arensberg Collection.

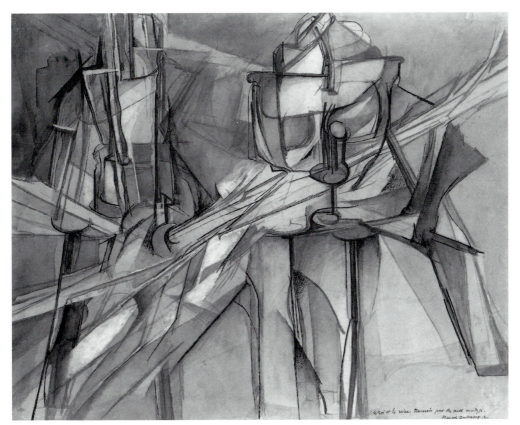

24 Duchamp, *The King and Queen Traversed by Swift Nudes at High Speed,* 1912, watercolor and gouache on paper, Philadelphia Museum of Art, The Louise and Walter Arensberg Collection.

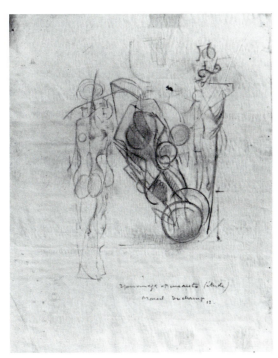

25 Duchamp, *2 Personages and a Car (Study),* 1912, charcoal on paper, Philadelphia Museum of Art, The Louise and Walter Arensberg Collection.

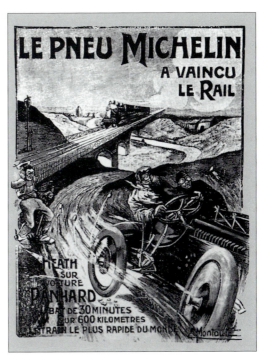

26 E. Montaut, *Le Pneu Michelin a vaincu le rail,* lithograph, n.d.

FIGURE 1.
Pompe pour extraire l'électricité de la terre.

Les Merveilles électriques de M. Tesla

27 "Pump for extracting electricity from the earth, from J. d'Ault," "Les Merveilles électriques de M. Tesla," *Revue des Revues,* May 1, 1895, p. 197.

Pôle N. rouge

Fig. 1

Pôle N. bleu

Fig. 2 Fig. 3

Fig. 4. — Réfraction des couches lumineuses de la main gauche à travers un prisme en plâtre.

28A Magnetic emanations from the human body observed by patients of Dr. Luys, from Albert de Rochas, *L'Extériorisation de la sensibilité* (1895), Paris, 1909, plate 2.

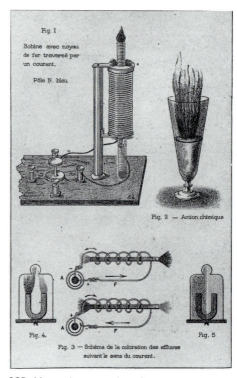

Fig. 1
Bobine avec noyau de fer traversé par un courant.

Pôle N. bleu

Fig. 2 — Action chimique

Fig. 4. Fig. 5

Fig. 3 — Schéma de la coloration des effluves suivant le sens du courant.

28B Magnetic emanations from magnets and electromagnets observed by patients of Dr. Luys, from Albert de Rochas, *L'Extériorisation de la sensibilité* (1895), Paris, 1909, plate 4.

29 Illustration of the Corkscrew Rule, from Silvanus P. Thompson, *Leçons élémentaires d'électricité et de magnétisme,* Paris, 1898, figure 108.

SPINTHARISCOPE

DE

Sir William CROOKES

Construit par la Maison WATSON and SONS de Londres

Le **SPINTHARISCOPE** a été décrit dans le numéro de février du **Radium**. Il met en évidence le bombardement produit par les petits projectiles qui constituent les rayons particuliers de l'émission permanente et spontanée du Radium.

Mode d'emploi: Pour se servir du Spinthariscope dans la journée, rester pendant 5 minutes dans la chambre noire avant de regarder afin que les yeux deviennent suffisamment sensibles. L'écran doit être mis soigneusement au foyer en faisant tourner la molette qui est au bas de l'appareil : dans ces conditions, il apparaîtra recouvert d'une multitude de petits points brillants qui scintillent et semblent se déplacer.

ENVOI FRANCO CONTRE MANDAT-POSTE DE **25** FRANCS

adressé à M. le DIRECTEUR de la LIBRAIRIE DU RADIUM

36, Rue de l'Arcade, PARIS

30 Spinthariscope of Sir William Crookes, *Le Radium,* January 1904, back cover.

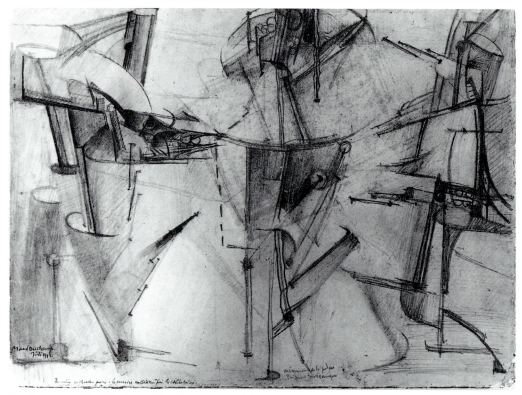

31 Duchamp, *First Study for: The Bride Stripped Bare by the Bachelors,* 1912, pencil and wash on paper, Musée National d'Art Moderne, Centre Georges Pompidou, Paris.

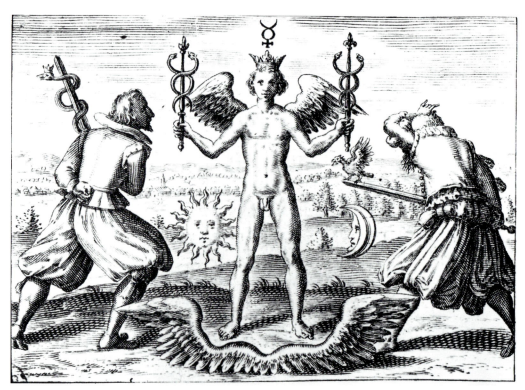

32 "Purification of Mercury by the 'Fiery Laundries,'" from Basile Valentin, *Les Douze Clefs de la philosophie* (1624), Paris, 1898, key 2.

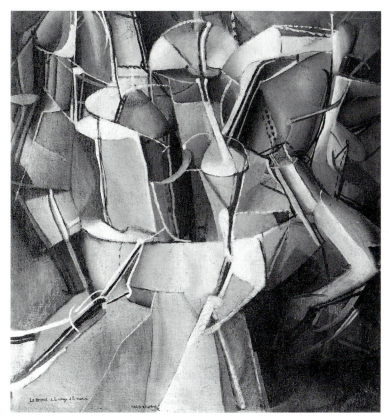

33 Duchamp, *The Passage from Virgin to Bride,* oil on canvas, 1912, Museum of Modern Art, New York.

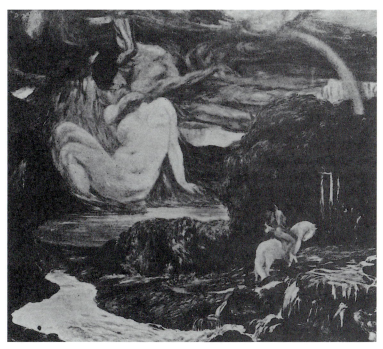

34 Clémentine Hélène Dufau, *Radioactivité, magnétisme,* 1908, mural for the Sorbonne, *Gazette des Beaux-Arts,* July 7, 1908, p. 68.

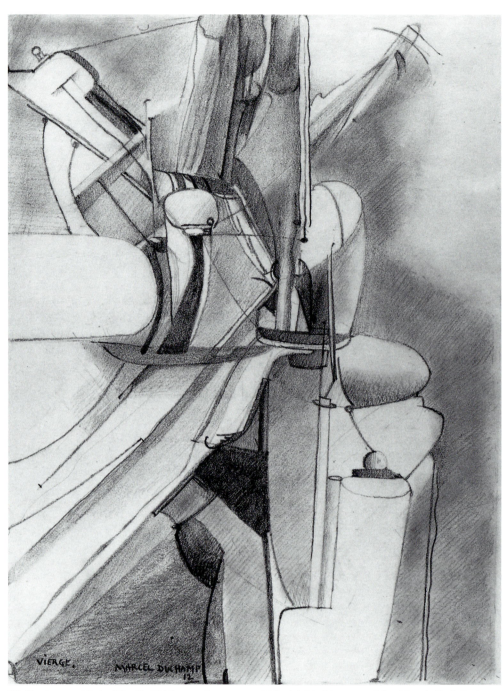

35 Duchamp, *Virgin (No. 1),* 1912, pencil on paper, Philadelphia Museum of Art, The A. E. Gallatin Collection.

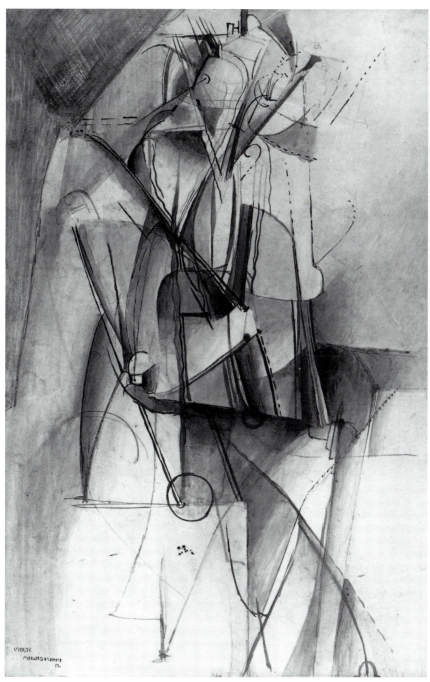

36 Duchamp, *Virgin (No. 2),* 1912, watercolor and pencil on paper, Philadelphia
Museum of Art, The Louise and Walter Arensberg Collection.

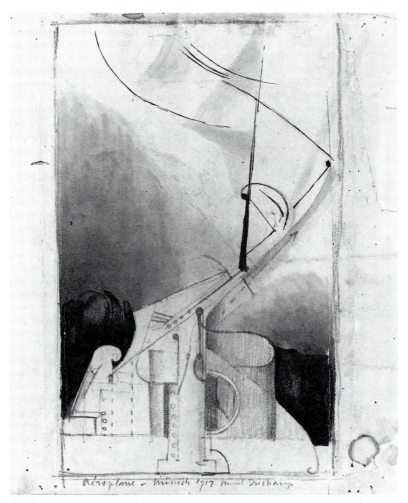

37 Duchamp, *Airplane,* 1912, wash on paper, The Menil Collection, Houston.

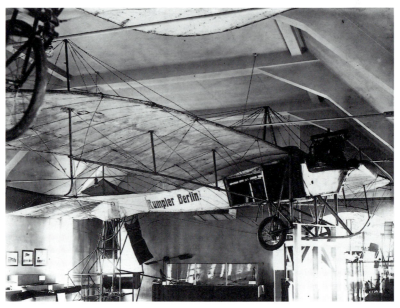

38 Aviation exhibition of the Deutsches Museum, Munich, 1910 (installed in temporary quarters on Maximilianstrasse).

39 Forces acting on an airplane's stability, from Commandant Paul Renard, *Le Vol mécanique: Les Aéroplanes,* Paris, 1912, p. 253 (reproduced inverted).

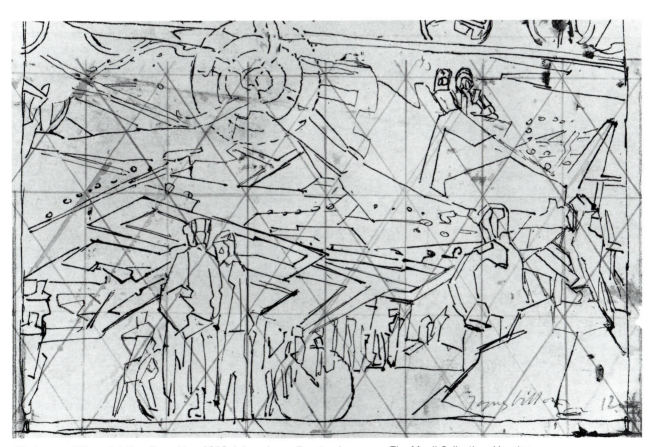

40 Jacques Villon, *Aviation Exposition,* 1912, ink and pencil on tracing paper, The Menil Collection, Houston.

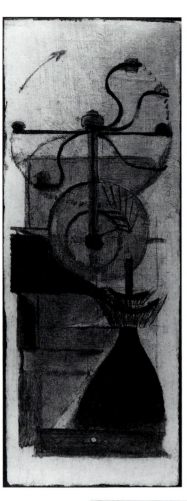

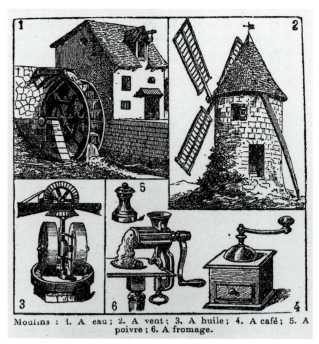

41 Duchamp, *Coffee Mill,* 1911, oil on board, The Tate Gallery, London.

42 *Moulins* (Mills), from *Petit Larousse illustré,* Paris, 1912, p. 647.

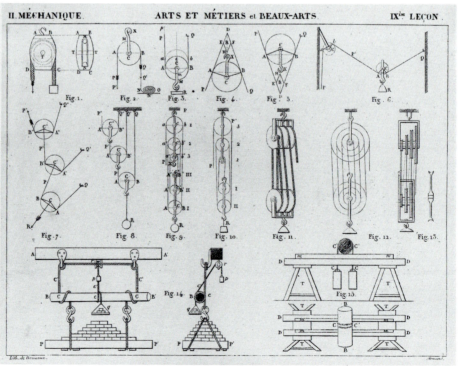

43 Mechanical drawing techniques, from Charles Dupin, *Géométrie et mécanique des arts et métiers et des beaux-arts,* Paris, 1826, vol. 2, lesson 9.

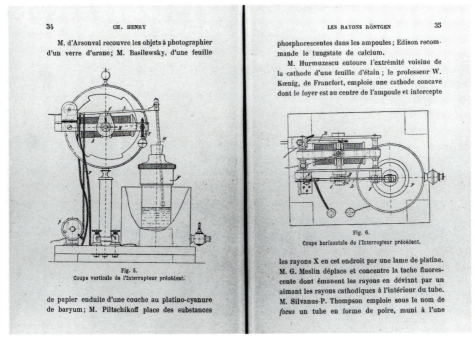

44 Vertical and horizontal sections of a Foucault *interrupteur,* from Charles Henry, *Les Rayons Röntgen,* Paris, 1897, pp. 34–35.

45 Duchamp, *Boxing Match,* 1913, pencil and crayon on paper, Philadelphia Museum of Art, The Louise and Walter Arensberg Collection.

L'ÉLECTRICITÉ (LA GRANDE ESCLAVE)

46 Albert Robida, "Electricity (The Great Slave)," from *Le Vingtième Siècle: La Vie électrique,* Paris, 1890, frontispiece.

Traduction picturale.

Les 5 nus, dont le chef, devront perdre, dans le tableau, le caractère de multiplicité. Ils doivent être une machine à 5 cœurs, une machine immobile à 5 cœurs. Le chef, dans cette machine, pourra être indiqué au centre ou au sommet, sans paraître autre chose qu'un rouage plus important (graphiquement).

Cette machine à 5 cœurs devra enfanter le phare.
Le phare sera l'enfant-Dieu, rappelant assez le Jésus des primitifs.
Il sera l'épanouissement divin de cette machine-mère.
Comme forme graphique, je le vois machine pure par rapport à la machine-mère, plus humaine. Il devra rayonner de gloire. Et les moyens graphiques pour obtenir cet enfant-machine, trouveront leur expression dans l'emploi des plus purs métaux servant à la construction basée (en tant que construction) sur l'idée qui se dégage d'une vis sans fin. (accessoires de cette vis sans fin, servant à unir ce phare enfant Dieu. à la mère machine. 5 nus.

47 Duchamp, note for "Jura-Paris Road" project, winter 1912, from *Marcel Duchamp: Notes,* ed. Paul Matisse, note 109.

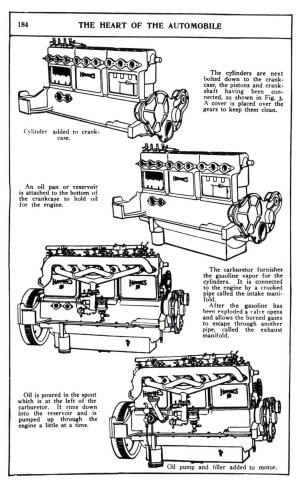

Cylinder added to crankcase.

The cylinders are next bolted down to the crankcase, the pistons and crankshaft having been connected, as shown in Fig. 3. A cover is placed over the gears to keep them clean.

An oil pan or reservoir is attached to the bottom of the crankcase to hold oil for the engine.

The carburetor furnishes the gasoline vapor for the cylinders. It is connected to the engine by a crooked pipe called the intake manifold.

After the gasoline has been exploded a valve opens and allows the burned gases to escape through another pipe, called the exhaust manifold.

Oil is poured in the spout which is at the left of the carburetor. It runs down into the reservoir and is pumped up through the engine a little at a time.

Oil pump and filler added to motor.

48 "The Heart of the Automobile," from *The Book of Wonders,* ed. Rudolph T. Bodmer, New York, 1916, p. 184.

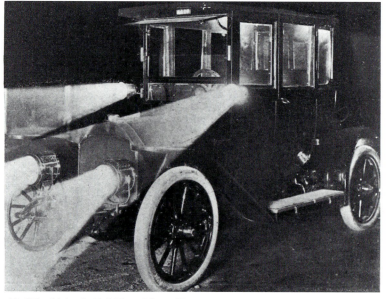

49 "The Lights in Full Blast," from "Automobile Electric Light Plant," *Scientific American,* July 2, 1910, p. 6.

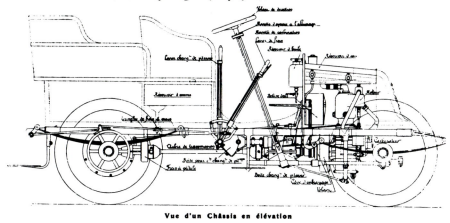

50 Renault Frères "light car" chassis in elevation, ca. 1901, from Yves Richard, *Renault 1898, Renault 1965,* Paris, 1965, p. 25.

51 Duchamp's *Virgin (No. 1),* 1912 (figure 35 above), turned ninety degrees to the right.

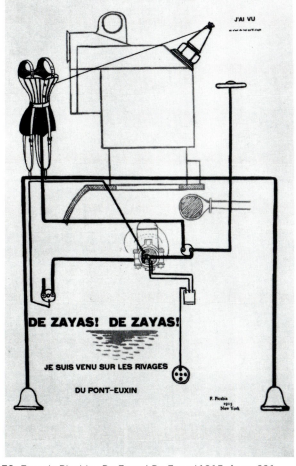

52 Francis Picabia, *De Zayas! De Zayas!* 1915, from *291,* July–August 1915.

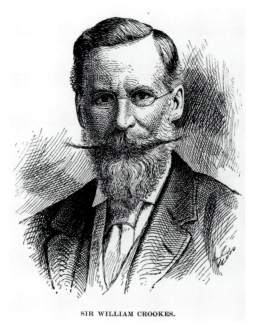

SIR WILLIAM CROOKES.

53 Sir William Crookes, from "Sir William Crookes and Psychical Research," *Review of Reviews,* February 1908, p. 232.

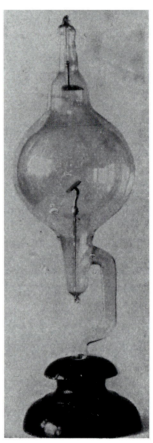

55 Early X-ray focus tube, from Otto Glasser, *Wilhelm Conrad Röntgen,* Springfield, Ill., 1934, figure 85.

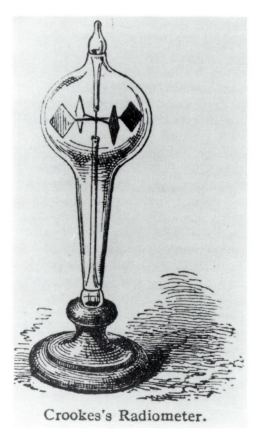

Crookes's Radiometer.

54 Crookes's radiometer, from the *New Century Dictionary,* ed. H. G. Emery et al., New York, 1948.

56 X-ray equipment advertised by Gaiffe Co., Paris, 1896, from Otto Glasser, *Wilhelm Conrad Röntgen,* 1934, figure 74.

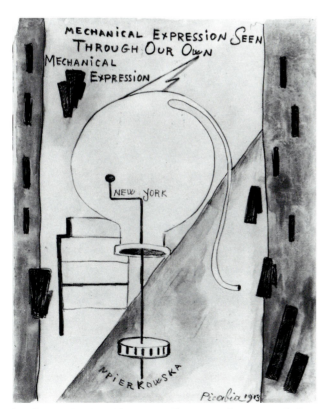

57 Francis Picabia, *Mechanical Expression Seen through Our Own Mechanical Expression,* 1913, watercolor and pencil on paper, Private Collection, Paris.

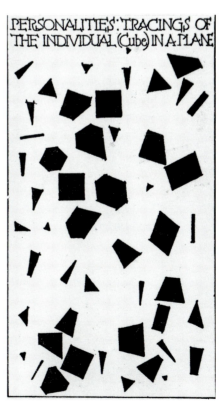

58 Claude Bragdon, "Personalities: Tracings of the Individual (Cube) in a Plane," from *Man the Square: A Higher Space Parable,* Rochester, N.Y., 1912.

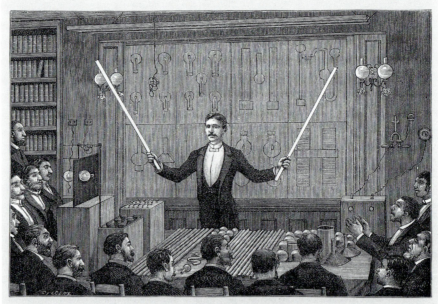

EXPÉRIENCES DE M. TESLA SUR LES COURANTS ALTERNATIFS DE GRANDE FRÉQUENCE

Fig. 1. — Conférence de M. Tesla devant la *Société de physique* et a *Société internationale des électriciens*, le 20 février 1892.

59 Nikola Tesla's lecture before the Société de Physique and the Société Internationale des Electriciens, Paris, 1892, from "Expériences de M. Tesla sur les courants alternatifs de grande fréquence," *La Nature,* March 5, 1892, p. 209.

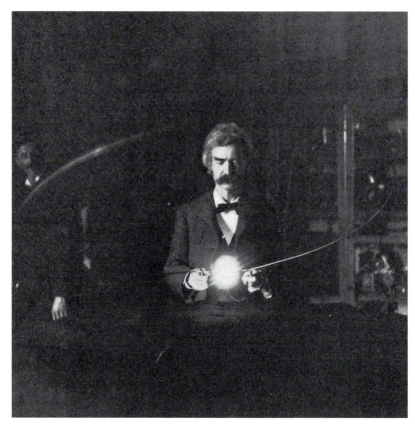

60 Mark Twain demonstrating Tesla's high-frequency apparatus in the laboratory of Tesla, from Thomas Commerford Martin, "Tesla's Oscillator and Other Inventions," *Century Magazine,* November 1894, figure 13.

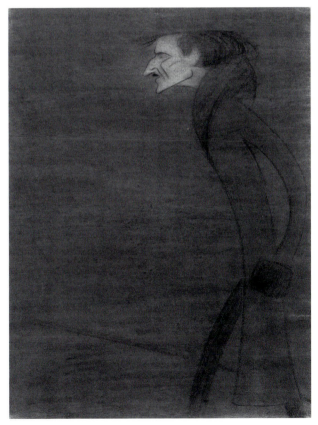

FIG. 8. EXPERIMENT TO ILLUSTRATE THE CAPACITY OF THE OSCILLATOR FOR PRODUCING ELECTRICAL EXPLOSIONS OF GREAT POWER.

61 Tesla's dramatic spark discharges in his Colorado Springs laboratory, from Nikola Tesla, "The Problem of Increasing Human Energy," *Century Magazine,* June 1900, figure 8.

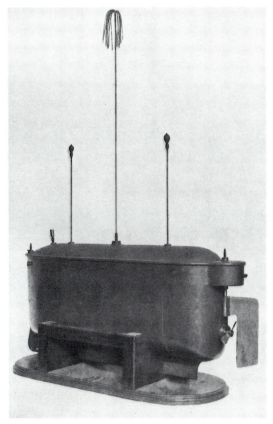

62 Tesla's "Telautomaton," from Tesla, "The Problem of Increasing Human Energy," *Century Magazine,* June 1900, figure 2.

63 Marius de Zayas, *Nikola Tesla,* ca. 1908, charcoal on paper, National Portrait Gallery, Smithsonian Institution, Washington, D.C.

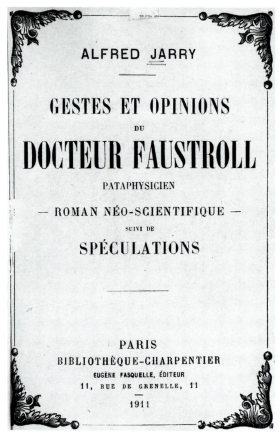

64 Title page from Alfred Jarry's *Gestes et opinions du docteur Faustroll, pataphysicien,* Paris, 1911.

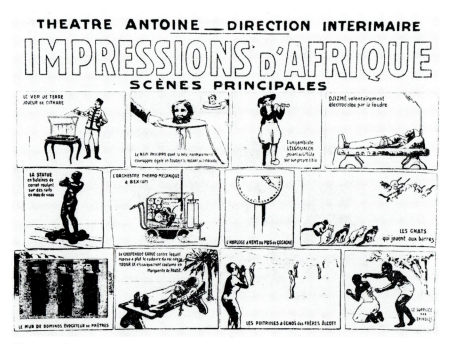

65 Poster for Raymond Roussel's *Impressions d'Afrique,* Théâtre Antoine, Paris, 1912, from *Jungessellenmaschinen/Les Machines célibataires,* ed. Harald Szeemann, Venice, 1975, p. 32.

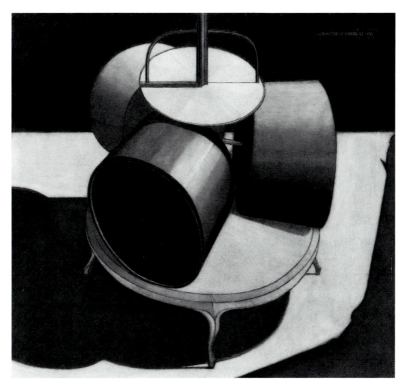

66 Duchamp, *Chocolate Grinder (No. 1),* 1913, oil on canvas, Philadelphia Museum of Art, The Louise and Walter Arensberg Collection.

67 Chocolate grinder sold by A. Savy & Cie., ca. 1900, from Jean Clair, *Marcel Duchamp, ou le grand fictif,* Paris, 1975, p. 160.

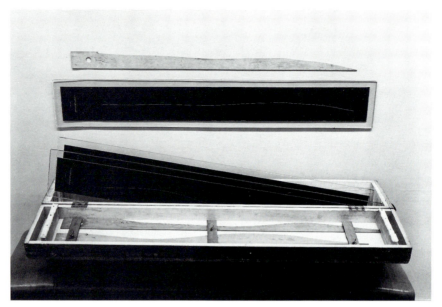

68 Duchamp, *3 Standard Stoppages,* 1913–14, three threads glued to three painted canvas strips, each mounted on a glass panel, housed in a wooden box, Museum of Modern Art, Bequest of Katherine S. Dreier.

69 Standard Meter, Pavillon de Breteuil, Sèvres, France.

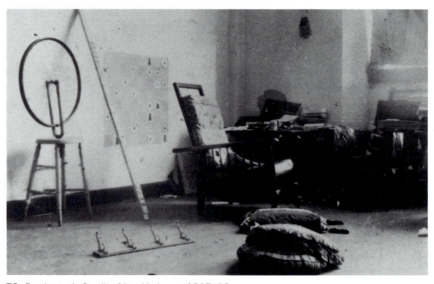

70 Duchamp's Studio, New York, ca. 1917–18.

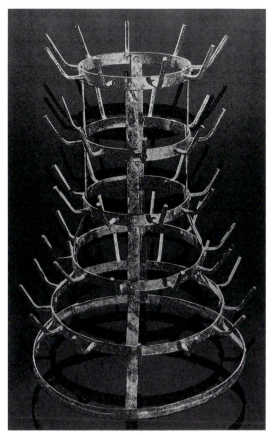

71 Duchamp, *Bottle Rack,* 1914, galvanized-iron bottle rack, as reproduced in Duchamp's *Box in a Valise,* 1941.

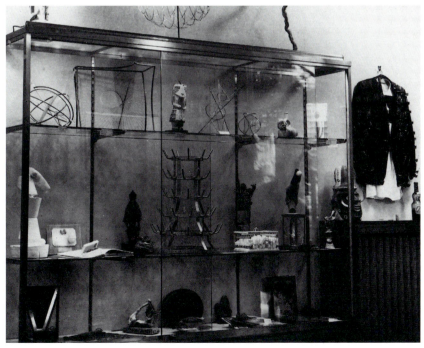

72 Exposition Surréaliste des Objets, Galerie Charles Ratton, Paris, 1936.

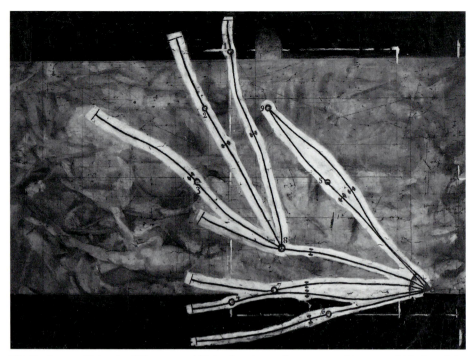

73 Duchamp, *Network of Stoppages,* 1914, oil and pencil on canvas, Museum of Modern Art, New York, Abby Aldrich Rockefeller Fund and Gift of Mrs. William Sisler.

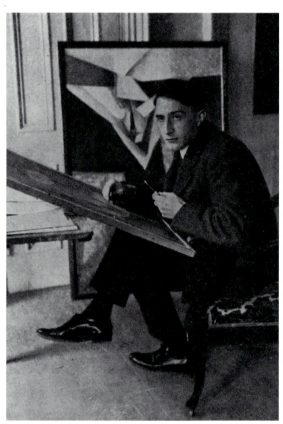

74 "Another Invader, Marcel Duchamp," from "The European Art Invasion," *Literary Digest,* November 27, 1915, p. 1226.

Chapter 9

Other Scientific and Technological Dimensions of the Bride

Replacing parallel automobile engines or clockwork mechanisms, electromagnetic waves had come to serve Duchamp as the primary vehicle for communication between the upper and lower halves of the *Large Glass*. The majority of the other scientific and technological themes in his notes, however, emphasize the irremediable distinctions between the realms of the Bride and the Bachelors rather than any continuity. In geometric terms, as we have seen, that contrast was one of dimensionality: the four-dimensional, immeasurable, infinite world of the Bride versus the three-dimensional, "mensurated," gravity-bound existence of the Bachelors.[1] In contrast to the Bachelors' largely mechanical activities, Duchamp augmented the Bride's antimechanical qualities during 1913, giving her the new identities of Wasp and Barometer/Weather Vane, and stressing her organic nature as well as her freedom and unpredictability in the context of her meteorological activities. For the Bachelor Apparatus, on the other hand, he continued to create primarily mechanical operations, which, even when chance intervenes, are contained within a gravity-bound realm of possibilities. Here his sources ranged from the liquefaction of gases to classical mechanics and contemporary agricultural technology. The scores of notes in which Duchamp worked out these specifics are remarkable both for the range of their scientific subject matter and for the subtle and humorous overlays from field to field that Duchamp, the Playful Physicist, accomplishes in them.

Seeking to distance the Bride from the comical, jerky mechanical actions of the Bachelors, on the model of the smooth blending of organic and inorganic in Villiers's *L'Eve future*, Duchamp made the decision to "introduce *organic materials* in the wasp and elsewhere."[2] His adoption of the term Wasp for what had originally been the Sex Cylinder (fig. 105) is chronicled in a number of notes in which "Cylindre/s Sexe" is crossed out or erased and

replaced by "Guêpe" (Wasp).[3] One note, which had begun with the heading "Cylindre Sexe balladeur: (mouche, abeille?)" (Geared Sex Cylinder: [fly, bee?]) and was subsequently reduced to "Guêpe," reveals Duchamp's consideration of other insect indentities before settling upon the wasp.[4] His distinct change in terminology from Sex Cylinder to Wasp at a certain point during 1913 also provides a useful chronological demarcation, enabling one to date the notes that include the latter term to the period following this decision.

Duchamp's "First Breakdown" of the Bride had been dominated by automobile and clockwork elements. However, in listing the "Properties" of the Bride under the heading "Wasp" (in a note joined to that in fig. 105), he introduced the new themes of her "Flair" and her "Vibratory property" (related to electromagnetic waves), as well as her *Secretion* of love gasoline by osmosis" and "*Ventilation.* determining the swinging *to and fro* of *the pendu with its accessories.*"[5] Additional notes elaborating the Bride's new meteorological and biological functions add a third theme: the "filament paste" or "filament material" that is central to the activities of the Wasp as Barometer/Weather Vane. In the context of wireless telegraphy, Duchamp had treated the Bride's filaments as "transparent paper filaments," modeled after party blowers, which served as physical analogues to the wave-borne dialogue between the Bride and the Juggler of Gravity (fig. 110). In the same note he had also explained that these filaments "are born out of their own material (sort of shapeless, vascularized paste)."[6] This statement and the references to filament paste connect the Bride's filaments to contemporary incandescent-lighting technology— now creatively blended with the Bride's meteorological and biological activities.[7]

Meteorology and the Eiffel Tower

Two notes included in the *Green Box* set forth the two primary meteorological functions Duchamp established for the Bride—barometer (fig. 126) and weather vane (fig. 127). As a "blossoming Barometer," Duchamp's Bride operates like an aneroid barometer: her filament material is "*extremely sensitive* to differences of artificial atmospheric pressure controlled by the wasp" and "might lengthen or shorten itself," just as the sensitive metal vacuum chamber of an aneroid barometer expands or contracts according to changes in atmospheric pressure.[8] A closer model for this

expansion of her filament material is the hair hygrometer, an instrument that indicates moisture levels in the air by means of human hair, which lengthens as it absorbs water. In another note Duchamp describes the Bride's "ventilation" as "of hygrometric nature (see Barometer)."[9]

The most unusual aspect of the Barometer (fig. 126), however, is that its readings are self-generated: the "*atmospheric pressure* [is] organized by the wasp," and "the storms and the fine weathers of the wasp" occur in the Bride's "isolated cage." In the resultant "self blossoming" of the Bride, "the filament material in its meteorological extension" reaches out to the Juggler of Gravity and "licks the ball of the handler displacing it as it pleases." Duchamp also refers to the Bride's filament material as a "solid flame"[10] (both this phrase and his reference to "lick[ing]" are treated below in the sections on incandescent lighting and biology, respectively).

Duchamp developed the meteorological paradigm for the activity of the Bride's filaments further in other notes (e.g., figs. 127, 128), modeling her in part on a weather vane swinging in the wind. Although the term *girouette* (weather vane) does not occur in Duchamp's *Green Box* drawing (fig. 127), it appears as the heading in the related, unpublished note (fig. 128). In both cases, the Bride's *hampe,* or shaft, which hangs by a "mortice . . . permitting movement in all directions of the shaft," is "agitated by the ventilation."[11] What had been the transmission shaft of the *arbre type* now becomes the hanging indicator of a weather vane (fig. 82). Indeed, the very notion of the wind-driven Air Current Pistons of the Top Inscription (i.e., "Wind: for the air current pistons," as he stated in the *Green Box*) may have originated in Duchamp's musings on the internal workings of the Bride, for whom Ventilation had become a central property.[12]

Duchamp ultimately devoted more notes to the swinging of the Bride as a weather vane than to the simple barometric expansion of her filaments according to atmospheric pressure; this theme was clearly central, because he included two relevant unpublished notes on the subject in his listings of the 1950s (notes 144, 146; app. A, nos. 14/15, 17). Note 144 (fig. 128) and several other notes published in 1980, along with one *Green Box* note bearing a single sketch, illustrate the lower half of the Bride's shaft, which angles to the left, ringed by a horizontally oriented circle (see also fig. 82).[13] In note 152, the more detailed version of note 144, Duchamp identifies this as the "circle of cardinal points "North/East/South/West" and labels the point on the lower shaft that intersects the circle as A and the vicinity of the Wasp's "Tympanum" as B. Paralleling and extending the text of notes 144 and 146, he explains:

Weather vane. The point A in its trajectory after the air-blown impact of the wasp at B. comes to "horse kick" a circle of cardinal points = this circle in chameleon metal (reforming itself at once) changing according to the orientation—Through the contact of the shoe A, with the circle of cardinal pts., the horse's kick brings about the fusion of a metallic *particle* (chameleon) *which,* becoming liquid will also increase in volume as it cools.

Tympanum The point B or tympanum absorbs the dew which the wasp spits out and serves the "hanged" as *a wing* which engulfs the ventilation: the dew must be the nutritive principle of the filament material.[14]

The procedures described here are obviously far more complex than a simple "meteorological extension" of the Bride's filaments (fig. 126). The meteorologically oriented activities are further clarified in a *Green Box* note devoted to the "pulse needle":

The pulse needle in addition to its vibratory mvt. is mounted on a wandering leash. It has the liberty of caged animals—on condition that it will blow (by its vibratory mvt. actuating the sex cylinder) the ventilation on the shaft [at the tympanum]. This pulse needle will thus promenade in balance the sex cylinder which spits at the tympanum the dew which is to nourish the vessels of the filament paste and at the same time imparts to the Pendu its swinging in relation to the 4 cardinal pnts.[15]

In this note the pulse needle emerges not only as central to the Bride's vibratory movement but also as the very source of her ventilation currents: "it will blow . . . the ventilation on the shaft [at the tympanum]."

Before turning to the question of the swinging of the *Pendu femelle* as Weather Vane, there are several other elements in these notes that should be addressed. Duchamp's four-page note 152 also included his discussion of the "hygrometric nature" of the Bride's ventilation, and several other themes from hygrometry's study of moisture conditions are involved in the weather-vane paradigm set forth here. Now, instead of atmospheric pressure enlarging the filaments, it is dew spit by the wasp that "nourish[es] the vessels of the filament paste," much like the moisture that lengthens the hairs of a hair hygrometer.[16] Dew and the determination of dew points are central concerns of hygrometry, and Duchamp cleverly blends the world of science and the sexual overtones of the word *dew* to refer to bodily secretions.[17]

Beyond dew, the effects of air currents on evaporation and the resultant cooling effect of evaporation are also key issues in hygrometry and are reflected not only in

Duchamp's preoccupation with the Bride's ventilation but also in his reference to a metallic liquid "increas[ing] in volume as it cools." Here he adopts the word *fusion*, a standard term applied to solids, such as ice, as they liquefy or melt; in fact, it is unusual for a substance to increase in volume as its temperature decreases—only ice and a few metals do so. Like physics textbooks of the period, which sometimes treated fusion and hygrometry as related topics under "Changes of State," Duchamp's notes demonstrate a deep interest in the changing states of matter.[18] In the journey of the Illuminating Gas, for example, his discussion of the "progress" of the Spangles of gas includes a variety of hygrometric and meteorological references: "retail fog," "vapor of inertia," "snow," "fog," and "frosty gas."[19]

To return to the issue of the Bride's swinging in the wind, which somehow originates in her pulse needle, Duchamp is never completely clear about how his system of cardinal points will function. In the notes that address the subject most fully, however, we learn that the free swinging of the Bride in some way assists the filaments passing through these "poles" in "tak[ing] up the coefficient of the displacement to impart to the black ball" (of the Juggler).[20] A marginal notation to this note elaborates further: *This lower swinging and the upper movement of the platform of the handler of C. of gravity: are* 'in correspondence' *according to the principle of subsidized symmetries,*" one of the "principles" of Duchamp's playful mechanics (see chap. 11). The one *Green Box* note bearing the diagram of the circle of poles surrounding the Bride connects this procedure directly to the Air Current Pistons and suggests that the results of the swinging "should be used in the decisions or inscriptions transmitted through the air current pistons."[21] Just as this note suggests a link back to wireless telegraphy, Duchamp's description of the Weather Vane's "'horse kick[ing]' a circle of cardinal points" and the resultant "fusion of a metallic *particle*" brings back the theme of sparking, which had been elemental to the Bride's functioning as he originally described it.[22]

Among the apparatuses used in this period to produce a high-frequency alternating current when only direct current was available was a device known as a "kicking coil." When a direct current was sent through this coil of copper wire wound on a laminated iron core and the circuit was suddenly broken, a condenser could be charged with the resultant self-induced voltage. A high-frequency alternating current could then be generated with the aid of a vibrating interrupter, actuated by magnetism in the core of the coil, to rapidly make and break the circuit.[23] The swinging of the Bride's shaft is not a gentle swaying but rather a powerful horse kick, a *choc,* or impact, that can produce a "fusion of a metallic *particle*," a description suggesting the physical transformation of any metal surface (such as a spark gap) through which a spark is emitted.[24] Indeed, the electrical and electromagnetic characteristics of the Bride were never far away, even in Duchamp's most meteorologically oriented notes. Significantly, of all the Bride's original automobile characteristics, it is the sparking Desire-magneto that continues to be mentioned in Duchamp's meteorological notes; and the "vibratory movement" of the Bride's "pulse needle" continues as its basic activity, in addition to its "blow[ing] the ventilation on the shaft."[25]

As noted in chapter 8, analogies were drawn in this period between air currents and electrical currents by figures such as the director of the British Meteorological Office, W. N. Shaw, and the idea of "electric wind" reinforced such a conflation.[26] Making this association of wind and electricity/electromagnetism himself, Duchamp added to his image of the filaments as *soufflets* a meteorological system of filaments expanding and contracting according to weather conditions as a visible manifestation of the invisible waves passing between the Bride and the Juggler/Handler of Gravity. Yet this was no ordinary meteorology: in the realm of Playful Physics the Wasp generates her own "storms and . . . fine weathers" and her own "interior *air current*."[27] Indeed, the very issue of air currents and their variability allowed Duchamp to emphasize the Bride's freedom from the gravity-bound mechanics that dominated the realm of the Bachelors. Like the variable surface-wind currents studied by Shaw and other meteorologists, the Bride would be both literally and figuratively a *girouette*, an individual who frequently changes his or her mind.[28]

If the traits associated with a weather vane made it a logical analogue to a human, the field of meteorology would have attracted Duchamp for other reasons. His precursor as artist-scientist, Leonardo, had been actively interested in weather instruments and had designed both a hygrometer and an anemometer (which measures wind speed).[29] One of the fictive creations of another of Duchamp's heroes, Roussel's "demoiselle" or "paving beetle" in *Locus Solus*, stands as a direct prototype for the Bride as Weather Vane. Although Roussel's paving beetle, like the Bride, is suspended in the air and driven by air currents, her motions are far more predictable than those of Duchamp's Weather Vane. As she assembled discarded teeth into a mosaic "of aesthetic merit," her every move could be anticipated by means of Canterel's "mass of fantastically sensitive and accurate instruments [which] enabled him to determine the direc-

tion and force of every breath of wind at a given spot ten days in advance."[30]

Meteorological instruments, including barometers and hygrometers, were examples of the *appareils enregistreurs* whose indexical activities interested Duchamp (fig. 117). Crookes and others had suggested analogies between human eyes and registering wave detectors, and Remy de Gourmont, in his *Lettres à l'amazone,* had compared the eyes to a manometer, an instrument for measuring the pressure of gases or vapors, also sold by Richard Frères.[31] Gourmont's letters, printed in *Mercure de France* between January 1912 and October 1913 and published in book form in 1914, included a prose sonnet celebrating the "topography" of the body of Natalie Barney, the "amazon" to whom he was ardently attracted. Gourmont's language in the sonnet ranges from the organic to the mechanical, from romantic images of the "soft light of the eyes changing like the sea" to the mechanical view that the eyes express "the degree of pressure of the cerebral matter."[32] "The eyes are the manometer of the animal machine," Gourmont concludes.[33] Duchamp's Bride, however, is herself the registering apparatus, a cousin to the manometer. Nonetheless, she also has eyes that are not so much organs of sight as indicators of her personality. As a marginal note in his *Pendu femelle* drawing (fig. 127) explains, the angle at which the shaft hangs from the mortice "will express the necessary and sufficient twinkle of the eye."[34]

Yet, unlike Gourmont's use of the single metaphor of the manometer, Duchamp's notes incorporate such a range of meteorological instruments and weather-related phenomena that the collection of the Musée des Arts et Métiers again comes to mind. Indeed, the Arts et Métiers devoted a room to its holdings of historical and contemporary meteorological devices.[35] Even more important, however, was the collection of weather instruments—in working order—at the top of the Eiffel Tower, a monument that already interested Duchamp because of its connections to wireless telegraphy (fig. 129). In another kind of "isolated cage" at the top of the tower, Gustave Eiffel had installed a variety of apparatuses: a weather vane, a barometer, and a hygrometer, along with a thermometer, anemometers, and a rain gauge, all of which were connected to recording cylinders in the offices of the Central Meteorological Bureau.[36] (Eiffel had also created the world's largest manometer on one of the lower supports of the tower.)[37]

To justify the continued existence of his tower after the 1889 Exposition Universelle, Eiffel had proposed future uses for it, including meteorological observations and other scientific activities, which he subsequently

chronicled in *Travaux scientifiques*, published in 1900.[38] Meteorology is a major theme of this volume, although it also treats briefly early experiments with the wireless telegraphy that would come to dominate the Eiffel Tower's identity in the years before World War I. Beyond these parallels between Duchamp's Bride and the scientific functions carried out at the top of the Eiffel Tower, there are other striking analogies between Duchamp's notes and the Eiffel text. In the chapter "Physical Phenomena," for example, Eiffel illustrates the elliptical paths traced by the top of the tower due to wind ("Déplacements dus aux vents"). Eiffel's diagram is labeled with directional markers (N, NE, E, SE, S, SW, W, NW) and suggests comparison to the circle of cardinal points Duchamp's swinging *Pendu femelle* was to horse kick in response to wind currents.[39] In addition, in his section titled "Atmospheric Electricity" Eiffel describes the way lightning, which is, in effect, a giant spark discharge, had struck the tower and produced "some droplets of iron *en fusion*."[40] This discussion calls to mind the "fusion of a metallic *particle*" accompanying the Bride's sparking horse kicking of the circle.

The lightning rods at the top of the Eiffel Tower were another of its celebrated features—along with the wireless telegraphy station and the battery of meteorological instruments. Lightning regularly struck the tower, causing it to sing "like a tuning-fork," as Duchamp-Villon put it in his 1913 essay "L'Architecture et le fer," published in *Poème et Drame* in 1914.[41] In 1889 the New York *Herald* had reported that "those who have observed the Tower closely have noted the powerful density of the rain and storm clouds which gather around it and which, emptied of their electricity by the lightning rods, move away to burst upon another part of the city."[42] With the "Louis XV clouds" of her Milky Way, her storms and fine weathers, and her sparking activities, Duchamp's Bride also suggests associations with the lightning at the Eiffel Tower.[43] Poised above the Chocolate Grinder, his Bayonet an antenna/lightning rod, the Bride reverses the image of Roussel's Djizmé on her lightning-rod bed about to be executed (fig. 65): in the *Large Glass* it is the Chocolate Grinder who is to receive the spark from above.[44] Indeed, wireless telegraphy and lightning were closely connected. Wireless antennae routinely picked up lightning discharges, which, as "huge electric sparks," had stood as models in nature for the generation of electrical oscillations and the dramatic effects of high-frequency alternating current cultivated by Tesla and others (fig. 61).[45]

Beyond the interrelated elements of meteorology and wireless telegraphy at the Eiffel Tower, including the daily wireless transmissions of weather conditions from the

tower, other of Eiffel's experiments at the tower would also have interested Duchamp, especially those involving aerodynamics.[46] In 1906, for example, Eiffel built a wind tunnel at the base of the tower and, using fan-generated air currents, carried out thousands of experiments on model-plane designs, focusing in particular on wings and propellers.[47] Given Duchamp's Munich drawing *Airplane* (fig. 37), his attendance at the 1912 Salon de la Locomotion Aerienne, where he had admired a propeller, and his general interest in wind currents, he would certainly have been interested in Eiffel's aviation-related activities. In fact, the aviation theme surfaces in his notes on the Bride as Weather Vane, where he writes that the Tympanum "serves the 'hanged' as a *wing* which engulfs the ventilation."[48]

Even more directly relevant for Duchamp, however, were Eiffel's earlier aerodynamic experiments with objects falling from the tower (fig. 160).[49] "Falls" were central to the operation of the Bachelor Apparatus, and the design of Eiffel's apparatus even suggests the appearance of Duchamp's inverted Bottle of Benedictine that was to power the Chariot/Glider (see chaps. 10, 11). In contrast to Delaunay, who celebrated the Eiffel Tower in paintings or Duchamp's brother, Duchamp-Villon, who praised its architecture, Duchamp seems to have evoked this symbol of modern Paris indirectly—through the scientific and technological operations carried on there. Thus, the engineer Eiffel, an independent experimenter working outside the French scientific establishment, may have served, along with Leonardo, Crookes, and Tesla, as yet another inspiration for Duchamp, who wanted to create like an engineer.[50]

The Bride as an Incandescent Lightbulb

The Eiffel Tower also bore a *phare,* or beacon (fig. 184, lower right). Breton titled his 1935 essay on the *Large Glass* "Phare de *La Mariée*" (Lighthouse of the Bride) in reference to the general luminosity of the work as a cultural beacon for a civilization that was ending, but there are, in fact, more specific elements in Duchamp's notes that associate the Bride with incandescent lightbulbs.[51] Most overt of these allusions are Duchamp's repeated uses of the terms "filament paste" and "filament material" as well as his description of the Bride's filament as a "solid flame," a term that aptly describes the ability of an incandescent filament to radiate without being consumed.[52] Indeed, the "anatomy" of early incandescent bulbs, which had two "female" openings into which the "male" "bayonet" of the socket would be inserted (fig. 130), provided a suggestive model for the potential union of the Bride and her Bayonet-wielding Chocolate Grinder.[53] As noted earli-

er, Picabia would subsequently employ an incandescent lightbulb as a stand-in for an American girl in his 1917 *Américaine* (fig. 131), just as he had earlier embodied the dancer Napierkowska as a Crookes tube in *Mechanical Expression Seen through Our Own Mechanical Expression* of 1913 (fig. 57).

Duchamp had briefly dealt with electric headlight technology in the "headlight child" of the Jura-Paris Road—the "pure child, of nickel and platinum."[54] Yet, characteristically, his use of the incandescent model was much less direct than Picabia's. The first indications of the Bride's connections to lighting may be his initial automobile-oriented references to her "boughs frosted in nickel and platinum." These branches of the *arbre type* would subsequently be discussed by Duchamp as filaments. Both nickel and platinum were components of incandescent-bulb manufacture, and the idea of frosting bulbs was already popular in literature on lighting. Through the early years of the century, platinum was the most widely used material for the electrodes or lead-in wires of incandescent lamps; the high cost of platinum, however, led to increasing experimentation with substitutes, and by the end of the first decade of the century, European manufacturers of less costly lamps were beginning to use a nickel-iron wire.[55] Although the frosting of bulbs did not involve these two metals, it utilized other materials of interest to Duchamp, such as hydrofluoric acid. Indeed, the French equivalents to articles such as "Frosting, Etching, and Coloring of Incandescent Lamps: Hints for the Manufacturer and Amateur" would have provided Duchamp with ideas for alternative means of applying color to glass. Like the do-it-yourself methods in electrical and wireless telegraphy literature, instructions for lamp production offered techniques characteristic of the laboratory, not of the artist's atelier.[56]

In the history of incandescent lighting, the greatest range of experimentation occurred in the quest for an ideal filament material. Edison, who invented the first commercially feasible incandescent lamp, experimented in the late 1870s and early 1880s with a variety of materials, including platinum, nickel (very briefly), and "carbonized" materials such as sewing thread, paper, and bamboo.[57] By the 1880s, others had begun to experiment with nonstructural filaments—in other words, a paste of various fibers that could be extruded through a die and subsequently carbonized.

By the early twentieth century, carbonized filaments were increasingly challenged by new experimental metallic filaments, either of drawn wire or of powdered metal mixed into a paste and then pressed or squirted through a die. Greater efficiency and stability were goals for the new

filaments, and an advertisement for the Société Auer, which Picasso included in his *Bottle and Glass* collage of 1912–13 (fig. 132), touts lamps that can be placed "indifferently in all positions" and are equipped with filaments boasting the "solidity of a drawn filament" and the "superiority of a pressed filament." Picasso's inversion of the newspaper in his still-life collage humorously returns the bulb to an upright position.[58] In 1913 the most up-to-date incandescent bulbs in Paris (fig. 133) would have had filaments either of powdered tungsten ("pressed") or of the ductile tungsten wire that had recently been perfected (and continues to be the primary material of bulb filaments).[59]

In the 1905 edition of *L'Electricité à la portée de tout le monde,* Georges Claude, however, still treated the creation of a carbon filament from a fibrous paste as standard in French manufacturing. Claude explains the procedure for such lamps (fig. 130), augmenting the parallel with Duchamp by his surprising mention of "nourishing" the filament material:

The filament of these lamps is generally obtained by the extrusion at the diameter desired of a suitable paste, a paste of wood, collodion, or another substance, which is then carbonized at a high temperature. Irregular and too soft, the filament thus produced is nourished [*nourri*] by being maintained in a red-hot state with the aid of a current in an atmosphere of hydrocarbons; these decompose on contact with the incandescent carbon and deposit particles of very dense carbon. . . . The nourishing [*nourrissage*] thus augments successfully the toughness and the homogeneity of the filaments, which are thus rendered suitable for their role.[60]

Duchamp was certainly responding to this aspect of filament manufacture in his image of the Wasp "nourishing" the filament material.[61] Just as automobile literature had provided the term *alimentation,* used to describe the "feeding" of fuel to the engine, lighting technology offered the same kind of organic metaphors in mechanical contexts.[62] Indeed, scientists had borrowed the term *filament* from the realm of the organic, where it was used in reference to muscle, nerve, and plant fiber.[63]

Electrical bulbs had come to function as modern equivalents to the torch of the classical goddess Demeter or of earlier allegorical figures of truth (fig. 133).[64] That technological transformation had begun with gas lighting (figs. 184, 185). Duchamp, in his final assemblage, *Etant donnés* (fig. 183), would come close to directly paralleling such imagery of woman and torch. At this earlier stage, however, the woman/Bride was embodied *as* the torch or bulb itself, along with her many other identities.

Duchamp reinforced the Bride's association with a

glass bulb in his *Boîte-en-valise,* or *Box in a Valise,* the portable "museum" of reproductions of his works that he began to issue in multiples in 1941 (fig. 166).[65] In it Duchamp carefully placed the miniature version of his Readymade *Air of Paris* of 1919, an empty serum ampoule brought from Paris, to the left of the Bride. Below the ampoule the miniature version of the Underwood typewriter cover, which Duchamp entitled *Traveler's Folding Item* (1916), parallels the Bride's Clothing at the horizon, and below that a tiny molded *Fountain* stands as the counterpart to the Malic Molds. Duchamp repeated this specific arrangement with versions of the actual Readymades themselves in his 1963 retrospective at the Pasadena Art Museum, reinforcing the sense that it was of particular significance for him. Ulf Linde, the first scholar to discuss this issue, has suggested that Duchamp may have considered these Readymades as specific analogues to the upper, middle, and lower ranges of the *Large Glass.* According to Linde, *Air of Paris* may relate to the Air Current Pistons, the typewriter cover may be suitable "clothing" for a typewriterlike Bride who communicates via "alphabetic units," and the *Fountain* may be appropriate to the Splashes produced by the Bachelor Apparatus.[66]

Although Linde focused on air as the connecting link between *Air of Paris* and the Bride, the enclosed glass bulb was undoubtedly the most important parallel to the Bride. That such enclosed vessels had a long-standing association with the Virgin Mary (fig. 168) suggests that the bulb analogy functioned on one level as another of Duchamp's recastings of traditional religious iconography (see chap. 12). Yet such glass bulbs had other contemporary associations in science, beyond incandescent lighting. "Put the whole bride under a glass cover [*sous globe*], or in a transparent cage," Duchamp had written in his note headed "General notes. for a hilarious picture." Although George Heard Hamilton, with Duchamp's approval, translated this phrase as "under a glass case," the *Petit Larousse illustré* defines *globe* as a "spheroidal envelope" for protection from dust and includes an illustration of a clock under a glass dome.[67] If this phrase evokes the Bride as enclosed within the glass globe of an incandescent lamp (or signified by an ampoule such as *Air of Paris*), it also has more specific associations with the realm of biology and is particularly appropriate for the Bride's identity as Wasp (fig. 134).

Biology and the Bride: J.-H. Fabre and Remy de Gourmont

Although Duchamp had considered a fly and bee as alternatives for the Bride's organic persona, he settled upon

Wasp, perhaps finding a visual analogy in the Bride's reverse-hourglass figure and the abdomen of the wasp.[68] There was, however, a far more powerful instigation for choosing such an insect. Wasps had been a major concern of the self-trained entomologist Jean-Henri Fabre (1823–1915), whose *Souvenirs entomologiques: Etudes sur l'instinct et les moeurs des insectes* appeared in ten volumes between 1879 and 1907 and in numerous other collections extracted from these volumes.[69] Fabre's writings were a major source for Gourmont's *Physique de l'amour: Essai sur l'instinct sexuel* of 1903, which stands as a classic "birds and bees" study of animal and human sexuality—with mechanical analogies integrated as well. Several of Gourmont's comments from *Physique de l'amour* have been cited in earlier chapters, but the centrality of Gourmont's book to Duchamp's *Large Glass* becomes clearest in the context of the organic, biological aspect of the Bride.[70]

Duchamp would not have been alone in his interest in Gourmont's book, which was in its tenth edition in 1912, or in Fabre, who, five years before his death in 1915, received acclaim in France and abroad.[71] In fact, Apollinaire greatly admired Gourmont's *Physique de l'amour* and was likewise a reader of Fabre's works. In a letter of October 1915, Apollinaire chronicled his enthusiasm for Fabre:

I read today of the death of the entomologist Fabre whose books I used to enjoy tremendously for his studies on insects taught me to know men and if I had the leisure for it I should like them [men] to be studied in my romanesque work as minutely as precisely as amorally. . . . I occasionally used to amuse myself by changing in Fabre's pages the names of insects into names of men and women, which gives those pages a terrifying aspect of overly real humanity à la Marquis de Sade.[72]

It has been suggested that the passages in Apollinaire's *L'Enchanteur pourrissant* (1909) dealing with flies, bats, and dragonflies may derive from Gourmont (or, in certain cases, Fabre), and it would seem that an enthusiasm for Gourmont and Fabre as sources of artistic inspiration was yet another common element in the friendship between Duchamp and Apollinaire.[73]

Just as *Impressions d'Afrique* and the Jura-Paris Road trip contributed to the origin and early stages of Duchamp's ideas for the *Large Glass*, Gourmont and Fabre were critical to his subsequent development of the Bride's organic character. Like Apollinaire, Duchamp seems to have read Fabre and Gourmont and mentally substituted "Bride" for wasp in the discussions of the

creatures he found there. It should be noted, however, that Duchamp avoided the "terrifying" aspects of insect habits that fascinated Apollinaire and the Surrealists after him.[74] Whereas Fabre's description of the female praying mantis devouring her mate was to be an archetypal motif in Surrealism, Duchamp avoided the de Sadian aspects of the insect world in his characterization of the Bride. Nonetheless, while working on the painting of the Bride in Munich in August 1912, Duchamp had had a dream that may have been a response to reading Fabre. As recounted by Lebel, "Upon returning from a beer hall where, so he says, he had drunk too much, to his hotel room where he was finishing the *Bride*, he dreamed that she had become an enormous beetle-like insect which tortured him atrociously with its elytra."[75] Although Duchamp's artistic concerns in the summer of 1912 were oriented primarily toward technology as the source of a new form language, he was undoubtedly already reading Gourmont, if not Fabre himself, at the beginning of his progress toward *The Bride Stripped Bare by Her Bachelors, Even*.

On the subject of insect behavior, Gourmont wrote that "only one observer seems trustworthy in these matters, J.-H. Fabre, the man who, since Réamur, has penetrated furthest into the intimate life of insects and whose work has created, perhaps unintentionally, a general psychology of animals."[76] Fabre, whom Charles Darwin termed an "incomparable observer," was never a member of the French scientific establishment; rather he was a popular-science writer who came to focus increasingly on the insects he painstakingly observed—primarily on his own land outside the village of Sérignan.[77] It was Fabre's technique of observing insects inside a transparent glass cage (fig. 135) or under a *cloche,* or bell glass, that likely inspired Duchamp's idea to "put the whole bride under a glass cover, or in a transparent cage."[78] Like Fabre, he would be an observer of the instincts and habits of this female creature.

Wasps of various types were a major subject for Fabre, and the wasp-related chapters of his *Souvenirs entomologiques* ultimately filled three volumes, published in translation as *The Hunting Wasps, The Mason Wasps,* and *More Hunting Wasps*.[79] In the eighth volume of *Souvenirs* Fabre described his observation of a nest of wasps, marveling at the instinctual wisdom of the female.[80] That superiority over her male counterpart would have struck Duchamp, whose four-dimensional Bride was to be in control of the events of the *Large Glass*. Moreover, the nest of paper wasps Fabre observed under his bell glass offered yet another model for Duchamp's conception of the Bride's filaments. Before the manufacturers of incan-

descent-bulb filaments had ever created a fibrous paste to produce filaments, wasps had been producing a "pâte de papier," which they literally "spit" to build their nests, much like Duchamp's Wasp's spitting of dew at the Tympanum to nourish the filament paste.[81] In fact, Duchamp may have become interested in the term *tympanum* through his vicarious study of insects: the tympanum is an external membrane on an insect's body that vibrates in response to sound waves, as does the human eardrum and its mechanical equivalent, the diaphragm of a telephone or its counterpart in wireless telephony.

At least one other element of the activities of Duchamp's Wasp and her filaments would seem to derive from naturalists' observations of the insect kingdom. In his discussion of the mating habits of Hymenoptera (the order to which wasps and bees belong), Gourmont recounts Réaumur's observation of a queen bee "approaching a male, licking him with her proboscis, offering him honey, [and] stroking him with her feet" in an effort to arouse him. Although Gourmont adds that "the real preludes, at least in the state of liberty, contradict the great observer,"[82] the female being not at all aggressive, Réaumur's licking episode offers a probable model for Duchamp's statement that the Bride's filament (here, like an insect's proboscis) "licks the ball of the handler displacing it as it pleases."[83] Many of Gourmont's assertions, based on his reading of Fabre, would likewise have supported Duchamp's scenario in the *Large Glass*, particularly in relation to the dominance of the female in the insect world. "Among insects the female is nearly always the superior individual," Gourmont asserts.[84] "Among the hymenoptera she is at the same time the brain and the tool, the engineer, the maneuver[er], the lover, the mother, and the nurse unless, as in the case of bees, she casts upon a third sex all duties not purely sexual. The males make love."[85]

Whereas the biologist Jacques Loeb viewed the human body as a "chemical machine," mechanical analogies were not part of Fabre's vocabulary.[86] Indeed, this may explain Fabre's appeal for Duchamp in 1913, as he sought to temper the Bride's mechanical qualities with a new emphasis on the organic. Loeb's mechanist language would have supported Duchamp's initial introduction of chemical apparatuslike forms in his August 1912 painting of the *Bride*, but the biological side represented by Fabre's almost folksy entomology was to be crucial in his final formulations of the Bride's character. Yet Duchamp was still fascinated by the fusion of the organic and the inorganic, and in Fabre's books the biological and the mechanical were juxtaposed inadvertently and provocatively in the advertisements that his publisher, Delagrave, included at the end of the books. On facing pages at the end of *Les*

Merveilles des instinct chez les insectes, for example, one finds book titles that invent new mechanomorphic phenomena, such as *Habits of Insects: Industrial Electricity* and *The Life of Insects: Electrical Technology.*[87]

Gourmont, as noted earlier, regularly utilized analogies between the organic and inorganic. "Love is profoundly animal; therein lies its beauty," he asserts near the beginning of *Physique de l'amour*.[88] Readily shifting from the animal world to the mechanical, Gourmont subsequently argues in a discussion of parthenogenesis, "The female appears to be everything; without the male, she is nothing. She is the machine and has to be wound up to go; the male is merely the key."[89] The title Gourmont chose for his six chapters surveying copulation techniques from species to species, "The Mechanism of Love," might also serve as a subtitle for the *Large Glass*.

Beyond the parallels between Gourmont and Duchamp cited here (not to mention Picabia's gearwheels in his 1916–18 *Machine Turn Quickly*),[90] Gourmont's ideas were also evident in Duchamp's studio in New York, both in Jean Crotti's title for his 1916 work on glass, *Mechanical Forces of Love in Movement* (Private Collection), and the joint newspaper interview he and Duchamp gave in April 1916. Crotti's painting on glass seems to echo Gourmont (and Duchamp) in both its title and its intention to focus on the mechanics of love in the way Gourmont had done.[91] At the same time, Crotti's comments in the New York *Evening World* interview confirm a view of love and sexuality akin to Gourmont's emphasis on the insect and animal worlds. When asked if he believed in love, Crotti replied, "In the sense of the strong, natural attraction of the sexes I believe in love, but not in the sense of pretty-pretty sentiment. . . . My picture does not undertake to express sentimental love. It is love in the most primitive sense."[92] He might have added, "love in the animal sense."

When Duchamp determined to "introduce *organic materials* in the wasp and elsewhere," he succeeded in restoring to the Bride a biological side that had nearly been lost in the midst of the automobile metaphor of his initial *Green Box* notes and his wireless telegraphy paradigm. The Bride's origins in his Munich painting of summer 1912 had been organic at base (X-ray images, Papus's physiology, an *arbre type* associated with blossoming trees and the Virgin Mary, as well as an automobile transmission shaft), but the technological language Duchamp began to explore that summer threatened to engulf this aspect of her character. The conversion of Sex Cylinder to Wasp ameliorated that tendency, which would have led to the Bride's greater similarity to the purely mechanical, anti-Bergsonian world below. In *Creative Evolution*, Bergson had relied upon Fabre's wasp

studies in his explanation of the contrast between instinct and intelligence. Because the philosopher considered intuition to be "instinct that has become disinterested,"[93] Duchamp's choice of the Wasp identity for the Bride may also have conveyed to her associations with intuition and thus further augmented the pseudo-Bergsonian contrast he seems to have been cultivating between the upper and lower halves of the *Large Glass*.

Under Duchamp's heading "General notes. for a hilarious picture," the artist had included the phrase "Of the hygiene in the bride; or of the Regime in the bride."[94] Whereas the Bergson of *Le Rire* would have seen the Bride's dual organic-mechanical nature as a source of laughter, Duchamp, as we have seen, was aiming for a subtle blend of these two oppositional characteristics.[95] The theme of hygiene demonstrates effectively the number of levels on which Duchamp could work simultaneously. The theme of ventilation in the Bride was itself closely related to issues of public hygiene: W. N. Shaw had undertaken his pioneering studies of interior air currents for the British magazine *Hygiene*, for example,[96] and "Hygiene" became a featured rubric in the *Revue Scientifique* in this period. Even the Musée des Arts et Métiers included a room devoted to hygiene along with heating and lighting by gas and oil.[97] In the realm of biology, Fabre attentively observed the hygiene of his insect subjects, including the wasp, whom he described as "so careful to keep clean, taking advantage of the least leisure to brush and polish herself."[98] Fabre's humanizing description might well be that of the young coquette in the turn-of-the-century poster for bathroom fixtures from the Parisian firm "L'Hygiène Moderne" (fig. 136). Indeed, Duchamp even brought a bathtub into his description of the Wasp's activities:

Reservoir.—concerning the nourishment layer of the wasp.

The reservoir will end at the bottom with a liquid layer from which the sex wasp will take the necessary dose to sprinkle the tympanum and to nourish the filament substance. This liquid layer will be contained in the oscillating bathtub (hygiene of the bride.)[99]

Although Duchamp never specified the location of such a bathtub, he would associate a "bath heater" with the never-executed Desire Dynamo of the Bachelor Apparatus.[100] It was the Bride/Wasp, however, to whom Duchamp applied Fabre's detailed observational techniques. In his later recasting of the theme of the *Large Glass*, *Etant donnés* (figs. 183, 186), Duchamp would in effect "put the whole Bride under glass," as if she were a specimen in a museum. In the *Large Glass*, however, it is the notes that function as the record, like Fabre's books, of the "instincts and habits" of Duchamp's four-dimensional Bride with her multiple, interrelated identities. Her rich complexity (augmented by her qualities associated with infinity and four-dimensionality) transcends a single image such as *Etant donnés*. X-ray image/chemical apparatus/automobile/organic automaton/wireless telegraphy emitter and receiver/barometer and weather vane (the latter two categories having associations to the Eiffel Tower)/incandescent bulb/wasp—the Bride was all of these things for Duchamp, as well as the symbol of a higher-dimensional, immeasurable existence contrasting with the three-dimensional, metrical realm of the Bachelors. In the end, she is far more than the shadow registered in paint on the upper half of the *Large Glass*: her "dossier," recorded in Duchamp's multitude of notes, is an essential part of her person.

Chapter 10

Other Scientific and Technological Dimensions of the Bachelors, I

The Bachelor Apparatus as Playground of the Would-Be Physical Chemist

As in the case of the Bride, Duchamp's posthumously published notes, read in the context of contemporary science and technology and together with the notes he selected for publication during his lifetime, provide a wealth of additional information on the Bachelor Apparatus. Beyond its functions in the wireless telegraphy paradigm, the Bachelor Apparatus was the site of Duchamp's exploration of a variety of other scientific and technological issues. In keeping with his conception of contrasting realms for the Bride and the Bachelors, these phenomena most often involve machines or other types of mechanical activity. Certain aspects of the Bachelor Apparatus, however, also parallel in visible terms the events of the atomic and subatomic realms that had been reported in the literature on cathode rays, X-rays, electrons, and radioactivity and that Duchamp had sought to embody in his paintings and drawings of 1912. Moving freely between the macroscopic and microscopic (or even the subatomic) and borrowing from traditional as well as current science, Duchamp created in the Bachelor Apparatus his most sustained system of Playful Physics and chemistry.

Old and New Identities in the Bachelor Apparatus

Duchamp's previously unpublished notes surprise a reader with a number of elements originally planned for the Bachelor Apparatus that have remained virtually unknown. The most important of these unexecuted components, the Desire Dynamo (fig. 149), was included as one of the five major components of the "Breakdown: Bachelor machine—" that Duchamp listed in the note beginning "First breakdown" of the Bride (see chap. 7).[1]

Even though he subsequently chose not to include his numerous notes on the Desire Dynamo in the *Green Box* or *A l'infinitif*, the Dynamo figures prominently in two of the *Large Glass*–related notes Duchamp contemplated assembling as a group in the late 1950s (app. A). Figure 149 is drawn from one of those notes (app. A, no. 12); the other note discussing the Desire Dynamo, the four-page note 153 (app. A, no. 11), stands as Duchamp's most complete description of the operation of the Bachelor Apparatus and clarifies the actions not only of the Desire Dynamo and related Mobile but also of elements such as the Scissors (here named "Horizontal Column" or "Horizontal Scissors") and their "Precision Brushes."[2] As in the other notes relating to Bachelor operations in appendix A, such as note 133 on liquefaction (app. A, no. 8), as well as in many other of his posthumously published notes, Duchamp exhibits a previously unknown degree of complexity in his scientific and technological imaginings for the Bachelors' activities.

Although in executing the *Large Glass*, Duchamp had replaced the Desire Dynamo with the Oculist Witnesses as an optical solution to the last stage of the Bachelor operations, the germ of the Desire Dynamo had been present from the beginning as the "desire motor" in Duchamp's extended, automobile-oriented note in the *Green Box*. Initially described and sketched by Duchamp (fig. 81) as a "steam engine on a masonry substructure on this brick base," the "desire-part," as Duchamp termed it, "alters its mechanical state—which from steam passes to the state of internal combustion engine."[3] It was this "desire motor," "the last part of the bachelor machine," which was to be "separated by an air cooler. (or water)" from the Bride.[4] Even though Duchamp seems to suggest that the modus operandi of the *Large Glass* will be simply the parallel functioning of two automobile motors, that plan was not to be enacted, as we have seen. Only the Bride would assume an elaborate automobile-based identity, among her many personae.

In heat engines such as steam and internal combustion engines, Duchamp found an appropriate metaphor for the sexual excitement of the Bachelors and a counterpart to his initial image of the Bride's orgasm as an automobile motor "turn[ing] over faster and faster, until it roars triumphantly."[5] Although he continued to include certain functions of an internal combustion engine in the Desire Dynamo, his retitling of this element documents the growing multiplicity in the lower half of the *Glass*. First a

steam engine and then an internal combustion engine, the renamed Dynamo (a generator of electrical current) points to the issue of energy and power sources, which was to become an important theme in the realm of the Bachelors. In fact, with the additional presence of the Water Mill Wheel and a falling weight as the motive force for the Chariot/Glider, the Bachelor Apparatus incorporates a virtual survey of major aspects of the technology of power generation. From the point of view of scientific theory, Duchamp's interest in heat energy and its transformation also reflects his awareness of basic issues in thermodynamics.

Duchamp's response to science and technology was most encyclopedic in the Bachelor Apparatus. Indeed, an overview of the phenomena he incorporated into the lower half of the *Large Glass* (as well as in the Bachelors' agent, the Juggler of the Center of Gravity) reads like a catalogue of the display rooms at the Musée des Arts et Métiers. As described in the *Guide bleu*, these rooms included the following holdings that are mirrored in one way or another in the Bachelors' operations:

Room 24. *General Mechanics, . . . Engines*: windmills, water wheels, steam engines, various engines [including internal combustion engines]. Room 26. *Physics, Mechanics*: [including] machines for studying the laws of falling bodies. Room 27. *Physics*: pressure and flow of liquids and gases, compressibility and elasticity, capillarity, chemical properties, heat, magnetic apparatus, electricity, magnetos and dynamos, induction apparatus, . . . apparatus for measuring the density and pressure of vapors, apparatus of Cailletet for the liquefaction of gas. Room 46. *Industrial chemistry*.[6]

When one adds to this the physics displays in room 30 (which included optics as well as the wireless telegraphy equipment and Crookes or Geissler tubes suggested by the Chocolate Grinder and Malic Molds), the agricultural machinery displayed in room 11, the cranes in room 13, the clocks and automatons in rooms 19 and 20, weights and measures in room 21, and the gearing systems in room 54, the Bachelor Apparatus offers a remarkable parallel to selected holdings of the museum. In Duchamp's Playful Physics and chemistry, however, all of these elements are no longer segregated, as in the displays, but rather interact fancifully in their new, anthropomorphized, multilayered incarnations, often with decidedly sexual overtones.

Duchamp's "Breakdown: Bachelor machine," made as part of his "First breakdown" of the Bride, set forth five elements of the Bachelor Apparatus. In addition to the "Stripping-bare" placed in an "intermediary" position (i.e., the Boxing Match), Duchamp listed the following:

1 *Chariot.*(supporting the / columns. / *Bumper.*
1a *motive force of the chariot.* / (in the background)
2 *Chocolate grinder*
3 *Tubes of erotic concentration* /(intake of the illuminating gas:/principle of the erotic liquid. / *Whistle*
4. *Desire dynamo—* / combustion chamber/ *Desire* centers / *Sources* of the stripping
5. Horizontal column[7]

Apart from the Chocolate Grinder, the aspects of the Bachelor operations listed here are unified by "falls," as Duchamp explained in one of the pivotal unpublished notes:

consideration: the falls in the bachelor mach. / (water fall/fall of the name brand bottles/fall in piano form) fall of the drops [*gouttes*] after compression / These 3 falls combined with the various physical forms (gas, spangles, etc.) that the gas takes, determine their compression after the handler [*manieur*] of the centers of gravity.
Tautology. in acts (bride stripped bare...)[8]

"The picture in general. is only a series of variations on 'the law of gravity,'" Duchamp stated, and if the Bride escapes gravity, the pronounced "falls" in the Bachelors' activities are an ever-present reminder of their subservience to gravity.[9] Falling entities as sources of motive power (Waterfall, "brand bottles" [i.e., Benedictine Bottles]) evoke basic principles of classical mechanics and confirm the importance of the interrelated systems of energy in the lower half of the *Glass* noted earlier. Falls were also central to Duchamp's experiments with chance and the "liberty of indifference," which centered on the Mobile (see chap. 5). Duchamp's phrase "fall in piano form" alludes to the falls of the Rams of the Boxing Match, after being released by the hammerlike blows of the Combat Marble, producing the "stripping-bare in piano form."[10] According to Duchamp's notes, the actions of the Boxing Match were variously the result of the "3 crashes" (i.e., the falls of the Mobile) as well as of the explosions within the Desire Dynamo.[11] Indeed, as will be seen, the little-known Mobile and Desire Dynamo were the critical links between the motion of the Chariot/Glider and the activities of the Juggler/Handler of Gravity perched on the Boxing Match—via the movement of the Horizontal Column or Scissors.

The reference in Duchamp's "falls" note to the "fall of the drops [of gas] after compression," however, also suggests the possible splashing (rather than exploding) of the gas, which was ultimately to assume a larger role as a mechanical means of activating the Boxing Match and the

Juggler/Handler of Gravity.[12] Just as Duchamp's posthumously published notes on the Bride provided a glimpse of his subtle shaping and reshaping of her character, the notes on the Bachelor operations in this group likewise reveal a process very much in progress. Because Duchamp was often considering differerent systems for the operating modes of the Bachelor Apparatus simultaneously, the notes are at times contradictory. Yet despite the difficulties, which may also have led him to simplify that process by omitting certain of these notes from the 1934 *Green Box*, the posthumously published notes are well worth the effort required to reconstruct the early stages of his endeavor. They are the definitive testament to the range of his scientific and technological meanderings as well as to the potential for humor he found there.

Chemistry, Physical Chemistry, the Liquefaction of Gases, and Jean Perrin's "Molecular Reality"

Duchamp had included the laws of both chemistry and physics in his note connecting the *Large Glass* to a "*reality which would be possible by slightly distending*" those laws.[13] In contrast to physics, chemistry readily lent itself to artistic activities with a scientific bent. Acid was the traditional material of the etcher, but Duchamp talked of obtaining a "hydrofluoric pencil" to mark lines on the glass or of using "picric acid and tincture of iodine etc. to tint the surface."[14] The medium of photography, which so intrigued Duchamp, also relied on chemicals and had from its beginnings been tied to chemistry.[15] In addition to casting paint formulas in terms that suggest a laboratory manual and experimenting with a variety of nontraditional materials, such as "ground glass and rust of different metals," Duchamp referred specifically to chemistry practices in his notes.[16] For example, his idea for a "Flat container. in glass—[holding] all sorts of liquids" was to involve "chemical reactions."[17] Likewise, he adopted the technical language of chemistry in certain notes, writing of "Trituration" and "Triturators," terms referring to the process of grinding a substance to a fine powder to enhance solution.[18] In these and other notes and projects, Duchamp contemplated or actually played the role of chemist, just as his placement of the netting of the Air Current Pistons onto the *Large Glass* seems to have rehearsed Becquerel's discovery of radioactivity (fig. 119).

One inspiration for Duchamp's activities in this area may have been the chemists in Roussel's *Impressions d'Afrique*. Louise Montalescot, Roussel's highly intelligent heroine with tubular metallic lungs, is described as "particularly fanatical in her devotion to chemistry" and performs "triturations," along with the "learned tritura-

tions" of her fellow chemist, Bex.[19] Many of the miraculous events in *Impressions d'Afrique* occur by means of "molecular alterations" or "atomic transformations," including certain of the photographic phenomena (see chap. 4).[20] As Duchamp was to do, Roussel united chemistry, photography, electricity, and electromagnetism in a fantastic realm in which chance also served as a means to negate virtuosity. Duchamp's exploration of chemistry and physics would ultimately lead him to the laws of chance in science, allowing him to parallel Roussel's celebration of chance in a far more extensive engagement with chemistry.

It is a measure of Duchamp's interest in chemistry that all his life he kept the chemistry textbook he had used as a lycée student, Louis-Joseph Troost's *Précis de chimie* (25th edition, 1893).[21] First published in the 1860s, Troost's text is filled with engraved illustrations of chemistry experiments, replete with glass vessels and capillary tubes, and even demonstrates the process of etching with hydrofluoric acid on glass.[22] Containing entire chapters on specific elements and compounds, including many of the metals that interested Duchamp, the *Précis de chimie* would have served as a useful reference. Moreover, in Troost's discussions of the physical properties of various gases, he also addressed their liquefaction and included an illustration of the compression apparatus designed by Paul Cailletet. That apparatus, along with a number of other examples of liquefaction equipment, had entered the collection of the Musée des Arts et Métiers by the end of the nineteenth century, as noted in the guidebook excerpt quoted above.[23]

The 1893 edition of Troost's text may have served as a basic reference manual for Duchamp, but by 1912 it was considerably out of date, given such discoveries as X-rays and radioactivity. Moreover, William Ramsay had established the existence of an entirely new group of elements, the inert gases, including neon, and these had been successively liquefied, culminating with Heike Kamerlingh Onnes's conquest of helium in 1908 (fig. 137). Duchamp's notes confirm that his interest in chemistry went beyond the artistic manipulation of chemicals and pseudochemicals or the adoption of processes associated with the field. Not surprisingly for an artist interested in depicting the invisible reality associated with X-rays and electrons, Duchamp demonstrates in his notes a deep-seated concern with the structure of matter and with new discoveries bearing on this topic. For example, reflecting his move beyond the métier of painting, he speculates about a new kind of color that will result from "matter having a source of light in its molecular construction."[24] Like this note, many of Duchamp's references to molecules or, in the fol-

lowing note, to atoms, were included in the *Green Box* or *A l'infinitif* in his discussions of the "appearance" and "apparition" of a "chocolate object." There he writes: "The *body* of the object is composed of luminous molecules and becomes the source of the *lighted* objects' substance (e.g. the chocolate emanating is the atomic mold of the opaque chocolate substance having a physical existence *verified* (?) by the 5 senses. . . ."[25] This "emanating" substance "endowed with a *'phosphorescence'* (?) and light[ing] up like luminous advertisements. . ." not only evokes radium emanation and the new neon gas lighting but also suggests a conceptual link to the inert Illuminating Gas in the Malic Molds (see chap. 8).[26]

Duchamp's notes also demonstrate a fascination with molecules and molecular motion as they correspond to different physical states of matter, which was to be a central theme in the Bachelor Apparatus. In *A l'infinitif,* for example, he refers to a "different molecular *composition*—hardness, porosity, etc.) for each substance" in contrast to its "chemical composition" or color blend.[27] In one of his unpublished notes, Duchamp muses whimsically on the possibility of "molecular braking (instead of brakes on wheels)," and other unpublished notes on the liquefaction process discuss the Illuminating Gas in terms of its "molecular cohesion."[28] Finally, Duchamp speaks in the *Green Box* of the "*Molecular or (Body) composition* of the bottles with lead bottoms *such* that it is impossible to calculate their weight. = Great density and in perpetual mvt. not at all fixed like that of metals (Oscillating density)."[29]

Duchamp, like Roussel and Jarry (in certain of Faustroll's adventures at molecular scale), found in the realm of molecules rich possibilities for invention and subtle humor.[30] In the case of his falling Benedictine Bottle(s) or Hook, Duchamp applied the highly active behavior of gas molecules to those of a solid, creating a fantastic world in which lead molecules are "in perpetual mvt. and not at all fixed like that of metals."[31] Yet his idea of "oscillating density" transcends not only the vibrations in situ characteristic of a solid's molecules but also the random, angular trajectories of gas molecules. "Oscillating density" here suggests the to-and-fro flowing of a liquid, such as that used to describe oscillatory electric circuits.[32] Similarly, Duchamp's very notion of "molding" the Illuminating Gas in the Malic Molds controverts the characteristics of molecules in a gaseous state: they will not cohere, nor will they retain the shape of a containing vessel if it is removed. Only as the Illuminating Gas changes state can it achieve "molecular cohesion"and become moldable, like chocolate.[33]

Beneath the humor of his molecular fantasies, Duchamp's interest in molecules reflects his study of both chemistry and physics, and in the late nineteenth and early twentieth centuries chemists and physicists often explored the same phenomena. For example, Crookes, Ramsay, and Soddy, all chemists, had made important contributions to research in radioactivity; Crookes's radiometer and cathode-ray experiments, in particular, were vital to the subsequent development of physics. In fact, a new field, physical chemistry, had been officially established in the late nineteenth century to study the correlations between the physical properties and chemical constitution of substances.[34]

Three of Duchamp's concerns in the Bachelor Apparatus were closely related areas of study in physical chemistry as well as in physics: the practical problem of the liquefaction of gases, the more general issue of the kinetic-molecular theory of gases, and the related questions of thermodynamics and transformations of energy. Thermodynamics and the kinetic theory of gases had been established fields of inquiry since the mid-nineteenth century; the successful liquefaction of gases had also made this topic a staple of textbook science by the end of the century. For example, all three subjects figure in two of the initial chapters of Lucien Poincaré's *La Physique moderne, son évolution* of 1906, "Principles" and "The Various States of Matter."[35] Expositions of the kinetic-molecular theory also appeared regularly in the overviews of science traditionally provided in the literature on X-rays, such as Guillaume's *Les Rayons X et la photographie à travers les corps opaques.*[36]

Before World War I, however, both liquefaction and kinetic-molecular theory developed a new currency because of recent scientific or technological developments. Kamerlingh Onnes's success in obtaining record low temperatures within a few degrees of absolute zero (i.e., $-273.15°C$) in order to liquefy helium won for him considerable acclaim and the Nobel Prize for physics in 1913 (fig. 137). In Paris liquefaction was also in the news because of Georges Claude's invention of a new technique for the liquefaction of air, which also made possible the commercial production of neon for his new form of lighting.[37] Roussel, in *Impressions d'Afrique,* registered contemporary interest in liquefaction in his design of Bex's "thermo-mechanical orchestra," in which a white cylinder "incessantly manufactures an intense cold capable of liquefying any gas."[38]

As for the kinetic-molecular theory, in the prewar years Jean Perrin established conclusively the existence of molecules and atoms through his study of Brownian movement, the ceaseless motion of particles in suspension. Perrin's major publications, beginning in 1909 and culminating in his highly influential *Les Atomes* of 1913,

offered another model for registering invisible molecular activity (figs. 142, 143). *Les Atomes* specifically called attention to the contemporaneous work of Rutherford and, in the 1914 edition, of C. T. R. Wilson in documenting the motion of subatomic particles (figs. 145, 146).[39] The molecular world chronicled by Perrin, and theorized by advocates of the kinetic theory of gases before him, was one of incessant collisions. As noted, the theme of collisions—on all scales—was central to Duchamp's conception of the *Large Glass* (see chap. 7).

Duchamp's preoccupation with molecules in the notes for the *Large Glass* stands as a natural extension of his earlier fascination with the theme of electrons and radioactive particles as speeding projectiles in works such as the *King and Queen Surrounded by Swift Nudes* series of spring 1912 (pl. 2, figs. 21–24) or as ballistic weapons in his first drawing for the *Large Glass* project, *First Study for: The Bride Stripped Bare by the Bachelors* (fig. 31). Here, however, the move from the alchemical associations of radioactivity (see chap. 2) to the fields of chemistry and physical chemistry was complete. Moreover, unlike his earlier painted evocations of the world of speeding electrons, in the *Large Glass* Duchamp would enact a molecular drama, using as his players the Spangles of Illuminating Gas in the process of liquefaction and other mechanical substitutes. Before addressing the themes of gas liquefaction and Perrin's molecular reality in the *Glass*, however, the general background of thermodynamics and the kinetic theory of gases should be examined briefly.

Duchamp, Thermodynamics, and the Kinetic-Molecular Theory of Gases: Themes of Energy and Chance

In *Les Peintres Cubistes*, Apollinaire wrote that Duchamp was "preoccupied with energy."[40] In 1912 Duchamp's interest in energy most likely centered on the newest associations of the word—those of radioactivity and Le Bon's widely touted conception of "intra-atomic energy."[41] Yet, just as Duchamp's subsequent reevaluation of painting included a reexamination of the perspective techniques of the past, his exploration of science and technology seems to have assumed a historical dimension and incorporated the investigation of energy by the science of thermodynamics, which focuses on heat and work and the transformation of one of these types of energy into the other.

The field of thermodynamics was deeply indebted to Sadi Carnot's study of steam engines in the early nineteenth century. Subsequent contributions were made by a number of figures, including Lord Kelvin, the addressee of Jarry's "telepathic letters." During the 1840s Julius

Robert Mayer, James Prescott Joule, and Hermann von Helmholtz had independently formulated theories about the conservation of energy. Building on the work of these individuals as well as on his own analyses, Rudolf Clausius in the 1850s articulated two basic principles concerning energy: "the energy of an isolated system remains constant," that is, energy cannot be created or destroyed; and the entropy of a system "strives toward a maximum."[42] These have come to be known as the first and second laws of thermodynamics, although French writers tended to identify them as Mayer's principle and Carnot's principle, respectively.[43]

Duchamp's concern in the *Large Glass* with various forms of engines and other sources of energy made thermodynamics and its focus on the transformation of heat into work a natural touchstone for aspects of his project.[44] Beyond his sexually suggestive references to steam engines and to internal combustion engines (i.e., the Bride's motor and the Bachelors' Desire Dynamo), Duchamp also responded creatively to a basic issue in practical thermodynamics: the loss of mechanical energy that is transformed into heat by friction. According to notes in the *Green Box*, the Chariot or Glider exhibits an "*inversion of friction*," the friction being "reintegrated." As Duchamp explains, "The friction of the runner on the rail [instead of changing into heat] is transformed into a returning force equal to the going force."[45]

Typically, Duchamp also playfully adopted the language of thermodynamics and applied it at will—often outside the specific context of his engines. For example, his creation of a "Transformateur à détente," or expansion transformer, in the context of the mechanical system of the Water Mill Wheel alludes to the energy transformations ubiquitous in thermodynamics at the same time that it creates an impossible functional union between an electrical apparatus, the transformer, and a *machine à détente,* or expansion engine such as a steam engine.[46] In fact, as discussed below, an expansion engine played a key role in Georges Claude's liquefaction process, so that the transformation of the Illuminating Gas, occurring in tandem with the activities of the Chariot/Glider, could be associated with a *machine à détente.* Moving from mechanics to electricity to liquefaction, Duchamp, in his "Transformateur à détente," achieved a freewheeling, linguistic energy transformation. As a much later note confirms, such unorthodox transformations would continue to fascinate him long after he had left behind his deep involvement in science and technology: "Transformer designed to utilize the little wasted energies like: the excess pressure on an electric switch / the exhalation of tobacco smoke / the growth of hair, whiskers, and nails," and a long list of other bodily

processes included "stretching, yawning, sneezing," and "ejaculation."[47]

By the second half of the nineteenth century, the focus of thermodynamics had shifted from engine technology to the study of gases at the molecular scale. Once heat was recognized as the result of the motion of molecules, the principles of thermodynamics could be investigated at the molecular level of activity posited by the kinetic theory of gases.[48] Thus, two different approaches to the same phenomena—the general laws of thermodynamics and the mechanism posited by the kinetic theory of gases (with its hypothesis of molecular structure)—would gradually be joined. Frederick Soddy described the situation metaphorically in his 1912 *Matter and Energy*: "Like twin dewdrops forming side by side, these two divisions of science have at length met and coalesced."[49] This melding, however, was hardly accomplished as readily as Soddy suggests. In fact, it was against the backdrop of the kinetic theory of gases and its thermodynamic applications that an intense debate about the very existence of atoms occurred in the late nineteenth and early twentieth centuries.[50]

Critics of the kinetic theory, such as the physical chemist Wilhelm Ostwald, argued that it was overly mechanistic and flawed by its dependence upon the atomic hypothesis, which they rejected. Ostwald proposed instead a system he called "Energetics," a generalized thermodynamics in which energy transformations were regarded as the fundamental reality in nature.[51] Ostwald's theories were known in Paris, where in 1909 his *Die Energie* (1905) was published in translation and reviewed in *Mercure de France*.[52] Yet, after the conclusive demonstrations of molecular activity by Perrin, beginning in 1908, Ostwald quickly reversed himself and admitted the existence of discrete atomic units of matter.[53]

Duchamp would certainly have been aware of Ostwald's ideas, and some of those views, such as Ostwald's equation of humans and machines as transformers of energy, would surely have interested him. Such notions would have been especially relevant in the early stages of his project, when human-machine analogies were influential in his adoption of mechanical substitutes for human subjects.[54] Duchamp's repeated references to molecules, however, and his interest in electrons and radioactive particles confirm his alliance with those who advocated the existence of the atom. Moreover, in 1913, by which time Duchamp was elaborating the actual workings of the *Large Glass*, the atomic hypothesis had clearly won the day.

Beyond the large-scale energy transformations embodied in the technological power sources of the

Large Glass and Duchamp's play with friction in the context of mechanics, he responded to at least two important aspects of thermodynamics at the molecular scale of the kinetic theory of gases: changing states of matter and the theme of chance. The best-known change of state in the *Large Glass* is, of course, the liquefaction of the Illuminating Gas. Yet, as noted in the discussion of the Bride and meteorology, changing states of water, such as fog and snow, figure in other notes.[55] Whether the transformation be from steam to water to ice or from Illuminating Gas to a liquid or solid form of that gas, these are thermodynamic phases that involve heat and changes in molecular states from kinetic to potential energy or vice versa.[56]

Duchamp also found in the kinetic theory of gases one of his favorite themes, chance. As mentioned in relation to his interest in the issues of chance and the "liberty of indifference," Duchamp had stated that chance was an idea that "many people were thinking about at the time. . . ."[57] The molecular thermodynamics on which the kinetic theory of gases focused was one of the central scientific contexts for the investigation of chance in this period. As early as the 1850s, the seemingly random nature of collisions between molecules had necessitated the introduction of statistical mechanics and the calculus of probabilities as a means of dealing with thermodynamic relations at this scale.[58]

Lucien Poincaré described this development and provided a graphic description of the molecular realm of collision and chance in *La Physique moderne*:

It is impossible to mentally follow every one of the many individual molecules which compose even a very limited mass of gas. The path followed by this molecule may be every instant modified by the chance of running against another, or by a shock which may make it rebound in another direction.

The difficulty would be insoluble if chance had not laws of its own. It was Maxwell who first thought of introducing into the kinetic theory the calculus of probabilities. Willard Gibbs and Boltzmann later on developed this idea, and have founded a statistical method which does not, perhaps, give absolute certainty, but which is certainly most interesting and curious. Molecules are grouped in such a way that those belonging to the same group may be considered as having the same state of movement; then an examination is made of the number of molecules in each group, and what are the changes in this number from one moment to another. . . .

. . . There are, in this space [a cubic centimeter], some twenty thousand millions of molecules. Each of these must

receive in the space of a millimetre about ten thousand shocks, and be ten thousand times thrust out of its course.[59]

Poincaré concluded his discussion of the kinetic theory on a note of triumph, declaring that although there had been resistance to the theory "until the last few years, . . . all the recent discoveries of the conductivity of gases and of the new radiations came to procure for it a new and luxurious efflorescence."[60]

Henri Poincaré's chapter entitled "Chance" in *Science et méthode* of 1908 includes the kinetic theory of gases in a discussion of randomness and the laws of chance.[61] That analysis is particularly interesting because of the randomly distributed phenomena he includes: the paths of gas molecules, grains of powder suspended in liquid, raindrops in a shower caught by "a thousand little capricious air-currents," and the stars of the Milky Way, which he treats in a later chapter, "The Milky Way and the Theory of Gases."[62] Poincaré's references to "air-currents" and his comparison of the Milky Way to a "mass of gas" as well as to Crookes's radiant matter suggest yet more overlays of associations for elements of the Bride's realm.[63]

Yet in his chapter on chance, Poincaré emphasizes issues that relate not to the Bride but to the Bachelor Apparatus. One of the main examples he uses to illustrate random mixing is the shuffling of a deck of cards.[64] He then generalizes the phenomenon of shuffling to other activities, which were to prove important in the context of the physical chemistry of the Bachelor Apparatus: "What we have just seen applies not only to the mixing of cards, but to all *mixings,* to those of powders and liquids, and even to those of the molecules of gases in the kinetic theory of gases."[65] For Duchamp, the amateur chemist who had described the Bride's blossoming as a "mixture, physical compound of the 2 causes (bach. and imaginative desire) unanalyzable by logic," Poincaré's text provided a suggestive model for the operations of the Bachelor Apparatus at scales ranging from submicroscopic to macroscopic.[66]

In his discussion of chance, Poincaré demonstrated how a slight cause may produce a considerable effect that could be attributed to chance, citing the unstable equilibrium of a cone on its apex, which might fall as the result of the "least defect in symmetry."[67] Displacements from equilibrium were to be central not only to the balancing act of the Juggler/Handler of Gravity but also to the falls of the Mobile, whose "crashes" expressed the "liberty of indifference."[68] Just as Poincaré's discussion progressed seamlessly from falling cones to colliding molecules, Duchamp's explorations of chance effects in the Bachelor

Apparatus—embodied, for example, in the falls or crashes of the Mobile or the falling threads of the *3 Standard Stoppages* translated into the Capillary Tubes—may be the large-scale analogues to the chance collisions of molecules described by the kinetic theory of gases and reflected in Perrin's Brownian movement, as will be seen.

Duchamp associated the fall of the Mobile with free will and the Ass of Buridan as well as with the "liberty of indifference," which he connected specifically to the "oscillating density" of his falling weights, whether Benedictine Bottle(s) or a Hook (see chap. 5).[69] The theme of free will versus determinism had been prominent in nineteenth-century debates concerning the kinetic theory of gases and thermodynamics, in particular, whether the motions of molecules were determined or random. The roots of the debate went back to the ancient philosophers Lucretius and Epicurus, who theorized that the unexpected swerve of a falling atom signals the possibility of free will, a notion Jarry had incorporated in *Faustroll* by titling one of his chapters "Clinamen" (from Lucretius's *clinamen principiorum*).[70] With the development of Newtonian mechanics, however, the view that molecular motions are "in principle" determined was increasingly adopted.

This "Laplacean determinism," enunciated by the French astronomer and mathematician Pierre-Simon de Laplace in the early nineteenth century, argued that a superhuman intelligence aware of the position and velocity of every particle in the universe and all the forces acting upon it would experience a world in which "nothing would be uncertain and the future, as the past, would be present to its eyes."[71] Yet, with the subsequent rise of kinetic theory and the recognition of the randomized nature of molecular movements, the traditional significance of the determinist view was increasingly undermined.[72] If the motions of molecules could be treated only statistically and the observer could never know all of them in detail, what would it mean to say that they are determined? Ultimately, the development of quantum theory and Werner Heisenberg's formulation of the principle of indeterminacy in 1927 would make Laplace's model definitively untenable.[73]

Given the philosophical import attributed to the unexpected swervings of atoms or molecules and their association with arguments for free will, Duchamp's mention of this issue in one of his *Green Box* notes is significant. He speculates: *Try to find a way to distribute the 'swervings of molecules'? according to the form of each part (roundness, flatness. . . ."* This musing occurs in a note headed "Interior lighting," which considers a "phosphorescence" that might be produced by a particular molecular construction of matter, as discussed earlier.[74] Although in the pub-

lished translations of Duchamp's notes, the phrase *'écarts de molécules'* is rendered as "distance between molecules" instead of "swervings of molecules," one of the primary meanings of the term *écart* is "swerving" or "deviation." The latter appears in French translations of Lucretius's *De rerum natura* as well in subsequent discussions of molecular motion, such as Guillaume's introduction to molecules and atoms in his 1896 *Les Rayons X*.[75] Thus, "écarts de molécules," which Duchamp set in quotation marks, evokes the whole history of this issue—from Lucretius's falling atoms through Jarry's "Clinamen" and contemporary treatments of molecular activity.[76]

Here Duchamp fancies himself as a "sorter" of molecular events, akin to Maxwell's "Sorting Demon," a mythical being who could separate molecules into fast- and slow-moving types (i.e., hot and cold) and thereby re-introduce a certain order into a molecular system. The Demon, whose hypothetical activities at the molecular level had also caught the attention of Jarry in *Faustroll*, had been invented by Maxwell in the 1860s in his argument that the second law of thermodynamics was not absolute and had only a "statistical certainty."[77] Duchamp's sorting, by contrast, simply seeks to create a pattern of molecular color effects, an artificial phosphorescence suggestive of a radioactive glow.[78] As the distributor of the molecular swervings, Duchamp also casts himself playfully in the role of a God-like determiner of molecular paths—a role carried out with the "strictness of a Huguenot sort," an allusion, perhaps, to the determinism of Calvinist predestination. With its mix of freely willed "swerves" and playful, determinist "distribution," this note is particularly interesting as the site of Duchamp's oft-quoted remark (jotted in the margin) that the *Large Glass* was to embody a *"reality which would be possible by slightly distending* the laws of physics and chemistry."

Although the "Interior lighting" note represents a humorous variation on the themes of free will and determinism, in general Duchamp carried out a more direct assault on determinist causality—countering it with his ideas of "ironic causality," "subsidized symmetry," chance, and the "liberty of indifference."[79] Indeed, under the "Laws, principles, phenomena" of his Playful Physics Duchamp included not only "oscillating density," "stretching in the unit of length," and metals emancipated from gravity, but also "—Adage of spontaneity = The bach. grinds his choc. himself."[80] Although never as free as the Bride, the Bachelors in their mechanical realm are nonetheless given spontaneity and free will. If in human terms that spontaneity seems to be embodied only in the Chocolate Grinder's forlorn masturbation, Duchamp's elaborate experiments with falling objects and their liber-

ty of indifference affirm his general philosophical commitment to free will.

Duchamp's humorous list of "Laws, principles, phenomena" represents in part a mocking attack on determinism and, seemingly, on Laplace himself, who had initiated the scheme of inductive progression from phenomena to laws to principles.[81] Evidenced in his negative attitude toward French metrology, symbolized by his law of "stretching in the unit of length" and his creation of the *3 Standard Stoppages,* Duchamp's real critique of science was directed against tradition-bound, classical French scientific practice and its laws and principles. He was much more receptive to more recent phenomena in science, many of which were themselves challenging or necessitating revisions in these laws and principles.

In a lecture delivered in 1904 in St. Louis on the current state and future of mathematical physics, published in *La Revue des Idées* in November 1904 and as three chapters of *La Valeur de la science* in 1904, Henri Poincaré referred to a "general collapse of principles" at the scale of the infinitesimal in physics.[82] In the chapter entitled "The Crisis of Mathematical Physics" Poincaré addressed not only "the principle of relativity," a subtle harbinger of the revolution to come in physics (predating Einstein) but also important recent challenges to Mayer's principle and Carnot's principle (the first and second laws of thermodynamics). Poincaré believed that the threat to the principle of the conservation of energy came from radium, which possessed a seemingly inexhaustible supply of energy.[83] He located the challenge to Carnot's principle and the principle of entropy in the phenomenon of Brownian movement, with its apparently perpetual motion.[84] Both radioactivity and Brownian movement were to play a role in the lower half of the *Large Glass,* with Perrin's work on Brownian movement and his resultant proof of "molecular reality" being of prime importance. Duchamp's choice of these issues is characteristic: unlike the abstract physics of nascent relativity theory, which was generated by anomalies between mechanics and electrodynamics and attracted no popular attention in this period, radioactivity and, to a lesser degree, Brownian movement were of considerable popular interest and represented continuations of his earlier concerns.[85]

In the end, physicists would recognize that Brownian movement at the molecular scale, where friction is not a factor, need not be considered a major challenge to the second law of thermodynamics and that the energy in radium would indeed be exhausted over a long span of time. Nonetheless, these two issues, and the controversy they generated at the time, would have underscored the

sense of openness and possibility in contemporary science that so stimulated Duchamp, as it had Jarry. In the Bachelor Apparatus, in particular, Duchamp would both operate as antiscientist, controverting long-standing principles of science, and play the role of new scientist, hypothesizing about fantastic events in the infinitesimal world of molecules, atoms, and subatomic particles. From the beginning of the journey of the Illuminating Gas in the Malic Molds to its final splash onto the upper half of the *Large Glass,* Duchamp would elaborate a new, playful physical chemistry, which he described, appropriately, as a "mixture of events."[86]

The Liquefaction of Gases as a Model for the Journey of the Illuminating Gas

When Duchamp was selecting notes for inclusion in the *Green Box*, he chose seven detailed notes and sketches to chronicle the changing states of the Illuminating Gas as it passed from the Malic Molds through the Capillary Tubes and the Sieves.[87] In *A l'infinitif* he added only one additional drawing: a graphic image of the transformation of the Spangles of gas entering the Sieves as dashlike forms and exiting in spiraling, flowing forms drawn at the base of a note that begins, "Do not forget the painting of Dumouchel: Pharmacy—snow effect. . . ."[88] From these *Green Box* notes comes the familiar narrative of the "Progress (improvement) of the illuminating gas up to the planes of flow," in which the anthropomorphized Spangles are "dazed by [their] progressive turning" in the "labyrinth of the 3 directions" (i.e., the Sieves), "can no longer *retain their individuality*," and exit the Sieves as a "liquid elemental scattering," a "scattered suspension."[89] As suggested earlier, Duchamp seems to be gently mocking commentaries on mystical access to higher-dimensional consciousness, which centered on overcoming one's sense of gravity and of left-and-right orientation (see chap. 6).

Although the dominant mood of these notes is one of whimsical narrative—a "spangle derby," as Duchamp terms it in another of his allusions to popular entertainment—the activities in this section of the Bachelor Apparatus are nonetheless grounded in contemporary physics and physical chemistry.[90] After all, Duchamp introduced the term Playful Physics in these notes at the side of his first long note on the passage of the *gaz d'éclairage* through the Capillary Tubes:

to develop this relationship of one *length* to the *change of state* [*changement d'état*] of the body (illum. gas) submitted to this unit of length.

in the case of *stretching,* the unit of length is variable in relation to the *section* of the tube. Given the unit of length with an element. section the tubes with a double section will have a length twice (Playful Physics) the standard of the elemnt. sect. (this to give importance not to the unit of length but to the phenomenon of *stretching* the gas.)[91]

Here the references to change of state and to stretching the gas allude not only to the French metrology challenged by the *3 Standard Stoppages* (fig. 68) but also to the physics of changing states of matter: expanding the volume of a quantity of gas was a standard step in the cooling required for liquefaction. As we shall see, Duchamp's *Green Box* contains numerous allusions to aspects of the liquefaction and solidification of gases as discussed in scientific and popular literature in this period. However, in the notes he excluded from the *Green Box* and *A l'infinitif,* Duchamp, sounding like a physical chemist in his laboratory, designed a much more technical series of procedures.

Two illustrated notes (figs. 138, 139) set forth his more complex and overtly scientific scheme for the liquefaction of the Illuminating Gas.[92] The text of note 114 (fig. 138), which continues on the verso as well, presents a numbered series of elements connected by capillary and other tubes:

> *Triturators and liquefiers.*
> arrival of the illuminating gas
> *Triturators:* 1. *Large Receiver*—
> 2. *Distribution*: (Phenomenon
> of separation and differentiation
> by the form of the capillary tubes)
> 3. *Collectors* short tubes: coming together
> in 1 first semi collector.
> (snail form long tubes: coming together
> or lyre) in a second semi collector
> 4. *Mixture bottle*—

His diagram having concluded with the flow of the gas through the mixture bottle "toward liquefier," Duchamp continues with a sketch of the Sieves on the reverse of the note.[93] In this drawing the Sieves have not yet assumed their parasol-like shape and are represented simply as a series of screenlike partitions in a wide, curved tube, producing the "liquefaction chambers."[94] The last of the Sieves in this drawing is labeled "horizontal filter," above which a chimneylike "exhaust pipe" leads up to the right.[95] A list of the components of the liquefying mechanism accompanies the drawing:

Liquefier—
5. Sieves—
large gas inlet—
numerous sieve sheets
and with holes more and more close together,
and less and less large.
up to the
6. *Filter* triangular in aqueous metal.
Horizontal filter. *leading to* the churn (barrel-shaped
(Curved conical trunk form with the *horizontal* filter for a
small base.)
7. *exhaust pipe*
(before the filter, exhaust pipe for useless substances
having served only as a
vehicle for the gas—)[96]

Like its more fanciful counterpart, the "Butterfly Pump," the Churn (fig. 139), mentioned in the discussion of the filter in number 6 above, was one of the ways Duchamp envisioned creating the suction to draw (or even siphon) the Spangles through the Sieves.[97] Aside from the Churn, this drawing introduces other, specifically mechanical components of this early model of the liquefaction process: a "Gear wheel on *central shaft*" and "Multiplication" of the speed of the larger gear wheel on the smaller gear of the Churn, a "suction and pressure pump," and, at the right, a "Compressor" with "exhaust tubes of the thick liquid." Compression of the liquefied gas was the last stage of its transformation before its arrival at the Desire Dynamo, a process Duchamp clarified in another unpublished note, which begins by reiterating number 7 above and continues:

8—*Pump*—suction and pressure
bringing the erotic liquid
into the compression charged with giving it
a *cream-like* molecular cohesion—
9—Compression—cones in elastic metal
(resembling udders.)
*the dew of Eros passing drop by drop [*goutte à goutte*]
*the erotic liquid
which descends toward the hot chamber
onto the planes of slow flow, to
impregnate it
with the oxygen required for the
explosion. . . .
10—Planes of flow—of special forms.
Slopes[98]

He gave visual form to one aspect of the "Planes of flow" in a drawing (fig. 141).

Duchamp's list also included observations on the relative placement in depth of the major components, indicating that he was seriously considering a more elaborate scheme in the *Large Glass*: "*4th plane* Large Receiver (passing under the waterfall)/*3rd plane* capillary tubes/*2nd plane* triangul. filter/*1st plane* Churn."[99] Although he would ultimately simplify his liquefaction procedure and adopt the Oculist Witnesses as the final agent in the journey of the Illuminating Gas, the mechanisms described in these notes continued to interest him, because he included the note just quoted among those he considered gathering together in the late 1950s. His first legal-tablet list (fig. 187, no. 8) includes a cryptic reference to the note, "Compression—cones. . . . Sieves on each cone"; on the recopied list (fig. 188), he elaborates: "*Udders in* elastic *metal* which pass drop by drop the liquid which descends slowly toward the hot chamber in order to absorb the oxygen necessary for the explosion."[100]

Although ultimately eliminated from Duchamp's overall visual scheme of the *Large Glass*, drawings such as figure 139, with its "exhaust tubes of the thick liquid" flowing from a boxlike Compressor, and figure 141, with its related "Planes of slow flow of special forms" entering an equally boxlike "dynamo," provide important evidence concerning the evolution of his formal language. Specifically, these two drawings hold a clue to the way Duchamp incorporated at least the "hot chamber"/Desire Dynamo in his initial conception of the imagery of the *Large Glass*. A full-scale drawing of 1913, *Perspective Sketch for the Bachelor Machine*, which has been lost but is visible in photographs of Duchamp's New York studio in 1917 or 1918 (fig. 140), features a mysterious cubic shape in the area above and to the right of the Chocolate Grinder.[101] Such a cubic form, like a conflation of those in figures 139 and 141, seems to have served as a sign for the Desire Dynamo. As depicted in the *Perspective Sketch* (fig. 140), the boxlike form functions as the casing for the upper part of the Dynamo, whose interior workings he explored in a drawing he included in his late 1950s overview of the *Large Glass* (fig. 149).[102]

It is particularly interesting to reexamine Duchamp's 1913 perspective layout for the entire *Large Glass* (fig. 75) in view of both the lost *Perspective Sketch for the Bachelor Machine* (fig. 140) and earlier drawings (e.g., figs. 139, 141). The most obvious difference is the conversion of the tubular "Planes of slow flow" into the Planes/Slopes of Flow as spiraling Toboggan or Corkscrew (see also fig. 77) that produce a pool of liquid at their base.[103] Yet despite this change, close examination of the 1913 perspective layout reveals that the cubic Desire Dynamo (as configured in the *Perspective Sketch*)

is nonetheless present. In the manner of other schematic indications of components in the layout, the Dynamo is indicated only by the abbreviated sign of its top, a rectangle in perspective drawn above the rightmost extension of the back Horizontal Scissor.[104] In both the 1913 layout and the 1913 *Perspective Sketch for the Bachelor Machine* the position of the cubic Desire Dynamo points up its role, along with the Mobile, as a predecessor of the later Oculist Witnesses in translating events below to the upper realm of the Bride. The "hot chamber" / Desire Dynamo was, in fact, a crucial element in Duchamp's initial verbal and, apparently, visual conception of the *Large Glass* (see chap. 11).[105] It was the endpoint toward which his complex process of liquefaction was directed—the internal combustion engine in which the liquefied Illuminating Gas would explode and activate the Boxing Match's stripping of the Bride.

Whether in the anthropomorphized notes he chose to publish or in the more technical scheme set forth in his unpublished notes, the literature on liquefaction offered Duchamp a wealth of possibilities for transforming his "inert illuminating gas" into a semenlike "erotic liquid" of great "molecular cohesion."[106] A sampling of contemporary discussions of liquefaction establishes the currency of this subject in the prewar years as well as its pertinence for Duchamp. The December 1910 article in *La Nature* that reproduced Kamerlingh Onnes's 1908 laboratory installation (fig. 137) provided a thorough introduction to the liquefaction of air and helium, including numerous diagrams of liquefaction equipment, particularly apparatuses developed by Georges Claude.[107] In December 1911 *La Nature* devoted an article to Claude's large-scale equipment and procedures for producing liquid nitrogen and liquid oxygen from liquid air, inventions that had also made possible his industrial production of neon for lighting purposes.[108] According to the author of the earlier article, G. Bresch, these discoveries had far-reaching ramifications and were "destined soon to revolutionize lighting, metallurgy, chemical industries, hygiene, and agriculture," all subjects of interest to Duchamp.[109]

Such popular treatments of liquefaction were based on more technical coverage of the subject in scientific journals and books. The *Revue Génerale des Sciences Pures et Appliquées*, for instance, had reprinted Claude's December 1905 presentation before the Société Française de Physique on the liquefaction of air and its applications and had published his article on industrial oxygen in November 1909.[110] As noted earlier, Lucien Poincaré's *La Physique moderne* of 1906 included a section entitled "The Liquefaction of Gases, and the Properties of Bodies at Low Temperatures."[111] In addition to Claude, one of the central figures in Poincaré's discussion was the British chemist Sir James Dewar, who had developed the "Dewar flask," the prototype of the modern thermos bottle, in order to store liquefied gases at extremely low temperatures. Dewar, the primary British researcher in cryogenics, had presented a presidential address before the British Association for the Advancement of Science in 1902, "The History of Cold and Absolute Zero," which was published in the same year in the *Revue Scientifique*.[112] Dewar's work would have been of particular interest in France, in that Pierre Curie had traveled to London in 1903 to test the behavior of radium in Dewar's liquid air.[113] Jarry's awareness of Dewar, for example, is documented in Faustroll's reference in his first telepathic letter to Lord Kelvin to "a residual molecule several centimeters distant from the others in a good modern vacuum of Messrs. Tait and Dewar."[114]

The two articles in *La Nature* noted above provide a useful summary of major elements of the liquefaction process and offer numerous points of comparison with Duchamp's systems of liquefaction, in both imagery and language. Visually, figure 138 parallels both the photograph and schematic drawings of Kamerlingh Onnes's equipment, which consisted of a maze of tubes, including capillary tubes, connecting various vessels (among them "receivers"); a compressor; and what the *La Nature* article termed the "liquéfacteur," where the cooling and condensing of the helium occurred.[115] The majority of the other diagrams in this article relate to Claude's procedure, which had introduced the possibility of accomplishing external work by means of an expansion engine powered by the expansion (and resultant cooling) of the gas after compression, the *machine à détente* noted earlier in relation to Duchamp's "Transformateur à détente." As a result, there are numerous images of two connected gearwheels (like those in fig. 139), which translate the rotary motion produced by the piston of the expansion engine. Claude's equipment also incorporated pumps as well as *tuyaux*, or pipes, as in Duchamp's "exhaust pipe" (*tuyau d'échappement*), which appears as number 7 in his list.[116] Finally, reference to elements of Claude's machine as "organs" capable of "autolubrication" by means of the liquid air produced would have offered Duchamp yet another sexually suggestive human-machine analogy for his Chocolate Grinder/Bachelor who "grinds his chocolate himself."[117]

Central to the liquefaction procedure was the Joule-Thomson or Joule-Kelvin effect, which had been established by the "porous plug" experiments of James Joule and Lord Kelvin (then William Thomson).[118] Joule and Kelvin had found that compressed gas cooled substantially as it passed through a small orifice into a larger con-

tainer. The procedures of the German Carl von Linde (whose liquefaction process produced no external work) and Claude (with external work) relied on successive expansions of compressed gas as the primary means of cooling it to its liquid state.[119] Duchamp's location of his "Liquéfacteur" in the area of the Sieves, which he described as "a *reversed image* of *porosity*," suggests his knowledge of the cooling effect of passing a gas through porous plugs and allowing it to expand in a larger chamber.[120] His "semi-collectors" (fig. 138) have much larger diameters than the Capillary Tubes that enter them. And, as noted earlier, Duchamp's connection of the "*change of state* of the body (illum. gas)" to "stretching in the unit of length" in the Capillary Tubes would seem to be another playful variation on this thermodynamic theme of cooling and condensation produced by expansion.[121]

Although Duchamp's original liquefaction procedure replicates certain aspects of the actual physics of liquefaction, the numerous anomalies in his system demonstrate his creative and playful admixture of other phenomena from chemistry and physics. The "Triturators" figuring in his first schemes refer to a procedure that cannot be applied to a gas: as noted earlier, trituration involves pulverizing a solid to enhance its solution in a liquid. Similarly, while Duchamp's "Distribution (phenomenon of separation and differentiation)" evokes the kind of fractional distillation of a gas by which the components of air were successively removed (making possible Ramsay's discovery of neon and Claude's subsequent production of it), in practice that kind of differentiation was achieved in the Sieves by "holes more and more close together and less large."[122] "Use screening," added Duchamp in another unpublished note;[123] as another laboratory procedure involving solids (like that of trituration), sieving or screening would have allowed for the collection of successively smaller grains of a solid material not a gas.

If a solid form of the Illuminating Gas was hinted at in Duchamp's use of trituration and screening, solidified gas Spangles soon became a central aspect of the journey of the "inert illuminating gas," inserted between its gaseous and liquid states. This change on Duchamp's part altered the normal progression from gas to liquid to solid as colder and colder temperatures are reached; it also meant that the "stretching" of the gas in the Capillary Tubes produced not the liquefaction expected but a solidification of the gas that required even lower temperatures.[124] As playfully as Duchamp employed solidification in the Spangles, however, his interest in the subject was a natural extension of contemporary work in low-temperature physics and physical chemistry. Ramsay had solidified as well as liquefied neon and other rare gases in the late 1890s, as

had Dewar, working with hydrogren; having liquefied helium, Kamerlingh Onnes was still seeking in the prewar years to solidify it, a feat achieved only in the 1920s.[125]

Like liquefaction, solidification produced unusual effects in elements subjected to these new levels of cold, effects that would have stimulated the imaginations of Duchamp and the public alike. In his presidential lecture, for example, Dewar described the ability of the vapor rising from liquid hydrogen to solidify the air above the vessel in which it was stored, creating "a miniature snowstorm of solid air . . . [which] accumulates as a white snow at the bottom of the liquid hydrogen."[126] Duchamp's discussion of the Spangles as "frosty gas" and "Vapor of inertia, snow" would seem to reflect such phenomena, including the ability of the liquid hydrogen vapor to transform highly mobile air molecules into inertia-bound "molecules in repose," the phrase used in *La Nature* to describe molecules at absolute zero.[127] Moreover, since liquid hydrogen was also the lightest liquid known to exist, as Dewar pointed out, Duchamp's description of the Spangles as "lighter than air" and "tend[ing] to rise" as they leave the Capillary Tubes may be associated with hydrogen in its snow-producing liquid form or its frothy solid form.[128]

At least four other aspects of the Illuminating Gas also seem to relate to the unusual properties of matter discovered by researchers working with intense cold: fragility, cohesion, magnetism, and phosphorescence. The Spangles themselves were the result of the solidified gas having broken "through fragility" as it left the Capillary Tubes, akin to the effects that low temperatures have on objects such as rubber balls, which shatter after being plunged into liquid air.[129] Some substances become brittle at extreme low temperatures, whereas others exhibit increased cohesion, suggestive of Duchamp's description of his "erotic liquid" as a "cream-like molecular cohesion."[130] In a posthumously published note on the action of the Splash of Illuminating Gas on the Boxing Match, Duchamp speculates on a "principle of *anti*? gravity which changes from the ascensional force of the gas to the state of magnetization [of the Combat Marble and Rams] normally directed toward a center of distraction."[131] Lucien Poincaré and Dewar both reported experiments in which liquefied oxygen acquired magnetic properties at the moment of liquefaction."[132] Finally, according to Poincaré, at extremely low temperatures "phosphorescence becomes more intense, and most bodies of complex structure—milk, eggs, feathers, cotton, and flowers—become phosphorescent."[133] Thus, Duchamp's attribution of phosphorescence to the *milk* chocolate associated with the Illuminating Gas in the Malic Molds might also have been based on its imagined behavior at low temperature as well as on the chocolate's

"emanating," "luminous molecules," which suggest radioactivity.[134]

Duchamp's apparent linkage of emanating chocolate and "inert illuminating gas" at extreme low temperatures may well reflect the connection between radioactivity and cryogenics research in this period. Pierre Curie had teamed with Dewar to investigate the phosphorescence of radioactive substances at low temperatures; similarly, Jean and Henri Becquerel, the discoverer of radioactivity, published with Kamerlingh Onnes a paper entitled "On Phosphorescence at Very Low Temperatures" in 1909.[135] Neon also served as such a link. Ramsay, who was subsequently associated with research on radioactivity, had originally reported that neon, like helium, was a product of radioactive decay.[136] Neon was also closely associated with the low-temperature liquefaction methods of Claude, who could now produce it on a large scale. The materials these experimenters used may have been beyond Duchamp's reach, but chocolate, a domestic substance, allowed him to play the role of physical chemist, speculating on its molecular composition and changes of state. In fact, in the industrial manufacture of chocolate, which involved a complex chemistry of its own, molds were often cooled by the expanding of a compressed gas.[137]

Just as the Chocolate Grinder could function simultaneously as a domestic object and telegraphy wave detector, the Malic Molds could be both impersonal dies for the molding of gas, as if chocolate in the "Die of Eros,"[138] and Crookes- or Geissler-like tubes full of illuminating neon gas. Rather than the overtly chemical vessels represented by the "Large Receiver" and the other "collectors" and "semi-collectors" of Duchamp's original laboratory scheme, however, the more anthropomorphic Malic Molds now took their place in the depth of the "4th plane" in the vicinity of the "waterfall."[139] With the molds humanized by their individual identities within a "Cemetery of Uniforms and Liveries" and united by a "plane of sex cutting them at a pnt. of sex," the Illuminating Gas in the form of Spangles commenced a somewhat humorous quest for the four-dimensional Bride above. Suffering the "Torture of Tantalus," however, the Spangles were destined never to "pass beyond the Mask."[140]

Yet even in the more anthropomorphic narrative in the *Green Box* notes, Duchamp's debt to the physical chemistry of liquefaction is still apparent. Beyond the issues noted above, a comparison of the contents of room 27 at the Musée des Arts et Métiers with the notes further confirms Duchamp's abiding interest in the thermodynamics of liquefaction and the behavior of gases, liquids, and solids.[141] Subjects addressed in the Arts et Métiers displays and their Duchampian counterparts include the

"pressure and flow of liquids and gases" (Duchamp's "plans d'écoulement," or Planes/Slopes of Flow[142]); *"compressibility and elasticity"* (8—"Pump—... bringing the erotic liquid into the compression charged with giving it a *cream-like* molecular cohesion—; 9—Compression—cones in elastic metal [resembling udders][143]); *"capillarity"* (Duchamp's Capillary Tubes, in which gases and solids instead of the usual liquids exhibit the capillarity caused by the molecular forces of cohesion and adhesion[144]); and, finally, *"apparatus for measuring the density and pressure of vapors and apparatus of Cailletet for the liquefaction of gas,"* both of which stand as more general parallels to the liquefaction mechanism of what Duchamp, significantly, termed his "Bachelor Apparatus."[145]

Liquefaction, with its ties to thermodynamics as well as kinetic-molecular theory, was a central theme for Duchamp as he developed the saga of the Illuminating Gas. Given the activities of Claude, in particular, the liquefaction of gases had a currency in pre–World War I Paris beyond its theoretical import in physics and physical chemistry. Like the engineer Claude, the physical chemist Jean Perrin offered Duchamp a high-profile local model for inventing the allusions to molecular activity in the Bachelor Apparatus. Compared to the general parallels found in the literature on liquefaction, Perrin's writings present a striking "concordance" (one of Perrin's favorite terms)[146] not only with Duchamp's specific notes on the Illuminating Gas but also with his conception of the *Large Glass* as a whole.

Molecular and Atomic Reality in the *Large Glass*: The Work of Jean Perrin

From the beginning of his career Jean Perrin's goal in scientific research was to establish experimentally the reality of the invisible atom and the discontinuous structure of matter.[147] He had been introduced to the kinetic theory of gases and the atomic-molecular hypothesis by his teacher, Marcel Brillouin, one of the strongest French partisans of these theories and an enthusiastic observer of the contemporary work of British scientists such as Crookes and J. J. Thomson. Although Perrin would become best known for his contributions to physical chemistry, his early research dealt with cathode rays, X-rays, and the structure of the atom, for which he had posited a planetary model as early as 1901.[148] Similarly, Duchamp's introduction to the physics of the infinitesimal occurred in the context of these subjects—X-rays, speeding electrons, and radioactive particles—which were explored by Perrin and his friends the Curies, among others.

Perrin turned to physical chemistry after the Sorbonne gave him authorization in 1898 to teach the first course in

the subject; he subsequently held the university's first chair in physical chemistry from 1910 to 1940. For his new course, Perrin wrote and published in 1903 a physical chemistry textbook, in which he dealt with thermodynamics from his position as an advocate of kinetic-molecular theory.[149] His experimental work at this time focused on the properties of colloids (suspensions in which minute particles of one material are dispersed throughout another material). During the period 1908–11 Perrin devoted himself to the question of the Brownian movement exhibited by colloid granules, research that was soon celebrated as providing the "*ocular* confirmation of the picture which the kinetic theory provides us of the world of molecules."[150] Perrin's dedication to proving the existence of the invisible, particulate structure of matter assured his continued concern with research on the physics of the atom and its components, and, as noted earlier, his *Les Atomes* (1913) incorporated the recent work of Max Planck and Rutherford, among others. For Perrin, and seemingly for Duchamp as well, physical chemistry and atomic physics were complementary routes for investigating the invisible.

Brownian movement was named after the Scottish physician Robert Brown, who in 1827 described the frenetic motion of granules of pollen in a suspension. Although Brown had suggested that the motion was somehow generated by the particles themselves, subsequent debate on its cause centered on issues such as electrical influences or currents in the liquid.[151] By the later 1870s Brownian movement was being discussed in terms of the kinetic theory of gases and thermodynamics as well as the cathode-ray experiments of Crookes, the "rays" (actually electrons) having initially been described as ionized gas molecules "bombarding" a target.[152] Both William Ramsay and the primary French investigator of Brownian movement before Perrin, Léon Gouy, argued that Brownian movement provided visible evidence of the internal molecular motions of the liquid in which the granules were suspended.[153] Poincaré had referred to Gouy's research in *La Science et l'hypothèse,* when he noted that Brownian movement, with its suggestion of perpetual motion, might contradict the second law of thermodynamics: "We see under our eyes now motion transformed into heat by friction, now inversely heat changed into motion, and that without loss since the movement lasts forever."[154]

In "De la relativité de la connaissance humaines," Crookes had mentioned Brownian movement among the forces of the "invisible world of the infinitely petite" that might be encountered by a homunculus on a cabbage leaf (Jarry's model for chap. 9 of *Faustroll*).[155] Yet despite such references by Poincaré and Crookes, Brownian

movement never attracted the kind of intense popular interest that X-rays or radioactivity had generated. Nonetheless, Perrin attempted to make his discoveries accessible both within and outside the scientific community, giving numerous lectures and publishing twenty articles between 1908 and 1912 as well as *Les Atomes* in 1913. Perrin argued his case for the particulate nature of matter and the reality of molecules and atoms in non-scientific magazines such as the *Revue du Mois* and the *Revue Scientifique* as well as in more specialized scientific journals. His successes were also chronicled in periodicals such as *La Nature,* which in December 1911 published "Les Preuves de la réalité moléculaire," a summary of a recent Perrin lecture before the Société Française de Physique.[156] In May 1913, soon after its publication, *Les Atomes* was reviewed favorably in *Mercure de France,* and by the end of 1914, it was in its fifth edition.[157]

Perrin would also have attracted public attention as an early critic of the highly popular Gustave Le Bon. In a blistering review of Le Bon's *L'Evolution des forces,* published in the *Revue du Mois* in 1907, Perrin criticized Le Bon's claims of priority over the Curies in research on radioactivity and denounced his "unjustified pretensions, confused language, grand pronouncements without the shadow of a proof, and disconcerting mistakes."[158] Responding the next month to Le Bon's answer to his review, Perrin described Le Bon's ideas on black light as "an extraordinarily confused mélange both of errors and accurate results."[159] Writing for *Mercure de France* and *La Revue des Idées,* Georges Matisse was less than sympathetic to Perrin, however. Even in 1913, when *Les Atomes* was earning almost universal praise, Matisse, an enthusiast of Ostwald's Energetics, still resisted Perrin's claim of having proven the validity of the atomic hypothesis.[160] For Duchamp to have followed Perrin into the realm of molecular reality and a discontinuous model of the structure of matter would have been one more means of defining himself outside the realm of Cubism, where the ideas of Le Bon and his colleague Bergson continued to dominate.

A sampling of two of Perrin's earlier publications provides a concise introduction to his research and offers a surprising number of parallels to Duchamp's notes. In particular, Perrin's "La Réalité des molécules," a March 1911 lecture delivered before the Société des Amis de l'Université de Paris and published in the *Revue Scientifique* of December 1911, introduces a lay audience to material he had presented two years earlier to the scientific community as "Mouvement brownien et réalité moléculaire" in the *Annales de Chimie et de Physique.*[161] That landmark text of 1909 was widely disseminated,

having been translated by Rutherford's former collaborator, Frederick Soddy, and published separately in London in 1910. Underlying Perrin's body of work on Brownian movement was his sense that an analogy existed between the activity of gas molecules and the behavior of particles in a colloid suspension. After reminding his audience at the Université de Paris that the laws of the kinetic theory of gases are applicable to molecules of all sizes, large and small, he queried them: "Is it unreasonable to think that the laws of perfect gases also apply to emulsions made of visible grains"?[162] Perrin's experimental work answered his question in the affirmative, proving that Brownian movement was the result of continuous buffeting of the visible granules suspended in liquid by blows, or "chocs moléculaires."[163] Brownian movement was, therefore, a kind of Peircian index of invisible molecular activity.

One of the primary materials Perrin used to produce his colloid suspension was the resin gamboge, which he describes as creating a "beautiful yellow liquid."[164] Perrin's research advanced beyond Gouy's when he succeeded in obtaining colloid granules of absolutely uniform size; this eliminated behavior based on differences in size and produced granules comparable to the uniform molecules of a particular substance.[165] He achieved this uniformity by means of "fractional centrifuging," by which larger grains are successively "sédimentées," or deposited at the bottom of a spinning vessel.[166] Given the filtering action of Duchamp's Sieves ("with holes more and more close together"),[167] Perrin's terminology here, as well as his subsequent reference to varying the viscosity of the liquid by the addition of glycerine, seems to be echoed in the artist's second long note on the Illuminating Gas: "sediment of the inert illuminating gas in a dense liquid preserving the exterior qualities of the dissolved spangles—putting up a front (before this Ventilator) by exaggerating their cohesion.—by turning, the ventilator forces the gas to attach itself at ab, cd, ef. etc. in a condition resembling glycerine mixed with water." This is the same note in which the terms "scattered suspension" (suspension éparpillée) and "liquid elemental scattering" occur, further suggesting the relevance of colloidal suspensions as a model for Duchamp.[168] Given Perrin's discussion of the tendency of molecules to "scatter" (éparpille) (see paragraph below), his work offered a parallel, in the molecular realm, to Rutherford's studies of the "scattering" of subatomic particles.

During Perrin's lecture the audience could actually observe Brownian movement by means of a film made through a microscope by his fellow researcher, Victor Henri, and the Pathé film company.[169] Perrin described the random motions of the particles in the film and in his own observations of uniform granules of gamboge in his "beautiful yellow liquid" as "profoundly irregular" and "eternal and spontaneous."[170] One of Perrin's central proofs of the parallel between molecular activity and Brownian movement was based on the "distribution of equilibrium" of a liquid suspension in a "vertical column."[171] He was able to study a miniature version of such a "column" with a specially created glass slide arrangement that sealed a drop of emulsion within it; the slide could then be mounted vertically in a horizontally oriented microscope. After shaking the drop in the slide to produce uniform distribution, Perrin could observe its progressive rarefaction, which replicated the known behavior of a vertical column of gas as equilibrium was established between the molecules' weight, "which makes them fall, and their agitation which scatters them unceasingly."[172] Photographic cross sections taken at descending levels within a vertical column of liquid (fig. 142) graphically illustrate the progressive settling of the granules that fall.[173]

Given Perrin's vivid image of his shaking his microscopic realm of particles suspended in yellow liquid, Duchamp might have imagined himself to be the physical chemist Perrin, working at a much larger scale, when he noted of his "Flat container. in glass" containing liquids as well as "pieces of wood [and] of iron," "Shake the container and look through it."[174] Moreover, Duchamp's subtitling of the Large Glass as "a world in yellow"[175] also suggests that, in addition to the yellow-ochre orientation of his palette in the painted areas, the chance effects explored therein make it a macroscopic reflection of Perrin's infinitesimal world of random Brownian movement. Finally, in this regard, Perrin's "colonne verticale," or vertical column, could be the linguistic stimulus for Duchamp's Horizontal Column or Scissors suspended above the Chocolate Grinder, which might then be seen as the playful, chemistry-derived counterpart to the Bride's organic "colonne vertébrale," or spinal column.[176]

For Duchamp, Perrin's work on Brownian movement would have given the kinetic theory of gases, with its emphasis on the laws of chance, an immediacy lacking in more theoretical treatments of the subject. Perrin established what Poincaré had predicted in his chapter on chance in Science et méthode, when he noted that Gouy's study of Brownian movement under the microscope was "on the point of showing us something analogous" to the "infinite variety which...hides under the uniform appearance of a gas."[177] Like Poincaré, Perrin mentioned "air currents" in his discussion of random motion, and, as noted earlier, the fluttering of the Air Current Pistons stands, along with the 3 Standard Stoppages/Capillary Tubes, as a manifestation of chance in the Large Glass.[178]

Duchamp's most elaborate experiments with chance, however, were carried out in relation to the Mobile, whose falls from its resting place on the Horizontal Column were to splash the liquefied gas (fig. 148). The splashing of the liquefied Spangles is thus doubly tied to Perrin and Brownian movement—both through its identity as a liquid "scattered suspension" and through the chance associated with the fall of the Mobile that splashes it.[179]

The destinations of the Splashes—some would activate the Boxing Match, others would be transformed into the Nine Shots striking the upper half of the *Large Glass*—further augment the association of the solidified or liquefied Illuminating Gas with molecules and their granular counterparts in Brownian movement. The Boxing Match, activated either by explosions in the Desire Dynamo or directly by the Splash, is itself the site of continual blows or "chocs" as the Combat Marble rises and falls in a series of "attack[s]."[180] The ballistic character of the Boxing Match is amplified in the upper half of the *Glass* as the Splash becomes identified as "shots" approaching a target. Although molecules of a gas travel much more slowly than do electrons (500 meters a second, for example, compared to the velocity of an electron in a cathode-ray tube, 160,000 kilometers a second), they, like electrons and radioactive particles, had long been referred to in terms of "bombardment" and the "chocs" produced when they collide.[181] That analogy was pervasive in Perrin's 1909 text; in discussing early determinations of Avogadro's number (i.e., the number of molecules in a cubic centimeter of gas), for example, he explains that "molecules in the liquid state cannot be more closely packed than bullets are in a pile of bullets."[182] The ballistic character of molecules is made even more specific in Perrin's presentation of the recent work of Albert Einstein on Brownian movement, which had centered on the calculation of molecular "displacements" resulting from collisions. According to Perrin, if Brownian movement were indeed a register of random molecular motion, the measures of the displacements charted from the center of the target "should distribute themselves around this origin as bullets fired at a target distribute themselves around a bull's-eye" (fig. 143).[183]

Although Picabia would simply personify woman as a target in his 1915 *Voilà elle* (fig. 109), Duchamp in the *Large Glass* developed a more complex program involving target shooting, which would seem to be a response to Perrin's work.[184] In his discussion of the Nine Shots, Duchamp, like Perrin, made the chance results of firing at a target and the resultant displacement central themes. A drawing in *A l'infinitif* illustrates the Splash as it passes through the "Weight with Holes" and into the upper realm of the glass, where, as if "fired from a cannon," it has a "trajectory analogous to that of a bullet."[185] The *Green Box* (fig. 144) illustrates the target that is the goal of the Splash/Shots in the same note that discusses the measure of distance or displacement by which the three-dimensional shots (with only "ordinary skill") are "demultiplied" from the ideal, single four-dimensional point that is their goal.[186] Unlike Duchamp, however, whose target shooting involved a translation from three to four dimensions, Perrin was dealing with two-dimensional mapping. Nonetheless, he had discussed the inaccuracy necessarily introduced as his assistant M. Chaudesaigues, observing the granules of gamboge through a camera lucida, dotted their positions every half minute: "Each time a granule is dotted, a small error is really made, analogous to that in target-shooting, which obeys the laws of chance and has the same effect on the readings as if a second Brownian movement were superimposed upon that which it is desired to observe."[187] Thus, Perrin's image, too, involved another kind of displacement, produced by "ordinary skill" as opposed to superhuman or, in Duchamp's case, four-dimensional precision. In reality, of course, Duchamp's procedure was carried out entirely in three-dimensional space, as he shot his paint-dipped matchsticks from a toy cannon onto the upper panel in one of the last of his chance-oriented experiments for the *Glass*.

For Perrin the agreement between Einstein's theoretical calculations for molecular displacements and his own experimental results was central to the proof of his theory of Brownian movement as molecular agitation.[188] From these and other Brownian movement observations, including the distribution of equilibrium in a vertical column of liquid suspension, he was able to calculate values of Avogadro's number, N, that offered what he termed a "miracle of concordance" with other recent scientific calculations of N based on quite different phenomena.[189] These additional scientific studies included Planck's work on quanta and black-body radiation, measurements of the electric charge of atoms and ions (based on the work of J. J. Thomson), and Rutherford's research on radioactivity and, particularly, bombarding alpha particles.[190] In *Les Atomes* Perrin provided extended discussions of these recent developments and surveyed the methods of registering the activities of "atomic projectiles," such as Crookes's study of "scintillations" in the spinthariscope and Rutherford's and Geiger's method of counting by means of an electrometer needle (the precursor of the Geiger counter).[191] To the 1914 edition of *Les Atomes* Perrin was able to add examples of C. T. R. Wilson's "instantaneous photographs" of the paths of ionizing particles (fig. 146).

References to "concordance" and "miracle of concordance" appear throughout Perrin's writings as well as in secondary accounts of his work and strongly suggest an association with Duchamp's talk of the "signe de la concordance" in his "Preface" and "Notice" notes commencing "Given..." (the second of which is printed in full at the beginning of chap. 7).[192] As Duchamp writes in the "Preface" note, the "sign of the accordance" (*signe de la concordance*) is to be sought between "the instantaneous state of Rest" (*Repos instantané*) "capable of all the *innumerable* eccentricities," and "a *choice of Possibilities* authorized by these laws and also *determining them*."[193] Along with the probable connection of Duchamp's "extra-rapid exposure" to the "instantaneous photography" of Worthington and Wilson (as well as to Perrin, who used a far slower exposure he nonetheless termed "instantaneous" in certain of his vertical column experiments [fig. 142]), his notion of an "instantaneous Rest" or repose takes on new significance in relation to the work of Perrin.[194] In his 1911 article in the *Revue Scientifique,* Perrin had stated in reference to a fluid in seeming equilibrium, "This apparent repose [*repos*] is only an illusion, due to the imperfection of our senses, and corresponds in reality to a permanent system of violent agitation."[195] Only some type of moderately fast instantaneous photograph of Brownian movement could bring the eternally moving granules into repose, temporarily halting the continual blows from colliding molecules.

In light of Perrin's preoccupation with "laws," such as Avogadro's and those of the kinetic theory of gases, his writings, even more than Rutherford's studies of the scattering of radioactive particles (see chap. 7), would seem to have been a prime model for Duchamp. Perrin's approach, which focused on molecular collisions as predicted statistically by the kinetic theory of gases, finds a parallel in Duchamp's talk in his "Notice," the second version of his "Given" note, of an "extra rapid exposition (= allegorical appearance/Reproduction) of several collisions/assaults seeming strictly to succeed each other *according to certain laws*."[196] And just as Duchamp presents the relation between the "extra rapid exposition" and the "choice of the possibilities" as a ratio a/b, Perrin's scientific writing, like Rutherford's, is full of algebraic expressions for numerical values, such as Avogadro's number and a variety of other scientific constants, such as the ratio e/m (the ratio of charge to mass of an electron).[197]

In the end, Duchamp chose not to try to capture instantaneity as he had done in his paintings of the "Swift Nudes" series or as Wilson's or Worthington's instantaneous photographs had done so dramatically (figs. 145–47). He acknowledged this difficulty in an unpublished note of 1913 relating to his "Preface" and "Notice," which begins, "Difficult to: describe a Rest in neither technical nor poetic terms": "In that the picture is incapable (despite all the well-intentioned Idealism of man's visual works, all the overwhelming yearning toward he knows not what; consequences of anthropocentrism) of producing a cinematic state (real or ideal), language can explain several stages of this rest not descriptively."[198] If Duchamp in 1913 set out to describe his "Rest" with the "precision" and the "transparent language" he discusses in the remainder of this note, he also found a means to embody the "cinematic" events of the molecular and subatomic worlds explored by Perrin and Rutherford by means of analogous occurrences in a "world in yellow" at visible scale. Thus, the Spangles of Illuminating Gas may well be the counterparts of Brownian movement particles in a "scattered suspension" (sieved by Duchamp or centrifuged by Perrin), whose random collisions with molecules are enacted in elements such as the chance-oriented crash of the Mobile or the blows of the Boxing Match. The final collision, that of the ballistic Splash/Shots (with their Perrin/Einstein-like displacements) and the upper half of the *Glass*, gives tangible form both to the collisions of the submicroscopic realm of atoms and molecules and to the necessary "collision" between the impossible striving of the three-dimensional Bachelors and their unreachable goal of the four-dimensional Bride.

Neither high-speed electrons nor radioactive particles appear directly anywhere in the "instantaneous Repose" of the *Large Glass*. Instead, the speeding projectiles of *The King and Queen Surrounded by Swift Nudes* and related works (pl. 2, figs. 21–24) are now hidden within the Malic Molds in their guise as Crookes tubes or Geissler tubes, filled with an "inert illuminating gas" such as neon. There the molecules of gas would be "excited" by collisions with a stream of electrons or by the passage of a Hertzian wave, itself generated by the jostling, "colliding" oscillation of the electrons producing a spark discharge (pl. 4, fig. 97). Duchamp's Water Mill Wheel might also stand as another laboratory-scale embodiment of subatomic events, since it may have been modeled, in part, on Crookes's mill wheel (figs. 151, 152), which had served as his primary means of demonstrating bombardment by cathode rays or electrons (see chap. 11).[199] Once again, Duchamp's subtle approach contrasts with that of Picabia, who based his 1917 painting *Music Is Like Painting* (Private Collection, Paris) directly on a diagram of the divergent paths of alpha and beta particles and gamma rays in a magnetic field, a discovery dating from the turn of the century.[200]

The result of the collisions of electrons or radioactive particles with atoms or molecules is the production of

ions. During this period it was increasingly being recognized that "ionization by impact" caused the luminescence of the gas in Crookes tubes and Geissler tubes.[201] Ionization was, in fact, a kind of "electrical stripping," to use Duchamp's multivalent phrase, in which electrons were knocked free from an atom or molecule.[202] Wilson's cloud-chamber photographs, included in the 1914 edition of Perrin's *Les Atomes* and quite possibly known to Duchamp from other sources as well, provided the first visual record of the process of ionization by X-rays and various radioactive particles. Like Duchamp's reference in the second version of his "Given" note to the collisions occurring "in the dark," Wilson's photographs, based on Worthington's technique, were taken in a darkened chamber illuminated for mere millionths of a second by the flash of a spark.[203] Compared to Perrin's photographs, which were simply snapshot alternatives to the manual counting of particles through a microscope and which required intense, continuous light, Wilson's images were momentary revelations of the invisible. Previously, photographs made by X-ray had been able to "strip" a subject, but these new photographic images were of X-rays or particles stripping atoms or molecules themselves.

Three of Wilson's photographs (including fig. 146), appear in Perrin's chapter entitled "Genesis and Destruction of Atoms," in which he recounts Wilson's procedure as follows:

A minute radioactive speck, placed at the end of a fine wire, is introduced into a closed space saturated with water vapor. A sudden expansion increases the volume and produces supersaturation by cooling. At very nearly the same instant a spark is produced and lights up the enclosure. In the form of white rectilinear streaks starting from the active granule, rows of droplets [*gouttelettes*] can be seen (and photographed) along the paths followed by the few particles emitted after the expansion and before the illumination of the vessel.

Closer examination, however, shows that the trajectories are not rigorously straight, but bend noticeably during the last few millimetres of their path, and even show sharp angles. . . . Each time the atomic projectile passes through an atom it undergoes deviation, very slight, but nevertheless not absolutely negligible. . . . Finally, in very exceptional cases (owing to the extreme smallness of the atomic nuclei) it happens that the nucleus into which almost all the mass of the projectile is condensed strikes the nucleus of another atom; a considerable deviation is then produced.[204]

Here Perrin was describing "compound scattering" and "single scattering," the types of collisions Rutherford had

announced in his May 1911 article in *Philosophical Magazine* and which Wilson had first illustrated in his June 1912 Royal Society lecture published in the *Proceedings* in December 1912 (fig. 145).

Much about the British scientist Wilson would have interested Duchamp, even after he had moved beyond his earlier goal of painting the tracks of speeding electrons or subatomic particles. Wilson, whose background was in meteorology, had originally created the cloud chamber in order to reproduce in the laboratory the formation of clouds; his preoccupation with condensation and dew prefigures Duchamp's concern with meteorology and the thermodynamics of changing states of matter.[205] Once Wilson's apparatus was being used by J. J. Thomson and, later, Rutherford, it became a major new *appareil enregistreur* for studying ionization by X-rays and, ultimately, for tracking invisible subatomic particles. In Lucien Poincaré's *La Physique moderne,* Wilson and Thomson are cited repeatedly in a section entitled "The Condensation of Water-Vapour by Ions."[206] When Wilson adopted A. M. Worthington's technique of electric-spark photography in 1909, he created a new model of photography, one of Duchamp's favorite media, as a tool of atomic science. Moreover, Wilson's reliance on electric sparks was a natural link to Duchamp's concern with electricity and electromagnetism, most notably the sparks issuing from the Bride's "emanating ball."[207]

In the work of both Wilson and his "instantaneous photography" mentor, Worthington, drops or droplets were central. For Wilson, droplets or "gouttelettes visibles," as Perrin described them, registered the invisible paths of subatomic particles.[208] Worthington's photographic experiments had focused on recording the splashes produced by falling drops alone or by the fall of a drop or other spherical object into pools of various liquids (fig. 147). Duchamp's inventive wordplay on the theme of *goût/gouttes*, which was given physical form in the *Bottle Rack* (*égouttoir*; fig. 71) of 1914, had already produced a variety of falling drops and splashes in the scenario of the *Large Glass*. These include the drops noted earlier in the present chapter as well as their subsequent permutations: the "fall of the drops after compression" and the "erotic liquid" that passes "drop by drop . . . onto the planes of slow flow," followed by his ultimate development of a "Sculpture of Drops" (*Sculpture de gouttes*) formed by the splash of the Mobile, with its "mirrorical drops" (*gouttes miroiriques*) that would be "dazzled" optically into the upper half of the *Glass*.[209]

Whether or not Duchamp's ubiquitous drops represent a further reflection of Wilson's work with the cloud chamber, he must surely have been delighted to find this theme

in the latest research on the atom. The relevance of Worthington to the splashing of drops in the *Large Glass*, on the other hand, seems indisputable.[210] Worthington's pioneering photographs were first presented in an 1894 Royal Institution lecture entitled "The Splash of a Drop" and were widely publicized in his 1908 *A Study of Splashes*.[211] Typical of his imagery is what he termed a "sheath" splash (fig. 147), produced by a smooth spherical object not unlike Duchamp's Mobile (fig. 148). Like Duchamp's adoption of chocolate for his vicarious experience of radioactivity, his exploration of splashes on the model of Worthington would have provided a concrete activity to complement his more theoretical invention modeled on the laboratory work of Wilson and Perrin.

One other aspect of the *Large Glass* may relate to the issues of condensing drops and Brownian movement: Duchamp's interest in dust. Wilson's research had established that electrical ions could serve as centers of condensation, just as particles of dust do in the atmosphere. As Lucien Poincaré explained in introducing Wilson's early work in *La Physique moderne*, "Grains of dust act by reason of the hygrometrical power, and form germs around which drops presently form."[212] Dust also figures in Perrin's writings, where he at times compared his granules to larger aggregates of molecules, "in a word a *dust*," as he phrased it.[213] That Duchamp carefully confined the dust produced in his "Raising of Dust" (fig. 123) to the area of the Sieves suggests that his dust particles may have borne associations with the Illuminating Gas—either as Wilson's condensation nuclei (substituting for ions) or as analogues to Perrin's grains in Brownian movement. Thus, in addition to the electrical properties associated with electrical "dust figures" (see chap. 8), Duchamp's dust would both evoke the role of dust as a condenser of water (appropriate for his Sieves as "Liquéfacteurs")[214] and give a physical embodiment to the solidified Spangles of Illuminating Gas as Perrin's suspended granules in the process of settling. Indeed, Perrin's photographic records of the distribution of equilibrium at increasingly lower levels of his vertical column (fig. 142) could almost be read as time-lapse photographs of the "falls" of the dust onto Duchamp's pane of glass.

Perrin's work on Brownian movement, along with Wilson's cloud-chamber photographs using Worthington's technique, provided the visual proof, the "*ocular* confirmation," required to convince skeptics of the existence of molecular and atomic reality.[215] Duchamp's Oculist Witnesses may also attest to this achievement, just as they may function as "eyewitnesses" to the possibility of telegraphic/telepathic communication by means of invisible electromagnetic waves. These scientific issues—electromagnetic waves to Brownian movement—with their pos-

sibility of visual modeling and indexical registering, would seem to frame Duchamp's scientific world, the realm of late classical ether physics. Perrin's *Les Atomes* introduced new aspects of contemporary science and pointed strongly to the new model of discontinuity embodied especially in the work of Planck.[216] From *Les Atomes* Duchamp would have learned of Planck's early work on quanta, yet his scientific worldview was solidly grounded in an earlier paradigm. He would adopt Perrin's model of molecular discontinuity, but quantum theory was a late addition to his scientific education and offered little of the visualizability that had made ether physics so appealing.[217] Similarly, Duchamp would have been aware of Einstein, again through *Les Atomes*, though not in the context of special relativity but, rather, through his work on Brownian movement.

Perrin's *Les Atomes* probably stood near the end of a long line of reading that had commenced with sources such as Guillaume's 1896 *Les Rayons X et la photographie à travers les corps opaques* and school textbooks like Troost's *Précis de chimie*. Physics and chemistry had come together, and thermodynamics and the kinetic theory of gases had come to play a surprisingly large role in Duchamp's conception of the Bachelor Apparatus. Duchamp had originally been inspired by an older generation of scientists such as Crookes and Tesla; Perrin, however, born in 1870 (only five years before Duchamp's oldest brother), offered a new, more contemporary role model. The moving force behind the founding in 1937 of the Palais de la Découverte, which would become another of Duchamp's favorite science museums, Perrin offered a highly sympathetic character for a young artist who wished to be like a scientist.[218] In particular, Perrin emphasized precision and clarity in scientific work at the same time that he stressed the vital role of imagination (albeit highly disciplined) in scientific endeavor.[219]

In the preface to his 1903 thermodynamics textbook, *Les Principes*, Perrin explained his emphasis on axioms, definitions, and logical deduction in order to achieve his goal of "great precision in language and thought."[220] Duchamp seems to echo Perrin in his numerous references to precision, including that in his "Difficult to: describe a Rest" note, quoted above, in which he asserts, "Idea predominant and language only as its instrument (of precision). . . ."[221] The relation to Perrin seems even more specific in Duchamp's long unpublished note headed "Text (general notes for the).," in which he writes,

Give the text the style of a *proof* by connecting the decisions taken by conventional formulae of inductive reasoning in some cases, deductive in others. Each decision or event in

the picture becomes either an axiom or else a necessary conclusion, according to the *logic of appearance*. This logic of appearance will be expressed only by the *style* (mathematical formulae, etc.*) and will not deprive the picture of its character of: *plastically imaged mixture of events* because each of these events is an *outgrowth* of the general picture. . . .

*the principles, laws, or phenom. will be written as in a theorem in geometry books. underlined. etc.[222]

Just as Duchamp suggests here that both inductive and deductive reasoning must figure in his text, Perrin had argued for the importance of both induction and deduction in his preface to *Les Principes*. As a prelude to his presentation of thermodynamics, a field dominated by deductive reasoning, Perrin defended the importance of induction and the hypothesizing of molecules and atoms that the Energeticist proponents of thermodynamics had rejected. Later, in the preface to *Les Atomes* Perrin presented a similar dichotomy between what he termed the "two kinds of intellectual activity . . . [that] have played a prominent part in the progress of physical science."[223] The first of the two methods he termed the "intelligence of analogies," or the ability to discern analogies among various phenomena; this technique he associated with the rise of the "doctrine of energy," that is, thermodynamics and Ostwald's Energetics. Perrin contrasted this approach with the willingness of advocates of the kinetic theory to hypothesize

intuitively about the existence of molecules and atoms and "to explain the complications of the visible in terms of invisible simplicity."[224] For an artist seeking "to put painting once again at the service of the mind," Perrin's celebration of imagination and "intuitive intelligence" would have struck a responsive chord.[225] At the same time, the ability to discern analogies was central to the humorous visual overlays and verbal punning Duchamp created in the *Large Glass*. Given the emphasis on analogies within the British tradition of mechanical models, going back to Maxwell, Duchamp may have considered his "intelligence of analogies" a major aspect of his working method and therefore of his self-definition as artist-scientist.

The use of analogies was to be important in the remaining components of the Bachelor Apparatus, as Duchamp added larger-scale technological elements to his laboratory-size scenario with its microscopic and submicroscopic allusions. This was to be particularly true in the case of the multivalent Chariot or Glider, which, along with the Juggler/Handler of Gravity, would be central to his witty play with the laws of mechanics. Here Duchamp would also extend his wordplay on the theme of *goût/gouttes* by inventing a "gouttière," or groove, in which the Chariot might slide.[226] These elements of the Bachelor operations, along with the Mobile and Desire Dynamo, though never executed, were to have functioned at the heart of the Bachelor Apparatus."

Chapter 11

Other Scientific and Technological Dimensions of the Bachelors, II

The Unknown Mobile and Desire Dynamo, Playful Mechanics, and Agriculture in the *Large Glass*

Having established the Chocolate Grinder as the first component of the Bachelor Apparatus, Duchamp quickly surrounded the Grinder with accessory elements to give mechanical form to the physiological processes of sexual desire and release. Going far beyond Gourmont's metaphor of interlocking gears, Duchamp used his technological expertise to construct what Gourmont termed a "Mechanism of Love."[1] In addition to their specific identities as individual "bachelors" (fig. 96), the Malic Molds, connected by Capillary Tubes instead of by vas deferens, function like testes, giving rise to the Illuminating Gas to be liquefied into an "erotic liquid."[2] Duchamp embodied an onanistic phallic thrusting in the Chariot or Glider, whose back-and-forth motion he modeled on such sources as traveling cranes and cable-drawn plows and which he used to comment playfully on the laws of mechanics. At the heart of the Bachelor Apparatus was Duchamp's attempt to create in the Desire Dynamo a mechanical equivalent for the interrelated psychology and physiology of sexual arousal. Connecting the mechanical "organs" at the left to the Desire Dynamo was the Horizontal Column or Scissors mounted on the Chocolate Grinder, which would also link the cyclical motion of the Chariot/Glider to the various possible falls of the Mobile and its successful or unsuccessful attempts to produce the orgasmic splash of the Gas. Finally, Duchamp established an adjunct to the Bachelor Apparatus to embody the only give-and-take of sexual desire and response in the *Glass*: the Juggler/Handler of Gravity, who responds both to the gravity-bound mechanics of the Bachelors' realm and to the etherial, wave-borne communications of the Bride.

Rediscovering the Mobile, the Desire Dynamo, and Aspects of Energy and Power in the Bachelor Apparatus

The "*Desire dynamo—/combustion chamber/Desire* centers/*Sources* of the stripping" and the "Horizontal column" were the two final elements listed in Duchamp's initial "Breakdown" of the Bachelor Apparatus, after the Chariot, the Waterfall (its "motive force"), and the elements associated with the Illuminating Gas ("*Tubes of erotic concentration,*" etc.).[3] Under "*Sources* of the stripping," Duchamp would ultimately include the Mobile as well, since its falls or crashes, like the explosions in the Desire Dynamo, would have a direct effect upon the Boxing Match, the mechanism for the Bachelors' erotic tugging at the Bride's Clothing. The functioning of the Desire Dynamo as the manifestation of sexual psychology and the Mobile as the related embodiment of chance are discussed and illustrated in a number of Duchamp's 1980 notes (e.g., figs. 148, 149). As noted earlier, the fullest discussion of their interaction with the Horizontal Scissors and, to some degree, with the Boxing Match occurs in Duchamp's four-page note 153 (app. A, no. 11), from which figure 148 is taken.[4] His decision to include this long and detailed compendium, along with figure 149 (app. A, no. 12), among the *Large Glass*–related notes he listed together in the late 1950s emphasizes the centrality of the Mobile and Desire Dynamo, as well as the Horizontal Column/Scissors, to the Bachelor Apparatus. These roles had been largely eclipsed as a result of the exclusion of such notes from the *Green Box*.

Unlike the Desire Dynamo, the Mobile is mentioned by name once in the *Green Box*, although no details are provided of its appearance or the way it would produce the "3 falls" or "3 crashes."[5] In the three notes relating to this mechanism, the reader of the *Green Box* learns simply that Duchamp had decided against a "vertical channeling of the encounter [with the Gas] at the bottom of the slopes" in favor of a splash or ejaculatory "uncorking" and that "the fall of A of the three-crashes helps the uncorking."[6] And in the note referring to the Mobile by name, headed "Study the 3 falls," Duchamp confirms that "after the center one, the *mobile* will splash the gas . . . " and that these Splashes will be "direct[ed]" and "used for the manoeuvering of the handler of gravity (Boxing Match)."[7] When these *Green Box* notes are read in conjunction with the diagrams and discussions of the Mobile's mechanism set

forth in note 153 (fig. 148) and its earlier incarnation in note 101, however, they clarify a question unanswered in Duchamp's longer unpublished notes: only one "crash"—the center one—will produce a successful result, splashing the Illuminating Gas upward toward the Boxing Match and into the Bride's realm. Thus, although the "liberty of indifference" was Duchamp's goal, for the Bachelors one solution was to be preferred over others.[8]

Notes 153 and 101, which set out the Mobile experiments exploring chance and "Free will—Ass of Buridan," are part of the series of laboratorylike procedures Duchamp designed in 1913 (see chap. 5).[9] As drawn by Duchamp (fig. 148), in a view looking toward the endpoints of the Scissors from the right, the Mobile O was to have been suspended from two "hooks," C and D, which were themselves hanging from cords attached to the ends of the Scissors. In this view the Mobile is also resting on some sort of support, labelled F and G. Jean Suquet's composite drawing of the *Large Glass* (fig. 111), shows the missing Mobile as it was to have been positioned in the Bachelor Apparatus.[10] Once the Scissors were opened by the movement of the Chariot toward the Chocolate Grinder, Duchamp envisaged several possible releases of the Mobile from the hold of hooks C and D. If the Mobile releases from (*abandonne*) C and D simultaneously, it will fall straight downward along the path X and will, as the *Green Box* suggests, splash the Gas. If either hook releases without the other, however, the Mobile will swing to the opposite side, diverted from its downward course. After the falls, the Mobile is restored to its "labyrinth" position (i.e., in the vicinity of the Sieves, "a sort of *labyrinth of the 3 directions*") by "a little cord . . . (*rolled up like a snail*) (sort of spring)," one of the numerous springlike forms Duchamp incorporated into the Bachelor Apparatus.[11]

Although Duchamp never specified how the release of the Mobile occurs, further information on the generation of its crashes is embedded in notes in the *Green Box* on the falls of the Weight (Benedictine Bottle[s] or Hook) that moves the Chariot. There he links the "choice . . . made between the 3 crashes" to the "oscillating density" of the Weight: because of "the decelerations and accelerations (caused by the continual changes in density), the right is chosen rather than the left or alternatively the center."[12] In other words, the activity of the Chariot is translated to the Mobile via the Scissors, which open with jolts reflecting the "*jerky* pace" of the Chariot.[13] Here, then, is how the "oscillating density [of the Weight] . . . expresses the liberty of indiff." of the Mobile, producing results that cannot be predicted any more than could inherently random events such as the "striking of bad coins," the *écart*

or swerve of Lucretius's atom embodying "free will," or molecular collisions.[14]

In another note of 1913, the content of which was never developed, Duchamp speculated on a different type of chance fall.[15] The musical orientation of the note, with its references to "Uniformity of rhythm, anaccentuation," and "Chance," suggests a connection to Duchamp's Rousselian *Musical Erratum* projects.[16] Yet the main theme is a "Race between 2 mobile objects A and B," which results in a "Fall of A in Y"; here Duchamp brings in magnets and a "continuum of points of magnetization or of repulsion," which relate to the magnetism theme that would figure in other parts of the Bachelor Apparatus. As in the case of the Mobile, this experiment reduced the infinite number of possible outcomes of chance events at the molecular level to the "choice between 2 or several solutions (by ironic causality)."[17]

In the end, the physical form of the Mobile and its chance experiments was not to be incorporated into the *Large Glass*. Because of Duchamp's adoption of the Oculist Witnesses, the endpoints of the Scissors would acquire, for a time at least, magnifying lenses (as in *To Be Looked At with One Eye, Close to, for Almost an Hour* [figs. 115, 171]), a function quite different from their original role in suspending the Mobile.[18] Although Duchamp's Mobile may have been known for most of the century only through a single *Green Box* reference, its namesake nonetheless became a mainstay of twentieth-century art. It was Duchamp who in 1932 applied the term "mobile" to Alexander Calder's early motor-driven wire constructions, which were the precursors of his more familiar hanging constructions.[19] As designed on paper, Duchamp's Mobile was, in essence, a combination of wires or cords and solid elements moved mechanically by other components of the Bachelor Apparatus. He must have been struck by Calder's embodiment of a similar mechanical "mover." Indeed, Calder's later mobiles, which were suspended from the ceiling and moved not by motors but by air currents, may have reminded Duchamp of the Bride as Weather Vane/*Pendu femelle* "swing[ing] at the will of a ventilation."[20]

If the Mobile itself did not enter the lexicon of *Large Glass* elements, its effect—the creation of a Splash like those of Worthington (fig. 147)—was preserved in notes of the *Green Box* and *A l'infinitif*. Thus, the "3 crashes" appear with no explanation of their source, and, ultimately, a "Crash-splash" (commencing with the Slopes of Flow) or a "splasher" would come to serve as the shorthand description of the right-hand elements of the Bachelor Apparatus, once Duchamp began to conceive these events in terms of optics.[21] The *Green Box* and

A l'infinitif notes therefore chronicle the evolution of his thinking about a means to conclude the Bachelor operations as well as the gradual displacement of the Desire Dynamo as the main generator of the Boxing Match's "stripping-bare."[22]

One of the Mobile-related notes, quoted above, documents a point at which Duchamp rejected the idea of a "vertical channeling" or piping (*canalisation verticale*) of the gas, perhaps the pipelike form shown supporting the cubic form (probable Desire Dynamo) in the *Perspective Sketch of the Bachelor Machine* (fig. 140).[23] This change, however, did not represent a rejection of the Desire Dynamo, for in note 153 the two systems coexist in a single description of the Bachelor Apparatus. However, another component was soon to develop: the Weight with Holes, which would "direct" and "regularize" the Splash, by "forc[ing] the splash to pass through 9 holes having the shape of the 9 molds" in their upward trajectory.[24] Ultimately, the upward motion of the Splash would come to dominate the events at the lower right side of the *Large Glass*, overshadowing the importance of the chance falls of the Mobile or the earlier manifestations of exploding desire in the Desire Dynamo.

Once Duchamp was at work on the *Glass* in New York, optics would largely replace mechanics in this area: his new solution involved the sleight of hand of a "mirror-ical return" of a Sculpture of Drops. The mirror image of the Drops would be reflected "to the high part of the glass to meet the 9 shots," having been transformed by the "Wilson-Lincoln system" operating in the "3 planes at the horizon." According to Duchamp, like an image that from one direction could be read as Wilson, from the other as Lincoln, the reflection of the Drops would be transformed at the horizon planes from a drawing in "perspective" to a "geometrical drawing" free of perspective.[25] He also used the term "Crash-splash" to describe aspects of the transit of the Splash and speculated on using "ground glass and rust," a Kodak lens, prisms, or the mirror silver he would adopt for the Oculist Witnesses and their "dazzling of the splash."[26] With these developments, however, the origin of those Shots now came into question, since the Splash had lost its bulletlike quality and was merely a mirror reflection. Nonetheless, Duchamp apparently still thought of the Splash as generated by the Mobile. As Jean Suquet has observed, the carbon-paper drawing for the Oculist Witnesses, which was reproduced in the *Green Box*, suggests the two cords of the suspended Mobile juxtaposed with the Oculist Witnesses.[27]

If a scaled-down, largely nameless Mobile had remained at least a ghostly presence in the *Large Glass* narrative in the notes of the *Green Box* and *A l'infinitif,*

the Desire Dynamo, by contrast, was completely displaced when Duchamp omitted all references to it from his 1934 and 1966 publications of notes. Yet the Desire Dynamo had been one of Duchamp's most creative responses to contemporary technology, as he tried to create a mechanical and geometrical equivalent for the emotion and physiology of desire. Duchamp ruminated on the operation of the Desire Dynamo in at least six unpublished notes, including the four-page note 153 and note 163 (fig. 149) (app. A, nos. 11, 12).[28] According to note 153, the explosion in the Desire dynamo ("combustion chamber. Hot chamber [bath heater]") is "produced by the alternate presentation of the 'desire centers,'" and "these desire centers belong to the horizontal column of the bachelor machine." Elsewhere Duchamp describes these "desire centers" (fig. 149) as "positive rods" "branch[ing] off the horizontal column and terminating in the desire dynamo with a *positive sponge.*"[29] As a result, these desire rods stand as analogues to the "horizontal [self-blossoming] branches of the *arbre type*" of the Bride as spinal column, or *colonne vertébrale.*[30] Rooted in her spark-producing Desire-magneto, the Bride's self-blossoming is paralleled in the igniting of the Bachelor's fuselike rods in the Desire Dynamo, which, despite its name, operates as a combustion chamber rather than an electrical dynamo.[31]

The notation "1 intention/2 fear/3 desire" (fig. 149) is explained in two of Duchamp's most detailed notes on the Desire Dynamo, which include diagrams and equations expressing the relation of "desire" (C) to "intention" (A) and "fear" (B). Here Duchamp succeeded in reducing the process of sexual arousal to algebraic expressions such as $C = A - B$ and $C = AB$ or $A/C = C'/B$, just as he had recast feelings in the form of a theorem in his *Box of 1914* note: "Given that....; if I suppose I'm suffering a lot...."[32] Duchamp's other main usages of algebraic expressions and related diagrams had occurred in brief jottings illustrating the Golden Section proportion, $a/b = b/(a + b)$.[33] Yet it was not the pleasing aesthetic admired by his Cubist colleagues that interested Duchamp but rather the use of such mathematical expressions, including the a/b ratio in his "Notice" note, to convey information about a sexual relationship. Just as he had taken four-dimensional geometry far beyond the Cubists' interest in the subject, he now explored proportional relations and triangles embodying the movement of a point down a line as signifying the triumph of intention or "possibility" over fear or "scruple."[34]

How, then, was this "Hot chamber of the triple decision" to function?[35] The drawing (fig. 149) says of the "Desire centers" or rods that they "contain a material analogous to platinum sponge (*mousse de platine*) = *slow*

to light." These "positive rods" would seem to be modeled on a kind of igniter in which a coil of platinum wire (which could be thought of as a kind of "moss" akin to steel wool) is made to glow red-hot because of resistance within the wire and will ignite a gas—be it the coal gas in a traditional lamp or, in Duchamp's case, a pool of highly flammable liquefied gas.[36] Although Duchamp's original model for the "desire motor"/Desire Dynamo was the internal combustion engine (he continued to refer to a carburetorlike "impregnat[ing]" of the gas with oxygen and the "alternate presentation of the 'desire centers'" as if they were spark plugs), the ignition system of his combustion chamber had ultimately come closer to the model of the cigarette lighter of an automobile or domestic igniters for lamps.[37]

One of the most widely used heaters of this type was a component of the popular Nernst lamp, which employed a "platinum spiral . . . secured by nickel wire" to heat the "glower" rod of the lamp.[38] That Duchamp in the *Green Box* spoke of the Bride/*arbre type*'s "boughs frosted in nickel. and platinum" suggests that this designation might have been rooted in the parallel case of the "branches" of the Horizontal Column serving as igniting rods in the Desire Dynamo.[39] "There are some astounding fuses," wrote Duchamp in an illustrated note included among those selected in the 1950s (fig. 150).[40] Here Duchamp's sketch blends the head of a male figure with a spiraling form suggestive of his fuselike "platinum sponge." Slowly achieving its red-hot glow in Duchamp's Desire Dynamo, such a fuse would be waiting to ignite the Illuminating Gas and produce the explosion which, along with or as an alternative to the Mobile's splashing, "'sets off' the cannons of the boxing match" and the resultant "stripping-bare."[41] It would have been the exploding force of the Gas, presumably bursting out of the top of Desire Dynamo, that would have imparted the necessary "force of projection" to the Combat Marble of the Boxing Match, which, along with the Rams, would also acquire a property of "ascensional magnetization."[42]

An electric current would be necessary in order to have the "positive rods" and "sponge" gradually achieve their glow. Note 153 reveals for the first time how the "horizontal scissors" or "pliers," as Duchamp terms them, were to have transmitted such an electrical current. Central to their activity was yet another "lost" element of the *Large Glass*, the "Precision Brush[es]" (*frottoir de précision*), which were clearly depicted by Duchamp as flat plates astride the left-hand extensions of the Scissors (above the second and third Sieves) in the *Glass* itself, as well as in his 1965 etching *The Large Glass Completed* and each of the studies for it (pl. 1, figs. 76, 77).[43] Such brushes, so

named in electrical practice because they were originally bunches of springy wires, were normally flat copper strips that rested against the revolving armature of a dynamo and received the current it was generating.[44] In Duchamp's arrangement, the "little upper wheels of the chariot" slide under the Scissors and, presumably, make contact with the Precision Brushes by means of the metal extensions that wrap over the top of the Scissors.[45]

One effect of this contact would be the transmission of current through the positive igniter rods, toward which negative electrons would flow. Note 153, however, introduces another function accomplished by the contact of the wheels with the brushes atop the Horizontal Column: "These little wheels, in their alternating movement raise or lower the horizontal column according to their contact with the *precision brush.*" The Scissors thus undergo a "double displacement"—a left-and-right motion of opening and closing (and the attendant releasing of the Mobile) and an up-and-down motion produced by an electrical connection made at each brush, which has an "influence on the arrangement of the desire centers in the dynamo." One of Duchamp's drawings of the geometrical relations in the "positive rods" gives a clue as to how these "desire centers" might adjust as the Scissors would raise or lower: the rod shown is equipped with two springs, so that it could lengthen when the Scissors were raised or shorten (and ignite more quickly?) when they were lowered.[46]

The ascription of precision to electrical brushes is a uniquely Duchampian invention, since that quality is not a descriptor of their operation. Another element in Duchamp's note, however, provides a clue to the source for the "de précision" added to "frottoir." In this same section of the note, Duchamp refers to the Scissors as "working like balance pans" (i.e., raising and lowering), which evokes the highly accurate scales for which precision is critical. Such precision balances, including the pioneering models developed by Antoine Lavoisier in the eighteenth century, were prominently displayed at the Musée des Arts et Métiers in the survey of weights and measures in room 21.[47] Responding playfully to French metrology, as he would also do in the mechanics of the Chariot and the Juggler/Handler of Gravity, Duchamp humorously displaces the "de précision" from the scale to the electrical brushes, creating the anomalous Precision Brushes.

That the Horizontal Column possesses electrical brushes, whether precise or not, indicates that even if the Desire Dynamo itself does not function as an electrical dynamo, electricity was nonetheless being generated by some sort of dynamo to power the operations of the *Large Glass*. As

discussed below, a dynamo would seem to be encoded in Duchamp's multivalent sign for energy and power in the *Glass*, the Water Mill Wheel (figs. 151, 153). It has already been suggested that the structure of the Water Mill Wheel may also recall Crookes's mill-wheel demonstration of bombardment by cathode rays within a vacuum tube (fig. 152).[48] The Water Mill Wheel offered Duchamp the possibility of exploring the theme of energy and its transformation on a variety of scales. His visual punning in the Water Mill Wheel may thus have extended from the infinitesimal to the 40-foot steam-driven dynamos exhibited at the 1900 Paris Exposition (fig. 154), whose "silent and infinite force" had overwhelmed Henry Adams as they "revolv[ed] within arm's-length at some vertiginous speed."[49] Indeed, in his *Perspective Drawing for the Water Mill Wheel* of 1913 (fig. 153), Duchamp extends the wheel below the ground "plane" of the Chariot's frame, like the dynamos that were displayed partially below ground. Even though Duchamp had originally associated the Bachelors with a "steam engine on a masonry substructure," his subsequent description of their "liv[ing] on coal" suggests a connection to such coal-fired, steam-driven dynamos.[50]

The Water Mill Wheel and the Chariot were to be the sites of Duchamp's fullest exploration of the issues of power and energy in relation to his playful mechanics. Under "Chariot" in his "Breakdown: Bachelor machine," Duchamp had listed "motive force of the chariot/in the background" (i.e., the Waterfall), and in another note he speculated on the mechanical interactions among the Waterfall, the Water Mill Wheel, and the Chariot:

Motor principle: waterfall
Uniform use of this fall: Mill wheel.—paddles.—
Storage of potential—Weight in metal denser than pb [lead].
Expansion transformer [*Transformateur à détente*]
Receiver acting directly on the 4 wheels of the chariot.
(perhaps mechanical multiplication of the force.)[51]

The reference here to the "4 wheels of the chariot" (not to be confused with the "upper wheels" of the Chariot that make contact with the Precision Brushes) is a reminder that Duchamp originally conceived the Chariot as a wagon with wheels, not as the Glider sliding in a groove that it would become.[52] And although in another note he described the Waterfall as a "sort of waterspout coming from a distance in a half circle over the malic molds (seen from the side)," it would remain an invisible element in the *Glass*.[53] Given Duchamp's determination to avoid any vestiges of traditional landscape painting, the Chariot was to "hid[e] in its bosom the landscape of the water mill."[54] Like the indexing of wind currents in the Bride's realm by

the Air Current Pistons or the Bride as swinging Weather Vane, the Water Mill Wheel stands as an indexical sign for the invisible Waterfall. In this function it parallels the registering of the presence of unseen, bombarding electrons by Crookes's mill wheel.

As noted earlier, Duchamp's phrase "Transformateur à détente," or expansion transformer, in this note invented a new kind of transformer, giving the electrical transformer the characteristic of an expansion engine, such as a steam engine. Yet although this particular conception was an impossible conflation, he was vitally concerned with transformations among types of energy, such as mechanical (water), thermal (steam), and electrical.[55] His description and the sketch accompanying the note portray a direct mechanical transfer of force from the Waterfall, which turns an axle, raising a Weight that stores potential energy and then "transforms" it into kinetic energy by its fall. Indeed, having invented the richly complex idea of an expansion transformer, Duchamp, in the note in question, focuses primarily on a transformation between potential and kinetic energy.[56]

Although Duchamp's design for the Chariot's operation seems to rely simply on mechanical forces (the Waterfall and the falling Weight), the predominance of electrical themes in the *Large Glass* (e.g., "electrical stripping," "electrical control," "the connections. will be. *electrical*"),[57] along with the electrical brushes of the Horizontal Column, suggests that he also intended some sort of transformation to take place between the mechanical energy of a waterfall and the electrical energy produced by a turning dynamo. In contemporary dynamo technology involving waterfalls, water turbines received the mechanical force of the falling water and imparted a rotary motion to a dynamo, whose coils generated an electrical current by cutting through the force lines of magnetic fields. As noted earlier, this was the very period in France when the conversion from hydromechanical to hydroelectric power was being carried out; a waterfall would therefore have had both a historic connection to mechanical power and a new association with electricity.[58] The waterfall illustrated in Claude's *L'Electricité à la portée de tout le monde* (fig. 100), for example, was included in a chapter discussing the suitability of waterfalls for electrical power generation.[59]

Duchamp's adoption of the term "desire dynamo" (albeit for a combustionlike engine) documents his interest in these electrical generators (or alternators, as they were called if producing alternating current). Dynamos, whose "self-exciting" ability enabled them to power their own electromagnets, were highly appropriate for the onanistic Bachelor Apparatus.[60] Moreover, in addition to

the general visual rhyming possible with circular dynamo structures (figs. 153, 154), sources on "Dynamo-Electric Machinery" often included large-scale mechanical drawings of the wheel of the dynamo/alternator (fig. 155), which would surely have appealed to Duchamp, the would-be mechanical draftsman.[61] Indeed, in creating the Water Mill Wheel in both the *Glider Containing a Water Mill (in Neighboring Metals)* (fig. 151) and the *Large Glass,* he used multistranded lead wire, which was then splayed out to form the eight spokes of the wheel, akin to a typical "Alternateur Triphase" (fig. 155). Jean Crotti had registered his own interest in the generation of triphase alternating currents in his 1920 gouache *Mademoiselle Triphase* (Private Collection), which presumably alludes to a female generator of sexual electricity.[62]

Having gained potential energy by being elevated, Duchamp's "Weight in metal denser than pb." was to serve as the immediate motive force for the motion of the Chariot.[63] Like the raised Weight, however, another element of the Chariot could also store energy: the "monotonous flywheel" (*volant monotone)* listed under Duchamp's "litanies of the Chariot" or "Exposé of the Chariot" (fig. 156A).[64] The flywheel was a favorite mechanical device of Leonardo da Vinci as well as of nineteenth-century British physicists such as Kelvin, who used governing flywheels in their mechanical models for molecular dynamics. As noted earlier, Jarry responded to Kelvin's flywheel models in formulating his "Time Machine," its bicycle wheel serving as gyrostat.[65] Picabia, paralleling Duchamp's interest in flywheels and their relevance to sexual machines, produced a painting in the period 1916–18 entitled *Wheel [Volant] Which Regularizes the Movement of the Machine* (Private Collection, Paris). Even Picabia's curious 1919 drawing *Molecular Construction* evokes the association of flywheels and molecular activity by its title and the wheel-like structure Picabia superimposes over a grid with names of his fellow Dadaists.[66]

Duchamp's phrase "volant monotone," then, offers yet another identity for his Water Mill Wheel—a flywheel associated with the operation of machinery as well as with events at the molecular scale. Yet *volant* also translates as "shuttlecock," a meaning particularly appropriate to the monotonous back-and-forth motion of the Chariot and undoubtedly enjoyed by Duchamp as another of the double entendres in the *Large Glass.*[67] Modeled on similar motions in the worlds of contemporary industry and agriculture, the "vicious circle"[68] of the Chariot offered Duchamp the setting in which to explore and to stretch the most basic laws of physics—those of classical mechanics.

Playful Mechanics in the Chariot and the Juggler/Handler of Gravity

Mechanics, on a basic level, was the most accessible and straightforward of the various aspects of science Duchamp explored. Like his introduction to chemistry through a school textbook, he would have encountered classical mechanics in any basic physics book used in the French education system. Because of its long history as well as its seeming simplicity, mechanics was the area of science in which Duchamp would have been most aware of the fallibility of scientific laws and the relevance of Henri Poincaré's philosophy of conventionalism.[69] When he remarked later that in science "every fifty years or so a new 'law' is discovered that changes everything," Duchamp was likely responding not only to the general paradigm shift to Einsteinian relativity theory and quantum physics, which he had lived through by the early 1920s, but also to the vicissitudes in the history of mechanics he observed in the writings of figures ranging from Leonardo to Poincaré and Perrin.[70]

If Leonardo's extensive notes on mechanics offered an image of personal invention in the face of seemingly naive, pre-Newtonian theories of mechanics, Poincaré's discussion of the principles of mechanics in *La Science et l'hypothèse* and of the "present crisis in mathematical physics" in *La Valeur de la science* documented contemporary ferment and scientific challenges to Newtonian mechanics.[71] Duchamp's exploration of a "*reality which would be possible by slightly distending* the laws of physics and chemistry" would certainly have been encouraged in such a context.[72] Perrin, for example, had declared in introducing mechanics in his 1903 *Les Principes* that he was among those "inclined to think that one could deviate enough from ordinary conditions to arrive at a realm where the laws of our present mechanics would be false or deprived of sense."[73]

Having originated with the work of Archimedes, mechanics deals with the effect of forces on bodies in motion (dynamics) or at rest (statics). Although a number of medieval thinkers, including Jean Buridan, had explored aspects of mechanics, the study of forces as we know it today was codified by Isaac Newton in his *Principia* of 1687, which built upon the work of Galileo and other seventeenth-century thinkers, including Descartes.[74] Newton's three laws of motion, set forth at the beginning of the *Principia*, form the basis of any discussion of mechanics:

1. Every body continues in its state of rest, or of uniform motion in a straight line, unless it is compelled to

change that state by forces impressed upon it [commonly referred to as the law of inertia].

2. The change of motion is proportional to the motive force impressed; and is made in the direction of the straight line in which that force is impressed.

3. To every action there is always opposed an equal reaction; or the mutual actions of two bodies upon each other are always equal, and directed to contrary parts.[75]

In addition, Newton posited a law of universal gravitation, which asserts that "every body in the universe attracts every other body with a force which varies inversely as the square of the distance between the two bodies."[76]

Because classical mechanics relies on the basic measurements of length, mass, and time, its practice was tied closely to metrology and the science of weights and measures, which was enshrined in France in the Bureau International des Poids et Mésures in Sèvres and at the Conservatoire des Arts et Métiers and its museum.[77] Duchamp's challenge to the French meter in the *3 Standard Stoppages* (figs. 68, 69) was to be paralleled by his play with the concept of weight, which is defined as mass times the force of gravity (W = Mg), and with gravity in general. In fact, four of the five "Laws, principles, phenomena" of his Playful Physics, listed together in the *Green Box*, relate to the principles of mechanics and the subversion of the measures and forces on which they are based: "Phen. of stretching in the unit of length"; "Phen. or principle of oscillating density"; "Emancipated metal of the rods of the sleigh"; and "Friction reintegrated *in reverse* (emancipated metal)."[78] Precise measurements of time were also a key element of the field, making mechanics the perfect science for Duchamp's anti-Bergsonian Bachelors' realm. Instead of distorting time, however, as he would do with length and mass, Duchamp allowed spatialized, segmented time to reign in the lower half of the *Large Glass*, thereby increasing its contrast to the more organic, fluid, gravity-free, four-dimensional world of the Bride.

As defined by Duchamp, the Bachelor Apparatus, augmented by the Juggler of the Center of Gravity or Juggler/Handler of Gravity, is a veritable catalogue of mechanical effects. Thus, Duchamp's statement in one of the general notes for the *Large Glass*—"The picture in general is only a series of variations on 'the law of gravity'"—is an overt reference to Newton's law of gravitation.[79] Rectilinear forces reign in the operations of the Bachelors—whether in the back-and-forth motion of the Chariot, the upward projection of the Combat Marble of the Boxing Match (and the Splash), or the downward

force of gravity which the Juggler seeks to "handle" and which occasions the numerous "falls" in the lower half of the *Glass*, including those of the Weight and the Mobile. (Here the rectilinearity of directions presents a clear contrast to the situation of the Bride, whose "mortice"/ball-and-socket joint allows her to swing freely in *all* directions.)[80] Issues such as force, inertia, friction, gravity, equilibrium, displacement, and the mechanical advantage obtained by gears and pulleys all figure in the activities of the Bachelor Apparatus and the Juggler/Handler, allowing Duchamp to demonstrate his creative response to the laws of mechanics.

Of all Leonardo's writings as an artist-scientist, those on mechanics were undoubtedly the richest source of scientific explorations for Duchamp. For Leonardo, mechanics was "the paradise of medieval science, because with it one comes to the fruits of mathematics," a reminder that he, like Duchamp, was deeply engaged in mathematics as well as science.[81] Leonardo applied his mechanical investigations not only to the inanimate world but to the realm of humans and animals as well—a tendency Duchamp would also have encountered in contemporary literature such as Jules Amar's 1914 *Le Moteur humain*; the work began with a 113-page section entitled "The General Principles of Mechanics," which were subsequently applied to the human body. Both Leonardo and Amar deal with the changing positions of the center of gravity in a body in motion, including the act of walking up and down a staircase.[82] Duchamp's coil-like Juggler/Handler, who "juggles" the position of his Center of Gravity, therefore has a precedent in the diagrammatic stick figures of both these writers. As part of his larger exploration of center of gravity and equilibrium, which was discussed by Duhem in his *Etudes sur Léonard de Vinci*, Leonardo also speculated on the center of gravity of both birds and "flying machines."[83] Similarly, Duchamp's 1912 drawing *Airplane* (fig. 37) included arrows suggesting his interest in contemporary diagrams of the forces affecting a plane and its center of gravity during flight (fig. 39).

Leonardo's notebooks offered page after page of suggestive models for Duchamp's mechanical investigations. In the Ravaisson-Mollien volumes, for example, one finds jottings and sketches from the fields of both statics and dynamics.[84] Beyond the specific problems in statics of center of gravity and equilibrium, Leonardo was generally concerned with effects of gravity and weight, including the behavior of falling bodies, as studied in pre-Galilean mechanics, an issue that was to be central in the *Large Glass*.[85] In the field of statics proper, Leonardo also explored the operation of balances for weighing as well as of levers and pulleys as means to overcome the force of

gravity. As noted earlier, Duchamp described the Scissors of the Bachelor Apparatus as "working like balance pans," and he would also incorporate a "balance arm" in his conception of the Juggler/Handler of Gravity.[86] In the field of dynamics, Leonardo studied force and motion extensively, repeatedly discussing the activities of a *mobile,* or "mover," as did Duchamp.[87] Here Duchamp would have been struck by the inadvertent Playful Physics of certain aspects of pre-Newtonian mechanics, such as the concept of "impetus," which suggested that an object in motion somehow carried with it the motive power that had produced its initial movement.[88]

The themes of "blows" and "percussion," like the numerous "collisions" of the *Large Glass,* also appear in Leonardo's writings—specifically, in his speculations on ballistics and the action of projectiles shot from cannons.[89] Duchamp talked of the "trajectories" of the Combat Marble of the Boxing Match, the Mobile, and the Splash and Nine Shots (fig. 144).[90] Moreover, when Duchamp shot matchsticks from a toy cannon to determine the placement of the Nine Shots, he was actually carrying out an experiment in dynamics on the model of Leonardo. Duchamp dipped his matchsticks in paint to record their impact on the glass panel, just as Leonardo had studied the bounces of a ball by soaking it in dye "so that it marks the spots where it strikes upon the marble."[91]

Leonardo's notebooks also contain designs for gearing systems intended to transmit mechanical force (including that of water wheels) as well as comments on the role of friction in any such system and ideas on how to reduce it, including a type of sprocket chain.[92] Duchamp's scheme for transferring the force of the Waterfall to the Chariot likewise involved a sprocket-and-chain mechanism that would raise the Weight, which "rises again to the top by means of the chain engaged on the axle of the water mill which turns a sprocket-wheel with . . . an increased gear ratio so that it goes faster."[93] For Duchamp, as for Leonardo, friction was to be a major issue. Whereas Leonardo sought to invent devices to minimize friction, however, Duchamp simply declared the metal of the Chariot to be "emancipated" from gravity and its friction to be "reintegrated."[94] As he designed the activities of the Bachelor Apparatus, Duchamp undoubtedly had Leonardo's forays in mechanical engineering in mind. Yet his playful mechanics also drew upon a number of contemporary sources of information and inspiration—from physics textbooks and displays of the Musée des Arts et Métiers to the events and actions in the world of technology around him.

Duchamp's notes on the Chariot (figs. 156A, 156B, 156C) are some of his most familiar writings and are the subset most fully represented among those published. In other words, unlike most of the other components of the *Large Glass* examined in the present volume, the posthumously published notes on the Chariot hold few surprises and are primarily earlier versions of the notes and drawings chosen for the *Green Box.*[95] Our enhanced understanding of the Chariot's functioning from unpublished notes comes mainly through note 153 (app. A, no. 11), which provides the connection via the Scissors to the activities of the Mobile and its crashes. As will be seen, however, when the combined notes are examined in the context of contemporary science and technology, even Duchamp's somewhat better-known notes take on new significance and demonstrate what a rich area for invention the Chariot was for him.

The relationship of published to unpublished notes is far different for the other focus of mechanical activities, the Juggler of the Center of Gravity, whose absence from the *Large Glass* kept him shrouded in mystery, despite a number of hints provided in the *Green Box.*[96] Two images of the Juggler/Handler appear in the *Green Box,* although only one drawing is labeled "Handler of Gravity" (fig. 112). That image is accompanied by the notations "Suppress the center" and "make the rod as a spring (to be studied:," along with the musing that the new terms Tender (*Soigneur*) or Handler (*Manieur*) are "complementary."[97] The other sketch of the Juggler (now recognizable in relation to then-unknown drawings of the Juggler and Bride, such as fig. 110) appears at the top of Duchamp's note on the Top Inscription, headed "[Blossoming] ABC," though the Juggler is not mentioned by name in the note and his function is not clarified. Only the *Green Box* note on the Boxing Match (fig. 45) uses the original, fuller appellation for the Juggler and provides a cryptic clue to his function: "The juggler of centers [*sic*] of gravity having his 3 points of support on this garment dances to the will of the descending rams controlled by the stripping." A separate note on the Splashes produced by the Mobile indicates that these "should be used for the manoeuvering of the handler of gravity./(Boxing Match)."[98] Finally, in two passing references in his "General notes. for a hilarious picture," Duchamp reminds himself to "give the juggler only 3 feet because 3 points of support are necessary for stable equilibrium, 2 would give only an unstable equilibrium" and that "the mvts. of the handler and of the hanged figure," or *Pendu femelle,* are an application of the "Principle of subsidized symmetries."[99] These brief, far-flung clues, however, have barely been noticed by scholars, except for Jean Suquet.[100] In contrast to the situation for the Chariot, then, it is only the detailed unpublished notes (e.g., note 150 [app. A, no. 18] and note 152 [fig.

110]) that have clarified the Juggler's central role in the events of the *Large Glass*.[101]

If the force of gravity is an overarching issue in both the Chariot's and the Juggler's actions, the two represent the fields of dynamics and of statics, respectively. Center of gravity and its relation to equilibrium and displacement dominate the Juggler's dance, while dynamics (including the laws of falling bodies) and Newton's laws of motion are the context for the fanciful activities of the Chariot, along with the related percussive events within the clockwork Boxing Match. The scope of Duchamp's inclusions in his playful mechanics is reminiscent of a textbook treatment of the subject or of the Musée des Arts et Métiers displays. The 1905 *Catalogue officiel des collections* devoted to physics, for example, lists its holdings for "General Properties of Matter" under the following topics:

I.—MECHANICAL PHYSICS. Composition of forces.—Levers—Pulleys.—Laws of motion.—Inertia—Centrifugal force.—Gyroscopes.—Impact [*Choc*] of Bodies.—Friction. . . .
III.—WEIGHT AND GRAVITATION.
 1.—Laws of falling bodies . . .
 2.—Equilibrium of heavy bodies.—Center of gravity.—Balances [scales].[102]

Among those holdings are two particularly suggestive items: a "Chariot [or sliding carriage] with a clockwork movement for experiments with friction" and an "Equilibrist in ivory," complete with a weighted pole that creates equilibrium by lowering its center of gravity.[103]

The Chariot / Sled / Glider

The Chariot was the second element Duchamp created for the Bachelor Apparatus.[104] In a September 1915 interview, he explained that the Chariot's "lines represent simply the art of sliding, and it is supposed to be an irony on the feats of the modern engineer."[105] Duchamp's feat of irony was to have produced in the Chariot a sexual perpetual-motion machine embodying a continuous onanistic thrusting that transcends the engineer's problems with inertia, friction, and gravity. After a brief incarnation with wheels, the Chariot's motion centered on sliding, and Duchamp's changing names for it (*Chariot, Traineau, Glissière*) reflect his preoccupation with this friction-oriented action. *Chariot* also signifies the "carriage" on a lathe or typewriter, and that action of sliding in a groove or track was also essential to the meaning of the term *glissière,* or Glider. (As Paul Matisse suggests, Slider is a better translation than Glider, although because of its widespread usage, Glider has been maintained here as an

alternative to Chariot.)[106] A *traineau* is a sled, and here Duchamp was likely responding to discussions of the mechanical forces involved in the action of pulling in a given direction, which frequently used a sled as an example. Although in textbooks such a diagonal force is then broken into component horizontal and vertical forces, Duchamp designed his system so that the pull created by the falling Weight was strictly horizontal (fig. 156C).[107] With its the rods of "emancipated metal," the Chariot thus responds only to a horizontal force and is subject neither to an upward pull nor to the downward force of gravity.

Having dismissed Newton's law of gravitation for the body of the Chariot, he also responded playfully to the Newtonian laws of motion as he invented the means by which the Chariot "goes and comes."[108] The first task was to set the Chariot in motion by overcoming its inertia in a stationary position; on the return trip, a "buffer" would "[stop] the momentum" the Chariot had acquired.[109] Both actions embody rather straightforwardly Newton's first law, the law of inertia, a term Duchamp employed elsewhere in comparing the chilled, liquefied Illuminating Gas to "Vapor of inertia, snow."[110] The actuation of the Chariot is accomplished by the falling Weight, whether Hook or Benedictine Bottle(s) (fig. 157), whose "oscillating density" causes the Chariot to move at a "*jerky* pace" determined by the "strength of the fall of the hook." This is a creative variation on Newton's second law, which holds that motion is proportional to the motive force.[111] Finally, Newton's third law (to every action there is an equal and opposite reaction) is implicit in two of the solutions Duchamp posited for the requisite return of the Chariot to its original position. In one sketch (fig. 156A), springs are attached to the Chariot, creating the "buffer" noted above; once extended, these springs will "slowly [resume] their first position."[112] This solution links the third law to the issue of elasticity and molecular forces, but Duchamp's alternative scheme involves his more playful toying with friction and thermodynamics.[113] Here his "Principle" of "friction reintegrated" declares that the friction of the runner, "instead of changing into heat," is transformed into another force, "a returning force equal to the going force."[114]

Duchamp took on the laws of falling bodies and the measurement of weight as he developed his ideas on the Weight or Hook that was to power the Chariot and give it its jerky motion. As depicted by Duchamp (fig. 156C; as overlaid onto the *Large Glass* by Suquet in fig. 111), the "brand bottle" Weight is shown falling through a "Trapdoor" into a "basement," catching as it goes the cord of the Chariot and "instantaneous[ly] pulling" the Chariot in a horizontal direction.[115] This would seem to be the same

mechanism Duchamp had drawn and labeled as "*Receiver acting directly on the 4 wheels of the chariot*" in his "Motor principle" note quoted above.[116] Duchamp's *Green Box* note (fig. 156C) also raises the possibility of more than one bottle falling and compares the action to the new (in 1914) phenomenon of "bombs which aviators let fall."[117]

Such a multiplicity of *coups,* or "blows," to the Chariot's cord would have been necessary to create its irregular pace and would seem to have been the reason for Duchamp's initial contemplation of using more than one bottle.[118] As he developed the concept of the Hook, however, the notion of variable weight and density replaced that of a succession of falling blows from multiple weights. Duchamp's very concept of "oscillating density," so crucial to his pursuit of the "liberty of indifference" in experiments with the Mobile, may therefore have begun as a playful solution to creating the lurching motion of the Chariot. Initially, the change in weight had been an energy-saving device: "by condescension" the weight of the Hook would be "heavier [or, elsewhere, denser] going down than coming up (*so as to save the power of the waterfall*)."[119] Then the Hook's density began to "oscillate," creating "an indeterminate, variable, and uncontrollable weight," an engineer's nightmare, except in Duchamp's "Regime of Coincidence" and chance.[120]

Suquet's composite drawing (fig. 111) includes two different Duchamp conceptions of the falling Weight mechanism and the Hook. At the base of the Bachelor Apparatus is the fallen Hook bearing a bottle weight (from fig. 156C); raised to the top is a much heavier and larger forklike Hook (*fourchette*), which Duchamp also contemplated as a self-sufficient weight.[121] The latter Hook design, which he seems ultimately to have discarded, had also been conceived initially as an enlarged version of a tiny hook-and-eye type of sewing fastener, or *agrafe,* as Duchamp calls it.[122] In relation to both this form of the Hook and its subsequent, forklike incarnation, Duchamp contemplated a more complex (and sexually suggestive) system for powering the Chariot, in which the two prongs of the Hook would "fall astride the axle and the two points of the fork [would] penetrate into the basement through two holes."[123] In the end, however, he seems to have returned to a Weight in the form of a "lead-bottomed bottle with a ring" that would be carried by a relatively smaller Hook as *crochet* (fig. 156C), with its dual domestic and industrial overtones (fig. 159).[124] It would be the lead bottom of the bottle, now inverted ("head down," as Duchamp says), whose density would oscillate rather than that of the Hook itself.[125] If he continued to refer to "4 Weights in the form of Brand bottles," it was, nonetheless, the molecular composition of

the bottles—and not their successive falls—that would produce the Chariot's uneven motion.[126] (Duchamp's linking of Benedictine bottles to science, incidentally, had a curious precedent in the prevalence of advertisements for the liqueur in *La Science et la Vie* during 1913–14 [fig. 157].)[127]

As Duchamp developed his ideas on the Benedictine Bottle(s), he added another, rotational motion to the fall. In notes headed "*Song*: of the revolution of the bottle of Bened.," he even alluded to Newton's laws of rotational motion in his reference to the bottle Weight's "m't of rotation" or moment of rotation.[128] Yet, typically, this is Newton made comical by the anthropomorphic qualities Duchamp gives to the Benedictine Bottle, which "pirouettes" with its "head down" after it has "fall[en] asleep as it goes up [and] the dead point wakes it up suddenly."[129] Human foibles, sexuality, and mechanics fuse readily in the Bachelor Apparatus. Thus, the "litanies" of the Chariot also combine mechanics and human qualities, specifically the sexual themes basic to the Chariot's origins: at one moment the Chariot's litany speaks of "Vicious circle" and "Onanism," and the next of "Crude wooden pulleys" and "Eccentrics" (circular mechanical devices with off-center axes that can convert rotary motion into rectilinear motion and vice versa). Gears, like pulleys, also play a role in Duchamp's constructed machine, but one with additional sexual associations given Gourmont's comparison in *Physique de l'amour* of sexual organs to interlocking gears. Although certain of Duchamp's gears function properly (e.g., "an increased gear ratio so that it [the sprocket chain raising the Hook] goes faster"), others described as "useless," "worn on one side," or "tormented," connote the sexual inadequacy of the Bachelor Apparatus.[130]

The Chariot, nonetheless, seems to have hopes for self-improvement, indicated by Duchamp's inclusion of a "Sandow" as an alternative to the springs that might pull it back into place. This is one of a number of elements from the outside world that enrich the humor and complexity of the Bachelor Apparatus. In a metonymy already current in popular culture, Duchamp evokes the German bodybuilder and weight lifter Eugen Sandow (1867–1925) by means of the elastic "developer" that bore his name (fig. 158).[131] In his *Green Box* note on the Chariot, Duchamp sketched it attached to a Sandow (fig. 156B) and explained: "Behind (at the left of the picture) the chariot is brought back into position by the Sandow. In the picture the Sandows will be at rest (*almost relaxed*)."[132] The Sandow was an early home-exercise apparatus that promised muscle development through the use of elastic cords attached to a wall or door. Like the

Chariot, it was free of friction ("there is no friction to wear out the covering of the cords"),[133] and, as an advertisement boasts (fig. 158), the Sandow exercises were "very scientifically grounded."

In the 1890s Sandow had pioneered the "physical culture" movement, which took the Greek body type as its ideal. According to Sandow's *Strength, and How to Obtain It* of 1897, "physical culture" involved the "cultivat[ion] of the whole of the body so that at last it shall be capable of anything that sound organs and perfectly developed muscles can accomplish. . . . The production, in short, of an absolutely perfect body."[134] Physical culture was extremely popular in Paris (Apollinaire, for example, had published in the periodical *La Culture Physique*).[135] Picabia revealed his interest in the movement in his 1913 painting *Physical Culture* (Philadelphia Museum of Art, The Louise and Walter Arensberg Collection), which replaces classical figure types by his characteristic ribbon-like forms of this period and which stands as part of the general Cubist-related celebration of sport.[136] Duchamp, by contrast, found the ideal human-machine analogy in the identification of Sandow with his exercise apparatus, humorously adding this theme in the *Large Glass* as another aspect of the mechanics of force. Indeed, one of the primary French bodybuilders in this period, Professor Desbonnet, published a book entitled *La Force physique: Culture rationnelle*, which included the "Sandow Method" as well as his own.[137] Duchamp's Chariot, complete with Sandow, was itself a kind of mechanical weight lifter as it raised and dropped its Benedictine Bottle(s) or Hook.

If strongmen lifting weights represented one type of "rois de la force" (the title of another Desbonnet book, published in 1911),[138] the mechanical "kings of strength" in this period were the industrial cranes that had become a standard part of manufacturing technology (fig. 159). In "rolling bridge" cranes Duchamp would have found the combination of back-and-forth motion and lifting and lowering of weights that came to characterize the Chariot. The central importance of cranes to the *Large Glass* is in fact documented in an unpublished note, "*The Crane*: Stationary transport/Mobile go-between," which he included in his 1950s lists (app. A, no. 13), as well as by the presence of this phrase in his unpublished overview of the *Large Glass* presented in note 104 (app. A, no. 22/23).[139] The crane joins Roussel's Helot's carriage, sliding back and forth lightly on its "gelatinous rails" (fig. 65), as a precursor of the Chariot's cyclical motion.[140] And, as will be seen, contemporary cable-drawn plows stand as another prototype for the Chariot's "round trip" motion. Yet here, instead of the functional analogy of raising weights by a hook, the plow operates symbolically to evoke agri-

culture—both modern and ancient—and its associations with sexuality and fertility. Moreover, in the same way that the *gouttières,* or grooves, in which the Chariot slides are rooted in wordplay, Duchamp's incorporation of a plow (*buttoir*) involves a Roussel-like linguistic play on *buttoir* (plow) and *butoir* (buffer).[141]

Duchamp found in crane technology a rich source of ideas for his creation of the Chariot mechanism (fig. 159). His incorporation of a *crochet*/Hook, at one point heavy enough to serve as a weight itself, seems to be a direct response to the massive hooks used on cranes. In addition to the presence of the sprocket-driven chain characteristic of cranes, the Hook's ability (as the "hook of revolution") to turn with the pirouetting Bottle of Benedictine also reflects the swiveling motion of crane hooks.[142] Moreover, the connection between the Scissors and the Chariot, which Duchamp effects by means of "little wheels" running under the Scissors, suggests not only the overhead tracks or trolleys on which a traveling crane moves back and forth but also a way of overcoming friction between the Scissors and Chariot.[143] Indeed, crane designers had to be well versed in the mechanics of motion, including friction and techniques of braking, as well as issues in statics, such as center of gravity and the mechanical advantage gained by pulleys and gears.[144] From textbooks to contemporary industrial installations and the exhibits of models of cranes at the Musée des Arts et Métiers, crane technology brought the laws of mechanics to life and updated the explorations by Duchamp's historical mentor in mechanics, Leonardo.[145]

Although Duchamp's variations on the crane theme included an "underground rail" that suggests the sloping rails of certain transport cranes that allowed them to move in one direction by gravity alone, the primary effect of gravity on the "emancipated" Chariot was experienced via the falling Weight, whatever its form.[146] Like the Chariot's parallel in turn-of-the-century cranes (or cable-drawn plows), Duchamp's falling Weight (and Mobile) had a contemporary analogue in Paris: the experiments that Gustave Eiffel conducted with falling weights at his tower (fig. 160). Just as the Bride's associations with telegraphy and meteorology evoked scientific activities at the top of the Eiffel Tower, the numerous "falls" in the Bachelor Apparatus surely reflect Eiffel's modern-day sequel to Galileo's fabled experiments with falling bodies at the Leaning Tower of Pisa.

In 1907 Eiffel published *Recherches expérimentales sur la résistance de l'air executées à la Tour Eiffel*, the first of his two studies of air resistance; the second involved the wind tunnel he constructed at the base of the tower.[147] The apparatus Eiffel used for his experiments

(fig. 160) consisted of two inverted, conical forms to which he attached objects of various shapes and dimensions in order to measure their wind resistance as they fell. These forms, which Eiffel called the *partie mobile* or *mobile*, were released from the second platform of the tower and traveled down a taut cable, reaching speeds of forty meters a second before being stopped at a height of about twenty meters by the action of friction and a *tampon*, or bumper of springs, in a tubular braking mechanism.[148] In addition to his use of the term *mobile*, Eiffel's language offers numerous parallels to Duchamp's notes. Eiffel uses the phrase "le mobile abandonne" to describe its initial fall from the tower's platform; Duchamp described his Mobile's departure from the point of the Scissors in this same phrase.[149] Eiffel also speaks of the *chocs* resulting from the fall, the *tampon* or bumper (a term Duchamp used in his "Breakdown" note), friction and braking, and the new "coefficients" (another of Duchamp's favorite terms) of resistance he was able to establish.[150]

Although Eiffel's *mobile* suggests comparison with Duchamp's Mobile, visually it is much closer to the inverted Benedictine Bottle or "magnum" upon which Duchamp settled as the Weight (or Weights—like Eiffel's double arrangement?) to be carried by the Hook (fig. 157).[151] If Duchamp's allusion to such bottles represented a "Little dig: an ironic concession to still lifes," their visual echo of the most well-known "falls" in Paris must also have pleased him.[152] Here was one more layer of falls in the continuum from atomic and subatomic realms to visible scale echoed in the *Large Glass*—from the falls of Lucretius's atoms turned aside by *clinamen* and Perrin's falling molecules and their metaphoric association with dust (fig. 142) to the demonstrations of falling bodies at the Arts et Métiers and their investigation in the mechanics of Leonardo, Galileo, and, now, Eiffel.[153]

Whereas Eiffel, like crane designers and the scientist-experimenters before him, had to concern himself with specific weights and coefficients of friction, Duchamp continued to play with such issues. In fact, scholarly treatments of mechanics might actually have encouraged Duchamp to deal with friction and weight more freely than could a practicing engineer, in that in theoretical discussions of mechanics and of the physics of work, friction is standardly discounted. Newton's "principle of work," for example, specifies that "*in all cases where friction may be neglected*, the work expended upon the machine is equal to the work accomplished by it."[154]

A completely frictionless machine, in which no energy would be lost as heat, could be in perpetual motion, the elusive concept that had so fascinated inventors through

the ages and that regularly appeared in discussions of mechanics.[155] Although the first and second laws of thermodynamics dictated the impossibility of such a machine, Poincaré had detected what he thought to be a challenge to the second law in the seemingly perpetual motion of granules in Brownian movement, believing he saw there "motion transformed into heat by friction, now inversely heat changed into motion" (see chap. 10).[156] Duchamp's "Principle" of "friction reintegrated" seems to echo Poincaré's suggestion that "the friction of the runner on the rail [instead of changing into heat] is transformed into a returning force. . . ."[157] Duchamp also described the "oscillating density" of lead-bottomed Benedictine Bottle(s) as the result of molecules "in perpetual mvt."[158] As in his experiments with chance and his interest in falls, Duchamp's play with the mechanics of friction could move freely from the visible scale of the sliding Chariot to the molecular realm of collisions and Brownian movement.[159]

Poincaré's comments on the challenge to the second law of thermodynamics had occurred in the context of his 1904 discussion entitled "The Present Crisis in Mathematical Physics" in *La Valeur de la science*.[160] Two years earlier, in his treatment of mechanics in *La Science et l'hypothèse*, Poincaré had mirrored the ferment that was occurring in this field as developments in electrodynamics threatened the traditional interpretation of such concepts as mass and inertia. A chapter entitled "The Classic Mechanics" is peppered with comments such as "This definition is only a sham" or "The absurdity of this consequence is manifest," assertions that would surely have delighted Duchamp.[161] Indeed, recent scientific discoveries in the field of mechanics were challenging long-held principles, the result of which would be the emergence of Einstein's special theory of relativity in 1905. Although Einstein's inauguration of relativity physics began to be noticed in scientific periodicals in Paris only in late 1912 or 1913, Poincaré was already discussing extensively the work of Lorentz (upon which Einstein was simultaneously building) and the synthesis that was attempting to preserve the electromagnetic model of nature centered on an ether.[162]

Duchamp need not have understood the complexities of developing relativity physics to gather from Poincaré's discussions that major challenges were afoot. In addition to the seeming threats to the first and second laws of thermodynamics presented by radium and Brownian motion, respectively, Poincaré included in the "new crisis" even more basic scientific laws, such as "Lavoisier's Principle" of the conservation of mass.[163] The discovery of cathode rays or electrons and of the particles emitted

by radioactive substances had led to talk of an "electric theory of matter," which, in turn, had raised questions concerning the material "mass" of such particles. The mass of the electron was considered to be solely electro-dynamic, that is, the result of its inertia in relation to the ether. Further, at the high speeds at which electrons traveled, the mass of such particles would increase appreciably with velocity. Lavoisier's principle would thus not hold at speeds approaching that of light, an idea that would ultimately become codified in Einstein's equation $E = mc^2$.[164] In the meantime, Poincaré's text gave ample documentation of the questions surrounding both Lavoisier's principle and Newton's law of action and reaction in the context of electromagnetic waves.[165]

Lucien Poincaré, in his *La Physique moderne* of 1906, likewise discussed contemporary challenges to the principles of mechanics, which, he argued, were due to be submitted to a critical evaluation. In relation to the "law of Lavoisier," Poincaré noted that the discovery of radioactivity had "rendered popular the speculations of physicists on the phenomena of the disaggregation of matter," which also seemed to controvert the conservation of mass. Poincaré's remark is a useful reminder of the contribution of popular writers such as Le Bon and his conception of matter as a "stable form of intra-atomic energy" in creating a milieu conducive to Duchamp's development of his playful mechanics.[166] In addition to Le Bon, whose 1908 *L'Evolution des forces* began with the chapter "The Present Scientific Anarchy," prominent alchemists such as Jollivet Castellot, who drew upon Le Bon and who found in electrons and radioactivity support for the idea of transmutation, had established the popular scientific context in which Duchamp's own investigations had begun.

With his disdain for French metrology, already manifested in the *3 Standard Stoppages* (fig. 68), and the encouragement provided by awareness of the contemporary challenges to the constancy of mass—whether in the writings of Le Bon, Poincaré, or others—Duchamp attacked standards of weight in a similarly iconoclastic way. His focus was on new types of metals—the "emancipated" metal of the Chariot (along with the "neighboring metals" of the Water Mill Wheel it contains)—as well as the substance of "oscillating density" for the Weight or Hook, which he ultimately identified with the lead of the Benedictine Bottle bottoms.[167] Because density is intimately connected to mass (mass = density × volume), the variable or "oscillating" density of a substance, if its volume does not change accordingly, would necessarily destabilize the measure of its mass. In addition, in the history of French metrology, the measurement of density had been crucial to the determination of the standard kilo-

gram, which was based on a platinum standard equal to a liter of water at its temperature of greatest density.[168] Thus, as in the case of Duchamp's *Stoppages* and their official counterpart in Sèvres (fig. 69), his metal Weight and Hook of an "indeterminate, variable, and uncontrollable weight" or a weight that is "impossible to calculate" are the iconoclastic counterparts to the kilogram standard in Sèvres and to the standard weights proudly displayed at the Musée des Arts et Métiers.[169]

Reflecting his interest in physical chemistry, Duchamp also proposed specific molecular characteristics for his new metals, such as the "Molecular or (Body) composition" of the Bottle(s) of Benedictine, which is "in perpetual mvt."[170] Similarly, his awareness of chemistry and, perhaps, alchemy may be reflected in his description of the two materials of the Water Mill as "neighboring metals."[171] Although Ulf Linde has noted this phrase in the writings of the alchemist Poisson, the phrase "éléments voisins" also occurs in sources closer to Duchamp, such as Jollivet Castellot's 1909 *La Synthèse d'or*, where the term "voisins" is applied to atomic weights as well.[172] Characteristically, Jollivet Castellot, the modern alchemist-chemist, seems to have been responding as much to the Periodic Table of Elements as to traditional alchemical cycles of metals; Duchamp, too, indicated that the metals were "neighbors . . . as far as their molecular composition was concerned."[173] As Duchamp invented the laws for his "Regime of Coincidence/Ministry of Gravity," he developed yet another unique metallic property, the "ascensional magnetization" transmitted to the Combat Marble and Rams of the Boxing Match from the Illuminating Gas.[174] Here, he may have been inspired in part by Roussel's fantastic chemical elements in *Impressions d'Afrique*, such as the "magnetine" demonstrated by the chemist Bex, which could send giant pencil-like projectiles hurtling dramatically through the air.[175] Finally, in the Bride's realm Duchamp had introduced a further metallic variation: the "chameleon metal (reforming itself at once) according to the orientation" of the Bride's "circle of cardinal points" (fig. 128).[176]

Just as Duchamp's play with dynamics and the laws of motion combined aspects of traditional mechanics with some of the current ferment in the field, so his exploration of the law of gravity in the context of statics drew upon both classical mechanics and contemporary ideas. His thinking on the subject may have been influenced, for example, by such works as Maurice Boucher's *Essai sur l'hyperespace: Le Temps, la matière et l'énergie,* which speculates on the relationship of gravity and the ether to the fourth dimension. Yet, the Juggler of the Center of Gravity was also just that—a vehicle to comment upon

the most basic principles of statics relating to equilibrium and displacement. And it was in the context of his consideration of the Juggler and the problem of gravity in general that Duchamp formulated two other so-called principles of his playful mechanics, beyond the list of "Laws, principles, phenomena" included in the *Green Box*: his "Principle of subsidized symmetries" and his "Principle of gravity"/"Principle of *anti*?gravity."[177]

The Juggler/Handler and the Bride: Gravity and "Anti?Gravity" in the *Large Glass*

Central to Duchamp's wireless telegraphy/telepathy theme in the *Glass* was the wave-borne communication between the Juggler of the Center of Gravity and the Bride, to which he gave physical form in the extension and retraction of the Bride's "filaments" (figs. 110, 111).[178] In the Juggler would meet that "voluntary horizontal blossoming of the bride" and the "vertical blossoming of the stripping-bare," which is registered by the Juggler's "dance" on the Bride's Clothing as the Boxing Match tugs upon it. The Juggler is the nexus of the two colliding realms of the Bride and the Bachelors—four-dimensional ether physics versus mechanics, "anti?gravity" versus gravity—and provides the only physical interaction in the *Glass*. Sexual give-and-take is here embodied in a process of equilibrium lost and recovered. And although Duchamp ultimately came to designate the Juggler simply as the Handler or Tender of Gravity, the mediating figure between the upper and lower realms, the Juggler of the Center (or Centers) of Gravity was originally conceived in terms of the mechanics of static forces and, in particular, balance.[179]

In the context of wireless telegraphy the Juggler's spiral, coil-like form, his "ball in *black* metal," and the configuration of his base (figs. 112, 113) suggest his association with electromagnetic wave-emitting and -detecting equipment.[180] Yet the Juggler was rooted in the issue of balance, as related to both physics and the popular forms of entertainment based on a performer's ability to maintain equilibrium. Thus, just as his spiral form may evoke the spring balance used to measure gravitational force, the "pole" he "carries" is that of a tightrope walker, or *équilibriste*, like the ivory toy at the Arts et Métiers.[181] Indeed, Duchamp's references to fairgrounds—where a weight could be sent upward by a hammer's blow ("Neuilly Fair—test your strength"), one could throw balls at a Bride, and party whistles could be found—establish the Juggler/Handler's connection to actual entertainers.[182] Jean Suquet has noted an additional fairground entertainment: strongmen who were concealed

under a waxed, wooden platform and made it tip precariously by kneeling and standing.[183] Finally, Duchamp's brother Villon had produced a series of works during 1913 on the theme of the *équilibriste* as acrobat, including an oil painting shown at the Salon d'Automne.[184] Moreover, the Juggler of the Center of Gravity as a balancing acrobat who responds to the clockwork mechanism of the Boxing Match echoes a popular type of automaton (see chap. 7).[185]

Whereas Villon attempted to evoke visually the forces and energy of an acrobat in motion, Duchamp created a physics demonstration of stable and unstable equilibrium to manifest the give-and-take of the Juggler with the Bride as well as the Bachelors (via the Boxing Match). In contrast to the sparse and scattered clues concerning the Juggler's activities in the *Green Box*, other of Duchamp's notes describe these events in detail, particularly his four-page compendium in note 152. The second page of this note (fig. 110) focuses on the interaction of the Bride's filaments and the "ball in *black* metal" of the Juggler, to which the filaments are "attract[ed]" and whose position they adjust in order to restore his equilibrium ("out of sympathy"). Duchamp's fullest development of the mechanics of that equilibrium occurs in the first page of the note:

The juggler of center of gravity. Handler [Tender] of gravity A man perched on a [parallelepiped rectangle] (truncated pyramid) very elongated,—*sways back and forth* to the point of falling. He avoids the fall by skillfully juggling with his center of gravity which he projects onto his polygon of support *just* in time to reach short unstable equilibriums—This takes place on the bride's clothing; this clothing is waxed or rather in slippery material.—This clothing could be called stage.[186]

In physics the center of gravity of an object is that point at which all the gravitational forces weighing on the object can be considered to be concentrated.[187] In other words, an equal and opposing force applied at that point from below will counteract the gravitational pull on the object and keep it from falling. An object is said to be in stable equilibrium if it returns readily to its original position when it is tipped or displaced. If such an object rests on a base (the three or four "feet" of Duchamp's Juggler),[188] the base is defined as the "*polygon* formed by connecting the points at which the body touches the plane." The object will be in stable equilibrium only as long as a vertical line drawn through its center of gravity remains within the polygon; it will be in unstable equilibrium, however, if the vertical line falls on the boundary

of the polygon. In the case of the Juggler on his "parallelepiped rectangle" (or, as seen in perspective, a "truncated pyramid"), even when he is able to "project" his center of gravity "onto his polygon of support," which should theoretically stabilize his position, Duchamp describes his accomplishment as "*just* in time reach[ing] short unstable equilibriums." Thus, the Juggler is not self-sufficient and requires the help of the Bride, whose filaments reach out to his "free ball" and "force it to restore the balance shifted by the dance of the feet. . . ."[189] That this relationship operates as well on the level of wave-borne information is confirmed in Duchamp's *Green Box* note on the Top Inscription or the "cinematic blossoming" of the Bride, which includes a sketch of the Juggler and explains that "... the inscription should, according to the need for equilibrium of the plate D, displace a [stabilizer] (a ball or anything)."[190]

The remainder of the first page of note 152 is taken from note 150, the main text on the Juggler that Duchamp chose to include in his 1950s listings (app. A, no. 18). Here Duchamp treats the Juggler in terms of a balance scale and introduces the curious notion of the "bathtub of pride," into which the Juggler's missteps downward may take him. Undoubtedly associated with the bath heater (and thus the Desire Dynamo), the phrase "bathtub of pride" introduces the notions of pride, humility, and indifference—which Duchamp associates with the positions of the balance arms of a scale. He explains of the Juggler (by implication giving imaginary anthropomorphic qualities to all such measuring scales):

The upper ball is not humility versus the steps of pride. The upper ball doesn't give a damn. It is the instrument of indifference or the balance arm which desires the 0. (because humility would only be pride of a − sign); without this upper ball, the juggler stretches out, descends toward. . . . ; he falls into the equations of durations and spaces. The balance arm or upper ball allows him every fantasy up to dead center, an instant of tranquility for seeing outside—[191]

Constantly in motion, the Juggler never achieves the equilibrium of his own "balance arm" at the 0 point or the related "instant of tranquility." Duchamp's identification of humility and pride with positive and negative readings of a balance arm was yet another means to convert human feelings into algebraic expressions, as he had done in the rods of the Desire Dynamo, composed of segments of "intention . . . fear . . . desire."[192] Here, as in the falls of the Mobile, indifference reigns—with the "upper ball" an emotionally detached agent.

On the third page of note 152, Duchamp connects the quality of indifference in the Juggler's dance to the random swinging of the Bride-as-Weather Vane—inventing what he terms the "principle of subsidized symmetries."[193] It is thus the swinging of the Bride's *hampe*, or shaft, in its "circle of cardinal points" (fig. 82) that determines, seemingly by chance, the "coefficient of the displacement to impart to the Juggler's ball." In a marginal note he adds: *This lower swinging and the upper movement of the platform of C. of gravity: are* 'in correspondence' *according to the principle of subsidized symmetries.*" Here in the Bride's realm, then, is the equivalent of the "liberty of indifference" Duchamp cultivated in the chance falls of the Mobile. Henri Poincaré, in his discussion of chance in *Science et méthode*, had used the example of the unstable equilibrium of a cone on its apex and a slight "defect in symmetry" making it fall.[194] In formulating his imaginary "principle of subsidized symmetries," Duchamp may also have had in mind the "principle of symmetry" that Pierre Curie had recently formulated and that Lucien Poincaré had discussed in *La Physique moderne*. In formulating his principle, Curie, like a crystallographer, applied considerations of symmetry to physical phenomena: "For a phenomenon to take place, it is necessary that a certain dissymmetry should previously exist in the medium."[195] Poincaré had introduced his discussion of Curie's idea by asserting that "the principles of physics, by imposing certain conditions on phenomena, limit after a fashion the field of the possible," a remark relevant to Duchamp's interest in the "Possible."[196]

Although in the *Green Box* the importance of the Juggler of the Center of Gravity to the *Large Glass* was hardly clear, Duchamp later testified to his centrality in the little-known 1947 tableau *The Altar of the Tender [Soigneur] of Gravity* (fig. 181). Assembled by the painter Matta Echaurren according to Duchamp's instructions for the Exposition Internationale du Surréalisme of 1947 in Paris, the *Altar* was one of Duchamp's early forays into the three-dimensional tableau, a medium that characterized Surrealist exhibitions of this period.[197] In retrospect, Duchamp's *Altar* is relevant to the recasting of the *Large Glass* theme he was beginning at this time in his *Etant donnés* project (figs. 183, 186). Although the catalogue indicated that the "Tender of Gravity" was an unrealized component of Duchamp's *Large Glass*, viewers of the *Altar* might well have perceived a culinary theme—witness the fork and the plate with some type of food on it at the back right corner of the box-stage, what appears to be a grater and some sort of grated material, and a covered food dish. That cover, however, also provocatively suggested the foam-rubber breasts whose nipples Duchamp

and Enrico Donati had tinted for the cover of the deluxe edition of the exhibition catalogue.[198]

In fact, Duchamp's *Altar* has multiple layers of meaning and, as its title suggests, does relate to the Juggler/Handler of the *Large Glass* and the playful mechanics he embodies. At the left hangs a reproduction of Duchamp's "Idea of the Fabrication" note, describing the production of the *3 Standard Stoppages*, whose deformation in falling at the pull of gravity had challenged the standard measure of the meter. Given the presence of the iron hanging as a weight in the background and the table/Juggler who is about to fall (needing to have the ball restored to the upper edge of the table), Duchamp's tableau stands as a latter-day commentary on weight, measure, and gravity and, seemingly, a miniaturization by metonymy of key elements of the *Glass*. Central to Duchamp's play on food/mechanics is the fork, which is no ordinary piece of flatware. Carrying on a balancing act of its own, the fork evokes the role commonly given it in popular demonstrations of how to balance an object, such as a cork or a potato, on a vertical support, by inserting two forks in the object's sides and thus lowering its center of gravity.[199] Given Duchamp's proclivity for wordplay, the fork may also allude to the forklike version of the Hook in the Bachelor Apparatus. Similarly, the grater suggests an extreme case of the friction that was to be "reintegrated" to allow the Chariot to return to its original position or, perhaps, the digging effect the Chariot-as-plow would have.

Upon closer examination, the "Idea for the Fabrication" note is not the only sign of the *3 Standard Stoppages* in Duchamp's *Altar*. The meter and its "diminished" alternatives are physically embodied in the three straight cords or wires stretched from side to side at the top of the box and their curvilinear, "fallen" counterparts at the front edge of the tableau. Both the Capillary Tubes, whose forms were based on the *Stoppages*, and the Bride, whose Clothing Duchamp associated with the fallen threads and glass plates of the *Stoppages*, are evoked by the written and physical evidence of the *3 Standard Stoppages* in the *Altar*. Another metonymy in the *Altar* also points to the Bride. In addition to echoing the catalogue cover, the breastlike covered food dish suggests both the physical embodiment of the Bride's anatomy to which Duchamp would turn in *Etant donnés* and the bell glass of the entomologist Fabre, discussed earlier as a source for his idea to "put the whole bride under a glass cover."[200] The *Altar of the Tender of Gravity* thus represents a rich layering of associations—from gastronomy to mechanics and sexuality. It also differs significantly, however, from the *Large Glass*, as does *Etant donnés*, by the absence of communi-

cation between the Juggler and the Bride. The Juggler/Handler desperately needs the "blossoming out" of the Bride's filaments to restore his equilibrium, but in this starkly three-dimensional realm dominated by gravity, the requisite help is not forthcoming.

There are no "subsidized symmetries" in the space of the *Altar,* nor is there any of the four-dimensional "anti?gravity" Duchamp posited in his double "principle of gravity"/"principle of *anti*?gravity," the last of his "principles" of Playful Physics/mechanics to be considered here. The image of the Juggler translated into the three-dimensional space of the *Altar* is a useful reminder of the sharp contrast Duchamp wished to create between the spaces of the Bride's and Bachelors' domains, and the mechanics of gravity and escape from it became a primary means for him to articulate that distinction. If the *Large Glass* was to be "a series of variations on 'the law of gravity,'" the variations on Newtonian mechanics in the lower half were modest compared to the "extraphysical situations" of the upper half.[201] The metal of the Chariot may be "emancipated" from the pull of gravity, but it remains rooted in its grooves and cannot go beyond its set course. Similarly, the "oscillating density" of the Weight and the "ascensional magnetization" of the Combat Marble and Rams were mild challenges to the effect of gravity operating in their "Regime of gravity."[202] Indeed, from the start, Duchamp had conceived such a contrast, declaring in his first, long automobile-oriented note that the Bride "does not need to satisfy the laws of weighted balance."[203] The only effect of gravity to be felt in the upper realm was that registered by the Bride's agent, the Juggler, and she ultimately helps him keep that gravity at bay.

The compelling force of gravity in the Bachelor Apparatus is given visual expression in the three-dimensional perspective scheme of the lower half of the *Glass*. Duchamp equated perspective and gravity in note 104 (app. A, no. 22/23), which includes his fullest single discussion of the issue of gravity:

Principle of gravity. putting the picture under the control of elastic bands extending from the center of the earth: each [material] is of such density and form that the object which makes up its limits is induced by the center of gravity to extend its dimensions into a surface without thickness and even to reduce this surface down to the point which attracts it (funnel)
(Only the wasp uses the *elevator* of gravity at will)
The principle of gravity on which the entire picture rests is the only Bridge of Common-Sense, the only human control over each one of the picture's parts; this principle is

expressed graphically through the linear means used: *ordinary perspective.* (available to all levels of intelligence)
The picture in general is only a series of variations on 'the law of gravity'
a sort of enlargement or relaxation of this law, submitting to it [glimpses of the effects of the law on] extraphysical situations or bodies less or not chemically conditioned[204]

Duchamp's comment that perspective is "available to all levels of intelligence" seems to be yet another retort to the Cubist theorists Gleizes and Metzinger, who had been so critical of perspective in *Du Cubisme* and had touted Cubism's lack of immediate accessibility to an audience as one of its virtues.[205]

In this note Duchamp posits a physical analogue for the experience of the pull of gravity—the "elastic bands extending from the center of the earth," an idea that suggests as well his interest in comparing "gravity and 'longitude' in the paintings."[206] Just as he would later give form to such an idea in his 1918 *Sculpture for Traveling,* which consisted of strips of rubber bathing caps stretched to fill an area of his studio, Duchamp had "physicalized" the experience of gravity in an *A l'infinitif* note comparing a "gravity experience" to an "autocognizance . . . in the region of the stomach."[207] The same *A l'infinitif* note had also stated more clearly his conception of the relationship between gravity and perspective: "Gravity and center of gravity make for horizontal and vertical in space³ [three-dimensional space]/In a plane² [two-dimensional plane]—the vanishing point corresponds to the center of gravity, all these parallel lines meeting in the vanishing point just as the verticals all run toward the center of gravity."[208] The vanishing point in the perspective scheme of the lower half of the *Glass* may therefore have symbolized the center of gravity of the Bachelor Apparatus as a whole as well as the point at which the earth's gravitational pull could be thought of as centered.

In visual terms, the freedom from perspective in the Bride's realm meant that there would be no vanishing point and, hence, no center of gravity, apart from that of the Juggler. Just as Duchamp speculated extensively in the notes published in *A l'infinitif* on how to create the antiperspective visual form of the Bride's four-dimensional realm, he attempted to formulate, albeit much more briefly, what the "extra-physical" mechanics of antigravity might be.[209] His playful "principle of *anti*?gravity" centered on the issue of magnetism and the substitution of a "center of distraction" for the attraction he associated both with magnetism and with the earth's gravitational pull. Duchamp introduced these terms in his note on "ascensional magnetization," which begins, "to develop: this

principle of *anti*?gravity which changes from the ascensional force of the gas to the state of magnetization normally directed toward a center of distraction."[210] The fullest discussion of how the "property of distraction" might function, however, occurs in a note in *A l'infinitif* in which he theorizes on a four-dimensional "body 0" that "is tangent to space" and "is the resultant of 2 forces (attraction in space and distraction in the continuum)."[211] Although here he is evoking a four-dimensional body bounded by three-dimensional tangent spaces, Duchamp's drawing is of a circular, seemingly three-dimensional solid bounded (and created by?) two-dimensional "threads" tangent to the body. Nonetheless, his description implies one higher level of dimensionality: the threads lead from points signifying three-dimensional locations ("Ceiling, rear of shop, Courtyard, Floor, balcony, Garden"), and Duchamp fills the central shape with spiraling forms that "stretch towards a new point of gravity," whose *"property of distraction* only applies on the confines of space. . . ."[212]

In this note Duchamp continued to invent other phenomena that might characterize the realm of antigravity in the four-dimensional continuum, further contrasting it to the three-dimensional space of the Bachelors:

Try to find the other properties of the new point of gravity e.g. Lack of *uniformity in the obedience movement* of body 0 toward the center, i.e. this movement can be *alternative* and body 0 enjoys an alternative freedom. The deviations of time measuring this *freedom* followed by an equal time deviation during which body 0 is *determined* by the center under certain conditions. (Find the certain.)
These time deviations are made of 2- or 3-dim'l periods (see special development of the dial seen in profile in the *"revolver chewer."*)[213]

Here is the possibility that a body will "disobey" a force, periodically experiencing the "center of distraction" and, alternatively, being free of its effect. Duchamp's use of the terms "freedom" and "determined" specifically connects this note (and the Bride, in general, as a manifestation of free will) to the problem of free will versus determinism he explored in relation to chance and the "écart de molécules" in the events of the lower half of the *Glass.*[214]

Unlike the strict measurement of time required for mechanics, the "science of time" as it was called in this period, the Bride's domain is characterized by "time deviations" that create a kind of "oscillating" temporality.[215] Duchamp thus used conceptions of time as yet another means to distinguish the three- and four-dimensional

realms of the *Large Glass*. In his note discussing the mechanics of the Juggler of the Center of Gravity, quoted above, he referred to the destination of the Juggler, should he fall, as the "equations of durations and spaces."[216] This description of the Bachelors' realm points specifically to its anti-Bergsonian, mechanical quality, since Bergson had repeatedly decried the spatialization of duration by analytical, intellectual systems of thought.[217] In the Bride's realm, by contrast, time "deviations" occur, and clocks seen in profile will be free of the "time . . . cut up by astronomical methods" that is symbolized by the segmented divisions on the face of the clock and the "throbbing jerk of the minute hand."[218] Duchamp's discussion of temporal "cutting" and the prominence of Scissors in the Bachelor Apparatus are undoubtedly a response to Bergson's metaphorical use of scissors for the process of analytical perception. Along with the clockwork Boxing Match, the Scissors stand as a sign for the "clockwork universe" of classical mechanics—the "equations of durations and spaces"—in the Bachelors' realm.[219]

Duchamp's conception of the Bride's "blossoming" as "cinematic" further emphasizes the oppositional quality between the upper and lower halves of the *Glass*: the fluid, continuous, organic motion of the "cinematic blossoming" represents the closest approximation to the Bergsonian ideal of duration—though profaning it humorously as the sign of the Bride's orgasm.[220] Bergson, however, had also criticized the "cinematographic" or cinematic depiction of motion as an inadequate representation of pure duration, and Duchamp himself recognized the impossibility of ever "producing a cinematic state."[221] Nonetheless, at least the verbal evocation of such a fluid, Bergsonian conception of time contrasted with the carefully measured time of mechanics (and the Bachelors' jerky motions) was another means to distinguish between the infinite and finite in the *Glass*.

In developing the scientific associations for the Bride's four-dimensional realm, Duchamp would have been encouraged by contemporary theorizing on the possible ramifications of four-dimensional space for science. Aspects of both his illustrated *A l'infinitif* note on the "center of distraction" and his discussion of the "principle of gravity" in note 104, along with certain more general issues concerning the Bride, suggest that he was looking at a unique book on this subject, Maurice Boucher's *Essai sur l'hyperespace: Le Temps, la matière et l'énergie* of 1903.[222] Boucher was one of a number of figures, including Crookes, who had discussed the inadequacy of human sense perception and the resultant "relativity of knowledge" in articles in the *Revue Scientifique* around the turn of the century; he was also the primary Parisian vehicle

for the theories of the pioneering English hyperspace philosopher Charles Howard Hinton.[223] It was Hinton who first associated the experience of four-dimensional space with an escape from familiar sensations of horizontal and vertical orientation and of gravity, an idea Duchamp had certainly encountered in his reading on the fourth dimension.[224] Hinton had also discussed the ether as a vehicle for four-dimensional phenomena, but Boucher's text now provided a more scientific treatment of a variety of issues that interested Duchamp, including "Infinity and Continuity" and "Matter and Energy," to which he devoted chapters, as well as gravitation and electromagnetism in relation to the ether.

In explaining four-dimensionality, Boucher had relied on the analogy of a two-dimensional world and its relation to three-dimensional space, a method used by Hinton and other writers on hyperspace after him. Like Duchamp's subsequent discussion of the four-dimensional "body 0" and its "center of distraction" in his *A l'infinitif* note, Boucher had also talked of four-dimensional spaces, including the ether, as "limited" by three-dimensional entities, just as three-dimensional objects are bounded by two-dimensional surfaces.[225] Boucher's text also seems relevant to Duchamp's description in note 104 of the physical, elastic-band-like effect of gravity according to his "principle of gravity." As part of his evidence for the existence of a fourth dimension of space, Boucher lists a number of phenomena, including the "diffusion of liquids and gases," an argument he borrowed from Hinton. Boucher compares the three-dimensional case of diffusion to that of a "liquid on a plane [which] spreads the same in the two known directions, and diminishes in thickness in the third," adding, "it is the force of gravity which produces this result."[226] He then suggests that a similar, unknown force may act from a fourth dimension on gases in three-dimensional space, causing them to diffuse. Duchamp's description of the effect of gravity in "the picture" seems to echo Boucher's: "Each [material] is of such density and form that the object which makes up its limits is induced by the center of gravity to extend its dimensions into a surface without thickness." Duchamp amplifies the idea, however, as the pull of gravity further "reduce[s] this surface down to the point which attracts it (funnel)."[227]

Central to Boucher's argument for hyperspace was the notion that the ether must possess an infinitely thin (*infiniment mince*) extension in the fourth dimension, making it capable of penetrating all material bodies, just as a three-dimensional entity can readily pass into a two-dimensional plane.[228] Accordingly, the passage of X-rays might occur via a fourth dimension; likewise, he asserts that "the absolute transparency of bodies to gravitation" suggests

that gravitation must be transmitted along a "fourth direction."[229] Duchamp's Bride, a four-dimensional being herself, seems to possess the ultimate transparency to gravity, which frees her from its effects altogether, allowing her to "use the *elevator* of gravity at will."[230] Boucher also discusses extensively the vibrations set up in the four-dimensional ether, invisible waves that, because of the inadequacy of our senses, are known only by their manifestations as light, heat, or registrations on sensitive photographic plates.[231] He even describes the transmission of forces via the four-dimensional ether in a way that suggests Duchamp's description of the Bride's "spherical *empty* emanating ball" in note 153 on the Bachelor Apparatus (app. A, no. 11). Thus, in addition to the sparking ball of a telegraphy-emitting apparatus, which is suggested by Duchamp's phrase, Boucher writes of four-dimensional "radiating forces acting as if they emanate from the center of a three-dimensional sphere toward the surface."[232]

From Boucher and other writers on the fourth dimension, Duchamp would have obtained a strong identification of the ether with a fourth spatial dimension, making the theme of electromagnetism a highly appropriate theme for the realm of the four-dimensional Bride of the *Large Glass*. In juxtaposing an etherial, four-dimensional realm of electromagnetic waves with the three-dimensional classical mechanics that dominate the visible activities of the Bachelor Apparatus, Duchamp, intentionally or not, paralleled the contemporary situation in physics, in which the new electromagnetic paradigm of Lorentz was challenging classical mechanics. Lucien Poincaré described the situation in the introduction to *La Physique moderne*: "Abandoning the search after mechanical models for all electrical phenomena, certain physicists reverse, so to speak, the conditions of the problem, and ask themselves whether, instead of giving a mechanical interpretation to electricity, they may not, on the contrary, give an electrical interpretation to the phenomena of matter and motion, and thus merge mechanics itself in electricity."[233]

Ultimately, this would seem to be what Duchamp did when he replaced the physical Splash, operating in the realm of mechanics, with the "mirrorical return" that optically reflected the image of the Illuminating Gas into the Bride's realm.[234] Optics, dealing with the band of visible light in the electromagnetic spectrum, brought together the old and the new. Light, explored by Leonardo in the context of optics, was, after all, an electromagnetic phenomenon and was closely tied to the theme of electricity.[235] Light, the traditional artist's tool, was now being touted in contemporary discussions of the "new mechanics" as a limiting velocity faster than which masses could not travel.[236] It was, perhaps, a natural choice for the only means

by which the Bachelors could achieve any unmediated contact with the Bride's realm; just as electromagnetic Hertzian waves were sent down from the Bride, the light-borne reflections of the Splash returned to the upper half of the *Glass*.

The Chariot as the "Plow of Life" in Duchamp's "Machine Agricole"

One of Duchamp's notes in the *Green Box* associated the *Large Glass* with the theme of agriculture and farming:

The Bride stripped bare by her bachelors, even
 —Agricultural machine—
 —(a world in yellow)—
 preferably in the text . . .
Apparatus
 instrument for farming[237]

It is clear now from other posthumously published notes that both "agricultural machine" and "a world in yellow" were to function as subtitles for the *Large Glass*.[238] Duchamp's note 104 (app. A, no. 22/23), for example, elaborates on the theme of agriculture: "*The bride possesses her partner and the bachelors strip bare their bride.* As subtitle: (agricultural machine) or *"extramural agricultural apparatus."*[239] If "a world in yellow" evokes the predominant palette of the *Large Glass*, with overtones of Perrin's physical chemistry, what is the "agricultural machine"?

Although Duchamp's use of this term as a subtitle suggests that the entire *Glass* might be considered the "agricultural apparatus," another posthumously published note points to a more specific identification. That note, cited earlier in the contexts of popular culture (the Pier Pavilion at Herne Bay; fig. 80) and of the Malic Molds as illuminated gas tubes (e.g., fig. 99), proposed: "As background, perhaps: An electric fete . . . —Figuratively a fireworks— In short, a magical (distant) back drop in front of which is presented.... *the agricultural instrument—*."[240] If the Malic Molds filled with Illuminating Gas create an "electric fete," in front of them stands Duchamp's primary vehicle for the specific agricultural content of the *Large Glass*: the Chariot as "buttoir de vie," or "plow of life." Duchamp's clever wordplay on *buttoir* (ridging plow) and *butoir* (buffer) was lost when Michel Sanouillet mistranscribed the word "buttoir" as "butoir" in his 1958 collection of Duchamp's writings, *Marchand du sel*.[241] That error, which may have seemed a logical choice since the accompanying drawing and text clearly concerned a "spring buffer," has recurred in all subsequent publica-

tions of Duchamp's writings, despite the presence of the original spelling in the reproduced notes (e.g., fig. 156A).[242]

Here was one of Duchamp's cleverest Rousselian homophones, rich with interpretations relevant to his theme. In the context of mechanics, the buffer with springs (in its original form or in its incarnation as the Sandow) was necessary to the Chariot's stopping and return motion: "*Buffer/plow of life* = stopping the action not by brutal opposition but by extended springs slowly resuming their first position" and "Bach. life regarded as an alternating rebounding on this buffer/plow."[243] Such a buffer could also evoke events at the molecular scale, where Kelvin had proposed "massless spring buffers" as part of his mechanical model for the ether as an elastic solid composed of gyrostatic units containing flywheels (Duchamp's "volant monotone") and springs.[244] And, as used by Duchamp in several other notes, "Buttoir de vie" was associated specifically with the frustration of the Illuminating Gas: "Like the refrain of the whole of this bachelor machine, (Buffer/plow of life, sexual block). these forms have no *certainty*—."[245]

Yet Duchamp also spoke of the "round trip for the buffer/plow," and indeed the cable-drawn plowing technique, like the coming and going of a crane, was a prime example of such a "round trip."[246] Cable-drawn plows, developed with the advent of steam technology, were originally powered by a steam engine at the edge of a field.[247] Between the power source and the other side of the field, where another windlass returned the cable, a reversing "balance plow" (fig. 161) moved back and forth, driven by the cable. This particular plow is electrically driven and represented the newest innovation in this technology, the substitution of an electrical power source at the edge of the field.[248] The decades around 1900 were a period of transition, and the benefits of electricity for agriculture were touted in sources such as Claude's *L'Electricité à la portée de tout le monde*.[249] As Henri de Graffigny asserted in the 1903 *Revue Scientifique* article from which this illustration is drawn, for "agriculteurs" with a stream of water on their property, electricity had proved to be "the most practical mode from all points of view" for distributing the mechanical energy of the running water.[250] By 1903, however, the internal combustion engine was beginning to be used in cable-drawn plowing (fig. 162), and in later decades it would replace the cable-drawn approach altogether.

The *buttoir*-as-plow had even richer associations than the *butoir*-as-buffer. Akin to the frustrations of a buffer's "sexual block," the phrase "tirer la charrue" (*charrue* being the most common word for "plow") means to experience great difficulty or drudgery, certainly the mood evoked by the litanies of the Chariot.[251] Like a crane, the *buttoir*/plow was also linked to the history of technology and its contemporary practice: the Musée des Arts et Métiers devoted room 11 to agricultural implements, including models of balance plows and the wagons known as *chariots agricoles*.[252] Most important, however, the plow was specifically associated with sexuality and fertility, making Duchamp's embodiment of phallic thrusting in the Chariot/plow highly appropriate. In fact, Rabelais, one of Duchamp's favorite authors, had referred to the phallus as "nature's ploughman."[253] The roots of such a connection go back to Greek culture, in which plowing and the sowing of seeds were associated with sexual union and insemination. As J. J. Bachofen noted, "Marriage was regarded by the ancients as an agrarian matter; the whole terminology of matrimonial law is borrowed from agriculture."[254]

In note 104, Duchamp alluded specifically to classical culture in his reference to the "agricultural machine" as "extra muros," placing it outside the walls of a city, just as a cemetery (i.e., the Cemetery of Uniforms and Liveries or Malic Molds) would have been outside the walls of a Greek or Roman city.[255] Such an allusion to an underground realm for the Bachelors (also, their "basement" and "underground rail"),[256] together with the general theme of plowing and sexuality, brings to mind the mythical theme of Persephone, one of the most famous brides of classical mythology. In addition to her association with fertility, Persephone was directly connected to plows and chariots through the tale of Triptolemos, who was sent by Persephone and her mother, Demeter, to teach the world how to plow, as depicted on a red-figured cup in the British Museum (fig. 163).[257] Here both Demeter and Persephone, flanking Triptolemos, bear torches, Demeter's emblem in her search for Persephone following her abduction by Hades. The Bride's incarnation as lightbulb represents a variation on the allegorical tradition of torch-bearing figures of truth and their modern counterparts in advertisements for gas and electricity (figs. 133, 184, 185) and, ultimately, in *Etant donnés* (fig. 183). Like Duchamp's Bride and the Virgin Mary, Persephone was also a kind of *arbre type*—in this case so closely associated with trees and their blossoming in the spring that English ballads, for example, contain references to her as the "blooming bride."[258]

Modern agricultural technology and ancient symbolism came together in Duchamp's *buttoir*/plow, giving a specific locus to his meditation on the *Large Glass* as an "instrument for farming."[259] Man Ray's photograph of *Raising of Dust* (fig. 123), published in *Littérature* in 1922, bore the caption, "Behold the domain of Rrose Sélavy/How arid it is—How fertile—How joyous—How

sad!"[260] Like his conception of the "Water Mill (landscape—),"[261] the theme of plowing brought Duchamp closer to the idea of a "domain" (not just "in the figurative [and mathematical] sense of a limited quantity of *plane space*" he desired) and to the issue of landscape itself.[262]

Yet, like his "ironic concession to still lifes" in the Bottle of Benedictine, Duchamp had consciously created in the *Large Glass* a new language that transcended any traditional type of representation, whether still life, portrait, or landscape.[263]

Part IV

Conclusion

Chapter 12

Conclusion, I
New Thoughts on Style and Content in Relation to Science and Technology in Duchamp's *Large Glass*

André Breton, in his 1935 essay "Lighthouse of the Bride," referred to Duchamp's *The Bride Stripped Bare by Her Bachelors, Even* (pl. 1, fig. 76) as both a "mechanistic and cynical interpretation of the phenomenon of love" and the "trophy of a fabulous hunt" through a variety of fields, including "the most recent data of science."[1] Although ironic and humorous might describe the mood of the *Large Glass* more accurately than cynical, Breton was nonetheless an astute reader of Duchamp's *Green Box* notes, recognizing the playful way Duchamp had merged sexuality, science, and technology. At this moment, he was Duchamp's ideal spectator—a sensitive observer who was himself grounded in the early twentieth-century milieu in which the *Large Glass* project had originated.[2] Recognizing the scientific underpinnings of the *Glass* would become increasingly difficult for subsequent generations, who became increasingly removed from the science of the pre–World War I era. As a result, the *Glass* would come to be interpreted primarily in relation to the impact of the machine on modern art and as the counterpart to Duchamp's iconoclastic Readymades.[3] From his posthumously published notes, however, following upon the geometric pursuits he revealed in *A l'infinitif*, it is now clear that *The Bride Stripped Bare by Her Bachelors, Even* stands as the single most complex and multivalent work in the history of modern art. Although it has had a tremendous impact on twentieth-century art on the basis of what has been known, our understanding of the *Large Glass* is greatly enriched by the rediscovery of aspects of the cultural context—science and technology as well as philosophy, literature, and art—to which Duchamp responded so creatively.

The Musée des Arts et Métiers, Roussel, and Duchamp's Humorous Invention of a "Plastically Imaged Mixture of Events"

Duchamp's *Green Box* had revealed to Breton that the subject of the *Glass*, on its most basic level, was the "phenomenon of love." With sources like Gourmont's *Physique de l'amour*, Duchamp found a "mechanistic" language to be the appropriate vehicle for his exploration of sexual interaction.[4] As he told Lawrence Steefel in the 1950s, "It is better to project into machines than to take it out on people."[5] As with many poets who adopted human-machine analogies, Duchamp's ability to discern analogies opened up the world of science and technology—a world he had discovered in his reading and at the Musée des Arts et Métiers (fig. 164). These fields were full of sexually suggestive elements—from electrical sparks and vibrations to heat engines and self-exciting dynamos—that seemed "ready-made" to embody sexual desire metaphorically (e.g., the Bachelors' Desire Dynamo [fig. 149]). As suggested earlier, the *Large Glass* as a structure resembles nothing so much as a compression into two dimensions of the bi-level cases at the Musée des Arts et Métiers, which were filled with the kinds of scientific objects that inspired his creation of its characters. And, like the contrast between the Bride's four-dimensional realm free of perspective and the Bachelor's measured, three-dimensional space below, many of the objects in the upper cases appear as if suspended on shelves at eye level, independent of the quasi-perspectival setting created by the floor of the lower cases seen from above.

Glass cases themselves were evocative objects for Duchamp, and he was highly sensitive to the changed status of objects within them. He had seen a chocolate grinder "behind the vitrine" of a confectioner's shop, and the notion of "put[ting] the whole bride under a glass cover or in a transparent cage," with its roots in Fabre's entomology (fig. 135), had voyeuristic sexual overtones that would be made literal in the forbidden tableau of *Etant donnés* (fig. 183).[6] Duchamp, in a 1913 note on "shop windows," demonstrated his reading of an observer's interaction with the objects in a case as a metaphor for sexual activity:

The question of shop windows . ˙ .
To undergo the interrogation of shop windows . ˙ .
The exigency of the shop window . ˙ .

The shop window proof of the existence of the outside world ∴. When one undergoes the examination of the shop window, one also pronounces one's own sentence. In fact, one's choice is "round trip." From the demands of the shop windows, from the inevitable response to shop windows, my choice is determined. No obstinacy, ad absurdum, of hiding the coition through a pane of glass with one or many objects of the shop window. The penalty consists in cutting the pane and in feeling regret as soon as possession is consummated. Q.E.D.[7]

Characteristically, Duchamp casts these personal feelings in the impersonal form of a geometrical proof, using the three-dot sign for "therefore" and concluding with the "Q.E.D." that affirms the completion of a proof. Such a blending of sexuality, geometric or scientific language (or imagery), and popular culture was typical of many of his notes for the *Large Glass*. His shop-window experience represents another example of the theme of collisions that was so central to the *Glass*—collisions, as we have seen, of various types and at all scales. In the *Glass* itself, however, the determinism present in the shop-window experience was banished in favor of the free will symbolized by the swerves or "écarts de molécules" and other chance occurrences, such as the fall of the Mobile.[8]

The objects in the cases of the Musée des Arts et Métiers were not "works of 'art'"[9] and, paralleling Duchamp's ideal Readymades, one specimen of a particular object could readily be replaced by another. In contrast to the practices of an art museum, judgments of taste and quality had not played a role in the selection of a particular object. Similarly, an impersonal mechanical drawing style and laboratory or industrial procedures characterize the execution of the *Large Glass*, whose format and materials were unprecedented in the art world. Like the indexical registering apparatus housed in the Arts et Métiers cases, Duchamp's *Glass* came to function as a kind of indexical registering instrument. One model for the detached expression Duchamp sought was the chemical photographic process, itself part of the displays of the Musée Industriel of the Arts et Métiers, although in the end his actual use of photography in the *Glass* was limited to preparatory elements, such as the *Air Current Piston* (fig. 120).[10] Instead, he utilized other industrial or laboratory techniques, applying metals to the glass panes (lead wire and foil) or, in the case of the mirror silvering of the Oculist Witnesses, replicating (by scraping the silver away) a contemporary technique for creating a wave-detecting "spark gap" and paralleling the creation of a tin-foil "zone-plate" (fig. 172).[11] Colors, too, were considered in terms of chemistry and industrial applications rather

than for their painterly value.[12] Even the "raising of dust" (fig. 123) bore associations with scientific phenomena, such as indexical "electric dust-figures" (fig. 124), and, analogously, with Perrin's granules in Brownian motion (fig. 142).[13]

In the Musée des Arts et Métiers, an entire world of physics and chemistry waited to have its laws "distend[ed]."[14] Indeed, in the *Large Glass* Duchamp achieved a remarkable, almost museumlike scope in his inclusion of science and technology, albeit in playfully intermixed and often eroticized forms. With the exception of her biological identity as Wasp, all of the Bride's identities listed at the end of chapter 9 are paralleled in exhibits at the Arts et Métiers of X-ray equipment, chemistry apparatus, automobiles, automatons, wireless telegraphy equipment, meteorological instruments, and incandescent lighting.[15] Similarly, as chronicled at the beginning of chapter 10, the components and activities of the Bachelor Apparatus correspond to exhibits demonstrating the principles and practices of mechanics and physics (as well as physical chemistry)—including the molecular behavior of liquids and gases, electricity, and electromagnetism (e.g., electrical discharge tubes, wireless telegraphy equipment)—and to displays of agricultural machines, cranes, clocks, and weights and measures.

Duchamp's breadth of coverage suggests that a contemporary physics book might also have challenged him to incorporate such a range of topics. There are, for example, playful Duchampian counterparts in the *Large Glass* for every chapter of Lucien Poincaré's 1906 *La Physique moderne*: "Measurements," "Principles," "The Various States of Matter," "Solutions and Electrolytic Dissociation," "The Ether," "Wireless Telegraphy," "The Conductivity of Gases and the Ions," "Cathode Rays and Radioactive Bodies," "The Ether and Matter," and the more historical, philosophical discussions in the first and last chapters, "The Evolution of Physics" and "The Future of Physics." The same can be said for a typical physics textbook of the period, which also treated more traditional topics such as classical mechanics and meteorology.[16] To physics, of course, Duchamp added his explorations in chemistry and, to a lesser degree, biology. Yet comprehensiveness for its own sake was not Duchamp's goal. Here his endeavor can be compared to the work of certain other visitors to the Arts et Métiers: Gustave Flaubert's fictional heros Bouvard and Pécuchet as well as Raymond Roussel.[17]

Flaubert's novel *Bouvard and Pécuchet*, which he worked on for eight years before his death in 1880, has been discussed in recent scholarship as a sign of the folly and futility of attempts to create a systematic body of

human knowledge by amassing information on the model of the "Library-Encyclopedia" or the museum.[18] The two hapless clerks Bouvard and Pécuchet are middle-aged bachelors who discover each other and a shared passion for information gathering. Before they ultimately move to the country and try their hand at farming (at which, as in all else, they are unsuccessful), they begin their "collecting" of knowledge in Paris:

They visited the Conservatoire des Arts et Métiers, Saint Denis, the Gobelins, the Invalides and all the public collections. . . .

In the galleries of the Museum [of Natural History] they viewed the stuffed quadrupeds with astonishment, the butterflies with pleasure, the metals with indifference; fossils fired their imagination; conchology bored them.[19]

A number of Bouvard's and Pécuchet's pursuits parallel Duchamp's own scientific interests, including agriculture, meteorology, and magnetism, as well as the chemistry and atomic theory they mention but do not pursue.[20] As Eugenio Donato has noted, however, the two Frenchmen are handicapped by their lack of knowledge of the new science in the 1870s (i.e., thermodynamics);[21] by contrast, as we have seen, Duchamp was deeply involved in the issues of energy and chance or randomness associated with thermodynamics. A much more basic difference between Duchamp and the fictional Arts et Métiers visitors, however, is Bouvard's and Pécuchet's belief in the possibility of finding some kind of truth and meaning in the bits of knowledge they have assembled. Flaubert, who spent years preparing to write the novel, referred to it as "a kind of encyclopedia made into farce."[22] In the end, when all their pursuits have failed, they are reduced to their original occupations—as clerk copyists—simply recording anything that comes their way: "They copy papers haphazardly, everything they find, tobacco pouches, old newspapers, posters, torn books, etc. . . . Keep on copying! The page must be filled. Everything is equal, the good and the evil. The farcical and the sublime—"[23]

If Bouvard and Pécuchet's endeavor is simply copying, Roussel's was inventing—a term Duchamp used frequently to describe his own approach to art. Like Roussel's, Duchamp's response to the scientific milieu around him was, in the words of Pierre Janet, to produce "completely imaginary combinations . . . the ideas for an extra-human world." For neither Roussel nor Duchamp, however, would Janet's assertion that "the work must contain nothing real, no observations on the world or the mind" be true.[24] Science and technology, instead, provided the raw material (along with a variety of other cultural sources)

for creative invention, just as they had for Jarry. Duchamp rarely, if ever, copied mechanical or scientific objects directly, not even in his first *Airplane* drawing (fig. 37) made in Munich—unlike Picabia, whose works of the mid-1910s often reproduced recognizable objects with only slight modifications. Rather, he invented new objects that were a collage of multiple functions, brought together in the *Large Glass*/machine as a "plastically imaged mixture of events."[25] That he would have seen himself in contrast to Bouvard and Pécuchet is also suggested by Picabia's derogatory association of the Cubism of Gleizes and Metzinger with Bouvard and Pécuchet in a 1917 text in *391*.[26]

"It was Roussel who gave me the idea of inventing new beings whether made of metal or flesh," Duchamp asserted in a radio interview in 1959. Pointing up his debt to the many linguistically generated components of Roussel's *Impressions d'Afrique*, he continued, "I actually thought of it . . . in terms of words before I actually drew it."[27] For Roussel and his admirer Duchamp, the game of homophones was a powerful tool for the imagination, and the number of words available to each increased significantly as he moved into the realm of science and technology. As we have seen Duchamp played with the issue of *goût*/taste in his *Bottle Rack* (*égouttoir*) of 1914 (fig. 71) as well as with the ubiquitous *gouttes*/drops in the *Large Glass* scenario. In this case, in particular, language seems to have generated a component of the Bachelor Apparatus—the *gouttière,* or groove, in which the Chariot as Glider was to slide.[28] Here, along with his play on *buttoir*/*butoir* (plow/buffer),was one of the sources of the humor in Duchamp's "hilarious picture."[29] He explained his interest in puns to Katherine Kuh in this way: "For me this is an infinite field of joy. . . . Sometimes four or five different levels of meaning come through."[30] Thus, the Bride's description as an *arbre type* could simultaneously evoke branching trees, automobile transmission shafts, the Virgin Mary, and even Persephone.[31]

Duchamp's pictorial invention, then, was a creative response to scientific and technological forms driven in part by language and wordplay in the Rousselian manner. However, these "new beings whether . . . of metal or flesh" suggested by *Impressions d'Afrique* and other sources also stand as remarkable and unprecedented plastic forms—when seen against the artistic lineage, including Cubism, from which Duchamp had emerged. As his numerous notes on the subject attest, Duchamp was deeply interested in the nature of both verbal and pictorial language or representation, including the character of "elementary signs" in the linguistic and visual realms.[32] In conceiving the imagery of the *Large Glass,* not only was

he reforming artistic technique by adopting the execution of an engineer; he was inventing hybrid forms that went far beyond Cubism and constituted what he termed "a kind of illuminatistic Scribism in painting."[33] "The picture, itself, is the hieroglyphic data of the Bride stripped bare," Duchamp wrote; its information was to be conveyed in a new kind of schematic visual language of signs, accompanied by an explanatory text for which he briefly considered creating an "entirely new" alphabet or "ideal stenography."[34]

By such declarations Duchamp affirmed that he was not a traditional painter interested in plastic form for itself but rather a linguist-scientist concerned with "hieroglyphic" signs and "data." In fact, he may even have considered his ruminations on the nature of signs and language as part of his scientific activity. Bergson, in *Creative Evolution,* had discussed the signs that compose a language as central to the functioning of intelligence (and scientific practice) and as yet another analytical factor impeding the experience of duration and continuity. According to Bergson, "It is of the essence of science to handle *signs,* which it substitutes for the objects themselves." Because it is "the general condition of the sign . . . to denote a fixed aspect of reality under an arrested form," signs substitute for "the moving continuity of things, an artificial reconstruction"—a tendency of which Bergson found science particularly guilty.[35]

If Duchamp's interest in signs reflects another countering of Bergsonism, his comments on the subject of "plastic" form also suggest that much of his thinking about pictorial form was a conscious rejection of the Bergsonian Cubist theory codified in *Du Cubisme.* In their text, Gleizes and Metzinger—as if setting Duchamp's program for the *Glass*—had declared: "Is not a simple Impressionist notation preferable to those compositions brimful of literature, metaphysics, and geometry, all insufficiently pictorialized? We want plastic integration: either it is perfect or it is not; we want style and not a parody of style."[36] The Cubist painter's "Taste" and sensitivity to "Beauty" had been central to Gleizes and Metzinger's conception of how this perfect "plastic integration" was to be attained. Responding aggressively, Duchamp describes his "illuminatistic Scribism" as "a plastic for plastic retaliation."[37] "It can no longer be a matter of plastic Beauty," he concludes his note describing the *Large Glass* as a "plastically imaged mixture of events," as if addressing Gleizes and Metzinger directly. Instead, each "event remains definitely only *apparent* and has no other pretension than a signification of image (against the sensitivity to plastic form)."[38]

Duchamp's "plastic retaliation" took the form of what he termed "pictorial nominalism," his transformation or "nominalization" of objects from their sources in science, technology, or elsewhere into individuals for which no universal type could be said to exist.[39] Just as he considered new alphabets for the text that would accompany the *Glass,* he sought "the *progressive* distortion of the conventional hieroglyphic phenomenon (Chocolate grinder etc.) into its nominalization which then only expresses a single [dead] idea."[40] Like the laws of physics and chemistry, his visual sources would be "slightly distended," changed, and, often, condensed by means of metonymy into hybrid objects.[41] The nominalization or distancing of these forms from their object model is particularly visible in the *Bride*. Although loosely based on the structure of an automobile (figs. 50, 51, 82), the Bride is a collage-machine made up of both organic and mechanical parts from the "dictionary" of forms Duchamp contemplated assembling from "films, taken close up, of parts of very large objects" or "photographic records which no longer look like photographs of something."[42] In addition, many of the Bride's characteristics or parts exist only verbally in Duchamp's notes, denying even the possibility of her "plastic integration" in a single form.

Duchamp's later *Box in a Valise* (fig. 166), juxtaposing as it does the *Large Glass* and its preparatory works with miniature replicas of objects chosen as Readymades, effectively points up the degree of formal invention in the *Large Glass* project. These were "two different departments" of his activity, as he stated later.[43] Duchamp's commitment to "pictorial nominalism" assured that no element in the *Glass*—even in the Bachelors' realm, with the exception, perhaps, of the Water Mill Wheel and the Oculist Witnesses—replicated an extant object from the outside world. Nonetheless, as we have seen, objects such as automobile components, meteorological instruments, lightbulbs, liquefaction apparatus, and wireless telegraphy equipment were his stimuli and were crucial to the multilayered identities and the interaction of the players in the *Large Glass*. Rather than directly depicting them, however, Duchamp invented visual signs to encode such sources in the *Glass*'s elements (accompanied by comments in the notes) or included them by verbal references in the notes alone. This relationship of actual objects to the *Large Glass* assumed another form in the case of the Readymades, a connection that operated on a more conceptual and even symbolic level.

Although the *Box in a Valise* emphasizes the formal contrast between Duchamp's two modes of activity, a close relationship nonetheless exists between the three Readymades mounted vertically in the *Box* and their counterparts in the *Glass* (see chap. 9). The ampoule of *Air of Paris* gives an alternative literal form to Duchamp's dis-

cussion of the Bride as an incandescent lightbulb (fig. 130), and there is a further allusion to the Virgin Mary by means of her traditional association with enclosed vessels (fig. 168). Similarly, the typewriter cover of *Traveler's Folding Item*, which Duchamp associated with a skirt, would appropriately clothe a message-producing Bride and parallels the Bride's Clothing in their manifestation as the mid-section glass strips associated with the *3 Standard Stoppages*.[44] Finally, the *Fountain* as hollow, molded, male object offers yet another incarnation for the Malic Molds.[45] In fact, it would seem that many early Readymades stood in a similar relationship to some part of the *Glass*: certain Readymades seem to have functioned as actual, objectified counterparts in the real world to the information signified in the "nominalized" realm of the *Glass*, which had originated in other prototype objects. Here, as in the *Large Glass* itself, Duchamp had discovered new means for conveying content. In the case of the Bride, for example, he fused multiple scientific and technological identities, including the incandescent lightbulb, in the "plastically imaged" Bride of the *Glass* and then subsequently distilled the Bride/Virgin Mary into a single, metonymical object-sign, the Readymade *Air of Paris*.

Duchamp's notes for the *Large Glass* reveal how consciously he was working to avoid the traditional genres of portrait, landscape, and still life, which still dominated even Cubism. Having included the Bottle of Benedictine as an "ironic concession to still lifes," Duchamp focused more on inventing new ways of signifying landscapes and figures.[46] His *Glass* would be far removed not only from the Cubist style but also from more traditional renderings of landscape and the figure, such as the printed landscape he adopted for his "Assisted Readymade" *Pharmacy* (fig. 167) or Jan Van Eyck's *Lucca Madonna* (fig. 168). As his notes on the subject of color reveal, he was seeking "a certain inopticity" in the *Glass*.[47] Now, for example, he would "use only the blue of the blue-print paper which architects use" rather than risking "blue in mixtures" with "its imbecile atmospheric tendency."[48] As we have seen, Duchamp, conscious of the "trap of being a landscape painter again," hid the image of the Waterfall in the "bosom" of the Chariot and indicated it only by means of the indexical recipient of its force, the Water Mill.[49] Likewise, the Malic Molds as Crookes or Geissler tubes filled with Illuminating Gas evoke metonymically rather than describe an "electric fete" at Luna Park or the Pier Pavilion at Herne Bay (fig. 80).[50] Indeed, Duchamp's "Preface" and "Notice" notes establish a conceptual, verbal landscape for the *Large Glass*: "Given: 1. the waterfall/2. the illuminating gas."[51]

Duchamp's reconsideration of the nature of landscape (and painting, in general), however, was even more radical.

Having discovered the power of "hieroglyphic" signs he now considered other more schematic ways to signify landscape:

A geographic "landscapism"—"in the manner" of geographic maps
—but
The landscapist from the height of an aeroplane— . . . The geographic landscape (with perspective, or without perspective, seen from above like maps) could record all kinds of things, have a caption, take on a statistical look.—
There is also "geological landscapism": Different formations, different colors—A mine of information!
Meteorological landscapism (Barometry, thermometry, etc.)[52]

Here Duchamp defined a new kind of scientific or technological landscape that would be concerned with information such as statistics rather than with an "imbecile atmospheric tendency."[53]

In the *Large Glass* Duchamp did achieve a kind of "meteorological landscapism" in which the Bride's meteorological functions, including "Barometry," linked her to a specific locale in Paris—the Eiffel Tower. Another example of this landscapism was his verbal evocation of "snow" and "frosty gas" in the notes on the liquefaction of the Illuminating Gas. His reference to *Pharmacy* in one of these notes suggests that its wintry scene, complete with a stream of water, might well be a Readymade embodiment of another part of the *Glass*'s conceptual landscape, particularly appropriate for the Chariot/Glider in its incarnation as Sled.[54] Such metonymical substitutions (e.g., the words "snow" for the entire landscape and Bride-as-Barometer/Weather Vane for the top of the Eiffel Tower) were central to his method.

This type of substitution reached its most graphic form in the aspect of the *Glass* that comes closest to Duchamp's description of a "geographic 'landscapism' . . . from the height of an aeroplane." The caption of Man Ray's photograph of *Raising of Dust* (fig. 123) in *Littérature* bore not only a reference to the "domain of Rrose Sélavy" as "arid" and "fertile" but also the title "*View Taken from an Airplane by Man Ray, 1921*."[55] Although the title and caption may not have been entirely Duchamp's doing, they nonetheless capture the landscapelike character of the scene that Duchamp acknowledged in the statement "My landscapes begin where Leonardo's end."[56] Whereas Leonardo had found in hillocks of dust the suggestion of fantastic scenes for the painter to invent,[57] Duchamp's dust was a landscape by metonymy—the dust serving as the indexical record of the *Glass*'s presence in his New York studio. As early as his Jura-Paris notes, Duchamp

had stated his commitment to "a state entirely devoid of Impressionism"; by means of the inventive, scientific-technological landscapism of the *Large Glass,* he achieved that state.[58]

Duchamp would have discovered the possibility of representing figures by reduced formal signs in Cubism, which had developed, in part, as a result of Picasso's discovery of the conceptual power of African art to communicate through a few key signs.[59] Yet Cubist signs had always maintained some resemblance to the body part or other element represented, displaying an "indispensable mixture of certain conventional signs with new signs," as Metzinger wrote in August 1911 and demonstrated in *Le Goûter* (fig. 169).[60] As in his exploration of "landscapism," Duchamp, in his approach to the Bride and the question of the portrait or figure, developed a system of more disembodied or purely informational signs. Although Duchamp refers to the "eyes" of the Bride, he identified them with the semicircular element or "upper part" at the top of her columnar shaft.[61] More important to Duchamp was the angle at which her "upper part"/eyes would turn toward the Juggler/Handler of Gravity. Initially he considered 35 or 40° (fig. 127), but ultimately settled on 22½°, an angle that he associated with "greek heads ¾ turned./imitated by Coysevox" and that he would "in the text recall ironically."[62] The angle was meant to express the "necessary and sufficient twinkle of the eye" (fig. 127), much like his translation of emotions into algebraic expressions.[63]

As we have seen, Duchamp also alluded to another central element of figure painting or portraiture—clothing. Typically, however, the fallen Clothing of the "stripped" Bride is embodied metonymically as the threads of the *3 Standard Stoppages* and is "present" in the *Glass* only in their association with the three glass strips at the mid-section of the *Glass.*[64] Instead of drapery as such, we see the hybrid organic-mechanical "anatomy" of the Bride, with its roots in X-ray imagery and the automobile (figs. 50, 51). In addition to making up her bodily structure, the Bride's scientific or technological components, along with her 22½° eyes, convey her personality, creating a new kind of portraiture akin to Duchamp's scientific-technological landscapism. She communicates her physiological desire metaphorically through the functioning of her automobile combustion engine, and her coolness or act of "warmly reject[ing]" the Bachelors is signified by her "refroidisseur," or cooler, linked, like her clothing, to the mid-section of the *Glass* (fig. 88). That cooler further resembles the electrical condenser (fig. 89) that would have been necessary to produce her "splendid vibrations" and her emission of sexually charged, spark-generated commands.[65] The Bride's identity as a Weather Vane suggests changeability, as she swings in the wind currents she herself has generated. And, finally, her incarnation as Wasp reaffirms her dominance in the scenario being played out with the Bachelors below.

Duchamp's comments on the half-moon "upper part" of the Bride suggest another aspect of his formal inventiveness and his anti-Cubist iconoclasm in the *Large Glass*: an interest in symmetry. In one of his illustrated notes on the Bride as Weather Vane (fig. 144; app. A, no. 14/15), Duchamp writes, "The eyes or upper part of the 'hanged' have a general shape recalling that of the chocolate grinder (head)," adding at the side the notation, "extract a sort of principal form on which the entire picture rests."[66] In fact, if one formal element is pervasive in the *Glass*, it is the inverted semicircle, which undulates across the top of the three principal units of the Bachelor Apparatus. In a *Green Box* note Duchamp stated: "The sieves (6 probably) are semi-circular parasols, with holes. [The holes of the sieve parasols should give in the *shape of a globe* the *figure* of the 8 malic molds, *given* schematic. by the 8 summits (polygon concave plane). by subsidized symmetry]."[67] Another note, published posthumously, affirmed this notion once Duchamp had changed from eight molds to the familiar nine: "On each cone there are 9 *imperceptible* holes which together form the same figure as the 9 malic molds (diagram) a sort of polygon. . . ."[68] Completing this circular rhyming would have been the Weight with Holes (i.e., "9 holes having the shape of the 9 molds") through which the Splash was to pass.[69] Even when the Oculist Witnesses were later substituted at the right side of the *Glass*, they, too, offered a semicircular top profile.

Here, then, was Duchamp's "subsidized symmetry"—distinct from the "principle of subsidized symmetries" in his playful mechanics that governed the interaction of the Bride and the Juggler/Handler.[70] Unlike the "complex rhythm" and "plastic integration" of a Cubist surface, Duchamp conceived aspects of the composition of the *Large Glass* in terms of subtly rhyming geometric shapes and numerical relationships, an approach that might be associated with more traditional modes of painting.[71] That symmetry was further "subsidized" by the chance cracking of the *Glass* in 1931, which Duchamp welcomed not only as a manifestation of chance but also because the curvilinear patterns of cracks "have form, a symmetrical architecture."[72] In the 1960s, Duchamp explained his purposeful introduction of symmetry to Dore Ashton: "Since asymmetry dominated from 1870, I re-introduced symmetry in order to use something not accepted at the time."[73] He might have said the same thing of his resurrection of perspective for the lower half of the *Glass*: this was yet

another iconoclastic kind of formal invention that challenged the Cubist avant-garde's notion of what was acceptable.

Like "subsidized symmetry," Duchamp found in the number three "a kind of architecture for the Glass"; as he told Arturo Schwarz, "It gave the Glass some sort of unitary organization, at least as far as its technical elaboration was concerned."[74] Or, as he explained to Cabanne, "For me the number three is important . . . from the numerical, not the esoteric, point of view: one is unity, two is double, duality, and three is the rest."[75] Duchamp's preoccupation with three and sets of three, which led him to increase the Malic Molds to nine, can also be understood as specifically anti-Bergsonian.[76] "The numb. 3. taken as a refrain in duration—(numb. is mathematical duration," wrote Duchamp in his "General notes. for a hilarious picture," celebrating the numbering and resultant cutting up of duration that Bergson decried.[77] Despite the Puteaux Cubists' initial devotion to mathematics and geometry, by late 1912 such mathematical concerns, along with simple decorative rhythms, symmetry, and perspective, were an affront to the Bergsonist theory codified in *Du Cubisme*.[78]

Duchamp later described the *Large Glass* as a "renunciation of all aesthetics," a statement typical of his tendency to say what the *Glass* was *not*.[79] Just as his notes had stated that the form of the *Glass* "could no longer be a matter of plastic Beauty," he also declared that the content of *The Bride Stripped Bare by Her Bachelors, Even* was not just "a fight between social dolls."[80] Here and elsewhere in his notes, Duchamp provides hints of his desire to generalize the content of the *Glass* beyond specific women in his life.[81] And just as he toyed iconoclastically with such dangerously traditional forms as symmetry and perspective, finding new ways to use them in the twentieth century, he took on the issue of allegory, seeking to make of the *Glass* an "allegorical appearance" couched in the language of science and technology.[82]

The *Large Glass* as a Scientific-Technological Allegory of Love and Life: The Virgin, Persephone, and the Eiffel Tower

An allegory "says one thing and means another" and, according to the third-century rhetorician Longinus, stands as a "fresher expression of a different kind."[83] Duchamp's commentary on human sexual relationships in the *Large Glass*, undoubtedly rooted in his personal experience, recasts the theme of sexual desire in terms of a "mixture of events" in the realms of science and technology. As Duchamp's "Preface" and "Notice" notes establish, it is

the "allegorical appearance" or "allegorical Reproduction" of "several collisions" that will be presented in the *Glass*.[84] Thus, the Bachelors' "inaccessible request"[85] or quest for the Bride is presented as a series of collisions in the realms of geometry (three- versus four-dimensional spaces) or science and technology (e.g., the basic contrast between the gravity-bound mechanics of the Bachelors versus the etherial, wave-borne activities of the Bride with her additional organic qualities). More literal, ballistic collisions, at scales ranging from subatomic and molecular collisions to target shooting also pervade the events of the *Glass*.[86]

Despite Longinus's notion of a "fresher expression," by the time Duchamp contemplated fusing science and technology with allegory, the use of female allegorical figures to express new scientific or technological developments had become hackneyed.[87] Artists as well as advertisers (figs. 133, 184, 185) used old language and conventions to embody new ideas. Robida, for example, had personified electricity as a female nude, the "great slave" powering contemporary society (fig. 46), and Mlle Dufau, in a mural for the Sorbonne, interpreted the themes of radioactivity and magnetism in terms of sexual attraction and the embrace of a female "earth" by the male "sky" (fig. 34).[88] Duchamp, however, inverted the equation, wittily recasting the age-old interaction of the sexes in the new languages of science and technology. In addition to the collision metaphor, sexually charged metaphorical substitutions abound in the *Large Glass*—from the Bride's gasoline engine and electrical sparks and vibrations to the responsive glow of the Bachelors' neonlike Illuminating Gas, the phallic thrusting of the Chariot/plow, the attendant liquefaction of gases into an "erotic liquid," and the explosion of desire in the never-executed Desire Dynamo.[89]

The Italian Futurists had warned against using the nude as an allegorical figure and "deriving the meaning of the picture from the objects held by the model."[90] Even though certain Puteaux Cubists had painted allegories (e.g., Henri Le Fauconnier's 1910–11 *Abundance* [Gemeentemuseum, The Hague]), by 1912 Gleizes and Metzinger had firmly rejected the use of "any allegorical or symbolic artifice" and argued instead that their message could be expressed "with only inflections of lines and colors."[91] Even if Duchamp shared the Futurists' disdain for the traditional allegorical nude, he seems once again to have challenged Gleizes and Metzinger by overtly declaring his interest in allegory (and literature) and by rejecting the painterly inflections of surface or "plastic integration" they extrolled.[92] Only in the Bride's pseudo-Bergsonian "cinematic blossoming," which

Duchamp signalled ironically as "the most important part of the painting (graphically as a surface)," would he attempt to express "the last state of the nude bride before the orgasm," in "a completely different way from the rest of the painting."[93] Although there was "no question of symbolizing by a grandiose painting this happy goal—the bride's desire," he would nonetheless pursue an "allegorical reproduction" in his newly invented "hieroglyphic" pictorial language and its counterpart in his written notes.[94]

In contrast to Gleizes and Metzinger, the poet Apollinaire, Duchamp's compatriot in this period, touted allegory as an appropriate form for the modern writer or artist: "Allegory is one of the noblest forms of Art. Academicism had reduced it to a banal figment of the imagination, yet nothing is innately more in harmony with nature; indeed, our brain can hardly conceive of compound things except through allegories."[95] As suggested earlier, it may well have been Apollinaire's example that encouraged Duchamp to develop a second level of meaning for both his biomechanical Bride and mechanical Bachelors, raising them above the level of a sexual relationship or simply a "fight between social dolls" conveyed in scientific-technological terms.[96] With Duchamp's Bride in her alternative identity as Virgin Mary/Bride of Christ (or as Persephone), suspended in her unreachable four-dimensional "heavenly" realm, the collision theme of the *Glass* seems to embody a commentary on the conflict between the finite and the infinite, the striving for the beyond or some higher, ideal state that is a leitmotiv throughout Western culture—from Plato and classical mythology to Christianity. In religion and myths, the act of ascending often signifies the attainment of an ideal state, an implied perfection that in the *Large Glass* is contrasted to the Bachelors' mensurated, "imperfect" forms.[97]

In his Jura-Paris Road notes, Duchamp expressed the quest for the infinite as the transit of "5 nudes" or Bachelors in an automobile/"machine-mother" on a road that becomes a "pure geometrical line without thickness," the Christ-like "headlight child" serving as intermediary and an "opening towards the infinite."[98] In the *Large Glass* the role of intercessor is played by the Handler/Juggler of Gravity and the Virgin/Bride exists beyond the reach of the Bachelor/travelers of the "Jura-Paris Road" in a four-dimensional realm associated with infinity. She is the "married divinity" in contrast to the "celibate human," and Duchamp recasts the divine/human distinction in various scientific and technological metaphors as well as in the basic geometric contrast between four and three dimensions.[99] The Bride possesses an organic "life center" (including her "emanating ball"), whereas the Bachelors

have no "life center . . . and live on coal or other raw material."[100] Unbeknownst to Duchamp, Henry Adams, too, had found a metaphor in contemporary technology—the whirling dynamo as a "symbol of infinity"—to express the power of the Virgin Mary as a cultural force in Europe, a force still "as potent as X-rays."[101] Duchamp, however, was far more iconoclastic as he transformed his Virgin/Bride into a hybrid creature of science and technology: the combination X-ray image/chemical apparatus/automobile/organic automaton/wireless telegraphy emitter and receiver/barometer and weather vane/incandescent bulb/wasp.[102]

"We had to be iconoclastic then," Duchamp stated in a 1959 interview, even admitting that he was "a little ashamed" of what he had done.[103] Apollinaire, scholar of erotica, mythology, and world religions, must have been an inspiration for Duchamp in this regard, having blended in his poetry religion and sexuality as well as the old and the new.[104] In *Zone*, for example, Christ as modern aviator gave technological form to the upward motion that characterized the Icarus-like striving Apollinaire explored in religious and sexual terms. His mistress, Marie Laurencin, was the Madonna to his Christ, just as the passionate love poems of the biblical Song of Songs had long been associated with the Virgin Mary as Bride of Christ.[105] As Julia Fagan-King has suggested, in 1908 Apollinaire believed the goal of the modern poet to be the "incorporation of the past, the present, and the future in one ecstatic unity, a revelation of eternal truth."[106] Duchamp's tone was ultimately far more detached and ironic, more akin to Jarry's than to Apollinaire's messianic quest for eternal truth. Nonetheless, from at least the Jura-Paris trip onward the humorous possibilities of the mix of sexuality, religion, and science-technology would have been highly apparent to Apollinaire, Duchamp, and Picabia. As in the creation of the Virgin/*arbre type* as transmission shaft, Duchamp's transformation of the Queen of Heaven into a queen bee/wasp, based on the writings of Fabre and Gourmont, would have delighted Apollinaire, a fellow admirer of these two writers.[107]

In his section on Duchamp in *Les Peintres Cubistes,* Apollinaire had compared the modern-day escorting of Blériot's airplane to the Arts et Métiers to fourteenth-century religious processions carrying Cimabue's paintings (see chap. 2).[108] Indeed, the Musée des Arts et Métiers offered another model for the fusion of religious icons and objects of modern technology: Blériot's plane and contemporary automobiles and motors were displayed in the chapel of the old priory that served as part of museum's quarters. Here, too, was Eiffel's model for the torch-bearing Statue of Liberty, a modern engineering marvel evok-

ing Demeter, Persephone, and the classical tradition.[109] Offering a survey of ancient and modern technologies, the Arts et Métiers juxtaposed past and present and offered within the chapel a suggestive substitution of scientific and technological objects for religious icons as objects enshrined for society's veneration.

Although in an early drawing (fig. 81) Duchamp had signified the Virgin/Bride by an image resembling the Madonna, he quickly returned to the automobile-based *arbre type* of his *Virgin (No.1)* drawing and *Bride* painting of summer 1912 (figs. 50, 51, 17; pl. 3), which he augmented in his new, "hieroglyphic" language of images and, particularly, in his written notes.[110] In the same automobile-oriented note in the *Green Box* in which figure 81 appears, Duchamp refers twice to the "bride" or "bride motor" as the "apotheosis of virginity" and identifies the Bride's "cinematic blossoming" as her "halo." Duchamp's subsequent talk of "put[ting] the whole bride under a glass cover" raised the prospect of her identity as observed insect (figs. 134, 135) and her incarnation as sealed incandescent bulb evoking the Virgin Mary as enclosed vessel (figs. 166, 168). Because of Duchamp's interest in Gourmont's writings and contemporary awareness of Jacques Loeb's work on artificial parthenogenesis, his specimenlike "bride under a glass cover" (as well as his visual treatment of the Bride as a Loeb-like "chemical machine") may also stand as a humorous allusion to the Immaculate Conception of the Virgin Mary.[111] Finally, Duchamp's statement that the Bride "uses the elevator of gravity at will" suggests a technological updating of the Assumption of the Virgin, to which the *Large Glass* has been compared in the past.[112] Mary's apotheosis-like Assumption gave her ubiquity or the ability to appear miraculously anywhere, and her four-dimensional existence in the *Glass* expressed the same power in geometric terms vis-à-vis the three-dimensional Bachelors.[113]

Duchamp not only layered scientific or technological identities one over another in his invention of the *Large Glass*'s components but also multiplied the allegorical associations of these elements. Thus, to the Bride's basic identity as woman, Duchamp seems to have added characteristics not only of the Virgin Mary but also of Persephone.[114] Through Apollinaire or other sources Duchamp may have known of the traditional association between the Virgin Mary and Persephone and her mother, Demeter, whose identity was so closely tied to her own.[115] If the Bride's ready access to the "elevator of gravity" suggests the Virgin Mary's Assumption, it also evokes Persephone's ability to escape (at least for six months of the year) the underworld kingdom of her "Bachelor," Hades. Just as the Malic Molds form an underground "Cemetery

of Uniforms and Liveries," the Chocolate Grinder wears "half-mourning," a term that describes the attire of the second stage of official mourning but that suggests Persephone's half-year absence from Hades's realm.[116] Adding yet another classical allusion, Duchamp describes the Bachelors as suffering the "Torture of Tantalus," whose everlasting thirst and hunger was produced, in part, by a tree branch that constantly blew out of reach when he tried to pick its fruit.[117] As a fertility goddess associated with trees, Persephone may also be evoked in Duchamp's Bride as a blossoming *arbre type* that evades the grasp of the Bachelors as Tantalus.

Like the Virgin Mary, Duchamp's modern Persephone is equally a mechanical *arbre* or transmission shaft and is encoded in technological terms in the *Glass*. The incandescent bulb as sealed vessel, which served as an updated symbol for the Virgin, was also a modern torch, evoking the tradition of light-bearing females rooted in the myth of Demeter and Persephone (figs. 133, 163, 184, 185). Linked to the activities of the Bachelors' "agricultural machine" as *buttoir*/plow (figs. 161, 162), Persephone is also suggested in Duchamp's merging of the automobile, electricity, and agriculture in the "irrigation law of the desire-magneto" he posits for the Bride.[118] And, like Duchamp's original wordplays on *arbre de transmission* and *buttoir*/plow, Persephone offered an extension of his Rousselian variations on *goût* and *gouttes*. In discussing Demeter and Persephone in *Origine et ésthétique de la tragédie* of 1905, Péladan, for example, noted that Persephone's fate was sealed when she tasted [*a goûté*] the fatal pomegranate."[119]

In his allegorical references to personages and themes in Western culture, Duchamp displayed erudition and humor comparable to his scientific and technological inventiveness.[120] A ritual bath of purification, suggested by the Bride's "bathtub" and "bath heater," is a longstanding theme in the Christian and classical traditions, although the more central theme in the *Large Glass*, that of stripping, is not generally associated with these traditions or with the Virgin Mary or Persephone.[121] Stripping and a ritual marriage bath do, however, figure in the alchemical tradition, which would still seem to be the most direct source for Duchamp's original conception of the image of the "Bride Stripped Bare by the Bachelors" in his Munich drawing of summer 1912 (figs. 31, 32). Like the attributes of the Virgin Mary and Persephone, Duchamp recasts these themes in terms of modern science and technology. Beyond the Bride's possession of a modern heated bathtub, the stripping, translated into the ballistic collisions of radioactive particles, is figured in the language of chemistry, physics, and, ultimately, elec-

tricity in the *Glass* as a painting of (electromagnetic) frequency.[122] Like Apollinaire, who not only identified his mistress with the Virgin Mary but called her his "alambic," or alembic, Duchamp gave his Virgin/Bride the look, in part, of a chemical apparatus.[123] Indeed, alchemy, newly energized in this period by the discovery of radioactivity, was itself an elaborate allegorical system and another aspect of Western culture that could be evoked, if only briefly, in the *Large Glass*. Significantly, alchemy had functioned as an image-text system, in which, for example, the seventeenth-century *Exposition of the Hieroglyphicall Figures*, attributed to Nicolas Flamel, offers a suggestive model for Duchamp's conception of the *Large Glass* as the "hieroglyphic data of the Bride stripped bare."[124]

Duchamp added another possible association for the stripping theme in the *Large Glass* when he remarked in interviews in 1945 and 1959 that there was a "naughty" connotation to the *Glass* because Christ, like the Bride, was "stripped bare."[125] It is the self-confessed naughtiness that is perhaps the most important component of this statement, pointing up, as it does, the iconoclasm that would lead Duchamp to include a priest as the first of the sexually desirous Malic Molds (fig. 77) or, later, to propose a "Christ glued on an automobile carriage window with the paw serving for lifting the glass."[126] Awareness of this humorous, irreverent stance is crucial to any consideration of Duchamp's use of religious themes, including the Assumption of the Virgin, to which the *Large Glass* was first compared by Harriet and Sidney Janis in 1945. In an article for the special Duchamp number of *View*, the Janises prefaced their suggestion of the relevance of images of the Assumption to the *Glass* with the statement that "all of Marcel's human mechanism pictures are both playfully and seriously ironical in their implications."[127] Subsequent commentators, however, have often taken the comparison more literally, implying at times the presence of a deeper religious content in the *Glass*.[128] Yet Duchamp's discomfiture at readings of the *Glass* as a "religious painting" is particularly apparent in his 1966 interview with Ron Kitaj, Richard Hamilton, Robert Melville, and David Sylvester, in which he continually answered queries proposing some sort of generalized religious content with an uneasy "Hmm."[129]

Indeed, when Duchamp drew on traditions such as Christianity, classical mythology, and alchemy, his attitude was as a detached observer rather than as an advocate. In the *Large Glass*, then, he was not "practic[ing] alchemy"—a subject hardly alluded to in his extensive notes.[130] Nor was the *Glass* a celebration of the classical tradition or a veneration of the Virgin Mary. It was about the relationship (in the sense of a ratio) of two incommensurable types of entities and the collision and frustration of aims between the lower and upper halves of the expression. Couched in a scientific and technological language rich in metaphor and metonymy, the *Large Glass* could at the same time comment on human sexual relationships and on humankind's quest for a sacred or secular *au-delà*, or beyond, expressed as the Bride's four-dimensional realm. It was a vehicle by which Duchamp could define himself as engineer-scientist while further transgressing the strictures of Cubist theory to engage the past in a creative manner—just as he had done with perspective and symmetry. In the *Large Glass* project Duchamp could test his newly invented artistic language on the grand themes of Western culture, recasting them on the model of his friend Apollinaire's syncretic vision of old and new. Here Duchamp also parallels the poets Ezra Pound and T. S. Eliot in their recognition of the uses of the past for their modernist poetry—what Eliot later termed the "historical sense . . . not only of the pastness of the past but of its presence."[131]

Unlike Apollinaire and the English poets, however, Duchamp's tone was deliberately ironic and humorous. It was free of the pessimism of Michel Carrouges's interpretation of the Bachelor Machine as a double-edged instrument of sexuality and death, which Duchamp essentially denied in a 1945 letter published in the Surrealist periodical *Medium*. There Duchamp asserted that the phrase "machine célibataire" did not signify an "intentionally mythic theme," as Carrouges had interpreted it.[132] Instead, the mood was closer to that of Jarry, who had humorously envisioned "The Passion [of Christ] as an Uphill Bicycle Race."[133] Once the scientific and technological components of the *Large Glass* are rediscovered, it would seem that Duchamp, like Jarry, modernized and even localized a specific sacred event. As we have seen, many of the scientific and technological components of the *Glass* are related to Gustave Eiffel's experimental activities at the Eiffel Tower. If Jarry transformed Christ's passion into a bicycle race, Duchamp, whose Bride "uses the elevator of gravity at will," may have conceived the Assumption of the Virgin as an Elevator Ride up the Eiffel Tower.[134]

Roland Barthes, writing in 1964, described the Eiffel Tower as a "pure—virtually empty—sign" that "means everything."[135] In the early years of the century, however, the tower bore far more specific associations as a result of Eiffel's aggressive campaign to assure its continued existence by making it into a renowned scientific laboratory. Although for Barthes the uses Eiffel proposed "seem quite ridiculous alongside the overwhelming myth of the Tower," those scientific or technological activities, partic-

ularly wireless-telegraphic communication of time signals, news, and weather conditions, were central to its meaning in the pre–World War I era.[136] The do-it-yourself articles on how to tune in the signals from the tower on one's balcony document the popular fascination with the new communication and its relevance for individual Parisians.[137] Just as poets responded to the tower's technological connotations, so Duchamp seems to have purposely incorporated a number of its experimental operations into the *Large Glass*, subtly localizing certain events at the Eiffel Tower through his metonymical "landscapism."[138] As noted, the relevant scientific and technological aspects of the Eiffel Tower include wireless telegraphy antennae (for both emitting and receiving) and the codes transmitted (figs. 101–4); the electrical condensers atop the tower that made spark telegraphy possible, condensers (fig. 89) whose stacked glass plates are paralleled in the encased *3 Standard Stoppages* (fig. 68) and the Bride's Clothing (fig. 88);[139] barometers and weather vanes (figs. 126–29); the powerful lightning sparks the metal structure attracted; the tower's displacement by wind; the beacon light at the top (fig. 184); and Eiffel's aerodynamic experiments with weights dropped from the tower (figs. 111, 156C, 160). If the tower's beacon was identified with a modern lamp-bearing nymph in advertisements (fig. 184), Duchamp, in typical fashion, embodied his Bride/Persephone only in verbal descriptions of her functions as an incandescent bulb.

One further aspect of Duchamp's evocation of the tower derives from one of its more poetic and metaphorical identities. In his 1913 poem "Tour," Blaise Cendrars, one of the poet enthusiasts of the wireless telegraphy at the tower, referred to the structure as a *gibet,* or gallows: "In Europe you're like a gallows/(I would like to be the tower, to hang on the Eiffel Tower!)."[140] Cendrars's poem "La Prose du Transsibérien et de la petite Jeanne de France," also of 1913, concluded, "Paris/City of the incomparable Tower of the Rack [*grand Gibet*] and of the Wheel," linking the tower and the Grand Roue ferris wheel that likewise dominated the skyline of Paris in those years.[141] Although Duchamp uses the term *potence* rather than *gibet* in his three notes on the Bride that refer to a gallows or gibbet, his usage would seem to derive from this same contemporary allusion to the Eiffel Tower as a gallows.

In his ten-page *Green Box* note laying out the composition and developing the Bride's automobile identity, Duchamp stated that "a shiny metal gallows [*potence*] could simulate the maiden's attachment to her girl friends and relatives." Two versions of another posthumously published note clarify the gallows or gibbet further:

"*Gibbet*—this gibbet taking root on the insulator (or on solid ground) is the only support of the entire *bride*. such that *she* will really have the look of a rattle."[142] Duchamp's gallows or gibbet, then, is not an instrument of death but rather a technological metaphor for the "maiden's attachment to her girl friends and relatives." Given the Eiffel Tower's poetic association with the gallows theme, his terminology would seem to be one more aspect of the Bride that locates her, if anywhere, at the top of the Eiffel Tower. This modern, technological Virgin/Bride hangs, free of the effects of gravity, from a mastlike "gallows," emitting signals to the world below from the "emanating ball" at her "life center" (fig. 101). And, if she has experienced an Assumption, it would certainly have been by the latest mode of vertical transport—the *ascenseur*, or elevator.[143]

Unlike Robida's allegory of electricity (fig. 46), which carefully illustrated the new technology of communication, that technology is largely invisible in the *Large Glass*. Similarly, compared to Apollinaire, Cendrars, and Delaunay, who acclaimed the Eiffel Tower publicly in poetry and paintings (figs. 83, 84), Duchamp was far more oblique about his interest in the Eiffel Tower. In typical fashion, he used his newly gained expertise in science and technology to incorporate the tower subtly and humorously in the *Glass*. In doing so, Duchamp further distanced himself from Puteaux Cubist painting, such as that of Delaunay, as well as from the romantic glorification of the tower, as expressed by his brother Duchamp-Villon. In his 1913 essay on the Eiffel Tower, Duchamp-Villon exuberantly likened the tower to the cathedral of Notre Dame, proclaiming them products of the "same boundless ambition always to achieve the greater, the taller, the more daring."[144] The two structures "fulfill a dream of superhuman exaltation," he wrote; the tower, in addition, "makes a point of infinity tangible for man."[145] The younger Duchamp, in his typically detached and ironic manner, fused the themes of the Virgin of Notre Dame and the tower in the four-dimensional, infinite realm of the Bride of the *Large Glass*. Here sexual and spiritual striving were joined in Duchamp's allegory of quest, in which the Eiffel Tower, science, and technology themselves were not the subject (as in Delaunay's or Robida's case) but rather the vehicle for his message.

From the moment the design for Eiffel's tower was first unveiled, it was the object of scorn. A protest published in *Le Temps* in February 1887, as "Artists against the Eiffel Tower," railed against the "useless and monstrous Eiffel Tower," all "in the name of *unappreciated French taste*, in the name of French art and history." Further, the prominent signatories, including Charles Garnier, the architect of the

Paris Opéra, challenged Eiffel's credentials: "Is the City of Paris going to continue to maintain an association with the baroque commercial imaginings of a *builder of machines*?"[146] Although Duchamp-Villon defended its innovative architecture on aesthetic grounds in "L'Architecture et fer," his younger brother would have found in the protests against Eiffel the very credentials he was seeking to establish for himself: a builder of machines operating beyond the bounds of French taste. As suggested earlier, the engineer-inventor Eiffel, who also functioned outside the realm of official French science, undoubtedly served as one of Duchamp's several role models in his self-fashioning as artist-engineer-scientist. Thus, if the Eiffel Tower offered Duchamp a rich supply of iconographical elements for the *Large Glass*, it was also important because of the person of its inventor.

We have come full circle to the theme of invention. While Duchamp clearly associated invention with the realms of science and technology, in the late nineteenth century the term was also utilized in art theory and criticism. Interestingly, a number of Duchamp's attitudes evidenced in the *Large Glass* project parallel the invention-oriented side of an opposition Richard Shiff has identified in art writing of the late nineteenth century. That basic contrast between "making" (associated with "inventiveness") and "finding" (linked to "genius") tended to privilege the contemporary painter as a radically original "finder" versus the traditional or academic artist as merely a creative "maker."[147] In his determination to separate himself from his Cubist colleagues, Duchamp was willing to transgress modernist prohibitions against traditional techniques and practices such as perspective, symmetry, and allegory. Indeed, certain of Shiff's oppositions between the inventive maker and the genius/finder read as if describing Duchamp's opposition to Cubism and the modern painting he dismissed as "retinal" and overly concerned with artistic touch:

To think or philosophize is to make, to see is to find; to refer or relate a given thing to another is to make, to present or express some thing is to find. . . . The hierarchical composition was made, the uniform surface was found; the finished surface seemed made, the unfinished found; the historical or allegorical subject was made, the modern-life or landscape subject was found; makers used line, finders preferred color.[148]

Given his goal of "put[ting] painting once again at the service of the mind," Duchamp sought to present a complex series of relations, both between the upper and lower halves of the *Glass* and within those realms themselves as he invented the multiple components of his collagelike machines.[149] There would be no unfinished surfaces but rather the model of mechanical drawing's detached line, free of taste, now embodied as lead wire. In contrast to the emphasis on color in Fauvism and even Puteaux Cubism, Duchamp declared of his project, "There are no colors in the *coloration of a surface* sense"; instead the *Glass* would be characterized by "inopticity."[150] Finally, the work would be an "allegorical appearance," engaging the past and recasting it in a new scientific and technological idiom. "I was really trying to invent, instead of merely expressing myself," declared Duchamp, the maker, to Katherine Kuh in 1962.[151] And, indeed, Duchamp was a new kind of maker for the twentieth century: his cool, precise pictorial language, minus its complex intellectual content, would become a widely practiced alternative to the direct self-expression that nineteenth-century critics had associated with the modern painter as genius-finder.[152]

In his 1964 lecture "Apropos of Myself," Duchamp used the phrase "inventiveness and pataphysics" to characterize "another form of activity that followed alongside my painting."[153] Although in the lecture he illustrated this notion only with his *Raising of Dust* on the *Glass* (fig. 123), the *3 Standard Stoppages* (fig. 68), and Readymades, the *Large Glass* itself was the major arena in which Duchamp explored "inventiveness and pataphysics." Unlike the Readymades, however, such an interpretation of the *Glass* required knowledge of his complex ruminations in a multitude of notes, the content of which could not be easily communicated in a lecture. Based on the study of the notes in the preceding chapters, the second part of the conclusion proposes an overview of Duchamp's use of science and technology in the *Large Glass*, along with a consideration of his attitude toward science itself and the way he fashioned his identity as playful engineer or scientist in the course of his project.

Chapter 13

Conclusion, II

An Overview of Duchamp's Playful Science and Technology in the *Large Glass* and Related Early Works

The phrase "continuum of points of magnetization or of repulsion" appears in one of several notes in which Duchamp set up laboratory-like experiments with falling objects meant to explore the effects of chance and indifference.[1] Such a magnetic continuum offers an effective model for his relationship to science. Duchamp's self-fashioning as artist-engineer-scientist during the course of the *Large Glass* project derived in part from the "magnetism" of certain aspects of science and technology, for example, the value placed on the inventive capabilities of the mind and on precision in thinking and practice. At the same time, he undoubtedly found these qualities attractive because of his growing repulsion toward Bergsonian Cubist theory as it was ultimately codified by Gleizes and Metzinger in *Du Cubisme* by late 1912.

From Bergsonian Cubism to Science and Invention: A "Continuum of . . . Magnetization or of Repulsion"

Initially Duchamp's interest in new developments in science, such as X-rays and radioactivity, and in four-dimensional and non-Euclidean geometries had been a means to identify *with* the Cubist avant-garde. But by 1913 his self-construction as artist-engineer-scientist or artist-geometer served as a declaration of independence from the art world. Conversely, his humorous critique of scientific laws and determinist causality assured a degree of freedom from the magnetic pole of science. Like the approach of his mentors Jarry and Roussel (and unlike that of Flaubert's Bouvard and Pécuchet), his was a selective adoption of science, not an unconditional embrace. This attitude toward science paralleled his views on Cartesianism: drawn to this philosophy "as a form of thinking—logic and very close mathematical thinking," Duchamp also valued "getting away from it."[2]

Although the term *invention* possessed artistic associations in turn-of-the-century art criticism, Duchamp preferred invention in the fields of technology, science, and mathematics as the model for his own activity. Frederick Kiesler's three-page photographic montage of the artist's New York studio for the special Duchamp issue of *View* in March 1945 (fig. 179) made clear that this was not the workplace of a traditional painter. Instead, Duchamp, seen behind a transparent overlay of the *Large Glass*, projects the air of an inventor ensconced in his workshop, surrounded by whatever gadgets he might need—none of them paints or brushes. To ensure the message of the photograph, Kiesler (undoubtedly with Duchamp's help) added parallel schematic "genealogies" on the back of the fold-out pages, which feature the phrases "Marcel D.—born 1887—*artiste-inventeur*" and "R. Roussel—born 1877—*artiste-inventeur*."[3] Similarly, on the first page of the *View* issue Breton proclaimed Duchamp's inventiveness, just as earlier authors had celebrated the intellectual powers of Leonardo. Referring to a number of Duchamp's recent activities, including his design of the *View* cover, Breton argued that these works "continue to bear witness to the absolutely exceptional span of his imaginative compass and mark his unshakeable fidelity to the sole principle of *invention, mistress of the world*."[4]

In 1915 Duchamp staged his first photographic portrait as antipainter, in the photograph taken in New York for *Literary Digest* (fig. 74); at the time Leonardo was his most immediate model of an individual who spanned the worlds of art and science. The publication of Leonardo's notes, beginning in the 1880s, had revealed the scientific side of the painter, resulting in universal praise for his force of intellect and his ability to "invent" in the fields of science and technology.[5] These were the mental powers of invention—celebrated in the scientist or engineer but denigrated by art critics of the period who preferred "finding" over "making"—that Duchamp evoked in his later statements about "exploring the mind more than the hand."[6] Julien Levy's comments on this subject are particularly relevant here: "Marcel wanted to show that an artist's mind, if it wasn't corrupted by money or success, could equal the best in any field. He thought that, with its sensitivity to images and sensations, the artist's mind could do as well as the scientific mind with its mathematical memory."[7]

In 1915, Duchamp's *Literary Digest* photograph and his statements in interviews about the need for a "scientific" art created an image of the artist as thinker, embarked on

a voyage through science and mathematics as well as technology.[8] Thirty years later he appears in the 1945 *View* photograph in the guise of a tinkerer or technician. By 1945 Duchamp had actually functioned for a fifteen-year period (1920–35) as the designer-"engineer" of various optical machines, beginning with the *Rotary Glass Plates (Precision Optics)* of 1920 (fig. 174). In 1935 he had even presented himself to the public as a bona fide inventor at the Salle des Inventions of the Concours Lépine inventors' fair, marketing without much success his *Rotoreliefs (Optical Discs)* (figs. 178A, 178B).[9] It was this image of technician or modest engineer that Duchamp cultivated in later life, downplaying his earlier knowledge of science or mathematics. Yet, as Levy's comment documents and as Duchamp's notes and the analysis in the preceding chapters establish, he had been actively engaged in invention based on science and mathematics as well.

These two types of invention, that of the engineer or technician versus that of the scientist or mathematician, reflect, to some degree, the lessons Duchamp had learned from Roussel and Jarry. Roussel's linguistic engineering of fantastic new machines, often based on contemporary developments in science and technology, had been important primarily for Duchamp's invention of the verbal and pictorial forms of the *Large Glass*. In contrast, Jarry's pataphysics had been concerned with inventing humorous new scientific laws and procedures. Drawing more deeply than Roussel on recent science, Jarry endeavored to provide a model of witty, inventive creation at the level of the structure of science and mathematics. At the same time, he, like Roussel, designed new mechanisms, particularly machines with sexual overtones, such as the "machine-to-inspire-love" in *Le Surmâle*.

Between Duchamp's portrait photographs of 1915 (fig. 74) and 1945 (fig. 179), the *Large Glass* stands as his greatest act of self-definition and therefore as another kind of self-portrait. Even the French title of the work, *La Mariée mise à nu par ses célibataires, même*, which includes the pun "*Mari*ée" and "*Cél.*" (fig. 81), functions as a type of self-portrait.[10] But Duchamp's redefinition of himself in the *Large Glass* was far more extensive than this simple pun; the *Glass* was the most tangible evidence of the visual/verbal project by which he declared his opposition to Cubism and his allegiance to Roussel and Jarry. Significantly, the work included not only technological invention drawn from the engineer's workshop but also elements derived from the scientific laboratory or the mathematician's study. Functioning as a "precision" engineer in the *Large Glass* project, Duchamp was also deeply engaged in formulating his personal laws of four-dimensional geometry as well as a Playful Physics

and chemistry that was far more extensive than has previously been recognized.[11]

Another of Duchamp's heroes, Henri Poincaré, may have given him particular encouragement to believe that he, too, could "invent" in the realms of mathematics and science. In his chapter "Mathematical Invention," in *Science et méthode,* Poincaré initially emphasized the importance of "a very sure memory" or "a power . . . like that of the chess-player who can visualize a great number of combinations and hold them in his memory."[12] He continued, "Every good mathematician ought to be a good chess-player, and inversely."[13] Duchamp was already a chess player in the pre–World War I years, and Poincaré's statement—along with his own success as a student of mathematics—would have supported Duchamp's venture into playful mathematical invention.[14] In the 1920s, when he largely gave up art making to play chess, that activity was clearly another means for him to declare his intellectual orientation. Chess playing functioned as a conceptual substitute for his earlier invention in the *Large Glass* or in his optical machines. According to Duchamp, playing chess was like "constructing a mechanism of some kind": it was "very plastic," but the "imagining of the movement" was "completely in one's gray matter."[15]

For Poincaré, however, a "sure memory" was not the most crucial ingredient in the mathematician's ability to invent new mathematical laws. Even more important than memory, which Poincaré confessed to be lacking himself, was what he termed the "intuition of mathematical order."[16] "Invention is discernment, choice," Poincaré declared, and what keeps the mathematician from choosing "sterile combinations" of previously unconnected facts is "a feeling of mathematical beauty, of the harmony of numbers and forms, of geometrical elegance."[17] Duchamp would surely have preferred this alternative within mathematics to Gleizes and Metzinger's pronouncements on artistic beauty and taste in *Du Cubisme*. Moreover, choice was obviously a basic theme for Duchamp in activities ranging from his Readymades to his chess playing; later he would even talk of the chess player's choices in terms of a "beauty" that is "not . . . a visual experience."[18]

Apollinaire, in his 1918 essay "L'Esprit nouveau et les poètes," declared that poets should model themselves on scientists and mathematicians, who were the truly inventive creators of the epoch. Praising the mathematician's imagination, Apollinaire, as if echoing Poincaré's language, argued that "there are a thousand natural combinations which have not yet been composed."[19] And, according to Apollinaire, a "new spirit" in poetry now "fights . . . for the opening of new vistas on the exterior and interior universes which are not inferior to those

which scientists of all categories discover every day and from which they extract endless marvels."[20] Although Duchamp's embrace of science was hardly as uncritical as Apollinaire's, he had long before adopted a similar viewpoint. By 1918 he had convincingly put it into practice in his invention of the *Large Glass*, both in preparatory notes and projects and in its actual execution.

A Review of Science, Technology, and Self-Fashioning in Duchamp's Early Works, the *Large Glass* Project, and the Readymades

Duchamp's Early Self-Construction as an Anti-Cubist, Intellectual Artist

As a young painter in 1911 Duchamp had adopted the style of the Puteaux Cubists, along with their commitment to revealing the hitherto invisible realities or "new vistas" that had been discovered by contemporary science.[21] The newly transparent, fluid forms he began to utilize were a clear marker of his adherence to the style and of his membership in the Puteaux circle. Yet, Duchamp's friendship with Kupka had already exposed him to other aspects of that new, invisible reality, so that even from the start he included in his paintings evidence of his knowledge of X-rays, such as the "X-ray noses" in *Yvonne and Magdeleine Torn in Tatters* (fig. 9). By late 1911 and early 1912 he was consciously differentiating his work from standard Cubist practice, as he explored the humorous implications of X-ray stripping and, especially, the issue of motion, in works such as *Nude Descending the Staircase (No. 2)* (fig. 12). Like Kupka, Duchamp was to acquire a knowledge of the new science that would go far beyond his colleagues. Already he had discovered that he could define his position vis-à-vis Cubism or the realm of science by including particular formal signs within his painting.

Duchamp incorporated his first overtly non-Cubist sign—the dotted line associated with both chronophotography and mechanical drawing techniques—in a painting destined for a limited audience: the *Coffee Mill* (fig. 41), painted for Duchamp Villon's kitchen in December 1911. When his January 1912 *Nude Descending the Staircase (No. 2)* was first exhibited publicly (after its removal from the Salon des Indépendants at the behest of Gleizes and company), Jacques Nayral described the work in terms that must have pleased Duchamp. Writing in the catalogue of the Cubist exhibition at the Galeries Dalmau in Barcelona, Nayral declared, "The mathematical spirit seems to dominate Marcel Duchamp. Some of his pictures are pure diagrams, as if he were striving for proofs and syntheses."[22] During the first half of 1912 Duchamp continued to use

such dotted and dashed lines in his paintings; in addition, in the "Swift Nudes" series of spring 1912 (pl. 2, figs. 21–24) he explored imagery seemingly based on flamelike electric sparks in order to evoke speeding electrons. By means of such formal signifiers, Duchamp established his knowledge of scientific imagery and of the schematic language of engineering practice, the quality of the "pure diagram" he would increasingly adopt as his formal model in the project that would culminate in *The Bride Stripped Bare by Her Bachelors, Even* (pl. 1, figs. 76, 165).

Duchamp's self-construction as an intellectual artist had begun subtly. By fall 1912 Apollinaire, in *Les Peintres Cubistes,* would also respond to the "intellectual" quality of Duchamp's art. Commenting on his imagery and his addition of titles to the surface of paintings such as *The King and Queen Surrounded by Swift Nudes* (pl. 2, fig. 21), Apollinaire declared, "To the concrete composition of his picture, Marcel Duchamp opposes an extremely intellectual title. He goes the limit and is not afraid of being criticized as esoteric or unintelligible."[23] In this period, words—his inscriptions on paintings (or, later, on Readymades), the notes he began to make in late 1912, the Roussel-like wordplay by which he would generate ideas for the *Large Glass*, and his general reevaluation of the nature of both verbal and visual language—were to be crucial to Duchamp's project and his progressive definition of himself. He was proving his belief, as he told Cabanne, that "it was much better to be influenced by a writer than by another painter."[24]

The writers who interested Duchamp were not just any authors. Central were Roussel (about whom Duchamp was speaking here) and Jarry, who themselves had responded so creatively to the striking developments in late nineteenth-century and early twentieth-century science and technology. These discoveries, popularized by charismatic scientific figures like Crookes and Tesla and by a vast amount of popular literature, ranged from invisible electromagnetic waves (including not only X-rays but also Hertzian waves for wireless telegraphy) and the high-frequency, alternating electrical currents demonstrated by Tesla with dramatic sparks and illuminated tubes to new conceptions of matter as composed of high-speed subatomic particles and subject to dematerialization by means by radioactive decay. In a far more comprehensive way than Roussel or Jarry, Duchamp mastered what he needed of the content of the newest science and technology—as well as more traditional fields such as mechanics.

During the course of his apprenticeship Duchamp also learned important lessons about practicing science from the writings of figures such as Henri Poincaré and Jean Perrin. Poincaré's philosophy of conventionalism served

Duchamp well in his attack on mathematical or aesthetic absolutes—be they the principles of Euclidean geometry, the standard of French metrology measures (e.g., *3 Standard Stoppages* [fig. 68]), or the standards of taste and beauty as set forth in Cubist theory. The work of the young physical chemist Perrin was touted in this period for its logic and precision and offered Duchamp a model for the verbal style of the text he was planning as the counterpart to the *Large Glass* as a "painting of precision."[25] Like Roussel, Jarry, and Kupka, Duchamp was drawn to the realm of science in a period when distinctions between electromagnetism and occult Magnetism, telegraphy and telepathy, or alchemy and chemistry were not always clearly drawn, and authors such as Albert de Rochas, François Jollivet Castelot, and Gustave Le Bon commanded considerable respect. However, in style at least, Duchamp moved toward the pole of more mainstream science and the view of Perrin, who, for example, roundly condemned the popular pseudoscientist Le Bon for his "confused language" and "disconcerting mistakes."[26] Similarly, Duchamp's initial interest in alchemy, which was linked closely in this period to radioactivity in the writings of Jollivet Castelot and others, moved definitively toward the practice of chemistry and even the physical chemistry underlying such phenomena as the liquefaction of gases.

Another critical model for Duchamp's creation of his persona as an intelligent and inventive artist-scientist was, of course, Leonardo da Vinci. Ironically, both Leonardo and Poincaré were admired by Gleizes and Metzinger. For the Puteaux Cubists, Leonardo was the great painter of tradition to be emulated in the modern Cubist style: Metzinger's *Le Goûter* (fig. 169), for example, was nicknamed the "Joconde [Mona Lisa] du Cubisme" when it was exhibited in fall 1911, and several members of the circle, including Duchamp's brother Villon, read Leonardo's *Treatise on Painting*.[27] In *Du Cubisme* Gleizes and Metzinger had borrowed Poincaré's ideas on tactile and motor space and had suggested a general association between Cubist deformation of forms and non-Euclidean space. In addition, Cubist theorists used Poincaré's conventionalist philosophy to argue that, like the axioms of Euclid, no painting style could be considered truer than any other; rather, Renaissance art and Cubism were equally valid conventions.[28] Yet, more typical of Gleizes's attitude by late 1912 was his essay "La Peinture moderne," published in Picabia's journal *391* in 1917, in which he warned against the artistic "sterility" that results from "dangerous incursions" into the "mathematical absolute of a Henri Poincaré."[29]

By contrast, Duchamp found in Leonardo and Poincaré models for his activity as an anti-Cubist artist-engineer-scientist, and he used their ideas to undermine the increasingly antimathematical, antiscientific stance of the Bergsonian Puteaux Cubists. Just as he adopted Poincaré's conventionalist philosophy in his attack on Euclidean geometry and measure in the *3 Standard Stoppages*, he applied Poincaré's views to the status of scientific laws in his Playful Physics. Likewise, Duchamp drew directly on Poincaré's writings on a number of scientific phenomena. Poincaré's ideas on chance, in particular, supported his pursuit of the "beauty of indifference" in Readymades like the *Bottle Rack* [*égouttoir*] (fig. 71), with its humorous play on Cubist notions of taste (*goût*) and even on Metzinger's painting *Le Goûter*.[30] When Duchamp looked to Leonardo, he was most interested in the artist's notebooks, which demonstrated his intellect and established the recording of ideas in notes as a legitimate form of artistic production.

By the time Duchamp began making his first notes for the *Large Glass* project, including the Jura-Paris Road notes of winter 1912, he had adopted the concept of human-machine analogies prevalent in the works of Jarry, Roussel, Pawlowski, and other writers as well as in the technical literature of this period. In his Munich works of summer 1912, *Virgin (No. 1)* (figs. 35, 51) and *Bride* (pl. 3, fig. 17), Duchamp had already fused the general structure of an automobile (fig. 50), centered on its *arbre de transmission*, with forms suggesting internal organs. His paintings of 1911 and early 1912 had engaged sexuality through the theme of X-ray stripping; now he began to employ imagery drawn from machines and scientific equipment as a vehicle for his iconoclastic and humorous commentary on sexuality—and on religion, myth, and even Bergsonian philosophy.

During the course of 1913 he would arrive at the style of execution he termed "painting of precision," in which a precise, mechanical drawing style and laboratorylike fabrication techniques would match his new technological and scientific content.[31] Initially, in his Munich drawings and paintings (figs. 17, 31, 33, 35, 36) Duchamp had experimented with artistic variations on machine forms in a style that, apart from *Airplane* (fig. 37), did not break definitively with traditional drawing and painting techniques. Thus, despite the subtle inclusion of his draftsman's dashed line and his manipulation of paint with his fingers to get away from expressive brushwork in the *Bride*, his summer 1912 paintings and drawings generally exhibit carefully modeled forms and dramatic contrasts of light and dark, attesting to his reconsideration of the history of painting itself. Nonetheless, in their unprecedented form language, these works do stand as a definitive step beyond Cubism. Duchamp had now begun to think of

visual representation as a system of "hieroglyphic" signs for encoding information in an image.[32]

Duchamp's subsequent reevaluation of verbal signs and his speculation on the possibility of creating an "entirely new" alphabet or "ideal stenography" for the text he envisioned to accompany the *Large Glass* exist as subthemes within his notes, although the impossibility of communicating in such an idiosyncratic language meant that he never put it into practice.[33] Instead, the language of Duchamp's notes underwent a general metamorphosis similar to the stylistic evolution of his pictorial language from summer 1912 through 1913. Thus, although certain of his earliest notes present scientific or technological content in an almost poetic form, in many of the notes there is a move toward a more "transparent language" that emulates geometrical and logical proofs or the technical writing style of a scientist like Perrin.[34] Duchamp's Jura-Paris Road notes and the ten-page automobile-oriented note in the *Green Box*, for example, resemble highly metaphorical literary forms, suggesting that Duchamp's stylistic model was a contemporary writer rather than an engineer or scientist. Indeed, the *Green Box* note might well be the statement of the "poëme," or epic narrative, to which Duchamp refers in subsequent notes that discuss the place of the "stripping-bare" "in the poem" or distinguish the text he was planning from other notes: "The purpose of this text is to explain and not to express in the manner of a poem."[35] It was not the style but the content of the long *Green Box* note (i.e., references to electricity, vibrations, sparks, and automobile components) that was the sign of Duchamp's developing erudition in science and technology. Just the act of composing such a text, however, would have confirmed his self-image as someone outside the milieu of Cubist painting.

Duchamp's poetic automobile-oriented note would not find a public audience until the appearance of the *Green Box* in 1934. But because from the start he put a premium on the ideas behind the *Large Glass*, his notes were crucial acts of private self-fashioning—to be revealed at some point in the future. As an experiment in note publishing, the edition of about five copies of the *Box of 1914* was a particularly important (and unprecedented) gesture, announcing to a small audience of close friends Duchamp's new interests beyond painting. Among these were his practice of photography, with its technological associations (figs. 78, 79 and references in notes), his carrying out of experiments relating to geometry and metrology (*3 Standard Stoppages*), his interest in electromagnetic frequency, and his commitment to translating emotional expression into the dispassionate language of geometry.[36] Like the geometrical proof format of the *Box of 1914* note "Given

that....; if I suppose I'm suffering a lot....," Duchamp was to write in other notes about the language of the text that might accompany the *Glass*, which was to "hav[e] the style of a *proof.*"[37] As if fulfilling Nayral's supposition in his Galeries Dalmau review that Duchamp was "striving for proofs and syntheses," Duchamp even set forth the terms of the sexual encounter of the Bride and the Bachelors in the *Large Glass* in the style of a geometry proof or a scientific article: "Given: 1. the waterfall / 2. the illuminating gas, *in the dark*, we shall determine (the conditions for) the extra rapid exposition (= allegorical appearance) of several collisions. . . ."[38]

Duchamp's private note making was accompanied by a number of more public acts of self-definition in late 1912 and 1913. Having taken a job at the Bibliothèque Sainte-Geneviève in November 1912, in October 1913 he moved to an area near the Sorbonne, away from the Cubist context of suburban Puteaux and Neuilly. Most important, as of spring 1913 he ceased exhibiting at the yearly Salon des Indépendants or Salon d'Automne, which had been central forums of Cubist activity. In a May 1914 *Paris-Journal* article about a poetry reading at Villon's studio in Puteaux, where works by Villon and Duchamp-Villon were on view, Apollinaire commented on Duchamp's absence from exhibitions and revealed his library activities. Praising him as "the most obviously talented and the most original" member of his family, Apollinaire here made his comment about Duchamp's "catalogu[ing] books not far from the same Charles Henry whose scientific investigations exerted a great influence on Seurat." He concluded by explaining that "this is why we have seen no painting by Marcel Duchamp anywhere for more than two years."[39]

Rather than a French audience, American visitors to New York galleries in 1915–16 would be the first public to view the preparatory works for the *Large Glass* that exemplified Duchamp's new precision style.[40] Compositions such as *Boxing Match* (fig. 45) and *Network of Stoppages* (fig. 73) had taken on the look of a "pure diagram," to use Nayral's term, as part of Duchamp's inventive "plastic retaliation" against Bergsonist Puteaux Cubism.[41] Here not only mechanical drawing but also the abstract, diagrammatic language of geometry or even circuit diagrams (fig. 102) offered a further remove from expressive drawing. On the model of Roussel, Duchamp was also actively exploring antivirtuoso techniques, including the role of chance in artistic creation.[42] In the *3 Standard Stoppages* (fig. 68), the dashed or precision-drawn line was now replaced with the chance configurations of fallen threads; in the *Chocolate Grinder (No. 2)* (pl. 5, fig. 91), Duchamp produced "lines" by winding thread through the

189

canvas, a technique he extended to "drawing" with lead wire on glass in the *Large Glass* and preparatory works such as *Glider Containing a Water Mill (in Neighboring Metals)* (fig. 151).

Beginning in 1914, Duchamp completely escaped the intervention of the artist's hand as well as the question of taste through the "beauty of indifference" of the Readymades, the extant objects that served him for "unloading ideas," as he said.[43] Although initially private gestures, several Readymades were exhibited in New York in spring 1916, including *Pharmacy* (fig. 167) and two objects whose identities are uncertain. Reviewers hardly noticed the latter works, but Duchamp's provocative *Fountain* (see figs. 118, 166), exhibited anonymously in 1917, would ultimately become a major sign of his detached, impersonal stance. That was also the image he had codified in his 1915 *Literary Digest* photograph (fig. 74)—the young proponent of scientific values in art, a thinker and inventor who was most certainly not "stupid as a painter."[44] Yet, while Duchamp's photograph suggests all seriousness, the Readymades as well as the *Large Glass*, Duchamp's "hilarious picture," were full of iconoclastic humor. Indeed, the wealth of new words and images he found in the realms of science and technology made possible much of the humor in the *Glass* and the Readymades.[45]

One of Duchamp's stated goals for his text to accompany the *Glass* was to "avoid words that are metaphorical or general (equivocal, rubber words)" by adopting the model of geometrical and logical proofs or scientific texts.[46] Nonetheless, his love of verbal and visual puns and his skill at the game of Rousselian homophones assured that neither the text nor the *Glass* would have the strict one-to-one correspondences of precise mathematical or scientific writing. Instead, in the context of seemingly scientific language, meanings multiply and shift readily from one field of science or technology to another and sometimes wander out of those domains altogether. In fact, scholars in the field of literature and science, such as James J. Bono and others, argue that metaphor plays a crucial role in the thinking and writing of scientists.[47] Just as Perrin in Duchamp's day emphasized the importance of the "intelligence of analogies" in scientific work, the historian of technology Thomas P. Hughes has contended that "independent inventors' frequent resort to both verbal and visual metaphor offers the most suggestive key to understanding the moment of inventive insight. . . . Metaphor, being far more than a decorative literary device, is one of our most often used and effective ways of knowing."[48] Indeed, Duchamp would have found abundant examples of such analogies or scientific

metaphors in contemporary sources, particularly on the subject of electromagnetic waves, where, for example, hydraulic analogies were widely used to explain oscillating circuits and basic terms such as *current* derived from the behavior of liquids.[49]

Although practical invention and bona fide scientific discovery were not Duchamp's goals in his Playful Physics, the "intelligence of analogies"—verbal and visual as well as functional—was a major aspect of his activity in the *Large Glass* project. His comment to Katherine Kuh about his delight at puns in which "four or five different levels of meaning come through" describes the operative mode of the *Glass* as well.[50] It was flowery literary metaphor and its attendant "formal lyricism"— and not metaphorical thinking—that Duchamp was rejecting as he sought to create his new persona as playful, detached artist-engineer-scientist.[51] In the *Large Glass,* the precise, engineerlike style and the scientific content he had been developing since 1912 came together. Duchamp's notes document the range of his study of geometry, science, and technology, which now enabled him to invent the scenario of the *Glass* and the forms in which to embody it. The very acquisition of that knowledge (and, as a result, the ability to draw analogies among fields in and out of science) was a central facet of his self-fashioning.

Visual and Verbal Signs of Duchamp's Self-Fashioning in the *Large Glass*

In early paintings Duchamp had indicated his awareness of contemporary science by means of imagery, such as the characteristics of X-ray photographs; later, however, it was the equipment of science and technology that served as the basis for his pictorial invention. Although the components of the *Large Glass* seldom replicate actual objects and are instead hybrid machines, they nonetheless evoke the laboratory of the scientist or the displays of a science museum like the Musée des Arts et Métiers. Moreover, just as the preparatory drawings are executed in the precise style of mechanical drawing, the forms of the *Glass* are created by techniques characteristic of the laboratory, such as metal (lead wire, lead foil, and mirror silvering) applied to glass or dust gathered in the tradition of electric dust figures (figs. 123, 124). Other signs of Duchamp's interest in impersonal, indexical techniques for registering an image are apparent only in his notes, where he discusses the possibility of using photography to transfer the Top Inscription/Milky Way to the *Large Glass* or speculates on imprinting the Air Current Pistons on the *Glass*, seemingly, by means of the radioactive netting in gas mantles

(figs. 119, 120).[52] Even though the direct use of photography ultimately proved impossible, Duchamp was determined to use its visual sign: "The imitation of photography: make it noticeable in the *Pendu femelle* [Bride]," he reminded himself in a note.[53]

Duchamp's notes also hold other important visual signs of his self-fashioning, including numerous drawings and diagrams far removed from the tradition of artistic drawing. In addition to his finished, precision drawings (e.g., figs. 45, 75, 96, 153), most of which were included in the *Green Box*, there are numerous sketches or working drawings for parts of the *Large Glass* in both the notes that were published during his lifetime and those published posthumously.[54] Many of these drawings explore the functioning of a particular component, such as the motion of the Chariot (figs. 156A, 156B) or the fall of the Bottle of Benedictine (fig. 156C). Others are designs for "machines," such as the Desire Dynamo (fig. 149), or schemes for a series of processes, such as Duchamp's initial, detailed plan for the liquefaction of the Illuminating Gas (figs. 138, 139, 141). In keeping with his developing self-image, these drawings and their numerous counterparts resemble an inventor's sketches or the preliminary versions of patent drawings. Additional drawings clarify details of individual elements, such as the Chocolate Grinder's leg, or, in the case of the Bride, establish her component parts (figs. 105, 127, 128) or her functions (figs. 101, 110, 128) as her identities multiplied.[55] Another group of diagrams and sketches relates to various experiments Duchamp designed to be carried out in his "laboratory"-studio, such as those involving the chance falls of the Mobile (fig. 148) or the placement of the Nine Shots (fig. 144).[56] Finally, Duchamp's explorations of geometry, both *n*-dimensional geometry and simpler geometric relationships like the Golden Section, are chronicled in the drawings related to the fourth dimension in *A l'infinitif* and in geometrical diagrams in the posthumously published notes.[57] Of course, despite their surface appearances, virtually all these drawings and diagrams differ significantly from actual patent drawings or geometry demonstrations because of Duchamp's playful intentions—especially the underlying sexual content of his mechanisms. Geometric proportions, for example, symbolize the relation of "intention" and "fear" to "desire" in the igniting rods of the Desire Dynamo (fig. 149).

The verbal signs in Duchamp's notes are even more crucial to the identity he was fashioning than his visual signs. As we have seen, Duchamp's speculations on a precise, "transparent language" for the text that was to accompany the *Glass* are one of the surest markers of his intentions.[58] Although he never produced such a finished "Text—typed on good paper," the notes addressing it serve essentially the same purpose: we see him as a self-styled linguist and "scientist" of language.[59] If other notes employ the "Given . . ." construction of a geometry proof or imitate the language of a report on scientific findings, most of the notes do not achieve that formal rigor.[60] Nonetheless, with the exception of Leonardo's notebooks, they are unique in the genre of artists' writings, and their content clearly signals his role as scientist, engineer, or geometer.

Paralleling Duchamp's sketches, there are written specifications for how components of the *Glass* are to function, as well as instructions or reminders to himself about how these will be executed, including paint formulas that seem to come from a chemist's notebook.[61] His mention of the pigment combinations of various metals that are to be approximated in paint and his references to materials that are to be used (e.g., "Use of mica" or his choice of *papier d'aluminium* for the "neck band" of the Chocolate Grinder) clearly indicate an industrial, not a painterly, orientation.[62] Other notes register Duchamp's observations on such materials: "Lead embossed, hammered or 'tufted' is less dense."[63] Many notes record actions that are to be performed, including both the experiments Duchamp designed for himself and single gestures that mimic the activities of the scientist in the laboratory. Thus, when he instructs himself to "shake" the liquid-filled "Flat container. in glass" and "look through it," Duchamp plays the role of chemist or, more specifically perhaps, of a Brownian motion investigator like Perrin.[64]

Beyond descriptions of materials and experiments, Duchamp's verbal signs of self-fashioning include his formulations of his playful "Laws, principles, phenomena."[65] The field of mechanics, in particular, offered Duchamp largely familiar laws he could "distend" creatively and humorously, attacking standards of weights and measures to produce a "Regime of Coincidence."[66] Four-dimensional geometry was the other area in which Duchamp actively invented new "laws," which were often just as fanciful, though their humor is far less apparent. Duchamp's notes relating to other areas of science rarely formulate actual laws but rather evoke a particular field by the use of words or phrases closely associated with it: "triturations" for chemistry; "écarts de molécules" for atom theory and the kinetic theory of gases; "luminous molecules" and "emanating object" for radioactivity; and "sparks," "frequency," and "vibration" for electromagnetism.[67] Both verbal and visual metonymy were central techniques for Duchamp's encoding of scientific content in the *Large Glass*. Just as he used characteristic words to evoke a specific field, he often employed

events or equipment—alluded to in the notes or depicted in partial form in the *Glass*—to signify entire areas of science or technology.

The *Large Glass* Seen Anew: Reflections of Contemporary Science and Technology in Duchamp's "Hilarious Picture"

In the standard "litany" of the *Large Glass*, codified long before the appearance of his unpublished notes in 1980 and repeated again and again in the Duchamp literature, the main connections to science and technology are made through the Bride's identity as an automobile, the metamorphosis of a mysterious Illuminating Gas into a liquid Splash, and the suggestion of mechanics in the activities of the Chariot/Glider propelled by a falling Weight.[68] When his notion of Playful Physics has been treated at all in this literature, it is reduced to a brief mention of any or all of the "Laws, principles, phenomena" listed in the *Green Box*: the "stretching in the unit of length," "oscillating density," "emancipated metal," and "friction reintegrated."[69] Studies of the notes on four-dimensional geometry in *A l'infinitif* subsequently added Duchamp's engagement with geometry as another aspect of the "mental ideas" behind the *Large Glass* project.[70] Here, too, was the first demonstration of the way Duchamp could use a field, such as geometry, to embody the contrasts or collisions between the realms of the Bride and the Bachelors.[71] Yet many questions about the *Large Glass* project remained unanswered or even unasked.

The publication of Duchamp's remaining 289 notes forces us to break out of the long-held attitude, expressed for example by Arturo Schwarz, that the two long *Green Box* notes on the Bride "give all the basic information on the theme of the *Large Glass* and the psychology of its protagonists."[72] In fact, those two notes, the ten-page note and the one immediately following it, were only an initial statement of the project, and Duchamp was to add many more layers of meaning by the time he stopped making notes for the work. Although the present study is just a beginning in the attempt to understand Duchamp's body of notes as a whole, the focus here on the theme of science and technology has made it possible to enlarge considerably previous knowledge of the components and processes embodied in the *Glass*.

Turning first to the Bride, early twentieth-century automobile literature held the clue Duchamp's *arbre type,* or tree type, is an automobile transmission shaft (*arbre*) and that, like the drawing *Virgin (No.1)* (figs. 35, 51), the painted *Bride* (pl. 3, fig. 17) and the Bride of the *Large Glass* (pl. 1, fig. 76) are based loosely on the structure of an automobile (fig. 50). In the Bride, Duchamp

cleverly conflated his interest in internal bodily organs and skeletal structures, revealed by X-rays of the body, to create the combination of spinal column, transmission shaft, and blossoming tree that serves as the Bride's basic persona. The Bride as *arbre* (organic or mechanical) also offered an iconoclastic allusion to the Virgin Mary as well as to the goddess Persephone—creating another level of allegorical meaning in the *Glass* beyond its basic sexual content. Duchamp's original conception of the form and structure of the Bride, which also took on associations with chemical apparatus, remained largely unchanged from the painting of summer 1912 through her initial incarnation in the *Glass*. Gradually, however, he developed additional identities for her in his notes, humorously augmenting the Bride's personality and sexual functions as well as her links to other areas of science. Although the names of many of the Bride's constituent parts were known from Duchamp's published notes, his posthumously published notes now make it possible to propose locations for most of those components (fig. 82).

There is a delicate blend of the organic and the mechanical in the Bride, a quality that distinguishes her markedly from the comically mechanical Bachelors. Several of the Bride's identities reinforce this organic-mechanical quality. Specifically, her associations with the "organic" automaton envisioned by Villiers de l'Isle-Adam in *L'Eve future* brought together the type of clockwork mechanism seen in the Bachelors and in traditional automatons and Villiers's descriptions of the "flesh" and "organs" of Hadaly that evoke the "visceral" quality of the Bride, whom Duchamp described as "half-robot, half four-dimensional."[73] In addition to her all-important associations with wireless telegraphy, Duchamp gave her three other identities: her functioning as various meteorological instruments (barometer, weather vane), her association with incandescent lightbulbs, and her persona as Wasp. Cleverly linking all three was the concept of the Bride's "filaments," which take on specific meanings in each of these contexts. As a Barometer (fig. 126), the Bride registers her own "storms and fine weathers" by means of the "meteorological extension" of her filaments—as if she were a hygrometer with hair stretching in response to moisture. As Weather Vane, she swings freely in those "air currents" and randomly "horse kicks" a "circle of cardinal points," determining (by the "principle of subsidizied symmetries") the displacement she will communicate to the never-executed Juggler/Handler of Gravity by the extension of her filaments (figs. 127, 128).[74]

Duchamp's use of the term "filament" and of seemingly organic notions such as "nourishing the filament paste" relates directly to contemporary technology for making

incandescent lightbulbs, in which extruded paste filaments were "nourished" with carbon. Like the *arbre*, as we have seen, both the glass bulb and the notion of "put[ting] the whole Bride under a glass cover" have strong overtones of religious and mythological figures associated with sealed glass vessels, such as the Virgin Mary (fig. 168), and with torches (Persephone) and their modern electrical counterparts (figs. 163, 133). In addition, the idea of putting a figure under glass suggests that the Bride as Wasp relates to the observations of the entomologist J.-H. Fabre (fig. 135) and their use in Remy de Gourmont's *Physique de l'amour*, which abounds with organic-mechanical analogies. Indeed, Gourmont's treatment of human sexuality in terms of the animal kingdom and mechanical processes must now be recognized as a crucial prototype not only for Duchamp but for any artist interpreting sexuality in mechanical terms in this period. In giving her the guise of highly intelligent Wasp, Duchamp reasserted the organic side of the Bride and linked her filaments to the "vascularized paste" produced not only in the lightbulb industry but by paper wasps (fig. 134).[75]

The Bride's filaments were primarily a physical sign for what he termed the "horizontal" aspect of her "cinematic blossoming" or imagined orgasm, a process to which he gave visual form in several drawings (e.g., fig. 110). In his ten-page note in the *Green Box,* Duchamp had already distinguished between the Bride's "vertical" and "horizontal" blossomings, associating them, respectively, with the "stripping" or tugging on her garment by the Bachelors' Boxing Match mechanism and with her "voluntary-imaginative" stripping or her "self blossoming."[76] Although he talked in that first note about the "collision" and subsequent "conciliation" of these two blossomings, Duchamp had not yet developed the Juggler/Handler of Gravity to serve as the locus of the meeting of the two blossomings. Indeed, the Juggler was to become the crucial intermediary between the Bride in the upper level of the *Glass* and the Bachelors below, carrying on a wave-borne dialogue with the Bride (identified with her horizontal "self-blossoming") and, at the same time, registering the physical movement of her Clothing as he balances on it above the tugging Boxing Match (the vertical blossoming/stripping) (fig. 111). While Duchamp never added the Juggler/Handler to the *Glass* before he abandoned work on it in 1923, he remained committed to this central figure, celebrating his role in the 1947 *Altar of the Handler of Gravity* (fig. 181).

In his first, automobile-oriented notes on the Bride, Duchamp treated her sexual response metaphorically in terms of the firing of a gasoline combustion engine in an automobile. While the Bride's sexual functions center

around a motor, for which she secretes "love gasoline" and for which her Desire-magneto produces the "sparks of her constant life," the notes also stress the role of electricity, including references to "electrical stripping," "electrical control" of the stripping, and the fact that between the Bride and the Bachelor Machine "the connections. will be. *electrical.*" In conjunction with Duchamp's description of the Bride's "cinematic blossoming" as the "sum total of her splendid vibrations" and the prominent role of sparks in Duchamp's scenario (including the "artificial sparks" that both control the Bachelors' Boxing Match and provide a second "stroke" to the Bride's motor), the suggestion of the theme of communication via electromagnetic waves (i.e., wireless or spark telegraphy) is unmistakable. Indeed, Duchamp further confirmed such an interest in the notes of the *Box of 1914,* which include references to "Electricity at large" as the "only possible utilization of electricity 'in the arts'" and to his intention to "make a painting *of frequency.*"

In this period, words such as *vibration* and *frequency* would have called to mind the electromagnetic waves that were revolutionizing the field of communication, just as X-rays earlier had produced a radically new way of seeing (and with it a distrust of human perception) and had popularized the notion of space as filled with vibrating waves of varying frequencies.[77] Both Kupka, Duchamp's informal mentor, and the avant-garde poets of the prewar years, including his friend Apollinaire, responded enthusiastically to wireless telegraphy and its implications for contemporary culture (figs. 84, 86). For Duchamp the realms of electricity and electromagnetism must have been particularly appealing because of their sexually suggestive language— from excitation to sparks and vibration. Further, Edouard Branly's (and earlier Tesla's) development of what we now term "radio control" of objects by means of wave signals (figs. 107, 108) offered an even more specific model for the interaction of Duchamp's Bride with her Bachelors— whose mechanical activities she stimulates by her actions.

Duchamp's allusions to electromagnetic communication, however, could only be indirect—that is, by means of the apparatus, materials, and functions relating to the emission and detection of Hertzian or wireless telegraphy waves. The mid-section of the *Large Glass,* for example, with its three stacked glass strips (fig. 88), strongly suggests the construction of an electrical condenser, a vital element in the production of sparks for wireless, spark telegraphy (fig. 89). The primary source of sparks in the *Glass* is the Bride, and located at her "life-center," according to Duchamp, is a "spherical, *empty* emanating ball," or the kind of ball associated with a spark gap in wireless telegraphy.[78] He also refers to the Bride as an

"isolated cage," and as she hangs at the top of the *Large Glass,* her form and functions suggest the insulated, cage-like emitting antennae for wireless telegraphy atop the Eiffel Tower (fig. 103).[79] Moreover, the Bride sends commands to the Bachelors in the form of code-like "alphabetic units" through the Air Current Pistons of the Top Inscription and Milky Way, the cloudlike form of the Bride's "blossoming" actually executed on the *Glass* (figs. 76, 77, 101).[80]

The other emitter of waves or signals in the *Glass* is the Juggler of the Center of Gravity or Handler of Gravity, whose "ball in *black* metal" projects "waves of disequilibrium" toward the Bride.[81] Here Duchamp cleverly combines the fields of mechanics and electromagnetism, using the theme of equilibrium and its displacement: in statics, the disruption of equilibrium means loss of balance, whereas in an oscillating electrical circuit such a disruption accompanies the production or detection of Hertzian waves. Both the Bride and the Juggler are capable not only of emitting signals but also of detecting and receiving wave-borne messages. Among the Bride's properties are a "*Flair* or sense receiving the waves of disequilibrium" and a "Vibratory property determining the pulsations of the needle," seemingly a reference to wave detectors using magnetized needles.[82] Duchamp specifically suggests the Juggler's identity as an electrical wave detector in a sketch he included in the *Green Box* (fig. 112): here the Juggler's base closely resembles the popular Branly tripod coherer (fig. 113), a detector that would "dance" at the passage of a wave, just as the Juggler dances on the Bride's Clothing (albeit registering the mechanical tugging of the Boxing Match). This, then, was the wave-borne interchange between the Bride and the Juggler embodied in her filaments (figs. 110, 111). With their "movement . . . rooted in the Desire-magneto" (and its sparks) these filaments/waves of her horizontal "self blossoming" move back and forth, like the unrolling and rerolling of "certain party whistles from the fair in Neuilly."[83]

In a typical Duchampian overlay, the interaction between the Bride and the Juggler operates both as etherial wave communication and as the physical manipulation by the Bride's filaments of the Juggler's black ball/stabilizer as he seeks to recover his lost equilibrium—suggesting another metaphor for sexual experience as equilibrium lost and regained.[84] In this interplay of messages and movement, Duchamp had described the Bride's "Inscription" with its "alphabetic units" as able to "displace a [stabilizer]."[85] Yet, those "commands, orders, authorizations" sent through the Air Current Pistons of the Top Inscription were destined for the Bachelors (fig. 101).[86] Indeed, a more direct form of "broadcasting" to the lower half of the *Glass* is basic to the Bride's interaction with the Bachelors and the inauguration of the sexual/technological activities of the Bachelor Apparatus that culminate in the "vertical stripping" by the Boxing Match. Unlike the Bride and Juggler, who, as denizens of the etherial realm Duchamp conceived as four-dimensional, can both emit and detect waves, the three-dimensional Bachelors can communicate only mechanically with the Juggler (via the Boxing Match) and function solely as receivers of commands. Given Duchamp's interest in indexical registering procedures and the prevalence of scientific apparatus for detecting invisible phenomena in this period, the theme of wireless telegraphy and wave detection offers a number of new identities and functions for familiar components of the Bachelor Apparatus.

Duchamp's Chocolate Grinder, with its sexually suggestive grinding of chocolate, would seem to be a hybrid object based equally on the idea of a chocolate grinder (figs. 67, 94) and a type of wave detector utilizing electromagnets (fig. 93). Having wound thread through the canvas of *Chocolate Grinder (No. 2)* (pl. 5, fig. 91) as if he were winding an electromagnet (fig. 92), Duchamp approximated the look of that procedure in the *Large Glass* using lead wire. Outlining the forms of the Grinder and the rest of the components of the *Glass* with such wire, which was used to create electrical fuses in France in this period, Duchamp effectively "wired" his "painting *of frequency.*" If the Bayonet atop the Chocolate Grinder (figs. 76, 77) suggests a single "aerial" or antenna, the conical Sieves or Umbrellas/Parasols above it evoke even more directly the experimental forms of early "umbrella" antennae used for gathering waves. Most important, however, in this rethinking of functions in the Bachelor Apparatus is the clarification that the Bachelors/Malic Molds are filled, according to Duchamp, with an "inert illuminating gas"—not the natural-gas-like substance meant to be burned, which he represented much later in *Etant donnés* (fig. 183).[87] Indeed, the appearance of the Malic Molds (figs. 76, 96) calls to mind the variously shaped electrical discharge tubes, such as Geissler or Crookes tubes, that could be filled with inert gases at low pressures for use in both scientific and popular contexts (pl. 4, figs. 97, 98). Because such gases, including the newly popular neon, would fluoresce when electrified or "excited," the tubes could also be used to demonstrate the presence of an electromagnetic wave—and thus came into use as wave detectors in wireless telegraphy practice.

Nikola Tesla was the most dramatic demonstrator of the spectacular effects that could be achieved with such gas-filled tubes in conjunction with the high-frequency alternating current produced by a Tesla coil. Georges

Claude's *L'Electricité à la portée de tout le monde* had illustrated a re-creation of such a Tesla performance (fig. 99), as well as a photograph of a waterfall (fig. 100). These two images in a book on electricity point up that theme as a unifying factor behind Duchamp's "Notice" or "Preface" for the *Large Glass* project: "Given: 1. the water-fall/2. the illuminating gas, *in the dark*."[88] Duchamp's specification that the events occur "in the dark" reinforces the connection of the *Glass* to Tesla-like demonstrations of illuminated tubes as well as to the nighttime spectacle of an "electric fete," such as that at Luna Park or the Pier Pavilion at Herne Bay (fig. 80), which Duchamp cited in another note.[89] Here as in so many other aspects of the *Large Glass*, popular culture added another layer of significance to the scientific events Duchamp was exploring.

Following its "Given" terms, Duchamp's "Notice" announced that the subject to be considered in the *Large Glass* was the "extra-rapid exposition (= allegorical appearance) of several collisions seeming strictly to succeed each other *according to certain laws.* . . ." The term "extra-rapid" in conjunction with Duchamp's use of "instantaneous" in the "Preface" version of this note strongly suggests photography in the dark—specifically the new "instantaneous spark photography" that was being explored by such figures as A. M. Worthington and, subsequently, C. T. R. Wilson. Wilson had photographed subatomic collisions for Rutherford in his radioactivity research (figs. 145, 146), and his work stands at the infinitesimal pole of the range of collisions Duchamp was to explore in the *Large Glass*. Duchamp later cited booths at county fairs with balls "that you throw at the heads of the bride, the bridegroom, and the guests" as one of the roots of the *Glass*.[90] Indeed, it was to be filled with ballistic events at all scales—from subatomic and molecular collisions to the "blows" of the Combat Marble of the Boxing Match and the impact of the Nine Shots targeted at the Bride's realm (figs. 45, 144). All these events were metaphors, in a sense, for the overarching collision between the goals of the Bachelors and the position of the Bride, high above them and forever beyond their reach. With overtones of a religious and philosophical quest for the beyond, the incommensurability of the relationship of the Bride to the Bachelors is represented most overtly in terms of dimension—her etherial four-dimensionality versus their confinement in a three-dimensional, perspective construction. Yet science and technology offered crucial means to augment the distinction between the upper and lower halves of the *Glass*, just as it had offered a vehicle for the communication between the Bride and Bachelors via electromagnetic waves.

Duchamp described the *Large Glass* as a "series of variations on 'the law of gravity.'"[91] Although the Bride's

various identities are modeled on familiar objects, she is nonetheless meant to transcend their three-dimensionality, as she hangs, free of gravity, in her etherial realm of anti-gravity. The Bachelors, by contrast, are forever subject to the effects of gravity, and various "falls" as well as collisions dominate the operations of the Bachelor Apparatus. The world of the Bachelors—who "live on coal or other raw material drawn not from them but from their not them"—is purely mechanical; there is none of the smooth blending of organic and mechanical present in the Bride, with her "life center" and internal energy.[92] The actions of the Bachelor Apparatus are jerky, and any element that exhibits anthropomorphic qualities invariably produces a comical effect. Even so, the lower half of the *Glass* was Duchamp's richest area of scientific and technological invention—the one in which he created a complex and humorous layering of events. From his commentary on male sexual physiology in the thrusting Chariot/Glider and the exploding Desire Dynamo to his exploration of chance and free will at the molecular level, Duchamp in the Bachelor Apparatus responded creatively to aspects of chemistry, physical chemistry (including the kinetic theory of gases), thermodynamics, and mechanics.

The Juggler/Handler of Gravity was the crucial component never added to the upper half of the *Large Glass*, but the Bachelors' realm as executed is missing much more of Duchamp's original conception, as revealed in his posthumously published notes. As he described the operations of the *Glass* in a 1953 interview, "Oh yes, it was very well connected, there was no splashing and no disconnection. It could almost work."[93] Duchamp's "First breakdown" note had indicated that, in addition to the Chariot, Chocolate Grinder, and "Tubes of erotic concentration" (the liquefaction apparatus leading from the Malic Molds), there were to be "4. *Desire Dynamo—/combustion chamber/Desire* centers/*Sources* of the stripping" and "5. Horizontal column."[94] Although Duchamp finally substituted an optical Splash mechanism, involving the mirror image of the drops of liquefied Illuminating Gas, as the final stage of the Bachelor operations, his earlier inventions continued to interest him decades later. The group of notes he was contemplating assembling in the late 1950s (app. A) retrieves the crucial Desire Dynamo and fully functioning Horizontal Column or Scissors, along with the Mobile, the mechanism that was to produce the physical Splash of the gas and that was a central vehicle for his exploration of chance and the "liberty of indifference."[95]

The central operation in the Bachelor Apparatus is the liquefaction of the inert Illuminating Gas, from its origins in the Bachelors/Malic Molds (and associations with gas-filled vacuum tubes) through successive changes of state

until it becomes a semenlike "erotic liquid."[96] The *gouttes*, or drops, of that liquid play a critical role in Duchamp's various scenarios for the final phase of the Bachelor operations, allowing him to develop the Roussel-like wordplay on *goût*, or taste, that underlies his *Bottle Rack* (*égouttoir*) as well (fig. 71). Responding to the important work being done on the liquefaction of gases in this period by figures such as Kamerlingh Onnes (fig. 137) and Georges Claude, Duchamp originally designed a more complex series of procedures for the liquefaction process (figs. 138, 139). Ultimately, he simplified that laboratorylike approach into the anthropomorphic "journey" of the Illuminating Gas and its solidified Spangles as they emerge from the Capillary Tubes linking the Molds, having experienced Duchamp's humorous "stretching in the unit of length." Duchamp played with a number of ideas borrowed from the physics of changing states of matter and contemporary discussions of liquefaction, including the intense cold required for the liquefaction (and solidification) of gases. This phenomenon is the root of his references to "frosty gas" and "snow," as well as the connecting link to the wintry landscape in the Readymade *Pharmacy* (fig. 167), which Duchamp associated specifically with the liquefaction in the *Glass* and which seems to have stood as a surrogate landscape for the Bachelors' surroundings.[97] In Duchamp's *Pharmacy*, the addition of red and green dots converted the landscape into a chemist's shop; in the *Large Glass* a chemist's laboratory becomes a landscape, complete with invisible waterfall and a Water Mill Wheel.

Because of Duchamp's interest in "*slightly distending the laws of* [both] *physics and chemistry,*" many of his notes relate to traditional chemistry.[98] Yet his notes for the Bachelor Apparatus also contain references to molecules or molecular activity that reflect a concern with the newly developed field of physical chemistry and its study of the physical and chemical properties of matter. More specifically, certain notes point to the work of the pioneering physical chemist Perrin on Brownian movement as a source for a general methodological precision, noted earlier, and for information on molecules, atoms, and subatomic particles.[99] Perrin's best-selling *Les Atomes* of 1913 summarized his research on Brownian movement, which had revealed the incessant motion of granules in a suspension to be the indexical buffeting of those granules by colliding molecules. By 1909, in fact, Perrin's publication of his research had provided the first "*ocular* confirmation" of the very existence of molecules and atoms, a topic still in debate. Perrin's writings, along with many other scientific and popular sources of the time, presented the world of molecules, like that of the speeding electrons Duchamp had evoked in *The King and Queen Surrounded by Swift*

Nudes series (pl. 2, figs. 21–24), as dominated by continuous collisions among ballistic projectiles. Now, however, instead of the images of Rutherford's subatomic collisions captured by Wilson's instantaneous spark photographs of ionized drops in his cloud chamber (figs. 145, 146), which Perrin illustrated in the 1914 edition of *Les Atomes*, Duchamp evoked such a realm by terminology and procedures associated with this research and by the large-scale collisions enacted in the Bachelor Apparatus.

Among these collisions, which include the blows in the Boxing Match, the Nine Shots projected into the Bride's realm suggest a particular parallel to Perrin. Duchamp discusses the displacement of the Shots from a single four-dimensional target or point in much the same way that Perrin used the image of a target and displacements from its center to graph the molecular deviations resulting from random collisions (figs. 143, 144). There are numerous other examples of Duchamp's language or procedures that seem to echo Perrin and even Rutherford. The theme of "scattering," for example, was central to the work of both Perrin and Rutherford, and Duchamp refers to the liquefied Illuminating Gas as a "liquid elemental scattering" and a "scattered suspension." Perrin also frequently used the term "concordance"; at the end of *Les Atomes* he celebrated the "miracle of concordance" among his findings and those of numerous other researchers concerning the number of molecules that exist in a cubic centimeter of gas (Avogadro's number). In Duchamp's "Preface" and "Notice" notes, which approximate the scientific style of Rutherford or Perrin, it is the "sign of the accordance" (*signe de la concordance*) between the "extra rapid exposition . . . of several collisions" and the "choice of possibilities" that is to be sought.

Thermodynamics and the kinetic-molecular theory of gases, two independent but interrelated fields, formed the backdrop for Perrin's work and provided Duchamp with themes that deeply interested him—namely, energy and chance.[100] The issue of energy in the *Large Glass* extends from the large-scale generation of power to the molecular and subatomic levels where, for example, Henri Poincaré discussed radioactivity and Brownian movement as seeming violations of the first and second laws of thermodynamics. Poincaré also wrote extensively on chance, and the random molecular movements studied by the kinetic theory of gases were a central focus for discussions of chance—as well as of determinism and free will—in this period. Atom theory had also been associated with the question of free will since the time of Lucretius and Epicurus, who interpreted the unexpected swerve (*écart*) of a falling atom as a sign of the possibility of free will. In a note addressing "molecular construction" and "phospho-

rescence," with its links to radioactivity and "excited" luminescent gases, Duchamp quoted the phrase "écarts de molécules," encoding the age-old debate on free will versus determinism, newly current in the context of kinetic-molecular theory, into the *Large Glass.* Thus, although the tragicomical Bachelors will never achieve their goal of the Bride, they nonetheless do possess free will. Similarly, Duchamp embodied his quest for the "liberty of indifference" and free will versus determinism in his experiments with chance at a visible scale.

The three primary exemplars of chance in the *Large Glass,* as finally executed, were the ballistic Nine Shots, the *Air Current Pistons* photographed fluttering in a breeze (fig. 120), and the Capillary Tubes based on the fall of the *3 Standard Stoppages.* Yet Duchamp's primary agent for his exploration of chance and the "liberty of indifference" was the never-executed Mobile (figs. 148, 111).[101] It was to have hung from the ends of the Horizontal Column/Scissors and to have fallen in a Splash-producing "crash" as a result of the jerky opening of the Scissors as the Chariot/Glider moved toward the Chocolate Grinder, responding to the erratic fall of the Benedictine Bottle(s) with their "oscillating density." With the recovery of the Mobile and its functions, Duchamp's assertions that "it is by this oscillating density that the choice is made between the 3 crashes," and that "it is truly this oscillating density that expresses the liberty of indiff.," can now be understood. In fact, only the successful fall of the Mobile in the center of its three possible positions would splash the liquefied gas upward. Some portion of the Splash would set off the Boxing Match's clockwork-like tugging on the Bride's Clothing, while the remainder would be projected through a never-executed Weight with Holes and produce the Nine Shots in the Bride's domain.

The Splash remained in Duchamp's final scenario, although it was ultimately as light (a mirror reflection through the later Oculist Witnesses [fig. 114]) that a Sculpture of Drops would ascend "to meet the 9 shots."[102] Just as electromagnetic waves had provided the communication from the Bride, such waves, now in the form of reflected visible light, would transcend the Bachelors' gravity-bound existence. Initially, however, before there was ever a Splash and long before the Oculist Witnesses, the Illuminating Gas was to have exploded in one of Duchamp's most unique creations, the Desire Dynamo (fig. 149), which was originally to have triggered the Boxing Match alone. Shown encased in a cubic box to the right of the Sieves in early drawings (figs. 140, 141), the Desire Dynamo included three rods or "desire centers," each composed of "desire," "intention," and "fear," in

varying proportions. As these rods received an electrical current, they would glow and ultimately ignite a pool of liquefied gas that had been channeled upward. The electrical connection for these igniters was provided by the Precision Brushes, flat plates visible above the Sieves on the left-hand extension of the Scissors (pl. 1, fig. 76). That contact would occur when the "little wheels" Duchamp considered for the Chariot's upward extensions slid along the Horizontal Column/Scissors. The result of that contact would be both the transmission of current and the "double displacement" of the Scissors, which could now shorten and produce a quicker ignition of the Gas. Duchamp's extensive note 153 (app. A) describes this process in detail.

Finally, the Chariot/Glider, like the Juggler of the Center of Gravity, was a centerpoint for Duchamp's play in the field of mechanics.[103] Here, however, his focus was dynamics or the motion of the Chariot, which slides on runners in the *gouttières,* or grooves, that extended his wordplay on *goût* and *gouttes.* Countering the second law of thermodynamics by "emancipating" the runners of the Chariot/Glider from friction (or "reintegrating" any frictional heat as useful energy), Duchamp created a sexual perpetual-motion machine for the Bachelor Apparatus. Yet the Chariot/Glider hardly glides smoothly: its pace is the characteristic irregular lurching of the Bachelors' demeanor—produced by the "oscillating density" of the Weight in the form of Benedictine Bottle(s) as they fall and pull the Chariot toward the Chocolate Grinder. Those Bottles were raised to their height by energy from the Water Mill Wheel at the center of the Glider (fig. 151), itself a multilayered sign for power and energy, seemingly ranging from water mill wheels and electrical dynamos (figs. 154, 155) down to the "mill wheel" used by Crookes to demonstrate the flow of cathode rays (i.e., electrons) in a vacuum tube (fig. 152).

Duchamp formulated his most extensive "Laws, principles, and phenomena" in the area of mechanics. His creative invention and challenge to accepted principles of mechanics reflect not only the rich history of this field—including the contributions of Leonardo—but also the ferment in contemporary physics, chronicled by Henri Poincaré and others, in which, for example, anomalies in the area of electrodynamics were challenging the traditional interpretation of basic concepts such as mass and inertia. Although Einstein's 1905 special theory of relativity had addressed those anomalies, his formulation of relativity, which would come to dominate physics after World War I, was not acknowledged in Paris until late 1912–13. Instead, what Duchamp knew of this ferment would have come from general comments in the writings

of figures like Henri and Lucien Poincaré, who made no mention of Einstein. Indeed, if Duchamp knew the name of Einstein, it would have been through *Les Atomes*, in which Perrin cites a different aspect of Einstein's work—his theoretical calculations of molecular displacements in relation to Brownian movement—to support his own experimental findings (fig. 143).

Duchamp's *Large Glass* was a work deeply rooted in the culture of pre–World War I Paris, and when he abandoned work on it in 1923, it may have been not only because, as he said, "it became so monotonous" and "there was no invention," but also because the new paradigms of relativity theory and quantum physics and new technologies such as radio had supplanted the earlier science and technology—from X-rays and radioactivity to wireless telegraphy—that he had explored so extensively in the prewar years.[104] It is little wonder that Duchamp's later comments on the subject downplayed his knowledge; he asserted, for example, that "every fifty years or so a new 'law' is discovered that changes everything. . . ."[105] He was right—it had happened to him. And yet, when we are willing to go beyond Duchamp's later disclaimers about his knowledge of science and recover that cultural moment as best we can, the rewards are extremely rich.

The Chariot/Glider itself is a superb example of the multiple layers of meaning and humor Duchamp could develop on a specific theme, such as back-and-forth motion and the lifting and falling of weights. The most important alternative identity for the Chariot/Glider derives from the cable-drawn plow (fig. 161), encoded in Duchamp's notes in the Rousselian homophone *buttoir*/*butoir* (plow/buffer) and providing, at last, a specific locus for his references to an "agricultural instrument" in the *Large Glass*. Duchamp also wrote of a crane or "mobile go-between" (app. A, nos. 13, 22/23; fig. 159), surely another parallel to the Chariot's tracking motion and the rising and falling weights carried on huge hooks. Eugen Sandow, the highly popular weight lifter of the period, is also included metonymically in Duchamp's Chariot mechanism in the form of the elastic "Sandow" (fig. 158), which is meant to pull the Chariot back into place. If Duchamp's Chariot took on historic, mythological dimensions with its plowing theme, its reflection of Eiffel's contemporary aerodynamic experiments with falling objects at the Eiffel Tower made it up-to-the-minute technologically (fig. 160). Spanning the past and the present and encompassing science and technology as well as popular culture, the Chariot/Glider epitomizes Duchamp's sophisticated and humorous invention in the *Large Glass* in general.

When Duchamp recorded his first conception of the theme of *The Bride Stripped Bare by the Bachelors* in a

drawing in Munich in summer 1912 (fig. 31), he may have derived the theme in part from alchemy and its emblematic depictions of chemical processes (fig. 32). The title of the *Large Glass*, however, is its single most important debt to alchemy, an ancient tradition newly current in this period in the wake of the discovery of radioactivity. Instead of alchemy, it was science and technology, from X-rays through Perrin's work on "molecular reality," that offered Duchamp the most fertile possibilities for figuring the theme of "stripping" and the more general "collision" between the Bride and her Bachelors. Indeed, in his move to science and technology Duchamp came to term the "stripping" specifically an "electrical stripping," and he subsequently created a number of possible significations for this term: an electromagnetically controlled stripping (i.e., "electrical control of the stripping"), a stripping by the Bachelors carried out by means of the electrical connection made by the Precision Brushes, igniting the rods in the Desire Dynamo and setting off the Boxing Match, or, in a more general way, the themes of X-ray stripping (denuding) or the subatomic collisions and actual stripping of electrons that occurs in the process of ionization, for example, as photographed by Wilson (figs. 145, 146). Similarly, from the Jura-Paris Road project through the last of his preparatory notes written for the *Large Glass*, Duchamp developed a variety of elemental collisions or contrasts between the upper and lower halves of the *Glass*, utilizing specifically geometrical or scientific themes. Against the backdrop of Bergsonian Puteaux Cubist theory, these contrasts assumed philosophical dimensions as well.

Thematic Collisions, Duchamp's Anti-Bergsonism, and New Unities in the *Large Glass* and Early Readymades

Duchamp's first statement of the distinctions that would be set forth in the *Large Glass* occurred in the Jura-Paris Road notes, written after his October 1912 automobile trip. Here he suggests the conflict between the finite and infinite that was to be basic to the *Large Glass* as exemplified by a collision between a finite, physical automobile filled with "nudes" (prefiguring the Bachelors) and a road as a "geometrical line without thickness" that finds an "opening toward the infinite" by means of its headlight (or a "headlight child"/Christ child). In the Jura-Paris Road text, however, the travelers/Bachelors transcend the distinction between finite and infinite: unlike the Bachelors' hopeless quest for the unreachable Bride of the *Large Glass*, they are already ensconced within a "machine-mother"/automobile with distinct overtones of the Virgin Mary, and this "more human" Mary carries

them to a "victory" over the Jura-Paris Road.[106] Duchamp would ultimately specify a central contrast between the Bride and the Bachelors as that of the "married divinity" versus the "celibate human,"[107] and the Bride would acquire associations with both the Virgin Mary and mythological goddesses such as Persephone. Even in his first statement of the narrative of the "The Bride Stripped Bare by Her Bachelors" (in his ten-page automobile-oriented note), he drew the Bride as if she were the Virgin Mary (fig. 81) and referred to other related issues (i.e., the Bride possesses a "halo" and is the "apotheosis of virginity").[108] In general, Duchamp would develop this theme as one of perfection (above) versus imperfection (below), with all its possibilities for allegorical readings as an unattainable quest—sexual, religious, or philosophical.

In this same note Duchamp began to draw on aspects of science and technology to establish the differences in the essential natures of the two opposing parties in his narrative. The Bachelors as a "steam engine on a masonry substructure" are firmly rooted to the ground, whereas the Bride who hangs above is free of the effects of gravity and "does not need to satisfy the laws of weighted balance." In addition to the Bachelors' subservience to gravity, as opposed to the Bride's escape from it, the mechanical, clockwork quality of their activities is already enunciated. Dominated by gearwheels and the "throbbing jerk" of the clocklike Boxing Match, the Bachelors represent a stark contrast to the "cinematic blossoming" of the Bride, with its organic overtones of trees (as well as automobiles). Here the organic/mechanical Bride, free of gravity, is also clearly in control. From the Bride issue the sparks and other manifestations of internal energy (a "life center") that are absent in the Bachelors, whose energy sources ("raw material drawn . . . from their not them")[109] and activities are largely external to their incarnation in the Malic Molds.

Duchamp also turned to geometry to augment the distinctions between the Bride and the Bachelors. He defined the Bachelors' realm as "mensurable" and made up of "imperfect" forms in contrast to the Bride's topological freedom from measure.[110] In particular, he used the highly popular fourth dimension, and the four-dimensional geometry that lay behind it, to establish the Bride as a four-dimensional creature ever beyond the reach of the three-dimensional Bachelors in their perspective construction. Duchamp speculated extensively on four-dimensional geometry, working, as usual, by analogy and developing his own playful laws on the subject. Although he considered such ideas as geometric continua and cuts, mirrors, and virtual images as means to signal the Bride's four-dimensionality in the *Large Glass*, he ultimately

returned to simpler ways of evoking higher dimensions. In the end, he thought of the Bride as the "shadow" of a three-dimensional Bride, who was, in turn, the shadow or projection of a four-dimensional Bride. Similarly, he relied on a number of other issues widely associated with a fourth dimension of space in this period: infinity, immeasurablity, and freedom from gravity and specific spatial orientation, as well as the mirror symmetry suggested in his interest in "hinges" and the "mirrorical return" of the Sculpture of Drops.[111]

In contrasting the Bride's freedom from "mensurability" to the Bachelors' metrical realm, Duchamp suggested a distinction between quality and quantity—a basic Bergsonian theme present in Gleizes and Metzinger's references in *Du Cubisme* to the Cubist painter's creation of complex rhythms that are "unmeasurable" and ability to "change quantity into quality."[112] If, stylistically, Duchamp attacked Cubism's preoccupation with taste and profound Bergsonian self-expression in the *Large Glass*'s retaliatory plastic language as well as in the Readymades, aspects of his narrative of the Bachelors' quest for the Bride almost parody the Cubists' pursuit of Bergsonian goals.[113] As if speaking for the Bachelors and their dream of the Bride, whose perfection contrasts with their imperfect forms, Nayral, in his preface to the Cubist exhibition at the Galeries Dalmau in spring 1912, asserted, "The absolutely perfect work of art—if one can imagine such a thing—would be that which we could never possess completely, because it would contain infinity, this infinity toward which we reach desperately without the power ever to embrace it."[114] The loss by the Illuminating Gas Spangles of not only their sense of orientation but also their individual self-identities as they traverse the Sieves seems likewise to be a humorous commentary on the mystical approach to higher dimensional consciousness, toward which Cubist theory had moved and which stood in sharp contrast to Duchamp's more geometric approach to the subject. Even Duchamp's variations on the theme of equilibrium and disequilibrium in the mechanics of the Juggler of the Center of Gravity, with its metaphorical embodiment of the Bride's sexual response, may have been a witty response, in part, to Gleizes and Metzinger's boast that the Cubist painter achieved "that superior disequilibrium without which we cannot conceive lyricism."[115]

As Duchamp continued to develop the "mixture of events" that would be "plastically imaged" in the *Large Glass*, he augmented the basic antitheses set forth in his long automobile-oriented note by adding scientific or technological functions.[116] In his "painting *of frequency*" the Bride's wave-producing (and -detecting) activities define her realm as wave-filled and etherial, in contrast to

the gravity-bound domain of classical mechanics in the Bachelor Apparatus below.[117] Indeed, the ether was often associated with the fourth dimension in contemporary literature; it was suggested, for example, that an infinitely thin extension of the ether into the fourth dimension explained the ability of X-rays to penetrate a body.[118] The Bride's realm is that of invisible, vibrating waves, her own body modeled in part on X-rays of internal organs and her communication sent via Hertzian waves dependent on the registering apparatus of her receivers—the Juggler/Handler of Gravity or the Bachelor Apparatus below. Continuity reigns in the upper half of the *Glass*, and the ether of late Victorian physics was the sign of that continuity.[119] The Bachelors' domain, on the contrary, is filled with discontinuities—from the jerky motions of the Boxing Match and the Chariot/Glider to the molecular collisions they parallel. As we have seen, Perrin's establishment of the reality of molecules and atoms, based in part on the work of Planck and Einstein, pointed toward a new model of matter and energy as discontinuous that, unbeknownst to Duchamp, would come to dominate physics and supplant the continuity symbolized by the ether. For Duchamp, however, random molecular collisions and swerves may have been most important as signs of the free will he explored in his experiments with chance in both the Bachelors' and the Bride's realms.[120]

Although both possess free will, the Bride's range of options (she swings freely in a 360° circle, for example) is far greater than that of the Bachelors, whose possibilities for motion are circumscribed within the Bachelor Machine. Thus, while the Chariot/Glider's runners are "emancipated from gravity," it can go nowhere except back and forth, reciting its forlorn "litanies."[121] The Bride is always the more powerful figure in Duchamp's notes: she is never laughable, whereas the Bachelors can appear pitifully so. This is true even though Duchamp's construction of the Bride's hybrid organic-mechanical nature flirted dangerously with the comical effect Bergson had attributed to the "mechanical encrusted on the living" in *Le Rire*.[122] Because Duchamp relied primarily upon verbal description of the Bride's many scientific or technological identities, he avoided the humorous image that would have resulted had he produced a visual collage of these components. Instead, she maintains the largely organic appearance of his *Bride* painting (pl. 3, fig. 17), evoking her underlying automobile associations only subtly. Like the basic four-dimensional/three-dimensional contrast of the *Large Glass*, the organic-mechanical Bride set against the purely mechanical Bachelors creates one of its central collisions, transcendable only by the electromagnetic waves that carry the commands of the Bride.

Although Duchamp may have shared Bergson's commitment to free will, as evidenced in the *Glass*, many of the characteristics of the Bachelor Apparatus seem to satirize Bergson's pronouncement on the evils of the intellect and of scientific analysis that disrupt the intuitive experience of duration.[123] Not only was most of Duchamp's creative energy in the *Large Glass* project embodied in the written word, which Bergson decried as "impersonal" and "cover[ing] over the delicate and fugitive impressions of our individual consciousness," but the Bachelors' realm is dominated by themes such as measuring and cutting, the spatializing tendencies Bergson abhorred.[124] As we have seen, Duchamp referred to the lower half of the *Glass* as the "equation of durations and spaces," and both clockwork mechanisms (i.e., the Boxing Match) and the theme of cutting dominate the activities of the Bachelor Apparatus, with its prominent Scissors.[125] To describe such an intellectual process of cutting and spatializing time, Bergson also referred to our tendency to create "intellectual molds" (Malic Molds?) of experience, which destroy its flow and continuity.[126] Duchamp's only attempt in the *Large Glass* to represent fluid continuity was in the Bride's "cinematic blossoming" as cloudlike Milky Way, which might be seen as a humorous image of Bergsonian sexual duration. Whereas Bergson decried the "cinematographic" character of knowledge as segmented, Duchamp also declared it impossible to achieve such a "cinematic state."[127] His goal, after all, was not motion but an "instantaneous state of Rest," a "delay in glass"; the "instantaneous" photography that was so problematic to Bergson was a positive model for Duchamp.[128]

Turning finally to the Readymades and their relation to both Bergson and the *Large Glass*, we have seen that Duchamp's use of the term *ready-made* may derive from Bergson, who associated it with the very qualities Duchamp was seeking in art: the intellectual, the external, and the mechanical versus the expression of the organic "fundamental self" of the artist.[129] Challenging the Puteaux Cubists' belief that taste, beauty, and the touch of the artist were manifestations of profound self-expression, Duchamp found a means for "unloading ideas" via preexisting objects, such as the punning *Bottle Rack* (*égouttoir*) (fig. 71).[130] Moreover, as he made further notes about Readymades once he was in New York, he introduced the factor of time as an essential aspect of the Readymade, tying the choice of a Readymade to a specific moment: "by planning for a moment to come (on such a day, such a date such a minute), '*to inscribe* a readymade' . . . *The important thing then is just* this matter of timing [*horlogisme*]. . . ."[131] Instead of the Bergsonian expression of an artist's cumulative experience of duration, free of the

artificial spatializing of time by clocks, here was an external expression essentially defined by a clock. "Naturally inscribe that date, hour, minute, on the readymade as *information*," Duchamp continued.[132]

The connection between the Readymades and the *Large Glass* appears to be even stronger as these works become more fully understood. This should come as no surprise, given Duchamp's penchant for analogy as he generated ideas for the *Glass* project. Ideas such as his could easily be "unload[ed]" on surrogate objects, like the wintry landscape *Pharmacy* (fig. 167) as the domain of the Spangles of "frosty gas," as we have seen.[133] In his essay for the catalogue of the 1964 exhibition *Marcel Duchamp: Ready-mades, etc. (1913–1964)*, Ulf Linde provided the most extensive speculation to date on possible interconnections of the Readymades and the *Large Glass*. In addition to pointing up the parallels Duchamp established in the *Box in a Valise* (and echoed in the 1963 Pasadena retrospective) between the stacked *Air of Paris*, *Traveler's Folding Item*, and *Fountain* (fig. 166) and the Bride, Bride's Clothing, and Bachelors of the *Large Glass*, Linde also suggests numerous other pairings, based primarily on wordplay. Although Linde notes the presence of *gouttes* and a *gouttière* in the *Large Glass*, along with the fact that the urinal of *Fountain* might be considered "dégoûtant" (disgusting),[134] he does not discuss the *Bottle Rack* as an *égouttoir* in relation to drops (*gouttes*) and the avoidance of taste (*goût*), surely its most important linguistic significance. Even if certain other of Linde's discussions of wordplays seem somewhat fanciful (even for the Rousselian Duchamp), his essay is nonetheless valuable for its revelation of the importance of Duchamp's layout for Lebel's 1959 monograph as a source of clues about relationships among his works.[135]

In addition to certain wordplays, functional analogies would seem to be the primary way in which Duchamp's early Readymades relate to the *Large Glass*. At the time of the Pasadena installation, Duchamp commented to Walter Hopps that the three stacked Readymades echoing the *Box in a Valise* represented "readymade talk of what goes on in the *Glass*";[136] that notion may be generalized beyond these three Readymades. As suggested earlier, the proto-Readymade *Bicycle Wheel* of 1913–14 (fig. 70) likely stands in some relation to the theme of wheels in the *Large Glass*, setting in motion the Water Mill Wheel/dynamo that powers the Bachelor Apparatus. The connection to the *Glass* of the first two bona fide Readymades, the 1914 *Pharmacy* and *Bottle Rack* (figs. 167, 71) has been discussed repeatedly herein and seems firm. Indeed, in the Lebel monograph Duchamp reproduces the two works side-by-side, below and opposite images of the

Malic Molds or Cemetery of Uniforms and Liveries (including fig. 96), establishing a strong thematic link with that region of "snow," "frosty gas," and splashing drops in the Bachelor Apparatus. Duchamp's best-known Readymade of 1915, the snow shovel inscribed *In Advance of the Broken Arm* (suspended from the ceiling and visible at the top of fig. 118), playfully continues this theme with its clear link to snow. The same could be said of Duchamp's note to himself to "buy a pair of ice-tongs as a Rdymade."[137] Finally, the "Semi-Readymade" *Why Not Sneeze Rose Sélavy?* (fig. 72) may have evoked Duchamp's wintry theme via a clever metonymical play on Jack Frost–brand sugar cubes (see chap. 14).[138]

Duchamp's lost 1915 Readymade, *Pulled at 4 Pins*, a chimney ventilator capable of swinging in the wind, was apparently the first "readymade" embodiment of the Bride, in this case in her guise as Weather Vane.[139] (His 1964 etching of the ventilator, bearing this title as well, is printed in reverse, a subtle evocation of the mirror symmetry associated with the fourth dimension and, hence, the Bride.)[140] The theme of "ventilation" in the realm of the Bride, the source of her weather vane–like swinging, also found a readymade manifestation in 1921 in the taxicab notice headed "VENTILATION," which Duchamp included as a text in *New York Dada*, signing it "DADATAXI, Limited."[141] That the suspended *Hat Rack* of 1917 seems to have served as yet another stand-in for the Bride is confirmed in Duchamp's 1918 *Tu m'* (fig. 173), where her shadow is projected on the etherial realm at the right of the painting that contrasts sharply with the physical, perspectival world at the left (see chap. 14). And, as noted earlier, it is the 1919 *Air of Paris* as Bride/Virgin Mary/Persephone that hangs in the *Box in a Valise* above the Bride's Clothing represented by *Traveler's Folding Item* of 1916 (fig. 166).

In addition to that folding Underwood cover as a counterpart to the mid-section of the *Glass*, two other Readymades of 1916 may also function in this manner. Duchamp's linguistic play on the *gouttes/goût* theme in the *Bottle Rack* figures, on one level, in his 1916 metal *Comb* (Philadelphia Museum of Art, The Louise and Walter Arensberg Collection), to which he added the inscription "3 ou 4 gouttes de hauteur n'ont rien à faire avec la sauvagerie" (3 or 4 drops of height have nothing to do with savagery).[142] If "gouttes de hauteur" is read as "goût d'auteur" (author's taste), Duchamp may be echoing his earlier reaction to *Du Cubisme*, where Gleizes and Metzinger argued that, in contrast to the common, "rudimentary taste" of the "savage," one could "with infinitely greater justice consider as a savage the so-called civilized man who, for example, can appreciate nothing but Italian painting or Louis XIV

furniture."[143] Yet Duchamp's "drops of height" may also allude to the drops of Illuminating Gas that achieve some degree of height. The *Comb* itself suggests functional analogies to the mid-section of the *Glass*—Duchamp actually placed the *Comb* in that position on the right panel of the *Box in a Valise* (fig. 166). Although he had speculated on using a comb with broken teeth to generate a measuring system,[144] his *Comb*, whose metal "plates" alternate with insulating air, also evokes the structure of an electrical condenser (fig. 89), the spark-producing apparatus with which he seems to have associated the mid-section of the *Glass* (fig. 88). In Lebel's monograph, Duchamp reproduced the *Comb* in a vertical position next to the "Assisted Readymade" *With Hidden Noise* (Philadelphia Museum of Art, The Louise and Walter Arensberg Collection), emphasizing the formal parallels between the two (fig. 170). Constructed by bolting together two metal plates (bearing a playful coded message) around a ball of twine that contained a secret object unknown to Duchamp, *With Hidden Noise* bears a striking visual resemblance to an actual condenser (fig. 89).[145]

The photographs of Duchamp's studio taken in 1917 (figs. 70, 118) document the displacements he had given his chosen objects, sometimes contradicting the associations with the gravity-bound Bachelors that may have generated his interest in the first place (e.g., *In Advance of a Broken Arm* and *Fountain*, the molded male object he identified with the Bachelors in the *Box in a Valise*). Yet, along with the suspended Bride as *Hat Rack*, two of the works displayed replicate specific situations in the *Large Glass*. Although Duchamp said later that he did not buy the coatrack he subsequently titled *Trébuchet* (Trap) as a Readymade, when he finally nailed it to the floor of his studio (fig. 70), he created not only a reference to a trapping chess play but also an analogue to the historical *trébuchet* of the Middle Ages, a weapon that hurled projectiles at the wall of a fortress. Like the Combat Marble of the Boxing Match, Duchamp's visitors would be hurled into a collision with the nearest stationary object. Similarly, Duchamp's lost *Sculpture for Traveling* of 1918, a web of rubber strips, gave visible form to the "principle of gravity" in the Bachelors' realm, which Duchamp described as "putting the picture under the control of 'elastic bands' extending from the center of the earth."[146]

Duchamp took *Sculpture for Traveling* with him to Buenos Aires in late 1918, where he also worked on *To Be Looked At (from the Other Side of the Glass) with One Eye, Close to, for Almost an Hour* (figs. 115, 171), the work in which he began to develop the optical theme he was to add to the *Large Glass*. Although that work was far from "ready-made," when Duchamp hung it on a balcony in Buenos Aires, its counterpart was his 1919 Readymade-at-a-distance, *Unhappy Readymade*, the geometry book he instructed Suzanne to hang on her balcony in Paris, which served as a meteorological registering apparatus that converted Euclidean geometry to non-Euclidean geometry. Significantly, in Lebel's book Duchamp reproduced the two works facing each other.[147] Yet, with the succès de scandale of *Fountain*, Duchamp's Readymades had achieved a status that seems to have led to greater independence from the *Glass* as prime generator of their "ideas." Witness *L.H.O.O.Q*, the reproduction of Leonardo's *Mona Lisa* defaced with mustache and goatee and vulgar pun, although here, too, a connection could be made to the optical themes that now interested Duchamp: Look, he tells us.[148] Indeed, even when tied closely to the *Large Glass*, Duchamp's early Readymades never operated on a single level any more than did the individual parts of the *Glass* itself. They were ambiguous, three-dimensional signs or "hieroglyphs" filled with potential readings.[149] Stylistically, however, the message was unmistakable: modeling himself on the detached impersonality of an engineer or scientist, Duchamp had replaced artistic touch and canons of taste with a detached "beauty of indifference" associated with industrial culture and museums like the Musée des Arts et Métiers rather than the Louvre.

In the Readymades, as in the *Large Glass*, Duchamp achieved his goal of making an art that was not the "expression of a sort of inner life"—in stark contrast to the Bergsonism of his Puteaux Cubist colleagues.[150] His mordant wit, joined to his study of science and technology, was a powerful weapon, producing what he termed in one of his notes on the concept of the "Possible," "a physical caustic (vitriol type) burning up all aesthetics or callistics."[151] "I wanted to use my possibility to be an individual," Duchamp stated in an interview late in his life; he achieved that "Possible" by his creation of the humorous "hypophysics" of the *Large Glass* ("without the slightest grain of ethics of *esthetics* and of metaphysics—").[152] In the tradition of Roussel and Jarry and on the model of the extreme egoistic individualism of Max Stirner, whom Duchamp cited specifically in relation to the *3 Standard Stoppages*, Duchamp used his art to define himself as a highly inventive and iconoclastic artist-engineer-scientist.[153] If, in the Readymades in particular, he had done away with the idea of expressive originality manifested in the creation of an object (he preferred the model of music, in which the musical composition and not the score was given pride of place), his individual self-fashioning required the continued generation of original ideas. One

of Duchamp's greatest fears, after all, was repeating himself and falling into the dangerous trap of "taste": "Repeat the same thing long enough and it becomes taste," he told Sweeney in an interview.[154] The rich resources of science, technology, and geometry had assured his escape from that danger.

Duchamp's *Large Glass* project, whose execution was preceded by three years of extensive "research" and note writing, is unprecedented in the history of art. As a "self-portrait" central to his identity, the *Large Glass* was to serve Duchamp as the conceptual anchor for much of what he would do the rest of his career. "I had a certain love for what I was making," Duchamp told Cabanne, explaining his later efforts to assure that his body of work would be gathered together and displayed in a museum setting.[155] As Anne d'Harnoncourt has suggested in a Duchampian metaphor, there is a "network of interconnecting threads joining the most disparate items in his oeuvre."[156] Paralleling the situation of the Readymades, the rediscovery of the wealth of themes in the *Large Glass* rooted in contemporary science or technology reveals new thematic connections between the *Glass* and his later works as well.

After the 1910s, Duchamp was never again so closely engaged with science, technology, or geometry, and he often recast his earlier interests in terms of his everyday life. In the context of his notes on "infrathin," for example, differences in dimensionality were to be understood in terms of everyday experience, and the energy transformations that now interested him converted bodily energies instead of electricity (see chap. 14). As we shall see, Duchamp's studio, as it appears in the 1945 *View* triptych (fig. 179), suggests that he was living surrounded by three-dimensional counterparts to the components of the *Large Glass*. In view of this activity as well as his 1947 *Altar of the Handler of Gravity* tableau (fig. 181), the final surprise of the secret *Etant donnés* (figs. 183, 186) comes as less of a shock. According to Mme Duchamp, Marcel was never much of a reader during their years together, which began in the 1950s.[157] From the present study of Duchamp's notes for the *Large Glass*, however, one could logically deduce that the massive intellectual effort he expended in the 1910s was easily enough to sustain him for the rest of his life.

The *Large Glass* in the Context of Early Twentieth-Century Modernism

Apollinaire's short story "Le Roi-lune" (The Moon King), an erotic fantasy of lovemaking at a distance published in 1916, contains a remarkable image paralleling the "elec-

tric fete" Duchamp conceived in *The Bride Stripped Bare by Her Bachelors, Even*. At the conclusion of an underground adventure in the fantastic "palace" of the Moon King, which he had discovered when lost one night in the Tyrolean Alps, the narrator/Apollinaire emerges into a forest grotto. The sight he observes might well have been one of Tesla's spectacular performances:

The thousand lights which had been born there . . . expanded, changed colors, brought their tints together, modified these colors, flew into geometric shapes, flew apart glimmering, flaming, shooting sparks, solidified, so to speak, into incandescent geometric forms, into letters of the alphabet, numbers, into animated shapes of men and animals . . . in light with no visible source, in beams, in zigzags.[158]

That experience followed upon the narrator's observation of (and brief participation in) a transhistorical orgy of lovemaking with figures from the past. Such encounters were made possible by a Jarryesque time machine that could select a portion of historical space and then "make [it] visible and tangible to whoever wore the belt" that was attached to the phonographlike cylinders of the machine.[159] Apollinaire had already explored such intimate communication at a distance in his 1910 story "Le Toucher à distance," explaining the hero's ability to manifest himself in various geographical locations simultaneously as a result of his experiments with "wireless telegraphy and telephony" and other new technologies.[160] By 1916, in "Le Roi-lune," the Moon King possesses a proto-radio, based on contemporary experiments in wireless telephony: as he presses different keys, the machine brings him "the most distant sounds of terrestrial life" from around the world.[161]

The latest electrical and electromagnetic technology was a fertile source for Apollinaire, just as it had been for Villiers, Jarry, and Roussel, and as it was for Duchamp. In particular, vibrating electromagnetic waves and their manifestations emerge as a leitmotiv in the work of both Duchamp and Apollinaire, as well as a surprising number of other early modern artists and writers. Initially artists had responded to the visual ramifications of the X-ray, which offered a radically changed image of matter and space as transparent and interpenetrating. Among those who drew on X-rays were Kupka and Duchamp, along with other Cubists, the Italian Futurists, and the Russian Rayonist painter Mikhail Larionov, who named his style after the new rays.[162] The painted images of these artists function as glimpses of the invisible, and the analogy of the X-ray plate—able to index invisible effects—was to

be highly important. Yet, ultimately, Hertzian waves and wireless telegraphy technology offered an even more graphic model of vibrating waves that could be emitted and then registered by the appropriate *appareil enregistreur*, an apparatus compared to the human brain by respected figures such as Crookes. Adopted by occult proponents of telepathy and Magnetism as well as by enthusiasts of science, such vibrations and emanations offered abundant creative possibilities to early modern writers and artists alike.

Although Duchamp's *Large Glass* has often been treated as a solitary masterpiece, it was, in fact, squarely at the center of the modernist response to a radically changed paradigm of reality, now redefined in terms of electromagnetic waves. Of course, numerous other scientific phenomena commingled with his interest in electricity and electromagnetism. Similarly, Duchamp's response was distinguished from that of other modernists by his use of science and technology for humorous and iconoclastic ends and, specifically, as a commentary on sexuality, religion, philosophy, and art making itself. In this regard, his closest colleagues in spirit were Apollinaire and Picabia and, subsequently, his sister Suzanne, and Jean Crotti. These figures were inheritors of the irreverent tradition of Jarry and Roussel, or what Duchamp later termed the historical "Dada spirit," in which he included Rabelais. Duchamp adopted this designation in response to attempts by later critics to subsume his work within the larger rubric of a Dada movement, even though much of it had clearly preceded the emergence of European Dada in Zurich in 1916.[163]

In spite of the wit and irony evident in Duchamp's use of electromagnetism, there are nonetheless important parallels that link the *Large Glass* to art and literature in the early twentieth century. Delaunay (fig. 83), Cendrars, and, in a less iconoclastic moment, Apollinaire, in his 1914 "Lettre-Océan" (fig. 84), all celebrated the new simultaneous communication made possible by wireless telegraphy and symbolized by the Eiffel Tower. Apollinaire's typographical experimentation followed upon the Futurist Marinetti's declaration that wireless telegraphy represented a new stylistic model for poetic expression based on "wireless imagination," which would be free of the constraining "wires" of syntax.[164] Functioning on one level as a subtle, metonymical landscape that evokes the Eiffel Tower by means of the multitude of functions at its top, Duchamp's *Large Glass* is a unique product of this prewar Parisian milieu: at the same time it responds to and distances itself from contemporary enthusiasm for the tower.[165]

Although the model of Hertzian waves and wireless telegraphy led to important stylistic innovations in art making, its most widespread effect in both literature and art was the emergence of a conception of the artist or poet as a sensitive "registering apparatus," and of artistic communication as a process of emitting and receiving signals. As noted earlier, Ezra Pound, who was in contact with French writers in this period, compared poets to antennae and described them as "on the watch for . . . new vibrations." In his 1913 essay "The Approach to Paris," Pound spoke as well of writers attempting to compose "in new wave-lengths" that would require sufficient "verbal receiving stations" on the part of readers, and the metaphor of radio communication would remain central to his theories in subsequent years.[166] That theme was crucial to Kupka's thinking in this period as well. Having initially spoken of the artist as clairvoyant, possessing a sensitive "psychic film" able to detect invisible effects like the X-ray, Kupka by 1912 had adopted wireless telegraphy as his model for the artist's "emission" of his creative idea and its reception by a suitably sensitive viewer. As we have seen, Kupka even speculated on the possibility of a "telepathic" art involving a direct, vibratory transmission of images from the artist's mind to the viewer's, thereby eliminating the "laboriously" created painting or sculpture—a model of art as pure idea that would surely have pleased Duchamp.[167]

Largely through the literature on Wassily Kandinsky, *Thought-Forms*, the 1901 book by Annie Besant and C. W. Leadbeater, has come to stand as the icon of the literature on vibratory communication at the turn of the century; however, it was but one manifestation of a much larger body of writing on the theme of thought transference.[168] Authors on this subject included prominent scientists like Crookes and Flammarion (both with leanings toward spiritualism) as well as the Parisian occultists Baraduc and Rochas, whose advocacy of Reichenbach's Magnetism drew extensively on contemporary developments in electromagnetism. Indeed, Hertz's 1888 proof of the existence of electromagnetic waves and their ability to generate a spark in a secondary circuit at some distance had given scientific cogency to the arguments of occultists long fascinated by the possibility of thought transfer. Paris in the first decade of the century was filled with literature on vibrations, emanations, and the exteriorization of thought.[169] This was the context in which Duchamp matured as a painter, in close contact with Kupka. Duchamp's *Portrait of Dr. Dumouchel* (fig. 2) and *The King and Queen Surrounded by Swift Nudes* series (pl. 2; figs. 21–24) seem to reflect not only Rochas's concern with flamelike magnetic emanations projected from the body but also, in the "Swift Nudes" in particular, the manifestation of speeding electrons as flamelike sparks.

Kupka's notebooks are filled with the theme of vibrations. His solution, in lieu of a purely telepathic art, was to create abstract patterns of color, akin to Baraduc's capturing of abstract exteriorizations of thought on a photographic plate, which would themselves generate vibrations to be received in the eye and mind of a viewer (figs. 85, 86). Duchamp's brother Duchamp-Villon also responded to the prevalence of vibration theory in an unpublished manuscript: "The problem is to reveal the vibration of thought itself and thereby to provoke states of consciousness hitherto unexpected or unknown."[170] Yet although Duchamp drew inspiration from Kupka's erudition in the area of science, he did not share his mystical orientation. Nor did Duchamp partake of his brother's interest in provoking new "states of consciousness," a theme he indirectly mocked in the Spangles' loss of orientation and self-identity in the *Large Glass*. Instead, the vibrations in the *Glass* are vehicles for sexual communication and radio control between the Bride and the Bachelors—as well as the embodiment of the Bride's mental state of "self blossoming" projected toward the Juggler/Handler of Gravity. In addition to the clear model of wireless telegraphy, the Bride's "cinematic blossoming" as Milky Way seems to suggest the imprint of a telepathic thought projection or "radiation," which may also be echoed in Suzanne Duchamp's near-contemporary painting-collage *Radiations of Two Lone Ones at a Distance* (fig. 106).[171]

When Duchamp wrote the entry for Wassily Kandinsky in the catalogue for the Société Anonyme collection in 1943, he praised Kandinsky's geometric abstract paintings of the 1920s, suggesting that they were "a deliberate condemnation of the emotional; a clear transfer of thought on canvas."[172] Duchamp used the phrase "transfer of thought" knowingly, and, indeed, the theme of vibratory communication was as central to the evolution of Kandinsky's painting style as it was to Kupka's. Kandinsky, who lived on the outskirts of Paris in 1906–7, read many of the occult-scientific sources popular in Paris, including Crookes, Flammarion, and Rochas.[173] Although Duchamp had purchased *On the Spiritual in Art* during his Munich stay in 1912, he eschewed the kind of emotional resonance Kandinsky had initially hoped to generate in his viewers.[174] Nonetheless, Kandinsky, Duchamp, and Kupka were all grounded in the same model of electromagnetic wave communication. Just as Crookes's table of vibrations combined sound vibrations and electromagnetic waves, including visible light, Kandinsky believed that the color vibrations of his paintings were able to generate a *Klang*, or resonance, in the soul of the viewer. If the vibration of strings or a tuning fork served Kandinsky as inanimate

models in the realm of sound, it was the human-to-human communication based on the telegraphy/telepathy analogy that underlay his theory.[175] In 1944, Katherine Dreier, the patron of both Kandinsky and Duchamp, wrote of "the world of the spirit or the finer vibrations" she sensed in the *Large Glass*.[176] Although her emphasis on spirituality was misplaced, the theme of vibrations, if interpreted quite differently, was shared by two of her favorite artists.

In addition to their common interest in electromagnetic, wave-borne communication, Kandinsky and Duchamp both responded to the discovery of the electron and the inner structure of the atom in the early years of the century. Although Kandinsky's statement in his 1913 "Reminiscences" about the "crumbling" or "further division of the atom" has at times been interpreted as a reference to the work of Rutherford around 1911, his experience undoubtedly occurred in the context of the upsurge of public interest in this topic following the discovery of the electron and developments in radioactivity research around 1902–3.[177] That was the moment when popular literature announced that the atom was not indivisible but was composed of smaller components, such as electrons, which might be the fundamental building blocks of matter. In *On the Spiritual in Art*, Kandinsky refers to the "electron theory—i.e., the theory of moving electricity, which is supposed completely to replace matter" as contributing to the general shaking of the foundations of materialism and the move toward an era of greater spirituality.[178] Here and in his reference to the "further division of the atom," Kandinsky echoes the argument in such sources of 1904 as Le Bon's "La Dématérialisation de la matière," Lodge's "Electric Theory of Matter," or Lord Balfour's presidential address before the British Association for the Advancement of Science, "Reflections on the New Theory of Matter," which Rudolf Steiner quoted in his periodical *Lucifer-Gnosis*.[179]

Like Kupka and Kandinsky, the other great pioneer of abstract painting, Kasimir Malevich, also responded directly to wireless telegraphy in paintings such as *Suprematist Composition Expressing the Sensation of Wireless Telegraphy* (fig. 125). Electromagnetic waves and their registration may also have served as a more general model for Malevich: his painted surfaces function as a kind of sensitive "film," registering the passage of higher-dimensional forms or even waves.[180] As we have seen, Duchamp's *Large Glass* can also be thought of as a kind of indexical registering apparatus, constructed, rather than painted, using techniques that often approximate the creation of electrical or electromagnetic equipment. The *Glass* thus combines the two aspects of the artistic/literary response to electromagnetism: it depicts a narrative

centered on communication via vibrating waves, and it functions as a physical object suggestive of a registering apparatus capable of indexing its environment. In the introduction to his 1992 anthology *Wireless Imagination: Sound, Radio, and the Avant-garde*, Douglas Kahn defines the themes of vibration, transmission, and inscription as central to the work of twentieth-century artists and writers who have been involved with sound alone or transmitted sound via radio and its precursors.[181] These terms are appropriate as well to the more delimited field of early wireless telegraphy practice and the works of early modern art and literature that responded to the newly prominent paradigm of electromagnetic waves.

These issues were to remain relevant in the context of both Dada and Surrealism. In numerous works made in the context of the Dada movement, Picabia, in particular, would continue to figure sexual relationships in terms of electricity and electromagnetism (c.g., fig. 175), just as Duchamp, in his optical works (figs. 174, 177, 178A, 178B), would carry on his earlier theme of wave-borne sexual communication. Breton, in his first *Manifesto of Surrealism* of 1924, relied equally on metaphors from electricity and electromagnetism, presenting the Surrealist poet as a "recording instrument" capable of registering impulses from the subconscious mind and treating the value of a Surrealist image in terms of the "beauty of the spark obtained." Testifying to the prevalence of electrical discharge tubes (pl. 4, figs. 97, 99) in the early years of the century, Breton illustrated his argument that Surrealist "automatic writing" created an atmosphere "especially conducive to the production of the most beautiful images" by comparing it to the gaseous atmosphere of an electrical tube in which "the length of the spark increases to the extent that it occurs in rarified gases."[182]

Applying his terminology to Duchamp, Breton, in his "Lighthouse of *The Bride*" essay of 1935, introduced the artist as a "most sensitive recording instrument" who had detected the "vibrations" of the coming artistic and societal change.[183] Gabrielle Buffet echoed Breton in her 1936 essay "Fluttering Hearts," describing Duchamp as one of those individuals "gifted with antennae, thanks to which they detect and register, with the sensitivity of a seismograph, at their very inception, the first vibration of human evolution."[184] Although Breton obviously brought a Surrealist slant to his reading of Duchamp, he and Buffet were themselves highly sensitive respondents to Duchamp's project. As suggested earlier, Breton's (and Buffet's) grounding in early twentieth-century science made it possible for them to recognize in the *Large Glass* "the most recent data of science" upon which Duchamp had based his creative invention.[185] Restored to the scientific and technological milieu of that period, the *Large Glass* is again illumined as it would have been for Duchamp and his closest colleagues, the initial audience who shared in his witty Rousselian and Jarry-like variations on contemporary science and technology. Without such a context, we in the second half of the century have missed far too many of the resonances of this "painting *of frequency*."

Chapter 14

Coda

Extensions and Echoes of the *Large Glass*

Duchamp's study for the lower right corner of the *Large Glass, To Be Looked At (from the Other Side of the Glass) with One Eye, Close to, for Almost an Hour* of 1918 (figs. 115, 171), straddles the conclusion of an examination of the *Large Glass* itself and a consideration of his subsequent works.[1] Appropriately two-sided, this Janus-faced object looks back to the evolution of Duchamp's thinking about the upward transit of the Illuminating Gas to include the Oculist Witnesses and, at the same time, points forward toward his growing concern with optics per se and with spiraling optical disks. Electricity and electromagnetism, in particular, form a thread of continuity: working within the range of visible light waves, Duchamp would also begin to incorporate electrical current in actual motorized "machines," (e.g., figs. 174, 177). Just as he found witty sexual content in the science and technology he utilized in the *Large Glass*, his exploration of optics was also to produce sexually suggestive effects. The Readymades had functioned as three-dimensional actualizations of elements and themes for the *Large Glass,* and in later years the tendency to embody such themes in the form of objects and experiences from his daily life would become stronger. As his engagement with science and four-dimensional geometry of the prewar years receded, Duchamp's concept of "infrathin," which explored the liminal transition from one dimension or condition to another, and his project *Etant donnés* (figs. 183, 186) recast his earlier concerns in more familiar terms rather than in those of Playful Physics.

Electricity and Electromagnetism in Duchamp's Later Works

In his quest to move beyond "retinal" painting, Duchamp had conceived the *Large Glass* (pl. 1, fig. 76) as something other than "a painting to be looked at." As he told Cabanne, "One must consult the book [i.e., Duchamp's published notes], and see the two things together. The conjunction of the two things entirely removes the retinal aspect I don't like."[2] Yet, during his stay in Buenos Aires from August 1918 to June 1919, Duchamp created a study on glass for the area of the Oculist Witnesses that contained the specific instructions "*A regarder (l'autre côté du verre) d'un oeil, de près, pendant presque une heure*" (figs. 115, 171).[3] *To Be Looked At* announces looking as an acceptable activity for the retina, but this is looking defined as the physiological registering of an optical experiment. Clearly not the looking "in the aesthetic sense of the word"[4] he had avoided in the *Large Glass*, it is also not yet the sensual, sexually charged viewing that Rosalind Krauss, for example, has discussed in Duchamp's spiraling optical effects (figs. 177, 178).[5] In *To Be Looked At*, the eye must submit to an hour-long gaze and the visual exhaustion that will inevitably result. It is as if Duchamp had humorously determined to punish all those retinas that had taken sensual delight in the painterly "physical aspect" of modern paintings.[6] By the 1960s, however, he had commuted the sentence, telling Jeanne Siegel, "I just tell them not to do it because there's nothing to look at but exhaustion."[7]

The viewer who observes *To Be Looked At* as instructed does so from the mirror-reversed image of its back; moreover, seen through the convex lens, the view of the surrounding gallery is inverted. Like Duchamp's Bachelors and their Spangles of Illuminating Gas, an observer might well lose a clear sense of up and down, left and right, thereby paralleling the momentary, futile glimpse of four-dimensionality experienced in the Bachelor Apparatus.[8] If Duchamp places the viewer in a situation analogous to that of the Bachelors he gently mocked in the *Glass*, the fundamental connection between the *Large Glass* and *To Be Looked At* is the latter's inclusion of elements from the literature on perspective, Duchamp's primary means of constraining the Bachelors in their three-dimensional realm. Thus, the work includes both the suggestion of a visual pyramid, as if to imply the Bride's view from above, and an allusion to a specific perspective instrument, the portillon, the pointed, upright stylus with the lens at its top.[9] Unlike the *Large Glass*, however, in which he uses an underlying perspective system to structure the lower half, as painters before him had done, *To Be Looked At* incorporates the tools and visual schemas of the *perspecteur,* or student of optics. In addition to the visual pyramid and portillon, the work includes

a real lens as well as the Oculist Witness's circular pattern of radiating lines based on the optician's charts Duchamp had begun to collect (see, e.g., fig. 174).[10] In a typical gesture of self-fashioning, Duchamp here declared himself a self-conscious user of such tools and an investigator of the principles of optics. His interest in optics was now to be optics for physics' sake rather than optics for art's sake.

From his study of physics, Duchamp understood the behavior of light waves and phenomena such as reflection, refraction, diffraction, interference, and polarization. As noted earlier, he referred to the *Large Glass* as a "delay in glass," suggesting his interest in the "retarding" of light waves in glass by refraction.[11] Beyond the similarity of the glass-plate medium, *To Be Looked At* produces a specific effect of refraction through the convex lens on its surface: "Glue a magnifying glass on. Kodak lens," he wrote, in a note relating to the Oculist Witnesses.[12] It had been experiments investigating the wave properties of light that had established the wavelike nature of both X-rays and Hertz's "electrical radiations."[13] Indeed, in *To Be Looked At* Duchamp seems to have combined his earlier interest in Hertzian waves and his new concern with visible light by means of the phenomenon of interference. The painted stripes on his floating pyramid and the metallic "zone-plate" image around the lens, akin to Lodge's in his *Signalling across Space without Wires* (fig. 172), address the issue of interference in the contrasting realms of visible light reflected from painted pigment and of Hertzian waves (or visible light) explored in laboratory experiments with electromagnetic waves.

Interference patterns had played a critical role in the history of the wave theory of light: Thomas Young's establishment in 1801 of interference patterns when light was passed through two narrow slits had provided the first experimental confirmation of the light waves Christiaan Huygens had theorized in the late seventeenth century. Thomas Preston's well-known *Theory of Light* (1890) declared the principle of interference to be "one of the most fertile in physical science," and the concept remained fruitful for Duchamp.[14] His notes on infrathin, made between 1935 and 1945, include the phrase "watered silk—iridescents (see interference effects at the Palais Découverte)."[15] Several other of these notes include references to iridescence and, specifically, moiré patterns, both of which are the result of the overlay of two patterns. Iridescence results from the interference of light waves reflected differently from the top and bottom surfaces of a thin film; moiré images, by contrast, simply approximate true interference phenomena by their superposition of stripes. In *To Be Looked At,* Duchamp creates the effect of interference patterns by his layering of alternating bands of green over

yellow at the left and blue over red at the right, which results in the moiré-like effect of virtual vertical stripes. Likewise, he surrounds the lens below with silvered bands of decreasing width in the pattern characteristic of the zone plate, which optical experimenters had designed to function as a condensing lens by means of interference effects. Lodge's illustration of such a zone plate tied it specifically to Hertzian waves, although his text notes that he had not been as successful in interference experiments with Hertzian waves as he had with other of his "optical experiments" with those waves.[16]

To Be Looked At can be thought of as a kind of indexical registering apparatus, particularly as it hung on a balcony in Buenos Aires (fig. 115; see chap. 8). Incorporating two ranges of the electromagnetic spectrum, the work stands as a laboratory-like demonstration piece and points toward Duchamp's future exploration of the physics of optics in his motion-oriented "Precision Optics," beginning with the *Rotary Glass Plates (Precision Optics)* of 1920 (fig. 174). He would now leave painting completely behind, opting for the dematerialized color and light of the electromagnetic spectrum as an alternative to the painter's colored pigments. In fact, by the time Duchamp fabricated *To Be Looked At*, he had already produced a final painted statement about the inadequacy of painting in *Tu m'* (fig. 173), created in New York during the first half of 1918, before his departure for Buenos Aires.

Katherine Dreier had commissioned what was to be Duchamp's last oil painting on canvas to fit in a narrow space above a bookcase in her New York apartment. The title, *Tu m'*, suggests phrases such as "tu m'emmerdes," a coarse expression of irritation and boredom, which mirrored Duchamp's displeasure with the task.[17] Yet, pressed into service as a "painter," Duchamp succeeded in producing a disdainful commentary on the practice of painting, utilizing themes and techniques he had explored earlier in the *Large Glass* and related Readymades. As he told Marcel Jean in a 1952 letter, *Tu m'* was "a dictionary of the main ideas of the years preceding 1918—Readymades—standard stoppages, tear, bottle brush, cast shadows, perspective."[18] *Tu m'*, in fact, presents an interplay of shadows, painted illusions, and actual objects, which function as signs of shifting dimensions and realities. On the surface of *Tu m'*, the Readymades *Bicycle Wheel* and *Hat Rack*, along with an imaginary corkscrew, cast two-dimensional shadows; the actual objects attached to the canvas—a bolt "holding" the painted color samples in place, safety pins "mending" the trompe l'oeil tear in the canvas and, particularly, the bottle brush extending out from the tear—stand as Duchampian "shadows" of four-

dimensional objects. Even the curved lines at the right side of the canvas, radiating from the four corners of the foreshortened white square that bisects the composition, might be thought of as one-dimensional "shadows" of the *3 Standard Stoppages*, to which Duchamp had recently given physical form as wooden rulers.[19]

"After the bride....make a picture. of *shadows cast* by objects 1st on a plane. 2nd on a surface of such (or such) curvature . . . ," Duchamp had written in a note headed *"probably to relate to the notes on 4-dim'l perspective."* Another note had talked of the process of projection and the "shadow cast by 2, 3, 4, Readymades. *'brought together.'"*[20] Duchamp had used a projector to create the shadows he then traced onto the canvas, engaging the tradition of optics, perspective, and projective geometry he had studied earlier and would now pursue again. Yet, there are further references to perspective in *Tu m'* that are barely visible and that were virtually ignored until Robert Herbert's close analysis of the painting, published in 1984.[21] Beneath the shadow of the *Bicycle Wheel* is a series of diagonal red lines that recede to a vanishing point at the top edge of the canvas near the midpoint of the row of painted lozenges of color, which themselves also recede toward a vanishing point above, this time at the upper left corner of the canvas. Just to the right of the *Bicycle Wheel* shadow is a curious circular pattern, which Herbert compares to a radiating city plan and which reinforces the sense that this half of the canvas is seen from above, in conventional perspectival terms. By contrast, the right half of the canvas avoids such direct perspectival effects: the variously colored segmented lines radiating back into space from the curved linear tracings of the *Stoppages* do not meet in a vanishing point, nor do their segments diminish in size as they recede in space. Nonetheless, the downward direction of the lines does suggest a horizon line at the bottom—rather than at the top—of the canvas.

Perspective versus nonperspective, a horizon line above versus a horizon line below: we have encountered similar contrasts in the *Large Glass*, and it would seem that the two distinct regions of *Tu m'* parallel in a general way the two registers of the *Glass*. In contrast to the clarity and materiality of the left side of the canvas, the region to the right of the white plane offers a hazy shadow cast on a "curved," non-Euclidean space suggested by the lines of the *Stoppages*—a space similar to the Bride's nondescript, four-dimensional space. Duchamp reinforces this reading of the painting as a restatement of the collisions theme of the *Large Glass* by his choice of new or extant Readymades he seems to have associated with specific components of the *Glass*. Turned ninety degrees to the left, *Tu m'* juxtaposes the *Bicycle Wheel* as sign of the

Water Mill Wheel below to the hanging *Hat Rack* as surrogate Bride above. For the spiraling Slopes of Flow or Toboggan, down which the liquefied Gas was to flow in order to produce the Splash or "uncorking" (fig. 111), Duchamp adopted the very corkscrew to which he had compared the Toboggan in his notes.[22] For the most important other spiral in the *Glass*, the Juggler/Handler of Gravity (figs. 111, 112), he turned to the other most common household spiral besides the corkscrew: a bottle brush. Here, surely, the shadow-casting bottle brush functions like the Juggler in the *Large Glass*: as his shadow falls either to the left or to the right of the white plane, he is the intercessor able to participate in both realms.[23]

Tu m', however, is not primarily a work about sexual relationships but rather a commentary on the painter's craft, in which the now-established allegory of collision and contrast is repeated. Like the distinction between the three-dimensional mechanical world of the Bachelors and the four-dimensional etherial realm of the Bride, *Tu m'* presents a clash between the physical and what Duchamp called the "extra-physical," expressed in terms of paint and color.[24] To the left-hand manifestation of the painter's craft and the "uselessness of the physical color theories," about which he had complained as early as 1913, Duchamp opposes the dematerialized color of electromagnetic waves in the spectrum of visible light.[25] The physicality of painting, which he had studiously avoided in the *Large Glass*, is exemplified in the discrete color lozenges, which were painted not by Duchamp but by Yvonne Chastel, the ex-wife of Jean Crotti, and in the pointing hand, executed by a commercial sign painter who signed the hand "A. Klang."[26] Only the illusionistic tear engaged Duchamp's hand in a traditional and, significantly, premodern aspect of the painter's practice. By contrast, the right half of the canvas evokes another conception of color altogether by means of the spectral bands that extend back into space from the curved lines at the corners of the white plane. These linear bands of color are surrounded by a series of circles that in earlier works, such as *The King and Queen Traversed by Swift Nudes* (fig. 23), seem to have stood as "elementary signs" suggesting electricity and electromagnetism.[27] Duchamp's white plane of canvas, itself dematerialized in the area of the illusionistic tear, suggests the purity of a mixture of colored light unsullied by the pigment mixtures that grow ever muddier as the lozenges recede toward the left.

Although Dreier's commission had forced Duchamp to work in the medium of paint on canvas, he maintained a remarkable degree of freedom and impersonality in its execution. Not only did he enlist others to execute parts of the work, but he succeeded in letting the objects "draw"

themselves by means of the shadows they cast on the canvas surface, just as he had contemplated in his "Cast Shadows" note: "*the execution* of the picture by means of luminous sources."[28] He had pushed painting as far as possible in the direction of the impersonal, indexical registering of the photograph or the scientific instrument. As Gabrielle Buffet would later write, Duchamp's irony was aimed at "*art as a trance and mystery,* at the masterpiece born of inspiration and divination," and in *Tu m',* color as a revelation of that mystery may have been one of his targets.[29] Because Duchamp owned Kandinsky's *On the Spiritual in Art,* he was certainly aware of his theories, as certain of his own notes on color suggest. Yet, as much as he shared Kandinsky's interest in vibration, Duchamp could never accept the Russian painter's view of color as able to produce a spiritual inner *Klang,* or sound.[30] The presence of the word "Klang" in *Tu m'* is surely the result either of Duchamp's invention of a fictitious name for the sign painter he hired or of an incredible stroke of luck in finding an artisan with that name. By its inclusion, *Tu m'* seems to suggest that all that painting can ever produce as it strives for transcendence (i.e., spiritual expression, a fourth dimension, or some other unreachable goal) is the illusion of a *Klang.* Such a linguistic joke would have been particularly appropriate behind the back of Dreier, Kandinsky's enthusiastic advocate and the source of the unwanted commission that bored Duchamp.

Duchamp had realized his conception of a "painting of precision" in the *Large Glass* and its related studies on glass (fig. 151),[31] and his techniques of metal applied to glass with the minimum amount of pigment carried over into the panel *To Be Looked At,* his next major work after *Tu m'.* He later described the Oculist Witnesses of the *Glass* as an example of "precision optics," involving not only imagery based on an oculist's chart but also the "high precision" in the scraping of silver from the glass. He could also have applied the term to *To Be Looked At,* with its similar technique and imagery and its experimental optical effects.[32] Two other projects undertaken on his Buenos Aires sojourn further document Duchamp's turn to optics as an active concern. While in Argentina he executed the *Handmade Stereopticon Slide* (Museum of Modern Art, New York, Bequest of Katherine S. Dreier), drawing on each component of a stereoscopic photograph of a seascape a geometric figure composed of an upright and inverted pyramid joined at the base. Duchamp's interest in stereoscopy as a means of creating dimensionality would continue in subsequent experiments with filmmaking and, ultimately, in one of his last works, *Anaglyphic Chimney* of 1968 (Collection of Arturo Schwarz, Milan), based on H. Vuibert's *Les Anaglyphes géométriques,* a

book he had first purchased in 1930 and bought again in the weeks before his death.[33]

On the boat trip to Buenos Aires, or once there, Duchamp also speculated on a never-executed project that was to utilize layers of glass to explore the effects of refraction. His drawing and notes are recorded on a blank cablegram from the Central and South American Telegraph Co. and read, in part:

Make: Several sheets of glass or cardboard glued one *on top* of the other and of different dimensions a linear drawing (as much as possible)—as if it were drawn on a flat surface—and which when seen from point X, of a viewer, gives the impression of a flat drawing. I.e. that a straight line from A to B. (although A and B are on different planes appear straight from the sight, and broken into several levels from a totally different point—[34]

Here Duchamp may have been developing his thinking about the refraction of light in the "Wilson-Lincoln system" of the *Large Glass,* which was to be created by the strips of glass at the mid-section (fig. 88) or, as he mused, by "prisms stuck behind the glass."[35]

Although Duchamp never executed such an optical collage of glass and opaque plates, he made another application of individual glass plates with patterns drawn on them in his *Rotary Glass Plates (Precision Optics)* (fig. 174), executed in New York in 1920 after his return from Buenos Aires via Paris. The persistence of vision had long been investigated by means of spinning disks and, with this work, Duchamp began to explore circular motifs in motion.[36] When the glass plates are activated by an electric motor and viewed from a position one meter in front of the device, the individual plates fuse to create the illusion of a flat disk bearing concentric circles.[37] Or, in the *Rotary Demisphere (Precision Optics)* (fig. 177) and the *Rotoreliefs (Optical Disks)* (fig. 178), combinations of spirals and eccentric circles or such circles alone undulate and suggest effects of relief as well as recession into depth. Beginning with Joseph Plateau's spiral of 1850, the literature on optics, perception, and perceptual psychology offered Duchamp a rich field of prototypes.[38] Against this backdrop, he now overtly assumed the persona of engineer, designing actual machines to explore his version of Precision Optics, a field that had attracted new attention in America following World War I. Ironically, however, rather than seek to achieve an American "precision optics" to rival that of Germany, which was the expressed goal of the newly formed Optical Society of America, Duchamp, in his optical experiments, cultivated dimension-changing illusions, physiological effects, and sexual associations.[39]

Duchamp was not alone in his turn to optics in the 1920s. During that time Picabia also began to utilize sources relating to optics and visible light, just as he had paralleled Duchamp's interests in the 1910s (figs. 20, 55, 109, 130).[40] It is instructive to consider a text Duchamp wrote on Picabia in 1926 for a catalogue of a sale of his works—as well as to juxtapose the works of the two friends—to understand better the way these images functioned for the two. After praising the "precision of the cold line" of Picabia's "machines" of 1916, Duchamp noted Picabia's role, beginning in 1919, as one of the leaders of Paris Dada.[41] Then, almost as if writing about himself, Duchamp continued: "The 'optic' watercolors follow. He searched for optical illusions with almost 'black and white' means: the spirals and circles which play on the retina. This amusing physics found its esthetic formula in his hands. (Optophone)."[42]

Gears had earlier served Picabia as emblems of a mechanical sexuality rooted in sources such as Remy de Gourmont's Physique de l'amour; now spiraling forms and circles became a means to encode the theme of sexual electricity in his works.[43] A painting like Optophone I (fig. 175) provides concrete contemporary evidence for the sexual readings that have been proposed for Duchamp's undulating spirals and circular forms. Not only does the painting make overt the sexual target theme that both artists had employed earlier (Duchamp's shots and target in the Large Glass [fig. 144] and Picabia's in Voilà elle [fig. 109]), but Camfield has interpreted the image as a magnetic field around an electrical current, centered on the nude's sexual organs.[44] Duchamp's earlier works had also employed spiraling coils or circles as signs not only of electricity but of sexual activity (figs. 23, 91, 101, 112). Likewise, Suzanne and Jean Crotti seem to have utilized arcs, spirals, and circles as coded representations of electrical/sexual energy in their closely related works of the late 1910s and early 1920s.[45]

In the context of optics, Camfield has also compared the concentric circles of the Optophone series and related works to the interference effects known as "Newton's rings." Moreover, in another series of optically oriented paintings from 1922, Picabia adopted the successively narrow spacing of vertical lines demonstrated in photographs of diffraction fringes, yet another characteristic behavior of waves of visible light.[46] In fact, the title Optophone refers to a device first developed in 1912 by the electrical pioneer E. E. Fournier d'Albe, which converted light to sound to help the blind read.[47] Picabia had demonstrated a similar concern with the equation of waves of light and sound in the title of his painting Music Is Like Painting of 1917. That work incorporates spectral bands of color on certain of its curved, linear elements, akin to Duchamp's image of electromagnetic color in Tu m'.[48] Music offered a model of the "continuous passage of one tone to another" that Duchamp desired and had contrasted to the "uselessness of the physical color theories" with their artificial divisions.[49] Yet, while Picabia evoked the physics of electromagnetism in works such as Music Is Like Painting or Optophone and certainly remained alert to the symbolism of the science he adopted, by the early 1920s he seems to have looked to scientific images primarily as sources for abstract patterns in keeping with the geometric orientation of much postwar painting.[50]

This was undoubtedly what Duchamp referred to as Picabia's "esthetic formula" for an "amusing physics." In other words, while Duchamp actually experimented with optical effects, seeking to manipulate reflected light, Picabia remained a painter.[51] In 1925 Duchamp wrote to Jacques Doucet, who had financed the Rotary Demisphere project, urging him not to lend the work to an exhibition: "All expositions of painting and sculpture make me ill. And I'd rather not involve myself in them. I would also regret if anyone saw in this globe anything other than 'optics.'"[52] Duchamp would likewise tell an interviewer in 1936, at the time he was repairing the Large Glass, "For me, painting is out of date. It is a waste of energy, not good engineering, not practical. We have photography, the cinema, so many other ways of expressing life now."[53] Significantly, when Duchamp first sketched his plan for the "Optique de précision" of the Rotary Demisphere (fig. 176), he drew in a style no longer imitating the visual language of mechanical drawing that he had adopted in 1913 and that Picabia continued to use for most of his works. Instead, Duchamp's quickly made drawing conceptualizes an idea, just as an inventor's first sketch might do.[54]

Not only did Duchamp differ from Picabia in his interest in the workings of the physics of light, but he was committed to using his motion-oriented experiments to explore further the issue of dimensionality that had fascinated him since the prewar period. Gabrielle Buffet, in her article "Coeurs volants" (Fluttering Hearts), translated as "Magic Circles" in View in 1945, celebrated Duchamp's Rotoreliefs as "a successful unpublished optical experiment which falls within a mixed and complex scientific class at the borderline between psychology and physics."[55] Duchamp had talked of "virtuality" in his prewar notes on the fourth dimension, and now the cultivation of visual virtual effects became a means to create "plastic illusion[s]," as Buffet described them.[56] Here was a new chapter in Duchamp's pursuit of an alternative to the "plastic" form of Cubism, a "plastic retaliation,"[57] as

211

he stated in earlier notes, free of the painter's touch and operating in the realm of the physics of light reflected from the precisely painted hemisphere of the motorized *Rotary Demisphere* (fig. 177) or the commercially printed *Rotoreliefs* turning on a phonograph turntable (fig. 178B).

Duchamp would have been familiar with the effects of virtual, subjective color produced in optical experiments by rotating black-and-white forms; interference patterns, too, produced a kind of variable, "virtual" color that he would continue to pursue during the 1930s in the context of his theorizing on infrathin.[58] In his Precision Optics, however, Duchamp's focus was the creation of virtual relief using motion as a dimension-creating entity and an alternative to the effects of the anaglyph or stereoscopic photograph that also interested him. He had acquired a motion picture camera in 1920, explaining later that he was "interested in films as a means to express [another] dimension."[59] That interest resulted in his collaboration with Man Ray and Marc Allégret on the 1926 film *Anémic Cinéma*, in which revolving discs bearing puns written in spiral form alternate with a set of disks resembling the abstract *Rotoreliefs*.[60] Duchamp created the first studies for these patterns of eccentric circles and spirals in 1923, in the form of seven hand-drawn disks (Seattle Art Museum, Eugene Fuller Memorial Collection). In 1925 he and Man Ray sought to create a stereoscopic effect by filming the three-dimensional, spiraling *Rotary Demisphere* simultaneously in red and green from two slightly different viewpoints, as if to raise its three-dimensional form to a fourth dimension.[61]

Although Duchamp recognized the dimension-changing capability of the spiral, a standard theme in the literature on the fourth dimension, he rarely used the spiral alone. In general, he found it to be more effective when used in combination with eccentric circles or when only suggested by their placement, as in the *Rotary Demisphere*.[62] In 1924 the Italian psychologist C. L. Musatti defined what he termed the "stereokinetic effect" of such rotating eccentric circles, but Duchamp had already begun to explore this illusion in his 1923 disks.[63] Excerpts from a four-page note from the period detail Duchamp's observations on creating this illusion:

Primary experiment of 2 circles [diagram]/Turning on a center located between A and B on the line connecting them. Make different drawings of this exp. (diff. sizes, diff. thicknesses of lines, different colors/one line passing over another) etc—
The spiral at rest doesn't give any impression of relief (or at least only imagined psychologically)/Turning around the center of one of these circles the spiral gives the impression

of corkscrewing up toward the eye—this is a partial case of the above named principle of the 2 circles.
With the principle of the 2 circles one can draw any round object seen from above i.e. the line of sight going from the eye to the object *almost extending* the axis of the object (i.e., seen almost from the end and the circles constituting its form at different distances from the eye having their center on this axis) . . .
Spheres. Hemispheres/ Convexity, concavity/ Cylinders (total eclipse)/same things as the objects[64]

Duchamp's mention of "total eclipse" in the last phrase refers to one of the *Rotorelief* disks that creates the illusion of looking through a telescope at a solar eclipse (the centermost disk in fig. 178A). Both "Total Eclipse" and "Japanese Fish" (fig. 178A, lower right) are images occurring on the side of the *Rotoreliefs* set that features designs creating the illusion of specific three-dimensional objects as they rotate, such as a Japanese fish swimming in a bowl, a wineglass, or a lamp with an electric bulb. Most of the disks illustrated exhibit their opposite faces, the abstract patterns that undulate so provocatively and produce more general illusions Duchamp labeled "Cage," "Corollas," "Chinese Lantern," and "Circles" (fig. 178A, clockwise from bottom center). Duchamp achieved remarkable variety in these effects, and Buffet was correct to celebrate his invention of a "new form of illusion for the eye" based on the "collaboration between certain sensory and cerebral processes."[65] Given the multitude of visual illusions far simpler than those in popular sources such as Tom Tit's *Physique amusante*, it is little wonder that Duchamp set up his stand at the Concours Lépine inventor's fair in 1935 with some hope of commercial success. Yet, as reflected in a note contrasting "what one puts on view . . . and the glacial regard of the public (which sees and forgets immediately)," the venture failed completely.[66] Duchamp's last public work involving a specific optical illusion was a 1936 cover for *Cahiers d'Art*, which he entitled *Fluttering Hearts*, after the illusion of "fluttering" chromatic vibration discussed by Helmholtz and others.[67]

As noted earlier, Krauss has emphasized the sexual content of Duchamp's optical works and of the *Rotoreliefs*, in particular, interpreting them as objects of "optical pleasure" embodying an "optical unconscious" and the "projection of desire into the field of vision."[68] Given the prototype of Duchamp's use of science as a sexual vehicle in the *Large Glass* as well as Picabia's contemporaneous imagery (fig. 175), these works clearly do operate on one level as pulsating, sexual images. Here is "precision oculism" (*au culism*), as Duchamp advertised it on the calling cards he had made up for his alter ego, Rrose Sélavy.[69] Yet such a

reading may oversimplify Duchamp's project, deemphasizing his exploration of perceptual effects of relief and "plastic illusion" as a form of virtuality. Beginning in 1935, his notes on the infrathin testify to his continued interest in such optical virtuality—without, necessarily, sexual overtones.[70] Moreover, Duchamp's related notes on his experiments with film reveal that he was also concerned with nonsexual physiological effects, which were closer in spirit to the retinal exhaustion he had cultivated in *To Be Looked At*. In a note addressing a plan for an abstract film but relevant as well to his optical "machines" per se, he writes: "to develop/make the lines undulate/undulate the spiral, etc. object = obtain an effect similar to the emotions of the fair, dizziness/make something the eyes can't stand—."[71]

Being in charge of Duchamp's "precision oculism" was just one of Rrose Sélavy's many activities in the 1920s—a period in which much of Duchamp's time was taken up playing chess. In June 1919, he wrote to the Arensbergs from Buenos Aires: "I am absolutely ready to become a chess maniac—everybody around me takes the form of the knight or the queen. . . ."[72] From 1923 to 1933 Duchamp was deeply engaged in chess, training and playing in international tournaments, and in 1932 he co-wrote and published a chess treatise with Vitaly Halberstadt.[73] As suggested earlier, chess functioned for Duchamp as a form of intellectual invention and self-definition, and he would remain a committed, if low-profile, chess player for the rest of his life. From his first international tournament in 1923, in which he ranked third, Duchamp wrote Doucet of his successes, adding, "Rrose Sélavy has something of the *femmes savantes*—which is not disagreeable."[74] The next year he listed Rrose as his collaborator on another conceptually oriented project, his experiment in beating the roulette tables at Monte Carlo, the *Monte Carlo Bond*.[75] Other of Rrose's "intellectual" identities included the persona of engineer she shared as Duchamp's fictive collaborator in his optical and filmic experiments, as well as her roles as architect-designer (Duchamp's "window" projects such as *Fresh Widow* [Museum of Modern Art, New York, Bequest of Katherine S. Dreier]) and author of witticisms and wordplays.[76]

A quite different aspect of Rrose—the fashion plate—allowed Duchamp to comment on fashion and glamour, particularly in Man Ray's photographs of him dressed as Rrose and vamping like a contemporary actress.[77] Couture had been an occasional touchstone for Duchamp's earlier works, and in the 1920s and 1930s he would become increasingly interested in the realm of textiles, finding there concrete manifestations for his optical concerns and his infrathin speculations. In 1922 Duchamp even explored fabric dyeing as an alternative to the painter's craft, briefly forming a partnership with Leon Hartl in a dye shop in New York, so that he could, as he said, be a *teintre* rather than a *peintre*.[78] In 1924, while at work on the *Rotary Demisphere,* Duchamp wrote his patron Doucet, himself a couturier, asking for help in obtaining a black velvet to cover the metal plate around the demisphere: "An English velvet, a silky velvet" that would be a "mat backdrop that you see in movie houses."[79] Duchamp would rely on black velvet again in his *Etant donnés* assemblage, inserting a curtained, theaterlike "completely dark chamber" between the viewer and the tableau (see the draped black curtains in the upper right corner of fig. 186).

Black velvet provided the maximum absorption of light waves, but iridescent silks and moirés provided the means for studying interference effects in everyday life, bringing together optics and daily experience in the concept he termed *inframince,* or infrathin. Duchamp began to make his notes on infrathin in about 1935, at a time when he had just reviewed the corpus of his *Large Glass* notes while preparing the *Green Box* of 1934; at this time he was also beginning preliminary work on the *Box in a Valise*, which encapsulated his life's work in a miniature "museum" (fig. 166). This close engagement with the past was particularly intense in 1936, during which he spent a month and a half restoring the *Large Glass* after its having been shattered.[80] Not surprisingly, the connection between aspects of infrathin and the ideas of the *Large Glass* or works such as *To Be Looked At* is close, particularly in terms of optical themes. When Jeanne Siegel asked him in a 1968 interview if he had ever been "interested in dazzle or moiré effects," he responded:

Only once. I said in those notes in the *Green Box* speaking of the system "Lincoln, Wilson" this was because I had seen in a shop somewhere an advertisement of those two faces . . . and when you looked on the left you would see Lincoln, and when you looked on the right you would see Wilson. And I call that a system "Lincoln-Wilson" which is the same idea as the moiré. Because you see, those lines have two facets. And if you look at one facet you see something, if you see the other facet you see the other.[81]

In the *Large Glass,* the Wilson-Lincoln system was part of the optical scheme that was to "dazzle" the mirror image of the Splash of Illuminating Gas into the four-dimensional realm of the Bride. Duchamp's concern with dimensionality would continue in the infrathin notes, but now, instead of the large-scale oppositions and contrasts of the *Glass*, he was concerned with the most subtle dif-

ferences and liminal moments, such as the passage from two to three dimensions. In general, Duchamp explored these "infrathin separation[s]"[82] not in the context of geometry or physics, as he would have done earlier, but in the realm of objects and ideas from his daily experience, such as the "warmth of a seat (which has just been left)."[83] Describing infrathin as a "'conductor' from the 2nd to the 3rd dimension," he associated earlier interests such as "X-Rays and the 4th Dim." with "the cutting edge of a blade and transparency."[84] The question of "sameness" or "identicals" forms another theme within Duchamp's notes, which ponder such subtle divergences as the "difference (dimensional) between 2 mass produced objects [from the same mold]."[85]

Optics remains the most important scientific theme within the infrathin notes; yet although magnifying glasses and mirrors do appear, infrathin optics has as much to do with observed effects of various kinds of fabrics or other substances. Iridescent "shot silk," for example, could provide "(support for the visible infra thin) as opposed to corduroy which brushing against itself gives an auditory inf thin [sic]."[86] Duchamp later explained that he created the word *infrathin* for its blending of the prefix *infra*, from the realm of science, with *mince*, or "thin," "which is a human word, and not a precise laboratory measure."[87] Instead of playing the role of scientist in the laboratory, as he had done in the *Large Glass*, he had become a keen observer, philosophizing about the world around him. "Allegory (in general) is an application of the infra thin,"[88] he declared, as he allegorized four-dimensional geometry via the infrathin experiences of everyday life. Instead of inventing new principles of Playful Physics, he was now concerned with "Luggage Physics" or with "determin[ing] the difference between volumes of air displaced by a clean shirt (ironed and folded) and the same shirt when dirty."[89] Similarly, by this period his earlier focus on thermodynamics and the multitude of mechanical falls in the *Large Glass* was replaced by speculation on a "transformer designed to utilize the slight, wasted energies" of the body such as "the fall of urine and excrement," "the fall of tears," and "ejaculation," among others.[90]

Following upon the decade of his focus on infrathin, the year 1945 serves as a useful moment to consider Duchamp's life and art on the eve of the inauguration of his secret project, *Etant donnés: 1. la chute d'eau, 2. le gaz d'éclairage* of 1946–66 (figs. 183, 186). As we shall see, *Etant donnés* stands as the ultimate "secularization" of the theme of collision and futile quest that had been cast in terms of science and technology in the *Large Glass*. There was great surprise on the part of critics and

public alike when *Etant donnés* was unveiled after the artist's death in 1968.[91] Yet a closer look at Duchamp's activities during the 1940s, including his close involvement with Breton and his collaboration in the organization of several Surrealist exhibitions, provides a clue to his subsequent adoption of the three-dimensional tableau as a vehicle for restating the *Large Glass* theme. Frederick Kiesler's 1945 photomontage of Duchamp's studio had already documented his continuing embodiment of elements of the *Glass* in ready-made objects, which he was now assembling as related parts of a whole (fig. 179). The two artworks Duchamp exhibited in the Exposition Internationale du Surréalisme in Paris, *The Altar of the Tender of Gravity* (fig. 181) and *The Green Ray* (fig. 182), along with his first collage study for *Etant donnés* (fig. 180), likewise demonstrate a shift in his thinking toward a new means of manifesting the allegory of the *Large Glass*.

Kiesler's fold-out triptych of Duchamp in his studio was discussed earlier as a kind of self-portrait meant to reinforce his self-fashioning as inventor-engineer. Yet a closer examination of the contents of the triptych reveals, first, the creation of overt associations between Kiesler's montaged images from the *Large Glass* and the contents of the studio and, second, Duchamp's construction of a counterpart to the Bachelors' realm in the left-hand panel. In the central panel, Kiesler, undoubtedly in collaboration with Duchamp, overlays images of the Bride and the Chariot from the *Large Glass* onto Percy Rainford's photograph of Duchamp at his work desk; when the two side flaps, cut in the shape of a Malic Mold, are folded inward over Duchamp's image, the Chocolate Grinder rests squarely on the artist, with the Nine Malic Molds to the left. Further, the splatters of paint in the upper half of the right-hand panel evoke in a general way the Nine Shots.

In the central panel, however, actual objects are also positioned in the studio in places related to the components of the *Large Glass* laid over the image. Thus, reels of film on a movie projector beneath Duchamp's desk suggest the Water Mill Wheel, and a suspended saw (with a smaller saw immediately below) stands in for the Bride. Although Kiesler's accompanying text describes the phenomenon as "a definite although unintentional correlation between the daily utilities of the artist's environment and the inner structure common to all his work," these correlations were surely not haphazard.[92]

As if developing his earlier tendency to find Readymade equivalents for components or themes of the *Large Glass*, Duchamp by the 1940s seems to have been living in a three-dimensional re-creation of the themes of the *Glass* in his studio. This is particularly true of the bookshelf in the left-hand panel, on which are stored tools and materials

that, on the surface, simply establish Duchamp's activity as other than that of a painter. The choice and positioning of objects on this shelf, however, also suggest that he has carefully created a metonymical landscape of the Bachelors' realm. In general, the sense that this is a world of lower dimensionality is reinforced by the printing of much of the image in a negative reversal, which brings to mind Duchamp's description of the "mold" of an object as an "image in $n-1$ dimensions" and its association with the "negative (photographic)."[93] More specifically, on the top left edge of the bookcase stands the bottle Duchamp used for the cover design for this issue of *View*. That image was itself a collage of ideas from the *Large Glass*: a bottle bearing a label made from Duchamp's service record (evoking the falling Benedictine Bottle/Weights of the Chariot mechanism or the Malic Molds in uniform), gaseous smoke (the Illuminating Gas), and the "stars" of the Bride's Milky Way.[94] On the bookcase, the bottle is perched as if about to fall, like the pirouetting Benedictine Bottle. It is joined on the top of the bookcase by nine or so screwdrivers or similar implements, which may well be surrogates for the Nine Malic Molds.

Most important, on the top of the bookcase rests a box of Jack Frost sugar cubes, a marvelous stroke of Duchamp's ingenuity and wit. Jack Frost, as the personification of winter, sets the temperature of this realm as frosty and cold, as had Duchamp's notes and early Readymades, such as *Pharmacy* (fig. 167). This theme is echoed by a box of mothballs, an item identified with winter clothing, on the shelf below. Jack Frost was an ideal model for Duchamp: although often depicted with brush in hand, Jack's "masterpieces" on windows were produced automatically by the condensation and freezing of moisture.[95] The presence of sugar cubes in Duchamp's studio also provides a latter-day insight into his constructed "Semi-Readymade" of 1921, *Why Not Sneeze Rose Sélavy?* (Phildelphia Museum of Art, The Louise and Walter Arensberg Collection), a white birdcage filled with cubes of marble that appear to be sugar cubes (see fig. 72).[96] A thermometer protrudes from the top of the cage, and the Jack Frost/sugar cube connection suggests that this white object is meant to evoke the chilly days of winter—and sneezing; in addition there is the surprise of the unexpectedly heavy cubes.[97] Duchamp had mastered the use of metonymy in the *Large Glass*, and his box of Jack Frost sugar stands as a continuation of the kind of meteorological landscapism he employed there.[98]

Metonymy served Duchamp again in his *Altar of the Tender of Gravity* (fig. 181), executed by Matta, at the artist's direction, for the 1947 Surrealism exhibition in Paris.[99] This tableau gives three-dimensional form to the

Juggler/Handler of Gravity, whose role in the events of the *Large Glass* had been eclipsed because of his omission from the *Glass* itself and the paucity of clues about him in the *Green Box*. To reiterate, in addition to Duchamp's allusions to the weights and measures of Playful Physics, a covered dish serves as the metonymical condensation of the Bride as breast, a theme paralleled in the hand-colored foam-rubber breasts mounted on the cover of the deluxe catalogue for the exhibition. Duchamp's optical concerns are echoed in the beam of visible light that plays onto the Handler's table top as well as in his second work in the exhibition, *The Green Ray* (fig. 182).

Because Duchamp had returned to New York, Kiesler was charged with carrying out Duchamp's ideas for parts of the exhibition installation and with the construction of *The Green Ray* (fig. 182).[100] That work, which was viewed through a circular opening in a curtain, consisted of a seascape photograph showing an illuminated horizon line. The illusion of a band of green light at the horizon was produced by yellow light shining from behind a blue gelatin film mounted in the gap between sea and sky. The term "green ray" refers to a rare optical phenomenon produced at the horizon when the rays of the sun setting over the ocean are refracted, so that blue-green comes to dominate the light at the horizon.[101] The refraction encoded within this work provides an alternative to the horizon line of the *Large Glass,* with its refractive Wilson-Lincoln effect, but *The Green Ray*, along with *Altar* and the first studies for *Etant donnés*, dated about 1947, also confirms that the *Large Glass* project was still very much in Duchamp's mind. He had clearly begun to experiment with embodying those same themes in a new visual vocabulary, a language of illusionism and tableau construction that characterized the art of the Surrealist circle around Breton.

Duchamp was listed as a collaborator with Breton for the major Surrealist exhibitions organized in 1938, 1942, and 1947 and was instrumental in designing the exhibition installations.[102] Marcel Jean provides the fullest account of these exhibitions, including the 1947 Paris exposition to which Breton gave a strongly occult orientation. According to Breton's plan, from an entrylike "place of initiation," the visitor would travel through three spaces (a "hall of Superstition," a "Rain hall" with perpetual rain, and a final "Labyrinth"), and Duchamp contributed initial designs for these rooms before leaving Paris in early 1947. Breton had also determined that the Labyrinth should have a "cultic atmosphere," with "objects of an intercessory character" placed in its twelve recesses.[103] Although Duchamp's Juggler of Gravity played an intercessory role in the *Large Glass*, it seems unlikely that he would have made him the subject of an "altar" without this sce-

nario created by Breton. Likewise, Duchamp might not have dressed a mannequin as Rrose Sélavy, wearing only his suit jacket with a red lightbulb in the pocket, had this not been the joint plan for a "rue Surréaliste" of artist-dressed mannequins at the 1938 Surrealist Exposition Internationale in Paris.[104] In New York in 1945 he likewise used a mannequin (in this case, headless) in one of two window displays he created for books Breton had published. Here Duchamp was actually operating in the milieu of the shop window and putting a female "under a glass cover," as he had discussed doing in early notes for the *Large Glass*.[105] Those early speculations clearly took on new ramifications in the context of Surrealism and its orientation toward three-dimensional display.

While Duchamp was reconfiguring both the Juggler/Handler of Gravity and the horizon line of the *Large Glass* in his displays for the 1947 Surrealist exhibition, he was also rethinking the Bride in similar, more literal terms. Duchamp had begun work on the secret *Etant donnés* project in 1946; the image in figure 180 is one of his first conceptions of the Bride conceived as human rather than biomechanical and set in an illusionistic rather than an invisible landscape. Based on an earlier pencil sketch of a similar nude, entitled *Etant donnés: Maria, la chute d'eau et le gaz d'éclairage* (Moderna Museet, Stockholm), Duchamp's small collage sets a nude figure created in textured wax and ink in a landscape of collaged photographs.[106] The backdrop of the final tableau would also be a photo-collage, supplemented with paint and several technological illusions.[107] In contrast to *Etant donnés*, however, the female nude in figure 180 hangs in a vertical position amid tree branches—clearly elevated above the landscape and waterfall below, just as she had been placed far above the Bachelors in the *Large Glass*. Although the contrast between four and three dimensions in the *Glass* is lacking here, Duchamp nevertheless does his best to define this literal *arbre type* as "of the trees."[108]

A 1948–49 vellum-covered plaster relief of this figure, *Le Gaz d'éclairage et la chute d'eau* (Moderna Museet, Stockholm), gave the headless nude further volume and maintained her basic vertical positioning, although the velvet ground surrounding the relief creates an ambiguous nonspace. This curious work was the one direct clue to Duchamp's final project that was shown during his lifetime. Yet without the collage (fig. 180) and the related drawing, which have only recently come to light, his earlier, deliberate elevation of the nude above the landscape would never have been known.[109] Although elevation and separation were initially part of Duchamp's plan for *Etant donnés*, his final version of the tableau places the nude Bride horizontally. That she reposes on a bed of twigs can

still be interpreted as a sign of her height above the waterfall, which evokes the Bachelor realm of the *Large Glass*. Now, however, she holds high a gas lamp, suggestive of the Bachelors' Illuminating Gas, which further elides the distinction of realms within the tableau.

In fact, the installation of *Etant donnés* in the Philadelphia Museum of Art creates a different kind of separation, which is completely absent from the *Large Glass*—that between the Bride and her spectators. Unlike the recessed altars exhibited in the Surrealist exhibition, for example, the Bride and her landscape are not fully accessible to us, as they had been to viewers of the *Large Glass* or even the collage study (fig. 180). *Etant donnés* can be seen only through two peepholes in a weathered wooden door, behind which stands a partial brick wall with an irregular hole piercing it. The view from the space within Duchamp's tableau (fig. 186), hidden from the public, could hardly contrast more with the tour-de-force illusion observed from the peepholes (fig. 183). And, of course, as we gaze into this space at the splayed-legged body of the Bride, we become the voyeurs and, in a sense, the Bachelor-like figures whose access to this Bride is physically blocked by two walls that only vision (and light) can traverse. Here there are no electrical connections between Bride and Bachelors as in the *Glass*, nor is there a Juggler of Gravity to act as registering apparatus for messages from the Bride or index of the Bachelor's desires.[110] Returned to the anatomical form of the lamp-bearing allegorical nudes of the turn of the century (figs. 184, 185), whom Duchamp had transcended in his remarkable construction of the Bride of the *Large Glass*, the Bride/nude of *Etant donnés* flaunts her sexuality and, at the same time, seems more vulnerable than her masterful counterpart in the *Glass*.[111]

There is an abundance of literature on *Etant donnés*, and my goal here is to consider it briefly in the light of the new readings of the *Large Glass* and of Duchamp's activity set forth herein.[112] Before considering the issues of electricity and electromagnetism as well as the relation of this work to other aspects of the *Large Glass*, two recent contributions to scholarship in this area should be noted. The "Maria" named in the title of Duchamp's first sketch for *Etant donnés* has now been identified as Maria Martins, a sculptor and the wife of the Brazilian ambassador to the United States from 1939 to 1948.[113] Under the name Maria, she had shown in a number of Surrealist exhibitions, including the 1947 Paris exposition. Martins and Duchamp met sometime after his arrival in New York in 1942 and were involved in a love affair in the late 1940s. Duchamp gave Martins the 1948–49 plaster relief model for the *Etant donnés* nude now in the Moderna

Museet.[114] As in the case of the recent revelation of the identity of Jeanne Serre as a probable prototype for the unreachable Bride of the *Large Glass*, Duchamp was again attracted to a "Bride" beyond his grasp. As finally completed, the partial figure of the nude in *Etant donnés* acquired a blond wig, seemingly associating her with Alexina Sattler, whom Duchamp married in 1954 and to whom he gave as a wedding present his *Wedge of Chastity* (Marcel Duchamp Archive, Villiers-sous-Grez, France), one of his several sexually oriented cast objects of the early 1950s.[115]

The other individual whose probable importance for *Etant donnés* has only recently become clear is Kiesler, who not only designed the *View* photomontage of Duchamp's studio but also worked closely with him in this period and even rented him a room in his New York lodgings from fall 1942 to fall 1943.[116] As noted above, Kiesler actually executed *The Green Ray* for Duchamp and supervised the installation design for the 1947 Paris Surrealism show. Trained in architecture and design in Vienna, Kiesler was an avant-garde theater designer whose focus, after he arrived in the United States in 1926, turned to display, both in commercial shop windows and in museums.[117] In addition to his 1937 article on Duchamp's *Large Glass*, published in *Architectural Record*, Kiesler published *Contemporary Art Applied to the Store and Its Display* in 1930. In 1942 he designed the radically new exhibition spaces for Peggy Guggenheim's "Art of This Century" gallery, including a "Kinetic Gallery," which featured a peephole behind which the contents of Duchamp's *Box in a Valise* were displayed on a conveyor belt that the viewer advanced by turning a large, spiraling wheel.[118] From 1937 to 1942, Kiesler also ran an experimental laboratory at Columbia University, in which he studied perception and optical illusions and worked on what he called a "vision machine." *Etant donnés* has been compared to seventeenth-century camera obscura cabinets, and Kiesler's interest in the aesthetics of display and his perceptual experiments were undoubtedly another source for Duchamp's construction of his illusion behind the peepholes in the door.[119]

Duchamp's 1959 drawing *Cols alités* (fig. 87) conflated an image of a landscape and electrical poles with the *Large Glass*, emphasizing the importance of electricity in the *Glass* and, at the same time, pointing toward the as yet unknown *Etant donnés*. In his *Box of 1914* notes, Duchamp had specified that "the only possible utilisation of electricity 'in the arts'" would be "electricity at large"—the electromagnetic waves (X-rays, Hertzian waves and, ultimately, visible light) that were to be central to his conception of the *Large Glass*.[120] Visible light, of course, rep-

resents the only range of electromagnetic waves in *Etant donnés*. If the *Large Glass* is about wireless electricity and communication at a distance, *Etant donnés* is a product of wired electricity behind the scenes. Viewers of the tableau would not be aware of how much Duchamp's construction differs from its Surrealist prototypes had not the Philadelphia Museum reprinted his "Manual of Instructions" in facsimile. This notebook, handwritten in French and containing photographs that document the work's form in his New York studio, is a fifty-page instruction manual for the assembly of this highly complex, electrified ensemble.[121]

Etant donnés is, in fact, a kind of machine hidden behind a facade of sexual display and illusionism—reversing the situation of the *Large Glass,* in which the sexual content of the title, *The Bride Stripped Bare by Her Bachelors, Even*, is masked by a mechanical facade.[122] In both cases, it is Duchamp's written notes that reveal how each work operates. His instruction manual, for example, sets forth fifteen operations for the reassembly of the work in a museum setting. From the manual we learn that the "waterfall" is actually a transparent image on gelatin film, behind which a "Brevel motor" making "3 turns a minute" causes a perforated disk to rotate. That disk, interposed in front of a round fluorescent tube mounted in the biscuit tin attached to the back wall of the assemblage, produces a flickering light and creates the illusion of the falling water.[123] Duchamp's "sky" is actually a pane of glass in front of a painted, blue wall that is illuminated from above; the "clouds" consist of clumps of cotton placed behind the glass.[124] The "Bec Auer" gas lamp held by the nude is another technological illusion. Just as electricity "powers" the waterfall, it is the source for the illumination of an electric bulb painted green, hidden within the traditional mantle of a gas lamp. Although Duchamp ostensibly adopts traditional gas lighting as the model for the Illuminating Gas, it is once again electricity that illuminates the "gas," just as it had done in the *Large Glass* (pl. 4, figs. 97, 98, 99).[125]

Duchamp had long been interested in the light cast by various kinds of lamps, and in the manual he carefully designates a variety of electrical lighting sources, such as "3 fluorescent 46" long; 40 w. (Gen. Elect)/1st one daylight very white/2nd pinkish called 4500 white/3rd also pinkish," or three theatrical "Century Lights" focused on the torso of the nude, or a "spotlight 150 w. G.E.," which "must fall vertically, exactly, on the cunt."[126] Duchamp's stepson, Paul Matisse, has recorded his first impression of the tableau visible in figure 186, observed upon entering the artist's clandestine New York studio for the first time after his death. Of the "joyful chaos" of the studio,

Matisse writes: "In the piece itself, for example, there were all those electric wires! They were an incredible tangle of mismarked extension cords, bits and pieces tied together and insulated with whatever he might have at hand. What was so wonderfully clear in this mess of wires was that he had been quite unconcerned with the rules of the electrical game, and that he had won nonetheless."[127] Yet Duchamp's manual reveals that he was sufficiently conscious of the "rules of the electrical game": "Use breakers for groups of 3 or 4 lights at a time to avoid short circuits," he writes, for example.[128] Short circuits had been a distinct possibility in the high-voltage "electricity at large" of the *Large Glass*;[129] here, however, in a machine that must operate in order to be seen (i.e., to be lighted), they would have to be avoided at all costs.

Similarly, although Duchamp's instruction manual, written in ballpoint pen, hardly gives the visual impression of the "precision" he had initially pursued in his *Large Glass* notes, the effect of the manual is, in fact, absolute precision of direction.[130] Once again, rather than adopting the outward signs of the engineer, as he had done early in his career, Duchamp was operating self-sufficiently in private. Moreover, there are indeed inventor-engineers whose constructions are often not far from the look of the back of Duchamp's jerry-built assemblage, with its biscuit tin holding new, technological contents and its masses of electrical cords. As the daughter of such an inventor, who was actually trained as an electrical engineer, I frequently observed similar creative, make-do solutions to problems, which had little to do with the aesthetics of precision engineering.

When in 1968 Duchamp spoke to Cabanne of contemporary artists who are "offered new media, new colors, new forms of lighting," he might well have been speaking of himself.[131] In *Etant donnés* he had found yet another alternative to painting that avoided the physicality of paint and the artist's hand, although the product it created had a highly physical quality compared to the *Large Glass*. That work had been about transparency, invisible realities, and the virtuality of an "apparition"; *Etant donnés*, by contrast, presents the physical actuality of an "appearance."[132] Although it has been suggested that the two three-dimensional chambers of *Etant donnés* (i.e., the tableau itself and the antechamber in which the viewer stands) can be thought of as the counterparts to the upper and lower regions of the *Large Glass*, *Etant donnés* remains stubbornly three-dimensional in both its halves.[133] In contrast to the Bride of the *Large Glass*, whose elusive form could absorb a variety of identities, including the inner workings of Villiers's modern, organic automaton, the leather-covered nude of *Etant donnés* echoes only Hadaly's

remarkable "epidermis"; she is clearly identifiable as a kind of mannequin.[134] A modern Persephone illuminated by her own torch, the nude is spotlighted like a theater piece, like Fabre's insects under glass (fig. 135), or like a diorama at the American Museum of Natural History.[135]

By contrast, the *Large Glass*, as suggested earlier, parallels the displays at a museum such as the Musée des Arts et Métiers (figs. 164, 165), where individual cases housed a variety of scientific or technological objects. Similarly, Duchamp created in the *Glass* multivalent images (and verbal components) with interpenetrating identities, including the four-dimensional nature of the Bride. "Now I live in three dimensions," Duchamp told Dore Ashton in 1966, adding that his earlier interest in the fourth dimension had provided "an extra pictorial attraction."[136] The fourth dimension, along with turn-of-the-century science and technology, had been a crucial "extra-pictorial attraction," supporting Duchamp's creative and witty invention in the *Large Glass*, his "hilarious picture."[137]

The central role of subtle humor in the *Large Glass* points up another of the contrasts between the graphic imagery of *Etant donnés*, in which science and technology are covert, and the multivalent, overtly scientific/technological themes of the *Glass*. Duchamp's production had, in a sense, bifurcated in his later years; wordplay had become his primary tool for humor, and, while often responding to earlier themes related to the *Large Glass*, that verbal invention had little to do with *Etant donnés*. There was no longer the fertile interplay of verbal and visual punning that had characterized the *Glass*. Nonetheless, in the late 1950s, during his work on *Etant donnés*, Duchamp does seem to have reengaged his corpus of remaining unpublished notes from the era of the *Large Glass*. His listings of a carefully chosen selection of those notes, heretofore unnoticed, and his subsequent transformation of these lists into a collection of wordplays is the subject of this final section.

The 1950s Legal Tablet Listings: Thoughts of Another "Box"?

In the early 1930s, Duchamp was still closely involved with his writings and art from the era of the *Large Glass*; in the late 1950s a similar convergence occurred. Simultaneously, Michel Sanouillet was preparing the first edition of Duchamp's published writings, which appeared in 1958, and Robert Lebel was at work on the first monograph on Duchamp's career, published in 1959.[138] Breton's 1935 "Phare de La Mariée" essay, based on the *Green Box* and reprinted in the 1945 Duchamp issue of

View, had established what would become the canonical narrative of the events of the *Large Glass*, a narrative without such central figures as the Juggler/Handler of Gravity. Having already resurrected a mysterious Handler of Gravity in his 1947 tableau (fig. 181), Duchamp must have been particularly struck by the absence of this and other components of his original scheme for the *Glass* as he collaborated with Lebel on the monograph's layout.

Just as he had released the "Cast Shadows" note for publication in Matta's periodical *Instead* in 1948, in 1958 Duchamp provided Pierre André Benoit with his short note entitled "Possible" for deluxe publication that year.[139] A reference to two notes on the "Possible" appears in Duchamp's legal tablet lists (fig. 187, no. 5), as if his recovery of a note for Benoit's publication may have been part of a larger reconsideration of his unpublished body of notes. Indeed, these lists suggest that Duchamp was at least contemplating gathering a group of his unpublished notes. That collection of notes is reconstructed in appendix A for the first time, based on the phrases Duchamp listed in notes 250 and 251 of the posthumously published notes transcribed by Paul Matisse and first published by the Centre Pompidou in 1980 (figs. 187, 188). Only after extended work on the 1980 notes did the repetition of phrases from other notes in notes 250 and 251 alert me to the apparent function of these lists as a catalogue of specific earlier notes.[140] Happily, this relationship was confirmed by my discovery of circled numbers on the upper corners of the individual notes, which match their numerical designation on the lists.

Mme Duchamp has stated that Duchamp "kept with great tenderness all his archives," so that such a project was certainly conceivable.[141] He never published this compilation, however, and his supplement to the *Green Box* ultimately took the form of the 1966 box, *A l'infinitif*, whose seventy-nine notes focused largely on the fourth dimension and did not specifically augment the narrative of the *Glass*. By contrast, the legal tablet lists create a "box" that would have served in some ways like a mirror image of the *Box of 1914*. Just as that collection had announced Duchamp's range of interests in the *Large Glass* project, this group of notes would have formed a clarifying postscript, affirming basic issues that remained important and reinjecting lost components into the discourse on the *Glass*. Although in a letter to Serge Stauffer of August 1960 Duchamp would deny that any unpublished notes on the *Large Glass* remained, there were in fact well over two hundred relevant notes still in his hands, including the seventy-nine that would appear in *A l'infinitif*.[142] Clearly, by the time Duchamp wrote Stauffer he had decided against publishing the legal tablet collec-

tion. It is apparent from the form the original lists take in a subsequent recopying (figs. 189A, 189B) that they had begun to change, his wordplays and aphorisms now increasingly replacing phrases that had referred to individual notes. The phrases that do remain (fig. 189B, nos. 11–16) seem to be reevaluated as words in themselves and are subsequently transformed into a kind of prose poem. That section of the list, as recopied by Duchamp in note 255, is written in all capital letters and bears notations of the number of letters per line in the left margin.[143]

I have discussed most of the notes in this group in earlier chapters, and it was gratifying for me to discover during the course of my work that notes involving Duchamp's early concerns with overtly scientific or technological themes continued to have meaning for him much later in life. Although omitted from the execution of the *Glass* or from the *Green Box*, inventions like the Desire Dynamo had not been abandoned completely. The purpose of this final section is to provide a brief, initial consideration of Duchamp's choices for the group as a whole—in other words, how would such a "box" have served the artist's construction of himself and of the *Glass* by the 1950s? Based on internal evidence, such as the appearance in note 252 of the vests for "TEENY, PERET, SALLY, BETTY," a project initiated in 1957 and concluded in 1961, as well as on the amount of retrospective activity in which Duchamp was engaged in the late 1950s, I have adopted a date of the late 1950s to early 1960s for the legal tablet notes, although subsequent research on these issues may uncover other, more definitive means of dating them.[144] Because Duchamp's play with language has not been the central concern of this volume, I simply point to the transformations that begin to occur in the subsequent recopying of the lists, a process that obviously offers rich possibilities for future study. Yet the very abandonment of the project also points up interesting aspects of Duchamp's relationship to his early notes in the changed intellectual climate of mid-century America.

When in early December 1949 Duchamp received a forty-page essay from Jean Suquet, based on the latter's careful study of the *Green Box*, he responded that the text had "filled him with joy":

You know doubtless that you are the only person in the world to have reconstituted the gestation of the glass in its details, with even the numerous intentions never executed. Your patient work has permitted me to revive a long period of years in the course of which the notes of the green box were written at the same time the glass was taking form; and I confess to you that, not having reread these notes for

a long time, I had lost completely the memory of numerous points, not illustrated in the glass, that still enchant me.[145]

Perhaps it was Suquet's work that first stimulated Duchamp to return to his unpublished notes for the *Large Glass*, just as Sanouillet's and Lebel's projects further encouraged such activity in the 1950s. Having created his *Altar of the Tender of Gravity* in 1947 and encouraged by Suquet's careful reading of the *Green Box*, Duchamp seems to have concentrated in part on augmenting knowledge of the operations of the Bachelor Apparatus that had originally inaugurated the activities of the Boxing Match and the Juggler/Handler's subsequent dance. Thus, the largest concentration of notes listed in notes 250 and 251 has to do with the Bachelor Apparatus (see note 250, nos. 8, 10, 11, 12, 13, 16, 21); and an important single note (note 250, no. 18) is devoted to the Juggler himself, clarifying the widely separated clues within the *Green Box*.

Note 153 (listed as no. 11) is the carefully recopied four-page compendium made up of several other notes that provides a full overview of the the Bachelor Apparatus as originally conceived, including previously unknown activities of the Horizontal Column/Scissors, Mobile, and Desire Dynamo, some of Duchamp's wittiest and most inventive creations. Other notes clarify the liquefaction process (no. 8), the Desire Dynamo (no. 11), the association of the Glider/Chariot with a crane (no. 13), and the "little wheels" that travel atop the Scissors, among other issues (no. 21). Two Bachelor-related notes reiterate or develop notes in the *Green Box*: no. 10, having to do with his *To Have the Apprentice in the Sun* drawing, and no. 16, which treats the "Die of Eros," elaborating the "uniforms and liveries" of the Malic Molds.[146]

Although Duchamp's listings do not incorporate his four-page note 152 on the Bride, which stands among his unpublished notes as the counterpart to the Bachelor's note 153, they do include notes 144 (no. 14/15) and 146 (no. 17), two of the component notes of that larger compendium. Notes 144 and 146 clarify, in particular, the Bride's meteorological functions as well as the role of her multivalent "filaments," with their biological and lighting associations.[147] The Bachelor-oriented note 153 had concluded with a crucial reference to the Bride's "life center" or "emanating sphere," pointing up her role as an emitter of Hertzian waves—as well as a "married divinity." Beyond the specific notes on the Bride, two long general notes provide further information on the realms of the Bride and the Bachelors as well as on the *Large Glass* as a whole: note 77 (no. 2) and note 104 (no. 22/23). These notes, both written in blue ink on similar paper, would seem to be parts of a single whole: note 77 bears page

numbers 1 and 2, and note 104 bears a number 3 (as well as the coded 22). Together they provide a detailed overview of aspects of the *Large Glass*, ranging from information on its operations to the form the text accompanying the *Glass* should take. Specifically, note 104 presents the "definitive title" of the work as well as its designation as an "extramural agricultural apparatus"; it also includes Duchamp's discussion of gravity and his assertion that the "picture in general is only series of variations on 'the law of gravity,'" establishing this principal contrast between the Bachelors' gravity-bound realm and the Bride's domain, where she "uses the *elevator* of gravity at will."

Note 77 reunites the "General notes for a hilarious picture" note, which had appeared in the *Green Box*, with its original context, the first two pages of a note headed "Text (general notes for the)." The *Green Box* note had been cut from the second page of this note and subsequently was returned to its source once again, where Duchamp gave it a circled number 2, its assigned number on his lists.[148] Although Duchamp's phrase on the list is "In general the picture is an apparition of an appearance," the final phrase of the *Green Box* note, the fact that the note was reattached to its original source suggests that he was concerned with the entire note, particularly since the third page of the group (note 104) was added to the list as no. 22/23. The beginning of the "Text" note provides an extensive discussion of the clarity and prooflike nature Duchamp was seeking for the text that would accompany the *Glass*, his "plastically imaged mixture of events," as he calls it here. Such concern with language is also apparent in note 104, where his listing of terms from the narrative of the *Glass* and his use of phrases such as "look for another word than" establish by concrete example how important were details of language for the project. That same focus on language is clear in note 185 (no. 1), note 82 (no. 5), and note 164 (no. 9). Note 185, his 1914 "Principle of Contradiction" note, includes Duchamp's discussion of "literal Nominalism" and the "plastic existence of the word," while note 164 talks of the possibility of inventing an entirely new alphabet, an "ideal stenography" for the text to "explain" the picture, which he terms the "hieroglyphic data of the Bride stripped bare." Far more than the *Green Box* had done, these notes emphasize how thoroughly Duchamp was reconsidering the nature of visual and verbal language.[149]

It is the verso of note 82 that bears Duchamp's coded number 5, and this is undoubtedly the primary article on the "Possible" to which he refers in his list, his phrase "another article on the possible" most likely referring to the text published by his friend Benoit in 1958.[150] If the

recto of the note is included, it augments Duchamp's other notes on language, emphasizing the importance of precision in describing the "instantaneous state of Rest" to be explored in the *Large Glass*.[151] Both notes on the "Possible" stress the freedom from taste and aesthetics he associated with the term, which seems to have become something of a code name for him for the *Large Glass* project (i.e., connected to the "possibilities" that form the lower term in his relation a/b of the "sign of the accordance [*concordance*]" in his Preface/Notice notes).[152] Echoing Lucien Poincaré's discussion of the way the principles of physics "impos[e] certain conditions" and therefore "limit the field of the possible," Duchamp explored his own "possible" in an antiaesthetic realm of "hypophysics," governed only by his "*slightly distend[ed] . . . laws of physics and chemistry*."[153]

Duchamp's determination to avoid the painter's craft and artistic self-expression is further emphasized in several other notes signalled in the lists, which affirm his interest in nonartistic fields other than science or technology and language. Note 156 (no. 19) deals with geometry, and note 181 (no. 20) addresses both his idea of emotion-free "gap music" and the kind of laboratorylike experiments with chance events that had been central to his activity in 1913.[154] Finally, Duchamp appears as philosopher in his "Principle of Contradiction" note, discussed above for its linguistic content (note 185, no. 1), as well as in note 135 (no. 7). Here is Duchamp as logician, exploring the issue of difference in note 185, just as note 135 (no. 7) finds him commenting on time and duration and exploring the clock as a model for an anti-Bergsonist conception of duration.[155]

The final three notes in the group are one-sentence aphorisms, which seem to date from a later era than the *Large Glass* notes. In each case, as with his exploration of infrathin, these notes recast aspects of the *Large Glass* in terms of everyday experience. "There are some astounding fuses," reads the phrase above a drawing of a man's head in note 246 (no. 6) (fig. 150). As suggested earlier, this drawing, with its spiraling "fuses," may well be a human recasting of the mechanical metaphor for sexual excitement in the Desire Dynamo. The other two notes (nos. 3 and 4), which declare, "A mousetrap is like the will's last stroke of the comb before going out" and "Lead is the principal metal," are also more recent phrases, which do not occur on separate, earlier notes that have been preserved. The spring-action entrapment of a mousetrap, for example, might have served as an analogue both for the seduction preceded by the flick of a man's comb and for the stripping produced by the fall of the Rams of the Boxing Match. That these expressions already func-

tioned for Duchamp as aphorisms of some sort is suggested by their presence on the transformed list in note 252 (fig. 189A, nos. 8, 9). As in the *Box of 1914*, the inclusion of such phrases in Duchamp's compilation points up his concern with the play of words, although these two statements may also echo aspects of the *Large Glass* as well.

Although Duchamp's reference to lead as the "principal metal" undoubtedly alludes to the critical role of lead wire and lead foil in the *Large Glass*, it also likely manifests Duchamp's continued preoccupation with lead in the 1950s and 1960s, as described by Cleve Gray:

In later years the things Duchamp made came directly out of his life. A small *Medallic Sculpture*, for example, resulted from his successful attempt to stop the dripping from his bathroom shower in Spain. He melted some lead and fitted it into the holes of the shower head. The lead form was later declared a medal. He loved making things, puttering around in just that way. In Spain, if one chanced into the kitchen, one was apt to see a saucepan full of melted lead.[156]

Photographs of Duchamp's secret studio in New York also show lead ingots which he melted down to produce molds for parts of the nude, including her breasts.[157] For Duchamp in the 1950s lead was indeed the "principal metal," linking the *Large Glass* and his work in progress, *Etant donnés*. It is symptomatic of this later period that the lead wire that had served as a key element in his impersonal, engineerlike "painting of precision" now took the form of a bubbling pot in the kitchen. In his puttering Duchamp seems wryly to have been playing the role of pseudoalchemist—just at the time Breton and company were working hard to claim him as an alchemist worthy of Surrealism.[158]

Lead, in the form of printer's type, was also the metal of the "buttons" on the four "Rectified Readymade" vests for "TEENY, PERET, SALLY, BETTY," which become one of the replacement listings on note 252, as many of the coded references to earlier notes fall away (leaving only those that appear in fig. 189B).[159] Along with the indirect reference to the *Large Glass* in the "lead" and "mousetrap" phrases, only the "Soigneur de gravité" (Tender of Gravity) remains among the first ten notes of note 252. Instead of Duchamp's humorous commentary on the laws of mechanics and on sexual physiology as equilibrium lost and regained, however, the Juggler himself has become part of a wordplay and is now possessed of a "complexe adipeux," or fat complex.[160] It is impossible to know exactly how and why this transformation of Duchamp's lists took place. Like Fuxier's magical,

image-producing pastilles in the river in Roussel's *Impressions d'Afrique*, what had been a defined "picture," in Duchamp's case created by a group of written notes, gradually dissolves and reappears as something else.[161] In the end, did Duchamp conclude that there was no audience for his more serious speculations and his highly complex operations for the Bachelor Apparatus as originally conceived and set forth in a note such as 153 (no. 11)?

Certainly Duchamp's comments to Suquet document his appreciation of a spectator willing to study his notes—and the fact that there had been few such readers of his writings. In the 1950s Duchamp was still operating at the edge of an art world that would begin to embrace him only in the mid-1960s, creating an adulation that has continued to grow since his death.[162] There was the problem, too, of the deep engagement of his *Large Glass* project with the science and technology of the pre–World War I era. The humor that had been possible when vibratory waves, for example, were a commonplace was now out of context. Moreover, the science, technology, and four-dimensional geometry that had been such a rich source for his creative invention and a significant part of his self-fashioning as an intelligent artist-engineer had been largely supplanted by subsequent developments. Most notably, Einsteinian relativity theory and quantum physics had replaced the classical ether physics that had so nourished Duchamp and, to a lesser degree, a number of other modern writers and artists. A spatial fourth dimension, which had served as such a powerful symbol of the unknown in the early years of the century, had also been superseded by a temporal fourth dimension in the context of relativity theory.

Although Duchamp would publish his notes on four-dimensional geometry in 1966 in *A l'infinitif*, Cleve Gray's comments about the process, quoted in an earlier chapter, document his concern about "appear[ing] foolish" when "mathematics today has become such a special and complicated field."[163] In fact, as this volume establishes, in the course of his several years of note making for the *Large Glass* Duchamp had acquired a knowledge of early twentieth-century science and technology that far exceeded that of any other artist or writer of the period. Nonetheless, one can imagine the devastating effect on Duchamp of interchanges he had with his chess-playing friend François Le Lionnais, an engineer and author of books on science. Le Lionnais blithely recounted those conversations in an interview published in 1975:

FLL He liked talking to people with a scientific background, and he asked them questions; he talked about mathemat-

ics. But until the end of his life he was stuck at Poincaré—I managed to change his ideas quite a lot toward the end of his life. He had read a lot of books—not mathematical texts which he would not have been able to understand, but . . . philosophical works . . .

Q Popular science . . . ?

FLL That's it, for instance "Science and Theory." That is the philosophical musings of a great mathematician, which combine philosophical and mathematical qualities. This influenced him a lot. And then when we ran into each other I surprised him by saying (and I have no idea what influence this may have had) "Poincaré—he's completely out of date." That surprised him, shocked him.[164]

If only Duchamp could have lived to see the great renewal of interest in Poincaré in the context of chaos theory today.[165]

Duchamp's feeling of being out of touch with contemporary science could only have increased during the 1950s, as articles on quantum theory, for example, were published in sources such as the avant-garde periodical *Trans/formation*, which listed him as a "consulting editor." At the same time, a number of articles linking art and science had begun to appear, attempting to relate Cubism to relativity theory, or Picasso to Einstein.[166] In fact, the comments Duchamp began to make in the 1950s and 1960s on the subjects of art and of science contain interesting parallels. "The public always needs a banner; whether it be Picasso, Einstein or some other. After all, the public represents half of the matter," he told Cabanne.[167] Such statements are clearly rooted in his own position—as an artist who, compared to Picasso, had not yet received much acclaim and who was aware of the great complexity of the early twentieth-century science that had been reduced to the "banner" of Einstein.

If Duchamp's conventionalist beliefs made him conscious of scientific laws as conditional solutions responsive, in part, to their historical context ("myths," as he described them to Denis de Rougement), he was also well aware of the way artist's reputations rose and fell according to the taste of the public at a particular cultural moment.[168] Just as he argued that in science "every fifty years or so a new 'law' is discovered that changes everything,"[169] he talked of cycles of public taste in art: "Every 50 years El Greco is revised and re-adapted more or less to the taste of the day. It is the same with all works which survive, and this leads me to say that a work is made entirely by those who look at it or read it and make it survive through their acclamation or even their condemnation."[170] Duchamp put a great deal of emphasis on the ability of the "posthumous spectator" to alter the reputa-

tion of an artist.[171] Although there is some variation among his statements on the relationship of artist and audience, in general he believed that his true public would come later: "I would rather wait for a public that will come fifty years—a hundred years—after my death. It is the ideal public—the right public—that I want."[172] As in the case of science, however, Duchamp also recognized that "fifty years later there will be another generation and another critical language, an entirely different approach."[173]

In the 1960s, fifty years after beginning his work on the *Large Glass,* Duchamp began to find his "ideal public" to supplement the initial readings that colleagues like Breton had made.[174] Today, some eighty-five years after his work on the *Large Glass* began, Duchamp's spectators have a new field of possibilities opened to them, in the form of the 289 notes patiently transcribed by Paul Matisse. Outnumbering the notes published in boxes during his lifetime, this incredibly rich and complex collection forms a time capsule of working documents

unprecedented among twentieth-century artists. In the present volume I have followed one major thread through the notes, focusing on themes from science and technology in their contemporary context, but in the process it has inevitably pointed up a variety of other issues as well. There is obviously much more to be gleaned from the writings of such a remarkable intellect, beginning with his thoughts on language and philosophy, which are strongly represented in the 1980 collection. In discussing the relationship of art and audience with Calvin Tomkins in the 1960s, Duchamp, appropriately, used an electrical metaphor: "The work of art is always based on these two poles of the maker and the onlooker, and the spark that comes from this bi-polar action gives birth to something like electricity."[175] For Duchamp's serious "onlookers" in the 1990s and the early twenty-first century who are willing to engage his posthumously published notes and to explore aspects of their early twentieth-century cultural context, those sparks should fly as never before.

Appendix A

The Collection of Notes Duchamp Contemplated in His 1950s Legal Tablet Listings

The following notes have been compiled on the basis of two legal tablet notes Duchamp made in the late 1950s, which can now be recognized as a numbered catalogue of earlier notes (*MDN*, notes 250 and 251; see also figs. 187 and 188 herein). Each entry is headed by the number Duchamp assigned it and by the phrase or phrases he used to refer to it in notes 250 and 251. The English translations used here are based generally on those by Paul Matisse in *MDN*. If Duchamp recorded a number corresponding to his list in an upper corner of the original note, as he most often did, that numeral is indicated opposite the *MDN* note number. When the original, handwritten note is illustrated, the figure number immediately follows the *MDN* note number.

The notes as a group and their dating are discussed in the final section of chapter 14.

1. 1 Principle of contradiction (note 250)
 1—Redo literal nominalism (note 251)

Note 185 **1**
[recto] 1914/*Principle of Contradiction.*/Research on its meaning, and its definition (scholastic, Greek
—Through grammatical simplification, one ordinarily / understands / principle of contradiction to mean, exactly: principle / of *non* contradiction.
From the Principle of Contradiction, defined only /by these 3 words: i.e. *Co-understanding of* / *Opposites* [*abstract*], abrogate all sanctions establishing the *proof** of *this* / in relation to its abstract opposite / *that* / [on the side] *see *"Proof"*
thus understood, the principle of contradiction / [permits] insists on the abstract uncertainty / the immediate contrast, to the concept A, of / its opposite, B. / develop.
Again here, the principle of contradiction / remains constant i.e. contrasts 2 more opposites / *By nature, it can contradict its own self* / and require.

1. either a return to a logical, non / contradictory continuation. (Plato...
2. or the very contradiction, by the principle of contr, the statement / A., against B no longer A's opposite, / but different (the no. of B's is infinite, analogous)

[verso] to the plans of a game which would no / longer have rules.)
After having multiplied B. to infinity / the result eventually no longer validates the statement / of A. (A, theorem, is no longer formulated, nor formulatable.) / It liberates the word from *definition*, from the / *ideal meaning*. Here again / 2 stages: 1. each word keeps / a *present meaning* defined only for the / moment by fantasy (sometimes auditory); here the word / almost always keeps its kind; it is either noun / or verb or complement etc. The sentence still has its structure (Literary examples / Rimbaud, Mallarmé)
2. *Nominalism* [literal] = No more/generic/specific/ numeric/distinction between words (tables is/not the plural of table, ate has nothing in/common with eat). No more physical/adaptation of concrete words; no more / conceptual value of abstract words. The/word also loses its musical value. It/is only readable (due to/being made up of consonants and vowels), it is readable/by eye and little by little takes on a form / of plastic significance; it is a sensorial / reality a plastic truth with the same title / as a line, as a group of lines.
[on the side] This plastic existence of the word differs from the plastic existence of any / form whatever (2 lines) as it does from the conventional alphabet.

2. 2 In general the picture is the apparition of an appearance (note 250)
 2 apparition and appearance? (note 251)

Note 77 (A circled **2** appears in the upper left corner of the final segment of this note ["General notes. for a hilarious picture—"] which had
been detached and published in the *Green Box*.)
Text (general notes for the)./Heading the text, like an introductory quote (analogous to those signed / Pascal, Plato, or Ecclesiastes) write a form business letter / e.g.:
In reply to your esteemed letter of...inst....I have the honor...
Simplify the spelling: eliminate double letters (as long as / it doesn't upset the pronunciation. Arrive at a sort of short /hand, avoiding long developments, explanation of a word when /necessary, more its stenographic equation than a /tirade = Avoid all *formal lyricism*.; let the text be a /catalogue—
clarity i.e. choice of words whose meanings don't lend

225

themselves to ambiguity / (don't confuse this clarity with the etymologism of the word.) / avoid etymological research and approximate the current / meaning of the words; use neologisms, slang....

Repeat as in logical proofs, entire / phrases to keep from falling into hermeticism; / that every idea, even the most obscure, can be clearly / understood.

Give the text style of a *proof* by connecting / the decisions taken by conventional formulae of / inductive reasoning in some cases, deductive in others. / Each decision or event in the picture becomes either / an axiom or else a necessary conclusion, according to a / *logic of appearance*. This logic of appearance will be expressed / only by the *style* (mathematical formulae, etc.*) / and will not deprive the picture of its character of: *plastically imaged mixture of events*, because each of these events is an / *outgrowth* of the general picture.

As an outgrowth, the ev / ent remains definitely only *apparent* and has no other / pretention than a signification of image (against the sensitivity / to plastic form)

Use the *conditional* form in the style: Also introduce / some presents, some imperfects to reinforce the proofs— The / future can give an ironic tone to the sentence—

In parenthetical clauses, or those explicative of a preceding phrase / underline the pronoun which refers to a substantive of that preceding / phrase and also underline that word—

[on the side]* the principles, laws, or phenom. / will be written as / in a theorem / in geometry books. / underlined. etc.

[continuation] *Punctuation* / the analysis mark ∴ or : separating each phrase which / explains the preceding one. / < > angle brackets / The small and the large comma. /, I— Enrich the punctuat. to eliminate useless / words.

Text—typed, on good paper leaving the backs / of the pages for demonstration figures (which will be / diagrams of the finished state) or photos retouched / with red, blue ink for the explanation.

In the text, a photo (Fresson) of the picture in black and in / colors(?) very large (double the format of the text) and other / photos of parts, colored.

[note from the *Green Box*] *General notes. for a hilarious picture*— / Put the entire bride under glass, or in a trans / parent cage.

Contrary to the old notes, the bride no longer supplies / the gasoline to the breast cylinders. (look for a better name than / "breast cylinders")

Of hygiene in the bride; or of the *Régime* in the bride.

only give the juggler 3 feet because 3 points of support are / necessary for stable equilibrium, 2 would only give an / unstable equilibrium

Painting of precision and beauty of indifference.

Solidity of construction: / Equality of superposition: the principal dimensions / of the general foundation of the bride and of the bachelor mach. are / equal.

Directions: / the form (sketch) = space— / the number 3. taken like a refrain in duration / (numb. is mathematical / duration.

Always give or almost the reason for the choice between 2 or more / solutions (through ironic causality).

The ironism of affirmation: differences with the negating ironism de / pendent only on the Laugh.

[on the side] Professor of beer (litany of the carriage) / Principle of subsidized symmetries. (its application in / the motions of the handler / and the "hanged"; see / the "hanged" (female)) In general, the picture is the apparition / of an appearance (see explanation)

3. 3 A mousetrap is like the last stroke (note 250)
 4 OK. mousetrap (note 251)

A mousetrap is like the will's last stroke of the comb before going out
(see *MDN*, note 252, no. 8; fig. 189A)

4. 4 Lead is the first metal (note 250)
 4 OK lead (note 251)

Lead is the first metal
(see *MDN*, note 252, no. 9; fig. 189A)

5. 5 Possible (?)—and another article on the possible (note 250)
 5 OK (only 2nd part) (note 251)

Note 82 (A circled **5** appears in the upper right corner of the *verso* of this note, apparently the "2nd part" to which Duchamp refers above.)

[recto] Difficult to: / describe a Rest in / neither technical / nor poetic terms: find the / *indispensable* vulgarity / so much so / that it loses its vulgar taint / 1—Use vulgar words / avoid words that are metaphorical / or general (equivocal, rubber / words). / But no research for the vulgar / word which is picturesque / (the indispensable vulgarity only) 2—Idea predominant / and language / only as its / instrument (of precision) / a—*the idea itself of precision* / and b. transparent language

describe a Rest "capable of the / worst excentricities"

In that the picture is / incapable (despite all the well-intentioned / Idealism of man's visual works, all the overwhelming / yearning toward he knows not what; consequences / of anthropocentrism) / of producing a cinematic state / (real or ideal), language can / explain several stages of / this rest not descriptively
[on the side] 1913

[verso] (any more than *probably*). / But *explain a possible* / of the Rest which develops.. / *The Possible* even submitted / to low level logic / or to the alogical consequence / of a self-indulgent will.
The Possible without the / slightest grain of ethics of *esthetics* / and of metaphysics—
The physical Possible? / yes but which physical / Possible. rather / hypophysics.

6. 6 There are some astounding fuses (note 250)
 6 there are some astounding fuses (note 251)

Note 246 (fig. 150) **6**
There are some astounding fuses.

7. 7 at each fraction of duration (note 250)
 7 Time has several dimensions = the clock in profile (redo) (note 251)

Note 135 **7**
= in each fraction of duration (?) *all / future and antecedent fractions* are reproduced—
All these past and future fractions / thus coexist in a present which is / really no longer what one usually calls / the instant present, but a sort of / present of multiple extensions—
See Nietzsche's eternal Return, neurasthenic / form of a / repetition in succession to infinity
—The Clock in profile, / with the clock full face, allowing / one to obtain an entire perspective / of duration going from the time recorded / and cut up by astronomical methods / to a state where the profile is a / section and introduces / other dimensions of duration
Review.

8. 8 compression—cones....Sieves on each cone (note 250)
 8 Udders in elastic metal which pass drop by drop / the liquid which descends slowly toward the hot chamber / in order to absorb the oxygen necessary for the explosion. (note 251)

Note 133 **8**
7—*exhaust pipe*: / before the filter, pipe for the es / cape of the vehicular materials of the gas, / become useless.

8—*Pump*—suction and pressure / bringing the erotic liquid into / the compression charged with giving it / a *cream-like* molecular cohesion—
9—Compression—cones in elastic metal / (resembling *udders*.) / passing drop by / drop the* erotic liquid / which descends toward the hot / chamber, onto the planes of slow flow. / to *impregnate* it with the oxygen / required for the explosion. / *the dew of Eros
4th Plane Large Receiver (passing under the waterfall) / *3rd plane* capillary tubes / *2nd plane* triangul. filter / *1st plane* Churn / [on the side] Depth
10—Planes of flow. / of special forms. / Slopes

9. 9 Text external form. (note 250)
 9 This juxtalinear translation that one can understand with the / eyes but not read with the eyes not / out loud (note 251)

Note 164 **9**
Text (external form—) / Of the different motions recorded on the picture / draw up *a kind of reference table* (from the / picture to the text and vice versa). reference sketch
The purpose of this text is to explain (and not / to express in the manner of a poem) i.e. it is a / juxtalinear translation of the figure (picture). This / juxtalinear translation, which must no longer have any hieroglyphic / intention (the picture, itself, is the hieroglyphic / data of the Bride stripped bare—), / this translation should not be based on words and / letters, or at least, / the alphabet used will be entirely new / i.e. without any similarity to latin / greek—german letters—it will no longer be / [phonetic], but only visual / one will be able to understand it with the eyes but / one will not be able to read it with the eyes or / out loud—/
The principle of such an alphabet / will be an *ideal stenography*—The symbols as / numerous as possible and will be the / elements / (as in every alphabet) of the groups (analogous / to words) destined to translate the *progressive* / distortion of the conventional hieroglyphic phenomenon / (Chocolate grinder etc.) into its nominalization which then only expresses / a single [dead] idea.

10. 10 on the slopes of flow apprentice in the sun (note 250)
 Entry for 10 omitted from note 251.

Note 128
on the slopes / of flow: put like / a comment / illustrating / the photo of / *having the apprentice / in the sun.*

11. 11 stripped bare in piano form (note 250)
 11 Stripped bare in piano form—the 3 crashes—striking of / bad coins"—Childhood memories of the / illu-

minating gas—Emanating sphere. (note 251)

Note 153 (see fig. 148 for page 2) **11**

[page 1] *(Horizontal scissors)*—Pliers—/ horizontal column—/ Sort of horizontal scissors. working like/balance pans/by means of the/little upper wheels of the carriage. These/little wheels, in their alternating movement raise/ or lower the horizontal column according to/their contact with the *precision brush.*/Study the form of this friction *brush*, its influence/on the arrangement of the desire centers/in the dynamo.

Displacement of the scissors/Opening and displacement from/top to bottom.. Determine the curve/of the double displacement—

stripped bare in piano form/the 3 crashes./Central section of the stripping bare:/Labyrinthe.

In the *poem*: the stripping-bare is not/an extreme of the picture, but the celibate/means of reaching the celibate/ stripped-bare blossoming.

At the top of the stripping-bare: little marble-shooting cannons (or small wagons.)

[page 2] [sketch] in A and B tension points (opening of the scissors/as far as A'B'.). The mobile O is retained by F/and G. The hooks C and D let go.—3 solutions.

1. the mobile O releases C and D at the same time/and falls along X—determining/by its fall a crash to show/2. The mobile releases only C and the/tension ceasing in A', it is drawn along/following the trajectory R (other crash)/3. the mobile releases D. and falls along/the trajectory S. (other crash) after the 3 falls, the mobile is brought back/to its labyrinth position/by: a little cord in the/center which is *accustomed* to the labyrinth position/*(rolled up like a snail)* (sort of spring)/which lets the mobile go after the drawing apart/of the scissors and brings it back to its *labyrinth/* position (little cord with an inclination of inertia) Free will = ass of Buridan. find a/formula— [on the side] use the fall of the mobile from the *"striking of bad coins"* point of view.

[page 3] *Clockwork System*/Spring and gears—/ on impact of the combat marble, release/of the clockwork system which removes its/point of support from the juggler's feet—/ Boxing match—/ (see the cross-section of the clock-work system/combined with the breast-cylinder. (Recopy/here) /

Introduce a useless gear/worn on one side.

Explosion of the liquid gas on contact with/the sponge—/This explosion "sets off" the cannons/of the boxing match and the combat/marble carries away, in addition to its force of projection,/a property of *ascensional/magnetization*: From which on its contact/with the rams, double

phenomenon /1. phenomenon of descent of the rams/by impact of the marble taking away their/point of support,/ 2. instantaneous ascensional mag/netization of these rams (out of metal suitable/for receiving this magnetization) making them/slowly (but surely) rise back up/to their initial position (vertical/position of flattened hinge)/This ascensional magnetization (normal (?) i.e./vertical.) = childhood memories of the illuminating gas/last wish of the illuminating gas transmitted

[page 4] to the rams which, after the descent, rise back up/ by this ascensional magnetization *(which/lasts only a moment)*. Develop well = the change from: this *physical* ascensional force of the gas. to an ascensional *magnetization/*acting on the metal of the rams, magnetization directed/toward a center of *distraction* anti-gravity/principle. *Breast-cylinders*—/ see special cross section drawing/of the cylinder and the clock work system/combined. *Desire dynamo..*/combustion chamber. Hot/chamber [bath heater]. This explosion produced by/the alternate presentation of the "desire/centers" (these desire centers belong/to the horizontal column of the bachelor/ machine.

Effects of the explosion on the stripping-bare: /—but on the sources of this stripping-/bare in the desire dynamo = these numerous/sources and leading toward numerous/ starting-ups, (mechanical this time)/of the stripping-bare —to enumerate—

For the life center of the bride end up at/a little mathematically spherical/*empty* emanating ball—(emanating sphere)/always to contrast the married divinity/to the celibate human—

12. 12 Desire centers 3 in number—containing... (note 250)
 12 the Desire-centers contain a material analogous/to platinum sponge: slow to light (note 251)

Note 163 (fig. 149) **12**
[sketch] 1 intention/2 fear/3 desire
Desire centers, *3* in number./Contain a material/analogous to platinum /sponge = *slow to light.*

13. 13 The crane stationary transport (note 250); crossed out in note 250. Entry for 13 omitted from note 251. Phrase recurs in note 104 (see no.22/23 below).

Note 100
The Crane: Stationary transport/Mobile go-between

14/15. 14 The "hanged" with all the access./15 The weathervane could come and horse-kick (note 250)

14 The "hanged" suspended with all the accessories must/15 swing at the will of a ventilation and increase in volume while cooling— (note 251)

Note 144 (fig. 128) **14/15**

The "hanged"—suspended/with all the accessories/must swing/at the pleasure of a ventilation (?)

The eyes or upper part of the "hanged"/have a general shape recalling that/of the chocolate grinder (head)*

[on the side]* extract/a sort of principal form/on which/the entire picture/rests

[diagram] The Hatching indicates/the way of ending the upper part of the bride in mossy metal (like/in the 1st study of Munich)

Weathervane = The pt. A in the trajectory after/impact of the sex wasp at B. could/come and horse kick/a circle of cardinal points./This circle in changing/chameleon metal (reforming itself at one)/according to/the orientation.—/Through the contact of the shoe/with the circle of the horse's kick will bring about/a metallic particle fusion which. becoming liquid/would increase in volume while cooling

16. 16 The die of eros (note 250)

16 the celibate squeezing together, of the uniforms and liveries starting from the plane of sex. (to redo) (note 251)

Note 123 (A circled **16** appears on the verso of this note.)

[recto] *Die of eros. (malic molds)*/arrival of the gas—in the *die of eros*:/Distribution of the gas in the different *malic molds.*

A. *The moldings* of gas in malic forms, thus/obtained, like the refrain of this/bachelor machine *(Buffer/plow of life, sexual block)*,/have no/addressee. They long for one regretfully and try/to respond to all questions of love by/their fineries of brutality. These moldings are/as if enveloped, the length/of their negative request, by a mirror which/sends back to them their own complexity to/the point of hallucinating them fairly onanistically./P.T.O.

[verso] A'—/ The *die of eros* is a selection of uniforms and liveries/which, by the dimensions of their cut, determine as many/malic molds. Each of these molds develops /according to the *model of cut* of its corresponding uniform or livery,/starting from a common point (or from a common horizontal/plane), the point of sex, or plane of sex.—/ "The bachelor oath"/? *Meeting* of the uniforms and liveries/? *Quadrille...*/? *Bouquet...*/? *Round...*/? *Farandole...*/? *Ball...*/? *Choir*/*Wardrobe*/=/ Look of a cemetery\ =/*Uniforms* of/Gendarme/Cuirassier/Officer of law/Priest/Station Master/*Liveries* of/Bus boy/Dept store delivery boy/Flunkey/Undertaker.

17. 17 Tympanum absorbing the dew (note 250)

17 Tympanum absorbing the dew that the wasp spits (note 251)

Note 146 **17**

[folio] tympanum absorbing the dew/which the wasp spits out and/serving the "hanged"/as a wing which the ventilation rushes into.

(nutrition of the filament/material)

18. 18 The juggler of the center of gravity (note 250)

18 Each step to go down is for him a/step into a bathtub of pride (note 251)

Note 150 **18**

[recto] vertical stripping-bare by her bachelors

The juggler of the center of gravity *physical/comparison:* /on the bride's clothing/the juggler of the c. of gravity *dances* i.e. he/is surrounded by several: "caution/there is a step to go down."—These/steps to go down are/immediate because/each descent of the ram is/a step to go down. =/for him each step to go down/is a *step into a bathtub of pride./* The upper ball is not/humility/against the steps of pride. The/upper ball doesn't give a damn. It/is the instrument of indifference

[verso] or the balance arm which desires the 0./(because humility would only be a/pride of a – sign). — /Without/this upper ball—the juggler/stretches out, descends toward.....;/he falls into/the equations of durations and spaces./The balance arm or upper ball allows/him every fantasy up to/top dead center, an instant of/tranquility for seeing outside. But after the unstable equilibrium, the juggler/returns to the 0: The/Bride watches him out of the corner of her eye

19. 19 the perfect meeting(?) (note 250)

19 Redo (note 251)

Note 156 **19**

[recto] *Physical notion of curvature:*/Without considering regular/geometric curves, what/intuitive physical notion can one/have about a curve whose/ends meet without crossing each other at the/meeting point. i.e. *The perfect connection,*/when it is not a matter/of geometric curves, is to be studied—

[diagram] connection

[diagram] 2 straight lines/which cross each other.

[diagram] 2 curves which cross/each other less and less/pto

[verso] do they ever connect perfectly?/(like the 2 straight lines) or the geometric/curves).

20. 20 anaccentuation—end of the page and on the back/ gap music (note 250)

20 A and B are certainly the only kinds of indifference which as such, / are the fodder of the magnets, the subject of discord / between all these <u>foreign forces</u> / 20 also: gap music (note 251)

Note 181 **20**

[recto] Porte Maillot, 1913 / *Leave out* / Uniformity of rhythm, anaccentuation. / Chance / Race between 2 mobile objects A and B. / at each cut of time (i.e. the uniform interval between / 2 "measures"). A and B. are drawn spatially, i.e. A is / decorated with all the accidents of the road, B also / is shown in a different state: / there is not in this race, any rivalry between A. from B. / A follows its own way, B likewise, each one meeting / other roads Conventionally, one takes a minimum time period / which separates two successive spatial states of A and B. (1″, ½″, or / less / no importance) / To differentiate A and B, A for ex. could be the piano. B, / the violin, (no importance) The different notations of the non-A / [on the side] or non-B / could be pictured by: / magnets + or – of A.—In other words: at each moment / of the duration A will be drawn or repelled / by foreign elements (which / will be the notes accompanying the nucleus A at that moment of the duration) / A and B are certainly / the only kinds of indifference, which as such, are / the fodder of the magnets, *the subject* of discord between all these foreign / forces [diagram] Jagged line, continuum of magnetization or repulsion points of A / straight line, attraction mean of the mobile object A / Jagged line as above / Fall of A into Y

[verso] *Gap music:* from a (chord) group of 32 notes for ex. / on the piano / not emotion either, but *enumeration through the* cold thought of the other 53 missing notes. put / some explanations

21. 21 what bears on the little wheels is— (note 250)

21—Redo (note 251)

Note 94 **21**

[crossed out] For / the woods: / Sienna earth / burnt straw / Terre de Cassel / ivory bl. / Lake and / blue [sketch] / Whatever bears on / little wheels, is less / heavy.—(*for* the slider / at the top. (the / scissors which bear / on the little wheels of / the slider.)

[crossed out] for the / soft readymade, / use: *"Ordinary / Brick."* / in the inscription

[crossed out] Money box (or canned goods) / Make a readymade / with a box / enclosing something / and soldered shut / forever / or a long time the imitation of photography

22/23 22 extra-mural agricultural apparatus (note 250)

23 the groups or the families (?) (note 250)

22—<u>perspective</u> and gravity (redo) (note 251)

Note 104 **22**

the groups or the families. (name brand bottles, uniforms and liveries etc.) their role in the picture—/ note the astringent action in the bride. / gordian knot (for the fall of weight.) / black metal of the ball. / the word Parcel (to use) / the *word flask* / the word *bar* / instead of axle—/ *the word apparatus instead of machine* / also the word slanting, oblique / also the word *"domain"* in the figurative / sense of limited quantity of *plane* space / *Look for another word than material, metal, substance*, for / the text. (use *organic mat.* for certain wasp / parts.) / the word *body* for ex. (or material body(?)) / The crane—stationary transport—or mobile go-between / Look for (in the Style) some "prime words" (divisible only by themselves and by unity)

Title Definitive title: / The bride stripped bare by *her* bachelors *even* / to give the picture the aspect of continuity / and to not lay oneself open to the objection of having only / described a fight between social dolls. = *The bride / possesses her partner and the bachelors strip bare their bride.* / As subtitle: (agricultural machine) or *"extramural agricultural / apparatus"*

Principle of gravity. putting the picture under the control of / elastic bands extending from the center of the earth: / each [material] is of such density and form that the object / which makes up its limits is induced by the center of gravity to / extend its dimensions into a surface without thickness and even / to reduce this surface down to the point which attracts it (funnel) / (Only the wasp uses the *elevator* of gravity at will) / The principle of gravity on which the entire picture rests is / the only Bridge of Common-Sense, the only human control over / each one of the picture's parts; this principle of gravity / is expressed graphically through the / linear means used: / *ordinary perspective*. (available to all levels of intelligence) *The picture in general is only a series of variations on "the law of gravity"* / a sort of enlargement, or relaxation of this law, submitting to it / [glimpses of the effects of the law on] extraphysical situations or bodies less or not chemically conditioned

[on the side] In the "hanged" (female) the upp. part is turned 22° ½ towards the handler: in the text recall ironically the greek heads ¾ turned. / imitated by Coysevox

Appendix B

A Note on the Construction of Duchamp as Alchemist

In his 1976 article "La Fortune critique de Marcel Duchamp" as well as in his entry on the *Large Glass* in the 1977 Paris exhibition *L'Oeuvre de Marcel Duchamp*, Jean Clair critiqued the arguments of authors to that date on the subject of Duchamp and alchemy, particularly those of Ulf Linde, Arturo Schwarz, and Maurizio Calvesi, as well as writers on Duchamp and the tarot or the Cabala, such as Nicolas Calas or Jack Burnham. Clair's analysis emphasized the absence in these texts of any convincing ties to Duchamp's contemporary context.[1] As noted in chapter 2 above, Linde's essay for the 1977 Paris retrospective, "L'Esotérique," as well as John Moffitt's "Marcel Duchamp: Alchemist of the Avant-Garde" add a slightly more contextual element in taking note of the work of Albert Poisson in the 1890s.[2] However, these essays, too, tend to treat alchemy as the sole key to Duchamp's life's work and, like all previous discussions of the subject, miss completely the primary context for renewed interest in alchemy in the pre–World War I period—its association with radioactivity (see chap. 2).

Clair's essay also pointed out Linde's inadvertent error in using an illustration of the stripping of a female figure from Eugène Canseliet's 1964 *Alchimie: Etudes diverses de symbolisme hermétique et de pratique philosophale*.[3] Supposedly reproduced from a manuscript by Solidonius, Canseliet's color plate transformed Solidonius's image of the stripping of a hermaphroditic male figure into that of a demure young woman. Linde discussed his error in his "L'Esotérique" essay in the 1977 Paris catalogue, but his comparison had already been noted by Pontus Hulten in the 1968 exhibition catalogue *The Machine as Seen at the End of the Mechanical Age* and was subsequently cited by Golding in his 1973 monograph on the *Large Glass*.[4] In fact, Canseliet's 1964 compendium encouraged such a reading, since he labeled the illustration in question "Plate from the Philosopher Solidonius (the young virgin stripped)" and quoted in his text Basile Valentin's allegorical description of a virgin's stripping (see chapter 2 above at n. 102). For Canseliet, Solidonius's image

(described, however, by Linde and Clair as relating to the purification of the male Sun/gold) seems to have been preferable to Valentin's own more aggressive and male-oriented illustration of the passage (see fig. 32 above).[5]

It should be emphasized that the notion of Duchamp as practicing alchemist grew out of the milieu of late Surrealism and was never rooted in any historical examination of alchemy in the early twentieth century. In his 1976 essay, Clair noted that the first references to Duchamp and alchemy occurred in the context of postwar Surrealism (e.g., Michel Sanouillet's introduction to the 1958 *Marchand du sel* volume and Robert Lebel's 1959 monograph), where metaphorical allusions to Duchamp's art as alchemical were gradually replaced by claims for his intimate knowledge of alchemical practice.[6] Such assertions functioned as a means for Breton and others to link Duchamp to the Surrealists, whose esoteric interests were becoming more widely known through the writings of figures such as Michel Carrouges, author of "Surréalisme et occultisme," published in *Les Cahiers d'Hermès* in 1947.[7] Alluding to Carrouges's 1954 *Les Machines célibataires*, Pontus Hulten recently referred to what he terms a "sterile attempt to interpret the *Large Glass*, based on its relation to the work of Kafka and alchemistic terminology and concepts," as having "started in 1954 and continued for some time in circles close to Surrealism."[8] Dieter Daniels, in a useful 1992 overview of the literature on Duchamp and alchemy, has suggested an even earlier inception of the Duchamp-alchemy discussions: an article by Gaston Puel, "Lettre à Marcel Duchamp," in a 1949 issue of *Néon*.[9]

Duchamp's later statements on the subject of alchemy were somewhat contradictory. In 1957, the same year he distanced himself from alchemy in his statement to Lebel, he used the term "transmutation" in his "Creative Act" speech to describe the eye of the spectator who transforms "inert matter into a work of art."[10] In an August 15, 1959, letter to Serge Stauffer, Duchamp responded to Stauffer's question about his statement to Lebel by pointing out that "'to practice alchemy' doesn't translate into words and all the alchemical treatises I have never read would have been completely inadequate."[11] As in his answer to Lebel, Duchamp asserted in a July 11, 1967 letter to Jacques van Lennep that he had not shared the Surrealists' interest in occultism as manifested in the 1947 Exposition Internationale du Surréalisme in Paris.[12] It would seem to have been Breton's enthusiasm for alchemy and the resultant late Surrealist attempt to portray Duchamp as a fellow practitioner that evoked such specific denials from the artist, who usually did not bother to contradict any of the myriad interpretations made of his works. More typical of Duchamp's detached stance was his exchange with the

artist Robert Smithson, who encountered Duchamp at a show of the latter's works at the Cordier-Ekstrom Gallery in 1963. When Smithson commented, "I see you are into alchemy," Duchamp replied, "Yes."[13]

On the subject of Surrealism, it is interesting that Canseliet, whose variation on Solidonius's image Linde reproduced, was also linked to Surrealist circles in Paris. In his translation of Basile Valentin's *Les Douze Clefs*, Canseliet cites Carrouges's *Les Machines célibataires* as well as *Les Portes Dauphines*, which Carrouges had sent him, noting the correspondence between Carrouges's text and Valentin's discussion of the stripping of a virgin.[14] Carrouges, as noted above, had written on Breton and alchemy, and Canseliet had first published his introduction

to Valentin's text in January 1955 in the Surrealist periodical *Medium: Communication Surréaliste*; that same issue included a letter from Duchamp to Breton concerning Carrouges's *Les Machines célibataires*.[15] Canseliet and Carrouges were among the respondents to the "Enquête" on "l'art magique" published by Breton in his volume *Formes de l'art: L'Art magique*, the same volume in which Lebel first published Duchamp's denial of alchemy.[16] These connections of Canseliet, advocate of alchemy, to the Surrealist milieu now suggest that he may have had a previously unsuspected impetus to illustrate Valentin's passage with a more clearly feminine image in his 1964 volume: he was well aware of the relevance of the stripping theme for contemporary art and literature.

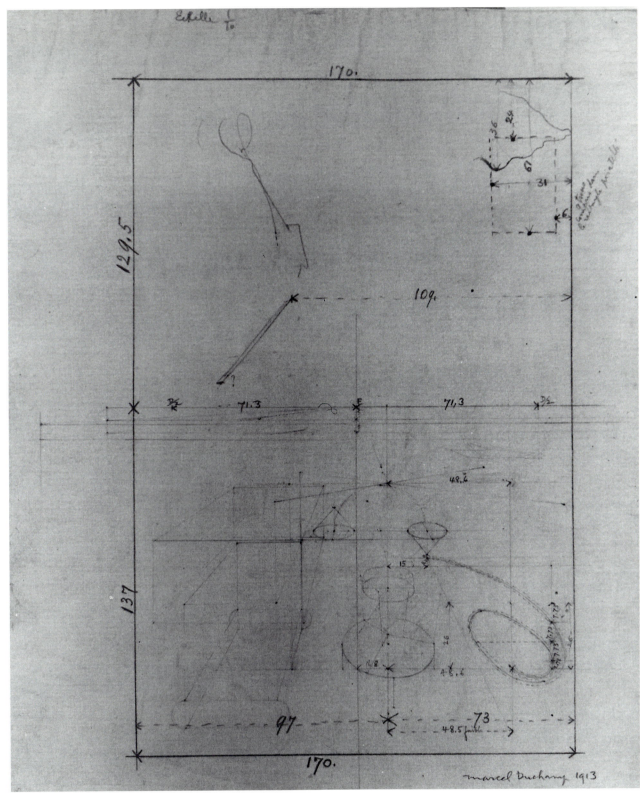

75 Duchamp, *The Bride Stripped Bare by Her Bachelors, Even,* 1913, pencil on tracing cloth, Collection Jacqueline Monnier, Villiers-sous-Grez, France.

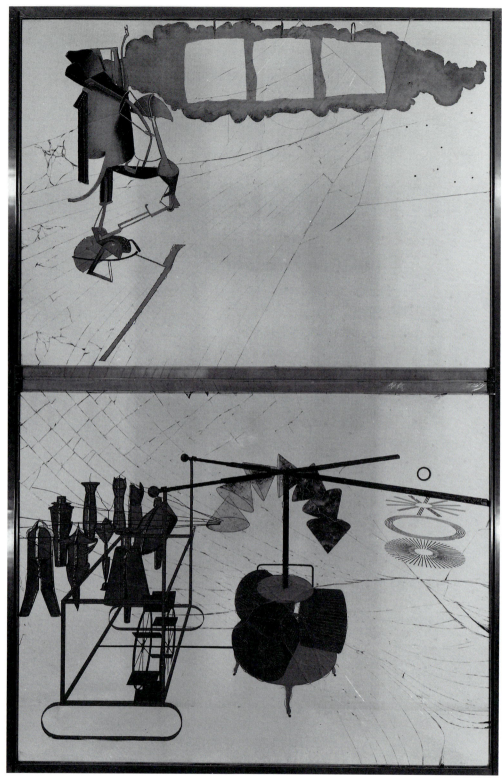

76 Duchamp, *The Bride Stripped Bare by Her Bachelors, Even (The Large Glass),* 1915–23, oil, varnish, lead wire, lead foil, mirror silvering, and dust on two glass panels (cracked), each mounted between two glass panels, with five glass strips, aluminum foil, and a wood and steel frame, Philadelphia Museum of Art, Bequest of Katherine S. Dreier.

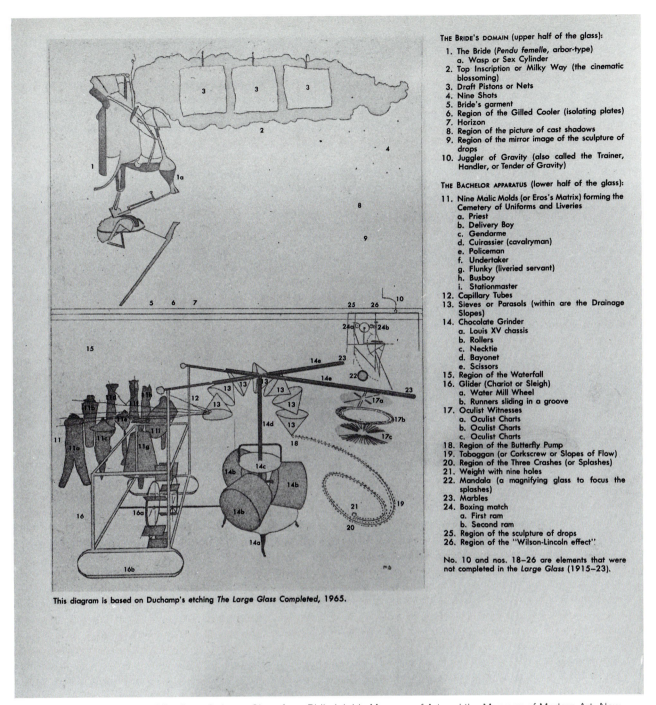

THE BRIDE'S DOMAIN (upper half of the glass):

1. The Bride (*Pendu femelle*, arbor-type)
 a. Wasp or Sex Cylinder
2. Top Inscription or Milky Way (the cinematic blossoming)
3. Draft Pistons or Nets
4. Nine Shots
5. Bride's garment
6. Region of the Gilled Cooler (isolating plates)
7. Horizon
8. Region of the picture of cast shadows
9. Region of the mirror image of the sculpture of drops
10. Juggler of Gravity (also called the Trainer, Handler, or Tender of Gravity)

THE BACHELOR APPARATUS (lower half of the glass):

11. Nine Malic Molds (or Eros's Matrix) forming the Cemetery of Uniforms and Liveries
 a. Priest
 b. Delivery Boy
 c. Gendarme
 d. Cuirassier (cavalryman)
 e. Policeman
 f. Undertaker
 g. Flunky (liveried servant)
 h. Busboy
 i. Stationmaster
12. Capillary Tubes
13. Sieves or Parasols (within are the Drainage Slopes)
14. Chocolate Grinder
 a. Louis XV chassis
 b. Rollers
 c. Necktie
 d. Bayonet
 e. Scissors
15. Region of the Waterfall
16. Glider (Chariot or Sleigh)
 a. Water Mill Wheel
 b. Runners sliding in a groove
17. Oculist Witnesses
 a. Oculist Charts
 b. Oculist Charts
 c. Oculist Charts
18. Region of the Butterfly Pump
19. Toboggan (or Corkscrew or Slopes of Flow)
20. Region of the Three Crashes (or Splashes)
21. Weight with nine holes
22. Mandala (a magnifying glass to focus the splashes)
23. Marbles
24. Boxing match
 a. First ram
 b. Second ram
25. Region of the sculpture of drops
26. Region of the "Wilson-Lincoln effect"

No. 10 and nos. 18–26 are elements that were not completed in the *Large Glass* (1915–23).

This diagram is based on Duchamp's etching *The Large Glass Completed*, 1965.

77 Diagram of components of Duchamp's *Large Glass,* from Philadelphia Museum of Art and the Museum of Modern Art, New York, *Marcel Duchamp,* 1973, p. 64.

78A, B Duchamp, *The Box of 1914,* 1914, Collection Dina Vierny, Paris; from Galerie Dina Vierny, *Marcel Duchamp et ses frères,* Paris, 1988.

79 Duchamp, *The Box of 1914,* 1914, Marcel Duchamp Archive, Villiers-sous-Grez, France.

80 Duchamp, "Grand Pier Pavilion Illuminated," from *Marcel Duchamp: Notes,* ed. Paul Matisse, Paris, 1980, note 78.

81 Duchamp, excerpt from note headed "The Bride Stripped Bare by the Bachelors," from the *Green Box,* reproduced in *Notes and Projects for the Large Glass,* ed. Arturo Schwarz, p. 22.

1. *Arbre type/Hampe modèle* ("Arbor type"/"shaft model"); *Squelette* ("Skeleton"): *MDN,* notes 98, 149; *GB,* in *SS,* p. 43.

2. "Eyes" of the Bride, identified with the semicircular "upper part": *MDN,* notes 144, 152, p. 3.

3. "Mortice" (extension of shaft below this point swings freely): *GB,* in *SS,* p. 47 (see fig. 127 herein); *MDN,* note 152, p. 3.

4. Area of the "filament material": *GB,* in *SS,* p. 47 (see fig. 127); *MDN,* note 152, p. 3. Also "open frame": *GB,* in *SS,* p. 47 (see fig. 127); and "isolated cage": *MDN,* note 105 (see fig. 126).

5. "Sex Cylinder"/"Wasp": *GB,* in *SS,* p. 46 (see fig. 105).

6. "Artery channeling the nourishment of the filament material": *GB,* in *SS,* p. 47 (see fig. 127); *MDN,* note 152, p. 3.

7. "Pulse needle": *GB,* in *SS,* p. 46 (see fig. 105). "Toward the life center of the bride" indicated by arrow to the left of "pulse needle" in Duchamp's drawing.

8. General area of "Desire-magneto": *MDN,* note 152, p. 3.

9. General area of "Tympanum": *MDN,* note 152, p. 4, note 106.

10. Probable location of "Reservoir of love gasoline": *GB,* in *SS,* pp. 43, 46 (see fig. 105).

11. Probable location of "Desire-gear"/"Clockwork box" (*Boîte d'horlogerie*): *MDN,* notes 98, 155.

12. Probable location of "Motor with quite feeble cylinders": *GB,* in *SS,* p. 42.

13. Point on shaft (13a) that "horse kicks" the "circle of cardinal points" (13b): *MDN,* notes 144, 152, p. 4 (see fig. 128).

82 Author's diagram of the components of the Bride of Duchamp's *Large Glass*.

83 Robert Delaunay, *Simultaneous Window,* 1912, oil on canvas, Solomon R. Guggenheim Museum, New York.

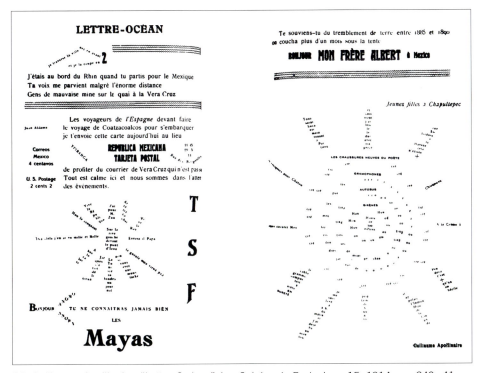

84 Guillaume Apollinaire, "Lettre-Océan," *Les Soirées de Paris,* June 15, 1914, pp. 340–41.

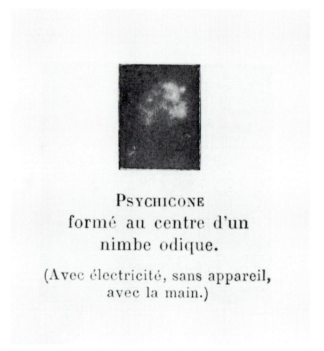

PSYCHICONE
formé au centre d'un
nimbe odique.

(Avec électricité, sans appareil,
avec la main.)

85 "Psychicone," from Hippolyte Baraduc, *L'Ame humaine, ses mouvements, ses lumières,* Paris, 1896, print 19.

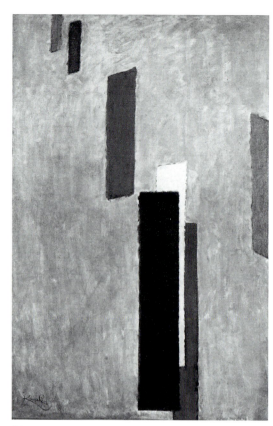

86 František Kupka, *Vertical Planes I,* 1912, oil on canvas, Musée National d'Art Moderne, Centre Georges Pompidou, Paris.

87 Duchamp, *Cols alités,* 1959, ink and pencil on paper, Private Collection, Paris.

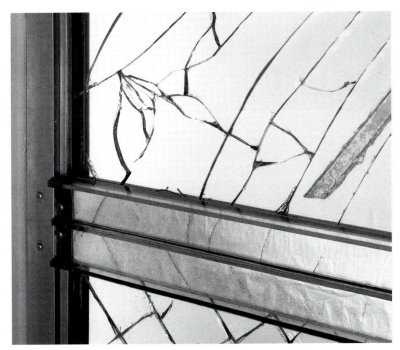

88 Mid-section of Duchamp's *Large Glass* (plate 1, figure 76).

89 Electrical condenser, from Georges Claude, *L'Electricité à la portée de tout le monde,* 5th ed., Paris, 1905, p. 284.

90 Advertisement for "Special" glass insulators made by Charbonneaux & Cie., from *La Lumière Electrique,* June 28, 1913, p. 394.

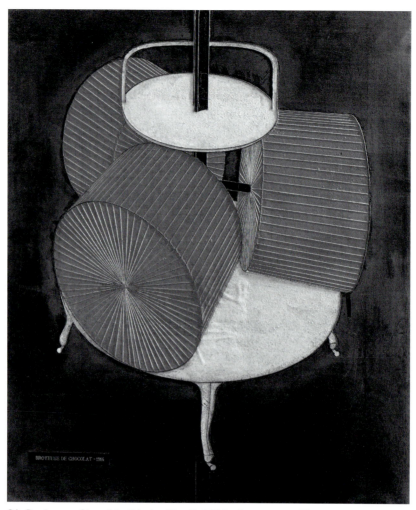

91 Duchamp, *Chocolate Grinder (No. 2),* 1914, oil on canvas, Philadelphia Museum of Art, The Louise and Walter Arensberg Collection.

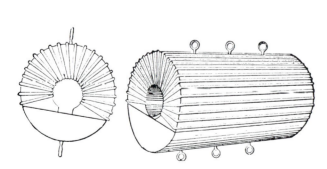

FIG. 7.—JOULE'S ELECTROMAGNET.

92 Joule's electromagnet, from Silvanus P. Thompson, *Lectures on the Electromagnet,* London, 1891, figure 7.

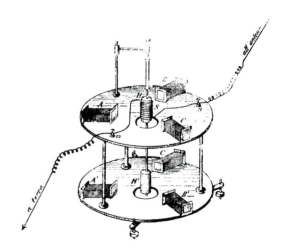

93 Arnò's magnetic wave detector, from Riccardo Arnò, "Rivelatore di onde hertzienne a campo Ferraris," *Atti Electrotechnica Italiana,* 1904, p. 355.

94 Letterhead of E. Gamelin Confectioners, rue Beauvoisine, Rouen, courtesy of Jennifer Gough-Cooper and Jacques Caumont.

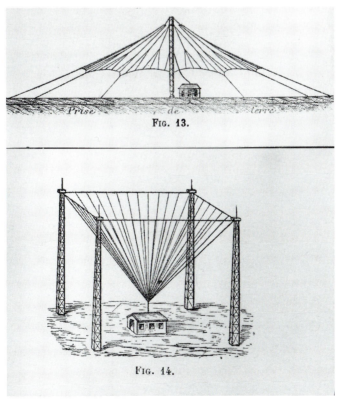

95 New antenna arrangements, from E. Monier, *La Télégraphie sans fil,* Paris, 1906, figures 13, 14.

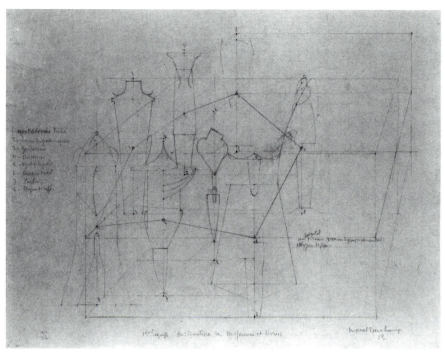

96 Duchamp, *Cemetery of Uniforms and Liveries (No. 1),* 1913, Philadelphia Museum of Art, The Louise and Walter Arensberg Collection.

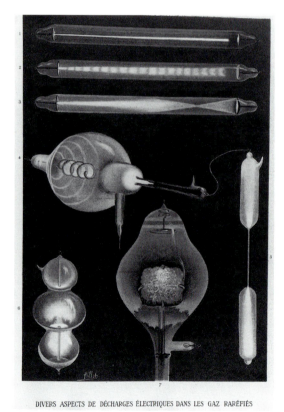

DIVERS ASPECTS DE DÉCHARGES ÉLECTRIQUES DANS LES GAZ RARÉFIÉS

97 Electrical discharge tubes, from Maurice Leblanc, "Aspects de la décharge électrique dans les gaz raréfiés," *La Nature,* December 3, 1910, facing p. 8.

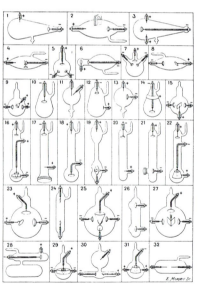

Nᵒˢ 1 à 32. — Divers modèles d'ampoules pour radiographie et fluoroscopie. — Nᵒ 1 et 2. Ampoules de Crookes. — Nᵒ 3. Ampoule Séguy. — Nᵒ 4. Ampoule Wood. — Nᵒ 5. Ampoule Séguy. — Nᵒ 6. Ampoule Chabaud et Hurmuzescu. — Nᵒ 7. Ampoule Séguy. — Nᵒ 8. Ampoule Tompson. — Nᵒ 9. Ampoule Séguy. — Nᵒ 10. Ampoule d'Arsonval. — Nᵒ 11. Ampoule Séguy. — Nᵒ 12. Ampoule Puluj. — Nᵒ 13. Ampoule Séguy. — Nᵒ 14. Ampoule d'Arsonval. — Nᵒ 15. Ampoule Le Roux. — Nᵒ 16, 17 et 18. Ampoules Séguy. — Nᵒ 19. Ampoule de Rufz. — Nᵒ 20. Ampoule Crookes. — Nᵒ 21, 22, et 25. Ampoules Séguy. — Nᵒ 24. Ampoule Röntgen. — Nᵒ 25. Ampoule Brunet-Séguy. — Nᵒ 26, 27. Ampoules Le Roux. — Nᵒ 28. Ampoule Colardeau. — Nᵒ 29. Ampoule Séguy. — Nᵒ 30. Ampoule Colardeau. — Nᵒ 31. Ampoule Séguy. — Nᵒ 32. Ampoule Röntgen.

98 Crookes tubes and other types of cathode-ray tubes for X-ray production, from J. L., "Etude expérimentale des ampoules utilisées en radiographie et fluoroscopie," *La Nature,* November 21, 1896, p. 585.

FIG. 174. — Effets lumineux de la haute fréquence.

99 "Luminous Effects of High Frequency," from Claude, *L'Electricité à la portée de tout le monde,* 5th ed., Paris, 1905, figure 174.

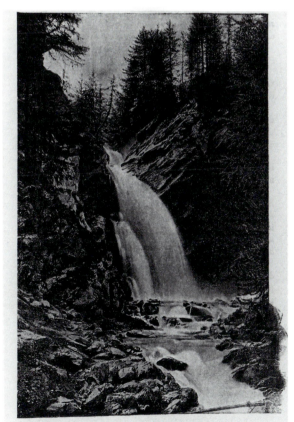

FIG. 28. — La cascade du Chadoulin. Cliché extrait des *Sites et Monuments de France.*
A la fois grande hauteur et grand débit : grande puissance.

100 "The Waterfall of Chadoulin," from Claude, *L'Electricité à la portée de tout le monde,* 5th ed., Paris, 1905, figure 28.

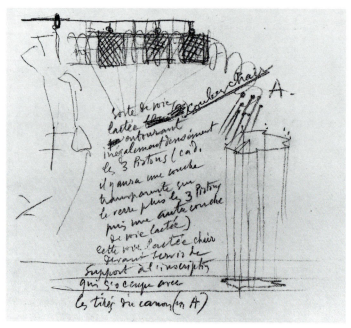

101 Duchamp, *Milky Way* (with Top Inscription), 1914–15, original lost, facsimile in the *Green Box* (reproduced in *Salt Seller,* ed. Michel Sanouillet, p. 37).

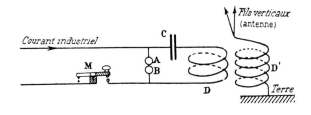

102 Circuit diagram for wireless telegraphy emitting apparatus, from P. Brenot, "La Télégraphie sans fil," *La Revue des Idées,* April 15, 1907, p. 300.

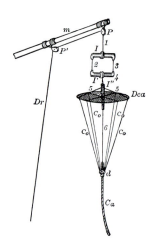

103 Guarini's antenna with Ducretet method of suspension, from Henri Poincaré and Frederick Vreeland, *Maxwell's Theory and Wireless Telegraphy,* New York, 1904, p. 142.

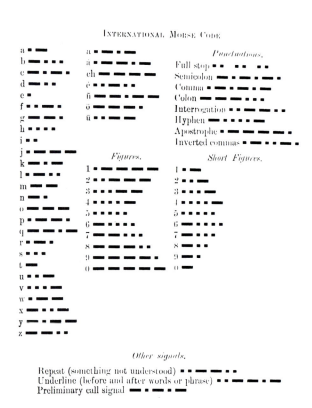

104 International Morse code signals, from Rupert Stanley, *Text Book on Wireless Telegraphy,* London, 1914, p. 335.

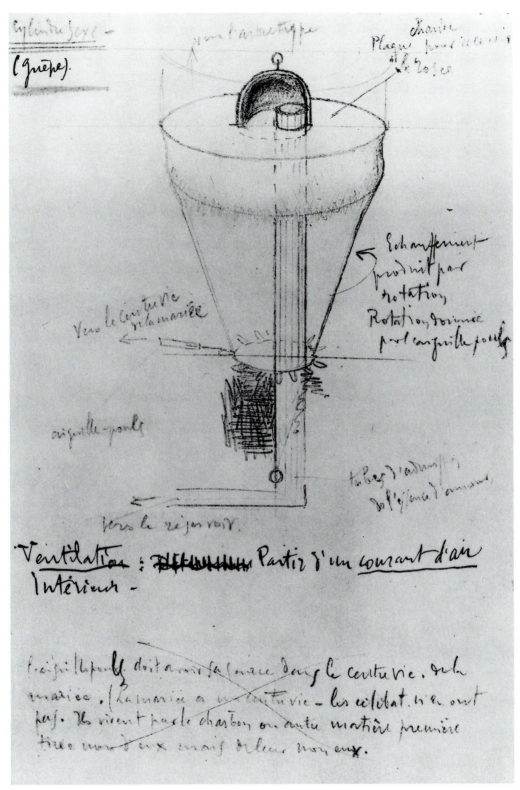

105 Duchamp, *Wasp, or Sex Cylinder,* 1913, original lost, facsimile in the *Green Box* (reproduced in *Salt Seller,* ed. Michel Sanouillet, p. 46).

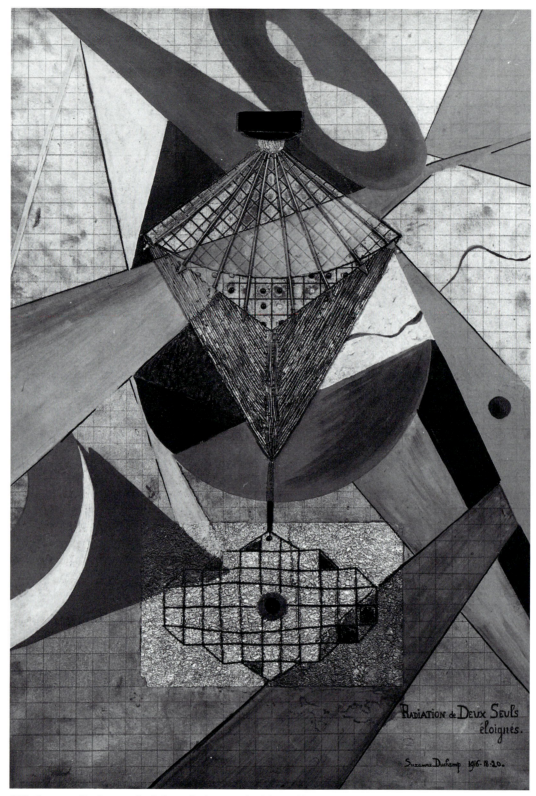

Radiation de Deux Seuls éloignés.

Suzanne Duchamp 1916-18-20.

106 Suzanne Duchamp, *Radiations de deux seuls éloignés* (Radiations of Two Lone Ones at a Distance), 1916–1918–1920, oil, lead wire, tinfoil, glass beads, pearls, string, Collection Alain Tarica, Paris.

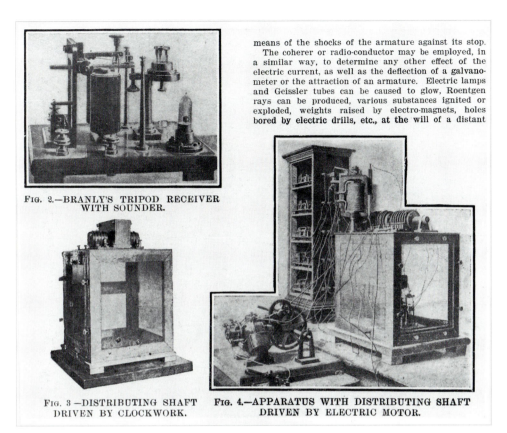

means of the shocks of the armature against its stop.

The coherer or radio-conductor may be employed, in a similar way, to determine any other effect of the electric current, as well as the deflection of a galvanometer or the attraction of an armature. Electric lamps and Geissler tubes can be caused to glow, Roentgen rays can be produced, various substances ignited or exploded, weights raised by electro-magnets, holes bored by electric drills, etc., at the will of a distant

FIG. 2.—BRANLY'S TRIPOD RECEIVER WITH SOUNDER.

FIG. 3 —DISTRIBUTING SHAFT DRIVEN BY CLOCKWORK.

FIG. 4.—APPARATUS WITH DISTRIBUTING SHAFT DRIVEN BY ELECTRIC MOTOR.

107 Edouard Branly's receiving station equipment, from Alfred Gradenwitz, "The Operation of Mechanical Devices at a Distance by Means of the Wireless Transmission of Energy," *Scientific American Supplement,* June 8, 1907, p. 26276.

FIGS. 7a AND b.—ELECTRIC FAN, LAMP BANK, PISTOL AND LIFTING MAGNET, ARRANGED FOR SUCCESSIVE OPERATION FROM A DISTANCE.

108 Devices operated by Branly from a distance, from Gradenwitz, "Operation of Mechanical Devices," p. 26277.

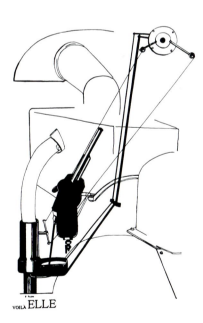

VOILÀ ELLE

109 Francis Picabia, *Voilà elle* (Here She Is), 1915, from *291,* November 1915.

mais après l'équilibre instable, le jongleur
revient au 0: la mariée le surveille du
coin de l'œil.
Épanouissements; épanouissement par conciliation.

Épanouissement horizontal volontaire de
la mariée allant à la rencontre de l'épa-
nouissement vertical de la mise à nu.

filaments
en papier
transparent
allant en épanouissement est suspendu
jusqu'à la boule du jongleur et
revenant alternativement comme
certains soufflets
de fête à Neuilly.

Le mt de ces filaments est dû à la magnéto
désir et constitue l'auto épanouissement en mise
à nu de la mariée.

Br grand plateau du jongleur de centre de
gravité. Boule du jongleur. Cette boule libre
est dirigée par les filaments de l'auto épanouis-
sement de la mariée, filaments qui la
forcent à rendre l'équilibre déplacé par la
danse des pieds, danse menée par la boîte
d'horlogerie aux sons de la mise à nu.
Phénomène d'épanouissement par conciliation.
La boule en métal (noir), a la propriété d'attirer
les filaments ou rameaux qui par sympathie
entretiennent l'équilibre du jongleur. Ces rameaux
se forment suivant une loi d'irrigation de la
magnéto-désir servie par le cylindre sexe. Ils
prennent naissance dans leur matière même (sorte
de pâte informe vascularisée)

110 Duchamp, Bride and Juggler of the Center of Gravity, from Duchamp's four-page note on the
Bride, 1913–14, from *Marcel Duchamp: Notes,* ed. Paul Matisse, note 152, p. 2.

111 Duchamp's *Large Glass* with overlay of various components by Jean Suquet.

112 Duchamp, Juggler of the Center of Gravity/Handler of Gravity, 1914–15, drawing on note from the *Green Box* (reproduced in *Salt Seller,* ed. Michel Sanouillet, p. 65).

FIG. 9.—Branly's Tripod Coherer.

113 Branly's tripod coherer, from J. A. Fleming, *The Principles of Electric Wave Telegraphy,* London, 1906, p. 366.

114 Oculist Witnesses, from Duchamp's *Large Glass* (plate 1, figure 76).

115 Duchamp, *To Be Looked At (from the Other Side of the Glass) with One Eye, Close to, for Almost an Hour,* 1918, oil paint, mirror silver, lead wire, and magnifying lens on glass, Museum of Modern Art, New York, Bequest of Katherine S. Dreier. Photograph of the work unframed, taken in Buenos Aires in 1918–19, Yale University Art Gallery, Société Anonyme Collection.

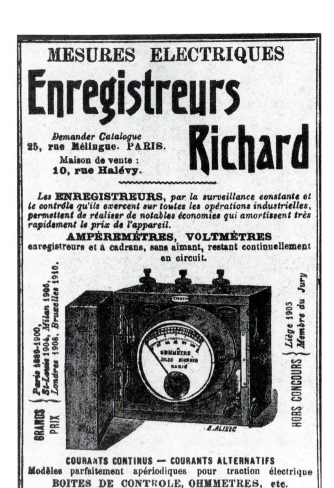

116 Advertisement for registering apparatuses from Richard Frères, from *La Lumière Electrique,* June 28, 1913, inside front cover.

117 Advertisement for measuring and controlling apparatuses from Jules Richard, from *Catalogue officiel des collections du Conservatoire National des Arts et Métiers,* vol. 1, Paris, 1905.

118 Duchamp's New York studio, ca. 1917–18.

FIG. 5. PHOTOGRAPH OF A PIECE OF WELSBACH MANTLE TAKEN BY ITS OWN BECQUEREL RAYS

119 "Photograph of a Piece of Welsbach Mantle Taken by Its Own Becquerel Rays," from Ernest Merritt, "The New Element Radium," *Century Magazine,* January 1904, p. 455.

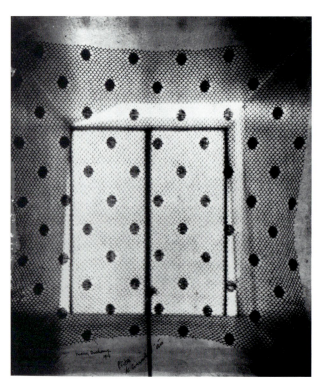

120 Duchamp, *Air Current Piston,* 1914, photograph, Marcel Duchamp Archive, Villiers-sous-Grez, France.

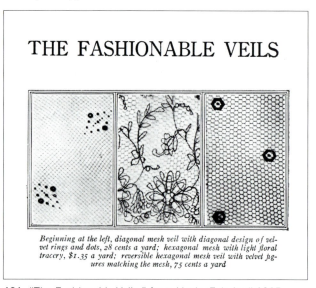

THE FASHIONABLE VEILS

Beginning at the left, diagonal mesh veil with diagonal design of velvet rings and dots, 28 cents a yard; hexagonal mesh with light floral tracery, $1.35 a yard; reversible hexagonal mesh veil with velvet figures matching the mesh, 75 cents a yard

121 "The Fashionable Veils," from *Vanity Fair,* April 1915, p. 78.

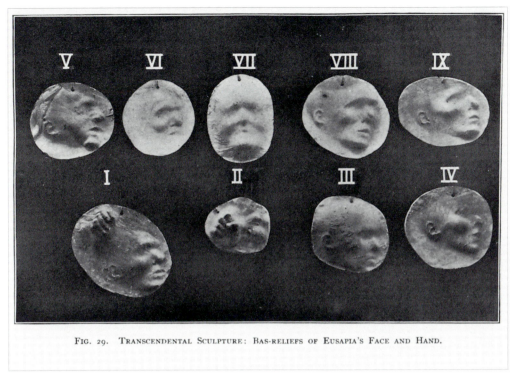

FIG. 29. TRANSCENDENTAL SCULPTURE: BAS-RELIEFS OF EUSAPIA'S FACE AND HAND.

122 Transcendental sculpture, from Cesare Lombroso, *Ricerche sui fenomeni ipnotici e spiritici,* Turin, 1909, p. 67; and Lombroso, *After Death—What?* Boston, 1909, figure 29.

123 Duchamp, *Raising of Dust,* 1920, photograph by Man Ray.

FIG. I.—HAMMER'S DUST-FIGURE ON GLASS. § 36a, p. 21.

FIG. 2.—HAMMER'S HISTORICAL COLLECTION OF INCANDESCENT LAMPS,
CONTAINED IN CASE HAVING THE DUST-FIGURES. § 36a, p. 21.

124 "Hammer's Dust-Figure on Glass," from Edward P. Thompson,
Roentgen Rays and Phenomena of the Anode and Cathode, New
York, 1896, p. 22.

'8 Suprematist composition expressing the fee
ing of wireless telegraphy. 1915.

125 Kazimir Malevich, *Suprematist Composition
Expressing the Sensation of Wireless Telegraphy,*
1915, pencil drawing, from *The Non-Objective
World,* Chicago, 1959, figure 78.

126 Duchamp, "In the *Pendu femelle* and the blossoming Barometer," 1913, note from the *Green Box,* reproduced in *Notes and Projects for the Large Glass,* ed. Arturo Schwarz, p. 117.

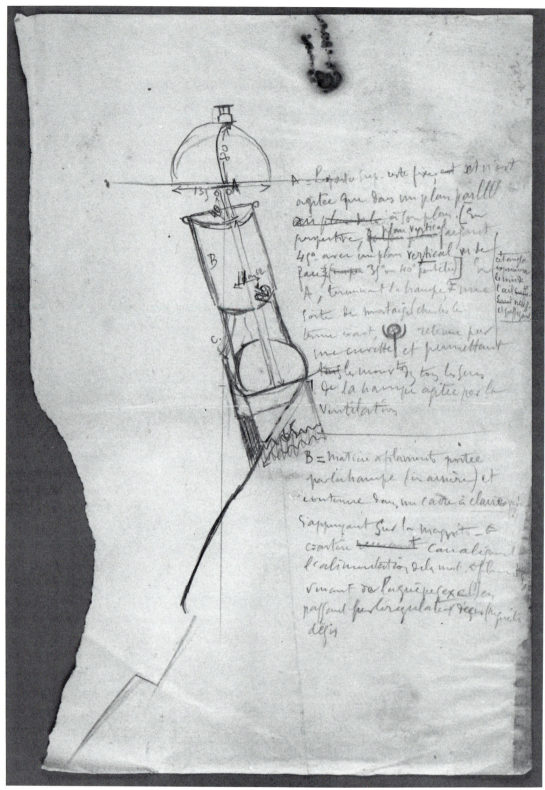

127 Duchamp, *Pendu femelle,* 1913, pencil, charcoal, and ink, Collection Robert Shapazian, Los Angeles; facsimile in the *Green Box* (reproduced in *Salt Seller,* ed. Michel Sanouillet, p. 47).

128 Duchamp, "The *Pendu*—suspended with all the accessories," ca. 1913, from *Marcel Duchamp: Notes,* ed. Paul Matisse, note 144.

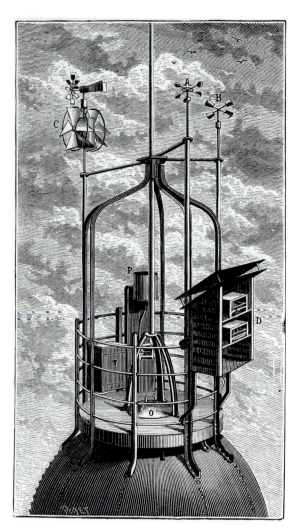

129 Installation of meteorological instruments on the Eiffel Tower, including anemometers (A, B), weather vane (C), shelter containing barometer, thermometer, and hygrometer (D), and rain gauge (P), from Gustave Eiffel, *Travaux scientifiques,* Paris, 1900, p. 44.

130 Incandescent lamp and its socket, from Georges Claude, *L'Electricité à la portée de tout le monde,* 5th ed., Paris, 1905, p. 114.

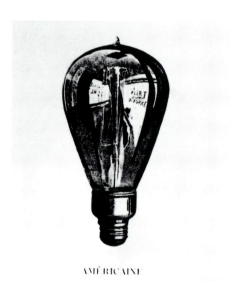

AMÉRICAINE

131 Francis Picabia, *Américaine,* 1917, cover for *391,* July 1917.

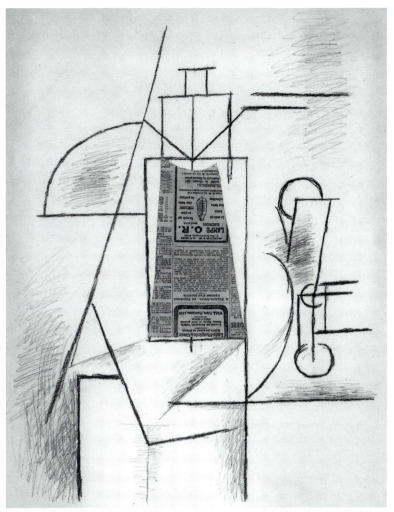

132A Pablo Picasso, *Bottle and Glass,* 1912–13, charcoal and newsprint on paper, The Menil Collection, Houston.

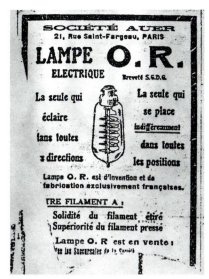

132B Detail of figure 132A.

133 Advertisement for an Elira unbreakable lamp, from *La Lumière Electrique,* June 28, 1913, p. 397.

134 *Guêpe* (wasp), from *Petit Larousse illustré,* Paris, 1912, p. 449.

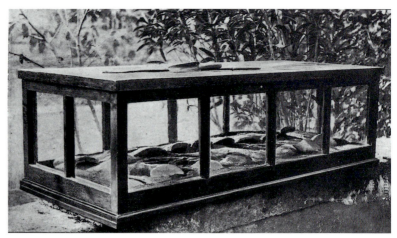

135 "The Large Glass Cage Containing the Scorpions," from J.-H. Fabre, *La Vie des insects: Morceaux choisis,* Paris, 1910, facing p. 252.

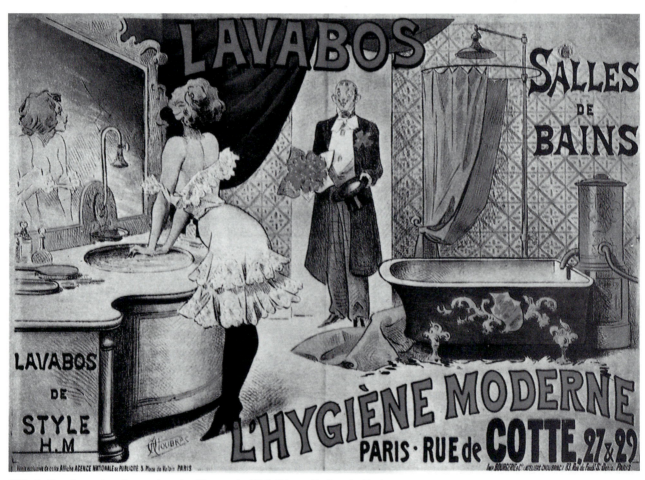

136 A. Choubrac, *Lavabos,* n.d., color lithograph, Bibliothèque Nationale, Paris.

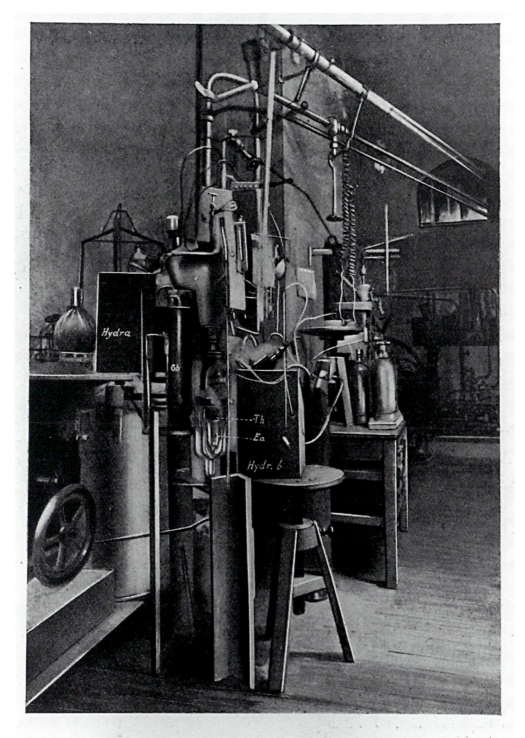

Fig. 7. — L'appareil et l'installation qui servirent à liquéfier l'hélium dans le laboratoire de M. Kamerlingh Onnes, à Leyde.

137 Apparatus used to liquefy helium in the laboratory of Kamerlingh Onnes in Leyden, from G. Bresch, "Les Gaz liquifiés (l'air, l'hélium)," *La Nature,* December 10, 1910, figure 7.

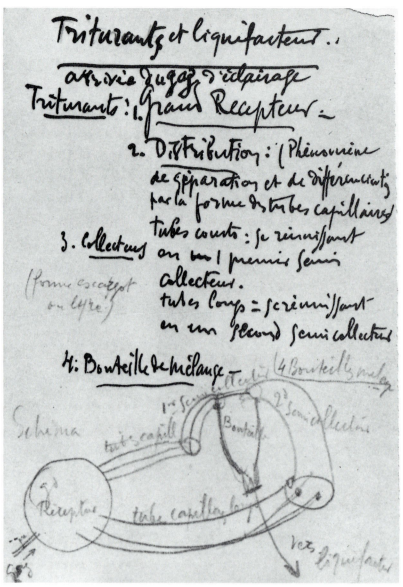

138 Duchamp, "Triturators and Liquifiers," 1913–14, from *Marcel Duchamp: Notes,* ed. Paul Matisse, note 114.

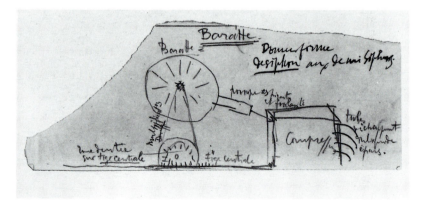

139 Duchamp, "Churn," 1913–14, from *Marcel Duchamp: Notes,* ed. Paul Matisse, note 125.

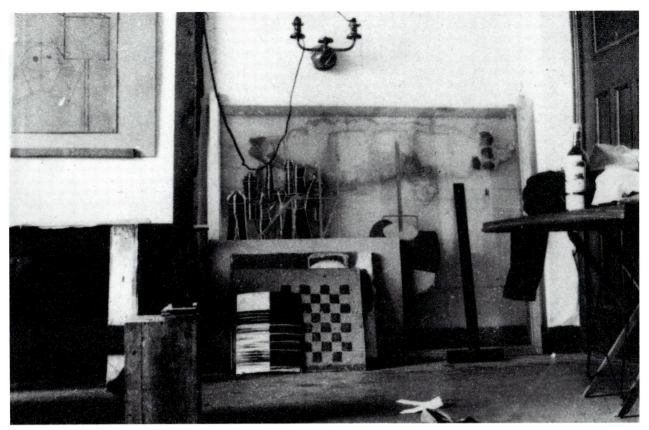

140 Duchamp's studio, New York, ca. 1917–18.

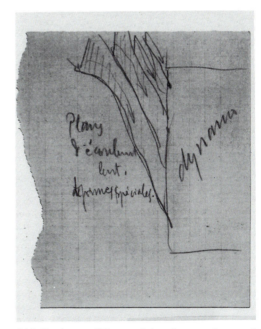

141 Duchamp, "Planes of slow flow . . . dynamo," 1913–14, from *Marcel Duchamp: Notes,* ed. Paul Matisse, note 122.

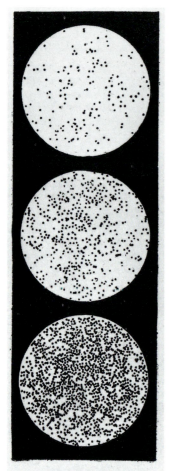

Répartition d'équilibre de grains de gomme-gutte de 0μ,6 de diamètre, 3 niveaux pris de 10 en 10μ.

142 Jean Perrin, "Distribution of equilibrium of grains of gamboge," from H. Vigneron, "Les Preuves de la réalité moléculaire," *La Nature,* December 2, 1911, p. 3.

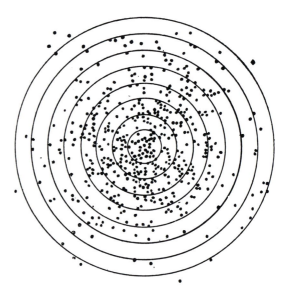

143 Random distribution of Brownian movement displacements measured from the center of a target, from Jean Perrin, *Les Atomes,* Paris, 1913, figure 10.

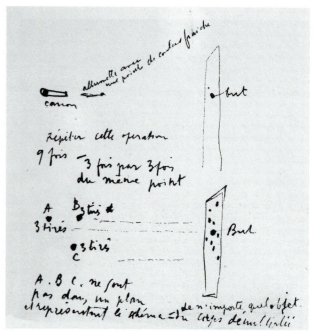

144 Duchamp, excerpt from note headed "Shots," 1914–15, from the *Green Box,* reproduced in *Notes and Projects for the Large Glass,* ed. Arturo Schwarz, p. 135.

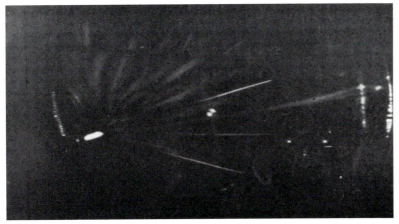

145 C. T. R. Wilson, "Cloud Formed on Ions due to Alpha-Rays," from "On a Method of Making Visible the Paths of Ionising Particles through a Gas," *Proceedings of the Royal Society of London,* November 1911, figure 1.

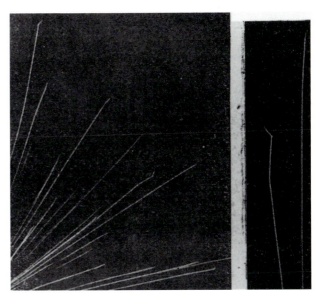

146 C. T. R. Wilson, "Cloud-Chamber Tracks of Alpha-Rays from Radium" (1912), from Perrin, *Les Atomes,* rev. ed., Paris, 1914, figure 15.

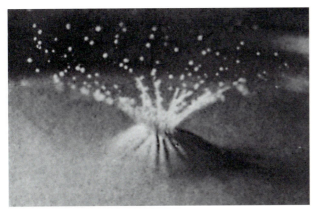

147 A. M. Worthington, "The 'Sheath' Splash of a Smooth Sphere," from *A Study of Splashes,* London, 1908, p. 91.

en A et B. points de tirage (écartement des ciseaux
jusqu'en A'B'.). le mobile o est retenu par F
et G. les crochets c et D cèdent. — 3 solutions

1°. le mobile o abandonne en même temps c et
D et tombe suivant x — en déterminant
par sa chute un fracas à ̶ ̶ exposer
2°. le mobile abandonne c seulement et la
traction cessant en A', il est entrainé
suivant la trajectoire R (autre fracas)
3°. le mob. aband. D. et tombe suivant
la trajectoire S. (autre fracas)

après les 3 chutes, le mobile est ramené
à sa position de labyrinthe par : un cordonnet
central habitué à la position de labyrinthe
(s'enroulant à l'escargot) (sorte de ressort)
qui laisse aller le mobile après l'écartement
des ciseaux et le ramène à sa position de
labyrinthe (cordonnet à tendance d'inertie)
Libre arbitre = âne de Buridan, trouver une
formule —

utiliser la chute du mobile au point de vue "frappe de plusieurs pièces"

148 Duchamp, note on the operation of the Mobile, ca. 1913, from *Marcel Duchamp: Notes,*
ed. Paul Matisse, note 153, p. 2.

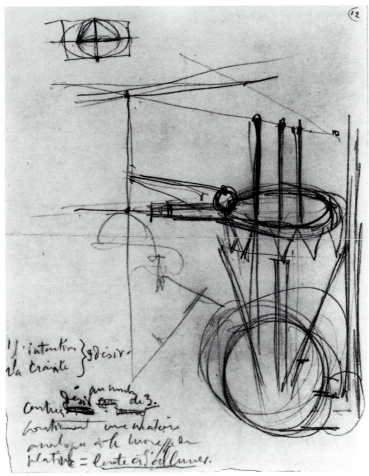

149 Duchamp, Desire Dynamo, 1913–14, from *Marcel Duchamp: Notes,* ed. Paul Matisse, note 163.

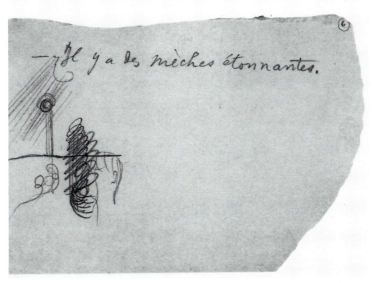

150 Duchamp, "There are some astounding fuses," date unknown, from *Marcel Duchamp: Notes,* ed. Paul Matisse, note 246.

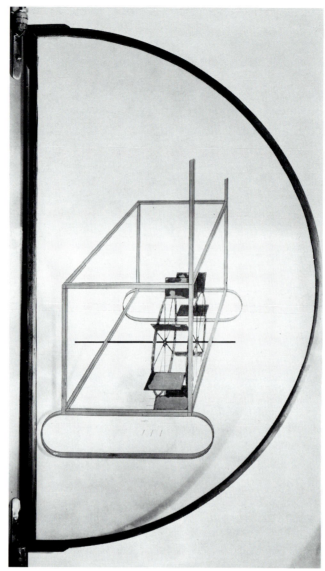

151 Duchamp, *Glider Containing a Water Mill (in Neighboring Metals),* 1913–15, oil and lead wire on glass, mounted between two glass plates, Philadelphia Museum of Art, The Louise and Walter Arensberg Collection.

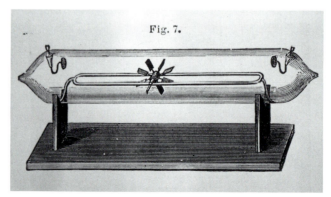

152 Crookes's mill wheel for demonstrating cathode-ray bombardment, from Charles-Edouard Guillaume, *Les Rayons X et la photographie à travers le corps opaques,* Paris, 1896, figure 7.

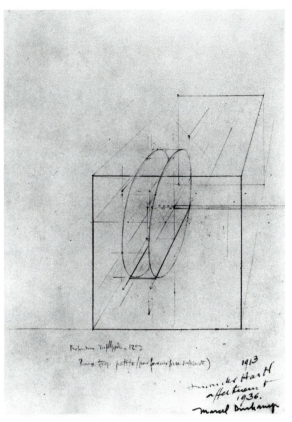

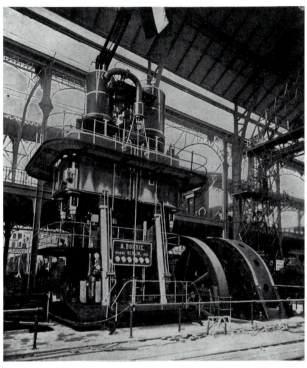

154 Borsig engine and Siemens & Halske generator at 1900 Exposition Universelle, from "The Power-Generating Plant at the Paris Exposition," *Scientific American Supplement,* June 16, 1900, p. 20447.

153 Duchamp, *Perspective Drawing for the Water Mill Wheel,* 1913, pencil on paper, Private Collection, New York.

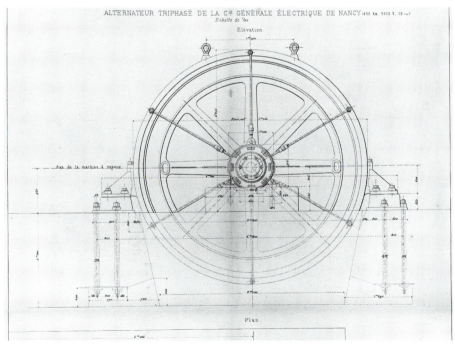

155 Triphase alternator, from A. Ferrand, *Les Dynamos et les transformateurs à l'Exposition Universelle de 1900,* Paris, 1902, plate 5.

Chariot — Traineau — Glissière

Exposé du Chariot (dans le texte: Litanies du Chariot)

- Vie lente —
- Cercle vicieux —
- Onanisme —
- Horizontal —
- Buttoir de vie
- Vie célibat considérée comme rebondissant alternatif sur ce buttoir.
- Rebondissement = camelotte de vie
- Construction à bon marché
- Fer blanc
- Cordes
- Fil de fer
- Poulies grossières en bois
- Excentriques
- Volant monotone

Buttoir de vie : arrêtant l'élan non par opposition brutale mais par des ressorts tirés reprenant lentement leur première position.

Le métal ou (matière) du chariot est émancipé. ca'd: qu'il a un poids mais qu'une force agissant horizontalement sur le chariot n'a pas à supporter ce poids (le poids du métal ne s'oppose pas à une traction horizontale (développer). le chariot est émancipé horizontalement il est libre de toute pesanteur dans le plan

156A *(see also* **156B, 156C** *on the following two pages)* Duchamp, "Exposé of the Chariot," 1913–15, from the *Green Box,* reproduced in *Notes and Projects for the Large Glass,* ed. Arturo Schwarz, pp. 192–99; original note, Collection Robert Shapazian, Los Angeles.

horizontal (propriété du métal des tiges qui
composent le chariot)

Ces tiges sont ≠ de forme :

section carrée □

type courant.

Couleur : jaune vert. (comme la reine du
Roi et la Reine)
(Cadmium clair
et blanc)

*rouge section
mise au centre. (grandeur
apparente
plus ou moins
définitif)*

*Voir aussi pour cette couleur les notes de Münich
sur la composition des couleurs des premières études.*

Le chariot est supporté par des patins qui
glissent (huile etc.) **dans une gouttière**

corde

patin

la corde devant tirer le chariot sous le
coup du poids bouteille, s'attache en A ~~par~~
au patin par un nœud provisoire.

multiplication intérieure
*de m⁰ de la roue
de moulin — pour
obtenir vitesse —*

A

Projection du chariot.

longueur = à l'enfoncement de la bouteille
en c⁰ poids

corde

c

En arrière (à gauche du tableau) le chariot est ~~peu~~ ramené en position
par le Sandow.

Dans le tableau les Sandows seront
au repos. (presque détendus)

Sandow.

156B

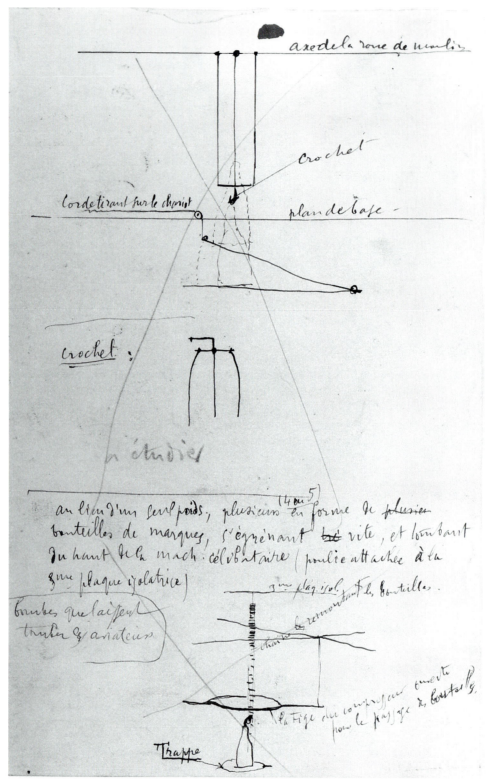

axe de la roue de moulin

crochet

Corde tirant sur le chariot

plan de base.

crochet :

à étudier

au lieu d'un seul poids, plusieurs (4 ou 5) en forme de plusieurs
bouteilles de marques, s'égrénant très vite, et tombant
du haut de la mach. célibataire (poulie attachée à la
3me plaque isolatrice)

3me plaq. isol. portant les bouteilles.

bombes que laissent
tomber les aviateurs

le remontant

chaine

la tige du compresseur ouverte
pour le passage des bouteilles.

Trappe

156C

Le Développeur

Sandow est le meilleur pour l'entraînement rationnel de tout le corps. Il est pratique, solide et très facile à monter.

LE MERVEILLEUX ATHLÈTE

SANDOW

doit à cet appareil son prodigieux développement. Tout le monde voudra le pratiquer, car il donne

la Force

Il est indispensable à tous, jeunes et vieux, car il donne

la Santé

Enfin, il convient également à la femme et à l'enfant comme au vieillard, car il conserve et donne

la Souplesse

Agent général : Henry ROYSTON
58, Boulevard de Sébastopol

Le modèle actuel très perfectionné possède les avantages suivants :

Il se monte en développeur avec la plus grande facilité.

Transformation rapide en extenseur de poitrine *de une à six branches doublant la force* de celui-ci.

Toutes les branches sont simples, d'égale longueur, et INTERCHANGEABLES.

La durée de l'appareil est ainsi triplée.

S'emploie sans déperdition de force dans les locaux exigus

SANDOW
Gymnase complet chez Soi

Enfants 15 fr. Adulte 21 fr.
Populaire 16 fr. Athlète 25 fr.

EXIGER LA MARQUE

Chaque appareil est accompagné d'un tableau d'exercices très scientifiquement établis, résultats de longues années d'études du créateur, le célèbre athlète **Sandow.**

Pour enfants (5 à 10 ans). . . 15 fr.
— adultes 21 fr.
— obèses. 21 fr.
— athlètes 25 fr.
Modèle populaire 16 fr.

Franco, **1** *franc en sus*

158 Advertisement for the Sandow developer, from Professeur Desbonnet, *Les Rois de la lutte,* Paris, 1910.

POUR LA MANUTENTION
DES GROSSES PIÈCES
Bâtis d'Alternateurs, Dynamos et Induits-volants

L'EMPLOI de nos **PONTS-ROULANTS électriques** FAIT RÉALISER des **ÉCONOMIES** de MAIN-D'ŒUVRE **considérables**

Pont roulant électrique à 2 crochets installé à la Société d'Escaut et Meuse à Anzin.

Société des APPAREILS de LEVAGE, 62, rue Vitruve, PARIS
AGENCES. — MAGNE : Marseille, 4, place de la Corderie; DELASSALLE : Bordeaux, 116, rue David Johnston; LEROY : Le Lude, Sarthe; BARSO : Lyon, 28, rue de la République; MESSAGER : Lille, rue des Ponts de Comines; TRUNEL : Nancy, 6, rue de la Commanderie.

159 Advertisement for rolling bridge cranes, Société des Appareils de Levage, from *La Lumière Electrique,* June 28, 1913, p. 394.

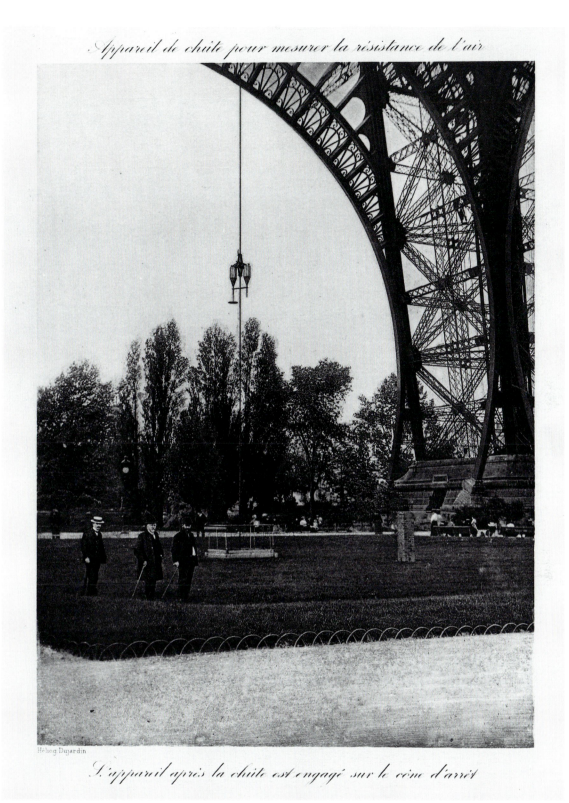

Appareil de chute pour mesurer la résistance de l'air

L'appareil après la chute est engagé sur le cône d'arrêt

160 Apparatus for measuring the air resistance of falling objects, from Gustave Eiffel, *Recherches expérimentales sur la résistance de l'air executées à la Tour Eiffel,* Paris, 1907, facing p. 12.

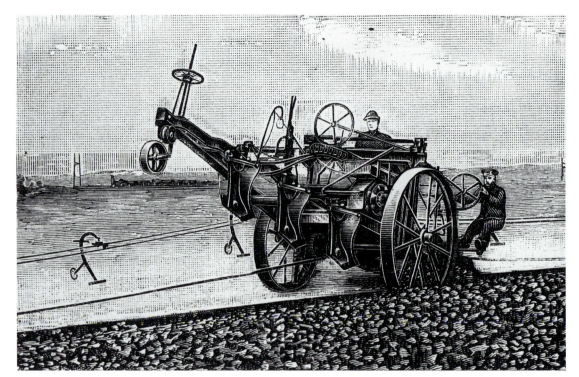

161 Electric cable-drawn balance plow, from H. de Graffigny, "Le Machinisme agricole," *Revue Scientifique,* April 4, 1903, figure 44.

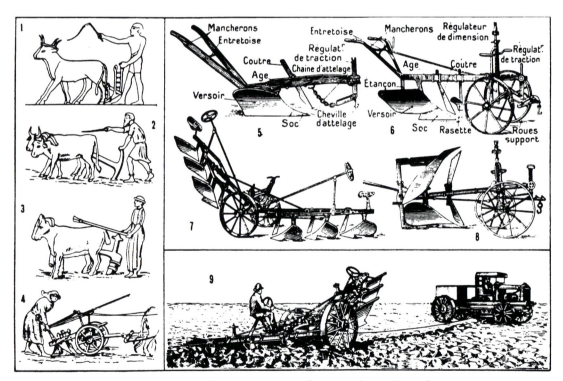

CHARRUES : 1. Egyptienne ; 2. Romaine ; 3. Etrusque ; 4. Du XIVᵉ siècle ; 5. Araire ; 6. Charrue à avant-train ; 7. Charrue-balance polysoc ; 8. Brabant double (tourne-oreille) ; 9. Charrue-balance actionnée par un moteur-treuil (motoculture).

162 *Charrues* (plows), from *Larousse du XXᵉ Siècle,* Paris, 1929, vol. 2, p. 159.

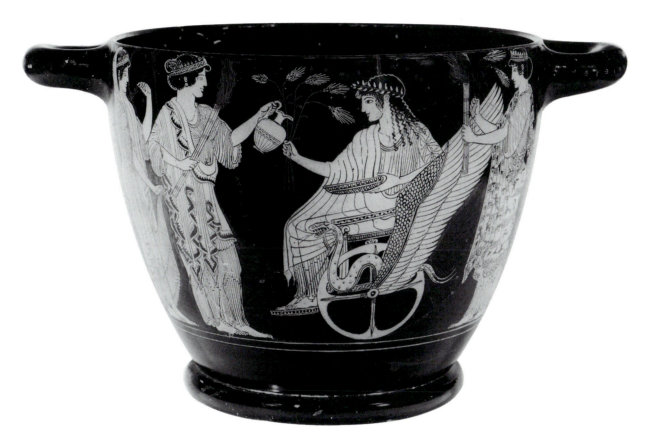

163 Makron and the Potter Hieron, red-figure skyphos depicting Demeter, Persephone, and a nymph sending off Triptolemos, 480 B.C., British Museum, London.

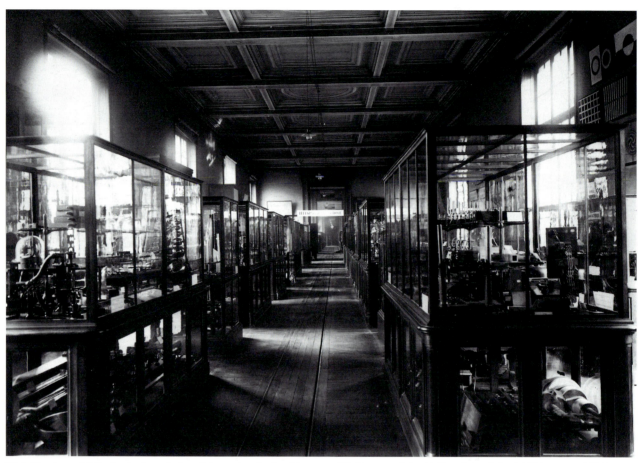

164 Physics exhibits (including wireless telegraphy displays) in room 30, Conservatoire National des Arts et Métiers, ca. 1920.

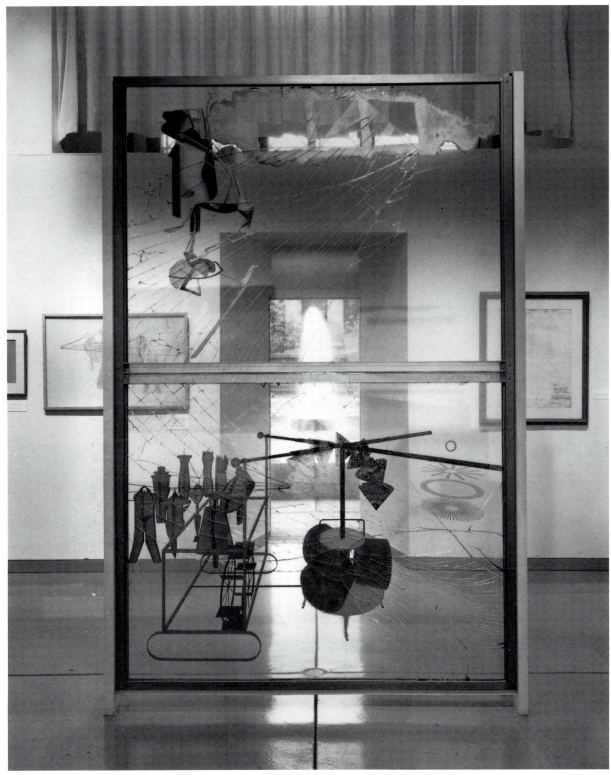

165 Duchamp, *The Bride Stripped Bare by Her Bachelors, Even (The Large Glass),* 1915–23 (plate 1, figure 76), as installed by the artist at the Philadelphia Museum of Art.

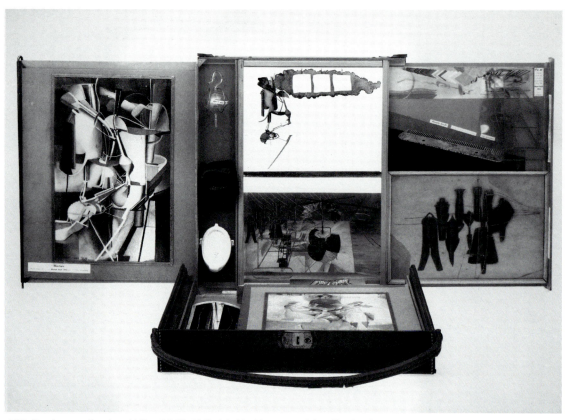

166 Duchamp, *Box in a Valise,* 1941, Philadelphia Museum of Art, The Louise and Walter Arensberg Collection.

167 Duchamp, *Pharmacy,* 1914, gouache on a commercial print, Private Collection, New York.

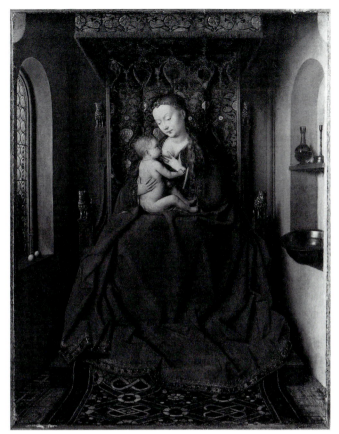

168 Jan van Eyck, *Lucca Madonna,* 1434, oil on panel, Städelsches Kunstinstitut, Frankfurt.

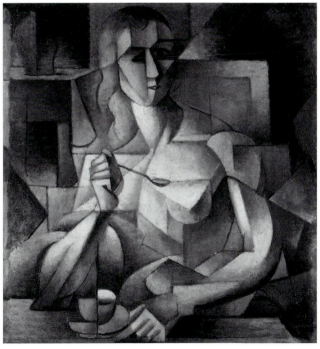

169 Jean Metzinger, *Le Goûter,* 1911, oil on canvas, Philadelphia Museum of Art, The Louise and Walter Arensberg Collection.

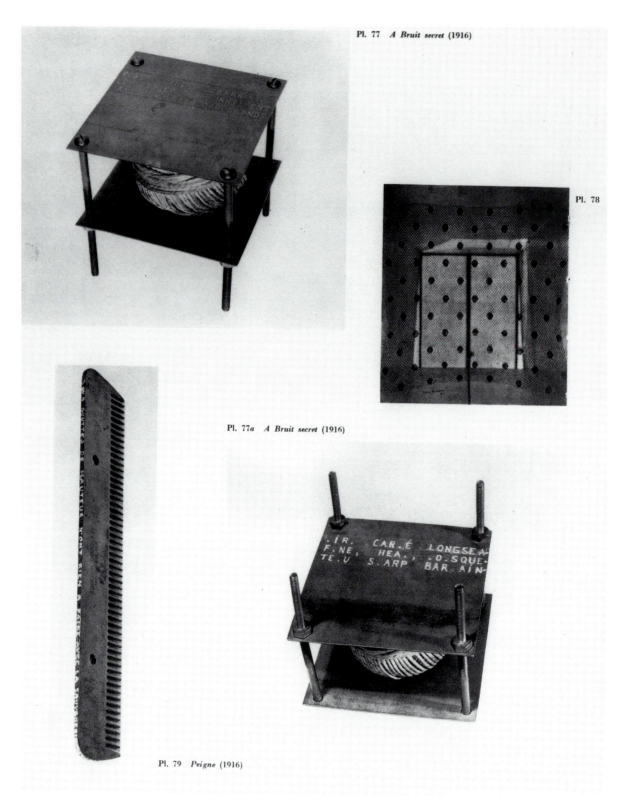

Pl. 77 *A Bruit secret* (1916)

Pl. 78

Pl. 77a *A Bruit secret* (1916)

Pl. 79 *Peigne* (1916)

170 Layout by Duchamp for Robert Lebel, *Sur Marcel Duchamp,* Paris, 1959.

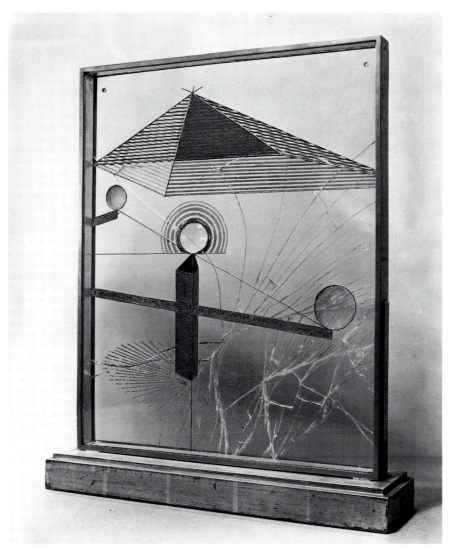

171 Duchamp, *To Be Looked At (from the Other Side of the Glass) with One Eye, Close to, for Almost an Hour,* 1918, oil paint, mirror silver, lead wire, and magnifying lens on glass, Museum of Modern Art, New York, Bequest of Katherine S. Dreier.

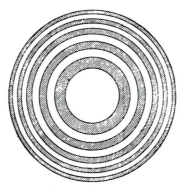

FIG. 22.—Zone-plate of Tinfoil on Glass. Every circular strip is of area equal to central space.

172 Zone-plate of tinfoil on glass, from Sir Oliver Lodge, *Signalling across Space without Wires,* London, 1913, figure 22.

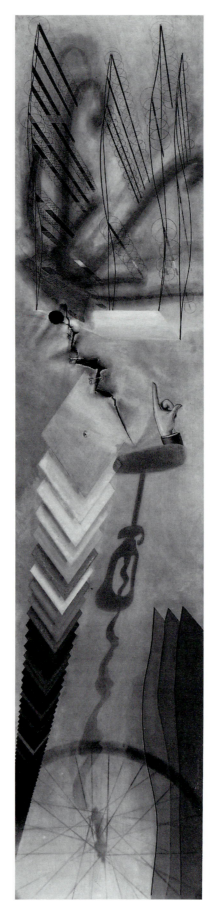

173 Duchamp, *Tu m'*, 1918, oil and pencil on canvas, with bottle brush, three safety pins, and a bolt, Yale University Art Gallery, Bequest of Katherine S. Dreier.

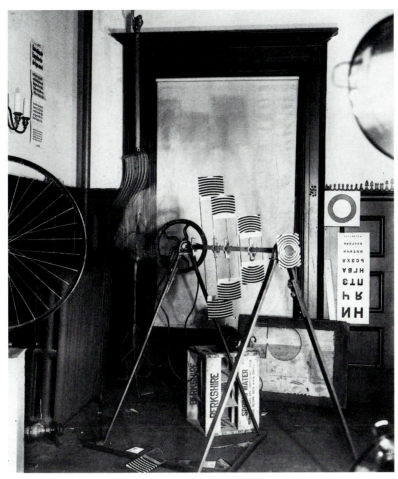

174 Duchamp, *Rotary Glass Plates (Precision Optics),* 1920 (photographed in Duchamp's studio by Man Ray, 1920), five painted glass plates turning on a metal axis, electrical wiring, wood and metal braces; from *Man Ray Photographs,* ed. Jean-Hubert Martin, London, 1982, p. 46.

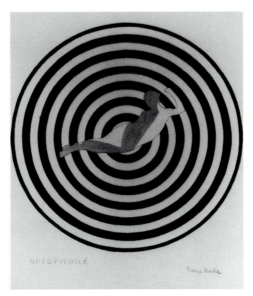

175 Francis Picabia, *Optophone I,* ca. 1922, ink and watercolor on composition board, Private Collection, Paris.

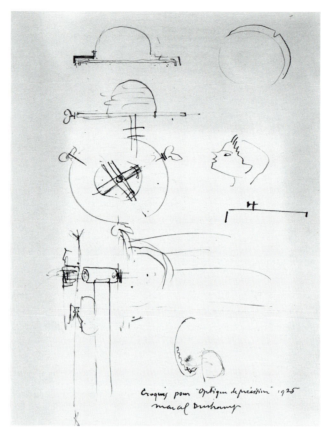

176 Duchamp, *Sketch for "Precision Optics,"* 1925, ink on
paper, Philadelphia Museum of Art, The Louise and Walter
Arensberg Collection.

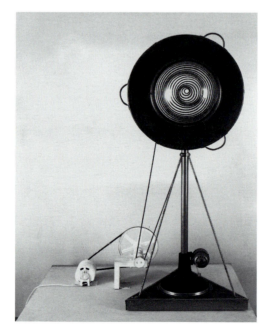

177 Duchamp, *Rotary Demisphere (Precision
Optics),* 1925, painted wood demisphere, fitted
on black velvet disk, copper collar with Plexiglas
dome, motor, pulley, and metal stand, Museum of
Modern Art, New York, Gift of Mrs. William Sisler
and Purchase, 1970.

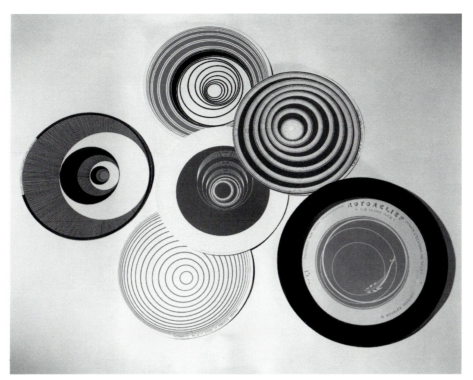

178A Duchamp, *Rotoreliefs,* 1935, color lithograph on six cardboard disks, with holder, Philadelphia Museum of Art, The Louise and Walter Arensberg Collection.

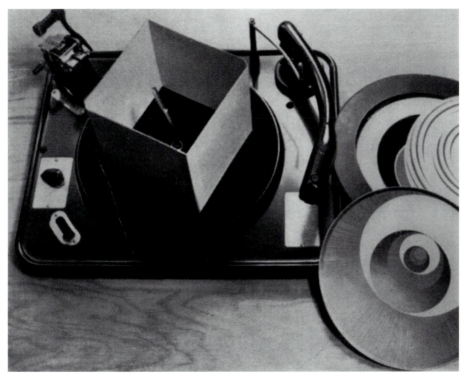

178B Photograph from Duchamp, *Rotoreliefs,* second edition, 1953, demonstrating cardboard support for use on phonograph turntable, Collection Mr. and Mrs. Joseph Rishel.

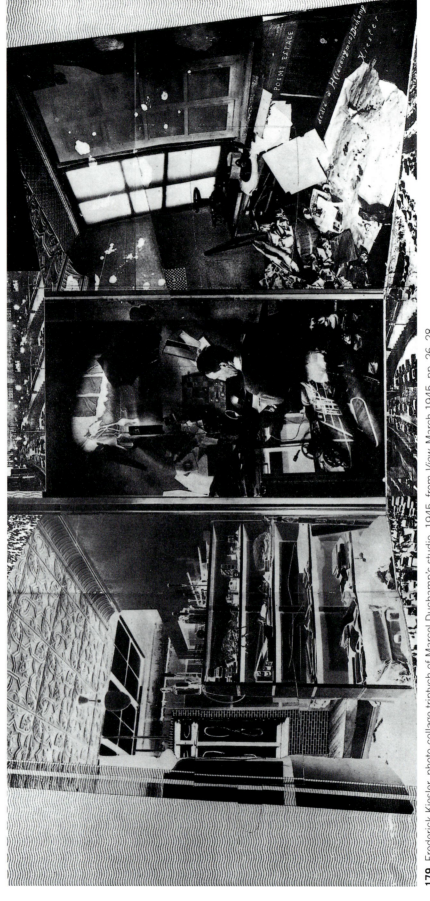

179 Frederick Kiesler, photo-collage triptych of Marcel Duchamp's studio, 1945, from *View*, March 1945, pp. 26–28.

180 Duchamp, *Study for "Etant donnés,"* ca. 1947, textured wax and black ink on yellow-toned paper and cut silver gelatin photographs, mounted on board, Loan from Mme Marcel Duchamp to the Philadelphia Museum of Art.

182 Duchamp, *The Green Ray,* 1947, assemblage (photograph with gelatin film and and electrical light) constructed by Frederick Kiesler according to Duchamp's directions for *Le Surréalisme en peinture,* Galerie Maeght, Paris, 1947; from Herbert Molderings, *Marcel Duchamp,* Frankfurt, 1983, p. 85.

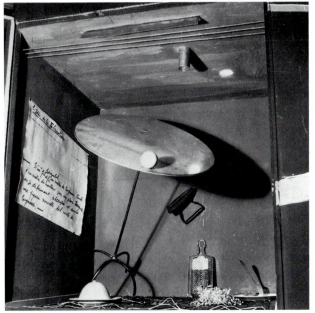

181 Duchamp, *The Altar of the Handler or Tender of Gravity,* 1947, mixed-media assemblage constructed by Matta according to Duchamp's directions for the exhibition *Le Surréalisme en 1947,* Galerie Maeght, Paris, 1947.

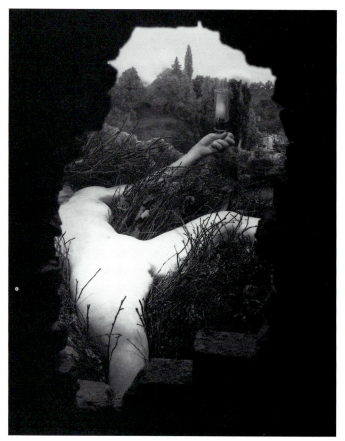

183 Duchamp, *Etant donnés: 1. la chute d'eau, 2. le gaz d'éclairage* (Given: 1. The Waterfall, 2. The Illuminating Gas), 1946–66, mixed-media assemblage, Philadelphia Museum of Art, Gift of the Cassandra Foundation.

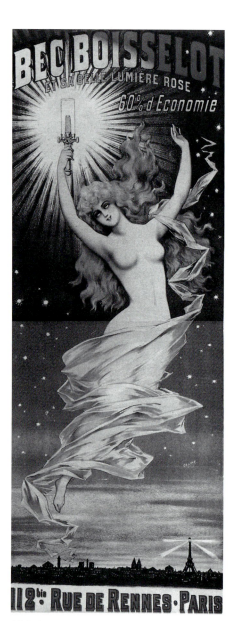

184 Charles Levy, *Bec Boisselot Gas Mantles,* 1895, color lithograph, Collection Phillip Dennis Cate and Family.

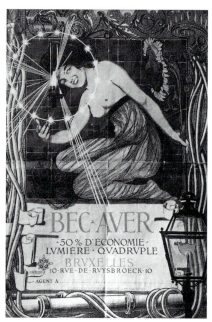

185 G. M. Mataloni, *Bec Auer Gas Mantles,* 1895, color lithograph, from John Barnicoat, *A Concise History of Posters,* London, 1972, figure 146.

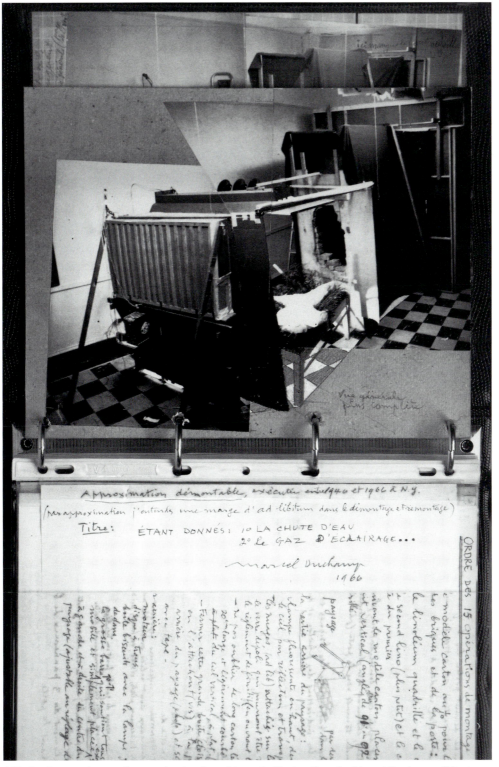

186 Duchamp, photo-collage and notes from *Manual of Instructions for Marcel Duchamp, "Etant donnés: 1. la chute d'eau, 2. le gaz d'éclairage,"* Philadelphia, 1987, frontispiece and p. 1.

187 Duchamp, First legal tablet list of phrases from earlier notes (late 1950s), from *Marcel Duchamp: Notes,* ed. Paul Matisse, note 250.

188 Duchamp, revised legal tablet list (late 1950s), from *Marcel Duchamp: Notes,* ed. Paul Matisse, note 251.

189A, B Duchamp, further revisions to legal tablet lists, (early 1960s), from *Marcel Duchamp: Notes,* ed. Paul Matisse, note 252, recto and verso.

Notes

and end of Duchamp's statements to indicate omitted words, both spoken and written, although this practice is not used for other quoted matter. Unspaced ellipses within a Duchamp note reflect his use of a line of dots. Italics indicate Duchamp's underlining of selected words for emphasis; italics have not been used, however, in quotations of entire phrases or sentences that are underlined in the original note. Unless otherwise noted, citations from Arturo Schwarz, *The Complete Works of Marcel Duchamp,* are taken from the 2d rev. ed. (1970).

ABBREVIATIONS

Published Collections of Duchamp's Writings

A L'INF *A l'infinitif (The White Box).* Trans. Marcel Duchamp and Cleve Gray. New York: Cordier & Ekstrom, 1966. Reprinted in *SS.*

DDS *Duchamp du signe.* Ed. Michel Sanouillet. Paris: Flammarion, 1975.

GB *The Green Box* or *La Mariée mise à nu par ses célibataires, même.* Paris: Editions Rrose Sélavy, 1934. Reprinted in *SS.*

MDN *Marcel Duchamp: Notes.* Ed. and trans. Paul Matisse. Paris: Centre National d'Art et de Culture Georges Pompidou, 1980.
Marcel Duchamp: Notes. Ed. and trans. Paul Matisse. Boston: G. K. Hall, 1983.

SS *Salt Seller: The Writings of Marcel Duchamp (Marchand du sel).* Ed. Michel Sanouillet and Elmer Peterson. New York: Oxford University Press, 1973. Contains *Box of 1914, GB,* and *A L'INF.* Reprinted as *The Writings of Marcel Duchamp.* New York: Da Capo Press, 1989.

Major Exhibition Catalogues

Duchamp (Madrid)
 Fundación Caja de Pensiones, Madrid, and Fundació Joan Miró, Barcelona. *Duchamp.* May–June 1984.
Duchamp (Philadelphia)
 Philadelphia Museum of Art and Museum of Modern Art, New York. *Marcel Duchamp.* Ed. Anne d'Harnoncourt and Kynaston McShine. Sept. 22–Nov. 11, 1973.
Duchamp (Venice)
 Palazzo Grassi, Venice. *Marcel Duchamp.* Ed. Pontus Hulten. Apr. 4–July 18, 1993. Milan: Bompiani, 1983. Reprinted as *Marcel Duchamp: Work and Life.* Ed. Pontus Hulten. Cambridge: MIT Press, 1993.
OeuvreMD (Paris)
 Musée National d'Art Moderne, Centre National d'Art et de Culture Georges Pompidou, Paris. *L'Oeuvre de Marcel Duchamp.* Ed. Jean Clair. 4 vols. Jan. 31–May 2, 1977.

A NOTE ON USAGE

For the sake of accuracy, I have used ellipses at the beginning

Introduction

1. The *Box of 1914* contained photographs of notes mounted on board, and four such examples of the *Box* are known today (see chap. 6, n. 36). The *Green Box,* which is so named for the green suede of its case, was published under the title *La Mariée mis à nu par ses célibataires, même* in an edition of 320 numbered copies (Paris: Editions Rrose Sélavy, 1934). *A l'infinitif (The White Box),* trans. Marcel Duchamp and Cleve Gray (New York: Cordier & Ekstrom, 1966), was published in an edition of 150 numbered copies. The initial publication information on these boxes, which was included in Arturo Schwarz, *The Complete Works of Marcel Duchamp,* 2d rev. ed (New York: Harry N. Abrams, 1970), pp. 584, 589, 604, is augmented in the new edition of Schwarz's volume, *The Complete Works of Marcel Duchamp,* 3d rev. ed. (New York: Delano Greenidge, 1997). Unlike the 1934 and 1966 boxes, which contained loose facsimiles of individual notes, *Marcel Duchamp: Notes,* ed. and trans. Paul Matisse (Paris: Centre National d'Art et de Culture Georges Pompidou, 1980) appeared in book form, with color photographic reproductions of the notes. This large format, deluxe edition (of one thousand numbered copies) was supplemented by the publication of a smaller, black-and-white version of the volume under the same title, ed. and trans. Paul Matisse (Boston: G. K. Hall, 1983). See the list of abbreviations for the form of citations to Duchamp's notes used in the present volume.

2. Duchamp, as quoted in James Johnson Sweeney, "Eleven Europeans in America," *Museum of Modern Art Bulletin* 13 (1946), 20.

3. Duchamp, as quoted in Katherine Kuh, *The Artist's Voice: Talks with Seventeen Artists* (New York: Harper & Row, 1962), pp. 81–82.

4. André Breton, "Phare de *La Mariée,*" *Minotaure* 2 (Winter 1935), 46; trans. as "Lighthouse of the Bride," in Robert Lebel, *Marcel Duchamp* (New York: Grove Press, 1959), p. 90 (emphasis added).

5. *GB,* in *SS,* p. 71.

6. Ibid., p. 49.

7. See Linda Dalrymple Henderson, *The Fourth Dimension and Non-Euclidean Geometry in Modern Art* (Princeton: Princeton University Press, 1983); and Craig E. Adcock, *Marcel Duchamp's Notes from the "Large Glass": An N-Dimensional Analysis* (Ann Arbor: UMI Research Press, 1983). Duchamp's interest in four-dimensional and non-Euclidean geometries is reviewed in chaps. 5 and 6.

8. See Herbert Molderings, *Parawissenschaft, das Ephemere und der Skeptizmus* (Frankfurt: Qumran, 1983); and Molderings, "Objects of Modern Skepticism," in *The Definitively Unfinished Marcel Duchamp*, ed. Thierry de Duve (Cambridge: MIT Press, 1991), pp. 243–65. See also Henderson, *Fourth Dimension*, pp. 15–17, 37, 97–98, 121–22, 131–32; and Craig Adcock, "Conventionalism in Henri Poincaré and Marcel Duchamp," *Art Journal* 44 (Fall 1984), 249–58. In contrast to Molderings, who asserts that it was "not so much specific scientific literature but rather the philosophical fashion of his time that inspired Duchamp" ("Objects," p. 244), the present volume argues for the importance of that "specific scientific literature" as a fertile source for Duchamp.

9. Another attentive observer of science in this period was the writer H. G. Wells, who helped to popularize the notion of a fourth dimension through his science fiction and who discussed X-rays and radioactivity as well (see chap. 1, n. 18, and chap. 2, n. 74). Wells's stories were popular in France and are known to have been read by Jarry and, very likely, Duchamp himself. On Wells and the fourth dimension, see Henderson, *Fourth Dimension*, pp. 33–35, 46–47.

10. See Henry Adams, *The Education of Henry Adams: An Autobiography* (Boston: Houghton Mifflin, 1918), chaps. 25, 26. Adams had forty copies of his text printed privately in 1907, but the book was not published commercially until after his death in 1918.

11. See, e.g., Dickran Tashjian, "Henry Adams and Marcel Duchamp: Liminal Views of the Dynamo and the Virgin," *Arts Magazine* 51 (May 1977), 102–7. Lawrence Steefel has noted that Duchamp was delighted by "Adams' reflections on mechanism, symbolism, eroticism, and art" when he brought them to the artist's attention in 1956. See Lawrence D. Steefel, Jr., *The Position of Duchamp's "Glass" in the Development of His Art* (New York: Garland Publishing, 1977), p. 344, n. 64.

12. Adams, *Education*, pp. 381, 455.

13. Ibid., pp. 381, 383, 388–89, 451, 456. As I note in chap. 10, Duchamp, unlike Adams, was not particularly concerned with the second law of thermodynamics and the issue of entropy. On Adams and contemporary science, see William Jordy, *Henry Adams: Scientific Historian* (New Haven: Yale University Press, 1952), chaps. 6, 7.

14. Adams, *Education*, p. 452; see also pp. 450, 454.

15. Ibid., pp. 380–81, 383.

16. Ibid., p. 459.

17. Gabrielle Buffet-Picabia, "Some Memories of Pre-Dada: Picabia and Duchamp," in *The Dada Painters and Poets*, ed. Robert Motherwell (New York: George Wittenborn, 1951), pp. 255, 258.

18. Pierre Piobb, *L'Année occultiste et psychique* (Paris: H. Daragon, 1908), vol. 2, p. 6.

19. On the slow popularization of relativity theory, which occurred on a wide scale only in 1919, see Henderson, *Fourth Dimension*, app. A. A close examination of French scientific periodicals makes clear how delayed was the reaction to Einstein's 1905 special theory of relativity in France. Although passing references to Einstein and to a "principe de relativité"

appeared in the popular journal *La Nature* (Dec. 1911), in an article on the lecture given by Paul Langevin to the Société Française de Physique (Langevin was the French scientist most interested in relativity theory), in general there was no considered discussion of Einstein's ideas in scientific periodicals before mid-1912 or 1913. (For Langevin's lecture, see H. Vigneron, "Les Grains d'électricité et la dynamique électrodynamique" *La Nature* 40 [Dec. 16, 1911], 45–47.) For example, the initial comments on Einstein's theory in the *Revue Générale des Sciences Pures et Appliquées* appear only in a book review of June 1912 and, in their first full treatment, in Eugène Bloch, "Revue d'électromagnétisme," *Revue Générale* 24 (Apr. 30, 1913), 309–19. By contrast, Einstein's work on Brownian movement had attracted the attention of Jean Perrin, who would discuss both Einstein and Planck in his publications on the subject from 1909 on. The relevance of Perrin's work on Brownian movement for Duchamp is considered in chap. 10.

20. For an introduction to developments in this period, see Alex Keller, *The Infancy of Atomic Physics: Hercules in His Cradle* (Oxford: Clarendon Press, 1983). On ether physics in particular, see Russel McCormmach, "H. A. Lorentz and the Electromagnetic View of Nature," *Isis* 61 (Winter 1970), 459–97; P. M. Harman, *Energy, Force, and Matter: The Conceptual Development of Nineteenth-Century Physics* (Cambridge University Press, 1982); and Donald R. Benson, "Facts and Fictions in Scientific Discourse: The Case of the Ether," *Georgia Review* 38 (Winter 1984), 825–37. One of the most accessible accounts of electromagnetism and electromagnetic waves is James Burke's "Making Waves," chap. 9 in *The Day the Universe Changed* (Boston: Little Brown, 1985); this is also available on videocassette.

For a typical early twentieth-century perspective on contemporary science, see Robert Kennedy Duncan, *The New Knowledge: A Popular Account of the New Physics and the New Chemistry in Their Relation to the New Theory of Matter* (New York: A. S. Barnes, 1905). On the sense of crisis felt from within science in the late nineteenth and early twentieth centuries, see, e.g., J. L. Heilbron, "*Fin-de-siècle* Physics," in *Science, Technology, and Society in the Time of Alfred Nobel*, Nobel Symposium 52, ed. Carl Gustaf Bernhard, Elisabeth Crawford, and Per Sörbom (Oxford: Pergamon Press, 1982), pp. 51–73; and Mary Jo Nye, *Molecular Reality: A Perspective on the Scientific Work of Jean Perrin* (London: Macdonald, 1972), pp. 29–41.

Duncan's book and many of its early twentieth-century French counterparts represent a contrast to the nineteenth-century tradition of scientific popularization, which was characterized by dramatic (often allegorical) illustrations and tone. For this earlier genre, as well as information on certain of the early twentieth-century authors treated herein, see two recent French sources: Bruno Béguet, ed., *La Science pour tous: Sur la vulgarisation scientifique en France de 1850 à 1914* (Paris: Conservatoire National des Arts et Métiers, 1990); and Musée d'Orsay, Paris, *La Science pour tous*, ed. Bruno Béguet (Mar. 14–June 12, 1994; Paris: Réunion des Musées Nationaux, 1994).

21. *Box of 1914*, in *SS*, p. 25. I discussed Duchamp's reference to frequency as relating to electromagnetic waves in a paper entitled "Marcel Duchamp's 'Painting of Frequency': Science and Technology in the *Large Glass*," presented in February 1991 in Craig Adcock's College Art Association session on "Interrelationships between Art and Science in the Twentieth Century." Adcock has more recently discussed this idea in relation to Duchamp's interest in sound in "Marcel Duchamp's Gap Music: Operations in the Space between Art and Noise," in *Wireless Imagination: Sound, Radio, and the Avant-Garde,* ed. Douglas Kahn and Gregory Whitehead (Cambridge: MIT Press, 1992), pp. 105–38.

22. For Duchamp's phrase, see *GB*, in *SS*, p. 30; *MDN,* notes 68, 77. See Arthur Good [Tom Tit], *La Science amusante,* 1st, 2d, 3d ser. (Paris: Librairie Larousse, 1890, 1892, 1906); as well as the advertisement from *La Nature* for "FABRIQUE D'APPAREILS DE PHYSIQUE AMUSANTE / TRUCS, FARCES, ATTRAPES," reproduced in Jean Clair, *Duchamp et la photographie* (Paris: Editions du Chêne, 1977), p. 25. See also the treatment of Tom Tit in Patrick LeBoeuf, "La Science amusante," in *La Science pour tous* (1990), ed. Béguet, pp. 96–111.

Jeffrey Weiss in *The Popular Culture of Modern Art: Picasso, Duchamp, and Avant-Gardism* (New Haven: Yale University Press, 1994) discusses Duchamp in relation to what he identifies as a general modernist preoccupation with mystification and the cultivation of *blague* ("a kind of ironic banter") at the expense of an audience (p. 119). Indeed, Weiss's text convincingly establishes this tradition as the general background for certain aspects of the Duchamp's activity. Duchamp's "hilarious" *Large Glass* project, however, as revealed in the examination of his notes that follows, was far too complex and internally consistent to have had as its goal only the negative expression of avant-garde disdain for the general public.

23. George Heard Hamilton, "Remembering Marcel," in *Duchamp* (Philadelphia), p. 201.

24. For a sampling of these references, see, respectively, *MDN*, notes 181, 162, 150, 152 (p. 1); *A L'INF*, in *SS,* p. 85 (molds and photographic negatives).

25. On this subject, see, e.g., Anne d'Harnoncourt and Walter Hopps, *"Etant Donnés: 1. la chute d'eau, 2. le gaz d'éclairage*: Reflections on a New Work by Marcel Duchamp," *Philadelphia Museum of Art Bulletin* 64 (Apr.–Sept. 1969), 16; Paul Matisse, "Some More Nonsense about Duchamp," *Art in America* 48 (Apr. 1980), 76–83; Rudolf E. Kuenzli, Introduction to *Marcel Duchamp: Artist of the Century,* ed. Kuenzli and Francis Naumann (Cambridge: MIT Press, 1989), pp. 1–11; and Francis M. Naumann, "Marcel Duchamp: A Reconciliation of Opposites," in *Marcel Duchamp*, pp. 20–40.

26. Robert Lebel, *Marcel Duchamp* (Paris: Pierre Belfond, 1985), p. 174.

27. See, e.g., Jacques Derrida, "Signature Event Context," in *Margins of Philosophy* (Chicago: University of Chicago Press, 1982), pp. 307–30. For a synoptic view of the various bodies of theoretical work that in recent years have affected historians' conceptions of their aims and limitations, see Quentin Skinner, ed., *The Return of Grand Theory in the Human Sciences* (Cambridge: Cambridge University Press, 1985).

28. See *GB*, in *SS*, pp. 27–28. For Duchamp's other references to the "Possible," which are addressed in various places in this text, consult the index.

29. Owing to the absence of notes by Duchamp before late 1912, in the first chapters I have relied on visual images, statements by contemporary critics, later recollections by Duchamp, biographical information, and the parallel case of colleagues such as František Kupka and Francis Picabia as evidence of Duchamp's engagement with a particular type of science.

30. The other author who has made a sustained study of Duchamp's notes as a whole is Jean Suquet, whose numerous publications are listed in the bibliography. See, e.g., his essay entitled "Possible," in *Definitively Unfinished Duchamp*, pp. 85–110.

31. For what is still the best initial introduction to the *Large Glass* and the works leading up to it, see John Golding, *Marcel Duchamp: The Bride Stripped Bare by Her Bachelors, Even* (New York: Viking Press, 1972), chaps. 1, 2. Another useful, if heavily psychological, introduction to Duchamp's work and thought has recently appeared: Jerrold Seigel, *The Private Worlds of Marcel Duchamp: Desire, Liberation, and the Self in Modern Culture* (Berkeley: University of California Press, 1995). Arturo Schwarz's catalogue raisonné, *The Complete Works of Marcel Duchamp*, first published in 1969, has long provided the most complete coverage of Duchamp's oeuvre, although the accompanying text is a highly personal reading of Duchamp's art based on Freud, Jung, and alchemy. The revised catalogue raisonné in the 1997 edition of Schwarz's *Complete Works,* which appeared after the completion of my text, is acknowledged by the addition of a few specific citations of relevant material (cited as *Complete Works* [1997]). This new edition incorporates many of the drawings first published in *MDN* in 1980, although the dates assigned to certain notes are quite arbitrary.

Other essential sources for the study of the artist's works are the catalogues of the major exhibitions devoted to Duchamp, which appear in the list of abbreviations preceding the notes. Of particular biographical interest is the catalogue of the Apr. 4–July 18, 1993, exhibition at the Palazzo Grassi, Venice: *Marcel Duchamp*, ed. Pontus Hulten (Milan: Bompiani, 1993), which contains an exhaustive chronology, "Ephemerides on and about Marcel Duchamp and Rrose Sélavy, 1887–1968," by Jennifer Gough-Cooper and Jacques Caumont. On this volume, reprinted as *Marcel Duchamp: Life and Work* (Cambridge: MIT Press, 1994), see chap. 1, n. 1. Calvin Tomkins's *Duchamp: A Biography* (New York: Henry Holt, 1996), which appeared near the end of my project, will be a vital resource for Duchamp scholars in the future. Two recent collections of essays provide an overview of the state of Duchamp scholarship by the early 1990s: Kuenzli and Naumann, eds., *Marcel Duchamp: Artist of the Century* (1989), and de Duve, ed., *Definitively Unfinished Duchamp* (1991).

32. Duchamp, as quoted in Richard Hamilton and George Heard Hamilton, 1959 BBC interview. This section of the interview is missing from the tape of the broadcast, reproduced on cassette as *Marcel Duchamp: An Interview by Richard*

Hamilton in London and George Heard Hamilton in New York, in *Audio Arts Magazine* 2 (1975). See instead the transcription of part of the interview published as George Heard Hamilton, "A Radio Interview," in *Duchamp: Passim (A Marcel Duchamp Anthology),* ed. Anthony Hill (London: Gordon and Breach Arts International, 1994), p. 77. On Duchamp's discouragement at the public's lack of interest in reading the notes, expressed in the continuation of his statement, see the final section of the coda below. On Duchamp's noncontradiction of his interpreters, see, e.g., Naumann, "Reconciliation of Opposites," in *Duchamp: Artist of the Century,* ed. Kuenzli and Naumann, p. 20.

33. During the 1980s, two European publications addressed certain aspects of the turn-of-the-century scientific context for early modernism considered here. See Musée d'Art Moderne de la Ville de Paris, *Electra: L'Electricité et l'électrotechnique dans l'art au XXe siècle* (Dec. 10, 1983–Feb. 5, 1984); and Christoph Asendorf, *Ströme und Strahlen: Die langsame Verschwinden der Materie um 1900,* Werkbund Archiv, vol. 18 (Giessen: Anabas-Verlag, 1989). Geared toward visual comparisons, Asendorf's book touches on several of the themes raised in the present volume, including electricity and electrical currents, X-rays and other radiations, lightning, and vibrations, and likewise recognizes the fluid relationship between science and occultism in this period. Aspects of Asendorf's treatment of the theme of electricity appear in the chapter "Nerves and Electricity," in his *Batteries of Life: On the History of Things and Their Perception in Modernity,* trans. Don Renau (Berkeley: University of California Press, 1993). More recently, the exhibition organized by Jean Clair, *L'Ame au corps: Arts et sciences, 1793–1993* (Galeries Nationales du Grand Palais, Paris, Oct. 19, 1993–Jan. 24, 1994), focused on the human body in relation to science and technology in this period. In general, however, art-historical texts have tended to engage the relationship of early twentieth-century art to technology and the machine far more than to science. That literature is noted in chap. 3, in the discussion of Duchamp's adoption of machine imagery.

Chapter 1: Duchamp's First Quest for the Invisible

1. Jacques Villon, born Gaston Duchamp, marked his turn from law student to artist by adopting the name Villon after the poet François Villon; Raymond subsequently created the hybrid of the two names. Duchamp also had two sisters, eight and eleven years younger than he, Yvonne and Magdeleine, who, like Suzanne, appear in his early paintings (e.g., fig. 8). For Duchamp's family history, see Tomkins, *Duchamp,* chap. 1. For a general chronology of Duchamp's life, see Jennifer Gough-Cooper and Jacques Caumont, *Plan pour écrire une vie de Marcel Duchamp,* vol. 1 of *OeuvreMD* (Paris), or the chronology in *Duchamp* (Philadelphia). For the specialist, Gough-Cooper and Caumont's substantial publication "Ephemerides on and about Marcel Duchamp and Rrose Sélavy, 1887–1968," in *Duchamp* (Venice) is filled with a massive amount of new biographical information, derived from

years of research. The drawbacks of this chronology for the reader and researcher are that the entries are arranged by day rather than by year (i.e., all entries for a particular day from 1887 to 1968 are grouped, making it difficult to find and recover information easily) and that sources for the information in an entry are often not provided.

2. For Duchamp's prizes in mathematics, see Gough-Cooper and Caumont, "Ephemerides," in *Duchamp* (Venice), entries for July 28, 1900, and July 31, 1902. Duchamp must also have enjoyed his study of chemistry, for he saved his textbook, the 1893 edition of Louis Joseph Troost's *Précis de chimie.* The early date of this edition, however, is a reminder that Duchamp's school textbooks probably included few of the new developments in physics and chemistry that occurred between the mid-1890s and his *baccalauréat* in 1904. On Duchamp and the Troost text, see chap. 10, n. 23 and the related text.

3. For these cartoons and drawings, see Schwarz, *Complete Works,* cat. nos. 23–73 and 79–128.

4. On Dumouchel and Tribout, see Tomkins, *Duchamp,* p. 24 and throughout. Jean Clair provides the fullest discussion to date of the *Portrait of Dr. Dumouchel,* including the relevance of Dumouchel's and Tribout's medical studies, in *Duchamp et la photographie,* pp. 14–25. Discussing the work in the 1950s, Duchamp attributed the halo around the hand of Dumouchel to his "subconscious yearnings in the direction of some sort of meta-realism" and the "craving for the 'miraculous' that preceded the Cubist period (Duchamp letter to Walter and Louise Arensberg, July 22, 1951, quoted in *OeuvreMD* [Paris], vol. 2, p. 34). On the Dumouchel portrait, see n. 33 below and the discussion of Colonel Albert de Rochas's work in Magnetism in chap. 2.

Dumouchel served as the model for Adam in Duchamp's painting *Paradise* of 1910–11, one of several enigmatic and seemingly esoteric canvases produced by the artist in this two-year period. For Duchamp's *Paradise, The Bush* (1910–11), *Baptism* (1911), and *Draft on the Japanese Apple Tree* (1911), which all suggest some sort of initiation rite or, in the case of *Draft,* a Buddha-like state of enlightened meditation, see Schwarz, *Complete Works,* pls. 31–33, 35. For the identity of the young woman in *The Bush,* see n. 101 below and the related text.

5. Duchamp, as quoted in Kuh, *Artist's Voice,* p. 89. On the move to Puteaux, see Tomkins, *Duchamp,* p. 34; and the chronology in Solomon R. Guggenheim Museum, New York, *František Kupka, 1871–1957: A Retrospective* (1975), p. 309. On the interaction of Kupka and the Duchamp family, including Duchamp's "life-long admiration" (p. 49) for Kupka, see Margit Rowell, "Kupka, Duchamp, and Marey," *Studio International* 189 (Jan.–Feb. 1975), 48–52.

6. For an introduction to the Puteaux Cubists, who also gathered regularly at Gleizes's studio in neighboring Courbevoie, and for bibliographical information on the group, see Henderson, *Fourth Dimension,* pp. 63–67. The Gleizes-Metzinger circle had come together around the poet Alexandre Mercereau, who had participated with Gleizes and other literary figures in the socialist commune for the arts, the Abbaye de Créteil. See Daniel Robbins, "From Symbolism to Cubism: The Abbaye of

Créteil," *Art Journal* 23 (Winter 1963–64), 111–16. There is a great deal of recent literature on Picasso's and Braque's development of Cubism, but one of the best overviews remains Edward F. Fry's introductory essay in his anthology *Cubism* (New York: McGraw-Hill, 1966), pp. 11–35.

7. On Cubist theory, including the role of the fourth dimension, see Henderson, *Fourth Dimension*, chap. 2. Maurice Raynal published an essay entitled "Conception et vision" in *Gil Blas*, Aug. 29, 1912, p. 4 (discussed in ibid., pp. 77–78). For a general introduction to the concept of four-dimensionality, see Rudy Rucker, *The Fourth Dimension: Toward a Geometry of Higher Reality* (Boston: Houghton Mifflin, 1984).

8. Buffet-Picabia, "Some Memories," p. 255.

9. On the issue of Cubism and X-rays, which is discussed further at the end of the present chapter, see Linda Dalrymple Henderson, "X Rays and the Quest for Invisible Reality in the Art of Kupka, Duchamp, and the Cubists," *Art Journal* 47 (Winter 1988), 323–24.

Several scholars have noted briefly the possible importance of X-rays for Duchamp. Bernard Dorival suggested the relevance of radiography for the 1912 painting *The Passage from Virgin to Bride* in his essay "Marcel Duchamp," in Musée des Beaux-Arts, Rouen, *Les Duchamps: Jacques Villon, Raymond Duchamp-Villon, Marcel Duchamp, Suzanne Duchamp* (Apr. 15–June 1, 1967), pp. 83–84. Jean Suquet, in *Miroir de la mariée* (Paris: Flammarion, 1974), compared the form of Duchamp's Bride in the *Large Glass* to an X-ray of the *Bride* as he painted her in 1912. Jean Clair is the only Duchamp scholar who has discussed X-rays as a factor in contemporary culture, although he considers them only in relation to the *Portrait of Dr. Dumouchel* (*Duchamp et la photographie*, pp. 20–22).

Other authors have evoked X-rays metaphorically in their attempts to describe particular effects of works such as the *Large Glass* and the *Coffee Mill*. In 1937, before he became Duchamp's close friend and collaborator, Frederick Kiesler had described the *Large Glass* as "the first x-ray-painting of space" ("Design-Correlation," *Architectural Record* 81 [May 1937], 53). William Rubin echoed Kiesler's notion in 1960, comparing the *Large Glass* to a "giant x-ray plate [that] had suddenly revealed the extra-retinal aspects of the realities in our midst" ("Reflexions on Marcel Duchamp," *Art International* 4 [Dec. 1, 1960], p. 53). That same year, Lawrence Steefel referred to the body of Duchamp's *Coffee Mill* as "'x-rayed' so that its internal function can be shown in motion" (*Position of Duchamp's "Glass,"* p. 114).

10. Umberto Boccioni, Carlo Carrà, Luigi Russolo, Giacomo Balla, Gino Severini, "Futurist Painting: Technical Manifesto" (1910), reprinted as "Manifeste des peintres futuristes," in Galerie Bernheim-Jeune & Cie., Paris, *Les Peintres Futuristes italiens* (Feb. 5–24, 1912), p. 17. See also Umbro Apollonio, ed., *Futurist Manifestos*, trans. Robert Brain, R. W. Flint, J. C. Higgitt, and Caroline Tisdall (New York: Viking, 1973), p. 28. The Futurists' concern with X-rays is noted by Germano Celant in his discussion of their interest in spirit photography and chronophotography in "Futurism and the Occult," *Artforum* 19 (Jan. 1981), 38.

11. Rosenthal's text continues, questioning whether artists alone can be expected to resist these new experiences and proposing that the Salon des Indépendants (with its freedom from a jury) should be considered a "laboratory" for contemporary artists. See Léon Rosenthal, "Les Salons de 1912," *Gazette des Beaux-Arts*, 4th ser., 7 (1912), 349.

12. Two of the most useful studies of Röntgen and his discovery are W. Robert Nitske, *The Life of Wilhelm Conrad Röntgen, Discoverer of the X Ray* (Tucson: University of Arizona Press, 1971); and Otto Glasser, *Wilhelm Conrad Röntgen and the Early History of the Roentgen Rays* (Springfield, Ill.: Charles C. Thomas, 1934).

13. George Sarton, "The Discovery of X-rays," *Isis* 26 (Mar. 1937), 357. In Röntgen's first paper on the subject, published in Würzburg at the end of December 1895, he speculated that because X-rays could not be refracted, reflected, or polarized, they might be a new kind of ultraviolet light propagated by "longitudinal vibrations in the ether" in contrast to the transverse vibrations of light waves. See W. C. Röntgen, "Upon a New Kind of Rays" (1895), reprinted in *Annual Report of the Smithsonian Institution, 1897* (Washington, D.C.: G.P.O., 1898), p. 143.

14. The wavelength of visible light is between one millionth and one ten-millionth of a meter. On Maxwell's theories and the work of Hertz, see, e.g., Sanford P. Bordeau, *Volts to Hertz... The Rise of Electricity* (Minneapolis: Burgess, 1982). Keller's *Infancy of Atomic Physics* also provides a useful overview of early work in electromagnetism.

15. Lawrence Badash, *Radioactivity in America: Growth and Decay of a Science* (Baltimore: Johns Hopkins University Press, 1979), p. 9.

16. Sarton, "Discovery," p. 356. On the popularization of X-rays, see the books by Nitske and Glasser, as well as Nancy Knight, "'The New Light': X Rays and Medical Futurism," in *Imagining Tomorrow: History, Technology, and the American Future*, ed. Joseph J. Corn (Cambridge: MIT Press, 1986), pp. 10–34. The press coverage of X-rays was truly international; American periodicals frequently reprinted texts from French and other foreign sources, and French journals followed closely developments in other countries. As the present book goes to press, a new cultural history of X-rays and other imaging technologies has appeared: Bettyann Holtzmann Kevles, *Naked to the Bone: Medical Imaging in the Twentieth Century* (New Brunswick: Rutgers University Press, 1997).

17. Nitske, *Röntgen*, p. 117. The *Revue Générale des Sciences Pures et Appliquées*, for example, published six articles on X-rays, including a translation of Röntgen's first paper, in its issue for January 30, 1896; numerous articles followed during that year. In addition to French scientific periodicals and photography journals (e.g., *La Photographie Française*), periodicals such as *Revue des Deux Mondes* and *Mercure de France* carried articles and information on X-rays.

18. On "medical futurism," see Knight, "'The New Light,'" which also reproduces a number of X-ray cartoons and provides a sampling of X-ray-oriented science fiction (pp. 27–30). In Wells's *The Invisible Man* (London: C. A. Pearson, 1897),

which was translated into French in 1901, the anti-hero Griffin uses "a sort of ethereal vibration. . .no, not these Röntgen vibrations" to achieve the same index of refraction as the air and become invisible (p. 153). One chapter of Pawlowski's *Voyage au pays de la quatrième dimension* (Paris: Eugène Fasquelle, 1912), "La Catastrophe de photophonium," dealt with the perception of invisible wave vibrations. A number of themes in Pawlowski's book were to be relevant for Duchamp's *Large Glass* project.

19. On the Bloomingdale's demonstrations, see Nitske, *Life of Röntgen*, p. 179. The Cinématographe Lumière poster is in the collection of the Musée d'Orsay, Paris. For Méliès's film, see Musée des Arts Décoratifs, Paris, *Exposition commémorative du centenaire Georges Méliès* (1961), p. 72. "Les Rayons Roentgen" are advertised on a poster for performances at Méliès's Théâtre Robert-Houdin in this period as well. See Emmanuelle Toulet, *Cinématographe: Invention du siècle* (Paris: Gallimard, 1988), p. 54. For the gradual recognition of the dangers of overexposure to X-rays, see Catherine Caufield, *Multiple Exposures: Chronicles of the Radiation Age* (New York: Harper & Row, 1989), pp. 8–21.

20. See "The Cabaret du Néant," *Scientific American* 74 (Mar. 1896), 152.

21. See Glasser, *Röntgen* (1934), chap. 19.

22. See Jules Trousset, ed., *Les Merveilles de l'Exposition de 1900* (Paris: Librairie Illustrée Montgredien, 1899–1900), vol. 2, pp. 3, 695, 712, 714, 784.

23. See Carl Snyder, "The World beyond Our Senses," *Harper's Monthly* 107 (June 1903), 119.

24. James T. Bixby, "Professor Roentgen's Discovery and the Invisible World around Us," *Arena* 15 (May 1896), 872.

25. Camille Flammarion, *The Unknown* (New York: Harper & Bros., 1900), pp. 11, 14.

26. Henri Poincaré, *La Science et l'hypothèse* (Paris: Ernest Flammarion, 1902), p. 209; H. Poincaré, *The Foundations of Science: Science and Hypothesis, The Value of Science, Science and Method*, trans. George B. Halsted (New York: Science Press, 1913), p. 152. Poincaré was one of the scientists to whom Röntgen sent his original paper in 1895, and in January 1896 he presented a paper on X-rays by Oudin and Barthélemy before the Académie des Sciences. That text was published under Poincaré's name as "Les Rayons cathodiques et les rayons Röntgen" in the *Revue Générale des Sciences Pures et Appliquées* 7 (Jan. 30, 1896), 52–59. On the contribution of non-Euclidean geometry to Poincaré's belief in the relativity of knowledge, as well as his importance for Duchamp and the Cubists, see Henderson, *Fourth Dimension*, as cited in the introduction, n. 8, and chap. 5, n. 42.

27. William Crookes, "De la relativité des connaissances humaines," *Revue Scientifique*, 4th ser., 7 (May 15, 1897), 612–13.

28. See Flammarion, *Unknown*, pp. 15–16. On Crookes and spiritualism, see Janet Oppenheim, *The Other World: Spiritualism and Psychical Research in England, 1850–1914* (Cambridge: Cambridge University Press, 1985), pp. 338–54, as well as the discussion of Crookes in chap. 4 below.

29. Annie Besant and C[harles] W[ebster] Leadbeater, *Thought-Forms* (1901; London: Theosophical Publishing Society, 1905), p. 11.

30. C[harles] W[ebster] Leadbeater, *Clairvoyance* (1899; 2d ed., London: Theosophical Publishing Society, 1903), pp. 11–12. See also the translation of Leadbeater, *De la clairvoyance* (Paris: Publications Théosophiques, 1910). Leadbeater's text goes on to connect X-ray-like "astral vision" to four-dimensional sight, based on the analogy of a three-dimensional being's ability to see readily into closed two-dimensional figures. Clairvoyance was the primary issue that brought together X-rays and the fourth dimension in popular literature in this period.

31. See, e.g., the text by Jacques Brieu, the editor of the regular "Esotérisme et spiritisme" section in *Mercure de France* 75 (Sept. 1, 1908), 141–42. On occult adaptations of X-rays, including the renewal of interest in Baron von Reichenbach's "Odic" force, see Nitske, *Life of Röntgen*, pp. 121–23, and Glasser, *Röntgen* (1934), pp. 206–9.

32. In *La Vie Mystérieuse*, see, e.g., Ernest Bosc, "La Clairvoyance," no. 68 (Oct. 25, 1911), 308–9, as well as the series of articles under the title "Le Spiritisme est une science," published during 1911–12 by Gabriel Delanne. On photography as a revelation of the "beyond," see Georges Didi-Huberman, "Photography—Scientific and Pseudo-Scientific," in *A History of Photography: Social and Cultural Perspectives,* ed. Jean-Claude Lemagny and André Rouillé, trans. Janet Lloyd (Cambridge: Cambridge University Press, 1987), pp. 71–75.

33. In the X-ray literature, both Baraduc and Rochas are noted, for example, in the volume devoted to X-rays in the series "Petite Encyclopédie populaire illustrée": L. Aubert, *La Photographie de l'invisible: Les Rayons X* (Paris: Schleicher Frères, 1898), pp. 160–61. For Baraduc's theories, see Hippolyte Baraduc, *L'Ame humaine: Ses Mouvements, ses lumières, et l'iconographie de l'invisible fluidique* (Paris: Georges Carré, 1896), as well as Besant and Leadbeater, *Thought-Forms*, pp. 13–14. See also Albert de Rochas, *L'Extériorisation de la sensibilité: Etude expérimentale et historique* (1895; 6th ed., Paris: Bibliothèque Chacornac, 1909), which Clair suggests may have been a source for Duchamp's *Portrait of Dr. Dumouchel* (*Duchamp et la photographie*, pp. 18–25).

On the various other emanations, see, e.g., G. Mareschal, "Photographie d'effluves humain et magnétique," *La Nature* 25 (Oct. 30, 1897), 349–50. After the discovery of radioactivity and the "N-Rays" of Blondlot (see n. 59 below), more types of emanations followed, such as the "rayons V" or "rayons vitaux" of Commandant Darget. Presented by Darget before the Académie des Sciences, the V-rays were discussed frequently in *La Vie Mystérieuse* and other spiritualist sources such as the *Revue Spirite*. Along with a number of other books on occult subjects, the poet Apollinaire owned Darget's *Exposé des différentes méthodes pour l'obtention de photographies fluido-magnétiques et spirites. Rayons V (Vitaux)* (Paris: Editions de l'Initiation, 1909). See Gilbert Boudar and Michel Décaudin, *Catalogue de la bibliothèque de Guillaume Apollinaire* (Paris:

Editions du Centre National de la Recherche Scientifique, 1983), p. 52.

34. Rowell, "Kupka, Duchamp and Marey," p. 49. On Londe's work with Charcot at the Salpêtrière, see Didi-Huberman, "Photography," pp. 73–74, as well as Didi-Huberman, *Invention de l'hystérie: Charcot et l'iconographie photographique de la Salpêtrière* (Paris: Macula, 1982). Didi-Huberman also discusses the photographic work of Baraduc, who was, however, only loosely associated with the Salpêtrière; see *Invention*, pp. 90–97.

35. On Londe's chronophotography, see Michel Frizot, *Avant le cinématographe—La Chronophotographie: Temps, photographie et mouvement autour de E.-J. Marey* (La Chapelle de l'Oratoire, Beaune, May 27–Sept. 3, 1984), pp. 129–33.

36. On Duchamp, Kupka, and chronophotography, see Rowell, "Kupka, Duchamp, and Marey"; Clair, *Duchamp et la photographie*, chap. 3; and Marta Braun, *Picturing Time: The Work of Etienne-Jules Marey (1830–1904)* (Chicago: University of Chicago Press, 1992), pp. 282–91. On the link between Duchamp's and Kupka's concern with chronophotography and the higher reality of the fourth dimension, see Henderson, *Fourth Dimension*, pp. 106–8, 127–28. Germano Celant's article "Futurism and the Occult" demonstrates the connection between the Futurists' interest in chronophotography and the transcendental reality suggested by spirit photography (and X-rays).

37. Bergson himself, however, objected to the "snapshot view of a transition" in cinematography or chronophotography (*Creative Evolution*, trans. Arthur Mitchell [New York: H. Holt, 1911], p. 302). For a lucid discussion of this distinction, see Braun, *Picturing Time*, pp. 277–81. On Bergson's philosophy and its relevance for the Puteaux Cubists, see Mark Antliff, "Bergson and Cubism: A Reassessment," *Art Journal* 47 (Winter 1988), 341–49; and Antliff, *Inventing Bergson: Bergson, Cultural Politics, and the Parisian Avant-Garde* (Princeton: Princeton University Press, 1993). For an overview of early radioactivity research, discussed in greater detail in chap. 2 below, see Badash, *Radioactivity in America*, pp. 10–16.

38. Badash, *Radioactivity*, pp. 24–32.

39. Knight, "The New Light," p. 25. Unlike X-ray experiments, which were inexpensive and simple to replicate, radioactive elements were rare and extremely expensive.

40. On Le Bon's career, see Mary Jo Nye, "Gustave Le Bon's Black Light: A Study in Physics and Philosophy in France at the Turn of the Century," *Historical Studies in the Physical Sciences* 4 (1974), 163–95. Timothy Mitchell was the first art historian to draw attention to Le Bon's importance for Cubist art and theory ("Bergson, Le Bon, and Hermetic Cubism," *Journal of Aesthetics and Art Criticism* 36 [Winter 1977], 175–83).

41. For Le Bon's black light and the response of the French Académie des Sciences, see Nye, "Gustave Le Bon's Black Light," pp. 173–81. Le Bon was the editor of Ernest Flammarion's series "Bibliothèque de philosophie scientifique," and it was Le Bon who commissioned Poincaré to set forth his ideas in the highly influential *La Science et l'hypothèse* of 1902 (Nye, p. 171).

42. See "La Lumière noire," *L'Illustration* 107 (May 23, 1896), pp. 431–32.

43. Gustave Le Bon, *L'Evolution de la matière* (Paris: Ernest Flammarion, 1905), p. 9. "La Dematérialisation de la matière" appeared in *Revue Scientifique*, 5th ser., 2 (Nov. 19, 1904), 641–51, and 2 (Dec. 10, 1904), 737–40, along with numerous other articles by Le Bon.

44. Mitchell, "Bergson, Le Bon," pp. 178–79. Nye ("Gustave Le Bon's Black Light") documents the friendship of Bergson and Le Bon (p. 171) as well as the great popularity of Le Bon's books (p. 179, n. 74).

45. On the spinthariscope, see chap. 2, n. 66 and the related text.

46. For a fuller discussion of Kupka's art and theory in relation to X-rays, see Henderson, "X Rays," pp. 328–30. Kupka's interest in other ranges of electromagnetic waves is discussed in chap. 8 below, as well as in Henderson, "Kupka, les rayons X, et le monde des ondes électromagnétiques," in Musée d'Art Moderne de la Ville de Paris, *František Kupka, 1871–1957, ou l'invention d'une abstraction*, ed. Krisztina Passuth (Nov. 22, 1989–Feb. 25, 1990), pp. 51–57.

Margit Rowell, who prepared the 1975 Kupka exhibition at the Guggenheim Museum, and Krisztina Passuth have generously shared Kupka archival materials with me. These include his notebook of 1910–11(?), an unpublished "credo" dated October 8, 1913, and the draft chapters of his treatise, which was published for the first time in 1923 in Prague. Recently, the treatise has been reconstructed in French by Erika Abrams and published as *La Création dans les arts plastiques* (Paris: Cercle d'Art, 1989). Synthesizing both the French and Czech versions and transforming Kupka's often problematic grammar into a more readable text, the new publication makes Kupka's theories available on a wide scale for the first time. Unfortunately for the historian of early twentieth-century culture, crucial terminology employed by Kupka, such as his repeated use of *émission* (discussed in chap. 8 below), is at times simply replaced by another French word, such as the more literary *énoncé* (enunciation), which the editor-translator deems to be closer to his original meaning. Thus, a student of Kupka and science (or any other element of his cultural context) cannot rely solely on the new publication and must return to the original draft chapters. On Kupka and the fourth dimension, see Henderson, *Fourth Dimension*, pp. 103–9.

47. On Kupka's scientific studies at the Sorbonne, see the chronology in Guggenheim Museum, *František Kupka*, p. 308, which adds that Kupka was again studying biology, physiology, and neurology in 1910 (p. 310). See also Ludmila Vachtova, "The Stigma of the Outsider," in Galerie Gmurzynska, Cologne, *Frank Kupka* (Feb.–Apr. 1981), p. 95.

48. See, e.g., Silvanus P. Thompson, *Light Visible and Invisible* (New York: Macmillan, 1897); translated as *Radiations visibles et invisibles*, 2d ed. (Paris: A. Hermann, 1914).

49. Léon Denis, *Dans l'invisible: Spiritisme et médiumnité (Traité de spiritualisme expérimental)* (Paris: Librairie des Sciences Psychiques, 1904), p. 195.

50. Kupka, Notebook, p. 21 (courtesy Margit Rowell).

51. Meda Mladek, "Central European Influences," in Guggenheim Museum, *František Kupka*, p. 28, n. 52.

52. *La Vie Mystérieuse* for July 25, 1911, announced the new collaboration of Eugène Figuière (p. 213); beginning on August 25, 1911, the names of Figuière, Mercereau, and Gleizes's friend Jacques Nayral (Figuière's editor-in-chief) were listed among the "Principaux Collaborateurs."

53. Clair, *Duchamp et la photographie*, pp. 21–22.

54. Guillaume Apollinaire, "An Engraving that Will Become a Collector's Item," *Paris-Journal*, May 19, 1914; reprinted in *Apollinaire on Art: Essays and Reviews, 1902–1918*, ed. Leroy C. Breunig and trans. Susan Suleiman (New York: Viking, 1972), p. 389.

55. See Charles Henry, *Les Rayons Röntgen* (Paris: Société d'Editions Scientifiques, 1897). Henry's experiments were discussed, along with those of Londe, in Fernand Honoré, "La Radiographie," in *L'Illustration* 54 (Mar. 7, 1896), 200–201.

56. See the interview with Duchamp by Alfred Kreymborg, "Why Marcel Duchamps [*sic*] Calls Hash a Picture," *Boston Evening Transcript*, Sept. 18, 1915, p. 12, as well as "A Complete Reversal of Opinions by Marcel Duchamp, Iconoclast," *Arts and Decoration* 5 (Sept. 1915), 427.

57. See, e.g., Théo Varlet, "Nouvelles Découvertes de Sir Electrod . . . ," *Les Bandeaux d'Or*, 2d ser., fasc. 8 (1908), 174–82. I am grateful to Mark Antliff, who brought Varlet's articles to my attention. F. T. Marinetti, the founder of Italian Futurism and a sometime participant with Mercereau in the Abbaye de Créteil group, referred to the latter as the "Central Electric of modern letters" (Robbins, "From Symbolism to Cubism," p. 116).

58. Under "Notes et analyses," *La Revue des Idées* regularly reported on presentations before the French Académie des Sciences. A review of Poincaré's *La Science et l'hypothèse* appeared in the second issue (Feb. 15, 1904, pp. 118–28), and Poincaré's address, "L'Etat actuel et l'avenir de la physique mathématique," delivered at the 1904 International Congress of Sciences and Arts in St. Louis (held in conjunction with the Louisiana Purchase Exposition) and subsequently printed in *La Valeur de la science* (1904), appeared in the issue for Nov. 15, 1904, pp. 801–18.

59. The existence of N-rays, which were also thought to be generated by human beings and were thus seen as a possible explanation for certain psychic phenomena, was widely debated during the decade before World War I, although many scientists (particularly those outside France or outside the traditional French scientific establishment) concluded against Blondlot's claims rather quickly. See Mary Jo Nye, "N-Rays: An Episode in the History and Psychology of Science," *Historical Studies in the Physical Sciences* 11 (1980), 125–56.

60. Marc Stéphane, "Esotérisme et Théosophie," *Pan* 5 (July–Sept. 1912), 550. Before the publication of *Les Opinions et les croyances: Genèse—Evolution* (Paris: Ernest Flammarion, 1911), however, Le Bon had already publicized his doubts about certain occult phenomena in a two-part article, "La Renaissance de la magie," *Revue Scientifique* 48 (Mar. 26,

1910), 391–97, and 48 (Apr. 2, 1910), 426–35, which also discussed his creation of the "Prix Le Bon" of two thousand francs for any spiritualist medium who could raise an object without touching it.

61. Alfred Jarry, *Gestes et opinions du docteur Faustroll, pataphysicien (roman néoscientifique), suivi de Spéculations* (Paris: Eugène Fasquelle, 1911), chaps. 9, 37, 38.

62. Kupka, Notebook, p. 33.

63. Duchamp, as quoted in Kuh, *Artist's Voice*, p. 89.

64. For *Sonata* and *Apropos of Little Sister* of October 1911, which utilizes a similar dematerializing style and contrasting nose, see Schwarz, *Complete Works*, pls. 40, 51.

65. See *MDN*, notes 23 and 189, which read, "Rayons X (?)/infra mince/Transparence ou coupaison" and "le coupant d'une lame et la transparence/et les Rayons X et la 4 Dim." Because note 189 also includes the mirror-reversed title of Duchamp's 1926 film *Anemic Cinema* and because he apparently began writing notes on "infrathin" only in the 1930s, his two written references to X-rays would seem to date from this later period. On these notes, see also chap. 14.

66. See Henderson, *Fourth Dimension*, pp. 120, 148–50, 152.

67. See Henderson, "X Rays," pp. 329–30, which also discusses the presence in this and other of Kupka's works of an analogue to the characteristic border of flesh around the bones in an X-ray photograph (p. 325).

68. Kupka, Notebook, p. 49.

69. On Kupka and chronophotography, see again Rowell, "Kupka, Duchamp, and Marey," as well as Rowell, "A Metaphysics of Abstraction," in Guggenheim Museum, *František Kupka*, pp. 49–67. See also Herbert Molderings, "Film, Photographie und ihr Einfluss auf die Malerei in Paris um 1910: Marcel Duchamp—Jacques Villon—Frank Kupka," *Wallraf-Richartz-Jahrbuch* 37 (1975), 247–86.

70. On Duchamp and chronophotography, see also Clair, *Duchamp et la photographie*, pp. 26–42. Duchamp also explored a schema for indicating motion in his *Coffee Mill* of late 1911 (fig. 41), which is discussed at the beginning of chap. 3 below. For Duchamp's *Nude Descending a Staircase (No. 1)*, see Schwarz, *Complete Works*, pl. 57.

71. See Glasser, *Röntgen* (1934), p. 44.

72. X-rays automatically accomplished the undressing Duchamp had made the theme of a cartoon he published in *Le Courrier Français* on Jan. 1, 1910. As part of a "Catalog of New Year's Gifts for Old Gentlemen," Duchamp presented a "Bébé marcheur" advertised as "se déshabillant." See *Duchamp* (Philadelphia), p. 13; and Gough-Cooper and Caumont, "Ephemerides," in *Duchamp* (Venice), entry for Jan. 1, 1910, which documents Duchamp's source in a Samaritaine department store catalogue.

73. See Pierre Cabanne, *Dialogues with Marcel Duchamp* (1967), trans. Ron Padgett (New York: Viking, 1971), p. 33. Clair has suggested "boulevard kinetoscopes," which were photographic images of women in successive stages of undress, as another source for *Dulcinea* (*Duchamp et la photographie*, p. 30).

74. Duchamp, as quoted in Cabanne, *Dialogues,* p. 35.

75. Duchamp, as quoted in Sweeney, "Eleven Europeans," p. 20.

76. This resemblance is stronger in the second version of the *Nude.* Yet despite the more volumetric orientation of the first version (Schwarz, *Complete Works,* pl. 57), it bears the same cross sections in the upper thigh and mid-calf that were produced in early full-body X-rays by the splicing of two images together (fig. 13). In December 1911, the same month in which he executed *Nude Descending a Staircase (No. 1),* Duchamp painted *Sad Young Man in a Train* (Schwarz, *Complete Works,* pl. 56), in which he depicted himself—with a pipe—in a similar style, emphasizing internal structure versus surface appearances.

77. See Frizot, *Avant le cinématographe,* pp. 93–99, as well as Braun, *Picturing Time,* chap. 3. For Duchamp's reference to Marey, see Cabanne, *Dialogues,* p. 34; on Duchamp and Marey, see again n. 36 above. For Marey's earlier graphic methods in relation to the evolution of registering apparatus in the field of physiology (relevant to the discussion of Duchamp in chaps. 3 and 8 below), see Braun, *Picturing Time,* chap. 2; and François Dagognet, *Etienne-Jules Marey: A Passion for the Trace* (New York: Zone, 1992).

78. Frizot (*Avant le cinématographe,* p. 132, n. 6) has also suggested the probable connection between Londe's chronophotography and Duchamp's *Nude* through Richer's drawings. Without citing Londe's role in its genesis, John Golding first compared this plate from Richer's book to the *Nude Descending a Staircase* in his 1972 monograph on *The Bride Stripped Bare by Her Bachelors, Even (Marcel Duchamp,* p. 22). On the work of Londe and Richer in relation to that of Marey, see Braun, *Picturing Time,* p. 85.

79. Duchamp, "Apropos of Myself," unpublished lecture delivered at the City Art Museum of St. Louis, Nov. 24, 1964, p. 6. For the geometric significance of the term "elementary parallelism," which Duchamp used in discussing his December 1911 *Sad Young Man in a Train,* as well as "demultiplication," see Henderson, *Fourth Dimension,* pp. 126–28.

Duchamp also experimented with color in the final painting by working in gaslight. As he told Cabanne, "You know, that gaslight from the old Aver [Auer] jet is green; . . . When you paint in green light and then, the next day, you look at it in daylight, it's a lot more mauve, gray, more like what the Cubists were painting at the time" (Duchamp, as quoted in Cabanne, *Dialogues,* p. 27).

80. Henderson, *Fourth Dimension,* pp. 123–25.

81. See H. J. W. Dam, "The New Marvel in Photography," *McClure's Magazine* 6 (Apr. 1896), 409, which also includes the only interview that Röntgen granted in early 1896. On Edison, see Cleveland Moffett, "The Röntgen Rays in America," in the same issue, p. 420.

82. Honoré, "La Radiographie, p. 201.

83. For Duchamp's preparatory works, see Schwarz, *Complete Works,* pls. 41–47. The contemporary "scientific" analogue to this idea is suggested in J. G. Speed's article "The Brain, X-Rays, and the Cinematograph," *Westminister Review*

175 (Mar. 1911), 269–73. See also L. Caze, "La Photographie de la pensée," *La Revue des Revues* 24 (Feb. 15, 1898), 438–42.

84. Duchamp, as quoted in John Russell, "Exile at Large," *Sunday Times* (London), June 9, 1968, p. 54. There has been much speculation on the possible reasons for Duchamp's choice of Munich for an extended stay during his summer 1912 trip, which also included stops in Vienna, Prague, Berlin, and Dresden on his return journey to Paris. Proponents of the view of Duchamp as alchemist or practitioner of hermeticism have suggested that alchemical manuscripts might have drawn him there, although there is no evidence in Duchamp's notes to support such a claim. See, e.g., Jack Burnham, "Unveiling the Consort," *Artforum* 9 (Mar. 1971), 59; or Ulf Linde, "L'Esotérique," in *OeuvreMD* (Paris), vol. 3, p. 60. For Thierry de Duve's more recent discussion of Duchamp's visit to Munich in relation to Germany's more unified view of art and craft, see chap. 2, n. 14.

85. See Gough-Cooper and Caumont, "Ephemerides," in *Duchamp* (Venice), entries for the period Mar. 1–Apr. 29, 1910, as well as for June 21, July 1, and July 10, 1912.

86. On Röntgen and the Deutsches Museum, see, e.g., Nitske, *Röntgen,* p. 215. Although the Deutsches Museum had been founded in 1903 and the cornerstone for the present building laid in 1906, at the time of Duchamp's visit to Munich the collections were displayed in temporary quarters on Maximilianstrasse and Zweibrückenstrasse. See *Deutsches Museum von Meisterwerken der Naturwissenschaft und Technik: Rundgang durch die Sammlungen* (Munich: Deutsches Museum, n.d. [before 1914]). I am grateful to Dr. Walter Rathjen of the Deutsches Museum for this guidebook and the photograph reproduced as fig. 38.

87. See B. E. H. Tutton, "Crystal Structure Revealed by Röntgen Rays: A Glimpse of the Molecular Architecture of Solids," *Scientific American Supplement* 74 (Dec. 21, 1912), 391; and Nitske, *Röntgen,* pp. 217–18.

88. Duchamp had married Alexina Sattler Matisse in 1954. Alexina Duchamp, letter to the author, Apr. 20, 1991; this information was first communicated to me by Calvin Tomkins in November 1990. Anne d'Harnoncourt has also noted in passing the possible importance of the Deutsches Museum for Duchamp in "Before the Glass: Reflections on Marcel Duchamp before 1915," in *Duchamp* (Madrid), p. 31.

89. See, e.g., Thomas B. Hess, *Willem de Kooning* (New York: Museum of Modern Art, 1968), p. 77.

90. *A L'INF,* in *SS,* p. 78.

91. *GB,* in *SS,* p. 44.

92. Duchamp, "Apropos of Myself," p. 9.

93. Gérard Encausse [Papus], "Comment est constitué l'Etre Humain," *La Vie Mystérieuse,* no. 65 (Sept. 10, 1911), 260–61; no. 66 (Sept. 25, 1911), 275–76; no. 68 (Oct. 25, 1911), 30; no. 70 (Nov. 25, 1911), no. 73 (Jan. 10, 1912) (both nos. 70 and 73 are missing from the holdings of the Bibliothèque Nationale); and no. 76 (Feb. 25, 1912), 436–37.

94. Nitske, *Röntgen,* pp. 168–69.

95. Alfred Gradenwitz, "A Novel System of X-ray Cine-

matography," *Scientific American* 103 (Sept. 24, 1910), 232. On the early attempts to produce "Röntgen moving pictures," see, e.g., Glasser, *Röntgen* (1934), pp. 241–43.

96. See Gérard Encausse [Papus], *Essai de physiologie synthétique* (Paris: Georges Carré, 1891), introduction.

97. Boudar and Décaudin, *Catalogue de la bibliothèque de Guillaume Apollinaire*, p. 121. For documentation of Duchamp's reading of a similar occult source on biology, physiology, and magnetism, see chap. 2, n. 57 and the related text.

98. In the *Large Glass*, however, the stomachlike form in the painting has been eliminated.

99. Duchamp, as paraphrased in Steefel, *Position of Duchamp's "Glass,"* p. 110.

100. See, e.g., Theodore Reff, "Duchamp and Leonardo: L.H.O.O.Q.-Alikes," *Art in America* 65 (Jan.–Feb. 1977), 89.

101. Information on Jeanne Serre first appeared in Gough-Cooper and Caumont, "Ephemerides," in *Duchamp* (Venice), entries for Apr. 16 and 26, 1910; Feb. 6, 1911; Apr. 21, 1911; June 23, 1966.

102. On the friendship of Duchamp, Picabia, and Apollinaire, see, e.g., Katia Samaltanos, *Apollinaire: Catalyst for Primitivism, Picabia, and Duchamp* (Ann Arbor: UMI Research Press, 1984). The Jura trip and *Impressions d'Afrique* are discussed in chaps. 3 and 4, respectively.

Although the Duchamp literature generally records that the artist attended an *Impressions d'Afrique* performance in May–June 1912, questions about this chronology have recently been raised (see Gough-Cooper and Caumont, "Ephemerides," in *Duchamp* [Venice], entries for June 10 and Oct. 11, 1912). E.g., in a letter to Jean Suquet of Dec. 25, 1949, Duchamp placed the event in Oct.–Nov. 1912 (see Suquet, *Miroir de la mariée* [Paris: Flammarion, 1974], p. 246). However, the only documented dates for the 1912 run of *Impressions d'Afrique* at the Théâtre Antoine are May 11–June 10, 1912 (see François Caradec, *Vie de Raymond Roussel (1877–1933)* [Paris: Jean-Jacques Pauvert, 1972], p. 126). Was Duchamp simply misremembering this date, confusing it with the other important events of fall 1912, such as the Jura trip? In the face of contradictory evidence, Gough-Cooper and Caumont, Calvin Tomkins, and I all remain uncertain; see, for example, Tomkins's recent discussion in *Duchamp*, pp. 90–91. For the purposes of my narrative, however, I am assuming that Duchamp saw the play in May or June 1912, although none of my arguments would be substantially affected if the event actually occurred in fall 1912.

103. On Picabia's and Buffet-Picabia's's visit to New York and their involvement with the Stieglitz circle there, see William A. Camfield, *Francis Picabia: His Life and Times* (Princeton: Princeton University Press, 1979), chap. 4, as well as Henderson, *Fourth Dimension*, pp. 210–18.

104. For Picabia's *Mechanical Expression* as well as a discussion of how the imagery of *La Ville* might relate to invisible reality, see chap. 4. For a fuller analysis, see Linda Dalrymple Henderson, "Francis Picabia, Radiometers, and X-Rays in 1913," *Art Bulletin* 71 (Mar. 1988), 114–23; and Willard Bohn, "Picabia's 'Mechanical Expression' and the

Demise of the Object," *Art Bulletin* 67 (Dec. 1985), 673–77.

105. Gabrielle Buffet, "Modern Art and the Public," *Camera Work*, special no. (June 1913), 14–21.

106. Albert Gleizes and Jean Metzinger, *Du Cubisme* (Paris: Eugène Figuière, 1912), p. 10; trans. in *Modern Artists on Art*, ed. Robert L. Herbert (Englewood Cliffs, N.J.: Prentice-Hall, 1964), p. 4. For a fuller discussion of Cubism and X-rays, see Henderson, "X Rays," pp. 334–36.

107. Christian Brinton, "Evolution Not Revolution in Art," *International Studio* 49 (Apr. 1913), xxxv.

108. For Rosenthal's statement, see n. 11 above; on the removal of *Nude Descending a Staircase (No. 2)* from the exhibition at the suggestion of Gleizes and other senior Cubists, see chap. 2, n. 6.

109. Henri Le Fauconnier, "La Sensibilité moderne et le tableau," *De Kunst* 5 (Oct. 12, 1912), 22.

110. Gleizes and Metzinger, *Du Cubisme*, p. 24; trans. as "Fraunhofer rays" in *Modern Artists on Art*, ed. Herbert, p. 10.

111. Discovered in the early nineteenth century, Fraunhofer lines had been mentioned by Ogden Rood in his analysis of the colors of the solar spectrum in *Modern Chromatics* (London: C. Kegan Paul, 1879), a major source for the Neo-Impressionist painters. Yet Rood's only interest in Fraunhofer lines had been as "landmarks to guide us through the vague tracts of ill-defined color" (p. 20). In contrast to Rood's usage and in keeping with the early twentieth-century preoccupation with the unseen, Gleizes and Metzinger treat the lines as signs of "the indefinite" (see the previous note). On Fraunhofer lines and the discovery of helium, see, e.g., Duncan, *New Knowledge*, pp. 123–24, 198–200.

112. Guillaume Apollinaire, *Les Peintres Cubistes: Méditations esthétiques* (Paris: Eugène Figuière, 1913), p. 35. See also *The Cubist Painters: Aesthetic Meditations*, ed. Robert Motherwell, trans. Lionel Abel (New York: George Wittenborn, 1949), p. 21.

113. Daniel-Henry Kahnweiler, *The Rise of Cubism* (1920), trans. Henry Aronson (New York: Wittenborn, Schultz, 1949), p. 10. Kahnweiler also uses the phrase "like a skeletal frame" in discussing the way the "underlying basic forms" of the physical world function as "the basis of the 'seen' form" in a Cubist painting (p. 14).

114. Sketchbook MP1866, sheet 4, Musée Picasso, Paris. On Picasso and photography, see Paul Hayes Tucker, "Picasso, Photography, and the Development of Cubism," *Art Bulletin* 64 (June 1982), 288–99; and Musée Picasso, Paris, *Le Miroir noir: Picasso, sources photographiques, 1900–1928* (Mar. 12–June 9, 1997). On Jarry's importance for Picasso, see Ron Johnson, "Picasso's 'Demoiselles d'Avignon' and the Theatre of the Absurd," *Arts Magazine* 55 (Oct. 1980), 102–13; and Patricia Leighten, *Re-Ordering the Universe: Picasso and Anarchism, 1897–1914* (Princeton: Princeton University Press, 1989). John Richardson agrees that Jarry had a great impact on Picasso but argues that the two did not actually meet. See John Richardson (with the collaboration of Marilyn McCully), *A Life of Picasso, Volume I (1881–1906)* (New York: Random House, 1991), chap. 23.

115. Kupka, unpublished "credo" dated October 8, 1913, p. 2 (courtesy Margit Rowell).

Chapter 2: The Invisible Reality of Matter Itself

1. The original French titles of these works are as follows: fig. 21, *Le Roi et la reine entourés de nus vites*; fig. 22, *2 Nus: Un fort et un vite*; fig. 23, *Le Roi et la reine traversés par des nus vites*; fig. 24, *Le Roi et la reine traversés par des nus en vitesse*. The oil painting (pl. 2, fig. 21) is painted on the back of Duchamp's 1910–11 composition depicting Adam and Eve, *Paradise*, which accounts in part for the cracking of the paint surface visible in plate 2. Duchamp explained to William Camfield that he had used the back of an earlier painting simply because he lacked money to buy a new canvas (Schwarz, *Complete Works*, p. 116). Lebel (*Marcel Duchamp*, p. 3) and Schwarz (ibid.), however, have suggested a connection between the Adam and Eve image and the king and queen of the Swift Nudes series; see also n. 105 below.

2. Golding seems to have intuited such a connection when he remarked in passing that the "swift nudes" in Duchamp's final painting were characterized by a "flurry of small planes . . . like an electric current rendered visible" (*Marcel Duchamp*, pp. 32–33).

3. Duchamp, as quoted in Sweeney, "Eleven Europeans," p. 20.

4. See F. T. Marinetti, "The Founding and Manifesto of Futurism" (published in *Le Figaro* [Paris], Feb. 20, 1909), in *Futurist Manifestos*, ed. Apollonio, p. 21. On the Futurists and their Paris exhibition, see Marianne W. Martin, *Futurist Art and Theory, 1909–1915* (Oxford: Clarendon Press, 1968). On the philosophical links between Futurism and the Puteaux Cubist circle via Marinetti's active involvement with the Parisian literary avant-garde, including the Abbaye de Créteil group, see Martin, "Futurism, Unanism and Apollinaire," *Art Journal* 28 (Spring 1969), 258–68.

5. Schwarz (*Complete Works*, p. 107) interprets the 1912 drawing *Mediocrity* (Private Collection, Paris) as a locomotive, although, unlike *2 Personages*, the image here is far from clear. *Mediocrity* is one of three sketches Duchamp made in late 1911 in response to the poetry of Jules Laforgue. On these drawings as well as Duchamp's *Sad Young Man on a Train* in relation to the poetry of Laforgue, see Ronald Johnson, "Poetic Pathways to Dada: Marcel Duchamp and Jules Laforgue," *Arts Magazine* 50 (May 1976), 82–89. In late 1911 Duchamp also painted his first image of a household machine, the *Coffee Mill* (fig. 42).

6. Duchamp's relationship to Futurism was complex. Although both versions of the *Nude Descending a Staircase*, with their roots in chronophotography, were completed by the time of the Futurists' February 1912 exhibition in Paris, in later interviews Duchamp found it necessary to emphasize the independence of the *Nude Descending* paintings from Futurism. (See, e.g., Cabanne, *Dialogues*, p. 35, as well as Sweeney, "Eleven Europeans," p. 20, where Duchamp mistakenly dates the Futurists' exhibition to January 1912.) In fact, since

1909–10 Kupka had been painting figures in motion (see chap. 1, n. 69), and Duchamp had already exhibited the motion-oriented *Portrait (Dulcinea)* at the 1911 Salon d'Automne. But Duchamp was not the only Cubist interested in motion: in the same room (*salle* 8) of that exhibition, Léger had shown his *Study for Three Portraits* (Milwaukee Art Center), which included hands in chronophotographic motion (see Christopher Green, *Léger and the Avant-Garde* [New Haven: Yale University Press, 1976], pp. 20, 23–27). Nonetheless, in the wake of the Futurists' exhibition, senior members of the Puteaux circle, such as Gleizes, requested that Duchamp remove *Nude Descending a Staircase (No. 2)* from the spring 1912 Salon des Indépendants, presumably fearing that its depiction of motion might mistakenly be associated with the Futurists' goals. For Duchamp's response to this event, see chap. 5, n. 2. Actually, Duchamp's focus on the nude as such was antithetical to Futurist doctrine, since in 1910 the Futurist painters had declared themselves "against the nude in painting, as nauseous and as tedious as adultery in literature" (Boccioni et al., "Futurist Painting: Technical Manifesto," in *Futurist Manifestos*, ed. Apollonio, p. 30).

Yet although he described the Futurist painters to Cabanne as "urban Impressionists who make impressions of the city rather than the countryside" (p. 35) and to Sweeney as practitioners of "an impressionism of the mechanical world" (p. 20), the Futurist manifestos, suggesting the possibility of a modern art nourished by the new science, must have struck a responsive chord in Duchamp. Just as in the 1910 "Technical Manifesto" Boccioni and his colleagues had pointed to the relevance of X-rays for painting, Boccioni's other writings reveal a deep interest in electromagnetism (in both its scientific and occult contexts) that paralleled Duchamp's and Kupka's growing concern with the subject. Likewise, Marinetti in his May 1912 "Technical Manifesto of Futurist Literature" had urged poets to "divine . . . forces of compression, dilation, cohesion and disaggregation [in matter], its crowds of massed molecules and whirling electrons" (*Marinetti: Selected Writings*, ed. R. W. Flint [New York: Farrar, Straus and Giroux, 1972], p. 87). For Duchamp's admission that the Swift Nudes series might be "a bit Futurist," see n. 9 below. The importance of occult interpretations of electromagnetism and figures such as Crookes for Futurism has been noted by Celant ("Futurism and the Occult"). I have discussed the relevance of both scientific and occult views of etherial vibrations for Futurism and Boccioni in a lecture in conjunction with the exhibition, *Boccioni: A Retrospective* (The Metropolitan Museum of Art, New York, Sept. 15, 1988–Jan. 8, 1989); and in Linda Dalrymple Henderson, "Die moderne Kunst und das Unsichtbare: Die verborgenen Wellen und Dimensionen des Okkultismus und der Wissenschaften," in Schirn Kunsthalle, Frankfurt, *Okkultismus und Avant-Garde: Von Munch bis Mondrian, 1900–1915* (June 2–Aug. 20, 1995), pp. 13–31.

7. Duchamp, "Apropos of Myself," p. 9.

8. Duchamp, as quoted in Kuh, *Artist's Voice*, p. 88.

9. Duchamp, as quoted in Cabanne, *Dialogues*, p. 35. In the sentence omitted from the text quoted here, Duchamp adds,

"Perhaps it was a bit Futurist, because by then I knew about the Futurists, and I changed it into a king and queen."

10. Duchamp, as quoted in Schwarz, *Complete Works*, p. 116.

11. In later interviews Duchamp did qualify certain of Apollinaire's remarks, including his statement in *Les Peintres Cubistes* that Duchamp would "reconcile art and the people" (a remark quoted and discussed below), to which Duchamp responded to Cabanne, "He wrote whatever came to him" (*Dialogues*, p. 38). In the same interview, however, Duchamp also asserted, ". . . I like what he did very much, because it didn't have the formalism of certain critics"; and "Apollinaire had guts, he saw things, he imagined others which were very good" (ibid., pp. 30, 38). Thus, although Apollinaire's style as a critic was highly poetic, his comments are a useful reflection of ideas in the air at a particular moment.

12. Apollinaire, *Les Peintres Cubistes*, pp. 73–74; *Cubist Painters*, p. 47. The quotations from Apollinaire's text that follow are drawn from *Les Peintres Cubistes*, pp. 73–76, and *Cubist Painters*, pp. 47–48 (with some variation in translation).

13. Apollinaire's remark calls to mind the Futurists' Bergsonian goal of creating in painting "a synthesis of *what one remembers* and of *what one sees*." See Boccioni et al., "Les Exposants au public," in Galerie Bernheim-Jeune, *Les Peintres Futuristes italiens*, p. 6; *Futurist Manifestos*, ed. Apollonio, p. 47.

14. See Apollinaire, *Cubist Painters*, p. 48. Thierry de Duve has discussed the French governmental division of "art" between the Louvre and the Ecole de Beaux-Arts versus the Conservatoire des Arts et Métiers, contrasting it to the more unified approach to art and craft in the German *Kunstgewerbeschulen*, which he argues may have been an important aspect of Duchamp's Munich experience of summer 1912 (*Nominalisme pictural: Marcel Duchamp, la peinture et la modernité* [Paris: Editions de Minuit, 1984], chap. 5). Yet de Duve does not consider the importance of the Musée des Arts et Métiers itself for Duchamp, and in the first English translation of this chapter he reused the mistranslated title "Academy of Arts and Sciences" (see "Resonances of Duchamp's Visit to Munich," in *Marcel Duchamp*, ed. Kuenzli and Naumann, p. 54). The 1991 English translation of *Nominalisme pictural*, however, corrects the translation of the term (see Thierry de Duve, *Pictorial Nominalism: On Marcel Duchamp's Passage from Painting to the Readymade*, trans. Dana Polan and Thierry de Duve, Theory and History of Literature, vol. 51 [Minneapolis: University of Minnesota Press, 1991], p. 110). De Duve's observations on Duchamp's Readymades in relation to the German Arts and Crafts tradition are noted in chap. 3 below.

15. Alexina Duchamp, letter to the author, April 20, 1991. On Kupka and the Arts et Métiers, see Rowell, "Metaphysics," in Guggenheim Museum, *Kupka*, p. 78. For the collections of the Conservatoire National des Arts et Métiers and its museum, see Conservatoire National des Arts et Métiers, Paris, *Catalogue officiel des collections du Conservatoire National des Arts et Métiers*, 6 vols. (Paris: E. Bernard, 1905–10); for its

history, see ibid., vol. 1, pp. 7–51. Blériot's plane was acquired in 1909 (Frédérique Desvergnes, letter to the author, Aug. 1, 1989). For the displays at the Musée des Arts et Métiers, I have also relied on guidebooks to Paris, such as Marcel Monmarché, *Paris et ses environs (Les Guides bleus)* (Paris: Hachette, 1921), always comparing that text, referred to subsequently as *Guide bleu*, to the official catalogue of prewar holdings. For Duchamp's later notes relating to the Palais de la Découverte, see chap. 14, n. 15.

16. Duchamp, as quoted by Léger in Dora Vallier, "La Vie fait l'oeuvre de Fernand Léger," *Cahiers d'Art* 29 (1954), 140; reprinted in *SS*, p. 160. The aeronautics exhibition at which this exchange occurred was quite certainly that of fall 1912. On this event, see also Tashjian, "Henry Adams and Marcel Duchamp," pp. 103–4.

17. A. Dastre, "Les Nouvelles Radiations: Rayons cathodiques et rayons Röntgen," *Revue des Deux Mondes*, 5th ser., 6 (Dec. 1, 1901), 695; reprinted in translation in *Annual Report of the Smithsonian Institution, 1901* (Washington, D.C.: G.P.O., 1902), pp. 271–86.

18. J. J. Thomson, as quoted in Keller, *Infancy of Atomic Physics*, p. 66.

19. Ibid., p. 66. Thomson continued to refer to these particles as "corpuscles," but the term "electron," coined by G. Johnstone Stoney, was adopted by other scientists and ultimately triumphed. Keller's text also provides an introduction to the work of Hendrik A. Lorentz, who as early as 1892 had theorized about the role of such electric particles, suggesting that their flow gave rise to electric and magnetic fields in the ether and their vibration generated waves across the ether. Lorentz's electron theories were to be vital to Einstein's formulation of the special theory of relativity in 1905. In the first decade of the century, however, his name was most often linked with that of his assistant, Pieter Zeeman, who had given Lorentz's theories an experimental base with his establishment of the magnetic widening of spectral lines (the "Zeeman effect"). The two shared the Nobel Prize in 1902. See, e.g., L. De Launay, "Les Ions et les électrons," *La Nature* 37 (Jan. 2, 1909), 70–71. For a fuller discussion of Lorentz's role, see McCormmach, "H. A. Lorentz and the Electromagnetic View of Nature," pp. 459–71.

20. See Keller, *Infancy*, chaps. 6, 8; and David Wilson, *Rutherford: Simple Genius* (Cambridge: MIT Press, 1983), chap. 10.

21. The subsequent identification of the alpha particle with the nucleus of a helium atom, so important for Rutherford's theory of the transformation of elements during radioactive decay, is discussed in the section on radioactivity and alchemy below.

22. Oliver Lodge, "Electric Theory of Matter," *Harper's Monthly* 109 (Aug. 1904), 387; and Lodge, "Electricité et matière," *Revue Scientifique*, 4th ser., 19 (May 2, 1903), 554–59. See also Lodge's important book, *Electrons, or the Nature and Properties of Negative Electricity* (1907; 4th ed., London: G. Bell, 1913). Many of the issues presented in that book were first raised in a 1902 lecture, "On Electrons," pub-

lished in the *Journal of the Proceedings of the Institution of Electrical Engineers* 32 (1903), 1–71. That text appeared in French, with a preface by Paul Langevin, as *Sur les Electrons*, trans. E. Nugues and J. Péridier (Paris: Gauthier-Villars, 1906).

See also Gustave Le Bon, "L'Energie intra-atomique," *Revue Scientifique*, 4th ser., 20 (Oct. 24, 1903), 513–14, where he draws upon the work of Lodge and other British scientists on the structure of the atom. Le Bon's three-part article was translated in the *Annual Report of the Smithsonian Institution, 1903* (Washington, D.C.: G.P.O., 1904), pp. 263–93, and he expressed many of the same ideas in his 1905 *L'Evolution de la matière*.

23. Henry Smith Williams, "Exploring the Atom," *Harper's Monthly* 127 (June 1913), 117.

24. Lodge, "Electric Theory," p. 384. In language typical of these discussions, Georges Claude in *L'Electricité à la portée de tout le monde* (1901; 5th ed., Paris: Ch. Dunod, 1905) refers to the "enormous speed" of cathode rays (p. 399). See also the texts cited in notes 48 and 49 below, where the "prodigious" speed of electrons is standardly noted in conjunction with their bulletlike character.

25. On these early models of the atom, see Keller, *Infancy*, chap. 8. Keller notes that Rutherford's findings were not immediately embraced by the world of physics (p. 144). Only with Niels Bohr's incorporation in 1913 of Planck's quantum theories into the Rutherford atom would a satisfactory explanation of the spectrographic evidence of atoms be achieved. See Keller, chaps. 10, 11.

26. See, e.g., Lodge, "On Electrons," p. 70; Le Bon, "L'Energie intra-atomique," p. 556; and the discussion of Perrin's ideas in Georges Bohn, "Le Radium et la radioactivité de la matière," *La Revue des Idees* 1 (Jan. 15, 1904), 8.

27. Lucien Poincaré, *The New Physics and Its Evolution* (London: Kegan, Paul, Trench, Trübner, 1907), p. 286. Poincaré's text was first published as *La Physique moderne: Son évolution* (Paris: Ernest Flammarion, 1906) in the "Bibliothèque de la philosophie scientifique" series edited by Le Bon.

28. G. Matisse, "Histoire extraordinaire des Electrons," *Mercure de France* 75 (Oct. 16, 1908), 744. Like Georges Bohn (n. 26 above), Georges Matisse wrote for both *Mercure de France* and Gourmont's *La Revue des Idées*. In general, Matisse seems not to have been particularly sympathetic to advocates of the atomic-molecular hypothesis, such as Jean Perrin (see chap. 10, n. 160 and the related text). As a result, Matisse's article may have been more facetious than his lay audience would have recognized at the time.

29. Ibid., pp. 744–45.

30. Ibid., p. 746.

31. Matisse was not alone in his response to electrons as fascinating creatures. See, e.g., Charles Robert Gibson, *The Autobiography of an Electron* (London: Seeley, 1911).

32. Duchamp, as quoted in Kuh, *Artist's Voice*, p. 81.

33. Duchamp, as quoted in Cabanne, *Dialogues*, p. 35. Duchamp's reference to a "procession" occurs in "French Artists Spur on an American Art," *New York Tribune*, Oct. 24, 1915, sec. 4, p. 3. Although Duchamp stated in that interview,

"To me the execution of the king is very much more masculine than that of the queen" (p. 3), readings of the identity of king versus queen throughout the Swift Nudes series have varied. In the final painting, at least, Schwarz (*Complete Works*, p. 116) and Golding (*Duchamp*, p. 32) agree that the figure on the right is the king.

34. E.g., Georges Bohn in his 1904 article in *La Revue des Idées* had described Perrin's model of the atom as having at its center "one or more masses strongly charged with positive electricity" ("Le Radium," p. 8).

35. See the text quoted at n. 10 above.

36. See, e.g., Ernest Rutherford, "The Scattering of α and β Particles by Matter and the Structure of the Atom," *Philosophical Magazine and Journal of Science*, 6th ser., 21 (May 1911), 670; and Jean Perrin, *Les Atomes* (Paris: Félix Alcan, 1913), p. 282. In his 1909 book, *La Synthèse d'or*, the alchemist François Jollivet Castelot (whose importance for Duchamp is discussed below) applauds Le Bon's success with "electric atoms," making them "traverse *visibly* from matter" (*La Synthèse d'or: L'Unité et la transmutation de la matière* [Paris: H. Daragon, 1909], p. 34).

37. Le Bon, "L'Energie intra-atomique," p. 498–99.

38. See ibid., p. 493, as well as *L'Evolution de la matière*.

39. On Wilson's work, see Keller, *Infancy*, pp. 67–69, 143.

40. See C. T. R. Wilson, "On a Method of Making Visible the Paths of Ionising Particles through a Gas," *Proceedings of the Royal Society of London*, ser. A, 85 (Nov. 1911), 285.

41. See C. T. R. Wilson, "On an Expansion Apparatus for Making Visible the Tracks of Ionising Particles in Gases and Some Results Obtained by Its Use," in ibid., ser. A, 87 (Dec. 1912), 277–93; for the term "instantaneous photography," see p. 280. Compared to virtually every other scientist discussed in the present work, the retiring Wilson attracted relatively little attention in pre–World War I France. Nonetheless, as discussed in chap. 10, his photographs were incorporated into Perrin's 1914 edition of *Les Atomes*, and they may well have appeared in other French sources available to Duchamp at the Bibliothèque Sainte-Geneviève. Wilson's photographs are also treated at the beginning of chap. 7, in the context of Duchamp's interest in "extra-rapid" photography, and in chap. 8, in the section "Appareils Enregistreurs and Other Indexical Signs in the *Large Glass*."

42. See, e.g., the reference to energy by Lucien Poincaré documented in n. 27 above, for which Poincaré himself cites Le Bon. Daniel Robbins noted the interest in "matter as energy and movement" among members of the Société Normande de Peinture Moderne (to which the Duchamp brothers belonged), citing specifically a lecture by the writer A. M. Gossez, author of the 1911 *Essai d'expansion d'une esthétique*, which discussed energy in terms of the "movement of rotating particles." See Fogg Art Museum, Cambridge, Mass., *Jacques Villon*, ed. Daniel Robbins (Jan. 17–Feb. 29, 1976), p. 17.

43. See n. 12 above.

44. Duchamp, as quoted in Sweeney, "Eleven Europeans," p. 19.

45. Duchamp, as quoted in Francis Roberts, "I Propose to Strain the Laws of Physics," *Art News* 67 (Dec. 1968), 46.

46. Duchamp, as quoted in Sweeney, "Eleven Europeans," p. 20. Duchamp's friend Salvador Dali interpreted the *Swift Nudes* painting in a similar fashion, declaring in a curious article of 1959 that the work revealed "the new intra-atomic structure of the universe, that is, the discontinuity of matter." Dali goes further, however, and relates the nudes to "the charged elementary particles of quantum physics," reflecting contemporary enthusiasm for that subject. See Salvador Dali, "The King and Queen Traversed by Swift Nudes," *Art News* 58 (Apr. 1959), 23.

47. See, e.g., Golding's description of the Bachelors as "two science-fiction male presences who point at the bridal figure a whole battery of upright phallic forms," which Golding compares to the fencing foils in Marey's well-known image of a lunging fencer (Golding, *Duchamp*, p. 41).

48. L. Poincaré, *New Physics*, p. 261. Although, in the end, the bombarding particles were electrons and not the gas molecules in a "fourth state of matter" that Crookes proposed, his experiments were highly influential: J. J. Thomson himself expressed his indebtedness to Crookes's "beautiful experiments on cathode rays" (Thomson, *Recollections and Reflections* [London: G. Bell, 1936], p. 91). On the debate over cathode rays, see Keller, *Infancy*, chap. 3.

49. See, e.g., Charles-Edouard Guillaume, *Les Rayons X et la photographie à travers les corps opaques,* 2d ed. (Paris: Gauthier-Villars, 1896), pp. 43–48; and Aubert, *Photographie de l'invisible*, pp. 27–39.

50. "La Photographie de l'invisible" (editor's note), *Revue Générale des Sciences Pures et Appliquées* 7 (Jan. 30, 1896), 50. See also Lodge, "On Electrons," pp. 16–17.

51. Dastre, "Les Nouvelles Radiations," p. 694.

52. Georges Bohn, "Le Mouvement scientifique," *Mercure de France* 68 (July 1, 1907), 140.

53. See chap. 4 and the Tesla section of the bibliography for documentation of the widespread coverage of his ideas and activities.

54. See J. d'Ault, "Les Merveilles Electriques de M. Tesla," *La Revue des Revues* 13 (May 1, 1895), 207; and, e.g., Joseph Wetzler, "Electric Lamps Fed from Space and Flames That Do Not Consume," *Harper's Weekly* 35 (July 11, 1891), 524. Tesla himself also talked of electric "flames" in his lectures of 1891–92 (see chap. 4, n. 47 and the related text).

55. See, e.g., Silvanus P. Thompson, *Leçons Elémentaires d'Electricité et de magnétisme*, trans. L. Binet (Paris: J. Fritsch, 1898), lesson 24. Thompson was a friend of Lodge and the other British "Maxwellians." For the English version of his text, see *Elementary Lessons in Electricity and Magnetism* (London: Macmillan, 1881; rev. ed., New York: Macmillan, 1894), lesson 24.

56. For this term, see the book review of *Code des couleurs,* by Paul Klincksieck and Th. Valette, in *La Revue des Idées* 6 (July 1909), 84.

57. See Jean Clair, "De quelques métaphores automobiles," *Revue de l'Art,* no. 77 (1987), p. 79, n. 9, where Clair cites a notation by David Gascoyne that Duchamp had "attentively read" Revel's book (information courtesy of Jacqueline Monnier, daughter of Mme Duchamp). See P[ierre] Camille Revel, *Le Hasard, sa loi et ses conséquences dans les sciences et en philosophie, suivi d'un essai sur La Métempsychose, basée sur les principes de la biologie et du magnétisme physiologique* (Paris: Bibliothèque Chacornac/H. Durville, 1909). Chacornac was the publisher of numerous editions of Rochas's books after 1900; Hector Durville was the publisher of the *Journal du Magnétisme* and a contributor, along with Papus, to *La Vie Mystérieuse*.

58. On Rochas, Reichenbach, emanations, and exteriorization, see Nandor Fodor, *Encyclopaedia of Psychic Science,* with a preface by Sir Oliver Lodge (London: Arthurs Press, 1933). On Animal Magnetism, as originally developed by Franz Anton Mesmer and modified by Reichenbach and others, see Thomas Hardy Leahey and Grace Evans Leahey, *Psychology's Occult Doubles: Psychology and the Problem of Pseudoscience* (Chicago: Nelson-Hall, 1983), pt. 2, chap. 5. During the first decade of the twentieth century in France, Magnetism was still practiced fairly widely and had not yet fallen into disrepute.

59. Rochas, *L'Extériorisation* (1909), pp. 39, 42.

60. Thompson, *Leçons Elémentaires* and *Elementary Lessons*, lesson 16, sec. 198. See also Claude, *L'Electricité*, pp. 160–64.

61. E.g., in *Les Etats profonds de l'hypnose* (1892; 3d ed., Paris: Chamuel, 1896), Rochas quotes extensively from Lodge's 1891 address before the Mathematical and Physical Science section of the British Association for the Advancement of Science (pp. 111–17) in his argument for the "science of Od" (p. 117). Rochas himself had published in the *Revue Scientifique*: Rochas and X. Darieux, "Pourquoi les rayons de Röntgen sont invisibles," *Revue Scientifique*, 4th ser., 5 (Feb. 22, 1896), 282. As noted in chap. 1, n. 33, Rochas's work was frequently cited in the popular literature on X-rays.

62. On Rochas's relevance for Kupka's interest in wireless telegraphy and telepathy, see Henderson, "Kupka, les rayons X," pp. 53–55, as well as chap. 8. The activities of Rochas were well known to the readers of *La Vie Mystérieuse*; see, e.g., Gabrielle Delanne, "Le Spiritisme est une science," *La Vie Mystérieuse,* no. 79 (Apr. 10, 1912), p. 485. Mercereau had also cited the works of Rochas in his *La Littérature et les idées nouvelles* (Paris: Eugène Figuière, 1912), pp. 67–68.

63. Badash, *Radioactivity*, p. 9. For a history of radioactivity research, see Keller, *Infancy*, chaps. 5, 6.

64. Robert Kennedy Duncan, "The Whitherward of Matter," *Harper's Monthly* 116 (May 1908), 884. The number of articles listed under "Radioactivity" and "Radium" in the *Readers' Guide to Periodical Literature* for 1900–4 increases dramatically in 1903 during what Keller has termed the "springtime of radium" (*Infancy*, p. 106). By the period 1905–9, the *Readers' Guide* lists sixty-six articles under "Radioactivity" and eighty-two under "Radium." In *Nuclear Fear: A History of Images* (Cambridge: Harvard University Press, 1988), Spencer Weart provides an excellent discussion

of early conceptions of radioactivity as the key to a new Garden of Eden, a golden age of limitless energy and prosperity (pt. 1, chap. 1).

65. In contrast to X-ray research, for which the necessary equipment was readily and cheaply available, radioactivity research was initially far more difficult to replicate because of the scarcity and expense of radium and other radioactive elements. On the Curies' early monopoly on the supply of radium, see Badash, *Radioactivity*, pp. 23–24.

66. On the importance of Crookes's invention as a demonstration of the reality of phenomena at the atomic scale, see Keller, *Infancy*, pp. 103–4, 140.

67. On the popular manifestations of radium, see Badash, "Radium, Radioactivity, and the Popularity of Scientific Discovery," *Proceedings of the American Philosophical Society* 122 (June 1978), 145–54; on its dangers, see Caufield, *Multiple Exposures*. For a typical contemporary discussion of radium and phosphorescence, see Duncan, *New Knowledge*, pp. 97–98.

68. In addition to major articles on the subject, such as Bohn's "Le Radium et la radio-activité de la matière," *La Revue des Idées,* in its "Notes et analyses" section, regularly summarized research reported in the *Comtes-rendus de l'Académie des Sciences* and other sources, including the British journal *Nature*. An homage to Pierre Curie, who had recently died in a traffic accident, appeared in 3 (May 15, 1906), pp. 337–45.

After 1903, the French would gradually lose their position at the forefront of international radioactivity research as a result of the important discoveries made by Rutherford and other British scientists (Keller, *Infancy*, p. 134). That situation, however, was not clear to contemporary advocates of French science. On the contrast between the French and British approaches, see Marjorie Malley, "The Discovery of Atomic Transmutation: Scientific Styles and Philosophies in France and Britain," *Isis* 70 (June 1979), 213–23.

69. Péladan, "Le Radium et l'hyperphysique," *Mercure de France* 50 (June 1904), 609.

70. Ibid., p. 622. Péladan's belief in human radioactivity was not unusual in this period. See, e.g., Raphael Dubois, "La Radio-activité et la vie" (*La Revue des Idées* 1 [May 15, 1904], pp. 338–48), which offers interesting parallels to Péladan's views.

71. See Malley, "Discovery of Atomic Transmutation"; and Lawrence Badash, "How the 'Newer Alchemy' Was Received," *Scientific American* 215 (Aug. 1966), 88–95. On these developments, see also Keller, *Infancy*, chap. 6.

72. Badash, "Newer Alchemy," p. 91.

73. Wilson, *Rutherford*, pp. 158, 581. See, e.g., Ernest Rutherford, "Disintegration of the Radioactive Elements," *Harper's Monthly* 108 (Jan. 1904), 279–84.

74. See Frederick Soddy, *The Interpretation of Radium (Being the Substance of Six Free Popular Lectures Delivered at the University of Glasgow, 1908)* (London: John Murray, 1909). Soddy's propagandizing for radioactivity and alchemy is reflected in numerous popular articles such as "The Garden

of Eden in the Light of the New Physics," *Current Literature* 47 (July 1909), 91–92. The first chapters of Weart's *Nuclear Fear* provide an excellent discussion of Soddy in context, including his role as a source for H. G. Wells's *The World Set Free: A Story of Mankind* (1913; New York: E. P. Dutton, 1914). Wells's book, which forecasts the "tapping [of] the internal energy of atoms" as early as 1933 (p. 40) and the possibility of atomic warfare, is dedicated "to Frederick Soddy's *Interpretation of Radium*."

75. Ramsay himself became another important popularizer of the transformational view and, like Rutherford and Soddy, was cited regularly in French periodicals. On Ramsay, see Badash, *Radioactivity*, p. 29 and throughout. These events also converted the Curies to the transmutation hypthesis, which they had resisted in favor of a thermodynamic model. See Malley, "Discovery of Atomic Transmutation."

76. In 1908 Rutherford earned the Nobel Prize for this discovery, though in chemistry rather than in physics (Keller, *Infancy*, p. 137).

77. Crookes's name appears repeatedly throughout *L'Evolution de la matière*; for Lockyer, see p. 289; for Berthelot, see, e.g., pp. 60, 76, 214, 220, 252–53, 259.

78. H. Carrington Bolton, "The Revival of Alchemy," *Annual Report of the Smithsonian Institution, 1897* (Washington, D.C.: G.P.O., 1898), pp. 207–17. *Mercure de France* (1 [Oct. 1890], 372–76) had published "La Théorie alchimiste au XIXᵉ siècle," by Edouard Dubus. Strindberg's "Introduction à une chimie unitaire" appeared in *Mercure de France* (15 [Oct. 1895], 15–36), followed the next month by an article by Jollivet Castelot entitled "L'Alchimie" (15 [Nov. 1895], 205–15). Although Jollivet Castelot's name is not well known today, he is familiar to Strindberg scholars because of Strindberg's contributions to Jollivet Castelot's periodicals and the correspondence between the two men. See, e.g., Michael Meyer, *Strindberg* (London: Secker & Warburg, 1985).

79. See A[imé] Porte du Trait des Ages, *F. Jollivet Castelot: L'Ecrivain—le poète—le philosophe* (Paris: Eugène Figuière, 1914).

80. See Gilbert Boudar and Pierre Caizergues, *Catalogue de la bibliothèque de Guillaume Apollinaire II* (Paris: Editions du Centre National de la Recherche Scientifique, 1987), p. 55.

81. As noted earlier, *Pan* had close ties to the Puteaux group through the original members of the group. See Stéphane, "Esotérisme et Théosophie," and the discussion in chap. 1, n. 60. Jollivet Castelot's *Sociologie et Fourierisme* (Paris: H. Daragon, 1908), which he serialized in *Les Nouveaux Horizons*, would surely have been of interest to former members of the Abbaye de Créteil circle, such as Gleizes and Mercereau.

82. Jollivet Castelot, "L'Alchimie," pp. 214–15. For the history of alchemy and its principles, see John Read, *Prelude to Chemistry: An Outline of Alchemy, Its Literature, and Relationships* (London: G. Bell, 1936). Jacques van Lennep provides a richly illustrated history of alchemical images in *Alchimie: Contribution à l'histoire de l'art alchimique*, 2d ed. rev. (Brussels: Crédit Communale de Belgique, 1985). For a concise

introduction to alchemy, its philosophical overtones, and its relevance for earlier artists, see Laurinda S. Dixon, *Alchemical Imagery in Bosch's Garden of Delights* (Ann Arbor: UMI Research Press, 1981). See also M. E. Warlick, "Max Ernst's Collage Novel, *Une Semaine de bonté*: Feuilleton Sources and Alchemical Interpretation" (Ph.D. diss., University of Maryland, 1984), who also discusses alchemical practice in France in the late nineteenth and early twentieth centuries. For alchemy as treated in the history of chemistry, see H. Stanley Redgrove, *Alchemy: Ancient and Modern* (1911; 2d ed. rev., London: William Rider, 1922) and Floyd L. Darrow, *The Story of Chemistry* (Indianapolis: Bobbs-Merrill, 1927).

83. Jollivet Castelot, "L'Alchimie," p. 207.

84. This idea, expressed in the 1895 article, is one of the mottos quoted on the title page and cover of Jollivet Castelot's *La Synthèse d'or*. Jollivet Castelot dedicated *La Synthèse d'or* to Marcellin Berthelot, who was a professor of chemistry at the Collège de France (as well as a minister of state for a time) and had written a number of texts on the history of alchemy before his death in 1907. See, e.g., Marcellin Berthelot, *Les Origines de l'alchimie* (Paris: Georges Steinheil, 1885). Berthelot's writings were also a source for Soddy (Weart, *Nuclear Fear*, pp. 7, 16).

85. Jollivet Castelot, "L'Alchimie," p. 208. On Crookes's radiant matter, see chap. 4, n. 11 and the related text.

86. Jollivet Castelot, "L'Alchimie," p. 209. For Lodge's early discussions of the ether, see his *Les Théories modernes de l'électricité: Essai d'une théorie nouvelle* (Paris: Gauthier-Villars, 1891). That book had been published as *Modern Views of Electricity* (London: Macmillan, 1889) and was augmented in two further editions of 1892 and 1907.

87. See, e.g., Joseph Hornor Coates, "The Renaissance of the Alchemists," *North American Review* 183 (July 1906), 93. See also the review of six books, from Berthelot's *Les Origines de l'alchimie* (1885) to Rutherford's *Radio-active Transformations* (1906), published as "The Old and the New Alchemy," *Edinburgh Review* 205 (Jan. 1907), 28–47.

88. William Crookes, "The Genesis of the Elements," *Chemical News* 55 (Feb. 25, 1887), 83–88; 55 (Mar. 4, 1887), 95–99; on Crookes's theory in context, see Keller, *Infancy*, 13–15.

89. See Sir Norman Lockyer, *Inorganic Evolution as Studied by Spectrum Analysis* (London: Macmillan, 1900), which was translated by E. d'Hooghe as *L'Evolution inorganique* (Paris: Félix Alcan, 1905).

90. Jollivet Castelot, *La Synthèse d'or*, title page. See, e.g., Le Bon, *L'Evolution de la matière*, pp. 288–92. In the 1890s Jollivet Castelot had published *La Vie et l'âme de la matière: Essai de physiologie chimique* (Paris: Société des Editions Scientifiques, 1894) and *L'Hylozoïsme: L'Alchimie, les chimistes unitaires* (Paris: Chamuel, 1896).

91. In reading *Les Nouveaux Horizons*, one is struck by the intelligence of Jollivet Castelot and the journal as a whole, including his measured response to issues such as spirit phenomena. From Rutherford's *Radio-activity* (Cambridge: Cambridge University Press, 1904), Jollivet Castelot reprinted

sections 115–35, as translated by Emile Delobel.

92. In the course of *La Synthèse d'or,* Jollivet Castelot cites the work of the following scientists: Crookes, Mendeleeff, Le Bon, Lodge, Lockyer, Röntgen (all, p. 8 and later); Tesla (pp. 13, 30); Branly (p. 30); Poincaré, Ramsay (p. 36 and later); and Quinton, Le Dantec, Flammarion (p. 36).

93. Jollivet Castelot, *La Synthèse*, p. 39.

94. For authors who have dealt with the question of Duchamp and alchemy, see app. B. Ulf Linde and John Moffitt, following Linde's lead, have cited Albert Poisson's *Théories et symboles des alchimistes* (1891) as well as the presence of alchemical references in Gaston de Pawlowski's *Voyage au pays de la quatrième dimension* (1912), approaching Duchamp's contemporary context more closely than had previous writers. (See Linde, "L'Esotérique," in *OeuvreMD* [Paris], vol. 3, pp. 60–85; and Moffitt, "Marcel Duchamp: Alchemist of the Avant-Garde," in Los Angeles County Museum, *The Spiritual in Art: Abstract Painting, 1890–1985* [Nov. 23–Mar. 8, 1987], pp. 257–69.) However, the issue of radioactivity, the dominant association for alchemy in the pre–World War I period, has never been discussed by any of the writers on this subject. Instead, the approach of Moffitt and a number of others has been to treat alchemy as the single key to the *Large Glass* (and even to all of Duchamp's oeuvre), establishing no stronger connection than simply visual or verbal similarities between "ancient" alchemical texts and Duchamp's works or notes. For further comments on the issue of Duchamp and alchemy, consult app. B, "A Note on the Construction of Duchamp as Alchemist," as well as the index.

95. Guy de Chanac, "L'Alchimie au Moyen-Age," *La Vie Mystérieuse*, no. 87 (Aug. 10, 1912), p. 616.

96. Duncan, *New Knowledge*, p. 149.

97. At this stage Duchamp had not yet conceived the notion of a work on glass, and the drawing suggests how Duchamp might have treated this theme in a painting on canvas.

98. See Schwarz, *Complete Works*, pl. 37 and p. 93; see also Schwarz, "Alchemist Stripped Bare," in *Duchamp* (Philadelphia), pp. 84–86. In Schwarz's view, *Young Man and Girl in Spring*, which Duchamp gave to his sister Suzanne as a wedding gift, is a manifestation of the supposed incestuous desire central to his Freudian interpretation of Duchamp. Although Schwarz's highly personal, psychoanalytical reading of Duchamp (with its equally strong Jungian overtones) has found little acceptance, the possible parallel of this work to alchemical imagery, which was itself filled with images of chemical marriage and sexuality, need not be rejected completely. For Naumann's alternative, nonalchemical reading of this work, see Francis M. Naumann, *The Mary and William Sisler Collection* (New York: Museum of Modern Art, 1984), pp. 138–39; Naumann, "Marcel Duchamp: A Reconciliation of Opposites," in *Marcel Duchamp*, ed. Kuenzli and Naumann, pp. 24–25; and Naumann, "Marcel Duchamp: A Reconciliation of Opposites," in *Definitively Unfinished Duchamp*, ed. de Duve, pp. 46–47. The discussion following Naumann's talk at the conference, published in *Definitively Unfinished Duchamp*, included the most recent debate on the subject of Duchamp

and alchemy (pp. 70–76) and, particularly, the question of Duchamp's use of the phrase "metaux voisins." On Duchamp and "neighboring metals," see chap. 11, n. 172.

99. Jollivet Castelot, "L'Alchimie," p. 214.

100. See Moffitt, "Marcel Duchamp: Alchemist of the Avant-Garde," p. 266. On the mysterious Valentin, whose first published writings appeared in 1599, see, e.g., Read, *Prelude to Chemistry*, chap. 5; and Van Lennep, *Alchimie*, pp. 195–203.

101. Jollivet Castelot, *La Synthèse*, p. 10. Moffitt has recently highlighted Jollivet Castelot's 1897 treatise *Comment on devient alchimiste* in a useful article chronicling alchemical holdings at the Bibliothèque Sainte-Geneviève: John F. Moffitt, "Fin-de-Siècle Paris Hermeticism: Hermetic and Alchemical Publications at the Bibliothèque Sainte-Geneviève," *Cauda Pavonis*, n.s., 14 (Fall 1995), 10–15.

102. Frère Basile Valentin, *Les Douze Clefs de la philosophie*, trans. and introd. Eugène Canseliet (Paris: Editions de Minuit, 1956), pp. 116–17. The first French edition of Valentin's text was published in Paris in 1624 by J. & C. Périer; subsequent publications of the text included an 1899 edition by Chamuel. For Moffitt's differing translation, based on a German version of Valentin's text, see "Marcel Duchamp," p. 266.

103. Valentin, "Clef II," facing p. 110; see also Moffitt, "Marcel Duchamp," p. 266.

104. Albert Poisson, *Théories et symboles des alchimistes* (Paris: Bibliothèque Chacornac, 1891), p. 110.

105. In the context of his alchemical interpretation of Duchamp's art in *Complete Works*, Schwarz argues for an essential connection between the kings and queens of chess and of alchemy, as well as their earlier incarnations in paintings such as the Adam and Eve of the 1910–11 *Paradise* (pp. 10–11).

106. Jollivet Castelot, *La Synthèse*, pp. 6–7.

107. Ibid., pp. 5–6. On Ramsay's activities in this area, see Sir William A. Tilden, *Sir William Ramsay: Memorials of His Life and Work* (London; Macmillan, 1918), chap. 6. See also "La Transmutation des Eléments chimiques," *Les Nouveaux Horizons de la science et de la pensée* 12 (Nov. 1907), 375.

108. Frederick Soddy, "The Energy of Radium," *Harper's Monthly* 120 (Dec. 1909), 54. On Rutherford's experiments, see Wilson, *Rutherford*, chap. 10.

109. Duchamp, as quoted by Lebel, in *Formes de l'art: L'Art magique*, ed. André Breton and Gérard Legrand (Paris: Club Français de l'Art, 1957), p. 98; and in Lebel, *Marcel Duchamp*, p. 73.

110. Duchamp confirmed to Steefel that alchemy was indeed "in the air" in the early years of the century (Steefel, *Position of Duchamp's "Glass"*, p. 38). On Kupka, see chap. 1 above. For Apollinaire's esoteric interests, see, e.g., Samaltanos, *Apollinaire*, pp. 81–83. Samaltanos notes that Apollinaire reviewed Marc Haven's reedition of the major alchemical text, *Mutus Liber*, in *Paris-Journal*, July 17, 1914 (p. 83). As noted in chap. 1 (nn. 33, 97), Apollinaire owned a number of occult books and periodicals, including books by Jollivet Castelot's colleague, Papus, and issues of *Les Nouveaux Hori-*

zons. See Boudar and Décaudin, *Catalogue de la bibliothèque de Guillaume Apollinaire* (books), and Boudar and Caizergues, *Catalogue . . . II* (periodicals).

111. Péladan, "Le Radium," p. 627.

112. André Beaunier, "Les Salons de 1908," *Gazette des Beaux-Arts*, 3d ser., 40 (July 1, 1908), 68.

113. Bohn, "Le Radium," pp. 9–10.

114. The two terms, however, actually derive from different roots. See chap. 3, n. 62 and the related text, for further discussion of the association of magnetism and sexual attraction.

115. Richard Hamilton describes Duchamp's theme in *Passage* as "metaphysical change" rather than as spatial movement ("The *Large Glass*," in *Duchamp* [Philadelphia], pp. 58–59).

116. See, e.g., K. G. Pontus Hultén, in Museum of Modern Art, New York, *The Machine As Seen at the End of the Mechanical Age* (1968), p. 77.

117. *GB*, in *SS*, p. 42.

118. On the *arbre* in automobiles, as well as its probable presence in the *Virgin (No. 1)* drawing, see the discussion of Duchamp's Jura-Paris Road project in chap. 3. Duchamp's use of the term *arbre* has been compared, for instance, to the "Tree of Life" (Schwarz, *Complete Works*, pp. 92–94), the "Philosophical Tree" of alchemy (Maurizio Calvesi, *Duchamp invisible: La Costruzione del simbolo* [Rome: Officina Edizione, 1975], pp. 100–105), and the "Tree of Knowledge" of the Kaballah (Jack Burnham, "Duchamp's Bride Stripped Bare," *Arts Magazine* 46 (Apr. 1972), 28–32. Octavio Paz has also treated Duchamp and trees, focusing specifically on the myth of Diana (*Marcel Duchamp*, pp. 124–25).

119. See *GB*, in *SS*, pp. 39–44. These notes are analyzed in chap. 7.

120. On airplane construction in this period, see, e.g., Paul Renard, *Le Vol mécanique: Les Aéroplanes* (Paris: Ernest Flammarion, 1912). See also "Novelties at the Paris Air Show," *Scientific American Supplement* 74 (Nov. 30, 1912), 344–47; 74 (Dec. 7, 1912), 360–63; and 74 (Dec. 14, 1912), 372–74.

121. The concept of the center of gravity was to figure importantly in Duchamp's ideas about the Juggler/Handler of Gravity in the *Large Glass*, as discussed in chap. 11.

122. *A L'INF*, in *SS*, p. 78.

123. See *MDN*, note 144 (app. A, no. 14/15).

124. This issue is addressed further in the context of a more detailed consideration of the Bride's "anatomy" early in chap. 7.

125. *GB*, in *SS*, p. 71.

Chapter 3: From Painter to Engineer, I

1. Duchamp, "Apropos of Myself," p. 10.

2. Duchamp, as quoted in Roberts, "I Propose," p. 46.

3. See Duchamp's statement quoted at n. 14 below, as well as the discussion of the *3 Standard Stoppages* and the Ready-mades in chap. 5.

4. Although earlier dates have usually been given for the

conclusion of Duchamp's employment, a letter of January 19, 1915, from Duchamp to Walter Pach confirms that he was still employed at that time. Writing on Bibliothèque Sainte-Geneviève stationery, Duchamp reports on the wartime situation: "I am writing you from the library, where life is even longer than in peace time. This tells you how little there is to do." See Francis M. Naumann, "Amicalement, Marcel: Fourteen Letters from Marcel Duchamp to Walter Pach," *Archives of American Art Journal* 29, nos. 3–4 (1989), 38.

5. Duchamp, as quoted in Cabanne, *Dialogues*, p. 59.

6. *GB,* in *SS,* p. 71.

7. Duchamp, as quoted in Kuh, *Artist's Voice,* p. 83, and Roberts, "I Propose," p. 65.

8. Duchamp, as quoted in Roberts, "I Propose," p. 64.

9. Levy, as quoted in Schwarz, *Complete Works,* p. 66; also quoted in Calvin Tomkins, *The Bride and the Bachelors: Five Masters of the Avant-Garde* (New York: Viking, 1972), pp. 51–52.

10. This has generally been true of the literature on Picabia as well, beginning with William Camfield's "The Machinist Style of Francis Picabia," *Art Bulletin* 48 (Sept.–Dec. 1966), 309–22. Camfield's monograph on Picabia, however, also takes note of more purely scientific sources for certain of his images (e.g., figs. 140, 230), and the present volume further establishes that Picabia eagerly accompanied Duchamp into this new realm of visual imagery.

11. Duchamp, as quoted in Cabanne, *Dialogues*, p. 31.

12. See Molly Nesbit, "The Language of Industry," in *Definitively Unfinished Duchamp*, ed. de Duve, pp. 351–84. Nesbit notes that Duchamp preserved his schoolboy drawing manual, Eugene Forel's *Guide pratique de dessin et de perspective à l'usage des instituteurs, des institutrices et spéciale-ment des aspirants et aspirantes aux brevets de capacité* (1897) (see ibid., pp. 372, 383, n. 24). Nesbit's essay examines the history of French drawing education and its establishment of mechanical drawing and projection (the *géométral*) as a "preaesthetic language" that, in contrast to perspective drawing, was accessible almost solely to male students. An earlier version of this study appeared as "Ready-Made Originals: The Duchamp Model," *October* 37 (Summer 1986), 53–64.

13. Duchamp, as quoted in Cabanne, *Dialogues*, p. 37.

14. Duchamp, as quoted in Sweeney, "A Conversation with Marcel Duchamp," NBC television interview, January 1956; edited and reprinted in *SS,* pp. 130, 134.

15. See Henry, *Rayons Röntgen*, pp. 32–34. Such "interrupters" were used to break the electrical circuit of the primary coil of an induction apparatus in order to induce a reverse current in the secondary coil.

16. Duchamp, as quoted in Sweeney, "Conversation," in *SS,* p. 129. Duchamp's manipulation of paint with his fingers represents an alternative to a painter's "touch" with a brush, as analyzed, for example, by Richard Shiff in his application of C. S. Peirce's notion of the "index" to the practice of painting. See Shiff, "Performing an Appearance: On the Surface of Abstract Expressionism," in Albright-Knox Art Gallery, Buffalo, *Abstract Expressionism: The Critical Developments,* ed.

Michael Auping (Sept. 19–Nov. 29, 1987); New York: Harry N. Abrams, 1987), pp. 94–123. Because "touch" to Duchamp also meant the stroke of a brush, his fingers ironically became an impersonal tool for eradicating brush strokes. Other aspects of Peirce's notion of indexicality, which prove to be highly relevant to the *Large Glass*, are discussed in chap. 8.

17. Although this particular comparison has not been made, Duchamp's work has been discussed in relation to couture in Olivier Micha, "Duchamp et la couture," *OeuvreMD* (Paris), vol. 3, 33–34.

18. *A L'INF,* in *SS,* p. 83; see also *GB,* in *SS,* p. 44.

19. Duchamp, as quoted in Sweeney, "Eleven Europeans," p. 20.

20. Apollinaire, "The Renaissance in the Decorative Arts," *L'Intransigeant,* June 6, 1912; in *Apollinaire on Art,* ed. Breunig, p. 241.

21. See chap. 2, n. 16.

22. Duchamp, as quoted in Sweeney, "Eleven Europeans," p. 21.

23. *GB,* in *SS,* pp. 26–27; *MDN,* notes 109, 110, 111.

24. As noted in chap. 2, Apollinaire completed his *Les Peintres Cubistes* text on Duchamp in fall 1912, in which he specifically mentioned Blériot's plane being carried to the Arts et Métiers.

25. For an overview of various artistic responses to the machine, including those of the Futurists and Duchamp, see Museum of Modern Art, *The Machine As Seen at the End of the Mechanical Age.* One of the most concise and perceptive considerations of Duchamp and the machine to date occurs in Steefel, *Position of Duchamp's "Glass,"* pp. 28–44. See also Steefel's later essay, "Marcel Duchamp and the Machine," in *Duchamp* (Philadelphia), pp. 69–80. For an initial consideration of the issue of gender and human-machine analogies, with a focus on Picabia's art, see Caroline A. Jones, "The Sex of the Machine: Mechanomorphic Art, New Women, and Francis Picabia's Neurasthenic Cure," in *Picturing Science, Producing Art,* ed. Caroline A. Jones and Peter Galison (London: Routledge, 1998).

26. Duchamp-Villon, as quoted in Walter Pach, *Queer Thing, Painting: Forty Years in the World of Art* (New York: Harper & Bros., 1938), p. 19.

27. On Duchamp-Villon's *Horse,* see William Agee, *Raymond Duchamp-Villon, 1876–1918,* introd. George Heard Hamilton (New York: Walker, 1967), pp. 86–103. Jacques Villon had depicted large-scale machinery in his paintings of 1913–14 on the theme of "L'Atelier du mécanique." See Fogg Art Museum, *Jacques Villon,* p. 79.

28. Duchamp, as quoted in Sweeney, "Eleven Europeans," p. 20.

29. For a brief overview of this subject, see, e.g., the introductory essay by Pontus Hultén in Museum of Modern Art, *The Machine,* pp. 6–13. For a fuller treatment of this history, see David F. Channell, *The Vital Machine: A Study of Technology and Organic Life* (Oxford: Oxford University Press, 1991). On automatons, see especially John Cohen, *Human Robots in Myth and Science* (London: George Allen and Unwin, 1966); and the essays in the section titled "L'Homme

machine," in *L'Ame au corps*, ed. Clair. See also several relevant essays in Jonathan Crary and Sanford Kwinter, eds., *Incorporations* (New York: Zone, 1992).

In *Les Machines célibataires* (Paris: Arcanes, 1954), Michel Carrouges recast Duchamp's "Bachelor Apparatus" or "machine célibataire" in terms of death as well as sex, as he developed the concept in relation to the work of a number of authors, including Jarry, Roussel, and Kafka. That view, rooted in Carrouges's Surrealist milieu, was embraced and extended by Harald Szeemann for his exhibition and collection of essays *Junggesellenmaschinen/Les Machines célibataires* (Venice: Alfieri, 1975), which also included texts by Carrouges (pp. 21–49). Robert Lebel strongly criticized Szeemann's project in his *Marcel Duchamp* (Paris: Pierre Belfond, 1985), pp. 177–82. For Duchamp's response to Carrouges's mythologizing of his Bachelor Apparatus, see chap. 12 at n. 132 below.

30. See chap. 1, n. 72, as well as the catalogue for "L. Lambert, Fabrique de jouets artistiques," reproduced in Christian Bailly, *L'Age d'or des automates, 1848–1914* (Paris: Editions Scala, 1987), pp. 35–51. For the documentation of automatons in the collection of the Musée des Arts et Métiers, see chap. 7, n. 70.

31. See, e.g., Günter Metken, "De l'homme-machine à la machine-homme: Anthropomorphie de la machine au XIXe siècle," in Szeemann, ed., *Junggesellenmaschinen*, pp. 50–63.

32. Maurice Maeterlinck, "En automobile," in *Le Double Jardin* (Paris: Eugène Fasquelle, 1904); quoted in Clair, "De quelques métaphores automobiles," *Revue de l'Art*, no. 77 (1987), 77. Clair's brief article (pp. 77–79) treats the Maeterlinck text as well as a 1926 book, *La Machine humaine enseignée par la machine animale*, by Dr. Chauvois, which documents how well established such human-machine comparisons had become.

33. Octave Mirbeau, *La 628–E8* (Paris: Charpentier, 1907); quoted in Gerald Silk, "Futurism and the Automobile" (1985), in *Twentieth Century Art Theory: Urbanism, Politics, and Mass Culture*, ed. Richard Hertz and Norman M. Klein (Englewood Cliffs, N.J.: Prentice Hall, 1990), p. 37.

34. See Silk, "Futurism and the Automobile," p. 38.

35. Marinetti, "Founding and Manifesto of Futurism," in *Futurist Manifestos*, ed. Apollonio, p. 20.

36. Marinetti, "Multiplied Man and the Reign of the Machine" (1911–15), in *Marinetti: Selected Writings*, ed. Flint, p. 91. See Silk, "Futurism and the Automobile," for a discussion of Marinetti's views.

37. Marinetti knew Jarry in the early years of the century and published certain of his works in *Poesia*. See Keith Beaumont, *Alfred Jarry: A Critical and Biographical Study* (New York: St. Martin's, 1984), pp. 262–63.

38. See Villiers de l'Isle-Adam, *L'Eve future* (1886; Paris: Jean-Jacques Pauvert, 1960), as well as the section of chap. 7 entitled "The Bride as a Modern Automaton Descended from Villiers's *L'Eve future*." Linda Stillman has discussed the artificial beings created by Jarry, Villiers, and Albert Robida, in "Le Vivant et l'artificiel: Jarry, Villiers de l'Isle Adam, Robida," in *Jarry et Cie: Communications du Colloque International*, ed.

Henri Behar and Brunella Eruli (Tournées: L'Etoile-Absinthe, 1985), pp. 107–16.

39. See A[lbert] Robida, *Le Vingtième Siècle* (Paris: Montgredien, 1883); and *Le Vingtième Siècle: La Vie électrique* (Paris: Librairie Illustrée, 1890). For an overview of Robida's work, see *Robida: Fantastique et science-fiction*, with a preface by Philippe Brun (Paris: Pierre Horay, 1980). I am grateful to Jim Housefield, a former University of Texas graduate student, for bringing Robida's image to my attention.

40. For Matisse's article, see chap. 2, n. 29 and the related text.

41. Gaston de Pawlowski, *Voyage au pays de la quatrième dimension* (Paris: Eugène Fasquelle, 1912), p. 241; rev. ed. (1923; Paris: Denoël, 1971), p. 209. Certain chapters of Pawlowski's text were first serialized in *Comoedia*, the newspaper he edited, during late 1908–10 and 1912, before their publication in book form in December 1912. Jean Clair and I (see my 1975 Yale dissertation, "The Artist, 'The Fourth Dimension,' and Non-Euclidean Geometry in Modern Art 1900–1930: A Romance of Many Dimensions") simultaneously and independently identified Pawlowski as the "Povolowski" to whom Duchamp referred in his interview with Cabanne (*Dialogues*, p. 39). On Pawlowski, see, e.g., Henderson, *Fourth Dimension*, pp. 51–57, 119–20, and Jean Clair, *Marcel Duchamp, ou le grand fictif* (Paris: Editions Galilée, 1975), which addresses a range of issues other than the fourth dimension as well. For a critique of certain of Clair's comparisons (owing to his use of the 1923 edition of Pawlowski's text as well as the timing of certain *Comoedia* installments), see Henderson, *Fourth Dimension*, pp. 119, n. 7, pp. 128–29, n. 33. In particular, Clair's comparison of Duchamp's August 1912 *Bride* to Pawlowski's discussion of bodies being turned inside out in the first stages of the revelation of the fourth dimension is problematic, since this chapter of *Voyage*, "Au-delà des forces naturelles," did not appear in *Comoedia* until November 11, 1912. See Henderson, *Fourth Dimension*, p. 128, n. 33.

42. Pawlowski, *Voyage* (1912), pp. 244–45; *Voyage* (1971), p. 209; also quoted in Clair, *Grand Fictif*, p. 100. This chapter of Pawlowski's novel, entitled "Le Massacre des homuncules," appeared in *Comoedia* on December 3, 1912.

43. Pawlowski, *Voyage* (1912), p.. 245; *Voyage* (1971), p. 209.

44. Pawlowski, *Voyage* (1912), p. 195; *Voyage* (1971), p. 176. This chapter, "Les Surhommes," was not among those serialized in *Comoedia* before the December 1912 publication of *Voyage* in book form. Pawlowski was versed in contemporary science and technology; his use of themes from electromagnetism is discussed in chap. 8.

45. Bergson's text, which was in its 10th edition by 1913, had been published as *Le Rire: Essai sur la signification du comique* (Paris: Félix Alcan, 1900). For these two statements, see Henri Bergson, *Laughter: An Essay on the Meaning of the Comic*, trans. Cloudesley Brereton and Fred Rothwell (New York: Macmillan, 1911), pp. 29, 31. Marcel Jean noted in passing the relevance of *Le Rire* for Duchamp in his 1959 *History of Surrealist Painting*, trans. Simon Watson Taylor (New York:

Grove Press, 1960), p. 98, as have Virginia Spate (*Orphism: The Evolution of Non-Figurative Painting in Paris, 1910–1914* [Oxford: Clarendon Press, 1979], p. 338) and several subsequent scholars, including Ivor Davies in "Reflections on the *Large Glass*: The Most Logical Sources for Marcel Duchamp's Irrational Work," *Art History* 2 (Mar. 1979), 84–94. None of these authors, however, considers Duchamp's relation to Bergson in the larger context of Puteaux Cubism, as does the present work.

46. Bergson, *Laughter*, p. 84.

47. *GB*, in *SS*, p. 30; *MDN*, note 77 (app. A, no. 2), note 68.

48. Bergson, *Laughter*, p. 130.

49. See, e.g., the discussion in chap. 5 at n. 64 and following, as well as Antliff, "Bergson and Cubism" and *Inventing Bergson*, chap. 2.

50. On Bergson's antimechanist view, as extended to science as a whole, see Nye, "Gustave Le Bon's Black Light," pp. 164–69. For a contemporary discussion of mechanism and vitalism, see John Theodore Merz, *A History of European Thought in the Nineteenth Century*, 4 vols. (Edinburgh: William Blackwood, 1903–14), vol. 2, chap. 10. Jack Burnham addresses the mechanist-vitalist debate and Bergson's role in it in *Beyond Modern Sculpture: The Effects of Science and Technology on the Sculpture of This Century* (New York: George Braziller, 1968), pp. 56–68.

51. See Frizot, *Chronophotographie*, pp. 64–66. On Marey and the "mechanics of the body," see Anson Rabinbach, *The Human Motor: Energy, Fatigue, and the Origins of Modernity* (New York: Basic Books, 1990), chap. 4; and Braun, *Picturing Time*, chap. 2.

52. There were, however, variations in the degree of mechanism among physiologists, with Claude Bernard and his followers emphasizing that their objects of study were, after all, living organisms. On Marey's opposition to Bernard, see Rabinbach, *Human Motor*, pp. 90–92; and Dagognet, *Marey*, pp. 58–61. On the history of physiology, see Börje Uvnas, "The Rise of Physiology during the Nineteenth Century," in *Science, Technology and Society,* ed. Bernhard et al., pp. 135–45; see also Everett Mendelsohn, "The Biological Sciences in the Nineteenth Century: Some Problems and Sources," *History of Science* 3 (1964), 39–54.

53. Etienne-Jules Marey, *La Machine animale: Locomotion terrestre et aérienne* (Paris: Masson, 1873), as quoted in Rabinbach, *Human Motor*, p. 90. Such a view would ultimately lead to the development of the "science of work" as studied, for example, by Jules Amar, who applied principles of classical mechanics to the human body in his *Le Moteur humain et les bases du travail professionel* (Paris: H. Dunod et E. Pinat, 1914). On Amar, see Rabinbach, *Human Motor*, pp. 185–88, as well as chap. 10 below.

54. *A L'INF*, in *SS*, p. 85. For Solvay's comment, see Ernest Solvay, "Physico-chimie et psychologie," *Revue Générale des Sciences Pures et Appliquées* 20 (Dec. 30, 1909), 984. In this context one should also mention the text by Charles Henry's friend, Charles Cros, *Principe de mécanique cérébrale* (1879), noted by Marcel Jean for its reinterpretation of speech and

vision in mechanical terms (*History of Surrealist Painting*, p. 107).

55. Jacques Loeb, *The Mechanistic Conception of Life: Biological Essays* (Chicago: University of Chicago Press, 1912), p. 3.

56. Georges Bohn, "Le Mouvement scientifique," *Mercure de France* 71 (Jan. 1, 1908), 118–19. Loeb's theories were propounded in France by the biologists Yves Delage and Anna Drzewina, who published a number of articles (along with Loeb himself) in *La Revue des Idées* during the period 1908–12. See, e.g., Drzewina, "Néo-vitalistes et mécanistes," *La Revue des Idées* 9 (Apr. 1912), 215–19.

57. See Camfield, *Picabia*, figs. 100, 133.

58. On Galvani's experiments, see, e.g., Herbert W. Meyer, *A History of Electricity and Magnetism* (Cambridge: MIT Press, 1971), chap. 3. On Mesmer, see Robert Darnton, *Mesmerism and the End of the Enlightenment in France* (Cambridge: Harvard University Press, 1968) as well as Leahey and Leahey, *Psychology's Occult Doubles*, pt. 2, chap. 5. As discussed in chap. 2, in the hands of Reichenbach's disciple Rochas, Magnetism attained a new degree of "scientific" legitimacy in the context of late nineteenth-century electromagnetism.

59. August Strindberg, quoted in John L. Greenway, "Strindberg and Suggestion in Miss Julie," *South Atlantic Review* 51 (1986), 29. (A Leyden jar was the earliest form of an electrical condenser, which stored electrical charge in a manner different from that of a battery; on condensers, see chap. 8, n. 91, and the related text below.) On electric medicine and the battery metaphor, see John L. Greenway, "'Nervous Disease' and Electric Medicine," in *Pseudo-Science and Society in Nineteenth-Century America*, ed. Arthur Wrobel (Lexington: University Press of Kentucky, 1987), pp. 52–73. On electricity and the body, see also Carolyn Marvin, *When Old Technologies Were New: Thinking about Electric Communication in the Late Nineteenth Century* (New York: Oxford University Press, 1988), pp. 129–43; Asendorf, *Batteries of Life*, chap. 11; and Laura Bossi, "L'Ame électrique," in *L'Ame au corps*, ed. Clair, pp. 160–80.

60. Jules Romains, "Mais, au fond des corps, les cellules," in *La Vie unanime* (Paris: Abbaye de Créteil, 1908); quoted in Betsy Erkkila, *Walt Whitman among the French: Poet and Myth* (Princeton: Princeton University Press, 1980), p. 163. Erkkila discusses the importance of Whitman for Gleizes's Abbaye de Créteil circle, with which Marinetti, another enthusiast of Whitman and electricity (p. 176), had also been associated.

61. See Camille Flammarion, *Stella* (Paris: Ernest Flammarion, 1897), chap. 13, "L'Etincelle." On electricity and sexuality, see, e.g., Marvin, *When Old Technologies Were New*, p. 131; Marvin also remarks on the popularity of puns created with the new language of electricity (pp. 48–49), some of which were undoubtedly sexually oriented. The *Oxford English Dictionary* cites the usage of *spark* as "to engage in courtship" as early as the first decade of the nineteenth century. See *O.E.D.* (Oxford: Clarendon Press, 1989), s.v. "spark."

62. On Kircher and his publications, see Marc Fumaroli, "Histoire de la literature et histoire de l'électricité," in *L'Electricité dans l'histoire: Problèmes et méthodes*, ed. Fabienne Cardot (Paris: Presses Universitaires de France, 1985), pp. 229–30. Fumaroli's essay also addresses the importance of Kircher for Mesmer and for Villiers de l'Isle-Adam. Jean Clair has noted Kircher designs for water-powered musical automatons in relation to Duchamp in "Duchamp and the Classical Perspectivists," *Artforum* 16 (Mar. 1978), 44–45. Calvesi has discussed Kircher in the context of the hermetic tradition in "Duchamp and Learning," in *Duchamp* (Madrid), pp. 58–67.

63. Villiers, *L'Eve future*, p. 153. This phrase is mistranslated in *Tomorrow's Eve*, trans. Robert Martin Adams (Urbana: University of Illinois Press, 1982), p. 86.

64. D. Renaud, *Cours complet d'automobilisme* (Paris: Librairie R. Chapelot, 1909), pp. 1, 4 ("organes"), and 90 ("alimentation"). Paul Matisse has noted the appeal for Duchamp of such anthropomorphic-mechanical terms as *alimentation*; see his "Translator's Note" at the back of *MDN* (n.p.).

65. For the dating of this trip to about Oct. 20–26, see Camfield, *Picabia*, p. 34.

66. Gabrielle Buffet-Picabia, *Rencontres avec Picabia, Apollinaire, Cravan, Duchamp, Arp, Calder* (Paris: Pierre Belfond, 1977), p. 68. The well-to-do Picabia indulged his passion for automobiles with a succession of models over the years. See Camfield, *Picabia*, illus. 9, for photographs of a number of these cars, including the Peugeot he owned in 1911. For the presence of Picabia's chauffeur, Victor, on this trip, a previously unknown detail gleaned from interviews with Gabrielle Buffet-Picabia, see Gough-Cooper and Caumont, "Ephemerides," in *Duchamp* (Venice), entry for Oct. 26, 1912. This entry also reveals a previously unknown closeness between Duchamp and Gabrielle, including a meeting in the Jura predating the October trip.

67. Duchamp told William Camfield that he "wrote the 'Route Jura-Paris' during the winter" (letter to Camfield, Apr. 25, 1961, quoted in Camfield, "La Section d'Or" [M.A. thesis, Yale University, 1961], p. 143). On the role of humor in the interactions of the three friends, see, e.g., Samaltanos, *Apollinaire*, pp. 61–64.

68. *GB*, in *SS*, pp. 26–27.

69. Ibid., p. 27. Schwarz notes Duchamp's explanation in 1959 that "silex is a material used for making road beds." See *Notes and Projects for the Large Glass*, ed. Arturo Schwarz, trans. George Heard Hamilton, Cleve Gray, and Arturo Schwarz (London: Thames and Hudson, 1969), p. 36.

70. *MDN*, note 111.

71. See n. 42 above. As noted above, Pawlowski's chapter including this phrase appeared in *Comoedia* on Dec. 3, 1912, and later that month in the book version of *Voyage*, close to the time Duchamp was working on the Jura-Paris Road notes.

72. Cecilia Tichi illustrates this image (p. 279) and discusses human-machine analogies in America in *Shifting Gears: Technology, Literature, Culture in Modernist America* (Chapel Hill: University of North Carolina Press, 1987).

73. For a five-cylinder engine, see, e.g., Renaud, *Cours*

complet, p. 60. Jim Housefield first suggested this interpretation of Duchamp's term several years ago while a student in one of my Duchamp graduate seminars. On the presence of Picabia's chauffeur, see n. 66 above.

74. On nickel reflectors, see A. L. Dyke, *Dyke's Automobile and Gasoline Engine Encyclopedia*, 12th ed. (St. Louis: A. L. Dyke, 1920), p. 508. For the use of platinum electrodes for incandescent bulbs, see, e.g., Claude, *L'Electricité*, p. 114. Nickel and platinum were to remain favorite metals for Duchamp, and they reappear in his conception of the Bride with her "boughs frosted in nickel and platinum" (*GB*, in *SS*, p. 43). This connection of the Bride to electric lighting is discussed in chap. 9.

75. See "Automobile Electric Light Plant," *Scientific American* 103 (July 2, 1910), 6.

76. Harold Whiting Slauson, "Lights for the Automobile," *Outing Magazine* 59 (Oct. 1911), 118.

77. Quoted in Keller, *Infancy of Atomic Physics*, p. 33. Comets had achieved a new currency after spring 1910, when Halley's Comet had once again appeared.

78. *GB*, in *SS*, p. 27.

79. Linde, "MARiée CELibataire," in Galleria Schwarz, Milan, *Marcel Duchamp: Ready-mades, etc. (1913–1964)* (Paris: Le Terrain Vague, 1964), p. 44. Linde's discussion is the fullest treatment to date of the Jura-Paris Road project, but it, like virtually all others, was published before the additional notes were known.

80. Such a connection between speeding objects—cars and electrons—may have been at the root of Duchamp's series of "swift nude" works, beginning with *2 Personages and a Car* (fig. 25), as discussed at the beginning of chap. 2.

81. See *GB*, in *SS*, p. 26; and *MDN*, note 111, the note headed "Title."

82. *MDN*, note 110.

83. *MDN*, note 111.

84. *GB*, in *SS*, p. 26.

85. *MDN*, note 111.

86. *GB*, in *SS*, p. 26.

87. See, e.g., Ch. Vernon Boys, "Les Corps radio-actifs et la Queue des Comètes," *Revue Scientifique*, 4th ser., 20 (Oct. 10, 1903), pp. 449–59.

88. Buffet-Picabia, *Rencontres*, p. 71.

89. Guillaume Apollinaire, "Zone," in *Selected Writings of Guillaume Apollinaire*, trans. Roger Shattuck (New York: New Directions, 1971), p. 119. On Apollinaire's preoccupation with Christian themes, see, e.g., Scott Bates, *Guillaume Apollinaire*, rev. ed. (Boston: Twayne, 1989); and Julia Fagan-King, "United on the Threshold of the Twentieth-Century Mystical Ideal: Marie Laurencin's Integral Involvement with Guillaume Apollinaire and the Inmates of the Bateau Lavoir," *Art History* 11 (Mar. 1988), 88–114.

90. See Cecily Mackworth, *Guillaume Apollinaire and the Cubist Life* (New York: Horizon Press, 1963), p. 141; see also Fagan-King, "United on the Threshold," pp. 91, 110, n. 29.

91. Fagan-King, "United on the Threshold," pp. 90–91.

92. See *GB*, in *SS*, p. 42. These notes are discussed further

in chap. 7. Renaud's *Cours complet*, e.g., speaks not only of the "arbre de transmission" (pp. 61–74), but also of an "arbre villebrequin" (crankshaft, p. 29), "arbres de soupapes" (valves, p. 43), "arbre de commande" (p. 85), and "arbre moteur" (p. 116).

93. See *GB*, in *SS*, p. 42.

94. On the Tree of Jesse, see, e.g., Emile Mâle, *The Gothic Image: Religious Art in France of the Thirteenth Century* (1913), trans. Dora Nussey (New York: Harper & Row, 1958), pp. 165–66.

95. Hultén also notes Duchamp's avoidance of obvious mechanical parts and his preference for sciences such as chemistry (Museum of Modern Art, *The Machine*, p. 77).

96. See Camfield, *Picabia*, p. 84, fig. 110.

97. Automobile components figure prominently in many of Picabia's portraits. In addition to *De Zayas! De Zayas!* (Camfield, *Picabia*, fig. 109), see fig. 106, *Portrait of a Young Girl in the State of Nudity*, 1915, based on a spark plug; fig. 107, *Here, This Is Stieglitz*, 1915, in which a gearshift is grafted onto a camera; fig. 108, *The Saint of Saints*, 1915, centered on a Klaxon horn; fig. 169, *Child Carburetor*, 1919; as well as Camfield's discussions thereof. See also William I. Homer, "Picabia's 'Jeune fille américaine dans l'état de nudité' and Her Friends," *Art Bulletin* 57 (Mar. 1975), 110–15.

98. Duchamp, as quoted in Sweeney, "Conversation," in *SS*, p. 136.

Chapter 4: The Lure of Science

1. Roger Shattuck and Simon Watson Taylor, eds., *Selected Works of Alfred Jarry* (New York: Grove, 1965), p. 17.

2. J. E. Emerson, "Tesla at the Royal Institution," *Scientific American* 69 (Mar. 12, 1892), 168.

3. Each of the issues raised here is documented in the discussion that follows. Carol Marvin has discussed the various means by which electrical science was popularized, including what she terms "electrical magic" (*When Old Technologies Were New*, pp. 56–62). Marvin's study of electrical communication in the late nineteenth century seconds my choice of Crookes and Tesla as two of the most prominent international spokespersons for electricity in this period (along with Oliver Lodge in his writings, but not personal appearances). Crookes and Tesla are cited or quoted repeatedly in her text (Crookes, pp. 47, 55, 113–14, 130, 145, 156; Tesla, pp. 57–58, 137, 147–48, 192, 224), although Crookes's name does not appear in her index, and the Tesla page citations there are incomplete. As an example of the popular craving for knowledge about electricity, Silvanus P. Thompson's *Elementary Lessons in Electricity and Magnetism* went through forty editions between its initial publication in 1881 and his death in 1916 (ibid., p. 39–40).

4. For Crookes's biography, see E. E. Fournier d'Albe, *The Life of Sir William Crookes, O.M., F.R.S.* (London: D. Appleton, 1923); Frank Greenaway, "A Victorian Scientist: The Experimental Researches of Sir William Crookes (1832–1919)," *Proceedings of the Royal Institution of Great Britain* 39 (1962), 172–98; and Oppenheim, *Other World*.

5. On Crookes, spiritualism, and psychical research, see Oppenheim, *Other World*, as cited in chap. 1, n. 28. Crookes's activities were well known in France, where his 1874 *Researches in the Phenomena of Spiritualism* was published as *Recherches sur les phénomènes du spiritualisme: Nouvelles Expériences sur la force psychique*, trans. J. Alidel (Paris: Librairie des Sciences Psychologiques, 1886). On the interest in psychic phenomena of Crookes and his colleagues, see David B. Wilson, "The Thought of Late Victorian Physicists: Oliver Lodge's Ethereal Body," *Victorian Studies* 15 (Sept. 1971), 29–48.

6. See, e.g., Lucien Poincaré's *La Physique moderne* of 1906 (*New Physics*, pp. 261–72, 276, 281). The bibliography herein provides a sampling of translations of Crookes's speeches and articles in French sources, including Jollivet Castelot's *Les Nouveaux Horizons*. Crookes was listed as a "corresponding member" of the Société Magnétique de France in the *Journal du Magnétisme* in this period, and he was cited repeatedly in *La Vie Mystérieuse*; Hector Durville reprinted his table of vibrations in "Théories et procédés du magnétisme" (*La Vie Mystérieuse*, no. 40 [Aug. 25, 1910], 244–46).

7. Pierre Valin, "L'Evolution de la philosophie du 19e au 20e siècle," pt. 1, *La Phalange* 6 (June 20, 1909), 165.

8. Crookes originally believed the radiometer was registering some kind of direct radiation pressure from light itself. See A. E. Woodruff, "William Crookes and the Radiometer," *Isis* 57 (Summer 1966), 188–98, which details the evolution of Crookes's thinking about what was happening in the radiometer, or "light mill," as he originally termed it (p. 193).

9. For Thomson's comment, see chap. 2, n. 48. Crookes's experiments became standard demonstration pieces for physics educators, and his mill wheel and other tube arrangements were regularly sold in science equipment catalogues. See, e.g., *Scientific Instruments, Laboratory Apparatus and Supplies* (Chicago: Central Scientific Co., 1936), pp. 1054–57.

10. Robert K. DeKosky makes this argument in "William Crookes and the Fourth State of Matter," *Isis* 67 (Mar. 1976), 36–60. Crookes's name, however, figures prominently in the literature on X-rays because of the standard discussions of cathode rays and the use of Crookes tubes (see, e.g., Guillaume, *Les Rayons X*, pp. 43–48).

11. William Crookes, "Radiant Matter," address before the British Association, Sheffield, Eng., Aug. 22, 1879, quoted in Fournier d'Albe, *Life of William Crookes*, p. 285.

12. Ibid., p. 290. On the popularity of this lecture, which included Crookes's cathode-ray experiments, see P. Zeeman, "Sir William Crookes, F.R.S.: The Apostle of Radiant Matter," *Scientific American Supplement*, no. 1672 (Jan. 18, 1908), pp. 44–45.

13. See the indexes of Helena Petrovna Blavatsky, *Isis Unveiled: A Master-Key to the Mysteries of Ancient and Modern Science and Technology*, 2 vols. (New York: J. W. Bouton, 1877); and Blavatsky, *The Secret Doctrine* (London: Theosophical Publishing Co., 1888; New York: W. Q. Judge, 1888).

14. See, e.g., William Crookes, "Modern Views on Matter: The Realization of a Dream," *Annual Report of the Smithson-*

ian Institution, 1903 (Washington, D.C.: G.P.O., 1904), pp. 229–41; and "Les Théories modernes sur la matière: La Réalisation d'un rêve," *Revue Scientifique*, 4th ser., 10 (Aug. 22, 1903), 224–33. This lecture, given in Berlin in 1903, reiterated the passage quoted at n. 12 above.

15. See chap. 2, n. 88.

16. Crookes's later exploration of the fabrication of artificial diamonds further endeared him to this occult audience; on Crookes and diamonds, see Fournier d'Albe, *Life of Crookes*, chap. 26. For Crookes and Jollivet Castelot's alchemy, see chap. 2 at n. 85 and following. See also Piobb, *L'Année occultiste*, vol. 1, p. 61, where he lists such illustrious scientists as "Berthelot, Moisson, Crookes, Curie, Röntgen, Bequerel, d'Arsonval, Hertz, Lebon [*sic*], Ramsay," who "make rubies . . . [or] diamonds" or "study black light," X-rays, new waves, radium, or radioactivity.

17. On the spinthariscope, see chap. 2, n. 66 and the related text. Crookes was also interested in measuring "psychic force"; see Oppenheim, *Other World*, pp. 345–46, on his use of such instruments as galvanometers and cameras to record spirit phenomena.

18. See, e.g., W.A.T., "Sir William Crookes, O.M., 1832–1919," *Proceedings of the Royal Society of London*, ser. A, 96 (Feb. 1920), iv–v.

19. William Crookes, "Some Possibilities of Electricity," *Fortnightly Review* 57 (Feb. 1892), 174–75.

20. See William Crookes, "Sir William Crookes on Psychical Research: I. Extract from Address before the British Association for the Advancement of Science; II. Address before the Society for Psychical Research," *Annual Report of the Smithsonian Institution, 1899* (Washington, D.C.: G.P.O., 1901), p. 199. The technology of wireless telegraphy is addressed at the beginning of chap. 8.

21. Both addresses appeared in nearly complete form in the *Revue Scientifique*. See chap. 1, n. 27, for the Society for Psychical Research address as it appeared in the *Revue Scientifique* (reprinted from the *Annales des sciences psychiques*); and Crookes, "Les Progrès récents des sciences physiques," *Revue Scientifique*, 4th ser., 10 (Oct. 8, 1898), pp. 449–57. For the review of *Discours récents sur les recherches psychiques*, trans. M. Sage (Paris: P.-G. Leymarie, 1903), see Jacques Brieu, "Esotérisme et spiritisme," *Mercure de France* 46 (May 1903), 513–14. Both of these addresses were reprinted in America: in addition to the article cited in n. 20 above, the *Annual Report of the Smithsonian Institution, 1899*, published in 1901, included another segment of Crookes's BAAS address under the title, "Some of the Latest Achievements of Science" (pp. 143–53).

22. William Crookes, "Address by Sir William Crookes, F.R.S., V.P.C.S., President," *Report of the Sixty-Eighth Meeting of the British Association for the Advancement of Science* (London: John Murray, 1899), p. 31; for Cookes's discussion of X-rays and telepathy, see chap. 1, n. 27.

23. Picabia encountered Napierkowska as he sailed to New York in January 1913. She served as the inspiration for a number of his paintings during 1913–14. See Camfield, *Francis Picabia*, chap. 4.

24. See chap. 1, n. 103 and following for Picabia's and Buffet's New York stay. See also Bohn, "Picabia's 'Mechanical Expression,'" and Henderson, "Francis Picabia, Radiometers, and X-Rays in 1913," in which the argument summarized here is presented in full.

25. Radiometers and the Crookes tubes used in X-ray work were sometimes connected in the early X-ray literature. The first report of Röntgen's discovery in *The Nation* in January 1896, for example, described the mysterious new rays as "proceeding from a Crookes' radiometer" (Nitske, *Röntgen*, p. 115). *McClure's Magazine* recounted Dr. William J. Morton's replication of Röntgen's "shadow photography" by means of a radiometer fitted with electrodes." See Moffett, "Röntgen Rays," p. 418.

26. Marvin notes the association of virility with terms such as *force*, *energy*, and *strength*, which were also used to describe electrical effects (*When Old Technologies Were New*, p. 131).

27. For a photograph of Napierkowska dancing, see Camfield, *Francis Picabia*, illus. 6, or Bohn, "Picabia's 'Mechanical Expression,'" fig. 2; Bohn also discusses a number of functional parallels between Napierkowska and the radiometer.

28. On Picabia's object portraits and his "machine style," in general, see Camfield, *Francis Picabia*, chap. 6.

29. Francis Picabia, preface to *Picabia Exhibition*, Little Gallery of the Photo-Secession, New York (Mar. 17–Apr. 5, 1913); reprinted in *For and Against: Views of the International Exhibition of Modern Art*, ed. F. J. Gregg (New York: Association of American Painters and Sculptors, 1913), p. 47.

30. On Bragdon's theories and their relevance for the Stieglitz circle, see Henderson, *Fourth Dimension*, pp. 186–201, 211–12. For his discussion of clairvoyance, see *A Primer of Higher Space (The Fourth Dimension)* (Rochester, N.Y.: Manas Press, 1913), pl. 19.

31. Buffet, "Modern Art," p. 11.

32. For an illustration of such a drawing of a cathode-ray tube, see Henderson, "Francis Picabia," fig. 4.

33. See Crookes, "Some Possibilities"; and Crookes, "L'Atome électrique," *Revue Scientifique*, 3d ser., 49 (Jan. 16, 1892), 80–81. For Tesla's use of the tubes, see the article cited above at n. 2.

34. The most useful biographies of Tesla are Margaret Cheney, *Tesla: Man Out of Time* (New York: Dell, 1981); and John J. O'Neill, *Prodigal Genius: The Life of Nikola Tesla* (New York: David McKay, 1944). Other sources on Tesla's place in the history of electrical technology include Kenneth M. Swezey, "Nikola Tesla," *Science* 127 (May 16, 1958), 1147–59; and Sanford P. Bordeau, *Volts to Hertz*, chap. 17. The most complete collection of Tesla's writings is *Nikola Tesla: Lectures, Patents, Articles* (Belgrade: Nikola Tesla Museum, 1956). The major Tesla lectures of 1891, 1892, and 1893, discussed here, are also included in Thomas Commerford Martin, *The Inventions, Researches and Writings of Nikola Tesla* (New York: Electrical Engineer, 1894). A sampling of other sources on Tesla and his inventions is included in the bibliography below; for the fullest listing of literature on Tesla, see John T.

Ratzlaff and Leland I. Anderson, *Nikola Tesla Bibliography* (Palo Alto: Ragusan Press, 1979).

35. On the "battle of the currents," see, e.g., Thomas P. Hughes, *Networks of Power: Electrification in Western Society, 1880–1930* (Baltimore: Johns Hopkins University Press, 1983), chap. 5; and Bordeau, *Volts to Hertz*, pp. 255–60. Hughes discusses Tesla's subsequent position as an independent inventor in constant need of financial backing in *American Genesis: A Century of Technological Enthusiasm, 1870–1970* (New York: Penguin, 1989), pp. 35–38, 64–67, 85–86.

36. For Tesla's display and lecture, see Martin, *Inventions, Researches*, chaps. 42, 43.

37. See Cheney, *Tesla*, pp. 44–45, on Edison's activities. See also Hughes, *Networks of Power*, pp. 106–8, and Marvin, *When Old Technologies*, pp. 149–50.

38. "Simple Explanation of High Frequency Current," *Popular Electricity in Plain English* 1 (Aug. 1908), 199.

39. For the texts of these lectures, see Martin, *Inventions, Researches*, chaps. 26, 27. Tesla's Paris lecture was published (in several installments) under the main title "Sur les courants de grande fréquence et de grande tension," in *Bulletin de la Société Internationale des Electriciens* 9 (1892), 67–69, 169–89, 228–48, 272–95. In 1904 Tesla's London lecture was published in book form as *Experiments with Alternate Current of High Potential and High Frequency* (New York: McGraw, 1904), to which was added an appendix, "Transmission of Electric Energy without Wires."

40. Emerson, "Tesla at the Royal Institution," p. 168.

41. "Tesla's Experiments," *Electrical Engineer* 14 (Mar. 11, 1892), 242. The continued fascination with Tesla is apparent in the d'Ault article, "Les Merveilles électriques de M. Tesla," in *La Revue des Revues* (noted in chap. 2 at n. 54).

42. E. Hospitalier, "Expériences de M. Tesla sur les courants alternatifs de grande fréquence," *La Nature* 20 (Mar. 5, 1892), 210. See also Hospitalier, "Mr. Tesla's Experiments on Alternating Currents of Great Frequency," *Scientific American* 66 (Mar. 26, 1892), 195–96. Hospitalier had also reported on Tesla's 1891 Columbia lecture in an article of the same title, published in *La Nature* 19 (Aug. 15, 1891), 162–67.

43. See, e.g., Guillaume, *Les Rayons X*, pp. 46, 102–3.

44. Claude, *L'Electricité à la portée de tout le monde*, p. 302. For the Arts et Métiers demonstrations and further discussion of Tesla, along with a Poyet illustration similar to that used by Claude, see J. Laffargue, "Production d'effluves—Appareil à grande tension et à haute fréquence: Expériences faites au centenaire du Conservatoire des Arts et Métiers," *La Nature* 26 (July 16, 1898), 103–6.

45. See, e.g., the text quoted at n. 69.

46. See Crookes, "L'Atome électrique," pp. 80–81.

47. Ibid., p. 81; Crookes, "Some Possibilities," p. 178. Here Crookes is paraphrasing Tesla's 1891 Columbia lecture to the American Institute of Electrical Engineers, where Tesla himself spoke of these electrical discharges as flames and associated them with "electrostatic molecular action." See Tesla, "Experiments with Alternate Currents of Very High Frequency and Their Application to Methods of Artificial Illumination,"

in Martin, *Inventions, Researches*, p. 167.

48. Tesla also gave his Franklin Institute lecture in St. Louis before the National Electric Light Association; for his lecture text, see Martin, *Inventions, Researches*, chap. 28. See also Tesla, "Les Vibrations électriques fréquentes," *Revue Scientifique*, 3d ser., 51 (June 17, 1893), 737–42.

49. Martin, *Inventions, Researches*, chap. 28; Tesla, "Vibrations électriques," 737–42. See also Thomas Commerford Martin, "Tesla's Oscillator and Other Inventions," *Century Magazine* 49 (Nov. 1894), 916–33; Martin's article illustrates several examples of Tesla's shaped tubes, including one spelling the word "Light" (p. 925). Martin's text was the original source for the photographs in d'Ault's *Revue des Revues* article (figs. 27, 60 herein), which also includes one of Tesla's shaped tubes (p. 201).

50. Tesla, "On Light and Other High Frequency Phenomena," in Martin, *Inventions, Researches*, pp. 319–20.

51. Arthur Brisbane, "Our Foremost Electrician," *New York World*, July 22, 1894, p. 17; reprinted in *Electrical World* 24 (Aug. 4, 1894), 97. Marvin notes this caption as it appeared in *Electrical World* (*When Old Technologies*, p. 57).

52. Tesla, "On Light and Other High Frequency Phenomena," in Martin, *Inventions, Researches*, p. 346; see also Tesla, "Les Vibrations électriques fréquentes," p. 739.

53. On this work see, e.g., Martin's 1894 *Century* article, "Tesla's Oscillator and Other Inventions."

54. For Tesla's description of these experiments, see Nikola Tesla, "The Problem of Increasing Human Energy, with Special Reference to the Harnessing of the Sun's Energy," *Century Magazine* 60 (June 1900), 175–211. See also Cheney, *Tesla*, chap. 13.

55. See, e.g., J. A. Fleming, *The Principles of Electric Wave Telegraphy and Telephony*, 3d ed. (London: Longmans, Green, 1916), pp. 5–8, 85–86. For a sampling of citations of Tesla in French wireless telegraphy literature, see chap. 8, n. 12.

56. Tesla's pioneering status in the field of radio communication was officially confirmed in June 1943, five months after his death. Tesla had sued Marconi in 1915; this and other patent suits involving Marconi were finally resolved after several decades, when the Supreme Court ruled that Marconi's four-circuit wireless patent was invalid because it had been anticipated in earlier patents by Tesla and other pioneers, such as Lodge. On this subject, see, e.g., Cheney, *Tesla*, chap. 17. For Tesla's argument against Hertzian waves, see, e.g., "Problem of Increasing Energy," p. 207; and Swezey, "Nikola Tesla," p. 1158.

57. See Tesla, "Problem of Increasing Human Energy," pp. 175–211, which was also amply illustrated with Tesla's projects, including dramatic photographs of spark discharges, such as fig. 61.

58. Ibid., p. 186; Tesla was particularly interested in the possible military applications of his telautomaton (pp. 187–88). See also "Nikola Tesla's Latest Invention: Controls a Boat by Radio," *Scientific American* 79 (Nov. 19, 1898), 326; see also Cheney, *Tesla*, pp. 123–26.

59. See, e.g., "La Direction des navires à distance," *Les*

Inventions nouvelles, December 17, 1898, p. 483. See also n. 70 below.

60. Tesla, "Problem of Increasing Human Energy," pp. 184–85.

61. I am grateful to Francis Naumann and to Wendy Reaves of the National Portrait Gallery, who brought this recently discovered caricature to my attention. On de Zayas's caricatures, see the essay by Douglas Hyland in Spencer Museum of Art, Lawrence, Kansas, *Marius de Zayas: Conjurer of Souls* (Sept. 27–Nov. 18, 1981). For the interaction of de Zayas and Picabia in New York, see Camfield, *Picabia*, chaps. 4, 6; and Henderson, *Fourth Dimension*, pp. 210–18.

62. On the Wardenclyffe tower project, which involved the collaboration of Tesla and his friend Stanford White, the well-known architect, see Cheney, *Tesla*, chaps. 15, 16. The title of Cheney's chap. 16, "Ridiculed, Condemned, Combatted," sums up what was increasingly to be Tesla's position in later life. Although certain of his statements in the *Century* article would, in fact, prove prophetic, negative articles began to appear in fall 1900, such as a Sept. 29, 1900, *New York Sun* article entitled "Tesla's Speculations Ridiculed—Severe Criticism of Electrical Inventor's Divagations in Higher Fields— His Work in Fundamental Theories Questioned." Marvin also notes this response as well as the discomfiture of the scientific establishment with Tesla's emphasis on spectacle (*When Old Technologies Were New*, p. 137).

63. See "Three Nobel Prizes for Americans," *Literary Digest* 51 (Dec. 18, 1915), 1426. Unlike Crookes, who was still revered by the British scientific establishment at the time of his death in 1919, Tesla died alone and in poverty in 1943. For Tesla's later years, during which his eccentricities became even more pronounced, see the final chapters in Cheney, *Tesla*, and O'Neill, *Prodigal Genius*.

64. See *Catalogue officiel . . . C.N.A.M.*, vol. 2, p. 148.

65. Swezey, "Nikola Tesla," p. 1154. See again the *Scientific Instruments* supply catalogue (cited in n. 9), pp. 1333–35.

66. See again nn. 44 and 55 above, as well as Claude's discussions of Tesla's high-frequency apparatus and its relevance for wireless telegraphy (pp. 290, 296–97, 381). See also general physics books, such as Lucien Poincaré's 1906 *La Physique moderne* (*New Physics*, p. 226) and Jules Basin's *Leçons de physique*, 3 vols. (Paris: Librairie Nony, 1902), vol. 3, pp. 621–22, 634. In its tenth edition in 1910, Basin's book, like Claude's, addressed both Tesla's high-frequency apparatus and his earlier work with lighted tubes.

67. In France, Professor A. d'Arsonval developed this medical usage of Tesla's high-frequency currents, attracting continued attention. See, e.g., R. Vigoreux, "Sur l'emploi thérapeutique des courants à haute fréquence (courants de Tesla)," *L'Electricien*, 2d ser., 10 (Nov. 14, 1896), 309–14. Tesla's later invention of a bladeless steam turbine also created a flurry of new articles in 1911 in *La Nature* and other sources. See, e.g., A. Troller, "La Turbine à vapeur Tesla," *La Nature* 39 (Nov. 4, 1911), 356–58.

68. Rochas, *L'Extériorisation*, p. 52.

69. Gérard Encausse [Papus], *L'Occulte à l'Exposition* (Paris: Librairie Paul Ollendorf, 1901), p. 24. Apollinaire owned this text (Boudar and Décaudin, *Catalogue* [books], p. 121).

70. Péladan, "Le Radium," pp. 617–18.

71. Jollivet Castelot, *La Synthèse*, pp. 13, 30.

72. Apollinaire, as quoted in Roger Shattuck, introduction to *Selected Works of Alfred Jarry*, ed. Roger Shattuck and Simon Watson Taylor (New York: Grove, 1965), p. 14. See Alfred Jarry, *Gestes et opinions du docteur Faustroll (roman néo-scientifique), suivi de Spéculations* (Paris: Eugène Fasquelle, 1911). Chaps. 6 and 10–25 of *Gestes et opinions* had been published in *Mercure de France* of May 1898, but these chapters were the least scientifically oriented in Jarry's text. On the circumstances surrounding this partial publication, see Beaumont, *Alfred Jarry*, p. 180.

73. Duchamp later described Jarry's importance for him as "an encouragement found in Jarry's general attitude toward what was called literature in 1911" (Duchamp, letter to Serge Stauffer, Mar. 28, 1965, in *Marcel Duchamp: Die Schriften*, ed. Serge Stauffer [Zurich: Regenbogen-Verlag, 1981]). For an overview of Duchamp's references to Jarry in later interviews, consult the index to *Marcel Duchamp: Interviews und Statements*, ed. Serge Stauffer (Stuttgart: Edition Cantz, 1992). In 1959 Duchamp joined the Collège de 'Pataphysique, founded in honor of Jarry, with the rank of "Transcendent Satrap" (*Duchamp* [Philadelphia], p. 28). On the Collège, see the collection of articles in *Evergreen Review* 4 (May–June 1960), 24–192, ed. Roger Shattuck and Simon Watson Taylor. The most recent extended discussion of Duchamp and Jarry is the freewheeling musing on the subject by William Anastasi, "Duchamp on the Jarry Road," *Artforum* 30 (Sept. 1991), 86–90.

74. For Jarry's biography, see Beaumont, *Alfred Jarry*. On Jarry and Picasso, see chap. 1, n. 114.

75. See Beaumont, *Alfred Jarry*, pp. 35–36, 180.

76. Jarry, *Gestes et opinions*, in *Selected Works*, ed. Shattuck and Taylor, pp. 192–93.

77. Barbara Wright, introduction to Alfred Jarry, *The Supermale*, trans. Ralph Gladstone and Barbara Wright (New York: New Directions, 1977), n.p.

78. Alfred Jarry, "De quelques romans scientifiques," *La Plume*, nos. 347–48 (Oct. 1–15, 1903), 431–32; in *Alfred Jarry: Oeuvres complètes,* 3 vols. (Paris: Gallimard, 1972–88), ed. Michel Arrivé (vol. 1) and Henri Bordillon et al. (vols. 2, 3), vol. 2, p. 520. On the contrast between the methods of British and French science in this period, see, e.g., Keller, *Infancy of Atomic Physics*, pp. 3–7. On the sources for Jarry's Pataphysics, see the annotations by Shattuck to the text of *Gestes et Opinions,* in *Selected Works*, ed. Shattuck and Taylor; the collection of articles published as the "Cahier Faustroll," in *Cahiers du Collège de 'Pataphysique*, nos. 22–23 (1956); and Linda Klieger Stillman, "Physics and Pataphysics: The Sources of *Faustroll*," *Kentucky Romance Quarterly* 26 (1979), 81–92.

79. See, e.g., Beaumont, *Alfred Jarry*, pp. 56, 62–63, 162.

80. Alfred Jarry [Dr. Faustroll], "Commentaire pour servir

à la construction pratique de la machine à explorer le temps," *Mercure de France* 29 (Feb. 1899), 387–96.

81. On Wells and the fourth dimension, including his *Mercure de France* article, as well as Jarry's "Commentaire," see Henderson, *Fourth Dimension*, pp. 33–35, 47–48.

82. On non-Euclidean geometry, see chap. 5, n. 42 and the related text. For Jarry's knowledge of Bergson, see Catherine Stehlin, "Jarry, le cours Bergson et la philosophie," *Europe* 59 (Mar.–Apr. 1981), 34–51.

83. Jarry includes a footnote to Lord Kelvin: "Cf. W. Thomson, 'On a gyrostatic adynamic constitution for ether' (C.R., 1889; Proc. R. Soc. Ed., 1890)" ("Commentaire," p. 390). Jarry also borrowed from Kelvin's collected lectures. For a similar argument, see William Thomson [Lord Kelvin], "A Kinetic Theory of Matter," in *Popular Lectures and Addresses*, 3 vols. (London: Macmillan, 1891), vol. 1, pp. 242–50. For further discussions of Jarry's debts to Lord Kelvin, see S. Lie, "De Lord Kelvin à Jarry," *Cahiers du Collège de 'Pataphysique*, nos. 22–23 (1956), 111–14; Stillman, "Physics and Pataphysics," pp. 85–89; and Henderson, *Fourth Dimension*, pp. 48–49.

84. See, e.g., Oliver Lodge's widely reprinted lecture before the Royal Institution, Feb. 21, 1908: "The Ether of Space," *North American Review* 187 (May 1908), 730.

85. For Jarry's description of Faustroll, see *Gestes et opinions*, chap. 2; the discussion of the "sieve-boat" and C. V. Boys occurs in chap. 6. Because the chapters of Jarry's text are quite short, references are to chapter numbers rather than to page numbers, so that the citations can be used with any of the French or English editions of *Gestes et opinions*. The translations used here are from *Selected Works of Alfred Jarry*, ed. Shattuck and Taylor. For Jarry's use of Boys's writings, see G. Petitfaux, "Des bulles de savon de Boys à l'as de Faustroll," *Cahiers du Collège de 'Pataphysique*, nos. 22–23 (1956), 45–49.

86. Crookes, "De la relativité," p. 640; and Crookes, "Sir William Crookes on Psychical Research," pp. 194–95.

87. See Jarry, *Gestes et opinions*, chap. 9. On Crookes's text and its reinterpretation in the *Revue Scientifique* two months later in terms of dwellers in a two-dimensional world, see Henderson, *Fourth Dimension*, pp. 38–39.

88. Crookes, "De la relativité," p. 611; Crookes, "Sir William Crookes on Psychical Research," p. 199.

89. Jarry, *Gestes et opinions*, chap. 8.

90. Crookes, "De la relativité," p. 612; Crookes, "Sir William Crookes on Psychical Research," p. 199.

91. Jarry, *Gestes et opinions*, chap. 37. See also Thomson [Lord Kelvin], "The Six Gateways to Knowledge," in *Popular Lectures and Addresses*, vol. 1, p. 265.

92. *Box of 1914*, in *SS*, p. 25.

93. See Jarry, *Gestes et opinions*, chap. 31.

94. Ibid., chap. 7.

95. Ibid., chap. 24.

96. In occultism the "astral body" was considered to be "an exact replica of the physical body but composed of finer matter" (Fodor, *Encyclopaedia of Psychic Science*, s.v. "astral body"). On Jarry and the astral body, see also Michel Car-

rouges, "Machines pataphysiques pour l'au-delà," *L'Etudes philosophiques*, no. 1 (1985), 77–89.

97. Thomson [Lord Kelvin], "Electrical Units," in *Popular Lectures*, vol. 1, p. 114.

98. Jarry, *Gestes et opinions*, chap. 37. As in his "Commentaire," Jarry's discussion of the ether relies on Kelvin's model employing gyrostats and spring balances (see n. 83 above). Jarry's use of the title "Clinamen" for chap. 34 of *Gestes et opinions* alludes to Kelvin's theory of atoms as vortices in the ether as well as to the atom theory of ancient writers such as Lucretius. On this subject and its relevance for Duchamp, see chap. 10, n. 70 and the related text.

99. Ibid., chap. 38. Although Jarry did not employ it, Kelvin also suggested a technique involving "electrical oscillations" (Thomson, "Electrical Units," in *Popular Lectures*, vol. 1, p. 121).

100. Ibid., chap. 41. For Jarry and four-dimensional geometry, see Jarry, *Gestes et opinions*, chap. 36, and Henderson, *Fourth Dimension*, pp. 48–49.

101. Jarry, *Gestes et opinions*, chap. 34. In 1946 Duchamp would create an artwork with his own seminal fluid: *Paysage fautif* (Wayward Landscape) was included in one of his twenty deluxe *Boites-en-Valise*, no. 12 (for Maria Martins). See Ecke Bonk, *Marcel Duchamp: The Box in a Valise*, trans. David Britt (New York: Rizzoli, 1989), pp. 282–83; the *Box in a Valise* project is addressed in chap. 13 below (fig. 166).

102. Jarry, *Le Surmâle*, in *Oeuvres complètes*, ed. Bordillon et al., vol. 2, p. 247; *The Supermale*, p. 58. Jarry's book was originally published as *Le Surmâle: Roman moderne* (Paris: Charpentier, 1902).

103. *GB*, in *SS*, p. 71.

104. See, e.g., *Duchamp* (Philadelphia), p. 271. For Jarry's text, see "La Passion considérée comme course de côte," in *Oeuvres complètes*, ed. Bordillon et al., vol. 2, pp. 420–22.

105. Alfred Jarry, "Copulativement parlant," in *Oeuvres complètes*, vol. 2, pp. 476–79. Compare, e.g., Duchamp's Bachelors/Célibataires as depicted in the *Cemetery of Uniforms and Liveries (No. 1)* (fig. 97). Jarry frequently used wordplays and other forms of linguistic humor in his "Spéculations" essays, including this one.

106. Jarry, "De quelques romans," in *Oeuvres complètes*, ed. Bordillon et al., vol. 2, p. 520.

107. See, e.g., Christophe Domino, "Villiers de l'Isle-Adam et Jarry: *L'Eve future* et *Le Surmâle*," in *Alfred Jarry*, ed. Henri Bordillon (Paris: Pierre Belfond, 1985), pp. 85–101. See also Linda Krieger Stillman, "Machinations of Celibacy and Desire," *L'Esprit Créateur* 24 (Winter 1984), 20–35; and Stillman, "Le Vivant et l'artificiel: Jarry, Villiers de l'Isle Adam, Robida."

108. Villiers de l'Isle-Adam, *Tomorrow's Eve*, pp. 64–65.

109. See, e.g., Villiers, *Tomorrow's Eve*, pp. 213, 209. Hadaly ultimately acquires a "soul" when she is adopted as a vehicle by the disembodied spirit who had served Edison as Hadaly's intellect. For the fictional Edison's explanation of this process, see pp. 208–16.

110. Jarry, *Le Surmâle*, in *Oeuvres complètes*, ed. Bordillon

et al., vol. 2, pp. 251, 266; *The Supermale*, pp. 61, 77.

111. On electricity in *L'Eve future*, see Fumaroli, "Histoire de la literature," in *L'Electricité dans l'histoire*, ed. Cardot, pp. 232–36.

112. Jarry, *Le Surmâle*, in *Oeuvres complètes*, ed. Bordillon et al., vol. 2, p. 189; *The Supermale*, p. 21. On Jarry's machines as examples of Carrouges's theme of "bachelor machines" oriented toward sex and death, see Carrouges, *Machines célibataires*, pp. 93–128; and Carrouges, "Mode d'emploi," in *Junggesellenmaschinen*, ed. Szeemann, pp. 21–49; see also Stillman, "Machinations of Celibacy and Desire."

113. Jarry, *Le Surmâle*, in *Oeuvres complètes*, ed. Bordillon et al., vol. 2, p. 191; *The Supermale*, p. 24.

114. Jarry, *Le Surmâle*, p. 212; *The Supermale*, p. 24.

115. See Jarry, *Le Surmâle*, chap. 5.

116. Ibid., p. 217; *The Supermale*, p. 28.

117. Jarry, *Le Surmâle*, p. 197; *The Supermale*, p. 9.

118. Jarry, *Le Surmâle*, p. 266; *The Supermale*, p. 76.

119. Jarry describes the motivation for the "combined efforts of the engineer, the chemist, and the physician" as their "pit[ting] one machine against another for the greater good of bourgeois science, medicine, morality" (ibid., p. 267; *The Supermale*, p. 77). It was, of course, French bourgeois science or positivist science that was the object of Jarry's Pataphysical critique.

120. Ibid., pp. 267–68; *The Supermale*, p. 78. Gough's explanation should add that the key to the current's safety was that it was a high-frequency alternating current, not simply that the voltage was high.

121. See, e.g., Domino, "Villiers de l'Isle-Adam et Jarry," pp. 96–97. Carrouges first noted the phonograph-Edison connection in *Les Machines célibataires*, as Domino points out here. Carrouges's *Junggesellenmaschinen* essay includes an illustration from an article in *La Nature* on the American electric chair. As noted earlier (at n. 37 above), Edison used electrocution by high-voltage alternating current as evidence in favor of the "safer" direct current he advocated in the "battle of the currents."

122. See, e.g., Marvin, *When Old Technologies Were New*, p. 137, as well as the discussion of Tesla above.

123. Unless otherwise indicated, the quotations in this and the following paragraph are drawn from the last three pages of Jarry's text.

124. See chap. 3, n. 59.

125. On the Lamarckian evolutionary theme implicit here, see, e.g., Beaumont, *Alfred Jarry*, p. 244. As noted in chap. 3 (at n. 36), a similar Lamarckian "transformism" was at the root of the Futurist theories of another of Jarry's admirers, Marinetti.

126. On Jarry and language, see, e.g., Beaumont, *Alfred Jarry*, pp. 68–70; and Stillman, "Physics and Pataphysics," pp. 82–83.

127. Stillman, "Physics and Pataphysics," p. 91.

128. For Duchamp's references to Roussel in later interviews, see the index to Stauffer, ed., *Marcel Duchamp: Interviews und Statements*.

129. Duchamp, as quoted in Sweeney, "Eleven Europeans," p. 21.

130. Ibid. On the conflicting evidence about whether Duchamp attended the play in May–June 1912 or that fall, see chap. 1, n. 102.

131. See, e.g., Lebel, *Marcel Duchamp*, p. 26. This tendency is especially apparent in more recent scholarship on Roussel, as well as on the Duchamp-Roussel relationship. See, e.g., Claudine Lautier, "Chant et champ," *Mélusine*, no. 6 (*Raymond Roussel en gloire*), ed. Anne-Marie Amiot (Lausanne: L'Age d'Homme, 1984), pp. 135–52; and George H. Bauer, "La Jolie Roussel brisée: Les Vairs du chant," in ibid., pp. 179–87.

132. Duchamp, as quoted in Cabanne, *Dialogues*, pp. 33–34. Duchamp also notes that he once caught sight of Roussel playing chess at the Régence.

133. See Carrouges, "Mode d'emploi," in *Junggesellenmaschinen*, ed. Szeemann, p. 21; see also Carrouges, *Machines célibataires*.

134. See n. 207 and the related text below.

135. By the early 1930s Roussel's life was increasingly dominated by his use of drugs, and in 1933 he committed suicide. For biographical information on Roussel, see, e.g., Rayner Heppenstall, *Raymond Roussel: A Critical Study* (Berkeley: University of California Press, 1967); and Caradec, *Vie de Raymond Roussel*.

136. Heppenstall, *Raymond Roussel*, pp. 2–3.

137. On the Surrealists and Roussel, see John Ashberry, "On Raymond Roussel" (1961), reprinted in Raymond Roussel, *How I Wrote Certain of My Books* (1935), trans. Trevor Winkfield (New York: Sun, 1977), pp. 45–55. See also the articles on Roussel written in the 1930s by Michel Leiris, an associate of the Surrealists, which are reprinted in *Roussel l'ingénu* (Paris: Editions Fata Morgana, 1987). For the new interest in Roussel among French intellectuals by the 1960s, see, e.g., Michel Foucault, *Death and the Labyrinth: The World of Raymond Roussel* (1963), trans. Charles Ruas (New York: Doubleday, 1986), which reprints Ashberry's essay and includes an important later interview with Foucault.

138. Janet, as quoted in Michel Leiris, "Conception and Reality in the Work of Raymond Roussel," *Art & Literature*, no. 2 (Summer 1964), p. 12. Originally published in *Critique* in 1954, this article is also reprinted in Leiris, *Roussel l'ingénu*, p. 64.

139. Roussel, *How I Wrote*, p. 3.

140. Ibid. In *Impressions d'Afrique,* the second phrase refers to the singer Carmichael (*blanc*, or white man), the Ponukelian warriors (*bandes*, or hordes), and the emperor Talou (*vieux pillard*, or old plunderer). See Heppenstall, *Raymond Roussel*, pp. 34–35.

141. Roussel, *How I Wrote*, p. 7.

142. Sanouillet has also made this point about Duchamp's response to Roussel's word games in "Marcel Duchamp and the French Intellectual Tradition," in *Duchamp* (Philadelphia), pp. 52–53. In Cabanne, *Dialogues*, p. 41, Duchamp mentions having read Roussel's later explanatory volume.

143. See n. 138.

144. For Duchamp's "buttoir de vie," see the final section of chap. 11.

145. For Duchamp and the *Larousse* dictionary, one of his favorite books, see Steefel, *Position of Duchamp's "Glass,"* p. 36; for Picabia's use of the *Petit Larousse* red pages, see Camfield, *Francis Picabia*, p. 65, nn. 81, 83, and p. 100. On Roussel's passion for encyclopedic dictionaries, especially the *Larousse* and his favorite, the *Bescherelle*, see Leiris, *Roussel l'ingénu*, pp. 15–16.

146. Roussel, *How I Wrote*, p. 13. The "library" of Jarry's Faustroll also included Verne's *Voyage to the Center of the Earth* (Jarry, *Gestes et opinions*, chap. 4).

147. See Leiris, *Roussel l'ingénu*, p. 15. In 1923 Roussel was the guest of Flammarion at the Observatory of Juvisy (Leiris, "Conception and Reality," p. 22; *Roussel l'ingénu*, pp. 81–83).

148. See Anne-Marie Amiot, *Un Mythe moderne: "Impressions d'Afrique" de Raymond Roussel*, Archives de Lettres Modernes, no. 176 (Paris: Minard, 1977), p. 3. See also Anne-Marie Amiot, "L'Idéologie rousselienne dans *Locus Solus*: Raymond Roussel et Camille Flammarion," in *Actes du 2e colloque de lexicologie politique, Sept. 15–20, 1980,* ed. Danielle Bonnaud-Lamotte (Paris: Librarie Klincksieck, 1982), pp. 115–23; and Masachika Tani, "Le Mort et le temps: Raymond Roussel et Camille Flammarion," *Europe* 66 (Oct. 1988), 96–105.

149. See Flammarion, *The Unknown*, chap. 1, as well as chap. 1, n. 28 and the related text above.

150. Georges Raillard has also noted the importance of *La Nature* and its type of popularized science for *Impressions d'Afrique*. See Raillard, "rien Peut-être," *L'Arc* 59 (1974), 54.

151. See Raymond Roussel, *Impressions d'Afrique* (Paris: Librairie Lemerre, 1910; Paris: Jean-Jacques Pauvert, 1963); and Raymond Roussel, *Impressions of Africa*, trans. Lindy Foord and Rayner Heppenstall (Berkeley: University of California Press, 1967). The novel was also serialized in *Gaulois du Dimanche* in 1907 but went largely unnoticed (Roussel, *How I Wrote*, p. 16).

152. Heppenstall, *Raymond Roussel*, p. 33. See also Jean Ferry's illustrated "guide" to Roussel's tale: *L'Afrique des impressions: Petit Guide pratique à l'usage du voyager* (Paris: Jean-Jacques Pauvert, 1967).

153. See Annie Angremy, "La Malle de Roussel: Du bric-à-brac au décryptage," *Revue de la Bibliothèque Nationale* 43 (Spring 1992), 37–49, on this discovery, which augments significantly the evidence known previously: the poster, a few photographs, and the script for one character. For the script, discovered by John Ashberry, as well as Ashberry's essay on Roussel's plays, "Les Versions scéniques d'*Impressions d'Afrique* et de *Locus Solus*, see *Bizarre*, no. 34–35 (1964), 19–30. For a summary of the play based on the new Bibliothèque Nationale holdings, as well as a sampling of relevant Rousselian wordplays, see Gough-Cooper and Caumont, "Ephemerides," in *Duchamp* (Venice), entry for June 10, 1912.

154. See Roussel, *Impressions of Africa*, pp. 96–100.

155. Carrouges, "Mode d'emploi," in *Junggesellenmaschinen*, ed. Szeemann, pp. 29, 31–32. In his original *Machines célibataires* discussion of Roussel, Carrouges included other elements in the square with Djizmé, including the execution of the adulterous empress Rul (pp. 77–78).

156. See, e.g., Golding, *Marcel Duchamp*, pp. 49–50; and Suquet, *Miroir de la mariée*, p. 222. See also Jeanine Parisier Plottel, "Machines de langage: *Impressions d'Afrique* et *La Mariée mise à nu par ses célibataires, même*," in *Le Siècle éclaté 2: Théorie, tableau, texte de Jarry à Artaud*, ed. Mary Ann Caws (Paris: Minard, 1978), pp. 13–23.

157. See Rosalind E. Krauss, *Passages in Modern Sculpture* (1977; Cambridge: MIT Press, 1981), pp. 69–76.

158. On the cross-dressing theme, see Golding, *Marcel Duchamp*, pp. 50–51; and Roussel, *Impressions of Africa*, pp. 16, 228, 302, as well as chap. 18, in which Talou's rival king, dressed as Marguerite in *Faust*, is laid out in the village square after his defeat and death.

159. See Roussel, *Impressions of Africa*, pp. 126, 266, for the phrascs quoted.

160. Duchamp, "Apropos of Myself," p. 20. See also chap. 14 at n. 75.

161. See Roussel, *Impressions of Africa*, pp. 226–28.

162. See ibid., pp. 40–45, for Bex's machine.

163. Ibid., p. 40.

164. Ibid., p. 41.

165. Ibid., p. 224.

166. Ibid., p. 43.

167. See ibid., pp. 56–59 and chap. 16.

168. Ibid., p. 59; for the "sound-waves" reference, see p. 271. Other examples of sound frequencies in a musical context are the wooden-legged Lelgoualch playing his own tibia bone (pp. 67–68; see fig. 65); Stephen Alcott's accoustical experiments with echoes from the emaciated chests of his six sons (pp. 84–88; fig. 65); and the musical chariots, whose wheels produced notes of a scale (p. 209).

169. See ibid., pp. 233–36. This episode from Roussel's text has recently been reprinted in *Duchamp: Passim*, ed. Hill, pp. 184–85.

170. Roussel, *Impressions of Africa*, pp. 233–34.

171. Ibid., p. 236.

172. Ibid., pp. 35–37.

173. See chap. 3, n. 46 and the related text.

174. On Louise Montalescot, see Roussel, *Impressions of Africa*, pp. 24–28 and chaps. 9, 19.

175. Ibid., p. 284.

176. Ibid., p. 282. Chap. 19 sets forth Louise's biography and the origins of the painting machine, and chap. 9 describes its performance. Louise and her brother arrive in Talou's realm separately from the shipwrecked travelers; she is in a particularly dangerous position because of the affair she has had with Talou's rival king, Yaour.

177. See ibid., pp. 224, 300, 311. See also *MDN*, notes 58, 80, 112, 114, and discussion of the *Large Glass* and chemistry in chap. 10 below.

178. Ibid., p. 243.

179. Ibid., p. 144.

180. Ibid., p. 282.

181. Ibid., p. 144. Duchamp's "Juggler/Handler of Gravity," who would also register electromagnetic waves, is discussed in chap. 8 at n. 198 and in the section of chap. 11 on "Playful Mechanics."

182. Ibid., p. 146.

183. Ibid., p. 314.

184. Henry de Varigny, "La Vision à distance," *L'Illustration* 134 (Dec. 11, 1909), 451. See also, e.g., Alfred Gradenwitz, "La Transmission à distance des écritures et dessins," *Revue Générale des Sciences Pures et Appliquées* 16 (Nov. 15, 1905), 924–25. Gradenwitz discusses another variation on this technology in "La Première Solution réelle du problème de la télévision," *Revue Générale* 20 (Sept. 15, 1909), 727–28.

185. For example, in the episode discussed at n. 198 below, Darriand uses a "system of spools and diaphanous strips" to project events from Seil Kor's life (*Impressions of Africa*, p. 106). The theme of projection is prominent among the activities of Villiers's fictional Edison in *L'Eve future* as well.

186. See ibid., p. 257; on Fogar's magical plants, see *Impressions*, chaps. 8, 15.

187. Ibid., p. 126.

188. Ibid., pp. 130, 244–45.

189. Ibid., p. 267.

190. See, e.g., Michel Durr, "Jules Verne et l'électricité," in *La France des électriciens, 1880–1980*, ed. Fabienne Cardot (Paris: Presses Universitaires de France, 1986), pp. 335–58.

191. See Roussel, *Impressions of Africa*, pp. 100–103, 179–87.

192. Ibid., p. 291.

193. Texts on electricity and electromagnetism also standardly included a section on atmospheric electricity. On lightning conductors in this period, see, e.g., Oliver Lodge, *Lightning Conductors and Lightning Guards* (London: Whittaker, 1892).

194. See Roussel, *Impressions of Africa*, p. 7; and GB, in SS, p. 56.

195. Roussel, *Impressions of Africa*, pp. 46–54.

196. See André Breton, *Anthologie de l'humour noir* (Paris: Edition du Sagittaire, 1950), p. 232. In his preface to Jean Ferry, *Une Etude sur Raymond Roussel* (Paris: Arcanes, 1953), Breton also argued that alchemy was the key to Roussel's work.

197. Roussel, *Impressions of Africa*, p. 105.

198. Ibid., pp. 105, 308–9.

199. Raymond Roussel, *Locus Solus*, trans. Rupert Copeland Cuningham (Berkeley: University of California Press, 1970), p. 5. Duchamp read *Locus Solus* in 1914 or 1915 (Duchamp, letter to Serge Stauffer, Aug. 6, 1960; see "Hundert Fragen an Marcel Duchamp," in *Duchamp: Die Schriften*, ed. Stauffer, p. 179).

200. Roussel, *Locus Solus*, pp. 58–59.

201. Ibid., p. 65. Carrouges also treats the "grand diamond aquarium" of Faustine as a "machine célibataire" (*Machines célibataires*, pp. 65–73; and "Mode d'emploi," in *Junggesellenmaschinen*, ed. Szeemann, pp. 29–30).

202. Flammarion, *Uranie*, p. 267; as quoted in Amiot, "L'Idéologie rousselienne dans *Locus Solus*," p. 118.

203. Carrouges, *Machines célibataires*, pp. 61–63; "Mode d'emploi," in *Junggesellenmaschinen*, ed. Szeemann, pp. 27–28. The English translation renders Roussel's term as "paving-beetle" or "rammer"; for Roussel's usage of *demoiselle*, see Raymond Roussel, *Locus Solus* (Paris: Gallimard, 1963), chap. 2.

204. Roussel, *Locus Solus* (Eng. ed.), pp. 30–31.

205. Ibid., p. 31.

206. Among the occult themes to be found in *Locus Solus* are alchemy and Paracelsus, the sixteenth-century physician and alchemist (ibid., pp. 228–31), as well as Tarot cards (p. 220).

207. Duchamp, as quoted in Schuster, "Marcel Duchamp, vite," *Le Surréalisme, même*, no. 2 (Spring 1957), p. 144.

208. See, e.g., Octavio Paz, *Marcel Duchamp: Appearance Stripped Bare*, trans. Rachel Phillips and Donald Gardner (New York: Viking, 1978), pp. 134–36.

209. Amiot, *Un Mythe moderne*, p. 98.

210. See n. 138.

211. Carrouges, "Mode d'emploi," in *Junggesellenmaschinen*, ed. Szeemann, p. 46. Leiris documents Roussel's knowledge of the Musée des Arts et Métiers (*Roussel l'ingénu*, pp. 19–20), which is discussed further at the beginning of chap. 12. Duchamp himself would respond to the illuminated displays at Luna Park (see *MDN*, notes 74, 80, quoted in chap. 7 at n. 7).

212. See chap. 2, n. 14 and the related text.

Chapter 5: From Painter to Engineer, II

1. For Duchamp's entries in the Salon de "La Section d'Or," see the listings in Donald E. Gordon, ed., *Modern Art Exhibitions, 1910–1916*, 2 vols. (Munich: Prestel-Verlag, 1974). The works titled *Peinture* and *Aquarelle* might have been the painting *Bride* and the watercolor and pencil drawing *Virgin (No. 2)*. On the "Section d'Or" exhibition in general, see, e.g., Henderson, *Fourth Dimension*, p. 66, nn. 53, 54. For the *Gil Blas* announcement, see Jean Suquet, *Le Grand Verre rêvé* (Paris: Aubier, 1991), p. 21. Suquet (p. 21) notes Ulf Linde's observation that the proportions of Duchamp's *Bride* painting approximate the Golden Section (Linde, "Esotérique," in *OeuvreMD* (Paris), vol. 3, pp. 73–74). Linde also proposed a geometric subdividing of the *Large Glass* that approximates the Golden Section (pp. 72–74). For Duchamp's references to the Golden Section in his notes for the *Large Glass*, see chap. 11, n. 33.

2. Duchamp, as quoted in Tomkins, *Bride*, p. 22; see also, Cabanne, *Dialogues*, pp. 17, 31. On Duchamp and Futurism, see chap. 2, n. 6.

3. See Galerie de La Boétie, Paris, *Salon de "La Section d'Or"* (Oct. 10–Oct. 30, 1912); see also Gough-Cooper and Caumont, "Ephemerides," in *Duchamp* (Venice), entry for Oct. 9, 1912.

4. On the Maison Cubiste, see Nancy J. Troy, *Modernism and the Decorative Arts in France: Art Nouveau to Le Cor-*

busier (New Haven: Yale University Press, 1991), chap. 2.

5. See chap. 2, n. 16.

6. *A L'INF*, in *SS*, p. 86. On Duchamp's library position, see Gough-Cooper and Caumont, "Ephemerides," in *Duchamp* (Venice), entries for Nov. 4, 1912, Nov. 3, 1913.

7. See chap. 3, n. 7.

8. Buffet-Picabia, "Some Memories," p. 257.

9. *GB*, in *SS*, p. 30; *MDN*, notes 68, 77 (app. A, no. 2). As the content of note 77 suggests, Duchamp was simultaneously exploring precision in language, which would emerge as a central theme in his notes for the *Large Glass*.

10. Duchamp letter to Walter Pach, as quoted in Pach, *Queer Thing, Painting*, p. 162.

11. Schwarz (*Complete Works*, p. 438) assigns this date to *Chocolate Grinder (No. 1)*.

12. Apollinaire, *Les Peintres Cubistes*, p. 68; *Cubist Painters*, p. 45.

13. For this *Perspective Sketch for the Bachelor Machine*, see Schwarz, *Complete Works*, cat. no. 202; see also chap. 10 at n. 101 below. For other drawings relating to the Bachelor Apparatus from spring 1913, see ibid., cat. nos. 198, 198 bis, as well as figs. 45, 97, and 153 herein. Although Schwarz and others have traditionally dated the first layout of the entire *Glass* (cat. no. 199; fig. 75 herein) to Duchamp's period in Neuilly, before his move to the rue Saint-Hippolyte studio in October, Gough-Cooper and Caumont have recently suggested that the pencil drawing on tracing cloth at $1/10$ scale may have been made after the full-scale drawing he produced on the plaster wall of the studio. See "Ephemerides," in *Duchamp* (Venice), entry for Oct. 22, 1913.

14. On the use of stencils, see *GB*, in *SS*, p. 80; *MDN*, notes 126, 127.

15. Duchamp, "Apropos of Myself," p. 10.

16. Ibid. Gough-Cooper and Caumont first published a detail of this image in *Duchamp* (Venice), p. 48, and discussed the Gamelin shop in "Ephemerides," entry for Mar. 8, 1915.

17. *GB*, in *SS*, p. 68; see also *MDN*, note 118. On the sexual associations of mills and grinding, see Steefel, *Position of Duchamp's "Glass,"* pp. 122–23.

18. In a commercial chocolate grinder (e.g., fig. 67), both the pan and rollers travel at relatively high speeds. See R. Whymper, *Cocoa and Chocolate: Their Chemistry and Manufacture* (Philadelphia: P. Blakiston's, 1912), chap. 14.

19. *GB*, in *SS*, p. 68.

20. See Schwarz, ed., *Notes and Projects*, note 75. Clair has noted that the original French was mistranscribed by Sanouillet as "Louis XV images" (*A L'INF*, in *SS*, p. 76). See Clair, "Duchamp and the Classical Perspectivists," p. 48, n. 16.

21. On Mare and the decorative arts, see n. 4 above. Gleizes and Metzinger, in *Du Cubisme* (p. 39), illustrate the "rudimentary taste" of a "savage" with the example of the "so-called civilized man" who can appreciate nothing but Italian painting or Louis XV furniture." See *Modern Artists on Art*, ed. Herbert, p. 16.

22. Pawlowski, *Voyage* (1912), p. 243; *Voyage* (1971), p. 208.

23. See, e.g., *Catalogue officiel. . .C.N.A.M.*, vol. 2, p. 97.

24. See, e.g., the *broyeur de pommes*, in ibid., vol. 4, p. 51. Duchamp talked of adding to the object the phrase "The bachelor grinds his chocolate himself" as if it were a "commercial slogan inscribed like an advertisement on a bit of glossy and colored paper" (*GB*, in *SS*, p. 68); he speculated on a similar usage in the "text" for the *Large Glass* (*MDN*, note 118).

25. See *MDN*, notes 80, 134.

26. Duchamp's response on the questionnaire concerning the *3 Standard Stoppages* (Artists' files, Department of Painting and Sculpture, Museum of Modern Art, New York). Francis Naumann discovered this previously unnoted document while researching Duchamp's *3 Standard Stoppages* for his catalogue of the *Mary and William Sisler Collection* (pp. 168–71).

27. See Cabanne, *Dialogues*, p. 37, as well as n. 16 above.

28. For the texts of these two works, see *Duchamp* (Philadelphia), p. 264; the works are illustrated in color in *Duchamp* (Venice), pp. 38–39. The first *Musical Erratum* was included in the *Green Box* (*SS*, p. 34). The second *Musical Erratum* was formerly in the collection of Duchamp's friend John Cage, whose musical philosophy closely paralleled Duchamp's views on art. On Duchamp and music, see Gavin Bryars, "Notes on Marcel Duchamp's Music," *Studio International* 192 (Nov. 1976), 274–79, who also notes the model of Roussel's Handel episode (see chap. 4 at n. 169); and Craig Adcock, "Marcel Duchamp's Gap Music: Operations in the Space between Art and Noise," in *Wireless Imagination*, ed. Kahn and Whitehead, pp. 105–38.

29. For a musical analysis of Duchamp's two works, see Carol P. James, "Duchamp's Silent Noise / Music for the Deaf," in *Duchamp: Artist of the Century*, ed. Kuenzli and Naumann, pp. 106–26.

30. See *Duchamp* (Philadelphia), p. 264.

31. Duchamp also utilized music composition paper for the four-page collection of wordplays titled *Written Rotten / Morceaux moisis*, which he produced for inclusion in the *Box in a Valise*; see Bonk, *Box in a Valise*, pp. 119–22, 251–52.

32. See *Box of 1914* in *SS*, p. 25.

33. See *Duchamp* (Philadelphia), pp. 264–65 for this and the quotations following. See also Duchamp's 1913 note on a "musical precision instrument" ("against 'virtuosism'"), in *A L'INF*, in *SS*, p. 75; and *MDN*, note 181 (appen. A, no. 20), in which he explores both chance and another emotion-free mode of expression he terms "gap music" ("from a [chord] group of 32 notes for ex. / on the piano / not emotion either, but *enumeration through the* cold thought of the other 53 missing notes."). The chance elements explored on the reverse of this note are discussed in connection with the Mobile in chap. 11 at n. 16.

34. Museum of Modern Art questionnaire (see n. 26 above).

35. *Box of 1914*, in *SS*, p. 22.

36. *GB*, in *SS*, p. 33.

37. Until very recently, it was generally assumed in the Duchamp literature that the entire assemblage was created in 1914 (see, e.g., Schwarz, *Complete Works*, cat. no. 206). Ecke

Bonk, however, has reconstructed the history of the *Stoppages* from Duchamp's correspondence with Katherine Dreier, establishing the 1918 date for the making of the templates and the 1936 date for the mounting of the narrowed canvases on glass and their placement in the wooden box (*Box in a Valise*, pp. 216–20).

38. Duchamp, as quoted in Cabanne, *Dialogues*, p. 46. Gough-Cooper and Caumont ("Ephemerides," in *Duchamp* [Venice], entry for May 19, 1914) suggest that Duchamp's title involves a wordplay on a sign advertising "stoppages et talons" (mending and heels).

39. Museum of Modern Art questionnaire (see n. 26 above).

40. See Henderson, *Fourth Dimension*, pp. 131–32, as well as Henderson, "The Artist, 'The Fourth Dimension,' and Non-Euclidean Geometry, 1900–1930: A Romance of Many Dimensions" (Ph.D. diss., Yale University, 1975), pp. 231–32.

41. On this geometry, which differs from the better-known Riemannian geometry based on a negation of the parallel postulate, see Henderson, *Fourth Dimension*, pp. 4–6. On the importance of this type of geometry in Cubist arguments for the "deformability" of figures, see ibid., pp. 93–94.

42. On the philosophical impact of non-Euclidean geometries, see, e.g., Henderson, *Fourth Dimension*, pp. 11–17; and Morris Kline, *Mathematics: A Cultural Approach* (Reading, Mass.: Addison-Wesley, 1962), pp. 572–77. If Gleizes and Metzinger drew briefly on Poincaré's writings on non-Euclidean geometry (and on the perception of space) to support aspects of Cubist theory (see Henderson, *Fourth Dimension*, pp. 81–85, 93–99), Duchamp was to engage his work in a much more thoroughgoing manner, as in the case of the *3 Standard Stoppages*.

43. Duchamp, "Apropos of Myself," p. 15.

44. On Jarry's individualist anarchism, see Beaumont, *Alfred Jarry*, pp. 64–65.

45. Max Stirner was the pseudonym of Johann Kaspar Schmidt. His 1845 book was first published in France in 1899 as *L'Unique et sa propriété* and appeared in a second edition in 1910. Mark Antliff's *Inventing Bergson* has brought to light the interest in Stirner by a group of Parisian anarcho-individualist Bergsonians around the periodical *Action d'Art*. This group included the Italian Futurist Gino Severini and featured a distinctly different reading of Bergson from that of the Puteaux Cubists. The writings of the major spokesperson for this group, André Colomer, celebrate a radical individualism and self-expression as well as a view of artistic creation as a state of mind rather than the act of producing art objects. Duchamp's reference to Stirner and the strong parallels to his own thinking suggest that despite Duchamp's reaction against the Bergsonism of his Cubist colleagues, he may have been encouraged by the radical individualism of the Stirneresque Bergsonians around *Action d'Art*. See Antliff, *Inventing Bergson*, chap. 5.

46. See Naumann, *Sisler Collection*, p. 170; Naumann's 1984 essay offered the first published discussion of the relevance of Stirner for Duchamp's *Stoppages*. See also Naumann, "Marcel Duchamp: A Reconciliation of Opposites," in *Duchamp: Artist of the Century*, ed. Kuenzli and Naumann, pp. 29–32; and in *Definitively Unfinished Duchamp*, ed. de Duve, pp. 53–56.

47. See William Hallock and Herbert T. Wade, *Outlines of the Evolution of Weights and Measures and the Metric System* (New York: Macmillan, 1906), p. 255. See *Catalogue officiel. . .C.N.A.M.*, fasc. 3, pp. 207–65, for the metrological displays in room 21 at the Arts et Métiers.

A 1907 article in *La Revue des Idées*, "La Crise du Conservatoire des Arts et Métiers," focused attention on the testing laboratory at the Arts et Métiers, where a conflict existed between the technical staff and the director, a "theoretician" more interested in abstract issues, such as the wavelength equivalent for the meter, than in testing standards for industry; see Lt-Colonel Hartmann, "La Crise du Conservatoire des Arts et Métiers," *La Revue des Idées* 4 (May 15, 1907), 385–99.

48. See Hallock and Wade, *Outlines*, chaps. 2, 10.

49. See "La Cinquième Conférence Générale des Poids et Mesures," *Revue Générale des Sciences Pures et Appliquées* 24 (Nov. 30, 1913), 828–29.

50. Charles-Edouard Guillaume, "Métrologie et législation," *Revue Générale des Sciences Pures et Appliquées* 23 (Oct. 15, 1912), 733, 739.

51. See Gough-Cooper and Caumont, "Ephemerides," in *Duchamp* (Venice), entry for Aug. 8, 1913.

52. See Cabanne, *Dialogues*, p. 39, for Duchamp's comment on discrediting science; see *GB*, in *SS*, pp. 30, 48–49 for the "phenomenon of stretching." In a note of 1915 Duchamp also contemplated a measuring system (and its application) that would be based on the space between the teeth of a comb, with intermediary points determined by the broken teeth (*GB*, in *SS*, p. 71).

53. On the problems in constructing and maintaining meter bars, see Hallock and Wade, *Outlines*, chap. 10.

54. *GB*, in *SS*, p. 33.

55. This issue and the relation of both the *Stoppages* and the mid-section of the *Large Glass* to electrical condensers are discussed in chap. 8. Ulf Linde's description of the coloration of the glass plates of the *Stoppages* in these terms alerted me to this color differentiation as I studied the mid-section of the *Large Glass*. See his *Marcel Duchamp* (Stockholm: Rabén & Sjögren, 1986), p. 138. Linde's 1965 comment on the connection between the appearance of the *Stoppages* in their box and the mid-section of the *Glass* is quoted at n. 96 in chap. 8 below; see also Linde, "MARiée CELibataire," in Galleria Schwarz, *Marcel Duchamp*, p. 48. On the chronology of Duchamp's mounting of the canvas strips, see again Bonk, *Box in a Valise*, p. 218. Duchamp first identified the horizon line–mid-section of the *Glass* with the Bride's Clothing in the *Boxing Match* drawing (*GB*, in *SS*, p. 67; fig. 45 herein).

56. Duchamp, as quoted in Cabanne, *Dialogues*, p. 42.

57. Plato, *Statesman*, ed. and trans J.B. Skemp (London: Routledge and Kegan Paul, 1952), 284d.

58. *A L'INF*, in *SS*, p. 74.

59. Duchamp, as quoted in Cabanne, *Dialogues*, p. 48. On Duchamp's subversion of Kantian aesthetics, see Thomas McEvilley, "empyrrhical thinking (and why kant can't)," *Artforum* 27 (Oct. 1988), 125–26.

60. Duchamp, as quoted in Cabanne, *Dialogues*, p. 48.

61. See *GB*, in *SS*, p. 30; *MDN*, notes 68, 77 (app. A, no. 2).

62. See *GB*, in *SS*, p. 30; *MDN*, notes 68, 77 (app. A, no. 2), for the "liberty of indifference"; see *GB*, in *SS*, p. 62, for the "irony of indifference."

63. Duchamp, as quoted in Cabanne, *Dialogues*, p. 46.

64. See Henri Bergson, *Time and Free Will* (1889), trans. F. L. Pogson (New York: Macmillan, 1910), pp. 6–11, 128–39. See also Antliff, "Bergson and Cubism," pp. 343–44; and Antliff, *Inventing Bergson*, pp. 45–46. It was Antliff's insightful analysis of Cubist theory in the light of Bergson's philosophy that pointed up for me the contrast between Duchamp's attitudes and the Bergsonist views of Gleizes and Metzinger as they developed during 1912.

65. Gleizes and Metzinger, *Du Cubisme*, pp. 43–44; trans. in *Modern Artists on Art*, ed. Herbert, p. 18. Jeffrey Weiss in his recent book *The Popular Culture of Modern Art* has likewise pointed to Gleizes's and Metzinger's preoccupation with taste and beauty (minus the issue of Bergsonism) as a "reverse model" for Duchamp's Readymades (pp. 128–29).

66. See, e.g., Bergson, *Creative Evolution*, pp. 151–65, as well as Antliff, "Bergson and Cubism" and *Inventing Bergson*, chap. 2. Although Cubist theory had initially attempted to link Cubism with the newest science and geometry, including a fourth dimension, by late 1912 such connections were being deemphasized in the writings of Gleizes and Metzinger as well as Le Fauconnier (see chap. 6 at nn. 52, 141).

67. Henri Bergson, *Time and Free Will*, p. 135; quoted in Antliff, "Bergson and Cubism," p. 343, and *Inventing Bergson*, p. 46. For Bergson's use of the *tout fait* phrase, see *Essai sur les données immédiates de la conscience* (Paris: Félix Alcan, 1889), e.g., p. 102.

68. See chap. 3 at n. 48. Bergson also used the phrase repeatedly in *Creative Evolution*, including a metaphorical reference to "ready-made garments" in his introduction (p. xiv). The term *ready-made* had been in use in the clothing industry since the mid-nineteenth century; see *O.E.D.*, s.v. "ready-made."

69. Duchamp, letter to Suzanne Duchamp, "Around 15th of January [1916]," in "Affectueusement, Marcel: Ten Letters from Marcel Duchamp to Suzanne Duchamp and Jean Crotti," ed. Francis M. Naumann, *Archives of American Art Journal* 22, no. 4 (1982), 5.

70. In Gleizes and Metzinger, *Du Cubisme,* the word *goût* occurs once at the beginning of chap. 4 and at least seven times in chap. 5. For Hulten's discussion, see Pontus Hulten, "'The Blind Lottery of Reputation' or the Duchamp Effect," in *Duchamp* (Venice), p. 16; see also Gough-Cooper and Caumont, "Ephemerides," in ibid., entry for Jan. 15, 1916. Naumann (*Sisler Collection*, p. 166) illustrated an advertisement for "Egouttoirs Hérisson" from the 1912 catalogue for the Grand Bazar de l'Hôtel de Ville, Paris, without commenting on the word *égouttoir* itself.

71. Duchamp, "Apropos of Readymades," in *SS*, p. 142; also in "Apropos of Myself," p. 16.

72. Gough-Cooper and Caumont have identified the painter of the *Pharmacy* landscape as a Swiss woman, Sophie de Niederhausern; see "Ephemerides," in *Duchamp* (Venice), entry for Apr. 4, 1916.

73. "Apropos of Readymades," in *SS*, p. 142. For a useful clarification of the terminology surrounding Duchamp's Readymades, see Francis M. Naumann, "The Bachelor's Quest," *Art in America* 81 (Sept. 1993), 72–81, 67–69. Martha Buskirk offers an insightful consideration of Duchamp's later replication of his Readymades (including the miniature versions in the *Box in a Valise*) and points up the indefinite status of these objects in "Thoroughly Modern Marcel," *October*, no. 70 (Fall 1994), 113–25. For the fullest investigation of these issues to date, see Dalia Judowitz, *Unpacking Duchamp: Art in Transit* (Berkeley: University of California Press, 1995); and Francis M. Naumann, *Marcel Duchamp: The Art of Making Art in an Age of Mechanical Reproduction* (Ghent: Ludion, forthcoming).

74. Duchamp, as quoted in Otto Hahn, "Passport No. G255300," *Art and Artists* 1 (July 1966), p. 10.

75. Duchamp, as quoted in Roberts, "I Propose to Strain," p. 47.

76. Cabanne, *Dialogues*, p. 48. Duchamp expressed a similar view in his "Apropos of Myself" lecture, p. 16, and in "Apropos of Readymades" (*SS*, p. 141).

77. Schwarz, *Complete Works*, p. 38, n. 23.

78. McEvilley, "empyrrhical thinking," pp. 122–23.

79. For evidence of Stirner's reading of Pyrrho, see Max Stirner, *The Ego and His Own*, trans. Steven Byington (London: A. C. Fifield, 1915), p. 28.

80. *MDN*, notes 101, 153 (p. 2) (app. A, no. 11).

81. See Nicholas Rescher, "Choice without Preference: A Study of the History and Logic of the Problem of 'Buridan's Ass,'" *Kant-Studien* 51 (1959–60), 142–75. See also the *Encyclopedia of Philosophy*, ed. Paul Edwards, 8 vols. (New York: Macmillan and Free Press, 1972), vol. 1, s.v. "Buridan, Jean."

82. Rescher, "Choice without Preference," p. 157.

83. *Petit Larousse*, s.v. "Buridan"; *GB*, in *SS*, p. 62.

84. See *MDN*, notes 101, 153 (p. 2) (app. A, no. 11).

85. *GB*, in *SS*, pp. 61–62.

86. See *Box of 1914*, in *SS*, p. 23; and, e.g., *MDN*, notes 30, 31, and 181, as well as those cited in n. 84 above. Notes 30 and 31 seem to deal with the issue of "symmetrical knowledge" and the determination of the location of a particular hidden "wanted piece." On the association of symmetrical knowledge and Buridan's Ass, see again *Encyclopedia of Philosophy*, ed. Edwards, s.v. "Buridan, Jean."

87. *GB*, in *SS*, p. 30; *MDN*, notes 68, 77 (app. A, no. 2).

88. See again nn. 36, 38 above. On Duchamp and chance as it was explored by literary figures such as Mallarmé, see Harriet Watts, *Chance: A Perspective on Dada* (Ann Arbor: UMI Research Press, 1980), chap. 2.

89. On Duchamp's reading of Revel's text, see again chap. 2, n. 57, and the related text.

90. Poincaré, *Science et méthode*, p. 93; in *Foundations*, p. 412. For Poincaré's chapter on chance, see *Science and Method*, book 1, chap. 4. See also Henri Poincaré, *Calcul des probabilités*, 2d ed. rev. (Paris: Gauthier-Villars, 1912), a book that would certainly have been known to Maurice Princet, the insurance actuary and friend of Duchamp and the Puteaux Cubists as well as Picasso (see chap. 6, n. 125).

91. See n. 87 above.

92. In 1914 Emile Borel published *Le Hasard* (Paris: Félix Alcan, 1914), codifying contemporary scientific views on chance and testifying to the importance of the theme in this period.

93. Duchamp, as quoted in Cabanne, *Dialogues*, p. 47.

94. Duchamp, "Apropos of Readymades," in *SS*, p. 141; also "Apropos of Myself," p. 16.

95. On this issue, see, e.g., William Camfield's discussion of Duchamp's *Fountain*, as well as his overview of interpretations of *Fountain* from 1917 through the 1980s, in *Marcel Duchamp: Fountain* (Houston: Menil Collection), 1989. Linde's essay "MARiée CELibataire," in the 1964 *Readymades* catalogue, first proposed substantive connections between Duchamp's Readymades and the themes of the *Large Glass*, frequently drawing on wordplay. For further discussion of Linde's ideas and my own reading of this relationship, see chap. 9, n. 66; chap. 12, n. 44 and following; and chap. 13, n. 134 and following.

96. Duchamp, as quoted in Hahn, "Passport," p. 10.

97. Duchamp, as quoted in Siegel, "Some Late Thoughts," p. 21. Gough-Cooper and Caumont have suggested that a wordplay may have been the source of Duchamp's combination of a wheel (*roue*) and a stool (*selle*), producing an allusion to Roussel, his mentor-at-a-distance in linguistic invention. See Gough-Cooper and Caumont, "Ephemerides," in *Duchamp* (Venice), entry for June 4, 1964. André Gervais notes Gough-Cooper and Caumont's suggestion of this idea as early as 1981 and develops the theme further in "Roue de bicyclette: Epitexte, texte et intertextes," *Les Cahiers du Musée National d'Art Moderne*, no. 30 (Winter 1989), 59–80.

98. For Jarry, Lodge, and bicycle wheels, see chap. 4, nn. 83, 84. For Duchamp's comment on the importance of wheels in his work, see Schwarz, *Complete Works*, cat. no. 205. Linde has discussed the possible geometric implications of Duchamp's spinning *Bicycle Wheel* in "La Roue de bicyclette" (*OeuvreMD* [Paris], vol. 3, pp. 36–37), as has Adcock in *Marcel Duchamp's Notes*; on Linde's discussion, see also Henderson, *Fourth Dimension*, p. 128, n. 31.

99. Naumann, *Sisler Collection*, p. 163. Michel Sanouillet includes an advertisement for bicycle wheels that shows them detached from their frames and mounted to demonstrate their strength; see Sanouillet, "Duchamp and the French Intellectual Tradition," in *Duchamp* (Philadelphia), p. 52.

100. Schwarz provided an early discussion of this type of displacement, as it occurs in linguistic puns and in Duchamp's Readymades (*Complete Works*, pp. 30–32).

101. de Duve, "Resonances," in *Duchamp: Artist of the Century*, ed. Kuenzli and Naumann, p. 58.

102. Breton, "Phare de *La Mariée*," p. 43; in Lebel, *Marcel Duchamp*, p. 89.

103. Dickran Tashjian has likewise compared Duchamp's objects to displays at the 1900 Exposition Universelle ("Henry Adams and Marcel Duchamp," p. 104).

104. *GB*, in *SS*, p. 65. On the 1936 Surrealist exhibition, which also included mathematical objects from the Institut Poincaré, see Jean, *History of Surrealist Painting*, pp. 247–51.

105. In a letter of April 1917 Katherine Dreier recorded her surprise at Duchamp's *Fountain* having been displayed as a single object at the Independents exhibition, noting that she had assumed the Readymades she had seen in the studio were a group (quoted in Camfield, *Duchamp: Fountain*, p. 31). On Duchamp's Readymades in their New York context, see Francis M. Naumann, *New York Dada, 1915–23* (New York: Harry N. Abrams, 1994), pp. 39–48; and Naumann, *Art of Making Art*. See also chap. 13, n. 40, for the New York exhibits of Duchamp's Readymades, which attracted little public attention before the scandal surrounding *Fountain*.

106. Duchamp, "Apropos of Readymades," in *SS*, p. 141; "Apropos of Myself," p. 16.

107. Duchamp, "Apropos of Myself," p. 16.

108. "The Richard Mutt Case," *The Blind Man*, no. 2 (May 1917), 5; reprinted in Camfield, *Duchamp: Fountain*, p. 38. See n. 75 above for Duchamp's later talk of Readymades as works of art.

109. Duchamp later credited Louise Norton with the writing of the text. See Camfield, *Duchamp: Fountain*, p. 37, n. 46.

110. Duchamp, as quoted in Sweeney, "Eleven Europeans," p. 20.

111. See n. 96 above.

112. Kupka, *La Création*, p. 229; for the full version of this statement and its manuscript source, see chap. 8 at n. 31.

113. See, e.g., Kupka, *La Création* (1989 reconstruction), p. 163.

114. See *GB*, in *SS*, p. 86; *MDN*, note 120. For Duchamp's photograph, see Bonk, *Box in a Valise*, p. 255.

115. The subject of Villon's portrait is Jacques Bon, Duchamp-Villon's brother-in-law, a painter and practicing spiritualist. See Fogg Art Museum, *Jacques Villon*, cat. no. 65. Both the *Chocolate Grinder (No. 2)* and Villon's portrait were exhibited at the Carroll Galleries in New York from Mar. 8 to April 3, 1915, before Duchamp's arrival.

116. Duchamp, letter to Walter Pach, Apr. 27, 1915, in "Amicalement, Marcel: Fourteen Letters from Marcel Duchamp to Walter Pach," ed. Francis M. Naumann, in *Archives of American Art Journal* 29, nos. 3–4 (1989), 40.

117. Duchamp, as quoted in Tomkins, *Bride and Bachelors*, p. 35.

Chapter 6: Toward the *Large Glass*

1. Duchamp, as quoted in "Complete Reversal of Art Opinions," p. 427.

2. Ibid., pp. 427–28.

3. See "The Iconoclastic Opinions of M. Marcel Duchamps

[*sic*] Concerning Art and America," *Current Opinion* 59 (Nov. 1915), 347.

4. See Robert Lebel, "Marcel Duchamp maintenant et ici," *L'Oeil*, no. 149 (May 1967), 18–23, 77; reprinted in Lebel, *Marcel Duchamp* (Paris: Pierre Belfond, 1985), pp. 119–30. See also the discussion of this issue in Camfield, *Duchamp: Fountain*, pp. 98–99, and Marquis, *Marcel Duchamp*, pp. 281–82.

5. Duchamp, as quoted in Cabanne, *Dialogues*, pp. 42, 39. Cabanne had led Duchamp to this latter statement, responding to Duchamp's assertion that "Everything was becoming conceptual" by countering, "Nevertheless, one has the impression that technical problems came before the idea." Duchamp answered, "Often, yes. Fundamentally, there are very few ideas. Mostly, it's little technical problems with the elements that I use, like glass, etc. They force me to elaborate" (p. 39).

6. Duchamp, as quoted in Kuh, *Artist's Voice*, p. 83.

7. Duchamp, as quoted in Sweeney, "Eleven Europeans," p. 20.

8. Duchamp, as quoted in Tomkins, *Bride and the Bachelors*, p. 35.

9. Cabanne, *Dialogues*, p. 39. Duchamp's description of Seurat as antiscientific represents a distinct departure from his youthful opinion, when Seurat's art had represented a scientific, intellectual alternative to the Cubists' admiration for Cézanne.

10. Cleve Gray, "The Great Spectator," *Art in America* 57 (July–Aug. 1969), 21. Paul Matisse has observed that the translation of Duchamp's notes for Richard Hamilton's 1960 "Typographic Version" of the *Green Box* (used subsequently in Sanouillet's *Salt Seller* as well) "was not always as faithful to the machine-world vocabulary of the Bride as it might have been." According to Matisse, Duchamp, in working with the translator, George Hamilton, seems to have "defined particular words as they struck his interest at that time, and enjoyed taking the author's liberty to modify or even improve upon his original" (Matisse, "Translator's Note" in *MDN*, n.p.). For the 1960 text, see *The Bride Stripped Bare by Her Bachelors, Even: A Typographic Version by Richard Hamilton of Marcel Duchamp's Green Box*, trans. George Heard Hamilton (New York: George Wittenborn, 1960).

11. On the widespread interest in Leonardo in this period, see Roger Shattuck, "The Tortoise and the Hare: Valéry, Freud, and Leonardo da Vinci" (1965), in *The Innocent Eye: On Modern Literature & the Arts* (New York: Farrar Straus Giroux, 1984), pp. 82–101. Leonardo's *Mona Lisa* had been stolen from the Louvre in August 1911, and Apollinaire had been falsely imprisoned for a time in relation to the case because his "secretary," Géry Pieret, had earlier stolen two Iberian sculptures from the Louvre. See Francis Steegmuller, *Apollinaire: Poet among the Painters* (1963; New York: Viking Penguin, 1986), chap. 6.

12. See Charles Ravaisson-Mollien, ed. and trans., *Les Manuscrits de Léonard de Vinci*, 6 vols. (Paris: A. Quantin, 1881–91); Péladan, trans. and comment., *Léonard de Vinci: Textes choisis—Pensées, théories, préceptes, fables, et facéties*

(Paris: Société du "Mercure de France," 1908); and Péladan, trans. and comment., *Léonard de Vinci: Traité de la peinture* (Paris: C. Delagrave, 1910).

13. See n. 36 below for the history of the examples of the *Box of 1914* known to have survived.

14. On the subject of Duchamp and Leonardo, see, e.g., Reff, "Duchamp & Leonardo"; Jean Clair, "Duchamp, Léonard, la tradition maniériste," in *Marcel Duchamp: Tradition de la rupture ou rupture de la tradition,* ed. Clair (Paris: Union Générale des Editions, 1979), pp. 117–44; and Marquis, *Marcel Duchamp*, pp. 36, 129–38. Duchamp himself mentioned the Leonardo examination in Cabanne, *Dialogues*, p. 20.

15. Leonardo, as quoted in Henri Bergson, "La Vie et les oeuvres de M. Félix Ravaisson-Mollien" (1904), trans. as "The Life and Works of Ravaisson," in *The Creative Mind* (New York: Philosophical Library, 1946), p. 273. Beyond Duchamp's numerous references to the mind and "mental ideas" (see, e.g., n. 6 above), Walter Pach referred specifically to Duchamp's commitment to painting as "an absolute, a 'mental thing' unconditioned by material support" in *Queer Thing, Painting* (p. 32).

16. Reff discusses each of these issues in "Duchamp & Leonardo," adding the association of each artist with alchemy. He also makes visual comparisons between a number of Duchamp's works and Leonardo's drawings, including, as noted in chap. 1, the pairing of the *Bride* with Leonardo's study of a woman's internal organs. Clair treats a number of these same comparative "resonances," as well as several others, in "Duchamp, Léonard." See n. 14 above.

17. On the issue of androgyny, see Reff, "Duchamp & Leonardo," pp. 89–90; see also Clair, "Duchamp, Léonard," who notes Péladan's discussion of the hermaphrodite as "le sexe artistique par excellence" (p. 129). Jack Spector has argued for another level of androgynous meaning in *L.H.O.O.Q.* in the light of Jean-Pierre Brisset's analysis of language in sexual terms. See Jack Spector, "Duchamp's Androgynous Leonardo: 'Queue' and 'Cul' in *L.H.O.O.Q.*," *Source: Notes in the History of Art* 11 (Fall 1991), 31–35.

18. Duchamp, as quoted in Roberts, "I Propose to Strain," p. 64. For Leonardo's ideas on dust, see, e.g., Edward MacCurdy, ed. and trans. *The Notebooks of Leonardo da Vinci* (New York: George Braziller, 1956), pp. 542, 805.

19. On Kupka and Leonardo, see, e.g., Spate, *Orphism*, pp. 110–13.

20. See Dora Vallier, *Jacques Villon: Oeuvres de 1897 à 1956* (Paris: Editions "Cahiers d'Art," 1957), p. 62. On Villon's comments about the titling of the Salon de "La Section d'Or," see also Henderson, *Fourth Dimension*, p. 66, n. 54. Gleizes and Metzinger cited Leonardo's views on perception to defend their argument in *Du Cubisme* that a "picture surrenders itself slowly . . . as though it reserved an infinity of replies to an infinity of questions" (p. 34); in *Modern Artists on Art*, ed. Herbert, p. 14.

21. Péladan, *Textes choisis*, p. 26. See also Péladan, "Un Idéalisme expérimental: La Philosophie de Léonard de Vinci

d'après ses manuscrits," *Mercure de France* 71 (Jan. 16, 1908), 193–214; 71 (Feb. 1, 1908), 440–61.

22. Remy de Gourmont, "La Science de Léonard de Vinci," *La Revue des Idées* 5 (Feb. 1908), 195. Gourmont was critical of Péladan for overstating the degree of Leonardo's scientific invention, arguing instead that Leonardo was more often choosing from past scientific theories.

23. Paul Valéry, "Introduction à la méthode de Léonard de Vinci," *La Nouvelle Revue* 95 (Aug. 15, 1895), 746. Valéry's essay was also published separately as *Introduction à la méthode de Léonard de Vinci* (Paris: Librairie de la "Nouvelle Revue," 1895). In his text Valéry quoted (inaccurately, according to Roger Shattuck) Leonardo's statement, that "the air is full of infinite straight, radiant lines crossing and interweaving without one ever entering the path of another, and they represent for each object the true FORM of its cause" and asserted that Leonardo had anticipated the wave theory of light and the work of Faraday, Maxwell, and Kelvin (see Shattuck, "Tortoise and the Hare," p. 87). Valery's discussion ("Introduction," pp. 766–68) stands as one of the earliest introductions of contemporary developments in electromagnetism into a nonscientific context. Duchamp would surely have appreciated Valéry's association of Leonardo with electromagnetism. According to Robert Motherwell, when he once suggested to Duchamp that he must have read Valéry's book, "he displayed a certain ambivalence and uneasiness not unlike Valéry's own toward Dada" (Motherwell, introduction to Cabanne, *Dialogues*, p. 11, n. 11).

24. For Duhem's discussion of Buridan, see Pierre Duhem, *Etudes sur Léonard de Vinci*, 2d ser., *Ceux qu'il a lus et ceux qui l'ont lu* (Paris: A. Hermann, 1909; Paris: F. de Nobele, 1955), pp. 419–23, 428–41. See also 3d ser., *Etudes sur Léonard de Vinci: Les Précurseurs parisiens de Galilée* (1913), chap. 13. For Duchamp and "Buridan's Ass," see chap. 5 at n. 80. On Leonardo's interest in equilibrium and center of gravity, see, e.g., Duhem, *Etudes sur Léonard de Vinci*, 1st ser., *Ceux qu'il a lus et ceux qui l'ont lu* (1906), pp. 73–79, 305–10. These two issues, as well as other parallels between Duchamp and Leonardo in the area of mechanics, are discussed in chap. 11 in the section on Duchamp's "Playful Mechanics."

25. Duhem, *Etudes*, vol. 1, p. v.

26. Ibid.; Jean Paul Richter, comp. and ed., *The Literary Works of Leonardo da Vinci* (London: Sampson Low, Marston, Searle & Rivington, 1883); reprinted as *The Notebooks of Leonardo da Vinci*, 2 vols. (New York: Dover Publications, 1970), vol. 1, p. xv.

27. See, e.g., *A L'INF*, in *SS*, pp. 88–89. See also, e.g., the notes from *A l'infinitif* discussed and reproduced, recto and verso, in Naumann, *Sisler Collection*, pp. 143–55.

28. Richter, *Notebooks of Leonardo da Vinci*, p. xv.

29. Duchamp, as quoted in Alain Jouffroy, "Conversations avec Marcel Duchamp," in *Une Revolution du regard: A propos de quelques peintres et sculpteurs contemporains* (Paris: Gallimard, 1964), p. 115. See also Cabanne, *Dialogues*, pp. 42–43. Sanouillet has discussed the catalogues of the Saint-Etienne Gun and Cycle Factory in "Duchamp and the French Intellectual Tradition," in *Duchamp* (Philadelphia), pp. 48–55.

30. Duchamp, letter to Jean Suquet, Dec. 25, 1949; reprinted in Suquet, *Miroir de la mariée*, p. 247.

31. Duchamp, as quoted in Kuh, *Artist's Voice*, pp. 81, 83. According to Francis Naumann, Duchamp, in a letter of Feb. 20, 1934, to Walter Arensberg, set forth his initial conception of the *Green Box* as containing "approximately 135 notes and a dozen photos" (Philadelphia Museum of Art, The Louise and Walter Arensberg Archive). In the end, there were eleven photographic reproductions of works and eighty-three notes and drawings in the standard edition of the *Box*.

32. See *MDN*, note 77 (app. A, no. 2). For other comments on the production and physical nature of the "text" Duchamp envisioned, see *MDN*, notes 66, 68, 71, 74, 164. Among the body of handwritten notes, some (e.g., *MDN*, notes 152, 153 [app. A, no. 11]) are carefully recopied syntheses of several other notes, in this case summarizing the Bride's and Bachelors' realms, respectively.

33. *MDN*, note 66.

34. *A l'infinitif* differed from the *Green Box* in its inclusion of a printed translation of the notes in the box. The translator, Cleve Gray, worked with Duchamp to organize the notes into categories and to establish an order for the printed text; in the box itself the notes were housed in folders labeled with the category headings. *Salt Seller* reproduces this configuration. On this process, see Naumann, *Sisler Collection*, p. 143. According to Arne Ekstrom, Duchamp appeared to be far less concerned with this process than were his publisher and translator, exhibiting an attitude of "genial remoteness" (Ekstrom, letter to the author, May 16, 1974).

Sanouillet himself had created the general categories and ordering of the *Green Box* for his 1958 *Marchand du sel*, an order maintained in his 1973 *Salt Seller*. Examination of the contents of a *Green Box* reveals that there is, in some cases, a subtle organizational substructure suggested by the varying types of papers Duchamp used. For example, the notes on the Illuminating Gas are all recorded on light blue paper. That these different paper types were important to Duchamp is clear from his recounting of the difficulty of finding the various papers on which to reprint the notes in the 1930s. See Michel Sanouillet, "Dans l'atelier de Marcel Duchamp," *Les Nouvelles Littéraires*, no. 1424 (Dec. 16, 1954), 5; quoted in *SS*, p. vi.

35. See Matisse, "Translator's Note" in *MDN*; and Schwarz, introduction to *Notes and Projects*, pp. 3–6; Richter, ed., *Notebooks of Leonardo da Vinci*, p. xv. Certain of the posthumously published notes were stored in folders labeled with names of parts of the *Large Glass* (see *MDN*, notes 47–63, where Matisse reproduces the folders). According to Matisse's notations, however, the folders contained only a few of the notes relevant to a given component.

The word *supprimer* (omit) or the Xs drawn through a number of posthumously published notes may have been added at the time Duchamp was making decisions about the contents of the *Green Box*, although segments of certain of those notes are also occasionally crossed out, suggesting an internal editing process as well (e.g., *GB*, in *SS*, pp. 45, 50, 56–57).

36. Four examples of the *Box of 1914* are known to survive today. Duchamp gave the original notes from which the photographs were taken to Walter Arensberg in 1915 (Schwarz, *Complete Works*, p. 584); these, along with Arensberg's *Box of 1914*, are in The Louise and Walter Arensberg Collection at the Philadelphia Museum of Art. The *Box of 1914* that Duchamp gave to Dumouchel (fig. 78) was acquired first by Arturo Schwarz and then by Galerie Dina Vierny, Paris. Another *Box of 1914* (fig. 79) is in the collection of the Marcel Duchamp Archive (Villiers-sous-Grez, France), as is a smaller box with photographic labels that contains the original glass negatives for the *Box of 1914* (see *Duchamp: Die Schriften*, ed. Stauffer, p. 17). The *Box of 1914* owned by Walter Pach came to light only in 1987 and has since been acquired by the Art Institute of Chicago. In addition to these four boxes, Jacques Villon in 1950 lent Jean Suquet yet another version of the *Box of 1914*, housed in a box of photographic plates produced by the Guilleminot firm (Suquet, letter to the author, Jan. 15, 1996). This box, which has since disappeared, is chronicled along with the other versions in the new edition of Schwarz, *Complete Works* (1997), pp. 598–603.

For the transcribed texts of the *Box of 1914* notes, see *SS*, pp. 22–25. The notes from Dumouchel's *Box* are reproduced legibly in Galerie Dina Vierny, Paris, *Duchamp et ses frères* (Oct.–Nov., 1988), p. 70; this version of the *Box*, however, lacks the sixteenth note: the three small photographs of the *3 Standard Stoppages* labeled "3 décistoppages étalon," which is present in the version of the *Box of 1914* in the Arensberg Collection.

37. Adcock has discussed the *Box of 1914* in terms of photography (*Marcel Duchamp's Notes*, pp. 3–8; "Marcel Duchamp's 'Instantanés,'" pp. 240–44), as has Jean Clair in *Duchamp et la photographie* (pp. 54–56). On the photography holdings of the Musée des Arts et Métiers, which were housed in rooms 42–45, see *Catalogue officiel . . . C.N.A.M.*, vol. 5, pp. 48–92, as well as *Guide bleu*, p. 190.

38. The term *plaques sensibles* appeared widely in the literature on X-rays and spirit photography and is discussed further in chap. 8.

39. On Duchamp's *Unhappy Readymade*, involving both chance and non-Euclidean geometry, see chap. 8, n. 211.

40. See again chap. 5, n. 9, for Duchamp's notes on the "painting of precision and beauty of indifference." For Duchamp's comments on "transparent" and precise language, which are discussed in chaps. 10 and 12 as well, see *MDN*, note 82 (app. A, no. 5). As noted in the section on the Desire Dynamo in chap. 11, Duchamp created equations in which emotions such as desire and fear were assigned algebraic letters (e.g., *MDN*, note 161).

41. *GB*, in *SS*, p. 28.

42. See Beaumont, *Jarry*, pp. 100–101.

43. An exception to this tendency is one of Robert Lebel's last essays before his death, "Marcel Duchamp et l'électricité en large," for which he accepted the translation "at large" and briefly raised the issue of "wire-less electricity" (see *Electra*, pp. 164–65). See also the discussion of Lebel's essay at the beginning of this section of chap. 8, "Wireless Telegraphy, Telepathy, and Radio Control in the *Large Glass*."

44. The term *éloignement* is translated in *Salt Seller* as "deferment," but the word signifies a spatial remoteness and distancing, not the temporal deferment derived, perhaps, from the military-service context of the note. See *SS*, p. 23. Duchamp's sister Suzanne also used this term in her collage-painting *Radiations de deux seuls éloignés*, dated 1916–1918–1920 (fig. 106), in a similar sense of communication at a distance.

45. See Guillaume Apollinaire, "Les Fenêtres," in *Selected Writings*, ed. Shattuck, pp. 140–41; and Apollinaire, "L'Amphion faux-messie ou histoire et aventures du baron d'Ormesan," in *L'Hérésiarque et Cie* (Paris: Editions Stock, 1910), pp. 238–54. Apollinaire's tale, which is discussed further in chap. 8, centers upon Ormesan's ability to appear as a messiah figure in multiple locations simultaneously.

46. See the sections on Crookes and Jarry in chap. 4.

47. *GB*, in *SS*, p. 27. Duchamp also considered using a photograph of the drawing "as a '*Commentary*' on the section Slopes" (*GB*, in *SS*, p. 51; *MDN*, note 128 [app. A, no. 10]), an issue discussed at the beginning of chap. 7.

48. *GB*, in *SS*, p. 23. Duchamp's note also contains a small drawing of the box showing openings into which small iron discs are tossed in the "barrel game."

49. See chap. 5, n. 55.

50. See *Petit Larousse illustré* (1912), s.v. "pissotière."

51. David Hopkins has remarked on the second of these two notes, suggesting that Duchamp's imaging of the urinal as female may have centered on the hole at its base. See Hopkins, "Questioning Dada's Potency: Picabia's 'La Sainte Vièrge' and the Dialogue with Duchamp," *Art History* 15 (Sept. 1992), 317–33. Camfield has also emphasized the feminine, sexual associations of a urinal's shape (Camfield, *Duchamp: Fountain*, p. 53).

52. Le Fauconnier, "La Sensibilité," p. 22 (cited in chap. 1, n. 109). Like other Cubist authors, Le Fauconnier specifically rejected perspective (ibid.).

53. For this argument, see ibid., pp. 22–23. Le Fauconnier's antimathematical stance here forms a contrast to his 1910 essay "Das Kunstwerk," in which the language of mathematics and number figured prominently. See Ann H. Murray, "Henri Le Fauconnier's 'Das Kunstwerk': An Early Statement of Cubist Aesthetic Theory and Its Understanding in Germany," *Arts Magazine* 56 (Dec. 1981), 125–33. Antliff has discussed the strongly Bergsonist orientation of Le Fauconnier's essay in the context of the Puteaux Cubists' embrace of Celtic nationalism versus, e.g., the emphasis on the Latin roots of French culture by the Action française group. See Antliff, *Inventing Bergson*, pp. 110–14.

54. See *A L'INF*, in *SS*, pp. 79–83. Other references to "a world in yellow" occur in *GB*, in *SS*, p. 44, as well as in *MDN*, notes 115 (p. 4) and 118 (p. 3); the latter two notes are devoted to paint formulas. Duchamp's phrase "world in yellow" has given rise to speculation on topics such as esoteric color symbolism, usually with little supporting evidence; see, e.g.,

Schwarz, *Complete Works*, pp. 79–80. On this phrase, see also chap. 10 at n. 175.

55. *A L'INF*, in *SS*, p. 82.

56. For Duchamp's "coefficient of displacement," see *MDN*, notes 137, 152 (p. 3). Although the translation of Duchamp's note on the "Shots" (*GB*, in *SS*, p. 35) appears to contain a reference to a "coefficient of displacement," the original French phrase is actually "cote de distance" (*DDS*, p. 54). Duchamp maintained an interest in "coefficients" to the end of his life, using the term "art coefficient" in a 1957 lecture, "The Creative Act," to describe the "difference between what [the artist] intended to realize and did realize" (see *SS*, p. 139).

57. Le Fauconnier, "La Sensibilité," p. 22.

58. See *GB*, in *SS*, p. 38, as well as the discussion of this subject and of the Air Current Pistons (figs. 119, 120) in chap. 8.

59. Duchamp, as quoted in Hamilton and Hamilton, 1959 BBC interview (*Audio Arts Magazine* cassette). For Duchamp's preceding reference to "an acceptance of all doubts," see Ashton, "Interview," p. 244. In that interview Duchamp continued: "I am not a Cartesian by pleasure. I happen to have been *born* a Cartesian. The French education is based on strict logic. You carry it with you. I had to reject Cartesianism in a way. I don't say that you can't be both. Perhaps I am" (pp. 244–45). David Hopkins provides a more extensive discussion of Duchamp and Descartes in his dissertation, "Hermeticism, Catholicism and Gender as Structure: A Comparative Study of Themes in the Work of Marcel Duchamp and Max Ernst" (Ph.D. diss., University of Essex, 1989), pp. 50–59.

60. For additional photographs of Duchamp's studio, see Bonk, *Box in a Valise*, p. 239. On Duchamp and the Arensberg circle, see Francis M. Naumann, "Walter Conrad Arensberg: Poet, Patron, and Participant in the New York Avant-Garde, 1915–20," *Philadelphia Museum of Art Bulletin* 76 (Spring 1980), 2–32; Naumann, *New York Dada, 1915–23*; and Whitney Museum of American Art, New York, *Making Mischief: Dada Invades New York* (Nov. 21, 1996–Feb. 23, 1997). See also *New York Dada*, a collection of essays and newspaper interviews with Duchamp, edited by Rudolf E. Kuenzli, with Naumann's assistance (New York: Willis Locker & Owens, 1986).

61. Other Europeans included the English poetess Mina Loy and her husband, Arthur Craven, as well as Baroness Elsa von Freytag Loringhoven. On Picabia's arrival in New York and his activities there, see Camfield, *Picabia*, chap. 6.

62. On the interaction of Man Ray and Duchamp, which is noted periodically in the chapters that follow, see, e.g., Naumann, *New York Dada*, chap. 5. For the impact of Duchamp's work on the *Glass* on other of the young Americans, see Linda Dalrymple Henderson, "Reflections of and/or on Marcel Duchamp's *Large Glass*," in Whitney Museum, *Making Mischief*, pp. 228–37.

63. See, e.g., Francis M. Naumann, "Cryptography and the Arensberg Circle," *Arts Magazine*, 51 (May 1977), 127–33. Certain members of the group, particularly Varèse and Covert, do seem to have shared Duchamp's interest in a fourth dimension. See Henderson, *Fourth Dimension*, pp. 218–30.

64. See n. 3 above.

65. Duchamp, as quoted in Tomkins, *Bride and the Bachelors*, p. 38. For the chronology of Duchamp's work on the *Glass*, see Schwarz, *Complete Works*, pp. 144–46.

66. Duchamp, as quoted in Tomkins, *Bride and the Bachelors*, p. 35.

67. Duchamp, as quoted in Cabanne, *Dialogues*, p. 65.

68. This is the image on which the diagram in fig. 77 is based; see Schwarz, *Complete Works*, cat. no. 390.

69. Although Duchamp's inscription on the restored *Large Glass* dates the breakage to 1931, the year Katherine Dreier discovered the damage, he later suggested that it occurred nearer the close of the 1926 exhibition (see Sweeney, "Conversation," in *SS*, p. 127). On Dreier's discovery of the damage, see Robert L. Herbert, Eleanor S. Apter, and Elise K. Kenney, eds., *The Société Anonyme and the Dreier Bequest at Yale University: A Catalogue Raisonné* (New Haven: Yale University Press, 1984), p. 761. For Duchamp's repairs, which included the insertion of a new piece of glass in the area of the Nine Shots, see Schwarz, *Complete Works*, pp. 148–49; and the entries from Gough-Cooper and Caumont's "Ephemerides," *Duchamp* (Venice), cited in chap. 14, n. 80. For the changes to the mid-section of the *Glass*, see chap. 8 at n. 91.

70. On Duchamp's periods in Paris in subsequent decades, see chap. 14, n. 41.

71. See Jean, *History of Surrealist Painting* (1959), pp. 101–12; Lebel, *Marcel Duchamp* (1959), chap. 7; and Schwarz, *Complete Works* (initially published in 1969), which includes sections on the "Bride's Psychology" and the "Bachelor's Psychological Pattern," in addition to its generally Freudian/Jungian slant. Calvin Tomkins's Time-Life monograph, *The World of Marcel Duchamp*, appeared in 1966. The first of the charts of the operations of the *Large Glass* was made by Richard Hamilton for his *Typographic Version . . . of Marcel Duchamp's Green Box* (1960).

72. *GB*, in *SS*, p. 42. For other descriptions of the Bride, see pp. 36–48.

73. Ibid., p. 51; for the *Green Box* notes on the Illuminating Gas, see pp. 48–53.

74. Ibid., p. 63.

75. Ibid.

76. Ibid., p. 66.

77. Ibid., p. 65.

78. Ibid.

79. Cf. ibid., p. 35, and *DDS*, p. 54.

80. *GB*, in *SS*, p. 56.

81. Ibid., p. 51.

82. Ibid., p. 60.

83. Ibid., pp. 60–62.

84. Ibid., p. 68.

85. Ibid.

86. Duchamp, as quoted in Schwarz, *Complete Works*, p. 156.

87. Unfortunately, Duchamp's experimentation with media has produced conservation problems that eventually will have to be addressed by the Philadelphia Museum of Art. Small pieces of lead wire and lead foil have detached from the glass

and slipped downward slightly. In addition, the lead sealed between the two exterior panes of protective glass is corroding, producing white "ash" at the bottom of the enclosure.

88. See *A L'INF*, in *SS*, pp. 76, 82–83. See pp. 80–83 for Duchamp's formulas for various metallic equivalents.

89. Man Ray chronicles the photographing of the glass and Duchamp's titling of the photograph in *Self Portrait* (1963; new ed., Boston: Little, Brown, 1988), p. 79.

90. See ibid., p. 73, for Man Ray's description of Duchamp at work and the tedium of the task. On contemporary techniques for "silvering" glass, see the *Encyclopaedia Britannica*, 11th ed. (1910), s.v. "mirror."

91. Duchamp, as quoted in Sweeney, "Conversation," in *SS*, p. 127; and in Cabanne, *Dialogues*, p. 75.

92. *GB*, in *SS*, p. 36, with slight variation in translation.

93. See Schwarz, *Complete Works*, p. 146.

94. *GB*, in *SS*, p. 38.

95. *MDN*, note 147.

96. See *GB*, in *SS*, p. 29, as well as the discussion of a segment of this note at the conclusion of the present chapter.

97. See "Cast Shadows," in *SS*, p. 72.

98. See again Cleve Gray's discussion, quoted at n. 10 above.

99. Cabanne, *Dialogues*, p. 38.

100. Duchamp, as quoted in Cabanne, *Dialogues*, p. 40. Duchamp had explained the Bride's four-dimensionality similarly in a letter of Oct. 4, 1954, to Breton, published in *Medium*, no. 4 (Jan. 1955), p. 33: "The Bride or the *Pendu femelle* is a 'projection' comparable to the projection of a four-dimensional 'imaginary being' in our three-dimensional world (and also in the case of the flat glass, to a re-projection of these three dimensions onto a two-dimensional surface)."

101. For a sampling of discussions of shadows as signs of a higher dimension, see Henderson, *Fourth Dimension*, pp. 18, 30, 154–55, 200.

102. Such a model was built at the time of the 1977 Paris retrospective; see *OeuvreMD* (Paris), vol. 2, cat. no. 252 (p. 177).

103. See *A L'INF*, in *SS*, pp. 83–84, for the version of the note beginning with the term "Perspective4" and followed by the short phrase quoted here.

104. See *GB*, in *SS*, pp. 44–45. Craig Adcock has discussed the upper half of the *Glass* in terms of topology, the geometry of forms unaltered by "elastic deformation," which is free of the quantitative basis of metric geometry. On topology (or *analysis situs*, as it was then termed), which was central to Poincaré's speculations on continua and cuts, see Adcock, *Marcel Duchamp's Notes*, pp. 126–29. In the "Jura-Paris" note in the *Green Box* Duchamp had described the road-line as "becom[ing] without topological form" as it approaches "the infinite" (*GB*, in *SS*, p. 27).

105. See Linda Dalrymple Henderson, "Mysticism, Romanticism, and the Fourth Dimension," in Los Angeles County Museum of Art, *The Spiritual in Art: Abstract Painting, 1890–1985* (Nov. 23, 1986–Mar. 8, 1987), pp. 219–37.

106. Apollinaire, *Les Peintres Cubistes*, p. 16; *Cubist Painters*, p. 14.

107. See Henderson, *Fourth Dimension*, p. 111. Boccioni was himself deeply indebted to Bergson's theories; see Brian Petrie, "Boccioni and Bergson," *Burlington Magazine* 116 (Mar. 1974), 140–47.

108. *GB*, in *SS*, p. 39.

109. *MDN*, note 67.

110. See Henderson, *Fourth Dimension*, pp. 28, 159, 286–87.

111. See *Notebooks of Leonardo da Vinci*, ed. Richter, p. 53.

112. See *A L'INF*, in *SS*, p. 86. Jean Clair has provided the fullest discussion of Duchamp and perspective to date. See Clair, "Marcel Duchamp et la tradition des perspecteurs," in *OeuvreMD* (Paris), vol. 3, pp. 124–59; trans. as "Duchamp and the Classical Perspectivists," *Artforum* 16 (Mar. 1978), 40–49. Carla Gottlieb has also discussed the *Large Glass* in relation to Leonardo and perspective but neglects the contrast between its lower and upper realms and therefore misinterprets the entire work as a critique of Leonardo and perspective. See Gottlieb, "Something Else: Duchamp's *Bride* and Leonardo," *Konsthistorisk Tidskrift* 45 (June 1976), 52–57.

113. Richard Hamilton, in Tate Gallery, London, *The Almost Complete Works of Marcel Duchamp* (June 18–July 31, 1966), p. 45.

114. See Cabanne, *Dialogues*, p. 41. As Duchamp told Francis Roberts, glass also solved the problem of having to paint backgrounds (Roberts, "I Propose the Strain," p. 46).

115. See Cabanne, *Dialogues*, pp. 38, 41–42.

116. Walter Pach, *The Masters of Modern Art* (New York: B. W. Huebsch, 1924), p. 88.

117. Kupka, Notebook, p. 49 (courtesy Margit Rowell).

118. See Cabanne, *Dialogues*, p. 41.

119. *GB*, in *SS*, p. 35; on this action, see also chap. 10 at n. 174. In addition, see *GB*, p. 70, where Duchamp comments on a greenhouse: "—In the greenhouse—[On a glass plate, colors seen transparently]."

120. *GB*, in *SS*, p. 30; *MDN*, notes 68, 77 (app. A, no. 2); this note and its translation are discussed further in chap. 9 at n. 67 and following. Duchamp's *A l'infinitif* notes on glass cases are also treated in the final section of chap. 8 and at the beginning of chap. 12.

121. See n. 109 above.

122. *A L'INF*, in *SS*, p. 88.

123. On the Cubist interest in tactile and motor space, see Henderson, *Fourth Dimension*, pp. 81–86; on Duchamp and tactility, see pp. 140–42.

124. *A L'INF*, in *SS*, p. 88.

125. On the role of the actuary Princet in Cubist circles, see Henderson, *Fourth Dimension*, pp. 64–72; on Duchamp and Princet, see pp. 123–26.

126. See ibid., pp. 129–30.

127. Because Craig Adcock and I have analyzed Duchamp's notes on the fourth dimension and non-Euclidean geometry in greater detail elsewhere, only a summary view is presented here. Adcock's extensive examination of the issue of Duchamp and the fourth dimension is presented in *Marcel*

Duchamp's Notes from the "Large Glass": An N-Dimensional Analysis as well as in a series of subsequent articles. John Dee has considered Duchamp's notes on the fourth dimension specifically in relation to the writings of Hinton; see John Dee, "Ce façonnement symmétrique," in *Duchamp: Tradition de la rupture*, ed. Clair, pp. 351–402.

128. E.g., in many cases his propositions must be prefaced by the condition "as seen by the four-dimensional eye" in order to be geometrically "true." See, e.g., Henderson, *Fourth Dimension*, pp. 145–50.

129. *A L'INF*, in *SS*, pp. 96–97.

130. *GB*, in *SS*, p. 29.

131. *GB*, in *SS*, p. 27. Jean-François Lyotard addresses the issue of the hinge in Duchamp in a chapter entitled "Hinges," in *Les TRANSformateurs DUchamp* (Paris: Editions Galilée, 1977); *Duchamp's TRANS/formers*, trans. Ian McLeod (Venice, Calif.: Lapis Press, 1990).

132. See *GB,* in *SS*, p. 65. On the operation of the "Wilson-Lincoln system," see chap. 11 at n. 25.

133. *A L'INF*, in *SS*, p. 98. As Adcock has noted, the name of Dedekind does not actually occur in Duchamp's handwritten note but was inserted by Cleve Gray, who, with Duchamp's approval, translated *coupure* as "Dedekind cut" (*Marcel Duchamp's Notes*, pp. 72–73). On this note and Poincaré's discussion of Dedekind cuts, see Henderson, *Fourth Dimension*, pp. 148–50.

134. *A L'INF*, in *SS*, p. 99.

135. *A L'INF*, in *SS*, pp. 91–92. Two of Duchamp's most difficult notes set forth the pseudogeometrical "proofs" of this interpretation of mirror space; see Henderson, *Fourth Dimension*, pp. 151–52.

136. On this subject, see Martin Gardner, *The Ambidextrous Universe: Mirror Asymmetry and Time-Reversed Worlds*, 2d ed. rev. (New York: Scribner's, 1979), chap. 17.

137. *GB*, in *SS*, p. 65.

138. See *GB*, in *SS*, pp. 84–86.

139. *A L'INF*, in *SS*, p. 89. Duchamp is here extrapolating from Jouffret's discussion of two-dimensional shadows; see Henderson, *Fourth Dimension*, p. 139.

140. Although Duchamp speculated far less on non-Euclidean geometry, it had clearly been important to projects such as the *3 Standard Stoppages* and was central to the writings of Poincaré that Duchamp was reading. Adcock *(Marcel Duchamp's Notes)* has analyzed a number of Duchamp's notes in terms of their possible roots in non-Euclidean geometry; in addition, he has considered the importance for Duchamp of the field of projective geometry.

141. Jean Metzinger, "Note sur la peinture," *Pan*, Oct.–Nov. 1910, p. 650.

142. Duchamp, in a 1961 interview with William Camfield; quoted in Henderson, *Fourth Dimension*, p. 71, n. 67.

143. Le Fauconnier, "Das Kunstwerk," quoted in Murray, "Henri Le Fauconnier's 'Das Kunstwerk,'" p. 127; see n. 52 above.

144. Gleizes and Metzinger, *Du Cubisme*, p. 17; in *Modern Artists on Art*, ed. Herbert, p. 8. See also Henderson, *Fourth Dimension*, pp. 93–94.

145. Gleizes and Metzinger, *Du Cubisme*, pp. 16, 31; in *Modern Artists on Art*, ed. Herbert, pp. 7, 13.

146. See Le Fauconnier, "La Sensibilité," pp. 22, 23. See also Gleizes and Metzinger, *Du Cubisme*, p. 18; in *Modern Artists on Art*, ed. Herbert, p. 8.

147. See Antliff, "Bergson and Cubism," p. 343, and *Inventing Bergson*, p. 44.

148. Gleizes and Metzinger, *Du Cubisme*, p. 21, as well as p. 27; in *Modern Artists on Art*, ed. Herbert, pp. 9, 12.

149. This reading, developed during the course of the chapters that follow, is summarized in chap. 13 in the section "Thematic Collisions." See also chap. 13, n. 123, on Lucia Beier's reading of the entire *Large Glass* as a Bergsonian project.

150. For "clockwork box," see MDN, notes 98, 155.

151. See the discussion of Bergson's *Le Rire* in chap. 3 at n. 45.

152. See Henderson, "Mysticism," pp. 220–21.

153. *GB*, in *SS*, p. 48.

154. Ibid., pp. 49–50.

155. See Henderson, "Mysticism," pp. 220–21; on Hinton, see also Henderson, *Fourth Dimension*, pp. 25–31.

156. See, e.g., Martin, "Futurism, Unanism, and Apollinaire," pp. 258–68.

157. *GB*, in *SS*, p. 65. Duchamp seems to parody here the mystical experience evoked by Gleizes and Metzinger in their reference to those who, "with a single beat of their wings, lift themselves to unknown planes" (*Du Cubisme*, p. 32; in *Modern Artists on Art*, ed. Herbert, p. 14).

158. *GB,* in *SS*, p. 29.

159. See *GB*, in *SS*, p. 35. If the Nine Shots had been able to overcome their three-dimensional existence, they presumably could have regained the unity of the single target, a point that, according to Duchamp's discussions elsewhere, can be considered to "conceal" an entire additional spatial dimension, "the 4th direction of the continuum" (*A L'INF*, in *SS*, p. 91).

160. See n. 92 above.

161. *GB*, in *SS*, pp. 56–57, 60.

162. Ibid., p. 39.

163. *MDN*, note 104 (app. A, no. 22/23).

164. See *MDN*, notes 104 (app. A, no. 22/23) and 140.

Chapter 7: First Conceptions of the Bride and Her Interaction with the Bachelors

1. Duchamp, as quoted in Hamilton and Hamilton, 1959 BBC interview (*Audio Arts Magazine* cassette). See also, Schuster, "Marcel Duchamp, vite," p. 143.

2. *Box of 1914*, in *SS*, p. 23.

3. The Grand Toboggan was a tall wooden structure with a curving, troughlike slide. See the postcard illustrated in Suquet, "Possible," in *Definitively Unfinished Duchamp*, ed. de Duve, p. 92. Duchamp's drawing of the "Butterfly Pump" that would pump (or suction) the Illuminating Gas through the Sieves, included in the *Green Box* (*SS*, p. 54), shows the top of the Toboggan drawn as a kind of slide (versus his subsequent, more schematic treatments of the theme).

4. See Monmarché, *Guide bleu*, p. 213.

5. *MDN*, note 152 (p. 2); for the note headed "Weight," see *MDN*, note 92.

6. See, e.g., *GB*, in *SS*, pp. 30, 66 (fig. 45 herein).

7. *MDN*, note 80. Note 74 is a preliminary form of the note and substitutes the phrase "*mariée..........célibataires...*" for "agricultural instrument" in the concluding line. As finally executed, the top panel measures 50 × 66 in. (127 × 167.6 cm); the bottom panel measures 53 × 66 in. (134.6 × 167.6 cm).

8. See Wilson, *Rutherford*, chap. 10.

9. See fig. 45 and *GB*, in *SS*, p. 66. Duchamp's use of a toy cannon to determine the positions of the Nine Shots amplified the ballistic associations of this process. On Duchamp's target shooting and its parallels to the work of Perrin, see chap. 10 at n. 184 and following. Shots and targets (as in a "shooting gallery at a fair") continued to interest Duchamp, as demonstrated in this later reference in one of his notes on "infrathin" (*MDN*, note 12).

10. *GB*, in *SS*, p. 28. The note begins with an alternate version of the "Notice" note quoted here, headed "Preface," which lacks Duchamp's restatement in algebraic expressions. For the original handwritten format of the note, which is followed here, see Schwarz, ed., *Notes and Projects*, note 124.

11. For the reference to the "instantaneous state of Rest" in the "Preface" note, see *GB*, in *SS*, p. 27. For "instantaneous electric-spark photography," see, e.g., Robert Andrews Millikan and Henry Gordon Gale, *Practical Physics* (Boston: Ginn, 1920), p. 422.

12. See A. M. Worthington, *A Study of Splashes* (London: Longmans & Green, 1908), which includes "197 illustrations from 'instantaneous photographs.'" Clair also notes that Worthington's images were reproduced in *La Nature* (*Duchamp et la photographie*, p. 62). In addition to this specific suggestion concerning Worthington, Clair's text provides the best general discussion of the role of photography in the *Large Glass* and in Duchamp's work in general. The allusions to photography in this note are discussed further in the section "Appareils Enregistreurs and Other Indexical Signs in the *Large Glass*" in chap. 8.

13. See chap. 2, nn. 40, 41 and the related text.

14. Ernest Rutherford, "The Scattering of α and β Particles by Matter and the Structure of the Atom," *Philosophical Magazine and Journal of Science*, 6th ser., 21 (May 1911), 670–71; see p. 684 for the reference to "laws." Rutherford's text was surely reported in France, although I have not found a particular source for it.

15. See ibid., p. 670; see also chap. 10, n. 193 and the related text. The scintillation method involved visual observation of the light flashes produced when particles struck a zinc-sulfide screen, the phenomenon first demonstrated by Crookes's spinthariscope (fig. 30); see Wilson, *Rutherford*, on scintillation and Rutherford's work "in a darkened room" (p. 283).

16. *GB*, in *SS*, p. 50.

17. For Perrin's discussion of scattering, see chap. 10, n. 174 and the related text; other parallels between Duchamp and Perrin are discussed in this same section. Duchamp's goal of approximating a scientific, mathematical style of writing is documented

in several of his notes, including notes 77 (app. A, no. 2) and 185 (app. A, no. 1). The former is discussed in relation to Perrin near the conclusion of the same section of chap. 10.

18. *MDN*, note 111.

19. *GB*, in *SS*, p. 27. See the discussion of the Jura-Paris Road in chap. 3 for the possible identities of these "figures."

20. *GB*, in *SS*, p. 27.

21. *GB*, in *SS*, pp. 26–27.

22. *MDN*, note 109. See also fig. 49.

23. *MDN*, notes 143, 153 (p. 4) (app. A, no. 11).

24. Ibid.

25. *MDN*, note 111.

26. *MDN*, note 109.

27. *GB*, in *SS*, p. 51.

28. *GB*, in *SS*, p. 51. See also *MDN*, note 128 (app. A, no. 10).

29. *GB*, in *SS*, p. 43.

30. In the *Green Box* this ten-page note (*SS*, pp. 39–43) is reproduced on a single, accordian-folded sheet. For the original format of the note, followed here, see Schwarz, ed., *Notes and Projects*, note 1.

31. Duchamp, as quoted in Hamilton and Hamilton, 1959 BBC radio interview (*Audio Arts Magazine* cassette).

32. These components of the Bride's anatomy are all discussed in *GB*, in *SS*, pp. 42–44. Duchamp's color note for "*The Bride. 2nd Study (Munich)*" (i.e., his August 1912 painting) had indicated that the "Machinery" would be "Gold ochre" (*A L'INF*, in *SS*, p. 82). That notation provides a clue for reading further automobile or mechanical components in the *Bride* painting (pl. 3). It is also controverted, however, by Duchamp's deliberate fusing of organic and mechanical components, resulting, for example, in the pink tonality given to an overtly mechanical form such as the Desire-gear.

33. This same striped, "mossy metal" form seems to be present in the *Virgin (No. 1)* drawing near the center top (fig. 35) or center right side (fig. 51). For Duchamp's reference to "mossy metal," see *MDN*, note 144 (app. A, no. 14/15; fig. 128); also, see the discussion in chap. 2 at n. 123. For the striping of Renault hoods in this period, see, e.g., Yves Richard, *Renault 1898, Renault 1965* (Paris: Pierre Tisné, 1965), pp. 61, 69, 72–75. Duchamp later compared the *Large Glass* to the "*capot* [hood] of the automobile . . . which covers the motor." See n. 96 below and the related text.

34. *GB*, in *SS*, pp. 42, 44. For Duchamp's reference to "visceral" forms, see again chap. 1, n. 92 and the related text.

35. It is less clear what Duchamp intended by the term "Breast Cylinders" (*MDN*, note 98), although he may simply have been adding female sexual characteristics to the theme of "feeble cylinders" in the Bride's motor. His dissatisfaction with the term "Breast Cylinders" and with their function is apparent in several notes (*GB*, in *SS*, p. 30, and *MDN*, notes 68, 77 [app. A, no. 2]), where Duchamp stipulates that the Bride no longer provides gasoline for the Breast Cylinders. Yet, he labeled one of his folders "Breast-Cylinders (fire arms)" (*MDN*, note 49), employing a ballistic pun, linking the "firing" of a motor's cylinders and a gun.

36. Duchamp's original "Rouage-désir" becomes the "Mag-néto-désir" (*MDN*, note 155), which comes to play a central role as spark producer, associated with the "empty emanating ball" at the center of the Bride (*MDN*, notes 143, 153 [app. A, no. 11]).

37. *GB*, in *SS*, p. 39. The Bachelor's "desire motor" would subsequently be developed as the Desire Dynamo (fig. 149), another element of the *Large Glass* that was never executed.

38. *GB*, in *SS*, p. 39.

39. MDN, notes 98, 154, 157.

40. *GB*, in *SS*, p. 42.

41. Ibid. As initially written, the first paragraph of the note as quoted here was even more specific in its automobile language: "distributed to the quite feeble cylinders, valves [*soupapes*] within reach of the *sparks of her constant life*" (see Schwarz, ed., *Notes and Projects*, p. 25, for the crossing out of *soupapes*). Throughout this discussion I have translated Duchamp's phrase "épanouissement en mise à nu" as "blos-soming through stripping" rather than as "blossoming into stripping," the translation by George Hamilton that appeared in Richard Hamilton's *Typographic Version. . . of Marcel Duchamp's Green Box* and that was repeated in Sanouillet's *Salt Seller* and Schwarz's *Notes and Projects*. That phrase sug-gests inadvertently that the blossoming somehow precedes the stripping.

42. *GB*, in *SS*, p. 42.

43. *MDN*, notes 148, 152 (p. 2). This process is discussed further in the context of wireless telegraphy and the activities of the Juggler/Handler of Gravity in chap. 8.

44. For the "First Breakdown," see *MDN*, note 98, quoted at n. 61 below. For the identification of clockworks and the Boxing Match, see, e.g., *MDN*, notes 141, 149, 152 (p. 2; fig. 110 herein), 153 (p. 3) (app. A, no. 11).

45. See *MDN*, note 98, as well as note 155, which is ana-lyzed below.

46. *GB*, in *SS*, p. 43.

47. That renaming occurs in *MDN*, note 155.

48. *GB*, in *SS*, pp. 43–44.

49. On this subject, see chap. 3, "Duchamp, the Machine, and Human-Machine Analogies." For the Pawlowski and Marinetti citations, see chap. 3, nn. 35, 42.

50. See Thomas Laqueur, "Orgasm, Generation, and the Politics of Reproductive Biology," in *The Making of the Mod-ern Body: Sexuality and Society in the Nineteenth Century*, ed. Catherine Gallagher and Thomas Laqueur (Berkeley: Universi-ty of California Press, 1987), p. 14.

51. Joris-Karl Huysmans, *Là-bas* (1891; Paris: Librairie Plon, 1911), p. 276.

52. Remy de Gourmont, *Physique de l'amour: Essai sur l'instinct sexuel* (1903; 30th ed., Paris: Mercure de France, 1924), pp. 77–78. See also Remy de Gourmont, *The Natural Philosophy of Love*, trans. Ezra Pound (New York: Boni and Liveright, 1922; new ed., New York: Willey Book Co., 1940), p. 46. Duchamp uses *rouage* (with its clockwork associations) rather than *engrenage*.

53. See Camfield, *Picabia*, pl. 8, as well as other Picabia images of gears, such as *Le Fiancé* of the same date (ibid., fig. 134).

54. On the functioning of magnetos, which rely on perma-nent magnets, see, e.g., Dyke, *Dyke's Automobile. . . Encyclo-pedia*, pp. 269–94. Suquet (*Grand Verre*, p. 97) discusses magnetos as generators of electricity, pointing out their greater self-sufficiency in comparison to dynamos, whose electromag-nets initially require an external source of current; once acti-vated, however, a "self-exciting" dynamo could provide the current for its own electromagnets.

55. L. Baudry de Saunier, "L'Electricité à bord des automo-biles," *L'Illustration* 142 (Dec. 27, 1913), 534.

56. See Harold Whiting Slauson, "The Motor Car's Spark of Life," *Outing Magazine* 58 (Apr. 1911), 92–96.

57. Bergson, *Laughter*, p. 158.

58. See chap. 3, nn. 96, 97 and the related text. For the *Magnéto* watercolors, see Borras, *Picabia*, figs. 413, 419.

59. *GB*, in *SS*, p. 39. Short circuits were a major theme in literature on magnetos and automobiles. See, e.g., A. Courquin and G. Dubedat, *Technique et pratique de la magnéto à haute tension* (Paris: Gauthier-Villars, 1920); and Slausson, "Motor Car's Spark."

60. *GB*, in *SS*, p. 44, with slight variation in translation.

61. *MDN*, note 98, with slight variation in translation.

62. *MDN*, note 155.

63. On Duchamp's folder originally labeled "Mariée. Boîte d'horlogerie," the word "Boîte" is crossed out and replaced by "Système" (*MDN*, note 54). The inclusion of notes relating to the Boxing Match (notes 140, 141) indicates the connection between the two clockwork systems, as does Duchamp's state-ment in note 141: "Boxing Match—See the cross-section of the clockwork system combined with the breast-cylinder. . . ."

64. Bailly, *L'Age d'or des automates*, p. 207.

65. Cohen, *Human Robots*, p. 81. See especially chap. 6, "The Fabrication of Actual Automata."

66. On Kircher, see chap. 3, n. 62.

67. See *A L'INF*, in *SS*, p. 86. See also Jurgis Baltrusaitis, *Anamorphoses, ou magie artificielle des effets merveilleux* (Paris: Olivier Perrin, 1969), chap. 4; Clair, "Duchamp and the Classical Perspectivists," pp. 43–45; and Paz, *Marcel Duchamp*, pp. 140–43.

68. Descartes, as quoted in Clair, "Duchamp and the Classi-cal Perspectivists," p. 43.

69. Bailly, *L'Age d'or des automates*, p. 12.

70. See *Guide bleu*, p. 248. For Duchamp's "Bébé marcheur," described as "se déshabillant," see chap. 1, n. 72.

71. See, e.g., Bailly, *L'Age d'or des automates*, pp. 92–97, 121, 132–35, 138–40, 166. The repertoire of automaton mak-ers also included writers, painters, and musicians—forerunners of the theme of depersonalized expression explored by Roussel (e.g., Louise Montalescot's painting machine) and Duchamp. See, e.g., Chapuis and Droz, *Les Automates*, chap. 24.

72. *MDN*, notes 149, 152 (p. 2).

73. Bailly, *L'Age d'or des automates*, p. 207.

74. See fig. 45 and *GB*, in *SS*, p. 66.

75. *MDN*, note 152 (p. 2).

76. *MDN*, notes 56, 153 (p. 1) (appen. A, no. 11). The action of a piano would have been familiar to Duchamp, who not only grew up in a musical family but who, according to Alfred Kreymborg in September 1915, could "illustrate on the piano with one stiff dramatic finger the themes of 'Sacrée [*sic*] de Printemps'" (Kreymborg, "Why Marcel Duchamps [*sic*] Calls Hash a Picture," p. 12).

77. In addition to the presence of gears in both automobiles and automatons, the parallelism of an *arbre de transmission* and the *arbre de commande* of an automaton connected automobiles and clockwork systems.

78. Villiers, *Tomorrow's Eve*, p. 61. On Jacques de Vaucanson's famous duck, in which he attempted to reproduce the process of digestion, see Cohen, *Human Robots*, pp. 86–87.

79. *GB*, in *SS*, pp. 43–44. On the workings of electric clocks, a relatively new development, but still centered on ratchet wheels, see Thompson, *Elementary Lessons in Electricity and Magnetism*, pp. 553–54.

80. *GB*, in *SS*, p. 61.

81. Villiers, *Tomorrow's Eve*, pp. 150–51.

82. Ibid., p. 129, with slight variation in translation (i.e., *théorème* is translated there as "theorem" rather than as "theory"). See also Villiers on the physics of Hadaly's eyes, which function by means of radiant matter in a spherical Crookes's vacuum tube, with "a tiny point of light—vague, almost invisible—created by electricity" (*Tomorrow's Eve*, p. 160).

83. See ibid., pp. 130–31, for this and preceding quotations.

84. For the text of the note accompanying Duchamp's drawing, see *SS*, p. 45.

85. Ibid., p. 146.

86. Villiers, *Tomorrow's Eve*, p. 162.

87. See the section "*Appareils Enregistreurs* and Other Indexical Signs in the *Large Glass*" in chap. 8.

88. Villiers, *Tomorrow's Eve*, p. 63.

89. See, e.g., ibid., pp. 65–71, 163–64.

90. See ibid., pp. 64–65, 157, 160 (cited at n. 82 above), as well as the reference to radiant matter quoted in chap. 4 at n. 110.

91. Ibid., p. 209, as well as p. 157 on Crookes.

92. See ibid., pp. 208–16.

93. See chap. 3 at n. 44 for Pawlowski's *Voyage au pays de la quatrième dimension*, as well as the discussion of Louise Montalescot and *Impressions d'Afrique* in chap. 4.

94. See chap. 3, n. 48.

95. For Villiers's phrase, see the text quoted at n. 82 above. For Duchamp's "mossy metal" reference, see n. 33.

96. Duchamp, as quoted in Schuster, "Marcel Duchamp, vite," p. 144.

97. *GB*, in *SS*, p. 43. For a subtle analysis of Duchamp's wordplay, including the *arbre* theme, see the article by Charles A. Cramer, a former student at the University of Texas: "Duchamp from Syntax to Bride: Sa Langue dans Sa Joue," *Word & Image* 13 (Apr.–June 1997), 1–25.

98. *GB*, in *SS*, p. 45.

99. *MDN*, note 102; see also note 104.

100. *GB*, in *SS*, p. 39.

101. See n. 31 above.

102. Bergson, *Laughter*, p. 130; see the discussion of Bergson in chap. 3.

Chapter 8: The *Large Glass* as a Painting of Electromagnetic Frequency

1. For this terminology, see, e.g., Poincaré's language in chaps. 11 and 12 of his "Maxwell's Theory and Hertzian Oscillations," pt. 1 of Henri Poincaré and Frederick K. Vreeland, *Maxwell's Theory and Wireless Telegraphy* (New York: McGraw, 1904); see also Millikan and Gale, *Practical Physics*, chap. 21. On Hertz's experiments, see Hugh G. J. Aitken, *Syntony and Spark: The Origins of Radio* (New York: John Wiley, 1976), chap. 3.

2. See chap. 1, nn. 13, 14, and 27, as well as the section on Crookes in chap. 4. See also, e.g., André Broca, "Le Spectre solaire et ce qui semble devoir s'y rattacher," *Revue Scientifique*, 4th ser., 6 (July 4, 1896), 1–5.

3. See, e.g., Henri Poincaré, "Light and Electricity according to Maxwell and Hertz," *Annual Report of the Smithsonian Institution, 1894* (Washington, D.C.: G.P.O., 1896), pp. 129–39; E. Monier, *La Télégraphie sans fil, la télémécanique, et la téléphonie sans fil à la portée de tout le monde* (1906; 9th ed., Paris: H. Dunod & E. Pinat, 1917), chap. 2; and Thompson, *Light Visible and Invisible*, pp. 230–37.

4. *Box of 1914*, in *SS*, p. 25. According to Monier in *Télégraphie sans fil* (1917), "Par le mot *fréquence*, on désigne le nombre des ondes électriques qui succèdent en une séconde" (p. 51); in other words, the frequency of an electromagnetic wave is the number of complete oscillations of that wave per second.

5. On this subject, see Stephen Kern, *The Culture of Time and Space* (Cambridge: Harvard University Press, 1983).

6. Ibid., p. 14.

7. Trousset, ed., *Les Merveilles de l'Exposition de 1900*, vol. 2, p. 784.

8. See P. Dosne, "La Télégraphie sans fil à la portée de tout le monde," *La Nature* 40 (June 15, 1912), 42–43; 40 (July 13, 1912), 99–101. See also "Comment installer chez soi un poste récepteur de télégraphie sans fil," *La Science et la Vie* 1 (May 1913), 266–67.

9. See Aitken, *Syntony and Spark*, pp. 73–74; and W. M. Dalton, *The Story of Radio*, 3 vols. (London: Adam Hilger, 1975). Articles on "wireless telephony" appeared periodically in the decade before World War I; see also the treatment of the subject in Fleming, *Principles of Electric Wave Telegraphy and Telephony* (1916), chap. 10.

In an isolated instance, the American radio pioneer Lee de Forest in August 1908 played phonograph records into a microphone at the top of the Eiffel Tower and succeeded in transmitting the music as far away as Dieppe. See Monier, *Télégraphie sans fils*, pp. 181–83, which also quotes the prediction of the "well-known American scientist" Tesla: "It will soon be possible to converse as distinctly across the ocean as across the table" (pp. 182–83).

10. See Poincaré and Vreeland, *Maxwell's Theory*, pp. 24–27. Claude, in *L'Electricité à la portée de tout le monde*, also used the hydraulic analogy for many of his explanations of electrical phenomena; see, e.g., chap. 24. For the tuning-fork analogy, see, e.g., S. R. Bottone, *Wireless Telegraphy* (London: Whittaker, 1900), p. 31.

11. See chap. 4, n. 19 and the related text.

12. Lodge, Branly, and Tesla all figure in Lucien Poincaré's section on wireless telegraphy in his 1906 *La Physique moderne* (*New Physics*, pp. 225–30). For other references to Tesla in the context of wireless telegraphy, see, e.g., J. A. Fleming, *The Principles of Electric Wave Telegraphy* (London: Longmans, Green, 1906), pp. 5–6, 49, 64–65, which is characteristic of both English- and French-language discussions; André Broca, *La Télégraphie sans fils* (Paris: Gauthier-Villars, 1904), p. 192; Lucien Fournier, "Télégraphie, téléphonie et télégraphie sans fil en 1905," *La Nature* 34 (Apr. 14, 1906), 305–7; and Dosne, "Télégraphie sans fil," p. 101.

13. E.g., Edouard Branly's introduction to Monier's *La Télégraphie sans fil* begins, "Wireless telegraphy is, properly speaking, a telegraphy by sparks [télégraphie par étincelles]" (p. v).

14. Fleming, *Principles* (1916), p. 600. For an overview of typical wireless telegraphy equipment, see his chap. 7, as well as individual chapters on various components such as wave detectors.

15. For Marconi's activities, see Aitken, *Syntony and Spark*, chap. 5, and Dalton, *Story of Radio*, vol. 1, chap. 3. Fleming, who collaborated with Marconi for a time, provides a useful firsthand account of these events (*Principles* [1916], pp. 576–99).

16. See the conclusion of the section on Tesla in chap. 4.

17. See Fleming, *Principles* (1906), pp. 357, 366; on Branly's radio control experiments, see below at n. 179.

18. On these experiments, which began with the work of Ducretet, see, e.g., G[ustave] Eiffel, *Travaux scientifiques* (Paris: L. Maretheux, 1900), pp. 178–79; Emile Guarini, "La Télégraphie sans fil en France," *Revue Scientifique*, 4th ser., 19 (May 9, 1903), 590–96; Monier, *Télégraphie sans fil*, chap. 4; and Joseph Harriss, *The Tallest Tower: Eiffel and the Belle Epoque* (Boston: Houghton Mifflin, 1975), pp. 172–73.

19. In addition to Kern, *Culture of Time and Space* (p. 14), see, e.g., G. Ferrié, "La Télégraphie sans fil et le problème de l'heure," *Revue Scientifique* 51 (July 19, 1913), 70–75.

20. See L. Houllevigue, "Le Problème de l'heure," *La Revue de Paris* (July–Aug. 1913), 871; quoted in Kern, *Culture of Time and Space*, p. 14. On the meteorological transmissions from the tower, see, e.g., Rupert Stanley, *Text Book on Wireless Telegraphy* (London: Longmans, Green, 1914), pp. 339–40.

21. F. T. Marinetti, "Technical Manifesto of Futurist Literature," in *Marinetti*, ed. Flint, p. 89. The classic study of "simultaneity" in literature is Pär Bergman, *"Modernolatria" et "Simultaneità,"* Studia Litterarum Upsaliensia 2 (Stockholm: Bonniers, 1962), which discusses wireless telegraphy (e.g., pp. 21–25) and its impact on poets such as Marinetti (pp. 185–207) and Apollinaire (pp. 391–411).

22. Blaise Cendrars, "Tour," in *Oeuvres complètes*, ed. Nino Frank, 15 vols. (Paris: Le Club Français du Livre, 1968), pp. 58–59. See also *Selected Writings of Blaise Cendrars*, ed. Walter Albert (New York: New Directions, 1966), pp. 142–43. On Cendrars and the Eiffel Tower, see also Marjorie Perloff, *The Futurist Moment: Avant-Garde, Avant Guerre, and the Language of Rupture* (Chicago: University of Chicago Press, 1986), pp. 195–213.

23. Robert Delaunay, "Simultaneism in Contemporary Modern Art, Painting, Poetry," in *The New Art of Color: The Writings of Robert and Sonia Delaunay*, ed. Arthur A. Cohen (New York: Viking, 1978), p. 49. On the evolution of Delaunay's paintings of the tower, see Sherry A. Buckberrough, *Robert Delaunay: The Discovery of Simultaneity* (Ann Arbor: UMI Research Press, 1982).

24. See F. Honoré, "La Télégraphie sans fil à la Tour Eiffel," *L'Illustration* 137 (Mar. 18, 1911), 200–201; and Lt. Carlo Toché, "Ondes qui passent, étincelles qui chantent," *Je Sais Tout* 8 (May 15, 1912), 645–54. Delaunay's reference to "symphonic, auditory waves" may also have been a response to the yet-undeveloped possibilities of wireless telephony suggested by Lee de Forest's experiment in playing phonograph records from the top of the Eiffel Tower (see n. 9 above).

25. See Apollinaire, *Les Peintres Cubistes*, p. 25; *Cubist Painters*, pp. 17–18, for the poet's categorization of this type of Cubism, which he defined as relying on "elements which have not been borrowed from the visual sphere, but have been created entirely by the artist himself." Although Orphism came to be identified primarily with Delaunay, Apollinaire also included in this category Duchamp, Picabia, Léger and, apparently, Kupka (see Spate, *Orphism*, p. 1), most of whom were indeed united in their interest in invisible electromagnetic waves of varying frequencies.

26. See Apollinaire, "L'Amphion faux-messie ou histoires et aventures du baron d'Ormesan," in *L'Hérésiarque et Cie*, p. 248.

27. First published in *Les Soirées de Paris* (no. 25 [June 15, 1914], 340–41), the poem appeared subsequently in Apollinaire's *Calligrammes* (Paris: Mercure de France, 1918). On "Lettre-Océan," see Roger Shattuck, "Apollinaire's Great Wheel," in *The Innocent Eye*, pp. 240–62; and Willard Bohn, *The Aesthetics of Visual Poetry, 1914–1928* (Cambridge: Cambridge University Press, 1986), pp. 17–24.

28. See Guillaume Apollinaire, *Oeuvres poétiques*, ed. Marcel Adéma and Michel Décaudin (Paris: Editions Gallimard, 1965), pp. 167–203.

29. On Pound and his French contemporaries, see Willard Bohn, "Thoughts That Join Like Spokes: Pound's Image of Apollinaire," *Paideuma* 18 (Spring–Fall 1989), 129–45. On the interest in science manifested in Gourmont's *La Revue des Idées* and *Les Bandeaux d'Or*, see chap. 1 at n. 57 and following; see also the major, illustrated article by P. Brenot, "La Télégraphie sans fil," *La Revue des Idées* 4 (Apr. 15, 1907), 289–313.

30. Ezra Pound, "The Teacher's Mission" (1934), in *Literary Essays of Ezra Pound*, ed. T. S. Eliot (London: Faber and

Faber, 1960), p. 58. For Pound's "on the watch" reference, see "The Wisdom of Poetry," *Forum* 47 (Apr. 1912), 500; reprinted in Ezra Pound, *Selected Prose, 1909–1965*, ed. William Cookson (London: Faber and Faber, 1973), p. 331. On the importance of electromagnetic communication for Pound, see Max Nänny, *Ezra Pound: Poetics for an Electric Age* (Bern: Francke Verlag, 1973). The fullest treatment of this subject, as well as Pound's more general interests in both geometry and science in this period (which were uncannily parallel to Duchamp's), is Ian F. A. Bell, *Critic as Scientist: The Modernist Poetics of Ezra Pound* (London: Methuen, 1981).

31. Kupka, preliminary manuscript of "La Création dans les arts plastiques," chap. 7, p. 1 (hereafter cited as "Manuscript IV"; manuscript numbers are based on Margit Rowell's designations of the various Kupka manuscripts in her essay "František Kupka," in Guggenheim Museum, *František Kupka*, pp. 60–61, n. 19); *La Création* (1989), p. 229. See above, chap. 1, n. 46, for information on the treatise in its published versions of 1923 (in Czech) and 1989 (its reconstruction in French). The evolution of Kupka's painting in this period is discussed more fully in Henderson, "Kupka et le monde des ondes électromagnétiques," with particular emphasis on the transitional work of 1912, *Amorpha, Warm Chromatics* (Mladek Collection, Washington, D.C.).

32. Kupka Notebook, p. 21.

33. Ibid., p. 31, as well as additional references on pp. 33, 39, 42.

34. Kupka, Manuscript IV, chap. 7, p. 1; *La Création*, p. 229.

35. See chap. 2, n. 58 and the related text.

36. See, e.g., Rochas, *L'Extériorisation*, pp. 30–31, 35–41, 231–41, and his chap. 2 in general. See also Baraduc, *L'Ame humaine*, pp. 3, 12–13, 115–16, 121, 150–55, 160–61, and his chap. 3 in general.

37. Baraduc, *L'Ame humaine*, p. 13.

38. Ibid., p. 3. For Baraduc's discussion of *psychicones*, see *L'Ame humaine*, pp. 107–22; for Baraduc's photographs in the context of the history of photography, see chap. 1, nn. 33, 34.

39. See Besant and Leadbeater, *Thought-Forms*, pp. 13–14.

40. Baraduc, *L'Ame humaine,* pp. 116, 121.

41. Ibid., pp. 11, 179, and his chap. 5.

42. Rochas, *L'Extériorisation*, pp. 52, 201–3.

43. For the Lodge excerpt, see ibid., pp. 201–2; for Houston's "La Radiation cérébrale," see "Note G," pp. 231–41. Houston was the cofounder of the Thomson-Houston Electric Company, which in 1892 merged with the Edison General Electric Company to form General Electric.

44. Houston, "Radiation cérébrale," in ibid., p. 236.

45. Ibid., pp. 232, 236.

46. Ibid., p. 238.

47. Ibid., p. 240. See also Besant and Leadbeater, *Thought-Forms*, p. 14, where they assert that Baraduc's photographs present "not the thought-image but the effect caused in etheric matter by its vibration." Rochas's translation of Houston's text supports the view, adopted by Kupka, that the photograph or other graphic record itself could induce the appropriate molecular vibrations in the viewer's brain. Houston's original article,

however, had suggested that "ether waves" would need to be generated by passing light through the photographic image in order for the process to work. See Edwin J. Houston, "Cerebral Radiation," *Journal of the Franklin Institute* 133 (June 1892), 495; compare Houston, "Radiation cérébrale," in Rochas, *L'Extériorisation*, p. 240.

48. See chap. 4 at n. 22

49. Crookes, "Address by Sir William Crookes," in *Report of the. . . BAAS*, p. 21.

50. Kupka, Notebook, p. 43. For "molecular state," see Kupka, Manuscript II (handwritten chap. 5), p. 29; or, e.g., *La Création*, p. 207.

51. Kupka, Manuscript IV, chap. 6, p. 3; *La Création*, p. 207.

52. Kupka, Manuscript IV, chap. 7, pp. 3–4; *La Création*, pp. 231–32. See also the discussion cited in the previous note, where a similar reference to flashing sparks occurs.

53. Toché, "Ondes qui passent," p. 650.

54. Kupka, Manuscript IV, chap. 7, p. 3; Kupka's reference to the desire of the "amateur" to "receive" does not come through in the treatise as recently reconstructed (see *La Création*, p. 231).

55. Ibid., chap. 7, p. 1; *La Création*, pp. 229–30.

56. Crookes, "Sir William Crookes on Psychical Research," in *Annual Report of the Smithsonian Institution, 1899*, p. 202; Kupka, *La Création*, p. 106, as well as Manuscript IV, chap. 3.

57. Kupka, Manuscript IV, chap. 7, pp. 1, 18; the phrase "'psychographie' de l'avenir" appears in the 1989 version of *La Création*, p. 245. Kupka's reference to "X...graphies," quoted at the beginning of this section, does not seem to refer to X-rays; rather, it parallels Röntgen's use of the variable *x*, when he was uncertain what to call the new rays. The term *psychographe* originated as early as 1843, when Dr. R. H. Collyer of Philadelphia published his *Psychography, or the Embodiment of Thought* (Fodor, *Encyclopedia*, p. 240); Baraduc also used the term in *L'Ame humaine* (pp. 34, 291).

58. Kupka, Manuscript IV, chap. 7, p. 1 bis; *La Création*, p. 230.

59. Kupka, Notebook, p. 21. For documentation of these usages of *appareil enregistreur* in science and occultism, see nn. 213, 214 below.

60. Crookes, "Address by Sir William Crookes," in *Report of the. . . BAAS* (1899), p. 21.

61. Kupka, Manuscript IV, chap. 4, p. 10; *La Création*, p. 130. A major source for Kupka's discussion of the physics of color was Ogden Rood's *Modern Chromatics* (1879), which drew upon both Thomas Young's confirmation of the wave theory of light and Maxwell's work on color (Rowell, "Metaphysics," in Guggenheim Museum, *František Kupka*, p. 73). In the wake of Hertz's discoveries, however, Kupka treats light waves as vibrations in an ether filled with electromagnetic waves oscillating at differing frequencies. See n. 3 above for examples of such discussions by contemporary science writers.

62. Kupka, Manuscript II, p. 1; *La Création*, p. 146. For the painted canvas as a source of waves in the ether, see, e.g., *La Création*, p. 255.

63. Kupka, Manuscript II, p. 10; *La Création*, p. 147. Kupka believed that the wavelengths of colors suggested appropriate forms: he associated the shorter wavelengths of blues with rectilinear forms and the longer wavelengths at the red end of the spectrum with curvilinear forms (see *La Création*, p. 154).

64. In the same way that occultists seized upon X-rays as a scientific rationale for clairvoyance, they embraced Hertzian waves as well. See, e.g., the article by F. G., "Analogie des phénomènes médiumniques avec certains phénomènes électriques," in *La Vie Mystérieuse*, no. 85 (July 10, 1912), p. 584, which also speaks of "vibratory particles" and "molecular movement."

65. See chap. 4, nn. 186–88 and the related text.

66. See chap. 4, n. 184.

67. See chap. 1, n. 47; Kupka's treatise also reveals his knowledge of aspects of chemistry, another of Duchamp's interests.

68. See chap. 2, n. 15, and chap. 6, n. 19.

69. Kupka, Notebook, p. 49.

70. See Kupka, *La Création*, p. 188, and Duchamp, *A L'INF*, in *SS*, p. 76, as well as his note on making a "mirrored wardrobe" (*Box of 1914*, in *SS*, p. 25). In his treatise, however, Kupka makes a distinction between four-dimensionality in nature (in which he believes) and its relevance to the practice of painting. Just as his "credo" of October 1913 criticized the Cubists' attempts to paint X-rays, Kupka's treatise also rejects the fourth dimension as a painterly goal—undoubtedly because of its adoption as a tenet of Cubist theory (Manuscript II, pp. 24–25). For Kupka's credo, see the conclusion of chap. 1; on Kupka's earlier pursuit of the fourth dimension, see again Henderson, *Fourth Dimension*, pp. 103–9.

71. Jean, *History of Surrealist Painting*, p. 105.

72. Lebel, *Marcel Duchamp*, p. 65; Tomkins, *World of Marcel Duchamp*, p. 91.

73. See Schwarz, *Complete Works*, p. 535, for this reading of the title. Schwarz treats the "telephone or telegraph wires" simply as an "allusion to the telegraphic system of communication between the Bride and the Bachelors in the *Large Glass*" (p. 535).

74. Paz, "* water writes always in * plural," in *Duchamp* (Philadelphia), p. 149. For Paz, the "electric" communication is only a metaphor for "the electricity of thought, of the glance, and of desire" (p. 149). Paz's interpretation of the title emphasizes that these mountain passes are ailing or obstructed [*alités*] (p. 149).

75. Hellmut Wohl, "Beyond the Large Glass: Notes on a Landscape Drawing by Marcel Duchamp," *Burlington Magazine* 119 (Nov. 1977), 766.

76. The drawing is also reproduced in *Duchamp* (Venice), p. 107. According to Wohl, Duchamp made the drawing while visiting the Maurice Fogt family near Grasse (ibid., p. 763). Duchamp's interest in power lines is also apparent in one of his later notes: "electric wires seen from a moving train—Make a film" (*MDN*, note 192).

77. See Apollinaire, "Ondes," in *Oeuvres poétiques*, ed. Adéma and Décaudin, pp. 198–99.

78. Robert Lebel, "Marcel Duchamp and Electricity at Large: The Dadaist Vision of Electricity," in Musée d'Art Moderne, *Electra*, p. 165; reprinted in Lebel, *Marcel Duchamp* (1985), pp. 205–13.

79. Jean Suquet, "La Signe de la concordance," *L'Arc* 59, no. 4 (1974), 37.

80. For these two references, see Suquet, *Miroir de la mariée*, p. 189; and Suquet, *Le Guéridon et la virgule* (Paris: Christian Bourgois, 1976), p. 67 ("condenser"). In addition to the *L'Arc* article cited above, in which Suquet also playfully compares the Handler of Gravity to "Maxwell's Demon" (p. 40), see Suquet, *Grand Verre rêvé*, pp. 34, 40, 60, 97, 107, 122, 153. Suquet first published a version of the schema in fig. 111 in "La Mère machine," in *L'Objet au défi*, ed. Jacqueline Chénieux and Marie-Claire Dumas (Paris: Presses Universitaires de France, 1987), p. 142; another variation on the drawing, with commentary, appears in Suquet, "Possible," in *Definitively Unfinished Duchamp*, ed. de Duve, p. 115.

81. *GB*, in *SS*, p. 42. The Bride's "vibrations" could have had an additional sexual association in Duchamp's mind in relation to the "electromechanical vibrators" used in this period for genital massage by a physician (for treatment of hysteria) or for masturbation. See Rachel Maines, "Socially Camouflaged Technologies: The Case of the Electromechanical Vibrator," *IEEE Technology and Society Magazine* 8 (June 1989), 3–11, 23. Naumann discusses such vibrators in relation to Picabia'a *Paroxysm of Sadness*, in *New York Dada*, pp. 64–65.

82. See *GB*, in *SS*, pp. 39, 42–43. On short circuits, see William Maver, *Maver's Wireless Telegraphy: Theory and Practice* (New York: Maver Publishing Co., 1904), p. 166.

83. See, respectively, René Merle, "Enregistrement des ondes hertziennes par la patte de grenouille," *La Nature* 40 (Sept. 21, 1912), 259; Fleming, *Principles* (1916), p. 497; Le Bon, *Evolution des forces*, p. 145.

84. For Duchamp's "Expansion transformer" (*Transformateur à détente*) and "Receiver," see *MDN*, notes 81, 95. Those notes also introduce the phrase "Storage of potential" (*Accumulation potentielle*), blending the idea of potential energy in mechanics with the electrically associated ideas of the storage battery (*accumulateur*) and "electrical potential," or the degree to which a body is electrically charged. On electrical potential, see, e.g., Millikan, *Practical Physics*, pp. 237–43 ("Potential and Capacity"). As discussed further in chap. 10 in the context of thermodynamics, Duchamp's "Transformateur à détente" is an invention without precedent in engineering; here he combines an electrical apparatus, a transformer, with the term "à détente," identifying it with a *machine à détente,* or expansion engine, such as a steam engine. Duchamp's interrelated systems of energy in the *Large Glass* are discussed further in the section of chap. 11 entitled "Rediscovering the Mobile, the Desire Dynamo, and Aspects of Energy and Power in the *Large Glass*." His references to a "Large Receiver" (*MDN*, notes 114, 145) are discussed in the section of chap. 10 entitled "The Liquefaction of Gases as Model for the Journey of the Illuminating Gas."

85. *GB*, in *SS*, pp. 45, 60–62.

86. On such systems, see Dyke, *Dyke's Automobile Encyclopedia*, p. 189; see also Renaud, *Cours complet,* the section entitled "Refroidissement."

87. *GB,* in *SS,* p. 39.

88. See *MDN,* notes 98, 57, 154, 157.

89. Bergson, *Laughter,* p. 158.

90. Claude praises condensers made of mica as better than those using glass (*L'Electricité*, p. 284). For Duchamp's references to mica, see *A L'INF,* in *SS,* p. 81, and *GB,* in *SS,* p. 53.

91. Duchamp included in the *Green Box* one of the few surviving photographs of the uncracked *Large Glass,* as exhibited in 1926 at the Brooklyn Museum. See *Typographic Version. . .of Marcel Duchamp's Green Box,* frontispiece; and *Duchamp* (Venice), facing p. 148, for a more legible reproduction. In the *Large Glass* as repaired (fig. 88), foil covers the heavy metal frame, and Duchamp has extended the lines of the cracks that exist in the panels above and below the mid-section by applying narrow bits of foil to the foil's surface. The Conservation Department at the Philadelphia Museum of Art has tested the foil and confirmed that it is aluminum foil and not tinfoil (for the history of aluminum foil, see n. 115 and the related text below). In the 1960s Richard Hamilton used a thicker foil made of tin (instead of lead) as the backing for his replica of Duchamp's *Glider* but returned to lead foil for the replica of the *Large Glass* he created in 1965 (letter to the author, Aug. 4, 1991; see also Richard Hamilton, "Son of the Bride Stripped Bare" [interview with Mario Amaya], *Art and Artists* 1 [July 1966], 25).

92. See n. 84 above.

93. See chap. 3, n. 59.

94. On condensers, see, e.g., Thompson, *Elementary Lessons,* lesson 6 (pp. 68–75); or Claude, *L'Electricité,* pp. 282–90, where his discussion of condensers introduces the section titled "Oscillations électriques," in which he uses hydraulic models for explanatory purposes.

95. See chap. 5, n. 55 and the related text.

96. Ulf Linde, "MARiée CELibataire," in Galleria Schwarz, *Marcel Duchamp: Readymades,* p. 48.

97. Emile Guarini, "Wireless Telegraphy Experiments at the Eiffel Tower," *Scientific American Supplement* 59 (Feb. 25, 1905), 24366.

98. See, e.g., Fleming, *Principles* (1906), pp. 58–60; and Thomas Stanley Curtis, *High Frequency Apparatus: Its Construction and Practical Application* (New York: Everyday Mechanics, 1916), chap. 4.

99. See chap. 3, n. 60.

100. *GB,* in *SS,* p. 39.

101. Kupka, "Credo," quoted in chap. 1 at n. 115.

102. *Box of 1914,* in *SS,* p. 23.

103. See *Duchamp* (Philadelphia), pp. 264–65, as well as chap. 5 above.

104. See n. 59 above.

105. See, e.g., Fleming, *Principles* (1916), chap. 6.

106. L. Poincaré, *New Physics,* p. 228. Of the many discussions of the computer in this regard, see, e.g., Margaret A. Boden, *The Creative Mind: Myths and Mechanisms* (New York: Basic Books, 1991).

107. Merle, "Enregistrement des ondes hertziennes," pp. 259–60.

108. Emile Guarini, "Les Ondes électriques et le cerveau humain," *La Nature* 30 (Aug. 25, 1902), 177–78.

109. D. Berthelot, "Les Mécanismes biologiques et les phénomènes électriques," *Revue Scientifique* 51 (July 12, 1913), 33–38.

110. Hamilton, "Son of the Bride Stripped Bare," p. 23.

111. See, e.g., Fleming's discussion of magnetic wave detectors in *Principles* (1916), pp. 493–507.

112. For the operation of the detector illustrated, see Riccardo Arnò, "Rivelatore di onde hertziene a campo Ferraris," *Atti Elettrotechnica Italiana* 8 (1904), 354–59. Although the source of this image of Arnò's detector is an Italian electrical magazine, it was undoubtedly reproduced in the scores of French wireless telegraphy books as well, since Arnò was a well-known figure in this period (cited, e.g., in L. Poincaré's *L'Electricité,* p. 173). Although this particular detector was not generally adopted in wireless telegraphy practice (as was Branly's tripod coherer), it was cited by authors such as Fleming (*Principles* [1916], p. 503).

113. See *MDN,* note 115 (p. 1). The 1997 edition of Schwarz's *Complete Works* adds a previously unknown drawing (cat. no. 297), which features two rollers as well as a gear mechanism. On the structure of chocolate grinders, see chap. 5, n. 18, and the related text. Gough-Cooper and Caumont have noted the huge steam engine at the right in the design in the Gamelin letterhead, suggesting a parallel with Duchamp's Bachelors as a "steam engine on a masonry substructure" (*GB,* in *SS,* p. 39). See Gough-Cooper and Caumont, "Ephemerides," in *Duchamp* (Venice), entry for Mar. 8, 1915. Yet the scale of Duchamp's Chocolate Grinder, with its delicate legs, seems to suggest use in the home or laboratory—not the industrial manufacture of chocolate. Nonetheless, as noted at the beginning of chap. 10 and elsewhere, the objects in the Bachelor Apparatus are by no means uniform in scale.

114. *GB,* in *SS,* p. 68; *MDN,* note 115 (p. 3).

115. On the history of aluminum, see L[ouis] Ferrand, *Histoire de la science et des techniques de l'aluminium et ses développements industriels,* 2 vols. (L'Argentière: Humbert & Fils, 1960).

116. See Keller, *Infancy of Atomic Physics,* p. 47.

117. On antenna types, including the "umbrella," see, e.g., Fleming, *Principles* (1906), pp. 549–51. See also, e.g., J. Laffargue, "La Télégraphie sans fils," *La Nature* 26 (June 4, 1898), where the author refers to the antenna as a "collector of electric waves" (p. 2). Duchamp described the structure of the Bayonet as "very strong triangular wood" (*MDN,* notes 115 [p. 2], 118 [p. 2]), suggesting that its function would be to support the antennae rather than to receive signals itself.

118. See *A L'INF,* in *SS,* pp. 86, 90.

119. Coal gas was referred to as an "illuminating gas," which allowed Duchamp a characteristic double referent for his phrase. See, e.g., Charles Henry Cochrane, *The Wonders of Modern Mechanism,* 3d ed. (Philadelphia: J. B. Lippincott, 1900), pp. 285–97.

120. *GB*, in *SS*, p. 50. For Duchamp's drawing, see *Duchamp* (Philadelphia), p. 234. Duchamp had also experimented with painting by gaslight in his *Portrait of Chess Players* (see chap. 1, n. 79).

121. See Sir William Ramsay, *The Gases of the Atmosphere: The History of Their Discovery* (1896), 3d ed. (London: Macmillan, 1905); and Morris W. Travers, *A Life of Sir William Ramsay, K.C.B., F.R.S.* (London: Edward Arnold, 1956). Ramsay received the Nobel Prize in chemistry in 1904, and his activities received wide coverage in French periodicals in this period, ranging from his contributions to the *Revue Scientifique* to regular mentions of his work in articles on radioactivity or the new gases in sources such as *La Revue des Idées* and Jollivet Castellot's *Les Nouveaux Horizons*.

122. See Ramsay, *Gases of the Atmosphere*, and, e.g., Maurice Leblanc, "La Lumière au néon," *La Nature* 39 (Jan. 28, 1911), 145.

123. On such tubes, see the representative articles from which figs. 98 and 96 are taken: J. L., "Etude expérimentale des ampoules utilisées en radiographie et fluoroscopie," *La Nature* 24 (Nov. 21, 1896), 585–87 (summarized as "Tubes for the Production of Roentgen Rays," *Nature* 55 [Jan. 28, 1897], 296–97); and Maurice Leblanc, "Aspect de la décharge électrique dans les gaz rarifiés," *La Nature* 39 (Dec. 3, 1910), 7–10.

124. For Crookes's "radiant matter spectroscopy," see chap. 4 at n. 18. On Ramsay's contributions to radioactivity research, see chap. 2, n. 75 and the related text.

125. On Geissler and Geissler tubes, see Keller, *Infancy of Atomic Physics*, pp. 37–41. Leblanc's *La Nature* article (see n. 123) states that such tubes were standardly included in "boites de physique amusante," kits for demonstrating entertaining aspects of physics (p. 8). For a typical contemporary discussion of the tubes, see, e.g., Claude, *L'Electricité*, pp. 302–3, 393–95. See also *Petit Larousse illustré* (1919), s.v. "tube."

126. Dastre, "Les Nouvelles Radiations," p. 685; trans. in *Annual Report of the Smithsonian Institution, 1901*, p. 273.

127. Burke, *The Day the Universe Changed*, p. 298.

128. Kupka, *La Création*, p. 141.

129. See *MDN*, notes 140, 153 (p. 3) (app. A, no. 11), 251, 252, 255 for "childhood memories of the illuminating gas." For the other quotations, see *MDN*, note 103.

130. For the variety of Geissler tubes available for purchase in the prewar years, see *Electro Importing Catalog 14*, 2d ed. (New York: Electro Importing Co., 1914; reprint, Bradley, Ill.: Lindsay Publications, 1988), pp. 64–65. In contemporary literature, see, e.g., Aubert, *La Photographie de l'invisible: Les Rayons X*, chap. 2 ("Les Décharges électriques dans le vide"). For the Arts et Métiers displays of Geissler tubes, see *Catalogue officiel. . .C.N.A.M.*, vol. 2, pp. 133–35; for the 1898 centennial celebration involving Geissler tubes, see chap. 4, n. 44, and the related text.

131. Hospitalier used the term "excited" in a review of Tesla's Paris lecture, quoted in chap. 4 at n. 42.

132. E. J. Dragoumis, a student of Oliver Lodge, was the first experimenter to use vacuum tubes specifically to detect electri-

cal oscillations. See Dragoumis, "Note on the Use of Geissler's Tubes for Detecting Electrical Oscillations," *Nature* 39 (Apr. 4, 1889), 548–49. Lodge cites the work of both Dragoumis and Tesla in *Modern Views of Electricity* (3d ed.), pp. 306–7. On these early experiments, see also Bruce J. Hunt, *The Maxwellians* (Ithaca: Cornell University Press, 1991), p. 161.

133. Fleming, *Principles* (1906), p. 254. See also, e.g., C. Tissot, "Détecteurs d'ondes électriques à gaz ionisés," *Journal de Physique Théorique et Appliquée* 4 (Jan. 1907), 25–31.

134. *MDN*, note 136; *GB*, in *SS*, p. 70.

135. See *A L'INF*, in *SS*, pp. 86, 90, for "red fellows." For Duchamp's view of the Malic Molds as "uniforms or hollow liveries" that could produce "gas castings," see *GB*, in *SS*, p. 51. He used the term "envelope" in Schuster, "Marcel Duchamp, vite" (p. 144). Two early drawings for the Malic Molds (*Duchamp* [Philadelphia], p. 268) also suggest their association with dressmaker's dummies; Olivier Micha has discussed them in these terms in "Duchamp et la couture," in *OeuvreMD*, vol. 3, pp. 33–34.

136. *GB*, in *SS*, p. 70–71.

137. *GB*, in *SS*, p. 71.

138. See *A L'INF*, in *SS*, p. 86. Duchamp uses the phrase "object in chocolate" in a related note (*GB*, in *SS*, p. 70). Phosphorescence was closely associated with radioactivity in this period; see, e.g., Duncan, *New Knowledge*, pp. 97–98.

139. See, e.g., the summary by G[eorges] B[ohn], "*Revue Scientifique*: La Découverte de nouveaux gaz dans l'atmosphère, par Sir William Ramsey (19 septembre)," in *La Revue des Idées* 5 (Oct. 1908), 378–79.

140. For the Salon de l'Automobile and Rouen's illumination for the "fêtes du millénaire normand," see Pierre Lamelin, "Les Recherches industrielles de l'air," *La Science et la Vie* 2 (Sept. 1913), 391–93. Rudi Stern notes the two early Paris usages in *Let There Be Neon* (New York: Harry N. Abrams, 1979), pp. 21, 23. For one of the first public announcements of Claude's invention, see "Une Nouveauté dans l'éclairage: La Lumière de néon," *Revue Générale des Sciences Pures et Appliquées* 21 (Dec. 10, 1910), 1003–4. For the Luna Park display and a brief biography of Claude, see Béguet, *La Science pour tous* (1990), p. 42. On the development of the neon sign industry, which Claude Neon came to monopolize (through the 1920s), see Stern, *Let There Be Neon*. Claude's pioneering activity in the liquefaction of gases is discussed in chap. 10 below.

141. See "Le Néon, gaz d'éclairage," *La Revue des Idées* 8 (Jan. 1911), 75; and Maurice Leblanc, "La Lumière au néon," *La Nature* 39 (Jan. 28, 1911), 145–46.

142. Georges Claude, "The Development of Neon Tubes," *Engineering Magazine* 46 (Nov. 1913), 272; see also Claude, *L'Electricité*, p. 302.

143. For Duchamp's note, see again chap. 7 at n. 7. On arc lamps, see, e.g., Arthur A. Bright, *The Electric-Lamp Industry: Technological Change and Economic Development from 1800–1947* (New York: Arno Press, 1972), chap. 2.

144. See one version of the note (quoted in chap. 7 at n. 10) as well as *GB*, in *SS*, pp. 27–28.

145. See Schwarz, *Complete Works*, p. 186. Paz has argued against such specific gender symbolism in "* water writes," in *Duchamp* (Philadelphia), pp. 150–51.

146. See chap. 4 for Tesla and the triumph of alternating current at Niagara Falls. On the history of the conversion to hydroelectric power in France, see Serge Benoit, "De l'hydro-mécanique à hydro-électricité: Le Role des sites hydrauliques anciens dans l'électrification de la France, 1880–1914," *France des électriciens, 1880–1910*, ed. Cardot, pp. 5–36.

147. See *MDN*, notes 143, 153 (p. 4) (app. A, no. 11). See, e.g., Fleming, *Principles* (1906), pp. 70–73.

148. See *GB*, in *SS*, pp. 45, 48. Frederick Vreeland, "The Principles of Wireless Telegraphy," in Poincaré and Vreeland, *Maxwell's Theory and Wireless Telegraphy* (p. 142), discusses such cage or cone antennae, which subsequently gave way to the more familiar simple vertical wire. See also, e.g., the discussion of this system at the Eiffel Tower in Maver, *Maver's Wireless Telegraphy*, pp. 105–6. On wireless telegraphy at the Eiffel Tower, see nn. 18, 24 above.

149. See C. Tissot, "L'Etat actuel de la télégraphie sans fil," *Revue Générale des Sciences Pures et Appliquées* 14 (Oct. 15, 1903), 979 (fig. 5).

150. See *MDN*, notes 149, 152 (p. 2); see also *GB*, in *SS*, p. 38.

151. *GB*, in *SS*, p. 38.

152. Ibid., p. 36.

153. Ibid.

154. Ibid.

155. Ibid., p. 31.

156. Ibid. Duchamp's shared concern with the word games and codes enjoyed by the Arensberg circle is evident in his New York experiments with language, including the 1916 *With Hidden Noise* (fig. 170), in which certain letters are omitted (see chap. 13 at n. 139). Duchamp also connected the missing letters in such a work to "a neon sign when one letter is not lit and makes the word unintelligible" ("Apropos of Myself," p. 17). On these activities, see Naumann, "Cryptography and the Arensberg Circle."

157. See P. Brenot, "La Télégraphie sans fil," *La Revue des Idées* 4 (Apr. 15, 1907), 289–313.

158. *GB*, in *SS*, p. 36.

159. The spiral form of the Juggler/Handler of Gravity has also been discussed in the context of the fourth dimension. See Henderson, *Fourth Dimension*, pp. 158–59; and John Dee, "Ce Façonnement symétrique," in *Marcel Duchamp: Tradition de la rupture*, ed. Clair, pp. 370–71.

160. Duchamp, "Apropos of Myself," p. 1.

161. See W[illiam] N[apier] Shaw, *Air Currents and the Laws of Ventilation* (Cambridge: Cambridge University Press, 1907), chap. 1. This analogy is discussed in E. Mathias's review of Shaw's book in *Revue Générale des Sciences Pures et Appliquées* 19 (June 30, 1908), 507.

162. Thompson, *Elementary Lessons*, p. 54 (sec. 47, "Effect of Points: Electric Wind").

163. Baraduc, *L'Ame humaine*, p. 115.

164. Several Duchamp scholars have discussed the *Large Glass* or the Milky Way/Top Inscription in such terms. Lebel used the analogy of the "emanations transmitted by spiritualists" (*Marcel Duchamp*, p. 73), and Schwarz described the Top Inscription as the "graphic representation of the Bride's psyche" (*Complete Works,* p. 158). Clair, in passing, has compared the events of the *Large Glass* to a séance in which the Bride-medium produces a kind of ectoplasmic projection of herself, accompanied by the table tipping of the Handler of Gravity and the careful observations of the scientific Oculist Witnesses (*Duchamp et la photographie*, pp. 24–25); Suquet has likewise associated the Handler of Gravity with a "spirit rapper" ("Le Signe," p. 42). Although Lebel ultimately dismissed his own suggestion, citing Duchamp's assertion of the "absence of investigations of this sort" (*Marcel Duchamp*, p. 73), that statement, like Duchamp's denial of the practice of alchemy, would seem to be a much later distancing of himself from topics marginalized in the late twentieth century but of widespread interest in the prewar years.

165. See *GB*, in *SS*, pp. 42–43. On Baraduc's psychicones, see n. 38 and the related text above.

166. For Crookes, see n. 48 and the related text above, as well as chap. 4 at n. 20 and following. For Lodge's position on the subject, see, e.g., Oliver Lodge, "Thought Transference," *Forum* 41 (Jan. 1909), 56–62; and L. De Launay, "La Matière et l'éther," *La Nature* 36 (Nov. 21, 1908), 391. See Flammarion, *The Unknown*, pp. 308–9. On the theme of thought transference in *L'Eve future*, see chap. 4, n. 109. In the periodicals named, see, e.g., G. Wilfred, "La Transmission de la pensée: Théorie et pratique," *La Vie Mystérieuse*, no. 8 (Apr. 25, 1909), 115–16; and F. G., "Analogie des phénomènes médiumniques avec certains phénomènes électriques," *La Vie Mystér-ieuse*, no. 85 (July 10, 1912), 584; Théo Varlet, "Télépathie," *Les Bandeaux d'Or*, 2d ser., fasc. 5 (1908), 31–48; "La Télé-pathie," *Le Radium*, no. 1 (Jan. 1904), 15–16 (reprinted from *Le Matin*, Dec. 28, 1903). Telepathy was covered most extensively in the *Annales des Sciences Psychiques* in this period. Telepathic communication is also a theme in Revel's *Le Hasard*, a book Duchamp is known to have read (see chap. 2, n. 57).

167. This association of the ether with the fourth dimension is documented in chap. 11, at the conclusion of the section on the Juggler of the Center of Gravity.

168. See n. 164, as well as the text below at n. 239 and following.

169. On Suzanne Duchamp and Crotti, see the catalogue by William A. Camfield and Jean-Hubert Martin for Kunsthalle, Bern, *Tabu Dada: Jean Crotti & Suzanne Duchamp, 1915–1922* (Jan. 22–Feb. 27, 1983), the first major exhibition of the works of the two artists; see especially the chronology (pp. 129–30) for the complex history of the two, who were initially married to others (Crotti to Yvonne Chastel, who was in New York with him). For the important series of letters from Duchamp to Suzanne and Crotti, see Naumann, ed., "Affecteusement, Marcel," pp. 2–19.

170. See the note quoted in chap. 6 at n. 44. Camfield has noted that Suzanne seems not to have known about Duchamp's

Readymades until he explained them to her in a letter of January 1916, after she had gone to clean out his Paris studio (Camfield, "Jean Crotti & Suzanne Duchamp," in Kunsthalle Bern, *Tabu Dada*, p. 18). For Duchamp's letter, see Naumann, ed., "Affecteusement, Marcel," p. 5, as well as the segment of the letter quoted in chap. 5 at n. 69.

171. Jean Crotti, "Jean Crotti" (manuscript), printed in Kunsthalle Bern, *Tabu Dada*, p. 82.

172. *GB*, in *SS*, p. 39. For Suquet's discussion, see *Grand Verre rêvé*, pp. 154–55. For these images, see Kunsthalle Bern, *Tabu Dada*, pp. 96–97, 99, as well as Camfield's discussion of the evolution of Crotti's mechanomorphic style (pp. 10–16), including a 1916 portrait drawing of Suzanne as a collection of gearwheels and his 1916 painting *Virginity in Displacement* (Musée d'Art Moderne de la Ville de Paris) (pp. 94–95). On Crotti's works on glass, see Linda Dalrymple Henderson, "Reflections of and/or on Marcel Duchamp's *Large Glass*," in Whitney Museum of American Art, New York, *Making Mischief: Dada Invades New York* (Nov. 21, 1996–Feb. 23, 1997), pp. 228–37.

173. See Kunsthalle Bern, *Tabu Dada* for these drawings, *Far From* (p. 54) and *Etude pour Radiation de deux seules éloignés* (p. 122), and Camfield's discussion of the series (p. 18).

174. See Camille Flammarion, *Death and Its Mystery before Death* (1920; New York: Century, 1921), p. 163. Flammarion's writings were filled with such language, including a similar discussion in *The Unknown*, pp. 303–4. For Houston's phrase, see n. 43 above.

175. In 1920 Crotti produced gouaches entitled *Edison* (Tate Gallery, London) and *Mademoiselle Triphase* (Private Collection; see Kunsthalle Bern, *Tabu Dada*, pp. 104–5). "Mademoiselle Triphase" would seem to refer to the triphase or polyphase system for the generation and transmission of alternating current developed by Tesla that had assured the victory of alternating current in the "battle of the currents" of the 1890s. Moreover, the image includes forms that suggest the electrical device used to demonstrate electrical discharges, like the dramatic demonstrations of Tesla or simply "electric wind" (see Thompson, *Elementary Lessons*, sec. 47). Suzanne's paintings of this period include *Broken and Restored Increase* of 1918–19 (Private Collection), with its suggestion of an electrical- or radio-transmission tower. For these images and Camfield's discussion of them, see *Tabu Dada*, pp. 18, 23, 104–5, 125.

176. Tesla, "Problem of Increasing Human Energy," p. 184; see chap. 4.

177. Ibid., pp. 186–88.

178. For Péladan's article, see chap. 4 at n. 70; for Tesla's term "telautomatics," see chap. 4 at n. 58.

179. Monier's *Télégraphie sans fil* (chap. 7) includes an account of a presentation on this subject by Branly at the Salle du Trocadéro, June 30, 1905.

180. See Alfred Gradenwitz, "The Operation of Mechanical Devices at a Distance by Means of the Wireless Transmission of Energy," *Scientific American Supplement* 43 (June 8, 1907),

26276–77; and "Dr. Branly's Apparatus for Control of Distant Mechanical Effects," *Scientific American* 97 (Dec. 28, 1907), 478–80.

181. See *GB*, in *SS*, p. 38.

182. See, e.g., *GB*, in *SS*, pp. 43–44, 66.

183. See Camfield, *Picabia*, p. 85. The *Large Glass* and *Voilà elle* also share target imagery, as noted in chap. 10 in relation to the themes of ballistics and target shooting in Perrin's work on Brownian motion.

184. Jollivet Castelot, *La Synthèse*, p. 30.

185. Duchamp, as quoted in Schwarz, *Complete Works*, p. 156.

186. *GB*, in *SS*, p. 45 (with variation in translation); see also the similar note (*MDN*, note 106). For Duchamp's handwritten note, see Schwarz, ed., *Notes and Projects*, p. 113.

187. *MDN*, notes 143, 153 (p. 4) (app. A, no. 11).

188. See also *MDN*, notes 149, 152 (p. 2), from which fig. 110 is taken.

189. This activity of the "Juggler of the Center of Gravity," as Duchamp termed him, is discussed in the context of mechanics in the section of chap. 11 devoted to the Juggler/Handler.

190. *GB*, in *SS*, p. 45 (with variation in translation). Both the Bride's "filament paste" and "tympanum" are also discussed in chap. 9 in the context of biology and the Bride as Wasp.

191. On wave detectors using telephone diaphragms or bulbs with filaments, see, e.g., Fleming, *Principles* (1906), pp. 381–82, 398–402.

192. See Villiers, *Tomorrow's Eve*, pp. 131–32, as well as chap. 7 at n. 83.

193. Gourmont, *Physique de l'amour*, p. 108; *Natural Philosophy of Love*, p. 65.

194. *MDN*, notes 137, 152 (p. 2).

195. *MDN*, note 140.

196. See Pawlowski, *Voyage* (1912), p. 147; *Voyage* (1971), p. 154. In the revised edition of 1923 Pawlowski changed the chapter title to "La Catastrophe de *Photophonium*."

197. Pawlowski, *Voyage* (1912), p. 151; *Voyage* (1971), p. 156. In the 1923 edition Pawlowski added a sentence describing a special optical device called an *Aphanoscope* (p. 155), which made it possible to "see the invisible." Pawlowski's change in chapter title and his need to posit a device to facilitate invisible seeing are indications of the change in mood from the prewar period, when such possibilities were more readily accepted.

198. *MDN*, notes 68, 77 (app. A, no. 2).

199. In addition to Fleming, *Principles* (1906), p. 366, see Gradenwitz, "Operation of Mechanical Devices," p. 26276. See also "Les Merveilles du télégraphie sans fil," *Je Sais Tout* 1 (July 1905), 66; although this article was signed "Dr. Branly," a subsequent issue of *Je Sais Tout* revealed that it had been written by a staff member of the magazine rather than by Branly himself.

200. *MDN*, note 152 (p. 2); *GB*, in *SS*, p. 42.

201. *GB*, in *SS*, p. 43; *MDN*, note 148.

202. *GB*, in *SS*, p. 44; *MDN*, notes 143, 153 (p. 4) (app. A, no. 11).

203. On Duchamp's interest in eye charts, see, e.g., Cabanne, *Dialogues*, p. 64. Information on the astigmatism-testing function of such charts courtesy of Dr. Ramon Burstyn.

204. Duchamp, letter to Crotti, Oct. 26, 1918; reprinted in Naumann, ed., "Affectueusement, Marcel," p. 11.

205. *GB*, in *SS*, p. 65.

206. Oliver Lodge, *Signalling across Space without Wires: The Work of Hertz and His Successors*, 4th ed. (London: "The Electrician," 1913), pp. 38–42. See also Thompson, *Light Visible and Invisible*, p. 214.

207. Lodge, *Signalling across Space*, p. 29. On Crookes's eye/detector comparison, see n. 60 and the related text.

208. See, e.g., Clair, *Duchamp et la photographie*, p. 25, n. 3. Typical of this usage is Albert de Rochas's assertion in his preface to *L'Extériorisation de la motricité* (Paris: Chamuel, 1896) that he has included the testimony of "témoins oculaires" to assure the reader that no fraud had taken place (p. vi). In this period the best known "scientific" eyewitness to sexual activity would have been Dr. Bathybius in Jarry's *Le Surmâle* (see chap. 4 at n. 117).

209. Aitken, *Syntony and Spark*, pp. 185–86.

210. See n. 8 above.

211. Duchamp, as quoted in Cabanne, *Dialogues*, p. 61. For the *Unhappy Readymade*, see Schwarz, *Complete Works*, cat. no. 260; and Camfield, "Jean Crotti & Suzanne Duchamp," in Kunsthalle Bern, *Tabu Dada*, pp. 20–21, 38–39. On its connection to non-Euclidean geometry, see Henderson, *Fourth Dimension*, p. 160. Duchamp's layout for Lebel's 1959 monograph, which carefully juxtaposes the two works on their respective balconies, reinforces the sense of a connection between them (see Lebel, *Marcel Duchamp*, pls. 87a, 88). The issue of Duchamp's layout for the Lebel volume is discussed further in chaps. 13 and 14 below.

212. Typical of the enthusiasm for the ever-increasing sensitivity of such instruments is a 1913 *Harper's Monthly* article, "Exploring the Atom," which celebrates a succession of these devices being used to study atoms, electrons, and radioactivity: the spectroscope, the bolometer (which measures infinitesimal changes in heat), Crookes's radiometer, the electroscope (newly in use in Rutherford's studies of the alpha particle), Crookes's spinthariscope, sensitive photographic plates, and the cloud chamber. See Henry Smith Williams, "Exploring the Atom," *Harper's Monthly* 127 (June 1913), 112–20.

213. See, e.g., Berthelot, "Les Mécanismes biologiques et les phénomènes électriques," p. 34. On Marey's instruments, see especially Braun, *Picturing Time*, chap. 2; Dagonet, *Passion*, chap. 1; Frizot, *Avant le cinématographe*, pp. 62–66; and Clair, *Duchamp et la photographie*, pp. 52–54. Given Duchamp's quest for alternative, impersonal means to draw lines, such mechanical methods of tracing a line would surely have interested him.

214. See, e.g., Cesare Lombroso, *After Death—What? Spiritistic Phenomena and Their Interpretation*, trans. William Sloane Kennedy (Boston: Small, Maynard, 1909), chap. 3

("Experiments with Accurate Scientific Instruments"). For Crookes's instruments to measure "psychic force," see his *Recherches sur les phénomènes du spiritualisme*.

215. For Kupka's usage, see n. 59 above; see also, e.g., Brenot, "Télégraphie sans fil," p. 291.

216. See *Collected Papers of Charles Sanders Peirce*, ed. Charles Hartshorne and Paul Weiss, 8 vols. (Cambridge: Harvard University Press, 1960), vol. 2, pp. 157, 159, 161, 170–72. See also Douglas Greenlee, *Peirce's Concept of the Sign* (The Hague: Mouton, 1973), pp. 84–93.

217. See Rosalind E. Krauss, *The Originality of the Avant-Garde and Other Modernist Myths* (Cambridge: MIT Press, 1985), pp. 196–206. More recently, Krauss, noting the Sieves, the Oculist Witnesses, and the Draft Pistons, has described the *Large Glass* as a "surface of impression" with "many of the signs it bears . . . organized as traces" (Krauss, *The Optical Unconscious* [Cambridge: MIT Press, 1993], p. 119).

218. See *MDN*, note 152 (p. 4) for the *girouette* usage, which is discussed in chap. 9. See also Peirce, *Collected Papers*, vol. 2, p. 161. I am grateful to my colleague Richard Shiff, who initially alerted me to Peirce's use of the example of meteorological instruments. For Shiff's insightful application of Peirce's ideas on indexical signs to the issue of "touch" in modern art, see, e.g., his "On Criticism Handling History" *History of the Human Sciences* 2, no. 1 (1989), 63–87, and his "Performing an Appearance." As noted earlier, however, in contrast to Shiff's association of indexicality with painterly painters from Edouard Manet to Jackson Pollock and Jasper Johns, I am here focusing on the impersonal type of indexical recording or imprinting that interested Duchamp, the arch-opponent of the artist's hand.

219. For Peirce's biography, including his isolated existence for much of his later career, see Murray G. Murphey, *The Development of Peirce's Philosophy* (Cambridge: Harvard University Press, 1961).

220. Peirce, *Collected Papers*, vol. 2, pp. 161, 171.

221. Ibid., p. 159. See Shiff's discussion of this issue ("Performing," p. 98), as well as Krauss, *Originality*, pp. 203, 215.

222. Roché's informal photographing of Duchamp's studio in June 1918 is recounted in Gough-Cooper and Caumont, "Ephemerides," in *Duchamp* (Venice), entry for June 3, 1918.

223. *GB*, in *SS*, p. 36.

224. Ibid.

225. Ernest Merritt, "The New Element Radium," *Century Magazine* 67 (Jan. 1904), 455; see also Keller, *Infancy of Atomic Physics*, pp. 79–81, and the discussion of radioactivity in chap. 2.

226. For gas mantles, invented by Anton von Welsbach, see W. J. Dibdin, *Public Lighting by Gas and Electricity* (London: Sanitary Publishing Co., 1902), pp. 222–26, as well as the mantle visible in figs. 184, 185.

227. William Henry Fox Talbot, *The Pencil of Nature* (London: Longman, Brown, Green & Longmans, 1844), note to pl. 15; as quoted in Shiff, "Performing," p. 99.

228. Arturo Schwarz, *Marcel Duchamp* (New York: Harry N. Abrams, 1970), p. 19.

229. Juliette Gleizes, unpublished memoirs, quoted in Daniel Robbins, "The Formation and Maturity of Albert Gleizes" (Ph.D. diss., New York University, 1975), p. 218.

230. Francis Naumann first made this suggestion to me in conversation some years ago.

231. Man Ray's best-known work involving shadows is the 1916 painting *The Rope Dancer Accompanies Herself with Her Shadows* (Museum of Modern Art, New York). On this work and Ray's commitment to a "new art of two dimensions," see Francis M. Naumann, "Man Ray, Early Paintings, 1913–1916: Theory and Practice in the Art of Two Dimensions," *Artforum* 20 (May 1982), 37–46.

232. Duchamp and Man Ray, as quoted in Man Ray, *Self-Portrait*, p. 73.

233. For illustrations of these two works, see National Museum of American Art, Washington, D.C., *Perpetual Motif: The Art of Man Ray* (Dec. 2, 1988–Feb. 20, 1989; New York: Abbeville, 1988), figs. 65, 112. Duchamp also used an indexical thumbprint as a "signature" at the end of his film *Anemic Cinema*, made with Man Ray and Marc Allégret; see *Duchamp* (Philadelphia), p. 300.

234. *A L'INF*, in *SS*, p. 85.

235. Ibid. See also the discussion of apparitions/molds in *GB*, in *SS*, p. 70.

236. See Villiers, *Tomorrow's Eve*, pp. 63, 162, as well as chap. 7 at n. 86.

237. *A L'INF*, p. 86; see p. 84 for "of a chocolate object for ex."

238. See n. 147 above.

239. See Cesare Lombroso, *Ricerche sui fenomeni ipnotici e spiritici* (Turin: Unione Tipografico-Editrice Torinese, 1909), p. 67, where Lombroso reprints the photograph from Bozzano's 1903 *Ipotesi spiritica* (fig. 122 herein); and the book's English translation, *After Death—What?*, chap. 11 ("Transcendental Photographs and Plastiques") and his fig. 29. See also Lombroso, *Hypnotisme et spiritisme*, trans. Rossigneux (Paris: Ernest Flammarion, 1910), pp. 189–99, although this French translation includes none of the illustrations. Celant has discussed the interest of the Italian Futurists in Eusapia and her "transcendental sculptures" in "Futurism and the Occult."

240. Lombroso, *After Death—What?*, pp. 70–71.

241. Ibid., p. 96.

242. Duchamp, letter to Jacques Villon, Dec. 25 [1922], courtesy of Francis Naumann.

243. See *GB*, in *SS*, p. 51; and *MDN*, notes 103, 112, 123 (app. A, no. 16).

244. See, e.g., Oliver Smith, *Press-Working of Metals* (New York: John Wiley, 1899), chap. 4 ("Dies").

245. *MDN*, note 153 (p. 2) (app. A, no. 11).

246. See Schwarz, *Complete Works*, cat. no. 353.

247. Ibid., cat. nos. 332, 335.

248. Gourmont, *Physique de l'amour*, p. 78; *Natural Philosophy of Love*, p. 46. Gourmont continues by speculating on the sexual organs' replication of one another if turned inside out or outside in, a topological theme that has been discussed in the context of Duchamp and geometry by Jean Clair. See

Clair, "Sexe et topologie," in *OeuvreMD* (Paris), vol. 3, pp. 52–59; and Clair, *Duchamp et la photographie*, pp. 106–10. See also Craig Adcock, "Duchamp's Eroticism: A Mathematical Analysis," in *Duchamp: Artist of the Century*, ed. Kuenzli and Naumann, pp. 149–67.

249. Duchamp, "Apropos of Myself," p. 14. In 1973 Georgia O'Keeffe recalled having seen Duchamp's studio in the early 1920s with "dust everywhere . . . so thick that it was hard to believe" (in *Duchamp* [Philadelphia], p. 214).

250. For Leonardo's soaped glass, see, e.g., MacCurdy, ed., *Notebooks*, p. 805. Jean (*History of Surrealist Painting*, p. 101) first noted Leonardo's ideas on dust as a model for Duchamp. See also Jarry, *Gestes et opinions*, chap. 2.

251. See Thompson, *Elementary Lessons*, sec. 324. Breton was to be interested in the German satirical writer and physicist Georg-Christoph Lichtenberg (1742–99), for whom the electrical effect was named; see *Anthologie de l'humour noir*, pp. 43–50. On red lead and the Malic Molds, see n. 134 and the related text.

252. For the original usage of the term "electric image" in electrical theory, see, e.g., Thompson, *Elementary Lessons*, sec. 275.

253. See Edward P. Thompson, *Roentgen Rays and Phenomena of the Anode and Cathode* (New York: D. Van Nostrand, 1896), p. 21. William J. Hammer was the collector of the bulbs in question.

254. Compared to the *Large Glass*, which with its frame measures 109¼ × 69¼ in. (277.5 x 175.8 cm), an Arts et Métiers case of the type illustrated in fig. 164 measures approximately 94½ × 47¼ in. (240 x 120 cm).

255. *A L'INF*, in *SS*, p. 74. Duchamp's related note on "shop windows" (p. 74) is discussed at the beginning of chap. 12.

256. *GB*, in *SS*, p. 71.

257. Ibid., p. 30.

258. See chap. 5, n. 30 and the related text.

259. See chap. 2, nn. 40, 41 and the related text; and the discussion in chap. 10 in the section "Molecular and Atomic Reality in the *Large Glass*."

260. Clair, as quoted in Lebel, "Marcel Duchamp and Electricity at Large," in *Electra*, p. 166; see also Clair's chapter on the *Large Glass*, in *Duchamp et la photographie*, pp. 44–63.

261. Kiesler, "Design-Correlation," p. 53. See also Clair, *Duchamp et la photographie*, p. 46.

262. See, e.g., the photographs demonstrating the effects of electrical discharges at wireless telegraphy emitting stations: Charles Torquet, "La TSF étend son règne sur le monde," *Je Sais Tout* 6 (Dec. 15, 1910), 589; and Honoré, "La Télégraphie sans fil à la Tour Eiffel," 200.

263. For this version of the title, see Kasimir Malevich, *The Non-Objective World*, trans. Howard Dearstyne (Chicago: Paul Theobald, 1959), p. 83. See also Troels Anderson, ed., *K. S. Malevich: The World as Non-Objectivity (Unpublished Writings, 1922–25)*, trans. Xenia Glowacki-Prus and Edmund T. Little (Copenhagen: Borgen, 1976), p. 373, where the title is translated as *Suprematist Group of Elements with Sensation of*

Current (Telegraph); the drawing is now in the Kunstmuseum, Basel.

264. See C[harles] Howard Hinton, *The Fourth Dimension* (London: Swan Sonnenschein, 1904), pp. 24–26. On Malevich and the fourth dimension, see Henderson, *Fourth Dimension*, chap. 5.

265. On Malevich and contemporary science, see, e.g., Charlotte Douglas, "Malevich and European Art Theory," in Charlotte Douglas et al., *Malevich: Artist and Theoretician* (New York: Abbeville, 1991), pp. 56–60. Like Pound and others, Malevich later used the metaphor of the radio receiver, writing in the 1920s in his *Non-Objective World*, "The human being can be likened, in a way, to the radio receiver which picks up and converts a whole series of different waves of feeling (p. 88).

266. *GB*, in *SS*, p. 26.

267. See, e.g., Thompson, *Light Visible and Invisible*, p. 34, where the author talks of the "retardation" of light waves by glass. On such experiments with Hertzian waves, see, e.g., Lodge, *Signalling across Space*, p. 39.

268. Duchamp, as quoted in Hamilton and Hamilton, 1959 BBC interview (*Audio Arts Magazine* cassette); also in Hamilton, "Radio Interview," in *Duchamp: Passim*, ed. Hill, p. 76 (which has an error in transcription).

Chapter 9: Other Scientific and Technological Dimensions of the Bride

1. See *GB*, in *SS*, pp. 44–45; *A L'INF*, in *SS*, p. 83; and chap. 6 above.

2. *MDN*, notes 102, 104 (app. A, no. 23/24).

3. See Schwarz, ed., *Notes and Projects*, p. 111, where the term "Guêpe" and the discussion of "Ventilation" below the image are added in a darker ink. See also *MDN*, notes 50, 106, 108; in note 106, the phrase replaced by "Guêpe" is illegible.

4. See *MDN*, note 106. Duchamp's use of "balladeur" would seem to be a misspelling of *baladeur*, a term for gears used standardly in contemporary automobile literature.

5. See *GB*, in *SS*, p. 45, as well as an earlier version in *MDN*, note 106. In Duchamp's ten-page automobile-oriented note, he had mentioned in passing that "the love gasoline is a secretion of the bride's sexual glands" (*GB*, in *SS*, p. 43), but those "glands" were understood as "organs" of the automobile. In the Wasp, Duchamp would create the organic persona for those glands.

6. *MDN*, note 152 (p. 2).

7. The present discussion is based on the following group of notes: *GB*, in *SS*, pp. 45–48, or Schwarz, ed., *Notes and Projects*, pp. 110–17, 124; and *MDN*, notes 105 (also in the *Green Box*), 106, 108 (both of which appear, recopied, in the *Green Box*), 137, 144 (app. A, no. 14/15), 149, and 152.

8. All quotations in this and the following paragraph are taken from fig. 126 (*GB*, in *SS*, p. 48; and *MDN*, note 105), unless otherwise noted. For the workings and history of the aneroid barometer, see W. E. Knowles Middleton, *The History of the Barometer* (Baltimore: Johns Hopkins Press, 1964), chap. 16.

9. *MDN*, note 152 (p. 3). See also *Encyclopaedia Britannica* (1910), 11th ed., s.v. "hygrometer."

10. *MDN*, note 152 (p. 2).

11. *GB*, in *SS*, pp. 47–48; *MDN*, note 152 (p. 3). Realizing that *mortaise* (mortice) was not the correct word, Duchamp notes that he must "look for the exact term" for the bowl-like joint that he draws (fig. 127), allowing multidirectional movement. "Ball-and-socket joint" describes more accurately Duchamp's image. In addition to fig. 128 (*MDN*, note 152 [p. 4]), the term *girouette* also appears in *MDN*, note 144 (app. A, no. 14/15).

12. See *GB*, in *SS*, pp. 36, 45.

13. In addition to *MDN*, note 144, see also notes 105 and 152 (p. 4). For the *Green Box* note, see Schwarz, ed., *Notes and Projects*, note 78, as well as *SS*, p. 45.

14. *MDN*, note 152 (p. 4).

15. *GB*, in *SS*, p. 45 (with variation in translation). In its original form (*MDN*, note 108), this was the note that had suggested "fly, bee" as alternatives to "Sex Cylinder" in its heading. I have adopted Paul Matisse's translation of *tympan* as "tympanum" rather than the term "drum" used by George Hamilton in his *Green Box* translation reproduced in *Salt Seller*. The word *tympanum* retains the specific entomological overtones of this term, as Duchamp surely intended (see the discussion of biology below).

A second issue of translation in these notes involves the word *hampe*, which Hamilton translated as "pole" rather than "shaft." This translation, however, creates confusion, since Duchamp elsewhere introduces the term *pôle* in relation to the directional "cardinal points" or poles through which the *Pendu femelle* swings. See, e.g., *MDN*, note 152 (pp. 3–4).

16. See, e.g., Middleton, *History of the Barometer*, p. 402. The presence of drums or diaphragms also suggests other types of instruments that rely on a drum or membrane, such as a telephone receiver (with its connections to wireless telephony); see chap. 8.

17. See, e.g., the section on hygrometry in Millikan and Gale, *Practical Physics*, chap. 10, pp. 173–81. For "dew" as "moisture produced by the body," see *O.E.D.*, s.v. "dew." Duchamp would later term the "erotic liquid" (i.e., Illuminating Gas) of the Bachelor Apparatus the "dew of Eros." See *MDN*, note 133 (app. A, no. 8), which is quoted and discussed in chap. 10 at n. 98.

18. See, e.g., Millikan and Gale, *Practical Physics*, chap. 10; or Alfred Payson Gage, *The Elements of Physics*, rev. ed. (Boston: Ginn, 1898), chap. 4 ("Molecular Dynamics—Heat").

19. *GB*, in *SS*, pp. 48, 50, 53.

20. *MDN*, notes 152 (p. 3), 137.

21. *GB*, in *SS*, p. 45.

22. See *MDN*, note 152 (p. 4), as well as note 144 (app. A, no. 14/15).

23. See Curtis, *High Frequency Apparatus*, pp. 14–15.

24. Here Duchamp introduces the theme of collision in the Bride, speaking of the "choc de la guêpe sexe" (*MDN*, note 144 [app. A, no. 14/15]) and "choc ventilé," or "air-born impact" (*MDN*, note 152 [p. 4]). On spark gaps, see, e.g.,

Fleming, *Wireless Telegraphy* (1916), pp. 679–80.

25. See *MDN*, note 108; although in this note Duchamp indicates his dissatisfaction with the term "desire magneto" ("bad name"), it continues to appear (notes 137, 149, 152 [p. 3]). Thus, even though *MDN*, note 51, one of Duchamp's "folders," bears an erased "Magnéto-désir" with "Tympan" written over it, he did not replace the one with the other.

26. See chap. 8, n. 161, which documents awareness of Shaw's work in France.

27. *GB*, in *SS*, pp. 45, 48.

28. William Napier Shaw, *Selected Meteorological Papers of Sir Napier Shaw* (London: Macdonald, 1955), chap. 4 ("The Variations of Currents of Air Indicated by Simultaneous Records of the Direction and the Velocity of the Wind"). For this usage of *girouette*, see *Petit Larousse illustrée* (1912), s.v. "girouette."

Duchamp created a Readymade counterpart to the Bride as Weather Vane in his lost 1915 Readymade, *Pulled at 4 Pins* (Schwarz, *Complete Works*, cat. no. 232). Although in 1964 Duchamp etched an image of a chimney ventilator with this title (cat. no. 372), in 1959 he had created an etching entitled *Tiré à 4 épingles* (cat. no. 357), which suggests a form stretched toward four corners, forming an "X." Duchamp described the 1915 object, which he gave to Louise Varèse, as a "weather vane (rather large) in galvanized iron on which I inscribed 'Tiré à quatre épingles M.D. 1915'" (Duchamp, letter to Schwarz, July 24, 1964, in ibid., p. 455). Since a chimney ventilator, like the Bride, would have swung and turned "at the will of a ventilation" (*MDN*, note 152 [p. 3]), perhaps the later etchings described both the path of the ventilator pulled toward the four "cardinal points" (1959) and the form of the object itself (1964). As such, it also bears comparison to Eiffel's diagrams of wind displacements of the Eiffel Tower (see n. 39 and the related text below).

Adcock has also noted briefly this possible parallel (*Marcel Duchamp's Notes*, pp. 178–79). André Gervais illustrates the two etchings and notes the translation "dressed to the nines" for "tirés à quatre épingles" in his discussion of Duchamp's wordplays in "Connections: Of Art and Arrhe," in *Definitively Unfinished Duchamp*, ed. de Duve, figs. 10.1, 10.7, p. 420.

29. See Margaret Cooper, *The Inventions of Leonardo da Vinci* (New York: Macmillan, 1965), pp. 104–7.

30. See again chap. 4, nn. 204, 205 and the related text.

31. See, e.g., chap. 8, n. 60.

32. See Remy de Gourmont, "Elle a un corps...—Sonnets en prose—," in "Epilogues: XXIIᵉ Lettre à l'amazone," *Mercure de France* 102 (Mar. 16, 1913), 353–56. See also Gourmont, *Lettres à l'amazone* (1914; 20th ed., Paris: Mercure de France, 1924), p. 202.

33. Gourmont, "Elle a un corps...," p. 356; *Lettres*, p. 202.

34. *GB*, in *SS*, p. 48.

35. *Catalogue officiel. . . C.N.A.M.*, vol. 2, pp. 201–13. See Monmarché, *Guide bleu*, p. 188, for the meteorological displays in room 28, which was located at the end of room 27, the large gallery devoted to General Physics.

36. See fig. 126 and *MDN*, note 105, for this reference, as well as the comparison of the "cage" to a wireless telegraphy emitting antenna on the Eiffel Tower in chap. 8 (fig. 102).

37. See Eiffel, *Travaux scientifiques*, chap. 3 ("Meteorologie"); see pp. 172–78 for the manometer. See also Harriss, *Tallest Tower*, p. 162, for a labeled version of the engraving in fig. 128.

38. Harriss, *Tallest Tower*, pp. 101–2.

39. Eiffel, *Travaux*, p. 161.

40. Ibid., p. 145.

41. Duchamp-Villon, "L'Architecture et le fer," *Poème et Drame* 7 (Jan.–Mar. 1914), 28; trans. as "The Eiffel Tower" in Agee and Hamilton, *Duchamp-Villon*, p. 118.

42. Quoted in François Landon, *La Tour Eiffel Superstar* (Paris: Editions Ramsay, 1981), p. 80.

43. *A L'INF*, in *SS*, p. 76; *GB*, in *SS*, p. 48.

44. See chap. 4 at n. 192 and following.

45. Millikan and Gale (*Practical Physics*, p. 236) refer to lightning as "huge electric sparks."

46. See chap. 8 at n. 20.

47. Eiffel's pioneering role in the history of scientific aerodynamics and aviation was recognized with the awarding of the Smithsonian's Langley Gold Medal in 1913; see Harriss, *Tallest Tower*, pp. 168–72. See also G[ustave] Eiffel, *Recherches expérimentales sur la resistance de l'air executées à la Tour Eiffel* (Paris: L. Maretheux, 1907).

48. *MDN*, note 152 (p. 4). On Duchamp and the Salon de la Locomotion Aerienne, see chap. 2 at n. 16.

49. See Eiffel, *Travaux scientifique*, pp. 150–60; Harriss, *Tallest Tower*, pp. 165–68.

50. On Eiffel, see Harriss, *Tallest Tower*, pp. 165–66. The French scientific establishment adopted Eiffel's new, improved methods for weather observation only gradually (p. 166).

51. Breton, "Phare," p. 49; in Lebel, *Marcel Duchamp*, p. 94.

52. See *MDN*, note 105, for the term "solid flame." For Duchamp's references to "filament paste," see *GB*, in *SS*, p. 45, and *MDN*, notes 108, 137; for "filament material," see *GB*, in *SS*, pp. 47–48, and *MDN*, notes 105, 152 (pp. 3, 4), 146 (app. A, no. 17).

53. For the term *baïonnette*, see Claude, *L'Electricité*, p. 114.

54. *GB*, in *SS*, pp. 26–27. See the section of chap. 3 entitled "The 'Jura-Paris Road' Project."

55. Bright, *Electric-Lamp Industry*, pp. 205–7. Edison had also experimented with filaments of platinum and, briefly, nickel. See Robert Friedel and Paul Israel, *Edison's Electric Light: Biography of an Invention* (New Brunswick: Rutgers University Press, 1986), pp. 46–48.

56. See "Frosting, Etching, and Coloring of Incandescent Lamps: Hints for the Manufacturer and Amateur," *Scientific American Supplement* 71 (Apr. 22, 1911), 255; and A. S. Neumark, "Coloring and Frosting Incandescent Lamps," *Scientific American Supplement* 73 (May 11, 1912), 295. For Duchamp's references to the use of acid, see chap. 10 at n. 14.

57. See, e.g., Bright, *Electric-Lamp Industry*, pp. 57–67, 117–21.

58. On Picasso's humorous inversion of the lightbulb, see

Robert Rosenblum, "Picasso and the Typography of Cubism," in *Picasso in Retrospect*, ed. Roland Penrose and John Golding (New York: Praeger, 1973), p. 40.

59. See Bright, *Electric-Lamp Industry*, pp. 183–98.

60. Claude, *L'Electricité*, p. 114.

61. For Duchamp's references to "nourishing" the filament material or paste, see *GB*, in *SS*, pp. 45, 47–48; *MDN*, notes 146 (app. A, no. 17), 152 (p. 4).

62. See, e.g., *MDN* note 152 (p. 3), as well as chap. 3, n. 64 and the related text.

63. See *Petite Larousse illustré*, s.v. "filament."

64. See Marvin, *When Old Technologies Were New*, for examples of the electrical pageantry that portrayed such figures, including the Statue of Liberty (pp. 138–40 and pls. following p. 108).

65. See Bonk, *Box in a Valise*, for the history of this project.

66. See Linde, "MARiée CELibataire," in Galleria Schwarz, Milan, *Marcel Duchamp: Ready-mades,* pp. 60–63.

67. See Hamilton's translation as used by Sanouillet in *GB*, in *SS*, p. 30, plus *MDN*, notes 68, 77 (appen. A, no. 2). In *MDN* Matisse translates the phrase simply as "under glass." See *Petit Larousse illustré*, s.v. "globe."

68. *MDN*, note 108.

69. See J[ean]-H[enri] Fabre, *Souvenirs entomologiques: Etudes sur l'instinct et les moeurs des insects*, 10 vols., 6th ed. (Paris: Librairie Delagrave, 1913). Fabre's eighth volume, which includes chapters on wasps, appeared in 1903 and is cited in Gourmont's bibliography in *Physique de l'amour* (p. 278). Numerous volumes of chapters extracted from *Souvenirs entomologiques* were published in the prewar years, including *Moeurs des insectes: Morceaux choisis* (Paris: Librairie Delagrave, 1911), and *Les Merveilles de l'instinct chez les insectes: Morceaux choisis* (Paris: Librairie Delagrave, 1913).

70. See chaps. 7 at n. 52, and chap. 8 at nn. 193, 248.

71. On Fabre and his reputation, see, e.g., Edwin Way Teale, ed., *The Insect World of J. Henri Fabre* (New York: Dodd, Mead, 1949), pp. ix–xvi. Maurice Maeterlinck, who would later write on bees (*La Vie des abeilles* [Paris: Eugène Fasquelle, 1901]), was a great admirer of Fabre.

72. Apollinaire, letter to Madeleine Pagès, Oct. 14, 1915; quoted in Bates, *Guillaume Apollinaire*, pp. 120–21. Bates also records Apollinaire's admiration for Gourmont (p. 120).

73. Bates, *Apollinaire*, p. 120.

74. See, e.g., William L. Pressly, "The Praying Mantis in Surrealist Art," *Art Bulletin* 55 (Dec. 1973), 600–615.

75. Duchamp, as quoted in Lebel, *Duchamp*, p. 73, n. 1.

76. Gourmont, *Physique de l'amour*, p. 109; *Natural Philosophy of Love*, trans. Pound, pp. 65–66 (with variation in translation).

77. For Darwin's quote as well as a discussion of Fabre's method, see Teale, *Insect World*, p. xiv and introduction.

78. For Fabre's usage, see *Souvenirs entomologiques*, vol. 8, p. 302.

79. See, e.g., J[ean]-H[enri] Fabre, *The Hunting Wasps*, trans.

Alexander Teixiera de Mattos (New York: Dodd, Mead, 1915).

80. See, e.g., Fabre, *Moeurs des insectes*, chap. 12 ("Le Sphex languedocien"). For Gourmont's echo of Fabre's view, see *Physique de l'amour*, pp. 40–41; *Natural Philosophy*, p. 22.

81. See, e.g., Fabre, *Souvenirs*, pp. 300–301.

82. Gourmont, *Physique de l'amour*, pp. 208–9; *Natural Philosophy*, pp. 127–28.

83. *GB*, in *SS*, p. 48; *MDN*, note 105.

84. Gourmont, *Physique de l'amour*, p. 37; *Natural Philosophy*, p. 20.

85. Gourmont, *Physique de l'amour*, pp. 40–41; *Natural Philosophy*, p. 22. Although Gourmont celebrated the females of various insect species, he was far less complimentary toward humans, asserting that "woman, while not physically inferior to her male, remains below him in nearly all intellectual actvities" (*Physique de l'amour*, p. 40; *Natural Philosophy*, p. 22). In contrast to Gourmont, Duchamp celebrated the intelligence of the American woman in interviews he gave upon his arrival in New York. See "The Nude-Descending-a-Staircase Man Surveys Us," *New York Tribune*, Sept. 12, 1915, sec. 4, p. 2.

86. On Loeb, see chap. 3, n. 56.

87. See n. 69 above for the Fabre texts noted here; see also J[ean]-H[enri] Fabre, *La Vie des insectes: Morceaux choisis* (Paris: Librairie Delagrave, 1910).

88. Gourmont, *Physique de l'amour*, p. 13; *Natural Philosophy*, p. 6.

89. Gourmont, *Physique de l'amour*, p. 29; *Natural Philosophy*, p. 16.

90. See n. 70 above. Other Picabia works, such as *Girl Born without a Mother*, ca. 1916–18 (Camfield, *Picabia*, fig. 133), likewise suggest the impact of Gourmont's biomechanical sexuality and interest in parthenogenesis.

91. See chap. 8 at n. 171 and following.

92. Crotti, as quoted in Nixola Greeley-Smith, "Cubist Depicts Love in Brass and Glass; 'More Art in Rubbers Than in Pretty Girl!,'" *Evening World* (New York), Apr. 4, 1916, p. 3.

93. Bergson, *Creative Evolution*, p. 176; for Bergson's discussion of wasps and Fabre, see pp. 172–73, 140–41.

94. *GB*, in *SS*, p.30; *MDN*, note 77 (app. A, no. 2).

95. For Bergson's *Le Rire* comments, see chap. 3, n. 45 and the related text.

96. Shaw, *Air Currents*, p. v.

97. See the Table des Matières of the *Revue Scientifique* in this period; for the Arts et Métiers holdings, see, e.g., Monmarché, *Guide bleu*, p. 190. On the development of gas-heated bathtubs, see Lawrence Wright, *Clean and Decent: The Fascinating History of the Bathroom and the Water Closet* (New York: Viking, 1960), chap. 14.

98. Teale, *Insect World*, p. 127.

99. *GB*, in *SS*, p. 45 (with variation in translation). Duchamp added this paragraph when he joined the notes numbered 106 and 108 (*MDN*) into the single note that appears in the *Green Box*. See also *MDN*, notes 150 (app. A, no. 18), 152 (p. 1) for Duchamp's reference to the "bathtub of pride," which is discussed further in chap. 11 at n. 191.

100. *MDN*, notes 143, 153 (p. 4) (app. A, no. 11). On the "bath heater," which Duchamp associated with the Bachelors' Desire Dynamo, see chap. 11 at n. 28 and following.

Chapter 10: Other Scientific and Technological Dimensions of the Bachelors, I

1. See the text quoted in part at n. 7 and in its entirety at n. 61 of chap. 7.

2. See *MDN*, notes 153 (app. A, no. 11), 163 (app. A, no. 12). On the structure and dating of appendix A, based on Duchamp's notes 250 and 251 (figs. 187 and 188) and their relation to notes 252 (fig. 189) and 255, see the final section of chap. 14.

3. *GB*, in *SS*, p. 39.

4. Ibid.

5. *GB*, in *SS*, p. 43. See again Laqueur, "Orgasm, Generation, and the Politics of Reproductive Biology," in *The Making of the Modern Body*, ed. Laqueur and Gallagher, p. 14.

6. These listings are selected from longer running lists, without the insertion of ellipses to indicate omissions. See Monmarché, *Guide bleu*, p. 188. As noted earlier, although this *Guide bleu* is dated 1921, it reflects the room arrangements of the prewar period, as recorded in the museum's multivolume *Catalogue officiel. . .C.N.A.M.* See also chap. 8, n. 133, for documentation of the Crookes and Geissler tubes mentioned below.

7. *MDN*, note 98 (with slight variation in translation).

8. The phrases "fall of the drops after compression" and, below the note, "Tautology. in acts (bride stripped bare...)" are added to the original note in darker ink. See *MDN*, note 91. Matisse translates *paillettes* as "flakes" rather than as the alternative "spangles," which have come to be a standard feature of discussions of the *Large Glass*, based on the George Hamilton translation used by Sanouillet (see *GB*, in *SS*, pp. 48–53). In fact, early twentieth-century usage specifically associates paillettes with a glittering quality that is lost in the more prosaic "flake." See *Petit Larousse illustré* (1912), s.v. "paillette."

9. *MDN*, note 104 (app. A, no. 22/23).

10. See, e.g., *MDN*, notes 56, 153 (p. 1) (app. A, no. 11); the latter phrase recurs in *MDN*, notes 250, 251, 252 (figs. 187, 188, 189B), and 255.

11. See again *MDN*, note 153 (app. A, no. 11).

12. See, e.g., *GB*, in *SS*, p. 66.

13. *GB*, in *SS*, p. 71.

14. For the references to hydrofluoric acid, see *MDN*, notes 80, 134; for the subsequent reference, see *GB*, in *SS*, p. 80, and *MDN*, note 80.

15. On photography and chemistry in nineteenth-century France, see Janet E. Buerger, *French Daguerreotypes* (Chicago: University of Chicago Press, 1989), pp. 91–92.

16. *GB*, in *SS*, p. 82; for Duchamp's formulalike notations, see, e.g., *MDN*, notes 115, 118.

17. *GB*, in *SS*, p. 35.

18. *MDN*, notes 58, 80, 112, 114; *A L'INF*, p. 80. See, e.g., Ralph K. Strong, ed., *Kingzett's Chemical Encyclopaedia*, 8th ed. (New York: D. Van Nostrand, 1952), s.v. "trituration."

19. See Roussel, *Impressions of Africa*, pp. 282, 224, 300.

20. Ibid., pp. 126, 266.

21. Information courtesy of Molly Nesbit and Mme Alexina Duchamp. Nesbit has also observed that the lower half of the *Large Glass* is structured in the left-to-right orientation of an illustrated chemistry experiment.

22. See L[ouis-Joseph] Troost, *Précis de chimie*, 25th ed. (Paris: G. Masson, 1893), p. 84.

23. See Troost, *Précis* (1893), p. 55 (fig. 53), which also includes a section on the distillation of the *gaz de l'éclairage* burned in gas lamps (pp. 154–56). For Cailletet's apparatus at the Musée des Arts et Métiers, see n. 6 above, as well as *Catalogue officiel. . .C.N.A.M.*, vol. 2, pp. 56–57.

24. *GB*, in *SS*, p. 71.

25. *A L'INF*, in *SS*, p. 86; see also pp. 84–85. Duchamp further clarified this notion of color "in the molecules" in two brief comments of 1965 (p. 86).

26. *GB*, in *SS*, p. 71; see also *A L'INF*, in *SS*, p. 85. See chap. 8 at n. 137 and following.

27. *A L'INF*, in *SS*, p. 79.

28. *MDN*, note 172 and notes 132, 133 (app. A, no. 8).

29. *GB*, in *SS*, p. 62; see also pp. 30, 61. Another *Green Box* note relating to molecules (*GB*, in *SS*, p. 71) is discussed at n. 76 below in the section on thermodynamics and the kinetic theory of gases.

30. See, e.g., chap. 4 at n. 86, as well as the discussion of Jarry's use of Maxwell's "Sorting Demon" at n. 77 below.

31. *GB*, in *SS*, p. 62. On the behavior of molecules in various states of matter, see, e.g., Millikan and Gale, *Practical Physics*, chap. 4 ("Molecular Motions").

32. See chap. 8, n. 10 and the related text.

33. See n. 28 above.

34. See the section "Physical Chemistry," in *Encyclopaedia Britannica* (1910), 11th ed., s.v. "chemistry" (p. 65). For the early history of physical chemistry, see, e.g., Aaron J. Ihde, *The Development of Modern Chemistry* (New York: Harper and Row, 1964), chap. 15; and John W. Servos, *Physical Chemistry from Ostwald to Pauling* (Princeton: Princeton University Press, 1990), chap. 1.

35. See L. Poincaré, *New Physics*, chap. 3 ("Principles"), secs. 2–4 on energy and thermodynamics and sec. 5 ("Atomism"), which includes the kinetic theory of gases; see also chap. 4 ("The Various States of Matter"), sec. 2 ("The Liquefaction of Gases and Low Temperatures").

36. See, e.g., Guillaume, *Rayons X*, pp. 1–8.

37. On Kamerlingh Onnes's procedure, see Kostas Gavroglu and Yorgos Goudaroulis, eds., *Through Measurement to Knowledge: The Selected Papers of Heike Kamerlingh Onnes, 1853–1926* (Dordrecht: Kluwer, 1991), p. lviii. For Claude's neon lighting, see chap. 8, nn. 140, 142 and the related text. Kamerlingh Onnes's and Claude's work in liquefaction is discussed further below.

38. See chap. 4, n. 164.

39. Perrin's career and publications are treated in the final section of the present chapter.

40. Apollinaire, *Les Peintres Cubistes*, p. 76; *Cubist Painters*, p. 48 (with variation in translation). See Apollinaire's full text quoted in chap. 2, following n. 13.

41. See chap. 1, n. 43 and the related text, as well as the discussion of radioactivity at the beginning of the section "Munich Works, Summer 1912" in chap. 2. Le Bon also treated energy in the context of thermodynamics in his *L'Evolution des forces*, pp. 38–63.

42. See *Dictionary of the History of Science*, ed. W. F. Bynum, E. J. Browne, and Roy Porter (Princeton: Princeton University Press, 1981), s.v. "heat and thermodynamics." For a detailed study of the development of thermodynamics, see D. S. L. Cardwell, *From Watt to Clausius: The Rise of Thermodynamics in the Early Industrial Age* (Ithaca, N.Y.: Cornell University Press, 1971). For the principles of thermodynamics as treated in the early twentieth century, see, e.g., Henry A. Perkins, *An Introduction to General Thermodynamics* (New York: John Wiley, 1912).

43. See, e.g., Henri Poincaré's discussion of these principles in *La Valeur de la science* (Paris: Ernest Flammarion, 1904), pp. 180–85, 198–99; *Foundations of Science*, pp. 303–5, 312–13, which is recounted at the conclusion of the present section.

44. Unlike his American counterpart Henry Adams, Duchamp seems not to have been particularly concerned with the philosophical implications of the second law of thermodynamics and its suggestion of the possible "heat death" of the universe through entropy. On Adams's concern with the dissipation of energy, see Jordy, *Henry Adams*, pp. 164–72. On entropy and heat death in general, see Stephen Brush, *The Temperature of History: Phases of Science and Culture in the Nineteenth Century* (New York: Burt Franklin, 1978), chap. 5.

The one possible connection of Duchamp's notes to philosophical interpretations of the second law of thermodynamics would seem to be an indirect one—through Friedrich Nietzsche. In a discussion written in the 1880s and published in *The Will to Power* after his death in 1900, Nietzsche had responded to the second law and the notion of heat death by arguing for the scientific necessity of "eternal recurrence." In one of Duchamp's unpublished notes, which begins "= in each fraction of duration (?) *all future and antecedent fractions* are reproduced —," he comments, "See Nietzsche's eternal Return, neurasthenic form of a repetition in succession to infinity" (*MDN*, note 135 [app. A, no. 7]). On Nietzsche's argument, see Stephen G. Brush, *The Kind of Motion We Call Heat: A History of the Kinetic Theory of Gases in the 19th Century*, 2 vols. (Amsterdam: North-Holland Physics Publishing, 1976), vol. 2, pp. 628–30; see also Brush, *Temperature of History*, 72–76.

45. *GB*, in *SS*, p. 56. As discussed in the section "Playful Mechanics" in chap. 11, Duchamp here suggests the possibility of a perpetual-motion machine, another prominent theme in the literature on thermodynamics.

46. *MDN*, notes 81, 95.

47. *MDN*, note 187; see also note 176.

48. Clausius had articulated this view in 1857 in the famous paper "The Nature of the Motion Which We Call Heat." See Brush, *Kind of Motion*, vol. 1, pp. 168–77, on this and other relevant developments in this period. For a concise history of the rise of the kinetic theory of gases and its principles, see Leonard B. Loeb, *Kinetic Theory of Gases* (New York: McGraw-Hill, 1927), chap. 1.

49. Frederick Soddy, *Matter and Energy*, (New York: Henry Holt, 1912), p. 71.

50. On this debate, see Nye, *Molecular Reality*, chap. 1.

51. Ostwald had announced his scorn for atom theory to the French scientific community in the article "La Déroute de l'atomisme contemporain," in *Revue Générale des Sciences Pures et Appliquées* 6 (Nov. 15, 1895), 953–58. On Ostwald's criticisms of atomism and mechanical models, see Nye, *Molecular Reality*, pp. 17–19; and Brush, *Kind of Motion*, vol. 1, 61–62 and throughout. For a concise introduction to Ostwald's philosophy, see Wilhelm Ostwald, "The Modern Theory of Energetics," *Monist* 17 (Oct. 1907), 481–515. On Ostwald as physical chemist, see Erwin N. Hiebert, "Developments in Physical Chemistry at the Turn of the Century," in *Science, Technology, and Society*, ed. Bernhard, Crawford, Sörbom, pp. 97–115.

52. See Wilhelm Ostwald, *L'Energie*, trans. E. Philippi (Paris: Félix Alcan, 1909). See also Georges Bohn, "Le Mouvement scientifique—W. Ostwald: *L'Energie*," *Mercure de France* 82 (Dec. 1, 1909), 506–8.

53. See Nye, *Molecular Reality*, p. 151; Brush, *Kind of Motion*, vol. 2, pp. 698–99. See also the anonymous critique of Ostwald's ideas, "Les Idées qui passent," published in the "Chronique" section of *La Revue des Idées* 10 (June 1913), 349–53.

54. Similarly, Duchamp-Villon's fusion of horse and engine in his 1914 *Horse* would seem to embody such a view of parallel energy transformations. See, e.g., Wilhelm Ostwald, "Machines and Living Creatures: Lifeless and Living Transformers of Energy," *Scientific American Supplement*, no. 1803 (July 23, 1910), 55. For a highly useful analysis of the impact of thermodynamics on ideas about human energy and fatigue in the nineteenth century, which establishes a context for Ostwald's views, see Rabinbach, *Human Motor*.

55. See chap. 9 at n. 19.

56. As explained in a 1906 article in *Living Age*, "The [latent] heat energy which disappears when we melt ice or boil water does work, overcomes the attraction between the molecules of the solid or liquid, starts these molecules on new careers, and becomes potential. According to this view, it should be possible to recover this energy undiminished, or nearly undiminished, in quantity by reversing the processes of evaporation and liquefaction. And so it is. It has been done times without number." See William Shenstone, "Matter, Motion, and Molecules," *Living Age* 30 (Mar. 1906), 598. See also, e.g., Millikan and Gale, *Practical Physics*, chap. 10 ("Change of State").

57. Duchamp, as quoted in Cabanne, *Dialogues*, p. 11. See also chap. 5 at n. 88.

58. On the contributions of Clausius, Maxwell, and Boltz-

mann to this development, see Brush, *Kind of Motion*, vol. 2, pp. 583–615.

59. L. Poincaré, *New Physics*, pp. 100–101.

60. Ibid., p. 103.

61. See Poincaré, *Science et méthode*, chap. 4; *Foundations*, pp. 395–412. In general, Henri Poincaré was not as enthusiatic an advocate of the kinetic-molecular theory as was Lucien Poincaré (see Nye, *Molecular Reality*, pp. 35–38). It was the former Poincaré, however, who pointed to Brownian movement as a possible experimental proof of theory (Nye, pp. 37–38).

62. Poincaré, *Science et méthode* (Paris: Ernest Flammarion, 1908), pp. 74–75; *Foundations*, pp. 400–401.

63. Poincaré, *Science et méthode*, pp. 275–81; *Foundations*, pp. 524–28.

64. Poincaré, *Science et méthode*, pp. 80–82; *Foundations*, pp. 404–5. Duchamp would employ a swirled stack of playing cards as a possible template for the corkscrewlike Slopes of Flow in a Dec. 1915 note: "Package of white cards / Stack of cards. to be used in the inclined ramp (Slopes of flow or Crash splash). Make in actual size and photograph." See *A L'INF*, in *SS*, p. 83. For the sketch accompanying the note, see Schwarz, *Notes and Projects*, note 117.

65. Poincaré, *Science et méthode*, p. 82; *Foundations*, p. 405.

66. *GB*, in *SS*, p. 42.

67. Poincaré, *Science et méthode*, pp. 67–68; *Foundations*, p. 397.

68. See *MDN*, notes 137, 152 (p. 3); *GB* in *SS*, p. 62.

69. See *MDN*, notes 101, 153 (p. 2) (app. A, no. 11); *GB*, in *SS*, p. 62. In chap. 5, see the discussion following n. 80.

70. On this debate, see, e.g., Brush, *Kind of Motion*, vol. 2, pp. 583–84. For Jarry's usage, see *Gestes et opinions*, chap. 34. Shattuck (*Selected Works*, n. 1 to chap. 34) notes that this swerve was also associated with the creation of matter by these philosophers and by Lord Kelvin after them. This association suggests the rationale for Jarry's use of the title for a chapter recasting biblical creation themes.

71. Laplace, *Essai philosophique sur les probabilités* (1814), as quoted in *Encyclopedia of Philosophy*, ed. Paul Edwards, 8 vols. (New York: Macmillan and Free Press, 1967), s.v. "Laplace." See also Ian Hacking, "Nineteenth Century Cracks in the Concept of Determinism," *Journal of the History of Ideas* 44 (July–Sept. 1983), 455–75.

72. On the role of Maxwell, in particular, in this change, see Brush, *Kind of Motion*, vol. 2, pp. 587–98. The connection of randomness to irreversibility in molecular systems, which seemed to violate the reversibility principle of mechanics, was the source of much innovative theorizing in this period by Boltzmann and others, including Maxwell's hypothesis of a "Sorting Demon." See pp. 598–615; on Maxwell's Demon, see pp. 589–91.

73. See, e.g., Banesh Hoffmann, *The Strange Story of the Quantum* (New York: Harper and Bros., 1947), chaps. 13, 14.

74. *GB*, in *SS*, p. 71 (with slight variation in translation). On such "phosphorescence," see nn. 24, 26 and the related text above.

75. For Duchamp's use of *écarts*, see *DDS*, p. 101; and Schwarz, *Notes and Projects*, note 35. For Lucretius's terminology, see Lucrèce [Titus Lucretius Carus], *De la nature des choses*, trans. LaGrange, 2 vols. (Paris: Chez Bleuet Père, 1794), vol. 1, pp. 143–45; and for a different translation, see, e.g., Lucrèce, *De la nature des choses*, trans. André Lefèvre (Paris: Société des Editions Littéraires, 1899), p. 51. Lucretius's Latin phrase *clinamen principiorum*, on the other hand, is translated as "déclinaison" (ibid. [1794], p. 149). For Guillaume's usage, see *Les Rayons X*, p. 3. The term *écart* does not appear in the subsequent literature on subatomic scattering (Rutherford, Wilson), which Perrin, for example, discusses using the word *déviation*. See the Perrin text quoted at n. 204 below.

76. The *clinamen* as a sign of free will found continued relevance in the group known as OuLiPo (Ouvroir de la Littérature Potentielle), which was dedicated to exploring experimental techniques for creating literature. Formed in 1960 by a group that included Duchamp's friend François Le Lionnais, OuLiPo was also associated with the Jarryesque Collège de Pataphysique, to which Duchamp belonged. See *Oulipo: A Primer of Potential Literature*, ed. and trans. Warren F. Motte, Jr. (Lincoln: University of Nebraska Press, 1986), pp. 19–20, 32–39, 48–50. On the periodic appearance of the *clinamen* in literature and literary theory, see Warren F. Motte, Jr., "Clinamen Redux," *Comparative Literature Studies* 23 (Winter 1986), 263–81.

77. Maxwell, as quoted in Brush, *Kind of Motion*, vol. 2, p. 589. Jarry had referred in passing to Maxwell's Demon in *Gestes et opinions du Docteur Faustroll* in his chapter "Concerning the Watch, the Measuring Rod, and the Tuning Fork." He relates Faustroll's ability to make a piece of glass produce the spectrum he needs to his "having met various demons, including the Sorting Demon of Maxwell, who succeeded in grouping particular types of movement in one continuous widespread liquid (what you call small elastic solids or molecules)" (chap. 37).

78. "*Begin with darkness* (black background) or rather picric yellow)," the note continues in relation to a sketch of a curved surface with gradations of dots (signs for molecules?) from far to near. For this drawing, see the original note reproduced in Schwarz, *Notes and Projects*, note 35. As reproduced in *Salt Seller*, the note includes only Duchamp's schematic diagram that may suggest light emerging from an interior molecule labeled "M" (*GB*, in *SS*, p. 71).

79. See the discussion of the issue of chance in chap. 5, as well as *MDN*, note 68 ("ironic causality"); *MDN*, notes 74, 77 (app. A, no. 2), 152 (p. 3), and *GB*, in *SS*, pp. 30, 49 ("subsidized symmetry" or "symmetries"); and *GB*, in *SS*, p. 62 ("liberty of indifference").

80. *GB*, in *SS*, p. 30. Duchamp's other "laws" are discussed more fully in chap. 11, under "Playful Mechanics."

81. See *Encyclopedia of Philosophy*, ed. Edwards, s.v. "Laplace" (vol. 4, p. 393). Duchamp followed Laplace's order more strictly in his unpublished note beginning, "Text (general notes for the).": "the principles, laws or phenom. will be writ-

ten as in a theorem in geometry books. underlined, etc." See *MDN*, note 77 (app. A, no. 2).

82. Poincaré, "L'Etat actuel et l'avenir de la physique mathématique," *La Revue des Idées* 1 (Nov. 15, 1904), 813. See also *Valeur de la science*, p. 200; *Foundations*, p. 314.

83. Poincaré, *Valeur de la science*, pp. 198–99; *Foundations*, pp. 312–13.

84. Poincaré, *Valeur de la science*, pp. 180–85; *Foundations*, pp. 303–5.

85. The possibility that Duchamp was responding to some degree to Poincaré's discussion of pre-Einsteinian relativity theory in relation to the conservation of mass is discussed in chap. 11, under "Playful Mechanics."

86. *MDN*, note 77 (app. A, no. 2); note 69.

87. *GB*, in *SS*, pp. 48–55; see Schwarz, ed., *Notes and Projects*, notes 100, 101, 92, 98, 106, 102, 104 for the corresponding notes in their original form.

88. *A L'INF*, in *SS*, pp. 76–77; Schwarz, ed., *Notes and Projects*, note 103. As discussed in chap. 12, Duchamp does seem to have associated the snow scene in his Readymade *Pharmacy* (fig. 167) with the frosty "spangles" entering the Sieves. For the "snow effect" produced during the solidification of gases, see the text below at n. 126 and following.

89. *GB*, in *SS*, pp. 49–50.

90. Ibid., p. 53.

91. Ibid., p. 49 (with variation in translation); see *DDS*, p. 72, n. 4, and Schwarz, *Notes and Projects*, p. 155, for the French text of the note.

92. In addition to notes 114, 125, and 122 (reproduced here in figs. 138, 139, 141), other relevant notes on this subject are *MDN*, notes 112, 132, 133 (app. A, no. 8), in particular, as well as 58, 103, 120, 123, 130, 145, and 158–60.

93. See *MDN*, note 114 (verso).

94. This phrase occurs in *MDN*, note 112. Matisse's translation of the term as "condensing plate" omits the sense of "partition" and suggests condensation forming on metal plates, another kind of "liquefaction" altogether.

95. This might well be the "whistle" Duchamp lists in his "breakdown" of the Bachelor Apparatus, quoted above at n. 7.

96. *MDN*, note 114.

97. See *G.B,* in *SS*, pp. 50, 54, for the Butterfly Pump.

98. See *MDN*, note 133 (app. A, no. 8). The phrase "dew of Eros" (*la rosée d'Eros*), written in pencil, appears to be a later addition to the original note written in blue ink. See the deluxe edition of *MDN* (1980), note 133.

99. Ibid.

100. *MDN*, notes 250, 251; see also notes 252 (fig. 189B herein) and 255, where Duchamp substitutes the phrase "dew of Eros," which he seems to have added later to the note quoted at n. 98; see also note 132 for an abbreviated form of note 133.

101. See Lebel, *Marcel Duchamp*, p. 164, where Lebel includes the drawing in his catalogue raisonné (no. 101), dating it to 1912 and illustrating the studio photograph reproduced in fig. 140. Lebel lists the height of the drawing as 67 in. (170 cm) and the medium as "oil on cardboard"; the text also

states that the work was given to Joseph Stella. Schwarz also listed the drawing in his catalogue raisonné (*Complete Works*, cat. no. 202) and corrected the dating to 1913, "according to Duchamp." A major preparatory work for the *Large Glass*, exceeding the height of the lower glass panel (53 in.; 134.6 cm) of the *Glass*, the lost drawing has rarely been mentioned in the Duchamp literature. Francis Naumann has established that the drawing was exhibited by Duchamp in New York in the Bourgeois Gallery's "Exhibition of Modern Art" (Apr. 3–29, 1916), where its title was awkwardly translated as "Celibate Utensil" (Naumann, ed., "Amicalement, Marcel," p. 48, n. 25). See also Schwarz, *Complete Works* (1997), cat. no. 272.

102. The illustrated note (minus its drawing) appears as no. 12 in app. A.

103. See *GB*, in *SS*, p. 63. Schwarz, *Complete Works* (1997), cat. no. 297, reproduces a related, previously unknown drawing.

104. The pencil line in the drawing has faded over time and is hardly distinguishable today. I am grateful to Francis Naumann, who pointed out its presence, based on his study of the reproduction of the perspective layout of the *Large Glass* in the *Green Box*.

105. In particular, see chap. 11 at n. 28 and following.

106. *MDN*, notes 132, 133 (app. A, no. 8); for the "inert" usage, see *GB*, in *SS*, p. 50.

107. See G. Bresch, "Les Gaz liquéfiés (l'air, l'hélium)," *La Nature* 39 (Dec. 10, 1910), 22–27.

108. See A. Troller, "Production industrielle de l'azote [nitrogen] et de l'oxygène par l'air liquide: La Machine G. Claude," *La Nature* 40 (Dec. 16, 1911), 41–45. For another popular account of liquefaction, see Edward W. Byrn, *The Progress of Invention in the Nineteenth Century* (New York: Munn, 1900), chap. 23 ("Liquid Air").

109. Bresch, "Gaz liquéfiés," p. 23.

110. See G. Claude, "Sur la liquéfaction de l'air et ses applications," reported in *Revue Générale des Sciences Pures et Appliquées* 17 (Jan. 15, 1906), 52–53; and Georges Claude, "L'Oxygène industriel," in *Revue Générale* 20 (Nov. 30, 1909), 923–25.

111. See L. Poincaré, *New Physics*, pp. 117–26 in chap. 4 ("The Various States of Matter").

112. James Dewar, "La Science du froid," *Revue Scientifique*, 4th ser., 18 (Oct. 4, 1902), 417–26; 18 (Oct. 11, 1902), 456–64; 18 (Oct. 18, 1902), 487–94. See also James Dewar, "History of Cold and Absolute Zero," in *Annual Report of the Smithsonian Institution, 1902* (Washington, D.C.: G.P.O., 1903), 207–40. For Dewar's account of the invention of the flask and his general history of liquefaction, see his article, "Liquid Gases," *Encyclopaedia Britannica* (1910), 11th ed., vol. 16, pp. 744–59.

113. Keller, *Infancy of Atomic Physics*, p. 106.

114. Jarry, *Gestes et opinions*, chap. 37.

115. See Bresch, "Gaz liquéfiés," pp. 25–26.

116. Ibid., p. 24; see Troller, "Production industrielle," p. 45, for a diagram of Claude's installation, complete with pumps and connected gearwheels. Double-acting "suction and compression pumps," such as Duchamp cites in *MDN*, note

133 (app. A, no. 8), were a feature of contemporary refrigeration techniques, which offer additional parallels to Duchamp's system. See, e.g., Byrn, *Progress of Invention*, chap. 22.

117. See *GB*, in *SS*, pp. 30, 68. See also Bresch, "Gaz liquéfiés," pp. 24–25.

118. See, e.g., Dewar, "History of Cold," pp. 220–21. See also Perkins, *Introduction to General Thermodynamics*, pp. 122–24.

119. The Joule-Thomson effect alone, however, had proved insufficient for Kamerlingh Onnes's liquefaction of helium, which required additional cooling by means of liquid hydrogen. See Bresch, "Gaz liquéfiés," p. 26.

120. *GB*, in *SS*, p. 53.

121. Ibid., pp. 30, 49.

122. *MDN*, note 114. See Ramsay, *Gases of the Atmosphere*, chap. 8; see also Claude, "Development of Neon Tubes," p. 271, and Troller, "Production industrielle," pp. 41–45.

123. *MDN*, note 112.

124. See *GB,* in *SS,* pp. 49, 53.

125. On Ramsay, see Keller, *Infancy of Atomic Physics*, p. 100; on Kamerlingh Onnes, see Gavroglu and Goudaroulis, eds., *Selected Papers of Kamerlingh Onnes*, p. lviii. For Dewar's experiments with hydrogen, see the following note.

126. Dewar, "History of Cold," p. 223; see also Dewar, "Solid Hydrogen," *Annual Report of the Smithsonian Institution, 1901* (Washington, D.C.: G.P.O., 1902), p. 252.

127. See *GB*, in *SS*, pp. 50, 53. See also, Bresch, "Gaz liquéfiés," p. 27.

128. Dewar, "History of Cold," p. 223; see also Dewar, "Solid Hydrogen," pp. 255–56.

129. See *GB*, in *SS*, p. 48. For a sample of such a demonstration, see Byrn, *Progress of Invention*, pp. 454–57.

130. *MDN*, note 133 (app. A, no. 8). For cohesion experiments carried out in this period, see Dewar, "Liquid Gases," p. 756.

131. *MDN*, note 140.

132. L. Poincaré, *New Physics*, p. 121; Dewar, "Liquid Gases," p. 758.

133. L. Poincaré, *New Physics*, p. 122. Another characteristic of many materials at low temperature was a reduction in resistance to electrical current. In 1911 Kamerlingh Onnes discovered and named the phenomenon of "superconductivity," which has attracted much attention in recent years. See Gavroglu and Goudaroulis, eds., *Selected Papers of Kamerlingh Onnes*, pp. xiv, 252–387.

134. *A L'INF*, in *SS*, pp. 85–86.

135. See Dewar, "History of Cold," p. 237; and Gavroglu and Goudaroulis, eds., *Selected Papers of Kamerlingh Onnes*, pp. 236–51.

136. See chap. 8, n. 139.

137. See, e.g., Whymper, *Cocoa and Chocolate: Their Chemistry and Manufacture*, p. 141 (for cooling procedures) and pt. 3 ("Chemistry of Cacao").

138. *GB*, in *SS*, p. 51. *MDN*, notes 103, 112, 123 (app. A, no. 16). See the discussion of dies in chap. 8 in the section "*Appareils enregistreurs* and Other Indexical Signs in the *Large Glass.*"

139. See *MDN*, note 133 (app. A, no. 8), quoted above at n. 99.

140. See *GB*, in *SS*, pp. 51, 53; for the "Torture of Tantalus," see *MDN*, note 103.

141. See the text at n. 6 above for the listing that follows.

142. *MDN*, note 122. Textbooks on thermodynamics also standardly dealt with the flow of gases and liquids. See, e.g., Perkins, *Introduction to General Thermodynamics*, p. 95; J. E. Emswiler, *Thermodynamics* (New York: McGraw-Hill, 1927), chap. 16 ("The Flow of Fluids").

143. See *MDN*, note 133 (app. A, no. 8), quoted above at n. 98.

144. See, e.g., Millikan and Gale, *Practical Physics*, pp. 93–101.

145. For the change from the term "machine," see, e.g., *MDN*, note 104 (app. A, no. 22/23).

146. See n. 192 below and the related text.

147. Nye, *Molecular Reality*, p. 65. The overview of Perrin's career that follows is based on Nye, chap. 2. On Perrin's position in the French scientific community and his close friendship with the Curies, see Spencer R. Weart, *Scientists in Power* (Cambridge: Harvard University Press, 1979), chap. 1.

148. For Perrin's model of the atom, see Nye, *Molecular Reality*, pp. 83–84, as well as the discussion of this subject in chap. 2 at n. 26.

149. See Jean Perrin, *Les Principes: Traité de chimie physique* (Paris: Gauthier-Villars, 1903); for Nye's summary of his views, see *Molecular Reality*, pp. 69–85.

150. H. W. Nernst, *Theoretische Chemie* (6th ed., 1909), quoted in Brush, *Kind of Motion*, vol. 2, p. 698; see pp. 693–701 for Brush's analysis of Perrin's contributions. For Perrin's colloid research and a more detailed discussion of his work on Brownian motion, see Nye, *Molecular Reality*, pp. 85–91 and chap. 3.

151. Nye, *Molecular Reality*, pp. 9–12.

152. See chap. 2, n. 48.

153. On this later period, see Nye, *Molecular Reality*, pp. 21–29.

154. Poincaré, *Valeur de la science*, p. 184; *Foundations*, p. 305. Perrin responded to this question at the beginning of his 1909 essay "Mouvement brownien and réalité moléculaire," arguing that perpetual motion at this scale "is in general so insignificant that it would be absurd to take it into account." See Jean Perrin, *Brownian Movement and Molecular Reality*, trans. Frederick Soddy (London: Taylor and Francis, 1910), p. 5.

155. Crookes, "De la relativité," pp. 609–10. See chap. 1, n. 27, and chap. 4, n. 21, on this address before the Society for Psychical Research, reprinted in the *Revue Scientifique*. On Jarry's use of Crookes's text, see chap. 4, n. 87 and the related text.

156. See H. Vigneron, "Les Preuves de la réalité moléculaire," *La Nature* 40 (Dec. 2, 1911), 3–4. For a complete list of Perrin's publications, see Nye, *Molecular Reality*, pp. 188–89.

According to Nye, journalists requested popular explanations of Brownian movement from Perrin (p. 152). On the reception of his discoveries, see ibid., chap. 4.

157. See Jean Perrin, *Les Atomes* (Paris: Félix Alcan, 1913), for which the copyright was filed in January 1913. In the revised fourth and fifth editions of *Les Atomes* of 1914, Perrin added a final section (four pages) to the last chapter, where he discussed and illustrated the work of C.T.R. Wilson. The English translation of *Les Atomes* cited here is Jean Perrin, *Atoms*, trans. D. Ll. Hammick, from the 4th rev. ed. (London: Constable, 1916). See also Georges Bohn, "Le Mouvement scientifique—J. Perrin: *Les Atomes*," *Mercure de France* 103 (May 1, 1913), 159–63.

158. Jean Perrin, "A propos de 'L'Evolution des forces,'" *Revue du Mois* 4 (Nov. 10, 1907), 609; see pp. 606–8 on the Curies.

159. Jean Perrin, "Les Arguments de M. Gustave Le Bon," *Revue du Mois* 4 (1907), 731. The Perrin–Le Bon exchange was also reported by Georges Bohn in his *Mercure de France* column, "Le Mouvement scientifique" (*Mercure de France* 71 [Jan. 1, 1908], 122). On Perrin's criticisms of Le Bon and on the latter's declining stature, see Nye, "Gustave Le Bon's Black Light," pp. 180, 190–92.

160. See, e.g. Georges Matisse, "La Théorie moléculaire et la science contemporaine," *Mercure de France* 103 (June 1, 1913), 520–25. Matisse's sympathies for Energetics versus atomism are apparent in his "Essai philosophique sur l'énergétique," *La Revue des Idées* 4 (Apr. 15, 1907), 353–71. Matisse had also written the fantastical "Histoire extraordinaire des Electrons," published in *Mercure de France* in 1908 (see chap. 2, n. 28, and the related text). For the few others figures who remained skeptical in response to Perrin's work, including Pierre Duhem, see Nye, *Molecular Reality*, pp. 165–69; see also Nye's earlier discussion of Duhem's commitment to thermodynamics minus atomism (pp. 33–35).

161. See Jean Perrin, "La Réalité des molécules," *Revue Scientifique* 49 (Dec. 16, 1911), 774–84. See also Perrin, "Mouvement brownien et réalité moléculaire," *Annales de Chimie et de Physique*, 8th ser., 18 (Sept. 1909), 1–114; and *Brownian Movement and Molecular Reality* (see n. 154 above).

162. Perrin, "Réalité des molécules," p. 779.

163. Ibid., p. 776.

164. Ibid., p. 780.

165. Nye, *Molecular Reality*, p. 105.

166. Perrin, "Réalité des molécules," p. 780.

167. *MDN*, note 114.

168. *GB*, in *SS*, p. 50; *DDS*, p. 75.

169. Perrin, "Réalité des molécules," p. 776.

170. Ibid.

171. Ibid., p. 779.

172. Ibid.; for Perrin's microscopic technique, see p. 781, as well as *Les Atomes* and *Atoms*, sec. 61. For Perrin's talk of "shaking," see, e.g., Perrin, *Brownian Movement*, pp. 35, 41.

173. Perrin, "Réalité des molécules," p. 781; see also *Les Atomes* and *Atoms*, sec. 62.

174. *GB*, in *SS*, p. 35.

175. *Box of 1914*, in *SS*, p. 23; *GB*, in *SS*, p. 44; *MDN*, notes 115 (p. 4), 118 (p. 3). For Duchamp's references to pigments in the yellow range, see chap. 6, n. 54.

176. See *GB*, in *SS*, p. 44; and *DDS*, p. 65. The "Horizontal column" (*MDN*, note 98) is discussed in the section on the Desire Dynamo that follows.

177. Poincaré, *Science et Méthode*, p. 89; *Foundations*, p. 410.

178. Perrin, "Réalité des molécules," p. 773. Perrin's discussion of particles in air currents, however, distinguished their movements from true Brownian motion, in which the movements of neighboring particles are independent of one another. For Poincaré's reference, see again n. 62.

179. *GB*, in *SS*, p. 50.

180. Ibid., p. 66; *DDS*, p. 96. The Hamilton translation of "choc" as "contact" in the Sanouillet volume misses the sense of a blow or collision.

181. See, e.g., Guillaume, *Rayons X*, p. 8; L. Poincaré, *New Physics*, p. 260. Perrin talks of "chocs" in "Réalité des molécules," p. 775; see also, e.g., *Les Atomes* and *Atoms*, sec. 44 ("Molécules sans cesse en état du choc").

182. Perrin, *Brownian Movement*, p. 15.

183. Ibid., p. 65. See also Perrin, *Les Atomes* and *Atoms*, sec. 73. Porter Aichelle has recently suggested that Perrin's diagram of the trajectories of granules (before their displacements were graphed around a target), may have been a source for two Paul Klee drawings of 1912, *The Expectant Ones* and *An Uncanny Moment*. See K. Porter Aichelle, "Paul Klee and the Energetics-Atomistics Controversy," *Leonardo* 26, no. 4 (1993), 309–15. For the Perrin diagram, see Perrin, "Réalité des molécules," p. 783; *Brownian Movement*, p. 64; and *Les Atomes* and *Atoms*, sec. 72.

184. For Duchamp's actual target-shooting experiments (see below), see his letter to Serge Stauffer, Apr. 17, 1958, in *Duchamp: Die Schriften*, ed. Stauffer, p. 254. In light of Picabia's interest in many of the scientific themes explored by Duchamp, he may have been aware of the possible scientific connections of the target-shooting theme as well. See the discussion of *Voilà elle* in chap. 8.

185. *A L'INF*, in *SS*, p. 84; see also *GB*, in *SS*, p. 63.

186. *GB*, in *SS*, p. 35. See *DDS*, p. 54, for Duchamp's use of "cote de distance" versus the more specific "coefficient of displacement" in the George Hamilton translation in *SS*.

187. Perrin, *Brownian Movement*, p. 62.

188. Perrin tested Einstein's theoretical calculations for molecular rotations as well as displacements. See Perrin, *Les Atomes* and *Atoms*, sec. 71.

189. Perrin, *Les Atomes*, p. 289; *Atoms*, p. 206.

190. Ibid., chaps. 6–8. Nye provides a detailed analysis of Perrin's use of this new research (*Molecular Reality*, chap. 3).

191. See Perrin, *Les Atomes*, secs. 114, 115; *Atoms*, secs. 114, 115.

192. Perrin uses the term "concordance" or a variant thereof several times in "La Réalité des molécules" (pp. 776, 782, 784). The December 1911 *La Nature* report of his lecture to the Société Française de Physique quotes the phrase "miracle de concordance" (Vigneron, "Les Preuves," p. 4); as noted earlier,

it also appears at the beginning of the last section of *Les Atomes*, beneath a chart summarizing the values of N established by Perrin and others.

193. *GB*, in *SS*, pp. 27–28.

194. See chap. 7 at n. 11. E.g., Perrin refers to "photographies instantanées" in "Réalité des molécules" (p. 781) and *Les Atomes* (sec. 62). In contrast to the electric-spark photography of Worthington and Wilson (which involved exposures of less than three-millionths of a second), Brownian movement researchers could use exposures in the range of 1/320 of a second. See Worthington, *Study of Splashes*, p. 2; and Nye, *Molecular Reality*, p. 126.

195. Perrin, "Réalité des molécules," 776.

196. *GB*, in *SS*, p. 28.

197. In addition to the numerous calculations of N, see, e.g., Perrin, *Les Atomes* and *Atoms*, sec. 102. Duchamp's note, however, indicates his preference for algebraic expressions as fluid "numerical relative values" rather than expressions of specific numbers.

198. *MDN*, note 82 (app. A, no. 5). Duchamp's note emphasizes the need for "vulgar words" free of metaphorical associations as well as "a—*the idea itself of precision*/ and b. transparent language."

199. See chap. 2 at n. 49.

200. For William Camfield's identification of this source for Picabia, see Camfield, *Picabia*, figs. 139, 140; for a color reproduction of the painting, see Borràs, *Picabia*, p. 195. On this phenomenon, see, e.g., Claude, *L'Electricité*, pp. 439–40.

201. See, e.g., L. Poincaré, *New Physics*, p. 252; and Silvanus Thompson, *Elementary Lessons in Electricity and Magnetism*, rev. and enl. ed. (New York: Macmillan, 1915), p. 305.

202. *GB*, in *SS*, p. 42.

203. For Wilson's technique, discussed further below, see Peter Galison and Alexei Assmus, "Artificial Clouds, Real Particles," in *The Uses of Experiment: Studies in the Natural Sciences*, ed. David Gooding, Trevor Pinch, and Simon Schaffer (Cambridge: Cambridge University Press, 1989), pp. 225–74. For Duchamp's reference to "in the dark," see *GB*, in *SS*, p. 28, quoted at the beginning of chap. 7 above.

204. Jean Perrin, *Les Atomes*, 5th ed. rev. (Paris: Félix Alcan, 1914), pp. 289–91; *Atoms*, pp. 204–5.

205. On Wilson's meteorological interests, see Galison and Assmus, "Artificial Clouds, Real Particles."

206. See L. Poincaré, *New Physics*, pp. 242–57.

207. *MDN*, notes 143, 153 (p. 4) (app. A, no. 11). The operation of Worthington's and Wilson's apparatus may also have suggested a model to Duchamp. The carefully timed flash of the spark (and, in Wilson's case, the necessary expansion of the cloud chamber to produce condensation) was triggered by an elaborate system of falling weights on cord, much like Duchamp's falling Weight(s) powering the Chariot or falling Mobile on a "little cord" (*MDN*, note 153 [p. 2] [app. A, no. 11]). See, e.g., Wilson, "On an Expansion Apparatus," pp. 280–81; and Worthington, *Study of Splashes*.

208. Perrin, *Les Atomes* (5th ed., 1914), p. 281.

209. See, respectively, *MDN*, notes 91, 133; and *GB*, in *SS*, p. 65 (*DDS*, p. 93). See n. 170 above for another such Duchamp reference to drops in relation to glycerine and viscosity. In addition to Perrin's concern with viscosity, noted there, Worthington also experimented with glycerine (*Study of Splashes*, pp. 101–4).

210. See chap. 7 at n. 12.

211. See, e.g., A. M. Worthington, "The Splash of a Drop and Allied Phenomena," *Annual Report of the Smithsonian Institution, 1894* (Washington, D.C.: G.P.O., 1896), pp. 197–211. As noted in chap. 2, Clair (*Duchamp et la photographie*, p. 92) notes that Worthington's photographic work was also reproduced in *La Nature*.

212. L. Poincaré, *New Physics*, p. 243.

213. Perrin, *Brownian Movement*, p. 20; see also, e.g., Vigneron, "Les Preuves," p. 3.

214. *MDN*, note 114.

215. See n. 150 above.

216. On Planck's quanta as well as the new quantum-based model of the atom to be formulated by Bohr in 1913, see Keller, *Infancy of Atomic Physics*, chaps. 7, 10.

217. On this subject, see, e.g., Arthur I. Miller, "Visualization Lost and Regained: The Genesis of the Quantum Theory in the Period 1913–27," in *On Aesthetics in Art and Science*, ed. Judith Wechsler (Cambridge: MIT Press, 1978), pp. 73–102.

218. For Duchamp's interest in the Palais de la Découverte, see chap. 2 at n. 15. Although Duchamp would have empathized with Perrin's scientific views, his own apolitical stance differed markedly from Perrin's socialism and his belief in the possibilities of a partnership between science and society. On Perrin's activities in the 1930s, including his role in the founding of the Centre National de la Recherche Scientifique, see Nye, *Molecular Reality*, pp. 56–58; see also Weart, *Scientists in Power*, chap. 2.

219. On this aspect of Perrin, see Nye, *Molecular Reality*, pp. 70–72.

220. Perrin, *Les Principes*, p. xvi. For Abel Rey's contemporary praise of Perrin's text as "a lesson of scientific integrity, a model of precision," see Nye, *Molecular Reality*, p. 79

221. *MDN*, note 82 (app. A, no. 5); note quoted at n. 200 above.

222. *MDN*, note 77 (app. A, no. 2).

223. Perrin, *Les Atomes*, p. i; *Atoms*, p. v.

224. Perrin, *Les Atomes*, pp. i–v; *Atoms*, pp. v–viii.

225. Duchamp, as quoted in Sweeney, "Eleven Europeans," p. 20. Perrin, *Les Atomes*, p. v.; *Atoms*, p. vii.

226. See *GB*, in *SS*, pp. 57–58 (fig. 156B herein); *MDN*, notes 63, 85.

Chapter 11: Other Scientific and Technological Dimensions of the Bachelors, II

1. See chap. 7, n. 52, for Gourmont on gears; see also the six chapters of *Physique de l'amour* entitled "Le Mécanisme de l'amour."

2. *MDN*, notes 98, 132, 133 (app. A, no. 8).

3. See *MDN*, note 98, which is quoted in part in chap. 10 at n. 7 and in full in chap. 7 at n. 61.

4. For the notes that form the basis of note 153, see *MDN*, notes 101 and 138–43. Fig. 149 is from *MDN*, note 163.

5. *GB*, in *SS*, p. 66; Schwarz, ed., *Notes and Projects*, note 116.

6. *GB*, in *SS*, p. 63. For the form of these two notes, see Schwarz, ed., *Notes and Projects*, notes 115, 118. Schwarz includes a rough sketch illustrating the note beginning "*after the 3 crashes=*," a drawing that was excluded from *Salt Seller*. In Sanouillet's text, this note and its successor, headed "*Planes of flow*," appear to be one note (p. 63).

7. *GB*, in *SS*, p. 66.

8. Ibid., p. 62, as well as the discussion of this subject in chap. 5 above.

9. See also *MDN*, notes 30, 31, as well as the discussion of the "Ass of Buridan" in chap. 5. Note 181 (app. A, no. 20) is another of these notes and is discussed below. See also the page of sketches of the Mobile (*MDN*, note 119).

10. Suquet is the only Duchamp scholar to have dealt with the new information on the Mobile contained in Duchamp's posthumously published notes. Following the publication of his overlay drawing in 1987 (fig. 111), Suquet, in his "Possible" essay (*Definitively Unfinished Duchamp*, ed. de Duve, pp. 93–95), discussed the Mobile briefly, illustrating Duchamp's note 153 drawing and his own superimposed scheme, this time showing the Mobile in its released position.

11. *GB*, in *SS*, p. 49.

12. Ibid., pp. 61–62.

13. Ibid., p. 61.

14. Ibid., p. 62. See *MDN*, note 153 (p. 2) (app. A, no. 11) for the reference to coins; for free will and molecular collisions in relation to the kinetic theory of gases, see chap. 10 at n. 69 and following, as well as the section "Molecular and Atomic Reality in the *Large Glass*."

15. Duchamp included this note among those he selected in the late 1950s. See *MDN*, note 181 (app. A, no. 20).

16. See chap. 5, n. 33 and the related text.

17. *MDN*, note 68.

18. See ibid., note 129, which includes a drawing of the Scissors bearing magnifying lenses.

19. See *Duchamp* (Philadelphia), p. 190, for Calder's letter explaining this history and his reconstruction of the work that generated Duchamp's application of the term. See also Alexander Calder, "A Conversation with Alexander Calder," *Art in America* 57 (July–Aug. 1969), 31.

20. *MDN*, notes 144 (app. A, no. 14/15), 152 (p. 3).

21. See *GB*, in *SS*, p. 63. For the later "Crash-Splash" and "splasher," see *A L'INF*, in *SS*, pp. 76, 82–83; see also Schwarz, ed., *Notes and Projects*, notes 112–14, 117.

22. *MDN*, notes 98, 143, 153 (pp. 1, 4) (app. A, no. 11).

23. *GB*, in *SS* p. 63. The term *canalisation* had specifically industrial associations: e.g., *canalisation de gaz* are gas mains. On the *canalisation* of water, gas, and electricity in this period, see Asendorf, *Ströme und Strahlen*, chap. 4, in which a passing reference to Duchamp's *Cols alités* drawing (fig. 87 herein) also occurs (p. 61).

24. See *GB*, in *SS*, pp. 66, 63, and *A L'INF*, in *SS*, p. 84.

25. See *GB*, in *SS*, pp. 63, 65. On the French drawing traditions of *le géométral* versus *le perspectif*, see, e.g., Clair, "Duchamp and the Classical Perspectivists," p. 41; and chap. 3, n. 12. For the source of Duchamp's Wilson-Lincoln idea in a shop advertisement, see Siegel, "Some Late Thoughts," p. 22.

26. *GB*, in *SS*, pp. 63, 65; and *A L'INF*, in *SS*, pp. 82–83.

27. For the drawing (Philadelphia Museum of Art, The Louise and Walter Arensberg Collection), see Schwarz, *Complete Works*, cat. no. 270. For Suquet's discussion and application of the image to the *Glass*, see n. 10 above.

28. In addition to *MDN*, notes 153 and 163 (app. A, nos. 11, 12), see notes 131, 140, 142, 143, 161, 162. Note 131 (marked "A Supprimer") appears to be a "folder" like those naming other components of the *Large Glass*, which Matisse includes as notes 47–63. As discussed earlier, the Dynamo is also mentioned in notes 98, 112, 132, 133 (app. A, no. 8), and the drawing in note 122 (fig. 141 herein).

29. *MDN*, note 162.

30. See ibid., note 98, and *GB*, in *SS*, p. 44.

31. On the Bride's Desire-magneto, see chap. 7 at n. 43 and following.

32. See *MDN*, notes 161, 162; see also the *Box of 1914* (*SS*, p. 23). In notes 161 and 162 Duchamp describes his calculations as an "algebraic absurd."

33. For Duchamp's Golden Section notes, one of which includes algebraic solving of an "equation of false degree" (although his mathematics is not quite correct), see *MDN*, note 84, as well as 70 and 183. In the latter note Duchamp's equation is written in ink different from that of the surrounding text on creating a sculpture of sound. The two notions may be unrelated or, alternatively, may be another example of Duchamp's unorthodox application of the traditional artistic proportion to a new field—in this case, relationships among sounds.

34. See *MDN*, note 162, for these alternate designations, including "Intention-state/Possibility-state." For Duchamp's "Notice," see *GB*, in *SS*, p. 28; quoted in chap. 7 at n. 10.

35. *MDN*, note 131.

36. See, e.g., Claude, *L'Electricité*, pp. 260–61.

37. See *MDN*, notes 132, 133 (app. A, no. 8); see also notes 143, 153 (p. 4) (app. A, no. 11). In addition to Claude's discussion of gas igniters (n. 36 above), see Baudry de Saunier, "L'Electricité à bord des automobiles," p. 535, for electric *allumoirs* for automobiles.

38. See Maurice Solomon, *Electric Lamps* (London: Archibald Constable, 1908), p. 143. On the popularity of Nernst lamps in Europe, see Bright, *Electric-Lamp Industry*, p. 173.

39. *GB*, in *SS*, p. 43.

40. See *MDN*, note 246 (app. A, no. 6).

41. Ibid., notes 143, 153 (pp. 1, 3, 4) (app. A, no. 11).

42. *MDN*, notes 140, 153 (p. 3).

43. See Schwarz, *Complete Works*, cat. nos. 385, 388–90. Matisse translates the term "precision friction plate" (*MDN*, note 153 [p. 1]).

44. See, e.g., Thompson, *Elementary Lessons*, p. 481.

45. See *MDN*, note 153 (p. 1), for this and the quotations in

the following paragraph. The first page of note 153 is a more fully developed version of note 142.

46. See ibid., note 162.

47. See *Catalogue officiel. . .C.N.A.M.*, vol. 3, pp. 207–39.

48. See chap. 2 at n. 49 and chap. 4 at n. 9.

49. Adams, "The Dynamo and the Virgin," in *Education of Henry Adams*, vol. 2, p. 163. See also, e.g., "The Power-Generating Plant at the Paris Exposition," *Scientific American Supplement* 49 (June 16, 1900), 20447–50; and "The Foreign Power Section of the Paris Exposition," *Scientific American Supplement*, 50 (July 21, 1900), 20534–35. As noted in the introduction, Tashjian has discussed Adams's response to technology and compared it to that of Duchamp in "Henry Adams and Marcel Duchamp."

50. *GB*, in *SS*, p. 45.

51. *MDN*, note 95 (with slight variation in translation). Note 95 includes a sketch of a chain-and-sprocket mechanism for raising the "Weights" and a circular "Receiver." Note 81 is a neatly recopied version of this note (minus the drawing), which bears a circled number seven at the top—as if it might have been intended for another grouping of notes, different from his 1950s assemblage.

For Duchamp's "Breakdown: Bachelor Apparatus" note in full, see chap. 10, n. 7. Although in translating that note Matisse uses the term "prime mover" for *force motrice*, he elsewhere translates it as "motive force," which better conveys its meaning in physics. See *MDN*, note 62.

52. See *MDN*, note 85, where the Chariot is initially drawn with wheels and subsequently depicted with runners.

53. See *GB*, in *SS*, p. 62.

54. Ibid., p. 61.

55. On Duchamp's "Expansion transformer," see chap. 10 at n. 46. Windmills were also included among the "mechanical recipients of force" displayed in room 24 of the Musée des Arts et Métiers, along with waterwheels and engines, a reminder that Duchamp's Air Current Pistons in the Bride's realm are yet another whimsical variation on the theme of energy and power. For the partial contents of room 24, see the text quoted at chap. 10, n. 6.

56. On transformations of potential and kinetic energy, a subject standardly treated in discussions of power and energy, see, e.g., Millikan and Gale, *Practical Physics*, p. 124.

57. *GB,* in *SS*, pp. 39, 42–44.

58. See chap. 8, n. 146 and the related text.

59. See Claude, *L'Electricité*, chap. 5. Duchamp never worked out the details of how this electricity might have been transferred to other parts of the *Glass* (e.g., the Chocolate Grinder or even the Bride).

60. See, e.g., Claude, *L'Electricité*, pp. 199–207; or Lazare Weiler, "Les Sources de l'électricité," *Revue des Deux Mondes* 150 (1898), 862–64.

61. A. Ferrand, *Les Dynamos et les transformateurs à l'Exposition Universelle de 1900* (Paris: E. Bernard, 1902); see also, e.g., Silvanus P. Thompson, *Dynamo-Electric Machinery*, 2 vols. (New York: P. F. Collier, 1902).

62. See Kunsthalle Bern, *Tabu Dada*, p. 105, as well as chap. 8, n. 175.

63. See *MDN*, notes 95, 81.

64. *GB*, in *SS*, pp. 56–57; *MDN*, note 86.

65. On Leonardo and flywheels, see, e.g., Cooper, *Inventions of Leonardo da Vinci*, p. 167. On models incorporating flywheels, including the work of Helmholtz in this area, see Martin J. Klein, "Mechanical Explanation at the End of the Nineteenth Century," *Centaurus* 17 (1972), 58–82. On Kelvin's model and Jarry, see chap. 4, n. 83, and the related text.

66. For these two works by Picabia, see Camfield, *Picabia*, figs. 137, 160. *Construction moléculaire* appeared on the cover of Picabia's periodical *391*, no. 8 (Feb. 1919).

67. See *Petit Larousse illustré* (1919), s.v. "volant."

68. See n. 64 above.

69. As noted earlier, Poincaré's conventionalism, developed in the context of his theorizing on the nature of geometrical axioms in the face of the development of non-Euclidean geometry, held that scientific laws and geometrical axioms are not absolute truths but simply the most useful means at a given moment to describe particular circumstances. See the introduction, n. 8.

70. Duchamp, as quoted in Tomkins, *Bride and the Bachelors*, p. 34.

71. See chap. 10, n. 82 and the related text.

72. *GB*, in *SS*, p. 71.

73. Perrin, *Les Principes*, p. xi.

74. For an overview of this history, see, e.g., *Dictionary of the History of Science*, ed. Bynum, Browne, and Porter, pp. 253–56.

75. See *Encyclopedia of Philosophy*, ed. Edwards, s.v. "Newtonian Mechanics and Mechanical Explanation." On the "law of inertia," see, e.g., Poincaré, *Science et l'hypothèse*, pp. 112–19; *Foundations*, pp. 93–97.

76. Millikan and Gale, *Practical Physics*, p. 66. The field of mechanics continued to develop in subsequent centuries, receiving an increasingly mathematical foundation in the eighteenth century and new applications in the nineteenth, such as wave mechanics and the statistical mechanics employed in relation to the kinetic theory of gases. See *Dictionary of the History of Science*, ed. Bynum, Browne, and Porter, pp. 254–56.

77. See chap. 5, n. 47 and the related text.

78. *GB*, in *SS*, p. 30.

79. *MDN*, note 104 (app. A, no. 22/23).

80. See *GB*, in *SS*, p. 48; *MDN*, note 152 (p. 2), as well as "Meteorology and the Eiffel Tower" in chap. 9.

81. Leonardo, quoted in Kemp, *Leonardo*, p. 302.

82. See Jules Amar, *The Human Motor, or the Scientific Foundations of Labour and Industry* (1914; London: George Routledge, 1920), pp. 363–66. On Amar, see chap. 3, n. 53. For Leonardo's studies of the mechanics of the human body, see, e.g., MacCurdy, ed., *Notebooks*, pp. 133–34; and Martin Kemp, *Leonardo da Vinci: The Marvellous Works of Nature and Man* (Cambridge: Harvard University Press, 1981), pp. 137–38.

83. See, e.g., MacCurdy, ed., *Notebooks*, pp. 438–89, 498–502, for Leonardo's discussion of birds and flying

machines from the manuscripts reprinted in Ravaisson-Mollien. For Duhem's discussion of Leonardo and center of gravity, see chap. 6, n. 24. Leonardo also developed a geometric means for determining the center of gravity of a solid such as a tetrahedron. See Ivor B. Hart, *The Mechanical Investigations of Leonardo da Vinci* (London: Chapman & Hall, 1925), a useful technical introduction of Leonardo's mechanics.

84. The manuscripts published by Ravaisson-Mollien were those known by the labels "A" through "M," along with those known as "Ash. I" and "Ash. II" (see Kemp, *Leonardo da Vinci*, p. 351). The citations of MacCurdy's edition of the *Notebooks* used here include only manuscripts available to Duchamp in the Ravaisson-Mollien volumes. Kemp's text provides the best analytical overview of Leonardo's scientific investigations.

85. For Leonardo's comments on gravity, weight, and falling bodies, see, e.g., MacCurdy, ed., *Notebooks*, pp. 528–77; on falling bodies, see also Duhem, *Etudes*, 3d ser., pp. 510–19. For Duchamp and "falls," see *MDN*, note 91 (quoted in chap. 10 at n. 8), as well as the discussion of Duchamp's falling Weight that follows.

86. For Duchamp's references, see *MDN*, notes 150, 152 (p. 1), 153 (p. 1) (app. A, no. 11). For Leonardo's ideas on balances, see, e.g., MacCurdy, ed., *Notebooks*, pp. 529–34, 537–38, 551–52, 573. For Leonardo on levers and pulleys, see Kemp, *Leonardo*, pp. 144–47; and Hart, *Mechanical Investigations*.

87. See, e.g., Duhem, *Etudes*, 2d ser., pp. 243–45.

88. See, e.g., MacCurdy, ed., *Notebooks*, pp. 526–27, 550–53; and Kemp, *Leonardo*, pp. 303–6.

89. For Leonardo's ideas on blows and percussions, see, e.g., MacCurdy, *Notebooks*, pp. 522–25. On Leonardo and ballistics, see, e.g., Kemp, *Leonardo*, pp. 142–44.

90. See *GB*, in *SS*, p. 66; *MDN*, notes 101, 153 (p. 2) (app. A, no. 11); *A L'INF*, in *SS*, p. 84.

91. Leonardo, as quoted in Kemp, *Leonardo*, p. 144.

92. See, e.g., Cooper, *Inventions*, pp. 122–23, on sprocket chains, as well as the general discussion of transmitting power; on gearing systems, see also Hart, *Mechanical Investigations*, pp. 130–33. On the issue of friction, see Kemp, *Leonardo*, pp. 301–4.

93. *GB*, in *SS*, pp. 60–61 (with slight variation in translation). For Duchamp's other depiction and description of the mechanism, see *MDN*, notes 95, 81.

94. *GB*, in *SS*, pp. 56–57; *MDN*, note 85.

95. Cf. *MDN*, notes 85–87, 89, 92, 93, 94 (app. A, no. 21), 97, 103 to the notes published in the *Green Box* (*SS*, pp. 56–62). For the original form of the notes, see Schwarz, ed., *Notes and Projects*, notes 127–33.

96. Although Duchamp discusses the issue of gravity in *A l'infinitif*, there is no mention there of the Juggler/Handler of Gravity.

97. *GB*, in *SS*, p. 65.

98. See ibid., p. 66, for both this note and the "Boxing Match" note itself.

99. Ibid., p. 30; *MDN*, note 77 (app. A, no. 2).

100. For Suquet's pioneering writings on the Juggler/Handler of Gravity, see chap. 8, n. 80.

101. The relevant posthumously published notes on the Juggler include *MDN*, notes 55, 91, 137, 141, 149 (includes drawing), 150 (app. A, no. 18), 151, 152 (includes drawing), 153 (p. 3) (app. A, no. 11), as well as notes 68 and 77 (app. A, no. 2), which parallel the *Green Box* (see n. 99 above).

102. *Catalogue officiel. . .C.N.A.M.*, vol. 2, p. 7.

103. See Conservatoire National des Arts et Métiers, *Catalogue du Musée, Section GA: Physique Mécanique* (Paris: C.N.A.M., 1955), pp. 18, 68; see also *Catalogue officiel. . .C.N.A.M.*, vol. 2, pp. 23, 28.

104. Duchamp, "Apropos of Myself," p. 11.

105. Duchamp, quoted in "The Nude-Descending-a-Staircase Man Surveys Us," *New York Tribune*, Sept. 12, 1915, sec. 4, p. 2.

106. Matisse, "Translator's Note," *MDN*, n.p.

107. *GB*, in *SS*, pp. 56–57.

108. Ibid., p. 60; *MDN*, note 92.

109. *MDN*, note 85; *GB*, p. 57. Matisse translates Duchamp's term *élan* as "momentum," although Duchamp's usage here is not so specifically technical.

110. *GB*, in *SS*, p. 50. See chap. 10, n. 127 and the related text.

111. Ibid., p. 61.

112. See *GB*, in *SS*, pp. 57, 61; see also *MDN*, note 85.

113. On the issue of elasticity and molecular forces in solids, see Millikan and Gibbs, *Practical Physics*, chap. 6.

114. *GB*, in *SS*, p. 56. See also the note on p. 60 (Schwarz, ed., *Notes and Projects*, note 133), where the term friction appears alone—the phrase "glissement (frottement récupéré)" having been crossed out and replaced simply by the term "frottement" (friction); nonetheless, the implication is that it is the reintegration of the friction that produces the returning force.

115. See *GB*, in *SS*, p. 60; for "instantaneous pulling" and another reference to "falling . . . through the trap door," see *MDN*, note 97.

116. See *MDN*, notes 95, 81. Duchamp's reference in his *Green Box* (fig. 156C herein) to "the compressor rod opened for the passage of the bottles" introduces the theme of compression that might relate in some way to the "expansion engine" suggested by his "transformer à détente" in notes 81 and 95.

117. *GB*, in *SS*, p. 60; *MDN*, note 92. A comparable bomb-like release of the Weight is suggested in Duchamp's reference to a "gordian knot (for the fall of the weight)" (note 104 [app. A, no. 22/23]; note 102), which would have added a mythic dimension to the Chariot's activity.

118. See *GB*, in *SS*, pp. 57–58 (fig. 156B herein) for Duchamp's use of "coup," or blow.

119. Ibid., p. 61.

120. See ibid., pp. 61–62, 33.

121. See ibid., pp. 59, 61. For the original form of the *fourchette* note, see Schwarz, ed., *Notes and Projects*, note 128.

122. See the sketch in *GB*, in *SS*, p. 60 (Schwarz, ed., *Notes and Projects*, note 127).

123. *GB, in SS,* p. 60.

124. *MDN,* notes 92, 95; see also *GB, in SS,* p. 62.

125. *GB, in SS,* p. 62; *MDN,* notes 92, 113.

126. *GB, in SS,* p. 61.

127. In addition to the June 1913 issue (fig. 157 herein), see also the back covers of *La Science et la Vie* for Jan., Mar., and June 1914.

128. For the notes beginning "Song," see *GB, in SS,* pp. 61–62; *MDN,* notes 92, 113. For "m't of rotation," see *MDN,* note 87; see also, e.g., Gage, *Elements of Physics,* pp. 45–46 on "moment of a force" and rotation.

129. *GB, in SS,* pp. 61–62; *MDN,* notes 92, 113.

130. Duchamp's references to "tormented gearing" (also "lubricious gearing") occur in his earliest conception of the "bachelor-machine" in his long, initial note on the Bride (*GB, in SS,* p. 39). For the other references, which relate also to the Boxing Match, see *MDN,* notes 63, 141, 153 (p. 3) (app. A, no. 11).

131. For contemporary usages of the term, see *Oxford English Dictionary,* s.v. "Sandow." I am grateful to Jan and Terry Todd of the Department of Kinesiology of the University of Texas at Austin, whose Todd-McKean Collection of materials on the history of physical culture was an invaluable source for information on Sandow and other turn-of-the-century body-builders.

132. *GB, in SS,* p. 57. George Hamilton first identified Duchamp's "Sandow" with the bodybuilder in his translation for the *Typographic Version . . . of Marcel Duchamp's Green Box,* n.p.

133. See, e.g., Eugen Sandow, *Strength, and How to Obtain It,* 3d ed. (London: Gale & Polden, 1905), p. 85, for the description of the Sandow developer as free from friction.

134. Ibid., p. 4. Max Ernst used a photograph of the fig-leaf-clad body of Sandow, or a bodybuilder very like him, in his collage *Health through Sport* of 1920 (Menil Collection, Houston), which seems to mock both an ancient artistic ideal and its modern counterpart in the practice of physical culture. For this image, see Museum of Modern Art, New York, *Max Ernst: Dada and the Dawn of Surrealism* (Mar. 14–May 2, 1993), pl. 65 and pp. 94–95.

135. See Musée National d'Art Moderne, Paris, *Francis Picabia* (Grand Palais, Paris, Jan. 23–Mar. 29, 1976), p. 72.

136. For Picabia's *Physical Culture* painting, as well as two works on the theme of wrestling, entitled *Catch as Catch Can,* see Camfield, *Picabia,* figs. 84–86. On male sport in Cubist painting, which Antliff interprets as an antidote to interpretations of Bergsonism as feminine, see *Inventing Bergson,* pp. 94–100.

137. Professeur Desbonnet, *La Force physique: Culture rationnelle—Méthode Attila—Méthode Sandow—Méthode Desbonnet,* 7th ed. (Paris: Berger-Levrault, 1910).

138. Professeur Desbonnet, *Les Rois de la force* (Paris: Librairie Berger-Levrault, 1911).

139. See *MDN,* notes 100, 104 (app. A, nos. 13, 22/23). In his essay "L'Architecture en fer," Duchamp-Villon recounted his memory of the dramatic *pont roulant* traveling back and forth over the Galerie des Machines at the 1889 Exposition Universelle; see Duchamp-Villon, "L'Architecture en fer," p. 23; trans. in Hamilton and Agee, *Duchamp-Villon,* p. 115.

140. See Roussel, *Impressions of Africa,* pp. 10, 26, as well as chap. 4 at n. 155 and following. On the subject of Roussel, another of his remarkable mechanisms, Bedu's loom driven by paddles (*aubes*) dipping into the river's current and equipped with an electromagnet (pp. 89–96), suggests one more model for the Chariot's back-and-forth motion as well as the Water-mill Wheel with its *aubes* (*MDN,* notes 85, 91). For the French version of Roussel's text, see *Impressions d'Afrique,* pp. 88–94.

141. The *buttoir/butoir* wordplay is discussed in the final section of the present chap. For Duchamp's *gouttière,* see chap 10, n. 226 and the related text. Duchamp might have discovered the usage of *gouttière* he adopted at the Musée des Arts et Métiers, where the mechanics displays included the "Gouttière de s'Gravesande," a quarter-circle grooved track which enabled one to study the trajectory of a rolling marble. See *Catalogue du Musée . . . Physique mécanique* (1955), p. 25, for an illustration of this device. See also *Catalogue officiel . . . C.N.A.M.,* vol. 2, p. 26.

142. See *GB, in SS,* p. 60; *MDN,* notes 92, 113. See also Anton Böttcher, *Cranes: Their Construction, Mechanical Equipment and Working,* trans. A Tolhausen (London: Archibald, Constable, 1908), secs. 90, 91.

143. See *MDN,* note 94 (app. A, no. 21), where Duchamp speaks of the "scissors which bear on the little wheel of the slider." On the relationship of the Chariot's "little wheels" and the Scissors, see also *MDN* notes 142, 153 (p. 1) (app. A, no. 11). Note 83 states, "The little wheels are in slate."

144. Böttcher's text *Cranes* begins with sections on "Statics," "Dynamics," and "Elasticity and Strength" (pp. 1–30).

145. For the displays of cranes at the Musée des Arts et Métiers, see *Catalogue officiel . . . C.N.A.M.,* vol. 1, pp. 367–74; see also Monmarché, *Guide bleu,* p. 187. On Leonardo's designs of cranes, see, e.g., Cooper, *Inventions,* pp. 49–51.

146. See *GB, in SS,* p. 56, for the "underground rail" reference, which Duchamp also sketched (fig. 156C herein; *SS,* p. 59). On gravity-driven transporter cranes, see *Encyclopaedia Britannica* (1910), 11th ed., s.v. "cranes" (p. 372).

147. See chap. 9, n. 47 and the related text, for Eiffel's wind-tunnel experiments.

148. Eiffel, *Recherches,* pp. 2, 6.

149. Ibid., p. 3. See *MDN,* notes 101, 153 (p. 2) (app. A, no. 11).

150. Eiffel, *Recherches,* pp. 5–7; for his "coefficients of resistance," see, e.g., ibid., chap. 2, sec. 7, as well as the numerous tables at the back of the book. For Eiffel's method of registering the speed of the falling apparatus, see ibid., pp. 3–4. See *MDN,* note 98, for Duchamp's use of "tampon" for buffer (rather than the "butoir"/buffer suggested by the "buttoir" in the litanies of the Chariot, as discussed in the section that follows).

151. *MDN,* notes 92, 107.

152. Ibid.

153. As noted at n. 102 above, this subject was amply represented at the Musée des Arts et Métiers. On Lucretius and *clinamen*, see chap. 10 at n. 70 and following.

154. Millikan and Gale, *Practical Physics*, p. 116. See also, e.g., sec. 148, entitled "General statement of the law of frictionless machines."

155. Ibid., pp. 156–7. On this subject, see also Arthur Ord-Hume, *Perpetual Motion: The History of an Obsession* (New York: St. Martin's Press, 1977).

156. Poincaré, *Valeur de la science*, p. 184; *Foundations*, p. 305. See chap. 10 herein, as well as nn. 84, 154 and the related text, including Perrin's clarification that friction was not a significant factor at molecular scale.

157. *GB*, in *SS*, p. 56.

158. Ibid., p. 62.

159. See the discussion of Kelvin's idea of a molecular "massless spring-buffer" in the final section of the present chapter.

160. See chap. 10, n. 82 and the related text.

161. Poincaré, *Science et l'hypothèse*, pp. 120, 126; *Foundations*, pp. 98, 101.

162. For the delayed reaction to Einstein's theories, see the introduction, n. 19; and Stanley Goldberg, *Understanding Relativity: Origin and Impact of a Scientific Revolution* (Boston: Birkhäuser, 1984), chap. 7 ("As If It Never Happened: The French Response"). Poincaré's final discussion of Lorentz occurs in *Dernières Pensées* (Paris: Ernest Flammarion, 1913), chap. 2. On Lorentz's theories, see again McCormmach, "Lorentz and the Electromagnetic View of Nature."

163. For the discussion that follows, see Poincaré, *Valeur de la science*, pp. 194–98; *Foundations*, pp. 310–12. See also McCormmach, "Lorentz."

164. See Goldberg, *Understanding Relativity*, pp. 131–49, 151–59.

165. For Poincaré's discussion of "Newton's Principle" in relation to "electrical phenomena," including his example of a wireless telegraphy oscillator, whose "action" may not have a "reaction," see *Valeur de la science*, pp. 190–98; *Foundations*, pp. 308–12.

166. Le Bon, *L'Evolution de la matière*, p. 9.

167. For these terms, as well as the identification with the Bottle bottoms, see *GB*, in *SS*, pp. 56–57, 61–62; *MDN*, note 85. The term "neighboring metals" appears in the inscription on Duchamp's *Glider* (fig. 151). Duchamp wrote to Marcel Jean in a letter of Mar. 15, 1952: "I don't know what these metals are but I know that they are neighbors" (*Marcel Duchamp: Letters to Marcel Jean*, ed. Marcel Jean [Munich: Verlag Silke Schreiber, 1987], p. 74).

168. Millikan and Gale, *Practical Physics*, p. 4. See also Hallock and Wade, *Evolution of Weights and Measures*, pp. 73–75.

169. *GB*, in *SS*, pp. 61–62.

170. Ibid., p. 62.

171. See n. 167 above.

172. See Jollivet Castellot, *La Synthèse*, p. 8, n. 1. For Ulf Linde's discussion, see Linde, "L'Esotérique," in *OeuvreMD*

(Paris), vol. 3, p. 68. On the subject of Duchamp and alchemy, see the discussions in chap. 2 and app. B.

173. Duchamp, as quoted in Schwarz, *Complete Works*, p. 136. Duchamp specifically described the "yellow green" color of the metallic rods of the Chariot as "like the queen in the King and Queen..." (pl. 2). See *GB*, in *SS*, p. 57, and *MDN*, note 89; see also note 93, where he lists the formula for the "Slider Colors/Wheel."

174. For "Regime of Coincidence," see *GB*, in *SS*, p. 33. For "ascensional magnetization," see *MDN*, notes 140, 153 (p. 3) (app. A, no. 11).

175. See chap. 4, n. 195 and the related text.

176. *MDN*, notes 144 (app. A, no. 14/15), 152 (p. 4).

177. For Duchamp's term "anti?gravity," see *MDN*, note 140. The sources for the other principles named here are given below.

178. See *MDN*, note 152 (p. 2), as well as chap. 8 at n. 150 and following.

179. For Duchamp's notes referring to the Juggler/Handler, see nn. 100–102, 104 above. Duchamp uses the full designation including "center/s of gravity" in *GB*, in *SS*, pp. 30, 66; *MDN*, notes 55, 68, 77 (app. A, no. 3), 91, 149, 150 (app. A, no. 18), 151, 152.

180. *MDN*, note 152 (p. 2).

181. See n. 104 above.

182. See the discussion of fairs and popular culture at the beginning of chap. 7.

183. See the discussion following Suquet's "Possible" article in *Definitively Unfinished Duchamp*, ed. de Duve, p. 118.

184. See Fogg Art Museum, *Jacques Villon*, pp. 74–75. Although this catalogue uses the title *L'Acrobate* for the 1913 painting, it was exhibited under the title *L'Equilibriste* at the Salon d'Automne. See Gordon, *Modern Art Exhibitions*, vol. 1, p. 766.

185. See chap. 7, n. 71 and the related text.

186. *MDN*, notes 152 (p. 1), 150 (app. A, no. 18). Duchamp uses the spelling "paralllpidède" in note 152.

187. For this and the discussion that follows, see, e.g., Millikan and Gale, *Practical Physics*, pp. 68–71. The very notion of "center of gravity" was also challenged by the recent developments in physics that questioned the constancy of mass, for, by implication, the object's center of gravity would no longer remain constant either. See Poincaré, *Valeur de la science*, p. 197; *Foundations*, p. 312.

188. Duchamp speculated on a Juggler with three or four feet (figs. 110, 112; see also the drawing in *MDN*, note 149). As noted in his "General notes. for a hilarious picture" (*GB*, in *SS*, p. 30; *MDN*, notes 68, 77 [app. A, no. 2]), the key issue was having more than two feet.

189. *MDN*, note 152 (p. 2).

190. *GB*, in *SS*, p. 38.

191. *MDN* notes 152 (p. 1), 150 (app. A, no. 18).

192. *MDN*, note 163 (app. A, no. 12); see the discussion of the Desire Dynamo above.

193. All the quotations in the following paragraph come from *MDN*, note 152 (p. 3). Duchamp also refers to the "prin-

ciple of subsidized symmetries" in two versions of the "General notes" note (*GB*, in *SS*, p. 30; *MDN*, note 77 [app. A, no. 2]), as well as *MDN*, note 74. He also used the term "subsidized symmetry" to refer to an aspect of the formal design of the *Large Glass*, an alternate usage discussed in chap. 12.

194. See chap. 10, n. 67 and the related text. Symmetrical knowledge was an issue associated with Buridan's Ass and the notion of indifference, as discussed in chap. 5, n. 84 and the related text.

195. See L. Poincaré, *New Physics*, pp. 54–55.

196. See ibid., p. 54. For Duchamp's "Possible," see chap. 13 at nn. 151, 152, and chap. 14 at n. 150 and following.

197. For the exhibition and the texts accompanying it, see Galerie Maeght, Paris, *Le Surréalisme en 1947: Exposition Internationale du Surréalisme présentée par André Breton et Marcel Duchamp* (Paris: Editions Pierre à Feu, 1947), especially pp. 135–38, Breton's "Projet initial." For an account of the planning and execution of the exhibition, as well as a photograph of Matta and Frederick Kiesler in front of the altar, see Jean, *History of Surrealist Painting*, pp. 341–44. Duchamp's friendship with Matta had already resulted in the text written by Matta and Katherine Dreier, *Duchamp's Glass: La Mariée mise à nu par ses célibataires, même: An Analytical Reflection* (New York: Société Anonyme, 1944). Because photographs of the *Altar* have been rediscovered relatively recently, it has rarely been discussed in the Duchamp literature. Since Kiesler oversaw the general installation of the exhibition in Duchamp's stead, the *Altar* has been treated briefly by Jennifer Gough-Cooper and Jacques Caumont in the essay "Kiesler und 'Die Braut von ihren Junggesellen nackt entblösst, sogar,'" in Museum des 20. Jahrhunderts, Vienna, *Friedrich Kiesler: Architekt, Maler, Bildhauer, 1890–1965*, ed. Dieter Bogner (Apr. 26–June 19, 1988; Vienna: Löcker, 1988), pp. 286–96; trans. in *Duchamp: Passim*, ed. Hill, pp. 99–109. See also Suquet's brief discussion of the *Altar* in his essay "Possible," in *Definitively Unfinished Duchamp*, ed. de Duve, p. 104.

198. See Schwarz, *Complete Works*, cat. no. 328.

199. Such a trick, still used today, would have been a standard part of the demonstrations of "Science amusante" featured in popular scientific sources. See Good [Tom Tit], *La Science amusante*, 1st ser. (1890), 27–28, 31–32, for two such demonstrations using forks. Physics books, too, sometimes included the technique in discussions of center of gravity. See, e.g., Basin, *Leçons de physique*, 1, p. 31.

200. *GB*, in *SS*, p. 30; *MDN*, notes 68, 77 (app. A, no. 2). See chap. 9, n. 78 and the related text.

201. See *MDN*, note 104 (app. A, no. 22/23), quoted below, for both quotations.

202. *GB*, in *SS*, p. 33. For Duchamp's terms in this and the preceding sentence, see ibid., pp. 56–57, 61–62; *MDN*, notes 85, 140, 153 (p. 3) (app. A, no 11).

203. *GB,* in *SS*, p. 39.

204. *MDN*, note 104 (app. A, no. 22/23) and note 99, an earlier, partial form of the note.

205. See, e.g., Gleizes and Metzinger, *Du Cubisme*, p. 34; in *Modern Artists on Art*, ed. Herbert, p. 14.

206. *MDN*, note 180 (dated 1912/1913 on verso).

207. See *A L'INF*, in *SS*, p. 87. For a photograph of *Sculpture for Traveling*, which has not survived, see *Duchamp* (Philadelphia), p. 286.

208. *A L'INF*, in *SS*, p. 87. See also p. 90, for Duchamp's consideration of "*flat equilibrium* corresponding to the equilibrium of gravity[3]."

209. See Henderson, *Fourth Dimension*, chap. 3, and Adcock, *Marcel Duchamp's Notes,* on Duchamp's *A l'infinitif* notes on the abstract principles of four-dimensional geometry, which are not discussed in the present volume. For the term "extra-physical," see Duchamp's note 104, quoted at n. 204 above.

210. *MDN*, note 140.

211. See *A L'INF*, in *SS*, p. 100, for this and the quotations that follow.

212. On the spiral as a sign of the transition to a higher dimension (and Duchamp's subsequent use of it in his optical experiments), see Henderson, *Fourth Dimension*, pp. 158–59, and chap. 14 below. On this note, see also Adcock, *Marcel Duchamp's Notes*, pp. 180–81.

213. *A L'INF, in SS*, pp. 100–101.

214. See chap. 10, n. 76, and the related text.

215. Georges Lechalas, *Etude sur l'espace et le temps* (1896), quoted in Maurice Boucher, *Essai sur l'hyperespace: Le Temps, la matière et l'énergie* (Paris: Félix Alcan, 1903), p. 58. Duchamp's talk of "time deviations" here is something other than the "time dilation" subsequently popularized in the context of relativity theory. See, e.g., Goldberg, *Understanding Relativity*, pp. 119–24.

216. *MDN*, notes 150 (app. A, no. 18), 152 (p. 1).

217. See chap. 5, n. 66 and the related text.

218. See *MDN*, note 135 (app. A, no. 7); *GB*, in *SS*, p. 43. See also Duchamp's 1965 note of explanation added to the *A l'infinitif* note (*SS*, p. 101): "A clock seen in profile so that time disappears, but which accepts the idea of time other than linear time." The note also documents Duchamp's subsequent interest in J. W. Dunne's *An Experiment with Time* (London: A. & C. Black, 1927) and *The Serial Universe* (London: Faber & Faber, 1934) and mentions his creation of the folding cardboard work *Le Pendule en profile* in 1964 (Schwarz, *Complete Works*, cat. no. 373). Dunne's books appeared in new editions in 1952 and 1955, respectively. Duchamp united time and space in the related phrase "The Clock *in profile*. and the *Inspector* of Space" in a note included in the *Green Box* (*SS*, p. 31). Jarry had also speculated on the unconventional view of a watch "in profile" that "looks like a narrow rectangle" rather than the circle observed "at the moment they look at the time" (Jarry, *Gestes et opinions*, chap. 8).

219. For Bergson's scissors metaphor, see, e.g., Bergson, *Creative Evolution*, p. 12. On the evolution of the idea of a "clockwork universe," see Channell, *Vital Machine*, chap. 2.

220. Duchamp uses the phrase "cinematic blossoming" (*épanouissement cinématique*) in his long automobile-oriented note on the Bride in the *Green Box* (see *SS*, pp. 41–42). The word *cinématique* also refers to the branch of mechanics

known as kinematics, a subset of dynamics that studies motion per se without concern for the forces producing it. Adcock has noted both this meaning and the existence of "géométrie cinématique," which may also have affected Duchamp's usage of the term (Adcock, *Marcel Duchamp's Notes*, pp. 147–48).

The adjective *cinématique* also appears in early Cubist criticism, evoking the sense of motion apparent in the new painting. In *L'Intransigeant* of Apr. 21, 1911, Apollinaire wrote, "This art, which in a sense can be called cinematic, aims to show us every facet of plastic reality, without sacrificing the advantages of perspective" (*Apollinaire on Art*, ed. Breunig and Chevalier, p. 151). André Salmon's *La Jeune Peinture française* (Paris: Société des Trente, 1912) added the geometric association of the term in his discussion of Cubism: "Geometrical signs—belonging to a geometry that was both infinitesimal and cinematic—came on the scene as the principal element in a kind of painting whose development, from now on, nothing could stop" (p. 46). Duchamp's use of the word may thus have had additional ironic overtones—as he, actively pursuing geometry, mechanics, and new technologies, tried to "stop" or, at least, "divert" Cubist painting.

221. *MDN*, note 82 (app. A, no. 5). For Bergson's view, see, e.g., *Creative Evolution*, pp. 305–6, where he compares the "mechanism of our ordinary knowledge" to that of the "cinematograph."

222. See Boucher, *Essai sur l'hyperespace*.

223. On the articles by Boucher and Crookes, see Henderson, *Fourth Dimension*, pp. 39–40. On Hinton's theories, see ibid., pp. 25–31, as well as Charles Howard Hinton, *A New Era of Thought* (London: Swan Sonnenschein, 1888); and Hinton, *Fourth Dimension*.

224. See, e.g., *GB*, in *SS*, p. 29, as well as the discussion of freedom from orientation as a sign of the fourth dimension in chap. 6 at nn. 110, 155 and the related text.

225. Boucher, *Essai*, p. 153. Boucher's book included a chapter recounting Hinton's ideas on a "monde surface," making readily accessible in France his standard comparisons between two- and three-dimensional phenomena.

226. Ibid., p. 108.

227. See *MDN*, note 104, quoted at n. 204 above.

228. See, e.g., Boucher, *Essai*, pp. 119, 161. Duchamp would develop the idea of "inframince" or "infrathin" in his later speculations, and writers on the fourth dimension such as Boucher (and Jouffret) were undoubtedly the source for his terminology. See Henderson, *Fourth Dimension*, pp. 162–63, as well as the further discussion of this concept in chap. 14.

229. Boucher, *Essai*, p. 122.

230. See *MDN*, note 104, quoted at n. 204 above.

231. See, e.g., Boucher, *Essai*, pp. 89–93, 155–61.

232. Ibid., p. 159.

233. L. Poincaré, *New Physics*, pp. 17–18. For Lorentz's carrying out of this approach, see again McCormmach, "Lorentz and the Electromagnetic View of Nature."

234. See the section on the Desire Dynamo and the Mobile above, as well as the further discussion of optics in chap. 14.

235. See, e.g., Henri Poincaré, *Electricité et optique*, 2d ed.

rev. (Paris: G. Carré et C. Naud, 1901); and chap. 12 of *Science et l'hypothèse* (*Foundations*, pp. 174–83), which partly reproduces the preface to that book.

236. See, e.g., H. Poincaré's 1904 *Valeur de la science* (p. 197; *Foundations*, p. 312), where he asserts, "From all these results, if they were confirmed, would arise an entirely new mechanics, which would be, above all, characterized by this fact, that no velocity could surpass that of light, any more than temperature can fall below absolute zero."

237. *GB*, in *SS*, p. 44. For the original form of the note, which bears considerable overmarking and crossing out, see Schwarz, ed., *Notes and Projects*, note 10.

238. For Duchamp's references to "A world in yellow: general subtitle," see *MDN*, notes 115 (p. 4), 118 (p. 3), which are notes on the Chocolate Grinder and the chemistry of its color. As noted in chap. 6, he also referred to "A World in Yellow" in the *Box of 1914* (*GB*, in *SS*, p. 23). On the "world in yellow" and Perrin's chemistry, noted below, see chap. 10, n. 175 and the related text.

239. See also *MDN*, note 99, for a shortened version of this statement.

240. *MDN*, note 80.

241. See Sanouillet, *Marchand du sel*, pp. 75–76; *DDS*, p. 82. See *Petit Larousse illustré* (1919), s.v. "buttoir," "butoir."

242. George Hamilton treated the term *buttoir* as *butoir* and translated it as "buffer" in the *Typographic Version. . . of Marcel Duchamp's Green Box,* produced with Richard Hamilton in 1960; that same translation appears in Sanouillet's *Salt Seller* (pp. 56–57) and in Schwarz's *Notes and Projects* (notes 131, 132). Paul Matisse likewise used the translation "buffer," although all of Duchamp's posthumously published notes also use the spelling *buttoir* (*MDN*, notes 85, 86, 103, 123 [app. A, no. 16]).

243. *GB*, in *SS*, pp. 56–57; *MDN*, note 85.

244. See again Kelvin, "Kinetic Theory of Matter," in *Popular Lectures and Addresses*, vol. 1, pp. 255–56, as well as the discussion at n. 65 above.

245. See *MDN*, notes 103, 123 (app. A, no. 16).

246. *GB*, in *SS*, p. 56.

247. See, e.g., Clark C. Spence, *God Speed the Plow: The Coming of Steam Cultivation to Great Britain* (Urbana: University of Illinois Press, 1960), chap. 6.

248. See Henri de Graffigny, "Le Machinisme agricole," *Revue Scientifique*, 4th ser., 19 (Apr. 4, 1903), 431–37.

249. See Claude, *L'Electricité*, pp. 244–45. See also Emile Guarini, "La Crise agricole et l'électricité," *Revue Scientifique*, 4th ser., 20 (July 4, 1903), 15–18; 20 (Aug. 22, 1903), 233–37.

250. De Graffigny, "Machinisme agricole," p. 435.

251. *Petit Larousse illustré* (1912), s.v. "charrue."

252. See Monmarché, *Guide bleu*, p. 187; see also *Catalogue officiel. . .C.N.A.M.*, vol. 6, pp. 199–206, 230–33; and *Catalogue*, vol. 1, p. 382.

253. Rabelais, as quoted in Schwarz, *Complete Works*, p. 456.

254. J. J. Bachofen, quoted in ibid., p. 86, n. 3. See also, e.g., Walter Burkert, *Greek Religion*, trans. John Raffan (Cam-

bridge: Harvard University Press, 1985), pp. 108–9.

255. See, e.g., Donna Kurtz and John Boardman, *Greek Burial Customs* (Ithaca, N.Y.: Cornell University Press, 1971), p. 70.

256. See *GB*, in *SS*, pp. 56, 60.

257. See, e.g., H. J. Rose, *A Handbook of Greek Mythology* (New York: E. P. Dutton, 1959), pp. 91–93. Octavio Paz has also noted in passing the relevance of Demeter and Persephone to Duchamp's Bride. See Paz, "* water writes always," in *Marcel Duchamp* (Phil.), pp. 155–56.

258. See T. W. Allen, W. R. Halliday, and E. E. Sykes, eds., *The Homeric Hymns*, 2d ed. (Oxford: Clarendon Press, 1936), p. 141. For Homer's reference to the "groves of Persephone" in the *Odyssey*, see ll. 509–10 of bk. 10. I am indebted to my late colleague Charles Edwards and to Debra Schafter, his student, for these references and for their invaluable assistance on the issue of Persephone. For Duchamp's Bride (and the Virgin Mary) as *arbre type*, see the discussion at the conclusion of chap. 3.

259. See again *GB*, in *SS,* p. 44, quoted above.

260. See *Littérature*, n.s., no. 5 (Oct. 1, 1922), facing p. 10; the photograph appeared in the context of Breton's article, "Marcel Duchamp," in ibid., pp. 7–10. See also *SS*, p. 52. Rrose Sélavy, the alter-ego Duchamp invented in 1920, is discussed briefly in chap. 14 at n. 69 and following.

261. *GB*, in *SS*, p. 62.

262. See *MDN*, note 104 (app. A, no. 22/23).

263. *MDN*, notes 92, 107.

Chapter 12: Conclusion, I

1. Breton, "Phare de *La Mariée,*" pp. 46, 48; in Lebel, *Marcel Duchamp*, pp. 90, 92.

2. Duchamp's ideas on the relationship of an artwork and its audience are discussed in chap. 14 below.

3. See, e.g., Museum of Modern Art, *The Machine as Seen at the End of the Mechanical Age.*

4. For the phrase "plastically imaged mixture of events" in the subhead, see *MDN*, note 77 (app. A, no. 2); note 69.

5. Steefel, *Position of Duchamp's "Glass,"* p. 301, n. 20.

6. *GB*, in *SS*, p. 30; *MDN*, notes 68, 77 (app. A, no. 2). For the vitrine reference, see, e.g., Schuster, "Marcel Duchamp, vite," p. 143, as well as the discussion in chap. 3.

7. *GB*, in *SS*, p. 74. On this note and Duchamp's subsequent interest in windows and doors, as well as their relevance to *Etant donnés*, see d'Harnoncourt and Hopps, *"Etant Donnés,"* especially pp. 30–33. On Duchamp and display windows, see also Charles F. Stuckey, "Duchamp's Acephalic Symbolism," *Art in America* 65 (Jan.–Feb. 1977), 94–99.

8. See, e.g., the section "Themes of Energy and Chance" in chap. 10, including the discussion at n. 74.

9. See *A L'INF*, in *SS*, p. 74, as well as the discussion at the conclusion of chap. 5.

10. See the section *"Appareils Enregistreurs* and Other Indexical Signs in the *Large Glass"* in chap. 8, as well as the documentation of the Arts et Métiers photography holdings at chap. 6, n. 37.

11. For Righi's wave detector, see chap. 8. at n. 209; for the "zone-plate," see chap. 8 at n. 206.

12. See chap. 6, n. 88 and the related text, as well as the initial discussion of chemistry in chap. 10.

13. On dust figures, see chap. 8, n. 251 and the related text. See chap. 10 at n. 213 and following, for Perrin and dust as well as for dust particles as condensation nuclei and their links to C. T. R. Wilson.

14. *GB*, in *SS*, p. 71.

15. An excerpted list from Monmarché's *Guide bleu* (pp. 187–90) documents the location of the following displays relevant to the Bride: "Rooms 19 and 20. . . . automata. . . .Room 28. *Meteorology*: barometers [etc.]. . . .Room 30. *Physics*: . . . radiography [X-ray], wireless telegraphy. . . .Rooms 38 and 46. *Industrial chemistry*." Automobiles and engines were displayed in the chapel of the priory that had become the museum (*Guide bleu*, pp. 185–86). Incandescent-bulb technology was included under "Physics" in room 27 (see *Catalogue officiel. . . C.N.A.M.*, vol. 2, pp. 172–76). X-ray photographs were exhibited in the context of photography in rooms 42–45 (ibid., vol. 5, p. 91).

16. In addition to Poincaré's *La Physique moderne*, see, e.g., Millikan and Gale, *Practical Physics,* or Basin, *Leçons de physique.*

17. For Roussel's acquaintance with the Musée Arts et Métiers, see Leiris, *Roussel l'ingenu*, pp. 19–20.

18. See, e.g., Eugenio Donato, "The Museum's Furnace: Notes toward a Contextual Reading of *Bouvard and Pécuchet*," in *Textual Strategies: Perspectives in Post-Structuralist Criticism*, ed. Josué V. Harari (Ithaca: Cornell University Press, 1979), pp. 213–38.

19. Gustave Flaubert, *Bouvard and Pécuchet* (1881), trans. T. W. Earp and G. W. Stonier (New York: New Directions, 1954), pp. 25–26.

20. Ibid., chap. 2, and pp. 30–31, 74–76, 222–23. Duchamp would certainly have known this book by Flaubert, a fellow Rouenais, and many other aspects of it would have delighted him, including Bouvard's and Pécuchet's comical difficulties in understanding aesthetic issues such as "beauty" and "taste" (p. 167). On the natural history museum, whose exhibits both Duchamp and Flaubert would have known in Rouen, see Maryline Cantor, "Un Muséum de province au XIXᵉ siècle: Félix-Archimède Pouchet et le Muséum d'histoire naturelle de Rouen," in Musée d'Orsay, *La Science pour tous*, pp. 49–59.

21. Donato, "Museum's Furnace," pp. 233–34.

22. Flaubert, as quoted in Lionel Trilling, introduction to *Bouvard and Pécuchet*, p. vi. Like Duchamp, Flaubert had to survey vast amounts of science in order to "invent" Bouvard's and Pécuchet's farcical activities as well as the "Dictionary of Accepted Ideas," which was to stand as the result of their copying. Flaubert bragged to his friends that he had read fifteen hundred books in order to write the novel (pp. vi, xxviii–xxix).

23. Gustave Flaubert, *Oeuvres complètes de Gustave Flaubert* (Paris: Club de l'Honnête Homme, 1971), 6, p. 607; quoted in Donato, "Museum's Furnace," p. 214.

24. Janet, as quoted in Leiris, "Conception and Reality," p. 12.

25. *MDN*, note 77 (app. A, no. 2); note 69.

26. See Picabia [Pharamousse], "D'une ville unfortuné," *391*, no. 4 (Mar. 25, 1917), p. 8; and *Francis Picabia et "391"*, ed. Michel Sanouillet (Paris: Eric Losfeld, 1966), p. 65.

27. Duchamp, in Hamilton and Hamilton, 1959 BBC interview (*Audio Arts Magazine* cassette).

28. On the theme of *gouttes* as well as Duchamp's *gouttière*, see chap. 10 at nn. 209, 226, as well as the discussion of the *Bottle Rack* in chap. 5.

29. *GB*, in *SS*, p. 30; *MDN*, note 77 (app. A, no. 2), note 68. On the *buttoir/butoir* wordplay, see the end of chap. 11.

30. Duchamp, as quoted in Kuh, *Artist's Voice*, p. 89.

31. See the conclusions of chaps. 3 and 11 as well as the discussion that follows.

32. *A L'INF*, in *SS*, p. 77.

33. Ibid., p. 78.

34. *MDN*, note 164 (app. A, no. 9).

35. Bergson, *Creative Evolution*, p. 329; see also pp. 158–61. Duchamp's exploration of signs needs study as another manifestation of the cultural moment at which Ferdinand de Saussure's linguistic theories emerged in Switzerland. A rich tradition of French scholarship on language would have nourished him, and his interest in the hieroglyph, for example, may well be rooted in Diderot's usage of the term. See James Doolittle, "Hieroglyph and Emblem in Diderot's *Lettre sur les sourds et les muets*," *Diderot Studies* 2 (1952), 148–67. Charles Cramer provides an introduction to aspects of French linguistic theory in this period, including Gourmont's idea of "verbal deformation," in "Duchamp from Syntax to Bride," pp. 12–16.

36. Gleizes and Metzinger, *Du Cubisme*, pp. 40–41; in *Modern Artists on Art*, ed. Herbert, p. 17.

37. *A L'INF*, in *SS*, p. 78.

38. *MDN*, note 77 (app. A, no. 2). Duchamp's reference to "plastic Beauty" occurs only in the earlier version of this discussion in note 69.

39. *A L'INF*, in *SS*, p. 78. On this subject and Duchamp's rethinking of verbal and visual language (particularly color), see also de Duve, *Pictorial Nominalism*, chap. 6 ("Color and Its Name").

40. *MDN*, note 164 (app. A, no. 9).

41. *GB*, in *SS*, p. 71.

42. *A L'INF*, in *SS*, p. 78.

43. Duchamp, in Hamilton and Hamilton, 1959 BBC interview (*Audio Arts Magazine* cassette).

44. See chap. 9, n. 66 and the related text, as well as chap. 5, n. 55 and the related text. Schwarz recounts Duchamp's identification of the typewriter cover with a skirt, noting it was meant to be displayed on a stand and to induce the viewer to look under it (*Complete Works*, cat. no. 240). "You have here another victim of gravity," Duchamp told Schwarz (ibid., p. 463), suggesting that the cover was a Readymade counterpart to the threads of the *Stoppages* as an embodiment of the Bride's fallen Clothing.

45. The *Fountain*, of course, lends itself to both male and

46. *MDN*, notes 92, 107.

47. *A L'INF*, in *SS*, p. 83. Duchamp was here considering different "coloring light sources" as opposed to hue differentiations in a single type of light. His full sentence reads: *There is a certain inopticity, a certain cold consideration, these colorings affecting only imaginary eyes* in this exposure."

48. *A L'INF* in *SS*, pp. 80, 82.

49. Duchamp. "Apropos of Myself," p. 11; *GB*, in *SS*, p. 61.

50. *MDN*, notes 74, 80.

51. *GB*, in *SS*, pp. 27–28.

52. *A L'INF*, in *SS*, pp. 78–79. Duchamp's "landscapist from the height of an aeroplane" was to record statistics such as "number of houses in each village" or "number of Louis XV chairs in each house" (p. 78). See also *MDN*, note 196, where Duchamp muses, "Take films, like from an airplane...(For this use very flat planes like a sheet of glass."

53. See n. 47 above.

54. For the *Pharmacy* reference, see *A L'INF*, *SS*, pp. 76–77, as well as chap. 10, n. 127 and the related text. Without addressing the theme of "frosty gas" (i.e., liquefaction), Linde has made a similar connection of *Pharmacy*'s wintry landscape and stream to the *Large Glass* in "MARiée CELibataire" (p. 56), as has Anne d'Harnoncourt in *Duchamp* (Philadelphia), p. 36. For the Chariot/Glider as Sled, in the end having more to do with mechanics than wintry sledding, see *GB*, in *SS*, pp. 56–57, as well as chap. 10, n. 107 and the related text.

55. See chap. 11, n. 260.

56. Duchamp, as quoted in Roberts, "I Propose to Strain," p. 63.

57. See *Notebooks of Leonardo da Vinci*, ed. MacCurdy, p. 542.

58. *MDN*, note 111.

59. For a recent overview of the problem of representation in Cubism in relation to semiotics, see Christine Poggi, *In Defiance of Painting: Cubism, Futurism, and the Invention of Collage* (New Haven: Yale University Press, 1992), pp. 46–51.

60. Jean Metzinger, "Cubisme et tradition," *Paris-Journal*, Aug. 18, 1911, p. 5.

61. See *MDN*, note 144 (app. A, no. 14/15).

62. *MDN*, note 104 (app. A, no. 22/23).

63. See *GB*, in *SS*, pp. 47–48. For Duchamp's expression of emotions and even desire via geometric or algebraic language, see, e.g., chap. 11 at n. 32.

64. Duchamp also gives the Bride a veil in the form of the *Air Current Pistons* of netting or tulle (figs. 120, 121 herein), but the associations are primarily scientific and technological (pistons, radioactive imprinting [fig. 119], and coded communication [figs. 101, 102, 104]).

65. For Duchamp's phrases, see again *GB*, in *SS*, pp. 39, 42, as well as the discussion in chap. 8 at n. 88.

66. *MDN*, note 144 (app. A, no. 14/15).

67. *GB*, in *SS*, p. 49.

68. *MDN*, note 160.

69. *A L'INF*, in *SS*, p. 84. Duchamp also described (and

drew) the Waterfall as "a sort of waterspout coming from a distance in a half circle over the malic molds" (*GB*, in *SS*, p. 62).

70. Duchamp specifically used the term "subsidized symmetry" in *GB*, in *SS*, p. 49. For his more frequently used mechanical "principle of subsidized symmetries," see chap. 11, n. 193 and the related text.

71. For "plastic integration," see n. 36 above. In his pursuit of "subsidized symmetry," Duchamp again seems to have positioned himself against the Bergsonian theory of Gleizes and Metzinger, who in *Du Cubisme* had dismissed the "simple rhythm" of past fresco painting in favor of the new Cubist oil painting, with its plastically integrated "complex rhythm" and expression of "supposedly inexpressible notions of depth, density, and duration" (*Du Cubisme*, p. 12; in *Modern Artists on Art*, ed. Herbert, p. 5). Mark Antliff discusses Duchamp-Villon's opposition to Gleizes and Metzinger on the subject of decorative rhythms in "Organicism against Itself: Duchamp-Villon and the Contradictions of Modernism," *Word & Image* 12 (July–Sept. 1994), 1–24.

72. Duchamp, letter to James Johnson Sweeney, quoted in Paz, *Duchamp: Appearance Stripped Bare*, p. 35.

73. Duchamp, as quoted in Ashton, "Interview," p. 246.

74. Duchamp, as quoted in Schwarz, *Complete Works*, p. 130.

75. Duchamp, as quoted in Cabanne, *Dialogues*, p. 47. On the philosophical implications of Duchamp's view, see Naumann, "Reconciliation of Opposites," pp. 30–31.

76. On the Molds and Stoppages and the numbers three and nine, see, e.g., *MDN*, note 120.

77. See *GB*, in *SS*, p. 30; *MDN*, note 77 (app. A, no. 2), 68.

78. See chap. 6 at n. 144.

79. Duchamp, as quoted in Cabanne, *Dialogues*, p. 42.

80. *MDN*, notes 96, 104 (app. A, no. 22/23).

81. E.g., Jeanne Serre, who was Duchamp's lover in 1910–11 and who bore him a daughter; see chap. 1 at n. 101.

82. *GB*, in *SS*, p. 28.

83. Longinus, *The Art of Rhetoric*, as quoted in Marina Warner, *Monuments & Maidens: The Allegory of the Female Form* (New York: Atheneum, 1985), p. xx. See also Angus Fletcher, *Allegory: The Theory of a Symbolic Mode* (Ithaca: Cornell University Press, 1964), p. 2. I am grateful to Bruce Clarke, whose work on allegory and science has further stimulated my thinking about the allegorical dimension of the *Large Glass*. See his development of Fletcher's ideas in *Allegories of Writing: The Subject of Metamorphosis* (Albany: State University of New York Press, 1995). See also Linda Dalrymple Henderson, "Etherial Bride and Mechanical Bachelors: Allegory and Science in Marcel Duchamp's 'Large Glass,'" *Configurations* 4 (Winter 1996), 91–120.

84. *GB*, in *SS*, p. 28. Duchamp's later notes relating to "infrathin," which are discussed in chap. 14, refer to "allegory on *forgetting*" (*MDN*, note 1) and "allegory of oblivion" (*MDN*, note 16). He also suggests that "allegory (in general) is an application of the infra-thin" (*MDN*, note 6), emphasizing the threshold that separates the layers of meaning basic to allegory. See also the 1943 assemblage Duchamp entitled *Allé-*

gorie de genre, or *Genre Allegory* (Schwarz, *Complete Works*, cat. no. 319), a double image of George Washington and the continental United States composed of gauze reddened to suggest both stripes and blood. As is the case with many of his ideas, Duchamp's exploration of allegory was prescient: in the late twentieth century, it has once again become a central issue for postmodern art and theory, particularly in light of Walter Benjamin's writings on the subject. See, e.g., Craig Owens, "The Allegorical Impulse: Toward a Theory of Postmodernism," in *Art after Modernism: Rethinking Representation*, ed. Brian Wallis (New York: New Museum of Contemporary Art, 1984), pp. 203–35.

85. *MDN*, note 103.

86. See the initial section of chap. 7 as well as chap. 10 at n. 180.

87. See, e.g., Warner, *Monuments & Maidens*, pp. 85–87; and Mount Holyoke College Art Museum, South Hadley, Mass., *When the Eiffel Tower Was New* (Apr. 9–June 18, 1989), pls. 63–66. (The catalogue's pl. 65 is reproduced here as fig. 184.) On the prevalence of female personifications of science in the seventeeth and eighteenth centuries, see Londa Schiebinger, "Feminine Icons: The Face of Early Modern Science," *Critical Inquiry* 14 (Summer 1988), 661–91.

88. See chap. 2 at n. 112, as well as chap. 3 at n. 39.

89. *MDN*, note 133 (app. A, no. 8).

90. Boccioni et al., "Les Exposants au public," in Galerie Bernheim-Jeune, *Les Peintres futuristes italiens*, p. 3; *Futurist Manifestos*, ed. Apollonio, p. 46.

91. Gleizes and Metzinger, *Du Cubisme*, p. 40; in *Modern Artists on Art*, ed. Herbert, p. 17. For a reproduction of *Abundance*, see Douglas Cooper, *The Cubist Epoch* (London: Phaidon, 1971), pl. 61.

92. See n. 36 above.

93. *GB*, in *SS*, pp. 42–43.

94. Ibid., p. 42. For Duchamp's "hieroglyphic" language, see n. 33 above.

95. Apollinaire, "François Rude, *Poème et drame*, Mar. 1913; trans. in *Apollinaire on Art*, p. 276. On the subject of Apollinaire and allegory (primarily in Cubist painting), see George T. Nozslopy, "Apollinaire, Allegory and the Visual Arts," *Forum for Modern Language Studies* 9 (Jan. 1973), 49–74.

96. *MDN* notes 96, 104 (app. A, no. 22/23). As these notes document, Duchamp believed that by changing "the bachelors" to "her bachelors" in his title, he had "give[n] the picture the aspect of continuity" and thus could not be criticized for "having only described a fight between social dolls" (note 104).

97. See *GB*, in *SS*, p. 44; *A L'INF*, in *SS*, p. 83. On the association of the fourth dimension with a Platonic ideal, which began in the late nineteenth century, see, e.g., Henderson, *Fourth Dimension*, p. 30.

98. See again *GB*, in *SS*, p. 27, as well as the discussion in chap. 3.

99. See *MDN*, notes 143, 153 (p. 4) (app. A, no. 11).

100. *GB*, in *SS*, p. 45; see also *MDN*, notes 143, 153 (p. 4)

for the Bride's "life center" and "emanating ball."

101. Adams, "The Dynamo and the Virgin," in *Education of Henry Adams*, pp. 380, 383. Adams's meditation subsequently turns to the underlying sexual dimension of the Virgin/goddesses' force as well. On Adams's essay and Duchamp's later knowledge of it, see the introduction at n. 10 and following.

102. See the conclusion of chap. 9 for this formulation of the Bride's "dossier."

103. Duchamp, in Hamilton and Hamilton, 1959 BBC interview (*Audio Arts Magazine* cassette). The specific impetus for Duchamp's remark about being "ashamed" is discussed at n. 125 of this chap.

104. On these themes in Apollinaire, as well as his grounding in erotica, see, e.g. Bates, *Guillaume Apollinaire*, pp. 16–17, 27–31, 66–85; see also Fagan-King, "United on the Threshold."

105. See chap. 3, nn. 89, 90, as well as Bates, *Apollinaire*, pp. 78, 93–94. On the biblical Song of Songs (Song of Solomon), see Marina Warner, *Alone of All Her Sex: The Myth and Cult of the Virgin Mary* (1976; New York: Vintage, 1983), chap. 8. Kupka included erotic drawings among his illustrations for an edition of the Song of Songs published in 1905. See Guggenheim Museum, *František Kupka*, p. 309, cat. no. 15.

106. Fagan-King, "United on the Threshold," p. 101; see also Guillaume Apollinaire, "Jean Royère," *La Phalange*, no. 19 (Jan. 1908), 596.

107. See chap. 9. Apollinaire was apparently not privy to Duchamp's visual image of the *arbre* pun in *Virgin (No. 1)* (figs. 51, 52), however, because in his Oct. 3 review of the fall 1912 Salon d'Automne he referred to it as the "very strange drawing of Marcel Duchamp" (*Apollinaire on Art*, ed. Breunig, p. 251).

108. See the text quoted following chap. 2, n. 13.

109. See *Catalogue officiel. . .C.N.A.M.*, vol. 6, p. 115; vol. 8, pp. 384–88. See also Monmarché, *Guide bleu*, pp. 185–87.

110. During the summer of 1912, Duchamp wrote family members that while in Munich he went to the Alte Pinakothek every day and that in the museums he visited on his travels he greatly admired the Cranachs—especially the nudes. Given this acquaintance with Old Master painting, traditional treatments of the Virgin, akin to fig. 168, would certainly have been part of Duchamp's mental catalogue of visual images as he commenced the *Large Glass* project. See Gough-Cooper and Caumont, "Ephemerides," in *Duchamp* (Venice), entries for Aug. 7–25, 1912.

The most extensive treatment of the question of religious themes in *Large Glass* is David Hopkins, "Hermeticism, Catholicism and Gender as Structure." Hopkins sees the *Large Glass*, in part, as a critique of the Neo-Catholicism of Maurice Denis and Emile Bernard. In contrast to this "modernist" Catholic painting, Hopkins suggests that Duchamp would have responded to the ambivalent attitude toward Catholicism expressed by Jarry and Gourmont in their short-lived journal *L'Ymagier* as well as to the "hieratic rigour" of the art they

reproduced—including works by Charles Filiger, one of the Rosicrucian artists around Péladan. See Hopkins, "Hermeticism," pp. 159–65.

111. See chap. 3 at n. 55. Hopkins also comments briefly on the Immaculate Conception–parthenogensis analogy, particularly in relation to Picabia ("Hermeticism," pp. 133–34).

112. *MDN*, notes 99, 104 (app. A, no. 22/23). On the Assumption, see nn. 127, 128 (and the related text) and n. 143 below.

113. On Mary's ubiquity, see Warner, *Alone of All Her Sex*, p. 94.

114. See the final section of chap. 11. In this same period and subsequently, the Persephone theme fascinated Ezra Pound as well. See, e.g., Guy Davenport, "Persephone's Ezra," in *The Geography of the Imagination* (San Francisco: North Point Press, 1981), pp. 141–64.

115. On the association of the Virgin Mary with Persephone/Demeter, see, e.g., Warner, *Alone of All Her Sex*, pp. 275–76, 283–84. Péladan, in his essay "Le Mystère d'Eleusis," in *Origine et esthétique de la tragédie* (Paris: E. Sansot, 1905), links Demeter and the Virgin as two types of "Mater Dolorosa" (p. 9). For the Greek tendency to conflate Demeter and Persephone, see, e.g., Jane Harrison, *Prolegomena to the Study of Greek Religion* (Cambridge: Cambridge University Press, 1903), pp. 272–73.

116. *MDN*, notes 115 (p. 3), 118 (p. 1).

117. See *MDN*, note 103. For the story of Tantalus, see, e.g., Rose, *Handbook of Greek Mythology*, p. 80.

118. *MDN*, note 152 (p. 2). On the *buttoir*/plow, see again the concluding section of chap. 11.

119. Péladan, "Le Mystère d'Eleusis," p. 10.

120. For a sampling of Duchamp's classical education, see the accounts of prizes in Latin, Greek, and German given at the Lycée Corneille during Duchamp's attendance, in Gough-Cooper and Caumont, "Ephemerides," in *Duchamp* (Venice), entries for July 28–31, 1898–1903.

121. For Duchamp's references to a bathtub and a bath heater, see chap. 9, nn. 99, 100. For the tradition of a ritual wedding bath for a Christian bride, see, e.g., Julius Held, *Rubens and His Circle: Studies by Julius Held*, ed. Anne W. Lowenthal, David Rosand, and John Walsh, Jr. (Princeton: Princeton University Press, 1982), p. 46. On Greek bathing rituals of purification, see Burkert, *Greek Religion*, pp. 74–79.

122. *Box of 1914*, in *SS*, p. 25.

123. See Fagan-King, "United on the Threshold," pp. 93–94.

124. *MDN*, note 164 (app. A, no. 9). On the issue of Duchamp and alchemy, see chap. 2 and app. B. Although this particular Flamel text is not mentioned in "L'Alchimie au moyen-âge," the Aug. 1912 article in *La Vie Mystérieuse*, which was quoted in chap. 2 for its linkage of alchemy and radioactive transmutation, Flamel was nonetheless the primary alchemist discussed in that article (see chap. 2, n. 95, and the related text). On Flamel's *Exposition*, see, e.g., Laurinda S. Dixon, "Textual Enigma and Alchemical Iconography in

Nicholas Flamel's *Exposition of the Hieroglyphicall Figures*," *Cauda Pavonis*, n.s., 10 (Spring 1991), 5–9.

125. Duchamp mentioned the usage of "mise à nu" for the stripping of Christ in a conversation with Alfred Barr in Dec. 1945 (see Gough-Cooper and Caumont, "Ephemerides," in *Duchamp* [Venice], entry for Dec. 21, 1945). In his 1959 BBC radio interview with Richard Hamilton and George Heard Hamilton, Duchamp stated that the *Large Glass* "had even a 'naughty' connotation with Christ . . . you know Christ was 'stripped bare' and it was a naughty form of introducing eroticism and religion . . . I'm ashamed of what I'm saying" (*Audio Arts Magazine* cassette).

David Hopkins has discussed other Christ-like aspects of the Bride and has suggested a conflation of the Virgin and Christ related to the theme of androgyny in the Rosicrucian and alchemical traditions. This analysis ("Hermeticism, Catholicism and Gender as Structure," pp. 112–24) is part of Hopkins's larger consideration of Duchamp's response to Catholicism's construction of gender.

126. *MDN*, note 178.

127. Harriet and Sidney Janis, "Marcel Duchamp, Anti-Artist," *View*, 5th ser., no. 1 (Mar. 1945), 24.

128. See, e.g., Maurizio Calvesi, *Duchamp invisible: La costruzione del simbolo* (Rome: Officina Edizione, 1975).

129. Arts Council of Great Britain, unpublished interview with Duchamp by Sir William Coldstream, Richard Hamilton, R. B. Kitaj, Robert Melville, and David Sylvester, London, June 19, 1966.

130. See chap. 2, n. 109 and the related text.

131. T. S. Eliot, "Tradition and the Individual Talent" (1917), in *Selected Essays* (New York: Harcourt, Brace, 1932), p. 4. Duchamp would cite this Eliot essay much later in his 1957 lecture "The Creative Act" (in *SS*, p. 138). Eliot's comment does not signify a Bergsonian sense of fusion or continuity with the past, since by 1917 his own thinking had moved beyond Bergsonism (see Douglas Kellogg Wood, *Men against Time: Nicolas Berdyaev, T. S. Eliot, Aldous Huxley, & C. G. Jung* [Lawrence: University of Kansas Press, 1982], pp. 74–75). Ezra Pound's defense of Vorticism had likewise criticized the Futurists' complete rejection of tradition as shortsighted: "The vorticist has not this curious tic for destroying past glories. . . . We do not desire to evade comparison with the past" (Pound, "Vorticism" (1914), quoted in Herbert N. Schneidau, *Waking Giants: The Presence of the Past in Modernism* [Oxford: Oxford University Press, 1991] p. 202).

The issue of Duchamp and tradition is a complex one and led to considerable discussion at the 1987 Duchamp symposium, published subsequently as *Definitively Unfinished Duchamp*, ed. de Duve (see the essay by Eric Cameron, "Given," pp. 1–29, and the discussion that followed it, pp. 31–39). Although Duchamp was absolutely opposed to repetition by himself or others (see, e.g. Cabanne, *Dialogues*, p. 103), he could nevertheless engage the past creatively just as he could invent rather than copy from his study of science and technology.

132. Duchamp, letter to André Breton, Oct. 4, 1954; pub-

lished as "Une Lettre de Marcel Duchamp," *Medium*, n.s., no. 4 (Jan. 1955), 33.

133. See chap. 4, n. 104.

134. *MDN*, notes 99, 104 (app. A, no. 22/23).

135. Roland Barthes, "The Eiffel Tower," in *The Eiffel Tower and Other Mythologies*, trans. Richard Howard (New York: Hill and Wang, 1979), pp. 4–5.

136. Ibid., p. 6.

137. See chap. 8, n. 8.

138. See chap. 8 at n. 21 and following.

139. For the boxlike variable condenser atop the Eiffel Tower, see chap. 8, n. 98, and the related text.

140. Cendrars, "Tour," in *Oeuvres complètes*, ed. Frank, p. 58; *Selected Writings*, ed. Albert, pp. 144–45.

141. Cendrars, "Prose du Transsibérien et de la petite Jeanne de France," in *Oeuvres complètes*, ed. Frank, p. 32; *Selected Writings*, ed. Albert, pp. 98–99.

142. *MDN*, notes 154, 157. See also *GB*, in *SS*, p. 39.

143. The Eiffel Tower elevators were a much-discussed feat of modern engineering: no elevators designed before that time had traveled to such a height, carried as many passengers, or ascended along an angled trajectory. See Harriss, *Tallest Tower*, pp. 89–99.

When asked by Alfred Barr in December 1945 if he was thinking about an Assumption of the Virgin while working on the *Glass*, Duchamp answered no, a response likely prompted by sensitivity on the subject in the wake of the Janises' *View* article earlier that year. However, even though he was not "thinking about" an Assumption composition while working on the *Glass* (which he undoubtedly was not, since he was inventing an entirely new kind of hieroglyphic language), that theme nonetheless would seem to have been part of the humorous conceptual play in the preparatory stages of note making. For the Barr interview, see again Gough-Cooper and Caumont, "Ephemerides," in *Duchamp* (Venice), entry for Dec. 21, 1945.

144. Duchamp-Villon, "L'Architecture en fer," p. 23; trans. in Agee and Hamilton, *Duchamp-Villon*, p. 116.

145. Duchamp-Villon, "L'Architecture en fer," pp. 23, 28; trans. in Agee and Hamilton, *Duchamp-Villon*, pp. 116, 118.

146. "Artistes contre la tour Eiffel," *Le Temps*, Feb. 14, 1887, p. 2; reprinted in Cate, *Eiffel Tower*, p. 31. In an essay highly critical of the tower, Joris-Karl Huysmans described it as having the "appearance of a scaffolding," a view that may have been one of the roots for the tower's association with a gallows. See Huysmans, "Le Fer," in *Certains* (Paris: Tresse & Stock, 1889); reprinted in Cate, *Eiffel Tower*, p. 34.

147. See Richard Shiff, *Cézanne and the End of Impressionism: A Study of the Theory, Technique, and Critical Evaluation of Modern Art* (Chicago: University of Chicago Press, 1984), pp. 68–69.

148. Ibid., p. 69. As Duchamp told Sweeney, although it was good to have had Matisse's painting "for the beauty it provided," it also "created a new wave of physical painting in this century . . ." ("Eleven Europeans," p. 20). In his opposition to Matisse, Duchamp would have found himself sharing the position of Péladan (also an advocate of allegory—albeit in the

305

Rosicrucian mode), who had roundly attacked Matisse and his Fauve colleagues in a review of the 1906 Salon d'Automne. Péladan's arguments against willful painterly self-expression had included the assertion that "any work which does not make one forget the artist is not a work of art." For Péladan's quote and his review, which prompted Matisse to compose his "Notes of a Painter" in 1908, see Roger Benjamin, *Matisse's "Notes of a Painter": Criticism, Theory, and Context, 1891–1908* (Ann Arbor: UMI Research Press, 1987), p. 155. Hopkins, too, has noted Péladan's advocacy of allegory as another possible stimulus for Duchamp's positioning himself as "ironically 'anachronistic'" as opposed to the Cubist avant-garde ("Hermeticism," p. 165).

149. Duchamp, as quoted in Sweeney, "Eleven Europeans," p. 20.

150. *A L'INF*, in *SS*, p. 83; for the former quotation, see *MDN*, note 136.

151. Duchamp, as quoted in Kuh, *Artist's Voice*, p. 82.

152. See also Shiff's discussion of Duchamp's Readymades as examples of what he terms "making a find" (*Cézanne*, p. 226).

153. Duchamp, "Apropos of Myself," p. 14.

Chapter 13: Conclusion, II

1. *MDN*, 181 (app. A, no. 20).

2. See chap. 6, n. 59 and the related text.

3. See Frederick J. Kiesler, "Les Larves d'Imagie d'Henri Robert Marcel Duchamp," *View*, 5th ser., no. 1 (Mar. 1945; Marcel Duchamp no.), 24–30. In the deluxe edition of *View*, the triptych was not bound into the volume. The original photographs of Duchamp's studio, taken by photographer Percy Rainford with Kiesler in Jan. 1945, are illustrated in Gough-Cooper and Caumont, "Kiesler und 'Die Braut,'" in *Friedrich Kiesler*, ed. Bogner, pp. 286–96 (trans. in *Duchamp: Passim*, ed. Hill, pp. 99–109); and Gough-Cooper and Caumont, "Frederick Kiesler and *The Bride Stripped Bare . . . ,*" in *Frederick Kiesler, 1890–1965*, ed. Yehuda Safran (London: Architectural Association, 1989), pp. 62–71. Gough-Cooper and Caumont also discuss the theme of chess embodied in Kiesler's parallel "genealogies," which begin and end with references to chess. On the photographing of Duchamp's studio and the *View* issue in general, see also Gough-Cooper and Caumont, "Ephemerides," in *Duchamp* (Venice), entries for Jan. 1, 11, and Mar. 15, 1945.

4. André Breton, "Point of View: Testimony 45," *View*, 5th ser., no. 1 (Mar. 1945), 5. Duchamp's cover design and its relation to themes in the *Large Glass* are discussed in chap. 14.

5. See chap. 6, nn. 22, 25 and the related text.

6. For the contrast between "making" and "finding," see chap. 12, n. 148 and the related text. For "exploring the mind," see Duchamp, "Apropos of Myself," p. 1.

7. Levy, as quoted in Schwarz, *Complete Works*, p. 66. Levy's statement continues, "He came damn close, too. But of course the memory boys were tougher, and they had trained for it at an early age. Marcel started too late in life." See again chap. 3 at n. 9

8. See chap. 6, nn. 2, 3 and the related text.

9. See Gough-Cooper and Caumont, "Ephemerides," in *Duchamp* (Venice), entry for Aug. 30, 1935. Duchamp's optical works, for which he sometimes relied on external engineering assistance, are discussed in chap. 14.

10. See Schwarz, ed., *Notes and Projects*, p. 23, for a reproduction of the handwritten note and drawing in the *Green Box*. In contrast to Duchamp's labeling of the drawing in cursive, which spells out "Mariée" and abbreviates "Cel." (fig. 81), a curious variation on the drawing, labeled by another hand simply "MAR" and "CEL," in capital letters, appears in Annette Michelson's article, "'Anemic Cinema': Reflections on an Emblematic Work," *Artforum* 12 (Oct. 1973), 64. That incorrectly relabeled drawing, which has been reproduced or cited in subsequent publications by both Michelson and Rosalind Krauss, has produced a falsely simplistic sense of Duchamp's more subtle wordplay. See, e.g., Krauss, *Originality of the Avant-Garde*, p. 202.

11. *GB*, in *SS*, p. 49.

12. Poincaré, *Science et méthode*, p. 46; *Foundations*, p. 384.

13. Ibid.

14. On Duchamp's success as a student of mathematics as well as Jouffret's comment, see chap. 1, nn. 2, 80. Poincaré had also associated chess playing with invention in his chapter "Intuition and Logic in Mathematics," in *La Valeur de la science* (1904).

15. Duchamp, as quoted in Cabanne, *Dialogues*, p. 19. The first two phrases here occur in Sweeney, "Conversation," in *SS*, p. 136. In 1944 Duchamp organized and served as a referee for five simultaneous blindfold chess matches played by George Koltanowski at Julien Levy's Gallery for the opening of the exhibition "The Imagery of Chess." See Gough-Cooper and Caumont, "Ephemerides," in *Duchamp* (Venice), entry for Dec. 12, 1944.

16. Poincaré, *Science et méthode*, p. 47; *Foundations*, p. 385.

17. Poincaré, *Science et méthode*, p. 57; *Foundations*, p. 391. For "invention is discernment," see *Science*, p. 48; *Foundations*, p. 386. For "sterile combinations," see *Science*, p. 49; *Foundations*, p. 386.

Poincaré used a model highly relevant for Duchamp as he discussed the role of the subconscious mind in the process of mathematical invention. Convinced that mathematical insight often occurred after a period of "unconscious work," Poincaré described the activity of the "subliminal self" in terms of the "atoms of Epicurus" or the "molecules of gas in the kinematic theory," which "flash in every direction through space." A period of conscious work beforehand would have set in motion only those atoms or molecules from which a useful solution might be expected, and in the disorder of the unconscious their "mutual impacts" could produce fruitful new combinations (*Science*, p. 60; *Foundations*, p. 393).

Martin E. Rosenberg has discussed this chapter (and noted Poincaré's passing use of the term *tout fait*, or "ready made," therein) in his essay "Portals in Duchamp and Pynchon," in

Thomas Pynchon: Schizophrenia and Social Control, ed. Eric Cassidy and Dan O'Hara, Proceedings of the International Warwick Conference, *Pynchon Notes* 35 (Fall 1996), 148–75. For Poincaré's usage, see Poincaré, *Science*, p. 61; *Foundations*, p. 394.

18. Duchamp, remarks before the New York State Chess Association, quoted in Schwarz, *Complete Works*, p. 68. Duchamp emphasized the important role of choice in chess: e.g., he countered Cabanne's comment that "there is in chess a gratuitous play of forms" with the assertion that "chess play is not so gratuitous; there is choice" (see Cabanne, *Dialogues*, p. 19). For additional Duchamp comments on nonvisual beauty, see, e.g., *MDN*, note 273; and Schwarz, *Complete Works*, p. 68.

19. Guillaume Apollinaire, "L'Esprit nouveau et les poètes," *Mercure de France* 130 (Dec. 1, 1918), 391. For Apollinaire's praise of the mathematician's imagination, see p. 396. See also Anna Balakian's discussion of this text in "Apollinaire and the Modern Mind," *Yale French Studies* 2 (1949), 79–90. Duchamp, however, would not have shared the strongly nationalist sentiment expressed by Apollinaire.

20. Apollinaire, "L'Esprit nouveau," p. 396.

21. Ibid.

22. Jacques Nayral, preface to Galeries J. Dalmau, Barcelona, *Exposició de Arte cubista* (Apr.–May 1912); reprinted in *Guillaume Apollinaire: Les Peintres Cubistes*, ed. L. C. Breunig and J.-Cl. Chevalier (Paris: Hermann, 1965), p. 181.

23. Apollinaire, *Les Peintres Cubistes*, p. 74; *Cubist Painters*, p. 47.

24. Duchamp, as quoted in Sweeney, "Eleven Europeans," p. 21.

25. *GB*, in *SS*, p. 30; *MDN*, notes 68, 77 (app. A, no. 2).

26. See chap. 10, n. 158. Although Le Bon opposed spiritualism (see chap. 1, n. 60), his ideas were regularly utilized by occultists as well as by members of the artistic avant-garde.

27. On the Puteaux Cubists and Leonardo, see chap. 6, n. 20 and the related text; for the "Joconde du Cubisme," see John Golding, *Cubism: A History and an Analysis* (New York: George Wittenborn, 1959), p. 158.

28. See Henderson, *Fourth Dimension*, pp. 81–83, 93–99. Here Gleizes and Metzinger utilize a geometrically associated rationale for Cubism more characteristic of early Cubist theory; by fall 1912 their Bergsonist orientation led them to distance Cubism from geometry and science.

29. Albert Gleizes, "La Peinture moderne," *391*, no. 5 (June 1917), 6.

30. See n. 25 above.

31. Ibid.

32. *MDN*, note 164 (app. A, no. 9). See chap. 12, n. 34 and the related text.

33. Ibid., note 164 (app. A, no. 9).

34. Ibid., note 82 (app. A, no. 5).

35. *MDN*, note 164 (app. A, no. 9). For the preceding "in the poem" reference, see notes 139, 153 (p. 1) (app. A, no. 11). Hector Obalk pointed out to me Duchamp's specific use of *poëme*, with its epic association.

36. See chap. 6 for a fuller discussion of these notes.

37. *MDN*, note 77 (app. A, no. 2).

38. *GB*, in *SS*, p. 28; see chap. 7 at n. 10 for a fuller version of the note.

39. See chap. 1, n. 54.

40. Among the five Duchamp paintings in the *Third Exhibition of Contemporary French Art* at the Carroll Galleries (Mar. 8–Apr. 3, 1915) were the two versions of the *Chocolate Grinder*. The Bourgeois Gallery exhibition *Modern Art after Cézanne* (Apr. 3–29, 1916) included a now-lost drawing of the Bachelor Apparatus (see fig. 140) under the title "Celibate Utensil," the two *Chocolate Grinder* paintings, "2 Ready Mades," and *Boxing Match*, along with the *King and Queen Surrounded by Swift Nudes*. In addition to three earlier Duchamp paintings, the *Exhibition of Pictures by Jean Crotti, Marcel Duchamp, Albert Gleizes, Jean Metzinger* (Apr. 4–22, 1916) at the Montross Galleries showed *Virgin* (No. 1) and *Pharmacie*. See "Chronological Table of Exhibitions," in *Duchamp* (Venice).

41. See *A L'INF*, in *SS*, p. 78, as well as chap. 12 at n. 37 and following. For the Nayral citation, see n. 22 above.

42. See "Beauty of Indifference" in chap. 5, as well as the discussion of Roussel's stance versus virtuosity in *Impressions d'Afrique* (chap. 4 at n. 166 and following).

43. Duchamp, as quoted in Hahn, "Passport," p. 10.

44. Duchamp, as quoted in Sweeney, "Eleven Europeans," p. 21. For Duchamp's comments on "scientific" values, see the beginning of chap. 6.

45. *GB*, in *SS*, p. 30; *MDN*, notes 77 (app. A, no. 2), 68.

46. *MDN*, note 82 (app. A, no. 5). For Duchamp's rejection of expression in favor of explanation, see *MDN*, note 164 (app. A, no. 9).

47. See, e.g., James J. Bono, "Science, Discourse, and Literature: The Role/Rule of Metaphor in Science," in *Literature and Science: Theory and Practice*, ed. Stuart Peterfreund (Boston: Northeastern University Press, 1990), pp. 59–89.

48. Thomas P. Hughes, *American Genesis*, p. 75. For Perrin, see chap. 10, n. 224 and the related text.

49. See chap. 8, n. 10.

50. See chap. 12, n. 30.

51. *MDN*, notes 71, 77 (app. A, no. 2).

52. See *GB*, in *SS*, p. 36, as well as the discussion in chap. 8. at n. 224.

53. *MDN*, note 147.

54. For the precision drawings in the *Green Box* (in addition to figs. 45, 75, 97), see *GB*, in *SS*, pp. 40, 41, 55, 64. Apart from an original *Green Box*, Richard Hamilton's *Typographic Version. . . of Marcel Duchamp's Green Box* provides the clearest record of the illustrations included in the *Green Box*. The largest of Duchamp's preparatory drawings was the lost drawing for the Bachelor Apparatus visible in fig. 141, which he exhibited in New York in 1916 (see n. 40 above). See also Schwarz, *Complete Works*, cat. no. 217, for the large working drawing for the *Sieves, or Parasols* of summer 1914, now in the Staatsgalerie, Stuttgart (formerly in the Mary Sisler Collection).

55. For the Grinder's leg, see *GB*, in *SS*, p. 69; *MDN*, note 121.

56. See chap. 11, n. 9, for these experiment-oriented notes among Duchamp's posthumously published notes.

57. For the latter, see, e.g., *MDN*, notes 70, 84, 161, 162.

58. Ibid., note 82 (app. A, no. 5).

59. Ibid., note 77 (app. A, no. 2).

60. See, e.g., *Box of 1914*, in *SS*, p. 23; *GB*, in *SS*, pp. 27–28, 51. 70; *A L'INF*, in *SS*, p. 85.

61. See chap. 10, n. 16 and the related text.

62. For "Use of mica," see *GB*, in *SS*, p. 53. For *papier d'aluminium*, see *GB*, in *SS*, p. 68; *MDN*, note 115 (p. 3); and chap. 8 at n. 114.

63. *GB*, in *SS*, p. 76.

64. Ibid., p. 35. On Perrin's experiments, see chap. 10 at n. 171 and following.

65. Ibid., p. 30.

66. Ibid., p. 33; see also *A L'INF*, in *SS*, p. 71, for Duchamp's idea of "*distending* the laws of physics and chemistry."

67. For these usages, see, e.g., the following notes and related text: chap. 10, n. 18; chap. 10, nn. 74, 75; chap. 10, n. 25, and chap. 8, n. 138; chap. 8, nn. 4, 81.

68. For Duchamp's phrase "hilarious picture," in the subhead, see *GB*, in *SS*, p. 30; *MDN*, notes 68, 77 (app. A, no. 2).

69. *GB*, in *SS*, p. 30.

70. Duchamp, as quoted in Kuh, *Artist's Voice*, p. 81.

71. See the text at n. 38 above.

72. Schwarz, ed., *Notes and Projects*, p. 1.

73. Duchamp, in Hamilton and Hamilton, 1959 BBC interview (*Audio Arts Magazine* cassette); for Duchamp's reference to "visceral," see "Apropos of Myself," p. 9 (quoted in chap. 1 at n. 90). On Villiers's Hadaly, see "The Bride as a Modern Automaton" in chap. 7.

74. For all weather-related quotations here, see "Meteorology and the Eiffel Tower" in chap. 9.

75. For documentation of all quotations in this paragraph, see "The Bride as an Incandescent Lightbulb" and "Biology and the Bride" in chap. 9.

76. For the phrase "self blossoming," as well as Duchamp's use of the terms "horizontal" and "vertical," see *MDN*, note 152 (p. 2). All quotations in this and the following paragraph, unless otherwise noted, are taken from *GB*, in *SS*, pp. 39–44, the ten-page, automobile-oriented note and its sequel. That note is discussed in detail in chap. 7.

77. The material on wireless telegraphy summarized here is discussed in detail in chap. 8.

78. *MDN*, notes 143, 153 (p. 4) (app. A, no. 11).

79. *GB*, in *SS*, p. 48, for "isolated cage."

80. Ibid., p. 38, for "alphabetic units."

81. See *MDN*, notes 137, 152 (p. 2) for the Juggler's "ball"; see the following note for the "waves" reference.

82. *GB*, in *SS*, p. 45.

83. *MDN*, note 152 (p. 2).

84. The interaction of the Juggler/Handler of Gravity with the Bride is discussed in the context of wireless telegraphy in chap. 8 and in the context of mechanics in chap. 11.

85. *GB*, in *SS*, p. 38.

86. Ibid., p. 36.

87. Ibid., p. 50.

88. Ibid., pp. 27–28.

89. *MDN,* notes 74, 80.

90. See chap. 7 at n. 1 and following on the general issue of collision.

91. *MDN*, note 104 (app. A, no. 22/23). For Duchamp's "principle of anti?gravity," see the "Playful Mechanics" of the Juggler of Gravity in chap. 11.

92. *GB*, in *SS*, p. 45.

93. Typescript of interview with Sidney, Harriet, and Carroll Janis (1953), sec. 5, p. 10.

94. *MDN*, note 98.

95. *GB*, in *SS*, p. 62.

96. *MDN*, note 133 (app. A, no. 8). For documentation of the issues and quotations in this paragraph, see "The Liquefaction of Gases as Model for the Journey of the Illuminating Gas" in chap. 10.

97. See *A L'INF*, in *SS*, pp. 76–77 (note at bottom and top of following page).

98. *GB*, in *SS*, p. 71.

99. The issues and quotations in this and the following paragraph are documented in "Molecular and Atomic Reality in the *Large Glass*," in chap. 10.

100. For the issues and quotations in this paragraph, see "Duchamp, Thermodynamics, and the Kinetic-Molecular Theory of Gases," in chap. 10. For the "écarts de molécules," specifically, see *DDS*, p. 101; *GB*, in *SS*, p. 71.

101. For sources of the discussion of the Mobile and Desire Dynamo that follows, see "Rediscovering the Mobile," in chap. 11.

102. *GB*, in *SS*, p. 65. Duchamp, however, never clarified how the Nine Shots would be produced once the Splash was transformed into a light-borne mirror reflection instead of a ballistic Splash/Shot.

103. For the discussion of the Chariot/Glider here, as well as its relation to the themes of plowing, Sandow, and Eiffel's experiments, see "Playful Mechanics," in chap. 11.

104. Duchamp, as quoted in Cabanne, *Dialogues*, p. 65.

105. Duchamp, as quoted in Tomkins, *Bride and the Bachelors*, p. 34. Duchamp's later comments on science, including Einstein, are discussed in chap. 14.

106. For the preceding phrases from the Jura-Paris Road notes, see *GB*, pp. 26–27; *MDN,* notes 109, 111. See also the discussion of these notes in chaps. 3 and 7.

107. *MDN*, notes 143, 153 (p. 4) (app. A, no. 11).

108. See *GB*, in *SS*, pp. 39–43, for all phrases from the ten-page automobile-oriented note in this and the following paragraph.

109. See *GB*, in *SS*, p. 45, for these two phrases.

110. See ibid., pp. 44–45; *A L'INF*, in *SS*, p. 83.

111. For all these issues, see "Space in the *Large Glass*," in chap. 6.

112. See chap. 6, nn. 145, 149 and the related text.

113. See chap. 12, n. 37 and the related text.

114. Nayral, "Preface," p. 178.

115. Gleizes and Metzinger, *Du Cubisme*, p. 28; *Cubism*, p. 12.

116. *MDN*, notes 77 (app. A, no. 2), 69.

117. *Box of 1914*, in *SS*, p. 25.

118. See chap. 11 at n. 229.

119. See, e.g., Keller, *Infancy of Atomic Physics*, pp. 173–74; and Benson, "Facts and Fictions in Scientific Discourse: The Case of the Ether."

120. See the discussion at nn. 99, 100 above.

121. *GB*, in *SS*, pp. 56–57.

122. See chap. 3, n. 46.

123. Lucia Beier has attempted to construct Duchamp as a committed Bergsonian in a problematic article, "The Time Machine: A Bergsonian Approach to 'The Large Glass,'" *Gazette des Beaux-Arts*, 6th ser., 88 (Nov. 1976), 194–200. Although Beier rightly detects a contrast between the instinct and intuition of the Bride and the intellectual, anti-Bergsonian qualities of the Bachelors (p. 197), she romanticizes Duchamp into an artist devoted to the experience of duration and the "momentary fusion of Intuition and Intellect" (195, 199).

124. Bergson, *Time and Free Will*, p. 132. On Bergson and language, see also Antliff, *Inventing Bergson*, pp. 49–50.

125. See *MDN*, notes 152 (p. 1), 150 (app. A, no. 18), as well as chap. 11 at n. 216.

126. Bergson, *Creative Evolution*, p. 177.

127. See chap. 11 at n. 221.

128. *GB*, in *SS*, pp. 26–28. For Bergson's comments on "instantaneous photography," by which he meant the chronophotograph that "isolates any moment," see, e.g., *Creative Evolution*, p. 332; see also chap. 1, n. 37.

129. See chap. 5 at n. 64 and chap. 3 at n. 48.

130. Duchamp, as quoted in Hahn, "Passport," p. 10.

131. *GB*, in *SS*, p. 32. Adcock discusses this temporal aspect of the Readymades and relates it to photography in "Marcel Duchamp's 'Instantanés.'" Adcock also notes Duchamp's use of the term *delai* in this note about looking for Readymades "with all kinds of delays," noting the contrast to his use of "Rétard en verre" for the *Large Glass*, which, though translated as "delay," implies a slowing rather than a temporal delay. See chap. 8 at n. 266.

132. *GB*, in *SS*, p. 32.

133. See chap. 12, n. 54 and the related text.

134. See Linde, "MARiée," pp. 48, 62, 64. Linde also suggests that Duchamp's *gouttière* may be a play on "goût d'hier" (yesterday's taste; p. 48).

135. Linde's discussion ("MARiée, pp. 66–68) focuses on four Duchamp works of the 1940s (Lebel, *Marcel Duchamp*, pls. 112–115) but is clearly applicable to other pages of the book's layout as well.

136. Walter Hopps, as quoted in Camfield, *Duchamp: Fountain*, p. 109.

137. *GB*, in *SS*, p. 33.

138. See chap. 14 at n. 96.

139. See chap. 9, n. 28.

140. See Schwarz, *Complete Works*, cat. no. 372.

141. For this text, see *SS*, p. 179; for the Bride's "ventila-tion" property, see, e.g., *GB*, in *SS*, p. 45.

142. See Schwarz, *Complete Works*, cat. no. 237. For new information on the alphanumeric word games of Duchamp and Walter Arensberg, which generated certain of the curious inscriptions used by Duchamp for Readymades in this period, such as "in advance of the broken arm," "3 ou 4 gouttes de hauteur . . . ," and "pulled at 4 pins," see Molly Nesbit and Naomi Sawelson-Gorse, "Concept of Nothing: New Notes by Marcel Duchamp and Walter Arensberg," in *The Duchamp Effect*, ed. Martha Buskirk and Mignon Nixon (Cambridge: MIT Press, 1996), pp. 131–75. The essay also reproduces a 1910 Underwood photograph of a typist at work next to a large typewriter cover that echoes the blocky shape of her skirt (fig. 11).

143. Gleizes and Metzinger, *Du Cubisme*, pp. 38–39; in *Modern Artists on Art*, ed. Herbert, p. 16. Thierry de Duve suggests the "goût d'hauteur" wordplay in "Echoes of the Readymade: Critique of Pure Modernism," *October* 70 (Fall 1994), 73.

144. See *GB*, in *SS*, p. 71.

145. See Lebel, *Marcel Duchamp*, pls. 77–79. For the inscription on *With Hidden Noise* and Duchamp's collaboration on the work with Arensberg circle regular Sophie Treadwell, see Nesbit and Sawelson-Gorse, "Concept of Nothing," in *The Duchamp Effect*, ed. Buskirk and Nixon, pp. 163–67.

Among the newly discovered Arensberg notes discussed by Nesbit and Sawelson-Gorse is a five-page note documenting Duchamp's continued disdain for taste. Recollecting a conversation with Duchamp critiquing the poetry of Apollinaire, Max Jacob, and Gertrude Stein, Arensberg writes: "Marcel dislikes the element of *taste*—gout [*sic*]—in the writings of all these folks—also in work of Picasso. They *weigh* the words— + choose accordingly—weigh for sound, also for sense—to get a sort of balance" (p. 156). Against this backdrop, Duchamp's continued play with the concept of weight takes on additional resonance. "Look for a Readymade which weighs a weight chosen in advance . . . ," he mused in an unpublished note (*MDN*, note 172).

146. *MDN* notes 99, 104 (app. A, no. 22/23). For a photograph of *Sculpture for Traveling*, see Schwarz, *Complete Works*, pl. 114.

147. See chap. 8, n. 211 and the related text.

148. See Schwarz, *Complete Works*, cat. no. 261. On *L.H.O.O.Q.,* see also chap. 6, n. 17.

149. See chap. 12, nn. 34, 40 and the related text for Duchamp's use of "hieroglyphic." Stephen Petersen, a graduate student at the University of Texas, stimulated my thinking about the Readymades as hieroglyphs.

150. Duchamp, as quoted in Cabanne, *Dialogues*, p. 18.

151. Duchamp, "Possible," in *SS*, p. 73. This note was originally published as *Possible* (Alès: PAB, 1958).

152. *MDN*, note 82 (app. A, no. 5).

153. On Stirner, a figure who merits serious study in relation to Duchamp, see chap. 5, n. 45.

154. Duchamp, as quoted in Sweeney, "Conversation," in *SS*, p. 134. On the musical score as model, see chap. 5 at n. 74.

155. Duchamp, as quoted in Cabanne, *Dialogues*, p. 74.

156. d'Harnoncourt, introduction to *Duchamp* (Philadelphia), p. 39.

157. Calvin Tomkins shared this information in conversation in Jan. 1994.

158. Guillaume Apollinaire, "Le Roi-lune," in *Le Poète assassiné* (1916; Paris: Gallimard, 1947), pp. 136–37. Apollinaire's mythical Moon King is the lost King Ludwig II of Bavaria.

159. Apollinaire, "Roi-lune," p. 126. For Jarry's time machine, see chap. 4 at n. 80. In contrast to Jarry's isolation-from-time machine, Apollinaire's machine featured large cylinders on which historical events were inscribed.

160. See chap. 8, n. 26.

161. Apollinaire, "Roi-lune," p. 132.

162. On Larionov, see Henderson, "X Rays," n. 122.

163. Duchamp used the term "Dada spirit" in a number of interviews, including his 1959 BBC conversation with Richard Hamilton and George Heard Hamilton. There he described the Dada spirit as "the nonconformist spirit which has existed in every century, every period since man was man" (*Audio Arts Magazine* cassette). See also, e.g., Cabanne, *Dialogues*, p. 56, where Cabanne uses the term in a somewhat different sense.

The question of Duchamp and Dada is a complex one that requires a careful reexamination of the way the history of Dada was constructed during the 1950s and 1960s. Duchamp did his best to resist his interviewers' insistence upon linking his works (the Readymades, in particular) to European Dada, exclaiming to the Janises in the early 1950s, "Why should I be called dada ten years later . . . [for] things I have done ten years before?" (typescript of 1953 interview with the Janises, sec. 3, p. 13). He continued: "What I meant is you have to decide whether dada is an attitude or a movement—once you have decided—it's up to you[.] I don't care what you decide—it's either one or the other—if it is a dada attitude then you have an attitude that was at the time of the Greeks, time of the Romans or time of Tzara—it's an attitude—but if it's a movement it starts at '16 with Zurich and ends in '23 with Surrealism—and then this doesn't come in at all—pre or no predada because this doesn't matter even if it prepared the idea" (sec. 4, p. 2).

Duchamp clarified the most basic difference between his stance and that of Tzara and the Zurich Dadaists in his 1957 interview with Jean Schuster: "With the standard stoppages I was hoping to give another idea of the unit of length. I could have taken a wooden meter stick and broken it at any point: that would have been dada." See Schuster, "Marcel Duchamp, vite," p. 145. On Duchamp and Paris Dada, see chap. 14, n. 41.

164. For Marinetti's terminology, see chap. 8, n. 21 and the related text. Gillian Beer has addressed the importance of wave theory in England in the late nineteenth century in "Wave Theory and the Rise of Literary Modernism," in *Realism and Representation: Essays on the Problem of Realism in Relation to Science, Literature, and Culture*, ed. George Levine (Madison: University of Wisconsin Press, 1993), pp. 193–213. Her focus, however, is upon scientific writers, such as Maxwell, who were far more aware of the problems inherent in scientific representation and the wave model than were the artists and writers discussed herein, who drew largely on a popular interpretation of science and technology that confidently embraced the model of electromagnetic waves.

165. For an overview of these functions, see chap. 12 at n. 140.

166. Ezra Pound, "The Approach to Paris, I," *New Age* 13 (Sept. 11, 1913), 578. On Pound and wireless telegraphy and radio, see chap. 8, n. 30 and the related text. The focus on emission and reception in early telecommunication also offered what would become a standard model for theorists of linguistics.

167. See chap. 8 at n. 31.

168. The focus on *Thought-Forms* is readily apparent in a segment of the literature on Kandinsky and is rooted in the work of Sixten Ringbom, from his *The Sounding Cosmos: A Study in the Spiritualism of Kandinsky and the Genesis of Abstract Painting* (Åbo: Åbo Akademi, 1970) through his essay "Transcending the Visible: The Generation of the Abstract Pioneers," in Los Angeles County Museum, *The Spiritual in Art*, pp. 131–53. In fact, Ringbom's 1970 text provided an unprecedented overview of the issue of "Thought Transference and Thought Images," briefly addressing various Russian, German, and French figures with occult interests, including Crookes (p. 51), Flammarion (pp. 51–52), Baraduc (pp. 54–55), and, in a separate chapter, Rochas, to whom Kandinsky referred in one of his notebooks (pp. 122–23). However, Ringbom's focus on the visual images in *Thought-Forms* (chap. 2, "The Colourful Worlds of Theosophy") eclipsed his larger contextual discussion.

In contrast to advocates of Besant and Leadbeater's *Thought-Forms*, Rose-Carol Washton Long has argued for the importance to Kandinsky of the more general notion of vibratory communication presented herein. See Long, *Kandinsky: The Development of an Abstract Style* (Oxford: Clarendon Press, 1980), pp. 30–33. Donald Benson has provided the fullest discussion to date of Kandinsky and ether vibrations in "Kandinsky's Dramatic Reconstitution of Pictoral Space," *Annals of Scholarship* 4 (1986), 110–21.

169. See chap. 8 at n. 36 and following for Baraduc, Rochas, and the scientific appendixes published by Rochas, including Edwin Houston's "La Radiation cérébrale."

170. Duchamp-Villon, "Manuscript Notes," in Agee and Hamilton, *Duchamp-Villon*, p. 112.

171. On this subject, see chap. 8 at n. 164 and following.

172. Duchamp, "Wassily Kandinsky," in *Collection of the Société Anonyme* (1950); in *SS*, p. 151.

173. See n. 168 above, as well as Kandinsky's reference to Crookes and Flammarion in a footnote in his 1911 *On the Spiritual in Art* (Wassily Kandinsky, *Concerning the Spiritual in Art*, trans. Francis Golffing, Michael Harrison, and Ferdinand Ostertag [New York: George Wittenborn, 1947], p. 32).

174. See Gough-Cooper and Caumont, "Ephemerides," in *Duchamp* (Venice), entry for Aug. 7, 1912.

175. See, e.g., Wassily Kandinsky, "Stage Composition," in *The "Blaue Reiter" Almanac (Edited by Wassily Kandinsky*

and Franz Marc), ed. Klaus Lankheit (New York: Viking, 1974), pp. 190–91. For the effect of color in general, see Kandinsky, *Concerning the Spiritual*, chap. 5.

176. Katherine S. Dreier and Matta Echaurren, *Duchamp's Glass: An Analytical Reflection* (New York: Société Anonyme, Inc., 1944), n.p. In the end, of course, the differences between Duchamp and Kandinsky outweighed their shared interest. See chap. 14 at n. 30. See also Thierry de Duve, "The Readymade and the Tube of Paint," *Artforum* 24 (May 1986), 110–21; and de Duve, *Pictorial Nominalism*, chap. 6.

177. See, e.g., George Heard Hamilton, *Painting and Sculpture in Europe, 1880–1940* (Baltimore: Penguin, 1967), p. 134. For Kandinsky's reference, see "Reminiscences," in *Kandinsky: Complete Writings on Art*, ed. Kenneth C. Lindsay and Peter Vergo (New York: Da Capo, 1994), p. 364. Ringbom (*Sounding Cosmos*, pp. 31–39) provides the fullest discussion of Kandinsky and the atom, including Johannes Eichner's suggestion that his statement referred to the period 1902–3; yet, as in the case of thought transference, Ringbom's commitment to Theosophy results in his downplaying of the larger, non-Theosophical, occult-popular scientific context (see, e.g., p. 38).

178. See Kandinsky, *On the Spiritual in Art*, in *Kandinsky: Complete Writings*, ed. Lindsay and Vergo, p. 142, where the phrase "der bewegten Elektrizität" is translated correctly. In the 1949 Wittenborn edition of *Concerning the Spiritual in Art*, the phrase is translated as "theory of the electrons, that is, of waves in motion" (p. 32).

179. For the first two texts, see chap. 2, n. 22 and the related text; and chap. 1, n. 43. Ringbom notes the Balfour address and Steiner's use of it (*Sounding Cosmos*, p. 37), but still argues that Kandinsky's theories "have little to do with science at all" (p. 38). Edna J. Garte has argued for the importance of science to Kandinsky in "Kandinsky's Ideas on Change in Modern Physics and Their Implications for His Development," *Gazette des Beaux-Arts*, 6th ser., 110 (Oct. 1987), 137–43.

180. See chap. 8, n. 263 and the related text. See also, e.g., Malevich, *Non-Objective World*, fig. 87, which is titled *Suprematist Composition Conveying the Sensation of a Mystic "Wave" from Outer Space*.

181. See Douglas Kahn, "Introduction: Histories of Sound Once Removed," in *Wireless Imagination*, ed. Kahn and Whitehead, pp. 14–26.

182. For Breton's spark references, see André Breton, "Manifesto of Surrealism" (1924), in Breton, *Manifestos of Surrealism*, trans. Richard Seaver and Helen R. Lane (Ann Arbor: University of Michigan Press, 1972), p. 37. For Breton and "recording instruments," see p. 28; on this topic and its connections to traditional telegraphy as well, see Jennifer Gibson, "Surrealism before Freud: Dynamic Psychiatry's 'Simple Recording Instrument,'" *Art Journal* 46 (Spring 1987), 56–60.

183. Breton, "Phare de *La Mariée*," p. 45; in Lebel, *Marcel Duchamp*, p. 88.

184. See Gabrielle Buffet, "Coeurs volants," *Cahiers d'Art* 9 (1936), 38; Buffet, "Magic Circles," *View*, 5th ser., no. 1 (Mar. 1945), 14–15.

185. Breton, "Phare de *La Mariée*," p. 46; in Lebel, *Marcel Duchamp*, p. 90. See chap. 12 at n. 1 and following.

Chapter 14: Coda

1. See the initial discussion of this work in the context of wireless telegraphy and registering apparatus in chap. 8 at n. 203.

2. Duchamp, as quoted in Cabanne, *Dialogues*, pp. 42–43. For Duchamp's phrase "une peinture à regarder," see Jouffroy, "Conversations," in *Révolution du regard*, p. 114.

3. Duchamp wrote to Jean Crotti that he was leaving New York for "many reasons that you already know: Nothing serious; only a sort of fatigue on the part of the A.—[the Arensbergs]." He continued in this letter, "I have a very vague intention of staying down there a long time; several years very likely—which is to say basically cutting completely with this part of the world"; Duchamp, letter to Crotti, July 18 [1918], in "Affectueusement, Marcel," ed. Naumann, p. 10.

4. Duchamp, as quoted in Cabanne, *Dialogues*, p. 43.

5. See, e.g., Krauss, *Optical Unconscious*, chap. 3.

6. Duchamp, as quoted in Sweeney, "Eleven Europeans," p. 20.

7. Duchamp, as quoted in Siegel, "Some Late Thoughts," p. 21.

8. See chap. 6 at n. 154 and following. In 1934, the work, then owned by Katherine Dreier, was exhibited under the title *Disturbed Balance* in a Museum of Modern Art exhibition. See "Amicalement, Marcel," ed. Naumann, p. 49, n. 44.

9. See, e.g., Clair, "Duchamp and the Classical Perspectivists," p. 44, and his figs. 35, 37.

10. On Duchamp's interest in such charts, see Duchamp, letter to Louise Arensberg, Jan. 7 [1919], in "Marcel Duchamp's Letters to Walter and Louise Arensberg, 1917–1921," ed. Francis M. Naumann, in *Duchamp: Artist of the Century*, ed. Kuenzli and Naumann, p. 211. The patterns of the Oculist Witnesses are characteristic of those used to test for astigmatism (information courtesy of Dr. Ramon Burstyn).

11. See chap. 8, n. 266 and the related text. Both Leonardo and Kupka would have provided Duchamp an early exposure to the principles of optics and the physics of visible light. See, e.g., chap. 8, n. 61, on Kupka.

12. *A L'INF*, in *SS*, p. 83. See also *MDN*, note 129, on the way lenses at the tips of the Scissors might have functioned.

13. See chap. 1, n. 13 and the related text; and chap. 8, nn. 1, 3 and the related text.

14. Thomas Preston, *The Theory of Light* (London: Macmillan, 1890), p. 23; on Young, see his chap. 2, sec. 3. The Musée des Arts et Métiers included numerous displays of the principles of optics, including interference and the work of Young and his important French counterpart, Augustin Fresnel, in this area. See *Catalogue officiel...C.N.A.M.*, vol. 2, pp. 80–117.

The principle of interference had already played a crucial role in the famous Michelson-Morley experiment of 1887, which attempted, unsuccessfully, to measure the motion of the

earth through the ether using an interferometer. See Preston, *Theory of Light*, pp. 417–18; and, e.g., Harman, *Energy, Force, Matter*, pp. 112–19.

15. *MDN*, note 9.

16. See Lodge, *Signalling across Space*, pp. 38–41. On zone plates in optics, see, e.g., Preston, *Theory of Light*, p. 178.

17. See Schwarz, *Complete Works*, p. 471, where Duchamp tells Schwarz that he never liked the painting "because it is too decorative; summarizing one's works in a painting is not a very attractive form of activity." For a photograph of *Tu m'* in situ, see *Duchamp* (Philadelphia), p. 20.

18. Duchamp, letter to Marcel Jean, in *Duchamp: Letters to Marcel Jean*, ed. Jean, pp. 76–77.

19. On the timing of the fabrication of the rulers, see Bonk, *Box in a Valise*, p. 218.

20. *GB*, in *SS*, p. 33. For the note headed "probably to relate," see "Cast Shadows," in *SS*, p. 72. This note continues, raising the possibility of shadows on "several transparent surfaces" and the transformations of objects that would result on these surfaces. Duchamp also specifies that the results of this experiment were intended "for the upper part of the glass between the horizon and the 9 holes" (p. 72).

21. See *Société Anonyme and the Dreier Bequest at Yale University*, ed. Herbert, Apter, and Kinney, pp. 231–32 and pl. 13. Herbert argues that the "fundamental distinction between the [left and right] sides of the work is a visual disquisition on reality (the instruments of measure) and illusion (the application of those instruments)" (p. 233).

22. *GB*, in *SS*, p. 63.

23. Ulf Linde has turned *Tu m'* in the opposite direction, locating the Juggler/Handler in Duchamp's corkscrew image (see Linde, *Marcel Duchamp*, pp. 160–61). Such a reading, however, ignores all the other signs in the painting that suggest the opposite identification of the two regions.

24. *MDN*, note 104.

25. *A L'INF*, in *SS*, p. 75.

26. Yvonne Chastel and Crotti were officially divorced in Dec. 1917, and she subsequently accompanied Duchamp to Buenos Aires. For her collaboration on *Tu m'*, see Gough-Cooper and Caumont, "Ephemerides," in *Duchamp* (Venice), entry for Apr. 12, 1918.

27. *A L'INF*, in *SS*, p. 77. See also figs. 101, 112, and 91 herein. Man Ray's *Catherine Barometer* of 1920 not only echoes Duchamp's meteorological theme but also exhibits a succession of differently colored sample paint strips and a central rod surrounded by a spiraling coil. For a reproduction of this work, see Naumann, *New York Dada*, p. 90.

28. "Cast Shadows," in *SS*, p. 72. See also *MDN*, note 158, where Duchamp speculates on shadows cast by the *Large Glass*.

29. Buffet, "Magic Circles," p. 15.

30. Cf., e.g., Kandinsky's discussion of the physiological effect of colors, including "perfumed colors," in *Concerning the Spiritual in Art* (1947 Wittenborn ed., chap. 5, p. 45), to Duchamp's meditation on avoiding such "perfumes," in *GB*, in *SS*, p. 70. On the similarities and differences between

Duchamp and Kandinsky, see chap. 13 at n. 172 and following.

31. See *GB*, in *SS*, p. 30; *MDN*, notes 68, 77 (app. A, no. 2).

32. Duchamp used both these terms in discussing the Oculist Witnesses with Cabanne in *Dialogues*, p. 64.

33. For the *Stereopticon Slide* and *Anaglyphic Chimney*, see Schwarz, *Complete Works*, cat. nos. 258, 410, as well as Clair, *Duchamp et la photographie*, pp. 82–86. Schwarz (p. 579) quotes Duchamp's letter of Sept. 22, 1968, recounting his discovery of a more recent edition of H. Vuibert's *Les Anaglyphes géométriques* (Paris: Librairie Vuibert, 1912).

34. *MDN*, note 184.

35. *GB*, in *SS*, p. 65. See chap. 11 at n. 25.

36. See, e.g., Rood, *Modern Chromatics*, chaps. 8, 13; and Thompson, *Light Visible and Invisible*, lec. 2. The Musée des Arts et Métiers also included examples of such apparatuses (see *Catalogue officiel . . . C.N.A.M.*, vol. 2, pp. 107–8.

37. Man Ray took a little-known stereoscopic photograph of the *Rotary Glass Plates* at rest (see Clair, *Duchamp et la photographie*, p. 94). Better known is his dangerous brush with the flying glass plates as a broken drive belt hurled them at his head during the course of work on the project. See Man Ray, *Self Portrait*, p. 62.

38. See, e.g., Edwin Boring, *Sensation and Perception in the History of Experimental Psychology* (New York: Appleton-Century-Crofts, 1942), pp. 588–602; and Jonathan Crary, *Techniques of the Observer: On Vision and Modernity in the Nineteenth Century* (Cambridge: MIT Press, 1990), chaps. 3, 4. See also Hermann von Helmholtz, *Helmholtz's Treatise on Physiological Optics*, ed. James P. C. Southall, 3 vols. (Rochester, N.Y.: Optical Society of America, 1924), vol. 2, pp. 205–64.

39. Major Fred E. Wright, "Wartime Development of the Optical Industry," *Journal of the Optical Society of America* 2–3 (Jan.–Mar. 1919), 2. I am grateful to Stephen Pinson, a former University of Texas graduate student, who brought this publication to my attention.

40. Picabia's *Universal Prostitution*, usually dated 1917, offers another parallel to Duchamp's sexual communication via Hertzian waves in the *Large Glass*: the upright male form, which emits verbal messages ("convier . . . ignorer . . . corps humain"), closely resembles a Hertzian wave-generating apparatus illustrated by Gustave Le Bon in *L'Evolution des forces* (frontispiece and p. 157). Recently, Arnaud Pierre has located two other convincing visual sources for this work and most of Picabia's production between early 1918 and late 1922 in the periodical *La Science et la Vie*, necessitating a redating of *Universal Prostitution* to early 1918. See Arnaud Pierre, "Sources inédites pour l'oeuvre machiniste de Francis Picabia, 1918–1922," *Bulletin de la Société de l'Histoire de l'Art français*, 1991 (Paris: Société de l'Histoire de l'Art français, 1992), pp. 255–81.

41. Between 1919 and 1922, Duchamp was in Paris for only periodic six-month stays (July 1919–January 1920, June 1921–Jan. 1922). Although he participated relatively little in Dadaist activities there, he did create one of its emblems—his

1919 defamation of the Mona Lisa in *L.H.O.O.Q.* (see chap. 6 at n. 17). Unlike Duchamp, the gregarious Picabia was a globe-trotting "networker" from 1916 through 1919: following an eight-month stay in Barcelona in 1916, he returned to New York; beginning in fall 1917, he then traveled to Barcelona, Paris, Zurich, Lausanne, and Paris. (For Picabia's activities and an overview of the various manifestations of Paris Dada, see Camfield, *Picabia*, chaps. 7–11.) Duchamp returned to Paris in Feb. 1923 and remained there, with only periodic visits to New York (1926–27, 1933–34, and 1936); in 1942 he resettled in the United States. For Duchamp's travels, see *Duchamp* (Philadelphia), pp. 17–18.

42. Marcel Duchamp [Rrose Sélavy], preface to *Tableaux, aquarelles et dessins par Francis Picabia appartenant à M. Marcel Duchamp*, Hôtel Drouot, Paris, Mar. 8, 1926; trans. as "80 Picabias," in *SS*, p. 166.

43. For Gourmont and Picabia's gear-oriented works, see chap. 7 at n. 153. Camfield has discussed Picabia's general predilection for human-electrical analogies (*Picabia*, p. 193); for works relying on spirals and circles, besides the *Optophone* series, see, e.g., Camfield's fig. 188 (*The Dancer Jasmine*, 1920) and fig. 214 (*Totalizer*, ca. 1922).

44. See, e.g., Millikan and Gale, *Practical Physics*, p. 252.

45. See, e.g., Kunsthalle Bern, *Tabu-Dada*, pp. 94, 97, 107–8 (works by Crotti), and pp. 126–27 (works by Suzanne Duchamp).

46. See Camfield, *Picabia*, figs. 233–36, as well as figs. 227–31.

47. On this invention by Fournier d'Albe, who was also the biographer of William Crookes, see, e.g., P. F. Mottelay, "Light Made Audible," *Scientific American* 107 (Sept. 21, 1912), 240. Continuous improvements in the optophone kept it in the news through the early 1920s; see, e.g., "The Type-Reading Optophone," *Scientific American* 123 (Nov. 6, 1920), 463.

48. As noted earlier, the painting's basic configuration derives from an unrelated diagram of the deflection patterns of radioactive particles and rays. See chap. 10 at n. 200.

49. See n. 25 above.

50. See n. 40 above on Picabia's active borrowing from the periodical *La Science et la Vie*.

51. Duchamp, nonetheless, praised Picabia for his use of "Ripolin enamel instead of the sacred color in tubes" in his preface, quoted in part at n. 42 above.

52. Duchamp, letter to Jacques Doucet, Oct. 19, 1925, in *SS*, p. 185.

53. Duchamp, as quoted in "Restoring 1,000 Glass Bits in Panels," *Literary Digest* 121 (June 20, 1936), 20–21.

54. Not all of Picabia's machine paintings were executed in a precise style, however. See, e.g., the several "painterly" works of 1916–18 illustrated in Camfield, *Picabia*, figs. 135–37. For details of the construction of the *Rotary Demisphere* and the involvement of an actual engineer and mechanic, see Duchamp's letters to Doucet, reprinted in *SS*, pp. 181–85.

55. Buffet, "Magic Circles," p. 14.

56. Ibid. For Duchamp's notes on virtuality and the fourth

dimension, see chap. 6 at n. 134, as well as *A L'INF*, in *SS*, pp. 98–99.

57. *A L'INF*, in *SS*, p. 78. On Duchamp's "retaliation" against Cubist plasticity, see chap. 12 at n. 37.

58. On subjective color, see, e.g., Rood, *Modern Chromatics*, chap. 8. Rood also discusses the "production of color by interference" (pp. 49–52).

59. Duchamp, as quoted in Roberts, "I Propose to Strain," p. 46. For Duchamp's purchase of a "Moving Picture Camera!" see his letter to Suzanne Duchamp, Oct. 20, 1920, in "Affectueusement, Marcel," ed. Naumann, p. 14.

60. For the disks used in *Anémic Cinéma*, see Schwarz, *Complete Works*, pls. 144–65. On the film itself, see Toby Mussman, "Anémic Cinéma," *Art and Artists* 1 (July 1966), 48–51; and Michelson, "Anemic Cinema." Duchamp's *Rotary Demisphere* also bore a pun engraved on the copper collar surrounding the globe; see Schwarz, *Complete Works*, cat. no. 284.

61. Clair illustrates frames from this film and discusses its making in *Duchamp et la photographie*, pp. 88–89.

62. One *Rotorelief*, illustrated at the right edge of fig. 178A herein, bears a white spiral over the eccentric circles beneath. On the spiral and the fourth dimension, see, e.g., Bragdon, *Primer*, pl. 16, as well as Henderson, *Fourth Dimension*, pp. 115, 200.

63. See Paul C. Vitz and Arnold B. Glimcher, *Modern Art and Modern Science: The Parallel Analysis of Vision* (New York: Praeger, 1984), pp. 196–97. Vitz and Glimcher also treat Duchamp's optical experiments and provide a useful bibliography for "Illusions: Movement Effects" (pp. 307–8).

64. *MDN*, note 170 (pp. 1, 2, 4).

65. Buffet, "Magic Circles," p. 14.

66. See *MDN*, note 10, as well as Cabanne, *Dialogues*, p. 80. Duchamp's contrast was an example of what he termed "infrathin separation," which is discussed below at n. 82.

67. Duchamp later stated that he had heard of the phenomenon from an "optical physicist" during his work on the *Rotoreliefs* and replicated it in *Fluttering Hearts*, with its overlay of two concentric blue hearts on a red heart-shaped background. See Duchamp's letter to Serge Stauffer, May 25, 1967, in *Duchamp: Die Schriften*, ed. Stauffer, p. 278. On this illusion, see Helmholtz, *Physiological Optics*, vol. 3, p. 258; and Vitz and Glimcher, *Modern Art*, pp. 201–2.

68. Krauss, *Optical Unconscious*, pp. 97, 137, 140. From Lebel's first monograph on, the undulations of Duchamp's optical works have been interpreted in sexual terms (see Lebel, *Marcel Duchamp*, pp. 51–52; or Schwarz, *Complete Works*, p. 53). Krauss examines these works against the background of nineteenth-century physiological optics, although her grounding in Freudian theory produces an interpretation focused solely on pleasure and desire. Certain of Duchamp's comments about his optical illusions, however, suggest that "optical pleasure" was not always his primary goal (see below).

69. For this card, see *SS*, p. 105, where Elmer Petersen suggests that Rrose advertises "precision ass and glass work." Explaining his invention of Rrose to Cabanne, Duchamp

claimed that his goal had been to "change my identity" and that he had first considered adopting a Jewish name. See Cabanne, *Dialogues*, pp. 64–65. Although Duchamp originally spelled her name simply "Rose," he added the second "r" in 1921, when he signed Picabia's painting of signatures, *L'Oeil cacodylate*, producing "Rrose Sélavy," a wordplay on *eros, c'est la vie*, or "eros—that's life." For this clarification, see Naumann, *New York Dada*, p. 228, n. 59. Herein the spelling has been standardized to the later "Rrose."

70. There is a strongly physiological orientation in certain of the infrathin notes (grouped as *MDN*, notes 1–46), but only this reference to "infrathin caresses" (*MDN*, note 28) suggests a possible sexual reading.

71. *MDN*, note 195. Another film project, using a group of lines "moving in a sense like worms" was meant to produce the effect of "sea sickness if possible" (*MDN*, note 201). From the early stages of his work on the *Large Glass* Duchamp had compared aspects of geometry or physics to bodily experience, such as his linking of gravity to an "autocognizance . . . in the region of the stomach" (*A L'INF*, in *SS*, p. 87) or his explanation of the "tactile grasp-image" he associated with four-dimensional perspective as "like a pen-knife grasped in one's fist" (*A L'INF*, in *SS*, p. 93).

72. Duchamp, letter to Louise and Walter Arensberg, June 15 [1919], in "Marcel Duchamp's Letters," ed. Naumann, in *Duchamp: Artist of the Century*, ed. Kuenzli and Naumann, pp. 218–19.

73. For an overview of Duchamp's chess career, see Schwarz, *Complete Works*, chap. 6. The chess treatise, dealing with the rare endgame problem of "opposition and sister squares," was entitled *L'Opposition et les cases conjugées sont réconcilées* (Paris: L'Echiquier, 1932).

74. Duchamp, letter to Jacques Doucet, Oct. 26, 1923; quoted in Schwarz, *Complete Works*, p. 59. See also *SS*, p. 181.

75. See the collection of documents in *SS*, pp. 185–88, for this project, in which Duchamp hoped to "force the roulette to become a game of chess" (letter to Jacques Doucet, Jan. 16, 1925, in *SS*, pp. 187–88). For a reading of the *Monte Carlo Bond* project and Rrose Sélavy from the stance of recent critical theory, see David Joselit, "Marcel Duchamp's *Monte Carlo Bond* Machine," *October*, no. 59 (Winter 1992), 9–26.

76. For Duchamp's window projects, see Schwarz, *Complete Works*, cat. nos. 265, 276. For a sampling of Rrose's wordplays, see *SS*, pp. 105–19. The definitive study of Duchamp's (and Rrose's) witticisms is André Gervais, *La Raie alitée d'effets* (Quebec: Editions Hurtubise, 1984). Breton published a group of Rrose's puns, along with his article, "Marcel Duchamp," in the Oct. 1922 issue of *Littérature*. Rrose's production of wordplays was subsequently expanded by the Surrealist poet Robert Desnos, who in the Dec. 1922 issue of *Littérature* published puns he claimed to have received telepathically "in a trance" from Rrose Sélavy in New York. See Robert Desnos, "Rrose Sélavy," *Littérature*, n.s., no. 7 (Dec. 1, 1922), 14–22. In a Dec. 1922 letter to his brother Jacques Villon, Duchamp commented on Desnos's wordplays: "Some of them were truly great but most of it was a little too obvious

and was a lot more like Desnos than me." For this letter, see chap. 8, n. 242.

77. Duchamp used one of these photographs for the relabeling of a Rigaud perfume bottle to create *Belle Haleine, Eau de Voilette*, an Assisted Readymade of 1921. For this photograph and a color reproduction of the work, see Naumann, *New York Dada*, p. 52. On the Man Ray photographs and their relation to contemporary cinema, see Naumann, "Duchamp: A Reconciliation of Opposites," in *Duchamp: Artist of the Century*, ed. Kuenzli and Naumann, pp. 21–23 (where Charlie Chaplin's filmic cross-dressing is suggested as a source); Moira Roth, "Marcel Duchamp in America: A Self-Readymade," *Arts Magazine*, 51 (May 1977), 92–96; and Dawn Ades, "Duchamp's Masquerades," in *The Portrait in Photography*, ed. Graham Clarke (London: Reaktion, 1992), pp. 94–114. On Duchamp and the issue of gender construction, see Amelia Jones, *Postmodernism and the En-gendering of Marcel Duchamp* (Cambridge: Cambridge University Press, 1994), chap. 5.

78. See Naumann, *New York Dada*, p. 55. In his speculations on alternative types of color in the *Large Glass*, Duchamp had talked of "physical dying" and "physical inner dye" (see *GB*, in *SS*, p. 70; *A L'INF*, in *SS*, p. 85).

79. Duchamp, letter to Jacques Doucet, Apr. 4, 1924, in *SS*, p. 183.

80. See Gough-Cooper and Caumont, "Ephemerides," in *Duchamp* (Venice), entries between May 26 and July 14, 1936. On the dating of Duchamp's infrathin notes, see Lebel, *Marcel Duchamp* (1980), p. 217.

81. Duchamp, as quoted in Siegel, "Some Late Thoughts," p. 22.

82. See, e.g., *MDN*, notes 9, 10.

83. Ibid., note 4.

84. See ibid., notes 46, 189. The mirror reflections Duchamp discusses in note 46 had been central to his early thinking on the fourth dimension (see chap. 6 at n. 135). Although Paul Matisse did not group note 189 in the section entitled "Infrathin," probably because the "ANEMIC/CINEMA" drawing it bears has to do with mirror reversals, the note is nonetheless very close to note 23 in the group, "X Rays (?) infra thin/Transparency or cuttingness."

85. See *MDN*, note 18, as well as notes 7, 35. Duchamp also connected his idea of the "Possible" to infrathin: "The possibility of several tubes of color becoming a Seurat is the concrete explanation of the possible as infrathin/The possible implying the becoming—the passage from one to the other takes place in the infra thin" (*MDN*, note 1).

86. Ibid., note 11.

87. Denis de Rougement, "Marcel Duchamp mine de rien," *Preuves* 18 (Feb. 1968), 45.

88. *MDN*, note 6.

89. See ibid., notes 229, 231. First published in the *London Bulletin* in 1939 (*SS*, pp. 192–93), this note appeared, along with the following note on "transformers," in Breton, *Anthologie de l'humour noir*, pp. 282–83. Both notes also occur in Duchamp's list of wordplays published as *MDN*, note 231. Duchamp's idea of "Luggage Physics" ("Physique de Voy-

age," note 229; and "Physique de Bagage," note 231) takes on a somewhat more scientific inflection when considered in relation to the *Boîte-en-Valise* project on which he was then working. As Francis Naumann and Ronny Van de Velde have suggested, Duchamp's *Box in a Valise* bears a striking resemblance to the flat cases sold under the category "Jeux Electriques et Scientifiques" by stores such as the Grands Magasins du Louvre. For an illustrated advertisement of such boxes, including a "Boîte d'électricité" and "Jolies boîtes d'expériences électriques et scientifiques," see Francis M. Naumann, introduction to L. & R. Entwistle, London, *The Portable Museums of Marcel Duchamp: De ou par* MARCEL DUCHAMP *ou* RROSE SÉLAVY (May 22–July 27, 1996), fig. 16. This exhibition was curated by Ronny and Jessy Van de Velde.

90. *MDN*, note 187; see n. 89 above.

91. For the best introduction to this work and its history, see Anne d'Harnoncourt and Walter Hopps, *"Etant Donnés: 1. la chute d'eau, 2. le gaz d'éclairage": Reflections on a New Work by Marcel Duchamp* (Philadelphia: Philadelphia Museum of Art, 1987); originally published in the *Philadelphia Museum of Art Bulletin* in 1969, the 1987 edition contains additional information (p. 11). The interior of the tableau and the wooden doors through which it is viewed are reproduced in color in *Duchamp* (Madrid), pp. 156–59.

92. Kiesler, "Les Larves d'Imagie," p. 24. On the *View* project, see chap. 13, n. 3.

93. *A L'INF*, in *SS*, p. 85.

94. See Peter Lindamood, "I Cover the Cover," *View*, 5th ser., no. 1 (Mar. 1945), 3, for a description of how the cover was produced. Ulf Linde ("MARiée, pp. 66–68) has discussed this cover as a Bachelor component of Duchamp's layout for the page of Lebel's book illustrating pls. 112–15, noted in chap. 13 at n. 135.

95. See, e.g., *Compton's Pictured Encyclopedia and Fact-Index* (Chicago: Compton, 1939), s.v. "Frost," where the photographs of frost are captioned "Four Masterpieces by the Artist, Jack Frost."

96. For more information on this work, see Schwarz, *Complete Works*, cat. no. 274.

97. Confirming this association with the Bachelor's realm, *Why Not Sneeze Rose Sélavy?* is located at the foot of the reproduction of the *Large Glass* in the *Box in a Valise*. See, e.g., Bonk, *Box in a Valise*, p. 13.

98. *A L'INF*, in *SS*, p. 79.

99. See chap. 11, n. 197, and the related text.

100. On *The Green Ray*, see Molderings, *Marcel Duchamp: Parawissenschaft*, chap. 8; and Molderings, "Objects of Modern Skepticism," in *Definitively Unfinished Duchamp*, ed. de Duve, pp. 259–60. Molderings first linked Duchamp's title to Jules Verne's 1882 novel *Le Rayon Vert*, which centered around the optical phenomenon of this name, discussed below. See also Gough-Cooper and Caumont, "Kiesler und 'Die Braut,'" p. 295; trans. in *Duchamp-Passim*, ed. Hill, p. 107.

101. See Marcel Minnaert, *Light and Colour in the Open Air*, trans. H. M. Kremer-Priest (London: G. Bell, 1940; New York: Dover, 1954), pp. 58–63. I am grateful to Craig Adcock for directing me to this volume.

102. For Duchamp's 1938 and 1942 installations, see Schwarz, *Complete Works*, cat. nos. 303–4 (the 1938 "Twelve Hundred Coal Sacks Suspended from the Ceiling over a Stove," possibly evoking the Bachelors of the *Large Glass*, who "live on coal" [*GB*, in *SS*, p. 45]); and cat. nos. 313–14 (the labyrinthine "Sixteen Miles of String" at the 1942 "First Papers of Surrealism" show in New York). In Paris in 1937 Duchamp executed a glass door for Breton's gallery Gradiva which featured the silhouette of two overlapping figures cut out of the middle of the glass panel (Schwarz, *Complete Works*, cat. no. 301). In New York in 1946 he also designed the book cover and jacket for Breton's *Young Cherry Trees Secured against Hares*, in which the head of Breton on the cover is surrounded by the image of a Demeter-like Statue of Liberty on the jacket (cat. no. 327).

103. Breton, as quoted in Jean, *History of Surrealist Painting*, p. 341; on the exhibition in general, see pp. 341–44. Breton's text, a letter to the participants that associated each of the altars with a sign of the Zodiac, was published in the catalogue as "Projet initial"; see Galerie Maeght, *Surréalisme en 1947*, pp. 135–38. The notion of a "Labyrinth," an appropriate mythological theme for the Surrealists, might also echo Duchamp's own "labyrinth of the 3 directions" in the Bachelor Apparatus (*GB*, in *SS*, p. 49).

Martica Sawin's recent *Surrealism in Exile and the Beginning of the New York School* (Cambridge: MIT Press, 1995) provides additional information on the 1947 Paris exhibition as well as on the Surrealist presence in New York in general; see especially chap. 10. On Breton's activities in New York, see also Dickran Tashjian, *A Boatload of Madmen: Surrealism and the American Avant-Garde, 1920–1950* (New York: Thames and Hudson, 1995).

104. See Schwarz, *Complete Works*, cat. no. 303.

105. See chap. 12 at n. 6. For these displays, see Schwarz, *Complete Works*, cat. nos. 324, 325. On this subject, see also Charles F. Stuckey, "Duchamp's Acephalic Symbolism," *Art in America* 65 (Jan.–Feb. 1977), 94–99.

106. For this drawing, see d'Harnoncourt and Hopps, *Etant Donnés* (1987), fig. 4.

107. For the specific Swiss waterfall that was the source of the tableau's landscape, see ibid., pp. 58–59.

108. *GB*, in *SS*, pp. 42–46.

109. For a reproduction of this work, see Schwarz, *Complete Works*, cat. no. 330. The back of the relief is inscribed, "Cette dame appartient à Maria Martins/avec toutes mes affections/Marcel Duchamp 1948–49" and was lent by Martins to the 1966 London exhibition *The Almost Complete Works of Marcel Duchamp*. Duchamp's relationship with her is discussed below.

110. For Duchamp's reference to electrical connections, see *GB*, in *SS*, p. 39, and the discussion in chap. 8.

111. Once again an interesting parallel exists between Duchamp and Picabia, who by the early 1940s was painting graphically erotic nudes (see, e.g., Borràs, *Picabia*, figs. 908–20, 948–56).

112. In addition to d'Harnoncourt and Hopps, *Etant Donnés*, see, e.g., Lyotard, *Duchamp's TRANS/formers*; Dalia Judovitz, "Rendezvous with Marcel Duchamp: *Given*," in *Duchamp: Artist of the Century*, ed. Kuenzli and Naumann, pp. 184–202; and Judovitz, *Unpacking Duchamp*, chap. 5. A text I discovered only after I had written this chapter is also relevant: Mason Klein, "Embodying Sexuality: Marcel Duchamp in the Realm of Surrealism," in *Modern Art and Society: An Anthology of Social and Multicultural Readings*, ed. Maurice Berger (New York: HarperCollins, 1994), pp. 139–57.

113. See Naumann, "Bachelor's Quest," pp. 77–80.

114. Ibid. On this work, see n. 109 above. In Apr. 1946 Duchamp gave Martins a deluxe *Boîte-en-valise* containing his "landscape" of seminal fluid, *Paysage fautif* (see chap. 4, n. 101).

115. For a reproduction of this work, see Schwarz, *Complete Works*, cat. no. 338, as well as the other objects, cat. nos. 331, 332, 335. On the issue of molding, see chap. 8 at n. 247.

116. See Gough-Cooper and Caumont, "Ephemerides," in *Duchamp* (Venice), entry for Oct. 2, 1942; entries for the rest of 1942 through 1948 document the considerable interaction of Duchamp with Kiesler. For reasons not yet entirely clear, Duchamp and Kiesler severed relations in the early 1950s (see entry for Feb. 2, 1953). For the essays by Gough-Cooper and Caumont on Duchamp and Kiesler, see chap. 11, n. 197.

117. On Kiesler's European career, which included membership in the De Stijl movement, see, e.g., Dieter Bogner, "Kiesler and the European Avant-garde," in Whitney Museum of American Art, New York, *Frederick Kiesler*, ed. Lisa Phillips (New York: W. W. Norton, 1989), pp. 46–55; on Kiesler as display designer, see Cynthia Goodman, "The Art of Revolutionary Display Techniques," in ibid., pp. 57–83.

118. For Kiesler's article on the *Large Glass*, see chap. 1, n. 9. On Kiesler's interest in kinetic display techniques and peepholes, see Linda Louise Landis, "Critiquing Absolutism: Marcel Duchamp's *Etant Donnés* and the Psychology of Perception" (Ph.D diss., Yale University, 1991), pp. 116–19.

119. For the former, see, e.g., Clair, "Duchamp and the Classical Perspectivists," pp. 48–49. For Kiesler's "vision machine" and other relevant aspects of his work, see the catalogue to the exhibition at the Centre d'Art et de Culture Georges Pompidou, Paris, *Frederick Kiesler: Artiste-architecte* (July 3–Oct. 21, 1996), which appeared while the present book was in production.

120. *Box of 1914*, in *SS*, p. 23.

121. See Marcel Duchamp, *Manual of Instructions for "Etant Donnés: 1. la chute d'eau, 2. le gaz d'éclairage . . ."* (Philadelphia: Philadelphia Museum of Art, 1987). The images in the manual are now supplemented by the publication of photographs by Denise Brown Hare, taken in Duchamp's New York studio after his death; see Denise Brown Hare, "Photographic Portfolio: Marcel Duchamp's *Etant Donnés* in His New York Studio," *SITES* 19 (1987), pp. 17–31.

122. Lyotard has noted the inversion of the titles of the two works and their contents: "a narrative function for the ascetic work, a logical one for the work of seduction" (*Duchamp's TRANS/formers*, p. 170).

123. All of the information in this paragraph derives from Duchamp's *Manual*, p. 20, with more detailed information on the Bec Auer lamp, for example, on additional pages.

124. Duchamp, *Manual*, pp. 2, 4–5.

125. In the *Large Glass*, where the Illuminating Gas is specified as "inert" and thus a gas like neon in a vacuum tube, the only sign of such gas lamps was a thorium gas mantle's radioactive imprint as a model for the imprinting of the Air Current Pistons. See chap. 8 at nn. 120, 226, and following. Already adopting the more familiar usage of "gas," Duchamp in 1958 created a facsimile of the French building signs advertising EAU & GAZ A TOUS LES ETAGES (Water & Gas on Every Floor), for use on the covers of the limited edition of Lebel's 1959 monograph. See Schwarz, *Complete Works*, cat. no. 347.

126. Duchamp, *Manual*, p. 20. A sheet of glass is interposed between the spotlight and the nude to protect the figure from the heat of the light. For Duchamp's sensitivity to various light sources, see, e.g., "Cast Shadows," in *SS*, p. 72.

127. Paul Matisse, "The Opening Doors of *Etant Donnés*," *SITES* 19 (1987), p. 6.

128. Duchamp, *Manual*, p. 20.

129. See *GB*, in *SS*, p. 39.

130. See, e.g., *MDN*, note 82 (app. A, no. 5).

131. Duchamp, as quoted in Cabanne, *Dialogues*, p. 93. Along with Kandinsky and a number of other artists, Duchamp was a signatory of the 1936 "Manifeste Dimensioniste," which advocated the exploration of new media. See Henderson, *Fourth Dimension*, pp. 342–43.

132. See *A L'INF*, in *SS*, pp. 84–86.

133. See, e.g., John Dee, "A Geographic Landscapism: Duchamp's View of Nature," *Aspects* 4 (Fall 1978), n.p.

134. See chap. 7 at n. 82.

135. Kiesler was clearly interested in the displays at the Museum of Natural History, since he at one time prepared sketches and drawings for an ecology exhibit there. See Goodman, "Art," in Whitney Museum, *Kiesler*, p. 61. Duchamp had known such exhibits since his youth in Rouen; see chap. 12, no. 20.

136. Duchamp, as quoted in Ashton, "Interview," p. 245.

137. *GB*, in *SS*, p. 30; *MDN*, notes 77 (app. A, no. 2), 68.

138. George Hamilton had already translated a selection of notes, published in 1957, as *From the Green Box* (New Haven: Readymade Press, 1957); Richard Hamilton's *Typographic Version of. . .Marcel Duchamp's Green Box*, with George Hamilton's translation, appeared in 1960.

139. Benoit also published four wordplays as *Quatre Inédits de Marcel Duchamp* (Alès: PAB, 1960); several other publication projects by PAB at this time evoked earlier themes in Duchamp's work, including the etching *L'Equilibre* to illustrate Picabia's 1917 poem of this name (Schwarz, *Complete Works*, cat. no. 346) and *Tiré à 4 épingles* (see n. 147 below).

140. Anne d'Harnoncourt remarked in passing that these notes appeared to be lists of "titles" of earlier notes; see her preface to the 1983 edition of *MDN*, p. x.

141. Alexina Duchamp, letter to the author, Dec. 8, 1994.

142. See question 99 attached to Duchamp's letter to Serge

Stauffer, Aug. 6, 1960, in *Duchamp: Die Schriften*, ed. Stauffer, p. 290.

143. See *MDN*, note 255, as well as note 256. André Gervais has speculated that Duchamp may have considered these twelve texts, as they finally evolved, for a never-completed project announced in the catalogue of the 1966 London exhibition: a deluxe publication to be entitled "Rrose Sélavy et autres c'est-la-visme," which was to include ten etchings by Jean Arp and to be published by Louis Brodeur. See Gervais, *Raie alitée*, p. 384.

144. Duchamp's first *Waistcoat*, which Schwarz dates to spring 1957, was a gift to his wife, Alexina (TEENY) Duchamp. Two more vests followed in 1958: a vest for Teeny's son, Paul Matisse, on his marriage to Sarah Barrett (SALLY), and a vest for Benjamin PERET. The last vest, for BETTY, the wife of Judge Julius Isaacs, followed in 1961. On these vests, see Schwarz, *Complete Works*, cat. no. 342.

Another 1961 project is also reflected in note 252 (no. 7): "de Ma Pissotière j'aperçois Pierre de Massot." In January 1961 Duchamp produced a drawing of a urinal inscribed with this wordplay for an auction to benefit de Massot. See Schwarz, *Complete Works*, cat. no. 359.

145. Duchamp, letter to Jean Suquet, Dec. 25, 1949, in Suquet, *Miroir*, p. 246.

146. See *GB*, in *SS*, p. 51 for both of the related notes, as well as *Box of 1914*, in *SS*, p. 24, for the *Apprentice* drawing.

147. As suggested earlier, the role of the Bride as Weather Vane, discussed in these notes and embodied earlier in a lost Readymade of 1916, *Pulled at 4 Pins*, seems to be echoed in Duchamp's 1959 etching *Tiré à 4 épingles*, produced for a collection of four poems by his friend Pierre de Massot, as well as in his 1964 etching of a ventilator, *Pulled at Four Pins*. See chap. 9, n. 28.

148. I am grateful to Paul Matisse for his general recollections of his work with the body of unpublished notes.

149. The *A l'infinitif* section on "Dictionaries and Atlases" served a similar purpose; see *SS*, pp. 77–79.

150. See "Possible," in *SS*, p. 73.

151. *GB*, in *SS*, pp. 27–28.

152. Ibid.

153. Ibid., p. 71; for Poincaré's discussion, see chap. 11 at n. 196.

154. See chap. 5, nn. 28, 33.

155. See chap. 13 at n. 124 and following.

156. Gray, "Great Spectator," pp. 26–27. For Duchamp's sculpture *Bouche-Evier* of 1964, see Schwarz, *Complete Works*, cat. no. 371.

157. See Hare, "Photographic Portfolio," pp. 28–29.

158. On this subject, see app. B. In fact, in June 1959 Duchamp had the zinc printing block for his "Interior Lighting" drawing in Sanouillet's *Marchand du sel* gold-plated as a gift for Mme Sanouillet, producing an artificial transmutation. See Schwarz, *Complete Works*, cat. no. 421.

159. See n. 143 above.

160. See Gervais, *Raie alitée*, p. 269.

161. See chap. 4 at n. 154.

162. On this subject, see Hulten, "Blind Lottery of Reputation," in *Duchamp* (Venice), pp. 13–19. In his 1959 BBC radio interview, Duchamp's remark that "there is nothing to converse about, unless you make an effort to read the notes in the Green Box . . ." (quoted in the introduction at n. 31) was immediately followed by "but who cares? I mean, it is not interesting for the public today, it has no public appeal." For a sampling of Duchamp's comments on his somewhat tenuous relation to the art world as he perceived it, even in the 1960s, see Cabanne, *Dialogues*, pp. 86, 92, 97.

163. Duchamp, as quoted in Gray, "Great Spectator," p. 21; on this issue, see chap. 6 at n. 10.

164. François Le Lionnais, as quoted in Ralph Rumney, "Marcel Duchamp as a Chess Player and One or Two Related Matters" (interview with François Le Lionnais), *Studio International* 189 (Jan.–Feb. 1975), 24. Le Lionnais was associated with the experimental writing group OuLiPo (see chap. 10, n. 76).

165. See, e.g., Charles Ruhla, *The Physics of Chance: From Blaise Pascal to Niels Bohr*, trans. G. Barton (Oxford: Oxford University Press, 1992), chap. 6.

166. See Werner Heisenberg, "The Quantum Theory: A Formula Which Changed the World," *Trans / formation: Arts, Communication, Environment* 1 (1952), 129–34. Typical of the articles on Picasso and Einstein is Paul Laporte's "The Space-Time Concept in the Work of Picasso," *Magazine of Art* 41 (Jan. 1948), 26–32. For additional articles by Laporte and other authors on this subject, as well as a critique of their content, see Henderson, *Fourth Dimension*, p. 401, and app. A of that volume.

167. Duchamp, as quoted in Cabanne, *Dialogues*, p. 26; see also pp. 69–71 and 84, where Duchamp reiterates this theme in discussing the text he wrote on Picasso in 1943 for the Société Anonyme catalogue. There he asserted that "every now and then the world looks for an individual on whom to rely blindly—such worship is comparable to religious appeal and goes beyond reasoning. Thousands today in quest of supernatural esthetic emotion turn to Picasso, who never lets them down" ("From the Catalog *Collection of the Société Anonyme*," in *SS*, p. 157). Duchamp restates this sentiment in Cabanne, *Dialogues*, p. 93.

168. See de Rougement, "Marcel Duchamp mine de rien," p. 43. This article recounts conversations on science that took place during Duchamp's stay with his friend de Rougement at Lake George in early August 1945, including his introduction to Gaston Bachelard's *Le Nouvel Esprit scientifique* of 1934.

169. Duchamp, as quoted in Tomkins, *Bride and Bachelors*, p. 34.

170. Duchamp, letter to Jean Mayoux, Mar. 8, 1956, quoted in Bonk, *Box in a Valise*, p. 252. "It is the SPECTATORS who make the paintings," Duchamp told Jean Schuster in an interview of spring 1957 ("Marcel Duchamp, vite," p. 143), a theme that also dominated his Houston lecture of April 1957, "The Creative Act" (see *SS*, pp. 138–40). In this text Duchamp referred to the artist as a "mediumistic being" dependent on an "esthetic osmosis" taking place between the work of art and

the spectator, producing a "transmutation" or "transubstantiation." Although this point is usually discussed simply in terms of Duchamp's emphasis on the spectator and his coining of the term "art coefficient" to describe the "difference between what the artist intended to realize and did realize," his deliberate use of words such as "medium," "osmosis," and "transmutation" makes clear that the text is a carefully worded construction reflecting a particular moment in his relation to the avant-garde, including Surrealism.

171. Duchamp, as quoted in Cabanne, *Dialogues*, p. 76.

172. Duchamp, as quoted in James Johnson Sweeney, "Marcel Duchamp" (1956), in *Wisdom: Conversations with the Elder Wise Men of Our Day*, ed. James Nelson (New York: W. W. Norton, 1958), p. 94; an edited version of this statement appears in Sweeney, "Conversation," in *SS*, p. 133. By the 1960s Duchamp talked more often of the limited lifetime of paintings (and sculptures): "After forty or fifty years the painting dies, loses its aura, its emanation. . . . And then it is either forgotten or it enters into the purgatory of art history" (Duchamp, as quoted in Tomkins, *Bride and Bachelors*, p. 18).

173. Duchamp, as quoted in Tomkins, *Bride and Bachelors*, p. 18.

174. Duchamp, as quoted in Sweeney, "Conversation," in *SS*, p. 133.

175. Duchamp, as quoted in Tomkins, *Bride and the Bachelors*, p. 18.

Appendix B

1. Jean Clair, "La Fortune critique de Marcel Duchamp: Petite Introduction à une herméneutique du Grand Verre," *Revue de l'Art*, no. 34 (1976), 92–100; and Clair, *OeuvreMD* (Paris), vol. 2, pp. 107–13. The same criticism could generally be made of more recent studies, such as Rory T. Doepel's work on Duchamp and the Cabala. See Doepel, "An Iconographical Analysis of Duchamp's Bride Image in the *Large Glass*," in *Pillars of Smoke and Fire: The Holy Land in History and Thought*, ed. Moshe Sharon (Johannesburg: Southern Book Publishers, 1996), pp. 187–222.

In addition to the individual books or articles by Linde, Schwarz, Calas, and Burnham cited in the bibliography, see the following essays included in exhibition catalogues: Linde, "L'Esotérique," in *OeuvreMD* (Paris), vol. 3, 60–85; Schwarz, "The Alchemist Stripped Bare in the Bachelor, Even," in *Duchamp* (Philadelphia), pp. 81–98; and Schwarz, "La Machine célibataire alchimique," in *Jungessellenmaschinen*, ed. Szeemann, pp. 156–71.

2. See chap. 2, n. 94.

3. See Eugène Canseliet, *Alchimie: Etudes diverses de symbolisme hermétique et de pratique philosophale* (Paris: Jean-Jacques Pauvert, 1964).

4. Linde, "L'Esotérique," in *OeuvreMD* (Paris), vol. 3,

pp. 60–62, where Linde illustrates both plates. See Museum of Modern Art, *The Machine as Seen at the End of the Mechanical Age* (1968), pp. 79–80; and Golding, *Marcel Duchamp*, p. 85. See also Calas, "Large Glass," p. 34.

5. See Canseliet, *Alchimie*, plate opposite p. 72 and pp. 63–64. Alchemy scholar M. E. Warlick has noted in conversation that gender depictions vary considerably in alchemical illustrations and that Canseliet may well have used another version of the Solidonius manuscript than that consulted by Linde in the Bibliothèque de l'Arsenal. In his 1986 book *Marcel Duchamp* (pp. 101–8), Linde returned to the Solidonius/Canseliet question, which remains a "riddle" for him. For the Clair and Linde discussions of the content of the Solidonius manuscript, see Clair, "Fortune critique," p. 100, n. 12; and Linde, "L'Esotérique," p. 62.

6. Clair, "Fortune critique," p. 93. Clearly, C. G. Jung's interest in alchemy played a role in keeping the theme alive for authors such as Schwarz. Clair notes specifically the importance of Jung's 1944 *Psychology and Alchemy* for later Surrealism (p. 42).

7. On alchemy's importance for Breton and Surrealism, as voiced by Carrouges, see "Surréalisme et occultisme," *Les Cahiers d'Hermès*, no. 2 (1947), 194–218; and Carrouges, *André Breton and the Basic Concepts of Surrealism* (1950), trans. Maura Prendergast (University, Ala.: University of Alabama Press, 1974), pp. 48–66. See also Anna Balakian, *André Breton: Magus of Surrealism* (New York: Oxford University Press, 1971).

8. Hulten, "Blind Lottery of Reputation," in *Duchamp* (Venice), p. 19.

9. See Dieter Daniels, *Duchamp und die anderen: Der Modelfall einer künstlerischen Wirkungsgeschichte in der Moderne* (Cologne: DuMont Buchverlag, 1992), p. 241; and Gaston Puel, "Lettre à Marcel Duchamp," *Néon*, no. 5 (1949), 3. Daniels's text (pp. 238–57 and related footnotes) is rich in bibliographical sources on this issue.

10. Duchamp, "The Creative Act," speech given before the American Federation of Arts, Apr. 1957 (in *SS*, pp. 139–40); for Duchamp's statement to Lebel, see chap. 2 at n. 109.

11. See Stauffer, ed., *Duchamp: Die Schriften*, p. 258.

12. See Van Lennep, *Alchimie*, p. 420.

13. See Moira Roth, "Robert Smithson on Duchamp: An Interview," *Artforum* 12 (Oct. 1973), 47.

14. See Canseliet's comments in Valentin, *Douze Clefs*, pp. 40, 116. For Valentin's discussion of stripping, see chap. 2 at n. 102.

15. For Canseliet's text, see *Medium: Communication Surréaliste*, n.s., no. 4 (Jan. 1955), 41–42; for Duchamp's letter to Breton, see chap. 12, n. 131.

16. See *Formes de l'art: L'Art magique*, ed. Breton and Legrand, pp. 78, 116–17; on the Lebel text, see chap. 2 at n. 109.

Outline of Bibliography

I. Writings by and about Marcel Duchamp

 A. Writings

 B. Interviews

 C. Exhibitions

 D. Books and Articles

 E. Unpublished Materials

II. Sources on Modern Art, Other Artists, and Art and Science; Studies of Photography and Film

 A. Contemporary Sources and Memoirs of the Period

 B. Secondary Sources

 C. Studies of Photography and Film, Including the Work of Physiologist Etienne-Jules Marey

 D. Unpublished Materials

III. Science and Technology

 A. General

 B. Individual Scientists

 1. Sir William Crookes

 2. Sir Oliver Lodge

 3. Nikola Tesla

 4. Leonardo da Vinci

 C. Electricity and Electromagnetism

 D. X-rays

 E. Wireless Telegraphy and Communication Technology

 F. Atom Theory, Electrons, and Radioactivity

 G. Thermodynamics, the Kinetic Theory of Gases, Physical Chemistry, and the Work of Jean Perrin

 H. Chemistry and the Liquefaction of Gases

 I. Wilhelm Ostwald and Energetics

 J. Optics, Color, and the Optophone

 K. Relativity Theory

 L. The Fourth Dimension and the History of Geometry

 M. Metrology

 N. Meteorology

 O. Life Sciences (Biology, Physiology, Entomology)

 P. Automatons and Human-Machine Analogies

 Q. Transportation

 R. Lighting

IV. Other Fields

 A. General Cultural History

 B. Occultism

 1. General Occultism

 2. Alchemy

 C. Philosophy

 D. Literature

 1. Avant-Garde Writers and Periodicals

 2. Alfred Jarry

 3. Raymond Roussel

 4. Science Fiction

Bibliography

I. WRITINGS BY AND ABOUT MARCEL DUCHAMP

Essays in the two primary Duchamp anthologies (*Marcel Duchamp: Artist of the Century*, ed. Kuenzli and Naumann; and *The Definitively Unfinished Marcel Duchamp*, ed. de Duve) are not cited individually in the bibliography. The 3d edition of Arturo Schwarz's *The Complete Works of Marcel Duchamp* (1997) provides the most detailed bibliography of writings on Duchamp to date. Because that volume appeared after the completion of this book, all citations of that title herein refer to the 2d edition (1970), unless otherwise indicated.

A. WRITINGS

Duchamp, Marcel. *A l'infinitif* (*The White Box*). Trans. Marcel Duchamp and Cleve Gray. New York: Cordier & Ekstrom, 1966. Deluxe edition of "Manuscript Notes of Marcel Duchamp 1912–1920."

———. *The Bride Stripped Bare by Her Bachelors, Even: A Typographic Version by Richard Hamilton of Marcel Duchamp's Green Box*. Trans. George Heard Hamilton. New York: George Wittenborn, 1960.

———. *Duchamp du signe*. Ed. Michel Sanouillet. Paris: Flammarion, 1975.

———. *From the Green Box*. Trans. George Heard Hamilton. New Haven: Readymade Press, 1957.

———. "Une Lettre de Marcel Duchamp [to André Breton]." *Medium*, n.s., no. 4 (Oct. 4, 1954), 33.

———. *Manual of Instructions for "Etant Donnés: 1. la chute d'eau, 2. le gaz d'éclairage . . . "* Philadelphia: Philadelphia Museum of Art, 1987.

———. *Marcel Duchamp: Notes*. Ed. and trans. Paul Matisse. Paris: Centre National d'Art et de Culture Georges Pompidou, 1980.

———. *Marcel Duchamp: Notes*. Ed. and trans. Paul Matisse. Boston: G. K. Hall, 1983.

———. *La Mariée mise à nu par ses célibataires, même* (*The Green Box*). Paris: Editions Rrose Sélavy, 1934.

———. *Notes and Projects for the Large Glass*. Ed. Arturo Schwarz. Trans. George Heard Hamilton, Cleve Gray, and Arturo Schwarz. London: Thames & Hudson, 1969.

———. *Salt Seller: The Writings of Marcel Duchamp (Marchand du sel)*. Ed. Michel Sanouillet and Elmer Peterson. New York: Oxford University Press, 1973. Reprinted as *The Writings of Marcel Duchamp*. New York: Da Capo Press, 1989.

———. [Rrose Sélavy]. Preface. In *Tableaux, aquarelles, et dessins par Francis Picabia appartenant à M. Marcel Duchamp*. Auction catalogue. Paris: Hôtel Drouot, 1926.

Duchamp, Marcel, and Vitaly Halberstadt. *L'Opposition et les cases conjugées sont réconcilées*. Paris: L'Echiquier, 1932.

Jean, Marcel, ed. *Marcel Duchamp: Letters to Marcel Jean*. Munich: Verlag Silke Schreiber, 1987.

Naumann, Frances M., ed. "Affectueusement, Marcel: Ten Letters from Marcel Duchamp to Suzanne Duchamp and Jean Crotti." *Archives of American Art Journal* 22, no. 4 (1982), 2–19.

———. "Amicalement, Marcel: Fourteen Letters from Marcel Duchamp to Walter Pach." *Archives of American Art Journal* 29, nos. 3–4 (1989), 36–50.

———. "Marcel Duchamp's Letters to Walter and Louise Arensberg, 1917–1921." In *Marcel Duchamp: Artist of the Century*, ed. Rudolf E. Kuenzli and Francis M. Naumann, pp. 203–27. Cambridge: MIT Press, 1989.

Stauffer, Serge, ed. *Marcel Duchamp: Die Schriften*. Zurich: Regenbogen-Verlag, 1981.

B. INTERVIEWS

"The Art of Assemblage: A Symposium" (1961). In *Essays on Assemblage*, ed. John Elderfield, pp. 118–59. Studies in Modern Art 2. New York: Museum of Modern Art, 1992.

Ashton, Dore. "An Interview with Marcel Duchamp." *Studio International* 171 (June 1966), 244–47.

Cabanne, Pierre. *Dialogues with Marcel Duchamp* (1967). Trans. Ron Padgett. New York: Viking Press, 1971.

Charbonnier, Georges. *Entretiens avec Marcel Duchamp*. Paris: André Dimanche, 1994. Text with compact disc recording.

"A Complete Reversal of Art Opinions by Marcel Duchamp, Iconoclast." *Arts and Decoration* 5 (Sept. 1915), 427–28, 442.

Crehan, Herbert. "Dada." *Evidence*, no. 3 (Fall 1961), 36–38.

Eglington, Laurie. "Marcel Duchamp, Back in America, Gives Interview." *Art News* 32 (Nov. 18, 1933), 3, 11.

"The European Art Invasion." *Literary Digest* 51 (Nov. 27, 1915), 1224–25.

"French Artists Spur On an American Art." *New York Tribune*, Oct. 24, 1915, sec. 4, pp. 2–3.

Greeley-Smith, Nixola. "Cubist Art Depicts Love in Brass and Glass: 'More Art in Rubbers than in a Pretty Girl.'" *New York Evening World*, Apr. 4, 1916, p. 3.

Hahn, Otto. "Passport No. G255300." *Art and Artists* 1 (July 1966), 7–11.

Hamilton, Richard and George Heard Hamilton. 1959 BBC interview. "Third Programme," Nov. 13, 1959. Based on interviews in New York (Jan. 19, 1959) and London (Sept. 14, 1959).

Rerecorded on cassette as *Marcel Duchamp: An Interview by Richard Hamilton in London and George Heard Hamilton in New York* (1959). *Audio Arts Magazine* 2 (1975).

Transcript of Jan. 19, 1959, session with George Hamil-

ton published as "A Radio Interview," in *Duchamp: Passim (A Marcel Duchamp Anthology)*, ed. Anthony Hill, pp. 76–79 (London: Gordon Breach Arts International). Includes some variation in wording and a final segment missing from *Audio Arts Magazine* tape. Same text published as "Mr. Duchamp, If Only You'd Known Jeff Koons Was Coming," *Art Newspaper*, no. 15 (Feb. 1992), 13.

Recording of Jan. 19, 1959, session included in *Marcel Duchamp: The Creative Act* (compact disc recording), ed. Marc Dachy (Brussels: Sub Rosa Records, 1994). Includes transcript of Jan. 19, 1959, session, the wording of which has been corrected to match the *Audio Arts* tape; also includes final segment missing from the *Audio Arts* recording.

"The Iconoclastic Opinion of M. Marcel Duchamps [*sic*] Concerning Art and America." *Current Opinion* 59 (Nov. 1915), 346–47.

Jouffroy, Alain. "Conversations avec Marcel Duchamp." In *Une Revolution du regard: A propos de quelques peintres et sculpteurs contemporains*, ed. Jouffroy, pp. 107–24. Paris: Gallimard, 1964.

———. "Marcel Duchamp: L'Idée du jugement devrait disparaître." *Arts-Spectacles*, no. 491 (Nov. 24–30, 1954), 13.

Kreymborg, Alfred. "Why Marcel Duchamps [*sic*] Calls Hash a Picture." *Boston Evening Transcript*, Sept. 18, 1915, sec. 3, p. 12.

Kuh, Katherine. *The Artist's Voice: Talks with Seventeen Artists*. New York: Harper & Row, 1962.

Lebel, Robert. "Marcel Duchamp, maintenant et ici." *L'Oeil*, no. 149 (May 1967), 18–23, 77.

"Marcel Duchamp Visits New York." *Vanity Fair* 5 (Sept. 1915), 57.

"Mr. Duchamp, If Only You'd Known Jeff Koons Was Coming." *Art Newspaper*, no. 15 (Feb. 1992), 13.

Norman, Dorothy. "Interview by Dorothy Norman." *Art in America* 57 (July–Aug. 1969), 38.

"The Nude-Descending-a-Staircase Man Surveys Us." *New York Tribune*, Sept. 12, 1915, sec. 4, p. 2.

Parinaud, André. "André Breton: Interview with Marcel Duchamp." In *Ommagio André Breton*, pp. 19–46. Milan: Galleria Schwarz, 1967.

Roberts, Colette. "Interview with Colette Roberts." *Art in America* 57 (July–Aug. 1969), 39.

Roberts, Francis. "I Propose to Strain the Laws of Physics." *Art News* 67 (Dec. 1968), 46–47, 62–64.

Russell, John. "Exile at Large." *Sunday Times* (London), June 9, 1968, p. 54.

Sanouillet, Michel. "Dans l'atelier de Marcel Duchamp." *Les Nouvelles Littéraires*, Dec. 16, 1954, p. 5.

Schuster, Jean. "Marcel Duchamp, vite." *Le Surréalisme, même*, no. 2 (Spring 1957), 143–45.

Seitz, William, "What's Happened to Art? An Interview with Marcel Duchamp on Present Consequences of New York's 1913 Armory Show." *Vogue* 141 (Feb. 15, 1963), 110–13, 129–31.

Siegel, Jeanne. "Some Late Thoughts of Marcel Duchamp." *Arts Magazine* 43 (Dec. 1968–Jan. 1969), 21–22.

Stauffer, Serge, ed. *Marcel Duchamp: Interviews und Statements*. Stuttgart: Edition Cantz, 1992.

Steegmuller, Francis. "Duchamp: Fifty Years Later." *Show* 3 (Feb. 1963), 28–29.

Sweeney, James Johnson. "A Conversation with Marcel Duchamp" (interview broadcast on NBC series "Wisdom," 1956). Transcript published as "Marcel Duchamp." In *Wisdom: Conversations with the Elder Wise Men of Our Day*, ed. James Nelson, pp. 89–99. New York: W. W. Norton, 1958. Edited version reprinted as "Regions which are not ruled by time and space....," in *Salt Seller*, ed. Sanouillet and Peterson, pp. 127–37.

———. "Eleven Europeans in America: Marcel Duchamp." *Museum of Modern Art Bulletin* 13 (1946), 19–21. Reprinted as "The Great Trouble with Art in This Country," in *Salt Seller*, ed. Sanouillet and Peterson, pp. 123–26.

C. EXHIBITIONS

Arts Council of Great Britain. *Marcel Duchamp's Traveling Box*. London, 1982. Essay by Dawn Ades.

L. & R. Entwistle and Co., London, *The Portable Museums of Marcel Duchamp: De ou par MARCEL DUCHAMP ou RROSE SELAVY*. May 22–July 27, 1996. Curated by Ronny and Jessy Van de Velde; essay by Francis M. Naumann.

Framart Studio, Naples. *Su Marcel Duchamp*. Nov. 22, 1975–Jan. 28, 1976. Essays by several authors.

Fundación Caja de Pensiones, Madrid, and Fundació Joan Miró, Barcelona. *Marcel Duchamp*. May–June 1984. Essays by several authors.

Galerie Dina Vierny, Paris. *Marcel Duchamp et ses frères*. Oct.–Nov. 1988. Essays by Frances M. Naumann, Bertrand Lorquin, and Pierre Cabanne.

Galleria Schwarz, Milan. *Marcel Duchamp: Ready-mades, etc. (1913–1964)*. Paris: Le Terrain Vague, 1964. Essays by Walter Hopps, Ulf Linde, and Arturo Schwarz.

———. *Marcel Duchamp: 66 Creative Years*. Dec. 12, 1972–Feb. 28, 1973. Catalogue by Arturo Schwarz.

Musée des Beaux Arts, Rouen. *Les Duchamps: Jacques Villon, Raymond Duchamp-Villon, Marcel Duchamp, Suzanne Duchamp*. Apr. 15–June 7, 1967.

Musée National d'Art Moderne, Centre National d'Art et de Culture Georges Pompidou, Paris. *L'Oeuvre de Marcel Duchamp*. Ed. Jean Clair. 4 vols. Jan. 31–May 2, 1977. Vol. 1: *Plan pour écrire une vie de Marcel Duchamp*, by Jennifer Gough-Cooper and Jacques Caumont; vol. 2: *Marcel Duchamp: Catalogue raisonné*, ed. Jean Clair; vol. 3: *Marcel Duchamp: Abécédaire*, ed. Jean Clair; vol. 4: *Victor*, by Henri-Pierre Roché.

Palazzo Grassi, Venice. *Marcel Duchamp*. Ed. Pontus Hulten. Apr. 4–July 18, 1993. Milan: Bompiani, 1983. Includes Jennifer Gough-Cooper and Jacques Caumont,

"Ephemerides on and about Marcel Duchamp and Rrose Sélavy, 1887–1968" (chronology). Catalogue reprinted as *Marcel Duchamp: Work and Life*. Ed. Pontus Hulten. Cambridge: MIT Press, 1993.

Palazzo Reale, Naples. *La Delicata Scacchiera: Marcel Duchamp, 1902–1968*. Ed. Achille Bonito Oliva. June–July 1973. Essays by Arturo Schwarz and Archille Bonito Oliva.

Philadelphia Museum of Art and Museum of Modern Art, New York. *Marcel Duchamp*. Ed. Anne d'Harnoncourt and Kynaston McShine. Sept. 22–Nov. 11, 1973.

Rose Fried Gallery, New York. *Duchamp Frères & Soeur: Oeuvres d'Art*. Feb. 25–Mar. 1952. Essay by Walter Pach.

Staatlichen Museum, Schwerin. *Marcel Duchamp Respirateur*. Aug. 27–Nov. 19, 1995. Essays by Kornelia von Berswordt-Wallrabe, Gerhard Graulich, and Herbert Molderings.

Szeemann, Harald, ed. *Junggesellenmaschinen/Les Machine célibataires*. Kunsthalle Bern and other locations. Venice: Alfieri, 1975. Essays by several authors.

Tate Gallery, London. *The Almost Complete Works of Marcel Duchamp*. June 18–July 31, 1966. London: Arts Council of Great Britain, 1966. Catalogue by Richard Hamilton.

Zabriskie Gallery, New York. *Conspiratorial Laughter/A Friendship: Marcel Duchamp and Man Ray*. Feb. 18–Apr. 15, 1995. Essay by Mason Klein.

D. BOOKS AND ARTICLES

Adcock, Craig. "Conventionalism in Henri Poincaré and Marcel Duchamp." *Art Journal* 44 (Fall 1984), 249–58.

———. "Geometrical Complication in the Art of Marcel Duchamp." *Arts Magazine* 58 (Jan. 1984), 105–9.

———. "Marcel Duchamp's Approach to New York: 'Find an Inscription for the Woolworth Building as a Ready-Made.'" In *New York Dada*, ed. Rudolf E. Kuenzli, pp. 52–65. New York: Willis Locker & Owens, 1986.

———. "Marcel Duchamp's Gap Music: Operations in the Space Between Art and Noise." In *Wireless Imagination: Sound, Radio, and the Avant-Garde*, ed. Douglas Kahn and Gregory Whitehead, pp. 105–38. Cambridge: MIT Press, 1992.

———. "Marcel Duchamp's 'Instantanés': Photography and the Event Structure of the Ready-Mades." In *"Event" Art and Art Events*, ed. Stephen C. Foster, pp. 239–66. Ann Arbor: UMI Research Press, 1988.

———. *Marcel Duchamp's Notes from the "Large Glass": An N-Dimensional Analysis*. Ann Arbor: UMI Research Press, 1983.

———. "Why Marcel Duchamp's Old Hat Still Addresses the Situation to the Nines." *Arts Magazine*, 59 (Mar. 1985), 72–77.

Ades, Dawn. "Duchamp's Masquerades." In *The Portrait in Photography*, ed. Graham Clarke, pp. 94–114. London: Reaktion, 1992.

Alexandrian, [Sarane]. *Marcel Duchamp*. New York: Crown, 1977.

Anastasi, William. "Duchamp on the Jarry Road." *Artforum* 30 (Sept. 1991), 86–90.

Bailly, Jean-Christophe. *Duchamp*. Trans. Jane Brenton. New York: Universe, 1986.

Beier, Lucia. "The Time Machine: A Bergsonian Approach to 'The Large Glass.'" *Gazette des Beaux-Arts*, ser. 6 (Nov. 1976), 194–200.

Bloch, Susi. "Marcel Duchamp's *Green Box*." *Art Journal* 34 (Fall 1974), 25–29.

Bonk, Eke. *Marcel Duchamp: The Box in a Valise*. New York: Rizzoli, 1989.

Breton, André. "Lighthouse of the Bride." *View*, ser. 5, no. 1 (Mar. 1945), 6–9. Translation of "Phare de *La Mariée*."

———. "Marcel Duchamp." *Littérature*, n.s., no. 5 (Oct. 1, 1922), 7–10.

———. "Phare de *La Mariée*." *Minotaure* 2 (Winter 1935), 45–49.

———. "The Point of View: Testimony 45." *View*, ser. 5, no. 1 (Mar. 1945), 5.

Bryars, Gavin. "Notes on Marcel Duchamp's Music." *Studio International* 192 (Nov. 1976), 274–79.

Buffet, Gabrielle. "Coeurs volants." *Cahiers d'Art* 9 (1936), 34–44.

———. "Magic Circles." *View*, ser. 5, no. 1 (Mar. 1945), 14–16, 23. Translation of "Coeurs volants."

Burnham, Jack. "Duchamp's Bride Stripped Bare." *Arts Magazine* 46 (Mar. 1972), 28–32; 46 (Apr. 1972), 41–45; 46 (May 1972), 58–61.

———. *The Structure of Art*, rev. ed. New York: George Braziller, 1973.

———. "Unveiling the Consort." *Artforum* 9 (Mar. 1971), 55–60; 9 (Apr. 1971), 42–51.

Buskirk, Martha. "Thoroughly Modern Marcel." *October*, no. 70 (Fall 1994), 113–25.

Buskirk, Martha, and Mignon Nixon, eds. *The Duchamp Effect*. Cambridge: MIT Press, 1996. Reprint of *October*, no. 70 (Fall 1994), with material added.

Cabanne, Pierre. *The Brothers Duchamp: Jacques Villon, Raymond Duchamp-Villon, Marcel Duchamp*. Trans. Helga and Dinah Harrison. Boston: New York Graphic Society, 1976.

Calas, Nicolas. "The Large Glass." *Art in America* 57 (July–Aug. 1969), 34–35.

Calder, Alexander. "A Conversation with Alexander Calder." *Art in America* 57 (July–Aug. 1969), 31.

Calvesi, Maurizio. *Duchamp invisible: La costruzione del simbolo*. Rome: Officina Edizioni, 1975.

Camfield, William A. *Marcel Duchamp: Fountain*. Houston: Menil Collection, 1989. Accompanied exhibition of the same name at the Menil Collection, Dec. 23, 1987–Oct. 2, 1988.

Carrouges, Michel. *Les Machines célibataires*. Paris: Arcanes, 1954.

Chalupecký, Jindřich. "Nothing but an Artist." *Studio International* 189 (Jan.–Feb. 1975), 30–47.

Chateau, Dominique. "Langue philosophique, et théorie de

l'art dans les écrits de Marcel Duchamp." *Les Cahiers du Musée National d'Art Moderne*, no. 33 (Fall 1990), 40–53.

Clair, Jean, "Duchamp and the Classical Perspectivists." *Artforum* 16 (Mar. 1978), 40–49.

———. *Duchamp et la photographie*. Paris: Editions du Chêne, 1977.

———. "La Fortune critique de Marcel Duchamp: Petite Introduction à une herméneutique du Grand Verre." *Revue de l'Art*, no. 34 (1976), 92–100.

———. *Marcel Duchamp, ou le grand fictif*. Paris: Editions Galilée, 1975.

———. "Opticeries." *October*, no. 5 (Summer 1978), 101–15.

———. "Les Vapeurs de la mariée." *L'Arc* 59 (1974), 44–51.

———. "De quelques métaphores automobiles." *Revue de l'Art*, no. 77 (1987), 77–79.

Clair, Jean, ed. *Marcel Duchamp: Tradition de la rupture ou rupture de la tradition*. Colloquium held at the Centre Culturel de Cerisy-la-Salle, July 25–Aug. 1, 1977. Paris: Union Générale d'Editions, 1979. Essays by several authors.

Clearwater, Bonnie, ed. *West Coast Duchamp*. Miami Beach: Grassfield Press (with Shoshana Wayne Gallery, Santa Monica), 1991. Essays by several authors.

Copley, William. "The New Piece." *Art in America* 37 (July–Aug. 1969), 36.

Cramer, Charles. "Duchamp from Syntax to Bride: Sa Langue dans Sa Joue." *Word & Image* 13 (Apr.–June 1997), 1–26.

Crary, Jonathan. "Marcel Duchamp's 'The Passage from Virgin to Bride.'" *Arts Magazine* 51 (Jan. 1977), 96–99.

Dali, Salvador. "The King and Queen Traversed by Swift Nudes." *Art News* 58 (April 1959), 22–25.

Daniels, Dieter. *Duchamp und die anderen: Die Modellfall einer künstlerischen Wirkungsgeschichte in der Moderne*. Cologne: DuMont Buchverlag, 1992.

Davies, Ivor. "New Reflections on the *Large Glass*: The Most Logical Sources for Duchamp's Irrational Work." *Art History* 2 (Mar. 1979), 85–94.

de Duve, Thierry. "Echoes of the Readymade: Critique of Pure Modernism." *October*, no. 70 (Fall 1994), 61–97.

———. *Kant After Duchamp*. Cambridge: MIT Press, 1996.

———. "Marcel Duchamp, or the *Phynancier* of Modern Life." *October*, no. 52 (Fall 1990), 61–77.

———. *Nominalisme pictural: Marcel Duchamp, la peinture et la modernité*. Paris: Editions de Minuit, 1984. Trans. by Dana Polan as *Pictorial Nominalism: On Marcel Duchamp's Passage from Painting to the Readymade*, Theory and History of Literature, vol. 51 (Minneapolis: University of Minnesota Press, 1991).

———. "The Readymade and the Tube of Paint." *Artforum* 24 (May 1986), 110–21.

———. *Resonances du Readymade: Duchamp entre avant-garde et tradition*. Nîmes: Editions Jacqueline Chambon, 1989.

de Duve, Thierry, ed. *The Definitively Unfinished Marcel Duchamp*. Cambridge: MIT Press, 1991. Essays by several authors.

Dee, John. "A Geographic Landscapism: Duchamp's View of Nature." *Aspects* 4 (Fall 1978), n.p.

d'Harnoncourt, Anne, and Walter Hopps. "*Etant Donnés: 1. la chute d'eau, 2. le gaz d'éclairage*: Reflections on a New Work by Marcel Duchamp." *Philadelphia Museum of Art Bulletin* 64 (Apr.–Sept. 1969), 6–64; rev. ed., Philadelphia: Philadelphia Museum of Art, 1987.

Doepel, Rory T. "An Iconographical Analysis of Duchamp's Bride Image in the *Large Glass*." In *Pillars of Smoke and Fire: The Holy Land in History and Thought*, ed. Moshe Sharon, pp. 187–222. Johannesburg: Southern Book Publishers, 1996.

Dollens, Dennis. "Interview: Denise Brown Hare on Duchamp's New York Studio." *SITES* 19 (1987), 7–16.

Dreier, Katherine S., and Matta Echaurren. *Duchamp's Glass ("La mariée mise à nu par ses célibataires, même"): An Analytical Reflection*. New York: Société Anonyme, Inc., 1944.

Duplessis, Rachel Blau. "Sub Rrosa." *Sulfur* 21 (Winter 1988), 152–64.

Feshbach, Sidney. "Marcel Duchamp on Being Taken for a Ride: Duchamp Was a Cubist, a Mechanomorphist, a Dadaist, a Surrealist, a Conceptualist, a Modernist, a Post-Modernist—and None of the Above." *James Joyce Quarterly* 26 (Summer 1989), 541–60.

Gervais, André. *La Raie alitée d'effets: Apropos of Marcel Duchamp*. Ville La Salle: Editions Hurtubise HMH, 1984.

———. "Roue de bicyclette: Epitexte, texte et intertexte." *Les Cahiers du Musée National d'Art Moderne*, no. 30 (Winter 1989), 59–80.

Gibson, Michael. *Duchamp Dada*. Paris: Casterman, 1991.

Golding, John. *Marcel Duchamp: The Bride Stripped Bare by Her Bachelors, Even*. New York: Viking, 1973.

Gottlieb, Carla. "Something Else: Duchamp's *Bride* and Leonardo." *Konsthistorisk Tidskrift* 45 (June 1976), 52–57.

Gough-Cooper, Jennifer, and Jacques Caumont. "Kiesler und 'Die Braut von ihren Junggesellen rackt entblösst sogar.'" In Museum des 20. Jahrhunderts, Vienna, *Friedrich Kiesler Architekt, Maler, Bildhauer, 1890–1965*, ed. Dieter Bogner, pp. 287–96. Vienna: Löcker Verlag, 1988. Reprinted in translation in *Duchamp: Passim (A Marcel Duchamp Anthology)*, ed. Anthony Hill, pp. 99–109. London: Gordon and Breech Arts International, 1994.

———. "Friedrich Kiesler and *The Bride Stripped Bare . . .*" In *Friedrich Kiesler*, ed. Yehuda, Safran, pp. 62–71. London: Architectural Association, 1989.

Gray, Cleve. "The Great Spectator." *Art in America* 57 (July–Aug., 1969), 20–27.

Hamilton, George Heard. "In Advance of Whose Broken Arm?" *Art and Artists* 1 (July 1966), 30–31.

Hamilton, Richard. "Son of the Bride Stripped Bare" (interview by Mario Amaya). *Art and Artists* 2 (July 1966), 22–27.

Hare, Denise Browne. "Photographic Portfolio: Marcel Duchamp's *Etant Donnés* in His New York Studio." *SITES* 19 (1987), 17–31.

Henderson, Linda Dalrymple. "Etherial Bride and Mechanical Bachelors: Science and Allegory in Marcel Duchamp's 'Large Glass.'" *Configurations: A Journal of Literature, Science, and Technology* 4 (Winter 1996), 91–120.

———. "Farewell from the Fourth Dimension: A Painter Renders the New Physics." *The Sciences* 24 (Sept.–Oct. 1984), 42–43.

———. "Marcel Duchamp's *The King and Queen Surrounded by Swift Nudes* (1912) and the Invisible World of Electrons." *Weber Studies* 14 (Winter 1997), 83–101.

———. "Reflections of and/or on Marcel Duchamp's *Large Glass*." In Whitney Museum of American Art, New York, *Making Mischief: Dada Invades New York*, pp. 229–37. Nov. 21, 1996–Feb. 23, 1997.

Hill, Anthony, ed. *Duchamp: Passim (A Marcel Duchamp Anthology)*. London: Gordon and Breech Arts International, 1994.

Hopkins, David. "Hermeticism, Catholicism and Gender as Structure: A Comparative Study of Themes in the Work of Marcel Duchamp and Max Ernst." Ph.D. diss., University of Essex, 1989.

———. "Questioning Dada's Potency: Picabia's 'La Sainte Vierge' and the Dialogue with Duchamp." *Art History* 15 (Sept. 1992), 317–33.

Hulten, Pontus. *Marcel Duchamp: Work and Life*. Cambridge: MIT Press, 1993. Reprint of 1993 Palazzo Grassi exhibition catalogue.

Janis, Harriet, and Sidney Janis. "Marcel Duchamp, Anti-Artist." *View*, ser. 5, no. 1 (Mar. 1945), 18–19, 21, 23–24, 53–54.

Jean, Marcel. *The History of Surrealist Painting* (1959). Trans. Simon Watson Taylor. New York: Grove Press, 1960.

Johnson, Ronald. "Poetic Pathways to Dada: Marcel Duchamp and Jules Laforgue." *Arts Magazine* 50 (May 1976), 82–89.

Jones, Amelia. *Postmodernism and the En-gendering of Marcel Duchamp*. Cambridge: Cambridge University Press, 1994.

Joselit, David. "Marcel Duchamp's *Monte Carlo Bond Machine*." *October*, no. 59 (Winter 1992), 9–26.

Judowitz, Dalia. *Unpacking Duchamp: Art in Transit*. Berkeley: University of California Press, 1995.

Kiesler, Friedrich. "Design Correlation." *Architectural Record*, 81 (May 1937), 53–60.

Kiesler, Frederick J. [Friedrich]. "Les Larves d'Imagie d'Henri Robert Marcel Duchamp." *View*, ser. 5, no. 1 (Mar. 1945), 24–30.

Klein, Mason. "Embodying Sexuality: Marcel Duchamp in the Realm of Surrealism." In *Modern Art and Society: An Anthology of Social and Multicultural Readings*, ed. Maurice Berger, pp. 139–57. New York: HarperCollins, 1994.

Kotte, Wouter. *Marcel Duchamp als Zeitmaschine*. Cologne: Walther König, 1987.

Krauss, Rosalind E. "The Blink of an Eye." In *The States of Theory: History, Art and Critical Discourse*, ed. David Carroll, pp. 175–99. New York: Columbia University Press, 1990.

———. "Notes on the Index: Seventies Art in America." *October*, no. 3 (Spring 1977), 68–81. Reprinted as "Notes on the Index, Part 1," in Krauss, *The Originality of the Avant-Garde and Other Modernist Myths*, pp. 196–209. Cambridge: MIT Press, 1986.

Kuenzli, Rudolf E., and Francis M. Naumann, eds. *Marcel Duchamp: Artist of the Century*. Cambridge: MIT Press, 1989.

Landy, Leigh. "Duchamp, Dada Composer, and His Vast Influence on Post–World War II Avant-Garde Music." *Avant-Garde* 2 (1989), 131–44.

Lebel, Robert. *Marcel Duchamp*. Trans. George Heard Hamilton. New York: Grove Press, 1959. Originally published as *Sur Marcel Duchamp* (Paris: Trianon, 1959).

———. *Marcel Duchamp*. Paris: Pierre Belfond, 1985.

———. "Marcel Duchamp and Electricity at Large: The Dadaist Vision of Electricity." In Musée d'Art Moderne de la Ville de Paris, *Electra: L'Electricité et l'électronique dans l'art au XX siècle*, pp. 164–73. Dec. 10, 1983–Feb. 5, 1984.

———. "Dernière Soirée avec Marcel Duchamp." *L'Oeil*, no. 167 (Nov. 1968), 19–21.

Leiris, Michel. "Arts et métiers de Marcel Duchamp." *Fontaine*, no. 54 (Summer 1946), 188–93.

Levy, Julien. "Glass Sparks." *Art News* 57 (Sept. 1958), 36, 64.

Lindamood, Peter. "I Cover the Cover." *View*, ser. 5, no. 1 (Mar. 1945), 3.

Linde, Ulf. *Marcel Duchamp*. Stockholm: Rabén & Sjögren, 1986.

Lyotard, Jean-François. *Les TRANSformateurs DUchamp*. Paris: Editions Galilée, 1977. Trans. by Ian McLeod as *Duchamp's TRANS/formers* (Venice, Calif.: Lapis Press, 1990).

Marquis, Alice Goldfarb. *Marcel Duchamp: 'Eros, cest la vie,' a Biography*. Troy, N.Y.: Whitston, 1981.

Masheck, Joseph, ed. *Marcel Duchamp in Perspective*. Englewood Cliffs, N.J.: Prentice-Hall, 1975.

———. "Readymades: Art accompli." In *Modernités: Art-Matters in the Present*, ed. Masheck, pp. 73–80. University Park: Pennsylvania State University Press, 1993.

Matisse, Paul. "The Opening Doors of *Etant Donnés*." *SITES* 19 (1987), 4–6.

———. "Some More Nonsense about Duchamp." *Art in America* 48 (Apr. 1980), 76–83.

McEvilley, Thomas. "empyrrhical thinking (and why kant can't)." *Artforum* 27 (Oct. 1988), 120–27.

Michelson, Annette. "'Anemic Cinema': Reflections on an Emblematic Work." *Artforum* 12 (Oct. 1973), 64–69.

Mink, Janis. *Marcel Duchamp, 1887–1968: Art as Anti-Art*. Cologne: Benedikt Taschen, 1995.

Moffitt, John F. "An Emblematic Alchemical Source for Duchamp's *Large Glass: La Mariée mise à nu par ses célibataires, même* (1915–23)." *Cauda Pavonis*, n.s., 2 (Fall 1983), 1–4.

———. "*Fin-de-Siècle* Parisian Hermeticism: Hermetic and Alchemical Publications in the Bibliothèque Sainte-

Geneviève." *Cauda Pavonis*, n.s., 14 (Fall 1995), 10–15.

———. "Marcel Duchamp: Alchemist of the Avant-Garde." In Los Angeles County Museum of Art, *The Spiritual in Art: Abstract Painting 1890–1986*, pp. 257–71. Nov. 23, 1986–Mar. 8, 1987.

Molderings, Herbert. "Film, Fotographe und ihr Einfluss auf diè Malerei in Paris um 1910: Marcel Duchamp—Jacques Villon—Frank Kupka." *Wallraf-Richartz-Jahrbuch* 37 (1975), 247–86.

———. *Marcel Duchamp: Parawissenschaft, das Ephemere und der Skeptizismus*. Frankfurt: Editions Qumran, 1983.

Moure, Gloria. *Marcel Duchamp*. Trans. Joanna Martinez. New York: Rizzoli, 1988.

Mussman, Toby. "Anémic Cinéma." *Art and Artists* 1 (July 1966), 48–51.

Naumann, Francis M. "The Bachelors' Quest." *Art in America* 81 (Sept. 1993), 72–81, 67, 69.

———. "*The Bride Stripped Bare by her Bachelors, Even* and Related Works on Glass by Marcel Duchamp." *Glass*, no. 60 (Fall 1995), 34–41.

———. "Duchamp at the Palazzo Grassi." *Apollo* 138 (Oct. 1993), 262–63.

———. *Marcel Duchamp: The Art of Making Art in an Age of Mechanical Reproduction*. Ghent: Ludion, forthcoming.

———. *The Mary and William Sisler Collection*. New York: The Museum of Modern Art, 1984.

Nesbit, Molly. "His Common Sense." *Artforum* 33 (Oct. 1994), 92–95, 124, 126.

———. "Ready-Made Originals: The Duchamp Model." *October* 37 (Summer 1986), 53–64.

———. "The Rat's Ass." *October*, no. 56 (Spring 1991), 7–20.

Nesbit, Molly, and Naomi Sawelson-Gorse. "Concept of Nothing: New Notes by Marcel Duchamp and Walter Arensberg." In *The Duchamp Effect*, ed. Martha Buskirk and Mignon Nixon, pp. 131–75. Cambridge: MIT Press, 1996.

Paz, Octavio. *Marcel Duchamp: Appearance Stripped Bare*. Trans. Rachel Phillips and Donald Gardner. New York: Viking, 1978.

Puel, Gaston. "Lettre à Marcel Duchamp." *Néon*, no. 5 (1949), 3.

Raillard, Georges. "rien Peut-être." *L'Arc* 59 (1974), 52–60.

Ramirez, Juan Antonio. "Duchamp: Corps démultiplié hasard objectif et action." In Centre Nationale d'Art et de Culture Georges Pompidou, Paris, *Feminimasculin: Le Sexe de l'art*, pp. 279–83. Oct. 24, 1995–Feb. 12, 1996.

Reff, Theodore. "Duchamp & Leonardo: L.H.O.O.Q.—Alikes." *Art in America* 65 (Jan.–Feb. 1977), 82–93.

"Restoring 1,000 Glass Bits in Panels." *Literary Digest* 121 (June 20, 1936), 20–21.

"The Richard Mutt Case." *The Blind Man*, no. 2 (May 1917), 5–6.

Richter, Hans. "In Memory of a Friend." *Art in America* 37 (July–Aug. 1969), 40–41.

Roché, Henri-Pierre. "Souvenirs of Marcel Duchamp." In Robert Lebel, *Marcel Duchamp*, pp. 79–87. New York: Grove Press, 1959.

Roth, Moira. "Marcel Duchamp in America: A Self Ready-Made." *Arts Magazine* 51 (May 1977), 92–96.

———. "Robert Smithson on Duchamp: An Interview." *Artforum* 12 (Oct. 1973), 47.

Rougement, Denis de. "Marcel Duchamp mine de rien." *Preuves* 18 (Feb. 1968), 43–47.

Rubin, William. "Reflexions on Marcel Duchamp." *Art International* 4 (Dec. 1960), 49–53.

Rumney, Ralph, "Marcel Duchamp as a Chess Player and One or Two Related Matters" (interview with François Le Lionnais). *Studio International* 189 (Jan.–Feb. 1975), 23–25.

Samaltanos, Katia. *Apollinaire: Catalyst for Primitivism, Picabia, and Duchamp*. Ann Arbor: UMI Research Press, 1984.

Schwarz, Arturo. *The Complete Works of Marcel Duchamp*. New York: Harry N. Abrams, 1969. 2d rev. ed., New York: Harry N. Abrams, 1970. 3d rev. ed., New York: Delano Greenidge, 1997.

———. *Marcel Duchamp*. New York: Harry N. Abrams, 1970.

———. "Rrose Sélavy, alias Marchand de [*sic*] sel alias Belle Haleine." *L'Arc* 74 (1974), 29–35.

Seigel, Jerrold. *The Private Worlds of Marcel Duchamp: Desire, Liberation, and the Self in Modern Culture*. Berkeley: University of California Press, 1995.

Specter, Jack J. "Duchamp's Androgynous Leonardo: 'Queue' and 'Cul' in *L.H.O.O.Q.*" *Source: Notes in the History of Art* 11 (Fall 1991), 31–35.

Steefel, Lawrence D., Jr. "The Art of Marcel Duchamp: Dimension and Development in *Le Passage de la Vièrge à la Mariée*." *Art Journal* 22 (Winter 1962–63), 72–79.

———. *The Position of Duchamp's "Glass" in the Development of His Art*. New York: Garland Publishing, 1977.

Stein, Gertrude. "Next. Life and Letters of Marcel Duchamp." In *Geography and Plays*, pp. 405–6. Boston: Four Seas, 1922.

Stuckey, Charles F. "Duchamp's Acephalic Symbolism." *Art in America* 65 (Jan.–Feb. 1977), 94–99.

Suquet, Jean. *Le Grand Verre: Visite guidée*. Paris: L'Echoppe, 1992.

———. *Le Grand Verre rêvé*. Paris: Aubier, 1991.

———. *Le Guéridon et la virgule*. Paris: Christian Bourgois, 1976.

———. "La Mère Machine." In *L'Objet au défi*, ed. Jacqueline Chénieux-Gendron and Marie Claire Dumas, pp. 143–54. Paris: Presses Universitaires de France, 1987.

———. *Miroir de la Mariée*. Paris: Flammarion, 1974.

———. *Regarder l'heure: Sur le ciel de Marcel Duchamp*. Paris: L'Echoppe, 1992.

———. "Le Signe de la concordance." *L'Arc* 59 (1974), 36–43.

Tancock, John. "The Oscillating Influence of Marcel Duchamp." *Art News* 72 (Sept. 1973), 23–29.

Taylor, Michael R. "Rrose Sélavy: Prostituée de la rue aux Lèvres: Levant le voile sur l'alter ego érotique de Marcel Duchamp." In Centre Nationale d'Art et de Culture

Georges Pompidou, Paris, *Femininmasculin: Le Sexe de l'art*, pp. 284–90. Oct. 24, 1995–Feb. 12, 1996.

Tashjian, Dickran. "Henry Adams and Marcel Duchamp: Liminal Views of the Dynamo and the Virgin." *Arts Magazine* 51 (May 1977), 102–7.

Tomkins, Calvin. *The Bride and the Bachelors: The Heretical Courtship in Modern Art*. New York: Viking, 1965.

———. "Dada and Mama." *New Yorker* 71 (Jan. 15, 1996), 56–63.

———. *Duchamp: A Biography*. New York: Henry Holt, 1996.

———. *The World of Marcel Duchamp, 1887–*. New York: Time, Inc., 1966.

Weiss, Jeffrey. *The Popular Culture of Modern Art: Picasso, Duchamp, and Avant-Gardism*. New Haven: Yale University Press, 1994.

Wohl, Hellmut. "Beyond *The Large Glass*: Notes on a Landscape Drawing of Marcel Duchamp." *Burlington Magazine* 119 (Nov. 1977), 763–72.

———. "In Detail: Marcel Duchamp and the *Large Glass*." *Portfolio* 4 (July–Aug. 1982), 70–75.

E. UNPUBLISHED MATERIALS

Arts Council of Great Britain, interview with Marcel Duchamp conducted by Sir William Coldstream, Richard Hamilton, R. B. Kitaj, Robert Melville, and David Sylvester, London, June 19, 1996.

Duchamp, Marcel. "Apropos of Myself." Lecture given at the City Art Museum of St. Louis, Nov. 24, 1964.

Gold, Laurence S. "Interview with Marcel Duchamp." Appendix to "A Discussion of Marcel Duchamp's on the Nature of Reality and Their Relation to the Course of His Artistic Career." Senior thesis, Princeton University, 1958. (Gold paraphrases Duchamp's remarks.)

Janis, Sidney, Harriet Janis, and Carroll Janis. Interview with Marcel Duchamp, New York, 1953. Manuscript in the possession of Carroll Janis.

II. SOURCES ON MODERN ART, OTHER ARTISTS, AND ART AND SCIENCE; STUDIES OF PHOTOGRAPHY AND FILM

A. CONTEMPORARY SOURCES AND MEMOIRS OF THE PERIOD

Apollinaire, Guillaume. *Apollinaire on Art: Essays and Reviews, 1902–1918*. Ed. Leroy C. Breunig. Trans. Susan Suleiman. New York: Viking, 1972.

———. *Guillaume Apollinaire: Les Peintres Cubistes*. Ed. L. C. Breunig and J.-Cl. Chevalier. Paris: Hermann, 1965.

———. *Les Peintres Cubistes: Méditations esthétiques*. Paris: Eugène Figuière, 1913. Trans. by Lionel Abel as *The Cubist Painters: Aesthetic Meditations*. Ed. Robert Motherwell. New York: George Wittenborn, 1949.

Apollonio, Umbro, ed. *Futurist Manifestos*. Trans. Robert Brain, R. W. Flint, J. C. Higgitt, and Caroline Tisdall. New York: Viking, 1973.

Beaunier, André. "Les Salons de 1908." *Gazette des Beaux-Arts*, 3d ser., 40 (July 1, 1908), 44–77.

Breton, André, and Gérard Legrand, eds. *Formes de l'art: L'Art magique*. Paris: Club Français de l'Art, 1957.

Brinton, Christian. "Evolution Not Revolution in Art." *The International Studio* 49 (Apr. 1913), xxvii–xxxv.

Buffet, Gabrielle. "Modern Art and the Public." *Camera Work*, special no. (June 1913), 14–21.

Buffet-Picabia, Gabrielle. *Rencontres avec Picabia, Apollinaire, Cravan, Duchamp, Arp, Calder*. Paris: Pierre Belfond, 1977.

———. "Some Memories of Pre-Dada: Picabia and Duchamp." In *The Dada Painters and Poets*, ed. Robert Motherwell, pp. 255–67. New York: George Wittenborn, 1951.

Cohen, Arthur, ed. *The New Art of Color: The Writings of Robert and Sonia Delaunay*. New York: Viking, 1978.

Duchamp-Villon, Raymond. "L'Architecture et le fer." *Poème et Drame* 7 (Jan.–Mar. 1914), 22–29.

Galerie Bernheim-Jeune & Cie., Paris. *Les Peintres Futuristes italiens*. Feb. 5–24, 1912.

Galerie de La Boétie, Paris. *Salon de "La Section d'Or."* Oct. 10–30, 1912.

Galerie Maeght, Paris. *Le Surréalisme en 1947: Exposition Internationale du Surréalisme présentée par André Breton et Marcel Duchamp*. Paris: Editions Pierre à Feu, 1947.

Gleizes, Albert. "La Peinture moderne." *391*, no. 5 (June 1917), 6–7.

Gleizes, Albert, and Jean Metzinger. *Du Cubisme*. Paris: Eugène Figuière, 1912.

Gossez, A[lphonse] M[arius]. *Essai d'expansion d'une esthétique*. Le Havre: Editions de la Provence, 1911.

Gregg, F[rederick] J[ames]. *For and Against: Views of the International Exhibition of Modern Art*. New York: Association of American Painters and Sculptors, 1913.

Herbert, Robert L., ed. *Modern Artists on Art*. Englewood Cliffs, N.J.: Prentice-Hall, 1964.

Kahnweiler, Daniel-Henry. *The Rise of Cubism* (1920). Trans. Henry Aronson. New York: Wittenborn, Schultz, 1949.

Kandinsky, Wassily. *Concerning the Spiritual in Art* (1911). Trans. Francis Golffing, Michael Harrison, and Ferdinand Ostertag. New York: George Wittenborn, 1947.

———. *Kandinsky: Complete Writings on Art*. Ed. Kenneth C. Lindsay and Peter Vergo. New York: Da Capo, 1994.

Kupka, František. *La Création dans les arts plastiques*. Ed. Erika Abrams. Paris: Cercle d'Art, 1989.

Le Fauconnier, Henri. "La Sensibilité moderne et le tableau." *De Kunst* 5 (Oct. 12, 1912), 21–23.

Malevich, Kazimir. *K. S. Malevich: The World as Non-Objectivity (Unpublished Writings, 1922–25)*. Ed. Troels Anderson. Trans. Xenia Glowacki-Prus and Edmund T. Little. Copenhagen: Borgen, 1976.

———. *The Non-Objective World*. Trans. Howard Dearstyne. Chicago: Paul Theobald, 1959.

Man Ray. *Self Portrait* (1963). New ed. Boston: Little, Brown, 1988.

Nayral, Jacques. Preface to Galeries J. Dalmau, Barcelona, *Exposició de Arte cubista*. Apr.–May 1912. Reprinted in *Guillaume Apollinaire: Les Peintres Cubistes*, ed. L. C. Breunig and J.-Cl. Chevalier, pp. 178–82. Paris: Hermann, 1965.

Pach, Walter. *The Masters of Modern Art*. New York: B. W. Huebsch, 1924.

———. *Queer Thing, Painting: Forty Years in the World of Art*. New York: Harper & Bros., 1938.

Picabia, Francis. Preface to Little Gallery of the Photo-Secession, New York, *Picabia Exhibition*. Mar. 17–Apr. 5, 1913. Reprinted in *For and Against: Views of the International Exhibition of Modern Art*, ed. F. J. Gregg, pp. 45–48. New York: Association of American Painters and Sculptors.

Picabia [Pharamousse]. "D'une ville unfortuné." *391*, no. 4 (Mar. 25, 1917), 8.

Raynal, Maurice. "Conception et vision." *Gil Blas*, Aug. 29, 1912, p. 4.

Rosenthal, Léon. "Les Salons de 1912." *Gazette des Beaux-Arts*, 4th ser., 7 (1912), 345–70.

Salmon, André. *La Jeune Peinture française*. Paris: Société des Trente, 1912.

B. SECONDARY SOURCES

Agee, William. *Raymond Duchamp-Villon, 1876–1918*. Intro. George Heard Hamilton. New York: Walker, 1967.

Aichele, K. Porter. "Paul Klee and the Energetics-Atomistics Controversy." *Leonardo* 26, no. 4 (1993), 309–15.

Antliff, Robert Mark. "Bergson and Cubism: A Reassessment." *Art Journal* 47 (Winter 1988), 341–49.

———. *Inventing Bergson: Bergson, Cultural Politics, and the Parisian Avant-Garde*. Princeton: Princeton University Press, 1993.

———. "Organicism against Itself: Duchamp-Villon and the Contradictions of Modernism." *Word & Image* 12 (July–Sept. 1996), 1–24.

Asendorf, Christoph. *Batteries of Life: On the History of Things and Their Perception in Modernity*. Trans. Don Renau. Berkeley: University of California Press, 1993.

———. *Ströme und Strahlen: Die langsame Verschwinden der Materie um 1900*. Werkbund Archiv, vol. 18. Giessen: Anabas-Verlag, 1989.

Barnicoat, John. *A Concise History of Modern Posters*. London: Thames and Hudson, 1972.

Benjamin, Roger. *Matisse's "Notes of a Painter": Criticism, Theory, and Context, 1891–1908*. Ann Arbor: UMI Research Press, 1987.

Benson, Donald R. "Kandinsky's Dramatic Reconstitution of Pictoral Space." *Annals of Scholarship* 4 (1986), 110–21.

Bohn, Willard. "Picabia's 'Mechanical Expression' and the Demise of the Object." *Art Bulletin* 67 (Dec. 1985), 673–77.

Buckberrough, Sherry A. *Robert Delaunay: The Discovery of Simultaneity*. Ann Arbor: UMI Research Press, 1982.

Burnham, Jack. *Beyond Modern Sculpture: The Effects of Science and Technology on the Sculpture of This Century*. New York: George Braziller, 1968.

Camfield, William A. *Francis Picabia: His Life and Times*. Princeton: Princeton University Press, 1979.

———. "The Machinist Style of Francis Picabia." *Art Bulletin* 48 (Sept.–Dec. 1966), 309–22.

Centre d'Art et de Culture Georges Pompidou, Paris. *Frederick Kiesler: Artiste-architecte*. July 3–Oct. 21, 1996.

Clair, Jean, ed. *L'Ame au corps: Arts et sciences, 1793–1993*. Galeries Nationales du Grand Palais, Paris. Oct. 19, 1993–Jan. 24, 1994. Essays by several authors.

Crary, Jonathan. *Techniques of the Observer: On Vision and Modernity in the Nineteenth Century*. Cambridge: MIT Press, 1990.

Celant, Germano. "Futurism and the Occult." *Artforum* 19 (Jan. 1981), 36–42.

Douglas, Charlotte, et al. *Malevich: Artist and Theoretician*. New York: Abbeville, 1991.

Fagan-King, Julia. "United on the Threshold of the Twentieth-Century Mystical Ideal: Marie Laurencin's Integral Involvement with Guillaume Apollinaire and the Inmates of the Bateau Lavoir," *Art History* 11 (Mar. 1988), 88–114.

Fogg Art Museum, Cambridge, Mass. *Jacques Villon*. Ed. Daniel Robbins. Jan. 17–Feb. 29, 1976.

Fry, Edward F., ed. *Cubism*. New York: McGraw-Hill, 1966.

Galerie Gmurzynska, Cologne. *Frank Kupka*. Feb.–Apr. 1981. Essays by several authors.

Garte, Edna J. "Kandinsky's Ideas on Change in Modern Physics and Their Implications for His Development." *Gazette des Beaux-Arts*, 6th ser., 110 (Oct. 1987), 137–43.

Gibson, Jennifer. "Surrealism before Freud: Dynamic Psychiatry's 'Simple Recording Instrument.'" *Art Journal* 46 (Spring 1987), 56–60.

Golding, John. *Cubism: A History and an Analysis*. New York: George Wittenborn, 1959.

Gordon, Donald E., ed. *Modern Art Exhibitions, 1900–1916*. 2 vols. Munich: Prestel-Verlag, 1974.

Green, Christopher. *Léger and the Avant-Garde*. New Haven: Yale University Press, 1976.

Hamilton, George Heard. *Painting and Sculpture in Europe, 1880–1940*. Baltimore: Penguin, 1967.

Held, Julius. *Rubens and His Circle: Studies by Julius Held*. Ed. Anne W. Lowenthal, David Rosand, and John Walsh, Jr. Princeton: Princeton University Press, 1982.

Henderson, Linda Dalrymple. "The Artist, 'The Fourth Dimension,' and Non-Euclidean Geometry in Modern Art, 1900–1930: A Romance of Many Dimensions." Ph.D. diss., Yale University, 1975.

———. *The Fourth Dimension and Non-Euclidean Geometry in Modern Art*. Princeton: Princeton University Press, 1983.

———. "Francis Picabia, Radiometers, and X-Rays in 1913." *Art Bulletin* 71 (Mar. 1988), 114–23.

———. "Italian Futurism and 'The Fourth Dimension.'" *Art Journal* 41 (Winter 1981), 317–23.

———. "Kupka, les rayons X, et le monde des ondes électro-magnétiques." In Musée d'Art Moderne de la Ville de Paris, *František Kupka, 1871–1957, ou l'invention d'une abstraction*, ed. Krisztina Passuth, pp. 51–57. Nov. 22, 1989–Feb. 25, 1990.

———. "Die moderne Kunst und das Unsichtbare: Die verborgenen Wellen und Dimensionen des Okkultismus und der Wissenschaften." In Schirn Kunsthalle, Frankfurt, *Okkultismus und Avant-Garde: Von Munch bis Mondrian, 1900–1915*, pp. 13–31. June 2–Aug. 20, 1995.

———. "Mysticism, Romanticism, and the Fourth Dimension." In Los Angeles County Museum of Art, *The Spiritual in Art: Abstract Painting, 1890–1985*, pp. 219–37. Nov. 23, 1986–Mar. 8, 1987.

———. "X Rays and the Quest for Invisible Reality in the Art of Kupka, Duchamp, and the Cubists." *Art Journal* 47 (Winter 1988), 323–40.

Herbert, Robert L., Eleanor S. Apter, and Elise K. Kenney, eds. *The Société Anonyme and the Dreier Bequest at Yale University: A Catalogue Raisonné*. New Haven: Yale University Press, 1984.

Hess, Thomas B. *Willem De Kooning*. New York: Museum of Modern Art, 1968.

Homer, William I. "Picabia's 'Jeune fille américaine dans l'état de nudité' and Her Friends." *Art Bulletin* 57 (Mar. 1975), 110–15.

Jean, Marcel, with Arpad Mezei. *The History of Surrealist Painting*. Trans. Simon Watson Taylor. New York: Grove Press, 1960.

Johnson, Ron. "Picasso's 'Demoiselles d'Avignon' and the Theatre of the Absurd." *Arts Magazine* 55 (Oct. 1980), 102–13.

Jones, Caroline A. "The Sex of the Machine: Mechanomorphic Art, New Women, and Francis Picabia's Neurasthenic Cure." In *Picturing Science, Producing Art,* ed. Caroline A. Jones and Peter Galison. London: Routledge, forthcoming.

Krauss, Rosalind E. *The Optical Unconscious*. Cambridge: MIT Press, 1993.

———. *The Originality of the Avant-Garde and Other Modernist Myths*. Cambridge: MIT Press, 1985.

———. *Passages in Modern Sculpture* (1977). Cambridge: MIT Press, 1981.

Kunsthalle Bern. *Tabu Dada: Jean Crotti & Suzanne Duchamp, 1915–1922*. Jan. 22–Feb. 27, 1983. Catalogue by William A. Camfield and Jean-Hubert Martin.

Landis, Linda Louise. "Critiquing Absolutism: Marcel Duchamp's *Etant donnés* and the Psychology of Perception." Ph.D diss., Yale University, 1991.

Laporte, Paul. "The Space-Time Concept in the Work of Picasso." *Magazine of Art*, 41 (Jan. 1948), 26–32. (See the critique of such articles in Henderson, *Fourth Dimension*, app. A.)

Leighten, Patricia. *Re-Ordering the Universe: Picasso and Anarchism, 1897–1914*. Princeton: Princeton University Press, 1989.

Long, Rose-Carol Washton. *Kandinsky: The Development of an Abstract Style*. Oxford: Clarendon, 1980.

Los Angeles County Museum of Art. *The Spiritual in Art: Abstract Painting, 1890–1985*. Nov. 23, 1986–Mar. 8, 1987. Essays by several authors.

Martin, Jean-Hubert. *Man Ray Photographs*. London: Thames and Hudson, 1981.

Martin, Marianne W. "Futurism, Unanism and Apollinaire." *Art Journal* 28 (Spring 1969), 258–68.

———. *Futurist Art and Theory, 1909–1915*. Oxford: Clarendon, 1968.

Metropolitan Museum of Art, New York. *Boccioni: A Retrospective*. Sept. 15, 1988–Jan. 8, 1989. Catalogue by Esther Coen.

Mitchell, Timothy. "Bergson, Le Bon, and Hermetic Cubism." *Journal of Aesthetics and Art Criticism* 36 (Winter 1977), 175–83.

Mount Holyoke College Art Museum, South Hadley, Mass. *When the Eiffel Tower Was New*. Apr. 9–June 18, 1989. Catalogue by Miriam Levin.

Murray, Ann H. "Henri Le Fauconnier's 'Das Kunstwerk': An Early Statement of Cubist Aesthetic Theory and Its Understanding in Germany." *Arts Magazine* 56 (Dec. 1981), 125–33.

Musée d'Art Moderne de la Ville de Paris. *Electra: L'Electricité et l'électrotechnique dans l'art au XXᵉ siècle*. Dec. 10, 1983–Feb. 5, 1984. Essays by several authors.

———. *František Kupka, 1871–1957, ou l'invention d'une abstraction*. Ed. Krisztina Passuth. Nov. 22, 1989–Feb. 25, 1990. Essays by several authors.

Musée National d'Art Moderne, Paris. *Francis Picabia*. Grand Palais, Paris, Jan. 23–Mar. 29, 1976. Essays by several authors.

Musée Picasso, Paris. *Le Miroir noir: Picasso, sources photographiques, 1900–1928*. Mar. 12–June 9, 1997.

Museum des 20. Jahrhunderts, Vienna. *Friedrich Kiesler: Architekt, Maler, Bildhauer, 1890–1965*. Ed. Dieter Bogner. Apr. 26–June 19, 1988. Vienna: Löcker, 1988.

Museum of Modern Art, New York. *The Machine as Seen at the End of the Mechanical Age*. 1968. Catalogue by K. G. Pontus Hultén.

———. *Max Ernst: Dada and the Dawn of Surrealism*. Mar. 14–May 2, 1993. Catalogue by William A. Camfield.

National Museum of American Art, Washington, D.C. *Perpetual Motif: The Art of Man Ray*. Dec. 2, 1988–Feb. 20, 1989. New York: Abbeville Press, 1988. Essays by several authors.

Naumann, Francis M. "Cryptography and the Arensberg Circle." *Arts Magazine* 51 (May 1977), 127–33.

———. "Man Ray, Early Paintings 1913–1916: Theory and Practice in the Art of Two Dimensions." *Artforum* 20 (May 1982), 37–46.

———. *New York Dada, 1915–23*. New York: Harry N. Abrams, 1994.

———. "Walter Conrad Arensberg: Poet, Patron, and Participant in the New York Avant-Garde, 1915–20." *Philadel-*

phia Museum of Art Bulletin 76 (Spring 1980), 2–32.

Nozslopy, George T. "Apollinaire, Allegory and the Visual Arts." *Forum for Modern Language Studies* 9 (Jan. 1973), 49–74.

Owens, Craig. "The Allegorical Impulse: Toward a Theory of Postmodernism." In *Art after Modernism: Rethinking Representation*, ed. Brian Wallis, pp. 203–35. New York: The New Museum of Contemporary Art, 1984.

Petrie, Brian. "Boccioni and Bergson." *Burlington Magazine* 116 (Mar. 1974), 140–47.

Pierre, Arnaud. "Sources inédites pour l'oeuvre machiniste de Francis Picabia, 1918–1922." *Bulletin de la Société de l'Histoire de l'Art français* (1991), 255–81. Paris: Société de l'Histoire de l'Art français, 1992.

Poggi, Christine. *In Defiance of Painting: Cubism, Futurism, and the Invention of Collage.* New Haven: Yale University Press, 1992.

Pressly, William L. "The Praying Mantis in Surrealist Art." *Art Bulletin* 55 (Dec. 1973), 600–615.

Richardson, John (with the collaboration of Marilyn McCully). *A Life of Picasso, Volume I (1881–1906).* New York: Random House, 1991.

Ringbom, Sixten. *The Sounding Cosmos: A Study in the Spiritualism of Kandinsky and the Genesis of Abstract Painting.* Abo: Abo Akademi, 1970.

Robbins, Daniel. "The Formation and Maturity of Albert Gleizes." Ph.D. diss., New York University, 1975.

———. "From Symbolism to Cubism: The Abbaye of Créteil." *Art Journal* 23 (Winter 1963–1964), 111–16.

Rosenberg, Martin E. "Portals in Pynchon and Duchamp." In *Thomas Pynchon: Schizophenia and Social Control.* Proceedings of the International Warwick Conference. *Pynchon Notes* 35 (Fall 1996), 148–75.

Rosenblum, Robert. "Picasso and the Typography of Cubism." In *Picasso in Retrospect*, ed. Roland Penrose and John Golding, pp. 33–47. New York: Praeger, 1973.

Rowell, Margit. "Kupka, Duchamp, and Marey." *Studio International*, 189 (Jan.–Feb. 1975), 48–52.

Safran, Yehuda, ed. *Frederick Kiesler, 1890–1965.* London: Architectural Association, 1989.

Samaltanos, Katia. *Apollinaire: Catalyst for Primitivism, Picabia, and Duchamp.* Ann Arbor: UMI Research Press, 1984.

Sanouillet, Michel. *Francis Picabia et "391."* Paris: Eric Losfeld, 1966.

Sawin, Martica. *Surrealism in Exile and the Beginning of the New York School.* Cambridge: MIT Press, 1995.

Schirn Kunsthalle, Frankfurt. *Okkultismus und Avant-Garde: Von Munch bis Mondrian, 1900–1915.* June 2–Aug. 20, 1995. Essays by several authors.

Shiff, Richard. *Cézanne and the End of Impressionism: A Study of the Theory, Technique, and Critical Evaluation of Modern Art.* Chicago: University of Chicago Press, 1984.

———. "On Criticism Handling History." *History of the Human Sciences* 2, no. 1 (1989), 63–87.

———. "Performing an Appearance: On the Surface of Abstract Expressionism." In Albright-Knox Art Gallery, Buffalo, *Abstract Expressionism: The Critical Developments*, ed. Michael Auping, pp. 94–123. Sept. 19–Nov. 29, 1987. New York: Harry N. Abrams, 1987.

Silk, Gerald. "Futurism and the Automobile." In *Twentieth Century Art Theory: Urbanism, Politics, and Mass Culture*, ed. Richard Hertz and Norman M. Klein, pp. 28–42. Englewood Cliffs, N.J.: Prentice Hall, 1990.

Solomon R. Guggenheim Museum. *František Kupka, 1871–1957: A Retrospective.* 1975. Curated by Margit Rowell. Essays by Margit Rowell and Meda Mladek.

Spate, Virginia. *Orphism: The Evolution of Non-Figurative Painting in Paris 1910–1914.* Oxford: Clarendon Press, 1979.

Spencer Museum of Art, Lawrence, Kansas. *Marius de Zayas: Conjurer of Souls.* Sept. 27–Nov. 18, 1981. Catalogue by Douglas Hyland.

Stokes, Charlotte. "The Scientific Methods of Max Ernst: His Use of Scientific Subjects from *La Nature*." *Art Bulletin* 57 (Sept. 1980), 453–65.

Szeemann, Harald, ed. *Junggesellenmaschinen/Les Machines célibataires.* Kunsthalle Bern, 1975. Venice: Alfieri, 1975. Essays by several authors.

Tashjian, Dickran. *A Boatload of Madmen: Surrealism and the American Avant-Garde, 1920–1950.* New York: Thames and Hudson, 1995.

Troy, Nancy J. *Modernism and the Decorative Arts in France: Art Nouveau to Le Corbusier.* New Haven: Yale University Press, 1991.

Tucker, Paul Hayes. "Picasso, Photography, and the Development of Cubism." *Art Bulletin* 64 (June 1982), 288–99.

Vallier, Dora. *Jacques Villon: Oeuvres de 1897 à 1956.* Paris: Editions "Cahiers d'Art," 1957.

———. "La Vie fait l'oeuvre de Fernand Léger." *Cahiers d'Art* 29 (1954), 133–72.

Vitz, Paul C., and Arnold B. Glimcher. *Modern Art and Modern Science: The Parallel Analysis of Vision.* New York: Praeger, 1984.

Watts, Harriet. *Chance: A Perspective on Dada.* Ann Arbor: UMI Research Press, 1980.

Whitney Museum of American Art, New York. *Frederick Kiesler.* Ed. Lisa Phillips. New York: W. W. Norton, 1989. Essays by several authors.

———. *Making Mischief: Dada Invades New York.* Nov. 21, 1996–Feb. 23, 1997. Curated by Francis Naumann. Essays by several authors.

C. STUDIES OF PHOTOGRAPHY AND FILM, INCLUDING THE WORK OF PHYSIOLOGIST ETIENNE-JULES MAREY

Braun, Marta. *Picturing Time: The Work of Etienne-Jules Marey (1830–1904).* Chicago: University of Chicago Press, 1992.

Buerger, Janet E. *French Daguerreotypes.* Chicago: University of Chicago Press, 1989.

Dagognet, François. *Etienne-Jules Marey: A Passion for the Trace.* New York: Zone, 1992.

Didi-Huberman, Georges. *Invention de l'hystérie: Charcot et*

l'iconographie photographique de la Salpêtrière. Paris: Macula, 1982.

———. "Photography—Scientific and Pseudo-Scientific." In *A History of Photography: Social and Cultural Perspectives,* ed. Jean-Claude Lemagny and André Rouillé, trans. Janet Lloyd, pp. 71–75. Cambridge: Cambridge University Press, 1987.

Frizot, Michel. *Avant le cinématographe—La Chronophotographie: Temps, photographie et mouvement autour de E.-J. Marey.* La Chapelle de l'Oratoire, Beaune, May 27–Sept. 3, 1984.

Musée des Arts Décoratifs, Paris. *Exposition commémorative du centennaire Georges Méliès.* 1961.

Toulet, Emmanuelle. *Cinématographe, invention du siècle.* Paris: Gallimard, 1988.

D. UNPUBLISHED MATERIALS

František Kupka Manuscripts, courtesy of Margit Rowell, New York, and Karl Flinker, Paris. Notebook (1910–11?) and preparatory notes and drafts for *Tvoření v umění výtvarném.* The original versions of these manuscripts are now held by Pierre Brullé, Paris.

III. SCIENCE AND TECHNOLOGY

A. GENERAL

1. Contemporary Sources

Basin, Jules. *Leçons de physique.* 3 vols. Paris: Librairie Nony, 1902.

Böttcher, Anton. *Cranes: Their Construction, Mechanical Equipment and Working.* Trans. A. Tolhausen. London: Archibald, Constable, 1908.

Borel, Emile. *Le Hasard.* Paris: Félix Alcan, 1914.

Byrn, Edward W. *The Progress of Invention in the Nineteenth Century.* New York: Munn, 1900.

Cochrane, Charles Henry. *The Wonders of Modern Mechanism.* 3d ed. Philadelphia: J. B. Lippincott, 1900.

Conservatoire National des Arts et Métiers, Paris. *Catalogue du Musée, Section GA: Physique Mécanique.* Paris: C.N.A.M., 1955.

———. *Catalogue officiel des collections du Conservatoire National des Arts et Métiers.* 6 vols. Paris: E. Bernard, 1905–10.

Deutsches Museum von Meisterwerken der Naturwissenschaft und Technik: Rundgang durch die Sammlungen. Munich: Deutsches Museum, n.d.

Dictionary of the History of Science. Ed. W. F. Bynum, E. J. Browne, and Roy Porter. Princeton: Princeton University Press, 1981.

Duncan, Robert Kennedy. *The New Knowledge: A Popular Account of the New Physics and the New Chemistry in Their Relation to the New Theory of Matter.* New York: A. S. Barnes, 1905.

Dupin, Charles. *Géometrie et mécanique des arts et métiers et des beaux-arts.* 3 vols. Paris: Bachelier, 1826.

Eiffel, G[ustave]. *Recherches expérimentales sur la résistance de l'air executées à la Tour Eiffel.* Paris: L. Maretheux, 1907.

———. *Travaux scientifiques.* Paris: L. Maretheux, 1900.

Gage, Alfred Payson. *The Elements of Physics.* Rev. ed. Boston: Ginn, 1898.

Good, Arthur [Tom Tit]. *La Science amusante,* 1st, 2d, 3d ser. Paris: Librairie Larousse, 1890, 1892, 1906.

Graffigny, Henri de Graffigny. "Le Machinisme agricole." *Revue Scientifique,* 4th ser., 19 (Apr. 4, 1903), 431–37.

Guarini, Emile. "La Crise agricole et l'électricité." *Revue Scientifique,* 4th ser., 20 (July 4, 1903), 15–18; 20 (Aug. 22, 1903), 233–37.

Helmholtz, Hermann von. *Popular Lectures on Scientific Subjects* (1873). Trans. E. Atkinson. New York: D. Appleton, 1885.

———. *Popular Lectures on Scientific Subjects.* Trans. E. Atkinson. 2d ser. New York: D. Appleton, 1881.

Kelvin, Lord [William Thomson]. *Popular Lectures and Addresses.* 3 vols. London: Macmillan, 1891.

Le Bon, Gustave. *L'Evolution de la matière.* Paris: Ernest Flammarion, 1905.

———. *L'Evolution des forces.* Paris: Ernest Flammarion, 1908.

———. "La Lumière noire." *L'Illustration* 107 (May 23, 1896), 431–32.

———. *Les Opinions et les croyances: Genèse—Evolution.* Paris: Ernest Flammarion, 1911.

———. "La Renaissance de la magie." *Revue Scientifique* 48 (Mar. 26, 1910), 391–97; 48 (Apr. 2, 1910), 426–35.

Lockyear, Sir Norman. *L'Evolution inorganique.* Trans. E. d'Hooghe. Paris: Félix Alcan, 1905.

———. *Inorganic Evolution as Studied by Spectrum Analysis.* London: Macmillan, 1900.

Meyer, Wilhelm M. *Die Naturkräfte.* Leipzig: Bibliographisches Institut, 1903.

Millikan, Robert Andrews, and Henry Gordon Gale. *Practical Physics.* Boston: Ginn, 1920.

Poincaré, Henri. *Calcul des probabilités.* 2d ed. rev. Paris: Gauthier-Villars, 1912.

———. *Dernières Pensées.* Paris: Ernest Flammarion, 1913.

———. "L'Etat actuel et l'avenir de la physique mathématique." *Revue des Idées* 1 (Nov. 15, 1904), 801–18.

———. *The Foundations of Science: Science and Hypothesis, the Value of Science, Science and Method.* Trans. George B. Halsted. New York: Science Press, 1913.

———. *Mathematics and Science: Last Essays (Dernières Pensées).* Trans. John W. Bolduc. New York: Dover, 1963.

———. *La Science et l'hypothèse.* Paris: Ernest Flammarion, 1902.

———. *Science et méthode.* Paris: Ernest Flammarion, 1908.

———. *La Valeur de la science.* Paris: Ernest Flammarion, 1904.

Poincaré, Lucien. *La Physique moderne: Son Evolution.* Paris:

Ernest Flammarion, 1906. Trans. as *The New Physics and Its Evolution* (London: Kegan, Paul, Trench, Trübner, 1907).

Scientific Instruments, Laboratory Apparatus and Supplies. Chicago: Central Scientific Co., 1936.

Smith, Oliver. *Press-Working of Metals.* New York: John Wiley, 1899.

Thomson, J. J. *Recollections and Reflections.* London: G. Bell, 1936.

Tracy, J. C. *Introductory Course in Mechanical Drawing.* New York: American Book Co., 1898.

Violle, J. *Cours de physique.* 4 vols. Paris: G. Masson, 1883–92.

Worthington, A. M. "The Splash of a Drop and Allied Phenomena." In *Annual Report of the Smithsonian Institution, 1894*, pp. 197–211. Washington, D.C.: G.P.O., 1896.

———. *A Study of Splashes.* London: Longmans & Green, 1908.

2. Secondary Sources

Beer, Gillian. "Wave Theory and the Rise of Literary Modernism." In *Realism and Representation: Essays on the Problem of Realism in Relation to Science, Literature, and Culture*, ed. George Levine, pp. 193–213. Madison: University of Wisconsin Press, 1993.

Béguet, Bruno, ed. *La Science pour tous: Sur la vulgarisation scientifique en France de 1850 à 1914.* Paris: Bibliothèque du Conservatoire des Arts et Métiers, 1990.

Benson, Donald R. "Facts and Fictions in Scientific Discourse: The Case of the Ether." *Georgia Review* 38 (Winter 1984), 825–37.

Bernhard, Carl Gustaf, Elisabeth Crawford, and Per Sörbom, eds. *Science, Technology, and Society in the Time of Alfred Nobel.* Nobel Symposium 52. Oxford: Pergamon, 1982.

Bodmer, Rudolph T. *The Book of Wonders.* New York: Bureau of Industrial Education, 1916.

Bono, James J. "Science, Discourse, and Literature: The Role/Rule of Metaphor in Science." In *Literature and Science: Theory and Practice*, ed. Stuart Peterfreund, pp. 59–89. Boston: Northeastern University Press, 1990.

Ferrand, L[ouis]. *Histoire de la science et des techniques de l'aluminium et ses développements industriels.* 2 vols. L'Argentière: Imprimerie Humbert & Fils, 1960.

Giedion, Siegfried. *Mechanization Takes Command: A Contribution to Anonymous History* (1948). New York: W. W. Norton, 1969.

Hacking, Ian. "Nineteenth Century Cracks in the Concept of Determinism." *Journal of the History of Ideas* 44 (July–Sept. 1983), 455–75.

Harman, P. M. *Energy, Force, and Matter.* Cambridge: Cambridge University Press, 1982.

Heilbron, J. L., "*Fin-de-siècle* Physics." In *Science, Technology, and Society in the Time of Alfred Nobel*, ed. Carl Gustaf Bernhard, Elisabeth Crawford, and Per Sörbom, pp. 51–73. London: Pergamon, 1982.

Hughes, Thomas P. *American Genesis: A Century of Technological Enthusiasm, 1870–1970.* New York: Penguin, 1989.

Keller, Alex. *The Infancy of Atomic Physics: Hercules in His Cradle.* Oxford: Clarendon, 1983.

Klein, Martin J. "Mechanical Explanation at the End of the Nineteenth Century." *Centaurus* 17 (1972), 58–82.

Musée d'Orsay, Paris. *La Science pour tous.* Ed. Bruno Béguet. Mar. 14–June 12, 1994. Paris: Réunion des Musées Nationaux, 1994.

Nye, Mary Jo. "Gustave Le Bon's Black Light: A Study in Physics and Philosophy in France at the Turn of the Century." In *Historical Studies in the Physical Sciences* 4 (1974), 163–95.

———. "N-rays: An Episode in the History and Psychology of Science." In *Historical Studies in the Physical Sciences* 11 (1980), 125–56.

Ord-Hume, Arthur. *Perpetual Motion: The History of an Obsession.* New York: St. Martin's Press, 1977.

Ruhla, Charles. *The Physics of Chance: From Blaise Pascal to Niels Bohr.* Trans. G. Barton. Oxford: Oxford University Press, 1992.

Spence, Clark C. *God Speed the Plow: The Coming of Steam Cultivation to Great Britain.* Urbana: University of Illinois Press, 1960.

Weart, Spencer R. *Scientists in Power.* Cambridge: Harvard University Press, 1979.

Wright, Lawrence. *Clean and Decent: The Fascinating History of the Bathroom and the Water Closet.* New York: Viking, 1960.

B. INDIVIDUAL SCIENTISTS

1. Sir William Crookes

a. Writings and Contemporary Sources

Brieu, Jacques. "Esotérisme et spiritisme" (review of Crookes's *Discours récents sur les recherches psychiques*). *Mercure de France* 46 (May 1903), 513–14.

Crookes, Sir William. "Address by Sir William Crookes, F.R.S., V.P.C.S., President." *Report of the Sixty-Eighth Meeting of the British Association for the Advancement of Science*, pp. 3–33. London: John Murray, 1899.

———. "L'Atome électrique." *Revue Scientifique*, 3d ser., 49 (Jan. 16, 1892), 80–81.

———. "De la relativité des connaissances humaines." *Revue Scientifique*, 4th ser., 7 (May 15, 1897), 609–13.

———. *Discours récents sur les recherches psychiques.* Trans. M. Sage. Paris: P.-G. Leymarie, 1903. Reprinted as "Discours sur les recherches psychiques." *Les Nouveaux Horizons de la Science et de la Pensée* 9 (Feb. 1904), 61–74; 9 (Mar. 1904), 106–11; 9 (Sept. 1904), 316–24; 9 (Oct. 1904), 348–56.

———. "Modern Views on Matter: The Realization of a Dream." *Annual Report of the Smithsonian Institution, 1903*, pp. 229–41. Washington, D.C.: G.P.O., 1904.

———. "Les Progrès récents des sciences physiques." *Revue Scientifique*, 4th ser., 10 (Oct. 8, 1898), pp. 449–57.

———. *Recherches sur les phénomènes du spiritualisme: Nouvelles Expériences sur la force psychique.* Trans. J. Alidel. Paris: Librairie des Sciences Psychologiques, 1886.

———. *Researches in the Phenomena of Spiritualism.* London: J. Burns, 1874.

———. "Sir William Crookes on Psychical Research: I. Extract from Address Before the British Association for the Advancement of Science; II. Address before the Society for Psychical Research." *Annual Report of the Smithsonian Institution, 1899,* pp. 185–205. Washington, D.C.: G.P.O., 1901.

———. "Some of the Latest Achievements of Science." *Annual Report of the Smithsonian Institution, 1899,* pp. 143–53. Washington, D.C.: G.P.O., 1901.

———. "Some Possibilities of Electricity." *Fortnightly Review* 57 (Feb. 1892), 173–81.

———. "Les Théories modernes sur la matière: La Réalisation d'un rêve." *Revue Scientifique,* 4th ser., 10 (Aug. 22, 1903), 224–33.

T., W. A. "Sir William Crookes, O.M., 1832–1919." *Proceedings of the Royal Society of London,* ser. A, 96 (Feb. 1920), i–ix.

Zeeman, P. "Sir William Crookes, F.R.S.: The Apostle of Radiant Matter." *Scientific American Supplement,* no. 1672 (Jan. 18, 1908), pp. 44–45.

b. Secondary Sources

De Kosky, Robert K. "William Crookes and the Fourth State of Matter." *Isis* 67 (Mar. l976), 36–60.

Fournier d'Albe, E. E. *The Life of Sir William Crookes, O.M., F.R.S.* London: D. Appleton, l923.

Greenaway, Frank. "A Victorian Scientist: The Experimental Researches of Sir William Crookes (1832–1919)." *Proceedings of the Royal Institution of Great Britain* 39 (1962), 172–98.

Woodruff, A. E. "William Crookes and the Radiometer." *Isis* 57 (Summer 1966), 188–98.

2. Sir Oliver Lodge

a. Writings and Contemporary Sources

Jollivet Castellot, François. "Les Théories modernes de l'électricité" (review and summary of Sir Oliver Lodge's *Modern Views of Electricity*). *Les Nouveaux Horizons de la Sciences et de la Pensée* 11 (July 1906), 290–93; 11 (Aug.–Sept.–Oct. 1906), 323–37.

Lodge, Sir Oliver. "Electric Theory of Matter." *Harper's Monthly* 109 (Aug. 1904), 383–89.

———. "Electricité et matière." *Revue Scientifique,* 4th ser., 19 (May 2, 1903), 554–59.

———. *Electrons, or the Nature and Properties of Negative Electricity* (1907). 4th ed. London: G. Bell, 1913.

———. *The Ether of Space.* London and New York: Harper & Bros., 1909.

———. "The Ether of Space." *North American Review* 187 (May 1908), 724–36.

———. *Lightning Conductors and Lightning Guards.* London: Whittaker, 1892.

———. *Modern Views of Electricity* (1889). 3d ed. London: Macmillan, 1907. First edition trans. by E. Meylan as *Les Théories modernes de l'électricité: Essai d'une théorie nouvelle* (Paris: Gauthier-Villars, 1891).

———. "On Electrons." *Journal of the Proceedings of the Institution of Electrical Engineers* 32 (1903), 1–71. Trans. by E. Nugues and J. Péridier as *Sur les électrons* (Paris: Gauthier-Villars, 1906).

———. *Signalling across Space without Wires: The Work of Hertz and His Successors.* 4th ed. London: "The Electrician," 1913. Originally published as *The Work of Hertz and His Successors.* London: "The Electrician," 1894.

———. "Thought Transference." *Forum* 41 (Jan. 1909), 56–62.

b. Secondary Sources

Rowlands, Peter. *Oliver Lodge and the Liverpool Physical Society.* Liverpool: Liverpool University Press, 1990.

Wilson, David B. "The Thought of Late Victorian Physicists: Oliver Lodge's Ethereal Body." *Victorian Studies* 15 (Sept. 1971), 29–48.

3. Nikola Tesla

a. Writings and Contemporary Sources

d'Ault, J. "Les Merveilles électriques de M. Tesla." *La Revue des Revues* 13 (May 1, 1895), 197–207.

Brisbane, Arthur. "Our Foremost Electrician." *New York World,* July 22, 1894, p. 17. Reprinted in *Electrical World* 24 (Aug. 4, 1894), p. 97

Emerson, J. E. "Tesla at the Royal Institution." *Scientific American* 69 (Mar. 12, 1892), 168.

Hospitalier, E. "Expériences de M. Tesla sur les courants alternatifs de grande fréquence." *La Nature* 19 (Aug. 15, 1891), 162–67.

———. "Expériences de M. Tesla sur les courants alternatifs de grande fréquence." *La Nature* 20 (Mar. 5, 1892), 209–11.

———. "Mr. Tesla's Experiments on Alternating Currents of Great Frequency." *Scientific American* 66 (Mar. 26, 1892), 195–96.

Laffargue, J. "Production d'effluves—Appareil à grande tension et à haute fréquence: Expériences faites au centenaire du Conservatoire des Arts et Métiers." *La Nature* 26 (July 16, 1898), 103–6.

Martin, Thomas Commerford. *The Inventions, Researches and Writings of Nikola Tesla.* New York: Electrical Engineer, 1894.

———. "Tesla's Oscillator and Other Inventions." *Century Magazine* 49 (Nov. 1894), 916–33.

"Nikola Tesla's Latest Invention: Controls a Boat by Radio." *Scientific American* 79 (Nov. 19, 1898), 326.

Tesla, Nikola. *Experiments with Alternate Current of High Potential and High Frequency.* New York: McGraw, 1904.

———. *Nikola Tesla: Lectures, Patents, Articles.* Belgrade: Nikola Tesla Museum, 1956.

———. "The Problem of Increasing Human Energy, with Special Reference to the Harnessing of the Sun's Energy." *Century Magazine* 60 (June 1900), 175–211.

———. "Sur les courants de grande fréquence et de grande tension." *Bulletin de la Société Internationale des Electriciens* 9 (1892), 67–69, 169–89, 228–48, 272–95.

———. "Les Vibrations électriques fréquentes." *Revue Scientifique,* 3d ser., 51 (June 17, 1893), 737–42.

"Tesla's Experiments." *Electrical Engineer* 14 (March 11, 1892), 242.

"Tesla's Speculations Ridiculed—Severe Criticism of Electrical Inventor's Divagations in Higher Fields—His Work in Fundamental Theories Questioned." *New York Sun*, Sept. 29, 1900.

"Three Nobel Prizes for Americans." *Literary Digest* 51 (Dec. 18, 1915), 1426.

Troller, A. "La Turbine à vapeur Tesla." *La Nature* 39 (Nov. 4, 1911), 356–58.

Vigoreux, R. "Sur l'emploi thérapeutique des courants à haute fréquence (courants de Tesla)." *L'Electricien*, 2d ser., 10 (Nov. 14, 1896), 309–14.

Wetzler, Joseph. "Electric Lamps Fed from Space and Flames That Do Not Consume." *Harper's Weekly* 35 (July 11, 1891), 524.

b. Secondary Sources

Cheney, Margaret. *Tesla: Man Out of Time.* New York: Dell Co., 1981.

Nikola Tesla: Livre commémoratif à l'occasion de son 80ème anniversaire. Beograd: Edition de la Société pour la Fondation de l'Institut Nikola Tesla, 1936.

O'Neill, John J. *Prodigal Genius: The Life of Nikola Tesla.* New York: David McKay, 1944.

Popovic, Vojin, ed. *Tribute to Nikola Tesla, Presented in Articles, Letters, Documents.* Beograd: Nikola Tesla Museum, 1961.

Ratzlaff, John T., and Leland I. Anderson. *Nikola Tesla Bibliography.* Palo Alto: Ragusan Press, 1979.

Swezey, Kenneth M. "Nikola Tesla." *Science* 127 (May 16, 1958), 1147–59.

4. Leonardo da Vinci

a. Writings and Turn-of-the-Century Sources

Duhem, Pierre. *Etudes sur Léonard de Vinci: Ceux qu'il a lus et ceux qui l'ont lu.* 1st ser. Paris: A. Hermann, 1906. Reprint, Paris: F. de Nobele, 1955.

———. *Etudes sur Léonard de Vinci: Ceux qu'il a lus et ceux qui l'ont lu.* 2d ser. Paris: A. Hermann, 1909. Reprint, Paris: F. de Nobele, 1955.

———. *Etudes sur Léonard de Vinci: Les Précurseurs parisiens de Galilée.* 3d ser. Paris: A Hermann, 1913. Reprint, Paris: F. de Nobele, 1955.

Gourmont, Remy de. "La Science de Léonard de Vinci." *La Revue des Idées* 5 (Feb. 1908), 193–96.

MacCurdy, Edward, ed. and trans. *The Notebooks of Leonardo da Vinci.* New York: George Braziller, 1956.

Péladan. "Un Idéalisme expérimental: La Philosophie de Léonard de Vinci d'après ses manuscrits." *Mercure de France* 71 (Jan. 16, 1908), 193–214; 71 (Feb. 1, 1908), 440–61.

Péladan, trans. and comment. *Léonard de Vinci: Textes choisis—Pensées, théories, préceptes, fables, et facéties.* Paris: Société du "Mercure de France," 1908.

———. *Léonard de Vinci: Traité de la peinture.* Paris: C. Delagrave, 1910.

Ravaisson-Mollien, Charles, ed. and trans. *Les Manuscrits de Léonard de Vinci.* 6 vols. Paris: A. Quantin, 1881–91.

Richter, Jean Paul, comp. and ed. *The Literary Works of Leonardo da Vinci.* London: Sampson Low, Marston, Searle & Rivington, 1883.

———. *The Notebooks of Leonardo da Vinci.* 2 vols. New York: Dover, 1970.

Valéry, Paul. "Introduction à la méthode de Léonard de Vinci," *La Nouvelle Revue* 95 (Aug. 15, 1895), 742–70.

———. *Introduction à la méthode de Léonard de Vinci.* Paris: Librairie de la "Nouvelle Revue," 1895.

b. Secondary Sources, Including Turn-of-the-Century Sources

Cooper, Margaret. *The Inventions of Leonardo da Vinci.* New York: Macmillan, 1965.

Hart, Ivor B. *The Mechanical Investigations of Leonardo da Vinci.* London: Chapman & Hall, 1925.

Kemp, Martin. *Leonardo da Vinci: The Marvellous Works of Nature and Man.* Cambridge: Harvard University Press, 1981.

Shattuck, Roger. "The Tortoise and the Hare: Valéry, Freud, and Leonardo da Vinci" (1965). In Shattuck, *The Innocent Eye: On Modern Literature & the Arts*, pp. 82–101. New York: Farrar Straus Giroux, 1984.

C. ELECTRICITY AND ELECTROMAGNETISM

1. Contemporary Sources

Bohn, Georges. "Le Mouvement scientifique" (review of Lucien Poincaré's *L'Electricité*). *Mercure de France* 68 (July 1, 1907), 139–41.

Broca, André. "Le Spectre solaire et ce qui semble devoir s'y rattacher." *Revue Scientifique*, 4th ser., 6 (July 4, 1896), 1–5.

Claude, Georges. *L'Electricité à la portée de tout le monde* (1901). 5th ed. Paris: Ch. Dunod, 1905.

Colwell, Hector A. *An Essay on the History of Electrotherapy and Diagnosis.* London: William Heinemann, 1922.

Ferrand, A. *Les Dynamos et les transformateurs à l'Exposition Universelle de 1900*. Paris: E. Bernard, 1902.

"The Foreign Power Section of the Paris Exposition." *Scientific American Supplement* 50 (July 21, 1900), 20534–35.

Guillemin, Amédée. *Electricity and Magnetism*. Rev. and ed. Silvanus P. Thompson. London: Macmillan, 1891.

Houston, Edwin J. "Cerebral Radiation." *Journal of the Franklin Institute* 133 (June 1892), 488–97.

Poincaré, Henri. "Light and Electricity According to Maxwell and Hertz." *Annual Report of the Smithsonian Institution, 1894*, pp. 129–39. Washington, D.C.: G.P.O., 1896.

Poincaré, Lucien. *L'Electricité*. Paris: Ernest Flammarion, 1907.

"The Power-Generating Plant at the Paris Exposition." *Scientific American Supplement* 49 (June 16, 1900), 20447–50.

"Simple Explanation of High Frequency Current." *Popular Electricity in Plain English* 1 (Aug. 1908), 198–201.

Thompson, Silvanus P. *Dynamo-Electric Machinery*. 2 vols. New York: P. F. Collier, 1902.

———. *Elementary Lessons in Electricity and Magnetism* (1881). Rev. ed. New York: Macmillan, 1894.

———. *Elementary Lessons in Electricity and Magnetism*. Rev. and enl. ed. New York: Macmillan, 1915.

———. *Leçons élémentaires d'électricité et de magnétisme*. Trans. L. Binet. Paris: J. Fritsch, 1898.

———. *Light Visible and Invisible*. New York: Macmillan, 1897.

———. *Radiations visibles et invisibles*. 2d ed. Paris: A. Hermann, 1914.

Weiler, Lazare. "Les Sources de l'électricité." *Revue des Deux Mondes* 150 (1898), 856–74.

2. Secondary Sources

Benoit, Serge. "De l'hydro-mécanique à hydro-électricité: Le Role des sites hydrauliques anciens dans l'électrification de la France, 1880–1914." In *La France des électriciens, 1880–1980*, ed. Fabienne Cardot, pp. 5–36. Paris: Presses Universitaires de France, 1986.

Bordeau, Sanford P. *Volts to Hertz . . . The Rise of Electricity*. Minneapolis: Burgess, 1982.

Burke, James. *The Day the Universe Changed*. Boston: Little, Brown, 1985.

Cardot, Fabienne, ed. *L'Electricité dans l'histoire: Problèmes et méthodes*. Colloque de l'Association pour l'Histoire de l'Electricité en France, Oct. 11–13, 1983. Paris: Presses Universitaires de France, 1985.

———. *La France des électriciens 1880–1980*. Actes du deuxième colloque de l'Association pour l'Histoire de l'Electricité en France, Apr. 16–18 1985. Paris: Presses Universitaires de France, 1986.

Electro Importing Catalog 14. 2d. ed. New York: Electro Importing Co., 1914. Reprint, Bradley, Ill.: Lindsay, 1988.

Greenway, John L. "'Nervous Disease' and Electric Medicine." In *Pseudo-Science and Society in Nineteenth-Cen-tury America*, ed. Arthur Wrobel, pp. 52–73. Lexington: University Press of Kentucky, 1987.

Hughes, Thomas P. *Networks of Power: Electrification in Western Society, 1880–1930*. Baltimore: Johns Hopkins University Press, 1983.

Hunt, Bruce J. *The Maxwellians*. Ithaca: Cornell University Press, 1991.

McCormmach, Russell. "H. A. Lorentz and the Electromagnetic View of Nature." *Isis* 61 (Winter 1970), 459–97.

Meyer, Herbert W. *A History of Electricity and Magnetism*. Cambridge: MIT Press, 1971.

D. X-RAYS

1. Contemporary Sources

Aubert, L. *La Photographie de l'invisible: Les Rayons X*. Paris: Schleicher Frères, 1898.

Bixby, James T. "Professor Roentgen's Discovery and the Invisible World around Us." *Arena* 15 (May 1896), 871–85.

"The Cabaret du Néant." *Scientific American* 74 (Mar. 1896), 152–53.

Caze, L. "La Photographie de la pensée." *La Revue des Revues* 24 (Feb. 15, 1898), 438–42.

Dam, H. J. W. "The New Marvel in Photography." *McClure's Magazine* 6 (Apr. 1896), 403–15.

Dastre, A. "The New Radiations: Cathode Rays and Röntgen Rays." In *Annual Report of the Smithsonian Institution, 1901*, pp. 271–86. Washington, D.C.: G.P.O., 1902.

———. "Les Nouvelles Radiations: Rayons cathodiques et rayons Röntgen." *Revue des Deux Mondes*, 5th ser., 6 (Dec. 1, 1901), 682–702.

Gradenwitz, Alfred. "A Novel System of X-Ray Cinematography." *Scientific American* 103 (Sept. 24, 1910), 232, 247.

Guillaume, Charles-Edouard. *Les Rayons X et la photographie à travers les corps opaques*. 2d ed. Paris: Gauthier-Villars, 1896.

Henry, Charles. *Les Rayons Röntgen*. Paris: Société d'Editions Scientifiques, 1897.

Honoré, Fernand. "La Radiographie." *L'Illustration* 54 (Mar. 7, 1896), 200–201.

Kaye, G. W. C. *X Rays: An Introduction to the Study of Röntgen Rays*. London: Longmans, Green, 1914.

L., J. "Etude expérimentale des ampoules utilisées en radiographie et fluoroscopie." *La Nature* 24 (Nov. 21, 1896), 585–87.

Moffett, Cleveland. "The Röntgen Rays in America." *McClure's Magazine* 6 (Apr. 1896), 415–20.

Niewenglowski, Gaston Henri. *Techniques et applications des rayons X*. Paris: Radiguet, 1898.

"La Photographie de l'invisible." *Revue Générale des Sciences Pures et Appliquées* 7 (Jan. 30, 1896), 49–51.

Poincaré, Henri. "Les Rayons cathodiques et les rayons Röntgen." *Revue Générale des Sciences Pures et Appliquées* 7 (Jan. 30, 1896), 52–59.

Rochas, Albert de, and X. Darieux. "Pourquoi les rayons de Röntgen sont invisibles," *Revue Scientifique*, 4th ser., 5 (Feb. 22, 1896), 282.

Röntgen, W. C. "Upon a New Kind of Rays" (1895). Reprinted in *Annual Report of the Smithsonian Institution, 1897*, pp. 138–55. Washington, D.C.: G.P.O., 1898.

Snyder, Carl. "The World beyond Our Senses." *Harper's Monthly* 107 (June 1903), 117–20.

Speed, J. G. "The Brain, X-Rays, and the Cinematograph," *Westminister Review* 175 (Mar. 1911), 269–73.

Thompson, Edward P. *Roentgen Rays and Phenomena of the Anode and Cathode*. New York: D. Van Nostrand, 1896.

"Tubes for the Production of Roentgen Rays." *Nature* 55 (Jan. 28, 1897), 296–97.

Tutton, B. E. H. "Crystal Structure Revealed by Röntgen Rays: A Glimpse of the Molecular Architecture of Solids." *Scientific American Supplement* 74 (Dec. 21, 1912), 391.

2. Secondary Sources

Glasser, Otto. *Wilhelm Conrad Röntgen and the Early History of the Roentgen Rays*. Springfield, Ill.: Charles C. Thomas, 1934.

———. *Wilhelm Conrad Röntgen und sie Geschichte der Röntgenstrahlen*. 2d ed. Berlin: Springer-Verlag, 1959.

Kevles, Bettyann Holtzmann. *Naked to the Bone: Medical Imaging in the Twentieth Century*. New Brunswick, N.J.: Rutgers University Press, 1997.

Knight, Nancy. "'The New Light': X Rays and Medical Futurism." In *Imagining Tomorrow: History, Technology, and the American Future*, ed. Joseph J. Corn, pp. 10–34. Cambridge: MIT Press, 1986.

Nitske, W. Robert. *The Life of Wilhelm Conrad Röntgen, Discoverer of the X Ray*. Tucson: University of Arizona Press, 1971.

Sarton, George. "The Discovery of X-Rays." *Isis* 26 (Mar. 1937), 349–64.

E. WIRELESS TELEGRAPHY AND COMMUNICATION TECHNOLOGY

1. Contemporary Sources

Arnò, Riccardo. "Rivelatore di onde hertzienne a campo Ferraris." *Atti Elettrotecnica Italiana* 8 (1904), 354–59.

Bottone, S. R. *Wireless Telegraphy*. London: Whittaker, 1900.

Boulanger, J., and G. Ferrié. *La Télégraphie sans fil et les ondes électriques*. Paris: Berger-Levrault, 1909.

Brenot, P. "La Télégraphie sans fil." *La Revue des Idées* 4 (Apr. 15, 1907), 289–313.

Broca, André. *La Télégraphie sans fils*. Paris: Gauthier-Villars, 1904.

"Comment installer chez soi un poste récepteur de télégraphie sans fil." *La Science et la Vie* 1 (May 1913), 266–67.

Curtis, Thomas Stanley. *High Frequency Apparatus: Its Construction and Practical Application*. New York: Everyday Mechanics, 1916.

Dosne, P. "La Télégraphie sans fil à la portée de tout le monde." *La Nature* 40 (June 15, 1912), 42–43; 40 (July 13, 1912), 99–101.

"Dr. Branly's Apparatus for Control of Distant Mechanical Effects." *Scientific American* 97 (Dec. 28, 1907), 478–80.

Dragoumis, D. J. "Note on the Use of Geissler's Tubes for Detecting Electrical Oscillations." *Nature* 39 (April 4, 1889), 548–49.

Erskine-Murray, James. *A Handbook of Wireless Telegraphy: Its Theory and Practice*. New York: D. Van Nostrand, 1909.

Ferrié, G. "La Télégraphie sans fil et le problème de l'heure." *Revue Scientifique* 51 (July 19, 1913), 70–75.

Fleming, J. A. *The Principles of Electric Wave Telegraphy*. London: Longmans, Green, 1906.

———. *The Principles of Electric Wave Telegraphy and Telephony*. 3d ed. London: Longmans, Green, 1916.

Fournier, Lucien. "Télégraphie, téléphonie et télégraphie sans fil en 1905." *La Nature* 34 (Apr. 14, 1906), 305–7.

Gradenwitz, Alfred. "The Operation of Mechanical Devices at a Distance by Means of the Wireless Transmission of Energy." *Scientific American Supplement* 43 (June 8, 1907), 26276–77.

———. "La Première Solution réelle du problème de la télévision." *Revue Générale des Sciences Pures et Appliquées* 20 (Sept. 15, 1909), 727–28.

———. "La Transmission à distance des écritures et dessins." *Revue Générale des Sciences Pures et Appliquées* 16 (Nov. 15, 1905), 924–25.

Guarini, Emile. "Les Ondes électriques et le cerveau humain." *La Nature* 30 (Aug. 25, 1902), 177–78.

———. "La Télégraphie sans fil en France." *Revue Scientifique*, 4th ser., 19 (May 9, 1903), 590–96.

———. "Wireless Telegraphy Experiments at the Eiffel Tower." *Scientific American Supplement* 59 (Feb. 25, 1905), 24365–66.

Honoré, F. "La Télégraphie sans fil à la Tour Eiffel." *L'Illustration* 137 (Mar. 18, 1911), 200–201.

Laffargue, J. "La Télégraphie sans fils." *La Nature* 26 (June 4, 1898), 1–2.

Maver, William. *Maver's Wireless Telegraphy: Theory and Practice*. New York: Maver, 1904.

Merle, René. "Enregistrement des ondes hertziennes par la patte de grenouille." *La Nature* 40 (Sept. 21, 1912), 259–60.

"Les Merveilles du télégraphie sans fil." *Je Sais Tout* 1 (July 1905), 63–72 (falsely signed as by "Dr. Branly").

Monier, E. *La Télégraphie sans fil, la télémécanique, et la téléphonie sans fil à la portée de tout le monde* (1906). 9th ed., Paris: H. Dunod & E. Pinat, 1917.

Poincaré, Henri, and Frederick K. Vreeland. *Maxwell's Theory and Wireless Telegraphy*. New York: McGraw, 1904.

Stanley, Rupert. *Text Book on Wireless Telegraphy*. London: Longmans, Green, 1914.

Tissot, C. "Détecteurs d'ondes électriques à gaz ionisés." *Journal de Physique Théorique et Appliquée* 4 (Jan. 1907), 25–31.

———. "L'Etat actuel de la télégraphie sans fil." *Revue Générale des Sciences Pures et Appliquées* 14 (Oct. 15, 1903), 973–90.

Toché, Lt. Carlo. "Ondes qui passent, étincelles qui chantent." *Je Sais Tout* 8 (May 15, 1912), 645–54.

Torquet, Charles. "La TSF étend son règne sur le monde." *Je Sais Tout* 6 (Dec. 15, 1910), 589–98.

Varigny, Henry de. "La Vision à distance." *L'Illustration* 134 (Dec. 11, 1909), 451.

2. Secondary Sources

Aitken, Hugh G. J. *The Continuous Wave: Technology and American Radio, 1900–1932*. Princeton: Princeton University Press, 1985.

———. *Syntony and Spark: The Origins of Radio*. New York: John Wiley, 1976.

Dalton, W. M. *The Story of Radio*. 3 vols. London: Adam Hilger, 1975.

Jolly, W. P. *Marconi*. London: Constable, 1972.

Lewis, Tom. *Empire of the Air: The Men Who Made Radio*. New York: HarperCollins, 1991.

Marvin, Carolyn. *When Old Technologies Were New: Thinking About Electric Communication in the Late Nineteenth Century*. New York: Oxford University Press, 1988.

F. ATOM THEORY, ELECTRONS, AND RADIOACTIVITY

1. Contemporary Sources

Bohn, Georges. "Le Radium et la radioactivité de la matière." *La Revue des Idées* 1 (Jan. 15, 1904), 3–15.

Boys, Ch. Vernon. "Les Corps radio-actifs et la queue des comètes." *Revue Scientifique*, 4th ser., 20 (Oct. 10, 1903), pp. 449–59.

De Launay, L. "Les Ions et les électrons." *La Nature* 37 (Jan. 2, 1909), 70–71.

———. "La Matière et l'éther." *La Nature* 36 (Nov. 21, 1908), 391–92.

Dubois, Raphael. "La Radio-activité et la vie." *La Revue des Idées* 1 (May 15, 1904), 338–48.

Duncan, Robert Kennedy. "The Whitherward of Matter." *Harper's Monthly* 116 (May 1908), 877–84.

"The Garden of Eden in the Light of the New Physics." *Current Literature* 47 (July 1909), 91–92.

Gibson, Charles Robert. *The Autobiography of an Electron*. London: Seeley, 1911.

Heisenberg, Werner. "The Quantum Theory: A Formula Which Changed the World." *Trans/formation: Arts, Communication, Environment* 1 (1952), 129–34.

Le Bon, Gustave. "L'Energie intra-atomique." *Revue Scientifique*, 4th ser., 20 (Oct. 17, 1903), 481–99; 20 (Oct. 24, 1903), 513–19; 20 (Oct. 31, 1903), 551–59.

———. "La Dematérialisation de la matière." *Revue Scientifique*, 5th ser., 2 (Nov. 19, 1904), 641–51; 2 (Dec. 10, 1904), 737–40.

———. "Intra-Atomic Energy." *Annual Report of the Smithsonian Institution, 1903*, pp. 263–93. Washington, D.C.: G.P.O., 1904.

———. "Naissance et évolution de la matière." *La Revue des Idées* 4 (Oct. 15, 1907), 861–80.

Leblanc, Maurice. "Aspect de la décharge électrique dans les gaz rarifiés." *La Nature* 39 (Dec. 3, 1910), 7–10.

Matisse, G. "Histoire extraordinaire des Electrons." *Mercure de France* 75 (Oct. 16, 1908), 744–46.

Merritt, Ernest. "The New Element Radium." *Century Magazine* 67 (Jan. 1904), 451–60.

Rutherford, Ernest. "Disintegration of the Radioactive Elements," *Harper's Monthly* 108 (Jan. 1904), 279–84.

———. *Radio-activity*. Cambridge: Cambridge University Press, 1904.

———. "The Scattering of α and ß Particles by Matter and the Structure of the Atom." *Philosophical Magazine and Journal of Science*, 6th ser., 21 (May 1911), 669–88.

Soddy, Frederick. "The Energy of Radium." *Harper's Monthly* 120 (Dec. 1909), 52–59.

———. *The Interpretation of Radium (Being the Substance of Six Free Popular Lectures Delivered at the University of Glasgow, 1908)*. London: John Murray, 1909.

———. *Matter and Energy*. New York: Henry Holt, 1912.

Williams, Henry Smith. "Exploring the Atom." *Harper's Monthly* 127 (June 1913), 112–20.

Wilson, C. T. R. "On a Method of Making Visible the Paths of Ionising Particles through a Gas." *Proceedings of the Royal Society of London*, ser. A, 85 (Nov. 1911), 85–88.

———. "On an Expansion Apparatus for Making Visible the Tracks of Ionising Particles in Gases and Some Results Obtained by Its Use." *Proceedings of the Royal Society of London*, ser. A, 87 (Dec. 1912), 277–93.

2. Secondary Sources

Anderson, David L. *The Discovery of the Electron: The Development of the Atomic Concept of Electricity*. Princeton: D. Van Nostrand, 1964.

Badash, Lawrence. "How the 'Newer Alchemy' Was Received." *Scientific American* 215 (Aug. 1966), 88–95.

———. *Radioactivity in America: Growth and Decay of a Science*. Baltimore: Johns Hopkins University Press, 1979.

———. "Radium, Radioactivity, and the Popularity of Scientific Discovery." *Proceedings of the American Philosophical Society* 122 (June 1978), 145–54.

Caufield, Catherine. *Multiple Exposures: Chronicles of the Radiation Age*. New York: Harper & Row, 1989.

Galison, Peter, and Alexei Assmus. "Artificial Clouds, Real Particles." In *The Uses of Experiment: Studies in the Natural Sciences*, ed. David Gooding, Trevor Pinch, and Simon Schaffer, pp. 225–74. Cambridge: Cambridge University Press, 1989.

Hoffmann, Banesh. *The Strange Story of the Quantum.* New York: Harper and Bros., 1947.

Malley, Marjorie. "The Discovery of Atomic Transmutation: Scientific Styles and Philosophies in France and Britain." *Isis* 70 (June 1979), 213–23.

Miller, Arthur I. "Visualization Lost and Regained: The Genesis of the Quantum Theory in the Period 1913–27." In *On Aesthetics in Art and Science,* ed. Judith Wechsler, pp. 73–102. Cambridge: MIT Press, 1978.

Weart, Spencer. *Nuclear Fear: A History of Images.* Cambridge: Harvard University Press, 1988.

Wilson, David. *Rutherford: Simple Genius.* Cambridge: MIT Press, 1983.

G. THERMODYNAMICS, THE KINETIC THEORY OF GASES, PHYSICAL CHEMISTRY, AND THE WORK OF JEAN PERRIN

1. Contemporary Sources

Bohn, Georges. "Le Mouvement scientifique" (on Perrin-Le Bon exchange). *Mercure de France* 71 (Jan. 1, 1908), 122.

———. "Le Mouvement scientifique—J. Perrin: *Les Atomes.*" *Mercure de France* 103 (May 1, 1913), 159–63.

Duhem, P[ierre]. *Thermodynamics and Chemistry.* Trans. George K. Burgess. New York: John Wiley, 1903.

Matisse, Georges. "La Théorie moléculaire et la science contemporaine." *Mercure de France* 103 (June 1, 1913), 520–25.

Perrin, Jean. "A propos de 'L'Evolution des forces.'" *Revue du Mois* 4 (Nov. 10, 1907), 606–10.

———. "Les Arguments de M. Gustave Le Bon." *Revue du Mois* 4 (1907), 729–32.

———. *Les Atomes.* Paris: Félix Alcan, 1913. 5th rev. ed. Paris: Félix Alcan, 1914.

———. *Atoms.* Trans. from 4th rev. ed. by D. L. Hammick. London: Constable, 1916.

———. *Brownian Movement and Molecular Reality.* Trans. Frederick Soddy. London: Taylor and Francis, 1910.

———. "Mouvement brownien et réalité moléculaire." *Annales de Chimie et de Physique,* 8th ser., 18 (Sept. 1909), 1–114.

———. *Les Principes: Traité de chimie physique.* Paris: Gauthier-Villars, 1903.

———. "La Réalité des molécules." *Revue Scientifique* 49 (Dec. 16, 1911), 774–84.

Perkins, Henry A. *An Introduction to General Thermodynamics.* New York: John Wiley, 1912.

Shenstone, William. "Matter, Motion, and Molecules." *Living Age* 30 (Mar. 1906), 591–98.

Vigneron, H. "Les Preuves de la réalité moléculaire." *La Nature* 40 (Dec. 2, 1911), 3–4.

2. Secondary Sources

Brush, Stephen G. *The Kind of Motion We Call Heat: A History of the Kinetic Theory of Gases in the 19th Century.*

2 vols. Amsterdam: North-Holland Physics Publishing, 1976.

———. *The Temperature of History: Phases of Science and Culture in the Nineteenth Century.* New York: Burt Franklin, 1978.

Cardwell, D. S. L. *From Watt to Clausius: The Rise of Thermodynamics in the Early Industrial Age.* Ithaca: Cornell University Press, 1971.

Emswiler, J. E. *Thermodynamics.* New York: McGraw-Hill, 1927.

Hatsopoulos, George N., and Joseph H. Keenan. *Principles of General Thermodynamics.* New York: John Wiley, 1965.

Loeb, Leonard B. *Kinetic Theory of Gases.* New York: McGraw-Hill, 1927.

Nye, Mary Jo. *Molecular Reality: A Perspective on the Scientific Work of Jean Perrin.* London: Macdonald, 1972.

Servos, John W. *Physical Chemistry from Ostwald to Pauling.* Princeton: Princeton University Press, 1990.

H. CHEMISTRY AND THE LIQUEFACTION OF GASES

1. Contemporary Sources

B[ohn], G[eorge]. "*Revue Scientifique*: La Découverte de nouveaux gaz dans l'atmosphère, par Sir William Ramsey (19 septembre)." *La Revue des Idées* 5 (Oct. 1908), 378–79.

Bresch, G. "Les Gaz liquéfiés (l'air, l'hélium)." *La Nature* 39 (Dec. 10, 1910), 22–27.

Claude, Georges. "L'Oxygène industriel." *Revue Générale des Sciences Pures et Appliquées* 20 (Nov. 30, 1909), 923–25.

———. "Sur la liquéfaction de l'air et ses applications." Société Française de Physique lecture, Dec. 15, 1905. Reported in *Revue Générale des Sciences Pures et Appliquées* 17 (Jan. 15, 1906), 52–53.

Dewar, James. "History of Cold and Absolute Zero." In *Annual Report of the Smithsonian Institution, 1902,* pp. 207–40. Washington, D.C.: G.P.O., 1903.

———. "Liquid Gases." *Encyclopaedia Britannica,* 11th ed. (1910), vol. 16, pp. 744–59.

———. "La Science du froid." *Revue Scientifique,* 4th ser., 18 (Oct. 4, 1902), 417–26; 18 (Oct. 11, 1902), 456–64; 18 (Oct. 18, 1902), 487–94.

———. "Solid Hydrogen," *Annual Report of the Smithsonian Institution, 1901,* pp. 251–61. Washington, D.C.: G.P.O., 1902.

Lamelin, Pierre. "Les Recherches industrielles de l'air." *La Science et la Vie* 2 (Sept. 1913), 383–93.

Ramsay, Sir William. *The Gases of the Atmosphere: The History of Their Discovery* (1896). 3d ed. London: Macmillan, 1905.

Troller, A. "Production industrielle de l'azote [nitrogen] et de l'oxygène par l'air liquide: La Machine G. Claude." *La Nature* 40 (Dec. 16, 1911), 41–45.

Troost, L[ouis-Joseph]. *Précis de chimie.* 25th ed. Paris: G. Masson, 1893.

Whymper, R. *Cocoa and Chocolate: Their Chemistry and Manufacture.* Philadelphia: P. Blakiston's, 1912.

2. Secondary Sources

Brock, William H. *The Norton History of Chemistry*. New York: W. W. Norton, 1992.

Gavroglu, Kostas, and Yorgos Goudaroulis, eds. *Through Measurement to Knowledge: The Selected Papers of Heike Kamerlingh Onnes, 1853–1926*. Dordrecht: Kluwer, 1991.

Ihde, Aaron J. *The Development of Modern Chemistry*. New York: Harper and Row, 1964.

Strong, Ralph K., ed. *Kingzett's Chemical Encyclopaedia*. 8th ed. New York: D. Van Nostrand, 1952.

Tilden, Sir William A. *Sir William Ramsay: Memorials of His Life and Work*. London: Macmillan, 1918.

Travers, Morris W. *A Life of Sir William Ramsay, K.C.B., F.R.S.* London: Edward Arnold, 1956.

I. WILHELM OSTWALD AND ENERGETICS

1. Contemporary Sources

Bohn, Georges. "Le Mouvement scientifique—W. Ostwald: L'Energie." *Mercure de France* 82 (Dec. 1, 1909), 506–8.

"Les Idées qui passent" (anonymous critique of W. Ostwald). *La Revue des Idées* 10 (June 1913), 349–53.

Matisse, Georges. "Essai philosophique sur l'énergétique." *La Revue des Idées* 4 (Apr. 15, 1907), 353–71.

Ostwald, Wilhelm. "La Déroute de l'atomisme contemporain." *Revue Générale des Sciences Pures et Appliquées* 6 (Nov. 15, 1895), 953–58.

———. *L'Energie*. Trans. E. Philippi. Paris: Félix Alcan, 1909.

———. "Machines and Living Creatures: Lifeless and Living Transformers of Energy." *Scientific American Supplement*, no. 1803 (July 23, 1910), 55.

———. "The Modern Theory of Energetics." *Monist* 17 (Oct. 1907), 481–515.

———. *Outline of General Chemistry*. Trans. James Walker. London: Macmillan, 1890.

———. "The Philosophical Meaning of Energy." *International Quarterly* 7 (June–Sept. 1903), 300–15.

2. Secondary Sources

Hiebert, Erwin N. "Developments in Physical Chemistry at the Turn of the Century." In *Science, Technology, and Society in the Time of Alfred Nobel*, ed. Carl Gustaf Bernhard, Elisabeth Crawford, and Per Sörbom, pp. 97–115. London: Pergamon, 1982.

———. "The Energetics Controversy and the New Thermodynamics." In *Perspectives in the History of Science and Technology*, ed. Duane H. D. Roller, pp. 67–86. Norman: University of Oklahoma Press, 1971.

J. OPTICS, COLOR, AND THE OPTOPHONE

1. Contemporary Sources

Bourdon, B. *La Perception visuelle de l'espace*. Paris: Schleicher Frères, 1902.

Helmholtz, Hermann von. *Helmholtz's Treatise on Physiological Optics*. Ed. James P. C. Southall. 3 vols. Rochester, N.Y.: Optical Society of America, 1924.

Minnaert, Marcel. *Light and Colour in the Open Air*. Trans. H. M. Kremer-Priest. London: G. Bell, 1940. Reprint, New York: Dover, 1954.

Mottelay, P. F. "Light Made Audible." *Scientific American* 107 (Sept. 21, 1912), 240.

Preston, Thomas. *The Theory of Light*. London: Macmillan, 1890.

Rood, Ogden. *Modern Chromatics*. London: C. Kegan Paul, 1879.

"The Type-Reading Optophone." *Scientific American* 123 (Nov. 6, 1920), 463.

Vuibert, H. *Les Anaglyphes géométriques*. Paris: Librairie Vuibert, 1912.

Wright, Maj. Fred E. "Wartime Development of the Optical Industry." *Journal of the Optical Society of America* 2–3 (Jan.–Mar. 1919), 1–7.

2. Secondary Sources

Baltrusaitis, Jurgis. *Anamorphoses, ou magie artificielle des effets merveilleux*. Paris: Olivier Perrin, 1969.

Cantor, G. N. *Optics After Newton: Theories of Light in Britain and Ireland 1704–1840*. Manchester: Manchester University Press, 1983.

Kemp, Martin. *The Science of Art: Optical Themes in Western Art from Brunelleschi to Seurat*. New Haven: Yale University Press, 1990.

Silliman, Robert H. "Fresnel and the Emergence of Physics as a Discipline." *Historical Studies in the Physical Sciences* 4 (1974), 137–62.

K. RELATIVITY THEORY

1. Contemporary Sources

Bloch, Eugène. "Revue d'électromagnétisme." *Revue Générale des Sciences Pures et Appliquées* 24 (Apr. 30, 1913), 309–19.

Vigneron, H. "Les Grains d'électricité et la dynamique électrodynamique." *La Nature* 40 (Dec. 16, 1911), 45–47.

2. Secondary Sources

Goldberg, Stanley. *Understanding Relativity: Origin and Impact of a Scientific Revolution*. Boston: Birkhäuser, 1984.

Hoffmann, Banesh. *Relativity and Its Roots*. New York: Scientific American, 1983.

Miller, Arthur I. *Albert Einstein's Special Theory of Relativity: Emergence (1905) and Early Interpretation (1905–1911)*. Reading, Mass.: Addison-Wesley, 1981.

L. THE FOURTH DIMENSION AND THE HISTORY OF GEOMETRY

1. Contemporary Sources

Boucher, Maurice. *Essai sur l'hyperespace: Le Temps, la matière et l'énergie*. Paris: Félix Alcan, 1903.

Bragdon, Claude. *Man the Square: A Higher Space Parable*. Rochester, N.Y.: Manas Press, 1912.

———. *A Primer of Higher Space (The Fourth Dimension)*. Rochester, N.Y.: Manas Press, 1913.

Hinton, C[harles] Howard. *The Fourth Dimension*. London: Swan Sonnenschein, 1904.

———. *A New Era of Thought*. London: Swan Sonnenschein, 1888.

Manning, Henry P., ed. *The Fourth Dimension Simply Explained: A Collection of Essays Selected from Those Submitted in the Scientific American's Prize Competition*. New York: Munn & Co., 1910. Reprint, New York: Dover, 1960.

2. Secondary Sources

Gardner, Martin. *The Ambidextrous Universe: Mirror Asymmetry and Time-Reversed Worlds*. 2d ed. rev. New York: Scribner's, 1979.

Kline, Morris. *Mathematics: A Cultural Approach*. Reading, Mass.: Addison-Wesley, 1962.

Rucker, Rudy. *The Fourth Dimension: Toward a Geometry of Higher Reality*. Boston: Houghton Mifflin, 1984.

———. *Geometry, Relativity and the Fourth Dimension*. New York: Dover, 1977.

M. METROLOGY

1. Contemporary Sources

"La Cinquième Conférence générale des Poids et Mesures." *Revue Générale des Sciences Pures et Appliquées* 24 (Nov. 30, 1913), 828–29.

Guillaume, Charles-Edouard. "Métrologie et législation." *Revue Générale des Sciences Pures et Appliquées* 23 (Oct. 15, 1912), 733–41.

Hartmann, Lt-Colonel. "La Crise du Conservatoire des Arts et Métiers." *La Revue des Idées* 4 (May 15, 1907), 385–99.

2. Secondary Sources

Danloux-Dumesnils, Maurice. *The Metric System: A Critical Study of Its Principles and Practice*. Trans. Anne Garrett and J. S. Rowlinson. London: Athlone Press, 1969.

Hallock, William, and Herbert T. Wade. *Outlines of the Evolution of Weights and Measures and the Metric System*. New York: Macmillan, 1906.

Wise, M. Norton, ed. *The Values of Precision*. Princeton: Princeton University Press, 1995.

N. METEOROLOGY

1. Contemporary Sources

Shaw, W[illiam] N[apier]. *Air Currents and the Laws of Ventilation*. Cambridge: Cambridge University Press, 1907.

———. *Selected Meteorological Papers of Sir Napier Shaw*. London: Macdonald, 1955.

Mathias, E. Review of *Air Currents and the Laws of Ventilation*, by W. N. Shaw. *Revue Générale des Sciences Pures et Appliquées* 19 (June 30, 1908), 507–8.

2. Secondary Sources

Middleton, W. E. Knowles. *The History of the Barometer*. Baltimore: Johns Hopkins University Press, 1964.

O. LIFE SCIENCES (BIOLOGY, PHYSIOLOGY, ENTOMOLOGY)

1. Contemporary Sources

Amar, Jules. *Le Moteur humain et les bases du travail professionel*. Paris: H. Dunod et E. Pinat, 1914. Translated as *The Human Motor, or the Scientific Foundations of Labour and Industry* (London: George Routledge, 1920).

Berthelot, D. "Les Mécanismes biologiques et les phénomènes électriques." *Revue Scientifique* 51 (July 12, 1913), 33–38.

Bohn, Georges. "Le Mouvement scientifique" (on Jacques Loeb). *Mercure de France* 71 (Jan. 1, 1908), 118–21.

Drzewina, Anna. "Néo-vitalistes et mécanistes." *La Revue des Idées* 9 (Apr. 1912), 215–19.

Fabre, J[ean]-H[enri]. *The Hunting Wasps*. Trans. Alexander Teixiera de Mattos. New York: Dodd, Mead, 1915.

———. *Les Merveilles de l'instinct chez les insectes: Morceaux choisis*. Paris: Librairie Delagrave, 1913.

———. *Moeurs des insectes: Morceaux choisis*. Paris: Librairie Delagrave, 1911.

———. *Souvenirs entomologiques: Etudes sur l'instinct et les moeurs des insects*. 10 vols. 6th ed. Paris: Librairie Delagrave, 1913.

———. *La Vie des insectes: Morceaux choisis*. Paris: Librairie Delagrave, 1910.

Gourmont, Remy de. *The Natural Philosophy of Love*. Trans. Ezra Pound. New York: Boni and Liveright, 1922. New ed. New York: Willey Book Co., 1940.

———. *Physique de l'amour: Essai sur l'instinct sexuel* (1903). 30th ed. Paris: Mercure de France, 1924.

Loeb, Jacques. *The Dynamics of Living Matter*. New York: Columbia University Press, 1906.

———. *The Mechanistic Conception of Life: Biological Essays*. Chicago: University of Chicago Press, 1912.

Maeterlinck, Maurice. *La Vie des abeilles*. Paris: Eugène Fasquelle, 1901.

Marey, Etienne-Jules. *La Machine animale: Locomotion terrestre et aérienne*. Paris: Masson, 1873.

Richer, Paul. *Physiologie artistique de l'homme en mouvement.* Paris: Octave Douin, 1895.

Solvay, Ernest. "Physico-chimie et psychologie." *Revue Générale des Sciences Pures et Appliquées* 20 (Dec. 30, 1909), 982–85.

Teale, Edwin Way, ed. *The Insect World of J. Henri Fabre.* New York: Dodd, Mead, 1949.

2. Secondary Sources

Boring, Edwin. *Sensation and Perception in the History of Experimental Psychology.* New York: Appleton-Century-Crofts, 1942.

Mendelsohn, Everett. "The Biological Sciences in the Nineteenth Century: Some Problems and Sources." *History of Science* 3 (1964), 39–54.

Uvnas, Börje. "The Rise of Physiology during the Nineteenth Century." In *Science, Technology, and Society in the Time of Alfred Nobel*, ed. Carl Gustaf Bernhard, Elisabeth Crawford, and Per Sörbom, pp. 135–45. London: Pergamon, 1982.

P. AUTOMATONS AND HUMAN-MACHINE ANALOGIES

1. Contemporary Sources (see other categories, including those immediately above)

La Mettrie, Julian Offray de. *Man a Machine* (1784). La Salle, Ill.: Open Court, 1912.

2. Secondary Sources

Bailly, Christian. *L'Age d'or des automates, 1848–1914.* Paris: Editions Scala, 1987.

Cohen, John. *Human Robots in Myth and Science.* London: George Allen and Unwin, 1966.

Channell, David. *The Vital Machine: A Study of Technology and Organic Life.* Oxford: Oxford University Press, 1991.

Chapuis, Alfred, and Edmond Droz. *Les Automates (figures artificielles d'hommes et d'animaux): Histoire et technique.* Neuchâtel: Editions du Griffon, 1949.

Crary, Jonathan, and Sanford Kwinter, eds. *Incorporations.* Zone 6. Cambridge: MIT Press, 1992.

Rabinbach, Anton. *The Human Motor: Energy, Fatigue, and the Origins of Modernity.* New York: Basic Books, 1990.

Metken, Günter, "De l'homme-machine à la machine-homme: Anthropomorphie de la machine au XIXᵉ siècle." In *Junggesellenmaschinen/Les Machines célibataires*, ed. Harald Szeemann, pp. 50–63. Venice: Alfieri, 1975.

Tichi, Cecelia. *Shifting Gears: Technology, Literature, Culture in Modernist America.* Chapel Hill: University of North Carolina Press, 1987.

Q. TRANSPORTATION

1. Contemporary Sources

"Automobile Electric Light Plant," *Scientific American* 103 (July 2, 1910), 6.

Baudry de Saunier, L. "L'Electricité à bord des automobiles." *L'Illustration* 142 (Dec. 27, 1913), 531–35.

Courquin, A., and G. Dubedat. *Technique et pratique de la magnéto à haute tension.* Paris: Gauthier-Villars, 1920.

Dyke, A. L. *Dyke's Automobile and Gasoline Engine Encyclopedia.* 12th ed. St. Louis: A. L. Dyke, 1920.

"Novelties at the Paris Air Show." *Scientific American Supplement* 74 (Nov. 30, 1912), 344–47; 74 (Dec. 7, 1912), 360–63; 74 (Dec. 14, 1912), 372–74.

"The Paris Automobile Show." *Scientific American Supplement* 71 (Jan. 14, 1911), 24–25.

Renard, Paul. *L'Aéronautique.* Paris: Ernest Flammarion, 1909.

———. *Le Vol mécanique: Les Aéroplanes.* Paris: Ernest Flammarion, 1912.

Renaud, D. *Cours complet d'automobilisme.* Paris: Librairie R. Chapelot, 1909.

Slauson, Harold Whiting. "Lights for the Automobile" *Outing Magazine* 59 (Oct. 1911), 118–22.

———. "The Motor Car's Spark of Life." *Outing Magazine* 58 (Apr. 1911), 92–96.

2. Secondary Sources

Bishop, Charles W. *La France et l'automobile.* Paris: Librairies Techniques, 1971.

Dodge, Pryor. *The Bicycle.* New York: Flammarion, 1996.

Richard, Yves. *Renault 1898, Renault 1965.* Paris: Pierre Tisné, 1965.

Wohl, Robert. *A Passion for Wings: Aviation and the Western Imagination.* New Haven: Yale University Press, 1994.

R. LIGHTING

1. Contemporary Sources

Claude, Georges. "The Development of Neon Tubes." *Engineering Magazine* 46 (Nov. 1913), 271–74.

Dibdin, W. J. *Public Lighting by Gas and Electricity.* London: Sanitary Publishing Co., 1902.

"Frosting, Etching, and Coloring of Incandescent Lamps: Hints for the Manufacturer and Amateur." *Scientific American Supplement* 71 (Apr. 22, 1911), 255.

Leblanc, Maurice. "La Lumière au néon." *La Nature* 39 (Jan. 28, 1911), 145–46.

"Le Néon, gaz d'éclairage." *La Revue des Idées* 8 (Jan. 1911), 75.

Lukiesh, M. *Artificial Light: Its Influence upon Civilization.* New York: Century, 1920.

Neumark, A. S. "Coloring and Frosting Incandescent Lamps." *Scientific American Supplement* 73 (May 11, 1912), 295.

"Une Nouveauté dans l'éclairage: La Lumière de néon." *Revue*

Générale des Sciences Pures et Appliquées 21 (Dec. 10, 1910), 1003–4.

2. Secondary Sources

Bright, Arthur A. *The Electric-Lamp Industry: Technological Change and Economic Development from 1800–1947.* New York: Arno, 1972.

Friedel, Robert, and Paul Israel. *Edison's Electric Light: Biography of an Invention.* New Brunswick: Rutgers University Press, 1986.

Miller, Henry A. *Luminous Tube Lighting.* London: George Newnes, 1945.

Miller, Samuel C., and Donald G. Fink. *Neon Signs: Manufacture—Installation—Maintenance.* New York: McGraw-Hill, 1935.

Solomon, Maurice. *Electric Lamps.* London: Archibald Constable, 1908.

Stern, Rudi. *Let There Be Neon.* New York: Harry N. Abrams, 1979.

IV. OTHER FIELDS
A. GENERAL CULTURAL HISTORY
1. Contemporary Sources

Adams, Henry. *The Education of Henry Adams: An Autobiography.* Boston: Houghton Mifflin, 1918.

Baedeker, Karl. *Paris and Environs.* Leipzig: Karl Baedeker, 1900.

Desbonnet, Professeur. *La Force physique: Culture rationnelle—Méthode Attila—Méthode Sandow—Méthode Desbonnet.* 7th ed. Paris: Berger-Levrault, 1910.

———. *Les Rois de la force.* Paris: Librairie Berger-Levrault, 1911.

Harrison, Jane. *Prolegomena to the Study of Greek Religion.* Cambridge: Cambridge University Press, 1903.

Mâle, Emile. *The Gothic Image: Religious Art in France of the Thirteenth Century* (1913). Trans. Dora Nussey. New York: Harper & Row, 1958.

Merz, John Theodore. *A History of European Thought in the Nineteenth Century.* 4 vols. Edinburgh: William Blackwood, 1903–14.

Monmarché, Marcel. *Paris et ses environs (Les Guides bleus).* Paris: Hachette, 1921.

Sandow, Eugen. *Strength, and How to Obtain It* (1897). 3d ed. London: Gale & Polden, 1905.

Trousset, Jules, ed. *Les Merveilles de l'Exposition de 1900.* 2 vols. Paris: Librairie Illustrée Montgredien, 1899–1900.

2. Secondary Sources

Allen, T. W., W. R. Halliday, and E. E. Sykes, eds. *The Homeric Hymns.* 2d ed. Oxford: Clarendon Press, 1936.

Barthes, Roland. *The Eiffel Tower and Other Mythologies.* Trans. Richard Howard. New York: Hill and Wang, 1979.

Benveniste, Emile. *Problems in General Linguistics.* Trans. Mary Ellen Meek. Coral Gables: University of Miami Press, 1971.

Boden, Margaret A. *The Creative Mind: Myths and Mechanisms.* New York: Basic Books, 1991.

Burkert, Walter. *Greek Religion.* Trans. John Raffan. Cambridge: Harvard University Press, 1985.

Cate, Phillip Dennis, ed. *The Eiffel Tower, a Tour de Force: Its Centennial Exhibition.* The Grolier Club, N.Y., Apr. 19–June 3, 1989.

Derrida, Jacques. *Margins of Philosophy.* Chicago: University of Chicago Press, 1982.

Gallagher, Catherine, and Thomas Laqueur, eds. *The Making of the Modern Body: Sexuality and Society in the Nineteenth Century.* Berkeley: University of California Press, 1987.

Harriss, Joseph. *The Tallest Tower: Eiffel and the Belle Epoque.* Boston: Houghton Mifflin, 1975.

Jay, Martin. *Downcast Eyes: The Denigration of Vision in Twentieth-Century French Thought.* Berkeley: University of California Press, 1993.

Jordy, William H. *Henry Adams: Scientific Historian.* New Haven: Yale University Press, 1952.

Kern, Stephen. *The Culture of Time and Space.* Cambridge: Harvard University Press, 1983.

Kurtz, Donna, and John Boardman. *Greek Burial Customs.* Ithaca: Cornell University Press, 1971.

Landon, François. *La Tour Eiffel Superstar.* Paris: Editions Ramsay, 1981.

Loyrette, Henri. *Gustave Eiffel.* Trans. Rachel Gomme and Susan Gomme. New York: Rizzoli, 1985.

Maines, Rachel. "Socially Camouflaged Technologies: The Case of the Electromechanical Vibrator." *IEEE Technology and Society Magazine* 8 (June 1989), 3–11, 23.

Mandell, Richard D. *Paris 1900: The Great World's Fair.* Toronto: University of Toronto Press, 1967.

Ory, Pascal. *Les Expositions Universelles de Paris.* Paris: Editions Ramsay, 1982.

Rose, H. J. *A Handbook of Greek Mythology.* New York: E. P. Dutton, 1959.

Schiebinger, Londa. "Feminine Icons: The Face of Early Modern Science." *Critical Inquiry* 14 (Summer 1988), 661–91.

Skinner, Quentin. *The Return of Grand Theory in the Human Sciences.* Cambridge: Cambridge University Press, 1985.

Warner, Marina. *Alone of All Her Sex: The Myth and Cult of the Virgin Mary* (1976). New York: Vintage, 1983.

———. *Monuments & Maidens: The Allegory of the Female Form.* New York: Atheneum, 1985.

B. OCCULTISM
1. General Occultism
a. Contemporary Sources

Baraduc, Hippolyte. *L'Ame humaine: Ses Mouvements, ses lumières; et L'Iconographie de l'invisible fluidique.* Paris: Georges Carré, 1896.

Besant, Annie, and C[harles] W[ebster] Leadbeater. *Thought-Forms* (1901). London: Theosophical Publishing Society, 1905.

Blavatsky, Helena Petrovna. *Isis Unveiled: A Master-Key to the Mysteries of Ancient and Modern Science and Technology.* 2 vols. New York: J. W. Bouton, 1877.

———. *The Secret Doctrine.* London: Theosophical Publishing, 1888; New York: W. Q. Judge, 1888.

Bosc, Ernest. "La Clairvoyance." *La Vie Mystérieuse*, no. 68 (Oct. 25, 1911), pp. 308–9.

Brieu, Jacques. "Esotérisme et spiritisme." *Mercure de France* 75 (Sept. 1, 1908), 141–46.

Darget, Commandant. *Exposé des différentes méthodes pour l'obtention de photographies fluido-magnétiques et spirites. Rayons V (Vitaux).* Paris: Editions de l'Initiation, 1909.

Delanne, Gabriel. "Le Spiritisme est une science." *La Vie Mystérieuse*, no. 79 (Apr. 1912), 485.

Denis, Léon. *Dans l'invisible: Spiritisme et médiumnité (Traité de spiritualisme expérimental).* Paris: Librairie des Sciences Psychiques, 1904.

Durville, Hector. "Théories et procédés du magnétisme." *La Vie Mystérieuse*, no. 40 (Aug. 25, 1910), 244–46.

Encausse, Gérard [Papus]. "Comment est constitué l'Etre Humain." *La Vie Mystérieuse*, no. 65 (Sept. 10, 1911), 260–61; no. 66 (Sept. 25, 1911), pp. 275–76; no. 68 (Oct. 25, 1911), 30; no. 70 (Nov. 25, 1911), n.p.; no. 73 (Jan. 10, 1912), n.p.; no. 76 (Feb. 25, 1912), 436–37.

———. *Essai de physiologie synthétique.* Paris: Georges Carré, 1891.

———. *L'Occulte à l'Exposition.* Paris: Librairie Paul Ollendorf, 1901.

Flammarion, Camille. *Death and Its Mystery before Death* (1920). New York: Century, 1921.

———. *L'Inconnu et les problèmes psychiques.* Paris: Ernest Flammarion, 1900. Trans. as *The Unknown* (New York: Harper & Bros., 1900).

G[irod], F[ernand]. "Analogie des phénomènes médiumniques avec certains phénomènes électriques." *La Vie Mystérieuse*, no. 85 (July 10, 1912), 584.

Leadbeater, C[harles] W[ebster]. *Clairvoyance* (1899). 2d ed. London: Theosophical Publishing Society, 1903. Trans. as *De la clairvoyance* (Paris: Publications Théosophiques, 1910).

Lombroso, Cesare. *After Death—What? Spiritistic Phenomena and Their Interpretation.* Trans. William Sloane Kennedy. Boston: Small, Maynard, 1909.

———. *Hypnotisme et spiritisme.* Trans. Rossigneux. Paris: Ernest Flammarion, 1910. Originally published as *Ricerche sui fenomeni ipnotici e spiritici* (Turin: Unione Tipografico–Editrice Torinese, 1909).

Mareschal, G. "Photographie d'effluves humain et magnétique. *La Nature* 25 (Oct. 30, 1897), 349–50.

Péladan. *Origine et esthétique de la tragédie.* Paris: E. Sansot, 1905.

———. "Le Radium et l'hyperphysique." *Mercure de France* 50 (June 1904), 608–37.

Piobb, Pierre. *L'Année occultiste et psychique.* 2 vols. Paris: H. Daragon, 1908.

Revel, P[ierre] Camille. *Le Hasard, sa loi et ses conséquences dans les sciences et en philosophie; suivi d'un essai sur La Métempsychose, basée sur les principes de la biologie et du magnétisme physiologique.* Paris: Bibliothèque Chacornac/H. Durville, 1909.

Rochas, Albert de. *Les Etats profonds de l'hypnose* (1892). 3d ed. Paris: Chamuel, 1896.

———. *L'Extériorisation de la motricité.* Paris: Chamuel, 1896.

———. *L'Extériorisation de la sensibilité: Etude expérimentale et historique* (1895). 6th ed. Paris: Bibliothèque Chacornac, 1909.

"La Télépathie." *Le Radium*, no. 1 (Jan. 1904), 15–16.

Varlet, Théo. "Télépathie." *Les Bandeaux d'Or*, ser. 2, fasc. 5 (1908), 31–48.

Wilfred, G. "La Transmission de la pensée: Théorie et pratique." *La Vie Mystérieuse*, no. 8 (Apr. 25, 1909), 115–16.

b. Secondary Sources

Darnton, Robert. *Mesmerism and the End of the Enlightenment in France.* Cambridge: Harvard University Press, 1968.

Fodor, Nandor. *Encyclopaedia of Psychic Science.* With a preface by Sir Oliver Lodge. London: Arthurs Press, 1933.

Greenway, John L. "'Nervous Disease' and Electric Medicine." In *Pseudo-Science and Society in Nineteenth-Century America*, ed. Arthur Wrobel, pp. 46–73. Lexington: University of Kentucky Press, 1987.

———. "Strindberg and Suggestion in Miss Julie." *South Atlantic Review* 51 (1986), 21–33.

Leahey, Thomas Hardy, and Grace Evans Leahey. *Psychology's Occult Doubles: Psychology and the Problem of Pseudoscience.* Chicago: Nelson-Hall, 1983.

Oppenheim, Janet. *The Other World: Spiritualism and Psychical Research in England, 1850–1914.* Cambridge: Cambridge University Press, 1985.

2. Alchemy

a. Contemporary Sources

Berthelot, Marcellin. *Les Origines de l'alchimie.* Paris: Georges Steinheil, 1885.

Bolton, H. Carrington. "The Revival of Alchemy." In *Annual Report of the Smithsonian Institution, 1897*, pp. 207–17. Washington, D.C.: G.P.O., 1898.

Canseliet, Eugène. *Alchimie: Etudes diverses de symbolisme hermétique et de pratique philosophale.* Paris: Jean-Jacques Pauvert, 1964.

Chanac, Guy de. "L'Alchimie au Moyen-Age." *La Vie Mystérieuse*, no. 87 (Aug. 10, 1912), 615–17.

Coates, Joseph Hornor. "The Renaissance of the Alchemists." *North American Review* 183 (July 1906), 82–93.

Delobel, Em., trans. "Radio-activité (de E. Rutherford)"

(excerpts from Rutherford's 1904 *Radio-activity*). *Les Nouveaux Horizons de la Science et de la Pensée* 11–13 (Dec. 1906–Jan. 1908).

Dubus, Edouard. "La Théorie alchimiste au XIXe siècle." *Mercure de France* 1 (Oct. 1890), 372–76.

Jollivet Castelot, François. "L'Alchimie." *Mercure de France* 15 (Nov. 1895), 205–15.

———. *Comment on devient alchimiste*. Paris: Chamuel, 1897.

———. *L'Hylozöisme: L'Alchimie, les chimistes unitaires*. Paris: Chamuel, 1896.

———. *Sociologie et Fourierisme*. Paris: H. Daragon, 1908.

———. *La Synthèse d'or: L'Unité et la transmutation de la matière*. Paris: H. Daragon, 1909.

———. *La Vie et l'âme de la matière: Essai de physiologie chimique*. Paris: Société des Editions Scientifiques, 1894.

"The Old and the New Alchemy." *Edinburgh Review* 205 (Jan. 1907), 28–47.

Poisson, Albert. *Théories & symboles des alchimistes*. Paris: Bibliothèque Chacornac, 1891.

Porte du Trait des Ages, A[imé]. *F. Jollivet Castelot: L'Ecrivain—le poète—le philosophe*. Paris: Eugène Figuière, 1914.

"La Transmutation des éléments chimiques" (on the work of Sir William Ramsay). *Les Nouveaux Horizons de la Science et de la Pensée* 12 (Nov. 1907), 375.

Valentin, Frère Basile. *Les Douze Clefs de la philosophie*. Paris: Chamuel, 1899.

———. *Les Douze Clefs de la philosophie*. Trans. and intro. Eugène Canseliet. Paris: Editions de Minuit, 1956.

b. Secondary Sources Including Those on Alchemy and Artists Other than Duchamp

Darrow, Floyd L. *The Story of Chemistry*. Indianapolis: Bobbs-Merrill, 1927.

Dixon, Laurinda S. *Alchemical Imagery in Bosch's Garden of Delights*. Ann Arbor: UMI Research Press, 1981.

———. "Textual Enigma and Alchemical Iconography in Nicholas Flamel's *Exposition of the Hieroglyphicall Figures*." *Cauda Pavonis*, n.s., 10 (Spring 1991), 5–9.

Fisk, Dorothy M. *Modern Alchemy*. New York: D. Appleton-Century, 1936.

Lennep, Jacques van. *Alchimie: Contribution à l'histoire de l'art alchimique*. 2d ed. rev. Brussels: Crédit Communale de Belgique, 1985.

Read, John. *Prelude to Chemistry: An Outline of Alchemy, Its Literature, and Relationships*. London: G. Bell, 1936.

Redgrove, H. Stanley. *Alchemy: Ancient and Modern* (1911). 2d ed. rev. London: William Rider, 1922.

Warlick, M. E. "Max Ernst's Collage Novel, *Une Semaine de bonté*: Feuilleton Sources and Alchemical Interpretation." Ph.D. diss., University of Maryland, 1984.

C. PHILOSOPHY

1. Contemporary Sources

Bergson, Henri. *The Creative Mind*. Trans. Mabelle L. Andison. New York: Philosophical Library, 1946.

———. *Essai sur les données immédiates de la conscience*. Paris: Félix Alcan, 1889. Trans. by F. L. Pogson as *Time and Free Will* (New York: Macmillan, 1910).

———. *L'Evolution créatice*. Paris: Félix Alcan, 1907. Trans. by Arthur Mitchell as *Creative Evolution* (New York: Henry Holt, 1911).

———. *Le Rire: Essai sur la signification du comique*. Paris: Félix Alcan, 1900. Trans. by Cloudesley Brereton and Fred Rothwell as *Laughter: An Essay on the Meaning of the Comic* (New York: Macmillan, 1911).

Dunne, J. W. *An Experiment with Time*. London: A. & C. Black, 1927.

———. *The Serial Universe*. London: Faber & Faber, 1934.

Lucrèce [Titus Lucretius Carus]. *De la nature des choses*. Trans. LaGrange. 2 vols. Paris: Chcz Bleuet Père, 1794.

———. *De la nature des choses*. Trans. André Lefèvre. Paris: Société des Editions Littéraires, 1899.

Peirce, Charles Sanders. *Collected Papers of Charles Sanders Peirce*. Ed. Charles Hartshorne and Paul Weiss. 8 vols. Cambridge: Harvard University Press, 1960.

Plato. *Statesman*. Ed. and trans. J. B. Skemp. London: Routledge and Kegan Paul, 1952.

Stirner, Max. *The Ego and His Own*. Trans. Steven Byington. London: A. C. Fifield, 1915.

———. *L'Unique et sa propriété*. Trans. Robert L. Reclaire. Paris: P. V. Stock, 1899.

Valin, Pierre. "L'Evolution de la philosophie du 19e au 20e siècle," *La Phalange* 6 (June 20, 1909), 159–77; 7 (July 20, 1909), 235–50; 7 (Aug. 20, 1909), 375–83; 7 (Sept. 20, 1909), 385–404.

2. Secondary Sources

Edwards, Paul, ed. *The Encylopedia of Philosophy*. 8 vols. New York: Macmillan & Free Press, 1972.

Greenlee, Douglas. *Peirce's Concept of the Sign*. The Hague: Mouton, 1973.

Murphey, Murray G. *The Development of Peirce's Philosophy*. Cambridge: Harvard University Press, 1961.

Rescher, Nicholas. "Choice without Preference: A Study of the History and Logic of the Problem of 'Buridan's Ass.'" *Kant-Studien* 51 (1959–60), 142–75.

D. LITERATURE

1. Avant-Garde Writers and Periodicals

a. Contemporary Writings

Apollinaire, Guillaume. *Calligrammes*. Paris: Mercure de France, 1918.

———. "L'Esprit nouveau et les poètes." *Mercure de France* 130 (Dec. 1, 1918), 385–96.

———. *L'Hérésiarque et Cie*. Paris: Editions Stock, 1910.

———. "Jean Royère." *La Phalange* no. 19 (Jan. 1908), 596–600.

———. *Le Poète assassiné* (1916). Paris: Gallimard, 1947.

———. *Selected Writings of Guillaume Apollinaire*. Trans. Roger Shattuck. New York: New Directions, 1971.

Balakian, Anna. *André Breton: Magus of Surrealism*. New York: Oxford University Press, 1971.

Breton, André. *Anthologie de l'humour noir*. Paris: Edition du Sagittaire, 1950.

———. *Manifestos of Surrealism*. Trans. Richard Seaver and Helen R. Lane. Ann Arbor: The University of Michigan Press, 1972.

Cendrars, Blaise. *Oeuvres complètes*. Ed. Nino Frank. 15 vols. Paris: Le Club Français du Livre, 1968.

———. *Selected Writings of Blaise Cendrars*. Ed. Walter Albert. New York: New Directions, 1966.

Carrouges, Michel. *André Breton and the Basic Concepts of Surrealism* (1950). Trans. Maura Prendergast. Tuscaloosa, Ala.: University of Alabama Press, 1974.

———. "Surréalisme et occultisme." *Les Cahiers d'Hermès*, no. 2 (1947), 194–218.

Desnos, Robert. "Rrose Sélavy." *Littérature*, n.s., no. 7 (Dec. 1, 1922), 14–22.

Eliot, T. S. *Selected Essays*. New York: Harcourt, Brace, 1932.

Flaubert, Gustave. *Bouvard and Pécuchet* (1881). Trans. T. W. Earp and G. W. Stonier. New York: New Directions, 1954.

———. *Oeuvres complètes de Gustave Flaubert*. Paris: Club de l'Honnête Homme, 1971.

Gourmont, Remy de. "Epilogues: XXII^e Lettre à l'amazone." *Mercure de France* 102 (Mar. 16, 1913), 353–56.

———. *Lettres à l'amazone*. Paris: G. Crès, 1914. 20th ed., Paris: Mercure de France, 1924.

Huysmans, Joris-Karl. *Certains*. Paris: Tresse & Stock, 1889.

———. *Là-bas* (1891). Paris: Librairie Plon, 1911.

Maeterlinck, Maurice. *Le Double Jardin*. Paris: Eugène Fasquelle, 1904.

Marinetti, Filippo Tommaso. *Marinetti: Selected Writings*. Ed. R. W. Flint. New York: Farrar Straus and Giroux, 1972.

Mercereau, Alexandre. *La Littérature et les idées nouvelles*. Paris: Eugène Figuière, 1912.

Mirbeau, Octave. *La 628–E8*. Paris: Charpentier, 1907.

Pound, Ezra. "The Approach to Paris, I." *New Age* 13 (Sept. 11, 1913), 577–79.

———. *Literary Essays of Ezra Pound*. Ed. T. S. Eliot. London: Faber & Faber, 1960.

———. *Selected Prose 1909–1965*. Ed. William Cookson. London: Faber & Faber, 1973.

Romains, Jules. *La Vie unanime*. Paris: Abbaye de Créteil, 1908.

Stéphane, Marc. "Esotérisme et Théosophie." *Pan* 5 (July–Sept. 1912), 550–58.

Varlet, Théo. "Nouvelles Découvertes de Sir Electrod...." *Les Bandeaux d'Or*, 2d ser., fasc. 8 (1908), 174–82.

b. Secondary Sources

Balakian, Anna. "Apollinaire and the Modern Mind." *Yale French Studies* 2 (1949), 79–90.

Bates, Scott. *Guillaume Apollinaire*. Rev. ed. Boston: Twayne, 1989.

Bell, Ian F. A. *Critic as Scientist: The Modernist Poetics of Ezra Pound*. London: Methuen, 1981.

Bergman, Pär. *"Modernolatria" et "Simultaneità."* Studia Litterarum Upsaliensia 2. Stockholm: Bonniers, 1962.

Bohn, Willard. *The Aesthetics of Visual Poetry, 1914–1928*. Cambridge: Cambridge University Press, 1986.

———. "Thoughts That Join like Spokes: Pound's Image of Apollinaire." *Paideuma* 18 (Spring–Fall 1989), 129–45.

Boudar, Gilbert, and Pierre Caizergues. *Catalogue de la bibliothèque de Guillaume Apollinaire II*. Paris: Editions du Centre National de la Recherche Scientifique, 1987.

Boudar, Gilbert, and Michel Décaudin. *Catalogue de la bibliothèque de Guillaume Apollinaire*. Paris: Editions du Centre National de la Recherche Scientifique, 1983.

Clarke, Bruce. *Allegories of Writing: The Subject of Metamorphosis*. Albany: State University of New York Press, 1995.

Davenport, Guy. *The Geography of the Imagination*. San Francisco: North Point Press, 1981.

Donato, Eugenio. "The Museum's Furnace: Notes toward a Contextual Reading of *Bouvard and Pécuchet*." In *Textual Strategies: Perspectives in Post-Structuralist Criticism*, ed. Josué V. Harari, pp. 213–38. Ithaca: Cornell University Press, 1979.

Doolittle, James. "Hieroglyph and Emblem in Diderot's *Lettre sur les sourds et les muets*." *Diderot Studies* 2 (1952), 148–67.

Erkkila, Betsy. *Walt Whitman among the French: Poet and Myth*. Princeton: Princeton University Press, 1980.

Fletcher, Angus. *Allegory: The Theory of a Symbolic Mode*. Ithaca: Cornell University Press, 1964.

Kahn, Douglas, and Gregory Whitehead, eds. *Wireless Imagination: Sound, Radio, and the Avant-Garde*. Cambridge: MIT Press, 1992.

Mackworth, Cecily. *Guillaume Apollinaire and the Cubist Life*. New York: Horizon Press, 1963.

Meyer, Michael. *Strindberg*. London: Secker & Warburg, 1985.

Motte, Warren F., Jr. "Clinamen Redux." *Comparative Literature Studies* 23 (Winter 1986), 263–81.

Motte, Warren F., Jr., ed. and trans. *Oulipo: A Primer of Potential Literature*. Lincoln: University of Nebraska Press, 1986.

Nänny, Max. *Ezra Pound: Poetics for an Electric Age*. Bern: Francke Verlag, 1973.

Perloff, Marjorie. *The Futurist Moment: Avant-Garde, Avant Guerre, and the Language of Rupture*. Chicago: University of Chicago Press, 1986.

Schneidau, Herbert N. *Waking Giants: The Presence of the Past in Modernism*. Oxford: Oxford University Press, 1991.

Shattuck, Roger. "Apollinaire's Great Wheel." In *The Innocent*

Eye: On Modern Literature & the Arts, pp. 240–62. New York: Farrar Straus Giroux, 1984.

Steegmuller, Francis. *Apollinaire, Poet among the Painters* (1963). New York: Viking Penguin, 1986.

Wood, Douglas Kellogg. *Men against Time: Nicolas Berdyaev, T. S. Eliot, Aldous Huxley, & C. G. Jung*. Lawrence: University of Kansas Press, 1982.

2. Alfred Jarry

a. Writings

Jarry, Alfred. *Alfred Jarry: Oeuvres complètes*. 3 vols. Vol. 1, ed. Michel Arrivé. Vols. 2, 3, ed. Henri Bordillon et al. Paris: Gallimard, 1972–88.

———. *Gestes et opinions du docteur Faustroll, pataphysicien (roman néo-scientifique), suivi de Spéculations*. Paris: Eugène Fasquelle, 1911; Paris: Fasquelle Editeurs, 1955.

———. *Selected Works of Alfred Jarry*. Ed. Roger Shattuck and Simon Watson Taylor. New York: Grove Press, 1965.

———. *Le Surmâle: Roman moderne*. Paris: Charpentier, 1902. Trans. by Ralph Gladstone and Barbara Wright as *The Supermale* (New York: New Directions, 1977).

Jarry, Alfred [Dr. Faustroll]. "Commentaire pour servir à la construction pratique de la machine à explorer le temps." *Mercure de France* 29 (Feb. 1899), 387–96.

b. Secondary Sources

Beaumont, Keith. *Alfred Jarry: A Critical and Biographical Study*. New York: St. Martin's Press, 1984.

Behar, Henri, and Brunella Eruli, eds. *Jarry et Cie: Communications du Colloque International*. Tournées: L'Etoile-Absinthe, 1985.

Bordillon, Henri, ed. *Alfred Jarry*. Colloque de Cerisy, 1981. Paris: Pierre Belfond, 1985.

Carrouges, Michel. "Machines pataphysiques pour l'au-delà." *Les Etudes Philosophiques*, no. 1 (1985), 77–89.

Lie, S. "De Lord Kelvin à Jarry." *Cahiers du Collège de 'Pataphysique*, nos. 22–23 (1956), 111–14.

Petitfaux, G. "Des bulles de savon de Boys à l'as de Faustroll." *Cahiers du Collège de 'Pataphysique*, nos. 22–23 (1956), 45–49.

Shattuck, Roger, and Simon Watson Taylor, eds. *Evergreen Review* 4 (May–June 1960), 24–192. Issue devoted to the Collège de 'Pataphysique.

Stehlin, Catherine. "Jarry, le cours Bergson et la philosophie." *Europe* 59 (Mar.–Apr. 1981), 34–51.

Stillman, Linda Klieger. *Alfred Jarry*. Boston: Twayne, 1983.

———. "Machinations of Celibacy and Desire." *L'Esprit Créateur* 24 (Winter 1984), 20–35.

———. "Physics and Pataphysics: The Sources of *Faustroll*." *Kentucky Romance Quarterly* 26 (1979), 81–92.

3. Raymond Roussel

a. Writings

Roussel, Raymond. *How I Wrote Certain of My Books* (1935). Trans. Trevor Winkfield. New York: Sun, 1977.

———. *Impressions d'Afrique*. Paris: Librairie Lemerre, 1910; Paris: Jean-Jacques Pauvert, 1963. Trans. by Lindy Foord and Rayner Heppenstall as *Impressions of Africa* (Berkeley: University of California Press, 1967).

———. *Locus Solus*. Paris: Librairie Lemerre, 1914; Paris: Gallimard, 1963. Trans. by Rupert Copeland Cuningham as *Locus Solus* (Berkeley: University of California Press, 1970).

b. Secondary Sources

Amiot, Anne-Marie. "L'Idéologie rousselienne dans *Locus Solus*: Raymond Roussel et Camille Flammarion." In *Actes du 2e colloque de lexicologie politique, Sept. 15–20, 1980*, ed. Danielle Bonnaud-Lamotte, pp. 115–23. Paris: Librarie Klincksieck, 1982.

———. *Un Mythe moderne: "Impressions d'Afrique" de Raymond Roussel*. Archives de Lettres Modernes, no. 176. Paris: Minard, 1977.

Amiot, Anne-Marie, ed. *Raymond Roussel en gloire. Mélusine*, no. 6. Lausanne: L'Age d'Homme, 1984.

Angremy, Annie. "La Malle de Roussel: Du bric-à-brac au décryptage." *Revue de la Bibliothèque Nationale* 43 (Spring 1992), 37–49.

Ashberry, John. "Les Versions scéniques d'*Impressions d'Afrique* et de *Locus Solus. Bizarre*, no. 34–35 (1964), 19–30.

Caradec, François. "Images, visages, et voyages de Raymond Roussel." *Revue de la Bibliothèque Nationale* 43 (Spring 1992), 24–35.

———. *Vie de Raymond Roussel (1877–1933)*. Paris: Jean-Jacques Pauvert, 1972.

Ferry, Jean. *L'Afrique des impressions: Petit Guide pratique à l'usage du voyager*. Paris: Jean-Jacques Pauvert, 1967.

———. *Une Etude sur Raymond Roussel*. Paris: Arcanes, 1953.

Foucault, Michel. *Death and the Labyrinth: The World of Raymond Roussel* (1963). Trans. Charles Ruas. New York: Doubleday, 1986.

Goodman, Lanie. "Le Corps-Accord Rousselian: Machines à composer." *L'Esprit Créateur* 26 (Winter 1986), 48–59.

Heppenstall, Rayner. *Raymond Roussel: A Critical Study*. Berkeley: University of California Press, 1967.

Leiris, Michel. "Conception and Reality in the Work of Raymond Roussel." *Art & Literature*, no. 2 (Summer 1964), 12–26.

———. *Roussel l'ingénu*. Paris: Editions Fata Morgana, 1987.

Plottel, Jeanine Parisier. "Machines de langage: *Impressions d'Afrique* et *La Mariée mise à nu par ses célibataires, même*." In *Le Siècle éclaté 2: Théorie, tableau, texte de*

Jarry à Artaud, ed. Mary Ann Caws, pp. 13–23. Paris: Minard, 1978.

Ringger, Kurt. "Le Jeu des appareils et des mots chez Raymond Roussel." *Etudes Philosophiques*, no. 1 (1985), 91–100.

Tani, Masachika. "Le Mort et le temps: Raymond Roussel et Camille Flammarion." *Europe* 66 (Oct. 1988), 96–105.

4. Science Fiction

a. Contemporary Writings

Flammarion, Camille. *Stella*. Paris: Ernest Flammarion, 1897.

Pawlowski, Gaston de. *Voyage au pays de la quatrième dimension*. Paris: Eugène Fasquelle, 1912.

————. *Voyage au pays de la quatrième dimension*. Rev. ed. Paris: Eugène Fasquelle, 1923; Paris: Denoël, 1971.

Robida, A[lbert]. *Le Vingtième Siècle*. Paris: Montgredien, 1883.

————. *Le Vingtième Siècle: La Vie électrique*. Paris: Librairie Illustrée, 1890.

Villiers de l'Isle-Adam. *L'Eve future* (1886). Paris: Jean-Jacques Pauvert, 1960. Trans. Robert Martin Adams as *Tomorrow's Eve*. Urbana: University of Illinois Press, 1982.

Wells, H. G. *The Invisible Man*. London: C. A. Pearson, 1897.

————. *The World Set Free: A Story of Mankind* (1913). New York: E. P. Dutton, 1914.

b. Secondary Sources

Brun, Philippe, Preface to *Robida: Fantastique et science-fiction*. Paris: Pierre Horay, 1980.

Domino, Chistophe. "Villiers de l'Isle-Adam et Jarry: *L'Eve future* et *Le Surmâle*." In *Alfred Jarry*, ed. Henri Bordillon, pp. 85–101. Paris: Pierre Belfond, 1985.

Durr, Michael. "Jules Verne et l'électricité." In *La France des électriciens, 1880–1980*, ed. Fabienne Cardot, pp. 335–58. Paris: Presses Universitaires de France.

Fumaroli, Marc. "Histoire de la littérature et histoire de l'électricité." In *L'Electricité dans l'histoire: Problèmes et méthodes*, ed. Fabienne Cardot, pp. 225–36. Paris: Presses Universitaires de France, 1985.

Stillman, Linda. "Le Vivant et l'artificiel: Jarry, Villier de l'Isle Adam, Robida." In *Jarry et Cie: Communications du Colloque International*, ed. Henri Behar and Brunella Eruli, pp. 107–16. Tournées: L'Etoile Absinthe, 1985.

Indexes

Following the General Index is a separate *Large Glass* Index, indicated by "LG" in cross-references, which catalogues all components of the *Large Glass* (whether executed or not) as well as major themes in Duchamp's notes and in this book's interpretation of the *Glass*. Subjects that are not limited to the *Large Glass*, including all fields of science and technology, are listed in the General Index, with subheadings identifying pages relevant to the *Large Glass*.

General Index

351

Large Glass Index